Summary of Contents

Art in Theory
1648–1815
An Anthology of Changing Ideas

Edited by Charles Harrison, Paul Wood and Jason Gaiger

BLACKWELL
Publishers

Copyright © Blackwell Publishers Ltd, 2000
Introduction, apparatus, selection and arrangement copyright © Charles Harrison, Paul Wood and Jason Gaiger 2000

First published 2000
2 4 6 8 10 9 7 5 3 1

Blackwell Publishers Ltd
108 Cowley Road
Oxford OX4 1JF
UK

Blackwell Publishers Inc.
350 Main Street
Malden, Massachusetts 02148
USA

British Library Cataloguing in Publication Data
A CIP catalogue record for this book is available from the British Library.

Library of Congress Cataloging-in-Publication Data
Art in theory 1648–1815: an anthology of changing ideas/edited by Charles Harrison, Paul Wood, and Jason Gaiger.
 p. cm.
 Includes bibliographical references and index.
 ISBN 0-631-20063-0 (alk. paper) — ISBN 0-631-20064-9 (pb: alk. paper)
 1. Art, Modern—17th–18th centuries—Philosophy. 2. Art—Early works to 1800. I. Harrison, Charles, II. Wood, Paul. III. Gaiger, Jason.

N6420 .A78 2001
709′.03′2—dc21 00-034312

Typeset in 10/12pt Ehrhardt by Kolam Information Services Pvt. Ltd, Pondicherry, India
Printed in Great Britain by T.J. International, Padstow, Cornwall
This book is printed on acid-free paper

Contents

I Establishing the Place of Art

II The Profession of Art

V Nature and Human Nature

VI Romanticism

VII Observation and Tradition

Acknowledgements

In the task of selecting, tracing and compiling material for this anthology we have benefited greatly both from the work of those who have written on the art of the period, and from the advice and assistance of friends and colleagues at the Open University and elsewhere. Among those who have been particularly helpful are Robert Anderson, Emma Barker, Jay Bernstein, Jeroen Boomgaard, Michael Charlesworth, Anthony J. Coulson, Thomas Crow, Jo Dahn, Katerina Deligiorgi, Steve Edwards, Trish Evans, Michael Fried, Andrew Hemingway, Gillian Perry, Michael Rosenthal, Nicholas Walker, Linda Walsh, Roberta Wood and Hester Ysseling. We are grateful to Joel Snyder for research facilities provided for Charles Harrison at the University of Chicago, and to Katherine Long for help in tracing material there.

We have benefited greatly from the commitment of those who have translated material for this volume: Katerina Deligiorgi, Susan Halstead, Akane Kawakami, Christopher Miller, Jonathan Murphy, Nicholas Walker and Hester Ysseling.

Our thanks go to those copyright-holders who have given permission where we have needed to reproduce modern translations or edited versions of texts. We are also grateful to the Leverhulme Trust for the initial funding of Jason Gaiger's Research Fellowship at the Open University, and for the Research Committee of the University's Faculty of Arts for continuing to support the Fellowship through the period of production of the present volume. At Blackwell Publishers, Senior Commissioning Editor Andrew McNeillie responded positively to our proposal for a two-volume survey of the art theory of the early modern period, to accompany *Art in Theory 1900–1990*, originally published in 1992. Jackie Newman was responsible for tracing copyright-holders and for securing permissions. We would also like to record our gratitude to Jane Robertson, formerly of Blackwell Publishers, who guided the earliest stages of our work on the *Art in Theory* project.

J. G., C. H., P. W.

A Note on the Presentation and Editing of Texts

Where a published document was originally given a title, this has generally been used for the present publication, in single quotation marks. Titles of books are given in italics. Where a specific subtitled section of a document has been taken, this subtitle is used for the extract. The title of the whole work is then given in the introduction to that text. In the absence of original published titles we have given descriptive headings without quotation marks. The term 'from' preceding a title signifies that we have taken a specific extract or extracts from a longer text, without seeking to represent the argument of the whole. Otherwise texts are given in their entirety or are edited so as to indicate the argument of the whole.

It is the aim of this anthology that it should be wide-ranging. We have therefore preferred the course of including a greater number of texts, of which several must appear in abbreviated form, to the course of presenting a small number in their entirety. Texts have been variously edited to shorten them, to eliminate references which cannot be explained within the space available, and where necessary to preserve the flow of argument. We have provided information as to the sources for complete versions of all edited texts. We have also clearly marked where texts have been edited.

The following conventions have been used throughout. Points of suspension '...' are used to denote the omission of words or phrases within a sentence. Suspended points within square brackets '[...]' are used to denote omissions extending from a complete sentence to a paragraph or several short paragraphs. Asterisks '* * *' denote substantial omissions of more than one paragraph, and may denote exclusion of a complete subdivision of the original text. It should be noted that a paragraph may end thus [...], either if the last sentence of that paragraph is omitted or if the following paragraph is omitted. A paragraph may also start thus [...] if one or more sentences at the beginning of that paragraph have been omitted, or if a previous paragraph has been omitted.

Notes and references have only been included where we judged them necessary to the text as printed. We have generally avoided the insertion of editorial footnotes, but have supplied essential references in the introductions to individual texts.

We have corrected typographical errors and errors of transcription where we have discovered them in the anthologized texts, but otherwise we have left idiosyncrasies of punctuation, spelling and style unchanged.

General Introduction

The aim of this book is to provide students of art, art history and aesthetics, as well as the interested general reader, with a substantial and representative collection of texts, drawn from a wide variety of sources from the mid-seventeenth century to the early nineteenth. As the third of a series, this volume completes a long project begun with *Art in Theory 1900–1990* and continued with *Art in Theory 1815–1900*. The result is a comprehensive overview of the art theory of a broadly defined modern period. *Art in Theory 1648–1815* is similar to its two companion volumes both in extent and in the principles of selection and organization employed. It continues our enterprise to improve access to the written materials associated with the development of art, both by rendering a broad selection more generally available for study and by providing information about original editions and about relevant complementary publications. While we have included those texts that are deservedly canonical, we have also aimed to improve understanding of the range and diversity of artistic theory during the period surveyed. Many of the relevant documents are difficult to trace without the resources of a specialized library, and several documents are reprinted here for the first time in a century or more. There are also many important texts that have not previously been published in English. The present volume includes original translations of material from French, German, Italian, Dutch and Latin sources, amounting to approximately a third of the contents.

The Extent of the Modern

Art in Theory 1900–1990 was motivated by the need for an up-to-date anthology of twentieth-century documents at a time when the end of the modern was being widely announced. When we originally undertook to compile it, we had no plans for further publications. A provisional proposal for a single additional volume was developed in response to two complementary promptings. One was the warm welcome extended to our first publication. The other was a growing conviction that most proclamations of the demise of the modern entailed unexamined assumptions about its historical character and its duration. If these assumptions were to be adequately reviewed, it would be necessary to consider relevant material from well before the beginning of the twentieth century. Accordingly, we envisaged a companion

volume extending back from the close of the nineteenth century to the last decades of the eighteenth, which is as early as modern art historians have generally been wont to look.

We aimed to preface this volume with a short selection of documents from the previous hundred years or so. These were to represent the practical and theoretical materials from which the modern had emerged. Two mutually reinforcing factors led us to revise this plan, however. It turned out to be very difficult to restrict the extent of the proposed preliminary section. And we found ourselves faced with an extra-ordinary wealth of potentially relevant material from the late eighteenth and nine-teenth centuries, much of it now difficult of access or as yet untranslated into English. It seemed that if we were properly to trace the theoretical development of the modern in art, we would need to accord due proportional weight to its earlier phases. We were also obliged to recognize that the artistic culture of the modern had had a longer and a richer life than we had at first believed. Taken together, these factors led us to conclude that we should consider not one but two new volumes to cover the earlier period.

Art in Theory 1815–1900 was accordingly published in 1998, representing a first division of material from this extended period. The present volume, covering the earlier phase, was from the start planned to follow as its complement. The end of the Napoleonic Wars provides as convenient a point of termination for our present period as it did previously for a commencement. In general and in the long term, the settlements that followed the battle of Waterloo were such as either to enable or to recognize government in the interests of the capitalist middle class, at a time when the powers of that class were sustained and increased among the countries of the West by the spread of industrialization. But as we acknowledged in our previous volume, an account of the modern that *starts* circa 1815 assumes a connection between the emergence of the bourgeoisie and the development of artistic modernism that must have its roots in the previous century. Other relevant issues are also left in need of examination, not least those which concern the identification of modernism with the currency of the Enlightenment project. If we were not to begin at some arbitrarily chosen date, it seemed that we could fix no *later* starting-point for the entire *Art in Theory* project as a whole than the middle of the seventeenth century. Accordingly we have taken as our marker for the commencement of the present volume that critical twelve-month period which brought the foundation of the French Academy in 1648 into a near coincidence with the end of the Thirty Years War, the achievement of independence by the Dutch Republic, and the execution of the English king.

Some of our texts pre-date 1648 by a few years. But we feel that all of these have something to contribute to the picture we are presenting. Thus, to take an example, while Franciscus Junius' *The Painting of the Ancients* first appeared a decade before the foundation of the Academy, we have felt able to include extracts because the text offers an unparalleled summation of the state of knowledge of the art of Antiquity. The legacy of Antiquity was itself of unparalleled significance for debates about the way forward to an adequately 'modern' seventeenth-century art. The materials of history do not fit into clean compartments. That said, whatever the actual dates of a few of our anthologized texts, our conceptual starting-point is the foundation of the

French Academy; just as our conceptual finishing point for this first phase of the art theory of the modern period is the end of the Napoleonic Wars.

We anticipate some deprecatory comment from those already well-versed in the art and art theory of the seventeenth and eighteenth centuries, along the lines that it takes an ignorant modernist to be surprised by the wealth of material from earlier periods. We are happy to acknowledge that we have been engaged in an absorbing process of self-education. However, it is of the essence of that process, and of the *Art in Theory* project as a whole, that we have worked with the idea of a modern art always in mind. We have been at least as concerned to enrich our readers' understanding of the present as to provide adequate reference material for the study of earlier periods. Overall, our aim has been to deepen the historical ground from which significant issues can be seen to have emerged, and to enlarge the problem-field on which evaluative judgements are made.

We remain aware of the dangers of anachronism. Yet while our selection of texts has never been entirely determined by considerations of their relevance to subsequent practice, we have felt it legitimate in our editorial matter to draw attention to features of historical debates which were to become significant for the work of later writers and artists. Again, we offer an example. There is nothing particularly modern, let alone 'modernist', about the recipes for making a painting published by the Spaniards Pacheco and Hidalgo. Yet they offer a fascinating glimpse into the sheer physical business of art-making: an aspect of art which tended to be sidelined at the time, the better to defend the case for painting as a liberal – and hence gentlemanly – pursuit; an aspect which it remains important to stress now, even if the material in question is video-tape rather than pigeon-droppings. We have always been less concerned to dig up the past for its own sake than to present an interesting archaeology of the modern. After all, if 300-year-old art theory is not of *some* relevance to our concerns in the here and now, it must appear a prime candidate for being consigned to what Marx called 'the gnawing criticism of the mice'.

One clear advantage in commencing a study of the modern with the theoretical writings of the mid-seventeenth century is that it serves to remind us how deeply the very concept of the modern is implicated in a contrast with the ancient. It thus becomes easier to understand why the classical should for so long have retained its powerful fascination, both as a positive repository of authority and as a negative image of resistance to change. The classical heritage received its first wholesale rebuff from the Romantic generation at the turn into the nineteenth century. Thereafter, the avant-garde tended to set its concern with modernity against a sense of the classical-as-moribund. But by the end of the century, avant-gardists such as Cézanne were re-engaging with the classical precisely as a way of advancing their modernism. So it continued into the twentieth century, with figures as different as Jeanneret (Le Corbusier) and De Chirico explicitly drawing on the legacy of the past, while others such as Marinetti were still sufficiently exercised by Antiquity to want to smash it to bits. Even in the allegedly post-modern period it is not unusual to find artists drawing in various ways on the imagery and narratives of Classicism, particularly in countries such as Italy which possess a deeply rooted classical tradition.

It is also significant that while the Academies served to maintain the prestige of classical art and culture, they also acted to focus debate about the different

requirements of the modern. While they generally paid due respect both to the heritage of Christian art and to the authority of the established Churches, the Academies were also fundamentally secular institutions, within which religious subjects generally had to jostle for a place along with the rest. We are reminded that in the establishment of distinctly modern theories of art, the process of secularization is a further significant strand, gaining in force throughout the eighteenth century. The type of criticism represented in the writing of Denis Diderot and his associates would be unthinkable in a culture still dependent on Christian doctrine for the establishment of its highest values. Indeed, the search for substitutes for religious values and functions is one of the impelling factors in the art theory of the later eighteenth century. And this search in turn needs to be understood in relation to the development of new social orders and market structures, within which art would have to establish its position in order to survive.

In *Art in Theory 1815–1900* we were at pains on the one hand to emphasize the relation between emergent modernism and the rise of the Western bourgeoisie, and on the other to stress art's relative independence from values associated with the market as such. In surveying the theory of the period 1648–1815, we confront a world in which many of these concepts are far less securely established or only emerging into currency. Thus, even the notion of the West was far less clearly defined at the beginning of this period than it was by the close, while its modern history had yet to be clearly detached from its roots in the ancient world. Nevertheless it needs to be acknowledged that there were powerful negative factors at work in defining the West from the start. The very manner in which the writers of the seventeenth century laid claim to the legacy of the Ancients served both to rule out alternative claims to that legacy, from the cultures of the Middle East among others, and to eliminate from significant consideration those contemporary cultures, particularly in the Far East, that were untouched by the classical heritage. The more the 'known' world enlarged during the eighteenth century, the more strongly a continuous Western culture came to be identified with civilization itself. In the margins of seventeenth- and eighteenth-century thought on the arts, we often encounter as an interesting supplementary theme the question of the relation of the Western canon to the visual cultures of the 'rest' of the world – the 'rest', that is, both geographically and historically speaking. A sense of the universality of taste or truth or value often sits uneasily with the acknowledgement of a certain cultural relativism. Our authors frequently display a willingness, deeply uncongenial to the contemporary sensibility, to trade in uncomplicated oppositions of civilization and barbarism, and in assumptions about the naturalness of gender and class distinctions. And yet they are equally often involved in sophisticated consideration of the competing claims of nature and culture, of the grounds of judgement either in experience or in the structure of our minds, and of the possibility that value in art might be somehow internally given, rather than being the result of mere fidelity to some external standard.

Terms of reference for social classes provide further examples of relative instability in central concepts. To speak with the late seventeenth century in mind of a middle class, or *a fortiori* of a bourgeoisie, is to conceive a social constituency still largely in the process of emergence, with a much less secure relationship to the very idea of culture, let alone of art, than it was to acquire by the end of the ensuing century. In

much of the material anthologized in the present volume, the practical possibility of an ambitious art remains inextricably associated with the interests of aristocracy, if not of royalty. The struggle to dissolve this association, we suggest, was a further condition of the emergence of a modern art, and one to which many of our texts bear vivid witness. Similarly, it was not until the very end of the period now under review that the idea of the aesthetic emerged clearly in its modern – or modernist – form, as a value to be set against the monetary or the utilitarian.

The Selection of Texts

As regards our principles of selection we repeat a point asserted in the introduction to *Art in Theory 1900–1990*: 'It is art we are concerned with, and the theory it is made of; not the culture it is made of, nor the theory of the culture.' Our attention has been primarily concentrated upon the practices of painting and sculpture as fine arts, and we have considered theory as relevant *prima facie* where it can be clearly connected to the pursuit of these practices or to the business of their critical reconsideration. We have also devoted considerable space in the present volume to the emergence and development of art criticism as a specific literary practice bearing upon the practice of art.

This conception of our primary concern carries with it an implication for our book relative to the concerns of much contemporary writing in the fields of art and cultural history. Much of the most influential work of the recent past has consciously sought to blur the boundaries of art history and cultural studies, or to expand the purview of the former to include issues hitherto deemed the proper concern of the latter. Numerous books and exhibitions have featured an interest in, say, science or the body, in sexuality or surveillance, or have issued from a redirected emphasis on the so-called 'minor' arts as important sites of women's creativity. The list of such revisions is endless. They provide recent historical writing with much of its distinctive flavour, and with the grounds of its claims to interest and innovation. But in compiling an anthology of those ideas out of which art has been made in the modern period, we have had to draw our boundaries somewhere. Thus, the writings of the Marquis de Sade may have been influential upon the artwork of, say, the mid-twentieth-century Surrealists, or upon some contemporary feminist work. But as far as we are able to establish, it was neither influential upon the art of his contemporaries nor in any way responsive to it. The logbook of Captain Cook's voyages to the southern continent may have much to tell us about Western men's perceptions of other cultures in the 1760s and 1770s, while the modern art of the Pacific area may in turn have much to say about the impact of European colonization in the aftermath of Cook's and others' voyages of exploration. There is no doubt that such texts, as well as related accounts and books of drawings and so forth were of significance to European civilization and to its sense of itself. But again, we have felt that the connections to art practice per se are too tenuous to merit the inclusion of such texts in our collection. For the most part, we have confined ourselves to texts and debates which were either responses to, or in some relatively direct manner influential upon, the practice of the arts in the period with which we are concerned. There are grey areas. Sometimes we have included texts to which these criteria may not be

thought to apply. As our guiding principle, however, we have always aimed to represent the ideas that bore upon the making of art, and we have looked for those texts that would enrich and animate our account of them. In the end we have tried to let that be the qualification, in all its historical ebb and flow, which decides our various inclusions and exclusions.

As with our two previous volumes, the process of selection of material started with a review of the work done by our predecessors to establish a body of relevant texts. Even in cases where we have decided not to duplicate the choice of any specific material, we have learned from previous surveys of the field. We have had reason again to be grateful for the extensive publications of Elizabeth Holt, in particular to the third volume of her *Documentary History of Art: From the Classicists to the Impressionists*, first published in 1966, and to her subsequent collection *The Triumph of Art for the Public 1785–1848* (1970). We are indebted to the two volumes of *Neo-Classicism and Romanticism*, edited by Lorenz Eitner, and to *Italian and Spanish Art 1600–1750*, edited by Robert Engass and Jonathan Brown, all first published in 1970 in the series *Sources and Documents*. Joshua Taylor's *Nineteenth Century Theories of Art* (1987) has also been a useful guide.

Invaluable as these various resources have been, we have been obliged both to look into areas of theory opened up by more recent publications, and to take account of those changes in the interests of art history which have led to a broadening of the very field of theory itself. Viewed through the legacy of modernism, the place of art in theory becomes ever harder to fix with any security. It is a consequence of the exorbitation of theory itself that, when one seeks to distinguish those theoretical considerations that are relevant to the production of art from those that are not, there are relatively few decisions that the art historian can still make *a priori* on secure methodological grounds. In the face of this circumstance, rather than seeking to reimpose an overview on the material surveyed, we have sought to profit from the opportunities for revision and expansion. As with both *Art in Theory 1900–1990* and *Art in Theory 1815–1900*, we have been more concerned to represent a body of ideas, of arguments and of concerns than to assemble a corpus of artist-authors or to do full justice to specific careers. We have intended no *a priori* distinction between authors. A text is a text whether the writer be a practising artist, a critic, a philosopher, or a functionary in a relevant institution. In general we have felt justified in positively pursuing such themes as seemed both to emerge from the material and to resonate with those concerns that may be identified with the longer development of a modern art. Once again, we have done what we can to strengthen the otherwise poor representation of women's voices within the established literature of art theory. But once again we have stopped short of retrospectively redressing those powers and mechanisms by which women were deprived of opportunity or otherwise silenced at the time.

In one significant respect, the problem of selection of texts has increased the earlier we have looked into the larger period surveyed by the *Art in Theory* project. Among the twentieth-century documents that come up for the count, there are many manifestos, letters, artists' statements and critical reviews. Of the items included in the present volume, however, very few presented themselves as complete texts capable of being anthologized without reduction. The typical seventeenth-century

treatise is a substantial work in several sections; in the later eighteenth century a Salon review might be a substantial book (Diderot's *Salon of 1767* ran to some 400 pages); an essay in aesthetics might run to several volumes. Faced with such quantities, we have hoped to reconcile two related though not always identical aims: to provide a representative selection of some relevance to a continuing body of concerns or to the wider development of art; and to interest the reader in the ideas of the author concerned. We are aware that some readers will be disappointed to find relatively few texts printed in their entirety. We hope that they will take consolation from the sheer range and variety of our selection. We have attempted to compensate for the necessities of excerpting and editing, on the one hand by providing careful indications of any excisions, and on the other by supplying full bibliographical information concerning dates and locations of original publications and, where these differ, of editions consulted.

Principles of Organization

The organization of material for this book has been the subject of a continuing conversation between us over the period of its production. This conversation was begun by Charles Harrison and Paul Wood in work on *Art in Theory 1900–1990* and was joined by Jason Gaiger at an early stage of work on *Art in Theory 1815–1900*. Argument among us has continually focused on the division of material into sections and subsections. At the heart of our project there has thus been a persistently discursive and dialectical process. Respecting the interests of a larger history, we have attempted to group the material into broad chronological divisions, but we have often had to reconsider what seemed like secure forms of periodization when the currency of theoretical debates proved these to be inappropriate. On the other hand, we have tried to recognize the tendency of the material to cluster about certain themes and issues, but have sometimes had to recognize that the significance of an aesthetic issue changes when the historical context of debate has shifted beyond a certain limit.

The titles of our sections and subsections represent the fruits of this process, in the form of topics and concepts. We have divided the material into seven broadly chronological sections. These contain the cross-currents of debate as to the role and concerns of art. Each section is introduced with an essay outlining major practical developments and theoretical concerns during the relevant period and, where appropriate, relating these to the wider political and economic forces at work in the history of the time. Within each of these sections texts are then grouped under thematic subheadings. Within each subheading the arrangement is generally chronological – the exceptions being where we have grouped a number of texts under a common author, or where we have meant to preserve a sequence of debate or a geographical connection. Each individual text is then provided with a brief introduction, specifying the original occasion of its publication and, where relevant, explaining its connection to contemporary events or controversies. A given text may thus be read for its independent content, as a moment in the development of a specific body of argument, or as a possible instance of a larger tendency or body of concerns within a broad historical period. Our organization of material intentionally reflects the

interests of a retrospective regard. But we hope that the categories we have devised are sufficiently open to encourage rather than to inhibit the exercise of historical imagination.

Finally, we should reiterate a point made in respect of the two previous volumes of *Art in Theory*. We have aimed to be responsive to the demands of curricula and of modern developments in theory and in art-historical work. But the agenda for this book has nevertheless been largely determined by a specific body of practical work to which nothing can now be added except through rediscovery: those actual paintings and sculptures of the period that constituted the practical outcomes of artists' aims and ideas, that stimulated the production of critical theories, and that served to illustrate debates on aesthetic and cultural matters. In the end, it is this absent resource that serves as an organizing principle for the material in the pages that follow. Like its companions, this anthology will be of greatest benefit to those readers who treat it not simply as a resource for the study of art history, but as an accompaniment to the first-hand experience of works of art.

Jason Gaiger
Charles Harrison
Paul Wood
March 2000

Part I
Establishing the Place of Art

I
Introduction

On 20 January 1648 a petition was delivered to Louis XIV requesting the establishment of a Royal Academy of Painting and Sculpture (IB4). Just ten days later the Royal Academy held its founding meeting and drew up a series of statutes and regulations which officially confirmed its status as a professional association dedicated to the pursuit of 'virtue' (IB5). The dignity of painting and sculpture as liberal arts was to be upheld through the emulation of the great models bequeathed by the Renaissance and Antiquity, and by dissociating the work of the Academy from the 'abject trades' and merely artisanal activities pursued by the guilds and corporations. Prominent among the tasks laid before the Académie Royale de Peinture et de Sculpture was the glorification of the French monarch and the visible projection of his achievements. Indeed, the foundation of the Royal Academy has become inextricably associated with the rise of absolutism and with the political ambitions of the 'Sun King'.

Yet when the court artists presented their petition, Louis XIV was just 10 years old and France was wracked by the Fronde, a series of civil wars which came close to toppling the regency of Anne of Austria and her first minister, Cardinal Jules Mazarin. Within the space of a year the Royal Household was forced to flee Paris for Rueil and in 1651 Mazarin was sent into exile. It was not until 1652, when the Fronde was finally brought under control, that the Academy succeeded in obtaining the registration of its privileges by the French Parliament. It would take another twenty years of financial and political struggle and the personal intervention of Jean-Baptiste Colbert, the most powerful of Louis XIV's ministers, before the Academy could defeat the challenge of the guilds and establish exclusive control over the training of artists and the distribution of commissions.

The first half of the seventeenth century has been termed an 'age of crisis' in reference to the violent upheavals which occurred across the whole of Europe. At the same time as the Fronde uprisings in France, England was suffering the final convulsions of a lengthy civil war between the armies of the king and the defenders of Parliament. In 1649 the failed absolutist Charles I was to be beheaded in London. Art and politics often seem to proceed in different worlds. But when those worlds touch, the flash can illuminate the real conditions of both: blind history finds meaning in an image; 'high' art drags its feet in the mud. In a scenario heavy with symbolism for the artistic advocates of absolute monarchy, Cromwell had Charles walk to his execution through the very room which Rubens, the 'modern Apelles', had decorated with resounding allegories of his father's royal magnificence. *Ars longa, vita brevis*

indeed. Across central Europe, order was only just being restored after thirty years of conflict, with the signing of the Treaty of Westphalia. The Thirty Years War had started in 1618 with upheavals in the Austrian monarchy but had quickly spread to the Holy Roman Empire, drawing in practically the whole of Europe, including the Netherlands, Sweden, Poland, Spain and France. The wars were a result not only of the increasing political and territorial fragility of the old Holy Roman Empire but also of the enormous changes brought about by the Reformation. Two separate struggles intersected and reinforced one another. The first involved a political contest between the ambitions of the Emperor and the claims of the princes who strove to preserve the independence of their various territories. The second was a religious conflict between the Catholicizing zeal of the Emperor and the resistance of Lutheran and Calvinist communities to the forces of the Counter-Reformation.

Large swathes of central Europe were devastated by the war. The destruction of towns and the scorched-earth policy of retreating armies compounded the losses suffered in the actual fighting. In certain regions the population fell to less than a third of its pre-war level. A general stagnation of trade and the loss of consecutive harvests forced many peasants into serfdom at the hands of local lords, and in many towns long-standing practices of self-government were eradicated.

The deeper causes of the crisis in Europe have been much debated. The expansion of absolutism seems to have been both a consequence and a condition of the instability. The policy of increasing centralization and the extension of administrative control pursued by the monarchs of Austria, Spain, England, France, Prussia, Sweden and Russia was fiercely resisted by the older aristocratic families, who sought to sustain their ancient privileges. The growing burden of taxation required to fund expansionist ambitions, combined with the removal of traditional privileges and rights of trade, led to violent protest and rebellion both by impoverished peasants and by the mercantile classes. On the other hand, the damage inflicted by internal conflict and the risk of a complete breakdown of social order also seemed to provide justification for absolutist control. Throughout the second half of the seventeenth century most of Europe saw the growth of monarchical power and the ever more efficient employment of the apparatus of the state.

The important exceptions were England and the Dutch Republic. Whereas the succession of the monarchy remained unbroken in France, the resistance of the English Parliament to the absolutist ambitions of Charles I led to an eleven-year 'Commonwealth'. In 1660 the restoration of Charles II brought stability of a kind, though it was experienced as a tragic defeat by those who had invested their hopes of political and religious freedom in the idea of the English Revolution. Then in 1685 the country was once again thrown into upheaval by the accession of James II. The new king was determined to enforce the Catholicism and absolutism he had learnt to admire in France and Spain during his years of exile. He encountered fierce opposition, however, and this time the opposition's success was permanent. Absolutism was extirpated from England by the 'Glorious Revolution' of 1688, when James II was replaced by William of Orange, Stadholder of Holland, who was both his son-in-law and his nephew. William's acceptance of the Revolution Settlement and his signing of the Bill of Rights enshrined the powers of Parliament and of property-owners and effectively restricted the authority of the Crown.

The consequences of this liberty were far from uniformly positive for the arts. Given the relative weakness of the English monarchy, there was no question of matching the great displays of patronage and power produced by its European rivals. Louis XIV built the palace of Versailles and funded the vast decorative schemes of Charles Le Brun. No major new palace was to be brought to completion by the Crown in England before the nineteenth century. Charles I was the last great royal patron of the arts, and his collection of paintings was dispersed after his execution. During the Puritan regime of Oliver Cromwell the visual arts were associated with monarchical decadence and with Catholicism (see ID4). The proscription of visual images upheld by some sections of the Protestant Church was in general motivated by criticism of the abuses of ecclesiastical authority. More positively, it was also fuelled by belief in the validity of the Second Commandment ('Thou shalt not make unto thee any graven image or any likeness of anything that is in heaven above, or that is in the earth beneath, or that is in the water under the earth'). In predominantly Protestant countries such as England and Holland, not to mention the new colonies in America, there was widespread acceptance that priority should be accorded to scripture, by means of which each individual would be allowed unmediated access to the word of God (ID8). Powerful arguments were mounted against the harnessing of art as a tool either for personal aggrandizement or for persuasion. Though he does not specifically address the visual arts, the True Leveller Gerrard Winstanley associates the imagination with all that is false, idle and misleading in human consciousness, and with the potential corruption of moral virtue (ID4). Writing from a very different perspective, Horace Walpole was later to observe, 'The arts were, in a manner, expelled with the royal family from Britain.' It is certainly true that the political and religious climate of the English Commonwealth served for some while to depress those kinds of painting and sculpture that could be connected to the legacy of classical and Renaissance art. In 1685 William Aglionby (IA5) lamented England's failure to produce 'an Historical Painter, Native of our own Soyl'.

The United Provinces, a confederation of republics, had been federalist in structure since the Union of Utrecht in 1579, but in 1648 the Dutch Republic finally obtained its independence from Spanish rule. At the mid-century it was the most densely populated country in Europe, Italian city-states apart, with more than half its population living in towns. Success as a commercial and trading centre and an unusual degree of freedom and tolerance accorded to its citizens led to what has become known as the Golden Age of Dutch culture. Despite waves of iconoclasm during the anti-Catholic wars, the visual arts flourished in Protestant Holland. But they did so in a distinctive fashion. Unlike the classically dominated traditions of the Catholic courts in Italy, France and elsewhere, the tendency of Dutch painting was to eschew idealization and instead to maintain an apparent focus on the mundane realities of contemporary bourgeois life. In this unusual concern with the conditions of its own modernity, the art of seventeenth-century Holland seems sometimes like a salient of the present, isolated in an otherwise alien past. As a counter to this impression, however, it may be observed that Dutch paintings were often imbued, through the use of allegory or emblems, with a spiritual and religious content that would have been readily comprehensible to their intended public at the time.

An astonishing quantity of paintings was produced in Holland to satisfy the demands of an expanding middle class. Collections of pictures between 100 and 250 in number are not exceptional in the surviving inventories of wealthy households. One effect of the Dutch embrace of the quotidian, however, was a relative lack of concern with the classics; and one effect of *that* was an equal indifference to high-level theorizations of the place of art relative to poetry and the rest of the classical canon. It seems there was no attempt during the short-lived Golden Age in Holland to produce a sustained body of artistic theory such as emerged from Italy or France. The legacy of the Ancients was as much a part of the consciousness of educated Dutch writers as of other Europeans of the mid-seventeenth century, but there remain few contemporary treatises on Dutch art (see, however, IE4, IE7).

England and Holland were exceptions to the general rule. But whatever the situation in the political and economic spheres, Protestant states seemed to match or even to exceed the dynamism of their Catholic rivals. The second half of the seventeenth century was marked by a shift in the *cultural* leadership of Europe from Italy to France. Italy still enjoyed enormous cultural prestige (see, for example, IB7 and IC3) but the rise of France as a continental power enabled Louis XIV and his ministers to provide unrivalled conditions for the expansion of the arts. The Académie Royale was a crucial instrument of this expansion. Given rivalry with the existing guild system, if the new academic artist was to convince as a Learned Gentleman, some distance had to be established between himself and the mere artisan. As might be expected under these conditions, such theoretical justification as accompanied the establishment and early development of the Académie Royale was intentionally distinct from those kinds of writing about art that were concerned principally with the transmission of practical knowledge and skills. Edward Norgate's *Miniatura or the Art of Limning* offers a vivid example of the latter type. Originally composed in 1627–8 and substantially revised in 1648, it contained detailed advice on the preparing and grinding of colours, on the use of binding media and on the preparation of surfaces (IE1). Other treatises written in France, Spain, Portugal and the Netherlands provided guidance in matters such as perspective, composition, the methods and techniques for achieving different effects and the employment of appropriate iconography (IE4–9). These kinds of text tell us a great deal about the actual practice of painting at the beginning of the early modern period and reveal what an arduous, labour-intensive business it was. This was not, however, an aspect of art which the Académie Royale was keen to emphasize in its theoretical deliberations.

In the transition of artistic initiative from Italy to France the key figure was the painter Nicolas Poussin. His standing as the 'learned painter' par excellence was a powerful motivating force to the new school of French painting (IB1–3). Though Poussin was born in France and though he sustained an important network of French patrons, he spent most of his career in Rome, where he assimilated the achievements of the Italian Renaissance and developed a new style of austere classicism. His life and his art alike were regularly cited as models to be followed by aspiring artists. In the 'Conferences' initiated by the French Royal Academy in 1667 canonical works of art were brought before the assembly of academicians so that their technique and underlying principles might be studied and demonstrated. The subjects of the first seven conferences were a cast of the Antique statue of *Laocöon*, one work each by

Titian and Veronese, and two works each by Raphael and Poussin (IB9–13). Among those thus dignified, Poussin was the only living artist.

Important changes within the Royal Academy itself may be measured in terms of developments in the role and character of its conferences. Under Félibien's editorship, the publication of the first series in 1667 reflected animated debate between academy members. However, the 'Table of Precepts' published by Henri Testelin in 1680 distilled academic doctrine into a system whose fixed and regulative structure was intentionally both impervious to challenge and readily assimilable by aspiring artists (IB15). The Academy had originally been founded in the name of artistic freedom in opposition to the restrictive practices of the guilds. But under the guiding hand of Jean-Baptiste Colbert it was indeed incorporated into the absolutist project. As an efficiently administered medium of regulation and royal patronage, it served increasingly to extend state control over the arts.

Seventeenth-century France inherited from Italy both a profound admiration for Greek and Latin arts and letters, and its corollary: controversy over the respective merits of the Ancients and Moderns. Thus while the achievements of Antiquity were taken to be paradigms of perfection, whose imitation offered the only possibility for future greatness in the arts, towards the end of the century these assumptions were subject to challenge. The resulting debate became known in France as the *Querelle des anciens et des modernes* (IA6–8). The quarrel was sparked at a meeting of the Académie Française in 1687, when Charles Perrault read a poem entitled 'The Century of Louis the Great'. A number of those present, including the poet and critic Nicolas Boileau, were scandalized by Perrault's comparison of the reign of Louis XIV with the Augustan age in Rome:

> La belle Antiquité fut toujours venerable;
> Mais je ne crus jamais qu'elle fust adorable.
> Je voy les Anciens sans plier les genoux,
> Ils sont grands, il est vray, mais hommes, commes nous;
> Et l'on peut comparer sans craindre d'estre injuste,
> Le Siecle de Louis au beau Siecle d'Auguste.

[Beautiful Antiquity has always been an object of veneration / but I do not believe that it has ever been worthy of adoration. / I look upon the Ancients without bending the knee; / they were great it is true, but they were men just like us; / without fear of being unjust we may compare / the century of Louis with the century of Augustus.]

Whilst belief in the political greatness of France undoubtedly contributed to the growing confidence of the moderns, the deeper source of the conflict is to be traced back to the scientific revolution of the sixteenth and seventeenth centuries. Many of the fundamental conceptions which dominated the medieval view of the world had been inherited from Antiquity, above all, from the ideas of the Greek philosopher Aristotle (384–322 BC). When these long-standing ideas were challenged by the work of figures such as Copernicus, Kepler, Bacon, Galileo, Descartes and Newton, many began to question whether in the domain of science the moderns had not indeed surpassed the Ancients. The methods of inductive reasoning, of experimentation and of systematic observation of natural phenomena offered a possibility of progress in

understanding the natural world which far outstripped the achievements of the Ancients. This, in turn, raised the question of whether there had been an unequal development in different domains. Some contributors to the debate argued that whereas the Moderns had outstripped the Ancients in the field of science, the Ancients remained superior in the domain of art. Comparison of the different levels of achievement led to a clear distinction being made for the first time between the arts and sciences. However, there was also a great deal that was held in common between the two sides in the dispute. All of the participants agreed that the goal of art was the ideal imitation of nature, that great art transcended time and that it was underpinned by universal values: beliefs which were to be increasingly questioned during the period covered by the present anthology.

One of the principal obstacles to the cult of Antiquity in the visual arts was the lack of any surviving manual of classical art theory. Whereas there were numerous treatises on rhetoric and poetry, there was no surviving work on painting and sculpture which could compare with the example of Horace's *Ars poetica* [The Art of Poetry]. An early attempt to rectify this situation was made by Franciscus Junius with his *De Pictura Veterum*, originally published in Latin in 1637 and subsequently translated by the author as *The Painting of the Ancients*. This provided a compilation of quotations gleaned from a wide variety of classical sources and woven into a continuous text (IA1). A further and more concerted attempt to make good this absence was made by Charles-Alphonse du Fresnoy. His *De Arte Graphica* [The Art of Painting] was a Latin poem, consciously modelled on Horace's example, through which he sought to give concentrated expression to the available wisdom on the practice of painting (IC4). In the mid-seventeenth century the prestige attached to Antiquity was acknowledged throughout Europe, even in the Low Countries (see IA2, IA4).

At the heart of the *doctrine classique* lay the conviction that reason was the instrument both of artistic creativity and of rational reflection. The true imitation of nature demanded that the artist not merely copy the external features presented by the natural world, but also penetrate through to the essential. The production of a work of art is guided by a set of eternally valid rules whose original apprehension is owed to the Ancients, but whose enduring validity is authorized by reason itself. In France, the dominance of rationalism and classicism resulted in a significant counter-tendency which emphasized the importance of those features of the work of art which seemed to escape determination by rules: the *je ne sais quoi* and the quality of 'grace' (ID6 and 7). Ironically, it is these minority positions which most seem to prefigure later developments in the evolution of modern art. In some respects, the story of modernism is a story of the move of subjectivity and sensibility from the margin to the centre of the discourse of art. It is as though, over a long period, rule-breaking rather than rule-following becomes a new rule in itself. The emergence of an alternative conception of the role of the artist, placing emphasis on the discriminatory capacities of the individual subject, can be traced back to the writings of the Spaniard, Baltasar Gracián (ID1 and 2). Though primarily concerned with the problem of right action in courtly and political life, Gracián placed a new emphasis on the concept of 'taste' and the *je ne sais quoi*. Since right action is grounded in the correct judgement of particular cases, an important role is accorded to the individual's own responses. The priority given to the role of feeling or sentiment

contributed to the formation of an aesthetic of *délicatesse* or individual sensitivity. Under the subsequent impact of empiricist philosophy in the first quarter of the eighteenth century, this tendency was to issue in a sustained challenge to rationalism (see section IIB).

Within the French Royal Academy itself a significant challenge rose from the so-called partisans of colour, who used a long-standing debate over the relative priority of *disegno* and *colore* to contest the authority of its leading figures (see IC4–5 and IC7–10). In the official doctrine of the Academy the priority of design was asserted to uphold the status of painting as a liberal art against the rival institution of the guilds. Line was associated with that part of painting which involved 'invention' and the production of an 'idea'. It showed that the artist was working with his mind or intellect rather than merely with his hands. By contrast, colour was associated with the manual task of grinding pigments and staining cloths, and was said to appeal primarily to the senses rather than to the mind. So closely interlinked were the pedagogical, theoretical and political functions of the Academy that an attack on one was construed as an attack on the others. The defence of line mounted by Philippe de Champaigne and Charles Le Brun has strong moral overtones, contrasting the aesthetic purity and austerity of drawing with the seduction or deception of colour. At stake, too, was the exemplary status of the great artists of the past. The defenders of colour sought to elevate Venetian artists such as Titian and Veronese, and the Flemish painter Rubens, alongside acknowledged classicist masters such as Raphael and Poussin.

The most eloquent and sustained defence of colour was mounted by Roger de Piles (see IC5, 10 and IIA2). By introducing a distinction between physical 'colour' and the art of 'colouring' De Piles showed that the correct imitation of colour is as much the work of the intellect as is drawing. Indeed, he contends that the neglect of colouring by the Academy was due to the greater difficulty of attaining excellence in this domain and to the impracticality of formulating appropriate precepts and rules. De Piles ultimately succeeded in bringing about a remarkable reversal of priorities. By according a positive value to colour's capacity to deceive and charm the eye, he developed a theory which elaborated the specifically *visual* interest of painting. A successful painting should be judged in terms of the 'whole together' and should strike the viewer powerfully and immediately. This celebration of the 'beautiful artifice' of painting restored the importance of physical properties and drew attention to the manner of composition and execution. With the death of Charles Le Brun in 1690 and the appointment of Jules Hardouin-Mansart as the new protector of the Royal Academy in 1699, De Piles was made an *amateur honoraire* and became the Academy's chief theoretician. This represented a decisive shift in the balance of power and marked the ultimate victory of the partisans of colour.

In the first section of the anthology, we have chosen to deal with these complex and intersecting issues in the art theory of the seventeenth century by placing discussion about the legacy of the Ancients first. This is followed by a selection of texts concerning the establishment of the Academy, and then by material from the rival protagonists of form and colour. Next we provide a sample of views alternative to those of the Academy, gathered under the rubric of the *je ne sais quoi*. The section ends with a collection of writings on the practical resources from which, all the theory notwithstanding, art continued to be made.

IA
Ancients and Moderns

1 Franciscus Junius (1589–1677) from *The Painting of the Ancients*

Junius was the son of an eminent Protestant theologian. He grew up in the milieu of the University of Leiden, where his father worked until his death in 1602. Junius followed in his father's footsteps and trained for the clergy, but he reacted against the sectarian disputes in the newly independent United Provinces and by 1620 he had left the Church. On the recommendation of prominent Dutch Protestants, however, he was able to take up a post in England in 1621 as librarian to the Earl of Arundel (see IE1). Arundel had the greatest art collection in England after the king himself, as well as an extensive library. It was from these resources that Junius compiled two major works, the *Catalogus*, a lexicon of classical artists, and *De Pictura Veterum*, an attempt to reconstitute a classical theory of art. This latter was published in Latin in 1637, and was followed a year later by Junius' own English translation, *The Painting of the Ancients*. The text is a tapestry of quotations from every surviving ancient source, woven together by Junius' own passionate advocacy of the improving power of the visual arts. *The Painting of the Ancients* consists of three Books. The first defines the fundamentals of art. The second is a kind of history or survey of art works from the ancient world. In the third, the 'parts' of art are discussed in sequence, as follows: 1. Invention, that is, the Idea or Content of the work; 2. Design, or Drawing; 3. Colour; 4. Expression, or in Junius' terms, the investing of the work with Action and Passion; 5. Disposition, or Ordering of compositional elements; and lastly that indefinable quality which Junius calls 'Grace', and which is referred to elsewhere as the *je ne sais quoi* (see section ID). This idea of the parts of art was indebted to Italian Renaissance theory, and the model was to remain influential throughout the seventeenth and eighteenth centuries, its authority reflected in writers as diverse as Fréart de Chambray (see IB6), Bellori (see IB8), Du Fresnoy (see IC4), Shaftesbury (see IIB3) and Reynolds (see IVA7). Our selections are all taken from the first Book of *The Painting of the Ancients*. Here Junius establishes at the outset that the principal business of art is imitation, going on to argue that this imitation is not merely mechanical copying but requires the work of imagination (or phantasy). It is this basis in imagination which makes the visual arts into an elevated equivalent of poetry. This is the doctrine of *ut pictura poesis*, or 'the sister arts', which held sway at least until Lessing (see IIIA10). Junius then turns from the practice of art to its judgement, establishing that this too requires the exercise of learning and imagination. The contemplation of art, no less than its production, is an intellectual and moral pursuit. Our

extracts are taken from Book One, chapters I, II, IV and V of Franciscus Junius, *The Painting of the Ancients*, edited by Keith Aldrich, Philipp Fehl and Raina Fehl, Berkeley and Oxford: University of California Press, 1991, pp. 11– 66.

I

THE GOOD and great maker of this Universe, created the world after so glorious and beautifull a manner, that the Greekes together with the Romanes, a consent also of the Nations perswading them thereunto, have called it by the name of an *Ornament*.[1] Moreover, Man, whom many ancient Authors call the little world, is not made after the image of God to resemble the wilde beasts in following of their lusts, but that the memory of his originall should lift up his noble soul to the love of a vertuous desire of glory. This opinion was of old grafted in the hearts of good men; neither doe the learned onely, but the vulgar sort also esteem the way of vertue to be the true way by which our mortall and transitory condition attaineth to an everlasting fame. But among such a number of vertuous courses as may serve to get a great and durable renowne, every one doth most commonly deliberate with his own naturall inclination. The one by a praiseworthy boldnesse undertaketh to compasse with his understanding the unmeasurable measures of heaven, 'leaving unto the following ages a full account of the innumerable number of heavenly lights, as a most certain and sure inheritance,' sayth *Plinie*, 'if peradventure afterwards anyone would take upon him to be heire thereof.' Another doth not stick to prie into the most profound mysteries of Nature; neither will he give his mind any rest till he hath in some measure conceived the nature of the floting clouds, the cause of thunder, lightning, and of all those things that above or about the earth doe terrifie the heart of man. He goeth about the search of those things with a very great confidence, as knowing himselfe to be placed in this stately theater, to view and to consider all such wonders of God. *Anaxagoras* being asked to what end he was brought forth, answered; 'To behold the Sunne, Moone, and Heavens.' Yea what is man, I pray you, but 'a creature approaching neerest unto God,' as *Quintilian* speaketh, 'and ordained to the contemplation of the things contained in the world.' Although now *Quintilian* and all the other Authors speak very well to the purpose; *Tullie* for all that commeth a great deal neerer to the point we have in hand; 'man himselfe,' sayth he, 'is borne to contemplate and to imitate the world; not being any manner of way perfect, but onely a small parcell of what is perfect.' [. . .]

'The painters,' sayth *S. Chrysostome*, 'after the mixing of their colours, endeavour to set forth a lively similitude of diverse visible things: thus doe they paint reasonable and unreasonable creatures, trees, warres, battels, streames of bloud, pikes, Kings, ordinary men; they make also a royall throne, the King sitting, a barbarous enemy throwne downe under his feet, the points of speares, running rivers, goodly medowes: to be short, they prepare unto the spectators a very pleasant sight, whilest they study by the force of their Art to expresse all manner of visible things.' The words of *Isidorus Pelusiota* are likewise worth noting; 'the Painters,' sayth he, 'when they make bodily shapes of things without bodie, use sometimes to paint a lone hand which setteth a crowne upon the head of the Princes of this world; signifying, that this soveraign power is given them from heaven.' *Socrates* toucheth also the large

extent of this Art, when he sayth, 'the Painters studie with their colours to expresse, hollow and swelling, darke and lightsome, hard and soft, rough and smooth, new and old bodies.' [. . .]

It remaineth . . . that among so many Arts as doe procure us everlasting glory, this Art [i.e. painting] is none of the meanest. And as it is a very great matter to carry in our mind the true images both of living and lifelesse creatures, so is it a greater matter to worke out a true and lively similitude of those inward images; especially if the Artificer doth not tie his imitation to some particular, though never so faire a body; but followeth rather the perfection of an inward image made up in his mind by a most earnest and assiduous observation of all such bodies as in their owne kind are most excelling. 'Such as carve images,' sayth *Maximus Tyrius*, 'having gathered all that in severall bodies is reputed to be faire, bring it by the means of their art in one singular imitation of a convenient, pure, and well-proportioned beautie to passe; neither shall you find in haste a body so accurately exact, as to compare it with the beautie of a statue: For the Arts doe ever seeke what is fairest.' [. . .]

Such Artificers therefore as carry in their mind an uncorrupt image of perfect beautie, do most commonly powre forth into their workes some certaine glimmering sparkles of the inward beautie contained in their minds: neither may we thinke this to be very easie; 'for,' according to *Apollonius Tyaneus* his opinion, 'that which is best, is alway hard to be found out, hard to be judged.' It is also well observed by an ancient Orator, that 'the imitation of a most absolute beautie is ever most hard and difficult; and as it is an easie matter to set forth a true similitude of deformitie by her owne markes, so on the contrary the similitude of a perfect beautie is as rarely seene as the beautie it selfe.' It was not unknowne unto *Zeuxis*, sayth *Tullie*, that Nature would never bestow upon one particular bodie all the perfections of beautie; seeing that nothing is so neatly shaped by Nature, but there will alwayes in one or other part therof some notable disproportion be found; as if nothing more should be left her to distribute unto others, if she had once conferred upon one all what is truely beautifull. Wherefore, when this noble Artificer intended to leave unto the inhabitants of Crotona a choice patterne of a most beautifull woman, he did not thinke it good to seeke the perfection of a faultlesse formositie in one particular body; but he pick'd out of the whole Citie five of the well-favouredst virgins, to the end he might find in them that 'perfect beautie,' which, as Lucian speaketh, 'of necessitie must be but one.' So doth Xenophon very fitly to this purpose bring in *Socrates* his discourse held with the Painter *Parrhasius*, 'seeing it is not so easie,' sayth Socrates, 'to meet with any one that doth altogether consist of irreprehensible parts, so is it, that you having chosen out of every part of severall bodies what is fittest for your turne, bring to passe that the whole figures made by your Art seeme to be most comely and beautifull.'

Out of this most absolute sort of imitation there doth bud forth the Art of designing, the Art of painting, the Art of casting, and all other Arts of that kind. So doth *Philostratus* also call this same Imitation 'an ancient invention, and altogether agreeing with Nature.' The proofe of which point could here most readily be drawne out of that busie eagernesse we do see in almost all young children, that follow the tender imaginations of their rude and unexercised conceits in making of babies and other images out of clay or wax, but that we thinke it better not to trouble our selves too much with the proofe of a thing which is cleare enough in it selfe, seeing every

one may sufficiently informe himselfe concerning this point, who will but cast an eye upon the daily pastimes used among little ones. Let us onely observe out of *Quintilian*, that 'all such things as are accomplished by Art, doe ever draw their first beginnings out of Nature;' as also, that 'the greater part of Arts,' to use the words of the same Author, 'doth consist in Imitation' [...]

II

BESIDES THIS newly-mentioned imitation of naturall things, by whose meanes Artificers doe expresse all kinds of visible things after the life, we are also to marke another sort of imitation, by which namely the Artificer emboldeneth himselfe to meddle also with such things as doe not offer themselves to the eyes of men: and although the chiefest force of this Imitation doth consist in the Phantasie, so must wee for all this thanke our eyes for the first beginnings as well of the Phantasie as of the Imitation it selfe. For the inward Imaginations that doe continually stirre and play in our minds, cannot be conceived and fashioned therein, unlesse our eyes some manner of way are made acquainted with the true shape of the things imagined, or at least that we have felt them with some of our senses. 'Our mind,' sayth *Strabo*, 'maketh up the conceivable or intelligible things out of the sensible: for as our senses doe certifie us of the figure, colour, bignesse, smell, softnesse, and taste of an apple; so doth our mind out of these things bring together the true apprehension of an apple; so falleth it likewise out with great figures, that our sense seeth the parts of them, but our mind putteth the whole figure out of those visible parts together.' *Themistius* doth wonderfull well expresse all this: 'the phantasie,' sayth he, 'is like a print or footstep of sense: for as a leaver mooved by the hand mooveth a stone, and as the sea stirred by the winde stirreth a ship, so is it no wonder at all that our sense should be subject to the same: for our sense being stirred by outward sensible things, and receiving the shape of such things as doe stirre it, stirreth also in perfect creatures another power of the soule, commonly called *phantasie*: whose nature is to lay up the prints delivered her by sense, and to seale them up after so sure a manner, as to keepe still the footsteps of the same, after that now the visible things are gone out of our sight.'

So doth then this same most fertile power of our soule, according to *Plato* his opinion, yeeld two sorts of Imitation; the first medleth onely with things seene, whilest they are set before our eyes; the other on the contrary studieth also to expresse things prefigured only and represented by the phantasie. [...]

Hence it is that *Phidias*, when he made *Jupiter*, did not cast his eyes upon any thing generated, but he fetched the patterne of his worke out of a *Jupiter* conceived after *Homers* description. Other famous Writers, besides *Proclus*, doe also very much harp upon this string, urging alwayes *Phidias* his example as an infallible rule of Art: and it seemeth by their words, that they held *Phidias* to be so excellent an Artificer, because he had a singular abilitie to imagine things invisible after a most majesticall manner. 'Nothing is in my opinion so beautifull,' sayth Tullie, 'but we must always conceive that to be fairer from whence the former, even as an image was wont to be made after a face, is expressed; which cannot be perceived by our eyes, nor eares, nor any of our senses, since we doe apprehend it onely by thought and minde. Hence it is that we

can imagine something fairer yet then *Phidias* his images, although our eyes cannot behold any thing fairer in that kinde. Neither did that same Artificer, when he made the images of *Jupiter* and *Minerva*, fixe his eyes upon one after whom he should draw such a similitude; but there did abide in his minde an exquisite forme of beautie, upon the which he staring, directed both his Art and his hand to the similitude of the same. There is then in the forme and shape of things a certaine perfection and excellencie, unto whose conceived figure such things by imitation are referred as cannot be seene.' '*Plato*, a most grave Author and teacher, not of knowing onely, but also of speaking, doth call these figures Ideas [Cicero].' [. . .]

The words of *Philostratus* are worth rehearsing. 'It is so,' sayth *Thespesion*, 'that *Phydias* and *Praxiteles* climbing up to heaven, and there expressing the severall shapes of the Gods, have afterwards applied them to the Art, or is there something else, that hath taught these Artificers to counterfeit?' 'Something else,' replied *Apollonius*, 'and that full of wisedome.' 'What is that?' sayth *Thespesion* againe; 'seeing you can, besides the Imitation, name nothing.' 'Phantasie,' answered *Apollonius*, 'hath accomplished these things; an Artificer farre exceeding Imitation in wisedome: for Imitation doth worke out nothing but what shee hath seene: Phantasie on the contrary doth take in hand also what shee hath not seene; for shee propoundeth unto her selfe unknowne things with a relation to such things as are. A certaine kinde of astonishment doth also often hinder our Imitation; whereas nothing can disturbe the Phantasie, being once resolved to follow undauntedly what shee undertaketh. As for an Artificer that meaneth to conceive in his mind an image not unworthy of *Jupiter*, the same must see him accompanied with the four seasons of the yeare, with the constellations, with the whole heaven: for such a one did *Phidias* then imagine. . . .

We doe see then plainly that the Artificers stand very much in need of the mentioned Imaginative facultie: and although wee must ingenuously confesse that they doe not so much want it, who content themselves with the Imitation of visible things, following stroke after stroke; for the exercise of this same faculty doth more properly belong unto such Artificers as labour to be perfect, studying alwayes by a continuall practise to enrich their Phantasie with all kinde of perfect Images, and desiring to have them in such a readinesse, that by them they might represent and resemble things absent, with the same facilitie others doe expresse things present: yet shall we more strongly be convicted[2] of the necessitie of this same exercise, if we take this into our consideration, that Artificers are often to expresse such things as can but seldome, and that onely for a little while be seene: as namely, the burning of a Citie, of a village, or else of a company of scattered cottages; the miserable confusion of them that run their ship against a rock; the bloudy skirmish of a drunken mercilesse crew, dying in a most horrid hurlie burlie on heaps. It is most certain that we doe but seldome meet with such spectacles, neither doe they stay our leisure to let us take a full view of them; all is but a flurt,[3] and away. It is left therefore that our Imagination should lay up carefully what she hath seen, still increasing her store with Images of things unseene, as farre forth as it is possible to conceive them by a relation of what we sometimes beheld. 'What shall we doe,' sayth *Seneca* the rhetorician, 'if wee are to paint a battle? shall wee arme two severall parties, to see them discomfit one another? must wee needs see how a sad and dejected multitude of captives commeth drouping

after the lascivious shouting, though all beblouded conquerours? as if the greatest part of mankinde had better perish, then the Painter faile.'

It is then not onely profitable but also necessary, that an Artificer should by a daily practice carefully provide himselfe of such kinde of Images, as might be ready at his call when he is to imitate things absent, and such things as never came before his eyes: 'and wee shall with much ease attaine to this,' sayth *Quintilian*, 'if wee are but willing: for as among the manifold remissions of our minde, among our idle hopes and wakefull dreams, these Images do follow us so close, that wee seeme to travell, to saile, to bestirre ourselves mightily in a hot fight, to make a speech in the middest of great assemblies, yea wee doe so lively propound all these things unto our minds, as if the doing of them kept us so busie, and not the thinking: shall wee then not turne this same vice of our minde to a more profitable employment?' [. . .]

IV

'ALL ARTS,' sayth *Tullie*, 'that doe belong to humanitie, have a common band, and are ally'd one to another, as by a kind of parentage.' *Tertullian* speaketh to the same effect, when he sayth; 'there is no Art, but shee is the mother of another Art, or at least of a nigh kindred:' seeing then that the connexion of the worke in hand enticeth us to prove the truth of these sayings by a mutuall relation there is between *Poesie* and *Picture*, it followeth also that wee should propound some properties of them both, out of which it might be perceived that they are very neere of the selfe same nature. Both doe follow a secret instinct of Nature: for we do daily see, that not *Poets* onely, but *Painters* also are possessed with the love of those Arts, not so much by a fore-determined advise,[4] as by a blind fit of a most violent and irresistible fury. As for *Poets*, 'there is a God in us,' sayth *Ovid*, 'by whose tossing of us we are enflamed: this same forwardnesse hath in it selfe the seeds of a sacred minde.' As for *Painters*, '*Nicophanes* had a most forward mind,' sayth *Plinie*, 'and there are but a few that may be compared with him in this.'[5] The same Author speaking of *Protogenes*, sayth againe in the same place, 'the forwardnes of his mind, and a certain inclination or pronenesse to the Art, have carried *Protogenes* to these things.' And it is very aptly put in here, that a certaine forward proneness to the Art made *Protogenes* so excellent an Artificer; seeing they do alwayes with the greatest ease and best successe exercise an Art, who out of a free desire give themselves so readily to it, that they cannot so much as give an account of this same most forward desire. The Peripatetike Philosophers seeme to have understood this perfectly when they doe maintaine, that 'no body can doe any thing neatly and finely, unlesse he hath a very good minde to it,' sayth *Tullie*. It is required therefore, that all such as would willingly attaine to these Arts, doe find in themselves some swift motions of their wits and minds, both quicke to invent, and copious to expresse what is found: neither may we thinke that the first beginnings of these Arts proceed from Art, seeing it is a gift of Nature that any man findeth this same aptnesse in himselfe; and our case standeth well enough, if Art can help such tender seeds to a full growth; for that Art should infuse them into us, is altogether unpossible. Out of this observation there doth arise a question propounded and answered by *Horace*: 'it hath been very much questioned,' sayth he, 'whether Nature or Art doth accomplish a Poeme. I cannot see what helpe there is in study without a

rich veine, or else in a rude wit; so doth one of these two alwayes require the others helpe, and they doe both very lovingly conspire.' [...]

As for the particular nature of the Artificers, it hath ever been so, that the livelinesse of great spirits cannot containe it selfe within the compasse of an ordinary practice, but it will always issue forth, whilest every one doth most readily expresse in his workes the inward motions of his most forward minde: so doe we also finde that the bravest Artists have spent their labour most prosperously about such things as they did much delight in by a violent driving of their passion, or else by a quiet guiding of their Nature. [...]

[W]e see it daily how Poets and Painters do with a bold hand describe not onely the shapes of their devised Gods, demi-gods, Worthies, other ordinary men, but they strive also by a mutall emulation to set forth the manifold actions of men: they doe represent the lascivious mirth of banquets, the toilesome pleasure of hunting, the bloudy outragiousnesse of fighting, the unevitable horror of ship-wrack, the lamentable and rufull sluttishnes of them that lie chained up in the deep night of a deadly dungeon. As for the Poets alone, 'Poesie,' sayth *Hermogenes*, 'is an imitation of all kinde of things: and he is the best *Poet*, that can with a ready and full utterance of words imitate speaking Orators, singing Musicians, with all other persons and things.' Of Poets and Painters both together are the following words of *Philostratus*, 'Whosoever doth not embrace Picture,' sayth he, 'wrongeth the truth, he wrongeth also the wisedome of the *Poets*; seeing both are alike busie about the shapes and deeds of the Worthies.' *Dio Chrysostomus* speaketh likewise of both together; 'Painters and Carvers,' sayth he, 'when they were to resemble the Gods, departed not one inch from the *Poets*; not onely to shun the punishment offenders in such a kinde undergoe; but also because they saw themselves prevented by the *Poets*, and that now the manner of Images made after their conceit went currant, as being upholden by antiquitie: neither would they seeme to be troublesome and unpleasant by lying novelties, but they have for the most part made their Images after the example of *Poets*: Sometimes for all that have they added one or other thing of their own, professing themselves to have an emulation with *Poets* about the same Art of imitation, endeavouring likewise to lay open before the eyes of more and poorer spectators, what *Poets* have plainly rehearsed to the eares of men.' Although now the words of *Philostratus* and *Dio Chrysostomus* may serve us for a sufficient proofe of that same great affinitie there is betwixt Painting and Poesie, yet hath *Simonides* expounded this point somewhat neatlier when he affirmeth that 'Picture is a silent *Poesie*, as *Poesie* is a speaking *Picture:*' and upon occasion of these words sayth *Plutarch*, 'the things represented by *Painters* as if they were as yet adoing before our eyes, are propounded by Orators as done alreadie: seeing also that *Painters* doe expresse with colours what *Writers* doe describe with words; so is it that they doe but differ in the matter and manner of Imitation, having both the same end [...]

Both doe hold the raines of our hearts, leading and guiding our Passions by that beguiling power they have, whithersoever they list. Of the *Poets* sayth *Horace*, 'it seemeth to me that such a Poet is most like to walke upon a stretched out rope, the which doth torment and vex my thought about matters of nothing; in chaunterlike angring, appeasing, and terrifying me with idle feares; conveying and at his pleasure transporting me sometimes to *Thebes*, some times to *Athens*.' Saint *Basil* speaketh of

both, 'Eloquent Writers and Painters,' sayth he, 'doe very often expresse the warlike deeds of valiant men; and both do stirre up a great many to courage; whilest the one studieth to set forth in lively colours, what the other goeth about to adorne with eloquence:' both then have a hidden force to move and compell our minds to severall Passions, but Picture for all that seemeth to doe it more effectually; seeing 'things that sinke into our hearts by the means of our eares,' sayth *Nazarius*, 'doe more faintly stirre our minde, then such things as are drunke in by the eyes.' *Polybius* doth likewise affirme, that 'our eyes are more accurate witnesses then our eares:' and it may be very well that *Quintilian* out of such a consideration hath drawne this same conclusion; 'Picture,' sayth he, 'a silent worke, and constantly keeping the same forme, doth so insinuate it selfe into our most inward affections, that it seemeth now and then to be of greater force then Eloquence it selfe.' [...]

Both are most of all advanced by the ready help of a strong and well-exercised Imagination: 'the Art of Painting,' sayth the younger *Philostratus*, 'is found to be a kin to Poesie; seeing both do therein agree, that as well the one as the other requireth a forward Phantasie. The Poets bring the presence of the Gods upon a stage, and all what is pompous, grave, and delightfull. The painters likewise doe designe as many things upon a boord, as the Poets possibly can utter.' So doth then the *Art of Painting* as well as *Poesie* relie upon a generous and bold strength of Imagination, so that they will no more creepe and crawle to feele and to follow the steppes of them that are gone before, but they take upon themselves to trie it somewhat further, if by chance they might be esteemed worthy to lead others the way. [...]

Having now spoken at large of the manifold fruits the Artificers reape out of the continuall exercise of their Imaginative facultie; it remaineth that wee should shew how they have need to stir up all the powers of fancie that are in them that would view the works of excellent masters with the contentment of a sound and well-grounded judgement.

V

No MAN hath ever beene able to conceive the miracles of these Arts that doe meddle with the imitation of all things, unlesse hee enjoying his hearts ease, hath likewise now and then holpen this same delicate studie of a most busie contemplation by the secresie of a retired and more solitarie place. 'None are more curious then such as are at leisure,' saith the younger *Plinius*. 'Poesie doth require retirednesse of the writer and leisure,' saith *Ovid*: wee may adde very well, that not Poets only, but such also as meane to reade Poets with good attention, and such likewise as desire to looke upon choice Pictures, and excellent Statues with a sound judgement (to adde this same propertie also to the comparing of Poets and Painters handled immediately before) have great need of retirednesse; 'the multitudes of necessary duties and affaires doe withdrawe and turn all men from the contemplation of such things,' saith *Plinie*, 'because such an admiration is only agreeable with leisure and a great stilnesse of place;' the reason is at hand, and may be drawne out of our former discourse, where we doe shew that solitary and silent places doe mightily helpe and nourish our Phantasie, the only means Artificers doe worke, and lovers of Art doe judge by: seeing also that a perfect and accurate admirer of Art is first to conceive the true

Images of things in his minde, and afterwards to applie the conceived Images to the examination of things imitated, it is cleare that neither of these can bee performed without the Imaginative facultie [. . .]

As manie therefore as resolve to follow this same contemplation earnestly, doe sometimes purposely take certaine Images of things conceived, and turne them many wayes, even as one lumpe of waxe useth to be wrought and altered into a hundred severall fashions and shapes: but principally do they labor to store up in their Phantasie the most compleat Images of beautie. Such Artificers as worke in brasse and colours receive out of the naturall things themselves those notions by the which they do imitate the outward lineaments, light, shadows, risings, fallings; they pick out of every particular body the most excellent marks of true beautie, and bestow them upon some one body: so that they seem not to have learned of Nature, but to have strived with her, or rather to have set her a law. For who is there, I pray you, that can shew us such a compleat beautie of any woman, but a quick-sighted Judge will easily find in her somthing wherein she may be esteemed to come short of true perfection? For although the whole absolutenesse of perfection doth consist in the rules and dimensions of Nature; yet doth the commixtion of both parents, the constitution of the place, aire, and season very often detract somthing from the naturall forme: seeing then that Artificers themselves doe not borrow the Image or patern[6] of a most excellent beautie from one particular worke of Nature; so is it likewise requisite, that Lovers and Well-willers of Art should not content themselves with the contemplation of any one particular body, but that they should rather cast their eyes upon severall bodies more exactly made by Nature, observing in them the differences of age, sexe, condition: and you shall seldome see them rest here, but they will fixe their eyes also upon many other naturall bodies, studying alwayes to enrich their Phantasie with lively impressions of all manner of things. They doe marke the wide heaven beset with an endlesse number of bright and glorious starres; the watery clouds of severall colours, together with the miraculously painted raine-bow; how the great Lampe of light up-rearing his flaming head above the earth, causeth the dawning day to spread a faint and trembling light upon the flichering gilded waves; how the fiery glimmering of that same glorious eye of the world, being lessened about noon-tide, lesneth the shadowes of all things; how darksome night beginneth to display her coal-black curtain over the brightest skie, dimming the spacious reach of heaven with a shady dampe:[7] they observe likewise the unaccessable height of the mountaines, with their ridge somtimes extended a good way, somtimes cut off suddenly by a craggie and steep abruptnesse; pleasant arbors and long rowes of lofty trees, clad with summers pride, and spreading their clasping armes in wanton intricate wreathings; thick woods, graced between the stumpes with a pure and grasse-greene soile, the beames of the Sunne here and there breaking through the thickest boughes, and diversly enlightning the shadie ground: gently swelling hillocks; plaine fields; rich meadowes; divers flowers shining as earthly starres; fountaines gushing forth out of a main rock,[8] sweet brooks running with a soft murmuring noise, holding our eyes open with their azure streames, and yet seeking to close our eyes with the purling noise made among the pebble-stones; low and smoakie villages; stately cities, taking pride in the turrets of their walls, and threatning the cloudes with the pinnacles of their spear-like steeples. They doe consider in Lions, horses, eagles, snakes, and all other creatures,

wherein the absolute perfection of their shapes doth consist: propounding unto themselves likewise parliaments, sacrifices, festivall meetings and dauncings, husbandrie-worke, smiths forges, footmen running a race, fishers, sailers putting off from the shore, or else landing, faire and foul weather, the sea calme and boisterous, great armies of men, depopulations of the countrie, surprisings of cities, and whatsoever useth to fall out in an expugnation[9] of a great and populous towne [. . .]

It appeareth now what care the well-willers of Art use to take about the exercising and preparing of their phantasie, seeing they do by a most accurat Imagination designe and make up in their mindes the compleat pictures of all kind of naturall things; and thus provided, they doe very often examine the works of great Artificers with better successe then the Artists themselves, the severitie and integritie of whose judgements is often weakened by the love of their owne and the dislike of other mens workes. As for the common sort of people, of them saith a certaine *Painter* very well in *Plutarch*, that 'rude spectators and such as are nothing at all acquainted with matters of Art, are like them that salute a great multitude at once; but that neat spectators on the contrarie, and such as are studious of good Arts, may be compared with them that salute one by one: the first namely doe not exactly looke into the workes of the Artificers, but conceive onely a grosse and unshapen image of the workes; where the others going judiciously over every part of the worke, looke upon all and observe all what is done well or ill.' *Tullie* doth call this same facultie of our mind 'intelligens judicium,' that is, an 'intelligent judgement.' We learne likewise out of the same Author that Lovers and well-willers of Art were named 'elegantes,' that is, 'neat and polished men;' and that they on the contrary were called 'idiotae,' that is, 'idiots,' the which had no skill at all and did not care for the delicacy of rare workes: 'how many things doe Painters see in the shadows and eminences,' sayth *Tullie*, 'the which wee cannot see?' Wherefore, 'as that kinde of hearing that doth onely discerne the sound,' sayth *Epictetus*, 'may very well be called the common hearing; and the hearing that doth discerne the tunes, is now no more a common but an artificiall hearing;'[10] so is there also great difference of seeing: 'the sight of one man is better by nature,' sayth *Plutarch*, 'then the sight of another: so are likewise the minds of Painters by Art exercised to discerne beautie in all kinde of shapes and figures. *Nicomachus* therefore hath very fitly answered an idiot, that could see no beautie in that same famous *Helena* painted by *Zeuxis*, "Take my eyes," sayd *Nicomachus*, "and you shal think her to be a goddesse."' *Aelianus* doth tribute this same apophthegme to *Nicostratus*: it doth then appeare that it is not enough wee should have eyes in our head as other men have, but it is also required here that we should bring to these curiosities 'eruditos oculos,' that is, 'learned eyes,' as *Tullie* termeth them.

[1] Junius here directly follows, and in the Latin more fully quotes, Pliny who, persuaded by the 'consent of the nations,' recognizes the inner connection between beauty, order, and the universe which is manifested in the terms the Greeks and Romans employ for *universe*. [. . .]

[2] 'Convicted' = convinced.

[3] 'Flurt': a quick or sudden movement.

[4] 'By a fore-determined advise' = on the basis of previously established principles.

[5] 'Forward' = impulsive or passionate.

6 'Image or patern' translates *idea*.
7 'Lesneth': lessens. 'Shady dampe': probably the evening mist.
8 'Out of a main rock' = out of a solid rock.
9 'Expugnation' = storming.
10 'Artificiall' = trained, skilled.

2 Peter Paul Rubens (1577–1640) Letter to Franciscus Junius

Although he was born in the German city of Heidelberg and spent most of his working life in England, Junius considered himself Dutch. It is therefore not surprising that when *De Pictura Veterum* was published in 1637 he should have sent copies to the two most prominent artists of the period whose careers likewise manifested a close connection between England and the Low Countries. Van Dyck and Rubens both seem to have appreciated the gift, but Rubens composed the more considered response. Apart from Flemish salutations, he did so moreover in formal Latin, which ensured that his letter was incorporated as a testimonial in subsequent editions. That said, Rubens was far from unequivocal in his praise of Junius' work. The burden of his reservation lay precisely in the area of the relation between the classical and the contemporary. The issue was in the air: in France the 'quarrel of the Ancients and Moderns' was about to get under way (see IA6 and 7). And Junius' book, for all its erudition, for all its concern to establish the visual arts as the equal of literature, contained not a syllable on the achievements of the Italian Renaissance. So Rubens, although fulsome in his praise of Junius' scholarship, nonetheless expressed the hope that someone could perform a similar task not for lost works of art, but for living works which it was possible to see, and against which intellectual claims could be measured. In essence, as Junius' modern editors have pointed out, Rubens wanted a *De picturis Italorum*. We have taken the text of Rubens' letter from the translation printed as Appendix II to Franciscus Junius, *The Painting of the Ancients*, edited by Aldrich, Fehl and Fehl, op. cit., pp. 325–30.

Sir:

You must for some time have wondered why you did not hear from me that I had received your book, which, as appears from your letter of 24 May, was sent to me before that date. However, I beg you to believe that the book was handed to me only a fortnight ago by a certain Leon Hemselroy of this city with many apologies for such a late delivery. That is also the reason why I did not answer your letter; I first wanted to see and to read the book, and this I have now done with attention. And, in truth, I find that you have done great honor to our art by digging out again with such diligence this immense treasure from all of antiquity, and by making it available to the public in such excellent order. For, to sum it up in one word, your book is truly a generously proffered hoard of all the examples, the opinions, and the tenets promoting the dignity and splendor of the Art of Painting which the ancients enshrined in their literature and which have, to our very great benefit, survived to our day. I find that you have to perfection done justice to the title and design of your book *De pictura veterum* and, moreover, that the admonitions and the rules, the judgments, and those examples which you have inserted afford us the greatest illumination and are put forth with admirable erudition and in a most elegant language. The entire work is laid out perfectly in proper sequence, and filed and polished with unusual care, from head to foot.

But now that we can more or less respond to the *exempla* of the ancient painters in our imagination – as well as each of us is able – I, for my part, would like it if at some time it were possible to compose with the same diligence a like treatise on the paintings of the Italians. They provide examples, or prototypes, which to this day are before the public. One can point at them with one's finger and say: 'here they are!' For those things which touch our senses are more sharply imprinted on the mind; they remain with us and demand a more minute examination. In addition they offer students a more fruitful scope for their improvement than does the study of a subject which reveals itself to us only through our imagination, in a dream, as it were, and to such an extent overlaid with words that, grasped three times in vain, they often elude us (as the image of Euridice eluded Orpheus), and frustrate a student in his hope. In this matter we artists speak from experience. When we attempt to render visible in its proper dignity a famous painting by Apelles or Timanthes that Pliny or other authors describe in detail, who among us will not produce a piece of work that is insipid or alien to the grandeur of the ancients? Each, indulging his own genius, makes a new wine instead of the bittersweet Opimian of the ancients and injures those great shades whom I honor with profound veneration. I adore their very footprints, as it were, rather than that I claim to come near them, even in my imagination.

I beg you, Sir, to receive in good part what I have in a friendly spirit felt free to say in the hope that after such a good entrée *you will not refuse us* the main course itself *for which we all eagerly long because so far none of the persons who have offered us such matter has satisfied our appetite*: there is need to proceed to particular cases, as I said.

With this I wholeheartedly solicit your favor and, thanking you greatly for the honor which you bestowed on me by the presentation of your book and by your friendship,

I remain ever, Sir,
your humble and affectionate servant,
Pietro Pauolo Rubens

Antwerp, in a hurry and
'standing on one foot,'
the first of August 1637

3 Francisco Pacheco (1564–1644) from *The Art of Painting, its Antiquity and Greatness*

Pacheco was a painter and poet as well as a writer on the theory of art. The bulk of his career was spent in Seville, although he visited Madrid and Toledo, among other centres of Spanish art. He also maintained contact with other painters, including El Greco. Pacheco was an established artist, though never a very eminent one outside Seville. He could, however, claim to have been the first teacher of Diego Velázquez; indeed Velázquez subsequently married his daughter. Pacheco played a leading role in the intellectual life of Seville. The intelligentsia there was closely bound up with the Church and Pacheco was no exception. His most important commissions came from the Church and his ideas about both the purpose and the subjects of art were influenced by his religious orthodoxy. Moreover, this was no merely ideological commitment to the Counter-Reformation. Pacheco took an active role as an inspector – and censor – of art for the Inquisition. He

is now best known for the compendious treatise on art, the *Arte de la pintura: su antigüedad y grandeza*, which he compiled throughout most of his career. The manuscript is believed to have been complete by the late 1630s, but it was only published posthumously in 1649, five years after his death. The *Arte de la pintura* is in three books, the first two of which concern the theory of art, the third being a handbook of practical instructions for the making of a painting. Extracts from the third book are printed below as IE5. The present selection is made from the first two books. The majority of texts in the present section of part I concern the relationship of modern art to the art of pagan Antiquity. But in the age of the Reformation and Counter-Reformation, another important aspect of determining the importance of art concerned its relation to the almost equally long-lived Christian tradition. In Catholic Spain, this was pre-eminent. Pacheco discusses technical parts of art, such as the composition of a picture and the colours to be employed, but his main emphasis is on painting as a means to a higher end. In his view painting matters because, more than any other art, it can transcend earthly existence and assist in the apprehension of the divine. From this perspective, art is far from an independent pursuit. The value of a work of art is directly related to the correctness of its religious content. In our selections, Pacheco begins by asserting that the principal task of art is imitation. But he has a very specific form of imitation in mind. For Pacheco the purpose of art is to instil belief in Christian truth, and what he does here is to prescribe the correct criteria of imitation for specific religious subjects: Angels, the Immaculate Conception and the Annunciation. The extracts have been translated by Nicholas Walker, from F. J. Sanchéz Canton ed., *Arte de la Pintura*, Madrid: Instituto de Valencia de D. Juan, 1956, vol. I, pp. 212–19, vol. II, pp. 193–4, 200–4, 208–12, 231–4.

Book I. Chapter XI: On the Purpose of Painting and of Holy Images, and the Good they do, and on the Authority they hold within the Catholic Church

When elucidating the purpose of painting, as we have here essayed to do, it is imperative to employ a distinction, one that has already been drawn by the Church Fathers, in order to clarify the issue: they say that the work has one purpose [*fin*] and the worker [*operante*] who produces it another. And in accordance with this teaching, I would likewise say that the painter has one purpose, and painting another. The purpose of the painter, considered simply as a craftsman, will be to acquire, by means of this his art, wealth, fame or credit, to procure enjoyment, to perform a service for another, or to labour for his own pastime or some such similar reason. The purpose of painting, ordinarily speaking, will thus be to depict, through imitation, the represented object with all possible boldness and propriety. This is what some call the very soul of painting because it endows the same with apparent life and treats beauty and the manifold variety of colour and other embellishments merely as accessories thereto. Hence it was that Aristotle averred that in confronting two different paintings, the one adorned with beautiful colours but little resembling its object and the other executed in straightforward lines but very faithful to the truth, the former must be adjudged inferior in relation to the latter. And this is because the former presents merely accidental features, while the latter encompasses the fundamental character and substance of the object and thus involves representing what is to be imitated through good drawing and perfect fidelity. If we now consider, however, the aim of

the painter precisely as a Christian craftsman (and it is only with such that we are here concerned), he could be said to entertain two purposes, one principal and another secondary or subsidiary. The latter, and less important, purpose might be to ply his craft for gain or fame or some other reason (as remarked above). But this should still be governed by the appropriate circumstances of person, place, time, and form, so that no one could fittingly accuse him of exercising his talent in a reprehensible fashion, or of working to thwart the highest purpose of all. The principal purpose, on the other hand, will be this: to attain unto a condition of blessedness through the study and the toil of his profession as undertaken in a state of grace. For a Christian, who has been expressly created for holy things, cannot feel satisfied in his deeds if his eyes are set so low that he strives merely after human reward and worldly recompense. Much rather will he desire to lift his eyes to heaven and pursue a different end, one far greater and more excellent, and one freely devoted to things eternal. And precisely in this sense Saint Paul would often warn both servants and all other men to remember, when ministering unto their neighbours, that this was chiefly for the sake of God, saying unto them: 'You who are servants obey your masters on earth not from due compliance or a wish to appear well in their eyes, but rather as servants of Christ who know that each one will receive his reward from the Lord in accordance with their deeds.' And again elsewhere he says: 'Whatsoever thing you do, do it from the heart as if you knew that you were at once serving and not serving men, that you will receive your full reward from the Divine Majesty.' And if we claimed before that the aim of painting, considered solely as an art, was that it must resemble with propriety what it undertakes to copy, we may here add that, practised as a craft by a Christian man, it will assume a still nobler shape, and find itself raised thereby into the very highest rank of the virtues. This privilege has its source in the greatness of God's law: all acts and deeds, therefore, which might otherwise be seen as very lowly, if they are only closely meditated upon and dedicated to the eternal purpose, will fortify and adorn themselves with the proper merits of virtue. And on this account, the purpose of art in itself is neither denied nor destroyed, but finds itself rather exalted and magnified by addition of this new perfection. Speaking therefore of our present theme of painting, which identified the sole purpose of the latter as the faithful depiction of what it essays to imitate, we see how, as an act of virtue, it comes now to wear a new and richer vestment still. For over and beyond the question of resemblance, painting here elevates itself to a supreme purpose in looking to eternal glory. And in serving thereby to turn men's faces away from every kind of vice, painting itself leads them rather towards the true veneration of God our Lord.

Thus we can see that Christian images are directed not only towards God, but also towards ourselves and our fellow men. For there is no doubt that all virtuous works are capable of serving at once the glory of God, our own instruction, and the edification of our fellow men. And the more these three elements are present, the more the work will be esteemed, for it is these elements which comprise the sum of Christian perfection. [. . .] Thus the pagans, in their blindness, when they wished to celebrate Jupiter, Minerva, Neptune or any of the other gods, could find no fitter way of doing so than by fashioning images and statues in great abundance. The Greeks, the Romans, and other nations, have also all availed themselves of this activity in

order to glorify their emperors or other celebrated men of record. Indeed all peoples, by a very instinct of nature, have done the same: desiring to give evidence of their respect and reverence towards some great prince or other eminent personage, they have erected a public statue to the latter. Thus it is no cause for marvel if the Christian law has likewise availed itself of the same means (although its own purpose is divine and sacrosanct) and permitted the use of sacred images in order to honour the true God through his saints, and thereby to extend His infinite power, mercy, justice and wisdom even further and spread the glory and majesty of His name into every corner of the earth.

As we have said, these images also serve us. Since our Lord God desires that all should praise Him with body and soul, such holy images help to procure outward expression for the reverence we bear within us and allow us to dedicate this reverence to God as an oblation and kind of sacrifice. Thus we give proof of the obligations we have towards Him, and of the boundless joy we feel upon beholding His Divine Majesty represented always before our eyes through painting that shows Him as Our Father and Lord.

These images, moreover, provide marvellous help in fulfilling both the practical needs and the spiritual edification of our fellow men. If we now consider the three kinds of good discussed by the philosophers – namely those of pleasure, utility and honest truth – we see that holy images encompass all of them perfectly, in so far as we promote these qualities by means of such holy images. Experience teaches us that nothing is more pleasing to the eye than is a perfectly executed work of painting, as Petrarch puts it in this celebrated passage: 'The delight which a well-painted picture procures, if properly considered, is one that elevates us to the realm of heavenly love by revealing its own divine origin. For is there anyone who delights in the little brook and hates the spring from whence it is born?'

As far as utility is concerned, the holy images perform innumerable services by disguising imperfections and wonderfully delighting the senses; they reveal splendour and beauty wherever they are displayed, for there is no place, no matter how lowly or crude it may be, which is not fittingly enhanced through decoration with the same; and they preserve antiquity, in so far as many things would now be forgotten had they not been once depicted for us. And furthermore, they serve the common good by acting as books for those who cannot read. Leaving aside much that could be said on this score, we shall now pass on to consider the quality of honest truth.

It is difficult to overstate the good to be obtained from holy images: they perfect our understanding, move our will, and refresh our memory of divine things; they reproduce within the soul the greatest and most powerful effects that can be produced by any and every thing in the world; they present heroic and magnanimous acts of patience, justice, chastity, meekness, charity and contempt for worldly things before our very eyes and so impress them upon our hearts that we are instantly moved to seek virtue and to shun vice, and thereby they serve to set us upon the proper road that leads to blessedness.

In addition to what has been said, there is also another very important effect of Christian painting that concerns the very purpose of the Catholic painter: for in the guise of an orator, the latter endeavours to persuade the people and bring them, by means of painting, to embrace things conducive to religion. For the sake of greater

clarity let us follow the teachers of oratory who distinguish between the office and the purpose of the orator. What I call the office of the orator involves all the means that are employed to attain a given purpose, and the purpose that constitutes his ultimate end and fundamental intention. Thus, as the means of the orator is speech that is appropriate and to the point, so his purpose will be to convince us of his argument. This purpose does not, as such, lie within his own hands, although the various means designed to accomplish it do. Just as the physician as such is incapable of healing the sick person, which is the proper purpose of medicine itself, although he is capable of treating him in a knowledgeable fashion, so too it is with the painter who, like the orator, will be obliged to paint in such a way as to attain his express purpose by means of the holy images he depicts. And this is not always successfully accomplished. If only the painters of today properly fulfilled these obligations! But how many of them indeed are even capable of understanding these my words? And what an irreparable shame this represents! This purpose, which consists simply in persuasion, will be achieved differently in accordance with the particular circumstances, just as the orator whose first desire is to persuade his hearers will nonetheless argue now for peace, and now for war, now to punish or to forgive or to reward, and so forth. Thus the painter may have several purposes in mind, according to the variety of things he is called upon to depict. But I claim that the principal purpose, as far as Christian images are concerned, will always be to persuade men to piety and raise them towards God. Touching immediately upon religion as these images do, and possessing the virtue of inspiring us to the required worship of God, it follows that their proper function is to move men to obedience and subjection. While it is quite possible that other specific purposes may also be involved, like encouraging men to penitence, to suffering gladly, to charity and contempt for the world, or to other virtues, these are all so many ways of uniting man with God, which latter is itself the very highest purpose to which the painting of holy images can aspire, as we have now discussed, it seems to me, at sufficient length already.

* * *

Book II. Chapter XI: Some Remarks of Importance concerning the Sacred Stories and the Truth and Fidelity with which they are to be Painted, in Accordance with Divine Scripture and the Holy Doctors of the Church

Although it may seem that in my book I have already insisted sufficiently and often enough upon the fidelity which is to be preserved in the painting of sacred scenes in the measure to which the latter have been dictated by the Holy Spirit and acknowledged by the Holy Doctors of the Church, these few further counsels will not be without value. And this in especial for the less cautious artists (since those that are skilled in this art love not merely their freedom, but tend to bear the yoke of reason with some reluctance).

The philosophers can exercise their quills to marvellous effect in the matter of these humble precepts, and in effect, as I have already averred, *tractent fabrilia fabri* ('each to his own office'). Harvested as they have been from my own seventy years of experience, these views will furnish good counsel to others. Whatever good and

excellent merits they may have, I owe them principally to the Company of Jesus. Since the year 1605 I have found myself, on occasion and according to my own desire, most richly rewarded with the teachings and observations approved by the wisest of men. Thus my words of advice to painters concerning the fidelity with which they must proceed will not appear alien to my own profession, particularly since as I have been expressly honoured by the Holy Tribunal of the Inquisition in being granted a special permission to examine the faults committed in such paintings, either through the inadvertence or malice of the artists concerned, a responsibility officially laid upon me on 7 March 1618. The following is an extract from the same:

'Given the full confidence that we entertain in the person of Francisco Pacheco, resident of this town, and excellent painter and brother of Juan Pérez Pacheco, Member of the Holy Office, and after having acknowledged his wisdom and prudence, we commit and charge him henceforth with the special care of overseeing the painting of sacred matters and of inspecting the said paintings in their workshops and in public places.

[...] If he find anything whatsoever to reprimand in such paintings, he must draw them at once to the attention of the Masters of the Inquisition in order that, once the pictures have been seen, the appropriate steps may consequently be taken.'

On the Painting of Angels

The question concerning the depiction of angels should be treated ... by virtue of the perfection of their own nature and the circumstance that they represent the faithful image of their Creator. Some painters depict them with the face and body of a woman, and not merely with their hair decorated with buckles and braid, but also endowed with breasts, which is quite unworthy of their perfection.

Yet it appears from the divine writings, and this is also approved by all the councils of the faith, that they bear the face of a man and not a woman, and that is why they are commonly given the name of *viri* in Holy Scripture (as one learned member of the Company of Jesus, reputed for the subtlety of his observations, has already emphasized).

And on this account I have heard it said that a certain number of the interpreters of sacred things have refused to follow Arias Montano in claiming that one of the cherubim of the Ark of the Covenant bore the figure and face of a woman: this rather denotes a weakness, being an unworthy thing in respect to angelic spirits that are vigorous substances of a spiritual order.

One should therefore represent angels as youthful, between the age of 10 and 20 years, which is the median age and corresponds, according to Saint Denis, to the force and vital power that remains ever constant in the angels, youthful beardless beings with beautiful and pleasing faces, with lively and shining eyes – although the virile gaze, the abundant and shining hair, fair or chestnut in hue, alluring and well-proportioned, is itself an external sign of the beauty of their souls, as Saint Augustine says of the appearance of the Archangel Gabriel when he attends upon the Most Holy Virgin. In the Old and New Testaments the angels also most commonly show themselves under the aspect of young men of suchlike age and comely presence.

Sometimes they also reveal themselves as magnificent children, as is recounted in the history of the virgin and martyr Saint Dorothea: 'There appeared an angel with the figure of a child: he bore a basket which contained three magnificent apples and three wonderful roses which the Saint was sending to Theophilus from the garden of her husband.' [...]

The cherubim of the Ark of the Covenant were also children, and it is with the face of children that one ought to depict the seraphim as well. Furthermore, it also transpires that angels, through the will of the Lord, through human necessity and the variety of the tasks they are called upon to perform, may assume the form of a captain, of a soldier at arms, of a traveller, of a pilgrim, of a guide or shepherd, of a guardian or minister of divine justice, of an ambassador or herald of good news, of a consoler, of a musician playing upon his instruments, as properly required in each case.

Thus it is with Saint Michael in his struggle against the devil, with the angel that guards the portals of Paradise, with the angel which brought death to the first-born, with the angel that utterly destroyed the army of Sennacherib... with the angel that appeared to Tobias, with the three angels that appeared to Abraham and consumed the cities with fire, with those that attended the birth of Christ, His Resurrection and His Ascension. Those painters who depict garments and devices in strict accordance with the historical story will succeed best in this respect.

And here I would also specify something which is well understood amongst the Doctors of the Church, namely that the angels, the virtues and the hierarchs, in accordance with the ancient histories, must be depicted girt with weapons and Roman armour, and that one should quite shun what is done in this regard in our times.

One may also depict some angel-children as naked new-born babes: including here those which are shown flying in a decent and responsible manner; the arms and shoulders of the other ones naked, the feet clad in ancient buskins or naked, dressed in tunics of silk or variously coloured cotton against pure white and shining vestments: they have often thus appeared in white, a symbol of their innocence and purity, the rich buckles of their belts studded with precious stones, an image of their eagerness to serve the Lord and a sign of chastity. [...]

Ordinarily one should paint angels with magnificent wings, diversely coloured in imitation of nature... not so much because God has created them thus but rather to convey their essentially ethereal character, the agility and speed with which they are endowed, the manner in which they may swoop down from the heavens quite unburdened with corporeal weight, their spirits ever concentrated upon God, moving amongst the clouds because the heavens are indeed their proper abode and from whence they may gently communicate to us that inaccessible light in which they rejoice.

How to Paint the Immaculate Conception of our Lady

Some say that this subject should be painted with the Christ Child in Her arms because some older images of this kind have been found. This opinion is likely founded upon the fact, as the learned Jesuit Father Alonso de Flores has observed,

that Our Lady enjoyed freedom from the taint of original sin from the very first instant by virtue of her dignity as the Mother of God, even though the moment had not yet arrived when she conceived Jesus Christ in the womb. Thus from that instant onwards, as the Saints know, she was Mother of God and never ceased at any time to be so. She was in such a way that it was quite beyond possibility for her to be better, just as it was quite beyond possibility for her to bear a better son. But without disputing the right of painting Her with the child in Her arms, for those devoted to painting Her thus, we hold nevertheless with those who paint Her without the Child. This is the more customary manner of proceeding. [. . .]

In this most lovely mystery the Lady should be painted in the flower of her youth, 12 or 13 years of age, as a most beautiful young girl, with fine and serious eyes, a most perfect nose and mouth and roseate cheeks, wearing loose her most beautiful golden hair, in short with as much perfection as the human brush is capable of achieving. Man is possessed of two beauties, that of the body and that of the soul, and the Virgin was possessed of both without compare. In body She was a miracle, as Saint Dionysos averred, and no other being so closely resembled her Son who was the model of all perfection. Other children may delight in reflecting the attributes of their father and mother who represent different principles. But Christ our Lord, not having any earthly father, resembled in everything His mother who, after Her son, was the most beautiful thing that God created. And thus we find her praised by the Holy Spirit: *tota pulchra es amica mea* (a text that is always cited in this kind of painting). She should be painted with a white tunic and a blue mantle, just as She once appeared to Dona Beatrice de Silva, a Portuguese lady, who later entered the Royal Convent of Santo Domingo in Toledo to found the Order of the Immaculate Conception, confirmed by Pope Julius II in 1511. She is clothed in the sun, an oval sun of whites and ochres must surround the whole image, sweetly fusing the latter with the sky. She is crowned with stars, twelve in all, arranged in an illuminated circle betwixt the rays that shine forth from Her sacred forehead. The stars are painted as very light spots of pure, dry white excelling all rays in their brightness. The monk Don Luis Pascal painted these better than anyone else in the Scenes of Saint Bruno which he fashioned for the great Carthusian monastery. An imperial crown should adorn Her head which should not hide the stars. Beneath Her feet we behold the moon. Although it is a solid planet, I myself rendered it light and translucent, hanging over the landscape as a half-moon with the extremities pointing downwards. If I am not mistaken, I was probably the first to lend more majesty to these adornments, something in which others have since followed. Especially with regard to the moon, I observed the learned opinion of Father Luis del Alcázar, illustrious son of Seville who writes: 'The painters commonly turn the moon at the feet of this figure upwards. But it is evident amongst mathematicians that if the sun and the moon are face to face, both extremities of the moon must be turned downwards lest the figure be represented as standing upon a convex form.' This was necessary in order that the moon, receiving its own light from the sun, would then illuminate the female figure standing upon it. Standing upon a solid but translucent body, as we have said, the figure had to rest upon the outer surface of the same. In the upper part of the painting one usually arranges God the Father or the Holy Ghost, or both, together with the words spoken by the Heavenly Spouse, as adverted to above. The various

attributes of the earth will be suitably distributed in the landscape, and those of heaven will be arranged, if so desired, amongst the clouds. Seraphim or full-bodied angels bearing some of these attributes may also be introduced. I forgot the dragon, the common enemy of man, whose head the Virgin broke when She triumphed over original sin. I always find it easy to forget this figure. And the truth is that I always depict him much against my will, and indeed omit him whenever I can in order not to embarrass my painting with him. But regarding all that I have said, other painters are, however, quite at liberty in this to try and do better.

The Painting of the Annunciation

[...] Our Holy Lady must be depicted on her knees, for that is surely what is most probable; before her some kind of table or dais bearing an open book; with a candle-stick to one side... This is properly approved by the venerable Father Juan Jeronimo of the Company of Jesus, with reference to a painting from my own hand. The angel should not suddenly appear from above or flying in upon the scene with naked legs, as some artists have depicted it; on the contrary, the angel should be clothed with all decency, should himself be kneeling upon the ground, as a sign of reverence and respect, before his Lady and Queen; while she, at the age we have here ascribed to her – of 14 years and 4 months – must appear humble, modest and very beautiful, with a delicate veil covering her spreading hair. She is dressed in a blue mantle and a pink robe secured with a girdle, as was the general custom amongst the Hebrews and as Christ himself also wore. The angel will have brightly coloured wings and will be dressed in refulgent white garments, just as Federico Zuccaro has properly succeeded in depicting the scene in a painting of *The Annunciation* now in Rome; one may also place some lilies in the angel's left hand, for this is how it has traditionally been depicted since the time of the Apostles. Our Lady has her hands folded or her arms crossed as if she were about to say the final words: *ecce ancilla Domini*. And indeed, as soon as these words were uttered, the holy mystery was itself accomplished: God was made man within Her womb. Right at the top of the picture the artist generally depicts a scene of heavenly glory with resplendent images of the Eternal Father, the seraphim, the angels, and the Holy Spirit in the likeness of a dove. One should here take great care not to paint any other angel that could rival the figure of Gabriel, lest the scene of salutation be thereby obscured!

Although these words should suffice upon this subject, I should like to add, for the sake of greater clarity, some further remarks on the latitude that painters of this scene have generally been accorded, and which we have ourselves observed amongst the best of them, in order that they might dispense with the same in future.

Michelangelo and Titian have both produced engravings of the scene. The former depicted the Virgin standing, as if she were about to flee from the angel, while the latter showed her turning away her face as the angel enters. Both of them represented the angel as more or less naked. But the boldest step of all was taken by the anonymous author of an engraving characterized by a scriptural text appended at the bottom: *Suscitabo David germen justum* (Jeremiah 23). For here, instead of the Holy Spirit, we are presented with a ray of light falling upon the head of the Virgin, and upon the ray a naked infant Jesus bearing a cross on His shoulder, amidst a

jubilation of angels with God the Father in glory. This picture is not merely a source of error, and dangerous in itself, but is actually heretical, as Molanus has said, in suggesting the interpretation of Valentinus and his followers, which the Holy Church has long since condemned as heresy for teaching that Christ Our Lord came down from heaven in corporeal form already. [...]

The lily held in the hand of the angel corresponds to Holy Scripture; it signifies the exaltation of the Virgin from the humble state in which she originally found herself to the highest and noblest state of all, that of the Queen of Heaven and Mother of God, according to a learned member of the Society of Jesus.

4 Jan de Bisschop (1628–1671) Dedication to Constantijn Huygens from *Icones I*

The Dutch draughtsman and etcher Jan de Bisschop was responsible for two substantial collections of prints, the *Signorum veterum icones*, published in The Hague in two volumes in 1668 and 1669, and the *Paradigmata graphices variorum artificium*, published in 1671, first in The Hague and then, in a revised form, in Amsterdam. The *Icones* contain 100 prints after classical and classicizing sculptures. De Bisschop was dependent on material available in the Northern Netherlands, and his work is largely based on drawings made by other artists, most of them from Roman figures that had been heavily restored. Some statues are shown in multiple views. The prints in the *Paradigmata* reproduce drawings by established masters, the majority of them Italians from the sixteenth and early seventeenth centuries. The volumes were highly successful in their intended aim, to furnish Dutch artists with a source of ideal instructive models for figures and figure compositions. In fulfilling this function they played an early and significant part in the revival of the classical tradition in the Low Countries during the later seventeenth century. In his dedication, De Bisschop rehearses a litany of classical authority – from ancient times, via Raphael and Michelangelo, to Poussin – that was the common currency of artistic theory at the time, particularly in France. In his acknowledgement of those 'who contend that nature herself is the best example', there may be some recognition of the relatively *un*classical work of those Dutch artists who were De Bisschop's own contemporaries. Yet in the matter of what to select, it is to the 'guiding hand' of Antiquity that he recommends artists to look, while in the dedication of the *Paradigmata* he is clear in his condemnation of those Dutch artists who find artistic virtue in 'ugliness'. The dedication to *Icones* was originally printed in both Dutch and Latin. De Bisschop's use of the latter suggests that this was a publication designed to attract the interest of educated humanists. Constantijn Huygens the Younger (1628–1697) was a close friend of De Bisschop, a member of a cultured family of scholars and collectors (see IE2, 3), and a fellow amateur artist. The present translation, made from the Latin text, is taken from Jan G. van Gelder and Ingrid Jost, *Jan de Bisschop and his Icones and Paradigmata*, ed. K. Andrews, Doornspijk: Davaco Publishers, 1985, pp. 89–90.

To His Worship Constantyn Huygens Lord of Zeelhem

It is not only on account of the many reasons which so closely attached me to you in the past, but also on account of one in particular that I thought it not unfitting to set your name at the head of this slight work of mine: you clearly feel the same as I do in

the estimation of those things whose images are shown here; namely that these antique monuments, sculptures, statues and marble tablets are of the highest artistic perfection, and the very best example for serious students of painting. This is no recent opinion of mine, but one which has become ingrained with time; from day to day it seems more true and indisputable, whether I consider it in my own judgement or that of another. When one examines the judgement of others, one is presented not only with the immense value attached to these things by experts, both in the past (Cicero in his Verrine Orations, Pliny in his Natural History, and other reliable authors refer to wonderful things almost exceeding belief) and in the present (as personal experience testifies), but also with the unanimous opinion of the greatest artists. Raphael of Urbino, Michelangelo Buonarroti and others are all known to have declared it in words and demonstrated it in what they did. They set all their work against this standard, so much so that they were often unashamed of transferring whole parts to their own works, incurring the charge of plagiarism as a result of their desire to imitate. The beholder is of the same opinion too, since he adjudges the most praiseworthy parts of their works those which most call forth the antique. Even the Venetians, whose excellence has always consisted more in colour and the art of the brush than in their use of drawing, could be adduced as evidence: Mantegna, Palma and others as well are said to have profited very greatly indeed from these examples. But let us look at the judgement of more recent times. Is not the sole thing which has made France (now deservedly owed the palm in this art) so skilled in art the fact that it paid close and thorough attention to the statues at Rome, and honourably received and esteemed Poussin, the imitator of statues? Now let me turn to my own judge-ment. Although it is weak, and can scarcely grasp a part of such skill, and I only see dimly, yet when I cast my still-wakening eyes around, and look on the muscles and superhuman strength of the Hercules, the gladiatorial energy of the athletes, manly old age in the Laocoon, an almost feminine softness in Antinous, youthful hand-someness in Apollo, well-turned limbs in Bacchus, a firm leanness in the Satyrs and Fauns, and the women represented now with delicate bodies and now with plump ones – and I pass over the various ages, actions, gestures, conditions, clothes, and many other things – I cannot stop wondering at the perfect grace in each and the most accurately distinguished variety of all of them, joined with the greatest simpli-city and all the other excellent qualities. One can guess how many and how fine these are from the fact that even the greatest artists have rarely satisfied either themselves or others in restoring one or another part of a mutilated statue, and have not easily ventured upon the undertaking of this hazardous task. Still, I do not condemn those who contend that nature herself is the best example, and that it is she who should especially be followed. Inasmuch as all the perfection of the old masters takes its origin from her, she should also be sought out by more recent artists. But since antiquity so judiciously selected from so great a variety of things whatever is excellent in nature herself (where the beautiful is often mixed with the unadmirable) it is rightly regarded as the best guide and the Ariadne's thread, as it were, of this road. Not, indeed, that anyone should be solely intent on the qualities of the antique and be blind in his contemplation of nature and the living. Relying on the guiding hand of its example he should be able to select the beautiful and admirably turn the whole of nature to his own use. Without it this would clearly be difficult and uncertain. For

these reasons, therefore, I have been impelled to undertake what others have set out to do before me, and most recently, with everyone's applause, that great artist François Perrier; and I am publishing some images of this kind under the lustre of your name to gain favour for the work and authority for the opinion. In collecting them I have made use of the kindness and works of friends who drew them at Rome and were not unwilling to allow me to use them for this purpose. There are some other drawings besides, whose authors are unknown to me. I have thus made use of the eyes of others; but they are superior to my own. A greater number of drawings would have appeared if there had been a larger supply at my disposal. Should anyone be dissatisfied that several aspects of the same sculpture are represented, let him trust that they will be both of service and of pleasure to beginners. If there are any mistakes in the descriptions it will readily be forgiven, since I have not made use of my own knowledge, but have relied on the authority of others. Should this slight work win your favour and be of some value to you, and by your example to others as well, it will serve as a stimulus to greater undertakings, and will certainly testify that I remain,

Your Lordship's
most faithful servant,
Jan de Bisschop.

5 William Aglionby (d.1705) from *Painting Illustrated in Three Dialogues*

Despite the efforts of artists, scholars and patrons, including figures as eminent as Van Dyck, Rubens, Junius and the Earl of Arundel, the visual arts were not established in England during the seventeenth century as successfully as they were in France. This comparative failure is reflected in William Aglionby's *Painting Illustrated in Three Dialogues*. Besides providing an exposition of key concepts, Aglionby also felt bound to equip his audience with brief sketches of the lives of the most eminent modern painters, and perhaps most tellingly, with 'an explanation of the Difficult Terms'. Almost forty years after the founding of the Academy in Paris (see section IB), Aglionby's first concern is still to establish that the Painter is no mere 'Mechanick' but has a 'Title to the Liberal Arts'. It is noteworthy that, writing in the Restoration period, Aglionby is quick to lay blame for the comparative backwardness of the arts in England at the door of the Revolution. In his preface he observes that Charles I 'had once Enriched our Island with the noblest Collection that any Prince out of Italy could boast of: but those Barbarous Rebels, whose Quarrel was as much to Politeness and the Liberal Arts, as to Monarchy and Prelacy, dissipated and destroyed the best part of it' (p. 13). The following extracts are taken from the Preface and from the First and Third Dialogues 'Between a Traveller and his Friend'. The Preface asserts the status of painting as a liberal art (our extracts are from pp. 1–2 and 4–7). The First Dialogue introduces the Parts of art (our extracts are from pp. 1–11, 13–15 and 16–18). The Third turns to the matter of making informed judgements about art (our extracts are from pp. 97–9, 101–2, 104–6 and 115–22). Our source was *Painting in Three Dialogues, Containing some Choice Observations upon the Art together with the Lives of the Most Eminent Painters from Cimabue to the time of Raphael and Michelangelo*, London: John Gain, 1685.

Preface

If the desire of perpetuating our Memorys to posterity, be one of the noblest of our Affections here below, certainly those ARTS by which we attain that kind of Immortality, do best deserve to be Cultivated by us. Therefore Historians and Poets, who keep, as it were, the Registers of Fame, have always been Courted by the Great and by the Good, as knowing that the Merit of their Actions depended upon their Pens; but because those very Men through whose Hands such Glorious Atchievements were to pass, might either be led away with Passion, or swayed with *Prejudice*, to make a false Representation of them to the World. Providence yet kinder, gave us two Arts, which might express the very Lines of the Face, the Air of the Countenance, and in it a great part of the Mind of all those whom they should undertake to Represent; and these are, Sculpture and Painting. [. . .]

I shall not undertake to determine here, which of these two Arts deserves our Admiration most: The one, makes Marble-Stone and *Brass* soft and tender: the other, by a strange sort of Inchantment, makes a little Cloth and Colours show *Living* Figures, that upon a flat Superficies seem Round, and deceives the *Eye* into a Belief of Solids, while there is nothing but Lights and Shadows there: But this I may say in favour of the Art of Painting, whose praises I am now to Celebrate, That it certainly is of a greater Extent than Sculpture, and has an Infiniter Latitude to delight us withal.

To see in one Piece the Beauty of the Heavens, the Verdant Glory of the Earth, the Order and Symmetry of Pallaces and Temples; the Softness, Warmth, Strength, and Tenderness of Naked Figures, the Glorious Colours of Draperies and Dresses of all kinds, the Liveliness of *Animals*; and above all, the Expression of our Passions, Customs, Manners, Rites, Ceremonies, Sacred and Prophane: All this, I say, upon a piece of portative Cloth, easily carried, and as easily placed, is a Charm; which no other Art can equal. And from this Idæa of the Art, we may naturally derive a Consequence of the Admiration and Esteem due by us to the Artist; he who at the same time is both Painter, Poet, Historian, Architect, Anatomist, Mathematician, and Naturalist; he Records the Truth, Adorns the Fable, Pleases the Fancy, Recreates the Eye, Touches the Soul; and in a word, entertains you with Silent Instructions, which are neither guilty of Flattery, nor Satyr; and which you may either give over, or repeat with new Delight as often as you please.

If these *Qualities* do not sufficiently recommend the Owner of them to our Esteem, I know not what can; and yet by a strange Fatality, we name the word Painter, without reflecting upon his Art, and most dis-ingeniously, seem to place him among the *Mechanicks*, who has the best Title to all the Liberal Arts.

First Dialogue

FRIEND: The extream delight you take in Pictures, is a Pleasure you have acquired abroad, for I remember before you travelled, all Pictures were alike to you, and you used to laugh at the distinction that some of your Friends did use to make of the Pieces of this and the other Master, saying, it was nothing but Humor in them.

TRAVELLER: What you say is very true, and when I reflect upon it, I cannot but blush at my own Ignorance, or rather willful Stupidity, that deprived me of one of the most Refined Pleasures of Life, a Pleasure as Lasting as Life it self, full of Innocency and Variety, and so Entertaining, that, alone, it often supplies the place of Company and Books; and when enjoyed in the company of others, it improves by being shared, and growes greater by the number of its Enjoyers, every one making some Observation, according to his Genius and Inclination, which still Illustrates the whole.

FRIEND: I must confess I envy you this Pleasure extreamly, for living, as we do, in a Country where the severity of our Climate obliges us to be much within Doors: Such a Pleasure as this ought to be Cherished, by all those who do not place their Felicity, as too many of us do, in a Glass of Claret: And I own, I would willingly be of your Society, but that there goes such a deal of knowledge to judg of a good Picture, that I dispair of ever being qualified that way, being naturally not much given to take pains for any Pleasure.

TRAVELLER: You are very much mistaken, every one naturally is so far a judg of Painting, as to observe something in a Picture, that is like to somewhat they have observed in Nature, and that alone is capable of giving them delight, if the thing be well represented; but those indeed who joyn to that Delight, the particular knowledg of the manner how the Painter has mannaged his Lines, his Colours, his Lights and Shades, and how be has disposed his Figures, and with what Invention he has adorned his Story. They indeed, have more Pleasure, as having in all this a greater scope for their Observations; and yet this, though infinitely hard for the Painter to Execute, is but moderately difficult for the Spectator to judg of it, requiring only a Superficial Knowledg of the first Principles of the Art, and a constant Observation of the Manners of the Different Artists, which is acquired by viewing their Works often, and Conversing much amongst them.

FRIEND: That Superficial Knowledg of the Principles which you speak of, is wrapt up in such a company of hard Words, and crabed Terms of Art, that a Man must have a Dictionary to understand them, and a good Memory to retain them, or else he will be at a loss.

TRAVELLER: If he undertake this Task with Order and Method, it will prove extream easie; for by following each part of Painting in its proper Division, he will come to the knowledg of the Terms of the Art insensibly.

FRIEND: Pray in the first place, give me a Definition of the Art of Painting, that I may at once see what is aimed at by it, and performed.

TRAVELLER: The Art of Painting, is the Art of Representing any Object by Lines drawn upon a flat Superficies, which Lines are afterwards covered with Colours, and those Colours applied with a certain just distribution of Lights and Shades,

with a regard to the Rules of Symetry and Perspective; the whole producing a Likeness, or true Idæa of the Subject intended.

FRIEND: This seems to embrace a great deal; for the words Symetry and Perspective, imply a knowledg in Proportions and Distances, and that supposes Geometry, in some measure, and Opticks, all which require much Time to Study them, and so I am still involved in perplexities of Art.

TRAVELLER: It is true, that those Words seem to require some Knowledg of those Arts in the Painter, but much less in the Spectator; for we may easily guess, whether Symetry be observed, if, for Example, in a Humane Body, we see nothing out of Proportion; as if an Arm or a Leg be not too long or short for its Posture, or if the Posture its self be such as Nature allows of: And for Perspective, we have only to observe whether the Objects represented to be at a distance, do lessen in the Picture, as they would do naturally to the Eye, at such and such distances; thus you see these are but small Difficulties.

FRIEND: Pray, would you not allow him to be a Painter, who should only Draw the Objects he intended to represent in Black and White, or with bare Lines upon Paper.

TRAVELLER: Yes without doubt, if what he did were well Designed, for that is the Ground-work of all Painting, and perhaps the most difficult thing in it.

FRIEND: What is it you call Design?

TRAVELLER: Design is the Expressing with a Pen, or Pencil, or other Instrument, the Likeness of any Object by its out Lines, or Contors; and he that Understands and Mannages well these first Lines, working after Nature still, and using extream Diligence, and skill may with Practice and Judgment, arrive to an Excellency in the Art.

FRIEND: Me thinks that should be no difficult Matter, for we see many whose Inclination carys them to Draw any thing they see, and they perform it with ease.

TRAVELLER: I grant you, Inclination goes a great way in disposing the Hand, but a strong Imagination only, will not carry a Painter through; For when he compares his Work to Nature, he will soon find, that great Judgment is requisite, as well as a Lively Fancy; and particularly when he comes to place many Objects together in one Piece or Story, which are all to have a just relation to one another. There he will find that not only the habit of the Hand but the strength of the Mind is requisite; therefore all the Eminent Painters that ever were, spent more time in Designing after the Life, and after the Statues of the Antients, then ever they did in learning how to colour their Works; that so they might be Masters of Design, and be able to place readily every Object in its true situation.

FRIEND: Now you talk of Nature and Statues, I have heard Painters blam'd for working after both.

TRAVELLER: It is very true, and justly; but less for working after Nature than otherwise. *Caravaggio* a famous Painter is blam'd for having meerly imitated Nature as he found her, without any correction of Forms. And Perugin, another Painter is blam'd for having wrought so much after *Statues*, that his Works never had that lively easiness which accompanies Nature; and of this fault *Raphael* his Scholar was a long time guilty, till he Reform'd it by imitating Nature.

FRIEND: How is it possible to erre in imitating Nature?

TRAVELLER: Though *Nature* be the *Rule*, yet *Art* has the *Priviledge* of Perfecting it; for you must know that there are few *Objects* made naturally so entirely *Beautiful* as they might be, no one *Man* or *Woman* possesses all the *Advantages* of *Feature*, *Proportion* and *Colour* due to each *Sence*. Therefore the *Antients*, when they had any Great Work to do, upon which they would Value themselves did use to take several of the *Beautifullest Objects* they designed to *Paint*, and out of *each of them*, Draw what was most *Perfect* to make up One *exquisite Figure* [...]

FRIEND: Then you would have a Painter study these Figures of the Antients to use himself to those Proportions and Graces which are there Expressed, but how can that be here with us where there are few such or none at all?

TRAVELLER: I confess the want of them is a great hinderance to our Painters, but we have so many Prints and Casts, the Best things of that kind, and those so well done, that they may in a great measure supply the want of the *Originals*; and this added to the study of *Nature* it self, will be a sufficient Help to any one.

FRIEND: Would you have a Painter study nothing but Humane Figures?

TRAVELLER: That being the most difficult in his Art, he must cheifly Study it: But because no Story can be well Represented without Circumstances, therefore he must Learn to Design every thing, as Trees, Houses, Water, Clothes, Animals, and in short, all that falls under the notion of Visible Objects; so that by that, you may guess how much Time he must spend in this one part of Painting, to acquire that Readiness, Boldness, and Strength, to his Designs; that must be, as it were, the Ground-work of all he does. [...]

FRIEND: When a Painter has acquired any Excellency in Designing, readily and strongly; What has he to do next?

TRAVELLER: That is not half his Work, for then he must begin to mannage his Colours, it being particularly by them, that he is to express the greatness of his Art. 'Tis they that give, as it were, Life and Soul to all that he does; without them, his Lines will be but Lines that are flat, and without a Body, but the addition of

Colours makes that appear round; and as it were out of the Picture, which else would be plain and dull. 'Tis they that must deceive the Eye, to the degree, to make Flesh appear warm and soft, and to give an Air of Life, so as his Picture may seem almost to Breath and Move.

FRIEND: Did ever any Painter arrive to that Perfection you mention?

TRAVELLER: Yes, several, both of the Antient and Modern Painters. Zeuxis Painted Grapes, so that the Birds flew at them to eat them. Apelles drew Horses to such a likeness, that upon setting them before live Horses, the Live ones Neighed, and began to kick at them, as being of their own kind. And amongst the Modern Painters, Hannibal Carache, relates of himself, That going to see Bassano at Venice, he went to take a Book off a Shelf, and found it to be the Picture of one, so lively done, that he who was a Great Painter, was deceived by it. The Flesh of Raphael's Picture is so Natural, that it seems to be Alive. And so do Titians Pictures, who was the Greatest Master for Colouring that ever was, having attained to imitate Humane Bodies in all the softness of Flesh, and beauty of Skin and Complexion.

Third Dialogue.

FRIEND: I have read with great pleasure the Lives of most of those Painters whom we discoursed of at our last Meeting, and that Study has given me so much Insight into the Art, that I must needs own, that a General Painter, such as *Raphael* and some others were, is a most extraordinary sort of Man; it being necessary he should not only have a Genius and Spirit infused from above, but also, that he be fraught with all the best part of acquired Knowledg here below; and I do no longer wonder now, that we have so few of such Transcendent Artists.

TRAVELLER: The World here in our Northern Climates has a Notion of Painters little nobler than of Joyners and Carpenters, or any other Mechanick, thinking that their Art is nothing but the daubing a few Colours upon a Cloth, and believing that nothing more ought to be expected from them at best, but the making a like Picture of any Bodys Face.

Which the most Ingenious amongst them perceiving, stop there; and though their Genius would lead them further into the noble part of History Painting, they check it, as useless to their Fortune, since they should have no Judges of their Abilities, nor any proportionable Reward of their Undertakings. So that till the Gentry of this Nation are better Judges of the Art, 'tis impossible we should ever have an Historical Painter of our own, nor that any excellent Forreigner should stay amongst us.

FRIEND: What you say is very true, and therefore I think it would be a good work to inform us how we should Judge of Paintings, and distinguish the Good from the Bad [...]

TRAVELLER: I must then repeat to you what I told you at our first Meeting; which is, That the Art of Painting has three Parts, which are, Design, Colouring, and Invention; and under this third, is that which we call Disposition; which is properly the Order in which all the Parts of the Story are disposed, so as to produce one effect according to the Design of the Painter; and that is the first Effect which a good Piece of History is to produce in the Spectator; that is, if it be a Picture of a joyful Event, that all that is in it be Gay and Smiling, to the very Landskips, Houses, Heavens, Cloaths, &c. And that all the Aptitudes tend to Mirth. The same, if the Story be Sad, or Solemn; and so for the rest. And a Piece that does not do this at first sight, is most certainly faulty, though it be never so well Designed, or never so well Coloured; nay, though there be Learning and Invention in it; for as a Play that is designed to make me Laugh, is most certainly an ill one if it makes me Cry. So an Historical Piece that doth not produce the Effect it is designed for, cannot pretend to an Excellency, though it be never so finely Painted. [. . .]

The next thing to be considered in an Historical Piece, is the Truth of the Drawings, and the Correction of the Design, as Painters call it; that is, whether they have chosen to imitate Nature in her most Beautiful Part; for though a Painter be the Coppist of Nature, yet he must not take her promiscuously, as he finds her, but have an Idea of all that is Fine and Beautiful in an Object, and choose to Represent that, as the Antients have done so admirably in their Paintings and Statues: And 'tis in this part that most of the Flemish Painters, even Rubens himself, have miscarryed, by making an ill Choice of Nature; either because the Beautiful Natural is not the Product of their Countrey, or because they have not seen the Antique, which is the Correction of Nature by Art; for we may truly say that the Antique is but the best of Nature; and therefore all that resembles the Antique, will carry that Character along with it.

FRIEND: I remember, you reckoned it to me among the Faults of some *Painters*, that they had studied too long upon the *Statues* of the Antients; and that they had indeed thereby acquired the Correction of *Design* you speak of; but they had by the same means lost that Vivacity and Life which is in Nature, and which is the true Grace of *Painting*.

TRAVELLER: 'Tis very true, that a Painter may fall into that Errour, by giving himself up too much to the Antique; therefore he must know, that his Profession is not tyed up to that exact Imitation of it as the Sculptor's is, who must never depart from that exact Regularity of Proportion which the Antients have settled in their Statues; but Painters Figures must be such as may seem rather to have been Models for the Antique, than drawn from it; and a Painter that never has studied it at all, will never arrive at that as Raphael, and the best of the Lombard Painters have done; who seem to have made no other Use of the Antique, than by that means to choose the most Beautiful of Nature. [. . .]

FRIEND: Pray, what is properly *Invention* in a Picture?

TRAVELLER: Invention is the Manner of Expressing that Fable and Story which the Painter has chosen for the Subject of his Piece; and may principally be divided into Order and Decorum. By the first, the Painter places the parts of his Subject properly, so as the Spectator may imagine that the thing did not happen otherwise than as it is there Represented; and so as the whole Content of the Story, though it imbrace never so many Figures, make but one BODY, Agreeing with its self in all its Parts.

For Example: Suppose a Painter to Represent the Story of the Jews gathering Manna in the Desart; he must so order it, that the Persons employed in the Piece do all do the same thing, though in different Aptitudes; and there must appear in their Countenances the same Joy and Desire of this Heavenly Food; and besides, he must Represent a Countrey proper, and give his Figures their Draperies according to the Customs and Manners of the Nation he Represents: all this Raphael has done in this very Story: and indeed, that part of Invention was so great in him, that he seldom Designed a Story in his first SCHIZZOS, that he did not do it four or five several ways, to choose at last the best. But to do this, a Painter, besides a Fanciful, Flourishing Genius of his own, must help himself by reading both History and Fable, and Conversing with Poets and Men of Learning; but above all, the Painter must have a care that he pitch not upon such an Invention as is beyond his Forces to perform.

Some Observations there are about the Number of Figures fit to be employed in an Historical Piece. Hannibal Carrache was of Opinion, that a Piece that contained above twelve Figures, could never be free from Confusion; and the Reason that he used to give, was; first, That he thought that no Piece could be well with more than three great Gruppos, or Knots of Figures: And Secondly, That that Silence and Majesty which is necessary in Painting, is lost in that Multitude and Croud of Figures. But if your Subject be such as constrains you to a Multitude, such as the Representation of a Battle, or of the Last Day of Judgment, then you are likewise dispensed from that great Care of Finishing; but must chiefly study Union, and the disposing of your Lights and Shadows. The Painter must also take Care, that his Scene be known by his Piece at first view, by some Ingenious Invention to express the Countrey: Such was that of Nealces a Greek Painter, who having Drawn a Sea-Fight between the Ægyptians and the Persians; to express, that the Action happened at the Mouth of the Nile, made an Ass drinking by the side of the River, and a Crocodile ready to devour him; that being the proper Animal of that River.

The second part of Invention is Decorum; that is, that there be nothing Absurd nor Discordant in the Piece: and in this part, the Lombard Painters are very faulty; taking Liberties that move one almost to Laughter; Witness Titian himself, who Drew Saint Margaret a Stride upon the Dragon: and most of the Lombard Painters are subject to a certain Absurdity of Anachronisaie's Drawing. For Example, our Saviour upon the Cross, and Saint Francis and Saint Benedict looking on, though they did not live till eight hundred Years after our Saviour's Passion. All Indecencies are likewise to be avoided: and Michael Angelo doth justly deserve to be Censured, in his great Picture of the Day of Judgment, for having exposed to view in the Church it self, the secret parts of Men and Women, and

made Figures among the Blessed that kiss one another most tenderly. Raphael on the contrary, was so great an Observer of Decorum, that though his Subject led him to any Liberties of that kind, he would find a way to keep to the Rules of Modesty: and indeed, he seems to have been Inspired for the Heads of his Madonna's and Saints, it being impossible to imagine more Noble Physionomies than he gives them; and withal, an Air of Pudour and Sanctity that strikes the Spectator with Respect.

FRIEND: This puts me in mind of the moving part of Painting; which is, the stirring of the Affections of the Spectator by the Expression of the Passions in the Piece; and methinks this might well be called a part of Painting.

TRAVELLER: It is Comprehended under that of Invention; and is indeed the most difficult part of it, as depending intirely upon the Spirit and Genius of the Painter, who can express things no otherwise than as he conceives them; and from thence come the different Manners; or, as one may call them, Stiles of Painting; some Soft and Pleasing, others Terrible and Fierce, others Majestick, others Low and Humble, as we see in the STILE of POETS; and yet all Excellent in their Kinds.

6 Bernard Le Bovier de Fontenelle (1657–1757) 'A Digression on the Ancients and Moderns'

Fontenelle sided resolutely with the Moderns in the great quarrel of the Ancients and Moderns which raged in France during the last quarter of the seventeenth century. A nephew of the French playwright, Corneille, he found an easy entry into literary circles in Paris but failed to achieve success as a dramatist. On the other hand, his success in bringing the work of figures such as Descartes and Copernicus to a much wider audience suggests that his real vocation lay in the popularization of science. He was elected to the French Academy of Sciences in 1697 and was subsequently made its permanent secretary. The starting-point of his 'Digression on the Ancients and the Moderns' is uncompromisingly naturalistic: since we have no reason to assume that trees were any larger in Homer's time than our own, we should not suppose that human nature was any different. Nature has always operated with the same basic 'clay'. Whilst Fontenelle acknowledges the influence of climate, he insists that any such differences are levelled out through the advance of time and the progressive exchange of ideas. Although the Ancients had the privilege of coming first, they were inevitably exposed to a wider range of mistakes and errors. The accumulation of knowledge and experience, together with the important advances in scientific thinking made in the seventeenth century, render the Moderns inevitably superior to the Ancients. It is possible that the arts represent an exception, however, for these may have flourished most successfully at the time of their inception. Nonetheless, Fontenelle concludes by seeking to replace the traditional image of mankind's youth, maturity and declining old age with a vision of potentially limitless progress. The Digression sur les Anciens et les Modernes was originally published as an appendix to Fontenelle's Poésies pastorales, Paris: M. Guérout, 1688. The following excerpts are taken from the translation in Scott Elledge and Donald Schier eds., The Continental

Model: Selected French Essays of the Seventeenth Century, revised edition, Ithaca and London: Cornell University Press, 1970, pp. 358–67.

Once the whole question of the pre-eminence of the ancients and moderns is properly understood, it boils down to knowing whether the trees which used to be seen in the countryside were taller than those of today. If they were, Homer, Plato, Demosthenes cannot be equaled in these latter centuries; but if our trees are as tall as those of former times, then we can equal Homer, Plato, and Demosthenes.

Let us explain this paradox. If the ancients were more intelligent than we, the reason must be that brains in those days were better arranged, made of firmer or more delicate fibers, and filled with more animal spirits; but why should the brains of those days have been better arranged? Trees too, then, would have been taller and more beautiful; for if Nature was then younger and more vigorous, trees as well as human brains must have felt the effect of that vigor and youth.

The admirers of the ancients ought to be very careful when they tell us that the ancients are the sources of good taste and reason as well as of knowledge destined to illuminate all other men; that one is intelligent only in proportion as one admires them; and that Nature wore herself out in producing those great originals; for in fact these admirers make the ancients of another species from ourselves, and science is not in agreement with all these fine phrases. Nature has at hand a certain clay which is always the same and which she unendingly turns and twists into a thousand different shapes, thus forming men, animals, and plants; and certainly she did not shape Plato, Demosthenes, or Homer from finer or better-prepared clay than she used for our philosophers, orators, and poets of today. As to our minds, which are not of a material nature, I am concerned here only with their connection with the brain (which is material) and which by its varying arrangements produces the differences between one man and another.

But if trees are equally tall in all centuries they are not so in all countries. Similar differences occur also among minds. The various ideas are like plants or flowers which do not flourish equally in all climates. Perhaps French soil is not suitable for Egyptian lines of thought as it is not for their palm trees; and not to go so far afield, perhaps orange trees, which do not grow so well here as in Italy, are an indication that in Italy there is a certain kind of mind which does not have its exact equal in France. In any case it is sure that through the connection and reciprocal interdependence which exist among the parts of the material world, the differences of climate, whose effect is observable in plants, must produce some effect on human brains as well.

However, this effect is smaller and less obvious because art and culture work more successfully on brains than on the land, which is of a harder and less manipulable substance. Thus the thoughts of one country can be more easily carried to another than its plants, and we would not have as much difficulty in capturing the Italian genius in our literary works as we would have in raising orange trees.

* * *

...the main question concerning the ancients and the moderns now seems to me resolved. Centuries do not put any natural differences among men. The climate of Greece or Italy and that of France are too much alike to be the cause of a perceptible

difference between the Greeks and the Romans and ourselves. Even if some such difference existed it would be very easy to eliminate, and after all would be no more to their advantage than to ours. So we are now all perfectly equal, ancients and moderns, Greeks, Romans, and Frenchmen. [. . .]

'The ancients discovered everything'; on this point their partisans triumph. 'Therefore they were much more intelligent than we'; not at all, but they were ahead of us. I should be just as willing to see them praised for having drunk first the waters of our rivers and for us to be blamed because we drink only what they left. If we had been in their place we would have done the discovering; if they were in ours, they would add to what has already been discovered. There is no great mystery about that.

I am not speaking here of the discoveries brought about by chance and for which credit may perhaps be given to the stupidest man in the world; I am concerned only with those discoveries which required thought and some mental effort. It is sure that the crudest of these were reserved for the greatest geniuses, and that all Archimedes could have done in the earliest ages would have been to invent the plough. Archimedes living in another century burns the Roman fleet with mirrors – if indeed that is not just a tale.

A man concerned to utter specious and brilliant remarks would maintain to the glory of the moderns that the mind need not make a great effort for first discoveries, and that Nature seems herself to lead us to them; but more effort is needed to add to them and a still greater effort in proportion to the amount already added because the subject is more nearly exhausted and what remains in it to be discovered is less apparent to the naked eye. Perhaps the admirers of the ancients would not neglect a line of reasoning as good as that if it favored their side, but I admit in all good faith that it is not very solid.

It is true that to add to earlier discoveries often requires a greater effort of mind than the original discoveries did, but one is in a much more advantageous position to make the effort. The mind has already been enlightened by the very discoveries one has before one's eyes; we have conceptions borrowed from others which can be added to those we form ourselves; and if we surpass the first discoverer, he himself has helped us to do so; thus he still has a share in the glory of our work, and if he withdrew what belongs to him we should have nothing more left than he.

So far do I carry the equity with which I consider this point that I give the ancients credit for numberless false ideas they had, for faults of logic they committed, and for foolish statements they made. In the nature of things it is not given to us to arrive quickly at a reasonable opinion on anything; we must first wander about for a long time and pass through many kinds of mistakes and many kinds of irrelevancies. It seems now that it would always have been easy to conceive the idea that the whole working of nature is explained by the shapes and movements of various bodies; however, before arriving at that point we had first to try the ideas of Plato, the numbers of Pythagoras, and the qualities of Aristotle; only when these had been recognized as false were we driven to accept the correct theory. I say we were driven to it, for in fact no other remained, and it seems that we avoided the truth as long as we could. We are grateful to the ancients for having worn out most of the false ideas conceivable; it was absolutely necessary to pay to ignorance and error the tribute the

ancients paid, and we ought not to be harsh toward those who discharged this debt for us. The same thing is true of various subjects about which we would say foolish things if they had not already been said and, so to speak, preempted; however there still are occasionally moderns who return to them, perhaps because these things have not yet been said as many times as necessary. Thus, enlightened by the ideas of the ancients and by their very mistakes, we might be expected to surpass them. If we only equaled them we should be far inferior to them by nature; we should barely be men compared with them.

However, if the moderns are to be able to improve continually on the ancients, the fields in which they are working must be of a kind which allows progress. Eloquence and poetry require only a certain number of rather narrow ideas as compared with other arts, and they depend for their effect primarily upon the liveliness of the imagination. Now mankind could easily amass in a few centuries a small number of ideas, and liveliness of imagination has no need of a long sequence of experiences nor of many rules before it reaches the furthest perfection of which it is capable. But science, medicine, mathematics, are composed of numberless ideas and depend upon precision of thought which improves with extreme slowness; sometimes indeed these studies must be helped by experiences which chance alone brings forth and which it does not produce at the desired place. It is obvious that all this is endless and that the last physicists or mathematicians will naturally have to be the ablest.

And in fact, the most important aspect of philosophy, and that which is applicable not only to philosophy but to everything, I mean the way we think, has been very much improved in this century. I doubt that many will be able to understand the remark I am about to make; nevertheless I shall make it for the sake of those who understand the problem of philosophical thought; and I may boast that it is evidence of courage to expose oneself for the sake of truth to the criticisms of all the others, whose number is assuredly not negligible. No matter what the subject is, the ancients rarely reason with absolute correctness. Often mere expediency, petty similarities, frivolous witticisms, or vague and confused discourse pass among them for proofs; therefore, it cost them very little effort to prove anything. However, what an ancient could prove in all frivolity would cause a good deal of trouble nowadays to a modern, for are we not much more rigorous in the matter of reasoning? Reasoning must be intelligible, it must be exact, it must be conclusive. Scholars are cunning enough to pick out the slightest ambiguity in ideas or in words; they are harsh enough to condemn the cleverest thing in the world if it does not bear on the point. Before Descartes reasoning was done more comfortably; past centuries are very fortunate not to have had that man. It is he, as I believe, who introduced this new method of reasoning which is much more estimable than his philosophy itself, for of that a considerable part has been shown to be false or uncertain according to the very rules he taught us. In sum, there now reigns not only in our good scientific and philosophical works but also in those on religion, ethics, and criticism a precision and an exactness which have scarcely been known until now.

I am even convinced that these will be carried yet further. A few arguments in the style of the ancients still slip into our best books, but we shall be the ancients some day, and will it not be just for our posterity in its turn to rectify our mistakes and to

go beyond us, especially in the technique of reasoning which is a science in itself and the most difficult as well as the least cultivated of all?

As far as eloquence and poetry are concerned, since these are the subject of the principal dispute between the ancients and the moderns although they are not very important in themselves, I think the ancients may have attained perfection in them because, as I have said, such perfection can be achieved in a few centuries, and I do not know exactly how many are necessary.

* * *

My intention is not to go into critical detail; I merely wish to point out that since the ancients were able to achieve ultimate perfection in certain things and not in others, we ought, in gauging their success, to show no respect for their great names nor have any indulgence for their faults; we ought, instead, to treat them as though they were moderns. We must be capable of saying, or of hearing others say without blinking the fact, that there are irrelevancies in Homer or in Pindar; we must make bold to believe that mortal eyes can see faults in these great geniuses; we must be able to accept a comparison between Cicero or Demosthenes and a man with a French name, perhaps even a commoner's name: this will require a great, a prodigious effort of the reason!

In this connection I cannot keep from laughing at the ridiculousness of men. Prejudice for prejudice, it would be more reasonable to favor the moderns than the ancients. Naturally the moderns have outdone the ancients: prepossession in their favor is thus well founded. What are, on the other hand, the foundations of prejudice in favor of the ancients? Their names, which sound better in our ears because they are Greek or Latin; the reputation they had of being the greatest men of their century; the number of their admirers, which is very great because it has had time to grow through a long period of years. Taking all that into consideration, it would still be better to be prejudiced in favor of the moderns, but mankind, not content to abandon reason for prejudices, often chooses among these the ones which are the most unreasonable.

Once we have decided that the ancients have reached the point of perfection in something, let us be satisfied to say they cannot be surpassed, but let us not say they cannot be equaled, as their admirers are very prone to do. Why should we not equal them? As men we always have the right to aspire to do so. Is it not odd that we need to prick up our courage on this point and that we, whose vanity is often based on nothing solid, should sometimes show a humility no less insecure? It is thus certain that no manifestation of the ridiculous will be spared us.

* * *

The comparison... between the men of all periods and an individual man may be extended to the whole question of the ancients and the moderns. A cultivated intelligence is composed, so to speak, of all the intelligences of preceding centuries; one intelligence only has been cultivated during all that time. Thus Mankind, which has lived from the beginning of the world to the present day, has had a childhood, during which he concerned himself only with the most pressing needs of life; and a youth, during which he succeeded rather well in the things of the imagination such as poetry and eloquence, and when he even began to think, but with less soundness than enthusiasm. He is now in the prime of life and reasons more forcefully and more

incisively than ever; but he would be much farther advanced if the passion of war had not occupied him for a long time and filled him with scorn for that learning to which he has at last returned.

It is a shame not to be able to carry to the end a comparison which is going so well; but I am forced to admit that mankind will never have an old age; in each century men will be able to do the things proper to youth as they will more and more those which are suited to the prime of life; that is to say, to leave the allegory, that mankind will never degenerate, and the sound views of all subsequent thinkers will forever be added to the existing stock.

* * *

7 Charles Perrault (1628–1703) Preface and 'Second Dialogue on the Three Visual Arts' from *Parallel of the Ancients and Moderns*

Perrault is best known today for his celebrated collection of fairy tales, the *Histoires ou Contes du temps passé* (1697), which includes 'Red Riding Hood', 'Bluebeard' and 'Sleeping Beauty'. However, it was Perrault's aggressive defence of the superiority of modern letters that initiated the quarrel of the Ancients and Moderns. This was contained in his poem 'The Century of Louis the Great' read before the French Academy in 1687. The *Parallel of the Ancients and Moderns* was published in a series of four volumes between 1688 and 1697. Each of the volumes addresses a different subject, ranging from eloquence and poetry through to geography and the natural sciences. Here we include a section from the Preface in which Perrault asserts his commitment to the cause of the Moderns and reminds his readers of the origins of the conflict. Our principal extract, however, is from the 'Second Dialogue', dedicated to the arts of architecture, sculpture and painting. Through the various partners in the dialogue, Perrault identifies Antiquity, the Renaissance and the age of Louis XIV as the three main periods in which the arts have flourished, but in each case argues for the superiority of the modern age. Achievements in relief and perspective have enabled modern sculpture to rise to new heights and to avoid the limitations imposed by the depiction of isolated figures. Similarly, advances in the use of chiaroscuro, perspective and compositional unity have brought painting to a new position of pre-eminence in the goal of the idealized imitation of nature. The two paintings he discusses in some detail are Veronese's *The Disciples at Emmaus* (1559–60, Paris, Louvre) and Le Brun's *The Tent of Darius* (sometimes known as *The Queens of Persia at the Feet of Alexander*), which is now at Versailles. *The Tent of Darius* was commissioned by Louis XIV and painted in his presence between 1660 and 1661. The two paintings were hung opposite each other in the King's Cabinet in the Tuileries. Perrault's praise of Le Brun's painting as a richly differentiated whole, achieved through the subtle gradation of light, colour and aerial perspective, is indebted to Le Brun's own account of Nicolas Poussin's *The Israelites Gathering the Manna* in a lecture given to the Royal Academy the previous year (see IB13). Trajan's Column is a monument erected to the Roman Emperor, Marcus Trajan, in the Forum of Trajan in Rome (dedicated AD 113). The gardens at Rueil were laid out between 1633 and 1642 for Cardinal Richelieu and contain a full-scale *trompe l'oeil* by Jean Lemaire (1598–1689). Both the Preface and the 'Second Dialogue' were published in volume I of the *Parallèle des anciens et des modernes*, Paris: Jean-Baptiste Coignard, 1688. These extracts are taken from the Preface (unpaginated) and

from pp. 188–90, 195–201, 206–15, 219–32. They have been translated for the present volume by Christopher Miller.

Preface

Nothing is more natural or reasonable than to show the utmost veneration for whatever is possessed of true merit in itself and has the additional merit of age. This sentiment, so right, proper and universal, redoubles the respect that we feel for our ancestors; by virtue of it, laws and customs show themselves still more authoritative and inviolable. But destiny has always decreed that the best things become prejudicial by excess, and this in proportion to their original excellence. Honourable in its inception, this reverence has subsequently become a criminal superstition, at times extending even to idolatry. Princes of extraordinary virtue secured the happiness of their people, and the earth resounded to the fame of their exploits; they were beloved in their lifetime and their memory was revered by posterity. But as time went by, people forgot that these were mere men, and began to offer them incense and sacrifice. The same thing happened to those who first excelled in the arts and sciences. The prestige that accrued to their century, and the utility that it derived from their inventions, brought them much glory and renown in their own lifetimes, and their works were admired by posterity, which made of them its greatest delight, and celebrated them in praises boundless and immoderate. Respect for their memory so increased that no taint of human weakness could be attributed to them, and their very faults were deemed sacred. A thing had only to be done or said by these great men to become incomparable, and even today, for certain scholars it is a sort of religion to prefer the least production of the Ancients to the finest works of any modern author. I confess to a sense of injury at this injustice; there seems to me such blind prejudice and ingratitude in the refusal to open one's eyes to the beauty of our century, on which heaven has bestowed a thousand distinctions altogether refused to Antiquity, that I have been unable to restrain a sense of veritable indignation. Of this indignation came the little poem, *The Century of Louis the Great*, which was read to the French Academy when it assembled to thank the Lord for the complete recovery of its august protector. All those present at that illustrious assembly seemed quite satisfied with it, save two or three fanatical admirers of Antiquity, who asserted that it had greatly offended them. It was hoped that their discomfiture might give rise to criticisms such as would disabuse the public; but their sense of offence has boiled away in protest at my attack, and in empty and ill-defined words. [...]

So many honourable persons have informed me, with a most tactful and gracious air, that I had, in their eyes, ably defended a bad cause, that I have taken it upon me to state unequivocally, and in prose, that there is nothing in my poem that is not seriously intended. That I am, in short, utterly convinced that, excellent as the Ancients are – on this point there is no disagreement – the Moderns are no whit inferior, and indeed surpass them in many respects. This is a clear statement of my position, which I claim to demonstrate in my dialogues.

* * *

Second Dialogue

* * *

L'ABBÉ : [. . .] Sculpture is indeed one of the finest arts to occupy the intellect and endeavours of mankind. But it can also be said that it is the simplest and most restricted of any of them; this is particularly true of figures in the round. All that is required is to choose a handsome model, place it in an agreeable pose, and then faithfully copy it. The many and various reflections thrown up by the passage of time are of no service here, nor any accumulation of precepts by which to proceed. No more is required than that men of genius be born and apply themselves to their task. It should further be noted that success in this form of work met with extraordinary rewards; the sculptor bestowed very gods upon entire nations and even on the princes of these nations, and when he had succeeded, he was little less honoured than the god formed by his hands. It was therefore possible for the Ancients to excel at sculpture in the round, without exhibiting the same degree of merit in other and more composite arts that require greater elaboration of reflection and precept. This is so true that, in the elements of sculpture *itself* in which reasoning and reflection count for most, such as low relief, the Ancients were noticeably weaker. Of the secrets of this branch of sculpture, a vast quantity were unknown to them even as they constructed Trajan's Column, in which there is neither perspective nor degradation.[1] In this column, the figures are almost all on the same line; where there are any to the rear, they are as big and as clearly defined as those in the foreground, as though they were raised on tiers to be visible one on top of another.

* * *

L'ABBÉ : Most ancient low reliefs, if closely examined, will be found not to be true examples of that art; they are sculpture in the round sawn in half from top to bottom, with the larger part applied and fixed to a uniform background. One need only look at the low relief of *The Dancing Girls*. The figures are, by all means, of extraordinary beauty, and nothing is more noble, lithe and attractive than the air, form and posture of these young *danseuses*. But they are, as I said, figures in the round, sawn in two, or as if half of their bodies had been sunk into the surface that bears them. This clearly demonstrates that the sculptor who made them, excellent as he was, lacked those skills that time and contemplation have since arrived at, and which have, in our own day, attained the utmost perfection. I refer to the skills by which a sculptor uses two or three inches of relief to make figures that not only seem to project out into the round, but also seem more or less recessed into the depths of the relief. I should add in passing that the principal beauties of the relief of *The Dancing Girls* are owed to a sculptor of our time. When Poussin brought it from Rome to France, it was only a rather formless outline, and it was the elder Anguier who gave it the elegance for which it is now admired.

LE PRÉSIDENT : If modern sculpture is so far superior to the ancient in the respect that you cite, it follows that today's painting must greatly exceed that of the

Ancients, since it was from painting that sculpture learnt all these secrets, such as degradation and perspective.

L'ABBÉ : I quite agree. The inference is correct. But since we are now talking of painting, we should begin by distinguishing the various periods in which it has flourished, and define three categories: the time of Apelles, Zeuxis and Timanthes, and of all those great painters whose wondrous achievements are known to us through literature; the time of Raphael, Titian, Paul Veronese and a number of other excellent Italian masters; and our own time. If we follow the common opinion, which almost invariably defines merit in terms of seniority, we shall place the century of Apelles far above that of Raphael, and that of Raphael far above our own. But I positively reject this hierarchy, and notably the preference accorded to the century of Apelles over that of Raphael.

LE PRÉSIDENT : But how can you fail to admit so reasonable and universal an opinion, especially when you have once acknowledged the excellence of the sculpture of Pheidias and Praxiteles? If the sculpture of that time exceeds that of all subsequent centuries, must we not, a fortiori, say the same of painting, when we consider that painting offers a host of refinements and pleasures of which sculpture is incapable?

L'ABBÉ : But that is precisely why your conclusion is inadmissible. If painting were as simple and restricted an art as sculpture is, in respect of works in the round – for only in that department did the Ancients excel – I should concede your point. But painting is so vast and so extensive an art that it has required the entire sum of the centuries for its every secret and mystery to be discovered. To convince you of the scant beauty of ancient painting, and establish how far below that of Raphael, Titian and Paul Veronese and, indeed, the paintings that are made today, we should esteem it, I need no other arguments than the praises bestowed upon it. It is said that Zeuxis represented grapes so accurately that birds came to peck at them. Is that so very wonderful? Multitudes of birds, attempting to fly through it, have hurled themselves against the sky in the perspective at Rueil, but the fact has elicited little astonishment, and has barely been cited in the praises bestowed on this perspective.

LE CHEVALIER : Recently, walking along the Fossé des Religieuses Anglaises, I saw an event as flattering to modern painting as the story of Zeuxis' grapes is to that of the Ancients, and vastly more entertaining. The door of Monsieur Le Brun was open, and a freshly painted picture had been taken out into the courtyard to dry. In the foreground of this painting was a perfect representation of a large thistle. A woman came past leading an ass, which, when it saw the thistle, plunged into the courtyard; the woman who was hanging on to its bridle was dragged off her feet. If it hadn't been for a couple of sturdy lads who gave it some fifteen or twenty blows each with their sticks to force it back, it would have eaten the thistle – and I say eaten, because the paint was fresh and would all have come off on its tongue.

L'ABBÉ: This thistle is no whit inferior to Zeuxis' grapes, of which Pliny makes so much. Pliny also tells us that Parrhasius had imitated a curtain so exactly that Zeuxis himself was taken in. Such *trompe-l'oeil* effects are commonly found today in works of no repute whatsoever. Often enough, cooks have reached out for accurately represented partridges or capons, intending to put them on the spit, and what happens? Everyone laughs, and the painting stays in the kitchens.

* * *

L'ABBÉ: [...] This sort of skill was long considered a great merit in painters. The 'O' of Giotto illustrates this. Pope Benedict IX was searching far and wide for excellent painters, and had their works brought to him so that he could establish their competence. Giotto refused to present a painting, but, in the presence of the Papal Envoy, took a sheet of paper, and with a single pen or pencil stroke, drew an 'O' as round as if it had been made with a compass. On the basis of his 'O' the Pope preferred him to all the other painters; indeed, it gave rise to a proverb which is still current throughout Italy, where, if you wish to imply that a man is stupid, you say that he is round as Giotto's 'O'. But skills of this kind have long ceased to be esteemed among painters. Monsieur Menage told me that he knew a monk who could not only draw a perfectly round 'O' with a single pen-stroke, but could place a dot precisely at its centre. This monk never took it upon himself to pass for a painter, and was content to be praised for his own little talent. Poussin, when his hand had begun to tremble, and he found it difficult to place his brush and colour as he wished, nevertheless painted pictures of indescribable beauty, while count-less painters capable of drawing a line ten times as fine as the most delicate of Poussin's brushstrokes have painted only pictures of the greatest mediocrity. This kind of exploit is a clear sign of painting still being in its infancy. Some years before Raphael and Titian, there were paintings made – they still survive – the principal beauty of which lies in the fineness of line; you can count every hair in the beard and on the head of each figure. Though Chinese art is very ancient, they have remained at this stage. They will, perhaps, soon learn to draw properly, to place their figures in noble attitudes, and attain exact expressions of all the passions. But it will be a long time before they attain a perfect understanding of chiaroscuro, the degradation of light, the secrets of perspective and the judicious organization of a large composition. To make my meaning clear, I should like to distinguish three qualities in painting: the representation of figures, the expression of passions, and the overall composition in which these are organized. In the first of these, I include not only the accurate delineation of their contours, but also the application of true and fitting colours. By the expression of passions, I mean the different characters of the faces and the various postures of the figures, which indicate what they intend to do, what they are thinking, in a word, all that is happening in the depths of their being. By overall composition, I mean the judicious assemblage of these figures, placed with understanding, and with their colours degraded according to their position within the picture. What I say here of paintings in which there are several figures should be understood to apply no less to a painting in which there is only one, since the relations between the different parts of the single figure are like those holding between multiple figures. Appren-

tice painters begin by learning how to draw the outline of figures, and to fill them in with their natural colours. Next they study how a figure can be given noble attitudes, and how to express the passions with which they wish it to seem animated. But it is only much later that they learn the rules to be observed in organizing the composition of a picture: the proper distribution of dark and light, and the placing of all the elements in accordance with the rules of perspective, in respect both of line and of the degradation of light and dark. In the same way, those who first began to paint in this world at first concentrated only on the exact representation of the outline and colour of objects; they desired nothing more than that those who saw their works should be able to say, 'This is a horse,' 'This is a tree' – though often enough they put this in writing, to spare the pains of those attempting to guess. Then they went on to arrange their figures in noble attitudes, and to animate them in a lively fashion with every passion imaginable. These are the two stages of painting to which we cannot but believe that Apelles and Zeuxis attained, if we consider the likely progress of their art and what the ancient authors report of their works; they never knew, or knew only very imperfectly, the third part of painting, which is concerned with the composition of a picture, according to the rules and criteria that I have explained above.

LE PRÉSIDENT: How is all this to be reconciled with the wonders that are related of the works of these great men? For whom, though they were paid in bushels of gold, no reward was thought sufficient? Paintings that restrained the fury of the assailant and curbed the greed of the conqueror, so that the fear of endangering these works by fire prevailed in their hearts over the desire to capture famous cities.

L'ABBÉ: Despite the marvellous powers of ancient painting, I persist with my thesis. For it is not the beautiful arrangement of a picture, the proper distribution of light and the well-judged degradation of the objects, nor, indeed, any part of the third element of painting, the one of which I have spoken, that touches, charms and overwhelms. It is only the accurate delineation of objects furnished with their true colours that makes such a strong impression on the onlooker, and, above all, the lively and natural expression of the impulses of the soul. For it should be said that, just as there are three parts to painting, there are three parts in man by which he may be moved: the senses, the heart and reason. The precise delineation of objects, combining with colour, makes a pleasant impression on the eye; the natural expression of the stirring of the soul goes right to the heart, where, by imparting the passions it represents, it affords distinct pleasure. And finally the understanding demonstrated by the proper distribution of light and shade in the degradation of figures according to their place in the picture, combined with the beauty of a harmoniously balanced composition, satisfies the faculty of reason; the joy thus felt is less keen, it is true, but more intellectual, and worthier of mankind. It is the same with the works of all the other arts. In music, the beautiful sounds and the tunefulness of the voice charm the ear; the cheerful or languishing movements of this voice, varying with the passions that it expresses, move the heart; and the harmony of the various parts mingled in admirable order and disposition

affords pleasure to reason. In rhetoric, pronunciation and gesture affect the senses, touching metaphors win the heart, and the beautiful organization of the speech rises to the superior part of the soul, giving it a peculiar and entirely intellectual joy that it alone can feel. I therefore assert that, for Apelles and Zeuxis to win universal admiration, no more was required than that they charm the eye and touch the heart; they did not need the third part of painting, which satisfies the rational faculty alone. So far from charming the common man, this part often has the contrary effect, and merely repels him. Indeed, how many there are who would prefer distant figures to be as clearly and definitely indicated as those in the foreground, the better to see them, and who would willingly spare the painter the pains that he takes in the composition of his picture and the degradation of the figures according to their position in the painting. In particular, they would be delighted if the painter were to omit shadows cast on the face, especially in the portraits of their loved ones.

* * *

Moreover, I can prove the relative incompetence of ancient painters by pointing to the few pieces of ancient painting still visible in one or two places in Rome. These works are not of exactly the same period as Apelles and Zeuxis, but they are clearly in the same manner, so that the only possible difference is that the masters who painted them were slightly less ancient, and might, as such, have a greater knowledge of painting. I have seen the *Wedding* in the Aldobrandini Vineyard, and the work called the *Tomb of Ovid*. The figures are well defined, the attitudes are wise and natural, and there is great nobility and dignity in the port of the heads. But little understanding is shown in the mixture of colours, and none at all in the perspective or overall arrangement. Every colour is as strong as the next, nothing in the picture either stands out or recedes. All the figures are on the same line, so that it is less a picture than an ancient low relief coloured in; everything in it is dry and motionless; it lacks unity, connection, and the softness by which the living body is distinguished from the marble and bronze that represent it. It follows that the major difficulty is not to prove that today we excel Zeuxis, Timanthes, Apelles and their like, but to demonstrate that we also in some measure surpass Raphael, Titian, Paul Veronese and the other great painters of the last century. Yet I make bold to state that, if we consider art in itself, considered as an accumulation, a collection of precepts, we shall find it more accomplished and perfect at present that it was at the time of these great masters. Let us, if you please, compare the picture of the *Pilgrims at Emmaus* by Paolo Veronese with that of *Darius and his Family* by Monsieur Le Brun; we have, after all, just seen them both in the antechamber of the *grand appartement* of the King, where they have been placed one opposite another as if to facilitate comparison.

LE PRÉSIDENT: What more remains to be said of these two pictures, after the *mot* of an Italian prelate? Monsieur Le Brun's painting, he said, is very beautiful; it is in every respect excellent, but it has an implacable neighbour. By which he meant that, handsome though it is, it can hardly be described as such when it has just been compared with the work of Paolo Veronese.

L'ABBÉ: Since the French tend no less to scorn the work of their countrymen than Italians systematically to elevate the merit of their compatriots whenever occasion arises, this *bon mot* was doubtless applauded. No doubt several persons took it upon themselves to repeat it, in order to suggest that they are possessed of exquisite taste and of a genius superior to that of their country. By this I am quite unmoved. I saw another Italian prelate do something still more discourteous in respect of the painting of the family of Darius. He passed it not only without a glance, but without raising his eyes from the ground, as though the picture might have offended his sight. This affectation at first made me angry, but a moment later, it made me laugh; I rather enjoyed it. At all events, I agree that the painting of the *Pilgrims* is among the most beautiful in existence; the figures are full of life, and it is as if their thoughts were no less visible than their outward actions. But a painting is a silent poem, in which the unity of time, place and action must be as religiously observed as it is in a veritable poem, since the place is fixed, the time indivisible and the action instantaneous. Let us consider how that rule is observed in this picture. All the protagonists are indeed in the same room, but they are as little together as if each had been in a different place. Here, between two of his disciples, our Lord breaks the bread; there are Venetian men and women who pay almost no attention to the mystery that forms the subject of the painting; and in the middle are little children playing with a big dog. It would surely be more reasonable for these three subjects to be featured in three different pictures rather than in a single composite to which they can impart no unity.

LE PRÉSIDENT: Yet you must admit: you can almost hear these people speak. And the breast of the woman in the foreground is true flesh and blood.

L'ABBÉ: I agree, but was it either necessary or fitting that these people should speak, or that the woman should display her flesh in such a place?

LE PRÉSIDENT: The convention of placing in a religious picture those who commissioned it, and their whole family besides, is so well established that this assemblage of persons of different times and places should have come as no surprise to you.

L'ABBÉ: I am aware of the convention, and do not condemn it; though painters have little to thank it for. In Nativity scenes one often sees those who commissioned the picture, but they are kneeling in adoration, like the shepherds. They are often seen in Crucifixion scenes too, but prostrate, and with their eyes raised towards the Saviour. In this way their own individual gestures are linked to the main action of the picture, and contribute to the same end. Here it is as if the protagonists were unable to see each other, and only the will of the painter has set them in one and the same place.

LE PRÉSIDENT: The faults that you find are not with the painter as such, but with the painter as historian.

L'ABBÉ: True, if you confine the painter's function to that of accurately representing an object, without troubling himself to consider verisimilitude, propriety and common sense in his composition. But I cannot believe that painters would willingly sacrifice the requirement that their paintings observe criteria as just and necessary in a work as these. Moreover, I would argue that simply as a painter, Veronese has had little more regard for the unity required in composing a subject than he has as a historian; there are two different points of view in the painting, one for the landscape, and the other for the room where our Saviour is sitting, with his disciples, at the table. The horizon of the landscape is much lower than the table, whose top is visible and suggests a different and much higher viewpoint. This is an error of perspective that we should find unpardonable today in the work of a schoolboy of 15. None of these criticisms can, I believe, be made about the picture of Darius and his family. It is a true poem in which all the unities are observed. The unity of place is this tent, in which we find only those persons who *should* be there. The unity of time is the moment when Alexander says that, in mistaking Hephaestion for himself, they erred but little, since Hephaestion is his second self. If one considers the care with which all things have been made to concur towards a single end, nothing could better connected, unified or united than the representation of this story. At the same time, if you consider the different postures of the protagonists, and the individual expressions of their feelings, nothing could be more diverse and varied. Everything combines to represent the astonishment, admiration, surprise and fear caused by the arrival of the most famous conqueror on earth, and these passions, which all have the same object, receive different expressions in the various people who feel them. Darius' mother, borne down by the combined weight of suffering and age, worships the conqueror and prostrates herself, embracing his feet, and attempting to sway him by the extremity of her grief. Though she is stronger, Darius' wife is no less affected, and, her eyes running with tears, she gazes fearfully at the man who holds her destiny in his hands. Statira, whose beauty is the more touching for the tears that she sheds, seems to have no resource but that of tears. Parisatis is younger, and consequently less affected by her misfortune; in her eyes we see the curiosity characteristic of her sex, combined with her pleasure at contemplating a hero of whom such prodigies are related. As his mother presents him to Alexander, Darius' young son seems surprised, but full of the noble self-assurance imparted by his birth and rank; he is, after all, accustomed to seeing men-at-arms like Alexander. And all the other protagonists are similarly characterized, so well that one perceives not only the general feelings that animate them, but the nature and degree of these feelings, in accordance with their age, condition and nationality. The slaves bow their heads to the ground in profound adoration, the weak, timid eunuchs seem overwhelmed rather by fear than astonishment, and the women seem to mingle with their alarm a measure of trust in the proprieties owed to their sex. And how beautiful and various are the postures of the heads in this picture: they are all, without exception, great and noble; indeed, they are, if I may put it thus, all heroic in their own way. One might say the same of the clothing of the protagonists, to which the painter has devoted the most extraordinary and meticulous attention. In Veronese's picture of the pilgrims, all the heads and all the robes, with the exception of

Christ and his two disciples, in whom some nobility inheres, are taken (men and women alike) from the painter's acquaintance. This debases the composition of the picture in the highest degree, creating the kind of ill-assorted mixture that might result if, in the sublimest tragedy, one should introduce scenes in a low, comic style. If we now attend to the art of painting as such, we find that [in Le Brun's painting] perspective is correctly observed throughout. Moreover, nothing can be added to the beautiful organization of the whole. Though the light falling on the figures seems almost identical, there is nonetheless a degradation of light such that, if any of the figures were moved, their harmony would be disrupted; for their colours, which seem identical as they stand, would seem very different if they were displaced. This cannot so positively be asserted of Veronese's *Pilgrims*, nor indeed of many of the paintings of his time. There is thus an analogy between excellent modern works and the live body; in each, the parts are so intimately connected with each other that they cannot be placed anywhere but where they are. Whereas most ancient paintings I compare to a heap of stones or other things thrown haphazardly together, which could be arranged in a completely different fashion without anyone noticing the difference.

* * *

[1] Translator's note: Perrault's term *dégradation* (which he spells without the accent) corresponds to the technical sense of the English word 'degradation': 'The gradual lowering of colour or light in a painting; *especially* that which gives the effect of distance'. He applies it in the latter sense to sculpture as well as painting. To avoid confusion, no other sense of the word has been used in these extracts.

8 William Wotton (1666–1727) from *Reflections upon Ancient and Modern Learning*

Wotton was born in the parish of Wrentham in Suffolk where his father, Henry, was the local Church of England incumbent. Henry was committed to the idea of a classical education, and had composed an 'Essay on the Education of Children' (posthumously published in 1753). The crowning glory of these ideals was his son. William was a child prodigy. By the age of 6 he could read Latin, Greek and Hebrew, and at 10 he was admitted to Cambridge. By the age of 21 he was a Fellow of the Royal Society. In his *Reflections upon Ancient and Modern Learning* he attempts to address the most pressing intellectual problem of the day across the whole field of human knowledge. The book, which runs to twenty-nine chapters and over 350 pages, considers two broadly distinct kinds of endeavour: on the one hand those where the Moderns have indubitably surpassed the Ancients; on the other, those where it may still be possible to claim pre-eminence for the Ancients. Under the former he lists 'Natural History, Physiology, and Mathematics, with all their Dependencies'. Under the latter he includes 'Poesie, Oratory, Architecture, Painting and Statuary' (p. 19). A conservative disparagement of modern achievement had been the burden of a recently published essay on the same subject (*An Essay Upon Ancient and Modern Learning*, 1690) by the eminent scholar and diplomat Sir William Temple (1628–99). Wotton is concerned to argue the case for the Moderns, and to this end he takes much from Perrault (IA7). In fact, his chapter VI, 'Of Ancient and Modern Architecture, Statuary and Painting', consists almost entirely of quotations from the French author. Out of his collage of quotations Wotton

produces what is, in effect, a new text. We have included it here because it offers a vivid testimony to the eager assimilation of contemporary French artistic and cultural theory by progressive intellectuals in the English-speaking world. Our extracts are taken from chapter VI of *Reflections upon Ancient and Modern Learning*, London: J. Leake, 1694, pp. 61–3 and 68–77.

Hitherto the Moderns seem to have had very little Reason to boast of their Acquisitions, and Improvements; Let us see now what they may have hereafter. In those Arts, sure, if in any, they may challenge the Preference, which depending upon great Numbers of Experiments and Observations, which do not every Day occurr, cannot be supposed to be brought to Perfection in a few Ages. Among such, doubtless, Architecture, Sculpture and Painting may, and ought here to be reckoned; both because they were extreamly valued by the Ancients, and do still keep up their just Price. They are likewise very properly taken notice of in this Place, because they have always been the Entertainments of Ingenious and Learned Men, whose Circumstances would give them Opportunity to lay out Money upon them, or to please themselves with other Men's Labours. In these Things, if we may take Men's Judgments in their own Professions, the Ancients have far out-done the Moderns. The Italians, whose Performances have been the most considerable in this kind, and who, as Genuine Successors of the Old Romans, are not apt to undervalue what they do themselves, have, for the most part, given the uncontested Pre-eminence to the Ancient Greek Architects, Painters and Sculptors. Whose Authority we ought the rather to acquiesce in, because Michael-Angelo and Bernini, two wonderful Masters, and not a little jealous of their Honour, did always ingenuously declare, that their best Pieces were exceeded by some of the ancient Statues still to be seen at Rome.

Here therefore I at first intended to have left off; and I thought my self obliged to resign what I believed could not be maintained, when Monsieur Perrault's *Parallel of the Ancients and Moderns* came to my Hands. His Skill in Architecture and Mechanicks was sufficiently manifested long ago, in his admirable Translation of, and Commentaries upon Vitruvius: And his long Conversation with the finest Pieces of Antiquity, and of these Later Ages, fitted him for judging of these Matters better than other Men. So that, though there might be great Reason not to agree to his Hypothesis of the State of Ancient and Modern Eloquence and Poesie; yet in Things of this Nature, where the *Mediums* of Judging are quite different, and where Geometrical Rules of Proportion, which in their own Nature are unalterable, go very far to determine the Question, his Judgment seemed to be of great weight. I shall therefore chuse rather to give a short View of what he says upon these Subjects, than to pass any Censure upon them of my own. [...]

Of Sculpture he says; 'That we are to distinguish between entire Statues, and *Basso Relievo*'s; and in entire Statues, between naked and cloathed Pieces. The naked Images of the Ancients, as Hercules, Apollo, Diana, the Gladiators, the Wrestlers, Bacchus, Laocoon, and some few more, are truly admirable: They shew something extreamly noble, which one wants Words for, that is not to be found in Modern Work: Though he cannot tell whether Age does not contribute to the Beauty. That if some of the most excellent of the Modern Pieces should be preserved 1500 or 2000 Years, or ting'd with some Chymical Water, that could in a short time make them

appear Antique, it is probable they would be viewed with the same Veneration which is now payed to Ancient Statues. That the naked Sculpture of single Figures is a very noble Art indeed, but the simplest of any that has ever charmed Mankind; not being burthen'd with a Multiplicity of Rules, nor needing the Knowledge of any other Art to compleat it; since a Man that has a Genius, and Application, wants only a beautiful Model in a proper Posture, which he is faithfully to copy: And therefore, That in the Cloathed Statues of the Ancients, the Drapery wants much of that Art which is discernable in some Modern Pieces; they could never make the Clothes sit loose to the Bodies, nor manage the Folds so as to appear easie and flowing, like well-made Garments upon living Bodies. That the *Basso Relievo's* of the Ancients plainly show, that the Statuaries in those Days did not understand all the Precepts that are necessary to compleat their Art; because they never observed the Rules of Perspective, they did not lessen their Figures gradually, to make them suitable to the Place where they stood, but set them almost all upon the same Line; so that those behind were as large, and as distinguishable, as those before; as if they had been purposely mounted upon Steps, to be seen over one another's Heads. That this is visible in the Columna Trajana at this Day, though that is the noblest ancient Performance in Basso Relievo still remaining; wherein, together with some very beautiful Airs of some of the Heads, and some very happy Postures, one may discern that there is scarce any Art in the Composition of the whole, no lessening of the Relievo in any part, with great Ignorance in Perspective in the whole. That the ancient Works in Basso Relievo did not truly deserve that Name, being properly entire Statues, either sawed down perpendicularly, from Head to Foot, with the fore-part fastned, or glued to a flat Ground, or sunk half way in: Whereas the true Art consists in raising the Figures so from their Ground, which is of the same Piece, that with two or three Inches of Relievo, they may appear like distinct Images rising out of the Ground, some more, some less, according to the several Distances in which they ought to be placed'.

Of Painting, he says; 'That three Things are necessary to make a perfect Picture; To represent the Figures truly; To express the Passions naturally; and, To put the whole judiciously together. For the First, It is necessary that all the Out-Lines be justly drawn, and that every Part be properly coloured. For *the* Second, It is necessary that the Painter should hit the different Airs and Characters of the Face, with all the Postures of the Figures, so as to express what they do, and what they think. The whole is judiciously put together, when every several Figure is set in the Place in which we see it, for a particular Purpose; and the Colouring gradually weakned, so as to suit that part of the Plain in which every Figure appears. All which is as applicable to the several Parts of a Picture that has but one Figure, as to the several Figures in a Picture that has more. That if we judge of Ancient and Modern Paintings by this Rule, we may divide them into three Classes: The First takes in the Age of Zeuxis, Apelles, Timanthes, and the rest that are so much admired in Antiquity. The Second takes in the Age of Raphael, Titian, Paul Veronese, and those other great Masters that flourished in Italy in the last Age. The Third contains the Painters of our own Age; such as Poussin, Le Brun, and the like. That if we may judge of the Worth of the Painters of the First Classe by the Commendations which have been given them, we have Reason to say, either that

their Admirers did not understand Painting well, or that themselves were not so valuable, or both. That whereas Zeuxis is said to have painted a Bunch of Grapes so naturally, that the Birds pecked at them; Cooks have, of late Years, reached at Partridges and Capons, painted in Kitchins; which has made By-standers smile, without raising the Painter's Reputation to any great heighth. That the Contention between Protogenes and Apelles shewed the Infancy of their Art: Apelles was wonderfully applauded for drawing a very fine Stroke upon a Table: Protogenes drew a Second over that, in a different Colour; which Apelles split into two, by a Third. Yet this was not so much as what Giotto did, who lived in the Beginning of the Restoration of Painting in Italy; who drew, without Compasses, with a single Stroke of a Pencil, upon a Board, an O, so exquisitely round, that it is still proverbial among the Italians, when they would describe a Man that is egregiously stupid, to say, That he is as round as the O of Giotto. That when Poussin's Hand shook so much, that he could scarce manage his Pencil, he painted some Pieces of inestimable Value; and yet very indifferent Painters would have divided every Line that he drew, into nine or ten Parts. That the Chineses, who cannot yet express Life and Passion in their Pieces, will draw the Hairs of the Face and Beard so fine, that one may part them with the Eye from one another, and tell them. Though the Ancients went much beyond all this; for the Remains of the ancient Painting discover great Skill in Designing, great Judgment in Ordering of the Postures, much Nobleness and Majesty in the Airs of the Heads; but little Art, at the same time, in the Mixing of their Colours, and none at all in the Perspective, or the Placing of the Figures. That their Colouring is all equally strong; nothing comes forward, nothing falls back in their Pictures; the Figures are almost all upon a Line: So that their Paintings appear like Pieces in *Basso Relievo*, coloured; all dry and unmoveable, without Union, without Connexion, and that living Softness which distinguishes Pictures from Statues in Marble or Copper. Wherefore, since the Paintings of these Ancient Masters were justly designed, and the Passions of every several Figure naturally expressed, which are the Things that the Generality of Judges most admire, who cannot discern those Beauties that result from a judicious Composition of the whole, so well as they can the distinct Beauties of the several Parts, there is no Wonder that Zeuxis and Apelles, and the other Ancient Masters, were so famous, and so well rewarded. For, of the three Things at first assigned, as necessary to a perfect Painter, true Drawing, with proper Colouring, affect the Senses; natural Expressing of the Motions of the Soul move the Passions; whereas a Judicious Composition of the whole, which is discernable in an Artful Distribution of Lights and Shades, in the gradual Lessening of Figures, according to their respective Places, in making every Figure answer to that particular Purpose which it is intended to represent, affects the Understanding only; and so, instead of Charming, will rather disgust an unskilful Spectator. Such a Man, and under this Head almost all Mankind may be comprehended, will contentedly forgive the grossest Faults in Perspective, if the Figures are but very prominent, and the View not darkned by too much Shade; which, in their Opinion, spoils all Faces, especially of Friends, whose Images chiefly such Men are desirous to see'.

When he compares the Paintings of Raphael and Le Brun together, he observes, 'That Raphael seems to have had the greater Genius of the two; that there is

something so Noble in his Postures, and the Airs of his Heads; something so just in his Designs, so perfect in the Mixture of his Colours, that his St. *Michael* will always be thought the first Picture in the World, unless his *H. Family* should dispute Precedency with it. In short, he says, That if we consider the Persons of Raphael and Le Brun, Raphael perhaps may be the greater Man: But if we consider the Art, as a Collection of Rules, all necessary to be observed to make it perfect, it appears much more compleat in Monsieur Le Brun's Pieces: For Raphael understood so little of the gradual Lessening of Light, and Weakning of Colours, which is caused by the Interposition of the Air, that the hindmost Figures in his Pieces appear almost as plain as the foremost; and the Leaves of distant Trees, almost as visible as of those near at hand; and the Windows of a Building four Leagues off may all be counted as easily as of one that is within twenty Paces. Nay, he cannot tell whether some part of that Beauty, now so peculiar to Raphael's Pieces, may not, in a great Measure, be owing to Time, which adds a real Beauty to good Paintings. For, in Works of this kind, as in New-killed Meat, or New-gathered Fruit, there is a Rawness and Sharpness, which Time alone concocts and sweetens, by mortifying that which has too much Life, by weakning that which is too strong, and by mixing the Extremities of every Colour entirely into one another. So that no Man can tell what will be the Beauty of Le Brun's *Family of Darius, Alexander's Triumph, the Defeat of Porus,* and some other Pieces of equal Force, when Time shall have done her Work, and shall have added those Graces which are now so remarkable in the *St. Michael,* and the *H. Family.* One may already observe, that Monsieur Le Brun's Pieces begin to soften; and that Time has, in part, added those Graces which it alone can give, by sweetning what was left on purpose, by the judicious Painter, to amuse its Activity, and to keep it from the Substance of the Work.' Thus far Monsieur Perrault.

Whether his Reasonings are just, I dare not determine: Thus much may very probably be inferred, That in these Things also the World does not decay so fast as Sir *William Temple* believes; and that Poussin, Le Brun and Bernini have made it evident by their Performances in Painting and Statuary, *That we have had Masters in both these Arts, who have deserved a Rank with those that flourished in the last Age, after they were again restored to these Parts of the World.*

IB
The Academy: Systems and Principles

1 Nicolas Poussin (1594–1665) Letters to Chantelou and to Chambray

The French painter Nicolas Poussin was born in the small village of Les Andelys in Normandy, but spent most of his working life in Italy. In 1640 he was recalled to Paris to serve as court painter to Louis XIII, but he was temperamentally unsuited to the demands of the post and he returned to Rome in 1642, where he remained until his death in 1665. Poussin avoided grand public and decorative projects, preferring to work on relatively small-scale paintings for a circle of erudite and like-minded collectors who were highly appreciative of his austere but poetic treatment of subjects from classical mythology and ancient history. The most important of his French patrons was Paul Fréart de Chantelou (see IC3), who commissioned a number of paintings, including the second series of the seven *Sacraments*, now housed in the National Gallery of Scotland in Edinburgh. The immediate occasion for the letter reprinted below was Chantelou's complaint that the artist had taken more care over his painting of *The Finding of Moses* for Jean Pointel than he had over the *Ordination* from the series of *Sacraments*. Poussin responds by pointing out that different subjects require different treatment and defends his position by elaborating a theory of the musical Modes in relation to painting. Poussin's suggestion that the disposition of the painting as a whole can be adapted to convey a mood or emotion exercised a considerable influence on later theorists, including André Félibien (see IB9) and Antoine Coypel (see IIA8 and 9). The second letter, written six months before Poussin's death, is to Roland Fréart de Chambray, Chantelou's brother and the author of *An Idea of the Perfection of Painting* (see IB6). This letter reaffirms Poussin's rationalist view of painting, whilst casting light on the unique fusion of Christian and pagan themes which characterizes his last paintings. It has been seen as a sort of artistic credo of his later years. The following translations are taken from Anthony Blunt, *Nicolas Poussin*, London: Phaidon, 1967, pp. 367–72. Blunt has shown that the source for Poussin's account of the Modes is a treatise by Gioseffe Zarlino, *Istituzioni harmoniche*, first published in 1553.

Poussin to Chantelou

Rome, November 24, 1647

Sir,

This letter will serve as an answer to your two last, one of the twenty-third of October and one of the first day of this month. I am keeping the promise I made you and that is that I shall not use my brushes for anyone but you until I have finished your Seven Sacraments. Therefore, having sent you the Last Supper, which is the sixth, I have taken in hand the last, the one you say you care for least; be that as it may, I promise it will not be inferior to the one you like most.

I have been paid for the last picture I sent you by an agent for M. Giericot. In any case, you must be aware of this from the letter of exchange that has surely reached you and from the one I wrote you about the dispatch of the picture which, I am sure, you will have received before the present letter.

I have decided to serve Monsieur de Lysle since you order me to do so, despite the fact that I had resolved, from now on, to do some work as though for myself, without having to submit any longer to the caprice of others and especially of those who only see through the eyes of others. Nevertheless, this gentleman must prepare himself to be patient, a difficult thing for a Frenchman.

I presented your regards to the Cavaliere dal Pozzo who reciprocates them with his customary courtesy.

Regarding what you write me in your last letter, it is easy to dispel your suspicion that I honor you less and that I am less devoted to you than to others. If this were so, why should I have preferred you, over a period of five years, to so many persons of merit and quality who ardently desired that I should do something for them and who offered me their purses? why was I satisfied with such a modest price that I would not even accept what you yourself offered me? And why, after sending you the first of your pictures composed of only sixteen or eighteen figures – so that I could have made the others with the same number or fewer in order to bring such a long labor to an end – why did I enrich them further with no thought except to obtain your good will?

Why have I spent so much time running here and there in hot or cold weather for your personal errands, were it not to prove to you how highly I esteem you? I don't wish to say more because I should go beyond the limits of the devotion that I have vowed you. You must certainly believe that I have done for you what I would not do for any living person and that I shall persist in my resolve to serve you with all my heart. I am not fickle or changing in my affection once I have given it to a person.

If you find the painting of the Finding of Moses which belongs to M. Pointel so attractive, is this a reason for thinking that I did it with greater love than I put into your paintings? Cannot you see that it is the nature of the subject which has produced this result and your state of mind, and that the subjects that I am depicting for you require a different treatment? The whole art of painting lies in this. Forgive my liberty if I say that you have shown yourself precipitate in your judgment of my works. To judge well is very difficult unless one has great knowledge of both the

theory and the practice of this art. We must not judge by our senses alone but by reason.

This is why I want to tell you something of great importance which will make you see what has to be observed in representing the subjects of paintings.

Those fine old Greeks, who invented everything that is beautiful, found several Modes by means of which they produced marvelous effects.

This word Mode means, properly, the *ratio* or the measure and the form that we employ to do anything, which compels us not to go beyond it, making us work in all things with a certain middle course or moderation. And so this mediocrity or moderation is simply a certain manner or determined and fixed order in the process by which a thing preserves its being.

As the Modes of the ancients were composed of several things put together, the variety produced certain differences of Mode whereby one could understand that each of them retained in itself a subtle distinction, particularly when all the things that pertained to the composition were put together in proportions that had the power to arouse the soul of the spectator to divers emotions. Observing these effects, the wise ancients attributed to each [Mode] a special character and they called Dorian the Mode that was firm, grave, and severe, and they applied it to matters that were grave, severe, and full of wisdom.

And passing on from this to pleasant and joyous things they used the Phrygian Mode because its modulations were more subtle than those of any other Mode and because its effect was sharper. These two manners and no others were praised and approved by Plato and Aristotle, who deemed the others useless; they held in high esteem this vehement, furious, and highly severe Mode that strikes the spectator with awe.

I hope within a year to paint something in this Phrygian Mode; frightful wars provide subjects suited to this manner.

Furthermore they considered that the Lydian Mode was the most proper for mournful subjects because it has neither the simplicity of the Dorian nor the severity of the Phrygian.

The Hypolidian Mode contains within itself a certain suavity and sweetness which fills the soul of the beholders with joy. It lends itself to divine matters, glory, and Paradise.

The ancients invented the Ionic which they employed to represent dances, bacchanals, and feasts because of its cheerful character.

Good poets have used great diligence and marvelous artifice in adapting their choice of words to their verse and disposing the feet according to the propriety of speech, as Vergil has observed throughout his work, because to all three manners of speech he accommodates the actual sound of the verse with such skill that he seems to set before our eyes with the sound of the words the things he is describing. So, when he is speaking of love, he has cleverly chosen certain words that are sweet, pleasing, and very grateful to the ear. Where he sings of a feat of arms or describes a naval battle or accident at sea, he has chosen words that are hard, sharp, and unpleasing, so

that on hearing them or pronouncing them they arouse fear. If, therefore, I had painted you a picture in which this manner was followed, you would imagine that I did not love you.

Were it not that it would amount to composing a book rather than writing a letter, I would like to bring to your attention several important things that should be considered in painting, so that you could fully realize how much I exert myself in your service. For though you are very knowledgeable in all matters, I fear that the frequentation of the many insensate and ignorant people that surround you may corrupt your judgment by contagion. I remain as always

<div style="text-align:right">

Sir

Your very humble and very faithful

servant

Le Poussin

</div>

Poussin to Chambray

Rome, March 1, 1665

Sir,

After such a long silence one must at last try to arouse oneself while the pulse still faintly beats. I have had ample leisure to read and examine your book on the perfect Idea of Painting which provided sweet refreshment to my afflicted spirit and I rejoiced that you should be the first among Frenchmen to have opened the eyes of those who only see through the eyes of others, allowing themselves to be deceived by false, generally accepted opinions. Now you have enlivened and softened a material that is rigid and difficult to handle, and, thanks to this, in the future some person may appear who, because of your guidance, may manage to give us something of his own for the benefit of painting.

After reflecting on the way Franciscus Junius divides this beautiful art into parts I have dared to set down here briefly what I have learned about it.

In the first place it is necessary to know what this kind of imitation is and to define it.

Definition:

It is an imitation with lines and colors on any surface of all that is to be found under the sun. Its aim is delectation.

Principles that any man capable of reasoning can learn:

Nothing is visible without light.

Nothing is visible without a transparent medium.

Nothing is visible without boundaries.

Nothing is visible without color.

Nothing is visible without distance.

Nothing is visible without instrument.[1]

What comes after this cannot be learned.

These parts are the painter's affair.

But first about subject matter –

It must be noble and not have taken on any common quality so that the painter may show his spirit and industry. It must be chosen so as to be capable of taking on the most excellent form. The painter must begin with disposition, then ornament, decorum, beauty, grace, vivacity, *costume, vraisemblance*, and judgment in every part. These last qualities spring from the talent of the painter and cannot be learned. They are like Vergil's Golden Bough which none can find or pick, unless he is guided by destiny.

These nine parts contain many beautiful things which deserve to be written about by good and learned hands, but I beg you to consider this small sample and to give me your opinion of it without ceremony. I know well that you know not only how to snuff a lamp but how to feed it with good oil. I would say more but nowadays when I overheat the front of my head by great concentration, it makes me ill. Moreover I am always ashamed to see myself placed on the same level with men whose merits and worth are farther above me than the Star of Saturn is above our head.

It is a result of your friendship that makes you see me as far greater than I am. For this I feel forever indebted to you and I am

<div align="right">

Sir
Your very humble
and very obedient servant
Le Poussin

</div>

I very humbly kiss the hands of your elder brother M. de Chantelou.

[1] These six 'principles' are the conditions of sight as generally accepted by seventeenth-century writers on optics, whose ideas on this subject were still based on their medieval predecessors, such as Vitellio and Alhazen [Blunt].

2 Nicolas Poussin (1594–1665) Observations on Painting

Poussin's 'Observations on Painting' have come down to us through their inclusion in Giovanni Pietro Bellori's *Le vite de' pittori, scultori et architetti moderni* (The Lives of Modern Painters, Sculptors and Architects), where they form the culmination of his life of the artist (see IB3 and 8). Organized under a series of thematic headings, they consist largely of passages excerpted from a variety of classical and Renaissance authors. It has been suggested that the choice of notes may reflect Bellori's own theoretical priorities. Nonetheless, it is clear that Poussin has drawn upon these sources in order to give expression to his own most fundamental views on painting. Painting is viewed as a rational activity whose primary goal is the expression of beauty and truth. Its proper concern is the depiction of noble human action. Poussin's emphasis on expression and clarity, and on the avoidance of all unnecessary detail, contrasts with the goals of the Italian Baroque as practised in Rome by contemporaries such as Pietro da Cortona. This translation is taken from Anthony Blunt, *Nicolas Poussin*, London: Phaidon, 1967, pp. 361–6, including the accompanying notes which identify the original source of Poussin's observations.

Of the Example of Good Masters

Even though instruction concerning practice follows the study of theory, unless theoretical precepts are confirmed by evidence they do not impress on the mind the working habits that are the result of practical experience; in fact, by leading the young man down long and winding paths, they rarely direct him to the desired end of his journey unless the firm guidance of good examples points the way to more rapid methods and less esoteric ends.

[The source of this passage has not so far been identified, but it probably comes from some sixteenth-century treatise on literary theory.]

Definition of Painting and of the Imitation Proper to it

Painting is simply the imitation of human actions, which, properly speaking, are the only actions worthy of being imitated; other actions are not imitable in themselves, as principal parts, but incidentally, as accessories; in this manner one can imitate not only the actions of animals but all natural things.

[This passage is copied from Tasso's *Discorso del poema eroico* (Torquato Tasso, *Prose*, Milan and Naples, 1959, p. 497). Poussin has simply changed the word 'poesia' to 'pittura.']

How Art Surpasses Nature

Art does not differ from nature nor can it go beyond her limits. Thus the light of knowledge, which, like a gift of nature, is scattered here and there and appears in different men at different times and places, comes together by means of art. This light in its entirety or in a large part is never to be found in a single man.

[The idea expressed here is also to be found in a letter of Poussin to Chantelou of June 27, 1655 (*Correspondance*, pp. 434 f), in which he quotes almost verbatim a passage in Quintilian's *Institutio oratoria* 12. 10.]

How the Impossible Constitutes the Perfection of Painting and Poetry

Aristotle, using the example of Zeuxis, wants to prove that the poet has license to say impossible things provided they are better [than the possible]. So it is impossible by nature that a woman should possess every beauty gathered in her one self as was the case with Helen who was very beautiful and consequently better than the possible. See Castelvetro.

[Here Poussin himself gives the clue to his source. In fact, the passage is taken from Castelvetro's *Poetica d'Aristotele* (Basel, 1576, p. 668).]

Of the Bounding Lines of Drawing and Color

A painting will appear elegant when its extreme elements join the nearest by means of intermediate ones in such a fashion that they do not flow into one another too feebly nor yet with harshness of line and colors; and this leads one to speak of the harmony or discord of colors and of their bounding lines.

[The source of this note has not as yet been identified.]

Of Action

There are two instruments which will affect the minds of your hearers, action and diction. The first is in itself so valuable and efficacious that Demosthenes gave it the first place in all rhetorical devices, and Marcus Tullius [Cicero] calls it the speech of the body. Quintilian attributes such efficacity and such power to it that he esteems conceits, proofs, and effects useless without it; and without it, lines and colors are useless.

[The gist of this passage is to be found in Quintilian's *Institutio oratoria* 11.3. 1–6, but in a different form. Poussin may have copied it from some sixteenth- or seventeenth-century critic who was summarizing the ancient author.]

On Certain Forms of the Grand Manner. On Subject Matter, on the Conceit, on Composition, and on Style

The grand manner consists in four things: the matter, that is, the subject, the conceit, the composition, and the style. The first thing that is required, as the foundation of everything else, is that the matter and the subject should be something lofty, such as battles, heroic actions, religious themes. But as the subject with which the painter is contending is grand, the most important advice is that he must avoid excessive details with all his power, in order to preserve the dignity of his story, and must not skim lightly over things great and magnificent to lose himself in vulgar and frivolous matters. Therefore the painter must exert his art not only in treating the subject but also his judgment in understanding it, and he must select it of such a nature that it may be endowed with every ornament and perfection; but those who select lowly subjects seek refuge in them because of the infirmity of their minds. Therefore lowly and base subjects should be scorned as being far removed from any artifice which may be used in their presentation. As for the conceit, this is purely a product of the mind that speculates about things, as was the conceit of Homer or that of Phidias when he conceived the Olympian Zeus who by a nod can move the universe; however, the design of things should be such as to express the conceits of these same things. The structure or composition of the parts should not be worked out with obvious effort, or labored, but natural. Style is a particular manner and skill in painting and drawing which comes from the particular genius of each individual in

his way of applying and using ideas; this style, manner, or taste comes from nature and intelligence.

[The principal ideas expressed in this note are to be found in Agostino Mascardi's *Dell'arte historica*, published in Rome in 1636, but, if this is his source, Poussin has put together passages scattered about in different parts of the book. Some points are also to be found in Paolo Aresi's *Arte di predicar bene* (Venice, 1611, Bk. III, ch. 28) and yet others in the first discourse of Tasso's *Discorsi dell'arte poetica* (ed. cit., p. 350).]

Of the Idea of Beauty

The idea of beauty does not descend into matter unless it has been prepared as much as possible: this preparation comprises three things: the order, the mode, and the species or form. The order concerns the interval of the parts, the mode relates to quantity, the form has to do with lines and colors. Neither the order nor the interval of the parts is sufficient, nor is it sufficient that all the limbs of the bodies be in their natural place unless, besides this, according to the mode, each limb be proportioned to the size of the body and, according to the species, all the lines be handled gracefully and with a suave harmony of lights adjacent to shadows. From all these considerations it is apparent that beauty is entirely removed from the physical aspects of the body and only comes close to them when it is prepared by these insubstantial preparations. And thus we conclude that painting is nothing but an idea of incorporeal things even though it shows bodies, for it only represents the order and the mode of the species of things and it is more intent upon the idea of beauty than on any other thing, so much so that there are those who have maintained that this only was the mark and the goal of all good painters, and that painting, looking on beauty with an enamored eye, was the Queen of the arts.

[As was first pointed out by Panofsky (*Idea*, p. 117) this note corresponds closely to a passage in the *Idea del tempio della pittura* (Milan, 1590) of G. P. Lomazzo who in his turn had borrowed the text from Marsilio Ficino's *Sopra lo amore over'convito di Platone* (Florence, 1544). But Poussin's text corresponds even more closely to a passage in the Italian translation of Dürer's treatise made by G. P. Gallucci and published in Venice in 1599 (*Della simmetria dei corpi humani libri quattro*, ch. 57). This text contains one sentence which is missing in both Ficino and Lomazzo and which corresponds to Poussin's sentence beginning: 'Et qui si conclude....'

This appears to be the only case in which Poussin copied out a passage expressing Neo-Platonic ideas.]

Of Novelty

Novelty in painting does not consist above all in choosing a subject that has never been seen before but upon a good and novel arrangement and expression, thanks to which the subject, though in itself ordinary and worn, becomes new and singular. In this connection one should recall the *Communion of St. Jerome* by Domenichino in

which the emotions and movements differ from those of the same subject by Agostino Carracci.

[The idea expressed in this note corresponds to one in the first discourse of Tasso's *Discorsi d ell'arte poetica* (ed. cit., p. 352).

Poussin is here defending his master Domenichino, who had been attacked for plagiarism in his painting of the Last Communion of St. Jerome, now in the Pinacoteca Vaticana, which was said by his critics to be a mere variant of Agostino Carracci's painting of the same subject, now in the Pinacoteca in Bologna.]

How to Make up for the Poverty of a Subject

If the painter wants to arouse admiration in people's minds but has not in hand a subject apt to produce it, he will not introduce strange and new things contrary to reason but will force his mind to make his work marvelous by the excellence of its manner, so that people will say: 'Materiam superabat opus.'

[The main points of this note can be found in contemporary writers on literature (e.g., Mascardi, op. cit., p. 158). Poussin is here no doubt alluding to the quarrel between the Baroque and Classical parties in the Academy of St. Luke and siding with the latter.]

Of the Form of Things

The form of each thing is distinguished by its function or purpose; some are intended to arouse laughter, others terror, and these are their forms.

[This definition of form, which goes back ultimately to Aristotle, was almost universally accepted by philosophers in the Middle Ages and the Renaissance.]

Of the Charms of Color

Colors in painting are a snare to persuade the eye, like the charm of the verse in poetry.

[Poussin has once again modified a passage from Tasso to make it apply to painting instead of literature. His source is found in the second discourse of the *Discorsi del poema eroico* (ed. cit., p. 537).]

3 Various Authors: Recollections of Poussin

Already during his lifetime Poussin was acclaimed as the embodiment of 'the perfect painter'. In France he was revered as the 'new Raphael' and as the only contemporary artist whose work could stand comparison with the achievements of the Ancients. His work was central to the foundation of the new French school of painting and was accorded

exemplary status within the newly formed Royal Academy of Painting and Sculpture. The image of Poussin as a 'philosopher-painter', who lived a life of austere nobility and artistic virtue, came to play an important role in promoting the ideal of the learned artist. Here we include excerpts from three texts which did much to consolidate this view. The first, *An Idea of the Perfection of Painting*, by Roland Fréart de Chambray, was published in 1662, three years before the artist's death. Poussin's measured response is given in the letter reproduced above (see IB1 and 6). The second is taken from Giovanni Pietro Bellori's 'Life of Poussin' published in Rome in 1672 as the last of his *Lives of Modern Painters, Sculptors and Architects* (see IB2 and 8). The third is from the eighth of André Félibien's *Entretiens sur les vies et les ouvrages des plus excellents peintres anciens et modernes* (Conversations on the Lives and Works of the Most Excellent Ancient and Modern Painters), which was published in France in 1685 (see IB9 and ID6). The eighth *Entretien* is entirely devoted to Poussin's life and work and is presented as the crowning achievement of the work as a whole. Our selections are taken from the translations by Fabia Claris and Bridget Maison appended to Alain Mérot, *Nicolas Poussin*, London: Thames and Hudson, 1990, pp. 314–17.

Roland Fréart de Chambray: *Idée de la perfection de la peinture démonstrée par les principes de l'art* (Paris, 1662), pp. 121 ff.

[...] this Poussin is indeed a mighty eagle in his profession, or, to put it more clearly and without using metaphors, he is the most accomplished and perfect of all our modern painters. It is not difficult to convince scholars of this, men who study and judge matters in the manner of mathematicians, that is to say with precision, on the basis of pure demonstration, through analysis of the principles involved, and without allowing opinion or favour, which are the bane of truth, to intrude. Others, however, who have only a superficial knowledge, but yet have a very over-inflated view of their own judgment, will see this statement as a paradox, and in so doing render themselves incapable of ever being shown its truth. That is why I leave them to argue about it, and content myself with having established in this treatise the fundamental principles and the method by which it should be dissected, without involving myself any further in this dispute. I would only add by way of information that anyone who is curious enough to get to the stage of seeking decisive proof of Poussin's worth will find it amply demonstrated in his set of *Seven Sacraments* ... which are to be seen in Paris at the residence of Monsieur Chantelou, a steward in ordinary to the King, and a close friend of this illustrious Poussin. It is a series of seven uniform pictures, moderate in size, but of extraordinary diligence, in which this noble painter seems to have given us not only a perfect demonstration of the art in accordance with all the parts examined in this treatise, but also an illustration of the highest state of excellence which can be achieved, through his innovation and inventiveness, the nobility of his ideas on each subject, his scholarly and judicious observance of costume (in which he is almost unique), the force of his figures' expressions, and, in a word, all the same qualities discernible in the great geniuses of antiquity, among whom he would, I believe, have held one of the topmost places, since in all his works he demonstrates all the same parts of excellence which Pliny and the others pointed out in Apelles, Zeuxis, Timanthes and Protogenes, and the rest of that first class of painters.

Gian Pietro Bellori: *Le Vite de' Pittori, Scultori et Architetti moderni* (Rome, 1672).

He led an extremely well-ordered life, for many are they who paint according to whim and who work for a time, full of ardour, but who then tire and cast aside their brushes for some long while. Poussin was in the habit of rising early in the morning and taking some exercise for an hour or two, sometimes walking through the City, more usually on the Monte della Trinità which is the Pincio hill, not far from his house, from which it is reached by way of a gentle slope, delicious with trees and fountains, whence the beautiful view of Rome and her pleasant hills unfolds, which together with its buildings is both scenic and theatrical. He lingered here with his friends, immersed in deep and learned conversations; returning home, he set about painting without a break, until midday. After a pause for refreshment, he continued painting for several hours; and thus he achieved more through continuous study than another artist would through practice. In the evening he again went out, and walking beneath the same hill, in the piazza, amid the crowd of foreigners who were wont to gather there. Here he was always surrounded by a retinue of intimate admirers; and those who, by dint of his reputation, desired to see him and to treat him as a friend found him here, admitting all good men to his circle. He listened readily to others, but then his observations were very serious, and attentively received: he would often talk about art, and with such expertise that not just painters but cultivated people in general came to hear him discourse on the supreme purpose of painting, not to educate [his listeners], but simply as ideas came to him. Having read widely and observed acutely, there was no subject about which he was ill-informed, and his words and ideas were so appropriate and well-ordered that they never gave the impression of being impromptu, rather the results of lengthy meditation. His unique talent was the reason for this, combined with the variety of his reading, in which history, fables and erudite tomes prevailed, but which also encompassed the other liberal arts and philosophy. His recollection of the Latin language, albeit imperfect, served him well, and his Italian was as good as if he had been a native of Italy. His reasoning was perspicacious, his ability to choose acute, his memory retentive: he thus possessed the most prized gifts of intelligence. The figures he drew in Leonardo's *Treatise on Painting*, printed with his drawings in Paris in 1651, are proof of his learning. He maintained that painting and sculpture were but one art, both dependent upon drawing and differing only in their execution, although the former was more artificial by dint of its feigning appearances . . .

As regards the style of this craftsman, it can be said that he envisaged a study, such as he had begun in Paris during his youth, based on the antique and on Raphael, such as when he wanted to create his compositions: having thought up his inventions, he then made a rough sketch of what he had in mind; he then made small wax models, half a hand's breadth in height, of all the figures striking their attitudes, and then con-structed the story or the fable in relief in order to study the natural effects of the light and the shadow of the bodies. He then made larger models, which he dressed, so as to make a separate study of their attire and the folds of material on the naked form, and

for this purpose he used fine canvas, or wet cambric, with just a few pieces of cloth providing a variety of colours. Thus he gradually sketched nude life studies, and the drawings emanating from his imaginings were done with simple lines, using simple chiaroscuro watercolours, which nonetheless effectively conveyed movement and expression. He continually sought action in historical subjects and maintained that it was the painter himself who had the right to choose the subject matter and that he should avoid subjects that had no meaning; and this is certainly evident in his compositions. He read Greek and Latin histories and made notes, which he then used when the occasion arose. With regard to this, we have heard him condemn those who make up a story of six or indeed eight figures, or another set number, which a half figure more or less could ruin, and laugh about them. With his great knowledge of art, it was easy for him to see where others went astray and he was openly critical of their errors, unswayed by groundless opinions and firm in his own reasoning. . . .

He was a tall and well-proportioned man with an exceptional temperament; his complexion was quite olive and his black hair had mostly turned grey with age. His eyes were almost sky-blue, his nose sharp and his forehead wide, all of which gave his face a noble yet modest look. . . .

As regards his habits and his intellectual pursuits, apart from what has already been said, Poussin was very perceptive and very wise. He avoided Court life and the conversation of great men, though he was by no means at a loss when he met them, in fact his virtuous spirit rendered him superior to their worldly fortunes. . . .

He treated himself honestly; he did not wear fine clothes, but dressed soberly, and it suited him. Nor was he afraid when away from home to deal personally with his own affairs. There was nothing ostentatious about his home, and he treated all his friends alike, whatever their rank. One day Monsignor Camillo Massimi, now a very distinguished Cardinal, of whom Poussin was very fond and whose opinions he respected, visited his studio. They discoursed together until late at night, and when the time came for his guest to leave, Poussin accompanied him downstairs to his carriage, lantern in hand, causing his visitor to say 'How sorry I am that you have no servant', to which Poussin replied 'And I am even more sorry for your Illustrious self, because you have many.' He never discussed the price of his paintings either with this gentleman or with any other of his friends, but when he delivered their paintings he marked the back of the canvas, and payment in full was immediately sent round to his home. One day I was visiting some ruins with him in Rome, together with a foreigner who was very desirous of taking some rare antique back to his own country. Poussin said to him 'I should like to give you the most beautiful antique you could possibly desire,' and, stretching out his hand, he picked out of the grass a handful of earth and pebbles, with tiny fragments of porphyry and marble turned almost to dust, saying 'Here, Sir, take this to your museum and tell them this is ancient Rome.' He had always planned to write a book about painting, making notes on various subjects or writing down his thoughts during the course of his readings and contemplations, with the intention of assembling them when he became too old to paint, for he was of the opinion that elderly painters should abandon their brushes once their spirits failed, as many of them have given us cause to think. . . .

André Félibien: *Entretiens sur les vies et les ouvrages des plus excellents peintres anciens et modernes*, fourth part, 8th Entretien (Paris, 1685), pp. 250–5.

. . . I know too that he scarcely ever stooped to copy other pictures, and even when he saw something worthy of note among the classics, he would do no more than make quick sketches of it. But he would look long and hard at whatever he saw that was of exceptional beauty, firmly fixing the image in his mind, often commenting that a painter increased his skull by observing things rather than by wasting his energies on copying them.

This immensely sound and fine understanding which he displayed from his earliest years, coupled with the great passion he had for his art, meant that he was more than happy to devote himself to it wholeheartedly and that he never found greater enjoyment than when he was working. He regarded every day as a day to work and study, and every minute he spent painting or drawing was a recreation for him. He took every opportunity to study, wherever he happened to be. As he walked through the streets, he would watch everyone around him, and if he saw anything remarkable he would note it down in a book he always carried expressly for this purpose. He would avoid gatherings whenever possible and would steal away from his friends and go off on his own into the vineyards and remotest corners of Rome, where he was free to stop and look at any classical statue or pleasant views, and to observe the finest effects of nature. It was on these retreats and solitary walks that he would make quick sketches of things which he encountered and thought suitable either for landscapes – like terraces, trees, or particularly beautiful lighting effects – or for history pictures – like satisfying arrangements of figures, combinations of clothes, or other details of decoration – sketches which he would later put to such good and judicious use.

He was not content simply to know the world through his senses, or to base his knowledge on the examples of the greatest masters: he strove particularly to discover the causes of the different sorts of beauty discernible in art, convinced as he was that a workman cannot achieve the perfection he seeks unless he knows the means by which he can do so and the traps he may fall into. For this reason, in addition to looking to the best books he could find to teach him what it was that constituted the good and the beautiful, what it was that caused ugliness, and in what way judgment should be exercised in the choice of subjects and in the execution of all the parts of a work, he also sought to make himself more competent in the practice as well as the theory of his art, by studying geometry, and particularly the science of optics, which is a vital instrument in painting, and helps set the senses straight, and prevent them, either from weakness or otherwise, from being deceived at times and taking illusions of form for solid truths. For this he turned to the writings of the Theatine, Father Matteo Zaccolini, of whom I have spoken to you. No painter has ever grasped the rules of perspective or understood the reasons for light and shade better than this priest. These writings are in the Barberini Library, and Poussin had a large part of them copied and studied them assiduously. Because some of his friends saw them in his hands, and because he talked so knowledgeably about [the science of] optics and made such felicitous use of it, people thought he had composed a treatise on light and shade. In fact, however, he never wrote anything on the subject; his own paintings

were sufficient evidence of all that he had learnt from Father Zaccolini, and indeed from the works of Alhazen and Vitellion. He also had a high regard for the writings of Albrecht Dürer and for Leone Battista Alberti's *Traité de la peinture*. He had learnt about anatomy while he was in Paris; but he studied it again and with even greater application when he was in Rome, as much through the writings and illustrations of Vesalius, as through the lessons he took with a learned surgeon who often performed dissections.

It was at the time when most of the young painters who were in Rome, attracted there by Guido Reni's great reputation, were flocking to copy his painting of *The Martyrdom of St Andrew* which is in S. Gregorio Magno. Poussin was almost alone in preferring to draw the painting by Domenichino in the same church; and so good was his exposition of its beauty that, swayed by his words and his example, the majority of other painters abandoned Guido Reni and copied the Domenichino instead.

For although Poussin looked primarily to the beautiful works of classical antiquity and to the works of Raphael, against which he measured all his own ideas, this did not prevent him from holding other masters in high esteem. He considered Domenichino to be the best of the Carracci school as a model for drawing and for powerful expressions. He also admired other artists for their fine brushwork, and it cannot be denied that in his early years he was more than a little influenced by Titian's use of colour. But it is notable that, as he perfected his skills, he became more and more insistent as regards the form and accuracy of drawing, which he rightly saw as the major aspect of painting, as have all the greatest painters who have, so to speak, abandoned all other aspects in its favour as soon as they have understood the essence of the excellence of their art.

4 Martin de Charmois (1609–1661) Petition to the King and to the Lords of his Council

On 20 January 1648 Martin de Charmois made a successful petition to the Regency Council of Louis XIV for the founding of a Royal Academy of Painting and Sculpture. His proposals represent an ambitious attempt to limit the power of the medieval guilds and to overturn their historic privileges. In 1646 the guild of master painters and sculptors, known as the *Maîtrise*, had put forward a request to Parliament limiting the number of *brevetaires*, or royal painters, who operated under the king's protection and thus beyond the guild's control. Charles Le Brun and other court painters responded by seeking to form a rival institution which could challenge the monopoly of the guilds. They found an able champion in Charmois, a former secretary to the French Ambassador in Rome, who was also an amateur painter. Charmois's petition, no doubt drawn up with the help of Le Brun, contrasts the role of the Academy in elevating painting and sculpture to the status of a 'liberal art' with the artisanal or merely 'mechanical' aspirations of the guilds. The *Maîtrise* had successfully imposed restrictions on the importation of foreign works of art and on the admission of foreign artists. Charmois rejects these as damaging to the flourishing of the arts. In place of the archaic and insular practices of the old corporations, he proposes a new system of education and training which will allow the arts to prosper in the service of the king. At the outset of the petition, he refers to an older Academy of Painting and Sculpture which had been founded under Louis XIII but which had survived for only a couple

of years. This translation of the complete text of the petition has been made for the present volume by Christopher Miller from L. Vitet, *L'Académie royale de peinture et de sculpture: Étude historique*, Paris: Michel Lévy, 1861, pp. 195–207.

Sire, the Academy of Painters and Sculptors, weary of the persecution that it has suffered these long years through the hostility of certain master craftsmen, who take the name of painters or sculptors only to oppress those who have spent their youth toiling at the study of beautiful things in order to merit this title, has finally been constrained to abase itself at the feet of Your Majesty, humbly soliciting his attention, in order to point out that the patience with which [the Academy] has endured these violent proceedings has so inflated the courage of its antagonists that they not only presume to oblige the most erudite exponents of this art to work for those who grind their colours and polish their statues, merely because these men have purchased the title of masters, but they also wish to limit the powers of Your Majesty, by reducing to a certain number those whom he has honoured with the name of painters and sculptors to the King. And this is the result of their ignorance, for they find the lustre of virtue insufferable, and wish to veil it in darkness, so that their failings cannot be distinguished from the beauty of knowledge. For a long time now these masters have inflicted their tyranny on the most excellent men of this profession working in Paris, and, after forcing some among them to become members of its corporation, they would already have obliged the others to do the same, if these had not garnered some support in their effort to prevent these noble arts falling into the void. But since this support, though it is of great assistance, does not remove them from the imminent danger in which they find themselves, and since their enemies are even now making renewed efforts to reduce them to the rank of the most abject trades, they here have recourse to the sovereign power, in order to be restored to their true status; to become such as they were in the time of Alexander in the Academy of Athens, when, as everyone knows, they occupied the first ranks among the liberal arts. And since Your Majesty has, since his earliest childhood, shown himself more marvellous in his actions than that great prince ever was in the flower of his age, they have the right to hope that they will be delivered from this oppression. For it is a deed worthy of Your Majesty, and they will glory in their past persecutions if they owe their liberty to the hand of a prince, whose birth and whose perfection are, at such a tender age, admired by the entire universe. Alexander allowed only the great Apelles to paint his portrait. We have only one Alexander, but Paris has several men such as Apelles and many such as Phidias and Praxiteles, who can ensure that the radiance of his august face is felt in the most distant climes, and that the handsome traits and graces bestowed on it by the heavens are revered in those places. Your Majesty will not allow these ignorant men to paint that face; he will have the practice of such elevated arts forbidden to slaves, as indeed it once was; he will preserve the nobility of these arts, and leave in captivity those who have voluntarily submitted thereto by creating a trade corporation and thus placing themselves on the same footing as the basest of artisans.

Nevertheless, the Academy intends no disservice to those painters and sculptors who, having been forced to qualify as master craftsmen because they were foreign, or lacked the resources to speak out against powerful enemies, or were received at such a young age that they were not able to understand the departure from duty this

entailed, will now leave the tumultuous crowd, and re-ascending Parnassus, willingly and happily renounce the prerogatives of an abject troop in order to attach themselves to the interest of those who would rather suffer voluntary poverty and conserve their honour than seek advantage by submitting to shameful laws such as would tarnish their reputation. It would indeed be a lamentable thing if these arts should suffer, when the other arts are universally cherished by all great men. It would be sad indeed if a city that is the refuge of foreign nations should lend its hand to the oppression of either its own children or those who have come to France in order to embellish it, and if those who flee from the sound of the cannon to seek in Paris a safe haven, should find in it a form of persecution more violent than that of the armies and encampments. Protogenes was as calm amid his enemies as in time of peace. Our Academy members, by contrast, remain at war at the very time when our neighbours envy France's good fortune and its happy government, particularly since the Regency, when their Majesties chose a minister who is alone comparable to his predecessor, so that one's knowledge of the war is confined to news of the victories daily won against those who threaten this state. The Academy might fear to state its petition at excessive length, and make ill use of Your Majesty's leisure, had it not often seen him take respite from the most important matters, in order to relax among the virtuous, and allow them to represent on canvas the external beauties that the heavens have bestowed on him. This persuades the Academy that Your Majesty will not refuse to cast his eye over its just complaints; or rather, to restore its former liberty, since he cannot learn of its misfortunes without seeking their remedy. It may seem that it spoke too boldly, when it boasted that it could imitate the attractions that shine forth from the face of Your Majesty so that they live on through several centuries. And it acknowledges, Sire, that nothing could more clearly suggest the degree of perfection to which our arts may rise. And nevertheless, it will go further, since the Academy can glory in the claim that it is composed of many painters and sculptors who are no whit inferior to the Ancients, whose chisels and paintbrushes were so expert, that one may judge the inclinations and favourable or unfavourable destiny of those who are represented in their pictures or statues. It even dares to say that, though Your Majesty has distinguished himself by very remarkable actions, his portraits, which are carried into the further reaches of the world, have played a great part in converting to adoration the admiration elicited in foreign minds by his renown.

This vanity should be pardoned, for, on the one hand, it is a truth very generally acknowledged, and on the other, those who are oppressed feel a certain relief and show that their hearts are not cast down when they thus attempt to raise themselves by praises of which they are not unworthy. Yes, painters and sculptors may pride themselves, Sire, that they can not only express the very least lineaments of the face, but that they can go beyond these to inclinations, and exhibit these to the eyes of those who have the least tincture of physiognomy. One might indeed add, that those who laid the foundations of the Ottoman Empire had these arts in such high esteem that they banned them in every land that came under their yoke; either because they deemed men unworthy to enter into competition with their Creator, or because they wished to maintain their subjects in ignorance, lest painting, which is a form of writing, if we are to trust to the interpretation of it given by the Greeks, should enlighten and improve them no less than the characters of printed books or

manuscripts. The first of these considerations has a very clear rationale, since it is certain that painters are the imitators of the works of their Creator; with dust soaked in oil or water, they make use of a flat surface to put before the eye everything that has or may have existed, or of which we can form any idea. As to the second, we read that Pythagoras and other ancient philosophers went to Egypt to learn this universal form of writing, which shows in an instant that which writers strive to express in many words; they sought to discover through these arts the beauty of the sciences and the mysteries of their religion. Indeed, one of the greatest men who has ever enlightened the Church with his writings, having spoken a funeral oration over the body of a saint of his own century, felt himself obliged to exclaim, on seeing the paintings of the saint's life: 'O what an advance painting today has over speech! Who could have imagined that dumb eloquence could be so strong and so persuasive? I have set out in many sentences the life and miracles of a holy man, and the painters have made them manifest to a single glance! They have touched the soul through the noblest of the senses, and have explained themselves without intermediary to all the peoples of the earth.' And yet the Academy does not seek to draw any conclusion from this praise, or to magnify itself at the expense of orators or writers, since their goal is no different from the painter's; all these arts have their beauties, and what one does with the paintbrush the other does with the pen. In a word, their object is simply to express things as we see them or conceive them. Nor does it seek to rob sculpture of the portion of these praises it is owed, or give painting some kind of primacy over sculpture. Painting explains itself through colour, sculpture through marble or other more tractable substances; painting by accretion, sculpture by excision. They are sisters, and their common father is drawing; and neither can dispute the nobility or antiquity of the other, since the bodies that God has created were simultaneously clothed in accidental qualities. Thus no objects can ever have appeared without being painted in their colours, which pertain to painting, nor could painting subsist without bodies, which pertain to sculpture.

This short digression seemed not irrelevant, inasmuch as it bars the route towards a question often raised, and which has always remained in the balance. Moreover, precautions must be taken to avoid either of these two arts bridling at the fact that no hierarchy is observed here, and that first one and then the other is accorded priority. An end must be put to this domestic divorce. Our hostility must be concentrated on those persecutors who stretch their arms in our direction rather in order to suffocate than support us, and who wish to ally themselves with us merely for our dishonour. The purpose of the Academy is to illustrate to Your Majesty their insolent attempt to claim to speak with his voice and curb his power, to seek admission to the councils of princes where sculptors and painters are admitted, when these others are employed only to paint the door of the farm courtyard or to polish some piece of marble. It would fain ask them whether painting and sculpture have been degraded or disgraced since emperors, kings – men such as [Caius] Fabius [Pictor] – and the greatest men of history have practised them as their most agreeable pastime. We have no need to seek examples abroad or in the remote past; we need not speak of the payments given for pictures (a single one having been sold for 106 talents), or of the liberality of Parrhasius, who could no longer receive payment for his works in gold coin, which was brought to him in bushels, because he was unwilling to take the trouble to count

or weigh them, and therefore presented them to the public, the Athenian Republic having declared that nothing could be of equal value to them. We have only to consider the esteem shown by our last six kings to sculptors and painters: the posts, profits and pensions that they accorded them, and the love and affection that they felt for them, to the point of visiting them when they were ill and holding them in their arms when they breathed their last. No one need open a book to remember that this honour was accorded to Leonardo da Vinci, who expired in the arms of François I, and that he honoured painters by bestowing the golden lily upon their arms, amid three escutcheons. Henri II loaded Primaticcio, the Abbé de Saint Martin and pupil of Giulio Romano, with honorary positions and benefits; Charles IX was immensely fond of M. Janet; and Henri IV bestowed signal honours on Messieurs Freminet, du Breuïl and Bunel. This continued almost to our very day. We have seen the late king, not content with sending his carriages to bring Monsieur Poussin to Fontainebleau and treating him and his suite with great magnificence, receive him at the door of his room, showing by this extraordinary generosity that he honoured the arts in the very person of one of his subjects. Those who are unaware of the excellence of Poussin will be astonished by this, but he knew it well, as Poussin had often painted members of his court, and the king wished to encourage many young men who have indeed been enthused by this example and have attained a considerable standard in this profession. For there is no greater stimulus to virtue than the hope of honour and the reward that is its concomitant. Our enemies will no doubt reply that they no longer have any memory of these events, and that painting and sculpture have since become a matter for commoners. And they are certainly right to speak thus, since they wish to place painting in the category of trades incompatible with nobility. Those who profess the fine arts have too great a confidence in the justice of Your Majesty to fear this disgrace, and they judge by the proofs he daily gives of his great genius that he will not merely emulate the fine parts with which the heavens had adorned so great a prince, but must believe that, just as his good fortune has allowed him to extend the boundaries of his states and carry his arms into kingdoms where the name of François [I] seemed forever buried, his excellent education will provide him with insights and knowledge such as have never been noted in any of his predecessors. For which reason, they have resolved not to let themselves be charmed by the vain arguments of those who envy them or be intimidated by their threats. They wish to defend the name and the prerogatives attached to their profession after so many sleepless nights devoted thereto, not simply in order to win the rewards that Dony, in the volume about his medals, says were previously awarded to those who, having excelled in the arts, were honoured by the governments of the provinces, but in order to protect themselves from the infamy into which their enemies seek to deliver them. If your Majesty were to do the Academy's enemies the honour of listening to them, he would hear of nothing but the protection of public interest and the damage caused by the swarms of foreigners and the ignorant. But the only remedy that they ask in order to obviate all these disorders is money, whether or not an artist is competent; on condition he submit to the jurisdiction of the masters, all difficulties will be resolved. Whereas the Academy can have no difficulty in showing that it is important to the public that painters and sculptors who have learnt their arts in Italy or elsewhere with much hard labour should return to embellish the first city of the

universe. It is as easy to show that their works, which are intended only to ornament temples and excite the devotee to piety, enhance the palace and other buildings, and instruct and entertain the eye, should not be exposed to the scrutiny of the commoner like goods necessary to life; or like the painting of a *porte-cochère*, which must be visited to determine whether the colours are oil or distemper and whether they can withstand inclement weather. Yet if Your Majesty were to follow their counsels, he would ban Michelangelo and Raphael of Urbino (if they were alive today) from working in Paris, unless under a master, when these masters are not worthy to grind the colours or polish the statues of these great men. It offends common sense to require that these excellent men, who were flattered and esteemed by the greatest princes on earth, should have ceased producing such beautiful representations unless they subjected themselves to some upholsterer; or that the said upholsterer should have the right, if [one of them] had painted a portrait of Your Majesty and the Queen Regent, to confiscate it injuriously without respect for so sacred an image. It offends common sense to claim that the number of painters to Your Majesty and the Queen should be limited, and that his family should lose their privileges after the painter's death, and that they should only be able to work if one of the masters order them to make a professional visit, were it indeed to the palace of Your Majesty; that it is a crime to profess virtue in a place of refuge; that painting and sculpture, which have been freely exercised in all kingdoms and republics, should be debased in Paris; that the other arts should be in all their glory here, and that the painters and sculptors who make use of them in order to perfect their works should be placed on a footing with the merest artisan. This truly is an extravagant claim, and one which could only occur to crude and malevolent minds. If anyone should doubt the fact that those who devote themselves to these arts make use of others if they wish to proceed with certainty and attain perfection, they will soon come round to our view if they refer to Vitruvius, who insists that no art should be unknown to the architect, since a painter must be a good architect if he is to represent buildings in his picture with due proportion and measure. This reason should be convincing in itself, but even were it not, everyone knows the inscription that Apelles had placed above his door, refusing entry to all who were not geometers; so there we have geometry; as to the perspective of lines and colours, it is so necessary to painters that they can do nothing without it, since painting and low-relief sculpture are nothing but true perspective. Music, which seems least likely to enter into it, is one of its main components, since we read that Praxiteles had established relations between the proportions of the human body and those of musical tones, and had called them harmonic, to the extent that he knew precisely what consonance the parts had with one another, and wrote a book about this, which has been lost, along with many another fine work. I have said nothing of arithmetic, given that without it one cannot be a good geometer. Astronomy is absolutely indispensable to the architect, and consequently to painters and sculptors. They must moreover have the art of logic, know the nature of animals in order to represent them correctly, learn fables and history in order not to make mistakes in their compositions, and be excellent anatomists in order to understand the relations of the part of the body and their movements. They must also understand physiognomy in order accurately to express passions in their pictures and paint in faces the virtues and vices to which those whom they paint incline. If, after an

Academician has spent several years acquiring all this knowledge, he finds himself reduced to requesting employment in the shop of a grinder of colours, a gilder or an upholsterer, for it is in this fashion that these master painters should describe themselves, or in that of a marble worker, who abusively seeks to claim the title 'sculptor', there will be no one who does not lose heart and hereafter there will be more sense in remaining ignorant than in toiling to acquire virtue.

In consideration of which, Sire, and given that the painters and sculptors do not in the least seek to destroy the privileges of the said gilders, upholsterers and marble workers, but only to remove themselves from this body of base artisans, as indeed several of those who have qualified as masters have already done; given that we do not here request bills against persons of whom we ask nothing; that most of those of the Academy have letters patent as painters and sculptors to Your Majesty, and that our remonstrance is also in favour of those others, French or foreign, who are currently living in Paris, or who may do so, inasmuch as the Academy seeks to preserve on their behalf the freedom enjoyed by those who practise noble and privileged arts;

May it please your graces, Sire, to place a very express ban and impediment on the said Masters, so-called painters and sculptors, hereinafter to assume that title while they keep a shop or belong to the said guild, and limit them to that of upholsterers or gilders; as regards these so-called painters and marble workers, to forbid them to undertake figure or history paintings or portraits or landscapes, figures in the round or in low relief for churches or other buildings public or private, permitting them only to gild, paint or make in relief Moorish, grotesque, arabesque, leaf and other decorations such as they are commissioned to make, on pain of a fine of 2,000 *livres* and the confiscation of the said pictures or sculptures; prohibiting them from troubling or harassing the said painters and sculptors of the Academy by inspections, distraint, confiscations or otherwise in whatsoever fashion or manner, under the same pains, and each painter and sculptor shall, in his own right, continue not only his zeal and long nights of work, in order to make himself the more capable of being employed in the embellishment of his buildings, but also his wishes and prayers for the prosperity and health of Your Majesty.

5 Statutes and Regulations of the Académie Royale de Peinture et de Sculpture

The first meeting of the French Royal Academy of Painting and Sculpture was held on 1 February 1648, just ten days after the granting of Charmois's petition to the king (see IB4). However, the rules governing its organization were not officially ratified by Parliament until June 1652. In pointed contrast to the rituals of communal pleasure which were so central to the collective practice of the guilds, the statutes of the new Academy expressly forbade the holding of festivals and banquets, together with all forms of 'inebriety, debauch and gambling'. Dedicated to the pursuit of 'virtue', the Academy sought to establish itself both as a professional association and as a school for training young artists. At its centre lay the provision of life-drawing classes, something which was too expensive for individual masters to keep up. The Academy sought to emulate the Italian academies in Florence and Rome, which had long incorporated drawing from the model. This was seen as the source

of the superiority of Italian art and as the indispensable route to competence in both painting and sculpture. Teaching was to be carried out by the twelve *anciens* (Elders), including Le Brun, Jacques Sarazin and Henri Testelin, whose signatures are to be found at the end of the document. This translation of the complete text has been made for the present volume by Christopher Miller from L. Vitet, *L'Académie royale de peinture et de sculpture: Étude historique*, Paris: Michel Lévy, 1861, pp. 211–15.

I: The place of assembly being dedicated to virtue, it shall be held in particular veneration both by those who compose the Academy, by interested parties whom they see fit to introduce therein, and by youths who do not form part of the Body of the Academy, but who shall be received there for drawing and for study. On this account, whoever shall blaspheme the Holy Name of God, or shall speak of religion and holy matters derisively or insultingly, or shall proffer impious words, shall be banished from the said Academy and shall forfeit the grace that His Majesty has been pleased to accord.

II: In the said Academy, only the Arts of Painting and Sculpture and questions arising therefrom shall be discussed, and no other subject shall be broached.

III: It is not proposed that festivities or banquets be held there, either for the reception of those deemed worthy of belonging to the body of the Academy, or for any other reason whatsoever. On the contrary, inebriety, debauch and gambling will be rigorously excluded. Moneys received from the pecuniary fines to which those who contravene these Statutes and Rules are sentenced, shall be placed in the hands of a bourgeois or banker by the Elder in charge at the end of the month, and shall be employed exclusively in the business of the Academy and in the decoration of the place where it assembles.

IV: The Academy shall be open every day of the week, with the exception of Sundays and devotional feast days, in winter from three until five in the afternoon, and in summer from six till eight in the evening, in which period the young and students will be admitted to draw, and to take advantage of the lessons that shall be given. They shall pay every week the price usually paid to ensure the services of the model, who will be posed by the Elder on duty that month. Whenever it pleases His Majesty to undertake these expenses, after the manner of the Grand Duke of Florence, anyone shall be able to draw there without payment.

V: The Elders, of whom there shall be twelve, meet on the first Saturday of every month at the Academy's [opening] hour in order to deliberate with the Rector (who shall act as President and shall announce the result of any vote) concerning the affairs of the Community. This they shall do on the aforesaid days and at Extra-ordinary Assemblies, whether in order to judge infractions of the present statutes or for the reception of candidates or for other cause. The other painters and sculptors of the Academy shall be present, if they wish, at these deliberations, and if any of the twelve Elders should be absent, the most senior of the others present shall take his place after the last of the Elders. If a larger number should be absent, the same rule

applies. In the said assemblies, the motions shall be prepared by the duty Secretary of the month, the permission of the Rector of the Academy having once been obtained, along with that of the duty Elder of the month. Should one of the said Elders be missing, either through his decease or because of a long absence, the others will nominate another of the Academicians in his place; each shall make thier vote in writing, in order that everyone may proceed sincerely, and without fear of offending anyone. This shall be done without intrigue, cabal or partisan feeling, both in respect of this matter and of any other in which a decision must be taken.

VI: New recruits to the Academy shall follow the last of existing members.

VII: The Secretaries will serve alternately, as allocated at the start of the year. They shall inform the Academicians by letter when necessary, shall attend to matters in hand, and when they have a legitimate impediment, they shall hand over their functions to one of their colleagues. Failing this, they shall pay the sum of 10 *livres* to the Elder on the first occasion, double that on the second, and on the third they shall be stripped of the privileges of the Academy, and will no longer number among the body of Academicians.

VIII: The duty Elder of the month shall be punished in the same way if he fails either to present himself for the opening of the Academy, pose the model and perform the other functions for which he is responsible, or to request another of the Elders to be present in his stead. Even in the latter case, he must recompense his absence by attending for opening as many times in the following month as he absented himself when on duty.

IX: There will be close and friendly relations among members of the Academy, there being nothing so antithetical to virtue as envy, malicious gossip and discord. If any should incline thereto, and should be unwilling to amend after reprimand by the Elder, he shall be excluded from the Academy. Academicians shall, on the contrary, mutually communicate in all respects the enlightenment that is theirs, since it is impossible for any single individual to understand everything, nor make progress without assistance in arts so profound, difficult and little known. In this way, we shall see these arts daily invigorated and augmented. And if a more favourable occasion should allow the princes to seek the beauty of these arts, and devote some of their leisure thereto, it is proper to hope that they will outdo the princes of Antiquity, whether by the esteem they display towards the excellent men with whom the Academy is filled, or by the rewards with which they recompense their works. The said Members shall therefore freely express their sentiments to those who raise artistic difficulties, so that these may be resolved, or when they display their drawings, pictures or relief works, so that they may hear the Members' views.

X: The assembly can change the premises that it chooses for the Academy, until such time as it please the king to provide premises, and if it decides to have one built at its own expense, it shall not be permitted to sell or alienate it for any cause or occasion whatsoever.

XI: All proceedings shall be written in the Academy Register of the Academy by the duty Elder of the month, who shall hand it over to his successor.

XII: All resolutions made in the general assemblies and inscribed in the Academy Registers as special regulations, and which are not contrary to the present, shall be considered of equal standing thereto and implemented without delay or temporization.

XIII: The provisions for admitting to the body of the Academy those who are thought capable shall be sealed with the stamps of its arms, and signed by the duty Elder of the month, in whose hands they shall swear to keep and observe the Statutes and Rules religiously. They shall do this in the presence of the Members, and in pursuance of the above, Monsieur de Charmois, Conseiller d'Etat, is elected Rector of the Academy.

The said statutes signed Le Brun, Perrier, Jacques Sarrazin, de la Hire, Charles Errard, Corneille, Juste d'Egmont, Girard Vanopstal, Sébastien Bourdon, les Beaubruns, Guillain, L. Testelin, H. Testelin.

Beside this is written: registered, witnessed the Procureur Général du Roy, to be kept and observed in its entirety as to form and contents, under the obligations signalled in this day's decree. At Paris, in Parlement, 7 June 1652. Signed DU TILLET.

6 Roland Fréart, Sieur de Chambray (1606–1676) from *An Idea of the Perfection of Painting*

Chambray had spent several years in the 1630s studying art and architecture in Rome. In 1639–40 he had been one of the leading actors in the episode of Poussin's abortive move to Paris as First Painter to the King (see IB1). He was deeply committed to classical principles in art, and in the Quarrel of the Ancients and Moderns became one of the leading defenders of Antiquity. For Chambray the intellectual appeal of geometrically based principles of design eclipsed the sensual dimension of art associated with colour. The latter was in fact regarded by him as the hallmark of decadence, a charge which he laid at virtually the whole modern school, from Michelangelo, through Titian to Caravaggio and Rubens. The main exceptions to his censure of the modern were Raphael and Poussin, whom he regarded as the only modern artists to match up to the classical ideal (see IB3). Chambray's literary career reflected his enduring commitment to rational principles and to Antiquity. He translated Palladio and Euclid, and in 1651 published Leonardo da Vinci's treatise on painting. The *Idea of the Perfection of Painting* appeared in 1662. The central part of the book consists of a systematic attempt to legislate all the aspects of painting in a series of chapters explicitly based on 'the learned Hollander' Franciscus Junius (see IA1). Junius' breakdown of the 'Parts' of art is followed exactly, but is then supplemented with a series of case studies. Several works by Raphael, Michelangelo and others, including Poussin, are measured against the general criteria regarding Invention, Proportion, Colour, and so on. Our selection is drawn from Chambray's preface and his introductory chapter. What is conveyed here is not only his sense of a decline in art from the golden age in

Greece but also his equally important motivating belief that the modern age has the potential once again to rival Antiquity, if only it adheres to the severest classical principles and abjures the temptations of modernity. The extracts are taken from John Evelyn's English translation, published as *An Idea of the Perfection of Painting: demonstrated from the Principles of Art and by Examples conformable to the Observations which Pliny and Quintilian have made upon the most celebrated Pieces of the Antient Painters, parallel'd with some Works of the most famous Modern Painters, Leonardo da Vinci, Raphael, Julio Romano and N. Poussin*, London: Henry Herringman, 1668, preface (unpaginated) and pp. 1–11.

Preface

THere is hardly that Man living, but has some inclination for PAINTING, and that does not even pretend sufficient Abilities to controll the Works which it produces: for not only Learned men, and persons of Condition, who are ever probably the most rational, are emulous of this Knowledge; but the very Common-People will adventure to spend their Judgements too; so as it seems, this Art is in some sort, the Universal Mystery.

Neither is this presumption a Vice peculiar to the French alone, or of this Age of ours only; 'tis as old as Painting it selfe, and sprung from her very Cradle in Greece. This is evident by that which Pliny has recorded of Apelles; who before he gave the last touches to his Pieces, was wont to expose them in Publique to the Censure of all the Passengers, whilst he conceal'd himselfe behind them, that he might hear what every one said, and make use of it accordingly; whence the Proverb, *Apelles post Tabulam*. Most of our Painters do to this day observe something of this very Custome, or at least, something like it, but which they have turn'd into a kind of Complement: For they usually request such as have the Curiosity to visit their Works, freely to tell them what they *think* of them; and whether they observe any thing which needs *reforming*. But as Complements are but vain and insignificant *words*, they seldom produce any real Effects upon these encounters; and to speak sincerely, these Painters would be but justly punish'd, should one really take the liberty of effectually rendring them this friendly Office, which they ask but in Ceremony, and that instead of those ordinary compliances with which they usually flatter them, they did ingeniously discover to them their miserable failings. But instead of receiving this Instruction in good part, and gratifying the Censure as becomes them, they would certainly be offended at the freedom, and we should see them rather Confounded than Reform'd by it; because they do not so much seek to be Able men, as they desire to appear so. The days of Apelles are now past, and our Modern Painters are quite of another strain from these Old Masters, who never came to be Considerable in their Professions, but by the study of Geometrie and Perspective, the Anatomy of Bodies, the assiduous Observation of those Characters which expres'd the Passions and Emotions of the Soul; by the Lecture of the Poets and good Historians; and in fine, by a continual research of whatever might best contribute to their Instruction.

They were in those days so Docile and Humble, that they not only would submit their *Works* to the Criticismes and Animadversion of Scholars and Philosophers, but

even to the Common People also, and to Artificers of all *Trades*, who did frequently and sometimes judiciously reprehend them. This was (I confess) something of a tedious way, and is indeed inaccessible to a great part of our Painters in this Age, who have neither the Genius of these illustrious Antients, nor the same Object in their working.

In effect, those Painters propos'd to themselves, above all other things, the Glory and Immortality of their Names, for the sole, and principal Recompense of their Labours; whereas, most of our Moderns, regard only the emergent Profit, and therefore they hold a quite different Method, and strive as much as they can to compass only their proposed aime.

To this purpose, they have introduc'd into their Cabals I know not what kind of licencious Painting, totally differing from those pretended subjections, which heretofore rendred this Art so incomparable and so difficult, whilst this incapacity of theirs makes them imagine, that this rare Painting of the Antients, was but an old Dotaress, who had only slaves in her service.

Under this pretext, they have dress'd themselves up a new Mistriss, trifling, and full of tattle, who requires nothing of them but Fard and Colour to take at first sight, without being at all concern'd whether she pleas'd long or not. [. . .]

What's now become of the Glory with which those antient Greeks, those Gallant souls had Crowned Painting, when they pronounc'd her Queen of all the Arts, and permitted only the most noble and renowned of men to be of her Retinues? what regard, think you, would they have to this Age of ours, which has so unworthily abandon'd her? and to these abject spirits who daily dishonour her by the contempt and disrespect which they put upon her Laws, and who by a yet more insufferable attempt, have resign'd her sacred Name to this fantastick Idol which they have establish'd in her place? with what indignation may we suppose do true and able Painters look on the temerity of these insolent Rivals, whom they behold so gay and jovial in this present Age, by the Capriciousness of Fortune, and the favour of an ignorant conjuncture? [. . .]

To recover then its pristine Lustre, and restore her to original Purity, we must of necessity recall that Primitive severity, by which they were wont to examine the Productions of those renowned Painters, who were of old so esteemed; and whose Works have surviv'd their Authors so many Ages, and rendred their own Names Immortal.

To accomplish this, there is nothing more expedient, than the exact observation of those Fundamental Principles, which consummate its Perfection, and without which 'tis imposible she should subsist.

But forasmuch as the long neglect hereof has almost banish'd the Science, to the infinite loss and prejudice of those who are curious of Painting; and since, without this succour, they can never enjoy the satisfaction which a cleer and perfect understanding will present them; I have made it here my particular enquiry; that laying before them in this Dissertation the same Compass by which the Antients steer'd their Course, they may sail by the same Route themselves, and discover those things to the very bottom, which they had never attain'd to without it, but superficially, and with much imperfection.

And since I consider how extreamly difficult it is to disabuse those who are already infected with so common, and pernicious an abuse, under the pretence of a specious

Liberty: I could not think it sufficient to talk of things only, and to prove them from pure and undeniable Reasons; had I not also made it appear, of what importance it is by authentique Demonstrations and examples.

For this effect, I have made choice of some amongst the Works of our most celebrated Painters; to which, having apply'd all those Principles which I have produced, there remains no more cause for us to suspect their Fidelity. And that I may the better and more generally comprehend the good and bad effects which result from them, by either observing or neglecting these Rules, I shall here present them in Order.

Raphael Urbino, the most excellent of the Modern Painters, and universally so reputed by those of the Profession, is the Person whose Works I shall propose as so many Demonstrations of the absolute necessity of exactly observing the Principles which we have establish'd in this Treatise. And on the contrary, Michael Angelo, superior in Fame, but far inferior to him in Merits, shall by his extravagant Compositions, amply furnish us to discover the Ignorance and Temerity of those Libertines, who trampling all the Rules and Maximes of Art under their feet, persue only their own Caprices.

An Idea of the Perfection of Painting

'TIS a very subtle and curious *Enquiry*, to know, from whence it should come to pass, that the Art of Painting is so much degenerated from that perfection, which it once obtain'd, and how it happens, that considering the weakness of its productions, compared with those admirable Master-pieces of the Antients, it seems of late to present the World with nothing but the meer shadow and phantosmes of it.

For my own part, I conceive, the principal cause of its decadence to have proceeded from that little esteem which it preserv'd, during the ignorance and barbarity of the Lower Empire, which did so far ignoble and debase it of its pristine Honour; that instead of that preheminence which it then held amongst the Sciences, it is now reduc'd and reckon'd amongst the most vulgar Trades; sufficient to let us see, how much the spirit and Genius of these latter Ages, have declined, in which the rare Inventions and Lights of this Divine Art are, for want of encouragement, almost totally extinguish'd.

However yet, that good Genius, which by a certain providence of Nature does still preside over Noble things, has always furnish'd us with some excellent Men, preserving, as it were, some Seeds of them from time to time: But as we find it in Trees, and even in the most perfect Bodies, that they attain not to their consummate forme upon the suddain, and till after many years; notwithstanding which they are yet obnoxious to destruction every instant, without any means of restauration, but the same from whence first they sprung: even so it is in the productions of Wit, which coming once, through negligence, to be lost, or opprest under the Tyranny of evil Government, never recover themselves but by a long and laborious research; so, as 'tis realy prodigious; that in the Age of Leonardo da Vinci, and Raphael (who were the Protogenes and Apelles of the Modern Painters) we should see the Art revive again with so much vigour, and flourish in so short a space. For Painting is none of those simple Arts, which Chance does now and then present us with, without any

disquisition, and which every one may light on without an extraordinary Talent, or study to attain them.

There is happ'ly nothing of Ingenious amongst Men, of more sublime, and whose Perfection is more difficult to attain, than that of Painting, the Noblest Instance which humane wit can boast of: 'Tis therefore plainly an insupportable abuse, to obscure and confound her amongst the Mechanical Arts; since she is established upon a demonstrative Science, infinitely more inlightned and reasonable, than that Pedantick Philosophy, which produces in us nothing but frivolous Questions and uncertainties, whence some have styl'd it, The Art of Doubting, a steril and idle speculation; whereas Paynting, founded upon the real Principles of Geometrie, makes at once a double demonstration of what she represents: But it will indeed require different Eyes to contemplate and enjoy her Beauty intirely: For the Eye of the Understanding, is the first and principal Judge of what she undertakes.

It will, in my opinion, be necessary therefore, in order to the restauration of her Honour, to evince by undeniable reasons, that she is still as worthy of the rank and dignity, which she formerly possest amongst the Greeks, the worthies of Genius's that ever Nature form'd, and that the shameful desertion, which has since arriv'd her, could proceed from no other cause but an universal depravation.

She has moreover had this particular misfortune, that all the Writings and Works which should contribute to her Instruction, and that divers excellent Painters had long since publish'd for the better intelligence of their Art, have been buried and lost by tract of time. [...]

The same unhappiness arriv'd to Architecture: All the Antient Books of it being utterly lost, that single work of Vitruvius being only excepted, which is very defective too, for want of its Profiles and lineal Demonstrations [...] But as Architecture is more gross and material in what it undertakes; the Solidity of it, which constitutes one of its very Principles, has honour'd it with some preheminence, even above Painting it selfe. It stands firm, and has continu'd many of its productions, which wonderfully supply the defect of those Books that are lost; whereas Painting, which is, as it were, altogether Spiritual, has not been able to furnish us with such permanent monuments. And yet for all this, she has within these two Ages reviv'd with so much vigor, as if she had receiv'd the very same assistances. And truely, she seems to me to have been the Restauratrix of Architecture; since we find, that almost all the first Masters of that Profession were also great Painters; such as Bramante, Baldassar Petrucci, Raphaelo, Julio Romano, and several more, which is no other then the result of being able to designe well, which is in truth the veritable Principle and only Basis, not of Painting alone; but, as one may well affirm, the universal Organ and Instrument of all the politer Arts. [...]

Supposing then, that all Arts whatsoever have their Fundamental Principles, the knowledge whereof is absolutely necessary for those who intend the Profession, and that This of Painting is superior to the rest, and consequently more difficult: It is not to be expected, there should any considerable progress be made without a due and perfect cognisance of those Principles; and they consist of no mean speculations, Perspective and Geometry; without which, a Painter can never emerge a good Artist.

Seeing now, it is not enough, that to the forming an able Painter, he be learned in these two Points alone (which study will soon accomplish) without three or four other

more curious Qualities, which he ought to be Master of; but which are not usually attain'd to without a singular favour of Nature; it happens that there appear so very few good Workmen amongst the multitudes of this Profession, that it may well be verified of Them, which was said of the Poets; That a Painter is so born, not made; and really their Genius is so conform, as it became Proverbial; That Picture was mute Poesie, and Poesie vocal Painting.

7 Jean-Baptiste Colbert (1619–1683) Letter to Poussin

After the death of Cardinal Mazarin, Jean-Baptiste Colbert rose to became the most powerful of Louis XIV's ministers. In 1664 he was made 'Superintendent of Royal Buildings, Arts and Manufactures', and in 1665 'Controller-General of Finances'. It was under Colbert's protection that the Royal Academy of Painting and Sculpture was finally given the power and financial support it required to triumph over the guilds. He established a new and enlarged code of rules in 1664 and provided the Academy with a monopoly on the training of artists. Although founded in the name of artistic freedom, the Academy was incorporated into Colbert's larger project of centralized state control and its growing power reflected his refusal to tolerate the comparative freedom of private societies and associations. Colbert's letter to Poussin, drafted by his secretary, Charles Perrault, concerns, first, his project for a new façade for the Louvre, and second, his plans for the founding of an Academy of France in Rome. (For further information on the Louvre project and for Chantelou's report of Bernini's subsequent visit to France, see IC3.) The letter was never sent, perhaps because its despatch was forestalled by news of Poussin's death late in 1665. The letter reveals the manner in which the new regime sought to project itself through a revival of the arts and sciences. Rome still enjoyed a high prestige and Colbert sought to found the future greatness of French art upon Italian cultural traditions rather than any native French school. Students at the French Academy in Rome were to serve the interests of the king by copying the achievements of Roman Antiquity and the Renaissance and transmitting them to France. The whole letter has been translated for this volume by Katerina Deligiorgi from Charles Perrault, *Mémoires de ma vie*, Paris: Libraire Renouard, 1909, pp. 54–7.

Sir,

This letter will acquaint you with the high esteem in which the king holds your talent. His Majesty, having decided to send to Rome the plans and elevations of his palace at the Louvre in order to solicit the opinions and thoughts of the most famous architects who live there, and requiring, to that end, a most intelligent and able person to consult them on his behalf on this matter, believes that this affair cannot be entrusted to better hands than yours. He has taken into consideration not only that your perfect knowledge of painting makes you highly suitable for this task, but also that your long stay in Rome, together with your talent, will surely have earned you the friendship of all the excellent men who reside there, so that you alone can gather the ideas and opinions we seek from them. The plans and elevations I send you are accompanied by an explanatory discourse which will give you sufficient information on the matters on which you will need to consult the architects. I need only add some observations on the manner in which you should conduct yourself towards them.

Before assembling them, I think it might be necessary to visit them, communicating our intentions to each separately and even leaving them some time to form their ideas individually. In this way their thoughts will display greater diversity, and also each will receive full recognition for what he has invented, since no one could be reproached with having been aided by someone else's idea. It would then be good to bring them all together, if this is possible, and to hear their praise or criticism of each other's plans, so as to form a general idea about the direction in which the opinion of the assembly tends and to find out what most gains the general approbation. I do not place any limit upon the number of those you may consult. Care should be taken, however, not to protract the proceedings by inviting indiscriminately all sorts of men to give their opinion. On the other hand, it is important not to forget those who have a great reputation, such as Pietro da Cortona, Reynaldi Areveti, the Cavalier Bernini, and a few others among the most famous. It is necessary to ask them all to give their opinion in writing. I think they will do so willingly, as it is unlikely that they will remain indifferent to the glory which they will receive for having made proposals for the most beautiful and most splendid palace in the world, and, if their opinion be followed, for having been chosen among the most famous architects of their century. It is especially important to impress upon them that whenever they criticize something in the plans we send them, they should add their reasons for doing so, and, similarly, when they put forward some thought or some plan, they should base it on architectural reasons or on important antecedents. This is how I think the matter should be handled. Nonetheless, since it is possible to encounter unforeseen difficulties as you proceed in this way, I trust to your prudent judgement and I leave to you the choice of arrangements you consider appropriate. This is, of course, a very important matter, for it will allow the most beautiful building in the world to be perfected and, if possible, made worthy of the grandeur and magnificence of the prince who will inhabit it. I do not doubt, Sir, that the decision of the king to bring his palace at the Louvre to completion makes you rejoice, since this plan clearly shows the love that His Majesty has for all the fine arts you possess. He certainly intends to bring them to the highest point of perfection they have ever reached and wants his reign to be famous not only for his own great deeds, but also for the great number of illustrious men in every profession who equal and even surpass those of Antiquity. To this end, he neglects nothing that can naturally excite virtue in the heart of those who have some disposition for great things, giving them, on his part, all the means they require to perfect themselves. To stimulate the sciences, he has given liberal endowments to all the men of letters who have a great reputation in some particular field. Wherever talent shines, not only in France, but also in the whole of Europe, there have appeared signs of his royal generosity. With respect to painting and sculpture, which His Majesty particularly loves and regards as two arts which must especially promote his glory and transmit his name to posterity, he omits nothing from what is required for their perfection. It was from this noble and laudable motive that he established in Paris, some years ago, a Royal Academy of Painting and of Sculpture. He engaged professors for the instruction of the young, offered prizes to the students, and granted to this assembly all the privileges they could wish for. This institution has not been without fruit: in it are formed young men who are very promising and who will, one day, become excellent masters. But, as

the young men of your profession appear still to require to spend some time in Rome in order to form their taste and style on the originals and models of the greatest masters of Antiquity and of recent centuries, and since it often happens that those with the greatest genius and gift neglect to undertake this trip – or cannot, on account of its expense – His Majesty has decided to send to Rome every year a certain number of students chosen from the Academy and to support them during their stay there. Considering further that it would be very useful for the advancement and progress of these young men to be under the direction of an excellent master who can guide their study, impart good taste, transmit the style of the Ancients, and reveal, in the works they copy, the secret and almost inimitable beauties which go unnoticed by the majority and are perceived by the ablest only, His Majesty has decided to have permanently in Rome an illustrious master who will take care of and direct the students sent there. For this, he has chosen you, Sir, and has named you as the one who is now in charge of this task. It is on this account and for this purpose that he has commanded me to send you the sum of 1,200 *écus* which you will receive with the enclosed letter of credit. This is, Sir, what His Majesty has commanded me to write. I do not doubt that he will receive from you every satisfaction in the execution of the two important things with which he entrusts you. For my part, I assure you that the honour that the King has conferred upon you gives me great pleasure and that I would be always prepared to do the same for persons of your talent.

8 Giovanni Pietro Bellori (1613–1696) 'The Idea of the Painter, Sculptor and Architect, Superior to Nature by Selection from Natural Beauties'

Giovanni Pietro Bellori was an antiquarian, collector and theorist, who worked in Rome. In 1671 he was appointed secretary to the Accademia di S. Luca (Academy of St Luke), at that time under the direction of Carlo Maratti. He had been brought up in a circle of scholars and artists, but was not himself primarily a practitioner of art. In his interpretation of classical theory he was close to Junius (see IA1), and followed his example in drawing together quotations from Greek and Latin authors in order to advance his own argument. He also shared with Junius the belief that the greatest artists were those who formed a concept of perfect beauty through judicious selection from nature. Where his predecessor had concerned himself with the painting of the ancients, however, Bellori wrote to establish a modern canon of 'classical' art. He reserved particular enthusiasm for the work of Raphael, Annibale Carracci, Domenichino and Poussin, who was a close friend. (See IB2 for Poussin's observations on painting as recounted by Bellori.) Caravaggio is cited, by contrast, as one who 'was criticized for being too natural in painting likenesses' and, by implication, for 'having imitated the worst and most vile' (Il Bamboccio – Pieter van Laer – was a Dutch painter and printmaker working in Rome in the early seventeenth century, known for his scenes of low life.) The 'idea' of the title refers us back to the Neoplatonism of earlier Italian art theory. As Panofsky has shown, however, Bellori sought to steer a middle course between the 'naturalism' of Caravaggio and the equal and opposing danger of descent into a mannerism, in which the study of nature was disdained in favour of mere 'phantastical ideas'. Art should imitate nature, he believed, but in what it selects it should be

guided by the example of the great artists of the past. Bellori's 'Idea del pittore, del sculptore, e del architetto...' was originally delivered as a lecture at the Accademia di S. Luca in Rome in 1672, the year following his election as rector. In 1689 he was made an honorary member of the Académie Royale de Peinture et de Sculpture in Paris. The lecture was first published as the preface to Bellori's *Le vite de' pittore, scultori e architetti moderni* ('Lives of Modern Painters, Sculptors and Architects', Rome 1672), where it immediately precedes the life of Annibale Carracci. (See IB3 for Bellori's life of Poussin). This translation by Victor A. Velen is taken from Erwin Panofsky, *Idea: A Concept in Art Theory* (1924, revised 1960), trans. Joseph J. S. Peake, Columbia: University of South Carolina Press, 1968, Appendix II, pp. 155–72. The 'Venus of Cnidos', the 'Athenian Minerva', the 'Farnese Hercules' and the 'Medicean Venus' were all surviving classical statues believed at the time to be Greek originals. Ludovico Castelvetro was a sixteenth-century commentator on Aristotle's *Poetics*.

The highest and eternal intellect, author of nature, in fashioning his marvelous works looked deeply into himself and constituted the first forms, called Ideas, in such a way that each species was expressed by that original Idea, giving form to the marvelous context of things created. But the celestial bodies above the moon, not subject to change, remained forever beautiful and well-ordered, so that we come to know them from their measured spheres and from the splendor of their aspects as being eternally most just and most beautiful. Sublunar bodies on the contrary are subject to change and deformity; and although nature always intends to produce excellent effects, nevertheless, because of the inequality of matter the forms change, and human beauty is especially disarranged, as we see from the infinite deformities and disproportions that are in us. For this reason the noble Painters and Sculptors, imitating that first maker, also form in their minds an example of superior beauty, and in beholding it they emend nature with faultless color or line. This Idea, or truly the Goddess of Painting and Sculpture, when the sacred curtains of the lofty genius of a Daedalus or an Apelles are parted, is revealed to us and enters the marble and the canvases. Born from nature, it overcomes its origin and becomes the model of art; measured with the compass of the intellect it becomes the measure of the hand; and animated by fantasy it gives life to the image. Certainly, according to the statements of the major philosophers, the exemplary motives reside with assurance in the spirits of the artists forever most beautiful and most perfect. The Idea of the Painter and the Sculptor is that perfect and excellent example of the mind, to which imagined form, imitating, all things that come into sight assimilate themselves: such is Cicero's fiction in his book on the orator, dedicated to Brutus... Thus the Idea constitutes the perfection of natural beauty and unites the truth with the verisimilitude of what appears to the eye, always aspiring to the best and the most marvelous, thereby not emulating but making itself superior to nature, revealing to us its elegant and perfect works, which nature does not usually show us as perfect in every part. Proclos confirms this value in *Timaeus* when he says that if you take a man fashioned by nature and another formed by sculptural art, the natural one will be less excellent, because art fashions more accurately. But Zeuxis, who formed with a choice of five virgins the most famous image of Helen, given as an example by Cicero in the *Orator*, teaches both the Painter and Sculptor to contemplate the Idea of the best natural forms in making a choice among various bodies, selecting the most elegant.

Hence I do not believe that he could find in one body alone all these perfections that he sought for in the extraordinary beauty of Helen, since nature makes no particular thing perfect in all its parts...Thus Maximus Tyrius claims that the image of the Painters taken this way from different bodies produces a beauty such as may not be found in any natural body that approaches the beautiful statues. Parrhasius conceded the same to Socrates, that the Painter who has placed before him natural beauty in each of its forms must take from various bodies together what each has most perfect in its individual parts, since it is impossible to find a perfect being by itself. Thus nature is for this reason so inferior to art that the copyist artists and imitators of bodies in everything, without selectivity and the choice of an Idea, were criticized. Demetrius was told that he was too natural, Dionysius was blamed for having painted men resembling us and was commonly called *anthropographos*, that is, painter of men. Pausanias and Peiraeikos were condemned even more for having imitated the worst and the most vile, just as in our time Michel Angelo da Caravaggio was criticized for being too natural in painting likenesses, and Bamboccio was considered worse than Michel Angelo da Caravaggio. Thus Lysippus reproached the vulgarity of the Sculptors who made men as they are found in nature, and prided himself for forming them as they should be, following the advice given by Aristotle to Poets as well as Painters. This shortcoming was not attributed to Phidias, on the other hand, who made marvels of the forms of heroes and gods and imitated the Idea rather than nature. Cicero asserts that Phidias, in shaping Jupiter and Minerva, did not look at any object that he could have taken for a likeness, but conceived a form full of beauty, in whose fixed image he guided his mind and hand to achieve a likeness... Hence it appeared to Seneca, although he was a Stoic and a severe judge of our arts, to be a great thing, and he marveled at how this Sculptor, never having seen either Jupiter or Minerva, had nevertheless conceived their divine forms in his mind... Apollonius of Tyana teaches us the same thing, that fantasy makes the Painter wiser than imitation, because the latter creates only those things that are seen, while fantasy creates even those that are unseen. Now if we want to confront the precepts of the sages of antiquity with the best methods of our modern teachers, Leone Battista Alberti maintains that we love in all things not only the likeness but mainly the beauty, and that we must select the most praiseworthy parts from the most beautiful bodies. Thus Leonardo da Vinci taught the painter to form this Idea, to consider what he saw and to consult himself, choosing the most excellent parts of everything. Raphael of Urbino, the great master among those who know, wrote thus to Castiglione of his Galatea: 'In order to paint a beauty I would have to see several beauties, but since there is a scarcity of beautiful women, I use a certain Idea that comes to my mind.' Guido Reni, who surpasses all the other artists of our century in creating beauty, wrote to Monsignor Massani, housemaster for Urban VII, when he sent the painting of Saint Michael to Rome for the Church of the Capuchins: 'I would have liked to have had the brush of an angel, or forms from Paradise, to fashion the Archangel and to see him in Heaven, but I could not ascend that high, and I searched for him in vain on earth. So I looked at the form whose Idea I myself established. An Idea of ugliness may also be found, but that I leave to the devil to explain, because I flee from it even in thought, nor do I care to keep it in my mind.' Thus Guido also boasted that he painted beauty, not as it appeared to his eyes, but as

he saw it in the Idea; hence his beautiful abducted Helen was esteemed as an equal of that by Zeuxis. But Helen was not as beautiful as they pretended, for she was found to have defects and shortcomings, so that it is believed that she never did sail for Troy but that her statue was taken there in her stead, for whose beauty the Greeks and the Trojans made war for ten years. It is thought therefore that Homer, in order to satisfy the Greeks and to make his subject of the Trojan War more celebrated, paid homage in his poem to a woman who was not divine, in the same way that he augmented the strength and intelligence of Achilles and Ulysses. Hence Helen with her natural beauty did not equal the forms of Zeuxis and Homer; nor was there ever a woman who had so much extraordinary beauty as the Venus of Cnidos or the Athenian Minerva, known as the beautiful form; nor did a man exist of the strength of the Farnese Hercules by Glycon, nor any woman who equaled in beauty the Medicean Venus of Cleomenes. For this reason the best Poets and Orators, when they wanted to celebrate some sublime beauty, turned to a comparison of statues and paintings. Ovid, describing Cyllarus, the most beautiful Centaur, praises him as most like the most famous statues: . . . And elsewhere he wrote in high praise of Venus that if Apelles had not painted her, she would have remained until now submerged in the sea where she was born . . . Philostratus upholds the beauty of Euforbus as similar to statues of Apollo and he claims that Achilles surpassed the beauty of Neoptolemus, his son, as beauties are surpassed by statues. Ariosto, in creating the beauty of Angelica tied to the rock, likens her to something moulded by the hands of an artist . . . Marino, in celebrating the Magdalena painted by Titian, hails the work in the same way and places the Idea of the artist above natural things . . . It appears that Aristotle, on Tragedy, was unjustly criticized by Castelvetro, who maintains that the virtue of painting is not in creating a beautiful and perfect image, but in resembling the natural, either beautiful or deformed, for an excess of beauty lessens the likeness. This argument of Castelvetro is limited to icastic [i.e. figurative] painters and portraitists who keep to no Idea and are subject to the ugliness of the face and body, unable to add beauty or correct natural deformities without violating the likeness. Otherwise the painting would be more beautiful and less accurate. The Philosopher does not mean such icastic imitation, but he teaches the tragedian the methods of the best, using the example of good Painters and Makers of perfect images, who rely on the Idea. These are his words: 'Since tragedy is the imitation of the best, we should imitate the good painters, because, in expressing the form proper to their subjects, they create them more beautifully . . .'

However, making men more beautiful than they ordinarily are and choosing the perfect conforms with the Idea. The Idea is not one beauty; its forms are various – strong, noble, joyful, delicate, of any age and both sexes. We do not, however, praise with Paris on lovely Mount Ida only soft Venus, or extol the tender Bacchus in the gardens of Nyssa, but we also admire in the wearying games of Maenalos and Delos the quiver-bearing Apollo and Diana the huntress. The beauty of Jupiter in Olympia and of Juno in Samos, as well as of Hercules in Lindos and Cupids in Thespiae, was certainly different again. Thus different forms conform with different people, as beauty is nothing else but what makes things as they are in their proper and perfect nature, which the best Painters choose, contemplating the form of each. In addition to which we must consider that Painting being at the same time the representation of

human action, the Painter must keep in mind the types of effects which correspond to these actions, in the same way that the Poet conserves the Idea of the angry, the timid, the sad, the happy, as well as of the laughing and crying, the fearful and the bold. These emotions must remain more firmly fixed in the Artist's mind through a continual contemplation of nature, since it would be impossible for him to draw them by hand from nature without first having formed them in his imagination; and for this the greatest care is necessary, since the emotions are only seen fleetingly in a sudden passing moment. So that when the Painter or Sculptor undertakes to reproduce feelings, he cannot find them in the model before him, whose spirit as well as limbs languish in the pose in which he is kept immobilized by another's will. It is therefore necessary to form an image of nature, observing human emotions and accompanying the movements of the body with moods, in such a way that each depends mutually upon the others. [...]

...this Idea and divinity of beauty was conceived in the minds of the ancient cultivators of wisdom, by observing always the most beautiful parts of natural things, because that other Idea, formed for the most part from experience, is ugly and base, according to Plato's concept that the Idea should be a perfect understanding of the thing, starting with nature. Quintilian teaches us that all things perfected by art and human ingenuity have their origin in the same nature, from which the true Idea springs. Hence those who without knowing the truth follow common practice in everything create spectres instead of shapes; nor are they dissimilar from those who borrow from the genius and copy the ideas of others, creating works that are not natural children but bastards of nature, so that it seems as though they are wedded to the paintbrushes of their masters. Added to this evil, arising from lack of genius or the inability to select the best parts, is the fact that they choose the defects of their teachers and form an idea of the worst. On the other hand, those who glory themselves with the name of Naturalists have no idea whatever in their minds; they copy the defects of the bodies and satisfy themselves with ugliness and errors, they, too, swearing by the model, as their teachers. If the model is taken from their sight, their whole art disappears with it. Plato likens these first Painters to the Sophists, who did not base themselves on truth but upon the false phantom of opinion; they resemble Leucippus and Democritus, who compose bodies of the vainest atoms at random. Thus the art of Painting is degraded by these Painters in concept and practice, since, as Critolaos argues, eloquence should be a manner of speaking and an art of pleasing...a habit without skill and reason, taking function away from the mind and turning everything over to the senses. Hence what is supreme intelligence and the Idea of the best Painters, they would prefer to be common usage, equating ignorance with wisdom; but the high-minded spirits, elevating thought to the Idea of the beautiful, are enraptured by the latter alone and consider it a divine thing. Yet the common people refer everything they see to the visual sense. They praise things painted naturally, being used to such things; appreciate beautiful colors, not beautiful forms, which they do not understand; tire of elegance and approve of novelty; disdain reason, follow opinion, and walk away from the truth in art, on which, as on its own base, the most noble monument of the Idea is built. It remains to be said that since the Sculptors of antiquity used the marvelous Idea, as we have indicated, a study of the most perfect antique Sculptures is therefore

necessary to guide us to the emended beauties of nature and with the same purpose direct our eyes to contemplate the other outstanding masters. [. . .]

Painters and Sculptors, choosing the most elegant natural beauties, perfect the Idea, and their works exceed and remain superior to nature – which is the ultimate value of these arts, as we have shown. This is the origin of the veneration and awe of men with regard to statues and paintings, and hence of the rewards and honors of the Artists; this was the glory of Timanthes, Apelles, Phidias, Lysippus, and of so many others whose fame is renowned, all those who, elevated above human forms, achieved with their Ideas and works an admirable perfection. This Idea may then well be called the perfection of Nature, miracle of art, foresight of the intellect, example of the mind, light of the imagination, the rising sun, which from the east inspires the statue of Menon, and fire, which in life warms the monument to Prometheus. This is what induces Venus, the Graces and the Cupids to leave the gardens of Idalus and the shores of Cythera and dwell in the hardness of marble and in the emptiness of shadows. In its honor the Muses by the banks of Helicon tempered colors to immortality; and for its glory Pallas scorned Babylonian cloth and vainly boasted of Daedalian linens. But as the Idea of eloquence yields to the Idea of painting, just as a scene is more efficacious than words, speech therefore fails me and I am silent.

9 André Félibien (1619–1695) from *Conversations on the Lives and Works of the Most Excellent Ancient and Modern Painters*

André Félibien des Avaux (see IB3) first conceived the idea for his monumental series of 'lives' during his stay in Rome between 1647 and 1649. As the Preface to the first volume shows, he was profoundly influenced by his encounter with Nicolas Poussin, who awoke in him a life-long interest in the theory and practice of art. His *Entretiens sur les vies et les ouvrages des plus excellents peintres anciens et modernes* appeared in a series of ten volumes, published successively in pairs between 1666 and 1688. They comprise a series of biographies of the most significant figures in Western European art from Antiquity to Félibien's own day, interspersed with theoretical excursuses. Félibien deliberately chose the dialogue form to present his ideas, insisting that the best way to make progress in the appreciation and understanding of art is through regular conversation on the subject. Here we include a section from the Preface, which provides an important background to the gestation of the project and which records Félibien's characteristic concern with mastering the actual practice of painting. Our principal excerpt is from the first *Entretien* in which the author, in conversation with his dialogue partner, Pymandre, identifies and ranks the constituent elements of painting. First comes composition, which is carried out in the mind of the artist. Composition represents a form of 'ideal activity' in contrast to the 'physical activity' of the brush or the pencil: conception is anterior to execution, just as theory precedes practice. Next come design and colour, both of which belong to the physical part of painting. However, both require complex skills of considerable subtlety and difficulty. The task of painting is the imitation of idealized natural beauty, and in fulfilling this goal painting participates in the divine order which regulates the visible world. The following extracts have been translated for the present volume by Jonathan Murphy from André Félibien, *Entretiens sur les vies et les ouvrages des plus excellents peintres anciens et*

modernes, Trévoux, 1725 (facsimile reprint, Farnborough: Gregg Press, 1967), pp. 17–27, 90–102. The section on grace and beauty to which Félibien refers in the text is reproduced below (see ID6).

Preface

If there were no other examples of great men who had written on sciences and arts that they had never practised themselves, I would be quite fearful of sitting down to write on an art so distant from any occupation in which I myself have been engaged. But as it is the case that here I am imitating some of the greatest minds of the age, let no one be surprised that I am writing on painting, above all because I have had a strong inclination for this beautiful art so long, that there are now very few parts of it of which I do not have a profound knowledge, or where I have not at some point attempted to put into practice my ideas.

It is also true that I have had the advantage of knowing most of the great painters of our day, and that I have spent much time in Italy, where I endeavoured to acquire whenever possible ever more knowledge about this art which interests me so.

Now when I cast my mind back to the ancient buildings, statues and pictures that were so often my greatest pleasure during the time I spent in Rome, I still feel a keen rush of pleasure at remembering so many rare and excellent things.

I had the honour of being employed by the Marquis of Fontenay, extraordinary ambassador for the king at the court of Pope Innocent X, whose first embassy had been to Urban XIII, when he first established the reputation for great ability, wisdom and probity which lives on today in the memory of so many. It was also during this time that the troubles in Naples allowed this worthy minister to demonstrate so many of his qualities, concerning affairs which at the time were the very centre of all that was happening in Europe.

Throughout the time of his embassy there many considerable events held his attention, and I was thus obliged to be almost constantly by his side, and had very little time of my own. But I employed the time that remained in visiting the most notable figures of the day in the fields of the sciences and the arts, and in visiting churches and palaces.

Amongst the great painters of the day then to be found in Rome were figures such as the Chevalier [Giovanni] Lanfranco, Pietro da Cortona, and Poussin, whom I mention last as he was at the time the youngest of the three. I cultivated their acquaintance, and above all frequented M. Poussin, with whom I struck up a close friendship. His merit of course is known to all, and for my part, I feel that there has never been a painter who had such a high idea of the perfection of painting, nor a painter who knew better how to ensure the total success of a painting. So much may be garnered simply from an examination of paintings done by his own hand, but in addition to that are the many fine speeches and writings that he has left. I must own that it was above all through his conversation that I learnt to appreciate all that is most beautiful in the work of the masters, and to take note of the subtle techniques they employed to heighten the perfection of their work.

Although M. Poussin claimed to be an extremely private man when working, this was largely to prevent great numbers of visitors coming to see him while

he worked, who would otherwise have interrupted his concentration. We were sufficiently close for him to allow me to watch him work, and this permitted me to see the interaction of the theory and the practice at first hand: while working, he would demonstrate the truth of the theories that he would expound to me in his discourses.

It was with great pleasure that I was thus able to see the manner in which he would set about representing on canvas the great and noble subjects that had taken shape in his mind. I watched closely as he outlined the figures, bringing out every single trait with a clarity which it seemed was an exact portrayal of his thought. I paid particular attention to the manner in which he would mix and combine colours to achieve the graduated shade necessary for modelling, to emphasize the different lights and shadows, and to produce the different degrees of depth, causing certain parts of the painting to come out and others to recede. All of this he would execute with great art and beauty.

Under his tutelage I began several small works, in an attempt to put into practice what I had learnt, but such were the demands on my time elsewhere, I was unable to finish even the first thing that I had begun. Despite the strength of my passion for an art so noble, I have never had the time to progress in the manner I that desire. But the small amount of experience that I have acquired has made it clear to me that whatever theories one may hold concerning painting, nothing perfect may ever be executed without a tremendous amount of practice. The work I have done has demonstrated that no sooner does one set to work than a thousand difficulties present themselves, and that no amount of intellectual preparation can surmount these difficulties in the execution of a work.

For there is no formula for giving great force, majesty or grace to figures: all depends on the genius of the painter. Neither is there a sure means of guaranteeing the different shades in colour, or the effects achieved through mixing. Such things are learnt slowly, for they demand great experience, much practice, and some solid reasoning. If there is a manner of bringing out different aspects of a painting, and lending certain elements greater force, beauty and grace, then it does not consist of rules that can be learnt, but rather discovered through the light of reason; on occasion one must even go against the normal rules of art. This should not cause inordinate surprise, as in Nature there are thousands of forms of beauty that are extraordinary precisely because they go against the natural order of things.

It should not be imagined that in this Art, any more than in any of the others, there are certainties as there are in geometry, such that one may always work with confidence, nor should it be allowed for an excellent picture to be criticized when in one part it appears to infringe some optical law in some minor sense; the law will have been broken with reason, with some higher purpose in mind.

* * *

First Conversation

* * *

We went out to go to the Tuileries, but no sooner had we stopped talking of architecture than we struck up a conversation about painting. Pymander spoke of

the paintings in the Louvre, and asked a multitude of questions about works carried out for the king and queen. After we had talked for some time about some of the beautiful paintings that I had described to His Majesty, he asked me why I never wrote about painting, as my friends had asked me to do so long ago now, so that I might share with others the knowledge that I have gradually accumulated about this noble art.

At first I merely smiled at this flattery, but after giving the matter some consideration, I answered him as follows:

'I would gladly follow your advice, if I felt that what I know would be of use to a number of people, and that I could share it as you feel that I should. But allow me to remark here that your opinion of painting is perhaps not as high as it should be. It is an art that covers so many areas that it would require a mind greater than mine to do it the justice that it deserves.

For you ignore the fact that to write intelligently of all that is necessary to make an excellent painter, and to give people not just a general notion but a detailed description of all that is required for this art, a truly vast design would be required.

To show you how many areas such a treatise would have to cover, and to demonstrate that such a project really is beyond my powers, if it meets your purpose I will draw an outline of the areas of knowledge that such a project would have to embrace.

In order to explain properly all that I have learnt from the greatest painters a work divided into three sections would be required. The first section, covering composition, would include almost all art theory, as it is an operation which is carried out in the mind of the painter, who must thoroughly prepare the work in his own imagination and master it perfectly before its execution.

The remaining parts would speak of drawing and colour, and would look at the practice of art, and thus be more workmanlike. This physical aspect renders them less noble than the first part, which is carried out in complete liberty, and which one may know and master without actually being oneself a painter.

To compose a painting in the correct manner, the painter must have both a general and particular knowledge of all aspects to be covered in the painting. As there is nothing in nature which might not on occasion be represented in painting, the painter must have a perfect knowledge of all natural bodies before undertaking any portrayal of their image. But he must bear in mind that although the art of representation covers all natural subjects both beautiful and ugly, when it comes to the actual execution of the painting, if he wishes to be ranked among the most notable of our painters, he must choose that which is most beautiful, for even though natural bodies are to serve as a model, the fact that they are not all equally beautiful means that he must consider only the most perfect amongst them.

As we are often wrong in our choice of beautiful things, we should first of all define beauty and examine it closely, principally where the human form is concerned, as the human body is the most perfect thing that God created on earth. As we have already remarked that beauty is a result of the proportion of the different parts, we should move on to consider what is necessary in the proportion of these different parts in order to produce this admirable quality, so that the painter may have an exact knowledge of it and may equal the beauty of his subjects when he comes to draw

them from life. We shall then further expand on the question of proportion and measure when speaking of drawing in our second part.

Given that a picture is an image of a particular action, the painter must order his subject and distribute the figures according to the nature of the action that he is representing. As each picture is either a new invention of the painter, or an illustration of an episode from history or mythology already described by historians or poets, we must show how each of these different subjects should be treated, and how the movements of the body and soul should be expressed therein. We should even speak of the passions of the soul: although this is a part which depends on drawing, it must be properly conceived in the mind of the painter beforehand as it cannot really be drawn from life.

What should then be taught is the correct observation of the proprieties, regardless of the subject. To that end, it would be useful to demonstrate how the painter must have a profound knowledge of history and mythology, of the religions of ancient peoples, of the customs of such peoples and of their way of life, of their gods, their temples and buildings, of their sacrificial, funerary, and triumphant ceremonies, of their games, their different attire in times of peace and war, their arms, and their furnishings.

After this long section on the theory rather than the practice of painting, which is of the utmost necessity to any practitioner of the art desirous of achieving perfection, the second part concerning drawing could then begin. This is the most common starting-point for all who wish to learn this art, for it is through the tracing of lines that the first principles of art are learnt, and on these that all subsequent knowledge will rest. Without a solid foundation here, all other parts will come to naught.

This obliges whoever undertakes such a project to lay out principles to guide the progress of apprentices in the art step by step, leading them by the hand; and just as the traveller will learn nothing simply by seeing new provinces and kingdoms unless he also considers the nature of the country and the customs of the peoples, so should this book demonstrate how to teach the art, instructing students in the appreciation of beautiful things so that through remarking upon them they may engrave them on their souls, mixing them with nothing that may be harmful or of little use.

The author should demonstrate the surest and easiest ways of arriving at this destination, and through familiar examples enable students to guide themselves through the work that will become their lives. Above all, he must demonstrate how mathematics is necessary to painting, instilling a knowledge of geometry and perspective which should underpin his whole work.

It will also be necessary to demonstrate how the painter must become expert in matters of anatomy, principally where muscles, nerves, sinews, bones and ligaments are concerned, in order to become expert in their depiction.

He would also note that as proportion goes hand in hand with drawing, it must be observed in all parts of the painter's work. The painter himself must learn to judge the fittingness and balance of each part, and the position of each figure in the picture; to bring them out to their best advantage he must judge the necessary degree of equilibrium or ponderousness that they require, while still attempting as far as possible to attain the degree of excellence in beauty and grace that we referred to above, that inexpressible *je ne sais quoi* which comes entirely from the drawing.

He would then pass to the third part, which would treat colour. Having spoken of the nature of colours, of the union and kinship that exists between them, he would demonstrate how they are employed to produce beautiful effects of chiaroscuro, giving relief and depth to figures inside the painting.

It would also be necessary to talk of the type of perspective known as aerial perspective, which is nothing other than the manner in which distant colours tend to fade, as the quantity of air between the object and the viewer increases; of the accidents of luminous and diaphanous light to be found in nature, and of how observation of this is to be made, of the different forms of light, either as sources or as illuminated bodies, of reflections and shadows, of common errors made by painters working under particular lights, of the different views or aspects of things according to the angle from which they are studied, of the appearance of bodies in water, and of all that produces the force, pride, strength, softness and preciousness of the best colourist paintings; of the different manners in colour, where figures or landscapes are concerned, and of that which must be followed as the most excellent. This teaching must all be accompanied by examples, where the beauty and perfection of these three parts, Composition, Drawing and Colour, are all manifest.

What a work then this would be! Are you genuinely of the opinion that it should be mine? It would require the skill of the greatest painter of the century to reveal all the secrets of practice, but who could speak of painting with the necessary grace? Painting represents objects so nobly through the vivacity of its colours: whose wise and knowing pen could adequately depict the agreement and strength that we find in great paintings?

As I find myself unable to undertake an enterprise so disproportionate to the forces I have at my disposal, please do not think ill of me if I do not bend before your persuasion, but say instead that such a work as I have outlined I myself am incapable of bringing to fruition. I would be quite hurt if you did not accept my reasoning; my intention was merely to draw up the principles for such a work, and provide some information for all those knowledgeable men who today do teach with much success. Indeed some of these people, with whom I have often spoken and from whom I have learnt much, would be incomparably better than I if they chose to undertake such a work.

This is not to say that I will never return to the subject; indeed I hope often to be able to provide you with a degree of satisfaction. Whenever possible I will share with you all that I once noted purely to satisfy my curiosity about the various parts of painting, either through looking at the pictures of the greatest painters, or through different conversations that I have had on this subject.'

Pymander then replied that even if I spoke but little about painting, and treated the subject much less amply than it deserved, I would still demonstrate the advantage that this art enjoyed above all the others. Painters themselves, he continued, would be glad that so many were improved by my conversation, and learned to judge the excellence of their paintings and the beauty of their figures, studying the secrets of the art, and learning through the perfection of the work to take note of its executioner.

'Quite rightly do they take an interest,' I replied. 'The excellence of painting is not merely a matter for the knowledgeable, but should interest all right-thinking people. All too often they consider only the surface of painting, and fail to direct their thoughts to the more profound aspects of this science, which one might say has something of the divine, as nowhere better can man imitate the power of God, who fashioned the universe out of nothing, than in representing all creation merely through the use of colours. As God made man in his image, so does man in turn make an image of himself when he expresses his actions and thoughts in such an excellent manner on a canvas that they remain constantly exposed to our sight for ever, such that not even the diversity of nations prevents this dumb yet eloquent language, more agreeable than all others, from being instantly comprehensible to all.

Whenever one pauses to reflect upon the diverse parts of this art, one cannot fail to own that it constantly furnishes us with ever more material for our meditations, ever returning us to that great first light from which all beautiful ideas emanate, the base of all the noble inventions that we express in our work.

For if in considering the beauty and art of a painting, we admire the invention and spirit of the mind of him who first conceived the idea before his brush first touched the canvas, how can we not admire all the more the beauty of that source from which these noble ideas are drawn? Thus all the different beauties of painting serve to elevate us to that sovereign beauty, and what we see as admirable in the proportion of the different parts causes us to consider how much more admirable still is that proportion and harmony which is to be found in all creatures. The order in a beautiful picture will necessarily cause us to consider the beautiful order of the universe. The light and day that art can capture through the mixing of colour gives us some small idea of that eternal light by which and in which one day we will contemplate all that is beautiful in God and his creation. And finally, when we consider that all the marvels of art which so charm our eyes and surprise our senses here on earth are but a pale imitation of the mind in which they were first conceived, how much greater still will be our admiration of that eternal wisdom which shines the light of art into all minds, and which is itself the eternal and immutable law? Such light is the light of wisdom infinitely superior to the light of all created spirits, as the prophet Isaiah remarks: 'For my thoughts are not your thoughts, neither are your ways my ways, saith the Lord. For as the heavens are higher than the earth, so are my ways higher than your ways, and my thoughts than your thoughts.' (Isaiah, chapter 55, verses 8–9). 'When God created the stars,' a great saint once remarked, 'angels sang canticles of praise, admiring their number, their beauty, their position, their variety, grace, sparkle, harmony, and all the other perfections of those sublime bodies whose excellence they understand far better than we.' (Saint John of the Cross). Thus when we consider the work of the human spirit, with its beauty, grace and charm, as our knowledge increases we notice its perfection ever more; and thus are we led to praise ever more Him who placed such marvels on earth and in the heavens.'

10 André Félibien (1619–1695) Preface to *Seven Conferences*

André Félibien des Avaux was born into the provincial nobility. His education and early friendships with Charles Le Brun, Sébastien Bourdon and others encouraged an interest in the arts and helped to equip him for a role as a critic, historian and administrator. He was in Rome between 1647 and 1649, as secretary to the French Ambassador to the Holy See, and while there made the acquaintance of Claude Lorrain, Nicolas Poussin and Charles du Fresnoy (see IB 9). In the 1660s he benefited from the patronage of Jean-Baptiste Colbert, and was responsible for various publications on the royal collections. In 1669, in his role as historiographer of the Royal Buildings and honorary counsellor to the Royal Academy, he published *Conférences de l'Académie Royale de Peinture et de Sculpture pendant l'année 1667* (Paris: Chez Frédéric Léonard, Imprimeur ordinaire du Roy). Though the entire work is often attributed to Félibien (as in the English version cited below), he seems rather to have acted as the reporter and editor of the lectures. (The French *conférence* is usually translated as 'lecture', though early English translations refer to 'Seven Conferences'. In fact the occasions at the French Academy were generally both 'lectures', insofar as individual speakers opened the proceedings, and 'conferences', insofar as they involved an ensuing discussion.) Félibien's name is clearly attached to the lengthy preface, with its encomium to Colbert. The quality of Félibien's observation and writing lifts his account of painting far above the standard treatises of the time, and his recommendations, prescriptions and verdicts were to be frequently repeated in subsequent publications. Art as he represents it is no mere 'mechanic' practice, to be learned ad hoc. It is 'knowledge which one acquires', for which 'rules are laid down' and for which an elevated mind is required. In Félibien's framework, the highest moral and intellectual demands are made of the painter of elevated *subjects*. According to what became established in the Academy as a hierarchy of genres, the painter of History was thus accorded a status intrinsically superior to the painter of such specialized commodities as portraits, still lifes and landscapes. Félibien's close acquaintance with Poussin's ideas is revealed in his reference in the later part of the preface to the theory of the modes (see IB1), which itself played a part in the theoretical separation of painting into different manners for different functions. The lectures themselves were given by artists and connoisseurs – Le Brun, Bourdon, Philippe de Champaigne, Charles Perrault and the Flemish sculptor Gerard van Opstal – each speaker devoting himself to the virtues of one specific painting or sculpture (see IB11, 12, 13 following). The works selected for the conferences are significant of the academic priorities of the period: two works each by Raphael and Poussin (*The Israelites Gathering the Manna* and *Christ Healing the Blind*), one each by Titian and Veronese, and a cast from the *Laocoön* group. Where appropriate, Félibien's function as transcriber and editor of the lectures was extended over ensuing debates, so that occasional dissenting voices are represented in their printed form. It may have been for this reason that Félibien's publication met with a cool reception among the members of the Academy. The volume as a whole nevertheless serves to convey the impression that valuable instruction is here offered by a group of senior professionals, agreed upon a broad theory of art and upon a canon of excellence by which its findings may be demonstrated. (For reference to the subsequent hardening of the Academy's academic doctrine, see IB15.) The present text is taken from the anonymous English translation, *Seven Conferences held in the King of France's Cabinet of Paintings*, London: T. Cooper, 1740, pp. vi–lx.

[...] Towards the End of the Year 1663, the King, by giving to Mr. Colbert the Office of Superintendant of the Buildings, shewed that he intended to make the Arts flourish more than they had done hitherto. This great Man, who equally understood and loved the fine Arts, as he was zealous for his Master's Glory, re-established the making of Tapestries in Paris, and several other Places, and begun many other Works, 'till then unknown in France. But as he knew that the Art of Painting extends itself to every Kind of Workmanship, and that nothing contributes more to the Glory of a Prince than those immortal Works which Painters and Sculptors leave to Posterity, he afterwards procured from his Majesty new Favours to them that excelled in those Arts, in order to raise Emulation among them from the Prospects of Honour and Reward. [...]

As the particular Affection he bore to [the Academy] made him constantly endeavour to advance it and make it flourish; one Day when he honoured it with his Presence, to distribute the Prizes which the King allowed the Students; after he had examined the Pieces they had drawn, and they had told him what had been treated of in their late Assemblies; he said there was two Ways of teaching Arts and Sciences, by Precepts and by Examples; the one instructed the Understanding, and the other the Imagination: And as in Painting, the Imagination has the greatest Share of the Work, it is manifest that Examples are very necessary to make one perfect in that Art, and are the surest Guides to young Students: He therefore thought that if the Works of the best Masters were exposed in the Academy as Models, and if any one would inform the Students wherein the Perfection of the Art consists; this Method of Teaching, joined to their other Exercises already practised, would be of very great Utility. For though the Perfection of a Piece chiefly depends on the Force and Beauty of Genius; one cannot deny that the Remarks which might be made, would be of great Use, since here, as in all other Arts, Experience discovers many Things necessary to a Student, who, if he makes a proper Use of the Remarks already made by the Learned, may save himself from many painful Researches, which take up a great deal of Time to one who makes them without any Assistance. Thus in several other Arts, particularly Musick and Poetry, which are congenial to Painting, standard Rules have been found out to bring them to Perfection, though all who know them are not equally capable to put them in Practice.

That to instruct Youth in the Art of Painting, it would be necessary to shew them the Works of the greatest Painters, and in publick Discourses to inform them of what chiefly contributes to make up the Beauty and Perfection of Pieces. That every one being at Liberty to speak his Sentiments, they should examine all the Particulars which enter into the Composition of a Subject; and that even their different Opinions would help to discover many Things better than Precepts and Maxims. And, as these Discourses had not been in Use hitherto in their Assemblies, he said, there might perhaps be Persons found out, who though they might be afraid that they could not acquit themselves so well at first, yet they should not think so, for though they met with Difficultys in the Beginning, they would soon surmount them, and take no less Pleasure in discoursing of the Beauties of a Picture, than to shew them by their Pencil and Colours. This Method, be added, would be no less profitable than glorious to their Body, since in treating of the Art of Painting in a Way which had not been practised hitherto, they would one Day be sensible, that if they were not the first who

found out Rules, at least they had the Honour to be the first who brought them to their highest Perfection.

Mr. Colbert having thus shown them how great an Advantage must attend this Conduct and Method of Study, it was resolved they should meet on the first Saturday of every Month in the great Hall of the Academy, or in the King's Cabinet of Paintings, which he gave them the Use of to make their Observations in. That the Chancellor and Rectors of the Academy should open the Conferences in their Turn by a Discourse, in which they were to examine the Picture they had chosen for the Subject of the Day: That Mr. Le Brun, as Chancellor, should begin the first Saturday, and the Intendant of the Buildings should collect all the Conferences, and put them in order, to be published from Time to Time.

In Consequence of this, they began to assemble on Saturday the 7th of May, and we may see by their Conferences during the Rest of the Year, how many important Remarks they have made on Painting.

In short, the Academy being filled with Men of Learning, scarce the smallest Beauty or Fault escaped their Observation: Thus any one might learn to imitate the one and shun the other; and those who had been at more than ordinary Pains to increase their Knowledge, communicated to the Rest the Fruits of their long Study without impoverishing themselves.

They who assisted at these Conferences saw well of what Advantage they might be, not only to Painters, but to all the Lovers of the fine Arts. And as Use makes every Thing easy, we shall find in the Sequel, so great Discoveries in their Remarks on Painting and Sculpture, that very little remains to be said on these Subjects which can promote the Instruction of Students.

We may observe in these Discourses how many Parts of Painting they have already handled with great Accuracy. In the first which has for its Subject the Picture of St. Michael, by Raphael, there are learned Observations upon Design and Expression, which are so many excellent Lessons and important Precepts for such as are learning to design.

In the second they have not confined themselves to what belongs to Drawing only, because Titian, whose Work they examine, was not very famous for that Quality, but excelled in colouring, on which they have made very learned Remarks.

In the third Conference they treat of *Laocoön*, that celebrated and finest Piece of Grecian Antiquity: One may see that there is nothing very useful or necessary for Design and strong Expressions of Colour, which they have not taken Notice of.

The fourth treats of other different Expressions, having one of Raphael's finest Pictures for its Subject. There one may learn the Method of varying the Expressions according to the Quality of the Subject, and how he must distribute Light or Shade, according to the Scene of the Picture.

The fifth treats chiefly the Ordonnance, and as it is true that in these Compositions Ease is rather the Gift of Nature than the Effect of Study, we shall find greater Reason to admire the fine Composition of this Picture of Paulo Veronese, and his easy Manner of Painting, than be able to discover by it, any Means of imitating it. Not but these Observations that are made upon it may give us fine Ideas, with Regard to Colouring, and shew us how to give an Appearance of an easy and judicious Disposition to a Picture.

In the sixth there are several Remarks of different Kinds. As the Subject comprehends many Things, here they speak of Composition, Design, Proportions, Colours and Lights, in a very extensive and learned Manner; and particularly of all the Kinds of Expressions applicable to a History, such as that of the *Fall of the Manna*, represented by Mr. Poussin.

In the seventh, the same Parts of Painting are treated of, but the Subject of the Picture before them being one of Mr. Poussin's representing our Saviour curing the two blind Men, it has so little Resemblance of the other, that the Remarks are absolutely different. The first is chiefly taken up about Decorum, and the Manner of treating History: And the different Opinions of Persons give Occasion to shew how exact a Painter ought to be, to omit nothing that may be necessary to express the Action he would represent.

It is not to be doubted, as I have said, but in the subsequent Conferences many Things will be discovered, which have been hitherto unknown: And that Painters, who would work by the Principles of the Art, will form so clear and just an Idea of what they would represent, that they will be at no Loss in the Execution of it. For certainly the greatest Difficulty in the Production of a Work is in the well-forming of it in the Imagination, as Children untimely born give greatest Pain to their Mothers at their Birth, and but seldom grow up to be Men.

And though the Observations made in these Conferences are not delivered with all the Order that seems necessary, when one would lay down Rules for understanding an Art; all these Lessons being nevertheless expresly applied to particular Pieces, they will not fail to come into a just Arrangement in the Mind, so that when one sees a Picture, all the Ideas we have of the Parts which serve to make it perfect, come without Confusion one after another, and discover the Beauties in Proportion as we attend to it. The same will happen to those that work after having well formed an Idea, and conceived the whole Oeconomy of it.

'Tis true that to judge rightly of this, and to form a distinct Notion of a Work one would execute, we must have a perfect Knowledge of the Subject, and of the Parts of which it ought to be composed, and what Way we must proceed. And this Knowledge which one acquires, and for which Rules are laid down, is in my Opinion what we may call Art.

Now it is certain that the Art of Painting has not been perfectly understood but by the ancient Greeks, and some others, who appeared about two hundred Years ago: For though it deserves a considerable Rank among the liberal Arts, they who have given us any Rules concerning it, have always treated of the less useful Parts; they seem rather to have left it in the Number of mechanic Arts, than to give it the Place it deserves. But, indeed, Painting is of a much higher Class, and in this, surpasses the most celebrated Arts, that by forming as exalted Thoughts, and in treating the same Subject as History and Poetry it is not content to represent them, faithfully, or to invent with Genius, but forms Images of them so admirable that it makes us believe we see the Things themselves: And in showing them to the World agreeably, instructs the ignorant, and gives Pleasure to the greatest Artists.

As the Pleasure and Instruction one receives from Painting and Sculpture arises not only from the Knowledge of Design, and the Beauty of Colours, or from the Value of the Materials; but the Greatness of the Thoughts, and the Knowledge of the

Subject represented, it follows, that there is a peculiar Art different from the Materials and the Hand of the Artist, by which a Painter ought to form his Pictures in his own Mind, and without which he cannot, with a Pencil only, produce a perfect Work: Since it is not in this Art, as in some others, where Industry and Dexterity are sufficient to produce Beauty.

Now it is not the mechanical Part, but a greater Secret, a more useful Accomplishment wholly consisting in a refined Taste, that is to be learned from these Conferences, where all the Parts of which it is composed are treated by the best modern Painters. But that the Reader may understand them with greater Ease, I think it necessary to add a few Words concerning them, that they who have a Mind to learn may at least have a slight Notion of what follows, and may in some Manner be instructed in whatever is essential to make a perfect Painter.

This Art in general extends to all the different Ways of representing natural Bodies; and though Painters sometimes draw things which are not natural, such as Monsters and Grotesque Figures of their own Invention, yet even these, being always composed of Parts known, and taken from different Animals, cannot be said purely to be the Effects of Imagination.

The Representation that is made of a Body by Lines or Colours is considered as a mechanical Employment; for this Reason as there are different Workmen in this Art, who apply themselves to different Subjects; it is certain that in Proportion as one employs himself in the most difficult and noble Parts, he excells those which are low and common, and aggrandises himself by a more noble Study. Thus he who paints fine Landskips, is above him who only paints Fruits, Flowers, or Shells: He who paints after Life is more to be regarded than he who only represents still Life; and as the Figure of a Man is the most perfect Work of God upon Earth, it is also certain that he who imitates God in painting human Figures, is by far more excellent than all others. Moreover though it be no small Matter to make the Picture of a Man appear as if it was alive, and to give the Appearance of Motion to that which has none; one who can only draw Portraits, has not as yet attained to this high Perfection of Art, and cannot pretend to the same Honour with abler Painters. He must for that end advance from Painting one single Figure, to draw several together; he must paint History and Fable; he must represent great Actions like an Historian, or agreeable ones as the Poets. And soaring yet higher, he must by allegorical Compositions, know how to hide under the Vail of Fable the Virtues of great Men, and the most sublime Mysteries. He is esteemed a great Painter who acquits himself well in Enterprizes of this Kind. 'Tis in this that the Force, the Sublime and Grandeur of the Art consists. And it is this particularly that ought early to be learned by young Students.

We see then that a Painter is not only an incomparable Artist, as he imitates natural Bodies and the Actions of Men, but further he is an ingenious and learned Author; as he invents and produces thoughts quite his own. Insomuch that he is able to represent all Nature, and whatever passes in the World; and which is yet more, to produce things quite new, of which he is as it were the Creator.

I have already observed, that this Art is divided into different Parts, either because of the Diversity of the Bodies, and the Actions which are imitated, or the different Manner of imitating them, as in designing with one Colour simply, or in painting with different Colours mixed together, or in Engraving or Sculpture; it seems

necessary to say something of all these particular Manners. But rather than enter into so long a Detail, I believe, it will be better to speak in general of the Composition of a Picture where some Fable or Allegory, or History is represented, which are the more sublime Subjects, and as such, comprehend all the others. It is for this Reason that I have said there are two principal Parts to be considered, one which regards Reasoning or Theory, the other which has respect to the Hand or Practice.

The Parts belonging to the Theory, are these which make one acquaint'd with the Subject, and serve to render it Great, Noble, and Probable, as History or Fable; this is what they call Costume, which is the Truth necessary to express any particular History or Fable, and the Beauty of Thoughts in the proper Disposition of every Part.

The Parts which respect the Hand or Practice are Ordonnance, Design, Colouring, and whatever serves to express them in general or in particular.

What is called History or Fable in a Picture, is an Imitation of some Action which passed or may have passed between several Persons; but care must be taken that there be but only one Subject in a Picture; and though it may be filled with a great Number of Figures they must all have respect to the principal One, as may be seen in the sixth Conference upon the Picture of the Manna.

Moreover as in Pieces for the Theatre; the Fable is not in its Perfection if it has not a Beginning, a Middle, and an End, to make the Subject of the Piece intelligible; one may likewise in great Pictures (the better to instruct Spectators) so contrive the Ordonnance, and the Disposition of the Figures, that we may even judge what preceeded the Action: And this Mr. Poussin has done in the Picture of the Manna, where we see Signs of Hunger in the Faces of the Jews, which they had suffered before they received that Relief from Heaven. And although he may make several Actions be done at the same Time and at the same Place, he ought not for all that to represent them all, for a Painter who is Guilty of Faults like these, will meet with as much censure as Euripides, whose Tragedy of the Trojan Dames has been found fault with by every Body, because he has represented three Actions at once.

Besides this, there must appear in great Subjects, something marvellous in order to raise an Admiration of the History that is treated, and of the Painter's own Genius. This is expressed by the Beauty of the Figures, the noble Adjustments, and by a Grandeur and Majesty which shines through the whole Work, as we may observe in the miraculous Cure of the blind Men, which has given Occasion to the seventh Conference. Further, there must be Possibility in all the Actions, and in all the Motions of the Figures, as well as in the Expression of the principal Subject, to the End that Probability be found throughout as a most necessary Part, and which never fails to please the Eyes of the Beholder. One of the ancient Greek Painters having represented a Bird perched upon a single Ear of Corn which did not yield under it, was reprehended by the Peasants as one of small Judgment. If so minute a Thing does not fail to offend the Eyes of the most ignorant, how will greater Faults which appear in great Subjects, hurt an intelligent Eye. Thus in the fifth Conference, we do not think that the Miracle of breaking Bread at Emaus is treated with Probability, because the Nature of the Place, and the Characters of the Persons that are about our Saviour do not agree with the Action. But in the first Conference, we find that the St. Michael of Raphael could crush the Demon who is under his Feet tho' he does not

touch him; because it is not impossible for an Angel, to whom God has given Power to conquer the Devil, to crush him in that Manner.

What is of greatest Importance to the Perfection of Fable or History, is the different Expressions of Joy and Grief, and all the other Passions proper to the Persons painted: It is this which makes the fine Picture of Raphael so admirable which is the Subject of the fourth Conference. To this we may add the various Airs of Heads and Attitudes, for these are the fine Parts which agreeably affect those who behold a Picture, and which leading us pleasantly into the Knowledge of the Subject, makes us feel the same Sentiments of Joy or Admiration which the Persons represented are supposed to have. This is shewn in the sixth Conference where the Groupes represented by Mr. Poussin serve to instruct us in the History, and to shew the Change among the Israelites passing from a miserable to a more comfortable State.

Nor is this enough: to make a Work perfect, it must have particular Marks to distinguish the principal Figures from one another, and to note to the most extraordinary Actions, as in the Picture of the Manna, we may distinguish Moses from all the rest, as well by his Place as his Mein and his Vestments, and by an Air which gives one an Idea of what he has heard, and finally by the Actions of those about him. But if a Painter must vary his Subject by some particular Actions, he ought to be careful they be neither too many, or too low, even tho' they have some Connection with the History he is painting. Dominiquin's Picture of the Martyrdom of Saint Andrew is censured on this Account, for he has represented one of the Executioners falling as he was drawing a Rope, for which he is laughed at by the Spectators who are seen mocking him by their indecent Gestures; because this Expression, being unworthy [of] so serious a Subject, instead of attracting the Eyes, and raising Compassion for the Saint who is going to be martyred, distracts us by these ridiculous Actions. The expressions therefore of the particular Figures, which ought only to accompany the principal One, must be Simple, Natural, Judicious, and have a decent Relation to the Figure which serves as a Body to the Work of which the others are but as Members.

After having considered what belongs to History, which ought to be a single Action of competent extent, and of Beauty worthy of the Subject, which must be probable, and by its Expressions help to discover what is meant; I shall pass to the Costume, which is nothing else but a strict Observance of all that is proper to the Persons represented, who ought to appear with good or ill, high or low Characters according to those they represent. This is done in the fifth and seventh Conferences: And further it consists in the Knowledge of what is necessary to be observed with Regard to Ages, Sexes, Countries, and different Professions, and to give the Manner and Passions peculiar to each Country. In this Raphael has been admirably well skilled, but neither Titian nor Paulo Veronese have been Masters of this Art. It is nevertheless none of the least Qualifications; on the contrary we see it is one of the most necessary to instruct the ignorant, and most pleasing to intelligent Eyes.

As to the Beauty of Thoughts in the Disposition of every Thing, it consists in representing the Subject in an agreeable easy Manner, and in giving every Figure a natural Expression neither too weak nor too strong; in hitting off the Characters proper to each Person so as not to spoil the principal One in the Picture. We see in

the *Rebecca* done by Mr. Poussin, of which we shall speak in another Conference; how rich and agreeable the Composition is, both by the magnificent Disposition of the Figures, and the Variety of Faces, Actions, and Draperies. But as there are Subjects less noble, they must be treated more simply, not to fall into a Fault like that of the Bassons, and some other Flemish Painters, who in this have observed no Measure at all.

These are the Things which principally regard Theory, and in Truth it is surprising to see how some Painters and Sculptors, with all their Knowledge, all their Imagination and Invention, and all their Skill in the Disposition of great Subjects, do however find themselves as it were deserted by all their natural and acquired Abilities so soon as they attempt to execute what they had intended. On the other Hand, there are not a few who have a very good Hand, and yet have no Invention. Insomuch that it is no great Wonder there are so few excellent Works, since to produce such, not only a very fertile Genius is required, but likewise a solid Judgment to make a right Use of its Inventions, and great Practice to be able to set them in a fine Light.

For this Reason most of the ancient Greek Painters, knowing the great Compass of their Art, contented themselves with making Choice of one Part of it in which they endeavoured to perfect themselves; as a Dionysius who painted Men only, a Nicias of Athens who was famous for painting Women finely, an Aristodemus celebrated for painting Wrestlers: A Calaces remarkable for the Decorations of the Theatre; and even they among them who have excelled in great Compositions, have not been Masters of all the Parts equally, but have raised their Reputation by some one in which they have supassed others, as Apelles, in the Beauty and Grace of his Figures.

As to Practice, it regards the Manner of disposing a Subject, and putting every Figure in its due Place. For though I have said that Facility in the Ordonnance depends chiefly on the Strength of the Painter's Imagination, who must for that End have a particular Gift from Nature as is observed in the fourth Conference in speaking of Paulo Veronese: Yet a Painter may supply the Defects of Nature, by carefully disposing all his Figures in order, and not putting them in Places where they may create Confusion, or by giving them disagreeable Attitudes; but on the contrary, assembling them by Parts and Groupes in the Manner Mr. Poussin has so finely done in his Picture of the Manna. In him we see all that belongs to Design and Proportion, on which there are Remarks made in the sixth Conference, to shew how they must be handled agreeably to the Age and Quality of the Persons.

'Tis in this Conference and in the seventh, that they handle what belongs to the fine Harmony of Colours, which shews, how to distribute Lights and Shades to the best Advantage, and in observing an agreeable and judicious Contrast in all the Work, yet to preserve a general Union throughout the Body, by which one may at first Sight have a strong Idea of the whole Subject.

Although this second Part which treats of Practice be less noble than the first, we must not imagine it ought to be considered as purely mechanical, because in painting, the Hand does nothing without being conducted by the Imagination, otherwise it cannot draw one single Feature or Stroke of a Pencil with any Success. Insomuch that they who undertake to draw a Portrait even though they do not employ the utmost Efforts of their Genius, and make use of all their Knowledge on that Occasion,

though they do not find so much use for them as in composing a great Work: The Trouble is not very small when one must consider and mark distinctly all the Contours which form the Parts of a Face, for they must all be known from one another by a vast Number of Features which distinguish them, and be all set in their proper Place, and ranged in such a Manner as to imitate very nicely the Object proposed; to set them at a Distance, or bring them nearer differently one from another: To diminish or augment their Compass, and after that to give them such a Colour as may preserve to each of them their particular Character; lastly, to compose one entire Mass where all the Parts are joyned together with so much Union and Sweetness, that the Teints which are employed almost separately in several Places, may seem to make but only one Colour, which changes insensibly according to the different Places it is employed in, but yet in such a Manner that this Mass being enlightened or shaded in some Places more than others, the Lights and Shades, the Strong Teints and the weaker, may lose themselves in one another with so much Art, as to give Relief and Roundness, and represent real Flesh. It is however this ingenious Mixture of Colours, and the Knowledge of Designing well, and preserving the Features, which beget these fine Expressions and natural Motions that appear from the Life, and which imprint on a Face the Passions one Designs to represent. So that the Practice of Designing well, and mixing the Colours artfully, must not be reckoned things of small Account, for a great many Difficulties are to be surmounted in both. On the contrary we may consider, that if in drawing one single Head there are so many things difficult to be well represented, because in Nature herself, although all Faces have the same Parts, one cannot find two of an exact Resemblance; how much more difficult is it to produce a great Work, all the Parts of which ought to be handled with a thousand Considerations, on Account of the different Relations they have to one another either in Drawing, Colouring, or Expression.

Mr. Poussin being perswaded that the Beauty of a Picture consists in making every thing that enters into the Composition have a particular Mark of what the Work represents in general, made that his principal Study: And in all his Productions, the Expression of his Subject is so generally diffused, that there appears throughout an Air of Joy or Sorrow, Anger or Sweetness, according to the Nature of his Story. He was of Opinion that as in Musick the Ear is not delighed but by a just Agreement of different Voices or Sounds: So in Painting the Eye is not charmed but by a fine Harmony of Colours, and a just Agreement of all the Parts with one another. So that when he reflected that different Sounds occasion different Motions in the Soul, as it is touched by grave or sharp Notes, he doubted not but by setting forth Objects in a moving Disposition, and an Expression more or less violent, under different Colours laid one after another, and differently mixed, he might give the Sight different Sensations, which would render the Soul susceptible of as many different Passions.

It is also true, that if Musick can work Miracles, as is told of Pythagoras who by that means gave Health to the Sick: That Asclepiades the Physician cured phrenetick Persons, that a Player on Flutes put Alexander in a Passion, another appeased furious Persons, and all this by the Power of certain Sounds, and the Force of different Accords which struck the Ear in such a Manner, that the Soul which Delights in Proportion and Likeness, was pleased with the Sounds of these Instruments, and

with the Tones of the Voice where the Numbers are entire and harmonious. Thus in Painting, all the Beauty of which consists in Symetry and fine Proportion, if it be handled according to Nature, may raise in the Soul Sentiments of Joy and Delight as strong as Musick does: Since of all the Passions those that enter by the Eyes are the most violent: There are instances of as great Wonders performed by Painting, which have often been raised by the Imagination at the Sight of beautiful and deformed Objects, as any that are reported to have been done by Musick: One has only to find out different Modes in Painting for the Composition of Pictures and the Expression of Subjects, as the Ancients have done in Musick for different Recitals and Songs. We may observe three principal Ones, viz. the Dorian, the Ph[r]ygian, and the Lydian, to which they afterwards added several others: One of them was used to sing the Praises of great Men, others inspired Courage, and animated them in Time of Battle; some were designed to beget Love, others raised Grief, and some excited Joy. As these different Modes sprung from the Manners and Customs of those who invented them, some of them were more moderate, as the Greeks, others more soft and effeminate as the Lydians; we may compare with the different Manners of Painting, what is observed in the Schools of Rome, Florence, and Lombardy, where the first preserves more Majesty and Grandeur, the second more of Fierceness and Motion, the last more of Harmony and Sweetness. But it must be acknowledged there is something singular and incomparable in Mr. Poussin, for having found out the Art to practice all the different Manners, he was so much Master of them, and has laid down so certain Rules for them, that he has given his Pictures the Force to express what Sentiments he pleased, and to inspire the Soul of the Beholder, in the same Manner as in Musick these Modes which have been mentioned move the Passions. He has in this, even outdone the most famous ancient Painters, that in his Works are seen all the fine Expressions which do but meet in different Masters. For Timomachus was not remarkable except for Painting the most vehement Passions as an Ajax whom he has represented in Anger. Zeuxis knew how to express the softer Passions when he did that fine Picture of Penelope in whose Countenance was seen Modesty and Prudence. Clesiles was principally remarkable for Expressions of Grief, having painted a Man wounded and dying, with Characters so natural, that his Strength seemed to diminish gradually, and to shew how short Time he had to live. But as I have observed, Mr. Poussin was equally Master of all these Qualifications, and knew perfectly the Force and Extent of all the different Modes. Thus in his Picture of *Pyrrhus* he seems to have kept one Mode, which was to shew nothing but Fury and Anger; in that of *Rebecca*, all is gracious and delicate; in the *Manna*, we see nothing but Languor and Misery, in the *Cure of the Blind*, Joy and Admiration: and thus it is in all his other Pictures which are so admirably handled that every Part expresses the Quality of his Subject, in the same Manner as in these Modes of Musick all the Sounds contribute to express Joy or Grief. And it is this which he called sometimes the Dorian Modes, when it treated of grave Subjects, at other Times the Lydian, when it painted Bacchanals, sometimes Lesbian, for magnificent Things, and at other Times Ionic, for soft and pleasant Subjects; thus giving them different Names according to the Difference of Subjects.

But as that which rendered these Modes capable to elevate or intimidate, to afflict or rejoice, was the Manner in which the Voices or Sounds were ordered or combined,

some of them were quick, others languid, some were grave, others sharp; and these striking the Ear differently, occasioned a more or less violent Emotion in the Soul. Thus Mr. Poussin has represented his Figures with Actions stronger or weaker, and with more or less lively Colours according to the Subjects he handled; for having found the true Degrees of Force and Weakness which meet in Colours, he knew so well to use them, that in his Works we may see a harmonious Kind of Conduct as in Pieces of Musick. For when he has represented a sad and dismal Subject as in his Picture called the *Plague* in the King's Cabinet, all the Colours are smothered and half extinguished, the Light weak, and the Motions of the Figures slow and enfeebled. But in that of *Rebecca*, which ought to have been graceful, he has employed none but lively Colours which are softly and insensibly lost in one another, and which he has mixed so finely as to ravish the Sight: The Actions are modest and peaceable, a Calm appears throughout, mixed with a becoming Joy, and in this we may say he has imitated the Ionic Mode which is elegant and agreeable. I should enlarge too far if at present I continued the Comparison of all the Manners of Painting with the different Kinds of Musick. 'Twill be sufficient to have said what I have observed of this great Painter, who has been an Honour to the French Nation, and one of the strongest and greatest Genius's that has appeared in that Art: For nothing comes from his Pencil which is not performed with a profound Intelligence, and as he always carefully enquired after those things by which the greatest Masters have arrived to that Height of Science which has made them so famous, He has likewise rendered himself illustrious by the comprehensive Knowledge he acquired, and the inimitable Works he has left behind him. [...]

11 Charles Le Brun (1619–1690) 'First Conference'

The seven conferences referred to above (IB10) were inaugurated on 7 May 1677 by Le Brun, in institutional terms the most powerful French artist of the century, speaking on a painting by Raphael, then the most highly regarded painter of the Italian Renaissance. (Raphael's *St Michael triumphing over the rebel angels* is now in the Louvre.) Le Brun had been in Rome from 1642 to 1645, in company with Poussin, and works by Raphael were prominent among those he copied. In 1648 he was one of the founder members of the Académie Royale. During the 1650s and 1660s he completed an impressive number of paintings and decorative schemes, including those at the palace of Vaux-le-Vicomte, reorganized and supervised the Gobelins tapestry factory and its attendant schools, and took charge of the royal collection of paintings and drawings. In 1664 he was appointed First Painter to the King and between 1668 and 1683 was employed on the decoration of the palace of Versailles. He was made Chancellor of the Académie Royale in 1663 and Rector in 1668. In the following passage, the preliminary description of Raphael's painting was probably supplied by Félibien. Le Brun's account is notable for its appreciation of the quality of outline in the Italian painter's work and for his informed attention to those devices that contribute to its expressive effect. The text is taken from the anonymous English translation, *Seven Conferences held in the King of France's Cabinet of Paintings*, London: T. Cooper, 1740, pp. 1–10. (For Le Brun's 'Sixth Conference', on Poussin's *Israelites Gathering the Manna*, see IB13.)

ALL the Academicians and most of the Students being met in the King's Cabinet of Paintings, the *St. Michael* of *Raphael* was set before them in a favourable Light.

This Picture is eight Feet long and five broad: In the middle of a great Landskip, which represents a Desart, St. Michael descends from Heaven to Earth, having under him the Devil thrown to the Ground. This Angel is supported in the Air by two great Wings; he is cloathed with a Coat of Armour, made of Scales of Gold, which is tied with a Kind of Stuff of Gold after the Roman Manner, and reaches to his Knee; under that he has another Vestment of blue Stuff embroidered, opening a little, on which is written in Capital Letters, RAPHAEL URBINAS PINGEBAT, 1517.

Above the Armour there is like two Scarfs of a changing Colour floating in the Air, one of the Ends of them are carried away with great Violence between the two Wings of the Angel, the other is buoyed up by its natural Lightness.

He has a Sword by his Side, and holds a half Pike in both his Hands, but having his right Arm a little raised up, his left Arm appears to be drawn under it, because the upper Parts of his Body advance more than the lower. His left Leg is bent, and though the right Leg seems placed upon the Demon, it does not touch him.

His Hair fluttering in the Air makes the same Motion as the Drapery. His Shoes or Sandals are of a changing Colour, like the Scarfs.

The Demon, who is under him, and as it were crushed, is biting his Tongue and grinding his Teeth, and in his red and flaming Eyes we see Marks of Rage and Fury. He is on the Brink of a Precipice, between two Rocks, from whence issue Flames of Fire. He has the Hoofs of a Goat, the Wings of a Dragon, and a Serpent's Tail: He supports himself with the left Hand upon the Earth, and holds in his right Hand an iron Hook instead of a Sceptre, which is the fatal Ensign of his cruel Dominion over other Demons.

Mr. Le Brun, who was commanded to make Remarks on this Picture, observed first the Disposition of the Figure of the Angel, which is so much the more worthy to be considered, that it represents a Body supporting itself in the Air, and in a manner very difficult to be painted.

He shewed through all the Parts of the Body a most agreeable Contrast; for though the Face be fronting us, the fore Parts of the Body do not appear. The right Shoulder is drawn back, and the left coming forwards, only discovers the upper Part of the Stomach.

Below the left Arm we see all the Belly, the right Thigh and Leg, which are full in View, and stretching downward have a Motion contrary to the right Arm which is lifted up, and that of the other Leg which is bended and drawn back.

The Demon is placed with equal Art, his Body is thrown down on the Earth, and appears as it were crushed by the Power of the Angel. All the Members of his Body seem broken and bruised, as Mr. Le Brun observed particularly of his Neck, for his Face is turned about on his Shoulders.

After the Disposition, he observed the Drawing of the Figures in all their Parts; how admirably Raphael had finished even the minutest Things, but above all, how correct he was in Design, as we may be surprised to observe as well in the Contours of all the Members, as in the Arms and Hands, Legs and Feet, where through a fresh and solid Body, we see the Muscles in their natural Position.

As one of the greatest Difficulties in Painting is to form the Outlines well, Raphael has been careful to make them exact and correct, after the Example of the fine ancient Painters, who were so exact as to mark out even the least Members of a Body, to the End that a Picture may appear with the greater Advantage, when the Circumscription of the Lines (if I may use the Word) discover the true Shape of a Body. In this Particular, this great Painter has behaved with so much Discernment, and in so singular a Manner, that without diminishing in the least the Force of his principal Contours, he could give Beauty and Strength to all his Figures, even the most remote in the Piece, without any Hardness or Dryness, though that be the Fault, he seemed to lean to in some of his Works, which is owing to his great Precision in drawing Outlines, of which he was so passionate an Admirer.

Although it seems in painting Angels, who are Beings quite spiritual, one ought to give them a delicate Shape, and under the Bodies they are painted with to exhibit that Sort of Beauty which the ancient Sculptors have so well represented in the Figure of the antique Apollo; yet Mr. Le Brun observed that Raphael being to paint St. Michael in that Action, which expresses the Authority and Power of God, he has given him a masculine and vigorous Beauty: For the Features of his Face, and the Carnation resemble the Delicacy and Freshness of a young Man, together with a Force and Majesty, which expresses something powerful and divine, giving the Joints and Members extraordinary Strength, particularly the Arms, Knees and Fingers, which are firmly knit together by strong Nerves, like those in the most robust Bodies.

Never Painter knew how to express a Subject with more Grandeur than *Raphael*: As fierce and as terrible as the Visage of St. Michael appears, there is at the same Time a great Deal of Sweetness in it, and Grace withal. What Mr. Le Brun observed, discovered the Excellence of it the more. For the Nose being large above, and a little thinner below, discovers the Majesty which shines throughout the whole Countenance, the Forehead large and open in the Middle is the Seat as it were of the Greatness of his Spirit and his Wisdom.

We see a half Tint between the Eyebrows to shew a Disposition to elevate them, or to let them fall on the Eyes, as commonly happens to Persons capable of great Cares, and trusted with important Affairs, and which also appears when one is in a Passion. But this is only given him to prevent the Face being too smooth. For that Part is without any Motion, the Angel despising his Enemy whom he has overthrown, too much to shew any violent Efforts to conquer him. This Raphael has admirably represented by a certain Air of Disdain, which appears in his Eyes and Mouth: For his Eyes are a little open, and the Eyebrows forming perfect Arches are a Sign of Tranquillity, and even the Mouth where the upper Lip comes a little over the lower, is also another Sign of his Contempt.

We may not only perceive Action in all Parts of the Body, but the Painter has even put the Things about him in Agitation likewise, that there might be more Motion in his Picture.

Mr. Le Brun having made them observe how the Air, pressed by the Weight of the descending Body, lifts at the same Time every Thing that is light, and drives it violently wherever it finds Passage; likewise remarked, that not only the Angel's Hair stands on End, towards the Opening of his Wings, where the Wind passes with

great Violence, but the Scarfs which are about him flutter from one Side to another with such Exactness, that the Extremities of that which appears heaviest descends most, while the other is buoyed up in the Air.

Draperies disposed in this Fashion are admirable Secrets to set off the Motion and Action in a Figure, and in this Raphael has surpassed all other Painters, having never omitted any thing which might contribute to the best Expression of a Subject.

After M. Le Brun had made these Remarks, he begged the Company to give their several Opinions of the Picture, and submitted his own Sentiments to those of the Academy. But every Body was of his Opinion, and found nothing that could be contradicted of all that he had said, but owned that his Remarks were made with a great Deal of Judgement. [...]

12 Philippe de Champaigne (1602–1674) 'Second Conference'

The second of the 'Seven Conferences' (see IB10, 11, 13) was held on 4 June 1667. Born in Brussels, Champaigne spent his working life in France as a highly regarded portrait painter, and as a leading advocate and practitioner of a restrained classicism, exercised for the most part on religious themes. In 1628 he was appointed Painter to the Queen by Marie de Médicis. The tendency to formal austerity in his work may have been encouraged by his increasing commitment to the Jansenist religious movement. Like Le Brun, he was a founder member of the Académie Royale. The subject of his lecture was Titian's *Entombment of Christ* (now in the Louvre). His account of the painting follows the standard judgement that, whereas Raphael was to be esteemed for the quality of his drawing and formal construction, the strength of the Venetian painter's work lay in the richness of its colour and expression. A later conference by Champaigne, on Titian's *Virgin and Child with St. John*, gave rise to a heated debate within the Academy on the relative merits of colour and design (see IC7). The following text is taken from the anonymous English translation, *Seven Conferences held in the King of France's Cabinet of Paintings*, London: T. Cooper, 1740, pp. 20–30.

The Picture which was chosen for the Subject of this Conference was one of *Titian*'s, who on a Canvass of four Feet and a half long, and six Feet and a half broad, has painted the Body of our Saviour carried to his Tomb by St. John, Nicodemus, and Joseph of Arimathea, accompanied by the Virgin, and Mary Magdalen.

Mr. de Champagne the Elder who had been appointed to display the Beauties of this Piece, began by telling them that it was not to be doubted but it was really done by the Hand of Titian, and that it was one of the finest and best preserved Pictures of that excellent Hand; that it was done with so much Art and Fire, that we may easily judge it had been finished in the Strength and Vigour of his Age, while he painted with the greatest Freedom, and before the vast Intelligence he had acquired began to decline.

There was in that Work, he said, many Parts which well deserved to be examined, but that leaving for the present those of Ordonnance and Design, he would confine himself to speak of the Expression only, and observe with what Art the Painter had

conducted himself in the Distribution of Colours and Lights, in which one may justly say he has far surpassed all other Painters.

As Christ is the principal Figure to which all the others are subordinate, Mr. de Champagne observed that all the Characters of a dead Body meet here; all the Members appear heavy and without Motion, and the Want of Blood and Life makes them pale and livid, so that the Flesh and Veins, Muscles and Nerves, which in a living Body appear firm and round, are here inert, flat, and sunk. Then he desired them to observe in what manner the Body is disposed; the Legs and Feet are advanced, and the Head and Shoulders thrown at a Distance. *Titian* has supposed that the Shaddow of one of those who are carrying the Body must cover part of it, particularly the Face, thus to throw the Head at a Distance, and bring forward the Legs; the better to imprint the Character of Death on every Member of the Body of which Shades and Darkness are a proper Emblem: And to order it so, that in the Obscurity of the Colours, we may not see the adorable Face of the Saviour of the World, who appears now no more with those Beauties, which when he was alive, made him be looked upon as the most beautiful of all Mankind.

He observed, that as the Body was represented bloodless and lifeless, they who carry it discover by their Actions, and the Colours of their Flesh how deeply they are affected, and the Pain they endure in supporting the Weight of the Body. St. John is behind him who is lifting up the Shoulders, and the two other Disciples, one on each Side of him bearing up the rest of the Body; one of them is cloathed in a Garment of a very clear and lively brick Colour, but as it is tucked up, we may see the foldings of it which are of a Colour changing with red and green. He has likewise a Kind of Scarf about his Shoulders of white Cotton strip'd with blue. [...]

Mr. de Champagne made several Remarks on the other Parts of this Picture, observing first the Beauty of the Teints which appeared in the Naked, and the Dispositions of Colours so finely laid on one after another in the Draperies, either to sink the remote Parts, or bring out those that are near, and withal to express that Harmony of Colours which is so admirable in the Works of Titian.

Then he let them see the vast Art of the Painter in distributing of Lights and Shades: the Academy pointing out certain Glances of Light, and some Flashes in the Heaven behind St. John and about the Head and Arms of Christ, which being of an obscure Teint, make the Brightness of the Heaven and the Force of the Light appear to the greater Advantage; he desired them to observe how that Brightness which naturally ought to strike strongest, is nevertheless so well placed, that the dark Bodies hinder it from advancing, and that those Lights are at a Distance where they naturally ought to be. From hence we may learn, that when the Colours are well used, the Light and Dark are sometimes nearer, and sometimes at a Distance; and that this is the best Manner of disposing a Subject well: The Light and Shades contribute very much to the strengthening or weakening the Colours, and are of great Use either to bring out or set off a Body.

At last they all agreed, that with regard to that Part of painting, *Titian* was a perfect Master; and that in his Pictures we may chiefly observe how artfully he manages the Force of Colours to make the Shades and half Teints set off the great Lights with the better Advantage: But above all, with what skill he strengthens his Lights in order to

add the greater Beauty to his Picture, and that without letting one Part efface another; or one Colour diminish another.

Some of the Company moved to examine the Parts of the Design of this Picture, where they said, there was Ground of Objection against the Figure of St. John, and that of our Saviour; one they alledged was too small and the other too large in Proportion to the other Figures, and blamed *Titian* for having represented the Head of Christ in so great a Shade; a Part of his Body, which seemingly ought to have been most enlightened and appeared to the best Advantage, as it is considered to be the principal Object in the Picture.

To this it was answered, that as *Titian* had not been equally Master in all the Parts of Painting, they must confine themselves to those in which he had excelled, and which Mr. de Champagne had pointed out with great Discernment; and adding their Sentiments to all that had been said, they owned that what was chiefly to be admired in the Piece, was the Colouring, and the fine Harmony of Parts. And that this Harmony proceeded from the Arrangement of the Colours; thus we may observe that if Titian has cloathed one of them who are carrying the dead Body in red, it is to make the Body appear paler, and that the Head and Shoulders may seem to be at the greater Distance. And because our Saviour's Legs are enlightened, he has given the Figure who supports them a Garment of dark Green for a Ground.

We may further observe the Difference between the Carnation in the Body of Christ, and that of the Disciples who are carrying it, which Titian has express'd by a stronger Colour more inclining to the Red, and the Linnen which is wrapp'd about his Legs and Feet, serves by its Whiteness to make them appear of a fainter and dead-like Colour, and to come out quite from the Picture. But above all we may observe with what Sweetness and Tenderness the Painter has united his Colours; for between that green Habit and the Virgin's blue Mantle, we see Mary Magdalen's Robe which is yellow, but the Browns of it are broken and teinted with the different Colours which surround her; and thus one Colour does not fall immediately from green to blue, or from green to yellow; for though Mary Magdalen's Sleeve be of a deep Yellow and near the green Habit of Nicodemus, Titian has known well how to separate these colours by tucking up Nicodemus's Sleeve against the Yellow, and to make the Shades of the one fall into those of the other, so as the Colours do not cut upon those which have an equal Share of Light and Vivacity: always observing this Maxim which was peculiar to him, to make great Masses of Light and Shade.

Further it is to preserve this same Harmony of Colours and this fine Union of Teints, that he has given St. John a red Mantle heighten'd with a little of the yellow upon the light Parts; for thus it agrees well with the green Habit of Nicodemus; and makes an agreeable Harmony with Magdalen's Robe, and likewise with the red Vestment of Joseph of Arimathea; and which is more, serves to set off Christ's Arm which is above it. [. . .]

13 Charles Le Brun (1619–1690) 'Sixth Conference'

Le Brun's second contribution to the Seven Conferences (see IB10, 11, 12) was made on 5 November 1667. His subject on this occasion was the work of a modern painter, Poussin's

Israelites Gathering the Manna of 1637–9 (now in the Louvre). Poussin himself had suggested in a letter to Jacques Stella that the mixture of dispositions and ages represented in this ambitious work would 'not displease those who know how to read them'. Later he wrote to Chantelou, who had commissioned the painting (see IB1), 'Read the story and the picture, so that you can judge whether everything is appropriate to the subject.' As if to meet Poussin's challenge, Le Brun made this painting the focus for a tour de force of analysis and interpretation. The sixth conference is by far the most extensive of the series, and stands as a canonical document in the history of formal exegesis. Particular emphasis is laid by Le Brun on Poussin's use of prototypes from the classical art of the past, and upon his capacity to convey varied emotional content through the characterization and disposition of his figures. In the original published edition, the account of Le Brun's lecture is prefaced by a detailed and lucid description of the painting, no doubt inserted by Félibien for the benefit of those readers who would have no direct access to the work. This has been excluded from our version. The text of the conference is taken from the anonymous English translation published in *Seven Conferences held in the King of France's Cabinet of Paintings*, London: T. Cooper, London, 1740, pp. 85–120.

MR. Le Brun began by telling the Company, that if the Works of the greatest Painters who had lived in the two last Ages had furnished Matter for their past Conferences, it was but just that the Works of a Painter in our own Day should make up the present Entertainment.

That the first time he had spoken in the Academy, he took for the Subject of his Discourse a Picture of Raphael, the Merit of which had made it the Admiration of his Age, and an Honour to his Country.

But now he was to discourse of a Picture done by Mr. Poussin, who is the Glory of this Age, and an Honour to France.

The Divine Raphael was he on whose Works he had endeavoured to form his Studies; and that the illustrious Mr. Poussin had assisted him by his Counsels and directed him in this great Enterprize; so that he must own these two great Men as his Masters, and make this public Acknowledgment thereof.

When they were examining the Pictures of Raphael, and the Painters of his Age, every one indulged their Conjectures, and deferr'd giving their Opinion; because the Colours having lost their original Strength or true Teints, we cannot fully perceive what those great Men have represented, nor are we able to judge of all the Beauties of their Works. But as he had the advantage to converse often with the great Man of whom he was going to speak, and since his Pictures still retain'd the same Lustre and Vivacity of Colours as when he gave them the last Touches, one might tell his Sentiments of them with more Knowledge and Certainty than of the others.

And if all the particular Talents in every Italian Painter had been taken Notice of, all these Talents met together in our French Painter alone. If there is any one which he has not possessed to the greatest Perfection, he has been Master of them all in their more useful and principal Parts.

Raphael has furnished Matter of Discourse on the Grandeur of his *Contours*, and of his correct Manner of designing them, on the natural Expression of the Passions, and the noble Manner of cloathing his Figures.

In Titian we observe a thorough Intelligence of Colours, and the true Means to find out Union and Melody.

Paulo Veronese had furnished us with Means of Entertainment on his Facility of Handling, and on the Grandeur of his Ordonnance and Composition.

But in this Work of the famous Mr. Poussin all these Qualifications unite, with several others not observed in the Painters hitherto mention'd.

For that reason, he said, he would divide his Discourse into four Parts. In the first he would speak of Disposition in general, and of every Figure in particular. Secondly of Design, and the Proportions of Figures. Thirdly of the Expression of the Passions. And lastly material and aerial Perspective, and of the Harmony of Colours.

Disposition in general contains three things, which are very general in themselves, viz. the Choice of the Scene, the Disposition of the Figures, and the Colour of the Air.

The Composition of Figures which comprehend the Subject, ought to be composed of Parts, Groupes, and Contrasts. The Parts divide the Sight, the Groupes determine and connect the Subject, and Contrast gives Motion to it. [...]

Mr. Le Brun observed, that in this Picture we ought to consider the Disposition of the Scene, and to Mind how properly it represented a frightful Desert and an uncultivated Land.

The Painter being to represent the Jews in a Country unprovided of every thing and in extreme Necessity, his Work must carry some Marks to express his Thoughts, and which may agree with his Subject. For this Reason, the Figures are in a languishing Condition, to express the Weariness and Hunger with which they were distressed. Even the Light of the Air appears pale and weak, which imprints a kind of Sadness on the Figures. And altho' the Landskip be disposed in a very elegant Manner, and fill'd with admirable Figures, the Sight cannot find that Pleasure it desires, and which it commonly feels in other Pictures, designed only to represent a fine Country.

There is nothing but great Rocks, which serve as a Ground to the Figures. The Trees have only dry Leaves without any Sap; the Earth neither bears Plants nor Herbs; and there are neither Roads nor By-ways in the Country, to make us believe it has never been inhabited.

What he called Parts, he said, are all the Figures separated into different Places of the Picture, which divide the View, and give Occasion in some measure to lead it round these Figures, to consider the different Plans and Situations of all the Bodies, and the Bodies themselves differing from one another.

The Groupes are formed of the Assemblages of many Figures joined together, which do not divide the principal Subject, but on the contrary serve to unite and fix the Sight, that it may not always be wandring in so great an Extent of Country. For that Reason, when the Groupe is composed of more than two Figures, we must observe which of them appears most as the principal Part of the Groupe; and as for the others which are along with it, we may say that some of them are as it were in the Place, and the rest as Supporters.

Here we may observe that judicious *Contrast* which serves to give Motion, and which proceeds from the different Dispositions of the Figures that compose it; the Situation, Aspect, and Motions of which being according to History, produce that Unity of Action and fine Harmony that are so remarkable in this Picture.

We must observe the Woman, who suckles her Mother, as the principal Figure in this Groupe, and the Mother and Child as the Chain and Link. The old Man who beholds this Action, and the young Man who takes him by the Arm, serve to support the Groupe on each side, giving it a great space in the Picture, and setting the other Figures which are behind at a Distance.

There are none but the Woman who is giving Suck, with the Mother and her Child, which enter into the composition of this Groupe; and, if they had not these Figures to support them, opposed to Moses and the other Figures which are at a greater distance, it is evident that this Groupe would be dry and poor, and that all the Work would appear composed of too many small Parts.

It is the same of the Woman who is turning her Back; she is supported on one Side by a young Man who holds the Basket, and by him who is on his Knees; and on the other Side by these two Figures which are gathering Manna, and by the Man who is tasting it, and by the young Girl who holds out her Robe.

As to the Light, he observ'd it was shed confusedly over all the Objects. And to shew that this Action happened in the Morning, there are some remains of Vapour at the foot of the Mountains, and on the Surface of the Earth, which render it a little obscure, and make the distant Objects less perceptible. This serves to set off the Figures which are before to the greater Advantage. There are certain Gleams of Light striking on them from the opening of the Clouds, which the Painter has done on purpose, that the particular Lights which he distributes in different Parts of his Work may be more natural.

He has even affected to keep the Air darker and thicker on the Side where the Manna falls; the Figures are more enlighten'd there, than on the other Side where the Air is more serene. This he has done to vary all his Figures, and to give a more agreeable Diversity of Lights and Shades to his Picture.

After having made these Remarks on the Disposition of the whole Work, he next examined what regards the Design. And shewed, that Mr. Poussin had been intelligent and exact in that Part; that the Contours of the old Man, who is standing, are great and well designed; that all the Extremities of the Parts are correct, and pronounced with a Precision which leaves nothing further to be desired.

But what he took most Notice of in the Picture, and is indeed well worthy observation, is the admirable Proportion of Figures throughout, which Mr. Poussin has taken from the best Antiques, and perfectly suited them to his own Subject.

He observed, that the Figure of the old Man, who is standing, has the same Proportions as Laocoön, which consists in a well-made Shape, and a Composition of Members suitable to a Man who is neither very robust, nor too delicate. By the same Proportion he has formed the Body of the sick Man; for tho' he be meagre and extenuated, we may yet observe throughout all his Members a just Proportion, capable of making up a fine Body.

As to the Woman who is suckling her Mother, she resembles the Figure of Niobe; all the Parts are designed with much Symmetry and Correctness; and here, as in the Statue of that Queen, there is a masculine Beauty and Delicacy throughout, which shews her high Birth, and agrees perfectly with a middle-aged Woman.

The Mother is done by the same Proportion; but as she is older, she has more Meagerness and Dryness; for as the natural Heat begins to dry up in old People, their

Nerves and Muscles are no longer supported with so much Vigour as formerly, and thus they appear more relaxed, and even occasion certain Appearances upon the Skin, which a Painter ought not to omit, if he would imitate Nature well.

The old Man, who is lying behind these two Women, has his Resemblance from a Statue of Seneca at Rome, in the Garden of Borghese. For as Mr. Poussin had his Imagination stock'd with an infinite Number of fine Ideas, which he had acquired by long Study, he chose the Image of this Philosopher, as the most agreeable to represent exactly a venerable old Man, who seemed also to be a Man of Parts. Here there is a fine Proportion of Members, an Appearance of Nerves and Dryness in the Flesh peculiar to old Age, and to one who has borne much Fatigue.

As for the young Man who is speaking to him, his Proportions are much the same as those of Antinous at Belvedere, and discover in the Contours of the Members a solid Flesh to shew the Force and Vigour of his Youth.

The young Boys, who are fighting, have two different Proportions; the youngest seems to have for his Model, Laocoön's youngest Son; and the better to express his tender Age, the Painter has formed all the Parts of his Body delicate, and not fully shaped. But the other, who seems to be older and more vigorous, has in the Compositions of his Members a Resemblance of one of the Wrestlers in the Palace of Medicis.

The young Woman, who is turning her Back, has the same Resemblance to the Diana of Ephesus in the Louvre; for though this young Woman has more Cloaths on her, the Beauty and Elegance of her Members may be perceived through the Draperies; the fine and delicate Contours of which form that easy and agreeable Stature which the Italians call Svelta.

In this last Groupe the Painter has intended an Opposition of Proportions with the other first mentioned, so that there might be a Contrast between them, and that they might appear of different Ages, by the Delicateness of all their Figures, as well as by their Actions. In the young Man who carries the Basket, there is a Delicacy of Beauty which could have no other Model than the antique Apollo, the Outlines of the Members having something more charming than those of the Boy speaking to the old Man, who is not so well born.

The Girl, who holds her by the Robe, has the Air and Proportion of the Venus of Medicis, and the Man on his Knees seems to have been copied from Hercules Commodus.

After M. Le Brun had observed these admirable Proportions, and shewed that the Painter had followed them so well that they did not look like a Copy, and yet not entirely like the Originals, he proceeded to the third Part of his Discourse, and spake next of Expression.

First, he shewed that Mr. Poussin had made his Figures so proper to his Subject, that all their Actions had respect to the State of the Jews, who were reduced to extreme Necessity, and dreadful Weakness in the midst of a Desert, but in a Moment were supplied by Assistance from Heaven; so that some of them suffer without knowing of the Assistance sent them, while others, who were the first that felt the Effects of it, are employed in different Actions.

But in order to enter more particularly into these Figures, and to understand their Actions, not only those they are doing, but also their very Thoughts, he said, he would make an exact Detail of all their Motions.

It was not without design, that Mr. Poussin had represented an aged Man beholding the Woman who was suckling her Mother; because so extraordinary an Act of Charity ought to be considered by a grave Person, the more to heighten it, and be the Subject of Admiration to those who look on the Picture. He has not intended him for a clownish rustic Man, because that Sort of People never reflect on things worthy of Consideration.

As this great Painter has not disposed his Figures merely to fill up Room in his Picture, but also to make them all appear as if they moved of themselves, either by the Action of the Body, or the Motion of the Soul; he observed, that his Man looks like one astonish'd or surpriz'd with Admiration. His Arms are drawn back, and laid across his Body; because, on a great Surprize, all the Members commonly shrink one after another; but chiefly when the Object which surprizes, only imprints Admiration at what passes, and does not occasion Fear or Terror to trouble our Senses, and make us seek assistance to save our selves from the impending Evil. Thus as he is only wondering at a thing so worthy Admiration, he opens his Eyes as wide as he can; and, as if he comprehended the Greatness of the Action by looking more attentively, he employs all the Powers of the Body to assist the Sight in wondering at this Object, which he cannot cease to admire. [. . .]

In the old Man, who is lying behind these two Women, and who looks up and extends his Arms; and in the young Man, who shews the Place where the Manna is falling, the Painter has intended to express two very different Motions of the Soul: the young Man is filled with Joy on seeing the Food falling, and shews it immediately to the old Man without ever minding from whence it comes: but he, more sage and judicious, instead of looking to the Manna, lifts up his Eyes to Heaven, and adores the Providence of God who has filled the Earth with it.

As the Author of this Picture is admirable in expressing the Diversity of Motions, and knew what way to give Life to his Figures, he has made all their different Actions and Expressions proceed from particular Causes, which have respect to his principal Subject. This was well observed by Mr. Le Brun in the two Boys fighting for the Manna; for by this is signified the extreme Necessity to which the People were reduced; and because it was universally felt, the Painter has made the two Boys fight together, not as if they intended to hurt one another, but only that one may hinder the other from getting that which they both saw was so necessary to them. [. . .]

One of the finest Pieces in this Picture, as Mr. Le Brun observed, is the Groupe of Figures before Moses and Aaron, some of whom are kneeling, and others in a Posture of Humility, holding Vessels full of Manna, and seem to thank the Prophet, because they had received it. He shews that Moses, by lifting up his Eyes and Hands tells them it is from Heaven they have received this Assistance; And Aaron who is doing the Office of High-Priest, in joining his Hands, teaches them by his Example to be thankful to God.

We may observe, that the other Figures behind Moses are looking up to Heaven and thanking God for the Blessings he is showering down upon them: These are the

most ancient Sages of the Israelites who have a particular Knowledge of the Miracles God has done for them by the Intercession of his Prophet.

Among the Figures which are near Moses and are listening to him, there is a Woman, by her Action discovers her Curiosity; for as she is going to say it is from Heaven the Food is sent to her, she looks up, and that she may defend herself the better from the excessive Light which dazzles her, she interposes her Hand between her and it, as if she would penetrate into the Source of these Blessings.

Besides all these fine Expressions, we may consider further how Mr. Poussin has cloathed his Figures; and here it is we may say he has always excelled. The Habits he gives them are real ones, and which cover them entirely; not as other Painters do, who throw them at random, and do not cover the Body but with Labels, with the form of a Garment. In the Pictures of this great Master it is not so; as every Figure has a Body under its Habit, so every Habit is proper to the Body, and covers it well. But there is yet this more, he has not only made the Habits to conceal the Naked, and has not taken all the Fashions of every Country; but has been very careful of the Decorum, and known well how to manage that Part of the Costume, no less necessary in Historical Pictures than in Poetry. For that Reason he has not failed in it, but made use of cloathing as the Custom of the Country, or the Quality of the Persons represented required at his Hands.

Thus be observed, that as among the Jews there were People of all Ranks, and some more fatigu'd than others, the Figures are not all regularly cloathed in one manner. Some of them are half naked, as the old Man, who is looking to the Daughter nursing the Mother. And tho' the Folds of the old Man's Cloak be large and free, and made of coarse Stuff, they do not hinder the Nakedness of the Figure from being seen. The kind of Breeches which the Ancients called Bracca, that cover his Ancles and Legs, is not of the same Stuff with the Cloak; it has smaller and closer Folds; and yet the Legs do not appear too close, all the Beauty of their Contours may be seen.

The Rank of every Figure is particularly distinguished by the Beauty of the Draperies, some of which are enriched with Embroideries, and others, larger and more grand, give an Air of Majesty to those that wear them.

As to what regards lineal Perspective in this Picture, Mr. Le Brun shewed, that it is observed to great Perfection. And that Mr. Poussin being to represent a mountainous Country, the Situation of which is very unequal, he has made use of high Terrasses to place his Figures upon, which gives the greater Play and Variety to all the Dispositions of the Figures that compose this Work: and it is even this which serves to discover such a great Multitude in so small a Space, and which places the Figures of Moses and Aaron to the greater Advantage, who are as it were the Heroes of the Subject.

As to the Effusion of Light; having represented a thick Air, and loaded with Morning Vapours, he has hastened more the Diminutions of his distant Figures, and degraded them as much by the Quality, as by the Force of the Colours, to advance these the more, and to make them shine with the greater Vivacity, by the Light which they receive with the greater Force by the opening of a Cloud that is supposed to be above, which he likewise makes natural by other Clouds appearing half open in the Picture.

In the Effects of Light there are three Things worthy of Observation. The first is the principal Light, which shines most. The second is, a Light glancing on Objects. The third is, a faint Light, which is lost and as it were confounded by the Thickness of the Air.

It is this principal Light which strikes upon the Man's Shoulder who is standing surprized; upon the Woman's Head who is giving Suck; on her Mother who is sucking; and upon the Woman's Back clad in Yellow, who is turning about.

'Tis only the upper Part of these Pictures that are illuminated with this strong Light; for the inferiour Parts have only a faint glancing Light; as that of the sick Man, those of the old Man lying, and the young Man helping him up, and even those of the two Boys fighting, and all the rest about the Woman who is turning her Back; the Light of which is degraded by the Thickness of the Air in proportion to their Distances.

As to Moses and those who are about him, they are only enlightened by a Light which is weakened by the Air intervening in the Distance between the others and those which are in the fore Ground of the Picture, and which have yet less Light, as every Figure is at a greater Distance, according to its Situation and the Colour of the Draperies; some being more proper than others to be made appear with a stronger Light than they have.

Yellow and Blue being the two Colours which partake most of the Light and Air, Mr. Poussin has cloathed all his Figures with Stuffs of these Colours; and in all the other Draperies he has constantly made use of these two principal Colours, making the Yellow in a manner prevail more than any other, because the Light which is shed on the Picture is very Yellowish.

After Mr. Le Brun had ended making all these Remarks, every one thought them not only very learned and judicious, but also very useful for understanding that Work, and very necessary for those that would perfect themselves in Painting.

A certain Gentleman said, there was indeed many things in this Picture worthy of Admiration, and which serv'd to recommend it, that he would not do it so much Injury, as to seek an Occasion of finding fault with it: he would likewise have them believe it was not to diminish the Esteem of it, if he ventur'd to say, that tho' Mr. Poussin had been so exact as to omit none of the necessary Circumstances in the Composition of a History, he had not for all that made so just a Representation of what pass'd in the Desert, when God caused the Manna to descend on the Israelites; since he has represented it as if it had happened by Day, and in the Sight of the People, which contradicts the Text in Exodus, that says, they found it fallen in the Morning round about their Camp like Dew, which they went to gather. Further; he found that the great Necessity and extreme Misery, which is expressed by the Woman who is forced to suck her own Daughter, does not agree with the Point of Action which he painted; since when the Manna fell in the Desert, the People had been already relieved by the Quails, which had been sufficient to quench the greatest Famine, and deliver them from so pressing a Necessity, as that the Painter has represented.

That to make a true Representation of the gathering the Manna, it was not necessary to paint the People so astonished; and still less so to make that miraculous Meat fall like Snow, since they found it on the Ground every Morning like Dew.

To this Mr. Le Brun replied: It is not the same [in] Painting as in History. An Historian can express himself by an Arrangement of Words, and a continued Thread of Discourse, which form an Image of what he would say, and represent successively any Action he pleases: But a Painter having only a Moment to take any Image he is going to represent, to shew what passed in that Moment, it is sometimes necessary to join many Accidents together which preceded, in order to make the Subject he is explaining be comprehended; without which they who see his Work will be no better instructed, than if this Historian, instead of repeating the Subject of his History, had contented himself only to relate the Event.

It is for this Reason that Mr. Poussin, intending to shew how the Manna was sent to the Israelites, did not believe it would be sufficient to represent it fallen on the Ground, where the Men and Women are gathering it, but likewise, to display the Greatness of the Miracle, that he must shew at the same Time the State of the Jewish People when that happened. That it was not enough to represent them in a desert Place, some of them pining away, while others are busy gathering Manna, and some are thanking God for his Benefits; these several States and different Actions serving him instead of Words in Discourse, to express his Thoughts: and since Painting has no other Language but these kinds of Expressions, it is this which obliges him to represent the Manna falling from Heaven, because he had no other way left to shew from whence it came. For if one do not see it falling down, but the Men and Women gathering it from the Ground only, he may be ready to take it for some Grain, or Fruit; and so this Circumstance, by which he points out to us, that it is a Food sent from Heaven, would not have place in his Work. [...]

14 Charles Le Brun (1619–1690) 'Conference on Expression'

There has been some confusion concerning the date of first delivery of Le Brun's influential lecture on the Expression of the Passions. However, Jennifer Montague has argued persuasively that it was given to the Académie Royale in two sessions in April and May 1668, and that it was repeated in the presence of Colbert ten years later (Montague 1994). In the lecture as delivered and in its published forms, Le Brun's introductory discussion was followed by descriptions of the physiognomies associated with individual passions, illustrated by his own line drawings, each duly labelled. (The original drawings are preserved in the collection of the Louvre.) In English translation, the passions are given as Admiration, Esteem, Veneration, Ravishment, Scorn, Horror, Terror, Simple Love, Desire, Hope, Fear, Jealousy, Hatred, Sorrow, Bodily Pain, Joy, Laughter, Weeping, Anger, Extreme Despair and Rage. Le Brun's account of the passions is much indebted to the *Traité sur les passions* of René Descartes, first published in 1649, and to a lesser extent to other recent studies on the physiognomy and definition of the passions. The originality and importance of his work lies in the imagery it furnished for the representation of emotion in art. (For a later application of the science of anatomy to the expression of the passions, see VIIA7.) We have included Le Brun's opening account of the nature of expression, a sample of his descriptions of the effects of emotion on the human face (designed to be accompanied by his drawings), and his concluding remarks on the bodily expression of the passions. Despite the interest it aroused, and notwithstanding a recommendation from Colbert, the lecture remained unpublished during Le Brun's lifetime. It was first printed in Amsterdam

and Paris in 1698, under the title *Méthode pour apprendre à dessiner les passions proposé dans une conférence sur l'expression générale et particulière*. Our text is taken from the first English translation, by John Smith, published under the title *The Conference of Monsieur Le Brun...upon Expression, General and Particular*, London: John Smith, 1701, introduction pp. 1–6, 13–15 and pp. 1–4, 10–12, 19–20, 28–9, 33–7.

GENTLEMEN,

At our last Assembly you were pleas'd to approve the Design which I then took to Entertain you upon Expression. It is necessary then in the first place, to know wherein it Consists.

Expression, in my Opinion, is a Lively and Natural Resemblance of the Things which we have to Represent: It is a necessary Ingredient in all the parts of Painting, and without it no Picture can be perfect; it is that which describes the true Characters of Things; it is by that, the different Natures of Bodies are distinguished; that the Figures seem to have Motion, and that every thing therein Counterfeited appears to be Real.

It is as well in the Colouring, as in the Design; it ought also to be observed in the Representation of Landskip, and in the Composition of the Figures.

This, GENTLEMEN, is what I have endeavoured to make you observe in my past Discourses; I shall now Essay to make appear to you, that Expression is also a part which marks the Motions of the Soul, and renders visible the Effects of Passion.

So many Learned Men have Treated of the Passions, that it is hardly possible to say any thing which they have not already written thereupon: And I should not take the pains to Report their Opinion in the Matter, if it were not the better to make you comprehend that which concerns our Art. It seems therefore necessary, that I should touch something upon it, in favour of the young Students in Painting, which I shall endeavour to do with the greatest Brevity I can.

1st. Passion is a Motion of the Soul, residing in the Sensitive Part thereof, which makes it pursue that which the Soul thinks for its good, or avoid that which it thinks hurtful to it: And for the most part, whatsoever causes Passion in the Soul, makes some Action in the Body.

Being true then, that the greatest part of the Passions of the Soul produce Bodily Actions; it is necessary that we should know what those Actions of the Body are, which express the Passions, and what Action is.

Action is nothing but the Motion of some part; and this Alteration cannot be, but by an alteration of the Muscles, and they have no Motion, but by the extremities of the Nerves which pass through them: The Nerves do not Act but by the Spirits which are contained in the Cavities of the Brain; and the Brain receives the Spirits from the Blood, which passing continually through the Heart, is thereby heated and rarefied in such manner, that it produces a certain subtil Air or Spirit, which ascends up to, and fills the Brain.

The Brain thus filled, sends back these Spirits to the other parts, by the Nerves, which are as so many small Channels, or Pipes, that convey the Spirits into the Muscles, more or less, according as the Action requires, in which they are employed.

So as that Muscle which is most in Action, receives the greatest quantities of Spirits, and consequently becomes more swell'd than the others, which are thereof

depriv'd, and by such privation seem more loose and more wasted or shrunk than the others.

Although the Soul be joined to all parts of the Body, yet there are divers Opinions touching the place where it exercises its Functions more particularly.

Some hold, that it is a small Gland in the middle of the Brain, because that only part is single, whereas all the others are double; and as we have two Eyes and two Ears, and as all the Organs of our Exterior Senses are double, it is necessary that there should be some place where the two Images which enter by the Eyes, or the two Impressions which come from one sole Object, by the two Organs of the other Senses may be united together, before they come to the Soul, that they may not represent to it two Objects instead of one.

Others say it is in the Heart, because in this part we feel the Passions. For my part, it is my Opinion, that the Soul receives the Impressions of the Passions in the Brain; and that it feels the Effects of them in the Heart. The exterior Motions I have observed, confirm me very much in this Opinion.

* * *

The Soul, as I have told you, being joined to all parts of the Body, every part of it serves to express its Passions. Fear, for example, may be expressed by a Man running or flying away: Anger, by one who clenches his Fists, and seems to strike at another.

But if it be true, that we have one part where the Soul more immediately exercises its Functions; and that this part is the Brain; we may also say, that the Face is the part where it more particularly makes appear what it feels.

And as we have said, that the Gland in the middle of the Brain, is the place where the Soul receives the Images of the Passions; so the Eye-brow is the part of the Face where the Passions are best distinguished, tho' many have thought it to be in the Eyes. It is true, the Eye-balls by their sparkling, and motion, shew the Agitation of the Soul. The Mouth also and the Nose have a great share in the Expression; but ordinarily, these parts do but follow the Motions of the Heart, as we shall observe in the sequel of this Discourse.

And as it hath been said, that there are Two Appetites in the Sensitive part of the Soul, in which all the Passions are ingendred;

So there are two Motions of the Eye-Brows, by which all the Motions of such Passions are expressed.

These Two Motions which I have remarked, have a perfect resemblance to the Two Appetites, for that which sets up towards the Brain, expresses all the savage and cruel Passions: But I shall farther tell you, that there is something yet more particular in these Motions; and that according as the Passions change their Nature, the motion of the Eye-Brow changes its Form. For a Simple Motion thereof expresses a Simple Passion: and if the Passion is mixt, the Motion is so likewise; If the Passion be gentle, so is the Motion; and if that be violent, the Motion is also violent.

But it is to be observed, that there are Two sorts of Elevations of the Eye-brows.

In one, the Eye-Brow is raised in the middle, and this elevation expresses pleasant Motions.

It is also to be observed, that when the Eye-Brow is raised in the middle, the Mouth is raised at the Corners; and in Sorrow, it is raised in the Middle.

But when the Eye-brow is drawn down in the middle, it shews Bodily Pain, and has a contrary Effect; the corner of the Mouth being then drawn downward.
* * *

ADMIRATION

As we have said, that Admiration is the first and most temperate of all the Passions, wherein the Heart feels the least disturbance; so the Face receives very little Alteration thereby; and if any, it will be only in the raising of the Eye-brows, the Ends thereof being yet parallel, the Eye will be a little more open than ordinary, and the Ball even between the Lids and without Motion, being fixed on the Object which causes the Admiration. The Mouth will be open, but will appear without Alteration any more than the other part of the Face. This Passion produces, only a Suspension of Motion, to give time to the Soul to deliberate what she has to do, and to consider attentively the Object before her; if that be rare and extraordinary, out of this first and simple Motion of Admiration is engendred Esteem.

ESTEEM

And Esteem cannot be represented, but by Attention, and by the Motion of the parts of the Face, which seem fixed upon the Object causing this Attention; for then the Eyebrows will appear advanced forward over the Eyes, being depressed next the Nose, and the other ends a little rising, the Eye very open, and the Eyeball turn'd upwards.

The Veins and Muscles of the Front, and about the Eyes, will appear a little swelled; the Nostrils drawing downwards; the Cheeks will be moderately sunk in

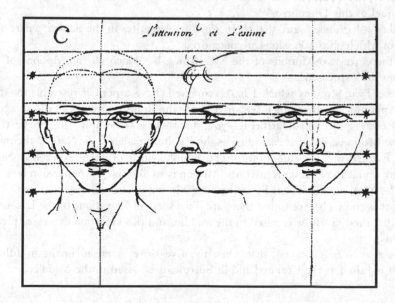

about the Jaws; the Mouth a little open, the corners drawing back, and hanging downward.

VENERATION

But if from Esteem proceeds Veneration, the Eyebrows will be depressed in the same manner as before; the Face will be also bowed downward, but the Eye-balls more turn'd up under the Brow; the Mouth shall be open, and the corners drawn back, but a little lower than in the preceeding Action. This depression of the Mouth and Eyebrows marks a Submission and Respect of the Soul to an Object She believes above her: The Eye-ball turned upward, seems to mark the Elevation of the Object considered, which it acknowledges, to be worthy of Veneration.

* * *

TERROUR

When it is excessive, causeth the Eye-brow to be very much raised in the middle, and the Muscles, which perform the Motion of these Parts, very much marked and swelled, and pressed one against another, being drawn down over the Nose, which will seem to be drawn up, as also the Nostrils; the Eyes ought to appear entirely open, the upper Eye-lid hid under the Brow; the White of the Eye ought to be environed with red; the Eye-ball as it were wandring, and situated nearer the lower part of the Eye than the upper; the lower parts of the under Lids swelled and livid; the Muscles of the Nose and the Hands also swelled; the Muscles of the Cheeks extreamly marked, and drawn into a Point on each side of the Nostrils: the Mouth shall be very open, and the Corners very apparent; every Thing shall be very much marked about the Forehead and Eyes; the Muscles and Veins of the Neck shall be very much raised and apparent; the Hair standing up on End; the Complexion pale and livid; and more especially, the end of the Nose, the Lips, Ears, and about the Eyes.

If the Eyes appear extreamly open in this Passion, it is because the Soul makes use of them to observe the Nature of the Object which causes the Fright. The Eye-brow, drawn down at one end, and raised at the other, makes appear, that the Part raised seems as if it would be joined to the Brain, to secure it from the Ill which the Soul apprehends; and by the end which is drawn downwards, and appears swell'd, we find, that in this Condition the Spirits come plentifully from the Brain, as it were to cover the Soul, and defend it from the Ill which it fears: The Openness of the Mouth makes appear, that the Heart is oppressed by the Bloud which is retired towards it; which obliges him that is possessed by this Passion, when he would breathe, to make an Effort, which causes the Mouth to open very wide, and which in passing by the Organs of the Voice, makes a kind of inarticulate Sound. Lastly, if the Muscles and Veins appear swelled, and puffed up, it is by the Spirits which are sent from the Brain into these Parts...

N *La Jalousie*

JEALOUSIE

It is expressed by the Forehead wrinkled, the Eye-brow drawn down and frowning, the Eye sparkling, and the Eye-ball hid under the lids, turning towards the Object which causes the Passion regarding it cross and sideways, contrary to the Situation of the Face; the Eye-ball should appear unsteady and fiery, as also the White of the Eye and the Eye-lids; the Nostrils pale, open, and more marked than ordinary, and drawn back, which makes Wrinkles in the Cheeks; the Mouth may be shut, and make known that the Teeth are set together; the under Lip is thrust out over the upper, and the Corners of the Mouth drawn back, and very much down; the Muscles of the Jaws will appear hollow.

One part of the Face will be inflamed, and another yellowish; the Lips will be pale or blackish.

ANGER

When Anger seizes on the Soul, he who feels this Passion, hath his Eyes Red and Inflamed, his Eye-balls wandring and sparkling, his Eye brows sometimes drawn down, and sometimes raised up one against the other; the Forehead will appear deeply furrowed, and wrinkles between the Eyes; the Nostrils will appear open and widen'd; the Lips pressed one against the other, and the under-Lip surmounting the upper, leaving the corners of the Mouth a little open, forming a kind of cruel and disdainful Grin.

He will seem to grind his Teeth, and to foam at the Mouth; his Face will be in some places Pale, and in others Red and Swell'd; the Veins of the Forehead, the Temples, and the Neck, will be strained and puffed up, the Hair standing upright;

and he who is possessed with this Passion, is swell'd and puffed up by a stoppage of the Breath, the Heart being oppressed by the great quantity of Bloud, which retires thither, as it were to its succor.

To Anger sometimes succeed Rage or Despair.

* * *

These (Gentlemen) are part of the External Motions which I have observed in the Face.

But as I have said in the beginning of this Discourse, that the other Parts of the Body may help to express the Passions, it will be proper to speak something of them by the by.

If Admiration makes but little Change in the Face, it produces as little Agitation in the other Parts of the Body; and this first Motion may be represented, by a Person standing upright, having both his Hands open, the Arms near the Body, and his Feet standing together in a like Situation.

But in Esteem, the Body shall be a little bowed, the Shoulders a little raised, the Arms bended and joining to the Body, the Hands open and near together, and the Knees bended.

In Veneration the Body shall be yet more bowed than in Esteem, the Arms and Hands almost joined the Knees on the Ground, and all the Parts of the Body shall mark a profound Respect.

But in an Action which shews Faith, the Body may be bowed intirely down, the Arms folded and joining to the Body, the Hands crossed one over the other, and the whole Action ought to shew a profound Humility.

Ravishment or Exstacy may be expressed by the Body thrown backwards, the Arms lifted up, the Hands open; and the whole Action shall mark a Transport of Joy.

In Scorn and Aversion the Body may retire backwards, the Hands as if they were pushing off the Object which causes the Aversion, or else they may be drawn back, as also the Feet and Legs.

But in Horrour, the Motions should be much more violent than in Aversion, the Body violently retiring from the Object which causes the Horrour; the Hands shall be wide open, and the Fingers spread, the Arms drawn in close to the Body, and the Legs in an Action of Running.

Terrour hath a great deal of these Motions, but they should appear greater and more extended; the Arms shall be stretch'd out straight forward, the Legs in an Action of flying with all their Force, and all the Parts of the Body in Disorder.

The rest of the Passions may produce Actions in the Body, according to their Nature, but there are some which are hardly perceptible; as Love, Hope, and Joy; for these Passions produce no great Motions in the Body.

Sorrow produces only a Dejection of the Heart, by which all the parts of the Face are cast down.

Fear sometimes may have Motions resembling those of Terrour, being only caused by an Apprehension of losing something, or that some Ill should befall us; this Passion may give Motions to the Body, which may be marked by the Shoulders pressed together, the Arms and Hands drawn close to the Body, and the other Parts gathered together and bended, expressing as it were a Trembling.

Desire may be represented by the Arms extended towards the Object desired; the whole Body may incline the same way, and all the Parts will appear in an unquiet and wavering Motion.

But in Anger, all the Motions are very great and violent, and all the Parts agitated; the Muscles should be very apparent, bigger and more swelled than ordinary, and the Veins and Nerves strained.

In Despair all the Parts of the Body are almost in the same State as in Anger; but they should appear more disordered; for you may make one in this Condition, tear off his own Hair, bite and tear his Flesh, or running and precipitating himself.

15 Henri Testelin (1616–1695) Table of Precepts: Expression

Henri Testelin's 'Table of Precepts' has long been seen as the apogee of academic doctrine. The six 'parts' of painting – line, design, expression, proportion, chiaroscuro, ordonnance and colour – are set out into tables, with each part subdivided into its various aspects. This codification of academic doctrine was intended to provide the teaching of the Academy with an enduring structure and to make it assimilable, in a finished and unalterable form, for successive generations of students. The idea for the project came from Charles Le Brun, who on 25 January 1670 charged Testelin with drawing up in written form an orthodox synthesis of the lectures which were given at the Academy in the presence of Colbert. Although Testelin offered a discussion and commentary on each of the six topics between 1675 and 1679, the tables were published on their own in 1680 without any

reference to the larger framework of explication. This presentation of the Academy's teachings stands in stark contrast to Félibien's transcription of the first seven conferences which offered some representation of the diversity of opinion amongst members of the Academy. The Edict of Nantes of 1598 had guaranteed limited rights to France's Huguenot (Protestant) minority. Its revocation in 1681 obliged Testelin to relinquish his post as Secretary to the Academy and to seek exile in the Netherlands. In 1696, however, he was given special permission to publish a second edition of the Table of Precepts, complete with commentaries. The first edition of 1680 was published in Paris under the title, *Sentiments des plus habiles peintres du temps sur la pratique de la peinture, recueillis et mis en tables de préceptes par H. Testelin*. Here we reproduce the table on expression, taken from the anonymous English translation which appeared just eight years later, *The Sentiments of the most Excellent Painters Concerning the Practice of Painting; Collected and Composed in Tables of Precepts*, London: Samuel Smith, 1688. We have included the 'Remarques' made by the anonymous translator who appended them in the form of footnotes, but we have modified his layout of Testelin's table to conform to the design of the present anthology.

The Third Table of the Precepts in Painting: about Expression

What we call *Expression in Painting* is a Representation of things after their nature; which therefore we may consider in reference to,

[A] The Subject in general, where we may observe that,

1. All the parts of the Composition ought to bear the Image and Character of the Subject which we would represent; so that the Idæa may pass from the Picture into the mind of those that look on it, to touch[1] the passions which the Subject requires according to their difference, *e.g.* in a subject of:

 – Joy and Peace, all things ought to appear agreeable and calm.
 – Of War, all must be turbulent and full of Terrour.
 – Of grave and serious things, we must make appear throughout the whole something of Grandeur and Majesty.

2. We must so far tye ourselves to this general Rule, that if we meet with some Circumstance in the Description of History which may invert and take from the Idæa, we must suppress it if it be not absolutely essential to the Subject; however we may joyn the Allegorical Figures to represent the Mythical sense without nevertheless mixing the Fable with the Truth.

3. To this end we must take great care to study well the History, or the Fable in those Authors that describe it, that we may truly conceive and comprehend the Nature and the Character of it, that we may form a true Idæa of it in the Imagination, and spread and carry it thro' all the parts of the whole.

4. We may take the liberty nevertheless of chusing some favourable Incidents, to diversifie the particular expressions, provided they be not contrary to the principal Image of the Subject, or the Truth of the History.

5. We must observe diligently as one of the principal parts, the harmony of the *whole together*;[2] Whether:

– In the concourse of the Actions, in distinguishing the Statues with the Figures, which ought to appear animated, that we do not give them Attitudes[3] answering the several things that pass in their presence;

– Or, in the agreement and disposition of the light and colour.

6. We must take great care of the Modes and Customs,[4] as the Italians call them, to conform all things to the Custom of Time, Place and Quality.

7. We must represent in one Picture only what we can comprehend under these three Unities[5] of the same time, at the same view, and what the extent of the picture can comprehend.

[B] The particular Affections and Passions, according to:

[B1] Simple Nature, where we must observe among living Creatures, that,

1. Brutes act only by a motion purely of sense, all their passions being form'd either in respect to their self-preservation, or the propagation of their kind.

2. Man is solely endued with understanding, which renders him rational and fit for Conversation, whence arises their difference from irrational Creatures, and these advantages, *Viz.*

2.1 That he carries his face and body upright.

2.2 That he hath his Eyes and Ears, which are the Organs of the Soul, situated in one streight line, whereas Brutes have one point of their Eye low, on the side towards their Nose, the other drawing toward their Ear, their natural sense conducting itself from the smell to the hearing, and thence to the heart.

2.3 That he can move his Eye-brows, whose point draws towards the Nose sometimes; but Brutes move not at all their Eye-brows, their points being always inclin'd downwards.

2.4 That he moves the Apple of his Eye every way, Brutes cannot lift them upwards; whence it follows that men, which have the Angle of the Eye, and their Eye-brows of the same form with those of some Brutes, have likewise something of their nature.

3. Children discern nothing by their understandings but do naturally such actions as express the motion of their passions, and so mark out what they desire, reject, are pleased with, or are vext at.

4. There are two Appetites, or Faculties in the sensitive Soul, the concupiscible, to which we attribute the sweeter passions, and the irascible, to which we give those of the violent kind.

5. As there are two inward Faculties, so there are two exterior Motions which represent, and express them, which depend either on

– the Brain, which draws towards it all the passions that proceed from thence.

– Or the Heart, which draws downward all the external signs that depend on it.

6. Every one of these Passions have divers degrees which cause different effects: for if the Passion be sweet, the external Motions are soft; likewise if they be violent and sharp, their external motions are so too.

7. Tho' we may express the Passions of the Soul by the actions of the Body, 'tis in the Face[6] nevertheless which men more particularly discern them, by the shape of the Eye, and motion of the Eye-brows.

8. There are two sorts of lifting up the Eye-brows, the one at the middle which argues pleasant motions, and which draws up the corners of the Mouth, the other at the point of the side of the Nose, which draws up the middle of the Mouth, and which are the effects of Grief and Sadness.

9. All the Passions may be reduced to these two heads: *Viz.*

TO JOY[7]

(i) Simple: Which causes a dilation of all the parts: As to the Face, the Eye-brows rise in the middle, the Eyes half open and smiling, the Apple of the Eye sparkling and moist, the Nostrils a little open, the Cheeks full, the Mouth draws the corners a little upwards, the Lips red, the Complexion lively, the Forehead severe. Or

(ii) Passionate, Whether of love in which the Fore-head is smooth and even, the Eye-brows a little elevated on the side where the Apple of the Eye turns, the Eyes sparkling, pretty open, the Head inclined toward the object, the Air of the Face smiling, and the Complexion pretty ruddy. Or, of Desire, which shews itself by the Body, the Arms extended towards the object, in uncertain and unquiet Motions.

TO SADNESS

(i) Simple, Where all the Body is cast down, the head carefully hanging aside, the Fore-head wrinkled, the Eye-brows elevated toward the midst of the Fore-head, the Eyes half-shut, the Mouth a little open, the corners downwards, the under-lip pouting and drawn back, the Nostils swell'd and drawing downwards.

(ii) Mixt with Fear, Which makes the Body move according to the disposition of the Subject, which causes it, if it be *amused*,[8] that then all the parts contract and palpitate, the members tremble and fold up, the visage pale and livid, the point of the Nostrils elevated towards the Nose, the Apple of the Eye in the midst of the Eye, the Mouth more open at the sides, the under-lip drawn back; fear adds disorder and great concern.

(iii) Anger, Whose Motions are great and violent, all the parts stirr'd, the muscles pufft up, the Apple of the Eye sparkling and wild, the point of the Eye-brows being fixt towards the Nose, the Nostrils open, the Lips big and prest down, the corners of the Mouth a little open and foaming, the Veins swell'd, the Hair standing upright.

(iv) Despair, Whose Motions are like the last, but more excessive and disorder'd; for the more the Passions are stirr'd up, so much more violent are the external Motions.

[B2] Nature judiciously chosen to give every figure its proper character agreeable to the actions, whether it be in reference to:

1. The *Sex*; Man, as he is of more vigorous and resolute nature, ought likewise to appear in his motions and actions more free and bold than the Woman, who must be more tender and modest.

2. The *Age*, whose different times and degrees carry them to different motions, whether by the Agitations of the Mind, or the actions of the Body.[9]
3. The *Condition*, the honours wherewith persons are invested renders their actions more reserv'd, their Motions more grave, contrary to the populacy, who give themselves over for the most part to their Passions; whence it comes that their external Motions are more rude and disorderly.
4. *Bodys Spiritualised* or deifi'd where we must retrench all these corruptible things, which serve only for the preservation of life, *viz.* Veins, Arteries and such like, making only what serves for the Beauty and Form of the Body.
5. *Angels*, which are only symbolical figures, to mark out their Virtues and Offices, where there ought not to appear the draught of any sensual Passions; we must only appropriate their characters proper to their functions or operations of Puissance, Activity and Contemplation.

REMARKS [appended by the English translator]

1. *Toucher*, to express
2. The *tout ensemble*; it generally signifies the harmony that runs through the whole Picture, and which results from the just distribution of the objects that compose the work, we say likewise such a picture is good taken piece by piece, but the *tout ensemble* is not so, which is the sense of this place.
3. Attitudes, signifies no more with us in a manner than action and posture; tho' it signifies really more; And where Action has no place, *e.g.* Action is not applicable to a dead person and we say better, the disposition, than the posture of a dead corps; so we say, not so well, this figure is an handsom posture, but rather in a graceful attitude or disposition.
4. Custom is a judicious expressing things suitable to the subject, as to express the last-Supper by Lamp-light (as a great many Painters forget themselves on that subject) and in the posture us'd in those days and places, which is a very important consideration in reference to St. *John's* lying in our Saviour's bosom; to do otherwise is a sin against Custom: The drawing the figures about our Saviour in proper habits, fit for their quality and Nation; not dressing up two or three squab Boobys in Monks Hoods and bald Crowns, with a knot of Beads and such like baggatels (the most unfit company, if there has been any then, for our Saviour as could be) to do so would be a sin against *coûtume*, wholly barbarous and Gothick. *Michel Angelo's* last Judgment is one whole continued sin against custom, from the beginning to the end, where so many villanous Nudities, such Porter-like contortions of the Muscles, that it seems no more fit to be plac'd in a Chappel than in a Country Ale-house, where the Country-Sessions are kept, where I have seen most of those mimick and rude postures he has in his work: To paint the *Parthians* fighting with other weapons than those of Bows and Arrows, as suppose Musquet and Pike, would be against *coûtume*.
5. We must observe, as they ought on the Stage, the unity of Time, Place and Action, as that Painter did, who to represent where he laid his Scene of a Sea-fight, *viz.* on the *Nile*, he drew an Ass as drinking on the River, and a Crocodile (which is only there to be found) creeping along to surprize it. When in a subject of Joy all appears agreeable, in War all things full of terrour and tumult, in a

serious subject every thing full of majesty; as above in the first Præcept of this leaf, and to do otherwise would be against Custom.

6. Besides the motions of the Face, that express our thoughts, our Hands, Fingers &c. help towards the pronouncing the thoughts; and because this has not been touch'd on much by any Painters, I will enlarge a little on the subject, to shew how the Hands, &c. help to the expressing our sentiments.

The raising of the Hands conjoyn'd towards Heaven, is the expression of Devotion.
Wringing the hands, a sign of excessive grief.
To throw up the Hands towards Heaven, a Note of Admiration.
Fainting and dejected Hands, amazement and despair.
Folding the Hands, Idleness.
Holding the Fingers indented, a musing Humour.
To hold forth the Hands together, yielding and submission.
To lift up one Hand to Heaven with the Eyes, calling God to witness.
Waving the Hands from us, to prohibit.
To hold out the bended Fist, Anger.
To extend the right Hand to any, Pity, Peace and Safety.
To lay Hands on another's shoulder, Authority of seizing.
To scratch the Head, thoughtfulness and care.
To kiss one's Hand, veneration or honour.
To lay the Hand to the heart, solemn Affirmation.
Imposition of the Hand on the Head, Benediction.
Holding up the Thumb, approbation.
Fore-finger put forth the rest contracted, *monstrari & dicere hic est.*
Holding up the Fore-finger, forbidding.
Laying the Fore-finger to the Mouth, bidding silence.
To give with Thumb and one Finger, *parce dare.*

7. 'Twas a Remarque of Sir *Harry Wootton*, and a good one too, that tho' grief and joy be opposite in Nature, yet they are such neighbours, and so a-kin in Art, that the least touch of a Pencil will translate a crying Face into a laughing one, and if you attend the Rules here given for joy and grief, you will find they are much alike, as one may find the thing true by experience.

8. *Si il est arresté,* I think this the sense of the word [Editor's note; actually *if it be stilled* or *stopped*]

9. Poets and Painters are near a-kin, therefore *vide Horace's* Art of Poetry:

> *The Beardless Youth from* Pædagogue *got loose,*
> *Does Dogs and Horses for his pleasure use,* &c.

IC
Form and Colour

1 Peter Paul Rubens (1577–1640) 'De Imitatione Statuorum'

The date of composition of the present text is not entirely clear. What is known is that it subsequently came into the possession of Roger de Piles, who translated it from Rubens' original Latin and published it in 1708 as a subsection of his *Cours de peinture par principes* (see IIA2). Because of this uncertain history, the status of *De Imitatione Statuorum* has on occasion been questioned, but recent scholarship reveals it to be a genuine work of Rubens, probably written c.1608–10 (Van Der Meulen, 1994, vol. 1, p. 78, n. 44). The text was written in a notebook in which Rubens jotted down both quotations from ancient authors and his own thoughts. The notebook was destroyed by fire in Paris in 1720. Rubens considers arguments for and against the copying of antique statues as part of the training and practice of modern painters. He has reservations, yet he himself assiduously copied antique sculptures, especially during visits to Rome. He undertook the first of these as early as 1601, when he copied the *Laocoön* and the Farnese *Hercules* amongst others. Later, in the 1620s and 1630s, he also engaged in correspondence on the subject with the French humanist scholar Nicolas Fabri de Peiresc. In essence Rubens is saying that the classical heritage has to be treated with care. On the one hand it can provide a heroic model for grandeur both in conception and literal proportion. On the other, slavish copying can result in dead work if the effects of stone are allowed to supervene over the illusion of living flesh. This question of the relation of colour and form in art was to become a major subject of controversy in the French Academy later in the century; an argument, moreover, in which De Piles himself was involved (see IC7–10). It is for this reason that, despite its early date of composition, we have felt justified in including the text in this section of the present anthology. It is also worth remarking that the other dimension of Rubens' concern, namely the competing claims of ideal form and naturalistic vividness, may be said to have echoed throughout the subsequent history of art, even into the twentieth century. We reprint Rubens' text in full from the English translation of De Piles, published as *The Principles of Painting*, London: J. Osborn, 1743, pp. 86–92.

To some painters the imitation of the antique statues has been extremely useful, and to others pernicious, even to the ruin of their art. I conclude, however, that in order to attain the highest perfection in painting, it is necessary to understand the antiques, nay, to be so thoroughly possessed of this knowledge, that it may diffuse

itself everywhere. Yet it must be judiciously applied, and so that it may not in the least smell of the stone. For several ignorant painters, and even some who are skilful, make no distinction between the matter and the form, the stone and the figure, the necessity of using the block, and the art of forming it.

It is certain, however, that as the finest statues are extremely beneficial, so the bad are not only useless, but even pernicious. For beginners learn from them I know not what, that is crude, liny, stiff, and of harsh anatomy; and while they take themselves to be good proficients, do but disgrace nature; since instead of imitating flesh they only represent marble tinged with various colours. For there are many things to be taken notice of, and avoided, which happen even in the best statues, without the workman's fault: especially with regard to the difference of shades; where the flesh, skin, and cartilages, by their diaphanous nature, soften, as it were, the harshness of a great many out-lines, and wear off those rugged breaks, which in statues, by the force and depth of their shade, make the stone, tho' very opaque, appear still more opaque and impenetrable to light, than it really is. There are, besides, certain places in the *natural*, which change their figure according to the various motions of the body, and, by reason of the flexibility of the skin, are sometimes dilated, and at other times contracted. These are avoided by the generality of sculptors; yet are sometimes admitted into use by the most excellent, and are certainly necessary to painting; but must be used with moderation. To this we must add, that not only the shade, but also the lights of statues are extremely different from the *natural*; for the gloss of the stone, and sharpness of the light that strikes it, raise the surface above its proper pitch, or, at least, fascinate the eye.

He who has, with discernment, made the proper distinctions in these cases, cannot consider the antique statues too attentively, nor study them too carefully; for we of this erroneous age, are so far degenerate, that we can produce nothing like them: Whether it is, that our groveling genius will not permit us to soar to those heights which the antients attained by their heroick sense, and superior parts; or that we are wrapt up in the darkness that overclouded our fathers; or that it is the will of God, because we have neglected to amend our former errors, that we should fall from them into worse; or that the world growing old, our minds grow with it irrecoverably weak; or, in fine, that nature herself furnished the human body, in those early ages, when it was nearer its origin and perfection, with every thing that could make it a perfect model; but now being decay'd and corrupted by a succession of so many ages, vices, and accidents, has lost its efficacy, and only scatters those perfections among many, which it used formerly to bestow upon one. In this manner, the human stature may be proved from many authors to have gradually decreased: For both sacred and profane writers have related many things concerning the age of heroes, giants, and *Cyclopes*, in which accounts, if there are many things that are fabulous, there is certainly some truth.

The chief reason why men of our age are different from the antients, is sloth, and want of exercise; for most men give no other exercise to their body but eating and drinking. No wonder therefore, if we see so many paunch-bellies, weak and pitiful legs and arms, that seem to reproach themselves with their idleness: Whereas the antients exercised their bodies every day in the academies, and other places for that purpose, and exercised them so violently as to sweat and fatigue them, perhaps, too

much. See in *Mercurialis de arte gymnastica*, how many various exercises they took, how difficult, and what vigour of constitution they required. Thus all those parts of the body which are fed by idleness were worn away; the belly was kept within its bounds, and what would have otherwise swelled it was converted into flesh and muscles: For the arms, legs, neck, shoulders, and whatever works in the body, are assisted by exercise, and nourish'd with juice; drawn into them by heat, and thus increase exceedingly both in strength and size; as appears from the backs of porters, the arms of prize fighters, the legs of dancers, and almost the whole body of water-men.

2 Francesco Scannelli (1616–1663) from *The Microcosm of Painting*

Most of what is known about Francesco Scannelli derives from his sole published work, *Il microcosmo della pittura*, printed in Cesena in 1657. He was born in nearby Forlì in Emilia in 1616 and was employed as a physician and a priest at the court of Mantua. He was also an enthusiastic amateur and connoisseur of art, entrusted with expanding the collection of Francesco d'Este, the Duke of Modena. The *Microcosmo* is dedicated to Francesco, who was a noted 'virtuoso' and one of the great collectors of his age. After Francesco's death, Scannelli travelled to Milan, Rome and Venice, forming close friendships with a number of artists, including Guercino, to whose studio he had access. The central conceit of a 'microcosm' of painting is based on the idea that the human body – created in God's image – is a microcosm of the universe as a whole. Scannelli relates different artists to different parts of the body, implying that their combination suffices to establish the entire 'corpus' of painting. In the full text Michelangelo is discussed first as the 'spine' or 'back-bone', Raphael is the 'liver', Titian the 'heart', Correggio the 'brain', Veronese the 'organs of generation' and the Carracci the 'skin'. It should be borne in mind that Scannelli's conception of the different functions which these organs fulfil differs somewhat from our own and that his knowledge of the body was that of a seventeenth-century physician. He opposed the classicizing tendencies of Florence and Rome, reserving his real enthusiasm for the painterly traditions of Northern Italy, especially the Lombard and Venetian schools. His praise for Correggio, whom he places on a par with Raphael, is particularly remarkable, given the widespread criticism directed at the artist's soft and highly voluptuous painterly style, though it anticipates – and may have helped to establish – the incorporation of Correggio in the canon of established Italian masters. The following excerpts have been translated for this volume by Katerina Deligiorgi from the edition edited by Guido Giubbini, *Il microcosmo della pittura*, Milan: Edizioni Labor, 1966, pp. 11–16, 22–3, 109–10.

In order to show clearly the many good qualities that can be observed in particular paintings as well as in a corpus of painting, and to single out the best among them, I shall use the analogy of the perfect microcosm of the human body. Although this is well suited to serve as a model in our study it is not immediately obvious how its different parts can correspond exactly to different parts of the microcosm of painting. The scholar, however, will readily discern which are the principal and most noble parts of this microcosm, whose existence gives nourishment, life and intelligence, and also motion and sustenance, and he will be able to draw other such correspondences, all of which properly conjoined form a composite whole. Let us then say that we can

compare natural talents to the functions of the most valuable and excellent organs within the microcosm of the human body, the liver, the heart and the brain. From these fundamentals we can draw, as if from a real source, the virtues of nourishment, of warmth and of intelligence. Certainly, beside the parts already mentioned, many others suggest themselves, which, however, are inferior by comparison and should reasonably be placed underneath them, as derivative from and attendants to the main ones. Now, there is hardly anybody, even among those less knowledgeable in the matter, who would not grant the work of the exalted Raphael the mark of greatest achievement and who would not recognize his great virtue in the body of painting. Just as the liver lies at the origin of a good disposition in the human body, Raphael holds the principal part in the microcosm of painting because, among other things, he never failed to choose well, with great diligence and characteristic study, from the perfect remnants of Antiquity.

How well the excellent Raphael suits the comparison with the liver in the microcosm of painting! When newly formed, the liver obtains from the maternal blood the fullness and perfection of its being. Raphael likewise draws from mother Antiquity, from whence painting gathers the right fluids and substance of wisdom. Just as the liver absorbs from the nutritious blood the finest and most fitting elements, Raphael extracts from the hard stones and bronzes of the statues subtle and delicate artifice, transmuting it into a delicacy that suits good painting. Once fully grown and transformed, so as to serve as a source itself, the liver sends blood, and with it all the necessary elements, to all the other parts of the body. Similarly, Raphael with his extraordinary judgement and continuous study reached the true essence of good painting, and through his paintings, which are like a surging source and a rich mine, he continues to transmit to other painters the right substance and the spirit of the best painting. It is therefore with good reason that he should be granted the main and principal part in the microcosm of painting. This is widely recognized by those who are of good intelligence and by those who have followed and imitated him in different ways, mostly at the very heart of the city of Rome, where a treasure of such rare substance can still be found and where great talent resides in the circles of the virtuosi who devote themselves with unique taste to this most esteemed profession. [...]

Like the heart which does not cease to perfect the nourishing humour which it receives from the liver and which enriches it with the excess heat of the vital spirits, so is the glowing Titian whose work can be compared with such excellent sap. Having received good nourishment, partly from the liver in question and partly from his contemporaries and other worthy precursors, and having thus fortified and fertilized his own talent, Titian was able to create works of great vigour, spirit and vitality. While we can still discern in his works the liver, as the true source of nourishment and the firm foundation, we also see more intense qualities; though its effects are not superior to the original, they are richer in detail and display greater naturalness. We see in Titian's works the results of a similar operation to the one performed by the heart, which fulfils the main functions of the human body and is a source of heat and of life. Likewise Titian, combining the strength of native colour and true imitation of what had previously been observed regarding natural bodies, has been able to give life to his profession. Founded upon a most robust and true style which continues to vivify truly good painting, this life has animated not only Titian's own work but also

that of his followers, who are like slender boughs, circling and imitating the main trunk, and who can stay alive only by drawing from the true vital root. By contrast, those who find themselves separated and unable to commune with the spirit and life of his excellent work waste away, lost. It is clear for all to see that here lies the heart and centre of painting, and I do not think it fitting to say any more to demonstrate yet again a truth that is already obvious, namely that Titian's unique and almost living works, which are stirring and enlivening above all others, have enabled painting to live on in posterity because of their supreme excellence. Painting partook of the value of their formidable strength, lively spirit and great naturalness which will last in the memory of mortals, and so their reputation will abide in this world as a testament to his rare and immortal virtue.

[...] According to the considered opinion of the most notable observers of the workings of the human body, an opinion which is based on reasonable evidence, there is a more noble part, and also a more important one too, in which is manifest the agency required for operations of the highest order and excellence, that is, the operation of reason. It is through the ministrations of this part that the blood from the heart and the vital spirits are put to the service of worthier substances, the animal spirits which are required for the intellect, for perfecting the functions of the head and also for the organs of sense to which they are subsequently distributed and to which they instantaneously communicate the various senses and motion, each according to their particular function. Therefore, this highly esteemed part, sometimes considered divine and standing above all the other natural functions like a treasured garrison, is justly placed above all else in merit and importance. As many scholars have claimed, including the Philosopher [Aristotle] himself, the appointed task of the brain is to refresh the heart. This most noble part, the instrument of the understanding, suits one painter only: Correggio. Notwithstanding the fact that he was a bright sun in the firmament of painting, radiating resplendent excellence and virtue, Correggio was not recognized as such in his own time. His contemporaries, and others who wrote on such matters, misjudged his work. But though in those days he was considered noteworthy chiefly for the feeble qualities of his particular manner of painting, he is in fact a unique master whose almost supernatural talent, worthy of any other, is esteemed in our days by the most discerning, intelligent and knowledgeable men. He is now elevated and praised above all others and is immortal, even though in his own lifetime he was held up as an example of wretchedness. As if lacking any knowledge of painting, his own neighbours and fellow countrymen held him in low esteem. They knew only the superficial parts and considered unworthy and vile that which was the result of a supreme and misunderstood virtue. Yet alongside this ill-thought-of exterior, posterity would shortly receive the inner substance whose contemplation intoxicates the greatest scholars, like nectar or some other celestial spirit, and sends them into wondrous ecstasy. Now that the almost divine achievements of this eminent individual are duly recognized, he is given a place similar to that occupied in the microcosm of the human body by the head, the seat of the most excellent operations. Correggio can thus be put on a par with Raphael, who is the natural source of the well-founded knowledge from which spring inventions and compositions of extraordinarily represented historical narratives, arrangements of rare lustre, original and magnificent attitudes, and also with

Titian, who combines spirit with strength, and vigorous naturalness with proud, impetuous motion. These and other similar qualities, which are usually either scarce or found in excess, in the climate of such an egregious company are exactly restrained and tempered.

* * *

The learned and great researchers of the highest parts of nature add with good reason to the first three and noblest parts of the human body a fourth one in which resides the genitive virtue. Though not as noble and necessary as the other three, this fourth part is said to follow immediately after them and to merit its place above the rest on account of the magnificent effects that are known to derive from it. The same is argued, and just as forcefully, by those who are knowledgeable in painting with respect to the gifted and extraordinary Paolo Veronese, whose achievement and multiple virtues distinguish him from an abundance of excellent and praiseworthy painters, and show him as a true propagator of priceless painting. To this day, this strong feeling seems unshakeable among the majority of the erudite and wise scholars who, with good and sincere judgement, have looked carefully at the rich and excellent works of this great master. His easy and fertile gift shows him to be a master of generous and abundant works and to possess the most excellent qualities of painting. He reveals himself in his paintings as accomplished in every respect, always coupling rich and beautiful invention with easy and rare naturalness. Thanks to his supreme and highly distinguished talent, this master, whose merit can easily be compared to that of any other, has conserved and increased more than anyone else the most worthy *microcosm of painting*. It is thus with justice that Paolo from Verona who is acclaimed by an almost infinite number of scholars is fourth among the principal parts of this composite body.

* * *

The most excellent Carracci were esteemed and praiseworthy reformers. Though in their days painting was ever straying from what is beautiful and natural, through their industry and study they managed to create paintings surpassing even those of the masters who correspond to the principal parts of the microcosm. They were able to develop a particular manner of composition and a temperate, beautiful and natural virtue which became a measure and a standard for future scholars. We might say that, together with the other main proponents of their school, they have served as a temperate epidermis or skin which covers over and finishes off the already well-formed *microcosm of painting*. And just as the less noble and less necessary membranes of the human body are still part of this same epidermis, similarly, in our great body of painting, other good but less important painters of this school united together function as the skin and help to establish the external order of this composite body. Next to these integral and necessary parts of this body we should finally add those which appear by accident and which sometimes form hard and callous growths and sometimes are filth applied to the skin, like superfluous clothing. The first are the product of excessive labour, the latter are added to the surface by those depraved individuals who seek thus to add a foolish beauty to a noble body which is already perfectly finished by mother nature.

* * *

3 Paul Fréart de Chantelou (1609–1694) from 'Diary of the Cavaliere Bernini's Visit to France'

When Gian Lorenzo Bernini was called to Paris in 1665 to complete a new façade for the east wing of the Louvre (see IB7) he was at the height of his powers, both as an architect and as a sculptor. A favourite of Pope Alexander II, he had already completed a number of projects for St Peter's in Rome, including the great colonnade around the piazza in front of the church and the new entrance to the Vatican known as the Scala Regia. Louis XIV's success in bringing Bernini to Paris reflects both France's increasing status as a European power and the ambitions of the young king to project his reign in highly visible public projects. For the five months that Bernini remained in Paris, Paul Fréart de Chantelou, a steward to the king and a connoisseur of the arts, acted as his constant guide and companion. Chantelou recorded the details of his stay in a diary, preserved in a copy which was made for his brother, Roland Fréart de Chambray (see IB6). The diary offers a remarkably rich and vivid depiction not only of Bernini's ideas on art and his working methods but of the conditions under which he was required to work at court. Our selections focus on the execution of the bust of *Louis XIV*, now in Versailles, the one tangible result of his visit to Paris. Bernini's plans for the Louvre were never realized. They failed to please Louis' powerful minister, Jean-Baptiste Colbert, and he encountered considerable opposition from Parisian architects jealous of this foreign competitor. We also include Chantelou's report of Bernini's visit to his home to view his collection of paintings, including the second series of *Sacraments* by Nicolas Poussin, which Chantelou himself had commissioned (see IB1). This part of the diary offers a rare insight into the conditions under which paintings were looked at. We learn, for example, that the *Sacraments* were normally kept covered by curtains and only revealed one by one. Chantelou's *Journal du voyage du Cavalier Bernin en France* was first published by Ludovic Lalanne in a series of articles in the *Gazette des Beaux-Arts* from 1877 to 1884. The following excerpts are taken from the edition edited by Anthony Blunt and translated into English by Margery Corbett, *Diary of the Cavaliere Bernini's Visit to France*, Princeton: Princeton University Press, 1985, pp. 7, 8–11, 14–19, 28–9, 69, 76–80, 88, 115–16, 186–7, 253–4.

1 June

During the evening one of the minister's servants was sent to look for me. I went over to him, and he told me that the King had chosen me to welcome the Cavaliere Bernini, not in my capacity as maître d'hôtel but as a special emissary to entertain and accompany him while he was in this country. I said this was a great honor but that it gave me cause for some anxiety; the Ambassador Extraordinary of the Knights of Malta was arriving at court the next day, the King was going to entertain him, and I was solely responsible for the arrangements as I was the only maître d'hôtel at Saint-Germain, both for ordinary and special duties. M. Colbert replied that I must send a note that evening to the other maîtres d'hôtel in waiting to come at once to relieve me, and that I should without further delay, leave very early the next morning. [...]

2 June

I took the carriage belonging to M. Colbert and started on the road for Essonne. On leaving Juvisy I met the Cavaliere's party. I signalled to his *litter* to stop and got down from my carriage. He had also alighted and I went to greet him addressing him in French. I realized at once that he did not understand a word and I said in Italian that I would not risk making compliments in his tongue, but begged him to get into the carriage that I had brought. His son and Signor Mattia also got out and came up to greet me. Having exchanged civilities, the Cavaliere and I, as well as my nephew, your son, whom I had taken with me, got into M. Colbert's carriage. Once installed I repeated my speech to him in as good Italian as I could muster. I explained to him the King's orders and with what pleasure I had received them, on account of the very great admiration I had always felt for him and for his talent. I reminded him that he had once done me the honor of giving me some of his figure studies which I treasured dearly. I then recalled to him several maxims on the subject of portraiture in marble, which I had heard him express and had carefully remembered because I had always greatly esteemed his opinions; he could judge for himself, therefore, of my eagerness to obey His Majesty's command to meet him and remain with him during his stay in France. He thanked me most courteously, and said that it was a great honor to be asked to serve a king of France; moreover the Pope, his master, had commanded him. Had it not been for these considerations he would still be in Rome. He had heard on all sides that the King was a great prince with a great heart and a great intelligence, as well as the greatest gentleman in his kingdom. It was this that had chiefly induced him to set out, for he was curious to make his acquaintance and eager to serve him; he only regretted that his gifts were not sufficient to justify the honor done him, nor the high opinion in which he was held. He then turned to the business that had brought him. Beauty in architecture, he declared, as in all else, lay in proportion, the origin of which it might be said was divine; for did it not derive from the body of Adam which not only was shaped by divine hands but was made in the likeness and image of God? The difference between the male and female forms and proportions was the source of the various orders in architecture, and he added many other observations on the same subject, with which we are familiar. Later, when talking about the ambassadors, he said that first Cardinal d'Estrées and then the Cardinal Legate had spoken so highly of M. Colbert, under whose personal direction he would be working, that he had finally made up his mind to come; further, Father Oliva, General of the Jesuit Order and his intimate friend, whose opinion he had sought at the time, had told him that he should not hesitate; if an angel appeared from heaven telling him that he would die during his journey, he would still advise him to go. I replied that we in France had reason to be very grateful to Father Oliva and I was sure that the King would thank him. While we talked, we reached Paris and drove to the hôtel de Frontenac which M. Colbert had had got ready for the Cavaliere and his suite. On alighting, we found M. Du Metz, Keeper of the Royal Furniture and clerk to M. Colbert, who welcomed him with a speech and showed him the apartment that had been prepared. It was very well furnished and fitted up. He then showed him a gallery and smaller rooms in which there was everything necessary for his comfort; apartments for his son Paolo

and Signor Mattia de' Rossi, his architectural assistant, and rooms for his other attendants. Then, as the Cavaliere was tired I took my leave and left him to rest.

* * *

6 June

While the tables and other things necessary for drawing were being installed, we passed the time in conversation, and as the Cavaliere is a man with a great reputation whose name is very famous, I considered as you did, my dear brother, that it would not be entirely fruitless to keep a record of what he said for our common study and even for our amusement. As you have never seen him, perhaps it would help you if I made a little sketch, or *schizzo* as the Italian painters say, of him and his character. Let me tell you then that the Cavaliere Bernini is a man of medium height but well proportioned and rather thin. His temperament is all fire. His face resembles an eagle's, particularly the eyes. He has thick eyebrows and a lofty forehead, slightly sunk in the middle and raised over the eyes. He is rather bald but what hair he has is white and frizzy. He himself says he is sixty-five. He is very vigorous for his age and walks as firmly as if he were only thirty or forty. I consider his character to be one of the finest formed by nature, for without having studied he has nearly all the advantages with which learning can endow a man. Further, he has a good memory, a quick and lively imagination, and his judgment seems perspicacious and sound. He is an excellent talker with a quite individual talent for expressing things with word, look, and gesture, so as to make them as pleasing as the brushes of the greatest painters can do. [...]

Speaking of sculpture and the difficulty of making a success of it, and particularly of getting a likeness in marble, he told me a remarkable thing, which he has since repeated on many occasions – that if a man bleached his hair, his beard, his eyebrows, and, if it were possible, the pupils of his eyes and his lips, and showed himself in this state to those who were accustomed to see him every day, they would have difficulty in recognizing him. To prove it he added that the pallor which fainting brings makes a man almost unrecognizable, so that people exclaim, 'He no longer seems to be the same man.' For this reason it is extremely hard to get a likeness in marble that is all of one color. He told me something even more extraordinary, that to imitate nature in marble it may be necessary to put in that which is not there. He said something even more paradoxical, that sometimes in a marble portrait, in order to represent the dark which some people have around their eyes, one must hollow out the marble, in this way obtaining the effect of color and supplementing, so to speak, the art of sculpture, which cannot give color to things. So naturalism is not the same as imitation. Later he made an observation on the subject of sculpture, which did not convince me so entirely. 'A sculptor,' he said, 'makes a figure with one hand raised, the other placed on the breast. Practice makes one realize that the hand in the air must be made larger and broader than the other because the air surrounding the first changes and consumes something of its form or rather of its quantity.' As for me, I believe that in nature itself the object undergoes a certain diminution, so that it is not necessary to put into the imitation what is not in nature. I said nothing at the time, but since then I have remembered that the ancients were careful to make the columns at the angles

of their temples larger by a sixteenth than the others, for, as Vitruvius says, they are surrounded by a greater quantity of air that consumes something of their size and without it would appear slenderer than those next to them, which in fact they are not.

He next compared painting with sculpture, both of which have had their supporters, who during the course of the last two or three hundred years, just as in the time of ancient Greece have argued endlessly about which of them should be regarded as superior and more noble; but he endeavored to show with many excellent reasons that painting is by far the easier art, and that it requires much more ability to obtain perfection in sculpture. To prove his claim, he gave me an example, 'Let us suppose,' he said, 'that the King wants a beautiful piece of sculpture. He discusses the matter with a sculptor and allows him to choose his subject and take one, two, or three years or as long as he likes to complete it. He makes the same proposal to a painter, asking for a product of his art and laying down the same conditions as regards time and subject. If at the end of the given time, he asks the painter whether he has put all his skill into the work, the painter can assent without hesitation, for not only has he been able to imbue it with all the knowledge with which he began, but has been able to add what he has learned during the six or twelve months or longer during which he has been engaged on it. How different is the sculptor's case! If when his work is finished he is asked whether that is the best he can do, he is obliged to reply in the negative and with good reason, for he can add nothing to the knowledge that he possessed in the beginning; the pose must remain that which he first selected, nor can he modify it as he acquires more skill in the practice of his art.'

Then, passing from his room in which we were into the gallery, he told me he had one very similar in his house in Rome; it was there that he designed most of his compositions, walking up and down the while; using charcoal, he drew his ideas on the wall as they came into his head; it is usual for fertile and lively minds such as his to pile up idea after idea on the same subject; when one occurs to them they jot it down; then a second, they jot that down, too; a third and a fourth, without altering or improving any of them; he always preferred the last on account of its novelty. In order to remedy this inclination he found it desirable to leave these different ideas for a month or two without looking at them, until his mind was ready to judge which was the best. But if it so happened that there was need for haste or his patron was unable to give sufficient time for this process, then he resorted to colored spectacles or to a magnifying glass, or one that made objects smaller, or to looking at the sketches upside down; in fact by changing the color, the size, and the position, he tried to correct the illusion which love of novelty engenders, and which nearly always prevents one from choosing the best idea.

* * *

11 June

When I went to see the Cavaliere during the morning, I found him drawing heads on paper. I just glanced at them in passing and went over to see Signor Mattia, who was drawing the elevation of the Louvre façade. Having watched him a little at work, I returned to the Cavaliere who stopped what he was doing and, drawing me aside, told

me in confidence he was very annoyed; he had heard from various different sources that the King wanted him to do his portrait, and that of the Queen, but that M. Colbert had said nothing about it; the duc de Créqui had been the first to mention it, then M. de Lionne and Cardinal Antonio Barberini; he had no greater desire than to please and serve His Majesty in every way, so that if it were true that he really wanted the portraits he would like to start as soon as possible; he had planned to leave at the end of August, but for such an undertaking he would willingly stay until the end of October, two months longer than he had intended, but he could not spend the winter here because of the cold, nor set out on his journey later than November on account of his age. I replied that M. Colbert had meant to make the same proposition, that he had spoken to me about it, but as he had not authorized me to talk about it, I had remained silent. I added that the minister had probably waited before making this suggestion until he was less busy with the designs at present in hand. The Cavaliere replied that did not matter, as he could be preparing for the work on the bust while Mattia was finishing the designs; that was why he had asked for clay so that he could try out a pose while waiting to start work on the likeness. He repeated he would gladly stay two more months than he had planned; further, if it needed ten years (had he so long to live) he would give them, even if it meant that he had to die here; that he was so grateful for the honorable way in which he had been received, he felt he ought to devote the rest of his life to the King's service. I offered to write to M. Colbert, but he said it was not necessary; he would think about it between now and Wednesday when M. Colbert was coming again, and then he would speak to him himself; he thought that by Thursday the drawings would be finished and ready to be taken to the King; he would soon know what decisions had been reached.

We then went to see the procession of the Octave of the Blessed Sacrament. While waiting for it to pass, in the parish of Saint-Sulpice, the Cavaliere went into the Luxembourg. He looked at it very carefully, and declared it was the most beautiful building that he had yet seen in France.

* * *

22 July

The marquis de Bellefonds sent in the morning to know whether I was there and to say that he was coming. He entered the room where the bust was, and after looking at it said he wished the Cavaliere had put hair over the forehead. I said the forehead was one of the principal parts of the head and from the point of view of physiognomy the most important, that it therefore should be visible; moreover, the King had a forehead of great beauty and it should not be covered up; besides he might not always wear his hair as he did at present. He replied that should the King at some future time not have as much hair as now, he would wear a wig. The Cavaliere said that the sculptor was not so fortunate as the painter who, by means of different colors, could make on object appear through another so that the forehead could be seen even when depicted with the hair falling over it; the sculptor could not do this; each art had its own limitations.

* * *

25 July

[...] as he had put aside this morning for looking at Jabach's drawings and the arrangements had gone wrong, he expressed a desire to visit me; it was half past eight. His son and Mattia accompanied him.

On coming into the anteroom he first looked at a bust of myself done in Rome. He threw a glance at a copy after Domenichino, the canvas of which had been knocked and unfortunately was torn just across the head of one of the girls. He noticed it and said with a laugh, 'This was touched with too much vigor.' He looked for a minute at the pictures by Lemaire, saying the architecture was very good. Passing into the small room where the copies of Raphael were, he examined them all thoroughly. I drew his attention to the copy by Mignard and then to the *Virgin with a Cat*, copied by Ciccio of Naples. He remarked that those were the sort of copies that he valued. He looked at the *Madonna della Misericordia* by Annibale Carracci, and asked me who had made the copy. I replied that it was a painter by the name of Lemaire. He looked for a very long time at the portrait of Leo X, saying that Raphael had painted it in the manner of Titian. He admired its truth, its air of grandeur, its beauty and the painting of the velvet and the damask and said, 'It is in his latest and grandest manner, grander even than that of the *Virgin*,' pointing to the copy of Mignard. He studied Poussin's *Virgin* for a long while, without asking whose it was, and everyone admired its beauty and its grandeur. From there, we went into the study; before entering he gazed at length at the portrait of M. Poussin, and then enquired whose it was; I asked him if he did not recognize the features, he said it must be Nicolas Poussin. I then told him it was his self-portrait, and that he was not accustomed to portraiture. He said he thought this one was unique. Everyone admired it and then passed into the study. I told him that there were several copies there, the originals of which were in the château de Richelieu. He looked at the first – the *Bacchanal*, where the masks are thrown on the ground – for a good quarter of an hour at least. He thought the composition admirable. Then he said, 'Truly this man was a great painter of history and fable.' He then studied *Hercules carrying off Dejanira* and said, 'This is beautiful.' Then after considering it again, added, 'He has made the Hercules very elegant and also the little children carrying the club and the skin.' Of the *Triumph of Bacchus*, he said he would not have taken it to be by Poussin. He examined the third thoroughly and praised the foreground and the trees and the whole composition, repeating once again 'Oh! What a great painter of fables.' He then passed into the room where the *Seven Sacraments* were; only the *Confirmation* was uncovered. He looked at it with real interest, remarking, 'In this picture he has imitated the coloring of Raphael; he is a great painter of history: What piety! What silence! How beautiful is that little girl.' His son and Mattia admired the young Levite, then the woman clad in yellow, then each figure, one after another. I had uncovered the *Marriage*, which he examined as he had done the first, in silence, drawing aside the curtain which hid part of a figure that is behind a column, and finally said, 'It is St. Joseph and the Virgin,' and added that the priest was not dressed as a priest. I replied that it was before the establishment of our religion. He answered that there had still been High Priests in Judaism. They admired its qualities of grandeur and majesty and studied the whole with the greatest

attention. Coming to details, they admired the nobility and the intentness of the girls and women whom he has introduced into the ceremony, and among others, the one who is half behind a column. They then saw the *Penitence*, which they also looked at for a long time and greatly admired. I had the *Extreme Unction* got down and placed it near the window so that the Cavaliere could see it better. He looked at it standing for a while, and then got onto his knees to see it better, changing his glasses from time to time and showing his amazement without saying anything. At last he got up and said that its effect on him was like that of a great sermon, to which one listens with the deepest attention and goes away in silence while enjoying the inner experience.

Next I had the *Baptism* brought in and placed near the window, saying to the Cavaliere that it showed the sunrise. He looked at it for a long while sitting, and then again got on his knees, changing his position from time to time in order to see it better, looking at it sometimes from one end, sometimes from the other, and said, 'This one pleases me no less than the others.' He asked me if I had the seven, and I replied that I had. He did not tire of studying them for a whole hour. On getting up he declared; 'Today you have caused me great distress by showing me the talent of a man who makes me realize that I know nothing.' I replied that he should be satisfied to have reached absolute perfection in his own art, and that his works were equal to any of those of antiquity. I then brought him the little picture by Raphael, which he looked at for a long while, turning from time to time to the *Extreme Unction*. At last he said, 'In my opinion these pictures are equal to those of any painter in the world.' He wanted to know on what the picture by Raphael was painted, so I took it from its box to show him that it was on a wooden panel strengthened with cross pieces. I pointed out to him with what force it was painted. He said that was the more extraordinary as the picture was highly finished. He then saw the two other *Sacraments*, and studied them with the same attention. In the *Ordination* there is a sort of tower. He pointed it out to me with a smile, saying that it should please me as it so resembled a French roof. The *Last Supper* greatly delighted him and he drew the attention of MM. Paolo and Mattia to the beauty of the heads, one after the other, and the harmony of the light. He turned from one to the other and then he said, 'If I had to choose one of these pictures, I should be much embarrassed,' and, putting Raphael's with the others, he said he would not know which to take. 'I have always esteemed M. Poussin very highly, and I remember how annoyed Guido (Reni) was with me because of the way in which I spoke of his Martyrdom of S. Erasmus, which is in St. Peter's, as in his opinion I had exaggerated its beauty to Urban VIII, to which I had replied, "If I was a painter I should be mortified by that picture."' He has great genius, and further, he has made antiquity his chief study. Turning afterward to me, he said, 'You must realize that in these pictures you possess a jewel that you must never part with.'

* * *

29 July

I found him working at the bust and saw that he had added a lock of hair where formerly the forehead had shown. I commented on this new feature, and said that it was no doubt in deference to the views of M. de Bellefonds who had pointed out that

the King never wore his forehead uncovered. I added that I had liked it that way as it showed the slight hollow in the middle of the forehead. He agreed with me. I brought him my bust of Ptolemy, or Hephaistion, as some think it is. He looked at it closely, admiring the beauty of this Greek work. He pointed out to me how similar was the forehead to that of the King, and said they were both beautiful in shape; he looked at it from every side and made his son observe it too.

* * *

12 August

[...] At five o'clock in the afternoon M. Le Tellier and M. de Lionne came to see the Cavaliere. They began by praising the beauty of his work. The Cavaliere said the King had come to see it on his arrival from Saint-Germain and declared his satisfaction. M. de Lionne asked what were the black marks in the eyes. The Cavaliere told him that when the work was finished he would make a tap or two where the black was and the shadow of the cavity would represent the pupil of the eye. The two ministers told him that M. Colbert had assured the King, in front of them, that he was always at work whenever the King would like to visit him. He told them that His Majesty had had the goodness to say, as he went out, that he would come back whenever the Cavaliere needed him and that he had replied that he never moved from his work and would be delighted to see His Majesty at any time; that the King and he would have to finish the face together. He had got it to that state in which they saw it from memory, from the image he had formed of it and imprinted on his imagination while drawing at the council room, as they had seen him, with the King walking around and talking as usual without being tied down in any way; had he been constrained to stay in one position, he would not have been able to make the portrait so lively, he had not even used his own drawings, lest he should make a copy of his own work instead of an original: he had made these many studies only 'to soak and impregnate his mind with the image of the King'; those were his own words. He spoke again of the difficulties of doing a portrait in marble, which I have put down at length in one or two places in this journal and will not repeat here. He said Michelangelo was always reluctant to do one.

 M. de Lionne mentioned portraits in bronze. The Cavaliere said it was an even less suitable material than marble because it darkened. If it were covered in gilt, the luster made reflections which prevented one from observing the delicacy and beauty of the portrait; on the other hand, nine or ten years after marble had been worked, it acquired an indescribable softness of tone and in the end became the color of flesh. He told these gentlemen how great was his anxiety every time he was forced to undertake a portrait; that he had already made up his mind many times never to do one again, but as the King had done him the honor to ask him for his, he could not refuse so great a prince for whose person he cherished so great a love and admiration. Moreover, his feelings towards him were heightened by the fact that, as far as those sciences that he professed were concerned, he was the most learned man in the country; His Majesty had noticed things in his drawings which those with great knowledge of art might not have recognized.

* * *

10 September

...the Cavaliere took me aside and showed me a design he had made for the pedestal of the bust. It was in the form of a terrestrial globe, with an inscription reading *Picciola basa* [small base]. He asked me what I thought of his idea. I said it was a fine and lofty conception; it signified great things from the King in the future. He pointed out that apart from its innate grandeur it had another advantage, which was that the spherical shape of the globe would prevent people from touching the bust, which is what happens in France whenever there is anything new to be seen. I remarked that his idea recalled very happily the King's *Nec pluribus impar* [But not unequal to many]. The pedestal could not be more imposing; the Cavaliere must put his name to it to show that it was he who had thought of the idea and carried it out, lest it might be thought that it was the King declaring thus that the world was too small a sphere for him. He added that the effect would be splendid, the blue of the sea contrasting with the rest of the globe, which would be of gilt bronze.

* * *

5 October

When I went to the Cavaliere's, I learnt that he was working in his room at his self-portrait in red chalk from the mirror. M. Colbert had asked him for it. When he had finished, his son showed it to me. I thought it in the grand manner and a very good resemblance. He also showed me a drawing of *Cain murdering Abel*, which he had done the evening before. I reminded the Cavaliere that I had begged him to spare me a few hours, in which I could have a likeness made of him and that he had promised me one by himself. At first he pretended to have forgotten, but then it came back to him; when we rose from dinner, he requested me to ask M. Colbert whether the King was coming or not, because if he was not coming he would arrange to do something else. I went to M. Colbert's, who had just come from the Gobelins, where the King had also been. He told me the King would come as soon as he had dined, and in fact he arrived soon after. Directly he saw the bust on the stand, draped round with the velvet, he showed his delight. He studied it for some time and made them all do the same. The duc de Mercoeur, who accompanied the King, admired it extremely, and everyone vied with each other in praising it. His Majesty then placed himself in the usual position and asked if work was being done on the pedestal. The Cavaliere replied that it was not being worked on yet, and leading the prince de Marsillac, who stood near him, to a place where the King could turn his eyes on him, he took a piece of charcoal and marked the pupils on the bust. That done, he said to His Majesty that the work was finished and he wished that it had been more perfect; he had worked at it with so much love that it was the least bad portrait he had done; one thing only he regretted, that he was obliged to leave; he would have been happy to spend the rest of his life in the King's service, not only because he was King of France and a great king, but because he had realized that His Majesty possessed a spirit even more exalted than his position; he could hardly speak and, unable to say more, he broke down and withdrew. The King behaved in the most kindly way in the world, and told

the abbé Buti, who was near, to tell the Cavaliere that, if he had only understood his language, he would be able to communicate his feelings to him and say many things that should make him very happy and would reveal how warmly he returned the Cavaliere's affection.

* * *

4 Charles-Alphonse du Fresnoy (1611–1668) from *De Arte Graphica*

The French painter and writer Charles-Alphonse du Fresnoy is principally known for his poem, *De Arte Graphica* (The Art of Painting), in which he provided a concise and memorable summation of available wisdom on the practice of painting. He worked on the poem for some twenty-five years, polishing and reducing it to just 549 elegant Latin hexameters. Directly modelled on Horace's *Ars poetica*, it was intended to make good the lack of any comparable ancient treatise on painting. Du Fresnoy originally trained to be a doctor and pursued the career of a painter against the wishes of his parents. He studied under François Perrier and Simon Vouet in Paris before moving to Rome in late 1663 or early 1664. There he was strongly influenced by the works of Poussin and Raphael, and by the remains of classical Antiquity. His surviving paintings from this period show a marked classicizing tendency. In 1653 he was called away from Rome on family business, travelling through Lombardy to Venice, where he stayed for eighteen months. Experience of the works of the great Venetian masters served to counterbalance the emphasis on design which he had assimilated in Rome, and he developed a lasting appreciation of the role of colour. This is reflected in the text of *De Arte Graphica*, which acknowledges colour as an essential component of artistic beauty. It was published in its original Latin version shortly after his death in 1668, but its contemporary reception was decisively influenced by the French translation which Roger de Piles published later that same year, together with an extensive commentary (see IC5). The poem together with De Piles' notes was translated into English by John Dryden in 1695. Dryden also wrote a substantial preface entitled 'A Parallel betwixt Painting and Poetry'. As subsequent scholars have pointed out, Dryden relied principally on De Piles' French prose rather than the Latin text. His translation was published as *De Arte Graphica. The Art of Painting, by C. A. Du Fresnoy. With Remarks*, London: J. Heptinstall, 1695. The following excerpts are taken from *The Works of John Dryden*, ed. A. E. Wallace Maurer and George R. Guffey, vol. 20, Berkeley, Los Angeles and London: University of California Press, 1989, pp. 84–98, 100. The original line numbers of the poem are marked in square brackets in the text to facilitate the location of De Piles' remarks (see IC5).

Painting and Poesy are two Sisters, which are so like in all things, that they mutually lend to each other both their Name and Office. One is call'd a dumb Poesy, and the other a speaking Picture. [5.] The Poets have never said any thing but what they believ'd would please the Ears. And it has been the constant endeavour of the Painters to give pleasure to the Eyes. In short, those things which the Poets have thought unworthy of their Pens, the Painters have judg'd to be unworthy of their Pencils. For both of them, that they might contribute all within their power to the sacred Honours of Religion, [10.] have rais'd themselves to Heaven, and, having found a free admission into the Palace of *Jove* himself, have enjoy'd the sight and conversation of the Gods; whose Majesty they observe, and contemplate the wonders

of their Discourse, in order to relate them to Mankind; whom at the same time they inspire with those Cœlestial Flames, which shine so gloriously in their Works. From Heaven they take their passage through the World; and are neither sparing of their pains nor of their study [15.] to collect whatsoever they find worthy of them. They dive (as I may say) into all past Ages; and search their Histories, for Subjects which are proper for their use: with care avoiding to treat of any but those which, by their nobleness, or by some remarkable accident, have deserv'd to be consecrated to Eternity; whether on the Seas, or Earth, or in the Heavens. [20.] And by this their care and study it comes to pass, that the glory of Heroes is not extinguish'd with their lives: and that those admirable works, those prodigies of skill, which even yet are the objects of our admiration, are still preserv'd. So much these Divine Arts have been always honour'd: and such authority they preserve amongst Mankind. [25.] It will not here be necessary to implore the succour of *Apollo*, and the Muses, for the gracefulness of the Discourse, or for the Cadence of the Verses: which containing only Precepts, have not so much need of Ornament, as of Perspicuity.

[30.] I pretend not in this Treatise to tye the hands of Artists, whose skill consists only in a certain practice, or manner which they have affected, and made of it as it were a Common Road. Neither would I stifle the Genius by a jumbled heap of Rules: nor extinguish the fire of a vein which is lively and abundant. But rather to make this my business, that Art being strengthned by the knowledge of things, may at length [35.] pass into Nature by slow degrees; and so in process of time may be sublim'd into a pure Genius which is capable of choosing judiciously what is true, and of distinguishing betwixt the beauties of Nature, and that which is low and mean in her; and that this Original Genius by long exercise and customs, may perfectly possess all the Rules and Secrets of that Art.

Precept I. Of *what is Beautifull.* The principal and most important part of Painting, is to find out and thoroughly to understand what Nature has made most beautifull, and most proper to this Art; and that a choice of it may be made according to the gust [i.e. taste] and manner of the Ancients, [40.] without which, all is nothing but a blind, and rash barbarity; which rejects what is most beautifull, and seems with an audacious insolence to despise an Art, of which it is wholly ignorant: which has occasion'd these words of the Ancients: *That no man is so bold, so rash, and so overweening of his own works, as an ill Painter, and a bad Poet, who are not conscious to themselves of their own Ignorance.*

[45.] We love what we understand; we desire what we love; we pursue the enjoyment of those things which we desire; and arrive at last to the possession of what we have pursu'd, if we constantly persist in our Design. In the mean time, we ought not to expect that blind Fortune should infallibly throw into our hands those Beauties: For though we may light by chance on some which are true and natural, yet they may prove either not to be decent or not to be ornamental. Because it is not sufficient [50.] to imitate Nature in every circumstance, dully, and as it were literally, and meanly; but it becomes a Painter to take what is most beautifull, as being the Soveraign Judge of his own Art; and that by the progress which he has made, he may

understand how to correct his errours, and permit no transient Beauties to escape his observation.

II. *Of Theory, and Practice*. In the same manner, that bare practice, [55.] destitute of the Lights of Art, is always subject to fall into a Precipice like a blind Traveller, without being able to produce any thing which contributes to a solid reputation, so the speculative part of Painting, without the assistance of manual operation, can never attain to that perfection which is its object, but sloathfully languishes as in a Prison: for it was not with his Tongue that *Apelles* perform'd his Noble Works. [60.] Therefore though there are many things in Painting, of which no precise rules are to be given (because the greatest Beauties cannot always be express'd for want of terms) yet I shall not omit to give some Precepts which I have selected from among the most considerable which we have receiv'd from Nature, that exact School-mistress, after having examin'd her most secret recesses, as well as those Master-pieces of Antiquity, which were the first Examples of this Art: And, 'tis by this means that the mind, and the natural disposition [65.] are to be cultivated, and that Science perfects Genius, and also moderates that fury of the fancy, which cannot contain it self within the bounds of Reason, but often carries a man into dangerous extremes: *For there is a mean in all things; and a certain measure, wherein the good and the beautifull consist; and out of which they never can depart.*

III. *Concerning the Subject*. This being premis'd, the next thing is to make choice of a Subject beautifull and noble; [70.] which being of it self capable of all the charms and graces, that Colours, and the elegance of Design can possibly give, shall afterwards afford, to a perfect and consummate Art, an ample field of matter wherein to expatiate it self; to exert all its power, and to produce somewhat to the sight which is excellent, judicious, and well season'd; and at the same time proper to instruct, and to enlighten the Understanding.

Thus at length I enter into the Subject-matter of my Discourse; and at first find only a bare strain'd Canvass, on which the whole Machine (as it may be call'd) of the Picture is to be dispos'd, and the imagination of a powerfull, and easy Genius; [75.] which is what we properly call *Invention*.

Invention the first part of Painting. Invention is a kind of Muse, which being possess'd of the other advantages common to her Sisters, and being warm'd by the fire of *Apollo*, is rais'd higher than the rest, and shines with a more glorious, and brighter flame.

IV. *The Disposition or Oeconomy of the whole Work*. 'Tis the business of a Painter, in his choice of Postures, to foresee the effect, and harmony of the Lights and Shadows, with the Colours which are to enter into the whole; [80.] taking from each of them, that which will most conduce to the production of a beautifull Effect.

V. *The faithfulness of the Subject*. Let your Compositions be conformable to the Text of Ancient Authours, to Customs, and to Times.

* * *

VII. *Design, the second part of Painting*.　The Parts must have their out-lines in waves resembling flames, or the gliding of a Snake upon the ground: They must be smooth, they must be great, they must be almost imperceptible to the touch, and even, without either Eminences or Cavities. [110.] They must be drawn from far, and without breaks, to avoid the multiplicity of lines. Let the Muscles be well inserted and bound together according to the knowledge of them which is given us by Anatomy. Let them be design'd after the manner of the *Græcians*: and let them appear but little, according to what we see in the Ancient Figures. In fine, let there be a perfect relation betwixt the parts and the whole, that they may be entirely of a piece.

[115.] Let the part which produces another part, be more strong than that which it produces; and let the whole be seen by one point of Sight.

Though Perspective cannot be call'd a certain rule or a finishing of the Picture, yet it is a great Succour and Relief to Art, and facilitates the means of Execution; [120.] yet frequently falling into Errors, and making us behold things under a false Aspect, for Bodies are not always represented according to the Geometrical Plane, but such as they appear to the Sight.

VIII. *Variety in the Figures*.　Neither the Shape of Faces, nor the Age, nor the Colour ought to be alike in all Figures, any more than the Hair: [125.] because Men are as different from each other, as the Regions in which they are born, are different.

IX. *The Members and Drapery of every Figure to be suitable to it*.　Let every Member be made for its own head, and agree with it. And let all together compose but one Body, with the Draperies which are proper and suitable to it.

X. *The Actions of Mutes to be imitated*.　And above all, let the Figures to which Art cannot give a voice, imitate the Mutes in their Actions.

XI. *Of the principal Figure of the Subject*.　Let the principal Figure of the Subject appear [130.] in the middle of the Piece under the strongest Light, that it may have somewhat to make it more remarkable than the rest, and that the Figures which accompany it, may not steal it from our Sight.

XII. *Grouppes of Figures*.　Let the Members be combin'd in the same manner as the Figures are, that is to say, coupled and knit together. And let the Grouppes be separated by a void space, to avoid a confus'd heap; which proceeding from parts that are dispers'd without any Regularity, [135.] and entangled one within another, divides the Sight into many Rays, and causes a disagreeable Confusion.

* * *

XIX. *That we must not tie our selves to Nature, but accommodate her to our Genius*.　Be not so strictly ty'd to Nature, that you allow nothing to study, and the bent of your own Genius. But on the other side, believe not that your Genius alone, and the Remembrance of those things which you have seen, can afford you wherewithall to furnish out a beautifull Piece, without the Succour of that incomparable School-

mistress, Nature; [180.] whom you must have always present as a witness to the Truth. We may make a thousand Errors of all kinds; they are every-where to be found, and as thick set as Trees in Forests; and amongst many ways which mislead a Traveller, there is but one true one which conducts him surely to his Journey's end; as also there are many several sorts of crooked lines, but there is one only which is straight.

XX. *Ancient Figures the rules of imitating Nature.* Our business is to imitate the Beauties of Nature, as the Ancients have done before us, [185.] and as the Object and Nature of the thing require from us. And for this reason we must be carefull in the search of Ancient Medals, Statues, Vases and Basso Relievo's: And of all other things which discover to us the Thoughts and Inventions of the *Græcians*; because they furnish us with great Ideas, and make our Productions wholly beautifull. [190.] And in truth, after having well examin'd them, we shall therein find so many Charms, that we shall pity the Destiny of our present Age, without hope of ever arriving at so high a point of Perfection.

XXI. *A single Figure, how to be treated.* If you have but one single Figure to work upon, you ought to make it perfectly finish'd and diversify'd with many Colours.

XXII. *Of the Draperies.* [195.] Let the Draperies be nobly spread upon the Body; let the Folds be large, and let them follow the order of the parts, that they may be seen underneath, by means of the Lights and Shadows; notwithstanding that the parts should be often travers'd (or cross'd) by the flowing of the Folds which loosely incompass them, [200.] without sitting too straight upon them; but let them mark the parts which are under them, so as in some manner to distinguish them, by the judicious ordering of the Lights and Shadows. And if the parts be too much distant from each other, so that there be void spaces, which are deeply shadow'd, we are then to take occasion to place in those voids some Fold to make a joining of the parts. And as the Beauty of the Limbs consists not in the quantity and rising of the Muscles, but, on the contrary, [205.] those which are less eminent have more of Majesty than the others; in the same manner the beauty of the Draperies, consists not in the multitude of the folds, but in their natural order, and plain simplicity. The quality of the persons is also to be consider'd in the Drapery. As supposing them to be Magistrates, their Draperies ought to be large and ample: [210.] If Country Clowns or Slaves they ought to be course and short: If Ladies or Damsels, light and soft. 'Tis sometimes requisite to draw out, as it were from the hollows and deep shadows, some Fold, and give it a Swelling, that receiving the Light, it may contribute to extend the clearness to those places where the Body requires it; and by this means we shall disburthen the piece of those hard Shadowings which are always ungracefull.

* * *

XXX. Gothique *Ornaments are to be avoided.* [240.] We are to have no manner of relish for *Gothique* Ornaments, as being in effect so many Monsters, which barbarous Ages have produc'd; during which, when Discord and Ambition caus'd by the too large extent of the *Roman* Empire, had produc'd Wars, Plagues and Famine through

the World, then I say, the stately Buildings fell to Ruin, and the nobleness of all beautifull Arts was totally extinguish'd: [245.] then it was that the admirable and almost supernatural Works of Painting were made Fuel for the Fire: But that this wonderfull Art might not wholly perish, some Reliques of it took Sanctuary under ground, and thereby escap'd the common Destiny. And in the same profane age, the noble Sculpture was for a long time buried under the same Ruines, with all its beautifull Productions and admirable Statues. The Empire in the mean time under the weight of its proper Crimes and undeserving to enjoy the day, [250.] was invelop'd with a hideous night, which plung'd it into an Abyss of errors, and cover'd with a thick darkness of Ignorance those unhappy Ages, in just revenge of their Impieties: From hence it comes to pass, that the works of those great *Græcians* are wanting to us; nothing of their Painting and Colouring [255.] now remains to assist our modern Artists, either in the Invention, or the manner of those Ancients; neither is there any man who is able to restore the Chromatique part or Colouring, or to renew it to that point of excellency to which it had been carry'd by *Zeuxis*: who by this part which is so charming, so magical, and which so admirably deceives the sight, made himself equal to the great *Apelles*, that Prince of Painters; [260.] and deserv'd that height of reputation which he still possesses in the World.

Colouring the third part of Painting. And as this part, which we may call the Soul of Painting and its utmost perfection, is a deceiving Beauty, but withal soothing and pleasing: So she has been accus'd of procuring Lovers for her Sister, and artfully ingaging us to admire her. But so little have this Prostitution, these false Colours, and this Deceit, [265.] dishonour'd Painting, that on the contrary, they have only serv'd to set forth her Praise, and to make her merit farther known; and therefore it will be profitable to us, to have a more clear understanding of what we call Colouring.

The light produces all kinds of Colours, and the Shadow gives us none. The more a Body is nearer to the Eyes, and the more directly it is oppos'd to them, the more it is enlightn'd, because the Light languishes and lessens the farther it removes from its proper Sourse.

[270.] The nearer the Object is to the Eyes, and the more directly it is oppos'd to them, the better it is seen, because the Sight is weaken'd by distance.

XXXI. *The conduct of the Tones of Light and Shadows.* 'Tis therefore necessary that round Bodies, which are seen one over against the other in a right Angle, should be of a lively and strong Colouring, and that the extremities turn, in losing themselves insensibly and confusedly, without precipitating the Light all on the sudden into the Shadow; [275.] or the Shadow into the Light. But the passage of one into the other must be common and imperceptible, that is, by degrees of Lights into Shadows and of Shadows into Lights. And it is in conformity to these Principles that you ought to treat a whole Grouppe of Figures, though it be compos'd of several parts, in the same manner as you would do a single Head.

* * *

XXXIII. *That there must not be two equal Lights in a Picture.* We are never to admit two equal Lights in the same Picture; but the greater Light must strike forcibly on

the middle, and there extend its greatest clearness on those places of the Picture, [315.] where the principal Figures of it are, and where the strength of the action is perform'd, diminishing by degrees as it comes nearer and nearer to the Borders; and after the same manner that the Light of the Sun languishes insensibly in its spreading from the East, from whence it begins, towards the West where it decays and vanishes, so the Light of the Picture being distributed over all the Colours, [320.] will become less sensible the farther it is remov'd from its Original.

The experience of this is evident in those Statues which we see set up in the midst of Publique Places, whose upper parts are more enlighten'd than the lower; and therefore you are to imitate them in the distribution of your Lights.

Avoid strong Shadows on the middle of the Limbs; least the great quantity of black which composes those Shadows, should seem to enter into them and to cut them: [325.] Rather take care to place those shadowings round about them, thereby to heighten the parts, and take so advantageous Lights, that after great Lights, great Shadows may succeed. And therefore *Titian* said, with reason, that he knew no better rule for the distribution of the Lights and shadows, than his Observations drawn from a *Bunch of Grapes*.

XXXIV. *Of White and Black*. [330.] Pure or unmix'd white either draws an object nearer, or carries it off to farther distance: It draws it nearer with black, and throws it backward without it. But as for pure black, there is nothing which brings the object nearer to the Sight.

The light being alter'd by some Colour, never fails to communicate somewhat of that Colour to the Bodies on which it strikes, and the same effect is perform'd by the Medium of Air, through which it passes.

XXXV. *The reflection of Colours*. [335.] The Bodies which are close together, receive from each other that Colour which is opposite to them; and reflect on each other that which is naturally and properly their own.

XXXVI. *Union of Colours*. 'Tis also consonant to reason, that the greatest part of those Bodies which are under a Light, which is extended and distributed equally through all, should participate of each others Colours. The *Venetian* School having a great regard for that Maxim ([340.] which the Ancients call'd *the Breaking of Colours*) in the quantity of Figures with which they fill their Pictures, have always endeavour'd the Union of Colours, for fear that being too different, they should come to incumber the Sight by their confusion with their quantity of Members separated by their Folds, which are also in great number; [345.] and for this reason they have painted their Draperies with Colours that are nearly related to each other, and have scarce distinguish'd them any other way, than by the Diminution of the Lights and Shadows joining the contiguous Objects by the Participation of their Colours, and thereby making a kind of Reconciliation or Friendship betwixt the Lights and Shadows.

* * *

XLV. *The field or ground of the Picture.* Let the Field, or Ground of the Picture, be clean, free, transient, light, and well united with Colours which are of a friendly nature to each other; [380.] and of such a mixture, as there may be something in it of every colour that composes your work, as it were the contents of your Palette. And let the bodies mutually partake of the colour of their ground.

XLVI. *Of the vivacity of Colours.* Let your Colours be lively, and yet not look (according to the Painter's Proverb) as if they had been rubb'd or sprinkled with meal: that is to say, let them not be pale.

Let the parts which are nearest to us, and most rais'd, be strongly colour'd, and as it were sparkling; and let those parts which are more remote from sight, and towards the borders, be more faintly touch'd.

XLVII. *Of Shadows.* [385.] Let there be so much harmony, or consent, in the Masses of the Picture, that all the shadowings may appear as if they were but one.

XLVIII. *The Picture to be of one piece.* Let the whole Picture be made of one piece, and avoid as much as possibly you can, to paint drily.

* * *

5　Roger de Piles (1635–1709) 'Remarks on *De Arte Graphica*'

Roger de Piles was a French diplomat, amateur painter and art theorist. His *Principles of Painting* (see IIA2), published at the end of his career in 1708, has been described as the *summa* of academic art theory (Crow, 1985). He had studied philosophy and theology in Paris and in 1662 became tutor to Michel Amelot de Gournay, son of Charles Amelot, President of the Grand Conseil. When Michel Amelot was appointed ambassador to Venice in 1682 De Piles was made his secretary. Further diplomatic missions to Germany, Austria and Portugal enabled him to acquire first-hand experience of a wide range of art. In 1692, however, he was arrested whilst undertaking secret negotiations in the Netherlands during the War of the League of Augsburg, and was imprisoned for five years in The Hague. He used this time to compose his *Abrégé de la vie des peintres*, published in Paris in 1699 and translated into English in 1706 as *The Art of Painting*. His first important contribution to art theory dates from 1668 when he published a French prose translation of Du Fresnoy's Latin poem, *De Arte Graphica*, together with an extensive commentary (see IC4). Both the translation and the 'remarks' helped to present Du Fresnoy's poem as 'a manifesto for a new colourist offensive' (Lichtenstein, 1989) against the theoretical and institutional dominance of the Académie Royale de Peinture et de Sculpture. This challenge was subsequently taken up from within the Academy by Louis Gabriel Blanchard (see IC8). De Piles responded with his *Dialogue upon Colouring* of 1673 (see IC10). *L'Art de peinture de Charles-Alphonse Du Fresnoy, traduit en français, avec des remarques nécessaires et tres amples* was published in Paris by Nicolas Langlois in 1668. The following excerpts are taken from the translation by John Dryden (*De Arte Graphica. The Art of Painting, by C. A. Du Fresnoy. With Remarks*, London: J. Heptinstall, 1695) as reprinted in *The Works of John Dryden*, ed. A. E. Wallace Maurer and George R. Guffrey, vol. 20, Berkeley, Los Angeles and

London: University of California Press, 1989, pp. 126–7, 142–3, 163–4, 168, 170–3, 175–6. Each of the 'Remarks' is prefaced by the corresponding line number of the poem, which is shown in square brackets in the selection.

* * *

[¶ 75.] *Which is what we properly call Invention*, &c. Our Author establishes three parts of Painting, the Invention, the Design or Drawing, and the Colouring, which in some places he also calls the *Cromatique*. Many Authors who have written of Painting, multiply the parts according to their pleasure; and without giving you or my self the trouble of discussing this matter, I will onely tell you, that all the parts of Painting which others have nam'd, are reducible into these three which are mention'd by our Author.

For which reason, I esteem this division to be the justest: and as these three parts are Essential to Painting, so no man can be truly call'd a Painter who does not possess them all together: In the same manner that we cannot give the name of *Man* to any Creature which is not compos'd of Body, Soul and Reason, which are the three parts necessarily constituent of a Man. How therefore can they pretend to the Quality of Painters, who can onely copy and purloyn the works of others who therein employ their whole industry, and with that onely Talent would pass for able Painters? And do not tell me that many great Artists have done this; for I can easily answer you that it had been their better course, to have abstain'd from so doing; that they have not thereby done themselves much honour, and that copying was not the best part of their reputation. Let us then conclude that all Painters ought to acquire this part of Excellence; not to do it, is to want courage and not dare to shew themselves. 'Tis to creep and grovel on the ground, 'tis to deserve this just reproach, *O imitatores servum pecus!* ['Oh, sheep-like flock of imitators'] 'Tis with Painters, in reference to their productions, as it is with Orators. A good beginning is always costly to both: much sweat and labour is requir'd, but 'tis better to expose our works and leave them liable to censure for fifteen years, than to blush for them at the end of fifty. On this account 'tis necessary for a Painter to begin early to do somewhat of his own, and to accustom himself to it by continual exercise; for so long as endeavouring to raise himself, he fears falling, he shall be always on the ground.

* * *

[¶ 129.] *Let the principal Figure of the Subject*, &c. 'Tis one of the greatest blemishes of a Picture, not to give knowledge, at the first Sight, of the Subject which it represents. And truly nothing is more perplexing, than to extinguish, as it were, the principal Figure by the opposition of some others, which present themselves to us at the first view, and which carry a greater lustre. [. . .] A Painter is like an Orator in this. He must dispose his matter in such sort, that all things may give place to his principal Subject. And if the other Figures, which accompany it, and are onely as Accessaries there, take up the chief place, and make themselves most remarkable, either by the Beauty of their Colours, or by the Splendour of the Light, which strikes upon them, they will catch the Sight, they will stop it short, and not suffer it to go further than themselves, till after some considerable space of time, to find out that which was not discern'd at first. The principal Figure in a Picture is like a King among his Courtiers, whom we ought to know at the first Glance, and who ought to

dim the Lustre of all his Attendants. Those Painters who proceed otherwise, do just like those who in the relation of a story ingage themselves so foolishly in long digressions, that they are forc'd to conclude quite another way than they began.

* * *

[¶ 256.] *The Cromatique part or Colouring*, &c. The third and last part of Painting, is call'd the *Cromatique* or *Colouring*. Its object is Colour, for which reason, Lights and Shadows are therein also comprehended, which are nothing else but white and brown (or dark,) and by consequence have their place among the Colours. *Philostratus* says in his life of *Apollonius, That it may be truly call'd Painting which is made only with two Colours, provided the Lights and Shadows be observ'd in it: for there we behold the true resemblance of things with their Beauties; we also see the Passions, though without other Colours: so much of life may be also express'd in it, that we may perceive even the very Bloud: the Colour of the Hair and of the Beard, are likewise to be discern'd, and we can distinguish without confusion, the fair from the black, and the young from the old, the differences betwixt the white and the flaxen hair; we distinguish with ease betwixt the* Moors *and the* Indians; *not onely by the Camus Noses of the Blacks, their woolly Hair and their high Jaws, but also by that black Colour which is natural to them.* We may add to what *Philostratus* has said, that with two onely Colours, the Light and the Dark, there is no sort of Stuff or Habit but may be imitated. We say then, that the colouring makes its observations on the Masses or Bodies of the Colours, accompany'd with Lights and Shadows more or less evident by degrees of diminution, according to the Accidents: First of a luminous Body, as for example, the Sun or a Torch; Secondly, of a diaphanous or transparent Body, which is betwixt us and the object, as the Air either pure or thick, or a red Glass, *&c.*; Thirdly, of a solid Body illuminated, as a Statue of white Marble, a green Tree, a black Horse, *&c.*; Fourthly, from his part, who regards the Body illuminated, as beholding it either near or at a distance, directly in a right Angle, or aside in an obtuse Angle, from the top to the bottom, or from the bottom to the top. This part, in the knowledge which it has of the vertue of Colours, and the Friendship which they have with each other, and also their Antipathies, comprehends the Strength, the Relievo, the Briskness, and the Delicacy which are observ'd in good Pictures; the management of Colours, and the labour depend also on this last part.

[¶ 263.] *Her Sister*, &c. That is to say, the Design or Drawing, which is the second part of Painting, which consisting onely of Lines, stands altogether in need of the Colouring to appear. 'Tis for this reason, that our Author calls this part her Sisters Procurer, that is, the Colouring shows us the Design, and makes us fall in love with it.

* * *

[¶ 329.] *A bunch of Grapes*, &c. 'Tis sufficiently manifest, that *Titian* by this judicious and familiar comparison, means that a Painter ought to collect the objects, and to dispose them in such a manner, as to compose one whole; the several contiguous parts of which, may be enlighten'd, many shadow'd, and others of broken Colours to be in the turnings; as on a Bunch of Grapes, many Grapes, which are the parts of it, are in the Light, many in the Shadow, and the rest faintly colour'd to make them go farther back. *Titian* once told *Tintoret, That in his greatest works, a Bunch of Grapes had been his principal rule and his surest guide.*

* * *

[¶ 332.] *But as for pure black, there is nothing that brings the Object nearer to the Sight*, &c. Because black is the heaviest of all Colours, the most earthly, and the most sensible: This is clearly understood by the qualities of white, which is oppos'd to it, and which is, as we have said, the lightest of all Colours. There are few who are not of this opinion; and yet I have known some, who have told me, that the black being on the advanc'd part, makes nothing but holes. To this there is little else to be answer'd, but that black always makes a good effect, being set forward, provided it be plac'd there with Prudence. You are therefore so to dispose the Bodies of your Pictures which you intend to be on the fore-ground, that those sorts of holes may not be perceiv'd, and that the blacks may be there by Masses, and insensibly confus'd. See the *47ᵗʰ*. Rule.

[. . .]

This Rule of White and Black is of so great consequence, that unless it be exactly practis'd, 'tis impossible for a Picture to make any great effect, that the Masses can be disentangl'd, and the different distances may be observ'd at the first Glance of the Eye without trouble.

It may be inferr'd from this Precept, that the Masses of other Colours, will be so much the more sensible, and approach so much the nearer to the Sight the more brown they bear; provided this be amongst other Colours which are of the same Species. For example, A yellow brown shall draw nearer to the Sight, than another which is less yellow. I said provided it be amongst other Colours, which are of the same Species, because there are simple Colours, which naturally are strong and sensible, though they are clear, as Vermillion; there are others also, which notwithstanding that they are brown, yet cease not to be soft and faint, as the blue of Ultramarine. The effect of a Picture comes not onely therefore from the Lights and Shadows, but also from the nature of the Colours. I thought it was not from the purpose in this place to give you the qualities of those Colours which are most in use, and which are call'd *Capital*, because they serve to make the composition of all the rest, whose number is almost infinite.

Red Oker is one of the most heavy Colours.

Yellow Oker is not so heavy, because 'tis clearer.

And the Masticot is very Light, because it is a very clear yellow, and very near to white.

Ultramarine or Azure, is very light and a very sweet Colour.

Vermillion is wholly opposite to Ultramarine.

Lake is a middle Colour betwixt Ultramarine and Vermillion, yet it is rather more sweet than harsh.

Brown Red is one of the most earthy and most sensible Colours.

Pinck is in its nature an indifferent Colour, (that is) very susceptible of the other Colours by the mixture: if you mix brown-red with it, you will make it a very earthy Colour; but on the contrary, if you joyn it with white or blue, you shall have one of the most faint and tender Colours.

Terre Verte (or green Earth) is light; 'tis a mean betwixt yellow Oker and Ultramarine.

Umbre is very sensible and earthy; there is nothing but pure black which can dispute with it.

Of all Blacks, that is the most earthly, which is most remote from Blue. According to the Principle which we have establish'd of white and black, you will make every one of these Colours before-nam'd more earthy and more heavy, the more black you mingle with them, and they will be light the more white you joyn with them.

For what concerns broken or compound Colours, we are to make a judgment of their strength by the Force of those Colours which compose them. All who have thoroughly understood the agreement of Colours, have not employ'd them wholly pure and simple in their Draperies, unless in some Figure upon the foreground of the Picture; but they have us'd broken and compound Colours, of which they made a Harmony for the Eyes, by mixing those which have some kind of Sympathy with each other, to make a Whole, which has an Union with the Colours which are neighbouring to it. The Painter who perfectly understands the force and power of his Colours, will use them most suitably to his present purpose, and according to his own Discretion.

* * *

[¶ 382.] *Let your Colours be lively, and yet not look (according to the Painters Proverb) as if they had been sprinkled with Meal*, &c. *Donner dans la farine*, is a Phrase amongst Painters, which perfectly expresses what it means, which is to paint with clear, or bright Colours, and dull Colours together; for being so mingled, they give no more life to the Figures, than if they had been rubb'd with Meal. They who make their flesh Colours very white, and their Shadows grey or inclining to green, fall into this inconvenience. Red Colours in the Shadows of the most delicate or finest Flesh, contribute wonderfully to make them lively, shining and natural; but they are to be us'd with the same discretion, that *Titian, Paul Veronese, Rubens* and *Van Dyck*, have taught us by their example.

To preserve the Colours fresh, we must paint by putting in more Colours, and not by rubbing them in, after they are once laid; and if it could be done, they should be laid just in their proper places, and not be any more touch'd, when they are once so plac'd; it would be yet better, because the Freshness of the Colours is tarnish'd and lost, by vexing them with the continual Drudgery of Daubing.

All they who have colour'd well, have had yet another Maxim to maintain their Colours fresh and flourishing, which was to make use of white Grounds, upon which they painted, and oftentimes at the first Stroke, without retouching any thing, and without employing new Colours. *Rubens* always us'd this way, and I have seen Pictures from the hand of that Great Person, painted up at once, which were of a wonderfull Vivacity.

* * *

6 Marco Boschini (1613–1705) from *The Rich Mines of Venetian Painting*

Boschini has been described as 'an instinctive empiricist, interested above all in colour, light, atmosphere and movement' (Mahon, 1947). He distanced himself from the idealism and classicism promoted by Roman theorists such as Bellori (see IB8), championing instead the art of his native Venice with its rich colourist tradition. He also sought to challenge Vasari's claim that the art of Florence was pre-eminent throughout Italy. Besides his work as a painter, he was also active as a printmaker, cartographer, merchant and restorer. In 1664 he published *Le Minere della Pittura Veneziana*, a guide to the wealth of paintings to be found in Venice. It was prefaced by a vast poem, *La Carta del Navegar Pitoresco* (The Map of Pictorial Navigation), made up of some 20,000 verses in which he developed his ideas on painting through a dialogue between himself and an unidentified Senator. In 1674 he published a second edition of this work entitled *Le Ricche Minere della Pittura Veneziana* in which he summarized the contents of the poem in a set of 'Brief Instructions' to a young novice. Although Boschini recognizes the importance of design, he places equal stress on the role of colour and invention. His suggestion that design without colour is to be likened to the body without a soul anticipates the defence of colour mounted by Roger de Piles, who employs the same metaphor (see IC10). Boschini emphasizes the role of invention over imitation, defending the artist's freedom to transform what he sees in accordance with his own personal vision. The following excerpts have been translated for the present volume by Katerina Deligiorgi from the edition edited by Anna Pallucchini, *La Carta del Navegar Pitoresco, edizione critica con la 'Breve Instruzione', premessa alle 'Ricche Minere della Pittura Veneziana'*, Venice and Rome: Istituto per la collaborazione culturale, 1966, pp. 747–8, 752–6.

Design

It has reached my ear that certain novices, having heard me say that those who are ignorant of design, colour and invention are unable to understand painting, would like me to say something more on these three parts. For their sake I have decided to declare here what I know. As this is not all that can be said on these subjects, I beg the forgiveness of those who know more than myself. Since design is the base and principal foundation of this marvellous art I will begin my discourse with it. Being well aware, however, that those who have already written on design, such as Albrecht Dürer and others, treat only of outline and symmetry and do not go beyond that (despite the fact that the body of design contains an infinity of parts), I am not sure whether it is appropriate for me to exceed these limits. Nonetheless, since the great Mover has bestowed upon me this gift, namely to have been born in Venice, a city from which issue a great many law-givers of painting, and since I have innumerable examples in front of my eyes and have observed many things through my own practice, I will endeavour to discuss this matter as best I can.

I say then that design is the base and principal foundation of the edifice; and just as an edifice cannot exist without foundations, so painting without design is a heap which cannot stand up. As I have said previously, some believe that design consists only of outlines. I say, however, that though outline is necessary to design, it should be treated in the same way as a writer treats a feint line: he uses it while he writes but

throws it away when he is done. This is because painting should follow nature and appear delicate, supple and without a sharp finish. And if the painters of Antiquity had done the same, once the good art was lost, then their works would not seem so dry, hard and harsh. Outline can also be compared to the skeleton of the human body which must be covered with flesh to be perfect. And this is one of the most important parts of design, because over this outline the painter, using *chiaroscuro*, must render conspicuous the fleshy parts. To explain this better, I will give an example. If one wants to draw a round ball, then one must, of course, use a compass to make a circle, but this is not sufficient, for without shadows, highlights and half-tones, this outline, round, or circle could never be said to be a globe or a ball. It would be simply a mathematical circle which requires the artifice of chiaroscuro to be rounded up in each of its parts. And this waits for the brushstroke to represent nature with the artifice of colour, for without colour design remains imperfect. [. . .]

Some people believe that statues should serve as the true model for those who want to acquire knowledge of design and that without studying statues one cannot become a good painter. It is said that statues represent the best of nature, rendered perfect by able sculptors, and also that there is little in nature itself that is perfect.

There is also an opposite opinion on this, which is held by those who concede that everything in nature is not perfect, but add that the same can be said of statues too.

The first reply that this is true, but that they speak of the good ones. But, the others say again, the same can be said of natural forms, and moreover, nature does not receive its perfection from statues, but rather the statues from nature. The first then say that ancient statues, such as the Laocoön, the Farnese Hercules, the Venus of the Medici, are absolutely perfect. The others reply that the most ancient figure is the human figure created by the divine Mover and that it ranks higher than the statues. And then they smile and add that we no longer live in the mythical age of Deucalion and Pyrrha, who made men and women spring forth from stones. Finally, they say that since painting and sculpture imitate nature, one could tell sculptors that they should learn from fine paintings, such as Tintoretto's *Last Judgement* in the Madonna dell'Orto, or many others in the Scuola di San Rocco, and conclude that every man confesses to enjoying being a man and not a statue. The truth, however, is this, that our unique painters have studied both statues and nature, extracting the best from each and creating a blend of true perfection. This is why everybody wants to acquire Venetian paintings and is willing pay a great deal of gold for them.

Colour

Since I must now expound upon the second topic, colour, I say that painting acquires its name by virtue of the learned brush of the good painter who, clothing his design with colour, renders it alive. We could say that without colour design is a body without a soul. We may reasonably compare colour to light, which enables us to see clearly that which is in the sky and on the earth. Because of its different hues, colour likewise allows us to discern each and every thing to the point that it even adds blood to the flesh and can be likened to a bright sun which enables us to see the perfection of every detail with its luminous rays.

To help the novice understand the topic better, I must now come to the details and, grasping the brush of my own weakness, tinge it with Venetian colour which I shall convey on the page as follows. I will say that just as design has many parts, so colour extends to cover different circumstances and particular applications. Sometimes it is used in *impasto*, and then it forms the base; when it is mottled, it is style; when it is used for blending, it is delicacy; when it is used for staining or smudging, it makes the parts distinct; when it lightens or darkens the hues, it conveys things in the round; used in a 'scornful stroke', it shows assurance in colouring; applied as a veil, or as they say, by brushing against the surface, it finishes off and gives great unity to the work. It is with these and other similar applications that Venetian colour is created. By 'colour', I mean here the nude of the human figure, for different applications are required for colouring other things. But since the colouring of the flesh is essential, it requires as detailed an explanation as possible.

When the Venetian painters – and here I speak of the best – worked on a large canvas, they drew first the outline of the figures of the historical or mythical narrative they wanted to represent and then sketched them in with solid colours which served as the foundation and base of their particular mode of expression. These first oil-sketches and outlines were born out of ideas in the painters' minds. The painters did not consult nature, sculpture or bas-reliefs, for their greatest concern was to arrange harmoniously the inner and outer parts of the composition, that is, to make the figures distinct from the background with the help of chiaroscuro; this is one of the most important components of colour and design, and even of invention. Once these basic elements were thus arranged and the oil-sketches dried out, the painters observed both nature and statues, without, however, becoming beholden to either. Instead, from just a few marks on paper, they finished their figures and, without any further reference to nature, they seized their brushes and started to work with brushstrokes on the oil-sketches and paint the colour of the flesh using earths more than any other colours. What they used most was a little cinnabar, red lead, and lacquer [reddish-brown resin]. They loathed like the plague light blues, bright yellows, smalts, azure greens, Naples yellows, and also glosses and varnishes. Once the second coat of paint was dry, to make a figure stand out more and throw it into relief, they would, for example, veil the figure next to it with a darker hue. Or they would paint in some highlights on the head, or the hand, or the foot, to lift them, so to speak, from the canvas. This can be seen in the church of San Rocco on the right of the main altar, where Tintoretto has artfully represented the imprisonment of St Roch. By multiplying these well-judged touches laid on dry in appropriate places, the painters seasoned every harmonious composition. Notice that they never covered all the figures, but, adorning them thus with these vigorous brushstrokes, often putting a coat of pitch on the darker areas, they animated them and always left the great masses in half-tones with much darkness and little light. There is no doubt that, as I have already said, each master established his own style, even though they all followed the same general rules. In the past, there have been those, like our Giovanni Bellini and many others of his time, who allied precision to their blending of colours. Their works are too precise, however, and, despite their exquisite rarity, not so successful, for they lack the delicacy of the works of their successors. Unique among them was Palma Vecchio who rendered the impossible possible, for he combined

precision and delicacy. One sees this in the figure of St Barbara above the altar-table of the Bombardiers in Santa Maria Formosa, which is considered very precious. Always praised for its refinement and precision, this figure, which is not to be enjoyed from a distance, is truly a thing of rarity. On the other hand, the painterly brushstroke, the 'scornful stroke', like that of Schiavone and of Bassano, is an astonishing and miraculous stroke.

We must admit, however, that nature has bonded herself for ever to the immortal Titian. Every adjective conveying perfection of colour is appropriate for him: for not just the flesh, but also the landscapes, the animals, and every other thing in his work is a true twin of reality. Just as an example let us simply contemplate the St Sebastian in the main altar of San Niccolò of the Friars Minor. If anyone does not freely admit that this is more marvellous than nature, he is blindly ignorant and therefore cannot judge anything about colour.

Invention

But what must be said of invention, a treasure kept in the coffers of imagination, a power of the soul which raises images and, with the guidance of a fine understanding, consigns them to the attentive hand which takes them down through its actions. Invention organizes the parts within the whole, disposes the materials, introduces the forms, integrates the incidents, represents the events and renders harmonious the elements of the composition. This part is the most essential in painting. Since it is the first and principal foundation of everything, it is impossible to begin the least thing without it. For the good inventor must perceive not only the historical narrative or fable which he must represent, but also all the incidents and circumstances of his subject, that is, the appropriate number of people, the various objects, the harmonious colours, the site in which the action takes place, the disposition of the figures, the attitudes of the bodies, the passions of the soul, the diversity of garments, the peculiarities of the thoughts and the novelty of things. He who is lacking in invention of his own is not esteemed by others, for he shall never be considered a master. But he who understands all the parts of invention and expresses them well cannot but succeed in becoming a distinguished painter. Such was certainly our Paolo Calliari Veronese who, having made invention his helpmeet, indeed, his disciple, then instructed, guided and assisted it in his greatest works. Oh what marvellous things were produced out of that intellect which went beyond nature and which, having penetrated the things of this world, lifted itself up to celestial spheres and invented divine forms. The human mind delights in these forms since here it finds itself communing with figures from paradise. What better example of this than the painting in the main altar in Santa Cattarina [*The Mystic Marriage of St Catherine*], an admirable architectural composition with a magnificent representation of the Virgin with the child Jesus placing the ring around the finger of the saint, surrounded by angels who combine celestial and musical harmony. The great Agostino Caraccio of Bologna with his immortal graver has certified the uniqueness of this invention. Though there is without doubt an infinite number of such prodigious and distinguished inventions, I cannot stop myself from recalling the dignified *Banquet at Cana*, painted by Veronese in the refectory of the Benedictine monks at San Giorgio

Maggiore. Here, invention is the queen of all the depictions which have been made up to the present day by any master whatsoever, making them all tribute-bearers and vassals. First, there is invention in the structure of the buildings, which are of an architectural majesty which has never been seen before. Then there is invention in the rich decor and ornaments, in the dignified and extravagant garments, in the charms of the colour, in the arrangement of the attitudes that are appropriate for the figures of the guests, the servants and the onlookers. There is invention finally in the ideas, which are so varied and so natural that one could not wish for more. In the ideas of the Saviour and of the Virgin we see figures from paradise which demand our veneration. The invention of the musical concert which appears in the foreground, and these four musicians, could not be better conceived. Veronese sought to season with these his immortal work, for in these four figures he has expressed the extract of what is rarest in painting: the old man who plays the viola da gamba is Titian, another who plays the flute is Giacomo Bassano, the one who plays the violin is Tintoretto, and the fourth one, dressed in white, is Paolo Veronese himself. Whoever can combine the musical harmony of painting better, let him approach with his own instrument. To conclude: no other invention is so well organized in the whole, so well crafted in the detail, so exemplary and so dignified! Veronese, you are the seasoning of painting, because from you is drawn the extract of the finest charms imaginable by a human mind. You are the universal painter who pleases and delights the entire universe. On the subject of invention, I cannot dare to place anyone above you. Thus I declare myself ! My only regret is that I lack a similar gift for invention to invent concepts that are fitting to such merits. I admit that I am but a shadow which, lowering itself on the ground, pays the tribute of a humble gift to your resplendent rays. Novice, farewell!

7 Philippe de Champaigne (1602–1674) 'Conference on Titian's *Virgin and Child with St John*'

The dispute between the advocates of 'design' and the partisans of 'colour' raged in France with unusual ferocity in the last forty years of the seventeenth century. Although the arguments employed by the two sides in the dispute were largely the same as those that had been rehearsed in Italy during the previous century concerning the relative merits of *disegno* and *colore*, the conflict in France took on a very different complexion. The difference lies in the fact that the priority of design had been made the official doctrine of the Royal Academy under Colbert and Le Brun. As Jacqueline Lichtenstein has shown (Lichtenstein, 1989), the three functions of the Academy – pedagogical, theoretical and political – were so tightly interwoven that an attack on one was construed as an attack on the others. In his conference on Titian's *Virgin and Child with St John*, delivered before members of the Academy in June 1671, Philippe de Champaigne (see also 1B12) sought to respond to the new challenge raised by partisans of colour such as Charles du Fresnoy (IC4) and Roger de Piles (IC5). Whilst praising Titian's excellence in this domain, he criticizes the artist for a corresponding weakness in the drawing of the figures. Champaigne's attack on colour is voiced in highly moral terms. To give preference to colour over line is like being attracted by the outer appearance of a person rather than by their mind or soul. Colour appeals to the senses rather than to the intellect, operating as a form of

seduction or deception. It was generally accepted that Poussin had been attracted early on to the work of the Venetian colourists, but had renounced these influences in pursuit of the greater virtue and discipline of an art based on line. Once again, his work is held up as exemplary to the artists of the Royal Academy. The painting discussed by Champaigne is now held in the Musée des Beaux-Arts in Dijon and is thought to be a product of Titian's studio rather than the work of the artist himself. The text of the conference was first published by André Fontaine in *Conférences inédites de l'Académie royale de Peinture et de Sculpture*, Paris: Minerva, 1903, pp. 9–13. It has been translated for the present volume by Katerina Deligiorgi.

Gentlemen, I believe that this painting by Titian merits our attention and I am confident that our discussion of it will be beneficial and rewarding in the manner intended by the founders of our Academy, who instituted these seminars for our cultivation and for the elevation and advancement of our profession.

The subject of this painting, as you can see, is the Virgin seated with the infant Jesus in her arms. St John the Baptist appears to be offering a lamb to another figure, seated on the ground, who is in all probability St Anne. The flesh tones of the figures, set against a limpid sky and a bright landscape, are worthy of our admiration. The brilliancy of the tints is achieved without the advantageous contrast of a dark background. Only a painter who has mastered the 'beautiful manner' of painting to the highest degree can achieve such an effect. The infant Jesus is charming and the forward position of his right leg is convincing in every respect. Indeed, it seems to me that together with the head of St Anne these are the most highly achieved parts of this incomparable painting. For you must agree that another work in which tenderness and greatness are thus combined would be difficult to find. This rare and learned colourist has gathered here and blended together with his brush all the elements that good painting requires.

Must not everyone agree that the landscape is extraordinarily beautiful? It is handled and coloured with the same force as the figures, and no attempt is made to render it more conspicuous by using darker tints. Indeed, it looks as if the bright and clear tones of the areas around the figures have made a pact not to clash with one another, entering a special agreement with the painter – this learned imitator of nature. For it is obvious that Titian was not concerned here with avoiding those things which, as a rule, painters seek to avoid for fear of rendering the flesh dull and inconspicuous. Nor was he troubled by awkward contrasts as can be seen, for instance, in the yellow used for the terrace behind St Anne's head, where we can also see a small herd of sheep. For this is a colour one would not usually place next to skin tones. This juxtaposition, however, has not in the least harmed the brilliance of the beautiful colours used for the saint's head. We see here what can be achieved through Titian's extensive and masterful study of the gradation of colours which, together with his practical observations, enabled him to make his paintings like a second nature.

Were we to seek to diminish in some way these enchanting qualities of Titian's brush, we would be committing a great injustice and we would be failing to recognize what an unparalleled gift was bestowed upon him. We must accept that he was born with this talent and that those who have not been so favoured by nature have failed to equal his achievement, despite all their efforts.

As regards the proportions and the correct drawing of figures, it seems that this was not the part of the painting with which Titian most concerned himself. In truth, the legs of the Virgin appear short and the outline from St Anne's waist to her foot is rather poorly drawn, with the curve of her belly hardly prominent. It often happens that the folds of the draperies obscure the contours of the body because the painter copies the adventitious aspects of what he sees. Although we should follow nature, we can discover that which is truly beautiful in her only through diligent searching. Such search is arduous and must occupy the painter most, for it reveals the most beautiful part of painting, namely correct and well-proportioned drawing. This skill is not bestowed by nature, but is only to be acquired through the effort of study.

We know from experience, and all agree, that there are only a few painters who know how to draw correctly and that they are greatly outnumbered by those who have a facility with colours. This is because many artists turn naturally to beautiful colour, having a native propensity for its beautiful external sheen which touches their hearts. I do not deny the importance of this part of painting. However, to give it precedence over the principal part, to make it the exclusive object of study, is to allow oneself to be deceived. It is like choosing a beautiful body and allowing oneself to be dazzled by its splendour while neglecting to discover what animates its beautiful appearance. Whatever its beauty, a body cannot sustain itself without the soul and the spirit that animate it. Let me support my argument by invoking the example of one of the greatest painters of the century, M. Poussin, who is admired by all fellow Academicians without exception. His early studies were directed towards beautiful colour, as if he wanted to force his genius, which was inclined towards the solid, to follow external splendour. This he did succeed in capturing, at least in part, for, although he did not entirely abandon himself to this study as if it were the thing that was closest to his heart, he did spend several years pursuing a career as a colourist. Once he saw the truth, however, his change of mind was so complete that he declared with great confidence that such disproportionate study is an obstacle which inevitably hinders young painters who seek the correct path to painting. He thus showed with incontrovertible arguments that he who concerns himself with the chief excellence of the art, namely that which is solid, will acquire in good time and without undue effort a sufficiently beautiful way of painting.

8 Louis Gabriel Blanchard (1630–1704) 'Conference on the Merits of Colour'

With his 'Conference on the Merits of Colour', delivered on 7 November 1671, Louis Gabriel Blanchard took the arguments of the colourists into the very heart of the Royal Academy. As the text of the conference makes clear, he was stung into action by the criticisms of Titian which had been made by Philippe de Champaigne a few months before (see IC7). With remarkable courage and tenacity, Blanchard undertook not only to defend the Venetian artist's work, but to present the case for the importance of colour to painting in general. Although he repeatedly affirms his admiration for the merits of design as well as of colour, he will have been aware that to challenge the priority of design was to question

the theoretical principles on which the authority of the Academy was based. The source of his claim that the different arts are distinguished by the different means of imitation they employ is the *Poetics* of Aristotle, and the lecture as a whole is characterized by a systematic and scholarly style of presentation which was no doubt intended to add persuasion to his case. Amongst the artists who have achieved excellence in colour, Blanchard lists Titian, Giorgione, Tintoretto and Veronese, and, for the first time in the conferences of the Academy, Peter Paul Rubens. Before long, the names of Poussin and Rubens would be used as a convenient shorthand to identify the supporters of each of the opposing camps. Louis Gabriel was the son of a painter, Jacques Blanchard, known as the 'French Titian'. He was elected to the Royal Academy in 1663 with an *Allegory of the Birth of Louis XIV* (Versailles), which was strongly influenced by the work of Le Brun. He went on to pursue a successful career and in 1684 was sent by Louis XIV to acquire pictures in recently conquered French Flanders. The text of the conference was first published by André Fontaine in *Conférences inédites de l'Académie royale de Peinture et de Sculpture*, Paris: Minerva, 1903, pp. 14–26. It has been translated for the present volume by Katerina Deligiorgi.

Gentlemen, the conferences of the Academy were established to help us to discover the truth and to throw light on matters that appear uncertain. I hope that you will find my thoughts on the merits of colour to be in accordance with this general purpose.

I have long been debating with myself whether I should raise this issue again. I have decided to do so after long deliberation on account of the importance of the subject and because, in my opinion, the matter has not so far been adequately examined or thoroughly debated. This is what I venture to do now, relying on your goodwill and hoping that, without judging my efforts too harshly, you will encourage me, and assist me with your own views.

You see, then, gentlemen, that I wish to present a case for the merits of colour. I shall endeavour to do so in a few words, so that each of you may have the opportunity to speak in turn and to express your thoughts on the subject.

1. Before I begin, however, I want to assure you that the spirit which animates this discourse is not one of contradiction. Nor is my intention to diminish the importance of design. On the contrary, it is a skill I esteem highly since it is a part of painting that is all the more precious for being difficult to acquire. In fact, I need not say a word more on this subject: the remnants of sculpture which survive from Antiquity constitute by themselves sufficient praise for the merits of design.

2. In submitting my arguments to your judgement, therefore, I have no other motive than that of discovering whether you consider them good or bad. Indeed, I find it all the more necessary to seek advice from you in this way since the task I am about to undertake is beyond my capacities and I am a young man with but little knowledge of painting. I am greatly honoured that you have entrusted me with giving this lecture and with proposing the subject.

3. As you know, gentlemen, colour was only recently the subject of a discourse. I confess that I listened with growing impatience to what was said before one of Titian's beautiful paintings. For this incomparable painting does not in the least accord with the testimony of those who showed their total indifference to the beauty

of its colours, when all the while the entire assembly was charmed by it. I for one was among its admirers and it is with great pleasure that I seek to defend that part of the painting which represents its greatest worth and value.

4. I shall have nothing to say regarding the effects of colours. The great M. Le Brun, who plans to discuss all the different parts of painting and who has already treated of some so admirably, will surely fulfil this task consummately and comprehensively as usual.

5. It is necessary to begin by explaining not only what we understand by colour, but also what painting is.

6. We may, I believe, define painting as an art which by means of form and colour imitates on a flat surface all manner of objects which come before our eyes. This definition is, it seems to me, the correct one because it is perfectly fitted to painting alone and so serves to distinguish it from all the other arts.

7. Painting has three parts: Invention, Design, and Colour. The first part invents the objects and disposes them on the canvas in the most advantageous and appropriate manner; the second gives them their correct proportions; and the third distributes upon the canvas the colours which are best able to captivate and to deceive the eyes.

I intend to speak of this last part of painting, whose merits were recently disparaged in one of our conferences where it was decided that colour was of little consequence and that we ought to apply ourselves to design alone.

In my view, this decision was arrived at too hastily and without having sufficiently considered the reasons which support a different opinion which is more widely held and which is closer to the truth.

8. It seems to me, gentlemen, that we can reasonably establish three things in defence of colour:

9. First, that colour is just as necessary to the art of painting as design.

10. Secondly, that if we diminish the worth of colour, we thereby also diminish the worth of painters.

11. And thirdly, that colour merited the praise of the ancients, and that it merits it again in our own age.

12. The first truth is not difficult to establish. Consider simply this. Every art is what it is by virtue of the different parts which compose it. Were we to remove one of its elements, even the slightest, we would be taking away something of its beauty and perfection. If now there is one part which may be considered more important than any other and which is indispensable to a particular art, this is because it makes a vital contribution to the aim of that art.

In the art of eloquence, for instance, the aim is to persuade. It is clear, then, that if there is a part of eloquence which is more important than any other, it must be that which most contributes to persuasion.

13. We must now examine two things: first, what general aim does the painter pursue in his work, and secondly, is design or colour more efficacious in achieving that end?

14. Is it enough to say in answer to the first question that the aim of the painter is to imitate nature? No, because all the fine arts do this. Could we then say that he aims to deceive our eyes? Again, No! For in many instances sculpture can do the same.

15. What, then, is the aim of the painter? It is, of course, both to deceive the eyes and to imitate nature. But we should add that this is done through the medium of colour, and herein lies the difference that distinguishes painting from all the other arts and which gives painting its own specific end. A painter is a painter only because he uses colours which are capable both of seducing the eyes and of imitating nature. Colour, therefore, should guide the painter, for it is colour that serves this goal.

16. That colour best serves the painter's purposes as we have sought to establish is, I believe, something that no one can doubt. I would be abusing your patience if I sought to establish such an obvious truth with mere words.

17. We should turn instead to consider some possible objections to my argument.

18. It could be argued that the purpose of painting is to represent on a flat surface the volume of bodies and that this can easily be done in black and white through drawing.

19. It could also be argued that single-colour paintings, or 'camaïeux', have often been produced by expert painters whose sole purpose was the imitation of nature, and that, for this reason, it is not colour but drawing that best serves this purpose.

20. It is easy to respond to both objections by saying that a single-colour painting can scarcely be considered a true work of art. Rather, it captures an idea for a work that the painter plans to execute, a work which the painter will realize fully using to that end whatever colours are required. Had the painter no intention to proceed in this way, we should conclude that he had misunderstood his aim, which is the imitation of nature. For natural objects are not monochrome – God bestowed different colours on them which serve to distinguish them from one another. It would therefore be best to say that the painter who uses only a single colour for his paintings does not seek to imitate nature but sculpture.

21. There are still others who suggest that the end of painting is only to delight and pleasingly to deceive the eye. They argue that design is better suited to that end, assuming that figures are drawn correctly and in accordance with the rules, because colour, even in nature, is extremely changeable. They add, too, that many wise painters, whose example it is always good to follow, did not rate colour highly and devoted their lives to design.

22. Again, the answer to this objection is simple. Even if we concede that the purpose of painting is merely to please, it would surely be preferable to please all rather than a few. The truly correct design is properly understood only by a few; it is savoured by the finest of connoisseurs and the most able of painters. Colour, by contrast, when harmoniously and skilfully applied, delights and enchants everybody. To please only the ignorant is a deficiency. To please the experts alone is excessive. But to please everybody alike is perfection itself.

23. Now, I am not in the least surprised that there are some who devote themselves to design, whilst neglecting colour, for design has its own beauty and charm. Moreover, as you know, design is valued all the more because it requires time, effort and application – a lifetime does not suffice to perfect this skill. I do not find it at all difficult to believe, therefore, that learned painters who made design their chief pursuit and dedicated themselves to it avidly pursued their study, always discovering something new to add to their knowledge. Perhaps, while seeking after beauty and

knowledge, they were surprised by death and were granted no time even to think about acquiring knowledge of colours.

24. It is, of course, possible that they neglected this knowledge simply because they thought it easy to acquire, believing that they could master it whenever they wished. Experience shows, however, that they would have been deluding themselves. Many a painter has searched hard for this knowledge but, having mistaken it for something it was not, was never able to acquire it. Others, having found it by accident, failed to recognize it and let it escape them.

25. It is certainly a matter of some importance to acquire knowledge of colour at the outset so as not to be deceived later on. For having thus accustomed ourselves to its charms we are less likely to let them dazzle us or lull us into forgetting the other parts of painting. It is not my intention here to promote colour to the detriment of design. Rather, I wish to unify them so that they can serve the same end together. In this way we can avoid replicating the errors of the Roman and the Lombard schools, which find fault with each other for having neglected one or the other part of painting. Let us rather combine these two beautiful parts, and if one is less well represented let us not regard it with indifference, or, we should rather say, contempt.

26. As to what best captivates and deceives the eye, clearly a painting with a mediocre design but with bright and harmonious colours will have a greater effect and better deceive the eyes than one in which excellence of design contains mediocre colours. This is because masterfully applied colour always represents the truth, whereas design represents only a reasonable possibility. We see very few bodies which possess the proportions which our rules teach us and yet we do not trouble ourselves as to whether bodies are really as exquisitely proportioned and as beautiful as we draw them. For such beauty is at least possible. By contrast, the eyes are accustomed to observe different colours and even take delight in such diversity.

27. My second point is proven by the very definition of painting through which I sought to show that it is colour which makes the painter and which distinguishes him from all other artists.

28. Man has in common with plants that he grows and with animals that he senses. He is man only through reason, and we may well add that the better he uses his reason the more human he becomes. The painter imitates nature in common with all those who pursue the fine arts, and, like sculptors and engravers, he draws. He is, however, a painter only through colour, so that we may reasonably assert that the better he possesses and uses the part of painting which we call colour, the wiser he is as a painter.

29. If, then, it is colour that distinguishes us from other artists and it is colour that makes the special quality of the painter, would we not, if we were to neglect it, also neglect ourselves? Could we diminish its merit without diminishing our own?

30. It remains now for me to convince you that the ancients held colour in high esteem and that it still deserves esteem in our own century.

31. Anyone who has read about the time when the fine arts were in their prime in Greece will know that Zeuxis was highly praised for his knowledge of colour and Apelles for the correctness of his design. Colour and design were thus equally admired at a time when design had reached a level of achievement that is superior to ours today, whereas colour was by comparison less advanced. Yet in our own age,

even though colour has progressed since the invention of oil painting, achieving a high degree of force and beauty, we seem inclined to deny it its due merit. Why is this? Have our eyes suddenly become more discerning? Have we come upon some new fact that was hidden from the ancients and which entitles us to put colour on trial when it was held in such high esteem in the age of Alexander? Very well, gentlemen, let us place colour in the court of judgement. But then let us also try Zeuxis and Titian, who were both as favoured by princes as they were by painting herself. Let us further add Giorgione, Tintoretto, Veronese and all the Venetians, and also Rubens and his school. The only crime these great men can be supposed to have committed is to have been sensitive to the beauty of colour. If this is so, gentlemen, then I doubt whether anyone in this company would not find himself guilty of the same crime when considering attentively these miracles of art, these admirable works where no effort has been spared in order to allow colour to appear with all its charms. Therefore, gentlemen, since we ourselves succumb to the charms of colour, and since you too would be found guilty were you to indict these great men whose works enchant you and make you forget what might be missing in them, I suggest that you cherish this beautiful enchantress and work to perfect this beautiful part that makes us painters, allowing us to excel in a domain that is well regarded and admired by those who have a discerning taste.

32. In conclusion, gentlemen, I hope you will agree that colour is an essential part of painting which contributes more than any other to the attainment of the painter's aim and to the perfection of his work; that it distinguishes our art from all the others; that therefore it is as necessary as design; that we cannot diminish it without diminishing the merit of painters; and finally, that it merits our admiration as it has merited in the past the admiration of the ancients.

9 Charles Le Brun (1619–1690) 'Thoughts on M. Blanchard's Discourse on the Merits of Colour'

Blanchard's 'Conference on the Merits of Colour' (see IC8) was met by a swift and powerful response from within the Academy itself. On 9 January 1672 two conferences were given, challenging his arguments. The first was by Jean-Baptiste de Champaigne, a cousin of Philippe de Champaigne, whose conference on Titian had initiated the conflict the previous year (see IC7). Here we reproduce the second and more cogently argued of the two, given by the director of the Academy himself, Charles Le Brun. Le Brun had been ill and unable to attend the Academy's monthly assembly on the occasion of Blanchard's lecture. However, he sought to answer the issues which his younger colleague had raised with a degree of finality. Where Blanchard had argued that colour is the 'specific difference' which distinguishes painting from all the other imitative arts, Le Brun contends that design retains its primacy, for colour cannot exist without design: were it not for design, 'colour by itself could not depict even the slightest fold of drapery.' He repeats the familiar charge against colour that it is variable and inconstant, changing in response to conditions of light and atmosphere. Colour belongs to mere matter or substance, whilst the more noble quality of design is proper to the intellect or mind. Finally, against Blanchard's claim that colour was held in high esteem by the ancients, Le Brun makes recourse to the famous story of the origin of painting, pointing out that the shepherdess of the story is said to have traced her

lover's outline on the wall without the use of colour. In the last part of the lecture, Le Brun uses the occasion of the recent opening of the French Royal Academy of Architecture to suggest that the three major arts of painting, sculpture and architecture should all be united under the authority of design. The text of the conference was first published by André Fontaine in *Conférences inédites de l'Académie royale de Peinture et de Sculpture*, Paris: Minerva, 1903, pp. 35–43. It has been translated for the present volume by Katerina Deligiorgi.

To speak well of the merit of something, one must first have an idea of the nature of the thing. Now, true merit is that which stands on its own and does not require anything extraneous. Therefore to discover the respective merits of design and of colour, and to distinguish between them, we must consider which of the two things is the more self-sufficient and independent than the other.

I propose the following theses:

That design consists of two parts, one that is intellectual or theoretical, and one that is practical.

That the intellectual or theoretical part depends on imagination alone, that it can be expressed with words, and that it extends through to all the other products of the mind.

That the practical part of design, insofar as it presupposes the intellectual part, depends on the imagination as well as the hand; it too can be expressed with words.

It is this latter, practical side of design that with the help of a pencil gives form and proportion and which imitates all visible things, even expressing the passions of the soul without the need for colour except for showing blushing and pallor.

We may add here that design imitates everything that is real whereas colour only represents what is accidental.

For we are all agreed that colour is itself but an accident produced by the reflection of light and that it varies according to circumstances. By night and under the illumination of a torch, green will look blue, and yellow will look white. So it is that colour changes depending on the light that falls on it.

We should also note that the colour we see in paintings depends on the pigments that are used to produce it: its tint and hue cannot vary unless this material base itself is altered. We cannot produce, for instance, green from red nor blue from yellow. We may thus say that colour is wholly dependent on matter and thus that it is less noble than design, which pertains to the intellect alone.

We could add here that colour also depends on design inasmuch as colour alone could not represent any figure whatsoever were it not for the guidance of design.

Design is indeed utterly necessary for colouring: if it were not for design which gives it form, colour by itself could not depict even the slightest fold of drapery. Without design it would be impossible to organize the distribution of colours upon the canvas. If design were of no account, then colour-grinders would be of equal rank with painters, for they too use colours and have almost as much knowledge in the practical application of colours as painters do.

Thus we see that it is design and not colour that establishes the merit of painting.

If, as we have said, the merit of something is proportionally greater the less it depends on extraneous causes, then it would follow that the merit of design is infinitely greater than that of colour, which owes all its lustre to design. We should desist, therefore, from elevating colour too high and we should not pretend that we owe our paintings to it, or that without colour there would be neither painters nor painting. As we have just seen, design precedes and guides colour, endowing it with its brilliance and splendour. If we remind ourselves of the ancient story about the origin of painting, we can see that colour had no part in it. We are told that the shepherdess who drew the portrait of her beloved had neither colours nor brushes at her disposal, but an awl, or at best a pencil, with which to trace the image of her lover. Despite the fact that no colours were used in its making, it is this first portrait that the ancients unanimously regarded as the origin of painting.

It is thus easy for us to conclude that it is not colour that makes the painter or the painting. Nonetheless, I agree that it does contribute to the ultimate perfection of painting, in the same way that a lovely complexion contributes to the perfection of a face with beautiful features.

Certainly a painter cannot reach perfection if he cannot apply colour properly, and likewise a painting cannot be considered accomplished in every respect if it lacks colours that are experly and sparingly applied. But I would also say that such expertise and prudence are acquired through design and that, in a word, the role of colour is exclusively to satisfy the eye, unlike design, which satisfies the intellect.

Since paintings aim to please both the senses and the intellect, colour has its own part to play, as I have just said, in the perfection of the work.

Therefore we should not neglect it, nor should we hold it in low esteem. On the contrary, we should apply ourselves to its study with care. We should, however, let design be our guide, leading and directing our study like a compass so that we do not become submerged in the ocean of colour in which many drown who seek refuge there.

In order to avoid those dangers, we must apply ourselves with assiduity to the study of design. To encourage you in this study, gentlemen, I would like to draw your attention to the eloquent discourse in praise of architecture which was delivered at the opening of the Academy of Architecture, in which design was given the highest praise for enabling architecture to create its most beautiful ideas.

It is design that enables the architect to trace the plans for the great edifices, the bridges, the elevations, the fortifications, the public squares and all the splendid structures that architects create. For a proof that it is design which perfects the architect's art we need look no further than the teachings of Vitruvius. Vitruvius argues that it is necessary for the architect to master design and to know not only how to draw buildings but also the human body, because it is on the proportions of the body that he models the proportions and even the parts of his great structures.

Vitruvius teaches us also that columns are drawn from nature's most magnificent creation, for their proportions correspond to those of the human form, some being modelled on the male body, others on the female, and still others on the figure of young girls.

He shows us, therefore, that the architect must have a thorough knowledge of proportions and that he must be able to draw correctly everything that he sees in

nature, for without this he would be unable to devise the ornaments which adorn buildings. How could an architect create pyramids and obelisks laden with hieroglyphs without design?

How else could architecture bring to the light of day superb mausoleums, marking the greatness of those who are buried there, or again magnificent triumphal arches, those splendid pedestals invented by design to carry the statues of conquerors and images made of marble, representing the feats of battle and the triumphs of the victors.

It is design that gives form and proportion to the marble and bronze statues raised to honour virtuous men. Indeed, the wisest and most celebrated of sculptors owe the beautiful shape and correct proportion of their figures to design.

In short, architecture and design are the same thing insofar as it is design that enables both the painter and the sculptor to become architects. [...]

In our own times, Pietro da Cortona, Andrea Sàcchi, Alessandro Algardi, and the Cavalier Bernini, who is still alive, demonstrate through their achievements that a painter and a sculptor can, if he is a good draughtsman, also be a good architect.

And if one day our monarch were to learn of the union and harmony existing between painting and architecture, he would no longer wish to keep them apart, but would form a single school instead of the two separate ones he has established.

I am further convinced that if the pressing affairs of our protector, the Superintendent of the Royal Buildings, allowed him a pause for reflection, he would join painting and architecture together in a single school, as they are joined in the works they produce. Then, gentlemen, you will recognize the value of design and will have no difficulty in discerning its superiority and in granting it a place infinitely higher than that of colour.

It will be design, gentlemen, that will allow you to work for the renown of the French School, for it will enable you to create works rich in allegory as well as in ornament which fittingly celebrate the glorious state of France today under the reign of Louis XIV, the greatest and most victorious monarch France has ever known.

10 Roger de Piles (1635–1709) from *Dialogue upon Colouring*

With the publication of the *Dialogue upon Colouring* in 1673, Roger de Piles once again raised a challenge to the authority of the Academy, assuming the role of the leading theorist of the partisans of colour. Svetlana Alpers has suggested that he employed the dialogue form in order to advance conversation as an appropriate form of response before a painting and that this intimate dialogue between amateurs is his alternative to the public conferences instituted at the Academy (Alpers, 1991). The figure of Damon presents the arguments for design, whilst Pamphilus seeks to persuade him of the merits of colour. Through Pamphilus, De Piles makes a crucial distinction between colour (*couleur*), the physical property of objects that renders them visible, and colouring (*coloris*), the part of painting by which the artist imitates the appearance of objects. By breaking with the idea that there is any direct correlation between the 'colouring' employed by the artist and the 'colours' which he imitates, he shows that the correct use of colour is as much the work of the mind as is design. Like Blanchard (see IC8), he maintains that it is colour which differentiates painting from the other arts. But he also refutes Le Brun's counter-argument

that colour is dependent upon design because it cannot imitate objects on its own (see IC9). Reversing the traditional equations of colour with matter and design with the intellect, he likens design to the body and colour to the mind or soul. Just as the body attains its true perfection only once it is animated by the soul, so painting attains its true excellence only when it is perfected by colour. Colour has hitherto been neglected because it cannot easily be formulated in rules and precepts, escaping the doctrinaire approach of the Academy. De Piles voices cautious criticism of Poussin's relative neglect of colour, whilst praising the *beau fard* (beautiful artifice) of Rubens. The positive connotations which he gives to this term are obscured by the English translator's choice of 'speciousness'. For this reason, we have occasionally given the original French term in square brackets in the text. De Piles turns the traditional criticism of colour's deceptive qualities into praise for its capacity to charm and deceive the eye. The 'colouring' by the painter does not serve merely to imitate the colours we see in the world but creates autonomous effects whose harmonious arrangement on the canvas is one of the principal sources of our pleasure in painting. *Dialogue sur le coloris* was first published in Paris, by Nicolas Langlois, in 1673. The following excerpts are taken from the translation by John Ozell, *Dialogue upon Colouring*, London: Daniel Brown, 1711, pp. 3–10, 16–19, 28–31, 36–8.

Pamphilus and Damon, some time since, after the breaking up of the *Academy* of Painting, not knowing how to dispose of themselves the remainder of the Day, thought fit to give me a visit. And as they are Men of Good Merit, and not only Lovers, but very good Judges of Art, I thought I cou'd no way better acknowledge their Civility, than by shewing them some Pictures and other Curiosities I had receiv'd the Day before from Rome. The first I shew'd them were five or six Pictures of a middling size, which they were mightily pleas'd with; and afterwards, upon my pointing to a large *Bacchanal* (a Picture representing the Feasts of Bacchus) which an ingenious man had copied for me after Titian; behold (cried Damon) abruptly, the Subject of our Quarrel! and turning towards Pamphilus, this I hope will please you, said he, since you are such a Lover of fine Colouring.

It is true, said Pamphilus, I am sensibly touch'd with the Beauties I see in that Picture, and am heartly vex'd that the generality of Painters will not so much as endeavour to discover them, in order to practise them.

May I be the judge of your difference, interrupted I, pray what is your Quarrel?

We just now left the Academy, reply'd Pamphilus, and in our way hither, Damon and I entertain'd our selves with what had pass'd at the Conference.

I presently thought, since my Picture of Titian was the occasion of reviving the Dispute, that the Academy had been treating of *Colouring*. I desir'd 'em to impart to me what they had heard in that Conference (which they readily granted) and to engage 'em to it the more, I kept them to Sup with me; in the mean while we went through all the Curiosities that had been sent me. At Table we talk'd of nothing but News, but drawing afterwards nearer the Fire, I put 'em in mind of their Promise; Damon said, that in order to let me into the whole thing, and to give me the more Pleasure, he wou'd take it from the beginning and wou'd do it by way of Dialogue; that Pamphilus, if he pleas'd, shou'd be the Respondent; and he himself wou'd make what Objections he cou'd think of against the Merit of *Colouring*, which had been the Subject of the Conference in the Academy (for Pamphilus you must know was an

extreme Lover of that part of Painting). I signify'd my Thoughts that it would be the best way in the World and Pamphilus yielding to it, Damon with his Eye on him began thus.

Pray, says he, let me first of all ask you, what it is you call *Colouring*?

It is, answers Pamphilus, a part of Painting by which the Painter knows how to imitate the Colour of all natural Objects, and to give to artificial ones that Colour which is the most advantageous to 'em for deceiving the Sight.

And pray what do you call *Colour*? proceeds Damon.

To answer you like a Painter, says Pamphilus, and to let alone any Philosophical Disputes, namely, whether it be any thing real, or whether it be only the Refraction of Light with the Modification of the Body coloured: I say, *Colour* is what renders the Object sensible to Sight. Now as painters are to consider two sorts of Objects, the Natural or that which is true, and the Artificial or that which is painted; they ought likewise to consider two sorts of Colours, the Natural and the Artificial. The Natural Colour is that which renders actually visible to us all the Objects which are in Nature; and the Artificial is the Materials which Painters make use of to imitate those Objects: And in this sense we may call those artificial Colours which are on the Painter's Palette, since it is only by the Artifice of their Mixture, that the Colour of Natural Objects can be imitated. A Painter ought to have a perfect Knowledge of these two sorts of Colours; the Natural, that he may know what he is to imitate; and the Artificial to make a Composition and a Teint capable of perfectly representing the natural Colour. He shou'd likewise know that in the Natural Colour there is the true Colour of the Object, the reflected Colour, and the Colour of the Light: And among the artificial Colours he ought to know those which have a Friendship together (if I may so say) and those which have an Antipathy; he shou'd know the value of 'em separately, as also comparatively with each other.

But what signifies it to know this Friendship and this Antipathy of Colours, reply'd Damon, since all that is to be done, is, by the mixture of artificial Colours, to imitate those that are natural to the Object before us.

Nature, replied Pamphilus, is not always fit to imitate; a Painter must chuse her according to the Rules of his Art, and if he does not find her such as he expects, he must correct what is before him. And as the (*Designer* or *Drawer*) does not imitate all he sees in a faulty Model, but on the contrary, in the Proportions and the Colours where he finds it most convenient, he alters the Faults he meets with: So the *Painter* should not imitate all the Colours that present themselves indifferently; he ought only to chuse those he likes, to which (if he thinks fit) he adds others that may produce such an effect as he fancies, for the Beauty of his Work; he not only endeavours to render every particular Object Beautiful, Natural and True, but he likewise studies the Union of all together; sometimes he takes from the Vivacity of Nature, and at other time she adds to the Lustre and Strength of the Colours he meets with.

But what will you say, cried Pamphilus, if I shall prove, that this Strength and Vivacity you speak of, tend only to the more perfect imitating of Nature? and that the Pieces where this is wanting, are weak and penurious. To be satisfied therefore of this, you must consider, that a Picture is a flat Superficies, That the Colours cease to have their first Freshness some time after they are laid on; and lastly, That the Distance of the Picture causes it to lose some of its Lustre and Strength; and that

therefore it is impossible to supply these three things without Artifice. A good *Painter* ought not to be a Slave to Nature; he ought to be her Arbiter and judicious Imitator; and provided a Picture has its Effect and imposes agreeably on the Eye, it is all that can be expected of it.

I see, said Damon, you wou'd have a *Painter* let nothing escape him that is for the farther Advantage of his Art.

Most certainly, replied Pamphilus, and you are very sensible a Picture cannot be perfect if one of the parts of a Painting be wanting; and that a Painter is not a Master of his Art if he is ignorant of any one of the Parts which compose it, I should therefore as soon blame a Painter for neglecting the *Colouring*, as for not *Disposing* his Figures so advantageously as he might have done, or for *Drawing* them ill.

It is certain, replied Damon, that a Work is never perfect, so long as there is any thing wanting; but you will have the *Colouring* to be as necessary a part of Painting as the *Drawing*?

Why not, says Pamphilus, do you not know that you destroy the whole if you take away a part, especially a part that is so essential to its Whole, as is that of Colouring to the Art of Painting?

If I apprehend you right, replied Damon, you mean that all Objects falling under the Sight no otherwise than by the Colour, and being distinguish'd from each other only by that, they ought to be imitated in their Colour as well as in their exterior form: and I grant you that. But what will you say when I shall show you some Pictures of Polydore de Caravage, which are reckoned some very excellent Pieces of Painting, though they are only painted in one and the same Colour, in *claro-obscuro*? (black and white.)

It is true, said Pamphilus, those are very fine Pieces; but it is as true, that they are no true Works of Painting, and are very far from deceiving the Sight: For you your self grant, that to imitate Nature, we ought to imitate her as she appears to us, and that she appears to us no otherwise than under the semblances of Colour.

But, proceeds Damon, though a Piece be but of one and the same Colour, yet if the Lights and Shades are so well manag'd as to look like a piece of Sculpture, what will you say then?

I shall say then that there is nothing wanting, reply'd Pamphilus, but it is a true Piece of Painting; since in the Design and Colour it will imitate a work of Sculpture which you suppose. The Beauty of Colouring does not consist in a multiplicity of different Colours, but in their just distribution, so that the painted Objects have the same colour as the true; a painted Stone for example to resemble a natural one; Carnation to appear true Flesh; and in a word, that not only each particular Object do perfectly present the Colour of those it imitates; but that they altogether make an agreeable Union throughout the whole Piece.

Since we are upon Works of *Claro-obscuro*, interrupted Damon, pray tell me under what part of Painting do you comprehend the knowledge of Light and Shades?

Under *Colouring*, reply'd Pamphilus, since in Nature, Light and Colour are inseparable; since whenever there is Light there is Colour; and wherever you find Colour, you will likewise there find Light. Thus *Colouring* comprehends two things; the local *Colour*, and the *Claro-obscuro*. The local Colour is that which is natural to each Object, and which the Painter ought to improve by comparison; and the

knowledge of this comprehends likewise the knowledge of the Nature of Colours; that is to say, their Union and their Antipathy.

The *Claro-obscuro* is the Art of distributing, to advantage, the Lights and Shades, not only upon the particular Objects, but likewise upon the general Picture. This Artifice, which but few Painters have been Masters of, is the most powerful means of setting off the local Colours, and the whole Composition of a Picture.

* * *

I imagin'd, proceeds Damon, that the *Colouring* was in Painting no more than an *Integrating* part, (as the Philosophers speak) which renders the whole more entire and perfect: Just as we consider an Arm or a Leg, or any other Part, without which a Man is still a Man, tho' less entire and less perfect, and thus, without the *Colouring* a Picture does not cease to be a Work of Painting, though a less perfect one.

I see, says Pamphilus, you have never consider'd what Painting is, and are ignorant of its Definition. *An Art, which by the means of exterior Form and Colours imitates upon a flat Superficies, all the Objects that fall under the Sense of Seeing.* This, in my Opinion, is a just Definition, since it gives a perfect Idea of Painting, and distinguishes it from all other Arts.

I confess, said Damon, I never well consider'd it.

Now if you mind, said Pamphilus, you will see that the Colouring is not only an essential part of Painting, but is likewise its *Difference*; and consequently the part that makes the Painter; as *Reason*, which is the difference of Man, is what makes Man.

And what will become of Drawing, reply'd Damon?

Drawing, answers Pamphilus, still holds its Place, since it is an essential part of Painting, without which Painting cannot subsist, any more than *Colouring*.

In short, says Damon, you would have *Drawing* to be the *Genus* of Painting, and *Colouring* to be its *Difference*?

Right, said Pamphilus; for the Genus, you know, communicates itself to several Species, and for that Reason is less noble than the *Difference*, which is a prerogative proper to its single Species; and thus the Degree of *Animal*, which is the genus of Man, communicates it self indifferently to Man and Beast, and the Degree of *Rational*, which is the *Difference* of Man, is communicated to Man only.

To what other arts, reply'd Damon, would you have *Drawing*, to communicate itself?

To Carving, replies Pamphilus, to Graving, to Architecture, and to other Arts which give Measure and Proportion.

But the *Design* of a Sculptor, reply'd Damon is not the same as that of a Painter; for the one is *Geometrical* and the other *Perspective*.

I answer you first, said Pamphilus, that the different manner of Communication does not hinder the thing from communicating. Secondly, it is certain, that the Design of the Sculptor and Painter is the same essentially; that both are founded on certain Proportions; and what is in Perspective may be measur'd like what is Geometrical: And lastly, it is manifest, that Sculptors make use of Perspective in their *Basso relievos* as Painters do in their Pictures.

I agree, said Damon, that Designing is communicated to several sorts of Arts but may it not be said, that Colour likewise communicates itself in the same manner, and that Tapistry-makers and Dyers use it as well as Painters?

As for Tapistry work, reply'd Pamphilus, I don't think it differs from that of Painting; Tapistry-makers, like Painters, represent the Colours and Forms, which are in Nature. Their Colours are fix'd in the Wooll, as the Painters Colours are in the Clay or Minerals, which they make use of; and this Difference of Materials, you know, is never essential. As for the Objection of Dyers, you might have spar'd that, and not have brought Dyers into the same Question with Painters; however, you shall be answer'd. Dyers, it is true, understand something of *Colours*, but not of *Colouring*, which is now under debate. That part of Painting which is call'd *Colouring*, goes often by the name of *Colour*; 'tis commonly us'd so; and this Ambiguity occasion'd your making the Objection concerning the Dyers; and yet there is a great deal of difference between *Colour* and *Colouring*; and I have shewn you, that *Colouring* is not, either White, or Black, or Yellow or Blue, or any such like Colour; but the *understanding* of these same Colours, which the Painter makes use of, to imitate natural Objects, and this Understanding the Dyers have not.

However, reply'd Damon, you must grant me, that *Drawing* is the Foundation of *Colouring*; that it supports it, that Colouring depends upon it; whereas it does not depend upon Colouring, since *Drawing* may subsist without *Colouring*, but *Colouring* cannot without *Drawing*

Supposing all this to be so, says, Pamphilus, what would you infer from it?

That *Drawing*, reply'd Damon, is more necessary, more considerable, and more noble than *Colouring*?

You are not aware, continued Pamphilus, that whatever you think you have been saying in Favour of Drawing, concludes nothing to its Advantage, in prejudice of *Colouring*. On the contrary, you thereby shew, that *Drawing* alone is something imperfect with respect to *Painting*, for though Drawing is the Foundation of *Colouring* and subsists before it; yet it does so, only that it may receive its whole Perfection from it: Nor is it surprizing, that the *Receiver* should have its Being and subsist before what is *Received*. It is the same with all *Matter*, which is to be Dispos'd, before it receives its Perfection from substantial Forms. The Body of Man, for Example, ought to be entirely form'd and organiz'd before the Soul be receiv'd into it. And in this Method it was that God make the first Man; He took Earth, he form'd a Body of it, he endu'd it with all the necessary Dispositions, then he created the Soul, which he infus'd therein for the perfecting of it and with it MAN.

* * *

But pray, continu'd I, what do you take to be the reason for the Indifference the Generality of Painters have for fine Colouring?

It proceeds in my Opinion from several Causes, said Pamphilus. I have already told you that it is not common for Men to esteem a thing or to have it at Heart, when they do not understand it, and there are but few Painters who understand this Part of Painting. One wou'd think to hear you talk, cry'd I, that Colouring was a very difficult thing.

More difficult than you imagine, said he to me; and all I have to say to you on this Subject is, that for near three Hundred Years since Painting was reviv'd, we can hardly reckon six Painters that have been good Colourists; where as we may reckon up at least thirty who have been very good Draughtsmen. The Reason is, because Drawing has Rules founded upon proportion, upon Anatomy, and upon a continual

Experience of the same thing; whereas Colouring has not yet any well known Rules: and the *Experience* that is made in it, being almost always different, because of the different Subjects that are handled, cou'd never yet be able to establish any very certain and precise Rules for it.

What, replies Damon, has Colouring no Rules?

I do not say so, answers Pamphilus, but only that they are not very much known.

Do you think, continued Damon, that Titian and other good Colourists did not understand these Rules?

I believe, said Pamphilus, that they knew the best part of them; but Giorgion, Titian, Rubens and Vandike, more than the others.

Nay, said Damon, what they have left us are so many publick Books, which may serve for the Instruction of all Painters, who need do no more than examine their Works well, copy them for some considerable Time, and make such Remarks thereupon, as may be thought necessary for their own Improvement.

That is not all, replied Pamphilus; a great many Painters have done what you speak of without any success.

Pray then, reply'd Damon, let us know which way wou'd you have them go to Work?

In the manner you prescribe, said Pamphilus: But besides that, they must have a Turn of Mind to make Advantage of every thing, to observe nothing but what is worth Observation, and to penetrate into the true Causes of those Effects that are admir'd. You said very well, that those great Mens Works were Books which contain'd the Precepts of Colouring. But do you not know, that all sorts of Persons are not capable of understanding all Books and improving by them, especially such difficult Books as those are? There are Painters who have copied Titian for many Years together, who have examin'd him with Care, and made all the Reflections they were capable of; and yet, not having made those they shou'd have done, they have never comprehended him, and therefore it is that the Copies which they made with all the Care that was possible, and which they fancy'd to be with very great Exactness, are still very short of the Conduct that is visible in the Originals.

Was not Poussin, said I, such a one? Speak ingeniously; for tho' he copied the Works of Titian, so much as he did, his own have not much of him.

Now you mention a Man, replyed Pamphilus, whose memory will ever be dear to Posterity. He was so Perfect a Master of Draught; he handled his Subjects so learnedly; in short, he knew so many other necessary parts of Painting, that he may be well forgiven if the Pains he took in searching after fine Colouring did not succeed with him.

You own then, reply'd Damon, he did not comprehend the Artifice which is in Titian's Pieces?

Most certainly, said Pamphilus, and the greatest part of his Works confirm it.

It is very certain, that after he had copyed Titian's Works, his own had something of 'em, but then it was only superficial and if he had really comprehended the Maxims, the Finesses and Delicacies of Titian, he would have made Advantage of them; he had too much good Sense not to have done it. The same Spirit which made

him conceive the Beauties of Titian's Works, in so much as to bend himself strenuously to copy them for the sake of the *Colouring*, I say, this same Spirit, far from making him depart from it, wou'd have caused him diligently to have cultivated it, had he penetrated into that part; and his last Pieces, which are the weakest in point of Colour, wou'd have been the strongest.

* * *

You abandon your Friend Rubens, I see, interrupted Damon. Are you fallen out with him since I heard you so much extol his Works?

I was just going to speak of him when you interrupted me, said Pamphilus, tho' I have nothing to add to what I have said of him heretofore. I shall only say, since we are fallen upon the Subject, that the best Counsel I can give a Painter (if I were capable of giving him any) shou'd be once a Week for the Space of a Year to visit the Gallery of the Luxembourg, to lay all things else aside, and to spare nothing for that purpose. That day wou'd be undoubtedly the best spent of any in the Week. Rubens is methinks the Man of all Painters who has made the Road to Colouring more easy and clear of Incumbrances; and the Work I speak of, is the *friendly hand* to deliver the Painter from the Shipwreck wherein he may be innocently engag'd.

And ought to be added to the *Regimen*, said Damon smiling. I know well enough, continued he, that Rubens is one of your Hero's in Painting, and that you have always esteem'd the Gallery of Luxembourg as one of the finest Things in *Europe*, if we except (you'll say) the Manner of the Design, in many Places. But every body has not your Palate, and those who are of a contrary Opinion, say that there is but little Truth in Rubens's Works when narrowly examin'd, that the Colours and Lights are exaggerated, that they are only Specious [*que ce n'est qu'un fard*], and in short that it is not as Nature is commonly seen.

Specious! [*O le beau fard!*] cry'd Pamphilus, wou'd to God, Friend Damon, the Pictures that are drawn now-a-days were *So Specious*! Are you ignorant that Painting is nothing but *Speciousness* [*que la Peinture n'est qu'un fard*], that it is its Essence to deceive, and the greatest Deceiver in that Art is the greatest Painter. Nature is of herself ungrateful, and he that aims at copying her simply as she is, and without Artifice, shall always produce something poor and of a very mean manner. What you call Exaggeration in the Colours and Lights, is an Act of wonderful Ingenuity which represents the painted Objects truer (if one may so say) than the true ones themselves. And thus the Pictures of *Rubens* are more beautiful than Nature herself, who seems to be nothing but a Copy of that great Man's Works. And tho' the things after a narrow Examination shou'd not be as exact, as you suppose, what matters it, provided they *appear* so; since the End of Painting is not so much to convince the mind as to cheat the Eye [*tromper les yeux*].

This Artifice, says Damon, I think marvellous in great Works.

And in those too, reply'd Pamphilus; wherein it is apparent *Rubens* has made it more sensible to such as have a Capacity to attend to it and examine it; for to Persons who have but little Skill therein, nothing is more hidden to them than Artifice.

11 Jusepe Martinez (1600–1682) from *Practical Discourse on the Most Noble Art of Painting*

Martinez was a Spanish painter and engraver whose father had been an artist before him. In his twenties he spent time in Italy, visiting Rome and Naples, meeting contemporary artists, studying the Antique, and generally assimilating the classical values of harmony, balance and strong pictorial structure. From the 1630s he was based in Madrid, where he was on friendly terms with Velázquez, and also made the acquaintance of Francisco Pacheco (see IA3). In 1643 he was appointed a court painter and tutor to the king's son. Martinez's surviving works are almost exclusively of religious subjects. In the last decade of his life he seems to have abandoned painting and turned to writing. His *Discursos practicabiles del nobilisimo arte de la pintura* was complete by the mid-1670s, but remained unpublished until 1866. The text combines theoretical reflections on painting with an account of the artist's travels in Italy and Spain. In the following extracts Martinez discusses the need for an overarching pictorial unity, and the need to control colour so that it does not disrupt this fundamental unity. He then goes on to discuss what is required for a proper understanding of art, making the case that pictorial art requires more than either abstract knowledge or craft skill. The book's claim on our attention resides in its unique status as a synthesis of the work of mind and hand alike. The extracts from Martinez's Chapters VI 'Concerning Unison', VII 'Concerning Colour', and XIV 'Concerning the Science and Wisdom of the Painter', were translated by Nicholas Walker from J. Gallego ed., *Discursos practicabiles del nobilisimo arte de la pintura*, Barcelona: Selecciones Bibliófilas, 1950, pp. 86–91, 134–8.

Chapter VI. Concerning Unison

Unison is a necessary requirement without which the work will be lacking in harmony and will not look well. This definition is accepted in music where several voices, no matter how excellent they are, will prove dissonant if they are lacking in harmony and fail to submit to the direction of the choir master. By disposing everyone in his proper place, he will obtain a harmony so sweet and delicate that it will leave the ear in suspense and will produce a unison in which each voice can be distinguished. From this we may conclude that without submitting to the master everything would fall into outrageous confusion. The careful painter will proceed in precisely the same manner in his sketches and models and, in order to find such unison and effect it properly, he will do it first of all in black and white. Thus, in light and dark, the artist will clearly and distinctly perceive the unison which his pictorial subject possesses. For if he uses colour even in his preliminary sketches, he will easily fall into confusion. It may transpire that the artist, enamoured of the beauty of the colours, will fail to distribute light and shade with absolute sureness. I have seen how this can happen to the most experienced masters when they have to produce a work of great importance and difficulty.

As an example of this doctrine, the student is well advised to study the engraving of the finest masters. These will provide sufficient instruction, although certain visionaries and conceited people, ignoring all truth, have condemned this way of studying. It is quite clear that the example set by the ancients has been a cause of the

progress of the moderns. Thus, without beholding the works of the ancients, the moderns would remain in complete ignorance. Therefore every student should be prepared to submit to his teacher, and one who fails to do so can never prove a good pupil. But through obeying this rule, he will avoid disappointment and will quickly benefit from the instruction received.

Chapter VII. Concerning Colour

The colours of a painting are to the eye what the strings of a musical instrument are to the ear. Therefore unison or unity, through which a design becomes harmonious, must be accomplished with moderation as far as colours are concerned lest their vivacity cause them to clash one with another. The student must therefore be warned that there is only one given perfect light and colour for a religious or historical painting. This light and colour will only be found in the principal figures or in the foreground since the other figures, insofar as they recede into the background, according to the space they occupy, will have less and less thereof. Many artists in the desire to enrich and ennoble their works have simply made them ostentatious in colour rather than producing fine examples of art and study, and caused the various figures to clash agaisnt one another. Even if the latter were properly disposed and in correct proportion, the painting will win small praise if the artist neglects this harmony in the colours.

The proper choice of colour is an extremely difficult task and is not easily accomplished, even under the instruction of a master, unless the student's natural talent assists him. It is nonetheless true that study and practice go to make up half the talent. All the best masters have attempted in their works to follow what is most beautiful. As I have remarked before, we can see this, for example, in Titian, from whose school all the other colourists have hailed. I mention this example by way of introduction. Many artists have proceeded according to different methods and have produced very splendid works as long as they followed their own natural talents and always fixed their eyes on beauty. But the student should specifically be warned against changing his style lest he fall into confusion. This can happen even with great talents, merely leaving them indecisive and only multiplying their labours. He is fortunate indeed who finds a practical and direct master, handling the brush naturally and without constraint. Such a simple and direct approach will encourage a certain dexterity which is not merely agreeable to behold in itself but also conceals the toil involved and renders the paintings beautiful. But the student should always try and follow his natural inclination so that talent and art may succour one another.

Let us now discuss the question of the appropriate location for a painting. It is necessary to find a place of sufficient illumination in which the vigour and force of the relief will be revealed to advantage. I have seen far too many paintings prove unsuccessful here for failure to heed this warning and to consider the distances required. On the other hand, fresco paintings generally achieve the required perfection precisely because they are executed in their actual location. The student should keep this warning in mind lest he share the experience of many experienced masters whose paintings, though perfect in themselves, did not possess or at least reveal the third part of their intrinsic quality once they had been put in place. It follows that it is

necessary to employ scaffolding as a convenient means of overcoming lack of familiarity with the destined location of the work. If painters were better acquainted with this important consideration, they would not object to this procedure, whatever amount of work may be involved thereby. Scaffolds deserve much credit though it is very seldom given.

In conclusion allow me to cite an incident which occurred with a most prudent master. He was commissioned to produce a number of oil paintings for a very ostentatious chapel and set about the work with much study and care. After producing the paintings to the satisfaction of connoisseurs he brought the works to the church where the chapel was located. His patron arrived and looked at the pictures very briefly. The painter, who was there at the time, asked him how he liked the paintings and received the answer: 'Sir, I never expected from your hands such poor and unfinished work since these are nothing but crude sketches. Please bring them to that degree of perfection that I had expected.' To this the ingenious painter replied: 'The work is not finished, and I cannot be accused until the paintings stand in place. If you would kindly give me the key to the chapel, I shall finish these paintings by myself to the perfection you demand.' He had a wooden enclosure constructed with its own key and door, without any aperture through which he might be observed. After a month, and once the paintings were in place, he invited his patron to visit. When the latter entered and saw the excellent paintings in place he was much amazed to behold such great improvements in so short a space of time. The master's pupils laughed very much because they knew full well that he had not performed the slightest retouching of the pictures. This may teach the student not to show his works or declare them finished until he has seen them in their proper place.

Regarding the application of colour, there are many ways of proceeding. Some artists paint their work in a single approach, finishing them all at once, while others apply a heavy impasto and finish the work with very careful retouching afterwards. Others again make very sure of their design right from the first sketch on the canvas, then apply the pigment very delicately and retouch the work where necessary. This last method is the one that is observed by most masters. It is a matter of no less importance for the student to possess the spirit and desire to bestow impressive greatness upon his works, for there are some ignorant minds who have held the small and delicate aspects of painting in much higher esteem than this. But those so minded will never succeed in accomplishing great works executed in the proper manner. And I have a perfect example of this principle in mind; a great lord commissioned two pictures of the same kind which he then had brought to his palace. He placed both pictures in a position with good light. One picture was twelve hands in height and nine in width, whereas the other was not even a quarter of the size. The great lord was very knowledgeable and experienced in the field of art, having beheld an abundance of works by the more important artists. Three other nobles were present on this occasion and, being eager to learn which was the most excellent and skilful of the two pictures, they asked the lord for his opinion. The latter replied with his customary sagacity: 'They have both been deftly executed, but with this difference – that the great nevertheless always remains great.'

This example may inspire the learner artist to accomplish his works with great esteem, hoping that they may indeed occupy very public sites, like the sumptuous

temples and palaces adorned with terraces and objects of great size, with great pictures that can be appreciated and enjoyed from some considerable distance. The smaller objects placed alongside these greater ones strike us as poor and mean by contrast, even if they have been executed with the same skill and boldness as the former. Thus it is that the prudent master keeps these latter things for his smaller rooms and chambers, his chapels and his lesser sites and places. But let it not be thought that what I have said about such small things here implies little regard for this kind of work, for I do indeed value and venerate the same as is only right. I say simply that the great is always great.

Chapter XIV. Concerning the Science and Wisdom of the Painter

[. . .] There are three ways of comprehending art. The first involves the concrete knowledge of art, the second involves the techniques and practices of art, and the third involves the foundation of art, the very root and origin of all our other knowledge and understanding of the subject. A general knowledge of art is possessed by many who feel a natural inclination towards this profession and, enchanted by the beauty of the same, acquire further knowledge through practice under the guidance of learned masters, having sought them out and studied with them precisely on account of the difficulties that arise in such fields. In this way they obtain a certain knowledge which could indeed be perfected by understanding if they continued in regular instruction, but which remains merely a worthy desire as long as the substance of that knowledge is not actually put to work. Their own judgement thus remains a matter of fantasy that is lacking in firm foundations, that is incapable of properly distinguishing between a good thing and something better or quite unique and evaluating it accordingly. Such judgement involves nothing more than the recognition of what is good or bad in general and, lacking any deeper reflection, remains content with the simple knowledge it already possesses. The second way of comprehending art, the practical one, is more advanced than the former. It is acquired in the actual production of art in the following way. The practitioner learns this art mechanically, as one might almost say. They proceed by copying and imitating what they see without any greater understanding than is required by the exercise of memory. Let us supply an example: a great orator delivers an excellent speech with all the fundamental means of admirable rhetoric. Now let it be repeated by someone else who fails to understand the content of the speech: he will never be able to perform it with the like degree of vivacity or intelligence as the orator who first delivered the speech. For to read is not the same as to feel what one reads.

The third kind of understanding, which constitutes the very foundation of art, consists in making oneself fully conversant with the nature of symmetry, of anatomy, of the outline and contours of the body. To proceed surely and confidently with regard to perspective, to secure the appropriate disposition of figures and ensure that each occupies its proper place and setting, to realize the particulars of the story depicted in a wholly unified fashion, lending them the requisite degree of illumination and paying careful attention to the intended location of the painting and the point from which it will be viewed: all of this constitutes the perfect understanding and proper foundation that is required in order to exercise sound judgement with

respect to a given work, however complex and difficult the latter may be, and to set about its practical realization on the basis of this knowledge.

I have been prompted to supply these indications by observing the vanity of many who have attempted to produce art and promulgate precepts on the basis of their own imaginings. But it is a manifest and most pernicious deceit to violate the truth in such a fashion, to turn art into a manual skill, to measure without the use of the compass, to look without seeing, to judge and labour without the exercise of reason. All corporeal things that live were fashioned by God with due foresight and proper measure, so that one may neither add nor omit anything that would disfigure the same. We have many examples close to hand. Simply consider a horse, a man, a bull, a lion, or any of the other animals: if they did not possess different forms, symmetries and features, they could never be distinguished one from another. In order to represent these forms with perfection art must enter the lists, and must provide the proper measure that the depiction may be perfect and he who beholds it satisfied. By working with imagination alone, on the other hand, the artist would produce a horse instead of a man, and devoid of the proper parts and features required. In saying this it is by no means my intention to encourage the artist to prepare himself for painting by literally taking up the compass and so forth, for that is a tiresome and tedious approach injurious to the matter. The artist must simply ensure that when he sets to work, the results will appear free and spontaneous instead of forced.

Turning now to those who have no desire to undertake such work themselves, but rather wish to recognize the equality, the artistic character and the perfection of a picture when they behold it, we shall now enumerate, in order to assist them, the parts that are most essential to such perfection. A perfect picture or story, then, must exhibit a certain majestic fullness together with various effects of light and shade that should not disturb our gaze. The principal figures should display the requisite gravity, respect and decorum, each performing his particular function with no suggestion of ambiguity as regards the significance of the action. One should also be able to recognize the figures distinctly set off one from another, all of which should occupy their proper places in accordance with the overall disposition so that even if a multitude is involved the figures neither obstruct nor distract from one another. One must ensure that everything is uniformly combined with respect to colour and artistic finish, presenting thus a unity in which no single part predominates over another. For nothing is more conspicuous than when the various parts of a picture fail to cohere with one another, than where some things stand out over against others and disrupt the overall unity, however excellent these things may be in themselves. If this counsel is heeded, then the general harmonious effect will be esteemed more highly than any dissonance, even if certain things in the painting have been depicted with greater attention and accomplished perfection than others. For this is what unity consists in. It can easily be seen even from good paintings which have committed and continue to commit this fault that our eyes naturally delight in the contemplation of things depicted with the greatest fidelity and fail to take to notice the other ones that are also good in themselves. Many artists have availed themselves of the forms of brocade, books, drinking glasses, grasses and flowers of one kind or another, as observed in their natural state of stillness. These give the painter the time he desires and requires since they neither change nor move. Thus the artist succeeds here with

greater patience and productivity and produces works of greater perfection as a result. It is quite another matter with living things which cannot long remain unchanged in state. For the latter a very different kind of study and facility is required.

12 Felix da Costa (1639–1712) from *The Antiquity of the Art of Painting*

Felix da Costa was a Portuguese painter, one of a family of painters, whose father was also an artist. The history of Portuguese art in the period is relatively little known in the English-speaking world, indeed none of da Costa's paintings appears to have survived. Nonetheless, it seems likely that the father had published a Portuguese edition of Dürer's theory of art, that one of his artist sons worked in Paris, and that Felix was in England in the early 1660s (in connection with the marriage of Catherine of Braganza to Charles II). The second half of the seventeenth century was a time of economic depression in Portugal, and the arts languished as a consequence. One of the principal motivations for da Costa's text was to right this situation through the institution of a Royal Academy. He was working on the *Antiguidade da arte da pintura* in the late 1680s, and directed his report to the Portuguese Council of State in 1696 via his patron, the Count of Villarmaior. Da Costa's first line of argument was to establish the credentials of painting as a liberal art, and the painter as a multi-talented intellectual. To this end he began at the top, with the claim that the first artist was God himself. He went on to draw on many sources, notably classical, biblical and Italian sixteenth-century theorists, for a division of art into three 'parts': invention, design and colour. He also took a considerable amount from Vicente Carducho's *Dialogos de la Pintura* which were published in Madrid in 1633. Da Costa's argument was far from merely academic however, including as it did a criticism of the continuing artisanal status of painting in Portugal and an enumeration of the benefits that would accrue to national commerce from the thriving practice of art. But the plea fell on deaf ears. A Portuguese Academy did not materialize until the nineteenth century, and, apart from some fragments which appeared in 1823, Da Costa's report remained unpublished until the 1960s when it was revived by art historians at Yale University. Our selections highlight Da Costa's claim for art's elevated status as well as its practical benefits. They are taken from *The Antiquity of the Art of Painting*, researched and introduced by George Kubler, translated into English by Kubler, George L. Hersey, Robert F. Thompson, Nancy G. Thompson and Catherine Wilkinson, New Haven and London: Yale University Press, 1967, pp. 379–82, 392, 426–30.

In order to set forth the excellence of painting it is fitting to tell of its beginnings and early development. Its Author was the Lord our God Himself, who in the act of creating the first man performed a most outstanding work of divine omnipotence with his own hands.

There are three principal parts to painting: invention, design, and color. Invention includes all considerations of placing the work in the mind by means of representation: such as the adjustment of the perspective plane to fit the subject, the placement of the figures, the posture of each body, and the concordance of the whole. Design includes the execution of all this when it has been thought out in the mind. It also includes the correctness of outlines, the proper anatomy and symmetry of bodies, the proportioning of every part to the whole, and the rules of architecture and

perspective with its diminutions. Color consists of the various hues and their shadow tones in chiaroscuro, their arrangement, and their relative brightness. When these three parts are all put together they reveal the intellectual intent, as well as the skill of the painter.

Painting is the likeness and image of all that is seen, as we see it. It is composed of lines and colors on a flat plane, imitating depth by the disposition of lines and shadows. And it is called painting whether it be executed with pencil, charcoal, wash, or any other medium that represents objects in relief.

This is Socrates' definition: *pictura est imitatio, et representatio eorum quae videntur.* ['Painting is the imitation and representation of that which is seen']. The Greeks called it Zoography, from *graphi* which means to write, and *zoy*, life. Thus it means living writing. Sculpture is included under painting because the rules and preparation are the same. Thus artists should learn one another's methods: the painter, when he paints, ought to consider the sculptor's relief; and the sculptor, when he models, should consider the finish of the painter. The two are actually equivalent when it is a question of sculpture in low relief.

The Lord God created the first man with a body and a soul. Its form and proportion come from clay. The muscles and bones come from blood, choler, phlegm, and melancholy; and He filled his creature with life by making him a soul, a memory, an understanding, and a will.

The painter is the imitator of this divine omnipotence, since when he paints the human figure he creates a body and then instills life into it. He must, however, portray it as mute, giving a soul to his figure by showing its actions. He provides it with flesh by making blood, out of vermilion; with choler, by adding a pale color; with phlegm, by adding white; and with melancholy, by blackening the shadows. When these four colors have been blended, the figure becomes lifelike, and earthly matter has been inspired to life by art.

Thus the Sovereign Artificer taught men how to paint. [1] *Faciamus hominem ad imaginem et similitudinem nostram,* [2] *praesit piscibus maris, et volatilibus coeli, et bestiis terrae, universaeque creaturae terrae, omnique reptili quod movetur in terra.* [Genesis 1]

[1] 'Let us therefore make men in our Likeness.' Thus our Lord wished the painter to make use of intelligence by conceiving in his mind the form the human figure must have, in all its postures, at all ages, with the coldness or warmth appropriate to its years, strong or weak, timid or angry, just or unjust, selfish or loving, happy or sad, proud or humble, as well as other characteristics – for example the kind of clothing, or lack of it, required by different climates, rites, and customs.

These aspects are those of which the portrayal most fatigues the mind, and with which the artist's skill is most concerned. Both sacred and profane subjects come to realization by means of geometry, perspective, anatomy, symmetry, physiognomy, architecture, and philosophy. The last requires the most thought. It is first of all concerned with the Idea, that is, internal intellectual drawing. From this proceeds external drawing, which is the actual execution adjusted to the imagination, set in order for discourse, and refined by the artist's skill.

[2] 'And he had dominion over the fish of the sea, and over the fowl of the air, and over the cattle, and over all the earth, and over every creeping thing that creepeth upon the earth.'

The human body is the most important subject to which the artist can devote his skill, and he must be well aware of the character of muscles and bones, and of their movements, making every other object subordinate to the rule of the human body. This is also the most important kind of drawing. Once it is understood, all other kinds become easy. Here, and here alone, is the perfection of painting to be found. Here the artist must command drawing to represent everything by the interplay of feelings, and by varying the play of muscles to accord with the movements of the bodies.

'So God created man in his own image.' By the baser image we may approach the greater archetype, the Divine Painter. For this reason the painter always seeks perfection. It contains the justest and most accurate proportion and symmetry; from it come beauty, delicacy, grace, and the exact proportions of bodily members: in sum, proportion and grace. These qualities, in turn, help the artist to express the mode of movement, the adjustment of the parts, the liveliness of the action and the play of muscles, the axis of the body, the stance of the feet, and the lights and shadows. So that the figures, though mute, may speak of their actions, and though not really alive, may seem to breathe and, at last, resemble their models.

Formavit igitur dominus deus hominem de limo terrae, et inspiravit in faciem eius spiraculum vitae, et factus est homo in animam viventem. [Genesis 2]

'The Lord God made man from the dust of the earth, and breathed into his face the breath of life, endowed him with a living soul.' The painter imitates his Creator with his colors made of earth, and human creatures are therefore derived from the same principle as the artist's figures. Also the painter models the relief of his subject upon a plane surface. In the same way God utilized the surface of the earth to form Adam. And God took these earth colors and substances, and by means of artistic skill created Adam, and filled him with life. Adam's body being formed of earth, received lights and shadows from its colors, and living spirit from its [Divine] Painter.

Plantaverat autem dominus paradisium voluntatis a principio. [Genesis 2] 'In the beginning the Lord God planted a delightful Paradise.' He made a forest or landscape, before He made man. The painter works in the same way, first creating the effect of receding space with the laws of perspective, and then placing man within its confines. Having made the field and forest of Eden He placed man within them: *in quo posuit hominem.* God created the earth and the sky, and trees, water, fish, birds, four-footed animals, and the greater part of the creatures on earth; and only after this did He create man and place him in Paradise. And when God had finished this, His handiwork, He made Adam. *Apellavit que Adam nominibus suis cuncta animantia.* 'And he called Adam by his name before all the animals,' and made him lord over them. This is what the painter intends and what he imitates. Having made the landscape he does not regard it as finished until its figures are all in place, having already studied by means of geometry and perspective, the diminution of distances, planes, and the foreshortening of bodies; and also the distribution of forms and colors. By means of anatomy he has studied the correctness of contours; by means of history he has studied appropriate expression, and through philosophy he knows about motives, while physiognomy tells him of the emotions. This latter quality is what gives soul to a picture and makes for figures that truly speak, and take precedence over all others.

* * *

The more the arts belong to intellect and understanding, the more decent and noble they are. What art can compete with the noble and spiritual one of painting, to which all branches of knowledge contribute? Without painting's discipline the other arts would be in extreme difficulties peculiar to them alone and found in no other field. Both kinds of philosophy are of use to painting: natural philosophy is altogether its proper subject, and philosophy no less, for knowledge of the affections, virtues, vices, and their expression in the appearances of the physiognomy, as the face is altered successively by joy, pain, effort, anger, fear, madness, and so on. And the study of anatomy is more proper to the artist than even to the doctor, for [the former] does not merely explain the subject, but must account for all its variations in the movement of the members and their actions, and everything that affects each subject according to age, sex, and estate, and according to its passions; whence the variations of drawing have no limits, and lie beyond understanding. Anatomy is accompanied by symmetry, or adjusted proportion, not only of human bodies, but also of beasts, and hence in every visible object, however its particular form or beauty be constituted.

To this added geometry, perspective, and architecture with all its skill, as equally necessary to the painter. Also all sacred and profane history belongs to him, not only to describe them as needed but also to explain with decorum the costumes, buildings, ornaments, customs, usages, and rites of all ages, kingdoms, and nations. Viewed thus, no knowledge is too recondite for at least some occasional use in painting. In painting no work is ever without perspective in the diminution of objects and their parts and members, which create foreshortening; and also in the quantity of the bodies, and in the strength of colors and the diminution of distances. A body of knowledge as immense and unusual as this need be learned only by the painter; and for this reason alone, the other arts must give painting precedence, and conclude that its results are truly miraculous.

* * *

The Most Christian King of France Louis XIV is devoted to painting as the whole world knows him to be. Witness his charter passed in the year 1663 for the purpose of establishing and fomenting the rents granted to the Royal Academy of painting in Paris. Among other things it says:

> We have considered that in order to make our Kingdom flourish more and the better to demonstrate the abundance and felicity of [the land] we cannot do anything better or more convenient than to cultivate the sciences and liberal arts, in keeping with the example set by the great kings who came before us: to honor those subjects whose [talents] surpass those of other men, with gifts, prizes, and public honors, so that these [awards] may incite others to emulation, by exerting themselves to become deserving of like honors. Among the fine arts there are none that are nobler than painting and sculpture. Both have always been held in great respect in our kingdom. To those who profess them we should like to bestow tokens of our special esteem. To this end in the year 1648 we established in our fair city of Paris a Royal Academy of painting and sculpture, to which we award special decrees and privileges augmented in the 21st year of our reign. LOUIS.

[. . .] To encourage art [the King] gave 4,000 pounds to the Royal Academy, as a public [institution] open to any person wishing to practice the art of drawing. The Prime Minister honors [this Academy] with his care, his protection, and with his visits always. The First Painter is rewarded most handsomely for his works, in addition to more than 12,000 pounds he receives annually as salary, as well as a house at the Gobelins factory where everything for the embellishment of the royal palace is kept, such as paintings, sculptures, wood carvings, tapestries, jewelry, and embroidery. There he designs, composes, and corrects everything that is done, all according to the invention and execution he chooses.

In Rome the same King has an Academy which sustains and gives [stipends] to thirteen French members, who study painting in the hope of future fame, at the font from which knowledge of the art of painting forever has flowed. At the beginning of their study, they practice diligently by copying the good works by excellent masters that are to be found in Rome, looking towards the double enrichment of their country by endowing it both with good pictures and good citizens. Some, already advanced in learning, return to their country, with others taking their places. Thus they receive for their art what it deserves in merit and honor for the hard work which its study requires.

This is why foreign nations possess greater advantage – not because of superior genius but rather because they are possessed of higher studies, finer honors, and greater rewards. These circumstances stimulate men to take on difficulties. One detects wisdom in man (as Aristotle points out) when he teaches himself fine works which stem from high custom. Many talents are squandered in Portugal for lack of that study, which alone can lead to due perfection.

[. . .] Many persons have a fine genius for painting and a large talent for invention; they can perform according to their natural gifts. But when [the painter's] judgment lacks acquaintance with the rules of art, he will fashion only its parts, but he will not achieve their happy unity, in the concordance between the part and the whole that produces them, [so that] all rests upon an equal level of perfection. And since he lacks this kind of awareness he lacks the knowledge to follow his natural gifts, and this is not acquired without a good deal of exercise. In addition [he should have] good intellect and a natural inclination towards an art founded upon [mastery] of the elements demanded in painting. Quintilian asserts that the arts have their origin in nature. What one needs to do is to search for the means by which to enable [art's] continuation, according to precepts and rules, in keeping with the saying of Apelles: *Nul[l]a dies sine linea* ['No day without a line']. Thus drawing and more drawing is the proper exercise of academies, whence come many remarkable and skillful men who, as draftsmen, are outstanding in all professions. Drawing is exceedingly necessary for painters, sculptors, and architects, for all three arts require much of it. It is a convenience to engineers, who use it to place figures in perspective, to show planes to foreshorten, to show fortresses as they appear to the eye, [as well as] mountains and adjoining valleys, and any town or city and whatever else the eyes can perceive. For only by means of the geometric plane can [one] comprehend the surface, which is made up of lines without relief or appearance of bodily substance. The plane remains hidden but it serves together with the view of a body when it is drawn, to show the object from within and without.

To gold- and silversmiths [drawing] is quite necessary, for it is a pity that jewelers are blinded by ignorance, admiring any sort of dross and subject that they see from the North. Drawing is like a light leading them obediently [out of] their ignorance. They imagine one cannot progress further for they do not know how to invent anything but cheap and tawdry things. Lacking an understanding of architecture, which they leave to the cabinetmaker's devices, they cast their silver without knowledge of what is being made for them. [Drawing] is essential to wood-carvers, for carving properly in relief, and so that they may invent altarpieces and other works with grace and skill. For they confuse the principle[s] of architecture, which are its order, with the members, such as moldings, Atlantios, seraphim, and children, lost in leaves and branches; which cover up [the wood-carver's] ignorance. Yet his ignorance remains apparent to those who understand [architecture], who strive for the essential and abhor the unnecessary.

[Drawing] is necessary for embroiderers also to gain true knowledge and to make embroideries [like those] of the ancients. [Otherwise], when they attempt figural designs they make them so formlessly that the work is more a discredit than an enhancement. Because they are ignorant of drawing, they need to consult painters for the realization and perfection of the work in designs they can follow.

For navigation, drawing is needed to make sea charts and maps of the earth. It is also useful to engravers for cutting the plate with the burin, as well as for the text figures and the frontispieces of books, as for coats of arms and emblems, poems, and initials and arabesques as well. It is intolerable to say that in this kingdom there is not one engraver whose work is not too deformed, ignorant, and clumsy to show abroad. Our engravers exert themselves only in marking the copper plate with the burin, wasting time, and taking money for monstrous things without form or art, and lacking, not talent, but drawing and instruction.

[Drawing helps] those who wish to be expert in penmanship, in calligraphy, and in the dexterous fashioning of letters. [Drawing aids] those who paint tiles and pottery so that they know what they are doing; for without drawing, no one can make [patterns], being unworthy of the name of painter of pottery. Those who design tapestries without a knowledge of painting can only imitate fault[s] not to look like repairs, which comes to the same thing. Those who enamel need drawing in order to color in light and dark with a sense of what they are about, and to paint what we see on watches and copperplates.

Cabinetmakers [need drawing] to make beds, buffets, counters and other well designed pieces. They should also be able to work out the designs and sketches by others, as well as to make good inventions and renderings of their own. Metalworkers in brass and tin also need drawing to make models and to repair gently with skill and care whatever comes to them. Lacemakers and seamstresses too [need drawing] to sew with imagination and grace by adapting and inventing clothes, and putting them right when they are shapeless, and making neat lace edgings on underwear, all evenly done and durable. There is no art or craft which in whole or in part does not depend upon the art of drawing. For it is impossible to preserve the commonwealth without it and a painter is always of service to any civilized court, as Pliny exactly said: *Pictorque res communis terrarum* ['The matter of painting is the whole world'].

The most useful and necessary kind of drawing represents the symmetry and anatomy of the human body. From this kind of drawing, as from a fountain, many streams arise and flow from high places to a variety of lower ones. The opposite case occurs in the imitation of leaves, which lack proportion, because no defect arises from their being higher or lower, shorter or longer, larger or smaller. Such is not the case with human figures which possess exact dimension in all their parts and varying degrees of grace in their movements.

Since the study [of drawing] is the same for everyone, like its instruction, as well, all who [profess it] will follow truth and will always be guided by good principles. Hence the possession of true understanding. The most inglorious and spirited students will gain sound knowledge and will become consummate [artists]. Even those who are not so active, nor possessed of such lively wit, if at least they labor, can learn how to imitate truth, though of course in an inferior way, not for the want of rules but because they lack genius, which, like grace, is a gift of nature. It is not acquired, but possessed only by those to whom Heaven imparted it at birth. Like courage, it is inborn, and not acquired.

With the establishment of an Academy we shall witness the spread of the art of drawing in this kingdom, [we shall] gain great repute for the [aforementioned] arts. Portuguese talent will be made famous, and [Portuguese] works will shine forth, to be known in foreign countries, and to enjoy applause.

ID
The 'je ne sais quoi'

1 Baltasar Gracián (1601–1658) from *The Hero*

According to the German philosopher Hans-Georg Gadamer, the concept of taste has always extended beyond aesthetics, describing an 'ideal of genuine humanity' (Gadamer, 1975). Indeed, the origins of its modern use are to be found not in discussions of art and beauty, but in the domain of ethics and politics. Central to the new meaning and prominence given to the term in the seventeenth century were the writings of the Spanish Jesuit, Baltasar Gracián. His first publication, *El Héroe* of 1637, somewhat like Machiavelli's *The Prince*, is a handbook for the ideal leader. In describing the qualities or attributes required to act well in courtly and political life, Gracián identifies a domain of judgement which cannot be reduced to rules. Since right action is grounded in consideration of individuals and particular things, an important role is played by the exercise of *gusto*, or taste, and by the *je ne sais quoi* which eludes rational comprehension. Gracián's writings form part of a powerful counter-current to the dominance of rationalism, bringing to the fore subtle modes of perception and judgement which were ignored or marginalized by an exclusive focus on reason. *El Héroe* was first published in Spain in 1637. Our selections are taken from the anonymous English translation by 'a gentleman of Oxford', *The Hero, from the Spanish of Balthasar Gracián, with Remarks Moral, Political and Historical of the Learned Father J. de Courbeville*, London: T. Cox, 1726, pp. 45–7, 141–5. We have omitted the remarks of the learned father. An earlier English translation was made in 1652 by John Skeffington.

Chap. V

That he should have an exquisite Taste.

It is not enough for this great Man, this Hero we are now treating of, to have a good Share of Wit and Ingenuity, and the Gifts of Nature accomplish'd by Art; he must likewise be born with an Elegancy of Taste, and have it perfected by Erudition. Wit and Taste are like two Brothers of the same Origin, and their Qualities are of near Proportion to each other. An elevated Wit is never allied to a mean Taste; the Taste must have an Equality, or otherwise it is degenerate; or rather the Wit itself was but

mean at first: For there are Perfections of different kinds, according as the Sense is more or less noble from whence they spring. A young Eagle can amuse itself with looking upon the Sun, while an old Butterfly is dazled, and loses the Sight of its weak Eye by doing it; and in like manner, the Strength and Compass of any Man's Parts is known by the Taste that is observable in him. It is a very valuable thing, no doubt, to have a good Taste; but in a great Man this is not much: His Taste must be excellent. And tho' it be one of those Talents, that may be communicated to others, and consequently acquir'd where there is an apt Disposition; yet where shall we find any that have done it? This is an Happiness that accrues to very few.

It may not be amiss to take notice by the by, that a great many People are perpetually applauding their own particular Taste, and, with a good deal of Arbitrariness, condemning that of others; but others are generally even with them: For they too, in their turn, admiring their own Taste, look upon their Adversaries with Scorn and Contempt. Thus has one part of the World been always bickering with the other; and tho' on one side there may be more Folly, on both sides there is enough. But to return. An excellent Taste is a formidable Qualification, and the Terror of every thing that is bad or indifferent in its kind; nay more, the best things dread it, and the most acknowledg'd Perfections are not secure of the Sentence of its Tribunal; for since it is the Rule of the just Worth of things, it examines them to the bottom, and makes as it were a Dissection of them before it gives in its Valuation. As Esteem is a very desirable Good, 'tis a Part of Wisdom and Justice to covet it; and the natural Punishment of such as are too prodigal of it, ought to be a Contempt of their Suffrage. Admiration is generally the Cry of Ignorance, and arises not so much from the Perfection of the Object, as from the Imperfections of our Understanding: Qualities of the first Rank only deserve our Admiration, and herein we ought to be very reserv'd.

* * *

Chap. XIII.

That he should have the *Je ne sais quoi* in him.

This certain something, which the *French* call *le Je ne sais quoi*, that is the Soul of all the other good Qualities requir'd in an Hero, that gives Ornament to his Actions, Grace to his Words, and an unavoidable Charm to every thing that comes from him, is as far above our Thoughts as it is our Expressions; for no Man ever yet did, or ever will be able to comprehend it. 'Tis the Lustre of Brightness, which does not strike us without it; and the Agreeableness of Beauty, which does not please us without it; for it only can give the Cast and Fashion, as I may call it, to all the good Qualities that do adorn us. In a word, 'tis the Perfection of Perfection itself, and what communicates a Flavour to every thing that is good or beautiful in us.

It discovers itself to us under certain Charms, that we cannot explain tho' we are sensible of them: 'Tis a Collection of Parts, the whole of which is very affecting and engaging, whether the Person be speaking or acting; and to examine it a little nearer, it seems to be the Gift of Nature, independent on Art, and what no Rules have hitherto taught us to acquire.

The Desire however of defining it, and the Impossibility of succeeding therein, has put Men upon inventing different Names, according to the different Impression it makes on them. 'Tis at one time, *a certain something*, so majestick and great; at another, *something* so lovely and genteel; in this case, 'tis *a certain something* so bold or so gracious; in that, *something* so lively or so soft; and every one in short gives it an Appellation, according to the different Views it represents. 'Tis a farther Property of this *Je ne sais quoi*, that some perceive it where others do not; for it does not strike all alike, but therein differs, according to the Measure of their Knowledge or Manner of their Sensibility.

What I have hitherto said relates to the *Je ne sais quoi* of what is *fine* and *delicate*, and usually so imperceptible, that it escapes most Men's Observation. What is more gross is universally understood, and makes an Impression upon the Sentiment of the Vulgar, who are touch'd and affected with it, tho' they seldom consider the Reason why.

Some, I know, are of Opinion, that this *Je ne sais quoi* is nothing else, but the Easiness and Freedom of a Person's outward Behaviour; but to make the Definition just, they should add a *Je ne sais quoi* of Easiness, of Freedom, *&c.* and then they tell us nothing new, but leave the Thing as obscure and undefin'd as it was before: Besides, that this is bounding its Character, which extends to every thing, in like manner as the Sun sheds its Influence upon all the Works of Nature. If the Sun were to refuse its kindly Warmth to the Earth, it would produce no Fruits; and if a Man chances to want this *Je ne sais quoi*, all his fine Qualities are dead and insipid; so that it is not so much a Circumstance, or any outward Property, as it is in the Being and Essence of the Thing itself.

If indeed it is the Agreeableness of Beauty, as I said before, 'tis as much the Flegm that is proper to Prudence, as it is the Martial Fire that suits with Valour; for it goes along with them both. Thus, for instance, we perceive in a Captain a *Je ne sais quoi* of lively Intrepidity, that inspires his Soldiers with Courage and Assurance. In like manner, we perceive in a Monarch, seated on his Throne, a *Je ne sais quoi* of august Appearance, that strikes us with an awful Respect: The one is sprightly, the other majestick; but both inseparable from the Perfection they are intended to signify; in the one case, the Dignity proper for a King upon his Throne; and in the other, the Valour fit for a Warrior in the Field of Battle.

[. . .]

In a word, this *Je ne sais quoi*, this certain something, without wanting any thing itself, enters into every thing to give it Worth and Value. It enters into Politicks, into Learning, into Eloquence, into Poetry, into Trade, and is equally found in the Conditions of both high and low.

2 Baltasar Gracián (1601–1658) from *The Art of Worldly Wisdom*

Gracián's *The Art of Worldly Wisdom* forms a sort of compendium or summary of his previous writings, expressing in condensed and aphoristic form his key teachings on how to get on in the world. He had already encountered the disapproval of his Jesuit superiors for his book *El Discreto* (The Man of Discretion), a handbook of courtly manners in the

tradition of Castiglione's *The Courtier*. After the publication of his three-part allegorical novel, *El Criticon* (The Critic), completed between 1651 and 1657, his teaching privileges were removed and he was exiled to Tarazona where he died in disgrace. *The Art of Worldly Wisdom* remains the best-known of Gracián's works and it was widely translated into other European languages. Though primarily concerned with the exercise of prudence or correct judgement in the social, political and ethical domains, Gracián's investigation of the nuances of social interaction helped to give rise to a new aesthetic of *délicatesse*, or sensitivity, which relies upon the individual's own capacity for experience and reflection rather than fixed general concepts. It was originally published in Spain as *Oráculo Manual y Arte de Prudencia* in 1647. As late as 1861, Arthur Schopenhauer undertook to produce the twelfth translation into German. Many of its key ideas, however, had long since been disseminated into European thinking. The first of several English translations appeared in 1694 under the title *The Courtiers Manual Oracle or the Art of Prudence*. The following excerpts are taken from the translation by Joseph Jacobs, *The Art of Worldly Wisdom*, London and New York: Macmillan, 1892, pp. 1, 3–4, 7, 14–15, 16–17, 23, 29, 30, 35, 37–8, 51–3, 57, 74, 86, 107, 170–1.

Character and Intellect: The two poles of our capacity; one without the other is but halfway to happiness. Intellect sufficeth not, character is also needed. On the other hand, it is the fool's misfortune to fail in obtaining the position, the employment, the neighbourhood, and the circle of friends that suit him.

A Man at his Highest Point. We are not born perfect: every day we develop in our personality and in our calling till we reach the highest point of our completed being, to the full round of our accomplishments, of our excellences. This is known by the purity of our taste, the clearness of our thought, the maturity of our judgment, and the firmness of our will. Some never arrive at being complete: somewhat is always awanting: others ripen late. The complete man, wise in speech, prudent in act, is admitted to the familiar intimacy of discreet persons, is even sought for by them.

Nature and Art: material and workmanship. There is no beauty unadorned and no excellence that would not become barbaric if it were not supported by artifice: this remedies the evil and improves the good. Nature scarcely ever gives us the very best; for that we must have recourse to art. Without this the best of natural dispositions is uncultured, and half is lacking to any excellence if training is absent. Every one has something unpolished without artificial training, and every kind of excellence needs some polish.

Keep the Imagination under Control; sometimes correcting, sometimes assisting it. For it is all-important for our happiness, and even sets the reason right. It can tyrannise, and is not content with looking on, but influences and even often dominates life, causing it to be happy or burdensome according to the folly to which it leads. For it makes us either contented or discontented with ourselves. Before some it continually holds up the penalties of action, and becomes the mortifying lash of these fools. To others it promises happiness and adventure with blissful delusion. It can do all this unless the most prudent self-control keeps it in subjection.

Common in Nothing. First, not in taste. O great and wise, to be ill at ease when your deeds please the mob! The excesses of popular applause never satisfy the sensible. Some there are such chameleons of popularity that they find enjoyment not in the sweet savours of Apollo but in the breath of the mob. Secondly, not in intelligence. Take no pleasure in the wonder of the mob, for ignorance never gets beyond wonder. While vulgar folly wonders wisdom watches for the trick.

Recognise when Things are ripe, and then enjoy them. The works of nature all reach a certain point of maturity; up to that they improve, after that they degenerate. Few works of art reach such a point that they cannot be improved. It is an especial privilege of good taste to enjoy everything at its ripest. Not all can do this, nor do all who can know this. There is a ripening point too for fruits of intellect; it is well to know this both for their value in use and for their value in exchange.

Observation and Judgment. A man with these rules things, not they him. He sounds at once the profoundest depths; he is a phrenologist by means of physiognomy. On seeing a person he understands him and judges of his inmost nature. From a few observations he deciphers the most hidden recesses of his nature. Keen observation, subtile insight, judicious inference: with these he discovers, notices, grasps, and comprehends everything.

Know how to Choose well. Most of life depends thereon. It needs good taste and correct judgment, for which neither intellect nor study suffices. To be choice, you must choose, and for this two things are needed: to be able to choose at all, and then to choose the best. There are many men of fecund and subtle mind, of keen judgment, of much learning, and of great observation who yet are at a loss when they come to choose. They always take the worst as if they had tried to go wrong. Thus this is one of the greatest gifts from above.

A Sound Judgment. Some are born wise, and with this natural advantage enter upon their studies, with a moiety already mastered. With age and experience their reason ripens, and thus they attain a sound judgment. They abhor everything whimsical as leading prudence astray, especially in matters of state, where certainty is so necessary, owing to the importance of the affairs involved. Such men deserve to stand by the helm of state either as pilots or as men at the wheel.

Elevated Taste. You can train it like the intellect. Full knowledge whets desire and increases enjoyment. You may know a noble spirit by the elevation of his taste: it must be a great thing that can satisfy a great mind. Big bites for big mouths, lofty things for lofty spirits. Before their judgment the bravest tremble, the most perfect lose confidence. Things of the first importance are few; let appreciation be rare. Taste can be imparted by intercourse: great good luck to associate with the highest taste. But do not affect to be dissatisfied with everything: 'tis the extreme of folly, and more odious if from affectation than if from Quixotry. Some would have God create another world and other ideals to satisfy their fantastic imagination.

Culture and Elegance. Man is born a barbarian, and only raises himself above the beast by culture. Culture therefore makes the man; the more a man, the higher. Thanks to it, Greece could call the rest of the world barbarians. Ignorance is very raw; nothing contributes so much to culture as knowledge. But even knowledge is coarse if without elegance. Not alone must our intelligence be elegant, but our desires, and above all our conversation. Some men are naturally elegant in internal and external qualities, in their thoughts, in their address, in their dress, which is the rind of the soul, and in their talents, which is its fruit. There are others, on the other hand, so *gauche* that everything about them, even their very excellences, is tarnished by an intolerable and barbaric want of neatness.

Know Yourself – in talents and capacity, in judgment and inclination. You cannot master yourself unless you know yourself. There are mirrors for the face but none for the mind. Let careful thought about yourself serve as a substitute. When the outer image is forgotten, keep the inner one to improve and perfect. Learn the force of your intellect and capacity for affairs, test the force of your courage in order to apply it, and keep your foundations secure and your head clear for everything.

Reality and Appearance. Things pass for what they seem, not for what they are. Few see inside; many take to the outside. It is not enough to be right, if right seem false and ill.

Grace in Everything. 'Tis the life of talents, the breath of speech, the soul of action, and the ornament of ornament. Perfections are the adornment of our nature, but this is the adornment of perfection itself. It shows itself even in the thoughts. 'Tis most a gift of nature and owes least to education; it even triumphs over training. It is more than ease, approaches the free and easy, gets over embarrassment, and adds the finishing touch to perfection. Without it beauty is lifeless, graciousness ungraceful: it surpasses valour, discretion, prudence, even majesty itself. 'Tis a short way to dispatch and an easy escape from embarrassment.

Look into the Interior of Things. Things are generally other than they seem, and ignorance that never looks beneath the rind becomes disabused when you show the kernel. Lies always come first, dragging fools along by their irreparable vulgarity. Truth always lags last, limping along on the arm of Time. The wise therefore reserve for it the other half of that power which the common mother has wisely given in duplicate. Deceit is very superficial, and the superficial therefore easily fall into it. Prudence lives retired within its recesses, visited only by sages and wise men.

Trust your Heart, especially when it has been proved. Never deny it a hearing. It is a kind of house oracle that often foretells the most important. Many have perished because they feared their own heart, but of what use is it to fear it without finding a better remedy? Many are endowed by Nature with a heart so true that it always warns them of misfortune and wards off its effects. It is unwise to seek evils, unless you seek to conquer them.

Have the Gift of Discovery. It is a proof of the highest genius, yet when was genius without a touch of madness? If discovery be a gift of genius, choice of means is a mark of sound sense. Discovery comes by special grace and very seldom. For many can follow up a thing when found, but to find it first is the gift of the few, and those the first in excellence and in age. Novelty flatters, and if successful gives the possessor double credit. In matters of judgment novelties are dangerous because leading to paradox, in matters of genius they deserve all praise. Yet both equally deserve applause if successful.

3 Thomas Hobbes (1588–1679) from 'Answer to Davenant's Preface to *Gondibert*'

Sir William Davenant (1606–68) was a poet, playwright and theatre owner who subscribed to the Royalist cause during the English civil war. His long chivalric poem *Gondibert* was written in exile in France in 1650. It was here that he encountered Hobbes, the foremost political philosopher of his time, also in retreat from the war in England. Hobbes was a classical scholar, though his literary work forms only a minor part of his legacy. Nonetheless his comments on Davenant provide a cogent statement of the new attitude to art which was emerging in England in the mid-seventeenth century. This involved an emphasis on the psychological dimension. Not just the unity or harmony of the poem (or painting) is at issue, but the imaginative work required to produce it. In Hobbes' philosophy the mind is conceived as a *tabula rasa* on which the world inscribes itself. He draws upon this wider philosophy to provide a brief account of how the world is got into the poem: how judgement on the one hand, and imagination (or Fancy) on the other, complement each other in the realization of the work of art. Our short extract is taken from *The English Works of Thomas Hobbes*, ed. Sir William Molesworth, vol. IV, London: John Bohn, 1840, pp. 449–50.

Time and education beget experience; experience begets memory; memory begets judgment and fancy; judgment begets the strength and structure, and fancy begets the ornaments of a poem. The ancients therefore fabled not absurdly, in making Memory the mother of the Muses. For memory is the world, though not really, yet so as in a looking-glass, in which the judgment, the severer sister, busieth herself in a grave and rigid examination of all the parts of nature, and in registering by letters their order, causes, uses, differences, and resemblances; whereby the fancy, when any work of art is to be performed, finds her materials at hand and prepared for use, and needs no more than a swift motion over them, that what she wants, and is there to be had, may not lie too long unespied. So that when she seemeth to fly from one Indies to the other, and from heaven to earth, and to penetrate into the hardest matter and obscurest places, into the future, and into herself, and all this in a point of time, the voyage is not very great, herself being all she seeks. And her wonderful celerity, consisteth not so much in motion, as in copious imagery discreetly ordered, and perfectly registered in the memory; which most men under the name of philosophy have a glimpse of, and is pretended to by many, that grossly mistaking her, embrace contention in her place. But so far forth as the fancy of man has traced the ways of

true philosophy, so far it hath produced very marvellous effects to the benefit of mankind. All that is beautiful or defensible in building; or marvellous in engines and instruments of motion; whatsoever commodity men receive from the observations of the heavens, from the description of the earth, from the account of time, from walking on the seas; and whatsoever distinguisheth the civility of Europe, from the barbarity of the American savages; is the workmanship of fancy, but guided by the precepts of true philosophy. But where these precepts fail, as they have hitherto failed in the doctrine of moral virtue, there the architect Fancy must take the philosopher's part upon herself. He, therefore, who undertakes an heroic poem, which is to exhibit a venerable and amiable image of heroic virtue, must not only be the poet, to place and connect, but also the philosopher, to furnish and square his matter; that is, to make both body and soul, colour and shadow of his poem out of his own store [. . .]

4 Gerrard Winstanley (c.1609–1676?) from *Fire in the Bush* and *The Law of Freedom in a Platform*

During the civil war period Winstanley became the leading figure and principal theoretician of the radical wing of the English revolution. In practical terms he is best known for his involvement with the Diggers, or True Levellers, and their project to cultivate common land at St George's Hill in Surrey. His intellectual production consisted of a series of pamphlets sketching the philosophy of an agrarian communist society. Winstanley did not write on art as such, but in the climate of the Reformation and the religious wars which followed it throughout Europe, the status of art, and of images in general, was of great moment on both sides of the Protestant/Catholic divide (see, for example, Pacheco IA3). In the first extract, from *Fire in the Bush* of 1650, Winstanley draws an absolute distinction between 'true knowledge' and the work of the 'imagination'. For Winstanley 'imagination' stands for all that departs from the knowledge of God, all that is potentially false, idle and misleading in human consciousness. Although his conception is specific to its time, Winstanley's argument stands as an early instance of the conflict between individual consciousness and social conscience which has continued to haunt so many programmes of emancipation. Throughout the modern period, and in a variety of forms, the imagination and the aesthetic dimension have frequently been treated as more of a threat than a promise by social improvers. (For a transatlantic echo of Winstanley's radical protestantism, see ID8; for later manifestations of unease with the independence of art, see *Art in Theory 1815–1900* IIA1 and IIIB9, and *Art in Theory 1900–1990* IIA3 and VC9.) The second extract from Winstanley's writings is from his best-known statement of the future communist society, *The Law of Freedom in a Platform* of 1652. Here the point concerns, not the place allocated to art in the future commonwealth, but its total absence. Various manufactures and handcrafts are allocated their place in social production and education; even music has a role (for girls). Practical knowledge is enthusiastically advocated, while contemplation and book-learning are disparaged. The visual arts are simply not mentioned, a silence which is significant in itself. Both extracts are taken from Gerrard Winstanley, *The Law of Freedom and other Writings*, ed. Christopher Hill, Harmondsworth: Pelican Classics 1973, pp. 220–1 and 362–5.

Fire In The Bush

[. . .] when all things were produced, and appeared very good in the liking and content of the creating spirit, the word of command was to whole mankind (not to one or a few single branches of mankind), 'Do thou take possession over the fish, fowl, beast; and do thou till the earth; and do thou multiply and fill the earth.' And no part or branch of mankind is shut out by him from this employment.

For as the great earth and the inferior creatures therein are as the commons, forests and delights of God in the out-coasts of the creation: even so mankind, the living earth, is the very garden of Eden, wherein that spirit of love did walk and delight himself principally, as being the head and lord of all the rest.

In this garden are five rivers: hearing, seeing, tasting, smelling, feeling; which we in our age of the world call five senses. And these five water springs do refresh and preserve the whole creation, both of the out-coasts and of the garden.

In this garden, mankind, and in every branch of him, there is a tree of knowledge of good and evil, called imagination; and the tree of life, called universal love or pure knowledge in the power.

When mankind, or the living soul, feeds upon or delights himself in the fruit of that tree of good and evil, which is selfish, unwarranted and unexperienced imagination which is his weakness and disease: then he loses his honour and strength and falls from his dominion, lordship, and becomes like the beasts of the field, void of understanding. For the lord of so great and vast a body as the creation is must know all things clearly, as they be, and not by blind imagination, that leads mankind sometimes astray, as well as sometimes in the right way.

When mankind is guided by imagination, he runs a great hazard upon life and death. This power is he that calls good evil, and evil good, this knows not the creating spirit in inward feeling, but does fancy him to be sometimes one thing, sometimes another; and still dwells in the dark chamber of uncertainty.

And while mankind eats of this tree and delights himself here, he is driven out of the garden, that is, out of himself; he enjoys not himself, he knows not himself; he lives without the true God or ruler, and is like the beasts of the field, who live upon objects without them; and does not enjoy the kingdom within himself, but seeks after a kingdom and peace without him, as the beasts do.

This imagination is he that fills you with fears, doubts, troubles, evil surmisings and grudges; he it is that stirs up wars and divisions; he makes you lust after every thing you see or hear of, and promises delight to you in the enjoyment, as in riches, places of government, pleasures, society of strange women: and when you have all these which you think or imagine to have content in, presently troubles follow the heels thereof; and you see your self naked and are ashamed.

So that the selfish imaginary power within you is the power of darkness, the father of lies, the deceiver, the destroyer, and the serpent that twists about everything within your self, and so leads you astray from the right way of life and peace. And the whole world of mankind generally at this day, through all the nations of the world, is eating of this tree of knowledge of good and evil and are cast out of themselves, and know not the power that rules in them: and so are ignorant of their God. This is the

fulness of the Beast's time, it is his last period; all places, persons and things stink with his imaginary power of darkness in teaching and ruling. Therefore it is that fulness of time in which the restorer of all things will come, to deliver the creation from that bondage and curse, and draw up all things to live in him, who is the true life, rest and light of all things.

The Law Of Freedom

What trades should mankind be brought up in?

In every trade, art and science, whereby they may find out the secrets of the creation, and that they may know how to govern the earth in right order.

There are five fountains from whence all arts and sciences have their influences: he that is an actor in any or in all the five parts is a profitable son of mankind; he that only contemplates and talks of what he reads and hears, and doth not employ his talent in some bodily action for the increase of fruitfulness, freedom and peace in the earth, is an unprofitable son.

The first foundation is the right planting of the earth to make it fruitful, and this is called husbandry. And there are two branches of it:

As first, planting, digging, dunging, liming, burning, grubbing and right ordering of land, to make it fit to receive seed, that it may bring forth a plentiful crop. And under this head all millers, maltsters, bakers, harness-makers for ploughs and carts, rope-makers, spinners and weavers of linen and such like, are all but good husbandry.

The second branch of husbandry is gardening, how to plant, graft and set all sort of fruit trees, and how to order the ground for flowers, herbs and roots for pleasure, food or medicinal. And here all physicians, chirurgeons,[1] distillers of all sorts of waters, gatherers of drugs, makers of wines and oil, and preservers of fruits and such like, may learn by observation what is good for all bodies, both man and beasts.

The second fountain is mineral employment, and that is to search into the earth to find out mines of gold and silver, brass, iron, tin, lead, cannel,[2] coal and stone of all sorts, saltpetre, salt and alum-springs and such like. And here all chemists, gunpowder-makers, masons, smiths and such like, as would find out the strength and power of the earth, may learn how to order these for the use and profit of mankind.

The third fountain is the right ordering of cattle, whether by shepherds or herdsmen; and such may learn here how to breed and train up cows for the dairies, bulls and horses for the saddle or yoke. And here all tanners, hatters, shoemakers, glovers, spinners of wool, clothiers, tailors, dyers and such like, may learn how to order and look to these.

The fourth fountain is the right ordering of woods and timber trees, for planting, dressing, felling, framing of timber for all uses, for building houses or ships. And here all carpenters, joiners, throsters,[3] plough-makers, instrument-makers for music, and all who work in wood and timber, may find out the secret[s] of nature, to make trees more plentiful and thriving in their growth and profitable for use.

The fifth fountain, from whence reason is exercised to find out the secrets of nature, is [to] observe the rising and setting of the sun, moon and the powers of the

heavens above; and the motion of the tides and seas, and their several effects, powers and operations upon the bodies of man and beast. And here may be learned astrology, astronomy and navigation, and the motions of the winds and the causes of several appearances of the face of heaven, either in storms or in fairness.

And in all these five fountains here is knowledge in the practice, and it is good.

But there is traditional knowledge, which is attained by reading or by the instruction of others, and not practical but leads to an idle life; and this is not good.

The first is a laborious knowledge, and a preserver of common peace, which we find God himself acting; for he put forth his own wisdom in practice when he set his strength to work to make the creation: for God is an active power, not an imaginary fancy.

The latter is an idle, lazy contemplation the scholars would call knowledge; but it is no knowledge but a show of knowledge, like a parrot who speaks words but he knows not what he saith. This same show of knowledge rests in reading or contemplating or hearing others speak, and speaks so too, but will not set his hand to work. And from this traditional knowledge and learning rise up both clergy and lawyer, who by their cunning insinuations live merely upon the labour of other men, and teach laws which they themselves will not do, and lays burdens upon others which they themselves will not touch with the least of their fingers. And from hence arises all oppressions, wars and troubles in the world; the one is the son of contention, the other the son of darkness, but both the supporters of bondage, which the creation groans under.

Therefore to prevent idleness and the danger of Machiavellian cheats, it is profitable for the commonwealth that children be trained up in trades and some bodily employment, as well as in learning languages or the histories of former ages.

And as boys are trained up in learning and in trades, so all maids shall be trained up in reading, sewing, knitting, spinning of linen and woollen, music, and all other easy neat works, either for to furnish store-houses with linen and woollen cloth, or for the ornament of particular houses with needle-work.

And if this course were taken, there would be no idle person nor beggars in the land, and much work would be done by that now lazy generation for the enlarging of the common treasuries.

¹ Surgeons.
² 'Cannel' is a bituminous coal.
³ Turners (probably).

5 Blaise Pascal (1623–1662) from *Pensées*

After an early career as a scientist and mathematician, during which he invented the first digital calculator and the syringe, and laid the basis for the modern theory of probability, Pascal was increasingly drawn to the religious austerity of Jansenism. One of the key principles of Jansenism was that the way to salvation lay not through good works but through acceptance of, and immersion in, divine grace. After an intense mystical experience on the night of 23 November 1654, the testament of which he kept sewn into his clothes, Pascal withdrew to the former convent of Port Royal where the Jansenists were

based. Although not a permanent resident there, Pascal thereafter wrote only in service of the Jansenist faith. His *Pensées* represent the surviving fragments of an unfinished work of Christian apologetics. They have remained influential to the present day as a counter to materialism and dogma, not least within the existentialist tendency of modern philosophy. Our extracts concern the power of the imagination in human existence on the one hand, and on the other a sense of the limitedness of that existence in the infinity of the cosmos, and, for Pascal, of God's grace. The selections are taken from Blaise Pascal, *Pensées*, translated with an introduction by A. J. Krailsheimer, Harmondsworth: Penguin Classics 1966, pp. 38–41, 89–91, 93–5.

Imagination. It is the dominant faculty in man, master of error and falsehood, all the more deceptive for not being invariably so; for it would be an infallible criterion of truth if it were infallibly that of lies. Since, however, it is usually false, it gives no indication of its quality, setting the same mark on true and false alike.

I am not speaking of fools, but of the wisest men, amongst whom imagination is best entitled to persuade. Reason may object in vain, it cannot fix the price of things.

This arrogant force, which checks and dominates its enemy, reason, for the pleasure of showing off the power it has in every sphere, has established a second nature in man. Imagination has its happy and unhappy men, its sick and well, its rich and poor; it makes us believe, doubt, deny reason; it deadens the senses, it arouses them; it has its fools and sages, and nothing annoys us more than to see it satisfy its guests more fully and completely than reason ever could. Those who are clever in imagination are far more pleased with themselves than prudent men could reasonably be. They look down on people with a lofty air; they are bold and confident in argument, where others are timid and unsure, and their cheerful demeanour often wins the verdict of their listeners, for those whose wisdom is imaginary enjoy the favour of judges similarly qualified. Imagination cannot make fools wise, but it makes them happy, as against reason, which only makes its friends wretched: one covers them with glory, the other with shame.

Who dispenses reputation? Who makes us respect and revere persons, works, laws, the great? Who but this faculty of imagination? All the riches of the earth are inadequate without its approval. Would you not say that this magistrate, whose venerable age commands universal respect, is ruled by pure, sublime reason, and judges things as they really are, without paying heed to the trivial circumstances which offend only the imagination of weaker men? See him go to hear a sermon in a spirit of pious zeal, the soundness of his judgement strengthened by the ardour of his charity, ready to listen with exemplary respect. If, when the preacher appears, it turns out that nature has given him a hoarse voice and an odd sort of face, that his barber has shaved him badly and he happens not to be too clean either, then, whatever great truths he may announce, I wager that our senator will not be able to keep a straight face.

Put the world's greatest philosopher on a plank that is wider than need be: if there is a precipice below, although his reason may convince him that he is safe, his imagination will prevail. Many could not even stand the thought of it without going pale and breaking into sweat.

I do not intend to list all the effects of imagination. Everyone knows that the sight of cats, or rats, the crunching of a coal, etc., is enough to unhinge reason. The tone of voice influences the wisest of us and alters the force of a speech or a poem.

Love or hate alters the face of justice. An advocate who has been well paid in advance will find the cause he is pleading all the more just. The boldness of his bearing will make it seem all the better to the judges, taken in by appearances. How absurd is reason, the sport of every wind! I should list almost all the actions of men, who hardly stir except when jolted by imagination. For reason has had to yield, and at its wisest adopts those principles which human imagination has rashly introduced at every turn. Anyone who chose to follow reason alone would have proved himself a fool. We must, since reason so pleases, work all day for benefits recognized as imaginary, and, when sleep has refreshed us from the toils of our reason, we must at once jump up to pursue the phantoms and endure the impressions created by this ruler of the world. Here is one of the principles of error, but not the only one.

Man has been quite right to make these two powers into allies, although in this peace imagination enjoys an extensive advantage; for in conflict its advantage is more complete. Reason never wholly overcomes imagination, while the contrary is quite common. [. . .]

Imagination decides everything: it creates beauty, justice and happiness, which is the world's supreme good.

* * *

Let man then contemplate the whole of nature in her full and lofty majesty, let him turn his gaze away from the lowly objects around him; let him behold the dazzling light set like an eternal lamp to light up the universe, let him see the earth as a mere speck compared to the vast orbit described by this star, and let him marvel at finding this vast orbit itself to be no more than the tiniest point compared to that described by the stars revolving in the firmament. But if our eyes stop there, let our imagination proceed further; it will grow weary of conceiving things before nature tires of producing them. The whole visible world is only an imperceptible dot in nature's ample bosom. No idea comes near it; it is no good inflating our conceptions beyond imaginable space, we only bring forth atoms compared to the reality of things. Nature is an infinite sphere whose centre is everywhere and circumference nowhere. In short it is the greatest perceptible mark of God's omnipotence that our imagination should lose itself in that thought.

Let man, returning to himself, consider what he is in comparison with what exists; let him regard himself as lost, and from this little dungeon, in which he finds himself lodged, I mean the universe, let him learn to take the earth, its realms, its cities, its houses and himself at their proper value.

What is a man in the infinite?

But, to offer him another prodigy equally astounding, let him look into the tiniest things he knows. Let a mite show him in its minute body incomparably more minute parts, legs with joints, veins in its legs, blood in the veins, humours in the blood, drops in the humours, vapours in the drops: let him divide these things still further until he has exhausted his powers of imagination, and let the last thing he comes down to now be the subject of our discourse. He will perhaps think that this is the ultimate of minuteness in nature.

I want to show him a new abyss. I want to depict to him not only the visible universe, but all the conceivable immensity of nature enclosed in this miniature atom. Let him see there an infinity of universes, each with its firmament, its planets, its earth, in the same proportions as in the visible world, and on that earth animals, and finally mites, in which he will find again the same results as in the first; and finding the same thing yet again in the others without end or respite, he will be lost in such wonders, as astounding in their minuteness as the others in their amplitude. For who will not marvel that our body, a moment ago imperceptible in a universe, itself imperceptible in the bosom of the whole, should now be a colossus, a world, or rather a whole, compared to the nothingness beyond our reach? Anyone who considers himself in this way will be terrified at himself, and, seeing his mass, as given him by nature, supporting him between these two abysses of infinity and nothingness, will tremble at these marvels. I believe that with his curiosity changing into wonder he will be more disposed to contemplate them in silence than investigate them with presumption.

For, after all, what is man in nature? A nothing compared to the infinite, a whole compared to the nothing, a middle point between all and nothing, infinitely remote from an understanding of the extremes; the end of things and their principles are unattainably hidden from him in impenetrable secrecy.

Equally incapable of seeing the nothingness from which he emerges and the infinity in which he is engulfed.

What else can he do, then, but perceive some semblance of the middle of things, eternally hopeless of knowing either their principles or their end? All things have come out of nothingness and are carried onwards to infinity. Who can follow these astonishing processes? The author of these wonders understands them: no one else can.

Because they failed to contemplate these infinities, men have rashly undertaken to probe into nature as if there were some proportion between themselves and her.

Strangely enough they wanted to know the principles of things and go on from there to know everything, inspired by a presumption as infinite as their object. For there can be no doubt that such a plan could not be conceived without infinite presumption or a capacity as infinite as that of nature. [...]

In the perspective of these infinites, all finites are equal and I see no reason to settle our imagination on one rather than another. Merely comparing ourselves with the finite is painful.

If man studied himself, he would see how incapable he is of going further. How could a part possibly know the whole? But perhaps he will aspire to know at least the parts to which he bears some proportion. But the parts of the world are all so related and linked together that I think it is impossible to know one without the other and without the whole.

There is, for example, a relationship between man and all he knows. He needs space to contain him, time to exist in, motion to be alive, elements to constitute him, warmth and food for nourishment, air to breathe. He sees light, he feels bodies, everything in short is related to him. To understand man therefore one must know why he needs air to live, and to understand air one must know how it comes to be thus related to the life of man, etc.

Flame cannot exist without air, so, to know one, one must know the other.

Thus, since all things are both caused or causing, assisted and assisting, mediate and immediate, providing mutual support in a chain linking together naturally and imperceptibly the most distant and different things, I consider it as impossible to know the parts without knowing the whole as to know the whole without knowing the individual parts.

The eternity of things in themselves or in God must still amaze our brief span of life.

The fixed and constant immobility of nature, compared to the continual changes going on in us, must produce the same effect.

And what makes our inability to know things absolute is that they are simple in themselves, while we are composed of two opposing natures of different kinds, soul and body. For it is impossible for the part of us which reasons to be anything but spiritual, and even if it were claimed that we are simply corporeal, that would still more preclude us from knowing things, since there is nothing so inconceivable as the idea that matter knows itself. We cannot possibly know how it could know itself.

Thus, if we are simply material, we can know nothing at all, and, if we are composed of mind and matter, we cannot have perfect knowledge of things which are simply spiritual or corporeal.

That is why nearly all philosophers confuse their ideas of things, and speak spiritually of corporeal things and corporeally of spiritual ones, for they boldly assert that bodies tend to fall, that they aspire towards their centre, that they flee from destruction, that they fear a void, that they have inclinations, sympathies, antipathies, all things pertaining only to things spiritual. And when they speak of minds, they consider them as being in a place, and attribute to them movement from one place to another, which are things pertaining only to bodies.

Instead of receiving ideas of these things in their purity, we colour them with our qualities and stamp our own composite being on all the simple things we contemplate.

Who would not think, to see us compounding everything of mind and matter, that such a mixture is perfectly intelligible to us? Yet this is the thing we understand least; man is to himself the greatest prodigy in nature, for he cannot conceive what body is, and still less what mind is, and least of all how a body can be joined to a mind. This is his supreme difficulty, and yet it is his very being. *The way in which minds are attached to bodies is beyond man's understanding, and yet this is what man is* [St Augustine, *City of God*, XXI.10.].

Man is only a reed, the weakest in nature, but he is a thinking reed. There is no need for the whole universe to take up arms to crush him: a vapour, a drop of water is enough to kill him. But even if the universe were to crush him, man would still be nobler than his slayer, because he knows that he is dying and the advantage the universe has over him. The universe knows none of this.

Thus all our dignity consists in thought. It is on thought that we must depend for our recovery, not on space and time, which we could never fill. Let us then strive to think well; that is the basic principle of morality.

The eternal silence of these infinite spaces fills me with dread.

Be comforted; it is not from yourself that you must expect it, but on the contrary you must expect it by expecting nothing from yourself.

6 André Félibien (1619–1695) on grace and beauty from *Conversations on the Lives and Works of the Most Excellent Ancient and Modern Painters*

Although Félibien des Avaux occupied an important position at the court of Louis XIV as historiographer of the Royal Buildings and honorary counsellor to the Royal Academy (see IB9), his own writings are marked by an independence of judgement and breadth of taste which goes beyond the orthodox opinion promoted by figures such as Jean-Baptiste Colbert and Charles Le Brun. This is revealed both in his preference for discursive means of presentation which could accommodate differences of opinion and in his admiration for artists such as Rembrandt, who fell outside the classicist framework. In the following excerpt, taken from one of the theoretical excurses to the first of his monumental series of *Entretiens*, Félibien addresses the distinction between grace and beauty. Grace is distinguished from beauty insofar as it escapes definition and, like the *je ne sais quoi*, does not obey any rule. It is what distinguishes a living representation from a wax model, expressing the inner movements of the soul. This excerpt has been translated for the present volume by Jonathan Murphy from André Félibien, *Entretiens sur les vies et les ouvrages des plus excellents peintres anciens et modernes*, Trévoux, 1725 (facsimile reprint, Farnborough: Gregg Press, 1967), pp. 82–8.

Pymander began again: 'What difference is there then between grace and beauty, and how can they be distinguished from each other? For if beauty is the result of the proportion of the parts, can one find grace in subjects which are neither beautiful nor well proportioned?'

I replied that I could address the issue of distinguishing these two charming qualities quite easily. Beauty is a result of the proportion and symmetry between corporeal and material parts. Grace is the result of the uniformity of inner movements, caused by emotions and feelings within the soul.

So that when there is merely symmetry between the different corporeal parts, the beauty that results from this is a beauty without grace. But when in addition to beautiful proportions one divines the unity and harmony of all interior movements, which not only unite all parts of the body, but also animate them and cause them to act together with the correct cadence in a uniformly balanced manner, then the sort of grace that we admire in the most accomplished persons is also engendered, without which even the most beautiful proportion in the various parts is somehow lacking in perfection. When this uniformity of movement appears on a less beautiful face, whose features are imperfect, we still admire it as what we detect is precisely this quality of grace. As spiritual beauties are more excellent than corporeal ones, we will always prefer a person whose body is but imperfectly beautiful but who possesses this quality of grace to a more beautiful person lacking this supplementary quality. Thus, in Tibullus, although Quintia was more beautiful than Lesbia, it was the latter

who was blessed with this *je ne sais quoi* that rendered her more agreeable than the former.

To demonstrate that grace is a movement of the soul one need only think of a beautiful woman. Her beauty we can easily judge by a simple examination of the proportions of the different parts of her body, but her grace we can judge only through her speech, through her laughter, or through some movement that she might make.

The same principles apply in sculpture and painting, where grace will be lacking unless the artist can join some sort of movement fitting to the beauty of the figures and the actions in which they are engaged. For that reason it occasionally comes to pass that our admiration is aroused by works that do not have the normal proportions necessary for beauty, but where movement is happily expressed. When we see figures drawn by the hand of the most excellent Masters, where the proportions of all the different parts of the bodies are perfect and there is also a beautiful uniformity of movement concerted to a single purpose, then we admire the manner in which beauty and grace concord in a perfect work of art.

This *je ne sais quoi* to which we so often refer yet which we describe so poorly is like the secret knot that binds together these two parts of the body and soul. It is the natural result of the beautiful symmetry of parts and the concerted movement; but as this mixture results from a highly subtle, hidden process, no matter how much we examine it or attempt to describe it, we can neither represent it nor express it in the manner that we would desire. But we can say that it may be noted in a face, with the same freshness and novelty that we find in a rose that begins to open its petals early in the morning; the shape and beauty of the colours are an incarnation of the iridescent freshness of spiritual beauty. For the *je ne sais quoi* is a truly divine splendour, born out of beauty and grace.

This observation of beauty and grace has led me to understand why I have never appreciated the strong resemblance that so many admire in those wax faces that are modelled from life.

At this point I noticed that Pymander was staring at me quite closely. I remarked upon this, and he replied that I seemed to be speaking in nonsensical paradoxes: how could a resemblance be any closer than one based on a wax moulding from life?

I replied that although my opinion may at first have appeared a little strange, I was nonetheless prepared to defend it. A wax model does have exactly the same features as the person it is intended to portray, and often the colour mixing is of such subtlety and precision that one may see all the different flesh tints, with the veins and muscles and even the pores, and that on occasion the eyes capture exactly the sparkle and crystalline humour that makes them so clear, and yet despite such mastery, the resemblance is surprising to the eye more than it is convincing to the spirit, and as such it is not in fact a true likeness of the person that it is intended to represent. The reason for this is that during the moulding process the subject is obliged to remain immobile throughout, and the material used is such that the natural function of the features is thus neglected. It forces the subject into such stasis that all the interior movements which give life to our features are placed in suspension, and the resulting portrayal is a true portrait of total immobility, and as such is a lifeless and insensible resemblance. It is infinitely less perfect than a resemblance achieved by a painter or

sculptor, with brush or chisel. Through their work the painter and sculptor strive to breathe life into their work and to instil it with beauty and grace, imitating to the best of their capacities the object that they have before them; in wax the mould alone is the artisan, and it can only imitate what it finds, and that which it is possible to imprint upon it.

For that reason, in wax figures moulded from life, grace and the quality of *je ne sais quoi* are both lacking, as grace is the portrayal of interior movements of the soul, together with the beauty of proportion as I explained above. The wax model can never convey or reflect the inner movements of the soul, and they are the true source of grace.

There is then a great deal of difference, not between an excellent painter or an artful sculptor and those who mould wax from life, whose art I count for nothing, but between a face modelled from life and a portrait painted by a great man, such as one finds on a beautiful medallion, like those of the king and queen which are produced with such skill at the Louvre.

7　Dominique Bouhours (1623–1662) From *The Conversations of Aristo and Eugene*

Dominique Bouhours, a Jesuit teacher of classical studies in Paris, published two influential works of literary criticism, *Les Entretiens d'Ariste et d'Eugène* in 1671 and *La Manière de bien penser dans les ouvrages d'esprit* in 1687. The former is composed of six separate sections in the form of dialogues, of which two are represented here. Contrary to the predominant intellectual rationalism of the time, Bouhours uses the dialogue form to explore the nature of those indefinable critical qualities that are perceived instantaneously through the workings of intuition, rather than gradually through the operations of reason. The 'bel esprit' of the first excerpt is conceived as a person who acts decisively on the basis of individual but justifiable intuition. The *je ne sais quoi* of the second excerpt may be thought of as that which the 'bel esprit' or the 'true artist' uniquely generates. As these suggestions imply, the tendency represented in Bouhours' speculations is more familiar from its later development in Romantic and Modernist writing on the arts: the isolation of an ineffable critical virtue from the wider category of aesthetic production, and of the 'artist' from the 'illustrator', the 'designer' or the 'entertainer'. Though both Bouhours' books were widely read outside France, only the second was translated into English before the twentieth century (in 1705 as *The Art of Criticism* and in 1728 as *The Arts of Logick and Rhetorick*). The present excerpts from *The Conversations of Aristo and Eugene* are taken from Scott Elledge and Donald Schier eds., *The Continental Model: Selected French Critical Essays of the Seventeenth Century, in English Translation* (1960), revised edition, Ithaca: Cornell University Press, 1970, pp. 160–6 and 182–92.

The bel esprit

Eugene and Aristo began their walk with the reading of a work containing both prose and verse which one of their friends had recently composed. They read it attentively, as new things are always read; and after examining it at leisure they were both of the

opinion that for a long time nothing had appeared which was wittier or more reasonable.

A man must be very intelligent, said Eugene, to write the kinds of works in which witticisms glitter everywhere and in which there are no paste jewels.

Intelligence alone is not enough, replied Aristo; a special kind is needed. Only the keenest wit produces masterpieces, for it is the quality which gives to excellent pieces of writing the special shape which distinguishes them from ordinary ones, and that characteristic of perfection by which new charms are always to be found in them. But everybody does not have this keen wit I am speaking of, he added, and he who counterfeits the clever man has it perhaps less than another. For there is much difference between being professionally clever and having a keen wit of a certain beauty which I can imagine.

If that beauty of wit which you imagine is a very rare thing, said Eugene, the reputation for cleverness is fairly common; it is the compliment most frequently paid in society. It even seems to me there is no quality more easily acquired. One need only be able to tell a story agreeably or turn a line of verse: a trifle gracefully said, a madrigal, a couplet for a song can often be the basis for a reputation as a wit; and you must agree that it is of these clever talkers and makers of pretty things that we are accustomed to say, He is a bel esprit.

I admit, answered Aristo, that this title has been as freely and unjustly usurped in our time as that of gentleman or marquis; and if the usurpers in the realm of letters were punished as severely as these other usurpers have been in France many people would be degraded from that rank as many have been from the nobility. Those clever gentlemen would have a hard time commanding respect for their madrigals, their jingles, and their impromptus and thus maintaining themselves in their present status; I am sure they would not find in their papers grounds for clinging to the eminence they claim. Their titles are no better than those of false nobles; the name they bear is a name floating in the air unsupported by anything substantial; they have a reputation for wit but without deserving it and without exemplifying it.

The witty man is a foolish type, said Eugene, and I don't know whether I wouldn't rather be a little stupid than to pass as what is ordinarily called clever.

All reasonable men are of your opinion, answered Aristo. Wit has been so much disparaged since its profanation through being made too common that the wittiest men object to the name and avoid being accused of it as though it were a crime. Those who are still proud of the name are not the decent people in society; indeed, they are far from being what they think they are; they are nothing less than beaux esprits, for true beauty of wit consists in a just and delicate discernment which those gentlemen do not have. That discernment shows things to be what they are in themselves, not stopping too soon, as do the common people who do not go below the surface, and not going too far like those refined intelligences which, through an excess of subtlety, evaporate in vain and chimerical imaginings.

It seems to me, interrupted Eugene, that this exquisite discernment is more closely related to common sense than to bel esprit.

True wit, answered Aristo, is inseparable from common sense, and it is a mistake to confuse it with that sort of vivacity which has nothing solid in it. One might say that judgment is the foundation for beauty of wit; or rather bel esprit is of the nature

of those precious stones which are not less solid than brilliant. There is nothing more beautiful than a well-cut and well-polished diamond; it shines on every side and on every facet.

Quanta sodezza, tanto ha splendore. [Its splendour is proportionate to its solidity.] It is solid but brilliant matter, it dazzles but has consistency and body. The union, the mixture, the proportion of the brilliant with the solid give it all its charm and all its value. There is a symbol for bel esprit as I conceive it. It is equally brilliant and solid: it might well be defined as common sense which sparkles. For there is a kind of gloomy, bleak common sense which is hardly less the contrary of wit than is a false brilliance. The common sense I am speaking of is entirely different; it is gay, lively, full of fire, like that which is seen in the *Essays* of Montaigne . . . it proceeds from a straight and luminous intelligence and from a clear and pleasant imagination.

The just apportionment of vivacity to common sense renders the mind subtle but not vapid, brilliant but not too brilliant, quick to conceive an idea, and sound in all its judgments. With that kind of wit one thinks of things properly and expresses them as well as they have been thought. Much meaning is gathered into few words, everything is said that need be said and only that is said which must be said. The bel esprit is concerned more with things than with words; yet he does not scorn the ornaments of language, neither does he seek them out; the polish of his style does not lessen its strength, and he might be compared to those soldiers under Caesar who, for all they were clean and perfumed, were nonetheless valiant men who fought well.

On the basis of what you are saying, remarked Eugene, there is not much difference between a bel esprit and a rationalist (*esprit fort*).

There is none at all, replied Aristo, if we take the latter expression in its literal meaning, a strong mind. The beauty of wit is a masculine and gallant beauty which has in it nothing soft or effeminate. [. . .]

But do not imagine that the bel esprit, because he is very strong, is for that reason lacking in delicacy: he resembles Achilles in Homer and Rinaldo in Tasso whose nerves and muscles were extremely strong under a white and tender skin. His solidity and profundity do not keep him from conceiving things with finesse, nor from giving refined expression to all that he thinks. The images by which he expresses his thoughts are like those paintings which have all the technique of art and in addition what must be called a tender and graceful air which charms the connoisseur.

There are excellent minds which have no delicacy and who are proud of having none, as if delicacy were incompatible with strength. Their way of thinking and saying things has no sweetness and no attractiveness. With all their learning and all their subtlety their imaginations are in some way sombre and crude, like that Spanish painter who could make only coarse strokes and who proudly replied one day to those who criticized him for this that he preferred to be *primero en aquella grossería que secundo en delicadeza* [first in that coarseness rather than second in delicacy].

But men of this turn of mind, however good they may be, are not so felicitous in their works as that painter was in his. The most learned writings and even the most ingenious are judged unfavorably in our day if they are not delicately handled. Besides their solidity and their strength they must have what I shall call an agreeable and flowery quality in order to please people of good taste, and that is what gives

individuality to beautiful things. To understand what I mean, remember what Plato says, that beauty is like the flower of goodness. According to that philosopher good things which do not have that flower are only good, and those which have it are really beautiful.

That is to say, added Eugene, that the bel esprit, if we define him Platonically, is a good mind in flower, like those trees which bear fruit and flowers at the same time and in which we see the maturity of autumn allied to the beauty of spring...

Those fruits and flowers, Aristo went on, indicate also that happy fecundity which is so fitting in a gifted man. For myself I consider there is not less difference between sterile minds and those which are not than there is between handsome orange trees and mean growths which produce no fruit.

I doubt, interrupted Eugene, whether fertility is a sound indication of beauty of mind. It seems to me that the most fecund minds are not always the most reasonable or the most acute. Great fecundity most often degenerates into an undesirable abundance, into a profusion of false and useless thoughts; and if you examine the question carefully you will see that what you are calling a property of the bel esprit is usually no more than the effect of an unbridled imagination.

I am well aware, replied Aristo, that there is a fertility of mind similar to that of trees which, because they are too heavy-laden with fruit, bear little that is good. The fecundity I am speaking of is not of that kind. It is what I have called a happy fecundity, not only a stock of good things but one which is controlled by common sense. A real bel esprit is like those rich and wise people who live magnificently in every way, yet who nevertheless are not extravagant. [. . .]

. . . a bel esprit is rich in his own resources; he finds in his own understanding what ordinary people find only in books. He studies himself and educates himself, as a learned man said of one of the greatest geniuses France has ever produced. Above all he does not take over the thoughts of others; he does not steal from the ancients or from foreigners the works he gives to the public.

Yet, said Eugene, that is what most of our clever men do. They continually pillage the Greeks and the Romans, the Italians and the Spaniards; and if anyone were willing to examine their works carefully he would discover that the land of Belles Lettres is full of robbers and that Mercury, who presides over the arts and sciences, is also, and not without cause, the god of thieves...

While forbidding larceny to the bel esprit, Aristo went on, I do not intend to forbid him to read good books; I do not even claim that his reading ought to be useless to him. I am willing for him to imitate the great models of antiquity if only he tries to surpass them in his imitation; but I cannot allow him to do like those minor painters who limit themselves to copying the originals and who would produce nothing beautiful if the masters of the art had not done so before them. [. . .]

But do not suppose that all of the beauty of wit can be reduced to this. Besides what I have just mentioned, it demands a nature able to acquire all the artistic skills, a lofty and broad intelligence, unlimited and unsurpassed. For beauty of wit is like that of the body: little men, however well formed, are not handsome, in Aristotle's opinion; at best they are only agreeable, because to have the advantage of stature is an essential part of beauty. Thus the little genius who is limited to a single thing, the maker of pretty verses who can do only that with whatever charm and decorum, is

not a bel esprit, say what you will; he is really only a wit and it would be enough for him to be accepted on that footing in society.

Moreover, to be a bel esprit it is not enough to have a solid, profound, delicate, fertile, just, and universal intelligence; the mind must have besides a certain clarity which all great geniuses do not have. For some of them are naturally obscure and even affect obscurity; a large proportion of their ideas are so many enigmas and mysteries; their language is a kind of cipher which can be understood only through divination. Among modern Spaniards Gracián is one of these incomprehensible geniuses; he can rise very high, he has subtlety, strength, and common sense; but most of the time the reader doesn't know what he means as perhaps he doesn't know himself; some of his works seem made to defy understanding.

However, there ought to be neither obscurity nor confusion in what comes from a bel esprit; his thoughts and expressions must be so noble and so clear that the most intelligent of his readers admire him and the least intelligent understand him.

* * *

The je ne sais quoi

When Aristo and Eugene had reached the place of their walk, they first gave expression to the joy they felt at passing such pleasant hours in each other's company. Eugene said: Though we may be solitary, yet I am not envious of the most agreeable society in the world.

Aristo thereupon said to his friend all those things which a warm friendship can suggest at such meetings; then, allowing his mind to rove wherever his heart might lead it, he said: It must be admitted, my dear Eugene, that there are few friendships like our own, for we can be always together and never tire of each other. Private conversations in which love plays no part are almost always tiresome when they are too frequent or when they are rather long. No matter what the esteem or the affection one may have for any gentleman, one gradually wearies of seeing only him and of speaking only to him; one even feels, in some inexplicable way, that this brings about a diminution in the feelings which his merits have caused, whether because one gradually becomes used to what at first appeared extraordinary in his person or whether through familiarity one discovers in him hidden defects which make his good qualities less estimable. Hence, for us daily to find new pleasures in our conversations, as we do, our friendship must necessarily be much stronger than ordinary ones, because, although it is virtuous, it arouses in us what love arouses in others.

In other words, added Eugene, we must be meant for each other, and there must be a rare sympathy between our minds.

What you say is very true, answered Aristo, and for myself I feel it deeply. The boredom which seizes upon me as soon as we are separated, the joy which our longest conversations give me, the slight attention I pay to learning new things and my lack of care in cultivating my old habits are apparently the effects of the great liking and those hidden inclinations which make us feel for one person an indefinable something which we do not feel for another.

From the way you speak, replied Eugene, you appear to know pretty well the nature of that indefinable something whose effects you feel.

It is something much easier to feel than to know, rejoined Aristo. It would not be indefinable if it were understood; its nature is to be incomprehensible and inexplicable.

But can we not say, Eugene responded, that it is an influence from the stars and an invisible effect of the planet which was in the ascendant when we were born?

Naturally we can say that, answered Aristo, or even that it is the tendency and instinct of the heart, that it is the most exquisite feeling of the soul for whatever makes an impression upon it, a marvelous liking and what might be called a kinship of the heart, to use the words of a Spanish wit: *un parentesco de los corazones.*

But to say that and a thousand other things is to say nothing. These feelings, these tendencies, these instincts, these likings, these kinships, are fine words which scholars have invented to delude their ignorance and to deceive others after they have been taken in themselves. One of our poets has described it better than all the philosophers; he settles the matter in a word:

> There are strong bonds of hidden, tender liking,
> Through whose sweet pow'r each lover finds his own;
> Each to each is join'd at glances' striking
> By something hidden, never to be known.

Even if that were true of the mysterious something one feels for people deep in one's heart, said Eugene, it might not be true of whatever it is that makes people pleasing, a quality which shows in their faces and which is obvious at first sight.

I assure you, said Aristo, that this latter something is as hidden and indescribable as the other. Because it is visible it is not better known or easier to define. For it is not really beauty, or a prepossessing appearance, or charming manners, or the gaiety of good humor, or brilliance of wit, because every day we meet people who have all these qualities without the faculty of being pleasing, and we see others who are very pleasant without having any agreeable qualities except the mysterious something.

Hence, the most reasonable and the most certain thing that can be said is that the greatest merit achieves nothing without it, and that it is sufficient in itself to create a very great effect. There is no advantage is being handsome, witty, gay, or what you will, if that mysterious something is lacking; all your fine qualities are as it were dead: there is nothing striking or touching about them. They are hooks without bait, pointless arrows and dull witticisms. Yet whatever defects may be found in body or soul, with this single advantage one is always pleasing, nor can one do anything wrong: the mysterious something makes everything right.

It follows from that, said Eugene, that it is a grace which brightens beauty and other natural perfections, which corrects ugliness and other natural defects, that it is a charm and an air which informs every action and every word, which has its part in the way one walks and laughs, in the tone of the voice, and even in the slightest gesture of the socially acceptable person.

But what is that grace, that charm, that air? asked Aristo. When one examines all those terms closely one ends by not making head nor tail of them, and one is forced

back upon the mysterious something. One of our clever gentlemen has said of a very likable young man:

> But most of all he had a grace
> A 'something' by which to surpass
> The sweetest charms of love's young face,
> A smile whose pow'r all words doth pass,
> An air distinctive and unique
> Whose secret others vainly seek.

This grace, this charm, this air are like the light which embellishes all of nature and which is seen by everybody though we do not know what it is, and so we cannot say anything more about it, to my way of thinking, except that it can neither be explained nor understood. Indeed, it is so delicate and imperceptible that it escapes the most penetrating and subtle intelligence; the human mind, which recognizes the most highly spiritual quality of the angels and the most divine quality in God, so to speak, does not recognize what is charming in a phenomenon which is both perceptible to the senses and capable of touching the heart.

If that is true, said Eugene, we must give the lie to philosophers who have always maintained that knowledge precedes love; that the will can love nothing which is unknown to the rational faculty.

They were right in their argument, said Aristo. Love is impossible without knowledge, and one always knows the loved person; that is, we may know that she is lovable, but not always know why we love her.

But if you please, interrupted Eugene, is that knowledge sufficient by which we know the person and recognize that she is lovable? Is it possible to love her and at the same time not to know what it is that makes her the object of love?

Yes, answered Aristo, and the mystery of the 'certain something' consists of exactly that. Nature, like art, is careful to hide the cause of unusual impulses: we see the machine, and with pleasure, but we do not see the spring which makes it work. A woman may be pleasing to us, or inspire love at first sight without our knowing why she has this effect. You will say that in these circumstances nature sets traps for our heart so as to catch it unawares, or rather that since she knows it to be as proud and as sensitive as it is in fact, she spares it and treats it gently by hiding the dart which is to wound it.

I am inclined to think, said Eugene, that if the soul does not perceive the quality by which it is touched in such encounters the reason is that the quality acts so fast as to be imperceptible to the soul. For, as you may have noticed, anything which moves very fast is invisible. Thus arrows, bullets, cannon balls, bolts of lightning all pass before our eyes without being seen. These things are visible in themselves but the speed with which they move hides them from our sight.

That reminds me, said Aristo, of the simple-mindedness of that savage who, having been shot and not being able to understand what had wounded him, said that it was either the flame he had seen or the noise he had heard.

If stone, fire, lead, and wood, Eugene continued, become invisible through the speed with which they fly through the air, should we be amazed that the quality

which at first sight makes an impression on the soul can pass unnoticed? For of all the things which move fast the fastest is the dart which wounds the heart, and the shortest of all moments, as I may say, is that in which the 'mysterious something' makes its effect.

However that may be, said Aristo, it is certain that this mysterious something belongs to that class of things which are known only by the effects they produce. Our eyes witness the wonderful movements which a magnet induces in iron filings; but who can say what the power of that marvelous stone really is? The wind which shakes mountains and rocky cliffs, which destroys towns and troubles all the elements is something unseen and which has not yet been well defined. Neither have the influences which fall from the heavens and which form minerals in the depths of the earth. Let us say the same of that charm and of that peculiar fascination we are discussing: it attracts the hardest hearts, it sometimes excites violent passions in the soul, it sometimes causes very noble sentiments; but it is never known except in that way. Its importance and its advantage lie in its being hidden; it is like the source of that Egyptian river, the more famous for not having yet been discovered, or like the unknown goddess of the ancients who was adored only because she was not known.

Might one dare say, Eugene added, that it is like God Himself and that there is nothing better known nor more unknown in the world?

One can at least say this with certainty, Aristo continued, that it is one of the greatest marvels and one of the greatest mysteries of nature.

Is that not the reason, said Eugene laughing, that the most mysterious nations give it a place in everything they say? The Italians, who make a mystery of everything, use their expression *non sò che* right and left. Nothing is more usual in their poets.

> Un certo non sò che
> Sentesi al petto.
> [An indescribable sensation is felt in the heart.]

[. . .] I should never finish if I tried to mention all the examples of *non sò che* which I remember. The Spaniards also have their *no sé que* which they use at all times and in all contexts, besides their *donaire* (grace) their *brio* (vigor) and their *despejo* (facility) which Gracián calls *alma de tota prenda, realce de los mismos realces, perfección de la misma perfección* (the object of all desire, splendor of all splendors, the perfection of perfection itself), and which is, according to the same author, above our thoughts and our words, *lisonjea la inteligencia, y estraña la explicación* (it deceives the intelligence and bemuses attempts at explanation).

If you took the trouble to read our books with as much care as you have read the Italians and Spaniards, said Aristo, you would find that the *je ne sais quoi* is very popular among us, and that in this we are as mysterious as our neighbors.

But to come back to what we were saying, the *je ne sais quoi* is like those beauties covered with a veil, which are the more highly prized for being less exposed to view, and to which the imagination always adds something. Hence, if by chance we were to see clearly the nature of this mysterious something which astonishes and overwhelms the heart at first glance, we should perhaps be less charmed and touched than we are;

but it has not yet been unveiled and perhaps never will be since, as I have already said, once unveiled it would cease to be what it is.

Moreover, since it cannot be explained, it cannot be described either, and this is perhaps the reason why showing a person's portrait is not enough to cause her to be loved by the beholder, any more than does singing her praises, whatever romances and fables may say. The most favorable description and the most flattering portrait can produce esteem for a person and a desire to see her, but neither the one nor the other ever causes a real affection because neither the brush nor the tongue can express that mysterious something which is all-powerful.

* * *

At least, Eugene added, the *je ne sais quoi* is restricted to natural phenomena for, as far as works of art are concerned, all their beauties are evident and their capacity to please is perfectly understandable.

I cannot agree, answered Aristo. The *je ne sais quoi* belongs to art as well as to nature. For, without mentioning the different manners of painters, what charms us in those excellent paintings, in those statues so nearly alive that they lack only the gift of speech, or who do not even lack that if we are to believe our eyes ... what charms us, I say, in such paintings and statues is an inexplicable quality. Therefore the great masters, who have discovered that only that is pleasing in nature whose attraction cannot be explained, have always tried to give charm to their works by hiding their art with great care and skill. [...]

Let us go further, my dear Eugene, and let us say in addition that when we examine carefully those things in this world which we most admire we see that what makes us admire them is the mysterious something which surprises us, which dazzles us, which charms us. We shall even come to see that this mysterious quality is, if it is rightly understood, the focal point of most of our passions. Besides love and hatred, which give the impetus to all the impulses of the heart, desire and hope, which fill up the whole of man's life, have practically no other foundation. For we are always desiring and hoping, because beyond the goal we have set for ourselves there is always something else to which we unceasingly aspire and which we never attain; that is why we are never satisfied with the enjoyment even of those things we have most ardently desired.

But to speak in a Christian fashion of the *je ne sais quoi*, is there not a mysterious something in us which makes us feel, despite all the weaknesses and disorders of corrupt nature, that our souls are immortal, that the grandeurs of the earth cannot satisfy us, that there is something beyond ourselves which is the goal of our desires and the centre of that felicity which we everywhere seek and never find? Do not really faithful souls recognize, as one of the Fathers of the Church says, that we were made Christians not for the goods of this life but for something of an entirely different order, which God promises to us in this life but which man cannot yet imagine?

Then, Eugene interrupted, this mysterious quality partakes of the essence of grace as well as of nature and art.

Yes, answered Aristo. Grace itself, that divine grace which has caused so much uproar in the schools and which produces such wonderful effects upon souls, that grace both strong and gentle which triumphs over hardness of heart without limiting the freedom of the will, which subjects nature by adjusting itself to her, which makes

itself master of the will while leaving the will its own master, that grace, I say, what is it but a mysterious quality of a supernatural order which can be neither explained nor understood?

The Fathers of the Church have tried to define it, and they have called it 'a deep and secret calling,' 'an impression of the spirit of God,' 'a divine unction,' 'an all-powerful gentleness,' 'a victorious pleasure,' 'a holy lust,' 'a covetousness for the true good'; that is to say that it is a *je ne sais quoi* which indeed makes itself felt but which cannot be explained and of which it would be better not to speak.

It is true, Aristo went on, that the *je ne sais quoi* is almost the only subject about which no books have been written and which the learned have never taken the trouble to elucidate. Lectures, dissertations and treatises have been composed on very odd subjects, but no author, as far as I know, has worked on this one.

I remember, said Eugene, reading in the *History of the French Academy* that one of the most illustrious academicians gave a speech in the Academy on the subject of the *je ne sais quoi*. However, since this speech has not been published, the world was no more illumined by it than it was before, and perhaps even if this academic discourse were to see the light we should not be much more informed than we are, the subject being one of those which have an impenetrable core and which cannot be explained other than by admiration and silence.

I am very glad, said Aristo laughing, that at last you have come to the proper conclusion and that you are satisfied to admire what at first you wanted to understand. Take my advice, he added, and let us stop here without saying anything further about a thing which continues to exist only because no one can say what it is. Besides it is time to bring our walk to an end; the sky is darkening all around us, it is starting to rain, and if we do not go in soon we shall be liable to feel the fury of the coming storm.

8 Samuel Willard (1640–1707) from *A Compleat Body of Divinity*

Samuel Willard was pastor of the Old South Church in Boston, Massachusetts, from 1678 until his death. For the last few years of his life he was Vice-Chancellor of Harvard College. While sophisticated European Christians such as Bouhours were interpreting the experience of art by reference to traditional concepts of divine grace (see ID7), a puritan distaste for the celebration of art ruled throughout most of North America well into the nineteenth century. As demonstrated in the following excerpts from Willard's published sermons, this distaste was given its clearest practical form in the proscription of religious images. It was a consequence of this proscription that domestic portraiture and the recording of local landscape provided the only generally tolerated means of practice for the aspiring American painter until at least the late eighteenth century (see IVA5). The more ambitious forms of history painting generally failed to take root, associated as they were with European traditions of religious painting. As the contrast with Bouhours serves to make clear, however, Willard and his fellow New England Protestants were driven by something more fundamental than the mere disapproval of pictures. What concerned them was that those who established their highest values by reference to the experience of art were, in effect, worshipping a false God; and that they thus threatened those values by which the community was bound together. (For an earlier but comparable English text see ID4.) The voice of

Protestant iconoclasm was to be heard with increasing rarity as the aesthetic discourse of modernism developed. An evolving opposition to that discourse was to keep pace, however, articulating in one form or another the continuing concerns of those who regarded the aesthetic as a value indifferent to human unhappiness and injustice, and who believed that they themselves spoke on behalf of threatened communities. Samuel Willard published several volumes of his collected sermons. The following passages are taken from his *A Compleat Body of Divinity in Two Hundred and Fifty Expository Lectures on the Assembly's Shorter Catechism*, Boston, 1726, Sermon XVII, April 23th 1689, p. 54 and Sermon LI, January 13th 1701, pp. 621–2, in the form reprinted in John McCoubrey, *American Art 1700–1960*, Englewood Cliffs, New Jersey: Prentice-Hall, 1972, pp. 3–5.

Enquiry into the Divine Attributes, 1689

... how very unsuitable is it to represent the Divine Nature by any Corporeal similitude. I mean in Pictures or Images, of any visible and bodily substance, and that whether it be for civility or devotion, i.e., either merely as Ornamental, or as some pretend, to increase devout Affections in any; how is it possible rightly to shadow a Spirit? Whoever was able rightly to decipher the form or shape of a being which is invisible! It is folly to pretend to afford us the Portraiture of an Angel, but it is a madness and wickedness to offer at any Image or Representation of God: How many solemn cautions did God give His people against this by Moses, besides the express forbidding of it in the second Command; and God declares it to be a thing Idolatrous. For any to entertain or fancy any other Image of God, but those reverend impressions of His glorious Perfections that are engraven upon his heart, is highly to dishonour Him, and provoke Him to Jealousy.

What Is Forbidden in the Second Commandment, 1701

First, this Command forbids the Worshipping of God by Images. This is expressly mentioned; and that in two Particulars.

1. The Making of them is prohibited. *Thou shalt not make.* And under a graven Image and Similitude is comprehended, every manner of Representation of God, whether in Statues or Pictures: For this general Prohibition doth not respect things merely Civil, but only a Representation of the Deity, as we may gather from Deut. 4.15, 16. *Take ye therefore good heed unto yourselves (for ye saw no manner of similitude on the day that the Lord Spake unto you in Horeb, out of the midst of the fire). Lest ye corrupt yourselves, and make you a graven image, the similitude of any figure, the likeness of male or female.* Isai. 40.18, 19. *To whom then will ye liken God, or what likeness will ye compare unto him? The workman melteth a graven image,* ...

2. The offering of Divine Worship to them or before them. *Thou shalt not bow,* ... And the latter is *exegetical* to the former. God reckons any religious bowing to an Image or Representation, to be a worshipping it. For although Idolaters have been so brutish, as to direct their Worship nextly and immediately to the Image, yea, the wise Heathens themselves were not so gross, as to acknowledge that they looked upon their Idols, to be real Deities in themselves, or terminate their Worship on

them; but they conceived of a God, whom they represented by the image, through which they supposed him to communicate himself to them, and in which they adored him, hoping for a better Acceptance. The Egyptians, when they found good or benefit by any Creature, they worshipped God in it, not supposing that the thing itself was God, but that God communicated himself to them, by and through the Creature, and that they ought to worship him in it, and the Creature no further, then they supposed God to be in it. For this End also they made Images, or Portraitures of these and those Creatures, before which they paid their Devotions, and on which they imposed the Name of their God. And this is represented as sinful and super-stitious, Rom. 1.21, 22, 23. *Because when they knew God, they glorified him not as God, neither were they thankful, but became vain in their imaginations, and their foolish heart was darkened. Professing themselves to be wise, they became fools: And changed the glory of the uncorruptible God, into an image made like to corruptible man, and to birds, and four-footed beasts, and creeping things.* Of this Nature was the Golden Calf, which Israel made in the Wilderness, in Imitation of the Egyptians, among whom they had lived and conversed. Nor did they suppose it to be God himself, but a Representation of him, and put his Name upon it, as we do of a Person on his Statue or Picture. Hence they kept the Feast to Jehovah, Exod. 32.5. *Tomorrow is a feast to the Lord.* Of the same Nature was *Jereboam's* Calves, which were erected at *Dan* and *Bethel*, to facilitate the People's Worship, and was surrogated in the room of the Ark, at the Temple in *Jerusalem*. Hence that Reason is given of the making of them, 1 Kin. 12.28. *Whereupon the king took counsel, and made two calves of gold, and said unto them, It is too much for you to go up to Jerusalem.* It is true, those are called Gods, in the Word of God, and the worshiping of them is called Idolatry, yea, they are named Devils and their Service Devil-Worship. See, II Chron. 11.15. *And he ordained him priests for the high places, and for the devils, and for the calves which he had made.* Psal. 106.36, 37. *And they served their idols which were a snare unto them. Yea, they sacrificed their sons and their daughters unto devils.* Partly because the ignorant among them, were become so brutish in their Imaginations, as to terminate their Service on the Idol. Hence that Complaint, Isai. 44.19, 20. *And none considereth in his heart, neither is their knowledge nor understanding to say, I have burnt part of it in the fire, yea also I have baked bread upon the coals thereof: I have roasted flesh and eaten it, and shall I make the residue thereof an abomination?* Partly also, because God doth not account himself to be acknowledged as God, if his Laws of Worship be neglected, and other Rules be invented in the room thereof, Acts 17.24, 25. And by this, the horrible Idolatry of the Church of Rome is manifested. Nor will all their Evasions, and copious Distinctions, excuse them from the Guilt of it. False Worship is supposed to be paid to a God that will accept of it, which must be a false God, for the true God abhors it.

9 Gottfried Wilhelm Leibniz (1646–1716) on art and beauty

The German philosopher and mathematician Leibniz was born in the university town of Leipzig. His range of work and interests was remarkable and he made original contribu-tions to optics, mechanics, logic, linguistics, geology and physics, as well as philosophy. Although most of his writings remained unpublished at his death in 1716, his ideas were

known and appreciated by his contemporaries through his extensive correspondence. His only work published in his lifetime, *The Theodicy* of 1710, initiated a widespread debate on optimism and the limits of Enlightenment ideas of progress and reason. It was satirized by Voltaire in *Candide* (1758). Leibniz's importance for art theory lies in his re-evaluation of the significance of the 'confused perceptions' of the senses. Cartesian rationalism had been taken up and assimilated into classicist poetics and art theory in the seventeenth century. Fundamental to it was the insistence that only clear and distinct ideas could possess the status of necessity; knowledge gained through the senses was to be profoundly mistrusted. By contrast, Leibniz recognized the virtues of those forms of knowing which were grounded in confused ideas or representations. Such knowledge requires the exercise of 'taste', a form of discriminative activity which involves both reason and experience. Lower and vaguer perceptions implicitly contain their own rational explanation, and though such knowledge might start out as a *je ne sais quoi* it could be brought to a higher level of rational demonstration. The following selections, drawn from a wide variety of Leibniz's writings, were selected by Milton C. Nahm for his book, *Readings in Philosophy of Art and Aesthetics*, Englewood Cliffs, New Jersey: Prentice-Hall, 1975, pp. 315–19.

The 'I know not what' and 'sympathy'[1]

Joy is a pleasure which the soul feels in itself. *Pleasure* is the feeling of a perfection or an excellence, whether in ourselves or in something else. For the perfection of other beings also is agreeable, such as understanding, courage, and especially beauty in another human being, or in an animal or even in a lifeless creation, a painting or a work of craftsmanship, as well. For the image of such perfection in others, impressed upon us, causes some of this perfection to be implanted and aroused within ourselves. [...]

We do not always observe wherein the perfection of pleasing things consists, or what kind of perfection within ourselves they serve, yet our feelings (*Gemüth*) perceive it, even though our understanding does not. We commonly say, 'There is something, I know not what, that pleases me in the matter.' This we call 'sympathy.' But those who seek the causes of things will usually find a ground for this and understand that there is something at the bottom of the matter which, though unnoticed, really appeals to us. [...]

Music is a beautiful example of this. Everything that emits a sound contains a vibration or a transverse motion such as we see in strings, thus everything that emits sounds gives off invisible impulses. When these are not confused, but proceed together in order but with a certain variation, they are pleasing; in the same way, we also notice certain changes from long to short syllables, and a coincidence of rhymes in poetry, which contain a silent music, as it were, and when correctly constructed are pleasant even without being sung. Drum beats, the beat and cadence of the dance, and other motions of this kind in measure and rule derive their pleasureableness from their order, for all order is an aid to the emotions. And a regular though invisible order is found also in the artfully created beats and motions of vibrating strings, pipes, bells, and, indeed, even of the air itself, which these bring into uniform motion. Through our hearing, this creates a sympathetic echo in us, to which our animal spirits respond. This is why music is so well adapted to move our minds. [...]

There can be no doubt that, even in touch, taste, and smell, sweetness consists in a definite though insensible order and perfection or a fitness, which nature has put there to stimulate us and the animals to that which is otherwise needed. [...]

I call any elevation of being a perfection... perfection shows itself in great freedom and power of action, since all being consists in a kind of power. [...]

The greater any power is, moreover, the more there is found in it the many revealed through the one and in the one.... Now unity in plurality is nothing but harmony [*Uebereinstimmung*], and, since any particular being agrees with one rather than another being, there flows from this harmony the order from which beauty arises, and beauty awakens love.

Taste consists of confused perceptions[2]

Taste as distinguished from understanding consists of confused perceptions for which one cannot give an adequate reason. It is something like an instinct. Tastes are formed by nature and by habits. To have good taste, one must practice enjoying the good things which reason and experience have already authorized.

Confused knowledge and the 'something, I know not what'[3]

Knowledge is *clear*, therefore, when it makes it possible for me to recognize the thing represented. Clear knowledge, in turn, is either confused or distinct. It is *confused* when I cannot enumerate one by one the marks which are sufficient to distinguish the thing from others, even though the thing may in truth have such marks and constituents into which its concept can be resolved. Thus we know colors, odors, flavors, and other particular objects of the senses clearly enough and discern them from each other but only by the simple evidence of the senses and not by marks that can be expressed. So we cannot explain to a blind man what red is, nor can we explain such a quality to others except by bringing them into the presence of the thing and making them see, smell, or taste it, or at least by reminding them of some similar perception they have had in the past. Yet it is certain that the concepts of these qualities are composite and can be resolved, for they certainly have their causes. Likewise we sometimes see painters and other artists correctly judge what has been done well or badly; yet they are often unable to give a reason for their judgment but tell the inquirer that the work which displeases them lacks 'something, I know not what.'

Contemplation of beautiful things is pleasant in itself[4]

Thus the contemplation of beautiful things is itself pleasant, and a painting of Raphael affects him who understands it, even if it offers no material gains, so that he keeps it in his sight and takes delight in it, in a kind of image of love. But when the beautiful object is at the same time itself capable of happiness, this affection passes over into true love.

Reason, imagination and the precepts of art[5]

Music is subordinate to Arithmetic and when we know a few fundamental experiments with harmonies and dissonances, all the remaining general precepts depend on numbers; I recall once drawing a harmonic line divided in such a fashion that one could determine with the compass the different compositions and properties of all musical intervals. Besides, we can show a man who does not know anything about music, the way to compose without mistakes. But as it is not enough to know Grammar and Prosody to compose a beautiful epigram, and since a schoolboy who is taught to avoid mistakes in his writing does not for that purpose have to compose a speech having the power of Cicero's eloquence, so in music what a man needs to compose successfully are practice as well as genius and vivid imagination in things of the ear. And as the making of beautiful verses requires a prior reading of good poets, noticing turns and expressions which gradually tinge one's own style, 'as they who walk in the sun take on another tint,' in the same way a Musician, after noticing in the compositions of talented men a thousand and one beautiful cadences and, so to speak, phrases of Music, will be able to give flight to his own imagination furnished with these fine materials. There are even those who are naturally musicians and who compose beautiful melodies just as there are natural poets who with a little aid and reading perform wonders, for there are things, especially those dependent on the senses, in which we do better by letting ourselves go automatically by imitation and practice than by sticking to dry precepts. And as playing the clavichord requires a habit which the fingers themselves have to acquire, so imagining a beautiful melody, making a good poem, promptly sketching architectural ornaments or the plan of a creative painting require that our imagination itself acquire a habit after which it can be given the freedom to go its own way without consulting reason, in the manner of an inspired Enthusiasm. The imagination will not fail to succeed in proportion to the genius and experience of the person, and we ourselves sometimes have the experience in dreams of shaping images which we should have great difficulty in creating while awake. But reason must afterwards examine and correct and polish the work of the imagination; that is where the precepts of art are needed to produce something finished and excellent.... we have said all these things only in order to forestall incidentally the false notions of those who might abuse what we have just said about the easy means of learning the sciences by some few precepts or principles of discovery.

Whole and part[6]

... Look at the most lovely picture, and then cover it up, leaving uncovered only a tiny scrap of it. What else will you see there, even if you look as closely as possible, and the more so as you look from nearer and nearer at hand, but a kind of confused medley of colours, without selection, without art! And yet when you remove the covering, and look upon the whole picture from the proper place, you will see that what previously seemed to you to have been aimlessly smeared on the canvas was in fact accomplished with the highest art by the author of the work. What happens to

the eyes in painting is equally experienced by the ears in music. The great composers frequently mingle discords with harmonious chords so that the listener may be stimulated and pricked as it were, and may become eager to know what is going to happen; presently when all is restored to order he feels so much the more content. In the same way we may take pleasure in small dangers, or in the experience of ills, from the very sense or proof they give us of our own power or felicity. Or again at the spectacle of rope-walking or sword-dancing we are delighted by the very element of fear that is involved, and we ourselves in play with children hold them as if we were going to throw them out of the window, and half let them go – in very much the same way as the ape carried Christian, King of Denmark, when he was still an infant wrapped in long clothes, to the edge of the roof, and then, when everybody was in terror, turned it into jest and put him back into his cradle safe and sound. On the same principle it has an insipid effect if we always eat sweet things; sharp, acid, and even bitter things should be mixed in to stimulate the taste. He who has not tasted what is bitter has not earned what is sweet, nor will he appreciate it. This is the very law of enjoyment, that positive pleasure does not come from an even course; such things produce weariness, and make men dull, not joyful.

What I have said, however, about the possibility of a part being disturbed without upsetting the harmony of the whole must not be interpreted to mean that no account is taken of the parts; or that it is sufficient for the whole world to be completed at all points, even though it should turn out that the human race was wretched, and that there was in the universe no care for justice and no account was taken of us – as is maintained by some people whose judgment about the sum of things is ill-grounded. For the truth is that, just as in a well regulated commonwealth care is taken that as far as possible things shall be to the interest of the individual, in the same way the universe would not be sufficiently perfect unless, as far as can be done without upsetting the universal harmony, the good of individual people is considered. Of this there could be established no better measure than the very law of justice itself, which dictates that each should have a part in the perfection of the universe and in his own happiness in proportion to his own virtue and to the extent to which his will is directed towards the common good; by which is fulfilled what we call the charity and love of God, in which alone, according to the judgment of wise theologians also, stands the whole force and power of the Christian religion. Nor ought it to seem remarkable that all this deference should be paid to minds in the universe, since they bear the closest resemblance to the image of the supreme Author, and their relation to Him is not that of machines to their artificer (like the rest of the world) but rather that of citizens to their prince; moreover they will endure as long as the universe itself, and they, in some manner, express and concentrate the whole in themselves; so that it might be said that minds are whole parts. [. . .]

God and the artisan contrasted[7]

. . . The reason why God is to be preferred above another mechanician is not only because He makes the whole, whereas the artisan has to seek for his material. This superiority would arise from power only. But there is another reason for the excellence of God, which arises from wisdom. This reason is that His machine also

lasts longer and goes more correctly than that of any other mechanician whatever. The buyer of the watch does not trouble himself whether the workman made the whole of it, or whether he had the pieces of it made by other workmen and merely adjusted them himself, provided that it goes properly. And if the workman had received from God the gift of creating as well the material for the wheels, the buyer would not be satisfied if he had not also received the gift of adjusting them properly. And in the same way the man who wants to be satisfied with God's handiwork will not become so merely for the reason alleged here.

Thus it is needful that God's invention should not be inferior to that of a workman; it must even go infinitely beyond it. The mere production of everything would indeed exemplify the power of God, but it would not sufficiently show His wisdom. Those who maintain the opposite fall exactly into the error of the Materialists and of Spinoza, from whom they protest they differ. They recognize power, but not sufficient wisdom in the principle of things. [...]

1 *On Wisdom* (in Gottfried Wilhelm Leibniz, *Philosophical Papers and Letters*, translated and edited by LeRoy E. Loemker; 2 vols (Chicago, 1956) II, pp. 697–9).

2 *Remarks on the Three Volumes Entitled 'Characteristics of Men, Manners, Opinions, Times...'* (in Gottfried Wilhelm Leibniz, *Philosophical Papers and Letters*, translated and edited by LeRoy E. Loemker; 2 vols (Chicago, 1956) II, p. 1031).

3 *Meditations on Knowledge, Truth, and Ideas* (in Gottfried Wilhelm Leibniz, *Philosophical Papers and Letters*, translated and edited by LeRoy E. Loemker; 2 vols (Chicago, 1956) I, p. 449).

4 *From the Preface of the CODEX JURIS GENTIUM DIPLOMATICUS* (in Gottfried Wilhelm Leibniz, *Philosophical Papers and Letters*, translated and edited by LeRoy E. Loemker; 2 vols (Chicago, 1956) II, pp. 690–1).

5 *Precepts for Advancing the Sciences and Arts* (in *Leibniz Selections*, edited by Philip D. Wiener, Charles Scribners' Sons, New York, 1951, pp. 42–3).

6 *On the Ultimate Origination of Things* (1697). From the book *The Philosophical Writings of Leibniz* by G. W. Leibniz. Selected and translated by Mary Morris. Introduction by C. R. Morris. Everyman's Library edition. New York: E. P. Dutton & Co, pp. 39 ff.

7 *New Essays on the Human Understanding*. From the book *The Philosophical Writings of Leibniz* by G. W. Leibniz. Selected and translated by Mary Morris. Introduction by C. R. Morris. Everyman's Library edition. New York: E. P. Dutton & Co., p. 196.

IE
Practical Resources

1 Edward Norgate (1580–1650) from *Miniatura; or The Art of Limning*

The impoverished son of a successful father who died young, Norgate seems to have shown early talent as a calligrapher and limner or illuminator, which, in seventeenth-century England, was esteemed the most respectable of occupations for a painter. Evidence suggests that he spent some time in the studio of Nicholas Hilliard in London. His first recorded appointments were as tuner (in 1611) and keeper of the king's musical instruments, and he was to earn his living as a cultured civil servant, not primarily as an artist. In the course of his working life, however, he was to acquire as good a practical knowledge of recent developments in art as anyone in England at the time. Appointments as Pursuivant and subsequently as Windsor Herald in the College of Arms came through the patronage of Thomas Howard, Earl of Arundel, whose collection of art was rivalled only by the king's. In 1630 Norgate was granted a monopoly by Charles I himself to 'write and limn' those official letters that would require an impressive presentation. In effect, he served as a general adviser to the king on artistic matters. In that role, and as an agent buying on Arundel's behalf, he made various journeys to the Low Countries and to Italy between 1618 and 1646. His treatise on the art of limning was dedicated to the third Earl of Arundel, who was a former pupil. It was left in manuscript form at Norgate's death. Muller and Murrell have argued persuasively that the first draft of the work was written in 1627–8, and that it was substantially revised in 1648 (Norgate, ed. Muller and Murrell, 1997). As they observe, not only is it 'the most important source for the study of Tudor and Stuart miniature painting', it also 'contains fundamental information and ideas about Netherlandish landscape, drawing in pastel, the naturalization of foreign critical terms into English, and the work of such artists as Rubens, Van Dyck, Holbein, Paul Bril, Orazio Gentileschi, and Hendrik Goltzius' (p. xi). Several of the artists named were acquaintances of Norgate's. Though the first version of the treatise was heavily plagiarized in William Sanderson's *Graphice* of 1658, no complete printed edition of either version was issued until 1919 (Norgate, ed. M. Hardie, Oxford). In the twenty years after Norgate's death a gradually enlarging number of manuscript copies circulated among a close network of gentleman-artists and royalist amateurs,

who regarded them as repositories of technical secrets. The Arundel family copy of the second version was given to the Royal Society in 1678 at the urging of John Evelyn. The opening sections of the treatise are concerned with the physical composition and manufacture of colours. We have selected Norgate's central instruction on the painting of portrait miniatures, with its considerable technical detail on such matters as the picturing of jewellery, together with a shorter passage from his account of the relatively novel art of landscape painting. Our text is taken from the first edition to compare different surviving manuscripts of the second version: Jeffrey M. Muller and Jim Murrell eds., *Edward Norgate: Miniatura or the Art of Limning*, New Haven and London: Yale University Press for the Paul Mellon Centre for British Art, 1997, pp. 71–81 and 82–4.

On portraiture

The first sitting Let the partie whose picture you intend to draw sit before you at a convenient distance, then draw the Lines or porfile of the face with white and lake mingled very faint, to the end that in case you mistake the distance or faile in your designe, You may with a touch of stronger and deeper Colour, amend what you finde amisse without hurt to your worke. The first draught being faintly made, will never be discernable where stronger touches appeare. The lines being truely drawne (where in above all things you ought to be exact and sure), observe the deeper and more remarkable shadowes, and with the same faint crimson Colour of lake and White, give some slight touches or markes somewhat roughly of those shadowes for your better memory and help, when you are againe to goe over them more exactly.

The Lines of the Face being drawne some what sharpe and neat you may if You please line out the posture and proportions of the Body, (which in common pictures is not much lower then the shoulders) where in you are to be carefull to observe the Life, as near as possibly you may. This posture is ordinarily drawne with some other darke colours, for as in this you neede not be soe exact, as in the lines of the Face, soe in case you mistake it you may easily deface alter or amend it without trouble to your selfe, or hurt to the picture. [. . .]

The Order to be observed in a picture by the life is upon the matter the same with oyle Painters, in their ordinary Pictures, which is the first sitting to dead colour the face onely, not troubling Your selfe with the Contorni [garnishes] or things about it, as ground, apparell, &c. And this first sitting comonly takes up two howres in time or if you list to be exact two or three or fower.

The second sitting ordinarily takes up three or fower howres, or more, for in that time you are to goe over the face, very curiously, observing what soever may conduce to the likenes (which is the principall) or to the judicious and fleshly colouring, and observation of the severall graces, beauties or deformities as they appeare in the Life, or else in the close, sharp, and neat workmanship, which is the least considerable, and is indeed but *Opus Laboris*, rather then Ingenii [a work of drudgery rather than native wit]. Yet with some much in estimation.

The third and last sitting is comonly of two howres, or three, according to the patience of the sitter, or skill of the Lymner, and this time is spent in closing what in the former sittings was left imperfect and rough, but principally, in giveing to every deepe shadow their strong touches, and deepnings, as well in the shadowes as in the eyes, eye browes, haire, eares &c. For you must remember that though Lymning

when finished, is of all kinds of painting the most close, smooth, and even, yet the best way to make it soe, and to drive the shadowes with that softnes, and airie tendernes, which the Italians call *La maniera fumata*, is to begin rough, with free, and bold hatches, strokes, and dashes, (which they call *Colpo Di Maestro*) with the sharp point of a reasonable bigg pencill, And after in the working to close it by degrees, filling, and stopping all those whitish bare, and unfinisht places with the point of a smaller pencill. Yet these touches and Observations, are ever the last part of this busines, and never to be done, till all the apparell haire and ground be finished. And this being done with Judgement and discretion, adds exceedingly to the life, likenes and roundnes of the picture, and is like good Musick, best heard and tasted at the close.

To returne to the dead colour description, too sutable to the name, your worke must bee done, or rather begun, the rudest, roughest and boldest of all. Having drawne your face, with lake and white, as I said before, you may adde a little Min or red lead to those Colours, tempering them to the red and crimson of the Cheekes, lipps, &c. but gently and faintly, because it is observable, that in all Colours of Lymning, you can adde as often as you please, but be sure never to lay them too deepe which if you doe, it wilbe hardly helpt without spoiling, or defacing your peece, because as I said before, there is noe heightning of a face in Lymning (the white touches for the light of the eyes, and haire excepted).

The first colours you are to begin the Face with all, is the Redds which are different according to the Life, some more towards a Crimson, others of a more sanguine or blushing redd, here and there disperst, mingled, and towards the shadow pleasingly obscured, with the *Mezzo tinto* or middle faint shadow, principally the lipps, cheekes, nose, bottome of the Chinne, and over and about the Eye Browes, and eyes, you will perceave a dellicate faint rednes, and underneath the Eyes inclining to a blewish and purple colour (above the power of a pen to describe).

These in faire and beautifull faces are ordinary; and must be dilligently observed. The Eare is comonly reddish or inclineing to a darke Crimson, but comonly in a picture it is lost in shadow, or hid most part in the haire.

These severall redds you may worke with the point of the pencill, but after the manner of washing, or hatching, drawing your pencill along with easy, faint, or gentle stroakes, washing and wiping it rather, then with stips, points, or pricks, to pincke or punch it, as some affect to doe. Certainly the true manner of working, must bee the fruit of your owne Industry and practice, and as you finde the Cast and dexterity of your hand, where in it is impossible to give or prescribe a law above that of *Nature* and *Custome*.

The summe of all is, that in your dead colourings, you must wash over and colour your ground and complexion, with this red, and the following shadowes, not caring in this first sitting to be exact, and curious, but rather bold and juditious. For I have seene pictures begun by a good hand, that though being beheld neere, they appeared exceeding rough, uneven, and unpleasant, yet at a little Distance from the eye, they appeared smooth, neat, and round. Which way of painting is called *La gran* Maniera, and is indeed the very best.

Therefore I would perswade you (specially the first sitting), to affect this bold, stout, and judicious manner of expressing what soever you see in the Life which

(though rude at first) you will finde in the working and finishinge, to be in your owne power to bring it to that close neatness, and curiositie, as you please.

The Redds thus done, the next is the blewes, and other broken blewish and grayish shadowes, that comonly are seene betweene the light and darke, specially about the balls of the eyes, Temples, about the forehead, rootes of the haire and other places, where the vaines appeare. These must be wrought in as the other faintly at first, and by degrees, sweetning, the shadowes, or deepning, according as your light falls harder or gentler, and in goeing over the face, be sure to strike in the hard and strong shadowes, under the nose, Chin, Eyebrowes, &c: and with some what more bold touches then before, bring up your worke together, visiting with your pencill the whole round, and uttermost extent of your worke, never giveing perfection to any one part, but to bring up all together, in an equall roundness. By which meanes you wilbe able better to observe the likenes, and the Musick and harmony of lights, and shadowes, wilbe the more full and compleate, when all parts appeare with an equality of perfection, yet as it were at randome, in a Cursory manner.

The fainter and sleighter shadowes, being thus put in, and smoothed, and wrought into the Red, you may then proceed to the hayre, disposing it into such Folds and Tramells, as may best become the Picture.

You must first draw them with Colours neere the life of browne *umber*, and soe of the rest, washing the colour with a bold hand, because the hayre you may heigthen or alter at your pleasure, without danger, or defacing the picture. Remember to cast the haire into a middle colour, not soe high as the heigthning, nor soe deepe as the deeping, but soe as you may worke in the one and the other at pleasure.

This done peruse your worke, and be carefull to fill up the void and empty places, (if any such you have left) that none be bare and uncovered with Colour, and for a parting blow, deepen it yet more strongly, then yet you did in the darkest shadowes, still carefully observing the life, which must bee your Loadstarr and director, and remembring by degrees, to bring up the fainter shadowes, to attend and follow those deeper you toucht last, and soe we have done our first sitting, wherein is exprest the face alone, and that in dead colour onely.

The Second Sitting Wilbe longer in time, but I hope not soe long in the Description, for this will take up three fower or more howres, according as you will bestowe more or lesse time or paines, as your owne and your freinds patience will hold out. And now the party being set in his former posture, you are more exactly to observe, and more curiously to expresse the severall Lineaments of the Face, and varieties of Nature in the Colouring, which as you did with a rude bold, and hasty pencill before, soe now you are after a second, and more leasurly reviewe, to examine your worke, and with the same Colours and some what more then the same Industry to revisite, the severall parts, and the most remarkables of the face, working, driving, and sweetning, the same Colours, one into another, to the end, that nothing bee left with a hard edge (which the Italians hate calling it, *La maniera tagliente or scorticata* [the hard-edged or flayed style]) or on heaps, or uneven patches, but all soe wrought one into an other, with the point of a sharper pencill then you used at first, as that your shadowes may lie soft and smooth, being disposed, and gently extended, into, and towards the lighter parts of the face Like ayre or breath.

Now after you have wrought an hower or two, and made a reasonable progresse over the face, and reduct your observables to a laudable improvement, and perfection it will bee time to lay your ground behind the Picture, to Dead colour the apparrell band, ruffe, or what other linnen you please. For the Fonde, or ground behinde pictures, they are made of all Colours as please Mr. Painter most commonly of blew, sometimes of Crimson like sattin or velvet Curtaines (much in request with Mr Hilliard), but most it is laid with darke and sad colour, to sett off the Picture, indeed nothing comes amisse, if the ground be different enough from the Picture. [...]

And now that your ground is laid you will find the Picture you began some what strangely changed from what it was, for the beauty of the ground will soe dim and darken the Beauty of your picture as at first will seeme strange. Therefore you must worke up your Linnen, and apparrell, to or neere to that height it must be. Soe deale with the hairc, or any other ornament about the body, which done worke over your face againe, giving more perfection to every part, and now the strongest, and deepest touches in all the *Face* would be brought in, to give it that roundnes and strong colouring as may bring forward and advance the face above the ground, and make it appeare in the due lustre and Life it should have, which cannot be done, but by retouching and revisiting with your strongest shadowes, the Eyes, Eyebrowes, the bottome of the Nose, the Dimples of the Chin, and mouth, and other shadowie places easier for you to find and doe, then me to write.

In this worke it wilbe necessary you make use of the best and sharpest pencill you have, where with all you may fill all those blanke places, which are bare and unfilled, whereby Your peece will (ere you are aware) become round and even.

To particularize every thing would be thought a plot upon your patience. There-fore I will here end this second sitting onely wishing you not to leave Your ground. To rest hard upon the porfile of the face with an edge, but with your pencill, soe to sweeten and drive in the ground, with the out line of the face, that when your worke is done, the ground may seeme a great way off, removed behinde the face which must appeare as embost and standing off from the ground, by shadowing it above, on the light side of the Picture, and below on the dark. Then goe over your haire heightning and deepning it as you shall see cause, and making the out most extremities of the loose, and scattered haires to fly and play over the ground which will give a grace to your worke, and ever is observed by all that are verst in this Art. [...]

If when you have done, and the party gone or weary with sitting (as comonly they are), and that your work appeares not altogether soe closed up as it should be, you must to bring it to perfection, spend some time in filling up the void and empty places which you may doe alone, sweetning the shadowes and supplyeing those defects which may have escaped your view (I meane for the face). But for the apparrell, Linnen Jewells, pearle and such like, you are to lay them before you in the same posture as your designe is, and when you are alone, you may take your owne time, to finish them, with as much neatnes and perfection as you please, or can.

And for Linnen it is best made by laying a *Mezzo tinto*, or middle colour, whereon to heigthen with the purest white, and to deepen with black broken with a little brownish and lesse blewish colour.

For black as satin or the like, you may observe the same order, for a middle colour, deepning with Ivory black, and for the heigthning, or light reflexions you may breake

your black with a little Indico, and white, you will find your blacks to render a very excellent reflexion, specially if your lights be strong and hard, where of, if you please to see almost inimitable expressions, you will find abundantly to your content, in the Gallery of my most noble Lord that *Maecenas of Vertue*, and patron of Arts, the Earle of *Arundell* and *Surrey Earle Marshall* of England, and done by the incomparable *Hans* Holbein, who in all his different and various manner of painting, either in Oyle, Distemper, Lymning, or Crayon, was it seems soe rare generall, and absolute an Artist, as never to imitate any man, nor ever was worthily imitated by any.

The third Sitting Wilbe wholely spent in repitition of your former order, for the strong touches, and deepe shadowes, where in it is odds [*sic*], but you ever find some thing to doe, and for the roundnes you wilbe better able to see your way before you, now the *Contorni*, the apparrell Linnen, ground &c, are laid in and finished, Then otherwise you could be.

In this sitting you shall doe well to bend your observations upon what conduces most to the Likenes, which all good workmen comonly make their principall, but yet their last care and to this purpose the party sitting is by occasion of Discourse to be sometimes in motion, and to regard you with a freindly merry and Joviall aspect, where in you must bee ready and suddaine, to catch at and steale Your observations, and to expresse them with an assured quick and constant hand, which is the last and best note I can give you, for this last and third sitting.

If you have occasion for Armour, gold workes Jewells pearles, or such like, For Armour lay a ground of fine shell silver, bound with Gum (that which comes from Holland is the best for this purpose, and soe is the shell gold), being dry and burnisht with the small tooth of a weasell fastned into a stick. Then temper a shadowe for your Armour, with silver, Indico and a little Litmus, or dash of Lake, and worke your shadowes upon, and over your silver, according to the Life, which must bee Laid before you, the heigthnings are to bee Left, not made, being the bright burnisht silver, the deepning, the deepest of your shadow, the thinner parte where of with some silver must be sweetly and neatly wrought into the ground of silver Laid at first.

And for gold you may lay a flat ground with English Oker tempered with liquid Gold. Yet there is a stone growing in the gall of an *Oxe*, that being ground and tempered with Gold, is excellent for all Gold workes, and gives a very good lustre, the deepning being made with *Lake* and burnt Umber, the heigthning of pure Gold the manner of the working I shall tell You within a few Leaves as I had it from Old Mr Hilliard.

If in your Gold works, there be any carving or embost Imagery (which must be done with strong, and bright reflexions) you may very fitly expresse them, by raysing in those high and eminent places a little heape of Gallstone, or *English* Oker, well gumd. These roundnesses or little heapes are made with your pencill full of Colour resting the point of it, in one and the same place for the Colour to flow out, till these heapes or touches bee raised above your other worke.

That done cover your raised worke with gold, which burnisht gently, will shew exceeding faire, and bright. The like you may doe with silver, to expresse the roundnes and lustre of pearles, the shadow and ground whereof must be *White*, *Indico*, *black* and a little Pincke.

Diamonds are exprest with Liquid silver, Laid flat, and high, the deepning Cherristone black, and Ivory. The silver dry, and burnisht is left for the heigthning, the stronger and darker your deepe shadowes are made, the fairer and brighter your *Diamonds* will appeare.

To make *Rubies* was delivered mee as a great secret in Cypher. In plaine English it is that on a ground of burnisht silver, of the fashion and size of your Rubie, You take Turpentine of the best and Purest, temper it with Indian or Florence Lake, then take a needle or such like small iron Instrument, heated in a Candle, and laid upon the ground of silver, fashioning the stone round, square, ovall, or how you please, with the point of your Instrument. This must rest a day or two to dry and you will find it faire, and transparant. If it be long in drying, adde to it a little Powder of clarified Masticke.

For an *Emerald*, adde to Turpentaine, *Verdigreece*, and a little *Turmericke* root scrapt, with *Vineger*. Let it dry, grind it into fine powder, and temper it with *Turpentine*, as you did for the *Rubie*.

Saphires are made with the same *Turpentine* tempered with *Ultramarine*, a costly colour, made of *Lapis Lazuli*. The manner to make this rich and beautifull colour you will finde here after, as I had it from that knowne *Antiquary Sigr Verstegan of Antwerpe*. [...]

On Landscape

An Art soe new in England, and soe Lately come a shore, as all the Language within our fower Seas cannot find it a Name, but a borrowed one, and that from a People, that are noe great Lenders, but upon good Securitie (the Dutch) perhaps they will name their owne Child. For to say truth the Art is theirs, and the best in that kind, that ever I saw spake *Dutch, viz Paulo Brill*, a very rare Master in that Art, Liveing in *Trinita del Monte* in *Rome*, and his Contemporary *Adam Elshamer* [Elsheimer] termed by the Italians *Diavolo per* gli *cose picole* [a devil for little things], *Momper, Bruegel*, Coningslo, and last but not least Sir *Peter Rubens*, a Gentleman of great parts, and abilities (over and above his Pencill) and Knighted by the best of Kings or Men.

Now Landscape, or shape of Land, is but the same with the Latine *Rus Regiones* Regiunculae, The French *Paisage*, or *Italian Paese*: and is nothing but a picture of *Gli belle Vedute*, or beautifull prospect of *Feilds, Cities, Rivers, Castles, Mountaines, Trees* or what soever delightfull view the Eye takes pleasure in. Nothing more in Art or *Nature* affording soe great variety and beautie as beholding the farre distant Mountaines and strange scituation of ancient Castles mounted on almost inaccessible *Rocks* whereof in *Savoy* and Piedmont after you have past *La* Tour *du Pin* many are to bee seene and in all probability built by the ancient *Romans*, and in some places with *precipices*, desperately falling into the *Lezere* [Isère], and other torrents, about the *Alpes* that with a roaring noise make hast to breake their necks from those fearfull *Rocks* into the Sea. Of these many strange yet very beautifull viewes are to be seene, from about *Mont Senis, Launebourg Novalaise*, and about *Mont Godardo* in *Germany*, and many other places about *Provence*, most of which have bene very well designed after the Life by Peter *Brugell* of Antwerp, and remaine in stampe [engravings] to his great Comendation.

Those, that write the Histories of *Plants* as *Mathiolus, Gerard*, and others begin ever with the name *Nature*, and vertues of the herbes and Plants they describe. Give me leave therefore to follow their method, and I owe much to this harmeless and honest Recreation, of all kinds of painting the most innocent, and which the *Divill* him selfe could never accuse of or infect with Idolatry. Soe I meane for your sake, and my owne, a little to retard your expectation with some circumstantiall observations concerning the Originall of *Lanscape* and by what occasion it hath got soe much credit, and is in soe much request as now it is. For it doth not appeare that the antients made any other Accompt or use of it, but as a servant to their other peeces, to illustrate, or sett off their *Historicall* painting, by filling up the empty Corners, or void places of Figures, and story, with some fragment of *Lanscape*, in referrence to their Histories, they made as may be seene in those incomparable *Cartoni*, of the *Acts* of the *Apostles*, and miracles of our Saviour, the figures some what bigger then the Life, soe rarely invented by the Divine *Raphael d' Urbino*, and done in water colours by him and *Julio Romano* [i.e. Raphael's tapestry cartoons, now in the Victoria and Albert Museum, London].

But to reduce this part of painting to an absolute and intire Art, and to confine a mans industry for the tearme of Life to this onely, is as I conceave an Invention of these later times, and though a *Noveltie*, yet a good one, that to the Inventors and Professors hath brought both honour and profit.

The first occasion as I have bene told abroad was thus

A Gentleman of Antwerpe being a great *Liefhebber* [Virtuoso or Lover of Art] returning from a long Journey, he had made about the Countrey of *Liege*, and *Forrest* of *Ardenna*, comes to visit his old friend, an ingenious Painter of that Citie, whose House and Company he useually frequented. The Painter he finds at his Easill – at worke – which he very dilligently intends, while his newcome friend walking by, recountes the adventures of his long Journey, and with all, what Cities he saw, what Beautifull prospects he beheld in a Countrey of a strange Scituation, full of *Alpine Rocks*, old Castles, and extrordinary buildings &c. With which relation (growing long) the prompt and ready Painter, was soe delighted, as (unregarded by his walking freind), he layes by his worke, and on a new Table, begins to paint, what the other spake, describing his description in a more legible and lasting Character, then the others words. In short, by that time the Gentleman had ended his long Discourse, the Painter had brought his worke to that perfection, as the Gentleman at parting by chance casting his eye that way, was astonisht with wonder, to see those places and that Countrey soe Lively exprest by the Painter as if hee had seene with his owne eyes, or bene his Companion in the Journey.

This first Essay at Lanscape it seemes got the Painter Crownes, and Credit. This began others to imitate, and now the Art is growne to that perfection, that it is as much as twenty or thirty yeares practice can doe, to produce a good Painter, at this one *species* of painting onely. Wherewithall Sir Peter *Rubens* of Antwerp was soe delighted in his Later time, as hee quitte all his other practice in Picture, and Story, whereby he got a vast estate, to studie this, whereof he hath left the world the best, that are to bee seene . . .

2 Constantijn Huygens the Elder (1596–1687) on Rembrandt and Jan Lievens

Huygens had become private secretary to the Stadholder Prince Frederik Hendrik in 1625. He was himself the son of the secretary to the first Stadholder, William of Orange, and had undergone a thorough education in the classics as well as being taught music and drawing. By the age of 30 he was not only one of the most prominent intellectuals in the United Provinces, but also one of the most politically influential. Part of his work was to keep an eye open for talented young painters who could potentially contribute to the image of the Dutch court in ways that might parallel the work of artists in Paris, Rome and elsewhere. It was thus that two young painters who had emerged in Leiden were brought to his attention. Jan Lievens (1607–74) worked closely with Rembrandt in the late 1620s, the two possibly sharing a studio. Later, Lievens worked in England, and then in Antwerp, increasingly influenced by the Flemish Baroque style of Van Dyck and Rubens. From 1644 Lievens pursued his career in Amsterdam where he painted political allegories of the Dutch Republic as well as portraits of many of its leading citizens. The son of a prosperous miller, Rembrandt (1606–69) had a Latin school education before spending an apparently fruitless time at Leiden University round about 1620–2. He then spent three years in the studio of Jacob van Swanenburg, an artist who had lived and worked for many years in Italy. After that he studied with Pieter Lastmann, a Raphaelesque painter, in Amsterdam, before returning to Leiden to set up his own practice. By 1630 both young painters had accrued a considerable reputation in history painting as well as portraiture, which evidently extended to Amsterdam and to the upper echelons of the Stadholder's court. Indeed the Stadholder himself had already acquired pictures by Lievens, whose reputation at this time was, if anything, the more advanced of the two. Huygens was writing an autobiography (*The Youth of Constantijn Huygens, written by himself*) between c.1629 and 1631, and it is from there that the present appreciation of the two emerging artists is taken. It is interesting both for what it has to say about class and career opportunities in independent Holland, and for Huygens' informed comments about the stylistic inclinations of the two painters. Also significant, given the way northern painting is conventionally distinguished from the classical tradition, is Huygens' emphasis on the benefits that would accrue to the young artists from an exposure to the Italian Renaissance. Our extracts are taken from the English text as translated from Huygens' Latin in Walter L. Strauss and Marjon van der Meulen, *The Rembrandt Documents*, New York: Abaris Books, 1979, pp. 69–72.

In Triarii, I have purposely singled out a noble pair of Leiden youths. If I said they alone were equal to those prodigies I have pointed out among so many great mortals, I would judge even this something less than what these two deserved. If I said they will shortly surpass them, I would leave nothing more to hope for than what certain sage observers have anticipated from their astonishing beginnings.

When I consider the parentage of each, I think no stronger argument can be given against nobility being a matter of blood. [. . .] The father of one of these young men [Lievens] is an embroiderer and a commoner; the other's [Rembrandt's father] is a miller and surely not of the same grain. Who could help but marvel that two prodigies of talent and creativity could emerge from these farmers. When I look at the teachers these boys had, I discover that these men are barely above the good

repute of common people. They were the sort that were available for a low fee; namely within the slender means of their parents. Should they come into sight of their pupils today, they would be confounded with the same shame as I imagine were those teachers who first brought Virgil to poetry, Cicero to oratory, and Archimedes to mathematics. To give each his due and yet do no harm to another (for what do I care?), they owe nothing to their instructors and everything to their natural gifts. [. . .]

The name of the first is Jan Lievens whom I called the son of an embroiderer. The other is Rembrandt, whose lineage I derived from a miller. Both are beardless, and, if you note their appearance in body and face, are closer to boyhood than to youth.

It is not appropriate for my talents or this biography to review the works and activity of individuals. What I hoped for regarding Rubens, I would also like to see used by these two, especially: that they compose a list of their works, a table of their paintings. If each made this modest reference to his works, it would show the marvel of every age, and in brief encompass by what plan and what judgment they constructed, ordered, and worked out each item. I will dare to pronounce perfunctorily on each man as follows. Rembrandt is superior to Lievens in judgment and in the liveliness of emotion. Lievens surpasses him in inventiveness and the loftiness of his daring themes and forms. From his youthful spirit Lievens breathes forth nothing except what is great and magnificent and he equals the size of the objects of his painted forms not as willingly as he exceeds it. Rembrandt, completely wrapped up in his activity, loves to work on a small canvas and present an effect by condensation, something you may search for in vain in the very spurious [efforts] of others.

I want to say that Rembrandt's finest painting is one of the penitent Judas, returning the silver coins – the price of the innocent Lord – to the high priest. All of Italy and whatever of beauty or deserving admiration that has survived from furthest antiquity may approach it [but will not surpass it]. The gesture of this one Judas in despair – not to speak of the many [other] fascinating figures in this one work – Judas, maddened, howling, begging forgiveness, yet not hoping for it, or reflecting any hope in his countenance, his expression frightening, his hair tangled, his clothes torn, his limbs twisted, his hands clenched to the point of blood, prostrate on his knees on a random impulse, his body twisted by every pitiful hideousness – this bearing I contrast to all the elegance of the centuries and one I want the most unaware mortals to know. This latter group asserts, and we have reproached them at other times, that nothing today is either accomplished or spoken that antiquity did not see accomplished or said long ago. But I say that it did not occur to Protogenes, Apelles, or Parthasius nor could it occur were they to return, how this adolescent (I am amazed just reporting it), this Dutchman, this miller without a beard has summed up individual elements in one human being and expressed what is universal. Blessed are you, my Rembrandt! Ilium and all of Asia were not carried to Italy for as much as the highest praise of Greece and Italy has been brought to Holland by this Dutchman, who till now has seldom left the confines of his city.

In the transition above, I prefaced something about Lievens. I think I have made a sufficient judgment of what sort of character he is. He is a young man of great spirit, and if he lives, nothing but the greatest is to be anticipated from him. In any matter you please, he is powerful in judgment which is sharp, deep and mature, beyond that

of a grown man. Among what should be discovered, I used to reprehend that one fault of his – a danger risked not just once – namely, that he either flatly rejected every criticism or took it once admitted with a bad spirit because of a certain rigidity based on too much confidence in himself. This is a vice quite harmful to a person of any age but is truly pernicious in youth so that 'a little leaven leavens the whole dough' [1 Cor. 5:6], and those who indulge in a vice close to this one are said in Scripture 'to delude themselves' [Gal. 6:3]. He abridges the wisdom of the great who think that God has given to each man 'with a chary hand what is sufficient' [Horace, *Carmina* 3:16, 44] and who is convinced that no one has emerged in control of everything by submitting a gentle spirit and docile nature to anyone nor could he be taught anything by anyone. An immense harvest of works by the outstanding is there for the ages, nor could you easily imagine, if you compared the painter with so many paintings, that such plentiful fruit came from so slender a trunk.

He has approached the miraculous in doing the expressions on faces and if the great and untamed power of his nature could be restrained, which now embraces all of nature in its daring and expectation, it would not be unjust to convince him to be a painter who devotes himself to this part especially, a wondrous compendium, as it were, of the whole person, body, I say, and spirit. For on historical subjects, as we say publicly, this certainly great and admirable artist will not easily attain the vivid invention of Rembrandt.

I can scarcely tear myself away from talk of such outstanding young men without turning again to that one fault for which I already censured Lievens – they are carelessly content with themselves and till now have not thought Italy of such great importance, though they need to spend a few months traveling there. In such talented natures there is a certain mixture of madness which one who will destroy young spirits has abundantly bestowed, indeed, this alone is lacking the two for the perfection of art. Oh, if only they were acquainted with Raphael and Michelangelo. They would eagerly visually devour so many monuments of these great souls. How quickly they would surpass them all and, as men born for the consummation of art (did they only realize it), they would summon Italians to their own Holland. But I will not be silent about the pretext by which they usually hide how much it is a matter of apathy, and excuse themselves. They say that in the bloom of their youth, when especially an account of themselves must be given, there is not leisure time to waste in travel. Besides, as there is today an eager delight in and choice of painting by kings and princes on this side of the Alps, they have seen Italian paintings especially outside Italy, which there you track down with great inconvenience scattered about, while here they are displayed *en masse* and one can have his fill.

3 Rembrandt van Rijn (1606–1669) Letters to Constantijn Huygens

Rembrandt wrote very little. The only correspondence to have survived is a late letter of 1662 to his Sicilian patron Don Antonio Ruffo, and the present series of seven letters to Constantijn Huygens the Elder, written relatively early in Rembrandt's career in 1636 and 1639. The Huygens letters are included here in recognition of Rembrandt's importance to the period covered by this volume. Around 1633 Rembrandt painted two panels, *The*

Elevation of the Cross and *Descent from the Cross* (now in the Alte Pinakothek, Munich). Both pictures entered the collection of the Stadholder Frederik Hendrik. Rembrandt was then commissioned to paint three further pictures on the theme of the Passion. His biographer has argued that this commission was 'both the most and least desirable of his career' (Schama, p. 1999, 433), and that even the first letters from 1636 contain a note of procrastination, as well as demanding twice the rate he had been paid for the *Descent* and the *Elevation*. In the event it was another three years before *The Ascension of Christ*, the *Entombment* and the *Resurrection* (all now also in the Alte Pinakothek, Munich) were finished. The letters from 1639 concern the completion of the work and the subsequent problems over payment, with Rembrandt having to settle for a lower price than he had wished. Even in the Dutch Republic it seems that the artist/patron relationship was not far removed from servant/master, though it must be said that Rembrandt did not take his rebuff lying down. Likewise in 1662, when Ruffo complained about the condition of a picture sent to him, Rembrandt responded: 'I am most astounded by what has been written about the *Alexander*, which is so well done that I must, suppose there are not many lovers of art at Messina,' going on, 'If your Lordship likes the Alexander as is, very well. If he does not want to keep it, six hundred florins remain outstanding' (cited by Schama, pp. 592–3). In the end the point is subtle. Rembrandt has to do as he is told if he wants to sell at all. But at the same time he is the sole provider of a commodity in short supply. In the end it all depends on who wants what, in the grey area where taste meets fashion meets power. Claims for its status as a liberal art notwithstanding, painting remains an emphatically material practice in a world of material exchange. The third letter to Huygens, dated 12 January 1639, is particularly significant for the rare statement it contains of Rembrandt's feelings about his own painting. However, even here there is room for doubt as the Dutch phrase *naetuereelste beweechgelickheijt* is ambiguous between 'motion' and 'emotion'. The editors of the *Rembrandt Documents* conclude that, rather than a single clear-cut meaning, what is implied is 'an animated interplay of motion and emotion of artist, subject and spectator' (p. 162). The letters are reprinted in full from the English translations in Strauss and Van Der Meulen op. cit., pp. 129, 133, 161, 165, 167, 171, 173.

I　*February 1636*

My [dear] Sir and most gracious Mr. Huygens: I hope your lordship will be so kind as to advise His Excellency that I am very diligently engaged in proficiently completing the three Passion pictures which His Excellency has personally commissioned me [to do]: an Entombment, a Resurrection, and an Ascension of Christ. These are companion pictures to Christ's Elevation and His Descent from the Cross. Of these above three, one has been completed, namely Christ's Ascension to Heaven, and the other two are more than half-finished. Please, Sir, let me know whether it would please His Excellency to have the finished piece first, or all three together, so that I may best serve His Excellency the Prince, according to his desires.

As a token of my readiness to serve you with my favor, I cannot refrain from presenting you, [dear] Sir, my latest work. I trust that you will most graciously accept it[1] in addition to my greetings. I command your lordship [and] all [of yours] all to God to health.

Your obliging and affectionate servant
Rembrandt

[1]　This probably refers to one or more etchings.

II 1636

My [dear] Sir: Let me first offer my kind regards. I agree that I should come soon to see how the picture accords with the rest. As regards the price, I certainly deserve 200 pounds for it, but shall be content with whatever His Excellency pays me. And if you, Sir, do not deem it presumptuous, I shall not neglect to requite the favor.

Your humble and devoted servant
Rembrandt

It will show to [the] best advantage in His Excellency's gallery, since there it will be [displayed] in bright light.

III 12 January 1639

My [dear] Sir:
Because of the great pleasure [I have had] and interest I have taken in the proper execution of the two pieces His Highness has commissioned me to do, i.e. the one of Christ's Entombment, and the other of His Resurrection – to the great consternation of His guards – and as a result of my diligent zeal, these two pieces have now been completed as well, and therefore I am now ready to deliver them and thus afford pleasure to His Highness, for in these two pictures the deepest and most lifelike emotion has been observed [and rendered]. That is also the main reason why they have been so long in my hands.
I ask you therefore, my [dear] Sir, whether you wish to inform His Highness of this, and [also] whether it would please you Sir, if the two pictures were first delivered to your house, as was done previously. In this regard, I shall first await a short note [from you] in reply.

And because you have become involved in these matters for a second time, I shall send along, as a token of gratitude, a piece measuring ten feet in length and eight feet in height which you will prize in your house.[1] Wishing you all happiness and the blessing of salvation, Amen.

Your obliging and devoted servant
Rembrandt

[1] Thought to be *The Blinding of Samson*, 1636 (now in the collection of the Städelsches Kunstinstitut, Frankfurt).

IV January 1639

My [dear] Sir:
With your permission, I am now sending you these two pieces, which I think will be considered fine enough to warrant His Highness paying me no less than a thousand guilders for each of them. But should His Highness not deem them worth that, let him pay me less, according to his pleasure. I rely on His Highness' knowledge and

discretion. I shall gratefully content myself therewith. And in addition to my regards, I remain his

obliging and devoted servant
Rembrandt

The sum I have advanced for frames and the crate is 44 guilders.

V *27 January 1639*

My [dear] Sir:
I have read your pleasant letter of the 14th with singular pleasure. I discern your kind inclination and affection which I feel deeply obliged to requite [you] with service and friendship. Because of [my] inclination to do this, [and] in spite of your wish, [I] am sending [you] along [with this letter] a canvas, hoping that you will accept it, because it is the first memento which I offer you, Sir.

Wtenbogaert, the tax collector, paid me a visit just when I was busy packing the two pieces and desired to see them once more before [they were crated]. He mentioned that if it pleased His Highness, he was prepared to make payments to me from his office here. Therefore, may I ask you, my [dear] Sir, that the money which His Highness allows me for these two pieces be paid here [in Amsterdam] as soon as possible, because I could use it well particularly at the present time. Awaiting your gracious reply, and wishing you and all of your family happiness and blessings besides my regards,

your obliging and affectionate
servant
Rembrandt

[Postscript]
My [dear] Sir: hang this picture in a bright light and in such a manner that it can be viewed from a distance. It will then sparkle at its best.

VI *13 February 1639*

Worthy Sir:
I have full faith in you, particularly as regards the [matter of my] remuneration for the last two pieces. If things had gone according to your wishes and to propriety, no objection would have been raised to the asking price. As for the pieces [which were] delivered previously, no more than 600 k. guilders were paid for each of them, and if His Highness cannot be persuaded in the face of valid arguments to pay a higher price, even if they are obviously worth it, I shall be content with 600 k. guilders each, with the provision that reimbursement shall be authorized for my [cash] outlay of 44 guilders altogether for the two ebony frames and the crate. Therefore, I ask you, Sir, kindly [to intercede] that I might as soon as possible receive payments here in Amsterdam, and I trust that with [your] kind help on my behalf I shall soon be able to enjoy my pennies, and I shall remain grateful for all your acts of friendship.

And with my greetings to you, Sir, and to all your close friends, [I] commend you to God, [may he grant you] long-lasting health.

Your obliging and affectionate servant
Rembrandt

VII *February 1639*

My [dear] Sir:
I hesitate to trouble you with this letter, but I am doing so because of what Wtenbogaert, the [tax] collector, told me after I complained to him about the delay in my payment. Volbergen, the treasurer, denied that dues were claimed annually. Last Wednesday, Wtenbogaert, the collector, replied to this that Volbergen had thus far laid claim to these dues every six months, so that more than 4000 k. guilders had been deposited again at his office. And because of this true state of affairs, I beg you, kind Sir, to have my payment order prepared promptly, so that I will now finally receive my well-earned 1244 guilders. I shall forever seek to requite you, Sir, for this with reverence, service, and evidence of friendship. With this, I give you, Sir, my heart-felt regards and wish that God [grant] you long-lasting good health and gives you His blessings,

Your obliging and affectionate
servant
Rembrandt

4 Philips Angel (*c*.1618–after 1664) from *In Praise of Painting*

Formerly confused with a contemporary painter of the same name who worked in Haarlem and Middelburg, Philips Angel worked in Leiden until 1645, when he joined the Dutch East India Company, travelling on the company's business to Batavia (now Jakarta). He was to remain there until his death, apart from a period of some five years in Persia, during which he served for a while as court painter to Shah 'Abbas II. Almost nothing survives of his work as an artist. 'In Praise of Painting' was originally delivered as a lecture to the painters' guild of Leiden on 18 October 1641, when Angel's audience probably included the artists Gerrit (or Gerard) Dou, David Bailly and Pieter van Steenwijk. It was first published as *Lof der schilder-konst*, Leiden: Willem Christiaens, 1642. There are two particular reasons for interest in the treatise. The first is the importance Angel places on naturalistic observation and upon the achievement of plausible illusions. This emphasis is consistent with his support for the kinds of detailed techniques then being developed by Dou and other Leiden painters, and for the Dutch painters' development of such relatively novel genres as battle-pieces, seascapes and guardroom group portraits. It is this emphasis that gives Angel's relatively standard account of the requisite skills a measure both of modernization and of specificity to the work of his Dutch contemporaries. Unlike his French and Italian contemporaries, he is little concerned with the edifying or didactic functions of art. Rather, he treats of painting as a respectable craft, leading to the production of things that delight the eye. The second reason for interest in Angel's treatise is the evidence it offers of his proximity to Rembrandt, who was also born in Leiden, and who returned to work there between 1626 and 1631. The approximate date of 1618 normally accepted for Angel's

birth would make him a surprisingly young authority to lecture to the guild of artists in 1641 on the name day of St Luke, their patron saint, or indeed to compose a substantial treatise on painting. It seems more likely that between 1626 and 1631 he would have been old enough to profit directly from Rembrandt's presence in Leiden. In any case, the form of attention that Angel devotes to history painting in general, and to Rembrandt's *Samson's Wedding Feast* (Dresden, Gemäldegalerie) in particular, suggests that his ideas on the subject were formed under the influence of the older painter and of his circle. Our text is taken from the facsimile reprint of the original Leiden edition of 1642, pp. 33–41, 43–4, 46–8, 51–8. The excerpts have been edited and translated for this edition by Hester Ysseling.

Let us conclude by examining what qualities a painter must have if he is to be counted amongst the number of praiseworthy artists without being subject to ridicule. For surely not all those who call themselves painters can be considered amongst them. Many incite themselves to mirth, thinking 'If our art is to be considered so excellent, then I should think rather highly of myself, since I am one of its citizens.' They are like peacocks who stick out their chests with pride and take pleasure in the beautiful plumes of their tails, but on looking down and seeing the dull colour of their feet, drop their tails and shuffle away backwards. This is the fate of those who, upon hearing such great things about the excellence of painters, conclude from the fact that they too bear the same name that they are like them. But when they compare their own work to that produced by these illustrious artists, then, like the peacock, they are obliged to slink away with their heads bowed, filled with shame and remorse. To learn what qualities you must have in order to be ranked among the illustrious, pay attention while I depict with my pen the figure of someone who deserves to be ranked their equal without being mocked. First of all, he has a healthy judgement, a steady and confident hand for drawing, a fluent mind to compose in accordance with nature, ingenious invention of pleasing abundance, correct arrangement of light and shadow together with a just observation of actual things in nature, a well-trained knowledge of perspective and no less a knowledge of history, accompanied by profound and natural reflections which arise from plentiful reading and enquiry. He also has a grasp of mathematics and a thorough understanding of anatomy. He seeks to imitate nature rather than the manner of painting employed by other masters. He knows how to mix lifelike [*vleysich*] colours and how to express the differences of woollen, worsted, linen, and silk fabrics. He has a brisk yet smoothly flowing brush. If to all these things he adds the mellifluous eloquence of Apelles, the virtue of Michelangelo, and the passion and diligence of Domenico Ghirlandaio, we are justified in saying of him that he should be honoured with an eternally enduring crown of honour. [. . .]

To appreciate the usefulness of the virtues which we have given as the requirements of a painter, we shall analyse each of them separately.

First, we observed that the first and foremost requirement of a painter is right judgement. I emphasize the usefulness this brings for the benefit of our art and the furtherance of its honour because whoever possesses good judgement without the ability to act on his judgement will rather make his impotence known by abstention than bring shame on himself through his deeds. To make this better understood I will give an example. Someone who has a sound understanding of a painting when it is

shown to him and who judges it to be pleasing and unsurpassable as far as he is concerned, knowing that he would not be able to imitate it, would not make the same careless mistakes which are all too common today. When he copies the work he will do no more than he is asked and refrain from wanting, as many do these days, to play the hypocrite and pretend that, having added something of his own composition, the whole piece was an object of his own invention. This is ridiculous, and no more respected by connoisseurs of art than a monkey who covers its naked behind by crouching under a mantelpiece, but who reveals his nakedness as soon as he dares to climb upwards. So it is with these people as long as they hide under the compositions of great masters. But even if their idiocy does not become visible, their nakedness is revealed as soon as they dare to climb up by their own invention. A healthy mind with sound judgement would avoid this, knowing that stealing someone else's good name is only to the disadvantage of art. But someone might ask: is it not allowed, then, to borrow from other masters? This I do allow, for otherwise I would be contradicting the teaching of Karel van Mander in his *Grontleggingen van de Schilder-Konst* [Outlines of the Art of Painting], chap. I v. 46, where reasons are given as to why this is permitted.

It is quite a different thing, however, to borrow something in order to elevate one's own imperfection to a higher degree of perfection than it is to add something defective to something which is already good. The one pays homage to the master from which it was taken, whereas the other, a careless addition, does him nothing but harm. Therefore we should distinguish between taking something and adding something. [. . .]

Second, a painter also needs a steady hand for drawing, which is of the utmost importance, since it will help to avoid gross mistakes, such as are made only too often by bands of good-for-nothings. When they produce a head, one finds that one eye is higher than the other, or that the ears are too small, the nose too short or too long, the mouth too thin and so forth. Alternatively, they will place heads on bodies which are either too small or too large, or of which the arms and legs are too short. In sum, many awkward things come to light, and such mistakes could be avoided by possession of a steady hand for drawing. [. . .]

Third, the artist requires a mind which can combine things in a fluid and natural manner. That this is indeed the case can be concluded from the fact that the artist who is fluent in composing will never be embarrassed by a difficult composition. When he concentrates his thoughts and makes them play around a single idea, his fertile mind produces thousands of changeable devices. When this fluency is accompanied by naturalness [*eyghentlijckheyt*], and when the two work together like sisters, this brings such a pleasing and graceful lustre to the art that it can better be understood from the example of master painters than it can be explained in words. This quality is also required of a painter because it allows him to represent the histories which he depicts in a way which makes it easier for enthusiasts and others to understand them.

Fourth, besides this smoothly flowing naturalness, no lesser radiance is added to the art by an abundance that pleasingly embellishes it. That a painter should be mindful of this can be seen from the warm affection which it arouses in the art lover's heart. This we see every day in those who embellish their works with abundance so

that they delight the eyes of enthusiasts and fill them with a wishful desire for things represented. Through this their paintings will sell readily. In view of the profit it brings us, we should pay the strictest attention to the representation of elegant abundance.

Fifth, on account of the gracefulness [*welstandigheyt*] it lends to our art, the proper arrangement of light and shadow is one of the most important laurels with which a good painter ought to be adorned. For shadows, if arranged well and put in the right place, render magical force and marvellous grace. Many things whose colours are barely imitable by any brush are made to appear highly realistic. For the force that living and real things have remains even if their shadows are scattered and confused, and the whole still retains grace. Because of the imperfections remaining in us, we cannot lend to our works such grace and such force as real things appear to us to have. We can bring this about only if we properly arrange shadow and light together. [. . .]

Sixth, it may sound strange to some of you if at this point I add to this chain of the art of painting a link which is the observation of actual things in nature. However, the ideas that I will present here in order to show the reason why will undoubtedly satisfy you, my lords, and you will agree that it is useful. Oh lovers of art! I have often noticed a serious mistake which is made not only by the lowliest, but also (I mention it respectfully) by the greatest and most esteemed masters. This mistake follows from nothing other than a failure to pay close attention to the observation of actual things in nature. This is particularly noticeable when artists paint a wagon. They make it seem as if the horses were in full gallop, whilst the wheels of the carriage remain standing still.

This is something I have seen not only in battle painters, but also in history painters. [. . .] If they had paid strict attention to the proper observation of actual things in nature, they would have avoided these mistakes by closely observing the natural movements and conceiving the form which appears the most adequate. When a wagon-wheel or a spinning-wheel moves at full speed we see that because of the fast turning no spoke is actually visible but only a vague shimmer. Even though I have seen many pieces with wagon-wheels in them, I have never seen this phenomenon properly represented. Rather, every spoke is drawn or painted as if the wagon did not move them, so that there is no difference between a wagon standing still and one that has the appearance of moving. Many may be of the opinion that adequacy is much harder to achieve in this than in other subjects, but since we are the imitators of life, we should not give up when confronted with a little more difficulty if this brings us closer to natural things.

* * *

Seventh, a well-practised understanding of perspective is required for the art of painting. I will show that this is the case in seven or eight words (to be brief). Through her rules, this art reveals to us that what is below our eyes should be seen as if we were looking down on it, whereas what is above our eyes should be seen as if we were looking up at it. Many people think that this is a trivial matter and say that this can be seen without any knowledge of perspective. But it is not true. They themselves reveal it in their work, where it is constantly shown up. Knowledge of perspective also helps in choosing the appropriate horizon for our works, such as

in landscapes, temples, houses, tables and the like. This gives the appearance of a fixed position to things, whereas in the work of inexperienced artists the things which are depicted usually seem to be toppling. To avoid these mistakes, a painter needs a well-practised understanding of this art.

Eighth, a no less experienced understanding and knowledge of histories is needed in order to avoid those misunderstandings in their representation which the inexperienced often make as a consequence of their negligence with respect to reading.

* * *

To avoid these mistakes, I strongly advise that we do as our predecessors did and adhere to the practice that is still pursued by many contemporary masters, that is, we should occupy ourselves with assiduously sniffing through [*doorsnuffelen*] old musty books in order to obtain knowledge of histories. If we wish to express this knowledge in drawings, prints or paintings, we should add our own elevated reflections and let the freedom which is allowed us merge in such a way that it does not violate the spirit of the histories but adds lustre to our work. This is what old masters did and what many of today's illustrious spirits still do. Here we may include the renowned Rembrandt, the illustrious Jan Lievens, the highly esteemed [Jacob] Backer, the good Bliecker and many others I will not mention for the sake of brevity. [. . .]

Among other things, I once saw a *Samson's Wedding* depicted by Rembrandt. If we read the story in Judges 14:10, we can see how that clever artist perceived it and what elevated reflections he brought to it, in this case regarding the naturalness of the guests sitting, or rather lying, at table. For the ancients used beds to lie upon, and they did not sit at table in the way we do now, but lay on their elbows, in the way that is still customary among the Turks. This he showed very pleasingly. In order to distinguish this wedding from other weddings, he put Samson in the foreground with long hair to make it clear that no razor had ever touched his head. Moreover, Samson is shown posing his riddle to a few attentive listeners, as can be told from his hands, for with his right thumb and middle finger he had grasped the left middle finger, a common but very natural act for someone who wishes to present something to others by means of speech. Since not all the guests were disposed towards the same thing, he painted others who were merry and not listening to the riddle, but holding up a flute of wine and laughing. Others are shown busy kissing – in sum, it was a lively wedding. And even though the movements are similar to those that can be found at our contemporary banquets, he had still added sufficient contrast to allow the observer to distinguish it from the wedding banquets of our day. You can see that this appropriate and natural representation is the fruit of his having read the histories well and considered them fully, with lofty and profound reflections.

* * *

Now let us see why it is necessary for a painter to have some knowledge of mathematics, the usefulness of which I will point out in one or two words. The reason is that it allows him to judge competently the features of a face and its proportions, which is of great importance for a painter. But I will elaborate on this on another occasion: I shall avoid starting on this road for it will inevitably lead us too far afield.

Further, I will consider to what end a profound knowledge of anatomy is useful. A good grasp of anatomy gives us the advantage that we learn from it the knowledge of

muscles, where they originate and where they end, how they move and how they change in their movements, how they recede and protrude again, and how a body should be divided so as to be well proportioned. Knowledge of anatomy shows us the difference between the bodies of a man and of a woman, and the difference in proportion between children and adults. Moreover, we learn from it how always to find a straight perpendicular or plumb line in the figure of a human being, and also an isosceles triangle, a square, a perfect circle, and many other useful things. To acquire this knowledge, Michelangelo and many other excellent men dissected several bodies, and split muscles apart to learn about them. I often regret that in this city the artists are not given so much freedom, and that they do not have at their disposal a freely accessible dissecting room which could further this useful science. By contrast, all the other arts, even including the school for martial arts, maintain their position. But our art, which gives to Leyden (the birthplace of all great minds) greater renown than any other art, is not given any freedom for further expansion. Nevertheless, dear brothers, in the absence of such accommodation (hoping that it will some day be provided, together with other things useful to us), I recommend to you the anatomy by Master Heynderick and Master Cornelis van Haerlem, who have bequeathed flayed plaster models to you, by which you may reach a certain degree of knowledge regarding the nude, which is highly to our benefit. [...]

Leaving the subject of anatomy behind us, I will now show that it is much more laudable to follow nature than to follow the manner of painting of other masters. It is contemptible to imitate the manner of painting of other masters, whereas it is advisable to follow nature. Let us, then, prefer what is advisable to what is contemptible, and follow life conscientiously. But how are we to go about this? Should we paint in such a way that every one can see that the work is by this or that master because of the manner in which it was painted? No, on the contrary, for as long as this can be known and identified the master is still adding too much of himself. But if he knows how to follow life to such an extent that we are in a position to judge whether his work adequately approaches life without being able to trace the manner of the master who made it – such an artist deserves praise and credit, and will be esteemed above others. [...]

Let us leave this behind, and choose that which will bring us the most praise, seeking out nature, which is so full of variety that if someone follows it truly it will be impossible ever to decide who made their work. Or it may be the case that someone comes so close to life that we would have to agree that it was the work of some particular master because it was at the same time so true and nevertheless so varied, and because no one had ever heard of such truthfulness to life except in his work. This we would not conclude from his manner of painting, but from its uncommon correspondence to life. Let us aspire in this way to the highest perfection, since it is open to all of us. And if no such artist has been found as yet, fellow art-lovers, strive diligently to come as close to him as possible. If you should ever achieve your aim, you will deservedly be adorned with a new crown of honour to cover your laudable head, since this is one of the excellent recommendable things to which sacrifice is made at the altar of eternal remembrance.

Having added this link of the imitation of nature to the chain of the art of painting, let us now swiftly forge the next link and see what lustre can be brought to our art by

the flesh-like [*vleysighe*] blending of colours. First, it takes away the dull sallowness; second, the green unnaturalness; third, the harsh stone-like quality, and instead of these despicable qualities it brings the highly esteemed naturalness of a fleshy, skin-like colour, which makes our art pleasant to the eye of art-loving enthusiasts. This virtue is so great that we have no further need to prove its necessity or to enlarge upon it in any more detail. Keeping to the terms we set ourselves, we proceed to the next necessity that is required of a painter, to wit, that he must know how to distinguish between silk, velvet, woollen and linen-worsted.

Velvet clothes which actually appear to have the lustre of velvet are rarely seen, and the difference between woollen and linen-worsted, with respect to the way it creases and folds, often escapes the attention of the painter. Neither does he observe the shine which is more brilliant in silk than in satin. He also neglects the fine delicacy [*dunne eellicheyt*] which should be imitated in fine linen and chiffon velvet. A praiseworthy painter should be able to represent these differences in a manner most pleasing to the eye (by means of his brush-work), distinguishing the roughness of worsted and the smoothness of satin. This is something in which that brilliant German [i.e. Dürer] exceeds other painters and for which he is still famous.

How necessary this requirement is in a painter I leave to the judgement of all just persons, and proceed to prove my last point, that as well as all the aforementioned necessary virtues, a painter should have at his command a brisk, bold and yet smoothly flowing brush, because without it all the virtues mentioned could not be put into practice. For alas, what good is a work of painting, even if one sits and sweats over it for months, seeking most conscientiously to figure it out, if a sweet disposition [*houdinge*] cannot be found there. However, this is not the case with every painter. Nor does neatness amount to much without a certain ease [*lossicheyt*], because the flaw of rigidity degrades the virtue (if it may be called a virtue) of neatness. Whoever chooses to privilege neatness in his studies should also practise that virtue which is constantly observed by Gerard Dou, who is never sufficiently praised. His is a curious ease, guided by a steady and confident drawing-hand. Whoever proceeds in any other manner will receive more ridicule than praise. And whoever does not know how to achieve such neatness should exert himself to acquire a loose, brisk, smoothly flowing brush, rather than suffocate in rigid, tidy unpleasantness. Oh distinguished brothers, now you have learned what qualities a painter must have in order to be ranked among the most illustrious men without being an object of ridicule.

If, besides these virtues of the painter, you also seek to promote your own person, then try to acquire the mellifluous eloquence of Apelles, which was so sweet that Alexander was much taken by it and visited him regularly to speak with him. On one such occasion it happened that King Alexander expressed a judgement on art which, to put it mildly, was inappropriate. In response, Apelles dared to demand that the king be silent, saying that His Majesty would much rather hold his tongue than utter such talk, since the apprentices at the back were laughing at him. He managed to convey this with such kind and courteous pleasantness that the mighty Alexander accepted it with grace. Behold how much influence sweet eloquence had on the feelings of this great monarch, whereas, on the contrary, gruff obstinacy leads to nothing but disadvantage and ridicule. [...]

Besides this virtue of courteous eloquence, noble minds, try to emulate the virtue of Michelangelo and to govern your earthly frame with discipline and decency. This will make you esteemed among men and loved by God, and these two things will serve to establish your name for ever. If, to conclude, you also devote yourself with the passion and diligence which once distinguished Domenico Ghirlandaio, then I have nothing more to say to you than that you rightly deserve that the crown of honour be seated on your head. To conclude, let us learn to exploit our time profitably and to spend it so well that there is 'no day without a line'.

This was the frequent saying of the renowned Apelles: let it not only be our proverb, but our daily reflection, because through work we extract fire from the stone, and the gods sell everything for sweat. If we follow this, we will be sacrificed on the altar of immortality along with all great artists, and our names will be held up to our successors for all eternity. Should it happen that someone asks how it has come about that we have achieved such excellence above others, let them be referred to the proverb of the philosopher Demosthenes which will be written for us in golden lettering: 'by having used more oil than wine', which means to say that we have added more nights to our days to improve on our studies than we have squandered on revelling and intoxication. If we take this into consideration conscientiously, through the strength of our art we will struggle free of the devouring jaws of death, and in spite of the grim reaper [*de breeckneck aller dinghen*] we will survive and blossom without withering from century to century.

* * *

5 Francisco Pacheco (1564–1644) from *The Art of Painting, its Antiquity and Greatness*

Pacheco's *Arte de la pintura* embraced two very different aspects of art. On the one hand, for the Catholic artist, committed to the ideals of the Counter-Reformation as spelt out by the Council of Trent, art was first and foremost a means to Christian salvation. The painter was to use the skills and knowledge at his disposal to bring images of the divine before the human consciousness, and thus to act as a kind of supplement to, or enhancement of, the teachings of the Church. This aspect of Pacheco's treatise is shown above, in IA3. There remained a very different side to painting. For all the emphasis on its intellectual or spiritual aspects, the actual making of a painting remained a laborious, physical affair, requiring mastery of a wide range of craft skills and any number of tricks of the trade. This dimension of art is treated in the third volume of Pacheco's book. The following selections begin with instructions about preliminary drawing. Pacheco then describes how to make an oil painting, from the preparation of the canvas, through the underdrawing, to the selection and application of colour. In the final two extracts Pacheco moves on from the *cuisine* of painting and offers suggestions about how to make, respectively, a landscape and a portrait. Our excerpts are taken from *Artists' Techniques in Golden Age Spain. Six Treatises in Translation*, edited and translated by Zahira Veliz, Cambridge and London: Cambridge University Press 1986, pp. 35, 36, 42 (sketches); pp. 68–70, 72–4 (oil painting); pp. 93–5 (landscapes); pp. 99–101, 103–5 (portraits). We have retained some of Veliz's explanatory footnotes.

Oh, illustrious *Artifice*, honor of the Spanish nation! We have discoursed to this point with appropriate care and attention on the art of painting in general, which your genius needs not, but which opens the door to the superior light of your doctrine; now, with your permission, we will familiarize those humble men who need some instruction in the ways to execute their works, and with your authority we will give substance to this third book about the practice of art, which I begin by discussing the ideas and sketches to be prepared for the execution of the painting. [...]

It is certain that the activity of making sketches, drawings, and cartoons directly belongs to painters who have achieved the third and final grade of their art; they are more obliged to invent new things, keeping away as much as possible from anything that has been done already, not only by others, but also by themselves, and this they do in various ways. When they are asked for an antique or modern figure or history, they prepare themselves to paint either by counsel from learned persons or by reading books, and thus forming their ideas, they fabricate a whole from parts. Then with charcoal, pencil, or pen, on paper, they draw the first rough ideas for the movements, expressions, and actions required for the lively expression of the subject to be painted. From three or four studies, they choose one to be used (either by their own taste or by the judgment of learned men), and then draw it cleanly with black pencil as did Becerra [1520–1570], adopting the method of the great Michelangelo; or with black and red, as did Federico Zuccaro [1542/3–1609]... or in soft washes with highlights, making use of paper tinted any color that serves as the middle tint for the lead white in gum used for the bright highlights, as you see in many things by worthy men and which our Vargas [Luis de Vargas, 1502–1568] and Maese Pedro [Pedro Campaña, 1503–1580] used. [...]

I paint in oil on primed paper or canvas the heads that I study from life for a history or figure, choosing the most beautiful and pleasant, whether they be of children, youths, dignified or aged men, or of women, in the postures required to express my idea; I draw hands, arms, feet, and nudes on tinted papers with charcoal, black and red pencils, highlighting with white chalk crayons and dry white lead because they are ready-prepared and blend well with the drawing. The draperies, plain cloth or silk, I make by dressing the live models with tunics or capes, and drawing the parts that are necessary for my history or figure, which I complete by drawing in its entirety on a large panel or canvas of the size I want, without squaring, as I have a certain facility in this.

* * *

PREPARATION OF CANVASES. The invention of oil painting was very useful because of the risk of panels splitting, and because of the light weight of canvas and the convenience of being able to carry a painting to distant places. Very large canvases are protected from humidity by stretching and nailing them over thick panels where they last many years.

Painters are accustomed to using various methods for preparing their linens, depending on where they are working. We will point out some to be avoided, as well as others, so that their advantages are known according to what we have experienced over many years.

Some prepare the canvas with *gacha*[1] of flour or of mill dust, cooking it with oil and a little honey (you could almost eat this, even without appetite). One layer of this

is spread over the well-stretched canvas so that the pores are filled. After it dries, the pumice stone is passed over and then it is primed with one or two layers of oil priming. Others prepare canvases with size from glovers' scraps, and when it dries, they go over it again with the same size tempered with sifted gesso. When the brushed layer is finished, the gesso is spread with a knife so it covers the threads. After drying it in the open air, the pumice stone is passed over the surface again and then it is primed one or two times with a brush. Others prepare linens with glue size and use sifted ashes in place of gesso, making an even mixture, and applying it with a brush and knife. When it is dry and gone over with the pumice stone, it is primed only with common red earth ground in linseed oil; they use this in Madrid. Others use a priming of white lead, red lead, and charcoal black, all ground in linseed oil and used over the gesso preparation.

THE BEST PREPARATION FOR CANVAS. But experience has taught me that all preparations of gesso, flour, or ash get moist and rot the linen in time, and what was painted there flakes off. Therefore, I consider it better to use weak size that is cooled and jelled and put on the linen with a knife, and this serves to fill the open pores of the canvas; do not load it on too heavily; and go over it with the pumice stone after it is dry and then prime on top. I do not object to going over the well-stretched linen with the pumice stone to remove knots before putting on the size. The best and smoothest priming is the clay used here in Sevilla, which is ground to a powder and tempered on the *losa*[2] with linseed oil. Put on a very even layer with a knife, and after the canvas is well dried, go along with the pumice stone to remove all the rough and uneven places so that it is ready to receive the second layer, leaving it more evenly covered. After [the canvas] is dry, finish up with the pumice stone for receiving the third layer for which (if you wish) a little white lead may be added to the clay. These three layers have to be put on with a knife. I also say that linens can be prepared very well even without the size, if these three layers of priming are used as we have described, although adding the thin size makes it smoother. [. . .]

Having all the things to be painted prepared and ready, we will be able to explain how to draw that which will be painted and how to begin with the *bosquexo*,[3] and then go on to painting, in the order that we will say.

HOW TO DRAW THAT WHICH WILL BE PAINTED IN OIL. That which you must observe in making your cartoons and drawings we have said at the beginning of this third book. Cartoons for pictures to be painted in oil are rarely made the same size, so the figures or histories must be drawn onto the wall, panels, canvases, copper plates, or stones from a small preparatory drawing [done] by eye or by using a grid of squares. The only difference in drawing onto the various surfaces to be painted is in the kind of crayon that is used. If the things to be painted are life-size or larger, then long, slender-pointed pieces of hard *yeso mate* will be made. A cane tube of three-quarters or a full *vara* in length is prepared by firmly fastening a piece of chalk of the appropriate size into the hole of the piece of cane, and this serves as a long drawing stick [*toca lápiz*]. Another cane of the same size is prepared by fastening a bunch of hen's feathers into the hole of the cane, and this serves to erase and clean away anything that is badly drawn and exceeds the limits of reason in art. From an appropriate distance, use the first cane to block out all of the figure or history, stepping back to look at it often and erasing and redrawing until it agrees with the design of the

cartoon. The sure and good grace of the entire work lies in the proper delineation of the figure or history, because it is certain that all the difficulty of painting consists in achieving the contours. After the entire picture is well-proportioned and outlined, the various figures are refined using smaller points in the cane. Thus the flesh tones as well as the draperies and all the other details to be painted are perfected.

HOW TO MAKE THE *BOSQUEXO*. Let us assume that everything to be painted has been drawn correctly with accurate profiles and that we wish to begin the *bosquexo*. This is done in various ways. Some paint it with black and white, or with white mixed with carmine and Italian umber. This is an easy and comfortable way for those who lack great resolve and certainty, and who wish to vary and depart from the drawings, freely altering one thing and another until it is to their taste. Some worthy men have used this method, but if everything to be worked is already clearly indicated, it is best to begin the *bosquexo* in colors for the heads and flesh of the figures, and especially if they are taken from life. For fair flesh, use white and vermilion and a little light ochre; for flesh that is not so fair, use red earth of Levante and ochre, adding more or less according to the variations of the shadows. The appropriate tints are made with bone black, Italian umber, lamp black, spalt, and red earth, and carmine is used as well for some darks. For rosy flesh, use vermilion and carmine, and for those that are less rosy, mix the vermilion with red earth.

THE BEST *BOSQUEXO*. Some make the *bosquexo* very complete and leave it as finished; others just paint it with blotches of colors and leave it confused. I agree with the first of these, and believe in doing as much as possible in the *bosquexo*, because with retouching and repainting, many things become cruder. [...]

Thus, the flesh colors are the first to be painted in the *bosquexo* and the last to be retouched and finished. After the *bosquexo* is completed and washed with a sponge and water, the skies should be finished first, then the distances, the buildings and fields, and all that serves as ornament to the figures. Then the figures should be dressed in their various appropriate colors, according to what we shall say, and the finishing of the faces and flesh waits until last.

HOW TO TEMPER COLORS FOR DRAPERIES. Next we shall speak of the colors for particular draperies, but before we go on, be advised that some of the colors we shall name must be ground first with water, and that all of them are tempered and ground with linseed or walnut oil.

ABOUT THE COLOR WHITE. We will begin with white, which has to be painted in oil and which is mixed with the other colors. It has to be the best lead white to be found and that is, above all, the one from Venice. It should be hard, and should break cleanly into pieces when it is cut with a knife. Some prepare it by crumbling it by hand in a good quantity of water, and when the bulk and residue of the white have settled, the liquid is poured off into another vessel. If the lead white is washed like this two or three times, it is not necessary to grind it in water. The sediment serves for priming. The usual manner of preparing it is to grind it very well in water and then make it into little loaves which are placed in the sun to dry. Afterwards grind it with fresh linseed oil or walnut oil that does not separate, and cover the paint with a thin, clean cloth to keep dust out. Store it covered in a glazed earthenware tub full of sweet, clean water that is replaced every eight days. [...]

ABOUT YELLOW COLORS. Some customarily use *jalde*[4] or orpiment for fine yellows in oil. Look for the strongest color and grind it well in water and set it aside to dry. A drier is needed, whether it is tempered with linseed oil on the wooden block [*el tablón*] or whether [the pigment and oil] are ground together. Some add glass that has been finely ground with water; others use linseed oil mixed with powdered red lead, letting the powder stand in the oil for several days, and this is the best drier. Also some use copperas, taking a sufficient quantity of it. Keep away from verdigris like the plague, because it is your worst enemy. Make it a custom to darken with the same *jalde* burned on a little palette over embers until it becomes runny and the color of honey, which shows that it is burned. This is also ground first in water and it serves as the second tint. Make the darkest tints with dark ochre or with umber and red earth. For those that are still darker, use carmine and splat. This same *jalde* is burned to obtain an orange color, or it may be mixed with red lead of the earth, or with vermilion. The second tints are made with the colors already mentioned. Do not keep the *jalde* in water: it has a bad odor, it is harmful to the head, and enough of it is poisonous, so keep away from it.

For grinding and tempering a yellow in linseed oil, massicot is safer to use, if it is good. Admit light and dark ochres for the second tints and add red lead and vermilion tempered with oil. *Ancorza* and ochre may also be used to darken the yellow, and for the darkest parts, Italian umber is used. Massicot may be mixed with white if a lighter golden-yellow tint is desired. One cannot do without massicot in any way for landscapes. Fortunately, the massicot I use exceeds the best *jalde* in color and beauty, and surpasses it in safety. Keep it in water like the white and it is a good drier. ABOUT GREENS AND THEIR VARIETY. Some make green by working first with white and black in oil and then glazing with verdigris ground in linseed oil. To purify the verdigris for this, it is usually first ground in water with vinegar and some leaves or shoots of rue. Then it is strained through a hair sieve, and after drying, it is ground in oil, as has been said. After glazing the first time, it is customary to glaze it one or two times more, adding a little varnish to it, and in this way it stays very brilliant. Other times green is worked with verdigris and white and glazed with the same verdigris. Others add a little massicot that is not too yellow to the white, and work this together with the verdigris, returning to glaze it later. Other times green is worked with mountain green[5] ground in oil, lightened with white and darkened with lamp black. It is glazed twice and stays a very pretty color. I do not use verdigris except with light and brilliant *cenizas de azul*.[6] With good yellow ochre I make a dark green that pleases me, strengthening the darkest tints with black, and for the lights I use good massicot with a little white, [which] makes a very pretty green. Iridescent tones may be desired in light greens, and these can be blended very nicely. The light tones may be massicot and white or various other light colors.

For painting in oil, carmine from Florence is better than that from the Indies, and it is more sure and durable, although the one from Honduras is not bad. If some rose-colored drapery must be worked, it is more permanent if the *bosquexo* is painted with vermilion. Then work the drapery with carmine and white and it can be glazed or left unglazed. If a crimson (*carmesí*) cloth is intended, or one of *grana*,[7] or one of velvet, the vermilion and carmine must be tempered together to make an even, bright color. Mix the light tones from this by adding more or less lead white, according to what is

desired. If pure carmine is not enough to darken it, help it out with a little black. When this color is dry, it can be glazed once or twice with good Florentine carmine and a little thickened linseed or walnut oil. The carmine should always have its bit of drier, either of glass or of litharge powder mixed into hot linseed oil recently taken from the fire. The oil shows that it is properly heated when a piece of bread dipped into it comes out toasted. This is an ordinary drier that does not kill the carmine. Fat-oil of minium is also a good drier. This is added to *jalde* and copperas powder ground or tempered in oil.

With this carmine color I have made some very convincing velvets, but all lag behind those of my friend Alonso Vázquez, who was unequaled in this.

Others work red draperies with pure vermilion and shade with carmine. Black is added for the half-tints of carmine and vermilion. Some are also accustomed to working curtains or cloth with red earth of Levante or with haematite (*albín*) and white before shading and glazing with carmine. But I am of the opinion that even those things that will be glazed should be worked with good colors because in that way the paint is permanent and more durable. [...]

BLUE AND HOW IT IS WORKED IN OIL. Blue (we mean the blue of Santo Domingo and not that of ultramarine, which is neither used in Spain nor have the painters enough wealth to use it) is the most difficult color to use and it dies on many very good painters. We will describe how it should be used cleanly in oil so that it stays bright. Most say that the blue, which is of a pretty color, thin, well refined, and clean, should be tempered on the wooden block with walnut oil. A quantity of white freshly ground with walnut oil is prepared and put aside. Then you take enough of this white and mix it with blue to make light blue and then to make the half-tints.

A NEW OPINION. It is my opinion that the blues should be worked light, and the dark parts be made with pure blue. For the darkest shadows, add no black to the blue, nor should purple carmine be added, and even less should you add indigo; instead, add a little good, fine smalt of a pretty color to the pure blue, with which it mixes very well. The reason I wish to counsel that the blues be light is that the blue darkens with time and turns black. This is seen in landscapes; and in my experience I have seen many draperies that were blue turn into a black blotch, so that the folds of the cloth no longer can be distinguished. But if the blue is painted light, it stays blue always, and its highlights and shadows can be seen. I have observed this in the painting of Mohedano, who followed this method.

* * *

LANDSCAPE PAINTING. Landscape painting is much used nowadays, and many have been pleased to work with it. The Flemings especially have been much inclined to this, using tempera and oil for the disposition of the sky and the land, with its fields, gardens, and rivers. [...]

HOW TO COMPOSE A LANDSCAPE. This is the order to follow when painting a landscape, assuming that the canvas is ready: The landscape is drawn by dividing the space into three or four distances or grounds. In the first distance, where the figure or saint is to be placed, the largest trees and rocks are made, keeping them in proportion to the figure. In the second distance, the trees and houses are made smaller, and in the third distance they are still smaller. In the fourth distance, where the ridges of land join the sky, everything is carried to the greatest degree of diminution. The drawing is

followed by the *bosquexo*, either with colors, or according to the habit of some who prefer to make it in black and white; but I consider it better to paint in colors at once, because the smalt stays brighter. Tempering the necessary quantity [of smalt], and preferably a little more, with linseed or walnut oil, and putting in enough white, a pleasant mixture will be made; it should not be dark, but rather inclining toward the light, because time darkens it. From this main mixture, two other lighter ones will be made by adding more white, making one lighter than the other, so that they may be differentiated. Then a rose color will be tempered with carmine and white, and it should be lighter than the blues. If the sun is shown rising or setting, a mixture of white and ochre should be made, lighter still than the ones we have described. After the colors are mixed, the sky should be divided in this way: the ochre and white mixture [should be applied] in the area of the horizon near the mountains; moving up from there, an equal amount of the rose color will be applied and blended toward the ochre and white. The blues follow this, finishing the highest part with the darkest mixture and keeping in mind that the colors must be blended together with great smoothness. Pleasing clouds can be made in the sky by adding a little carmine to the smalt mixture and a little black to the others, highlighting them with the same rose tone and adding some of the white and ochre in the parts near the glowing horizon from which they take their light. When the sky, which occupies the upper half of the canvas, has been applied, the painting of the land begins. This is done with the lightest mixture of smalt and white, which comes out somewhat darker than the horizon because the earth is always darker than the sky, and even more so where it is near the sun. These ridges of land closest to the horizon should have lights and darks because later, in finishing the painting, it is usual to form small cities or trees on the lower slopes. Then, moving down the canvas, larger houses or cities or trees will follow, and these are made with *azul fino* because it is more fitting for this distance. This blue has to be tempered with white, and to differentiate some parts, a very little massicot may be added, which will turn it a little green where it is used. If houses are made in this distance, a little black or red earth will be added to vary the tints from those painted above, and thus the proper color for this part is made. Approaching the first distance, the trees and houses have to be made larger – if it is desired, they may rise above the horizon line. These trees should be of a green color made with [blue] ashes or *costras*, and they should have some darks to make them stand out from what is behind; then some light touches of *ancorca* and massicot can be laid over the darks to brighten the trees. Should there be water at the foot of the trees, it ought to reflect them as if it were a looking glass. Likewise, if there are houses, grasses, or rocks, their reflections must be seen upside down; the rocks will have light parts whose exact reflection must appear within the water. Should there be figures in this part, they have to be in proportion, so that a figure stands convincingly next to a tree or a house. They need not be too exactly delineated, nor do the trees need to be painted with as many exact strokes, nor do the colors have to be as dark as in the first distance, but more so than those behind.

The foreground where the figure is placed is the first thing to be drawn and the last to be completed in the *bosquexo* and finishing, because the principal part of superior grandeur should conclude the work. The trees that are painted here must rise from the ground across all the height of the sky, so that all the other distances will

be made subject to this, as it is the first seen. The *bosquexo* [of the trees] may be made with brush strokes of black and umber and a little verdigris and *ancorca*. Do not form leaves with the lights because they will be made later with strokes overlapping the limits of the painted *bosquexo*; use a practical method for thus detailing the leaves, and mix some dry leaves among the green. If they look like natural leaves of known trees, it will be much better, and the trunks should be treated in the same way because they are in the main part of the picture, occupying space near the figure. If the grasses on the ground appear to be as they are in nature, the work will be worthy of greater praise, since this area is near the viewer. The landscapes must be finished with the same colors, at the same time forming some little clefts or peaks in the mountains with the lightest mixture of smalt and white, painting in some little trees or cities with the same color lightened or darkened, with some rose highlights, and in parts, with white and ochre highlights; do this in the mountains as well, as though the light of the horizon were retouching the peaks. Farther down the slopes there are more clearly formed highlights of blue and white. Then the stronger green highlights will follow, and the houses will be more finished, defining the buildings to a certain point, always keeping in mind that retouching must begin from the highest and most distant parts, descending through the distances to what lies nearest. This is done with intention that the light and dark colors be laid pleasingly one over the other. Do not forget that the skies and mountains have to be applied with great neatness the first time so that they may be finished with one retouching, because smalt turns green if it is applied two times, as we have noted before.

* * *

THE INGENIOUS INVENTION OF PORTRAITS AND HOW THEY ARE MADE. Now that we have disposed of many subjects, it is time for us to treat of portraiture, a part of painting so pleasant and worthy that the *buenos ingenios* readily embrace it. The first thing is to determine whether it is essential for the good painter to make portraits.

If we are to speak scientifically and accurately, it is certain that the grandeur of art does not depend on portraiture, as we have seen throughout these discourses. The great drawing studies made in many academies; the grandeur of imagination and fine ideas; the knowledge of the anatomy of the human body, of symmetry and the proportion of the parts to the whole, of perspective for the diminution of things; the knowledge of architecture, and the abundance of precepts in drawing and *colorido* – all these aspire to greater and more difficult things than painting a head from life. Indeed, there have been made very worthy painters to whom the name of portraitist has meant nothing and they have achieved great renown for their inventiveness in sacred and profane histories; this sufficed for the great Michelangelo, who embraced the greatest difficulties of painting and architecture, soaring like a supreme angel over the things most difficult to master, such as the beauty of the human form, with its musculature, contours and profiles, and difficult foreshortenings. [. . .] portraiture is not an essential requirement for a great painter if he is proficient and skilled in the rest, although there are those who would be displeased to hear such a thing and would say that such painters avoided painting portraits because they did not know how – but this seems a harsh opinion to me.

My opinion is thus because the name and fame achieved by Apelles in antiquity, and by Raphael of Urbino and the great Titian in their time, did not proceed from their portraits (although these were marvelous), but rather from the invention, skill, and grandeur of their histories. But truly, we cannot deny that the portraitist was born like the poet, and as long as he does not default on the other great obligations of painting, then such skill heightens and enriches his art and gives him access to the greatest sovereigns in the world – and those who are accomplished in portraiture are not excluded from the merits of great painters. [...]

TWO OBLIGATIONS OF PORTRAITURE. We approach, then, the working method for portraits. He who paints portraits is obliged to do two things – if I am not mistaken – and if he fulfills both, he is deserving of praise. The first is that the portrait appear very much like the sitter, and this is the principal end for which portraits are made, and that which satisfies the patron. Both good and bad painters are obliged to do this, and if it is not achieved, their work is for naught. The second obligation is that the portrait be well drawn, and painted in a good manner of *colorido*, with strength and relief. This second obligation is valued and credited among those who have appreciation of art because even if the sitter is unknown, he will yet be esteemed in regard to good painting. It sometimes happens that an ignorant and simple painter makes very good likenesses of his patrons and then they are recognized at a glance, as they achieve a rigid likeness as if cut from paper, are crudely made with such lack of art that in regard to painting, they have no value at all; and those who painted them usually are so puffed up with pride seeing their vulgar works celebrated, that they seem to lose their reason, while to those who knew, these same works only give cause for laughter and amusement. [...]

HOW TO PAINT PORTRAITS. With these preparations and precepts, and the canvas primed and ready, we arrive at how to begin the portrait. If it is to be full-length, and if the subject tires of standing, the canvas may be lowered a certain distance on the stretcher so both the artist and the person being portrayed may be seated, and the excess linen can be rolled at the bottom of the stretcher. North or northerly light will be more constant and temperate, and the other three directions should be avoided because of the harshness of their sunlight. Some like to paint in the afternoon because the flesh is in perfect color then. But my disposition is better accommodated in the morning, when no other occupation has yet distracted my concentration and understanding. From nine until twelve, it will be possible to draw and *bosquexar* the head, and if some parts remain unfinished, they can be completed another day at the same hour. First, the length of the face must be taken with a compass with the light falling from high above, but without making the shadows too strong. The painter should place himself at an appropriate distance, neither too close nor too far, from which he can turn easily to see both the subject and the canvas. The head should be studied carefully, to see whether it tends to be long or round, and the form of the whole in relation to its parts. The outlines will be made with a long pointed *yeso mate*, exercising dexterity and propriety as if you were going to leave the portrait thus. The painter should not move on until he is satisfied that in the contours he has captured a very good likeness of his patron, and if possible, that the patron himself [should] examine it before the colors are prepared. I do not consider it wise to leave the likeness to brushwork, preferring to achieve it little by little with the *bosquexo* and

the finishing touches. It happens that in my drawings, the subject can be recognized by the lines alone; but how can this ever be done by someone who does not lift a pencil to draw in a full year? I have observed, with all respect, that those who follow only the *oficio* of portraiture and do not study it thoroughly, never make the parts of the portrait accurately, but only approximate its totality (that is to say, the 'air' of the sitter), and all their portraits are made with one method of drawing and coloring, and therefore all the persons portrayed give the impression of being kin; in some parts, such as the ears, which rarely are studied and painted with care, there often is no difference at all from one head to the next. Yet those artists who are *valiente* reflect all the variety and difference found in their living subjects, even in the smallest details, because they have the advantage of knowledge and practice in drawing.

The painter should temper his colors somewhat lighter than life, because they almost always darken; he should take care that there always be more than enough of the colors for the light *encarnaciones*[8] and appropriate half-tints. The painting is begun by applying these tints in the forehead and eyes, and once this is accomplished, the rest is not so difficult; and if the eyes, which are the mirror of the soul, are well portrayed, the painter will be much credited. In the *bosquexo* the shadows must be left soft and round and not very dark.

To some very scrupulous painters it seems that for drawing large portraits a system of squares should be used, or a net (which we have recommended before), and for small ones, lenses that reduce the drawing to smaller than life-size. But habitual use of these devices implies a lack of freedom and mastery of drawing. It is therefore better that the *artífice* draw by looking and by learning quickness and dexterity, since assurance comes from a good eye, as I heard from the great Alonso Sánchez [Coello, 1531/2–1588] whom I once saw paint a portrait. Even after the portrait head is finished, it may be retouched many times in the absence of the sitter, as long as the contours are not altered.

When the head is finished to the satisfaction of all, if the figure is standing, then the body must be drawn with the proportion and gesture of the living subject. The same formula must not be used always, but rather a variety of different postures. I caution this because some artists seem to trace all their figures from a single pattern, and the heads portrayed from life contradict the movement suggested by the body, like someone taking dancing lessons, unmindful that many figures would fall to the ground were they to assume the postures given them in paint. It has been said already that there are differences in the stance and arrangement of men, women, and children. Some dispense altogether with the painting of women, thereby avoiding certain acts against beauty which, although one must promise them, are unjust to act out: any work that fails in the imitation of nature forfeits the good opinion it might have earned. [. . .]

1 *Gacha* is a kind of gruel made of flour and honey, mixed with water and cooked over high heat.
2 *Losa.* A stone slab, sometimes of porphyry, for grinding artists' colors.
3 *Bosquexo.* Underpainting.
4 Orpiment, the yellow sulphide of arsenic.
5 This is presumably malachite.
6 Blue carbonate of copper.

7 Precise translation of *carmín, carmesí*, and *grana* is difficult because of their overlapping seventeenth-century meanings. *Carmín* identified a red lake pigment made from kermes insects. [...] The word *carmesí*... describes the color of a silk or other cloth tinted with *grana*, a fine purple derived from the kermes insects that grow within the fruit of the kermes oak (*coscoja*).

8 *Encarnaciones*. Painted flesh tones.

6 Jean Dubreuil (1602–1670) Preface to *Perspective Practical*

Dubreuil is not a well-documented figure. In the seventeenth century, religious orders performed many of the functions now associated with university communities, and Dubreuil was one of several French members of the Jesuit order who concerned themselves in the seventeenth century with the theory, criticism and teaching of the arts. His treatise *La Perspective pratique* was published in Paris and was in its second edition by 1651. It was reissued in 1663. The first printed treatise on perspective had appeared in France in 1505 (Jean Pélerin's *De artificiali perspectiva*, with text in both Latin and French). By the middle of the seventeenth century a working knowledge of perspective was a condition of competence for any ambitious professional painter, and handbooks on perspective became relatively numerous (see also IE8). Dubreuil's is representative rather than exceptional. (His claim to have consulted all the previous authorities he cites is somewhat undermined in the English text by the listing of the important Dutch designer Hans Vredeman de Vries (1527–1606) as two separate authors, 'Uredement' and 'Uriesse'). In England, however, *La Perspective pratique* was to remain current through various editions and translations until the end of the eighteenth century. It seems likely that this success was due to two principal factors. The first was the care that Dubreuil had taken to make clear the extensive practical application of perspective for the representation of all things from palaces to footstools. The second was the quality of the 150 engraved illustrations to Robert Pricke's first English edition of 1672. We reproduce Dubreuil's preface in Pricke's translation. Our text is taken from *Perspective Practical, or a Plain and Easie Method Of true and lively Representing all Things to the Eye at a distance, by the Exact Rules of Art . . . by a Religious Person of the Society of Jesus a Parisian . . . set forth in English by Robert Pricke*, London: Robert Pricke, 1672. (The preface is unpaginated.)

The Art of Perspective, which hath the eye for its Principle, to whom Nature hath given more vivacity and more Perfections then to the other senses, and which holdeth amongst them the Rank, and the Advantages that the Soul hath above the Body, is likewise the fairest and most delightful of all the Parts, that the Science of the Mathematicks hath put forth into light. This Science may well boast it self to be the soul and the life of Painting, seeing that it is it which giveth unto Painters the Perfection of their Art, which in its ordering the heights and the measures of the Figures, the Moveables, the Architectures, and other Ornaments of a Picture: It instructeth what colours he should use, lively or sad, in what place he ought to apply the one and the other, what he ought to finish, and what ought not so to be: where one is to give a light, and where there is no need of it: in a word, it is this that ought to begin and finish, seeing that it ought to go throughout all. Without help, the best Master will make as many faults as draughts, principally in Architectures, wherewith they would enrich their Works, as I have seen in Pieces well esteemed, where they have failed so foully, that this in part hath been the motive of my design, for to cause

them to know their errours without naming them, and to teach the young ones to avoid them. How excellent a Painter soever one is, he must observe all these Rules, or he shall content none but ignorants, and a Reasonable Painter that shall know and use these well, shall do wonders to every ones content.

The Engraver in Copper ought not to be more ignorant of it then the Painter, seeing that he doth that with his Graver, which the other doth with his Pencil: It will make him to know that which he ought to touch toughly, and that which he ought to make faint. The need that he hath of this Science is so much the more necessary, as his Pieces are far more in number, then those of the Painter: the which if they be skilfully made, his praise is encreased: if on the contrary, his defects are thereby the more known, and every Piece is a Mouth which decrieth its Workman.

The Carver in Boss shall learn the height which he must give to his Statues, as well for below as for the midst, and in proportion to that which is higher, what Projector he must give to Buildings, and to other Bodies that have Mouldings or demi-Boss, the Angle for the point of the sight, for to take the heights and abridgements of all the Objects near and far off.

The Architect by this Science, may be able to give the understanding of his designes in a small space, he may also elevate one part, and leave the other in Plane, for to make his whole work appear; and seeing that we are upon Architecture, there needeth that the Perspective, (or he that professeth this,) be learned therein, at least in the Practice of the Hand, by reason that the fairest Pieces of Perspective are made in rich and sumptuous Buildings, framed according to the Orders of Columns, the Beauty of which dependeth on Proportions and Measures, which ought to be observed therein, otherwise they will offend the eye; wherefore they ought to be well studied, and whosoever knoweth them not when he ought to know them, is worthy of blame, seeing the easiness that he hath to learn them, having *Vitruvius, Vignola, Scamozzii,* and many other which have written thereof so pertinently.

It is not enough that he knows the Orders of Columns, he must understand all the Measures which are ordinarily given to Buildings, and to each particular things, Gates, Windows, Chimneys, &c. and to place them well, and to take days fit for the purpose, that he make not any thing like one eye or maimed, to take great care that every thing be right, nothing faulty, and that the symmetry and proportion be kept, as much as one is able, otherwise the Perspective, which is made for to content the sight, would offend it by its defects.

Goldsmiths, Embroiderers, Makers of Tapistry, Painters, workers in Silver, in Silk, and in Wool; Joyners, and all others that busie themselves in making designes, and with Painting, cannot let pass this Science, of Perspective, if they would do any thing that may be commendable.

The most part of those I have known to affect this Science, have assured me, that they have been beaten off by the great number of lines, that some Authors have set for to frame and finde the place of their Objects, Bodies, or Figures; others, by having met with too much obscurity in their Orders and Explications, and particularly, for that they have not set the Instructions over against the Figures, and that whilst that they turn over leaves to finde them, they forgat that which they desired to know. All these Complaints oblige me to be more clear, and more Methodical in the Instructions which I have set before every figure, that they might have before them the

Manner to set into Practice that which they desire, applying my self to their capacity, without giving such Demonstrations as would obstruct or hinder them rather than clear them, using words which all may be able to understand, even in the Definitions, ... Having also given to certain things qualities which the common sort give to them, though that in effect they have them not. As for example, ... where I discourse of the distance or removal far off, I have been constrained to say, against my thought, that it is the Apple of the eye which receiveth the Rays of the Objects, as if they were bounded there, by reason that I have experimented that when I say that the Vision is made upon the Retine, or fifth thin Membrane, at the bottom of the eye, that the Rays do but pass by the Apple, and that the representation, or species of that which we behold are turned back; it seemeth to me that I speak a new language, and that they cannot conceive that. Wherefore having considered that this knowledge did little import for the Practice of this Art: I gave to the Apple that which appertaineth to the bottom of the eye, which is the true place of the vision or sight, where the species of the Objects are framed although others say that it is in the Cristalline: Those which would be resolved in this, may look into *Aquilton Scheiner* and *des Cartes*, which have very well discoursed thereof.

Although I have used all diligence possible, for to render this Science very easie, yet I doubt not but many may finde trouble therein at the beginning; but he which shall be able to surmount the difficulties, which he shall finde at the first; there is nothing which he may not understand and practice, so that he be careful to understand well, and retain one Order, before that he turn over the leaf: because that they are, as it were linked together, and dependent the one of the other: this little pains will give the satisfaction, by the easiness which one shall have afterwards, in making all whatsoever he would.

It shall be known by the Table following, that this Book sufficeth for to make all sorts of Perspectives, by using the orders, which the Figures and Letters shall shew, the which one may bring together to have that which one desireth, in which he that would make some fair Perspective, shall be delighted to find presently that which he shall conceive will content his minde: and then he shall have far more delight then if he copied a Piece wholly made by another; and if one be constrained to imitate any one, this shall be done with facility, seeing that there are here orders, of all that possibly he can meet with. I confess freely that I have an incredible delight in making of new designs, and in inventing of new pieces which I would have published, as others have done, had it not been that my desire is, that every one should be partaker of this Recreation which he may take in composing them, & making them himself, having given him all the means, and the orders for to bring the same to pass. But if any one will not take this as pains, he shall find many of them all made already in *Marolois, Uredeman, Uriesse*, and others, which have taken delight to make their ingenuity appear therein.

So many, so fair, and excellent works have served to make some Painters lazy, that they will not learn to make that which they found already made; they are content only to design those the best that they are able, and as far as they understand them, the which would be tolerable, if they did imitate them well; but counterfeiting them without understanding, they make nothing that is good, giving ordinarily so many points in a Picture, as they shall meet with objects therein, lines and returns, they will

make you see the under part of a thing, which as a certain one hath very well said, steal from particulars that which they give to the publick, to draw glory to themselves from the labour of others.

I had rather say freely, that I intending to make this little Treatise of Perspective; I would see, as far as I could, those which had written thereof, and take from one and others, that which might serve for my subject, afterwards to make a General Restitution, with which I have mingled a little of mine own, for to bind them together, and to follow an Order, which they had forgot to keep. The first that I found to have given some light to this Science, is *George Reich*, an *High Germane*, in the tenth Book of his Works: After him *Viator*, a Cannon of Toul, which hath given store of good Figures, but too little Instructions. After him came *Albert Durer*, an excellent man, which hath left some Rules and Principles amongst his Works in the fourth Book of his Geometry: *John Cousin* also hath made a Book thereof, wherein there are many good things. After those came *Daniel Barbaro, Vignola, Serlio, du Cerean, Sirigary, Salomon de Caus, Maroleis, Uredement, Uriesse, Guidus Ubaldus, Pietro, Acolti, le Sieur de Vaulizad, le Sieur Desargues*, and lately the Reverned *P. Niceron a Minime*, whom I have seen all, the one after the other, admiring their study and pains, for to serve the Publick, esteaming my self much honoured to imitate that which they done, and to be the unknown Copier of their Works, besides those which I have named; there are many other brave spirits, which have written thereon, which I have not had the happiness to see, because I could not attain to it. This Multitude of Authors causeth sufficiently to understand, that this Science hath been in all times cherished and esteemed by the most curious spirits, and more in that age that we are in, then in any other pass'd, the which maketh me to hope, that this little work will not displease many, seeing that it bringeth Instructions, which have not been seen for setting into Perspective, that which falleth ordinarily under the senses, and by consequence giveth the manner of making all sorts of Perspectives which any one can imagine.

I desire to proceed to cause it to be seen, and to teach to set into Perspective all that may be set into it, not only in Pieces level, and upon an united Plane, but also the bending, round and oblique, as for to paint within Roofs, frettings or rais'd Works, Corners and Turnings again, making to appear square, or round, that which it shall not be. In one word, all the Rarities and Deceits of Perspective, whereof these ought to come forth first, being the foundations and principles of those which must follow. If I shall know that they may be pleasing, and that they are look'd upon with a courteous eye, it shall be such a contentment and satisfaction to me, as I hope not for, and which shall easily compel me to acquit my self of my Promise.

7 Samuel van Hoogstraten (1627–1678) from *Introduction to the Academy of Painting; or, The Visible World*

Samuel van Hoogstraten was born in Dordrecht in Holland, and underwent his earliest training with his father, who was a silversmith and a painter. After his father's death he went to Amsterdam, entering Rembrandt's studio at the age of 14 or 15. In 1648 he returned to

his native Dordrecht, where he was appointed provost of the city's mint. He developed a particular interest in the art of *trompe l'oeil* in the course of travels to Germany, Italy and Vienna between 1651 and 1655. His skill in this respect was rewarded by the Habsburg Emperor Ferdinand III. On his return to Dordrecht he opened a painting studio, where he gave practical demonstrations of his understanding of illusion. An ingenious *Perspective Box of a Dutch Interior* dates from this period (now in the National Gallery, London). In 1662 he travelled to England, where he fulfilled a number of commissions over the next four years, including a *trompe l'oeil* view down a corridor for Dyrham Park (Avon). After a few years in The Hague, he returned to Dordrecht in 1671, remaining there for the rest of his life. His major theoretical work was published shortly before he died: the substantial treatise *Inleyding tot de hooge schoole der schilderkonst, anders de zichtbaere werelt*, Rotterdam, 1678. The text is subdivided into nine books, each of which is overseen by one of the muses. The major Dutch precedents for this work were the *Schilder-boeck* of Karel van Mander (Haarlem 1603–4) and Franciscus Junius' *Painting of the Ancients* (see IA1). Hoogstraten drew heavily on both, though his work is distinguished from theirs, both generally by its practical and empirical character, and more particularly by its concern with techniques of description and illusion. In this respect at least his text represents what was distinctive in the Dutch art of the time, which otherwise received very much less literary and theoretical support than was given to art in France and Italy. The treatise was published near the end of what has been seen as the golden age of Dutch painting, when there was a tendency to reaffirm the authority of the classical tradition. Hoogstraten's submission to this tendency is revealed in his references to classical Antiquity and to the Italian Renaissance and in his insistence on the precedence of history painting over still life and landscape. Our text is taken from the original Dutch edition of 1678, pp. 10–12, 24, 35–6, 216–18, 231–7. The excerpts have been specially edited and translated for this edition by Hester Ysseling.

Book I, Chapter 1 – *How some have come to the art in very strange ways, and what sort of persons are suited to it*

* * *

I consider it a most difficult task to identify whether young people are naturally suited to the art of painting. Some already draw figures and images while still at school, instead of writing, and this leads us to suspect that they may have a natural propensity for painting. But this is too uncertain a ground to build on and cannot permit us to conclude that they really are well suited to it, as if they were born for it. Although they may show an inclination towards the art, a more particular test is required if we are genuinely to know their minds: namely whether they will be able to see it through to the end and face adversity with perseverance. For I am certain that those who do not follow it with heart and soul are unsuitable for it, even if, for a time, they have tasted its sweetness. [. . .]

Fabritius, a fellow student of mine, once put the following question to me: What are the certain distinguishing marks and fruits of the mind in a young student which justify the hope that he will grow up to be a good painter? I answered, according to the degree of understanding which I possessed at that age, that such a student should not only appear to care for the art, but that he should actually be in love with the representation of the pleasing features of nature. He should not only concern himself with the dead body of art and follow the trend of the day and do as others do, but he

should be infatuated with the soul of art: that is to say, he should seek to investigate the actual qualities of nature. He should be jealous when someone else knows something which is unknown to him and ashamed to learn something from someone else indirectly, seeking rather to figure it out by his own effort. This was my answer at the time.

* * *

Book I, Chapter 4 – *On the aim of the art of painting, what it is and what it brings about*

The art of painting is a science which allows us to represent all the ideas or notions the entire visible world can provide and to deceive the eye with outline and colour. [...] For a perfect painting is like a mirror of nature which makes things which are not appear to be and which deceives us in an admissible, diverting and laudable way. [...] It is a memorial for things past, a miraculous presentation of what is far off, a prophetic imagination of what is still to come, and the greatest of all arts. For this reason it is also called the book for laymen, since it works on the eyes of all sorts of people with persuasive force.

* * *

Book I, Chapter 7 – *How visible nature manifests itself*

[...] The specific qualities of all things present themselves to us first and foremost in their form and appearance, not as natural philosophers [physicists] describe them, but only to such an extent as determines their outward shape, like the shell around the egg, separating the bodies they contain from all other things, as if by a boundary. Just as wine contained in a bottle assumes the form of the bottle, so the shape of the bottle becomes the painter's object of contemplation such that he comprehends all natural things and each thing in particular. The determinations of a thing consist of length, breadth, height and depth, concavity and roundness, straightness and curvature, bias and obliqueness, and in such a variety of ways as can be drawn from lines and points to make out any kind of shape. It is by means of lines, then, that we should learn to reproduce things in nature as they appear to us. This is where the art of perspective comes into play, because the eye does not comprehend things in their entirety but only the faces which are turned toward us. What the eye sees ends at the boundary set by the outline, which is made by the limits [*zichteynden*] of the rays which are cast by our eyes.

Book I, Chapter 8 – *The usefulness of frequent drawing from observation*

...One should make a habit of always drawing attentively. It is necessary to devote oneself to this habit to such an extent that it would become a mortal sin ever to let it slacken. For if it slackens on one occasion, it may happen more often. But whoever avoids this slackening, as if it were a destructive wild beast, will steadily increase the alertness with which he perceives things. [...] The habit of close looking makes the judgement sound and lends a certain measure to the eye. And surely the eye must

first acquire accuracy and certitude before we can entrust it with judgement [...]. Thus, in time the eye will come to provide a compass. Although the prescription of the rules and principles of art to an ingenious enthusiast may supply him with enough understanding to talk about art, this does not mean that he will have acquired the habit of practice. He will still make great mistakes and will be surpassed by a less erudite person who has acquired the compass of the eye through much exercise. The habit of observation will be of great service to the eye and to the hand of a young pupil. Whoever diligently acquires the habit of drawing much from life through close looking will frequently be able to embarrass a great master and will come closer to the natural features of things than his intellect will ever be able to grasp even at a much later stage. Therefore it is very useful and highly necessary to begin drawing often from life at an early age. And even if it is true that there are still no schools available for studying from the nude, material for observation will not be lacking. For almost every part of nature suffices to feed this close attention and to whet the sharpness of the eye. To be sure, he who constantly needs a ruler and a pair of compasses goes about on crutches, whereas the eye, strengthened through exercise, can itself serve as a compass. Base idleness discourages many from hunting this quarry which cannot be gained except through sustained exercise, strengthened by the fiery hope of being able to enjoy the fruit of this laudable labour and of gaining honours such as even the great masters have had to do without. [...]

This will be the most useful course of study for the young, who must acquire the habit of imitating things just as they are, so that in time they will be able to choose the most beautiful things with justification. But, oh painting youths, do not pride yourself on too much at too early a stage, nor assume that you have grasped the art of drawing as soon as you can produce an acceptable head or portrait.

* * *

Book VI, Chapter 2 – *On painting and of flat surfaces*

* * *

The subject of painting, as we have said before, is the imitation of all things: its subject is the entirety of visible nature in which nothing shows itself to our eyes without its own form and appearance. Even these appearances, however, only become visible through the colours of things, which consist in simple, unmixed and mixed colours. The simple colours are not difficult for the artist to imitate with similar unmixed paints, unless the colours exceed in force the reach of our paints. Here we may sometimes find ourselves at a loss. But many careful artists have found paints that improve significantly over the common ones. [...] Some colours are used in coats of arms, but we shall pass over this since it is too common and will only speak of what belongs to the pictorial [*schilderachtich*]. For example, it is not difficult to put a smooth wall space or a knotted wainscot into your work, but this is a beneficial practice and an appropriate step towards gaining artistry. Playful young painters often start to produce ordinary things coloured from life which they cut out around the edges, or they paint letters and combs and develop their skill in representing flat things on a flat surface. Such skills may also be a source of honour since kings and queens have been deceived by it. Parrhasius' curtain gave him victory over the brave

Zeuxis, and the Malthese [Francesco Maltese, c.1610–60] is still praised to this day for his painted tapestries.

Book VI, Chapter 6 – *On the coloration of the human nude. Curvature. Hair, etc.*

[...] According to Nazianzenus, only those painters are to be esteemed the best artists who give to the things created through their paintings true naturalness, whereas others, foolishly mixing a diversity of amusing colours, show nothing but coarseness [*wiltzang*]. Not only do they deviate from true artistry, but they do not even deserve the name of painter. This is an important point since there are some who claim to be masters of the art even though their nudes seem to be flayed or smeared with red paint or the juice of berries. [...] Even though redness is very natural in a sunburnt fisherman, this feature which is required in skin and flesh should not be exaggerated. In painting the nude it is not enough to mix beautiful colours; rather the artist should seek out true naturalness. For neither marble nor alabaster nor shiny ivory is comparable to soft skin. The whiteness of snow does not attract us, but delicate nudity enthrals, indeed ravishes. Whether the artist paints nudes of children, youths, massive wrestlers, scrawny, emaciated bodies, bathing nymphs, or indeed, heavenly goddesses – he should see to it that the colours are refracted in such a way that the flesh glows and chalky whiteness is avoided. [...]

After likeness to flesh comes roundness. The ancients esteemed Nicias in this skill above all others, because his objects stood as if they were raised up and half round. Some think that they can bring about this effect by using hard black shadows and glaring lights which they call highlights [*hoogselen*], but their nudes seem to be made of metal rather than soft flesh – or at least to be shows of candlelight. The best painters have achieved roundness through delicate gentleness rather than by violence, because the nude body in nature curves just as well in ordinary light as in an all too forced shaft of light. It does so better when the light comes from the front rather than too much from the side, for roundness is nothing but a gradual recession on all sides [*omwijkende vermindering*].

Book VI, Chapter 7 – *On hair and clothes*

It produces an elegant effect to paint hair well and naturally. Holbein is said to have often painted the skin of the brow and the chin first, later painting the hairs over it, stroke by stroke. I will leave this great master his well-deserved esteem, but I care more for the unconstrained imitation of the colour that skin and hair produce together, with their gleam and reflection cast in their right place without pointing out every single hair. [...]

Alongside well-painted nudes belong pleasantly coloured clothes, so that your images may enjoy more grace. If you portray a queen, then let her shine in a silk robe with pearls and precious stones, but see to it that what befell Apelles' pupil does not befall you. This pupil painted Helen with such excessive finery that on seeing the work Apelles said, 'Surely you have painted this princess rich instead of beautiful.' This is the reason why this work was afterwards called the prosperous instead of the beautiful Helen. Do you wish to depict the Turkish sultan in all his splendour? Then

paint him in white satin or silver worsted mingled with green and decorated with large flowers. Place a large turban with colourful feathers on his head.

You can also gain honour with wall hangings and tapestries, as is said of Parrhasius, who deceived and conquered his challenger Zeuxis simply by painting a curtain hanging over his work, as the well-known story tells. Giovanni da Udine painted a tapestry or a wall hanging at the end of a gallery in the Vatican, and when the Pope came to see the paintings, a member of staff tried to lift it up as is customary but found himself deceived. In these things the ability to render the colours well is of the highest importance; perfection can be reached in this ability to the extent that what we seek to imitate lies within the reach of our paints.

* * *

Book VI, Chapter 9 – *On landscape*

The most pleasant colours, Plutarch says, strengthen and delight the eye by their liveliness and joy. To be sure, these colours do not have a special name, but I believe that we catch sight of them in the general impression of a landscape with its thousand refracted colours, when sweet spring renews the meadows and the fields, and the wood raises its newly budding crowns.

When the orchard, white with blossom, is overflowing with fruit, then, oh painting youths, do not let lazy sleep steal this inestimable time from you, but start with things which have never been seen before. Paint for me from life vegetables, dripping with dew, and fresh flowers. You will find colours that no painter ever put to work. Do not spare the beauty of nature from your labours but be confident that what is so delightful in nature will also make your work well-loved. Having depicted ordinary things for long enough, whoever then feels the sting of ambition can take on something more precious and he will easily invent something rare and new. [. . .]

It is a common flaw among artists to acquire a manner of colouring, as if things were bound to their manner of painting rather than their manner of painting being bound to the nature of things. Many, however, being drawn towards nature, have acquired a manner of colouring which seems highly appropriate to that part of the art to which they were most attracted. Thus Hercules Seghers was principally concerned with mountains, whilst Lijfring painted inspired rockwork. Precious stones also possess miraculous colours, and the peculiarities of marine plants and shells have their own particular enthusiasts. [. . .] Augustine says that the sea at one time puts on blue, at another crimson, like so many different robes.

Book VI, Chapter 10 – *On the manner of painting*

[. . .] Poetry may well be called the speaking art of painting, but just as the doing is more difficult than the saying, so painting is much more difficult than verse-writing. For when the poet has finished his poem in his mind, the pen flows on without labour, whereas the painter loses practically everything he has comprehended before he knows how to express it in paint. However diligently they exerted themselves, Protogenes and Neacles were at a loss to represent the froth, first of a dog and then of a horse. Indeed, they lost their patience at such a difficult task and in desperation

threw their sponges at their work. And even though the dirty sponges brought about the desired effect and made their animals froth at the mouth quite naturally, this only brought to light that their judgement was sound enough but their hands too slow. [. . .]

It is necessary, then, to acquire a method that can easily obey our reason. To this end it is highly advisable to acquire a brisk brushstroke which confidently points out the places that differ from the others, giving the drawing its proper features and, where appropriate, a playful flourish to the colours. This should be done without ever lapsing into wiping or erasing, however, because this would wipe away the good quality and leave nothing but a dream-like rigidity [*droomige stijvicheyt*] at the expense of the honest refraction of colours [*oprechte breekinge der verwen*]. It is better to seek gentleness with a full brush, lustily swabbing away, as Jordaens used to call it, without paying much attention to smooth blending, since the latter will emerge by itself in the course of the painting, however boldly you may set to work. The early work of Titian is well blended, even if it is painted with a full brush, but in his later work, when his eyesight began to falter, he left broad flat strokes untouched which, seen at arm's length, possess all the more force.

It is not as remarkable to render something attractive with a loose stroke as to execute it with the utmost intelligent labour. A good beginning ought to encourage us, but the greatest task is to make a good end. When our perception of a thing is fresh it is penetrating, but such close looking is needed even more when the work is at an advanced stage. One often sees it happen that someone starts their work enthusiastically, but as their capacity to look attentively slackens they bring nothing to it but a slick rigidity or neatness. Unfortunately this often still pleases unthinking enthusiasts to such an extent that with untimely words of praise they lull the budding pupil to sleep and miserably spoil him. In this way, many a noble mind is kept from the ladder he was about to climb and art itself is wronged. [. . .]

I earnestly recommend, therefore, that you set to work energetically and keep your senses alert to the end. Always keep the following thoughts in mind: exceed nature in force and gentleness; give light and shadow their proper place; bind the whole together well, never changing your method at the end from that with which you began; and never allow your close looking to slacken. In this way your reason will generally become sharper, your manner of treatment inimitable, and your work equal to nature in all parts of the art. Do not bother yourself with learning a method or a manner of painting, but concentrate on steadily becoming more certain in your observations, discerning the parts of art well and pursuing them diligently. Thus the hand will become the servant of the eye and will methodically be able to represent in the most elegant way the diversity of things, each in accordance with its own nature. [. . .]

A different kind of manner is required for light hair, quivering leaves and things of this sort. And yet another way of handling the brush is required for the beautiful nude and for shiny marble. But you will find your way in all these matters if your hand has become used to obeying your eye and your judgement. [. . .]

You will also have to change your method in accordance with the place where the work is to be hung. You will regret it dearly if you have wasted a great deal of time on subtleties in painting a piece which is to be hung up high on a wall and will be viewed

from afar. In this case you may use brushes that fill your hand and let each stroke be one and put the colours down practically unmixed in many places, because the height and the thickness of the air will give many things the appearance of merging even if they stand apart. [. . .]

A good artist, Seneca says, handles his tools dexterously, or with remarkable ease. A painter, having placed around him many different colours to make an image, skilfully chooses those which are of use to him, and his hand and eye quickly move back and forth between his oils and his work. Plutarch compares the paintings of Nicomachus with the writings of Homer and says that, beside other pleasant things and perfections which are found in both, they also share the following feature, that it can be seen that they were made with ease and without much labour. By contrast, the paintings of Dionysus and the poems of Antimachus, although full of force and meaning, seem sombre, as though they have been made with much worry. They say that what is done with difficulty is difficult to look at. And this is what befell the paintings of Baccio Bandinelli, who thought he could master the art without exercise. The skill of making things with ease comes with sustained exercise and much practice. Then it may come to pass that reason acquires the ability immediately to form the desired conception; or that the eye picks out certain forms in rough sketches of pleasant objects, the way we see shapes in the fire while sitting by the hearth; or that the hand, through habit, forms something more or less in the way we do when we write. Because a good writer forms good letters without even thinking about it, and his eye and his reason seem to be located in his hand.

* * *

8 Bernard Lamy (1640–1715) 'The Excellency of Painting' from *A Treatise of Perspective*

Like Dubreuil (IE6), Bernard Lamy pursued his studies as a member of a religious order, in his case the Oratory (a society of priests without vows, founded in Rome). His *Traité de perspective où sont contenus les fondements de la peinture* was published in Paris in 1684. In previous publications he had addressed the fields of rhetoric, mechanics, mathematics and geometry, and his discussion of perspective gains force and depth from his interest in the study of optics. Lamy conceives of optics as dependent on the practices alike of the scientist, the mathematician and the painter. His readiness to accord equal significance to the skills of each is one of the distinguishing features of his work. It might seem that his belief that mathematics is the 'foundation of painting' was not one to which all contemporary styles of painting could have been made to conform. Lamy's sophisticated argument, however, is that *any* representation will fail if its effect is not in some way equivalent to the experience of its object. His concern is not simply with the accuracy of pictures, but with value in the psychological experience that paintings provide. (It is significant that Abraham Bosse, who taught perspective at the Académie Royale, had been ejected in 1661 for too rigid an insistence on perspective as a rule-governed system.) The *Traité de perspective* was translated into English at the beginning of the eighteenth century, in an edition dedicated to the 'Commissioners of His Majesty's Ordnance'. We are reminded that the working-out of perspective projections was not simply a matter for artists and philosophers; it was also an issue of practical and theoretical interest to those

concerned with military planning. Our text is taken from *A Treatise of Perspective or The Art of Representing all manner of Objects as they appear to the Eye in all Situations, containing The Elements of Designing and Painting*, translated by 'an Officer of His Majesties Ordnance' (A. Forbes), London (publisher unspecified), 1702, chapter I, 'The Excellency of Painting; Perspective is its Foundation', pp. 1–18.

To represent upon Cloath, what is not there, as Cavities and Eminences, where all is Flat; and Distances when every thing is Near; is a Performance that merits Admiration. 'Tis an Effect, and at the same time, a Proof of what the Eye (to speak Philosophically) doth not see, but only the Soul which forms to it self different Images of Objects, according to the different Impressions of the reflected Light on the Eyes. Nothing is more difficult to be expressed, than the Nature of these Images; whither it be that the Soul forms them out of its own Substance, and so sees it self, as it were, transform'd into all things; or if it sees these Images in a Substance above it, which being the Principle of all Beings, can represent all.

By this Advance, I mean only to discover a Difficulty, on which it would be requisite to make serious Reflections; for it concerns not the Subject I intend to treat of, and therefore it's sufficient at present to consider, that the Operations of Nature being Simple and Constant, the like Impressions in the Organs of Sense, ought to be followed with the same Sentiments; so that as often as the Eyes are struck after the same manner, the Soul must have in its view the same Images, whatever be their Nature and Origine. If (I say) the Rayes, by which we see a Picture, pierce the Eye in the same order as if they came from the Objects themselves, tho' we see but the Painting; and if the small luminous Bodies which compose these Rayes, shake and move after the same manner the *Retina*, that is, the small strings of the Optick Nerve, which line the bottom of the Eye, then the Picture must have the same Effect as the Objects themselves: For the Optick Nerve furnishes the bottom of the Eye with a vast number of small Filaments into which it divides it self, and makes what we call the *Retina:* 'Tis there that the Rayes do in some measure paint the Features of the Objects from which they are reflected; as when a Chamber is shut so close, that there is no passage left for the Light, but through a Perspective-glass, the Rayes paint the Objects that are without, on a piece of white Paper, if it be opposed to the Glass. This Chamber represents the Eye, and the Paper the *Retina*.

The new Philosophy supposes the World full of small Bodies, and that it is their Action or Pressure, that makes us sensible of the Light. These small Bodies, in removing themselves from that which causes their Reflection, press those that oppose their Motion, and these in like manner press those that follow, by a Communication of Motion made in a direct Line from the Object to the Eye. 'Tis this Motion (according to our Philosophers) that informs the Soul of the Figure of the Object, as the Staff does a Blind-man of the Nature of things, by the Impression it makes in his Hand, as it is thrust forward or pulled back. So the Impression of the Luminous Bodies on the *Retina*, occasions the Soul's having the Idea of the Object, that caused the Impression. For, we must know, that the Picture made by the Rayes, is only the Motion they impart to the small Strings of the Optick Nerve: Now, since the Pressure of the Matter which rests on the Optick Nerve, is the Natural Cause of the Sense of Light and Colours, because Red appears still Red, both with a stronger

and weaker Light; we may conclude the different Celerity of Shakings or Vibrations of the Matter which presses the Eye, to be the only cause of the Variety of Colours; different Colours are in the same case as different Sounds, for the Sounds change not because of the variety of the force whereby the Air is agitated in the Motion, (for instance) of the Strings of a Lute, but because of the diversity of Readiness and Celerity in the Vibrations, the Parallel holds in all Points, bating that the Action of the Air conveys the Sound, and that of a Matter yet more Subtile, the Colours.

Thus 'tis the difference of the Shakings or Vibrations of the Matter which presseth the Eye, that adds the Colour of the Objects, to the Features of the Image, which the Rayes paint in the bottom of the Eye; that is to say, that 'tis the difference of the Motions, that this matter takes on the Surface of the Objects, from which it reflects it self, that causes different Sensations; or 'tis the occasion of these Sentiments that we call Colours; Just as the Soul is sensible of different Tasts, according to the Variety of the Food that affects the Fibres of the Tongue.

However it be in this New Philosophy, it is agreed upon, that a Picture, when seen from a certain Point, reflecting the Light in the same manner as the Object it self would do; ought to have the same Effect as the Object whose Features and Colours it represents. That is to say, When it sends back the Luminous Rays in the same Order and Disposition, and with those very Motions that give the true Sentiments of each Colour, the same will the Effect be. This is what's taught by that part of the Mathematicks call'd *Perspective*, which I design to treat of.

A *Picture* may be consider'd as an open Window or transparent Glass, through which the Eye which is supposed to be at a certain Point, may see the Objects represented by the Picture. Now by the help of the *Mathematicks*, the passage of the Rayes which render the Object Visible, may be trac'd in the Picture or transparent Glass. This passage being marked with suitable Colours, the Picture represents the Features of these Objects, their Form, their Colour, and in a word, all their Appearances. And since it makes the same Impression, the Soul must have the same Images in its view, and be thought to see the same things.

Mathematicians draw only Lines, they cannot finish a Picture; And on the other hand, Painters cannot begin it, without a regard to the Rules taught by the Mathematicians. Every *Picture* is a *Perspective*, so that what is taught in this part of the *Mathematicks*, is the Foundation of *Painting*, which ought to be well adjusted, for all Painters do not agree to it.

The Design of *Painting*, is to represent on a flat Body, as Paper, Cloath, or a Wall, whatever is desired. This can never be done, if the view of the *Picture* makes not the same Impression on the Eyes, as if they saw the things themselves. And this is what *Perspective* does exactly. Painters that are ignorant of this, can never succeed but by chance; for in Painting by the Eye in Imitation of Nature, as they do, 'tis impossible to form their Features so just, or range them so exactly in their true places, as the Rays of things supposed beyond the *Picture*, would do other Features in piercing the *Picture* if it were transparent.

For a clearer Conception of these things, Let us consider, that there is a great difference between *Carving* and *Painting*. A Statue that stands by it self may be seen on all sides, it shews all its parts. As for Example, the Statue of *Hercules* in the Palace of *Farnese*, represents the Body of *Hercules* intire; it may be seen all round, and

viewed from different parts; it is not the same with a Painted Picture, which is terminated by a single Stroke, representing only and precisely the Circumference in which the thing that is Painted appeared to the Painter that design'd it, and in which he designs it shall appear. So that this Circumference is different according to the different points of sight; and cannot be proper for representing the same Object seen from another side. This is the reason why all the Draughts of the *Hercules* of the Palace of *Farnese* are not alike, because this Statue was designed by different Persons, who did not all behold it from the same side.

Let us here consider, that Stones and other Inanimate Matters, can keep the same Situation a long time, whereas all that hath Life, is continually changing, and in a perpetual Motion. The most ingenious Painter cannot represent these Changes; all he can do, is to paint the Moment of an Action; that is to say, the Situation of every thing, the Motions, the Postures proper to every Actor, and the Character of the Passion with which he was animated in the Moment of the represented Action. Nor can he thus Paint several Actions in one Picture.

In Drawing the Picture of a Person supposed to be alone, it suffices to observe in his Visage, and in his Countenance, the Character of his Genius, and of his ordinary Inclinations, his Phisiognomy, or the Strokes of his Face, which are peculiar to himself; but in representing an Action of Consequence, to which many contribute as Actors, or Witness, every one, according to the part he undertakes, should make appear by his Eyes, and by his Posture, what he is thinking that Moment. This is the Moment a Painter can represent; this is the Point where all his Work tends; his nicest Point, I say, is, that having placed at a certain Station, him that is to consider his Picture, he sees the same thing as if the Cloath becoming in that Moment Transparent, he saw the Action it self, which is the subject of the Picture.

This being well considered, it is easie to establish the Necessity of Mathematical *Perspective*. It is impossible to see precisely the same things, from two different Stations or Points of Sight: The Eye being placed in a certain Point, from whence it sees at once a whole Action, perceives nothing but what is opposite to it. If it see the Front of a Person, his Back is hid; it cannot at the same time see above and below the same thing. The Line which terminates what the Eye discovers, is so peculiar to what it sees in the Situation it is in, that there would be a necessity of drawing a new the out-lines of a Figure, if the Eye were moved to another place; for it is evident, that the Figures of things alter, as they are seen sloping, sidewise, or in Front; they become likewise smaller or bigger, as they are more or less distant from the base of the Picture; so that a Picture can be only made for one single Point or Station.

'Tis impossible to find exactly by chance, all the out-lines of a Figure, and the bigness suitable to it in the place where it is designed to be: This cannot be done true by Just and Infallible Rules, without the Mathematicks: But after all, one cannot err in these things without mistaking grosly; for, once more, can a Figure be seen behind and before at the same time? What is seen at a distance, hath it the same Appearance as if it were near? Is it reasonable to give a Figure almost the whole height of a Column, which, in the Object represented, is 30 or 40 Feet, when at the same time the Natural Heighth of this Figure is not above 5 or 6? These are nevertheless Faults very ordinary to Painters, particularly to those who Copy the Works of some great Masters, not taking notice that the Painter, whose Works they steal, hath given a

Circumference to his Picture, which will not be convenient for it, in the place whither he carries it.

Many imagine *Perspective* to be useful only in representing Walks, Trees, or Architecture, because they distinguish it only by a Concourse of Lines to one single Point. But since a Picture cannot have its Effect, if the Rayes, which it reflects, come not to the Eye, in the same order as if the Cloath let the Light pass through, or that by the opening of the Picture, the things themselves were seen: 'Tis the passage of the Rayes that is searched for in the *Painting*, as well as in the *Perspective*, that ought not to be so distinguished. To inable us to judge the better, let us see what *Painting* is essentially.

We may say of *Painting* as of *Eloquence*: There are general Rules for Writing and Speaking Judiciously and Nobly; but as being Master of these Rules, is not sufficient for Speaking and Writing on all sorts of Subjects, on *Philosophy*, on the *Mathematicks*, or on *Theology*; and what Eloquence soever one may have, he can never speak reasonably on a Subject he knows little of. So a *Painter* cannot represent but what he knows, tho' he search to the bottom of his Art. For Example, He cannot represent a Battel well, if he is ignorant of the Method of Drawing up an Army; nor a Sea-fight, if he be no Seaman. But this does not imply, that a good Painter ought to be both Soldier and Sailer. 'Tis true, there are some Subjects that Painters so commonly treat of, that it seems essential to their Art, not to be ignorant of them. Could a Painter be Excellent, if he knew not a Man? I mean the outside of a Humane Body, and what may appear on that outside; the Veins, the Muscles, and the Tendons; he ought therefore to be perfectly well acquainted with the Anatomy of the outside of a Humane Body. Those who apply themselves to the Painting of Beasts, ought to make the same Inquiry. To paint a Horse well, 'tis convenient to know the Anatomy, and most esteemed Proportion of his parts.

In fine, Painting is not essentially limited to represent any particular Subject. It is in general the Art of Imitating; and its Perfection is, that the Imitation is so Natural, that the Picture makes the same Impression, as the Object it self that the Painter would imitate. There lies the Beauty of his Art: 'tis the Address with which he imitates what he would represent, that makes him esteemed; for we are sometimes charm'd to see that in a Picture, which would be frightful if we saw it really. A Serpent causes Fear, but its Picture, if well done, is charming: So that 'tis the Skill of the painter that pleases.

Now the Imitation is not perfect, if it have not the same Effect as the thing it self; that so the Eyes may be agreeably deceived. Therefore since a Picture can have only one point of sight, and since each Figure expos'd to view, hath a certain Circumference peculiar to it self, in relation to the point from whence 'tis supposed to be seen; and a certain bigness, which depends on the distance in which it is represented, we must of necessity have recourse to the Mathematicks, without which it cannot be done to the utmost Preciseness. It may be said, there are Pictures that please without that Nicety. I own it; but whom do they please? None but such as do not compare them with the things the Painter would have them represent. 'Tis the Resemblance of Truth that pleases in Painting, as hath been said. How can this Resemblance exist in a Picture, when every thing confutes it, when the Ground he represents is too large or too small for the Actions that are supposed to be done there? When what ought to be

separate, are huddled together; and what should be joyned, are remote? When all is too great, or too little, and nothing hath its just Measure? Painters, after having made their Figures, do generally adorn the bottom of their Picture with a piece of Architecture, rich and fine in appearance, for if we examine the Plan in order to find, for Example, the foot of a Column, we shall find it rests on the head of some Figure. Can such Pictures please indifferently? We shall now examine its Perfection, and the Enquiry is neither Vain nor Useless; for the Rules of *Perspective* are as easie as they are sure.

Let us then conclude *Perspective* and *Painting* to be the same thing; save only that *Perspective* is made to consist, in finding Geometrically, (as I do in this Treatise) the Points, at least the *Principal*, through which the Rayes pass, that would shew the Object that is painted, if the Picture were Transparent. I say, the *Principal* Points, for it would be too tedious to search for all with Rule and Compass. The Eye alone hath an infinite Number of Features proper to it self; and besides that, two Men have not their Eyes intirely alike, the same Eye can change as many ways, as the Soul can have different Motions. Only they who have study'd Nature, and by a search after all its Characters, have acquired that Facility of imitating what they see, or what they conceive; these can represent things as they are. All a Geometrician can do, is to determine the Greatness and Situation of Figures in a Picture. That's what belongs to *Perspective*, the rest is the Work of the Painter, or of one who is wont to imitate or design what is seen; especially to mark well the Outlines. 'Tis in this they exercise themselves in Academies, who design after a Copy, or in particular, after a *Relief-work*.

A Skilful Painter having once, by the help of *Perspective*, found the Position of some Points in the Circumference, which he endeavours to compass, finishes it easily; which is impossible to those that cannot design. There are a thousand fine Strokes, of which one may find several Points, and yet not be able to finish them. Every Motion hath a proper Posture; every Passion hath a Character in the Visage; every Age, every Sex, and every Condition, a certain Air, which he must be a Judge of, and know how to express; otherwise, what is done, represents nothing that hath Life, all is dead; for the Air and Features of a Body full of Life, are very different from these of a dead Body. However it may resemble something that had once Life, there are still the same Features but much changed. Nothing but a long Exercise, and an extraordinary Genius, a Curiosity and a Nicety more than ordinary, can make one sensible of the difference.

Let us add, that tho' the Art of Painting consists in Imitating, yet a Painter that can only Imitate what he sees, is no Artist. What he represents should be Beautiful and Fine, and there is no Beauty but what is Imperfect. He must therefore imagine what is not, and form a Resemblance finer than the finest things can be found; for when he forms to himself an Idea, it may happen that nothing can be found intirely resembliug it. He ought therefore to dive into what things may happen, in all the Conditions in which they can be apprehended. To represent the Posture of a Body that one sees before him, 'tis not requisite to be an Anatomist; but without the Knowledge of Anatomy, 'tis impossible to represent correctly a Posture, which he conceives but does not see.

* * *

... The Mathematicks make Abstraction of the sensible Qualities. *Perspective* then, which is but a part, can be no other than an Application of *Geometry*, to find the passage of the Luminous Rayes, that will make the things themselves appear, which are supposed to be behind the Picture, and are to be there represented. *Perspective*, I say, is the Foundation of *Painting*, but it is not sufficient to make an accomplish'd Painter, I am far from pretending it: The Idea which I have given of *Painting*, shews that I have other thoughts; but after all, what I have said, will serve to prove, that *Perspective* is useful to a Painter, that 'tis that which regulates his Designs; that without it he works but at random, and cannot keep up to the nicety of just Measures. ...

9 José Garcia Hidalgo (*c.* 1645–1717) *from Principles for Studying the Sovereign and Most Noble Art of Painting*

During his lifetime Garcia Hidalgo was better known as a painter than as a writer on art. In his youth he visited Italy, where he encountered the Baroque of Pietro da Cortona and Carlo Maratti. On his return to Spain he based himself in Madrid and built a successful career, mostly as a painter of religious pictures. He was a painter to successive Spanish monarchs in the late seventeenth and early eighteenth centuries, claiming later to have spent twenty-seven years in the service of the Crown. He also acted as a censor for the Holy Office of the Inquisition. From about 1680 Hidalgo worked on a treatise on painting. Published in 1693, the *Principios para estudiar el nobilisimo y real Arte de la Pintura* was intended, as its title suggests, as a practical handbook rather than a theoretical disquisition. The text of only eleven pages was accompanied by upwards of 130 etchings which Hidalgo made to assist the teaching of beginners, to help them follow technically difficult suggestions about foreshortening, posture, etc. Approximately half the text concerns oil painting, and Hidalgo's suggestions bear comparison with those of Pacheco (see IE5). For the present extracts, in order not to duplicate Pacheco, Hidalgo's descriptions of fresco painting technique and of engraving have been chosen, as well as some more general remarks about composition and about the need for artists to attend to the conditions under which their work will be seen. The selections have been made from *Artists' Techniques in Golden Age Spain*, edited and translated by Zahira Veliz, Cambridge and London: Cambridge University Press 1986, pp. 136–9. We have retained some of Veliz's explanatory footnotes.

In fresco painting, the preparation is made over a dry wall without any saltpeter. The lime and sand are applied with a trowel, making a layer as thick as a coin of eight *neales*: mix together equal parts of each, or two of sand, three of lime, and the sand should be sifted; neither the lime nor the water for painting or dampening should have any saltiness, and no more should be prepared than can be painted in one day; if too much has been prepared, it must be undone and scraped away, and prepared again on another day. Artificial colors are not used, but rather good slaked plaster for the white, and ochre, red earth, *pabonazo*,[1] *hornaza*[2] (for gold and yellow); for the highlights, in place of massicot, red *lápiz*[3] and calcined Roman vitriol, and natural vermilion for the reds. Haematite and eggshell white for *veladuras*, shafts of light, and transparent things; smalt and ultramarine for blues, and for purples, smalt and

pabonazo, which takes the place of carmine. For the greens, green earth or dark verdaccio from Verona, and mountain green. For browns, umber and red earth, black and ochre. For blacks, black earth, charcoal black, and ground coal. All the colors are reinforced in fresco; if you wish, the darks may be made with charcoal black or black earth. Make a sufficient amount of the tints to last for everything, because it is difficult to make adjustments later, and the tints can be tested on a new brick to see how much they will lighten [when they dry]. If it is to be legitimate fresco, neither the darks nor the lights may be retouched; it is customary to give some things a touch of gold over a mordant of glue and honey. For this kind of painting, everything that must be represented is drawn on paper and traced onto the wall, or pricked and transferred to the wall, which stands ready with its lime and sand preparation. Imitate the design and harmony of the drawing, or wash drawing, or color study, which you should have before you. There are few whose work comes out perfectly without these preparations. So you see that in this kind of painting, as in all, he who is the better draftsman, and has assurance and knowledge of architectural and optical perspective, will do everything better, even if it is only something executed in light and dark tones or black and white. Because although colors re-create sight, without good contours true to the original, and well-placed darks and lights, they are only blotches of good color and are of interest only to those who are ignorant and lack understanding of art. [...]

If anyone wishes to apply himself to engraving or etching with *agua fuerte*,[4] either to practice drawing, or to execute some works, I will present the best recipes that have come to my knowledge, although I myself have not used them with great delicacy or care. The first is from Callot [Jacques Callot, 1592–1635], for a soft varnish, and it is made in this way: Take two ounces of virgin wax or *engrumo*,[5] one of asphaltum, and one of colophony. Liquify all of this and then place it in cold water, and wetting your hands, form little balls or pellets of the mixture, and wrap them in taffeta and keep them to rub over the metal plate when it is to be etched. This plate, being quite clean and polished, is placed on a charcoal fire and rubbed with the little ball or pellet, coating it evenly and thinly. Then the plate is treated with the smoke of a tallow candle, and when it is evenly black, allow it to cool. The drawing is traced onto the plate and graven with slender needles with sharp or oval points used to make fine or heavy marks. After everything is graven, little balls of wax and turpentine as thick as a finger are made [to surround the plate] and *agua fuerte* is poured on, either pure, or diluted to some proportion with water. Where you do not wish it to go too deep, as in the distances, stop the open metal with a putty made of oil and tallow. The parts that must have more bite are stopped later, and the principal or foremost parts are not stopped, so they will come out stronger. These stages must be observed always, so that what is distant will separate from what is near, and so that the figures will have some outlines and shadows that are hard, and others that are soft. In everything, experience will teach you what the pen cannot: good judgment, patience, and knowledge together usually achieve their end.

The drawings are rubbed on the reverse with red ochre, or white lead or vermilion, rubbing and cleaning them well with the finger so that no more sticks to the metal than what is pressed through from the front of the drawing or script with the needle. All of the outlines transferred by the needle will be visible on the plate.

There is another recipe, for a so-called hard varnish, which is used for etching metal plates with *agua fuerte*: Take five ounces of colophony, and another five of pine resin, one ounce of mastic, and one of asphaltum, and four ounces of walnut oil. Cook it all together until it forms strings like sugar syrup. When it is like this, strain it and put it into a glazed or copper container and cover it against dust.

Then it is ready for use, and it will last a good twenty years or more. It is applied to the plate by hand, spreading it very thinly [as it is] heated over a fire and darkened with the smoke of a tallow candle. Turn it until it is evenly coated and when the smoke lessens, and a little stick touched to the surface does not scratch it, take the plate from the fire and let it cool; then transfer the drawing and engrave it, as was said for the other varnish, except in this case, if you have no *agua fuerte*, use the following vinegar: Distilled or very strong white vinegar, sal-ammoniac, common salt, and verdigris. For three *azumbres*[6] of vinegar, use six ounces of common salt and six of sal-ammoniac and four of verdigris, all powdered; place everything in a glazed vessel large enough so that these ingredients fill half of it. The rest remains empty so that the liquid will not overflow when it boils, because it bubbles a lot, and will lose its strength [if it overflows]. After boiling it three times, take it from the fire and cool it, then strain it and keep it well-stoppered in a double-glazed vessel. If the mixture seems strong when it is taken out [and applied to the plate], temper it with more vinegar. When the plate is sufficiently bitten, remove its coating with a soft and well-burned charcoal of pine wood, going over it until it is clean and the etched lines are clearly seen for printing. If there is any fault in the proof print, correct and retouch with the burin. Be warned that everything comes out the reverse of what was drawn or written on the plate, so the left comes out right, and the writing must be made in reverse, or copied, drawn, and written from the reverse [of a paper], by rubbing it with oil, or holding it up to the light or to a mirror.

The following knowledge is also important for those who wish their works to be well-directed; this is based on observations of great men, and it is advice of total and certain truth. The first thing is that you do not place figures in actions that are too violent because they will not be convincing and will become discomposed in their gestures. Do not have the head and the body facing in the same direction. Nor should the plumb of the neck be lost in a standing figure. Nor should both the arms and legs follow the same movement. Nor should the grace and contours of the nude be covered with drapery. Nor should the figure be doubled over so that the shoulders are lower than the navel. In kneeling figures, do not put the knees together. In laboring figures, work all of the muscles and parts. In the figures of standing, seated, or kneeling women, neither legs nor feet are to be separated, for this is indecent and indecorous. In striding figures only one foot needs to be seen clearly. In a figure carrying a load, the leg bearing the weight – that is, the perpendicular – should not try to indicate movement; rather the freer limb should be the one to express the movement. For every figure, represent the movements and functions required by the age of the figure. In a running figure, all the limbs should indicate lightness and agility. Do not show women in movements as vigorous as those of men, since generally they are to be represented with proper calm in any role they take. In histories, the figures or groups or crowds must be distinct, some near and some far, some seated, others standing, and in various appropriate activities and actions

pertaining to the history. They should be shown with distinct ages and costumes, so that they are lighter in the distance, and so the figures are not confused one with the other, nor draperies of one color with those of another, nor should there be many figures of like physiognomy and age. The principal figure of the history should be the most easily recognized, and the figure which gives greatest pleasure to the viewer. Half-figures should not be used, unless a stair or wall or slope is called for. Do not fill the canvas with figures if they are not required by the history and subject, because perspective and landscape give depth and art and beauty [to the work]. The figures of the history that are closer and more important are to have more beautiful colors and stronger lights and darks; those in the following distance have softer darks and less brilliant lights; in the third distance, still less bright; and so on in the fourth and fifth, with a diminution of the figures that is barely perceptible; all should be soft and mellow, and do not glaze the draperies except in the foreground; in some places, if the [colors] come out too strongly, they must be given a *veladura* with white and ultramarine or smalt, in landscapes just as in figures and architecture. In other bright places, you have to sully and tint the colors to temper their brightness with asphaltum or blue, or whatever is best for the color and distance of the thing. The distances or landscapes are always tempered and tinted so that details stand out properly, in the darks as much as in the lights. And thus, the painting will have coherence, since the diminution will be consistent in the tints as well as in the proportion and diminution of the figures, according to good perspective.

It is also very important that the painter see or know the light in which his painting will be seen, and the height and distance from which it will be seen, because for filtered light, the highlights should be strong and untempered, and the darks as well; for bright light, or a place made bright [artificially], everything must be soft and well-tempered in the colors and adjusted and soft in the execution; in works that will be seen from a distance, large figures should be used, and the strokes of light and dark should appear proportionate and strong, because they are tempered and lost with distance and height.

This seems enough for those discreet persons who know how to follow and apply information with good judgment. I have printed this work for the reasons I gave above and because it could be of some use to those who cannot participate in any other, better way, and so, without tiring anybody, they can still have some knowledge. Sometimes a poor traveler, ignorant of such a thing as a bright torch, contentedly lights his way through the darkness with a taper, being happy thus not to stumble and fall in obvious ignorance. Thus he can accompany other curious and virtuous travelers who journey through study and discourse on Art, and together they overtake those who move through [total] darkness with slow, uncertain steps. And all of this I give as a way of employing my time, as benefits all creatures, to the honor and glory of God and the Most Holy Mother.

[1] *Pabonazo*. Red mineral pigment used in fresco painting.

[2] *Hornaza*. Dark yellow pigment prepared in glass-makers' furnaces.

[3] A kind of red ochre.

[4] Nitric acid.

[5] A form of solidified animal fat, possibly a by-product of the process for extracting glue from animals.

[6] One *azumbre* is slightly more than a gallon.

Part II
The Profession of Art

II
Introduction

The first third of the eighteenth century saw few substantial developments in the styles of painting or sculpture, but considerable increase and intensification in the claims made for art in general. These rested on a series of interconnected theoretical advances: the assertion of the priority of sensory experience, made in John Locke's philosophical work (IIB1); the recognition of the eye as the prime organ for the receipt of sensation and of information about the world, made explicit in the writing of Joseph Addison (IIB4); and the work done by Roger de Piles (IIA2) and the Abbé du Bos (IIB6), which served to distinguish art's specific formal and technical concerns from those of literature.

To the advocates of painting, some of whom were themselves practitioners, the urgent task now was to demonstrate to a wider audience that it was no mere craft, but an intellectual pursuit with a respectable pedigree, fully deserving the thoughtful attention – and investment – of cultivated individuals. This imperative was driven by wider social and economic processes at work in the modern capitals of Europe. These were such as to produce substantial growth in the educated middle class, an increase in the availability of leisure for the members of this class, and a concomitant self-consciousness about the acquisition of culture. As Jonathan Richardson was concerned to affirm (II A6), even the painter of portraits was now required to 'think as a Gentleman, and a Man of Sense' (if only to conceal the true material conditions of his profession as one whose class position was actually far from secure). The success of Chambers' *Cyclopaedia* (IIA10) provides powerful evidence of the rising constituency it supplied: a constituency not of practitioners in search of instruction but of bourgeois self-improvers in pursuit of knowledge and consumers in pursuit of culture.

The growth of this constituency gradually affected the very character of art theory, leading to a broadening of its address and a loosening of its dependence upon classical authority. It is against this background that we should interpret the suggestion of Du Bos, made in 1719, that judgement in matters of painting should be exercised by the educated public rather than the professional painter, bearing in mind that in France the paradigm of professional painter belonged to a *royal* academy (see IIB6). We should not assume, however, that what had been the more or less exclusive concerns

of a minority were now transformed through a simple process of liberalization. There is plenty of evidence to suggest that those who already saw themselves as connoisseurs were far from eager to open their conversation to the world at large. For all Shaftesbury's assertion of the need for a 'public voice' to raise 'a true ambition in the artist', his patrician deliberation on an imagined painting could hardly be called a popular text (IIB3). In England as subsequently in France, an enlargement of the public could be countenanced only to the extent that the 'public' was 'polite'. A large question was now raised in the minds of any who deliberated about art's effect upon its audience: was 'taste' the innate property of the already cultured, or could it be acquired? If it was even possible that the 'vulgar' might *become* 'polite', then it would be increasingly difficult to prevent questions regarding the value of art from being implicated in political debates about the spread of education and of economic opportunity (see IIA7).

Together with these circumstantial changes came a degree of practical cosmopolitanism, encouraged by the relaxation of restrictive laws. In the late seventeenth century it had been illegal to import foreign works of art into England. In the early eighteenth there was a booming market in antiquities, paintings and prints from abroad. Throughout Europe there was an exponential increase in the amount of newly published literature on the arts, while translations were often made and printed with a rapidity that today's authors might envy. Shaftesbury's 'Judgement of Hercules' was published first in French and then in English, and was later translated into German; Richardson was translated into French by a Dutchman; the Dutch treatise of Gérard de Lairesse was translated into English, French and German; and so on. (There was also a high degree of recycling of antecedent publications, often unacknowledged in purportedly original texts.) In England this increase in publication was greatly encouraged after 1695 by the lapse of the Licensing Act, leading as this did to the ending of pre-publication censorship and of monopoly over the presses. Addison's important 'Pleasures of the Imagination' (IIB4) was published serially in a medium that could not have existed twenty years before, and it was addressed to a constituency that could not have been envisaged at that time, by a man occupying a profession that could not formerly have supported him. As a sustained piece of writing on aesthetic matters, it was also novel in the very nature of its concerns. Two years later, in 1714, Jean-Pierre de Crousaz published his *Treatise on Beauty*, marking the moment at which a specifically aesthetic discourse was initiated in France also (see II B5).

It would be some while, however, before this swelling literature could confidently establish its values with regard to the work of contemporary or even recent artists. In fact, the more aesthetics developed into a distinct discipline, the more resolutely its concerns were distanced from the contingencies of current practice. Meanwhile, with poetry's ancient pedigree always in view, the prevailing tendency of art theory and criticism was still to affirm the authority of classical antecedents and of the later Italian Renaissance masters, Raphael foremost among them. This generalization applies with a surprising consistency across the different national cultures of Europe, even though the respective native schools varied greatly in the length and depth of their establishment. For instance, while the Italians could refer to an unbroken tradition of pictorial art stretching back over centuries, and while the Académie

Royale and later the Salons provided French writers with a common point of reference, it was the need to ground an English school in the first place that impelled Jonathan Richardson's *Essay on the Theory of Painting* in 1715. Yet in each case, the litany of authorities tended to be much the same. In fact, there may have been some advantage in the relative novelty of painting so far as much of its educated English audience was concerned. Richardson's address to potential connoisseurs (IIA7) was well timed to coincide with the spread of empiricist theories, arguing as these did for the primacy of learning through direct sensory experience (IIB1, 4, 7). It was during this period that much of the early work was done to connect the evaluation of art to philosophical theories of mind and of perception.

In France, the Académie Royale continued to act as a regulator of competence and as a forum for elevated debate, tied irrevocably to the conditions of its royal patronage. Coypel's invocation of the grand manner testifies to the high aspirations that the Académie maintained and to their association with the work of Raphael, still the normal model for the 'perfect painter' (IIA8). In fact, however, the period produced no French artists whose careers could match those that had ended in the later seventeenth century: Nicolas Poussin (d. 1665), Philippe de Champaigne (d. 1672), Claude Lorrain (d. 1682) and Charles Le Brun (d. 1690). The reign of Louis XIV had been associated with a period of remarkable French cultural ascendancy, but that ascendancy was already effectively over by the turn of the century. The final decade and a half before the king's death in 1715 was vexed by the ravages of warfare and by divisive religious conflicts. Louis XV came of age in 1723 and lived for a further fifty years, but where comparisons with the earlier period were made explicit, they were rarely such as to favour the achievements of his reign. The clearest indication of its artistic character was the spread of rococo decoration throughout the interiors of the wealthy. (The term rococo is compounded from the French for rocks and shells: *rocailles* and *coquilles*.) Enlarged to the scale of history painting, rococo work tended to appear overblown, while the more ambitious compositions of the academic painters were significantly lacking in animation. That some quantity of large-scale painting was guaranteed royal patronage in France – indeed, was virtually commanded – seems not generally to have assured large paintings of abiding critical value during the first half of the eighteenth century. The most attractive French paintings of the time were relatively modest enterprieses. Not until the 1780s would the high ideals of French classical painting again be matched in practice, and then the source of their reinvigoration was a burgeoning republicanism.

In Holland in the early eighteenth century a well-established bourgeois market was kept supplied by a host of specialists working in a number of separate centres. From the perspective of the present, it is clear that the golden age of Dutch painting, like the golden age of classical art in France, was by then already over. Yet no such considerations seem to have troubled Gérard de Lairesse as he composed his massive and widely distributed treatise (IIA1). Following the prevailing tendency, he looked back through France and Italy to the classics for his models, paying relatively little regard to the recent achievements of his own countrymen. Lairesse's priorities seem to have been representative of the literate Dutch culture he addressed. If there were late seventeenth-century writers who responded sympathetically to the contemporary 'realism' of Jan Steen, Isaac Ostade, Adrian Brouwer and others, their texts have not

survived. The best testimony we have to the force of these painters' work is that the early eighteenth-century writers who aimed to promote the status of painting generally took pains to disparage it en bloc. It seems entirely appropriate that the 'Beau Ideal' promoted by ten Kate in 1732 should have been attached to Richardson's writing on the sublime, since it owes little enough to the Dutch painting of the previous century (IIB9, 10).

In Italy, the legacy of classical, Renaissance and Baroque civilizations could still be counted on during the first half of the eighteenth century to attract dealers, collectors and cultural tourists from the rest of Europe. It is clear from Richardson's testimony that current Italian painting was also maintaining its prestige at the time, at least as far as the English market was concerned (IIA6, 7). And with some justice. With the maturity of Giambattista Tiepolo (1696–1770), the long history of Italian monumental art came to a last late flourish, while the demand for topographical paintings was serviced at a high level, first by Antonio Canaletto (1697–1768) and later by his pupil Francesco Guardi (1712–93), both of them working principally in Venice. Canaletto's nephew Bernardo Bellotto (1720–80) was also to produce some remarkable views, many of them painted in Central European cities. We look in vain, however, for other than merely biographical texts by contemporary writers that we might put beside the Italian paintings in question. This was apparently not art of a kind that either required theoretical defence or generated significant interpretative comment. To those whose interests it satisfied, its merits must have seemed transparent and uncontroversial.

In fact, it is true of the early eighteenth century as a whole that its major painters tended neither to generate written theory themselves nor to attract any considered reflection on their work from others. As we have suggested, this latter deficiency may have been the result of a lingering lack of maturity in art theory as a whole, its pursuit of conservative ideals often disconnected both from the emerging concerns of aesthetics and from the contingent conditions of practice. Another factor may have been the absence of significant change in artistic style. During the first third of the century there was a perceived need both to advertise the value of art and to demonstrate the potentially elevated character of its accompanying theory. What was lacking was any strong external motivation to revise such protocols as art criticism had managed to establish. Watteau is perhaps the most original artist of the period, but he was not to live long, and even his exceptional achievement can be cited to prove the rule of relative stability. From the unconsidered materials of character sketches and theatrical decorations, he was able to distil an art of sustained pathos and complexity. Yet if the most ambitious of his compositions made reference to the protocols of history painting, it was only to dissolve history itself into a play of manners and gestures and moods. And this left little to discourse about, at least as discourse about art was conceived in France in the eighteenth century. Insofar as we have evidence of contemporary thought about Watteau and his work, it survives in the anecdotal materials of obituary accounts (see IIA2). This is not to imply that that work was unconsidered. Evidence of another kind survives in the great number of engravings that were made from his paintings and drawings.

There is a general lesson to be learned here – or rather to be reiterated in the face of this specific example. Developments in the theory of art do not necessarily proceed

in step with developments in practice, nor can the priorities of theoretical argument necessarily be matched in any systematic fashion against the conclusions of retrospective critical evaluation. At no period in the long history of the modern is this lack of symmetry so clearly demonstrated as it is during the first half of the eighteenth century.

IIA
Painting as a Liberal Art

1 Gérard de Lairesse (1640–1711) from *The Great Book on Painting*

From the mid-1660s until his death, Gérard de Lairesse worked principally in Amsterdam. A generation younger than Jan de Bisschop (IA4) and Samuel van Hoogstraten (IE7), he was a determined advocate of classical principles. These he implemented in his own painting in multi-figure compositions, allegories and decorative schemes produced for the benefit of a cultivated bourgeois audience with a taste for French art. Poussin was the dominant model for his work. In 1690, at the height of a highly successful career, he became blind. Thereafter he turned to lecturing on art. A first volume of his lectures was published by his sons in 1701 as *Grondlegginge der teekenkunst* (Principles of Design). *Het groote schilderboek* (The Great Book on Painting) followed in 1707, published in two volumes in Amsterdam. This work ran to numerous editions and was translated into several languages. Its contents are generally consistent with neo-classical and academic theory, in the sense that de Lairesse affirms the values of the antique and directs the artist's ambition towards those historical and allegorical compositions that are proper to the highest genres. The treatise nevertheless retains a distinctively Dutch flavour. This emerges in de Lairesse's fascination with the imaginary construction of emblematic pictures and allegories – a tendency which his blindness may have encouraged. It is also noticeable in those vivid passages where he discusses the interest of 'mode' or 'modern' painters in the depiction of everyday and urban subjects, and where he discourses on the decorum of still-life painting. De Lairesse's inclination is to disparage the endeavours of such painters as Bamboccio (Pieter van Laer), Brouwer, Ostade and (Anton?) Moller. Through the very vehemence of his opposition, however, he provides testimony to the strength of genre painting in the Low Countries, and to the kinds of 'kitchen' still life that accompanied it. Our excerpts are taken from the English translation of the *Groote schilderboek* made by John Frederick Fritsch and published as *The Art of Painting in All its Branches*, London: J. F. Fritsch, 1738, pp. 88–90, 126–36 and 547–50.

Book II. Of Ordonnance, or Composition.

Chap XV. *Of the four Sorts of Tables, or Ordonnances, and what they are.*

[...] I shall now treat of the Nature, Force and Quality of Tables or Ordonnances (as necessary for Landskip as History-painters) and therein consider 1. Their Kinds. 2. Their Names. 3. Which of them have double Uses, and which have single.

I suppose four Kinds, *viz. Historical, Poetic, Moral and Hieroglyphic*; the first is a simple and true Fact. The second, a double Fiction, exhibiting fabulous Stories, or a Mixture of Deities and Mortals: The third has a threefold Moral; teaching our Duty to God, our Neighbour and ourselves: And the last is fourfold, as couching, under a short and mysterious Sense, the three before going; handling Virtue and Vice for the Benefit of Soul and Body, and shewing the Happiness and Immortality of the one, and the Corruption of the other.

In *History*, the Poet or Painter, ought intirely to confine himself to *Truth*, without Addition or Abatement; his Ornaments, tho' borrowed from Poesy, must be so restrained, that nothing, serving for Illustration, create Improbability; for Instance, not to represent Day-break by the poetic Figure of *Aurora*; or the Night, by *Diana*; or the Sea, by *Neptune*; which is needless, and an Error, because those Things can be naturally expressed by Colours; as Day-break, by its Appearance, of Yellow, Red and Blue, or by the Sun-rays appearing on the Horizon; the Night, by it's Darkness, and by the Moon and Stars; the Sea by its Waves and Billows, Rocks, Monsters and Shells on the Shore; also the *Nile*, by it's Crocodiles, &c. or any Thing proper to the Sea or Rivers.

The *Poetic* Tables differ from the historical in this; that, instead of true Story, they consider *Fictions only*, intermixing Deities with Mortals, as we have said; and thereby signifying nothing else, but the Course of the World thro' the four Elements, as Air, Earth, Fire and Water; and tho' historically handled, yet each is a simple Figure, having a mystic Meaning, either in *Name or Shape*, and often in *both*; as *Scylla, Atlas, Leda, Cyclops*, and many others: And thus the Fable, being both philosophic and moral, in one and the same Manner prescribes Virtue and decries Vice; as we gather from *Ovid, Virgil*, and others. It is necessary therefore, in designing such an Ordonnance, to *keep intirely to the Fable*, as before is said, without any Addition of hieroglyphic Figures, as Temperance, Prudence, Anger, Jealousy, &c. which are so improper here, as hereafter shall be shewn, that they destroy the very Intent of it; for there are others, which (tho' in a different Manner) will express the same Passions; as *Cupid*, instead of *Love; Pallas*, instead of *Wisdom*, and many others; as we collect from the Poets.

The *Moral* Ordonnances are *true Facts, or Histories*, proposed only for Edification or Instruction; exhibiting either the gallant Acts, or Crimes, of human Nature; and these explained by some additional emblematic Figures, which express the Passions by which they were moved, or misled; for Instance, with *Alexander* we may place Ambition; next *Marcus Aurelius*, Humanity; next *Augustus*, Piety; next *Scipio Africanus*, Moderation, in restoring the young captive Bride to her Spouse, and many others, as *Horace* in his Emblems artfully exhibits. In this Sort of Ordonnances we are no ways confined to Time, the Sun's Place, or the Quality of the Country; for we may intermix Summer with Winter, even all the Elements may appear; the Subject may be in the Front of the Picture in *Africa*; and in the Offskip, at *Rome*, or elsewhere; even in Hell itself another Scene may be acting; so great a Latitude has a Moralist: But he must take Care to avoid Superfluity, and Things improper to the main Action, which, as in Plays, spoil the Beauty of the Representation.

The *Hieroglyphic* Ordonnances are quite different from the three former in their Nature and Quality, having no other Affinity with them than an Intention to *exalt Virtue, and debase Vice*, by the Rewards of the one and the Punishment of the other:

They are as well Christian as Heathen; the Christian affect the Soul, and the Heathen the Body: The former demonstrate the Immortality of the Soul, and the latter shew the Vicissitude and Vanity of the World. These Tables consist in assembling several emblematic Figures of different Passions, which all together are to express a single Meaning; as Piety, Peace, War, Love, &c. And such Tables are called Emblems, by their Application and emblematic Use, and by being made up of Objects which have their proper Meaning and Relation, or else Derivatives from them; as the Palm-tree, Laurel, Myrtle, Cypress, or the Sun, Moon, and Stars, or an Hour-glass, a Dart, Flame, &c. Which signify any Power, Virtue or extraordinary Effect. These Tables, like the preceding, admit not of the least Superfluity to obscure their Significations; because, having neither History nor Fable to build on, they consist only of a single Passion, proceeding from the Subject (which may be at our own Choice) explained and made intelligible by the other emblematic Figures, which must not be improperly introduced, lest the Sense of the whole Scene be altered: But here we must observe to make a Distinction between *Heathen* and *Christian* Representations; the *Heathen* admit of *Venus, Cupid* or *Anteros*, for Love; the Christian shews Charity, or a Woman with Children about her, and a Flame on her Head; the former has *Hercules*, for Fortitude, and the latter St. *Michael*; the one takes *Jupiter* with his Thunder, and the other, Justice; the former expresses Piety by a Woman with an Oblation-bowl in her Hand, and near her an Altar with a Crane, and the latter chuses a Cross instead of the Bowl: But all this is uncertain, and not confined to Time or Climate.

Book III. **Of Things** *Antique* **and** *Modern.*

Chap I. *The Difference between what is Antique and Modern.*

We are now obliged, to put in Execution our Purpose of making a proper Distinction between Things Antique and Modern; since the Difference between them is so great, that they cannot unite, without causing excessive Deformity; *for Things Antique are always the same, but the Mode continually changing*; its very Name implies its Mutability; since nothing is more unconstant than what depends on Fashion; which alters not only annually, but even daily in those who mimick the Court. These Contrarieties, which are so confounding, and cause such a Variance between what is *antique* and *modern*, we see chiefly in the Composition of Histories, Fables, Emblems, and such like; in which both (yet the *Modern* most) are blended together.

* * *

I think I can't better describe the Difference between what is *Antique and Modern*, than by a Windball and an Egg, thus; the Ball, by being tossed to and fro, and at last bursting, represents *short Duration*, affording nothing but Wind; but the Egg hatched and opened, produces a living Creature; not only *a Something*, but *something good*; the former, a mere Nothing; or, if it have a Name, 'tis Vanity, and therefore rather bad than good.

Painting was, by the ancient *Romans*, so highly esteemed, that none but Noblemen durst learn it: As we may also gather from the Painters, several of whom have been of noble Extraction: And the Reason of it is very evident, since 'tis not only probable, but reasonable, that such ingenious Spirits should have a distinguishing Inclination

for Arts, suitable to their Quality, above the Vulgar. Their Meditations, Actions, and Perceptions were fixed on great and sublime Things: They inquired into, and consulted many excellent Authors of History, Fables and Emblems, as well sacred as profane, and the Accounts of ancient Medals; from whence they have drawn plentiful and ingenious Matter for their Studies: What excellent Paintings have they not oblig'd the World with! How many Temples, Palaces, and other rare Structures have they enriched with elegant Devices inciting to Virtue; whereby they have bequeathed a lasting Name to Posterity! How did Architecture (never enough to be praised) flourish in their Times. But what Alterations do we see now? How are the Beauties and profitable Uses of Painting either sunk, obscured or slighted, since the *Bambocciades*[1] *are multiplied in these Countries*; at present we can scarce see one Virtue appear, but ten, nay an hundred Vices will rise counter to it; thus has sprung up a second *Hydra* like that of *Lerna*; so that we want a valiant *Hercules* to lop off those Dragons Heads which are always sprouting. Thus Architecture itself, how excellent soever, is, with the right Practice of Painting, brought into Disgrace, and slighted by other Nations; since we scarce see a beautiful Hall or fine Apartment of any Cost, that is not set out with Pictures of Beggars, Obscenities, a *Geneva*-Stall, Tobacco-smoakers, Fidlers, nasty Children easing Nature, and other Things more filthy. Who can entertain his Friend or a Person of Repute in an Apartment lying thus in litter, or where a Child is bawling, or wiping clean? We grant, that these Things are only represented in Picture: But is not the Art of Painting an Imitation of the Life; which can either *please or loath?* If then we make such Things like the Life, they must needs raise an Aversion. They are therefore too low and unbecoming Subjects for Ornament, especially for People of Fashion, whose Conceptions ought to surpass the Vulgar. We admit indeed that all this is Art, or at least called so, when the Life is thereby naturally exprest; but how much the beautiful Life, skilfully handled, differs from the defective Life of modern Painters, let the Curious determine. It's certain that Men (and Beasts too) have each a particular and different Inclination to particular Things; whereby they love what's agreeable to their Natures, the one good, the other bad, because (as some pretend) they are governed and influenced by certain Constellations happening at their Births: This at least we know, that one Man inclines to Hunting, and a Country-life; another, to War, Strife and Contention; another to Merchandise and Deceit; this, to Politicks and great Things; that, to Pleasures, *&c.* So that in each we discover what his Nature and Passion is prone to.

But let us reflect on the two Arts, Noble and Ignoble; or *Antique and Modern*, and see how much they differ both in Objects and Execution. *The Antique is unlimited*, that is, it can handle *History*, sacred as well as profane, *Fables* and *Emblems* both moral and spiritual; under which three Heads it comprehends, *all that ever was, is, and shall be*; the *past, present* and *to come; and that, after an excellent Manner, which never alters, but remains always the same: The modern, contrarily, is so far from being free, that it is limited within certain narrow Bounds; and is of small Power; for it may or can represent no more than what is present, and that too in a Manner which is always changing: What is past and to come is without its Power; as also Histories, Fables and Emblems, as well poetical and philosophic as moral.* Hence we may judge what the *modern* Art of Painting is, and why it cannot be called *noble*; much less have any Harmony with the *antique*. I could assign more Causes for this Disunion, but shall at

present omit them for two Reasons; first, because Men's Judgments are so various; and each argues according to his Passions and Inclinations, in Proportion as he likes or dislikes a Thing: Secondly (which is the principal) that I may not be thought to raise any Suspicions of Partiality or Prepossession. But why should I restrain my Thoughts? Let me speak plain in Spite of others; I say then, that altho' *modern* Things seem to have some Prettiness, yet they are only to be esteemed as *Diversions of the Art.* I moreover maintain, that such Painters, as never produce more than one Choice of Subjects, may truely be ranked among Tradesmen; since such Representations cannot be called an Exercise of the Mind, but an handycraft Trade.

By such Remarks as these, we may sufficiently perceive, that from *Apprehension, Knowledge* and *Judgment* spring the Lustre and Elevation of the *antique Art* of Painting; and contrarily that *Ignorance, Negligence* and *Self-will* debase and subject *the modern*: So that the Ancients have not improperly placed *Minerva* by the one, and *Midas* by the other; intimating by the former, *Skill in the Art, Practice, Carefulness and an heavenly Talent*; and by the latter, *Imprudence, blind Zeal, worldly Defects and Hindrances.*

But if any one would perhaps examine, whether there be not a Means to make the *Modern noble*, as well as the *Antique*, that they might both march together, they would find it to be Labour in vain; since Defects once got footing are not easily remedied: But further, we often hear with Wonder, that Painters persuade one another that, in handling a Subject, 'tis enough to follow Nature, tho' she be defective; as crooked, lame, squint-ey'd, or blind; and that when she is imitated with a delicate Pencil, that is sufficient; and such is their Zeal and extraordinary Pains, that one paints for that end the Air of his Wife, tho' ever so ugly, with all her Freckles and Pimples very exactly, whereby the Agreeableness of a beautiful Woman's Face is quite lost: Another chuses his clownish unmannerly Maid-servant for his Model, and makes her a Lady in a Saloon: Another will put a Lord's Dress on a School-boy, or his own Son, tho' continually stroaking his Hair behind his Ears, scratching his Head, or having a down-look; thinking it sufficient to have followed Nature, *without Regard to Grace*, which ought to be represented; or having recourse to fine Plaister-faces, which are to be had in Abundance.

The beautiful and well-composed Airs in a Picture of many or few Figures, have a great Effect on the Minds of the Knowing; of which the Ancients were thoroughly sensible; for in the most perfect Bodies they made the Face chiefly to excel in Beauty and Agreeableness. No one of Judgment will deny, that a beautiful and well-carriaged Woman has such an Ascendant as most effectually to move her Beholders in two different Manners, and by two contrary Passions; under Misfortune or in raging Pain, she will pierce a Man's Heart, and move him to Compassion; and when she entertains us on any joyful Occasion, with Singing or Laughing, she will at once delight us: A clownish Woman contrarily, will not produce any such Effects; for her Beholders, thro' her Unmannerliness and simple Behaviour, despise her Mirth, and mock her ridiculous Sorrow.

What great Defect do we not still find in *modern* Painters, when they use, or rather abuse, the Life; not doing like those, who being accustomed to *a nobler* Manner, view the Life with Knowledge and Judgment, that is, *not as it ordinarily appears, but as it ought to be, in its greatest Perfection*: Whereas the others, blinded by Custom, have no

such Nicety; because they imitate the Life just as they see it, without any Difference: We even see them make it more deformed than Nature ever produces; for the more mis-shapen Faces *Bamboccio, Ostade, Brouwer, Moller*, and many others made, the more they were esteem'd by Ignorants: By which *low Choices* we can easily judge, that they were Strangers to Beauty, and Admirers of Deformity: However 'tis an infallible Rule, that daily Custom and Converse with People like ourselves, contribute much to it. Thus Deformity and Vice are preferred to Virtue, and what should be shunn'd sought; whereas he who is sensible of Virtue will always endeavour to escape Error.

Chap. II. *Method for representing what is City-like, or elegant Modern.*

The continual Changes in worldly Things afford us plentiful Matter for *modern Manner*, without recourse to History, Fables or Emblems; even so much as to be endless; as may be gathered from the Assemblies for publick Worship, Pleadings in Courts, Plays, Family-occurrences, and the like: All which we perceive to be either majestic, amorous, sorrowful, or otherwise. *Those Things, how different soever, can be represented in the antique Manner as well as in the modern, provided each keep its Quality*; as I have already intimated, and shall further insist in the subsequent Examples; which can be handled in *both Manners alike natural and proper, without either's borrowing any thing from the other, but the Subject*. This I think worthy of Remark; and the rather, since, to my Knowledge, no Author, treating of *Things Antique and Modern*, has said any thing touching it.

Fra. Mieris has not only curiously followed his Master *Gerard Dou*, in the elegant *modern* Manner, but is, in some Things, his Superior; and the rare *Poussin*, and *Raphael*, Prince of the *Italian* Painters, excell'd in the *Antique*: Let us then follow their Examples in what is most agreeable to our Gusto's; and tho' the latter far exceed the former in Nobleness, it's however more commendable, to be like a *good* Mieris *in the modern Manner, than a bad* Raphael *in the antique*. Tho' I remember to have seen a Picture of old *Mieris*, which, as often as I think of it, surprises me; it was an half-length Figure, about the Bigness of the Palm of the Hand, representing the Art of Painting, holding a Vizor in her Hand; its Air, Head-attire, Dress and Furniture so very beautiful and truly *antique*, that I never saw the like done by any other *modern* Master, how skilful soever. Whence it appears, how rare it is for a *modern* Master to give into the *Antique*.

Let us now represent the Case of *Parents permitting their Children to take some Diversions in Bathing*: A Design which can be *as well executed in the Antique as the modern Manner*. The Bagnio comes forward in the Piece, having a Descent into it of two Steps: The Boys, from 12 to 15 Years old, about the Water and in it, are naked: A Daughter, of 20 Years of Age, is seen with a fine white Linnen Cloth over her Body, in order to cover what Modesty conceals, and as is customary on such Occasions; nevertheless her Arms and Part of her Legs are bare; she is coming up the Steps on the left Side: One of the aforesaid Boys holds her fast by a Flappet of the wet Cloth, in order to prevent her going up: Further behind, near a Bed, the eldest Daughter, about 25 Years old, appears almost unshifted; and near her, a Maid-servant to put the Cloth about her: The Father we represent, drest either in his Cloaths, or a *Japan* Night-gown, standing on the Brink of the Bagnio, and laughing at the Boys who are

in it, and playing their Tricks: One of them is standing with his left Leg on the Steps, and with the other Foot just touches the Water; the youngest Boy lies on his Belly extended on the lowermost Step, plashing with his Hands in the Water; the Cloth of the Daughter, who is stepping out of the Bagnio, dropping wet, sticks so close to her Body, that the Nakedness of the Members appear transparently through it: The Mother all this while is busy in serving some Sweet-meats on a Table covered with a Napkin, near which, a Child, of 2 or 3 Years of Age, is sitting in a Chair in his Shirt; to whom she offers a Macaroon. Somewhat further are seen silk Gowns, Petticoats, velvet Scarves, Hoods, &c. hanging on Pins: On a Table are lying pearl Neck-laces, Bracelets and other Trinkets: In fine, the whole Disposition is most orderly, natural and beautiful. As for the Boys Cloaths, to wit, Coats, Hats, Breeches, Stockings, Shoes, &c. they lie on the Brink of the Bagnio.

Now I refer it to the judicious Reader, whether the Daughter, who, on the left Side, is stepping out of the Bagnio, ought not, notwithstanding her being covered with the Cloth, to be represented beautiful and shapeable in her Arms, Legs, Hands and Feet, nay, even her Body also, so far as the Nakedness appears thro' the wet Cloth? Her Modesty appears evidently by her bashful Look: What a Carriage shew the Feet and whole Body, while she endeavours to cover the Parts which Modesty conceals! And how modestly does she step up, instead of exposing those Parts by a wanton Gate! I ask further, whether the Boy, who is stopping her by the Flappet of the Cloth, ought to be less beautiful and well-made than the Father in the flowered *Japan* Gown? The Boy the same, who lies extended on his Belly; in whom must appear Innocence and Childishness: The eldest Daughter in her Bloom, well descended and virtuously educated. To whom shall we liken her? Whence must we fetch her Beauty? And whom must we use for a Model? A vulgar Person, or one of a better Appearance: Even this latter would be insufficient for the Purpose, if not well educated and fine-carriaged; because Beauty without Grace looks mishapen and stiff: This Virgin then, who is, except in her Feet, quite naked, ought principally to be painted as beautiful and agreeable as a *Grecian Venus*; I mean not, a wanton one, but an Heavenly one,[2] *i. e.* a virtuous one; for as much as the Soul differs from the Body, and the Body from the Dress, does Nobility from Commonalty, Virtue from Defect. If any one ask, where he shall find those Beauties; I refer him in the first Place, to the Books which treat of perfect Proportion; wherein true Grace consists: Whilst he is studious in those, he ought to have the best Plaister-figures before him, in order to exercise his Understanding, and thereby acquire a solid Judgment. If it be again objected, that the Plaister is not equal to living Nature, I own it; for I mean not, that the Artist should paint Flesh-colour after them, but get a perfect Idea of their Beauty, Grace and Agreeableness,[3] both general and particular; whence Perfection springs; for the Colouring is evident, and easy enough to be found in the Life, as I could prove in several Instances of some ordinary Painters who coloured well; who, before they had made much Progress in the Art, were cried up for great Men, and yet, having any Thing extraordinary to do, were not able to sketch well an Head, Hand or Foot.

The *modern Painting* can therefore not be accounted *Art, when Nature is simply followed*; which is a meer imperfect Imitation or defective aping her. Even, were a Thing represented ever so natural, well-designed and properly ordered; the

Condition, Manners and Custom of the Country well observed, and the Colouring most exact, yet the Knowing will not think it artful: But when Nature is *corrected and improved* by a judicious Master, and the aforesaid Qualities joined to it, the Painting must then be noble and perfect.

I say therefore, with respect to the Naked, whether of Man, Woman or Child, that when 'tis not exhibited most beautifully, or in its *due Proportion*, the *modern Painting* cannot deserve the Name of *Art*; and with good Reason, since this is the only Method whereby to make those two unlike Sisters accord.

Van Dyk, never enough to be commended, gained Excellence in the *antique* as well as the *modern* Manner, by strictly following the aforesaid three Graces in both; and he thereby acquired the Epithet of *Matchless*: Let us therefore follow his noble Example in what made him so famous; since he is the first who carried the *modern* Manner so high as to gain it the Name of *Art*. Whence we may easily conclude, what great Difference there must be, between a Painter who makes the *modern or defective Life, his Study and Excellence*, and one who follows the *Antique, or makes a thorough Inquiry into every thing that's beautiful and perfect*: The Difference is even so great in every respect, that I cannot but wonder at it; especially, when I consider how much greater the Number of the former Sort is, and how they daily increase....The Reason of so great a Difference can be attributed to nothing else, but the different Inclinations of Painters, to Objects agreeing with their Tempers.

They, who content themselves with following *defective Life*, will never produce any thing *perfect*, or deserve the Name of artful Masters; because *not knowing, or not caring to know, what is best*, they cannot so much as strive at it: To which add, another Mischief; *they more easily judge of what is bad than good*; as I shall explain myself in the following Example.

A *young Man* as a Painter with Pallet and Pencils, attended by *Zeal*, is led, by a blind *Cupid*, to the Figure of *Nature*, whose Face is covered by *Vulcan* with a Veil. The *Sun* behind the young Man enlightens the aforesaid whole Figure. *Mercury*, on a Cloud, with his *Caduceus* in one Hand, holds a Star over the Artist's Head in the other. The Meaning is this.

Nature is the Painter's Object; the *Sun* represents *Knowledge*; Vulcan, *the gross Part of the Air, or Earthiness*; and *Mercury, inevitable Fate*. The rest explains itself. Thus much touching a *modern* Painter.

* * *

Book XI. of Still-Life.

Emblem, touching Still-life.

Judgment and *Prudence* sit here at a Table; by whom are seen some *Cupids* taking, out of a large *Horn of Plenty*, all Sorts of Things, as a Scepter, Crown, Necklaces, Books, a Shepherd's-staff, Musical Instruments, Garlands, Flowers, Fruit, *&c.* serving for Still-life, and presenting them to *Judgment*, who, by the Help of *Prudence*, lays them in Heaps on the Table, disposing them orderly for representing ingenious Ordonnances in that Part of Art.

Chap. I. *Of Still-life in general*

Having thus far treated of the Power and Dignity of the noble Art of Painting, together with the Lustre and Advantage accrueing to those who thoroughly consider and put it in Execution; we shall now, for the sake of weak Capacities, proceed to *Still-life*, or, *immoveable and inanimate Things; such as Flowers, Fruits, Gold, Silver, Stone, Musical Instruments, dead Fish*, &c. and shew which are the best and of most Advantage. These may, in their Turns, in different Manners, serve for Materials for a natural Composition, wherewith to please all Sorts of Men, the Great as well as the Little, the Learned as Ignorant. Wherefore, out of many, we shall fix on the following Objects, as the most beautiful, elegant, and agreeable.

1. *Flowers.*
2. *Fruit.*
3. *Gold, Silver, and other rich Things.*
4. *Musical Instruments.*

These four Sorts, artfully order'd and perform'd, may serve for the Ornament of Halls and Cabinets as well as the best Paintings, provided they have a *proper Light, and hang together*. But we must know, in the first Place, what constitutes a good Still-life-piece, since, tho' it be naturally handled, nothing but a *good Choice* can charm the Senses, and bring Fame to the Master. 'Tis Weakness to think that faded Flowers should please, much less in a Picture: Or who would hang a Piece of ordinary, unripe, or rotten Fruit in his best Room, and among a Cabinet-collection, seeing the Life itself is so disagreeable? Such Rubbish I did formerly admire; but as they only shew the Deformities of Nature, I have no Appetite to view them any more. But, to return to the Subject.

My Opinion is, that the Beauty and Goodness of a Still-life consists only in the most choice Objects: I say, *the most choice*; as, among Flowers, the most rare and beautiful, and the same in Fruits and other Things. These will gain a Master Credit, especially with the Addition of some *particular Significations proper to them*. It is not probable that wealthy People should be delighted with old-fashion'd Plate and Furniture, when they can have every Thing more beautiful and elegant; and as improbable, that judicious Lovers of Musick should be pleased with the modern Lyre, Dulcimer, or Bag-pipe. As for Cabbages, Carrots, and Turnips, as likewise Codfish, Salmon, Herrings, Smelts, and such-like (which are poor and mean Ornaments, and not worthy of any Apartment) he who is pleased with them may seek them in the Markets. I as little approve of Horse-furniture and hunting Equipage; tho' these latter, with wild Boars, Stags, Hares, Pheasants, Partridges, and other Fowls, depending on Princes and Noblemens Fancies, are more tolerable.

Having thus in general touched on Still-life, let the Judicious determine which Sort is best and most advantageous either to the Painter or Purchaser.

As for me, I think Eloquence very charming to the Ear; but *Goodness* alone makes Beauty amiable. What is a fine Flower, Apple, Gold Cup, or well-tun'd Violin, without good Smell, delicate Taste, proper Use, and agreeable Sound? *Goodness*, I

say, ought to be perfectly apparent: The Smell, Taste, Hearing, or Sound cannot be painted; but may be, in some Measure, exprest by occult Significations, either in Bass-relief by Fables, Hieroglyphicks, or emblematick Figures, or by many other Things, if the Will be not wanting.

As to the Nature and *Property of the Places* for Still-life, they are two-fold, close and open; the one representing it as if *hanging against a Wall* or Wainscot, and the other, as *lying on a Bench or Table, or on the Ground*.

We also suppose, that no Objects used in Still-life ought to be represented *less than the Life*.

'Tis likewise improper, and against the Nature of Still-life, to introduce, in any of the before-mention'd Choices, *colour'd Back-works*, or *Vistos*, either close or open, that is, Landskip, Architecture, or any Kind of living Creatures; which would spoil the very Name of a Still-life: Moreover, it is difficult, if not impossible, for such a Painter to hit every Thing; and granting he can, I yet question, whether he would be pleased with the Title of a Still-life Painter. I say then, that the *Depth* of the Picture is only to be represented by an hanging Curtain, or a Bass-relief of Wood or Stone, of such a Colour and Tint, as best suits the general *Decorum*; the one darkish, and the other somewhat lighter. With *Flowers*, a dark-grey Back-ground suits better than a white, yellow, or red one. With *Fruit*, white and grey Marble, but not yellow or red. Yet, as a fine Bass-relief requires more Skill than Flower or Fruit, and such like, you may, instead thereof, introduce a Niche, with a God or Goddess's Bust therein, proper to the Subject, as a *Flora, Pomona, Bacchus, Apollo, Diana*, or others, according to the Intent of your Design, and as you would have it bear either a *particular* or *general Meaning*, which each of those Figures will supply in Abundance. Flowers are various, and, like Fruits, may be divided into three Sorts, to wit, the Spring, Summer and Autumn; and, having different Qualities, are fit for many fine and uncommon Designs, in Conjunction with Bass-reliefs or Busts, as I have said; with this Caution, that *with Flowers* suit *no Fruit*, but Ears of Corn, as being airy and pliable; but among Fruits may be some Flowers, especially such as allude to *Rest* and *Mirth*, as Poppies and Roses. And yet these agree best with Grapes, either in Garlands or Festoons.

Let us now, for Exercise and Improvement in this Point, observe what the Learned say. The *white Lilly* is sacred to *Juno*; *Turnsol* to *Apollo*; the *Rose to Venus; Diana* and *Somnus* claim the *Poppies; Ceres*, the *Corn-Flowers; Juno*, the *Pomegranates; Bacchus*, the *Fig-tree* and *Vine; Ceres*, or, *Isis*, the *Peaches* and *Ears of Corn; Venus* and *Apollo*, the *Apples; Ops*, or Mother Earth, *every Thing she produces throughout the Year*. Of Instruments, the *Lyre* is dedicated to *Apollo, Mercury*, and the *Muses*; the *Flute*, to *Pan* and *Venus*; the *Trumpet*, to *Mars*, &c.

1 The followers of *Bamboccio*, a celebrated Painter of mean Subject [Pieter van der Laer].
2 *Venus Urania*.
3 The *Three Graces*.

2 Roger de Piles (1635–1709) from *The Principles of Painting*

With the appointment of Jules Hardouin-Mansart as the new protector of the Royal Academy in 1699, Roger de Piles was invited to join the Academy as an *amateur honoraire* and as its chief theoretician. After so many years in opposition, the victory of the principal spokesman of the partisans of colour was now complete. The last decade of his life was spent in producing a summation of his ideas on art, published a year before his death as the *Cours de peinture par principes*. Whereas earlier theorists within the Academy had sought to establish painting's status as a liberal art by stressing its affinity with poetry and by emphasizing its intellectual character, De Piles insists on the difference of painting from the other arts, elaborating its specifically *visual* interest. A successful painting must call to the spectator, obliging the viewer to approach the canvas 'as if he intended to converse with the figures'. This leads him to address problems of perception as well as of cognition: to examine the way in which paintings appeal to the eye as well as to the mind. With his conception of the *tout-ensemble*, or the effect of the 'whole together', he shows that pictorial unity is achieved through the balanced and harmonious relation between the constituent elements of the composition. It is through such effects that painting is able to astonish and delight the viewer, who takes pleasure in the very artifice itself. The *Cours de peinture par principes* was first published in Paris by J. Estienne in 1708. The following excerpts are taken from the anonymous translation by 'a painter', *The Principles of Painting*, London: J. Osborn, 1743, pp. 1–8, 10–12, 59–60, 64–6, 68–70.

Preface, on the Idea of Painting

The prize of a race is not to be won, if we have not the goal in our eye; nor is the perfect knowledge of any art or science to be acquired, without having *a true idea* of it. This idea is our goal or mark, and directs us unerringly to the end of our career; that is, to the possession of the science we desire.

But though there is nothing which does not include in itself and discover its true idea; yet we must not from hence infer, that this idea is so obvious, as not to be mistaken; or that the false idea does not often pass for the true and perfect. There are several ideas of painting, as well as of other arts: The difficulty lies in discovering which of them is the *true one*. For this purpose, it is necessary to observe, that, in painting, there are *two sorts of ideas; a general idea, which is common to all men, and a particular idea, peculiar to painters*.

The surest way to know infallibly the *true idea* of things is, to derive it from the very *basis* of their *essence and definition*; for definition was invented for no other purpose than preventing equivocation and ambiguity in ideas, banishing those that are false, and informing the mind of the true end and principal effects of things. Whence it follows, that the more an *idea* leads us directly and rapidly to the end which its essence points out, the more certain we ought to be, that such an idea is a *true one*.

The essence and definition of painting is, the *imitation of visible objects, by means of form and colours*: Wherefore the more *forcibly and faithfully painting imitates nature*, the more directly and rapidly does it lead us to its *end*; which is, *to deceive the eye*; and the surer proofs does it give us of its *true idea*.

The *general idea* above-mentioned strikes and attracts every one, the ignorant, the lovers of painting, judges, and even painters themselves. A picture, that bears this character, permits no one to pass by it with indifference; but never fails to surprise us, and to detain us for a while to enjoy the pleasure of our surprize. True painting, therefore, is such as not only surprises, but, as it were, calls to us; and has so powerful an effect, that we cannot help coming near it, as if it had something to tell us. And we no sooner approach it, but we are entertained, not only with *fine choice*, with the *novelty* of the things it represents, with the history or fable it puts us in mind of, with ingenious inventions, and with allegories, to give us the pleasure of employing our parts, either in discovering the meaning, or criticising the obscurity of them; but also with that *true and faithful imitation*, which attracted us at first sight, and afterwards lets us into all the particulars of the piece; *and which*, according to *Aristotle*, never fails to divert us, how horrible soever those natural objects may be which it represents.

The other *idea, which, as we said, is peculiar to painters*, and to which they ought to be perfectly habituated, concerns, in particular, the *whole theory of painting*; and should be so much at command, that it may seem to cost them no reflection to execute their thoughts: So that after having studied correct design, fine colouring, and all their dependencies, they ought to have those ideas always present and ready, which answer to the several branches of their art.

On the whole, *true painting*, by the force and great truth of its imitation, ought, as I have observed, to *call the spectator*, to surprise him, and oblige him to approach it, as if he intended to converse with the figures: In effect, when the piece bears the character of *truth*, it seems to have drawn us to it, for no other purpose, than to *entertain* and *instruct* us.

But here we must observe, that the *ideas* of painting in general are as different as the *manners of the several schools*. Not that painters are without those particular ideas, which they ought to possess: But the use they make of them not being at all times just, the *habits* which this use brings upon them, their attachment to *one part* more than another, and the affection they preserve for the *manner* of those masters whom they have imitated, prejudice their choice, and bias them to some favourite branch of the art; though they are under the strictest obligation to make themselves masters of every part of it, in order to contribute to the *general idea* above-mentioned: For most painters are always divided in their inclinations; some following *Raphael*, others *Michael-Angelo*, others the *Caracchis*, and others the scholars of these masters: Some prefer *the whole*; others *the abundance of thoughts*; others the *graces*; others *the expression of the passions of the soul*; and there are some who give themselves wholly up to the *heat* and transport of their genius, tho' but little improved, either by study or reflection.

But what can be done with all these vague and *uncertain ideas*? 'Tis certainly dangerous to reject them; we must therefore resolve to prefer to all other things that *truth*, which we have supposed in the *general idea:* For, to all *painted objects*, the appearance of *truth* is more necessary, than the manner of any master whatever; because truth in painting is the basis of all the parts which heighten the excellence of this art; as the *sciences and virtues* are the foundation of all those accomplishments, which can either exalt or adorn human nature. For which reason we must suppose

truth on the one hand, and virtue and science on the other, to be in perfection, when we talk of those finishings; or accomplishments, of which either painting or human nature is susceptible, and which, without resting upon such a basis, can have no good effect. In short, the spectator is not obliged to seek for *truth* in a painting; but *truth*, by its effect, must *call to the spectator*, and force his attention.

'Tis in vain to adorn a stately palace with the greatest rarities, if we have forgot to make doors to it, or if the entrance be not proportionable to the beauty of the building; so as to raise the passenger's desire to walk in, and gratify his curiosity. All *visible objects* enter the understanding by the faculty of *seeing*, as *musical sounds* do by that of *hearing*. The *eyes* and *ears* are the *doors*, which admit us to judge of *painting* and *musick:* The first care therefore both of the painter and the musician should be, to make these entrances *free* and *agreeable*, by the force of their harmony; the one in his *colouring* conducted by the *claro-obscuro*, and the other in his *accords*. The spectator being thus attracted by the force of the performance, his eye discovers in it those particular beauties which are capable of instructing and pleasing; the curious finds in it what suits his taste; and the painter there observes the different branches of his art, in order to improve himself by what is good, and to reject whatever may be vicious. Every thing in a picture is not equally perfect. Some paintings there are, which, with several faults, when minutely consider'd, do not fail, nevertheless, to catch the eye; because of the artist's excellent management in his *colouring*, and the *claro-obscuro*.

Rembrant, for instance, diverted himself one day with drawing his maid's picture, in order to set it at his window, and deceive passengers: His project succeeded; for the fallacy was not discover'd till some days after. And yet, as we may justly imagine of *Rembrant*, this effect was not owing to the beauty of the design, nor to the nobleness of the expression. When I was in *Holland*, I had the curiosity to see this picture; and, finding it to be well pencil'd, and of great force, I bought it, and it has at this time a considerable place in my cabinet.

Other painters, on the contrary, have shewn in their works a good many perfections in the several parts of the art; yet have not been so happy as *Rembrant*, to gain, at first sight, such favourable regards: I say, not happy; because, if they have sometimes succeeded, 'twas owing to a chance disposition of objects, which, in the places they filled, required an advantageous *claro-obscuro*; a perfection which cannot be denied them, but wherein the skill of the painter had very little share; since, if it had been the effect of science, it would have appeared in all his other productions.

Thus nothing is more common, than to see paintings set off a room, purely by the richness of their borderings, whilst the insipidity and coldness of those paintings is such, that people pass unconcernedly by them, without being attracted by that truth which calls to us. Now, to make this point clearer, I must explain it by the example of some skilful painters, who yet have not been masters enough to strike the eye, at first sight, by a faithful imitation, and a truth which ought to deceive, as even excelling nature itself. The most remarkable example I can quote is *Raphael*, because of his great reputation, and because there was never any painter who possessed so many parts of the art, or possessed them in so high a degree of perfection.

'Tis very certain, by the confession of many, that men of knowledge have often sought for *Raphael*'s works in the midst of them; that is, in the halls of the *Vatican*,

where are his best performances; and have asked their guides to shew them the works of *Raphael*, without giving the least indication of being struck with them at the first glance of the eye, as they expected to be, from that painter's reputation. The paintings of *Raphael* did not answer the idea they had conceived of so great a genius, because they measured them by that idea which one ought naturally to have of perfect works. They could not imagine, that the imitation of nature would not, in the works of so wonderful an artist, appear in all its vigour, and all its perfection. This shews, that without the knowledge of the *claro-obscuro*, and of whatever depends on colouring, the other parts of painting lose much of their merit, even when they are in that degree of perfection to which *Raphael* carried them.

* * *

It is certain, that the number of pictures which call the spectator is but few: But that is not the fault of the art; the essential effect of which is to surprise, and deceive the eye: We must only blame the painter's negligence, or rather impute it to his genius, as not being exalted enough, or not sufficiently furnish'd with the principles necessary for compelling, as it were, those who pass by, to stop, and give attention to his pieces.

But further; it argues more genius to make a good use of lights and shades, harmony of colours, and their suitableness to each particular object, than to design a single figure correctly.

Design, which requires much time to learn perfectly, consists of little more than an habit, which is often repeated, of giving measures and outlines; but the *claro-obscuro*, and harmony of colours, is a continual subject of reasoning, which employs the genius in ways that are as different as the compositions themselves. A moderate genius may, through perseverance, attain correct designing; but the *claro-obscuro* requires, besides the rules, such a compass of genius, as may incorporate with, and, as it were, diffuse itself through, all the other parts of painting.

'Tis well known, that the works of *Titian*, and of all the painters of his school, have scarce any other merit than their *claro-obscuro*, and colouring; and yet they bear a great price, are in great repute, and maintain their posts in the cabinets of the curious, as first-rate pictures.

When I speak of design, I must be understood to mean only that material part, which, by just measures, forms all objects in a regular manner; for I am not ignorant, that in design there is a genius capable to season all sorts of forms by the assistance of taste and elegance; yet it is easy to observe, that the effect, which calls to the spectator, arises principally from the colouring of all the parts; by which we are to understand the *claro-obscuro*, and the general harmony of colours, as also such as we call *local*, or colours which faithfully imitate those of any particular object. But all this hinders not the other parts of art from being necessary to help forward the whole work, and from mutually assisting each other; some to form, others to adorn the objects painted, in order to give them a taste and grace that may instruct, respectively, both lovers and painters, and, in a word, may please every one.

Thus, as it is the duty of painting, both to call and please; when it has called the spectator, it must necessarily entertain him with all the various beauties of which it is capable.

* * *

Of Disposition

* * *

In *composition*, the painter ought to contrive, as much as he possibly can, that the spectator may, at first sight, be struck with the character of the subject, or at least may, after some moments of reflection, take the principal scope of it. It will greatly contribute to this end, that he place the hero, and the principal figures, in the most conspicuous places; yet this must be done without affectation, and in such a manner as the subject and probability require; for œconomy, or management, depends upon the nature of the subject, which may be either pathetick or gay, heroick or popular, tender or terrible; in short, the picture must have more or less motion, as its subject is more or less stirring or still. As the subject points out to the artist the proper œconomy in the disposition of objects, so distribution, in its turn, wonderfully contributes to the expression of the subject, gives both force and grace to what is invented, prevents confusion in the figures, and makes every thing in the picture more clear, more apparent, and more capable to produce the effect above-mentioned, *of calling to and detaining the spectator.*

* * *

Of the Whole together.

The last point depending on disposition is, *the whole together*, which is the result of the parts that compose the piece; but the whole, arising from the combination of several objects, must not be like a number made up of several unities, independent and equal among themselves, but like one poetical whole, where the great have need of the lower people, and these have need of the great. All the objects, lines, colours, lights and shades, of a picture, are great or small, strong or weak, only by comparison; but, let their natures, qualities, or conditions, be what they will, they have such a relation to one another in their combination, as no one in particular can supersede; For the effect of the whole consists in a general subordination, where the darks heighten the lights, and the lights set off the darks, and where the merit of each part is founded on a mutual dependence. So that we may define *the whole together* to be, *Such a general subordination of objects one to another, as makes them all concur to constitute but one.*

Now this subordination, by which several objects concur to make but one, is founded on two principles, *viz. The satisfaction of the eye*, and *the effect of vision*. And this I shall explain.

The eye has this in common with the other organs of sense, that it cares not to be obstructed in its office; and it must be agreed, that a great many people, met in one place, and talking together at the same time, and with the same tone of voice, so as that no one in particular could be distinguished, would give pain to those who heard them: It is just so in a picture, where many objects, painted with equal force, and illuminated by the same light, would divide and perplex the sight, which, being drawn to several parts at once, would be at a loss where to fix; or else, being desirous to take in the whole at one view, must needs do it imperfectly.

Now, to hinder the eye from being dissipated, we must endeavour to fix it agreeably, by a combination of lights and shades, by an union of colours, and by oppositions wide enough to support the groups, and give them repose. But where the picture has several groups, one of them must predominate in force and colour, and besides, detached objects must be so united with their ground, as to make but one mass, that may serve as a repose to the principal objects: The satisfaction of the eye is therefore one of the foundations upon which the unity of objects in painting depends.

The other foundation of this same unity is, the effect of vision, and the manner of its operation. Now the eye is at liberty to see all the objects about it, by fixing successively on each of them; but, when 'tis once fix'd, of all those objects, there is but one which appears in the centre of vision, that can be clearly and distinctly seen; the rest, because seen by oblique rays, become obscure and confused, in proportion as they are out of the direct ray. [...]

It remains that we now speak of a wonderful effect, which the *whole together* produces, and it is that of putting all the objects into harmony. For harmony, where-ever it appears, proceeds from arrangement and good order. There is a harmony in moral as well as in natural philosophy; in the conduct of human life, as well as in the proportions of the human body; and, in short, in every thing that consists of parts, which, however different from one another, yet agree to make but one *whole*, more or less general. Now, as this order must be supposed to exist in all parts of painting separately, we must infer, that each part has its particular harmony. But it is not enough, that each part has its particular arrangement and propriety; they must all agree together in the picture, and make but one harmonious whole; in the same manner as it is not enough, in a concert of musick, that each part be heard distinctly, and follow the particular arrangement of its notes; they must all agree together in a harmony which unites them, and which, out of several particular *wholes*, makes but one *whole* that is general. This is what painting does, by the subordination of objects, groups, colours, and lights, in the general, of a picture.

There are in painting several sorts of harmony; the sweet and the temperate, as usually practised by *Correggio*, and *Guido Reni*; and the strong and great, as that of *Giorgione, Titian*, and *Caravaggio*. And these may be in different degrees, according to *places, times, light*, and *the hours of the day*. Great light, in a close place, produces strong shades; the same, in an open country, requires broken colouring, and sweet shadowing. In short, the skilful painter knows what use he ought to make, not only of the seasons of the year, but of the times of the day, and of the accidents that happen, either in the skies, or on the earth, in order to bring all, as we have said, into one harmonious whole.

This is the idea I have conceived of what is called, in painting, *the whole together*: And I have endeavoured to make it understood as a machine, whose wheels give each other mutual assistance, as a body, whose members have a mutual dependence; and, in short, as an harmonious œconomy, which stops and entertains the spectator, and invites him to please himself with contemplating the particular beauties of the picture.

3 Rosalba Carriera (1675–1757) on feminine studies

Rosalba Carriera was born in the parish of San Basilio in Venice, where she is recorded as a pupil of Giuseppe Diamantini (1621–1705). Her first works appear to have been painted snuff-boxes. By the early years of the century, however, she was already producing the pastels and miniature portraits for which she was to become famous across Europe. In 1705 she was admitted to the Accademia di San Luca in Rome, with a miniature as her reception piece. Her first commissions were largely from German princes, but her work found favour in courts throughout Europe. Between April 1720 and March 1721 she visited Paris, meeting several of the leading painters, including Antoine Coypel (see IIA8 and 9) and Antoine Watteau (see IIA12). Her success in Paris was confirmed by her reception into the Académie Royale de Peinture et de Sculpture just four months after her arrival. Her portraits are marked by great delicacy and freshness, and her innovative exploration of the pastel medium had a significant influence on artists such as Maurice de Latour and Jean-Etienne Liotard (see IVA12). The following fragment was found among the letters and papers pertaining to Carriera contained in the Biblioteca Laurenziana in Florence. These are bound in five volumes and carry the signature Ashburnham, 1781. The editors of her literary remains have given it the descriptive title 'A Proposito degli Studi Femminili'. The addressee of the piece and its date of composition remain unknown. It has been translated for the present volume by Katerina Deligiorgi from *Rosalba Carriera: Lettere, Diari, Frammenti*, ed. Bernardi Sani, Florence: Leo S. Olschki, 1985, vol. 2, pp. 738–9.

Dear Madam, since our recent conversation I have become more aware of how unreasonable it was of you to ask me to tell you something about a subject on which I have a lot to learn from you. The strong judgement, vivid imagination and admirable ease you showed on that occasion are clear evidence of how perfectly you have mastered this topic – and also, I am sure, any other you care to discuss. Anyone who would like to speak or write well on this would need first to be your student. Nonetheless, if only to show you how absolutely I am at your command, I would rather be your echo than stay silent when you ask me to speak and would rather beg forgiveness for my mistakes than fail to comply with your wishes. If you understand that I do not pretend to offer you my thoughts as a gift, but merely to pay the interest on my debt, I know that you will not accuse me if I do not give back what I received from you. Nor can you reproach me with vanity – it is inappropriate, and only another person who is less loved and esteemed by me would be capable of drawing out so much from me. This thought does not leave me in any doubt that you will tolerate my defects and correct the errors with your usual candour, for they are the result of my effort to oblige you, even if doing so will show my weakness. The defence of our sex against the many great minds who have attacked it with such force can indeed appear to be a task that is too difficult for a woman to undertake. I do not say this because I can or must concede that we are by nature less able in such undertakings than men – at least, before I finish I hope to give some plausible reasons for this.

Rather, I say so because men, especially in England, have expropriated us and because there are only a few women who have an educated mind and

knowledge of letters, who are thus sufficiently equipped for such things. For my part, I readily admit that though there are only a few, there may be many more who in their conversation show themselves more able than myself in defending our cause. It saddens me that because they pursue their own affairs or because of other distractions, or out of sheer indulgence, they fail to do public justice to their sex.

Whether because of interest or inclination, men are generally against us and one should not expect a man to show such generosity of spirit as to champion the cause of our sex against the injuries and oppressions they visit on us. The chivalrous times are gone and not even a Don Quixote is left to succour damsels in distress.

It is true that an apology of a similar nature was made three or four years ago by a man. I think though that even if he obliged his Eugenia thereby, the rest of his sex was much less obliged. For as you well know, Madam, he was more concerned to make his satire sharp than his apology powerful. He fared badly and received more blows than he gave, and like a renegade he fought under our own standard only to betray us. But what can you expect from a Ganymede? He is a creature who cannot truly praise the spirit of a woman over that of a man and who compliments us only to show his own good manners and education. He raises a scandal about our entire sex and believes us to be sufficiently strong because in a history of 2,000 years he manages to find a few examples of women distinguished for their intelligence, wisdom and virtue, and many of notorious men. I think that even the fiercest of our opponents would have saved him all this trouble by telling him that in all times we find famous and infamous people of both sexes – or else, we might as well abandon any pretence to modesty or reason.

I don't have any theories, and have no inclination or true desire to start now with the commonplaces of the book of M. N. and I will leave to the pedants and other scholars the study of Antiquity for the purpose of discovering sufficient heroes and heroines to stuff a herring or to fill some miserable proclamation with insistence rather than argument. I will not enter into a dispute about whether men or women are more intelligent or more gifted: what gives men the advantage over us is their education, the freedom to converse, and the variety of their affairs and acquaintances. Whatever the difference in gift and intellect, the greatest disparity is in these latter circumstances. Nor shall I debate whether we are more virtuous. I know that there are many villains and hope that there is also a good number of virtuous people from both sexes. I can only add that whoever of our sex makes a bad choice does so on account of her origin and her upbringing.

The question I am considering at present is whether or not an intelligent gentleman who spends his time in the company of women can be said to waste it.

I put this question in general terms.

4 Mary Chudleigh (1656–1710) 'To the Reader' from *Essays upon Several Subjects in Prose and Verse*

The poet and essayist Mary Chudleigh was born in Winslade, Devon. She was strongly influenced by the feminist views of Mary Astell (1666–1731) with whom she maintained a correspondence. Her best-known work is the poem *The Ladies' Defence* (1701) in which she responded to a sermon by John Sprint advocating the total subordination of women to their husbands. The *Essays upon Several Subjects in Prose and Verse* were published in the last year of her life. They form a miscellany of religious and moral writings on subjects such as Knowledge, Pride, Humility, Death and Fear. Although not directly concerned with the visual arts, her address 'To the Reader' casts light upon the very real obstacles which hindered the participation of women in the public culture of the arts. For Chudleigh, the development of an interior intellectual and imaginative life offered a form of compensation for the relative isolation of her existence in the country. She is acutely aware of her exclusion from 'ingenious Company' and of the effect this must have on her ability to express her ideas in the appropriate way. Indeed, she addresses her writings only to those of her own sex, declining to pretend that they 'deserve the Notice of the Men'. The unpaginated address 'To the Reader' is taken from *Essays upon Several Subjects in Prose and Verse*, London: R. Bonwick, 1710.

That the Pleasures of the Mind are infinitely preferable to those of Sense, intellectual Delights, the Joys of Thought, and the Complacencies arising from a bright and inlarg'd Understanding, transcendently greater and more satisfactory than those of the Body, than those that owe their Original to the Animal Life, has, through all Ages, been an acknowledg'd Truth, a Truth that comes attended with all the convincing Evidences that can be desired, and will soon be found to be undeniably so by all such as will be at the Pains of making the Experiment.

Such as have been so happy as to have had a Taste of these Delights, a pleasing Relish of these internal Joys, have always been blest with an inward Satisfaction, an unexpressible Felicity; their Minds have been calm, easy, and intrepid, amidst the greatest Storms, the most deafning Hurricanes of Life, never ruffled by Passions, nor disturbed by the most threatning, the melancholiest Circumstances of Fortune. They have long been the dear, the favourite Companions of my solitary Hours, and while they are mine, I cannot only be contentedly, but even chearfully alone; they fill up all the Spaces, all the Intervals of Time, and make my Days slide joyfully along.

O what Pleasures, what transporting Joys do rational instructive Thoughts afford! What rich Treasures do they yield to the Mind! What unexhausted Stores of Knowledge may be drawn from them! They leave no Vacancies, no room for dull insipid Trifles, debasing Impertinencies, nor any of those troublesome Reflexions which generally proceed from narrow groveling Souls, from Souls that have not learn'd to use their Faculties aright. Though I cannot boast of having mine improv'd, and must with Blushes own my Thoughts are infinitely inferior to multitudes of others; yet, mean as they are, to Me they prove delightful, are always welcome, they present me with new and useful Hints, with something that agreeably, as well as advantageously, entertains my Mind; the Notices they give me, I strive to improve by Writing; that firmly fixes what I know, deeply imprints the Truths I've learned.

The following *Essays* were the Products of my Retirement, some of the pleasing Opiates I made use of to lull my Mind to a delightful Rest, the ravishing Amusements of my leisure Hours, of my lonely Moments.

'Tis only to the *Ladies* I presume to present them; I am not so vain as to believe any thing of mine deserves the Notice of the *Men*; but perhaps some of my own Sex may have occasion for such Considerations as these; to them they may prove beneficial; they'll in 'em be perswaded to cultivate their Minds, to brighten and refine their Reason, and to render all their Passions subservient to its Dictates; they'll there be instructed by great Examples, read of several Men, and some Ladies, that have struggled with Pain, Poverty, Infamy, Death, and whatsoever else has been accounted dreadful among the Suffering incident to Humanity, without being overcome, without losing their Resolution, or lessening their Patience; see them cheerful and smiling amidst Misfortunes, submitting themselves with a decent Contentedness, with a becoming Resignation to the All-wise Disposal of their merciful Creator; they will there learn to be easy and Mistresses of themselves, amidst Sickness, the Loss of Friends, Indignities, Calumnies, and all the other Accidents that attend Mortality; will there be told, that the greater the Difficulties are which they encounter, the greater will be the Glory of the Conquest; and that when Death has put an end to their Conflicts, Virtue will remain victorious, and the Rewards of a Future-state abundantly compensate for all the Miseries of this.

I hope they will pardon the Incorrectness of my Stile: The Subjects of which I write are worthy of their Attention; 'tis those I recommend to them: Truth is valuable though she appears in a plain Dress; and I hope they will not slight her because she wants the Ornaments of Language: Politeness is not my Talent; it ought not to be expected from a Person who has liv'd almost wholly to her self, who has but seldom had the Opportunity of conversing with ingenious Company, which I remember Mr. *Dryden*, in the Preface to one of his *Miscellanies*, thinks to be necessary toward the gaining of Fineness of Stile; this being a Qualification I want, it cannot be suppos'd I should understand the Delicacies of Language, the Niceties of good writing; those things I leave to happier, more accurate Pens: My whole Design is to recommend Virtue, to perswade my Sex to improve their Understandings, to prefer Wisdom before Beauty, good Sense before Wealth, and the Sovereignty of their Passions before the Empire of the World: I beg them to do me the Favour to believe one that speaks it from a long Experience, That a greater Delight, a more transporting Satisfaction, results from a pure well-regulated Soul, from a Consciousness of having done Things agreeable to Reason, suitable to the Dignity of ones Nature, than from the highest Gratifications of Sense, the most entertaining Gayeties of an unthinking Life.

5 Antonio Palomino y Velasco (1655–1726) from *The Pictorial Museum and Optical Scale*

Palomino received a humanistic education in his native Cordoba, intended to prepare him for a career in the Church. However, he was encouraged by a friendship with the painter Valdés Leal (1622–90) to change his plans and to study art, which he did first in Cordoba

then, from 1678, in Madrid. Ten years after his arrival, he became an honorary *Pintor del Rey*, a post which was subsequently paid. Palomino produced many altarpieces, as well as major fresco commissions for municipal buildings and a wide range of theatrical decorations for royal entertainments. The encyclopaedic *El museo pictórico y escala óptica* was his major contribution to the theory and history of art. It was published in three volumes in the last decade of his life. The first part, the *Theory of Painting*, appeared in 1715, and ran to over 300 pages. There was then a long gap until 1724, when the second and third volumes were published together in a 500-page book. The second volume, on the *Practice of Painting*, was intended as a companion to the first. Its extensive descriptions of the preparation of canvases and brushes, and of a variety of artistic techniques, are comparable to those of Pacheco and Hidalgo (see IE5 and 9). The third volume was a relatively free-standing history of Spanish art, containing biographies of over 200 painters and sculptors. These proved popular, and were translated into French, German and English during the eighteenth century. The present selections are drawn from the first and second volumes. Extracts from Book II, chapter 1 come first, because there Palomino discusses general questions of the relationship between art and science, and between the liberal and mechanical arts (for a comparable discussion, see IIA10). Pacheco is unusually explicit about the class implications of the liberal/mechanical distinction, stretching back to Antiquity. In common with other Iberian authors of the time, Palomino is eager to enlist the visual arts thus defined in the service of the Christian religion (cf. IA3, IC11, 12). In the extracts from Book I, the *Theory of Painting*, Palomino discusses his version of the 'Parts' of art, which differ from the more usual breakdown into Idea, Design, Colour, Chiaroscuro, Expression, etc. Instead he offers an elaborate exposition of different types of metaphor said to animate the work of art. The extracts have been edited and translated for the present volume by Nicholas Walker from *El Museo Pictórico, y escala óptica*, Madrid: Da Sancha, 1715, vol. 2, pp. 82–3, 86–7; vol. 1, pp. 56–64.

Book II. Chapter I. That Painting must be Esteemed a Liberal Art

§3 Before proceeding to the demonstration of my conclusion, it is imperative first of all to indicate the nature of science and of art, and to define what it is that distinguishes the liberal from the mechanical arts. Science is a habit of understanding acquired by demonstration, whereas Art is a secure and proper approach to the producing of works. Science is therefore essentially concerned with theoretical and contemplative activities, and does not depend on practical or manual operations of any kind. Art does not exclude such speculative activities, but it essentially involves practical and manual operations wrought upon external and perceptible matter in order to construct a specific product according to appropriate rules and infallible teachings.

The domain of art is divided into the liberal and the mechanical arts. In liberal art, defined in accordance with its intrinsic essence, theoretical and contemplative activities prevail over practical and bodily operations. In mechanical art it is the latter which prevail over the former. Therefore the difference between the two kinds of art is merely that in liberal art there is more contemplation than toil, and in mechanical art there is more toil than contemplation. And to leave no doubt in the matter, we may also be permitted to mention the base art [*la arte sórdida*] which is commonly held to be such a contemptible occupation [*oficio vil*]: this is an art learned without reference to further theoretical activity but one that is executed exclusively through

the repetition of simple material practice and bodily exercise in humble, lowly and rather unworthy operations. It is regarded as contemptible or sordid because it stains, lowers and defiles the excellence of an individual's rank and person, although it is quite fitting for those who don the clothes of labour. Such an occupation, therefore, is not an art in the proper sense but only in the loose and extremely broad sense of the word. There are some who confuse the mechanical with the sordid arts without drawing the distinction that should properly be made here.

There are also other definitions that may be applied to the liberal arts. Although they are, in my own view, rather descriptive than intrinsic, they are worthy of mention because of the weighty authorities who formulated them. The first such definition is that of St Augustine who says: 'Liberal arts are those which are worthy of a Christian and which show us the way to true wisdom.' The second definition is that of Seneca, who says in Letter 88: 'Liberal studies are those which are worthy of being pursued by free men.'

In this connection one should know that the Romans distinguished between the free or free-born and slaves or servants. The latter alone were permitted to exercise the sordid or mechanical arts which were therefore known as servile arts. The noble and so-called liberal arts were reserved for the free or the noble and prohibited to slaves, a distinction of classes which corresponds in Spain to that between noblemen and commoners. [...]

§5 ... If the liberal arts, as St Augustine claims, are those which are 'worthy of a Christian and which show us the way to true wisdom', then I ask: is there then any art that is superior to that of those mute but eloquent lessons with which the early Church was wont to show the faithful the way of truth in the open books of sacred scripture, and the lives and martyrdoms of the saints that were depicted with the silent eloquence of the brush? Is there any art superior to that which has worked such miraculous effects in converting the most hardened souls to the delicious yoke of our religion and to the fear of God? Is there any art superior to that whose sacred shafts penetrate the most powerful of the senses? Such miraculous effects are obtained not only through the reverent depiction of sacred images, but also through the hidden, potent force of art in portraits or purely human and profane images, as it was with the image of the philosopher Polemon according to the reports of the Council of Nicea: the venerable expression of the face served of itself to reprimand a licentious woman led astray by a dishonourable youth, whereby she venerated the merely painted image as if it were a living man – a circumstance much pondered upon and extolled repeatedly by the Holy Fathers of the Council. Is there any art superior to that where the artist, in representing the highest and most profound mysteries of our faith and our salvation, must ineluctably meditate thereby upon the very things he is depicting, thus transforming a pleasurable diversion of the body into the delicious food of the soul? Will not the most indifferent mind begin to soar heavenward when exposed repeatedly to such opportunities for pursuing the path to true wisdom. This is amply proven by the praiseworthy Christian diligence with which so many artists proceed: when they are to represent a sacred subject, and most especially before the depiction of Christ our Lord or His most Holy Mother, they prepare themselves though prayer, mortification, self-castigation and the taking of the sacraments. Since

some of these are yet living, I shall refrain from naming them. Let it be sufficient here to remember the exemplary life and praiseworthy deeds of that venerable gentleman Geronimo Benet, who professed this liberal art and died but lately in Valladolid in the sacred habit of the Society of Jesus. Since painting is an art worthy of a Christian man, and since the definition of St Augustine properly confirms the same, we also affirm, in accordance with that definition, that painting is a liberal art.

* * *

Book I, Chapter VII: On the Integral Composition of a Painting

§I – In accordance with our method of real division, we come now to consider painting in relation to the various parts that make up an integral whole. This is how Seneca, in his philosophy, deemed it proper to proceed, dividing up the mysteries of the entire body of knowledge into its component parts the better to arrive at an understanding of the whole. It is the same with man himself: after considering the latter as a rational animal, determining his metaphysical properties in accordance with generic and specific differences, after considering him as a physical entity, as a substantial unity of matter and form, body and soul (as we did with painting in our previous chapters), the philosophers proceed to consider him in relation to his various component physical parts, like the head, the hands, the feet, and so forth, none of which can properly be understood without reference to all the other parts. Painting, therefore, from this point of view, is composed of, and can be divided into, seven aspects or parts which are: *argument, economy, action, symmetry, perspective, light and grace*, and *good style*. . . .

§II *The Historical Argument* – The first thing, then, *the argument or theme, is the event, happening, story or idea that is to be expressed*. And this in two distinct ways, the first of which depends entirely on the wit [*ingenio*] of the fabricator, and the second of which depends upon the details of the story in question: this latter we shall call the historical argument, the former the metaphoric argument. The historical argument thus comprises everything that possesses the character of a story: *sacred, human or fabulous*. Although fables are not, strictly considered, historical in nature, they are ultimately founded upon historical events, albeit ones that have been confused and obscured by the blind superstitions of the pagan mind. . . .

§III The said historical argument divides therefore into the following types: *the rational, the sensitive, the vegetative, the inanimate* and *the mixed*. (When considered, with all its latitude, in pictorial terms.) The *rational* type concerns the unfolding of action and the human figures involved – Raphael of Urbino, Domenichino, Lanfranco and many other artists have excelled marvellously in this respect. The *sensitive* type involves animals of one or more species, like birds, fish and wild beasts – and here Peter and Martin de Vos and Azneira, all of them pupils of Rubens, have proved outstanding, in the context of hunting scenes, watering places, inns and other such things. The *vegetative* type involves trees, fruits, flowers, in which the Jesuit Artoes, Mario and Ruo Polo have distinguished themselves. The *inanimate* type involves the disposition of various inanimate objects, like buildings, armour and harness, work-

shops, instruments and devices, costumes and garments, other rich accoutrements and similar precious things of greater or lesser value. There have been many celebrated masters in this domain, including our own outstanding Don Antonio Pareda. The *mixed* type involves all or some of the features described above. This is indeed the most pleasing and delightful type by virtue of its variety, and that which most clearly reveals the rich fecundity of the maker's inspiration. It must be said that the very practical approach adopted in Italy favours the collaboration of several hands in a single painting precisely because of the many differences involved in these various types of theme. This approach has not been pursued in Spain, either because the ardent spirit of her artists does not care to share the prize of glory, or because, in a more vulgar sense, an artist can no longer support himself in his work simply by painting flowers or landscape, as some formerly succeeded in doing. From the present point of view, therefore, when we behold a picture, whether it depicts the countryside, flowers, fruit or whatever, we declare it well or poorly composed historically insofar as it properly observes the precepts of history with respect to its overall arrangement, its progressive disposition of volume, and the treatment of light.

§IV *The Metaphoric Argument* – The metaphoric argument *is that which reveals the idea* [concepto] *of the artist through the use of ingenious metaphor*. For metaphor is the mother of all intellectual subtlety. It is the most ingenious, versatile, penetrating and wonderful part of our human understanding (according to Count Emanuel Tesauro), a precious treasure trove in which the skilled artist is able to discover a rich and fertile material with which to enrich the mind along the paths of erudition. I shall not expand further upon this matter here, lest I exceed the bounds imposed upon me by the present theme. I shall merely say something concerning the various kinds of metaphorical argument that most frequently present themselves in the art of painting. Of the latter, some of them specifically concern the painter, while others concern humanist scholars. Those that directly concern the painter are five in number: the metaphor is either *natural, moral, facial, instrumental* or *iconological*.

§V *The Natural Metaphor* – The natural metaphor is *that which reveals the idea of the painter by means of some natural sign*. This is what the ingenious artist Nealces did: after depicting a sea battle between the Persians and the Egyptians, and desiring to indicate that it transpired upon the Nile, whose waters are no different from any other river, he inserted a little donkey drinking at the banks with a crocodile lying in wait for it, such animals being peculiar to that celebrated river. The ingenious Temantes showed similar judgement when he wished to convey the huge dimensions of the giant Polyphemus within the confines of a rather small panel: having depicted the principal figure in foreshortened perspective, he placed some little satyrs of differing sizes alongside the vast bulk of the giant, measuring one toe against the size of four trees: a device enabling us to infer that the monstrous brute himself was forty-nine yards in height. For the foot is a seventh part in proportion to the body, and the big toe a seventh part in proportion to the foot, and multiplying seven with itself we arrive at the aforementioned forty-nine yards. A modern painter has proceeded with similar insight: in depicting the distress of Hagar thirsting in the desert, he has not failed to include the empty water-flask she had taken from the

home of Abraham. And likewise another painter in depicting the mysterious bush before which Moses stood, which burned and yet was not consumed: he showed neither ashes nor smoke, these being the two extremes into which every combustible substance divides. Since smoke and ashes are the natural signs of anything that can be consumed by fire, the very absence of these two extremes, on the other hand, is a natural sign for that which can never be so consumed. And all ideas which are thus expressed through such natural signs belong in this class of natural metaphor.

§VI *The Moral Metaphor* – The moral metaphor, or the metaphor of custom, is *that which reveals the idea of the artist by means of some sign which, through custom or the free interpretation of men, has assumed the right to a certain signification.* This it has accomplished through observing the habits of dress, the rituals and the customs that belong to different individuals, countries and times. And to proceed otherwise were indeed the greatest absurdity: as if one were to paint a Roman senator in a great cloak, or a Greek dressed in a toga, the latter without a beard, and the former with one; or a Visigoth sporting a ruff, and a Spaniard of that period with buttoned hose, and so forth; all of which is contrary to what was practised in former times. [...]

As far as the metaphor of custom is concerned, Centensis, known as Guarcino, furnished an admirable example in depicting the death of Amon at the hands of his brother Absolom, and the terrible violence inflicted upon his sister Tamara. Since this had all transpired at the end of a banquet, a circumstance which the artist wished to indicate, he painted aniseed upon the table, spilt and scattered from the dish in the sudden commotion of the deed. No less accomplished was the moral and ritual precision of another painter who depicted an act committed on a holy day within a temple and took care to reproduce the proper hues of the ceremonial vestments decreed by the Church for just such an occasion. All the arguments which express such things as depend upon the free interpretation, customs and usages of men belong in this class of moral metaphor.

§VII *The Facial Metaphor* – The facial metaphor is *that which reveals, through the expression of the human countenance, the work of those passions which hold concealed sway within individuals.* For the countenance is like the clock-face that indicates all the hidden stirrings that lie within ourselves. It reveals the *sex, the age, the thinking mind and the perturbations of the soul*: the sex because the visage of a man is quite distinct from that of a woman, and the age because the vigour of youth is quite different from the weariness of old age. But these are the simpler things to accomplish, whereas it is the other two which are intimately connected with the most precious and refined accomplishment of painting; as for the mind, we must look to see how far it reveals its workings in the face: the look of the reticent or the bold, the wise or the foolish, the expression of the sensualist, that of the hardy and the industrious, of the feeble and the slothful, and so forth. We must also look to see how the perturbations of the soul inflect the authentic and natural appearance of the face. For the countenance of an angry man is one thing, that of one possessed by lewdness another, and similarly that of one who is dolorous in contrast to one who feels happy, and so forth.

Aristides Thebanus was distinguished for his acuteness in this regard, being the first (according to Pliny) to depict the soul itself, its perturbations and customary expressions, and the Greeks indeed called him *Ethe*. And thus Aristotle also bestowed the title of *Ethics* upon his moral philosophy, since it concerned itself with the customs of men. This too is the reason why properly observed customary behaviour is called *etiquette*. But although the kind of argument under discussion here includes the expression of human custom, it does not for that reason properly belong amongst the former class of argument. For in that case, one merely infers an inner idea from some observance or universally shared custom expressed in external terms, whereas in the present case one deduces some internal and personal form of behaviour from external indications. And this is what it means to paint the expression of the soul, without which indeed the painting would appear lifeless, as if it were sculpture; for in living beings the soul alone reveals itself in such signs and expressions. Thus when we see the latter presented through painting, we are ready to excuse him who takes the image for life itself.

Zeuxis was no less excellent on this score since in his painting of Penelope he is said to have portrayed her accustomed manner of behaviour too. And Polygnotus proceeded in a similar fashion (according to Aristotle) in the images and portraits of men that he produced. Apelles indeed was so precise in his depictions that the astrologers prophesied what would later befall the subjects in question on the basis of their facial expression in the pictures. But it was the ingenious Timantes who excelled in such effects, for much more was gathered from his pictures than he actually painted there; and for all his excellence in the field of art, his intellectual ingenuity was greater still. His heroic brush was responsible for the celebrated picture of the sacrifice of Iphigenia, so often recounted by tongue and pen alike, which brought before our eyes the unhappy maiden stretched out upon the altar as the imminent victim of the wild Goddess of wild beasts [i.e. Artemis], and every detail of the figure depicted with an air of sadness that epitomized the expressive image of grief itself. And needing now to provide an even greater image of grief in the figure of Iphigenia's father, but reluctant to identify the same too explicitly, the artist presented the latter with his face covered, suggesting both the uncanny character of the deed and the sudden dispatch with which it must be performed: the image is thus a most convincing expression of paternal love, either because he could not bear to look upon such a tragic sight directly or in order to wipe away the pitiful tears from his own eyes. The artist thus leaves the precise imagination of the father's countenance to the better exercise of our own discretion, and thereby achieves with the eloquent colours of rhetoric what the mute speech of painting could never accomplish alone.

Nor is the kind of discretion shown here by Timantes without significance for sacred matters. For when the sacred historian of scripture recounts the mournful spectacle of the death of Christ our Lord, and thereby speaks of our Most Holy Mother, he tells us only that she stood close by the cross. For to be a mother and to stand close by the cross is of itself nothing but an expression of grief. Thus the writer did not wish to describe precisely what she suffered, leaving this rather to the thoughts of those who meditate upon the scene and reflect upon the events in question.

§VIII *The Instrumental Metaphor* – The fourth of the said metaphors available to the ingenious painter is the *instrumental metaphor: namely that through which some instrument or other determines the individual representation of the figure in a painting*. This is the case, for example, with the Holy Apostles, other martyred saints, and preachers of one kind or another, where we find a certain attribute, device or instrument associated with the martyrdom in question, or some particular and outstanding feature through which the individual concerned can be recognized: like the keys of St Peter, the sword of St Paul, the crucifix of St Andrew, the wounds of St Francis, and so forth; and it is the same with the gods of the pagans: the thunderbolt of Jupiter, the sickle of Saturn, the lyre of Apollo, the keys of Janus, and so forth, with every other figure possessing some instrument or device peculiar to himself as an individual. The instrument serves as a sign through which we may recognize what is signified, the precise hero who is here represented. There are many illustrious examples of this metaphor to be found amongst the ancients and the moderns since it is the one most commonly employed by practitioners of the painting profession.

§IX *The Iconological Argument* – The fifth and last metaphor of the painter is the iconological, *that which represents some abstract or invisible matter by means of the human figure*. Thus we have the Virtues, the Vices, the Sciences, the Arts, Day and Night, which serve to represent these things which are not themselves real physical entities as if there were indeed such; for the expression of such things many other metaphors are also employed: like the crane for Vigilance, the ostrich for Gluttony, the sword for Justice, the olive for Mercy. One must not neglect here the apt expression of feelings, the proper representation of colours, and all the other expressive signs for the underlying idea, whether sacred, prophetic or comic, that one wishes to communicate.

Nor was this iconological argument unknown to the ancients, for the great Apelles employed it when he essayed to show how Alexander not only conquered Persia by war, but also conquered that selfsame war by peace. He depicted the fury of war in the form of a raging and wrathful youth, his eyes darting fire, his mouth foaming and bloody, his body covered in wounds and bound with fetters; now disarmed, his hands tied behind his back, the youth is chained to the triumphal chariot of Alexander. It was from this original image that Virgil, replacing the head of Alexander with that of Augustus, drew his picture of the fury of war chained in the Temple of Janus:

> Furor impius intus.
> Saeva sedens super arma, et centum vintus aënis;
> Post tergum nodis, fremet horridus ore cruento.

['Within, impious Rage, sitting on savage arms, his hands fast behind with a hundred brazen knots, shall roar in the ghastliness of blood-stained lips.']

.... And when Apelles desired to expose the utterly inconstant nature of the Athenians, moved as they were by the most contrary of sentiments, he painted a kind of demon both wild and tranquil, constant and vacillating, bold and timid, warlike and pacific in what was surely a most ingenious painting! Pliny fails to tell us, however,

precisely how the picture was formed and fashioned, although Manuel Tesauro says with his accustomed boldness: I imagine that it was a demon with two heads, one that of a man, the other that of a wild beast, and two legs, one like a column, the other like a serpent, habited partly in lion skin and partly in a lamb's pelt, brandishing a sword in one hand and an olive-branch in the other; and who could put their faith in such a monster (he says) whose virtues are so closely entwined with its vices, who though it does not lack for pity, can never pluck the vileness from its breast? All of the ancient and modern artists recounted in the previous chapter have embellished their heroic frescoes with this kind of argument.

§X *The Emblem* – The various kinds of metaphorical argument that offer themselves to painting and strictly belong to the domain of the humanists are the following: *the emblem, the hieroglyph*, and *the imprint.* If the painter were himself a humanist, he would presumably never need to seek assistance from other wise and learned men. *The emblem, then, is a metaphor signifying some moral matter by means of iconological, ideal or fantastical figures, or of some other learned and ingenious representation like a motto, or a precise, penetrating and ingenious poem.* This kind of erudite allusion is much favoured in the apartments of Lords and Princes for the decoration of vaults, domes and friezes, and can be left, subject to the wishes of the institution commissioning the work, to the discretion of the artist.

§XI *The Hieroglyph* – The hieroglyph is *a metaphor that encompasses some doctrinal idea by means of a symbol, or a device without reference to a human figure, with a Latin motto from a classical author, or some poetic verse in the vernacular.* Such things are much used on occasion of the funeral ceremonies of heroes or mighty warriors, the coronations of Princes, for the official entrance of the Queen or other high officials. And similarly on occasion of the solemn feasts of the holy saints and the Immaculate Conception, of the canonization of saints and other such festivals, where the various figures and symbols of sacred Scripture, along with other theological, arcane and mystical conceits, are all put to use.

§XII *The Imprint* – The imprint is *a metaphor signifying a particular and heroic concept by means of a strange figure or attribute, enhanced by some clever motto, riddle or specimen of classical poetry.* These things are much used with shields, crests, insignia, armour and standards where the significance is not immediately obvious. The concept in question is intended precisely to be something concealed and enigmatic, presented without reference to the human figure. In fact it is the first of these three respective approaches, the emblem, that allows the greatest latitude with regard to the theme, figure or inscription, to the universality of reference, the free choice of images, and the decoration with an appropriate epigram. The hieroglyph, on the other hand, is much more limited in scope since its reference is not so general in character and it makes do without the addition of human figures or Latin verse. But the imprint is even more limited than this since the most important thing about a motto is the proper application of its ambiguous, enigmatic and hidden sense rather than its original inventiveness. The concept here signifies what it extols and extols what it signifies. . . .

This kind of pictorial argument is reserved for elevated minds. And for this reason the ancients were wont to set the image of the sphinx, enigmatic in its form and significance alike, upon the portals of their temples. Plutarch interpreted this as a demonstration that divine wisdom reveals itself to the wise through symbols and hidden signs. This species of language is therefore not vouchsafed to the ignorant who, even if guided by the light, are ever wont to tarry in their darkness. As the great tragedian Sophocles has uttered in his wisdom:

> *Mysteria numen tecta sapientis docet Fatuis Magister prorsus est inutilis.*

['Secrets taught to the wise are absolutely useless to fools.']

And as Our Lord said unto the disciples: You are sharers in the knowledge of the mysteries of the Kingdom of God; and parables must suffice for the others who seeing fail to see, and hearing fail to hear.

One must properly understand the full significance that attaches to this single metaphorical task of the painting art where no demonstration of true learning is excessive. For it encompasses the whole field of history, sacred and profane, and a great part of natural philosophy, as well as holy theology and the mysteries of the faith and of the sacraments, which themselves find daily expression in elaborate symbols and sacred metaphors. It also encompasses rhetoric in the expression of the effects, physiognomy in the various manifestations of face and mind, ethnological considerations in the representation of customs and practices, questions of character in the appropriate depiction of states of mind, poetry in the fashioning of its conceits and symbolic subtleties, mythology in recounting the fables and gods of the pagans, and finally the realm of law and right in respect of divine and human matters, ensuring to each the right that belongs to him according to his particular sphere. It would appear that no one capacity of human life is properly sufficient for such a universal task of understanding! Yet it behoves us to observe that painting, amongst all these arts and sciences, and those that shall concern us later, is fabricated as it were from all without assuming the specific task of any. The painter, therefore, without having to learn them, may never remain entirely ignorant of the latter. So that whatever the subject he may have to depict, he will know where to discover it – for the proper prosecution of which some counsel will be provided in the proper place.

6 Jonathan Richardson (1665–1745) from *Essay on the Theory of Painting*

Richardson was a prominent painter and collector of art as well as a writer, though it was as a writer that he made his greatest mark. Nonetheless he had a successful career as a society portraitist, and was arguably the leading London portrait painter in the 1720s and 1730s. It was enough to make him wealthy, and to fund a collection of drawings which included examples by Raphael, Michelangelo, Rubens, Van Dyck and Rembrandt. But it was as a writer that Richardson made a lasting impression. He is conventionally regarded as the first English author to have composed an original and comprehensive work on the

theory of art. Joshua Reynolds acknowledged his writings as the formative influence on his career, and indeed Reynolds' own *Discourses* (IVA7) can be viewed as the culmination of a tradition inaugurated by Richardson. His work was admired by figures as different as William Hogarth and Samuel Johnson. Richardson's *Essay on the Theory of Painting* first appeared in 1715. A second edition appeared in 1725, with a new chapter on the Sublime, and a three-volume French translation of this and other writings appeared in 1728. The bulk of Richardson's first book consists of an exploration of the 'Parts' of art (cf. IA1, IB6, IB8, IC4), now expanded to seven. These are, in the order in which Richardson treats of them: Invention; Expression; Composition; Drawing; Colouring; Handling; and Grace and Greatness. By this last, Richardson alludes to something of the *je ne sais quoi* (see ID *passim* and IIB10), as well as initiating discussion of the Sublime – which was to become a staple of later eighteenth-century aesthetic debate (see his own discussion in IIB9 and Edmund Burke in IIIB6). The selections here are all taken from the long general introduction to the *Essay on the Theory of Painting*, in which Richardson establishes the elevated status of his subject. There is no longer the slightest hint of defensiveness about this claim. Richardson begins by discussing painting as a source of pleasure before going on to claim for it a higher status as a stimulus to the mind. For him the artist, whether a history painter or a portraitist, is a learned figure, versed in a variety of intellectual disciplines as well as possessing psychological insight into the human character. For Richardson, and for those who came after him, painting has nothing left to prove: it is, in effect, *the primus inter pares* of the liberal arts. The extracts are taken from the second edition, London: 'A. C.', 1725, pp. 1–8, 12–13, 17–28, 33.

Because Pictures are universally Delightful, and accordingly made one part of our Ornamental Furniture, many, I believe, consider the Art of Painting but as a pleasing Superfluity; at best, that it holds but a low Rank with respect to its Usefulness to Mankind.

If there were in reality no more in it than an Innocent Amusement; if it were only one of those Sweets that the Divine Providence has bestow'd on us, to render the Good of our present Being superior to the Evil of it, it ought to be consider'd as a Bounty from Heaven, and to hold a Place in our Esteem accordingly. Pleasure, however it be depreciated, is what we all eagerly and incessantly pursue; and when Innocent, and consequently a Divine Benefaction, 'tis to be consider'd in That View, and as an Ingredient in Humane Life, which the Supreme Wisdom has judg'd necessary.

Painting is that Pleasant, Innocent Amusement. But 'tis More; 'tis of great use, as being one of the means whereby we convey our Ideas to each other, and which in some respects has the Advantage of all the rest. And thus it must be rank'd with These, and accordingly esteem'd not only as an Enjoyment, but as another Language, which completes the whole Art of communicating our Thoughts; one of those particulars which raises the Dignity of Human Nature so much above the Brutes; and which is the more considerable, as being a Gift bestowed but upon a Few even of our own Species.

Words paint to the Imagination, but every Man forms the thing to himself in his Own way: Language is very Imperfect: There are innumerable Colours, and Figures for which we have no name, and an infinity of other Ideas which have no certain Words universally agreed upon as denoting them; whereas the Painter can convey his

Ideas of these Things Clearly, and without Ambiguity; and what he says every one understands in the Sense he intends it.

And this is a Language that is Universal; Men of all Nations hear the Poet, Moralist, Historian, Divine, or whatever other Character the Painter assumes, speaking to them in their own Mother Tongue.

Painting has another Advantage over Words, and that is, it Pours Ideas into our Minds, Words only Drop 'em. The whole Scene opens at one View, whereas the other way lifts up the Curtain by little, and little: We see (for Example) the fine Prospect at Constantinople, an Eruption of Mount Ætna, the Death of Socrates, the Battel of Blenheim, the Person of King Charles the First, &c. in an instant.

The Theatre gives us Representations of Things different from both these, and a kind of Composition of both: There we see a sort of moving, speaking Pictures, but these are Transient; whereas Painting remains, and is always at hand. And what is more considerable, the Stage never represents things Truly, especially if the Scene be Remote, and the Story Ancient. A Man that is acquainted with the Habits, and Customs of Antiquity, comes to revive or improve his Ideas relating to the Misfortune of Œdipus, or the Death of Julius Cæsar, and finds a sort of Fantastical Creatures, the like of which he never met with in any Statue, Bas-Relief, or Medal; his just Notions of these Things are all contradicted and disturb'd. But Painting shews us these brave People as they were in their own genuine Greatness, and noble Simplicity.

The Pleasure that Painting, as a Dumb Art, gives us, is like what we have from Musick; its beautiful Forms, Colours and Harmony, are to the Eye what Sounds, and the Harmony of that kind are to the Ear; and in both we are delighted in observing the Skill of the Artist in proportion to It, and our own Judgment to discover it. 'Tis this Beauty and Harmony which gives us so much Pleasure at the Sight of Natural Pictures, a Prospect, a fine Sky, a Garden, &c. and the Copies of these, which renew the Ideas of 'em, are consequently Pleasant: Thus we see Spring, Summer and Autumn, in the depth of Winter; and Frost and Snow, if we please, when the Dog-Star rages. By the help of this Art we have the Pleasure of seeing a vast Variety of Things and Actions, of travelling by Land or Water, of knowing the Humours of Low Life without mixing with it, of viewing Tempests, Battels, Inundations; and, in short, of all Real or Imagin'd Appearances in Heaven, Earth, or Hell; and this as we sit at our Ease, and cast our Eye round a Room: We may ramble with Delight from one Idea to another, or fix upon Any as we please. Nor do we barely see this Variety of Natural Objects, but in Good Pictures we always see Nature Improv'd, or at least the best Choice of it. We thus have nobler and finer Ideas of Men, Animals, Landscapes, &c. than we should perhaps have ever had; We see particular Accidents, and Beauties which are rarely, or never seen by us; And all this is no inconsiderable Addition to the Pleasure. [. . .]

But when we come to consider this Art as it informs the Mind, its Merit is rais'd; it still gives Pleasure, but 'tis not Merely such; The Painter Now is not only what a wise Orator who is a beautiful Person, and has a graceful Action is to a deaf Man, but what such a one is to an understanding Audience.

And thus Painting not only shews us how Things Appear, but tells us what they Are; We are inform'd of Countries, Habits, Manners, Arms, Buildings Civil, and

Military, Animals, Plants, Minerals; and in fine, of all kinds of Bodies whatsoever. [. . .]

And if my Ideas are raised, the Sentiments excited in my Mind will be proportionably improved. So that supposing two Men perfectly Equal in all other respects, only one is conversant with the Works of the best Masters (well chosen as to their Subjects) and the other not; the former shall necessarily gain the Ascendant, and have nobler Ideas, more Love to his Country, more moral Virtue, more Faith, more Piety and Devotion than the other; he shall be a more Ingenious, and a Better Man. [. . .]

But (by the way) 'tis not every Picture–Maker that ought to be called a Painter, as every Rhymer, or Grubstreet Tale Writer is not a Poet, or Historian: A Painter ought to be a Title of Dignity, and understood to imply a Person endued with such Excellencies of Mind, and Body, as have ever been the Foundations of Honour amongst Men.

He that Paints a History well, must be able to Write it; he must be throughly inform'd of all things relating to it, and conceive it clearly, and nobly in his Mind, or he can never express it upon the Canvas: He must have a solid Judgment, with a lively Imagination, and know what Figures, and what Incidents ought to be brought in, and what every one should Say, and Think. A Painter therefore of this Class must possess all the good Qualities requisite to an Historian; unless it be Language (which however seldom fails of being Beautiful, when the thing is clearly, and well conceiv'd). But this is not sufficient to him, he must moreover know the Forms of the Arms, the Habits, Customs, Buildings, &c. of the Age, and Countrey, in which the thing was transacted, more exactly than the other needs to know 'em. And as his Business is not to write the History of a few Years, or of One Age, or Countrey, but of All Ages, and All Nations, as occasion offers, he must have a proportionable Fund of Ancient, and Modern Learning of all kinds.

As to Paint a History, a Man ought to have the main Qualities of a good Historian, and something more; he must yet go higher, and have the Talents requisite to a good Poet; the Rules for the Conduct of a Picture being much the same with those to be observed in writing a Poem; and Painting, as well as Poetry, requiring an Elevation of Genius beyond what pure Historical Narration does; the Painter must imagine his Figures to Think, Speak, and Act, as a Poet should do in a Tragedy, or Epick Poem; especially if his Subject be a Fable, or an Allegory. If a Poet has moreover the Care of the Diction, and Versification, the Painter has a Task perhaps at least Equivalent to That, after he has well conceived the thing (over and above what is merely Mechanical, and other particulars, which shall be spoken to presently) and that is the Knowledge of the Nature, and Effects of Colours, Lights, Shadows, Reflections, &c. And as his Business is not to compose One *Iliad*, or One *Æneid* only, but perhaps Many, he must be furnish'd with a Vast Stock of Poetical, as well as Historical Learning.

Besides all this, 'tis absolutely necessary to a History-Painter that he understands Anatomy, Osteology, Geometry, Perspective, Architecture, and many other Sciences which the Historian, or Poet, has little occasion to know.

He must moreover not only See, but thoroughly Study the Works of the most excellent Masters in Painting, and Sculpture, Ancient, and Modern. [. . .]

To be a good Face-Painter, a degree of the Historical, and Poetical Genius is requisite, and a great Measure of the other Talents, and Advantages which a good History-Painter must possess: Nay some of them, particularly Colouring, he ought to have in greater Perfection than is absolutely necessary for a History-Painter. [. . .]

A Portrait-Painter must understand Mankind, and enter into their Characters, and express their Minds as well as their Faces: And as his Business is chiefly with People of Condition, he must Think as a Gentleman, and a Man of Sense, or 'twill be impossible to give Such their True, and Proper Resemblances.

But if a Painter of this kind is not oblig'd to take in such a compass of Knowledge as he that paints History, and that the Latter upon Some accounts is the nobler Employment, upon Others the Preference is due to Face-Painting; and the peculiar Difficulties such a one has to encounter will perhaps balance what he is excused from. He is chiefly concerned with the Noblest, and most Beautiful part of Humane Nature, the Face; and is obliged to the utmost Exactness. A History-Painter has vast Liberties; if he is to give Life, and Greatness, and Grace to his Figures, and the Airs of his Heads, he may chuse what Faces, and Figures he pleases; but the Other must give all that (in some degree at least) to Subjects where 'tis not always to be found, and must Find, or Make Variety in much narrower Bounds than the History-Painter has to Range in. [. . .]

A Painter must not only be a Poet, an Historian, a Mathematician, &c. he must be a Mechanick, his Hand, and Eye, must be as Expert as his Head is Clear, and Lively, and well stored with Science: He must not only write a History, a Poem, a Description, but in a fine Character; his Brain, his Eye, his Hand, must be busied at the same time. He must not only have a nice Judgment to distinguish betwixt things nearly Resembling one another, but not the same, (which he must have in common with those of the noblest Professions;) but he must moreover have the same Delicacy in his Eyes to judge of the Tincts of Colours which are of infinite Variety; and to distinguish whether a Line be streight, or curv'd a little; whether This is exactly parallel to That, or oblique, and in what degree; how This curv'd Line differs from That, if it differs at all, of which he must also judge; whether what he has drawn is of the same Magnitude with what he pretends to imitate, and the like; and must have a Hand exact enough to form these in his Work, answerable to the Ideas he has taken of them.

An Author must Think, but 'tis no matter how he Writes, he has no Care about that, 'tis sufficient if what he writes be Legible: A curious Mechanick's Hand must be exquisite, but his Thoughts are commonly pretty much at liberty, but a Painter is engaged in Both respects. When the Matter is well Thought and Digested in the Mind, (a Work common to Painters and Writers) the Former has still behind a vastly greater Task than the other, and which to perform Well, would alone be a sufficient recommendation to any Man who should employ a whole Life in attaining it.

And here I must take leave to endeavour to do Justice to my Profession as a Liberal Art.

'Twas never thought unworthy of a Gentleman to be Master of the Theory of Painting. On the contrary, if such a one has but a superficial Skill that way, he values himself upon it, and is the more esteem'd by others, as one who has attain'd an Excellency of Mind beyond those that are Ignorant in that particular. 'Tis strange if the same Gentleman should forfeit his Character, and commence Mechanick, if he

added a Bodily Excellence, and was capable of Making, as well as of Judging, of a Picture. How comes it to pass, that one that Thinks as well as any Man, but has moreover a curious Hand, should therefore be esteem'd to be in a Class of Men at all inferior? An Animal that has Use of Hands, and Speech, and Reason, is the Definition of a Man: The Painter has a Language in common with the rest of his Species, and one superadded peculiar to himself, and exercises his Hands, and Rational Faculties to the utmost Stretch of Humane Nature; certainly he is not less Honourable for excelling in All the Qualities of a Man as distinguish'd from a Brute. Those Employments are Servile, and Mechanical, in which Bodily Strength, or Ability, is Only, or Chiefly required, and that because in such cases the Man approaches more to the Brute, or has fewer of those Qualities that exalt Mankind above other Animals; but this Consideration turns to the Painter's Advantage: Here is indeed a sort of Labour, but what is purely Humane, and for the Conduct of which the greatest Force of Mind is necessary. [. . .]

To conclude: To be an Accomplish'd Painter, a Man must possess more than One Liberal Art, which puts him upon the Level with those that do so, and makes him Superior to those that possess but One in an Equal Degree: He must be also a Curious Artificer, whereby he becomes Superior to one who equally possesses the other Talents, but wants That. A Rafaëlle therefore is not only Equal, but Superior to a Virgil, or a Livy, a Thucydides, or a Homer.

7 Jonathan Richardson (1665–1745) from *The Science of a Connoisseur*

Richardson's second publication took up where his first one left off. The *Essay on the Theory of Painting* (IIA6) had established the status of painting as a liberal art, and analysed it part by part. Now it was time to look at what people did with art, what it was *for*, how it could benefit the lives of those who devoted attention to it. Richardson published *Two Discourses* in one binding in 1719. The first was an *Essay on the Whole Art of Criticism as it Relates to Painting*. The second, a *Discourse on . . . the Science of a Connoisseur*, sought to redress the comparative neglect of the arts in England, which in Richardson's time was not yet the Great Power of the later eighteenth century, though the English ruling bloc was gaining in confidence. Raising the level of culture, not only of the 'Gentleman', but also of the 'Common People', was beginning to be seen partly as a desirable end in itself, but also as conducive to an increase in the mercantile and economic capacity of the nation. Indeed, Richardson's remarks about the future prospects of an English school of painting seem to have been inspirational for the young Joshua Reynolds. As such, they may be seen to stand in the prehistory of the Royal Academy itself, the institution par excellence of the arts in England until well into the nineteenth century, if not later. Our extracts are taken from *A Discourse on the Dignity, Certainty, Pleasure and Advantage of the Science of a Connoisseur*, London: W. Churchill, 1719, pp. 3–5, 6–9, 10, 12–13, 41–52.

'Tis remarkable that in a Countrey as Ours, Rich, and abounding with Gentlemen of a Just, and Delicate Taste, in Musick, Poetry, and all kinds of Literature; Such fine Writers! Such Solid Reasoners! Such Able Statesmen! Gallant Soldiers! Excellent

Divines, Lawyers, Physicians, Mathematicians, and Mechanicks! and yet so few! so very few Lovers, and *Connoisseurs* in Painting!

In Most of these particulars there is no Nation under Heaven which we do not excel; In Some of the Principal most of them are Barbarous compar'd with us; Since the Best times of the ancient Greeks and Romans when this Art was in its greatest Esteem, and Perfection, such a National Magnanimity as seems to be the Characteristic of our Nation has been lost in the World; And yet the Love, and Knowledge of Painting, and what has Relation to it bears no proportion to what is to be found not only in Italy, where they are all Lovers, and Almost all Connoisseurs, but in France, Holland, and Flanders.

Every Event in the Natural, and Moral World has its Causes, which are caus'd by other Causes, and so on up to the first Cause, the Immutable, and Unerring Will, without which not so Inconsiderable an Accident (as it will be call'd) as the falling of a Sparrow, or the change of the Colour of a Single Hair can happen [...] That so Few here in England have consider'd that to be a Good Connoisseur is fit to be part of the Education of a Gentleman, That there are so Few Lovers of Painting; not merely for Furniture, or for Ostentation, or as it Represents their Friends, or Themselves; but as it is an Art capable of Entertaining, and Adorning their Minds As much as, nay perhaps More than Any other whatsoever; This Event also has its Causes, To remove which, and consequently their Effects, and to procure the contrary Good is what I am about to Endeavour, and hope in some measure to Accomplish.

Nor is this a Trivial Undertaking; I have already been giving the Principles of it, and Here I recommend a NEW SCIENCE to the World, Or one at least little known, or consider'd as such: So New, or so little Known that 'tis yet without a Name; it may have one in time, till then I must be excus'd when I call it, as I do, *The Science of a Connoisseur* for want of a Better way of expressing my self: I open to Gentlemen a New Scene of Pleasure, a New Innocent Amusement; and an Accomplishment which they have yet scarce heard of, but no less worthy of their Attention than most of those they have been accustomed to acquire. I offer to my Countrey a Scheme by which its Reputation, Riches, Virtue, and Power may be increased. [...]

My present business then in short is to endeavour to persuade our Nobility, and Gentry to become Lovers of Painting, and Connoisseurs; Which I crave leave to do (with all Humility) by shewing the Dignity, Certainty, Pleasure, and Advantages of that Science.

One of the principal Causes of the General neglect of the Science I am treating of I take to be, that very few Gentlemen have a Just Idea of Painting; 'Tis commonly taken to be an Art whereby Nature is to be represented; a fine piece of Workmanship, and Difficult to be perform'd, but produces only pleasant Ornaments, mere Superfluities.

This being all they expect from it no wonder they look no farther; and not having apply'd themselves to things of this nature, overlook Beauties which they do not hope to find [...]

Painting is indeed a Difficult Art, productive of Curious pieces of Workmanship, and greatly Ornamental; and its Business is to represent Nature. Thus far the Common Idea is just; Only that 'tis More Difficult, More Curious, and More Beautifull than is Commonly Imagin'd. [...]

The Great, and Chief Ends of Painting are to Raise, and Improve Nature; and to Communicate Ideas; not only Those which we may receive Otherwise, but Such as without this Art could not possibly be Communicated; whereby Mankind is advanced higher in the Rational State, and made Better; and that in a Way, Easy, Expeditious, and Delightful.

The business of Painting is not only to represent Nature, but to make the Best Choice of it; Nay to Raise, and Improve it from what is Commonly, or even Rarely Seen, to what never Was, or Will be in Fact, tho' we may easily conceive it Might be.

* * *

The Dignity of the Science I am recommending will farther appear if it be consider'd, that if Gentlemen were Lovers of Painting, and Connoisseurs, it would be of great Advantage to the Publick, in

1. The Reformation of our Manners.
2. The Improvement of our People.
3. The Increase of our Wealth, and with all these of our Honour, and Power.

[1.] Anatomists tell us there are several Parts in the Bodies of Animals that serve to several Purposes, Any of which would justify the Wisdom, and Goodness of Providence in the making of them; but that they are Equally Useful, and Necessary to All, and serve the End of Each as effectually as if they were apply'd to One only: This is also true of Painting; It serves for Ornament, and Use; It Pleases our Eyes, and moreover Informs our Understandings, Excites our Passions, and Instructs us how to Manage them.

Things Ornamental, and things Useful are commonly distinguish'd, but the Truth is Ornaments are also of Use, the Distinction lies only in the Ends to which they are subservient. The wise Creator in the Great Fabrick of the World has abundantly provided for These, as well as for Those that are called the Necessaries of Life: Let us imagine our Selves always inhabiting between Bare Walls, wearing nothing but only to cover our Bodies, and protect them from the Inclemencies of the Weather, no Distinction of Quality, or Office, Seeing nothing to Delight, but merely what serves for the Maintenance of our Being; how Savage, and Uncomfortable must This be! Ornaments raise, and exhilarate our Spirits, and help to excite more Useful Sentiments than is commonly imagin'd; And if Any have this Effect, Pictures (consider'd only as Such) will, as being one of the Principal of This kind.

But Pictures are not merely Ornamental, they are also Instructive; and Thus our Houses are not only unlike the Caves of Wild Beasts, or the Hutts of Savages, but distinguish'd from those of Mahometans, which are Adorn'd indeed, but with what affords no Instruction to the Mind: Our Walls like the Trees of Dodona's Grove speak to us, and teach us History, Morality, Divinity; excite in us Joy, Love, Pity, Devotion, &c. If Pictures have not this good Effect, 'tis our Own Fault in not Chusing well, or not applying our Selves to make a Right Use of them. But I have spoken of This sufficiently already, and will only take leave to add Here, That if not only our Houses, but our Churches were Adorn'd with proper Histories, or Allegories well Painted, the People being now so well Instructed as to be out of Danger of Superstitious Abuses, their Minds would be more Sensibly affected than

they can possibly be without This Efficacious means of Improvement, and Edification. . . .

If Gentlemen were Lovers of Painting, and Connoisseurs, this would help to Reform Them, as their Example, and Influence would have the like Effect upon the Common People. All Animated Beings naturally covet Pleasure, and eagerly pursue it as their Chiefest Good; the great Affair is to chuse those that are Worthy of Rational Beings, Such as are not only Innocent, but Noble, and Excellent: Men of Easy, and Plentiful Fortunes have commonly a great part of their time at their Own Disposal, and the want of knowing how to pass those Hours away in Virtuous Amusements contributes perhaps as much to the Mischievous Effects of Vice, as Covetousness, Pride, Lust, Love of Wine, or any other Passion whatsoever. If Gentlemen therefore found Pleasure in Pictures, Drawings, Prints, Statues, Intaglias, and the like Curious Works of Art; in discovering their Beauties, and Defects; in making proper Observations thereupon; and in all the other parts of the business of a Connoisseur, how many Hours of Leisure would Here be profitably employ'd, instead of what is Criminal, Scandalous, and Mischievous! [. . .]

2. Our Common People have been exceedingly Improv'd within an Age, or two, by being Taught to Read, and Write; they have also made great Advances in Mechanicks, and in several Other Arts, and Sciences; And our Gentry, and Clergy are more Learned, and better Reasoners than in times past; a farther Improvement might yet be made, and particularly in the Arts of Design, if as Children are taught Other things they, together with These learnt to Draw; they would not only be qualify'd to become better Painters, Carvers, Gravers, and to attain the like Arts immediately, and evidently depending on Design, but they would thus become better Mechanicks of all kinds.

And if to learn to Draw, and to understand Pictures, and Drawings were made a part of the Education of a Gentleman, as Their Example would Excite the Others to do the like, it cannot be deny'd but that This would be a farther Improvement even of This part of our People: The whole Nation would by This means be removed some Degrees higher into the Rational State, and make a more considerable Figure amongst the Polite Nations of the World.

3. If Gentlemen were Lovers of Painting, and Connoisseurs, many Summs of Money which are now lavish'd away, and consum'd in Luxury would be laid up in Pictures, Drawings, and Antiques, which would be, not as Plate, or Jewels, but an Improving Estate; Since as Time, and Accidents must continually waste, and diminish the Number of these Curiosities, and no New Supply (Equal in Goodness to those we have) is to be hop'd for, as the appearances of things at present are, the Value of such as are preserv'd with Care must necessarily encrease more and more: Especially if there is a greater Demand for them, as there Certainly will be if the Taste of Gentlemen takes This Turn: Nay 'tis not Improbable that Money laid out This way, with Judgment, and Prudence, (and if Gentlemen are good Connoisseurs they will not be impos'd upon as they too often are) may turn to Better Account than almost in Any other.

We know the Advantages *Italy* receives from her Possession of so many fine Pictures, Statues, and other curious Works of Art: If our Countrey becomes famous in That way, as her Riches will enable her to be if our Nobility, and Gentry are

Lovers and Connoisseurs, and the Sooner if an Expedient be found (as it may Easily be) to Facilitate their Importation, We shall share with Italy in the Profits arising from the Concourse of Foreigners for the Pleasure, and Improvement that is to be had from the Seeing, and Considering such Rarities.

If our People were Improved in the Arts of Designing, not only our Paintings, Carvings, and Prints, but the Works of all our other Artificers would also be proportionably Improved, and consequently coveted by Other Nations, and their Price advanced, which therefore would be no small Improvement of our Trade, and with that of our Wealth.

I have observ'd heretofore, that there is no Artist whatsoever, that produces a piece of work of a value so vastly above that of the Materials of Natures furnishing as the Painter does; nor consequently that can Enrich a Countrey in any Degree like Him: Now if Painting were only consider'd as upon the Level with Other Manufactures, the Employment of More Hands, and the Work being Better done would certainly tend to the Increase of our Wealth; but This Consideration over and above adds a great Weight to the Argument in favour of the Art as Instrumental to This End.

Instead of Importing vast Quantities of Pictures, and the like Curiosities for Ordinary Use, we might fetch from Abroad only the Best, and supply other Nations with Better than Now we commonly take off their Hands: For as much a Superfluity as these things are thought to be, they are such as no Body will be without, not the meanest Cottager in the Kingdom, that is not in the extremest Poverty, but he will have something of Picture in his Sight. The same is the Custom in Other Nations, in Some to a Greater, in Others to a Less Degree: These Ornaments People will have as well as what is absolutely Necessary to Life, and as sure a Demand will be for them as for Food, and Cloaths; as it is in some Other Instances thought at first to be Equally Superfluous, but which are Now become considerable Branches of Trade, and consequently of great Advantage to the Publick.

Thus a thing as yet unheard of, and whose very Name (to our Dishonour) has at present an Uncouth Sound may come to be Eminent in the World, I mean the English School of Painting; and whenever This happens who knows to what heights it may rise; for the English Nation is not accustom'd to do things by Halves.

8 Antoine Coypel (1661–1722) on the grand manner, from 'On the Aesthetic of the Painter'

Antoine Coypel was the eldest son of the painter Noël Coypel, director of the Académie de France in Rome from 1672, and the father of Charles-Antoine Coypel (see IIA11). Having accompanied his father to Italy, he was immersed at an early age in the art of those widely regarded as the classics of the modern manner – Raphael, the Carracci, Domenichino and latterly Correggio – though his admiration for the Venetian painters and for Rubens was to put him on common ground with the 'colourists'. In the eight years after his return to Paris in 1676 he progressed through the hierarchies of the Académie Royale from student, to member, to assistant professor. He was made director of the Academy in 1714 and First Painter to the King the next year. Voiced in a lecture at the Academy, his advocacy of the grand manner represented some recapitulation of his own early commitments, at a time

when he saw himself as bearing a responsibility for the conduct of French painting. The 'perfect painter' as Coypel conceives him is first and foremost the ideal history painter in the classical mould, equipped at every technical point and in every moral aspect with an entirely faultless decorum. 'Sur l'esthétique du peintre' was originally published in Antoine Coypel, *Discours prononcés dans les conférences de l'Académie Royale de peinture et de sculpture*, Paris, 1721. It was reprinted in Henry Jouin ed., *Conférences de l'Académie Royale de peinture et de sculpture*, Paris: A. Quantin, 1883. The following translation has been made for the present volume by Jonathan Murphy, from pp. 277–86 of the 1883 edition. (See also IIA9.)

The mind of the perfect painter must be filled with divers sorts of knowledge. Not only should there be a strong foundation in the humanities, but also a considerable competence in rhetoric, so that he may abide by the same rules as an orator, and like him may instruct, please, and touch the heart. For it is these three elements which contribute most to the force of painting, and hence they must be sought above all else; yet they are often the most neglected.

The great painter must also be a poet. I do not mean that he should necessarily write verse, as one can versify without being a poet; but he should be filled with the same spirit that animates poetry, and he should be familiar with its rules and conventions, for...these are the same as those which govern painting. Painting and poetry are sister arts, which resemble each other so closely in all things that they constantly lend each other mutual support. Painting should do for the eyes what poetry does for the ear; both have the same principles, the same ideas, the same object and the same enthusiasm.

A great painter should be familiar with all types of history, from the Bible as well as from profane or fabulous sources. Geography, geometry and perspective are also requirements. Architecture is indispensable, and must be greatly cultivated, and the painter should know nature as a natural philosopher [physicist] does: how otherwise could the causes and effects of things be represented with certainty? A profound knowledge of the passions is essential, so that he may trace every fine distinction in the movements of the soul. His task will be to portray joy, sadness, pleasure, pain, love, hate, fear, and all the other passions which trouble and agitate the human heart. He must know not only the exterior man, in his correct anatomical proportions, but with the help of philosophy he must delve into the depths of his soul. Character cannot be portrayed without a substantial knowledge of the rules of physiognomy. He must also be familiar with the general rules of musical composition. Harmony, the product of the division of sounds, is founded on the same principles as those which govern the proportions of physical bodies, the gradations of light, and nuances of colour.

The rules of declamation are necessary in painting so that gesture and facial expression should be in good concord. The painter, who unfortunately cannot breathe speech into his paintings, must compensate for this by the use of lively expression and gesture, which should function in a similar manner to the sign language of the deaf.

Painters should also have some knowledge of the art of dance, not simply for the noble and gracious choice of posture, but also in order to imitate the celebrated

pantomimes of the ancient Greeks, where the story was communicated through carefully regulated movements: hands and feet spoke a language of gesture, and such was the art of their posture and the liveliness of their gestures that the spectators could easily decipher even the most mysterious of the actions of their gods.

In truth a tremendous variety of knowledge is required for a great painter. However, all this knowledge will be quite useless unless it is combined in the correct proportions with order and economy throughout the work. Great art must combine beauty and sublime thought, a noble and majestic treatment of the subject, and must faithfully transmit the truth of the story and the customs and costumes of the country. Expression should be lively and noble, execution freely handled, and the entire work should breathe an air of abundance and variety, all combined with exquisite judgement,[1] equally capable of bringing pleasure or displeasure, interest or disappointment.

The idea of the perfect painter, such as I am creating here, may appear slightly exaggerated, but it must be agreed that nowhere do I overstate the case, nor overstep the bounds of plausibility; indeed many other desirable elements could be added to this list. Such a painter would indeed be filled with great qualities, but it should be remembered that my task here is to lay out the necessary requirements for a truly great painter. It may be objected that few have ever achieved such a high degree of perfection, even amongst those painters whom we consider to be the most noteworthy; to which I would reply that indeed no painter has ever been beyond reproach. This should be noted in particular by a number of our contemporaries, who claim aloud that their own work is beyond correction, and that they have nothing left to learn. Painters of the calibre of Leonardo, Raphael, Michelangelo, Dürer, Domenichino, Rubens and Poussin, who were immensely learned men in many fields, never presumed themselves to be omniscient. The ancients, when they signed their work, would often use an imperfect tense to convey that such was their manner, rather than the boastful 'fecit'. They were rarely satisfied with their work, and mindful to demonstrate as much to subsequent generations.

* * *

The grand manner, or that which we have come to know as such, has its origin in a natural elevation of the spirit that we feel within us: as such it is more a gift from the heavens than a quality that we may obtain from the grandeur of our ideas or the beauty of imagination. But as the grand is also to be found in various aspects of painting, we shall examine these in turn, in an attempt to isolate a number of rules that might help painters to achieve greatness.

The grand resides both in the choice of subject-matter and in the manner in which it is treated: in disposition, in expression and in the execution of the drawing.

The painter is free to choose his own subject, and he should cherish this right: and should be mindful of choosing great, celebrated or singular events, where the action is both lively and easily characterized.

When in the choice of a subject the pathetic can be joined to the great, this will often lead to a successful outcome. Although the grand rejoices both the spirit and the faculty of judgement, not all can appreciate its beauty, but when the passions are joined together and manipulated with force, this cannot fail to move all who cast their eyes upon it. The pathetic leads more swiftly to the heart than the great does to the

spirit. And moreover one may touch the spirit without touching the heart, but one cannot move the heart without affecting the spirit.

As there is no action without circumstance, the grand may always be achieved if one chooses the most considerable set of circumstances, linking them together in a beautiful whole. A great painter should always ensure that no action extraneous to the central focus of his theme should intrude in the composition, so that all elements agree to augment its force and character. All that is added to the subject should increase and embellish the painting: the grand must contain nothing that is superfluous in any way.

Above all, where religious painting is concerned, it must be ensured that no base or childish circumstances liable to disfigure its character should be introduced. All must inspire respect and holiness.

* * *

When some sort of base circumstances are absolutely necessary for the subject, they should be positioned in the most inconsequential areas of the picture, so that they bring out the beauty of the action, which should always be in the middle of the scene and the brightest part of the picture. How ridiculous it would be in a nativity scene to give the animals pride of place, where the subject is so grand and holy, and demands that the Saviour be placed at the centre of the picture! When such base circumstances must unavoidably be introduced, it is a tremendous fault to introduce them in an inapt manner and afford them centre stage in the work, when they are the complete opposite of the seriousness of the subject in question. Nonetheless, whatever rules one draws up to govern such matters, they will count for nothing if they are not applied with delicacy and fine judgement by the painter.

All extraneous episodes should be avoided, and those intrinsic to the subject must be chosen with great care. Herein lies the art of disposition, or composition.

The composition of a painting is the correct distribution of the different parts, which when positioned correctly form an agreeable unity, lending each other mutual support so that no one element stands out excessively. The most vivid inspiration, the most sublime idea counts for nothing if the composition is lacking and each part is not in its rightful place. Without order, a painting is no more than a confused mass of figures which tire the eyes and the mind. But the order must not be an affected arrangement; objects should be placed so ingeniously that it appears that their positioning is nothing more than the result of a happy chance. True art should aim to hide art itself. The grand appears easy: but that which appears easy is in reality the most difficult thing to achieve, and can only be attained through a rigorous application of rules and prescriptions. If occasionally a sublime spirit appears to break free and overstep the boundaries, carried away by enthusiasm or by the verve of his execution, this is perhaps an indication of our imperfect understanding of art itself, but it ultimately serves to reinforce the rules that we have developed. [...] One cannot expect the rules to produce the enthusiasm necessary for the grand style: but the rules must justify that enthusiasm.

Variety and abundance are pleasing in composition, but here one should be neither mean nor prodigal, and the character and seemliness of the subject must always be preserved. The grand manner must always avoid complexity wherever possible, so that it is always better to leave something to the imagination rather than fatigue the

eyes with superfluous detail. Correction and judgement are all, and a wise and artful choice of elements to enter the subject is always paramount. The most interesting and evocative details must be chosen and placed with skill: all that is irrelevant, childish or insipid must be discarded.

Certain subjects are simple by their very nature. The majesty of a prince often consists in the choice of a few succinct words, and in similar fashion a small number of characters will create as much grandeur as is created by a wide variety of characters in a larger work.

When the subject is deeply serious, for instance, in the representation of a ceremony, a certain air of arrangement is necessary, and it is often here the grandeur or majesty lies, but this arrangement should always be accompanied by a softness, forming an almost imperceptible sort of contrast. The divine Raphael is a master in such situations, as demonstrated by paintings like *The Disputation over the Sacrament, The School of Athens, Pentecost* and *The Acts of the Apostles.* What unity of action! What knowing simplicity, what grandeur, what nobility, what majesty!

For those reasons that great man was ever distant from all that we so wrongly term the picturesque, and hence became the greatest painter in the world.

In battle scenes and other pictures filled with tumultuous action, abandon, variety and disorder are the keys. There a knowing sort of disorder is a vital feature of art; but that disorder must always be a result of art. Together with this apparent air of confusion, which sets in motion the spirit and the imagination, there must also be repose for the eyes, to be found in quieter groups, in the chiaroscuro blocks, and in the harmony and contrast of the colours. The grand is always a result of these, and the whole must be kept in mind when composition is being considered.

Grandeur is also a question of representing multiplicity, of suggesting far more than can ever be represented on one canvas. The spectator must be afforded an opportunity to exercise his own imagination. Thus is his self-esteem flattered, and accordingly he will admire the work all the more. His greatest pleasure perhaps is to believe himself to be the author of that which has merely been sketched out. There are few more important qualities than the ability to encourage this exercise in others.

Perhaps the greatest quality in expression is to ensure that the character of the subject treated can be divined at first glance. Clothing, the choice of location, proportion, expression, gesture, all are in concord to increase or diminish the grandeur of the subject. The painter must be sublime when divinities are to be represented. All must be magnificent and full of pomp when the actions of kings or heroes are to be represented; and a similar procedure should be used even when commonplace or ordinary subjects are to be represented. The greatest, most singular and most noble effects of nature should always be chosen, for therein lies all that is truly picturesque. Even the lowest style should have its own nobility. But verisimilitude should never be abandoned in pursuit of the extraordinary or grand. Each subject should have the character most fitting, in expression, physiognomy or gesture. The poses of old men should differ from those of impetuous youths. The actions of women should be more gracious than those of men, and those of children should have the naivety and tenderness that characterizes them, as in the painting of the great Correggio.

Regardless of the diversity of actions or attitudes, some form of unity must always be maintained. Nothing is further from the grand style than the unnecessary introduction of violent actions into a serious subject, where all should be in concord for a common end. An excess of movement in one figure juxtaposed with an overly immobile figure forms an unpleasant contrast, displeasing to the eye and the mind. Raphael is the great model to follow here.

Greatness in drawing is quite different from correctness. One may be exact and faithful, and draw with no taste at all. Examples are Lucas van Leyden, Albert Dürer, and many others besides. One may also draw with great taste but quite without correctness, as is often the case in Correggio's drawing. The great character of drawing is in the genius of the painter, and is often hard to determine. But we may say that it often consists in the ability to bring out large areas with big blocks, and in avoiding all that is dry, trenchant, harsh, and abrupt. Angles in contours are hard and mean. Contours should be animated by undulating forms, by all that resembles the flame and brings greatness, elegance and truth; such is the true spirit of the arabesque, and here it is impossible to imitate Correggio too closely. All that is opposed to this style is barbarous and ephemeral, and goes against nature and the tastes of the great masters. When one examines the work of Michelangelo, Leonardo da Vinci, Raphael and the Carracci, one finds the antidote to Lucas van Leyden, Dürer and Piero Testa.

The grand style is also a product of great attention to drapery, so much so that often the grandeur and nobility of a figure depend on the choice of a particular fold, or on the choice of the material disposed in one manner or other. On occasion the grandeur will result from a certain chance disorder in the drapery, as in the work of Correggio. On other occasions it is the result of order in the folds, which evoke all that is noble and majestic, and such was the taste of the ancients. Raphael has the admirable ability to combine the two together. His language speaks only to the painter. Many believe that the drapery is left to another hand, as they believe that in music the harmonies and the parts are the work of students, all of which serves to demonstrate that in all of the arts there are mysteries known only to the practitioners themselves.

[1] In the original French, *goût*. In the seventeenth century, the word *goût* – which in modern French simply means taste – referred much more narrowly to the intellectual faculty of judgement than it did to individual choices regarding personal preference [translator's note].

9 Antoine Coypel (1661–1722) from 'On the Excellence of Painting'

As in the previous text, here Coypel is concerned to advance the case for painting as not simply a civilized but also a civilizing art. His transparent aim is to ensure honour and recognition for those who practise it. 'L'Excellence de la peinture' was originally published in Antoine Coypel, *Discours prononcés dans les conférences de l'Académie Royale de peinture et de sculpture*, Paris, 1721. It was reprinted in Henry Jouin ed., *Conférences de l'Académie Royale de peinture et de sculpture*, Paris: A. Quantin, 1883. The following

excerpt has been translated for the present volume by Jonathan Murphy from pp. 220 and 224–5 of the 1883 edition. (See also IIA8.)

I recently overheard a man well regarded in both the sciences and the arts make the following remark, while studying a painting quite closely: 'That must be truly beautiful, for it lulls me into a state of most agreeable reverie.' I know full well that not all men are capable of such reflection, but they do appreciate that painting both embellishes and brings life to the area that surrounds it; and if it fails to occupy their spirit, it does at least amuse and please their eyes, although they may fail to understand the reasons for this. And indeed, even in the saddest and most forsaken place, a painting seems to keep one company, and one is never alone in one's cabinet except when the pictures have been moved. This is a fact universally recognized, for all men are touched by the objects that they behold. The conversation that follows is generally mute, but the language of the eyes is no less real for that. It is truly a pleasure to be able to entertain oneself while being spared the travails of frivolous discourse and spared the necessity of replying. Often it is the most pleasurable form of entertainment. Painting is a means of conversing with absent friends, relations and all those we hold most dear; not only those with whom we live, but also with those who lived in times now far distant; while pleasing our spirit and our eyes, it teaches us their customs and habits, their military valour, their arms, their clothing, their building, their ceremonies and their religion, and thus serves to instruct us in the most painless fashion; even, we might say, while bringing great pleasure all the while. While we believe ourselves to be involved in some quite different endeavour, it increases our knowledge and opens new vistas without our even being aware that this is being brought about. What a pleasure it is, to those who can think and cogitate upon it, those who can set its charms to work in tranquillity, thought being the only true and reliable pleasure to which we can aspire; so often we flee it, while thinking to call it hither. Such is the goal of all wisdom; the ancients so sought this happy tranquillity that they constructed temples and altars in its honour.

* * *

It must be acknowledged that painting so agreeably occupies the eyes, the spirit and the imagination that often, through a sort of enchantment, it softens the memory of past suffering, and even on occasion present pain. Not only does this beautiful art bring infinite pleasure to those who know and love it, but it also brings inexpressible happiness to all those who exercise it with distinction. What secret delight it is to see a tiny creation born beneath our fingers, solely through imagination, a few simple lines and the intelligence of light and shadow. Bodies and objects quite unreal come to life, agreeably deceiving our own eyes, and deceiving those of others as well. What delight it brings, as our genius reveals itself, and our spirit is filled with lofty ideas and all that nature herself can contain! The pleasure of such work is so sweet: I remember hearing one time in Rome that when Bernini's family or students would drag him away unwillingly from his tireless work, in architecture, sculpture or painting, he often remarked 'Ah! Why must you drag me away from my true mistress?' What a great privilege it is for great painters to see palaces and temples of great magnificence arise in their work, to charm the eyes and the heart not only of educated men, but even of ignorant and stupid people! What satisfaction it must bring to ornament one's

homeland, and attract admiration even from abroad! Gold and azure have their precious sparkle, but to see one's work outshine matter, and live on for posterity! Do we not still talk of Apelles, the worthy favourite of Alexander the Great? The course may not always run smooth, and the pleasure is often interrupted or allied with suffering; by an infinite amount of work and the ingratitude of the people, by the erroneous decisions of the high-handed and inconsiderate, or by unthinking scorn. A man who is a stranger to art is incapable of admiring an artist, as Cicero remarked: but the truly great man, who must always have glory in his sights, must think of doing well rather than of being recompensed. He should expect the arrows of envy and injustice, and remind himself that the bitterness of work might one day be softened by the honour it brings. For great paintings, and great painters, have ever been honoured down the ages.

10 Ephraim Chambers (1680–1740) from *Cyclopaedia*

Chambers was the son of a farmer in Kendal, then in the county of Westmoreland in the English Lake District. After education at Kendal grammar school, he was apprenticed in London to a maker of globes, maps and mathematical instruments. The resulting interest in science and geography stimulated him to conceive the idea of an all-encompassing survey of the contemporary state of knowledge, going beyond the only existing work of the kind, John Harris's *Lexicon Technicum* (1704). (The term 'encyclopaedia' is derived from Latin translations of Greek phrases found in Pliny and others, connoting 'the circle of the arts and sciences'; 'cyclopaedia' is an etymologically meaningless contraction which may have been intended to imply 'the circle – or cycle – of education'.) The late seventeenth century had given rise, in both France and England, to several attempts to measure the achievement of the new learning against that of the ancients (see IA7 and 8). Chambers' aspiration was to produce a distillation of the entire field, compiled, as he put it in his frontispiece, 'from the best Authors, Dictionaries, Journals, Memoirs, Transactions, Ephemerides &c. in several Languages'. The interest of Chambers' work today lies not in the originality of any particular definition, but rather in the opposite: its status as a distillation of contemporary received wisdom. In the early eighteenth century, England had achieved a measure of political stability and seemed poised for expansion. In his dedication to the new King, George II, Chambers spoke openly of the coming eminence of England, making direct comparison with the Greece of Alexander and the Rome of Augustus. In this perspective, knowledge played a crucial role. It was thanks to the Arts and Sciences, Chambers wrote, that 'the mind is reclaim'd from its native Wildness, and enrich'd with Sentiments which lead to Virtue and Glory. 'Tis these, in fine, that make the Difference between your Majesty's Subjects and the Savages of Canada or the Cape of Good Hope.' Subsequently, it was a proposal to translate Chambers' monumental achievement into French that led Diderot and D'Alembert to the still greater project of the *Encyclopédie* (see IIIC7, 8 and 9). These extracts on art are taken from Chambers' *Cyclopaedia: or an Universal Dictionary of Arts and Sciences*, 2 volumes, London: James and John Knapton et al., 1728, vol. 1, pp. 12–13, 144, 191–2, 230–1, 262, 370–1, 735, 794; vol. 2: pp. 36–7, 125. For the purposes of the present anthology, we have elected to replace Chambers' alphabetical organization with an order made in terms of generality. Thus: 'Art', followed by 'Painting', followed by the various 'Parts' of art, such as 'Design', Colour', etc.

ART is principally used for a certain System or Collection of Rules, Precepts, and Inventions or Experiments, which being duly observ'd, make the Things a Man undertakes succeed, and render them advantageous and agreeable. In this sense *Art* is opposed to *Science*, which is a Collection of speculative Principles and Conclusions. *Arts* in this Sense, may be divided, with respect to their Scope and Object, into *human*, as Medicine; and *divine*, as Theology. *Human*, again, may be subdivided into *Civil*; as Law, Politics, &c. *Military*, as Fortification, &c. *Physical*, as Agriculture, Chymistry, Anatomy, &c. *Metaphysical*, as Logicks, pure Mathematicks, &c. *Philological*, as Grammar, Criticism &c. *Mercantile*, to which belong the Mechanical Arts and Manufactures.

ARTS are more popularly divided into *Liberal* and *Mechanical*. The *liberal Arts* are those that are noble, and ingenuous; or which are worthy of being cultivated without any regard to Lucre arising therefrom. – Such are *Poetry, Musick, Painting, Grammar, Rhetoric*, the *military Art, Architecture* and *Navigation*. *Mechanical Arts* are those wherein the Hand, and Body are more concern'd than the Mind; and which are chiefly cultivated for the sake of the Profit they bring with them. – Of which kind are most of those which furnish us with the Necessaries of Life, and are popularly known by the Name of *Trades*. – Such are *Weaving, Turnery, Brewing, Masonry, Clock-making, Carpentry, Joinery, Foundery, Printing*, &c. The *mechanical Arts* take their Denomination from μηχανη [mekhane] 'Machine'; as being all practised by means of some Machine or Instrument. With the *liberal Arts* it is otherwise; there being several of them which may be learnt and practised without any Instrument at all: as Logic, Eloquence, Medicine properly so called &c. The *Arts* which relate to the Sight and Hearing, My Lord Bacon observes, are reputed liberal beyond those which regard the other Senses, which are chiefly employed in Matters of Luxury.

It has well been noted by some Philosophers, that during the Rise and Growth of States, the military *Arts* chiefly flourish; when arrived at their Height, the liberal *Arts*, and when on the declining hand, the voluptuary *Arts*.

PAINTING, the Art of representing natural Bodies, and giving 'em a Kind of Life, by the Turn of Lines, and the Degrees of Colours.

Painting is said to have had its Rise among the *Egyptians*; And the *Greeks*, who learnt it of 'em, carried it to its Perfection; if we may believe the Stories related of their *Apelles* and *Zeuxis*. The *Romans* were not without considerable Masters in this Art, in the later Times of the Republic, and under the first Emperors; but the Inundation of *Barbarians*, who ruin'd *Italy*, proved fatal to Painting, and almost reduced it to its first Elements. It was in *Italy*, however, that the Art returned to its ancient Honour, and in the beginning of the XVth century; when *Cimabue*, betaking himself to the Pencil, translated the poor Remains of the Art, from a *Greek* Painter or two, into his own Country. He was seconded by some *Florentines*: The first who got any Reputation was *Ghirlandaio, Michel Angelo's* Master; *Pietro Perugino, Raphael Urbin's* Master; and *Andrea Verrocchio, Leonardo da Vinci's* Master. But the Scholars far surpassed the Masters; they not only effaced all that had been done before 'em, but carried Painting to a Pitch from which it has ever since been declining.

'Twas not by their own noble Works alone that they advanc'd Painting; but by the Number of Pupils they bred up, and the Schools they form'd. *Angelo* in particular, founded the School of *Florence; Raphael* the School of *Rome*; and *Leonardo* the School of *Milan*; to which must be added, the *Lumbard* School, establish'd about the same time, and which became very considerable under *Georgian* and *Titian*. Besides the *Italian* Masters, there were others on this Side the Alps, who had no communication with those of *Italy*; such were *Albert Durer*, in Germany; *Holbens* in *Switzerland; Lucas* in *Holland*; and others in *France* and *Flanders*: but *Italy*, and particularly *Rome*, was the Place where the Art was practic'd with the greatest Success; and where, from Time to Time, the greatest Masters were produc'd. To *Raphael's* School, succeeded that of the *Caraches*, which has lasted, in its Scholars, almost to the present Time; wherein the *French* Painters, by the Munificence of the late *Louis XIV* seem almost in Condition to vie with those of *Greece* or *Italy*. In *Paris* they have two considerable Bodies of Painters, the one, the *Royal Academy of Painting and Sculpture*, the other the *Community of Masters in Painting, Sculpture*, &c.

The Art of *Painting* is divided, by Fresnoy, into three principal Parts, *Invention, Design*, and *Colouring*, to which some add a fourth, *viz. Disposition*. Felibien divides Painting into the *Composition*, the *Design*, and *Colouring*. Mons. Testling, Painter to the late King, divides it, somewhat more accurately, into the *Design* or *Draught*, the *Proportion*, the *Expression*, the *Clair-obscure*, the *Ordonnance*, and the *Colouring*; to which his *English* Translator adds the *Perspective*.

DESIGN, or *Draught*, with regard to the Arts and Sciences, signifies the Thought, Plan, Geometrical Representation, Distribution, and Construction of a Painting, Poem, Book or Building: 'This Painter has shewn the first *Design* of his Piece, in which the Figures are well disposed'. 'The *Design* of that Poem or Book is artfully laid'. '*Claudian* never sees his whole *Design* together: When he composes a Part, he thinks of nothing else; and works up every Member, as if it were separate from all the rest'. [. . .]

DESIGN in the Manufactories, the Figures wherewith the Workman enriches his Stuff, or Silk; and which he copies after some Painter. In undertaking such Kinds of figured Stuffs, 'tis necessary that before the first Stroak of the Shuttle, the whole *Design* be represented on the Threads of the Warp; we don't mean in Colours, but with an infinite number of little Pack-Threads, which being disposed so as to raise the Threads of the Warp, let the Painter see from Time to Time what Kind of Silk is to be put in the Eye of the Shuttle, for Woof. This Method of preparing the Work, is call'd *reading the Design*, or reading the Figure. [. . .]

DESIGN is particularly used in Painting, for the first Idea of a large Work drawn roughly, and in little; with Intention to be executed, and finish'd in large. In this simple Sense, the *Design* is the simple *Contour*, or *Outline* of the Figures or Things intended to be represented; or the Lines that terminate, and circumscribe them.

Such *Design* is sometimes drawn in Crayons, or Ink, without any Shadows at all: Sometimes it is *hatch'd*, that is, the Shadows are expressed by sensible Lines, usually

drawn a-cross each other with the Pen, Crayon or Graver. Sometimes again, the Shadows are done with the Crayon rubb'd so as as there does not appear any Lines: Sometimes the Grain, or Strokes of the Crayon appear, as not being rubb'd: Sometimes the *Design* is *wash'd*, that is, the Shadows are done with a Pencil, in *Indian* ink, or some other Liquor: And sometimes the *Design* is *colour'd*, that is, Colours are laid on, much like those intended for the Grand Work.

The Qualities, or Parts required in a *Design*, are *Correctness, Good Taste, Elegance, Character, Diversity, Expression*, and *Perspective. Correctness* depends principally on the Justness of the Proportions, and a knowledge of Anatomy. *Taste* is an Idea, or Manner of *Designing*, which arises either from the Complexion and natural Disposition, or from Education, the Masters, Studies &c. *Elegance* gives the Figures a Kind of Delicacy, which strikes People of Judgment, and a certain Agreeableness, which pleases everybody. The *Character* is what is peculiar to each Thing; In which there must be a *Diversity*; in as much as every Thing has its particular Character to distinguish it. The *Expression* is the Representation of an Object according to its Character, and the several Circumstances it is supposed to be in. The *Perspective* is the Representation of the Parts of a Painting, or Figure, according to the Situation they are in, with respect to the Point of Sight.

The *Design*, or *Draught*, is a Part of the greatest Import, and Extent in Painting. 'Tis acquired chiefly by Habit, and Application; Rules being of less Avail here than in any of the other Branches of the Art, as *Colouring, Clair-Obscure, Expression*, &c. [. . .] The rest relates to *Perspective*: As, that those Objects are seen at one View, whose Rays meet in a point: That the Eye and Object be always conceiv'd as immoveable: That the Space, or *Medium* between them be conceiv'd transparent: And that the Eye, Object and Picture, be at a just Distance; which is usually double the Bigness of the Subject, or Picture.

EXPRESSION, in Painting, the natural and lively Representation of the Subject, or of the several Objects intended to be shewn. The *Expression* consists principally in representing the human Body, and all its Parts, in the Action suitable to it; in exhibiting in the Face, the several Passions proper to the Figures; and observing the Motions they impress on the other external Parts. The Term *Expression*, is ordinarily confounded with that of Passion: But they differ in this, that *Expression* is a general Term, implying a Representation of an Object. Agreeably to its Nature and Character, and the Use or Office it is to have in the Work; and Passion, in Painting, is a Motion of the Body, accompanied with certain Dispositions, or Airs of the Face, which mark an Agitation in the Soul. So that every Passion is an *Expression*; but not every *Expression* a Passion.

The *Laws* or *Rules* of Expression in *painting. Expression*, we have said, is a Representation of Things according to their Character; and may be consider'd either with respect to the *Subject* in general; or to the *Passions* peculiar therein.
I. With regard to the *Subject*, 'tis to be observed,

1 That all the Parts of the Composition are to be transform'd, or reduced, to the Character of the Subject; so as they may conspire to impress the same Sentiment,

Passion, or Idea: Thus *e.g.* In a Representation of Joy and Peace, every Thing is to appear calm and agreeable; of War, turbulent, and full of Terror &c.

2 In Order to this, any Circumstance occur in History, or Description, that would invert, or take from the Idea; it must be suppressed; unless essential to the Subject.

3 To this End, the History, or Fable, is to be well studied in the Authors who describe it, in Order to conceive its Nature and Character truly, and impress it strongly on the Imagination; that it may be diffused and carried thro' all the Parts of the Subject.

4 A Liberty to be taken of chusing favourable Incidents, in order to diversifie the *Expression*; provided they be not contrary to the principal Image of the Subject, or the Truth of History.

5 The Harmony of the *tout Ensemble* to be particularly regarded, both with regard to the Actions, and the Light and Colour.

6 The Modes and Customs to be observed; and every Thing made conformable to Time, Place, and Quality.

7 The three Unities of Time, Place and Action, to be observed: That is, nothing to be represented in the same Picture, but what passes at the same Time, and may be seen at the same View.

II. With regard to the particular *Passions* and *Affections* of the Subject; the Rules are,

1 That the Passions of Brutes are few and simple, and have almost all an immediate Respect, either to Self-Preservation, or the Propagation of the Kind: But in Men, there is more Variety; and accordingly, more Marks and *Expressions* thereof. Hence, Man can move his Eye-brows, which, in Brutes are immovable: And can likewise move the Pupil every way, which Brutes cannot.

2 Children, not having the Use of Reason, act much on the footing of Brutes; and *express* the Motions of their Passions directly, and without Fear or Disguise.

3 Tho' the Passions of the Soul may be *express'd* by the Actions of the Body; 'tis in the Face they are principally shewn; and particularly in the Turn of the Eye, and the motion of the Eye-brows.

4 There are two Ways of lifting up the Eye-brows; the one at the middle, which likewise draws up the Corners of the Mouth, and argues pleasant Motions: The other, at the Point next the Nose, which draws up the middle of the Mouth, and is the Effect of Grief and Sadness.

5 The Passions are all reducible to Joy and Sadness; each of which is either simple, or mix'd and passionate.

6 Simple Joy causes a Dilation of all the Parts: The Eye-brows rise in the middle, the Eyes half open, and smiling, the Pupil sparkling and moist, the Nostrils a little open, the Cheeks full, the Corners of the Mouth drawn a little upwards, the Lips red, the Complexion lively, the Forehead serene.

7 Passionate Joy proceeding from Love, shews the Forehead smooth and even, the Eye-brows a little elevated on the Side the Pupil is turn'd to, the Eyes sparkling and open, the Head inclined towards the Object, the Air of the Face smiling, and the Complexion ruddy: – That proceeding from Desire, shews itself by the Body, the Arms extended towards the Object, in uncertain and unquiet Motions.

8 Simple Sadness, is *Express'd* by the Body being cast down, the Head carelessly hanging aside, the Forehead wrinkled, the Eye-brows rais'd to the midst of the Fore-head, the Eyes half shut, the Mouth a little open, the Corners downwards, the under-Lip pointing and drawn back, the Nostrils swell'd, and drawn downwards. – That mix'd with *Fear*, causes the Parts to contract and palpitate, the Members to tremble and fold up, the Visage to be pale and livid, the point of the Nostrils elevated, the Pupil in the middle of the Eye, the Mouth openest at the sides, and the under-Lip drawn back. – In that mix'd with *Anger*, the Motions are more violent, the Parts all agitated, the Muscles swell'd, the Pupil wild and sparkling, the Point of the Eye-brows fix'd towards the Nose, the Nostrils open, the Lips big and press'd down, the Corners of the Mouth a little open and foaming, the Veins swell'd, and the Hair erect. – That with *Despair*, resembles the last, only more excessive and dis-order'd.

9 The Hand has a great Share in the *Expression* of our Sentiments and Passions: The raising of the Hands conjoyn'd – towards Heaven, *expresses* Devotion: Wringing the Hands, Grief: Throwing them towards Heaven, Admiration: Fainting, and dejected Hands, Amazement and Despair: Holding the Hands, Idleness: Holding the Fingers indented, musing: Holding forth the Hands together, Yielding and Submission: Lifting up the Hand and Eye to Heaven, calling God to Witness: Waving the Hand from us, Prohibition: Extending the right Hand to anyone, Pity, Peace and Safety: Scratching the Head, Thoughtfulness and Care: Laying the Hand on the Heart, solemn Affirmation: Holding up the Thumb, Approbation: Laying the Fore-finger on the Mouth, bidding Silence: Giving with the Finger and Thumb, *parce dare*: And the Fore-finger put forth, the rest contracted *Monstrari & dicier hic est*.

10 The *Sex* of the Figure to be regarded; and Man, as he is of a more vigorous and resolute Nature, to appear in all his Actions freer and bolder than Women, who are to be more reserved and tender.

11 So also the *Age*, the different Stages whereof incline to different Motions both of Body and Mind.

12 The *Condition*, or Honours, a Person is invested withal, renders their Actions more reserved, and their Motions more grave; contrary to the Populace, who observe little Conduct and Restraint; giving themselves, for the most part, up to their Passions; whence their external Motions become rude and disorderly.

Lastly, in *Spirits* we must retrench all those corruptible Things, which serve only for the Preservation of Life, as Veins, Arteries &c. only retaining what may serve for the Form and Beauty of the Body. In *Angels*, particularly, as being symbolical Figures, we are to mark out their Offices and Virtues, without any Draught of sensual Passions; only appropriating their Characters to their Functions of Power, Activity and Contemplation.

CLAIR-OBSCURE, or CHIARO SCURO, in Painting, the Art of distributing, to advantage, the Lights and Shadows of a Piece, both with regard to the easing of the Eye, and the Effect of the whole Piece. Thus, when a Painter gives his Figures a strong Relievo, loosens 'em from the Ground, and sets 'em free from each other, by

the Management of his Lights and Shadows, he is said to understand the *Clair-obscure*.

The *Clair-obscure* makes one of the great Divisions, or Branches of Painting, the whole of a Picture being resolvable into *Light* and *Shadow*. The Doctrine of the *Clair-obscure* will come under the following Rules.

Light may be either consider'd with regard to itself; to its Effects; the Place where 'tis diffus'd; or its Use.

For the 1st, Light is either *Natural* or *Artificial*. *Natural*, either comes immediately from the Sun, which is brisk, and its Colour various according to the Time of the Day; or 'tis that of a clear Air thro' which Light is spread, and whose Colour is a little bluish; or a cloudy Air, which is darker, yet represents Objects in their genuine Colours with more ease to the Eye. *Artificial* proceeds from Fire, or Flame, and tinges the Object with its own Colour: but the Light it projects is very narrow and confin'd.

For the 2nd, the *Effects* of Light are either *Principal*, as when the Rays fall perpendicularly on the Top of a Body, without any Interruption; or *Glancing*, as when it slides along Bodies; or *Secondary*, which is for things at a distance.

3 For the *Place*, 'tis either the open Campaign, which makes Objects appear with great Softness; or an inclos'd Place, where the Brightness is more vivid, its Diminution more hasty, and its Extremes more abrupt.

4 For the *Use*, or Application: The Light of the Sun is always to be suppos'd without, and over against the Picture; that it may heighten the foremost Figures: the Luminaries themselves never appearing, in regard the best Colours can't express 'em. The chief Light to meet on the chief Group, and as much as possible on the chief Figure of the Subject. The Light to be pursu'd over the great Parts without being cross'd or interrupted with little Shadows. The full Force of the principal Light to be only one Part of the Piece: taking care never to make two contrary Lights. Not to be scrupulously confin'd to one universal Light; but to suppose other accessory ones, as the opening of Clouds &c. to loosen some Things, and produce other agreeable Effects. Lastly, the Light to be different, according to the Quality of Things whence it proceeds, and the Nature of the Subjects which receive it.

For *Shadows*; they are distinguish'd, 1st into those form'd on the Bodies themselves, by their proper Relievos. 2nd Those made by adjacent Bodies; those that make the Parts of any whole; and the different Effects, according to the difference of Places.

For the first, since the different Effects of Light only appear by Shadows, their Degrees must be well manag'd. The Place which admits no Light, and where the Colours are lost, must be darker than any Part that has Relievo, and dispos'd in the Front. The Reflex, or return of the Light, brings with it a Colour borrow'd from the Subject that reflects it; and flies off at a greater or less Angle according to the Situation of the reflecting Body, with regard to the luminous one: Hence, its Effects must be different in Colour, and in Force; according to the Dispositions of Bodies. Deepenings, which admit not of any Light, or Reflex, must never meet on the Relievo of any Member of any great elevated Part; but in the Cavities or Joints of Bodies, the Folds of Draperies &c. And to find Occasions for introducing great

Shadows, to serve for the Repose of the Sight, and the Loosening of Things; instead of many little Shadows, which have a pittiful Effect.

For the 2nd, the Shadows made by Bodies, are either in plain and smooth Places, or on the Earth; wherein they are deeper than the Bodies that occasion 'em, as receiving less reflex Light; yet still diminish as they depart further from their Cause; or on the neighbouring Bodies, where they are to follow the form of the said Bodies, according to its Magnitude and its Position, with regard to the Light.

For the 3rd, In Shadows that have Parts, the Painter must observe to take for a Light in a shadow'd Place, the Teint, or Lustre of the light Part; and, on the contrary, for the Shadow in the lighten'd Part, the Teint or Lustre in the Shadow: To make an Assemblage of Colour, Shadow, and Reflex in the shadow'd Part; but without interrupting the great Masses of Shadows: To avoid forming little Things in the Shadow; as not being perceiv'd, unless closely look'd at; and to work, as it were, in the general, and at one sight: Never to set the strong Shadows against the Lights, without softening the harsh Contrast by the help of some intermediate Colour: tho the Mass of Light may be plac'd either before or behind that of the Shadow; yet ought to be so dispos'd as to illuminate the principal Parts of the Subject.

For the 4th, The Effects of Shadows are different, as the Place is either wide and spacious; as in those coming immediately from the Sun, which are very sensible, and their Extremes pretty abrupt; and from the serene Air, which are fainter and more sweet; from the dark Air, which appear more diffus'd, and almost imperceptible; and those from an artificial Light, which makes the Shadow deep, and their Edges abrupt: or as it is more narrow and confin'd, where the Lights coming from the same Place make the Shadow more strong, and the reflex less sensible.

COLOURING, in Painting, the manner of applying and conducting the *Colours* of a Picture: Or, it is the Mixture of Lights and Shadows form'd by the various *Colours* employ'd in a Painting. The *Colouring* is one of the principal Branches of Painting.

M. Félibien divides the Painter's Art into three Parts; the Design, the Composition, and the *Colouring*. The *Colouring* strikes the most; but among Masters it always gives place to the Exactness of the Design. De Piles observes that the Word *Colouring*, in its confin'd Sense, is chiefly applicable to a History-piece; scarce at all to a Landskip. [...]

The *Colouring*, in its general Sense, takes in what relates to the Nature and Union of *Colours*; their Agreement, or Antipathy; how to use them to advantage in Light and Shadow, so as to show a Relievo in the Figures, and a sinking of the Ground: What relates to the aerial Perspective, *i.e.* the Diminution of *Colours* by means of the Interposition of Air; the various Accidents and Circumstances of the Luminary and the Medium; the different Lights, both of the Bodies illuminating and illuminated; their Reflections, Shadows, different Views, with regard either to the Position of the Eye, or the Object: What produces the Strength, Fierceness, Sweetness &c. in Paintings well *colour'd*: The various Manners of *colouring*, both in Figures, Landskips &c.

The Doctrine of Colouring is comprised under the following Rules.

Colours are consider'd, either in respect of their Use, or their Oeconomy and Disposition.

1st With regard to their *Use*. They are either in Oil, or Water: Those in Oil, again, are either consider'd with a View to their Preparation or Application. *In the Preparation of Oil Colours*, care must be taken that they be ground fine; that in putting them on the Pallet, those which won't dry of themselves, be mix'd with Oil, or other Dryers; and that ting'd *Colours* be mix'd in as small Quantities as possible. For their *Application*, it is consider'd either with regard to the Kinds of Painting in Works of various *Colours*, or in those of one single *Colour*.

For the *first*: in the larger Pieces, the *Colours* are either laid on full, so as they may be *impasted*, or incorporated together, which makes them hold more firmly. Or else we mix those more agreeable ones, which dry too hard, and too hastily, with a little *Colour*, and the clearest of the Oil: But in both Cases, the *Colours* are to be laid on strong at first; it being easy to weaken those that are to be thrust back, and to heighten the others: The Touches to be bold, by the Conduct of a free and steady Pencil; that the work may appear the most finish'd at a proper distance, and the Figures animated with Life and Spirit. [. . .]

For the 2nd Part of *Colouring*, or the *Oeconomy* and dispensing thereof in Paintings; regard is either had, first, to the Qualities of the *Colours*, to appropriate them according to their Value and Agreement: or secondly, to their Effect, in the Union and Oeconomy of the Work. For the first, it must be observ'd that *white* represents Light, and gives the briskness and heightening; *black*, on the contrary, like Darkness, obscures and effaces the Objects: again, black sets off the light Parts; and by that they serve each other to loosen the Objects. A proper Choice to be made of *Colours*, and the too much charg'd manner to be avoided [. . .]

For the *Effects of Colours*, they either regard the Union, or the Oeconomy: With respect to the first, care must be taken that they be laid so as to be sweetly united under the briskness of some principal one; that they participate of the prevailing Light of the Piece; and that they partake of each other by the communication of Light, and the help of Reflection. For the Oeconomy in managing their degrees, regard is to be had to the *Contrast*, or Opposition intervening in the Union of *Colours*; that by a sweet Interruption, the briskness, which otherwise fades and palls, may be rais'd to the Harmony which makes the Variety of *Colours* agree; supplying and sustaining the Weakness of some by the Strength of others; neglecting some Places on purpose to serve as a Basis or Repose to the Sight, and to enhance those which are to prevail thro' the Piece. [. . .]

PERSPECTIVE, the Art of Delineating visible Objects on a plane Surface, such as they appear at a given Distance or Height, upon a transparent Plane, placed perpendicular to the Horizon, between the Eye and the Object.

This, we particularly call *linear Perspective*, as regarding the Position, Magnitude, Form &c. of the several Lines, or Contours of Objects; and expressing their Diminution: In opposition to the *Aerial Perspective*, which regards the Colour, Lustre,

Strength, Boldness &c. of distant Objects consider'd as seen thro' a Column of Air; and expresses the Diminutions thereof. The former is a Branch of Mathematicks: Some make it a member of Opticks; others a rivulet therefrom; and its Operations are all geometrical. The latter is a Part of Painting, and consists wholly in the Conduct of the Colours, their different Teints, or Degrees, Force, Weakness &c.

SCULPTURE, the Art of Cutting or Carving Wood, Stone, or other Matter, to form various Figures for Representations; as also of fashioning Wax, Earth, Plaister &c. to serve as Models, or Moulds for the Casting of Metal Figures. *Sculpture*, in its Latitude, includes both the art of working in Creux, properly called *Engraving*, and of working in Relievo, which is what we strictly call *Sculpture*.

The Antiquity of this Art is past Doubt; as the Sacred Writings, the most ancient and authentic Monuments we have of the earliest Ages, mention it in several Places: Witness Laban's Idols stolen away by Rachel, and the Golden Calf which the Israelites set up in the Desart, &c. But 'tis very difficult to fix the Original of the Art, and the first Artists, from prophane Authors; what we read thereof, being intermixed with Fables, after the Manner and Taste of those Ages. Some make a Porter of *Sicyon* named *Dibutades* the first Sculptor. Others say the Art had its Origin in the Isle of *Samos*, where one *Ideocus* and *Theodorus* perform'd Works of this Kind, long before *Dibutades*' Time. 'Tis added that *Demuratus*, Father of *Tarquin the Elder*, first brought it into *Italy* upon his retiring thither; and that by Means of *Enciropus* and *Entygramma*, two excellent Workmen herein, who communicated it chiefly to the *Tuscans*; among whom it was afterwards cultivated with great Success. They add, That *Tarquin* sent for *Tauranus*, one of the most eminent among them, to *Rome*, to make a statue of *Jupiter* &c. of baked Earth, for the Frontispiece of the Temple of that Deity. About this Time, there were many *Sculptors*, both in *Greece* and *Italy*, who wrought altogether in Earth. Some of the most noted are, *Calisthenes*, an *Athenian*, who made himself and his House famous, by the great number of Earthen Figures he adorned it withal. *Demophilus* and *Gorsanus*, two Painters, who inrich'd the Temple of *Ceres* with great Variety of Painting and Earthen Images. In effect, all the first Statues of the Heathen Deities were either of Earth or Wood; and 'twas not so much any Frailty of the Matter, or Unfitness for the Purpose, as the Riches and Luxury of the People, that first induc'd them to make them of Marble, and other more precious Stones. Indeed, how rich soever the Matter were whereon they wrought, yet they still used Earth to form Models thereof. And to this day, whether they be for cutting Marble Statues with the Chissel, or for casting them in Metal, they never undertake the one or the other without first making a perfect Model thereof in Earth. Whence, doubtless, arose the Observation of *Praxiteles*, That the Art of Moulding Earthen Figures was the natural Mother of that of making Marble and Metal Figures; which last never appeared in Perfection till about 300 Years after the building of *Rome*, though the first was at its Height long before.

Phidias of *Athens*, who came next, surpass'd all his Predecessors, both in Marble, in Ivory and in Metals: And about the same Time appeared several others who carried *Sculpture* to the highest Perfection it ever arrived at; particularly *Polyclites* at *Sicyon*; then *Myron*; *Lysippus*, who alone was allowed the Honour of casting *Alexander's* image in Brass. *Praxiteles* and *Scopas*, who made those excellent Figures now before

the Pope's Palace at *Montecavallo; Briaxis, Timotheus,* and *Leochares,* who with *Scopas* wrought at the famous Tomb of *Mausolus* King of *Caria; Cesisodorus, Canachus, Dedalus, Buthious, Nyceratus, Euphanor, Theodorus, Xenocrates, Phiromachus, Stratonicus, Antigonus,* who wrote on the Subject of his Art; the famous Authors of the *Laocoön,* vis. *Agesander, Polydore,* and *Athenodorus,* and infinite others, the Names of some whereof have passed to Posterity; those of others have perished with their Works. For though the Number of Statues in *Asia, Greece* and *Italy* were so immense, that in *Rome* alone, as we are informed, there were more than there were living Persons, yet we have but very few now left, at least very few of the finest. When *Marcus Scaurus* was Ædile, his Office obliging him to provide what was requisite towards the Publick Rejoycings, he adorned the stately Theatre, which he erected, with 3000 Brazen Statues; and though *L. Mummius* and *Lucullus* brought away a great number out of *Asia* and *Greece,* yet there were still above 3000 remaining in *Rhodes,* as many at *Athens,* and more at *Delphi:* but what is most extraordinary is the Bigness of the Figures which those ancient Artists had the Courage to undertake. Amongst those *Lucullus* brought to *Rome,* there was one of *Apollo* 30 cubits high; the *Colossus* of *Rhodes,* made by *Cares* of *Lyndos,* the Disciple of *Lysippus,* far exceeded it; *Nero's* Statue, made by *Xenodorus* after that of *Mercury,* was also of an extraordinary Size, being 110 feet high. *Sculpture,* however, did not continue above 150 years, after *Phidias's* Time till it began insensibly to decline; not but that there were still some fine Pieces of Workmanship both in *Greece* and *Italy,* though not performed with so good a Fancy, and such exquisite Beauty. [...]

STATUARY, a Branch of Sculpture, employ'd in the making of Statues. Statuary is one of those Arts where the Ancients surpass'd the Moderns. Indeed 'twas much more popular, and more cultivated, among the former than the latter.

'Tis disputed between *Statuary* and *Painting* which of the two is the most difficult and most artful. The Invention of *Statuary* was at first very coarse. *Leon Battist Alberti,* who has an express Treatise on *Statues,* imagines that it took its Rise from something casually observed in the Productions of Nature, that, with a little Help, might seem disposed to represent the Figure of some Animal. The common Story is that a maid, full of the Idea of her Lover, made the first Essay, by the Assistance of her Father's Implements, who was a Potter. This, at least, is pretty certain, that Earth is the first Matter *Statuary* was practised upon.

STATUARY is also used for the Artificer, who makes *Statues.* In this Sense we say, *Phidias* was the greatest *Statuary* among the Ancients, and *Michael Angelo* among the Moderns.

11 Anne-Claude-Philippe de Tubières, Comte de Caylus (1692–1765) 'On Drawings'

Anne-Claude-Philippe de Tubières de Grimoard de Pestels de Lévis, Comte de Caylus – to give him his full name – was a wealthy antiquary, collector, amateur of art, engraver and writer. He devoted considerable energy to the acquisition of first-hand knowledge of the

arts, travelling as a young man to see classical sites in Turkey, Greece and Italy. He formed an extensive collections of coins and archaeological fragments, and made numerous engravings after Old Master drawings. Between 1752 and 1767 he published a seven-volume work on Egyptian, Etruscan, Greek, Roman and Gaulish antiquities, which was among the earliest art-historical studies to accord serious attention to pre-classical cultures. He was appointed an honorary amateur member of the Académie Royale in 1731 and became increasingly influential in its activities. Caylus' lecture on drawing was delivered to the Académie Royale on 7 June 1732. Among his qualifications to speak on the subject was his close acquaintance with drawings in the French royal collections and in the vast private collection of Pierre Crozat, hundreds of which he had himself reproduced, following tuition in etching and engraving from Charles-Antoine Coypel (son of Antoine Coypel; see IIA8). Through the study of drawings, he believed, practitioners and connoisseurs alike may gain special insight into processes of composition and into the artist's creative character and integrity. Caylus conceives of drawing essentially as a means of expression for the painter, rather than as an end in itself, criticizing the French artist Raymond La Fage (1656–84) and the Italian Parmigianino (1503–40, Caylus' 'Parmesan') for neglecting painting at the expense of drawing. (In the latter case this criticism was certainly misdirected.) The lecture was published as 'Discours du Comte de Caylus sur les dessins' in *Revue Universelle des Arts*, vol. 9, 1859, pp. 316–23. Our version is taken from the translation of this text in Elizabeth Gilmore Holt ed., *A Documentary History of Art*, vol. II (1947), Princeton: Princeton University Press, 1958, pp. 322–6.

Since the part of the inquiry which concerns drawings is naturally included in the scheme of your lectures, I thought I might communicate to you some reflections I have made not about drawing in particular, which I regard as the basis of an art in which I can only receive lessons here, but about drawings in general, their attraction, their usefulness and the knowledge of them. Such is my project and the subject I shall discuss with you.

All that great men bring to light is with reason to be recommended to their contemporaries but still more to those who succeed them. This general reflection pertains perhaps more to the arts and to painting in particular than to all the other products of the mind. Thus we observe that for a long time the drawings of the great masters have been esteemed and sought after and we are indeed fortunate that since the very infancy of painting there have been lovers of the arts zealous enough to have preserved them for us. Our obligation to them is all the greater to my mind because drawings are one of the most attractive things for a painter or for an amateur of the arts and it is certain that one is well advanced in connoisseurship of the arts when one knows how to read them well.

What is more agreeable than to follow an artist of the first rank in the need he had to produce, or in the first idea which struck him for a production, whose final execution one can compare, to delve into the different changes his reflections caused him to make before arresting his work, to seek to appraise them, to see oneself finally in his very studio and to be able to form one's taste by examining the reasons that prompted him to make changes. After having examined these first thoughts, with what pleasure does one not see studies correctly made from Nature, the nude parts of a draped figure, the details of this same drapery? Finally, all the parts that have contributed to the perfection of the painting or of the work which the Universe

admires. It also seems to me that the great artists make us experience impressions similar to those they themselves have felt. Poetry warms us in their first conceptions, Wisdom and Truth strike us in the finished things.

It seems to me that a simple stroke often determines a passion and proves how much at that time the mind of the author felt the force and the truth of the expression. The inquisitive eye and the animated imagination are pleased and flattered to finish what often is only sketched. The difference found in my opinion between a beautiful drawing and a beautiful painting is that in one, one may read in proportion to his ability all that the greater painter has wanted to represent and in the other, one has himself finished the object offered you. Consequently one is often more stimulated by the sight of one than by that of the other, for, the reasons for satisfaction and for the preference men accord to something must always be looked for in self-esteem. The only drawback to be found in this charming section of the art you practice, gentlemen, is the way in which several painters have let themselves be carried away by the pleasure of drawing. They have neglected painting to attach themselves solely to drawing. They have yielded entirely to the pleasing attraction of quickly tossing their ideas on paper, as well as to that of imitating nature in land-scapes and in the other beauties with which she so well knows how to pique the taste of her admirers.

However well these persons whom I have just mentioned have drawn, one must recognize that it is always a kind of licentiousness which should be censured. It is an ill consequence into which one must always prevent especially the young from falling with even more severity as this lazy process increases each day one's aversion to painting. On this subject, gentlemen, I will bring you the example furnished me by a Frenchman and an Italian, both eminent; one is the Parmesan and the other La Fage, and their works are an obvious proof of what I have just set forth. The first did very few pictures, the second none at all, and even the drawings that he wished to finish have constantly lost therefrom, their initial fire being extinguished. Without going into details of their styles, I will only tell you that it seems to me that one of them took up the graceful side of Raphael, or, to express it better, he was so possessed by this aspect of the works of that great man, that through the desire to make it perceptible to himself, he fell into the error of those who exaggerate. As for the other artist, he produced with an almost supernatural ardor the way of delineating muscles and his emphasized contours sometimes recall the conception of Michelan-gelo. Be that as it may, they both drew well, their pen was charming, and La Fage knew, so to speak, how to represent torrents of figures. But it seems to me that in recognizing the pleasure given by this sort of drawing, one must admit after all that they lack the solidity one finds in the great painters. The latter have as foundation the indication of color and that Economy, wise and majestic, which must rule in the compositions of pictures. So, strictly speaking, one could refuse to the Parmesan and La Fage the name of Painter, for in an examination of their drawings one finds neither that primal idea nor that reflection which proves that the work was composed in the mind before being put on paper. Harmony, this gift from heaven, the under-standing of chiaro-scuro, and perhaps the habit of using color are therefore alone able to contribute to the beauty of the work I am discussing with you. These reflections prove to me the necessity to study these aspects and of never setting them aside. I

flatter myself to have proved to you, gentlemen, how much they are to be recommended to a painter, since they make themselves felt with pleasure when perceived and wished for when they are not found in those very drawings which appear at first sight not to need them in order to please.

Harmony and the understanding of chiaro-scuro, which emanate solely from a greater profundity in art, seem to me lacking therefore not only in the sketches of those I have just named but in those of artists who only draw. One will see in their works a beautiful outline they will have given to a figure. They will make a beautiful grouping of nudes but true taste will not be fully satisfied by the study of their works.

This would be the place to speak of the abuse of sketches without straying too far from my subject, but it is not for me to teach. I have only resolved to test a few reflections. I am but an amateur and the amateur and the master must speak differently. The one may reflect, the other must give lessons, and I await them from you, Gentlemen.

I believe I have shown you in general what produces the attraction in the study and the knowledge of drawings. Now I will consult you on the usefulness that I believe they may have for the painter or for the amateur.

I am convinced that the great man is formed only by the gifts of nature; but this nature, beautiful as she may be, needs cultivation and adornments and the sight of beautiful drawings is one of the means that should be all the more employed for this purpose, as it smooths away a great number of the difficulties present at each step in the practice of an art so extensive as that of painting. Nothing so excites the genius of a Painter or gives him that inner fire so necessary to composition as the examination of a fine drawing. Here is already a useful purpose of considerable worth. In drawings one sees exposed and without any deception the manner in which the painter has known how to read nature and the manner in which he has sometimes known how to take a pleasing liberty [with it].

This reflection again makes the study of drawings commendable for me, but one of the most considerable arguments to my mind is that affectation reveals itself completely in drawings. Consequently they can prevent one from falling into this capital fault and they can correct a bad education as well as a false taste to which one has yielded. Color can sometimes make one excuse the fault of affectation in a picture, while a drawing with, so to speak, no covering, can invite and convince him who studies it to recognize the full extent of this drawback, even more so as the comparison one can make with similar works easily makes one sensitive to the true and to the beautiful imitation of Nature.

When I criticize affectation here, I do not mean to speak of the style and of the technique by which one distinguishes works of one man from those of another. I only wish to speak to you of the abuse of that manner which makes one draw from memory even though after nature. An abuse one has seen only too much at all times in the works of those who neglect Nature, or who submit her to habit; of those finally who sacrifice [her] to the imagination.

Moreover, the study of drawings uncovers the different routes that so many able persons have taken to arrive at the same goal. These routes are infinite and prove that when Nature has endowed a man with feelings he only has to give free rein to his

inspiration and to the lessons that Nature alone can give. Thereafter he will deserve admirers in one domain or another of all those which compose this art.

All these reasons would lead me to counsel a Painter to possess drawings and to study them. Rubens often did so and his example is particularly good to follow since there are moments when the more dormant genius needs to be awakened. One can study without becoming a slave and the criticism one can make of the weakest part of a drawing is often a marvellous lesson. I said that a Painter should abandon himself to the talent given him by nature. I am far from denying this, but at the same time I believe that an artist whose aim is the perfection of his art should not scorn or ignore the works of others. If he wishes to owe absolutely nothing to anyone but himself, he walks a road that is bound to lead him astray. [. . .]

12 Anne-Claude-Philippe de Tubières, Comte de Caylus (1692–1765) 'The Life of Antoine Watteau'

As an honorary member of the Académie Royale (see IIA11), Caylus had a hand in reviving the programme of 'Conferences' that had fallen into abeyance, and he became prominent among those advocating a return to a more expressive and elevated form of history painting along authentically classical lines (see IIIC4). It is in the light of this advocacy that we should understand the reservations he offers in writing of a painter whom he claims as a former close friend. Antoine Watteau ($c.$1684–1721; 'Wateau' is a variant spelling now rarely used) had been among the most successful French painters of the early eighteenth century. The types of composition in which he excelled had their origins in theatrical scenery and iconography and in rococo decoration, and were thus disqualified from the highest status in the eyes of the Academy. It was a testimony to Watteau's exceptional drawing skills and to the elusive emotional content with which he invested his work that the Academy accepted the *Pilgrimage to the Isle of Cythera* (now in the Louvre) as the *morceau de réception* (reception piece) finally confirming his membership in 1717. In doing so they were implicitly recognizing the genre of *fêtes galantes* that he had made his own. Watteau left no statement of his own concerning his work, but several accounts of his career were written after his early death, while engravings of his paintings and drawings were issued in considerable numbers. Caylus' text was read at the Academy on 3 February 1748. It was published by Edmund and Jules de Goncourt in *L'Art du dix-huitième siècle*, Paris, 1860. Our version is taken from the translation of this work by Robin Ironside, *French XVIII Century Painters*, London: Phaidon Press, 1948, pp. 10–26.

Antoine Wateau was born at Valenciennes in 1684. He was the son of a tiler. Birth is of no consequence in the eyes of philosophers and artists except in so far as it may facilitate education, but when it is of this humble kind it affords a convincing proof of talent and genius bestowed by Nature.

This proof is reinforced in the present instance by the severity which was the dominant characteristic of Wateau's father. It was with great reluctance that he was persuaded to place his son, whom Nature was already inspiring with the desire to imitate her, as apprentice to a painter working in his own town. What he did while with this painter is unknown to us and we need not regret our ignorance; for I seem to recall that this master was one who disposed of his pictures according to their

measurements, or at least that his standards were similar, and the point is not worth our discussion.

However that may be, the father was unwilling to provide the expenses of this education for any length of time. Not that he was in a position to judge how unprofitable it might be from the artistic point of view, but he wished to force his son to embrace his own profession. Wateau had more exalted ideas, or, at any rate, Painting had already destined him for her own; and so, rather than settle down in his father's profession, he left him and travelled to Paris, by what rustic means of transport one may imagine, in order to devote himself there to the Muse whom he already loved but scarcely knew.

Ill-informed and helpless, the Pont Notre-Dame was a resource he was only too happy to discover. This miserable factory of hundredth-hand copies made with stiff colours applied flat, even more hostile to the development of taste than illumination which at least preserves the forms of an engraving, was hardly suited to the sentiments that he had received in germ from nature. But to what depths are we not reduced by necessity? [...]

Instead of being discouraged by this pitiable occupation, he redoubled his efforts to rise above it. Such moments of freedom as he enjoyed – public holidays, even the nights – were devoted to drawing from nature. He set an example whose value to the young could hardly be over-emphasized – an example which is all very well on paper, the idlers will reply, but of which we may certainly say that only the love of art could ever inspire it. However that may be, continual study is never fruitless, or without some strengthening effect upon natural disposition. Nor, indeed, could we cite many instances of the same passionate industry that had not been followed by pronounced success.

With this grounding of study and these excessive powers of application, he prepared himself to leave the dismal employment to which necessity had reduced him. He made the acquaintance of Gillot who, at about the same time, had just become a member of this Academy. Gillot was an artist who was known as a painter of bacchanals, of other fanciful or even historical subjects, and had also concerned himself with decoration and fashion: he was now, however, largely confining himself to the representation of themes from the Italian Comedy. For Wateau, this meeting was to prove a stroke of fortune. It was, indeed, this type of subject which determined once and for all the direction of his taste, and the pictures of his new master opened his eyes to various aspects of the art of painting whose existence he had hitherto merely suspected. [...]

Wateau's talent was now unmistakably, though still faintly, evident; and he was still in need of further enlightenment. This he found; on leaving Gillot, he was received as a pupil by Claude Audran, concierge of the Luxembourg, an estimable character and a skilful decorator who, in this latter capacity, worthily upheld the reputation of the family which has provided your Academy with so many gifted members.

He was, moreover, a man of natural taste. Ornamentation had been his principal study, ornamentation of the kind that was used by Raphael at the Vatican and elsewhere by his pupils, of the kind also that Primaticcio employed at Fontainebleau. Audran revived the fashion of the latter's compositions, and it was due to his

activities that the heavy and oppressive taste of his own predecessors was forgotten. His works were designed, by the reservation of blank spaces, for the reception of figure or other subjects in accordance with the wishes of the various patrons whom he had inspired with a desire to have their walls and ceilings decorated in this manner; it was thus that artists in differing genres found employment in his studio.

And it was there that Wateau's taste for decoration was formed and that he developed that lightness of brushwork required by the white or gilded backgrounds on which Audran's designs were carried out. Skilful examples of his work can be seen at the Ménagerie at Versailles, and there are fine ceilings after his designs at the Château of Meudon.

But I must confess that it is with some regret that I speak with a kind of admiration of his work; for it resulted not only in the demolition of ceilings that had been painted by some of the most gifted artists, but the change of fashion involved, which has now been succeeded by the taste for plaster decoration, deprived you, as you are still deprived, of an opportunity of exercising your talents in a branch of art that encourages the expression of what is noble and heroic.

But let me return to Wateau. It was while he was living in the Luxembourg that he studied and copied, with avidity, some of the finest works of Rubens, that he drew, unremittingly, the trees of that beautiful garden which, less strictly planned, as it is, than those of the other royal houses, provided him with innumerable viewpoints, with that infinity of motives which only landscape painters are able to extract. [...]

So far, we have observed simply a young man intent, without any special advantages, on perfecting his talent, a young man who is assiduous and who is at once his own tutor and the architect of his own reputation. In what follows we shall examine this talent in its developed form; but we shall see it in the coils of a life agitated by inconstance and by the artist's disgust with himself and with humanity.

He left Audran when he had mastered those aspects of the art of painting which I have indicated in the foregoing account of his studies. He was so thoroughly versed in their practice that he was able to depart entirely from the manner of Gillot. He carried out a group of pictures, representing soldiers on the march or resting, in a style entirely opposed to that of his master; and these early works are perhaps equal in quality to the finest productions of his maturity. They are full of harmony and colour, the heads are subtly and intelligently perceived, and the brushwork preserves the particular quality of his drawing even in the extremities and the draperies and, generally, in his conception of the subject.

I cannot make up my mind to attribute the separation from Audran to his inconstant temper. Wateau was aware of his own powers. He had intelligence and he was not the dupe of his master's, who was no better endowed with this quality than he was with a knowledge of the world and who, moreover, finding it very convenient to retain Wateau's services for his own profit, was anxious to subvert his taste for any kind of work except that with which he entrusted him....

A desire to visit Rome and to benefit there from the excellent academy established by Louis XIV alike for the general advancement of art and the instruction of students, enrolled him, for a period, among the competitors for the prize offered by your school. He won the second prize in 1709, but he was not entitled to make the

journey to Italy; he had to be content, therefore, with continuing his studies in Paris, but he pursued these without renouncing his project of a visit to Rome.

With this object in mind, he submitted to you, in 1712, a group of pictures executed in his more personal style and much superior to the earlier prize-winning composition. A mature and distinguished talent and the inexpedience of the journey he wished to make were the motives that induced the Academy to receive him as a member. His reception was signalized by the support of M. de la Fosse, a man esteemed both for excellence of character and for achievement in various branches of painting; he asserted Wateau's merits and, though knowing him only by his works, took an active interest in his candidature.

It is thus that truth should prevail in the deliberations of the Academy; personal preferences are not a ground for the admission or exclusion of applicants. Prejudices for or against particular persons, based on their connexions, constitute a grave defect. Talent alone should influence our decisions, and shed lustre upon our choices. It was shortly after the Academy had conferred this merited honour upon Wateau that I made his acquaintance.

But the honour you did him and the originality and novelty of his style attracted more commissions than he was willing or able to deal with. It was not long before he also began to suffer from those importunities that distinguished talents tend to draw upon themselves in large towns where semi-connoisseurs abound, all too eager to inflict their presence in studios and private collections. And to what purpose? Merely to talk continual nonsense, to disturb and interrupt those meditations and researches that are so essential to the production of fine work. The best they can do is to utter false praise; flattery, indeed, is their main function. How wearisome and tormenting for an artist to have such people call upon him and establish themselves in his house and to be unable to get rid of them! For they are a tenacious species as impatient to make their appearance as they are difficult to dismiss.

Their multitude is usually followed by those dealers in second-hand goods, self-styled virtuosi of the art, who know how to take advantage of a practice which is common in society and weighs heavily upon painters with any facility of execution.

These persons take possession of sketches and present themselves with studies; and, what is worse, solicit the retouching of the mere leavings of the studio which they amass in heaps; and their whole object is to procure a complete painting by a master which should cost them little or nothing. There is no trick to which they will not stoop to achieve this end.

Wateau was persecuted by them; he distinguished easily these two types of importunates, understood them admirably, and being by nature caustic, he revenged himself in general by depicting in his work the personalities and intrigues of those by whom he was most sorely beset. In particular instances, however, he was none the less their dupe. Moreover, satirical caricature was no consolation for the tedium which in the end overpowered him. I have often seen him distracted to the point of wishing to abandon his vocation.

It might be thought that his brilliant success with the public would have flattered his self-esteem sufficiently to save him from such trifling annoyances. But his temperament was such that he was continually sickened by what he was doing. I believe that one of the strongest reasons for this disgust had, as its motivating

principle, the elevated views he entertained on the art of painting. I am in a position to affirm that he conceived the art more nobly than he practised it, an attitude of mind that was unlikely to prejudice him in favour of his own productions. The prices they fetched left him equally unaffected, and were, indeed, much smaller than those he could have obtained. Money he neither loved nor desired, and was thus deprived of that powerful support that so many have found in the mere passion for gain. . . .

Wateau was by temperament not only caustic but also timid, two characteristics that Nature rarely combines in the same personality. He had a quick intelligence, and though he had received no education, he was an acute, even a fastidious, judge of music and the arts. Reading was his great recreation. He knew how to take advantage of what he had read; but, though, in general, he discerned and was able to represent with remarkable insight the absurdities of those importunates who came to disturb his labours, he had not, as I have said, a strong character and was easily defrauded, imposed upon and deceived.

Possessed of an agreeable reputation, he had no enemies but himself, and a certain spirit of instability which dominated him. No sooner had he established his residence anywhere than he took an aversion to the place. Time after time, he changed his abode, and always on some specious pretext that he was moved to devise by a sense of shame at his behaviour. He was apt to stay longest in some rooms of mine in various quarters of Paris which we used only for painting, drawing and posing the model. In these retreats, consecrated exclusively to art, free from all importunities, he and I, together with a third friend impelled by the same tastes, experienced the joys of youth combined with the vivid pleasures of the imagination, a happiness which was perpetually enhanced by the charms of the art of painting. I may say that Wateau, so morose, so splenetic, so timid, so caustic everywhere else, was there purely the Wateau of his pictures, an artist, that is to say, such as they evoke, tender, agreeable, faintly bucolic.

It was in this seclusion that I recognized, to my advantage, how deeply Wateau thought about painting, and how inferior was his execution to his ideas. Indeed, since he had no knowledge of anatomy and had never drawn from the nude, he was unable either to comprehend or express it; so much so that the complete rendering of an academy study was for him an exacting and consequently a disagreeable exercise. The female body, requiring less articulation, was somewhat easier for him. Such difficulties illustrate my earlier observation that the dislike for his own work which so often affected him arose from his being in the situation of a man who thinks better than he acts.

A particular result of this deficiency of draughtsmanship was an inability to paint or to compose anything in the heroic or allegorical vein, or to render the human figure on a large scale. The *Four Seasons* that he painted for the dining-room of M. Crozat are a proof of this assertion. The figures here are almost half life-size, and though they were executed after sketches by M. de la Fosse, they display so much mannerism and aridity that one can find nothing to say in their favour. The style of these paintings differs only from that of his small-scale works in the treatment of the nude and in the draperies; but that light and subtle touch which is so effective in small pictures loses its value and becomes intolerable when employed over a large area such as, in this instance, was unavoidable.

Fundamentally, it must be agreed, Wateau was an infinitely mannered artist. Though he was endowed with certain graces and is captivating in his favourite subjects, his hands, his heads, even his landscape, all suffer from this defect of mannerism. Taste and general effect are his best qualities and these produce, it is true, very charming illusions, more especially as his colour is good, and very exact in the rendering of stuffs which he drew in a peculiarly delightful way. It should be added that he hardly ever painted other stuffs than silk, which falls always in small folds. But his draperies were well disposed and the pattern of the folds was correct because he always drew from nature and never made use of a lay-figure. His choice of local colour was good and was never out of harmony with his tonality. Finally, his delicate touch infused a life and piquancy into everything he painted.

M. Crozat, who was fond of artists, offered Wateau board and lodging at his house. The offer was accepted. This fine establishment, which at that time housed a greater number of valuable paintings and curios than perhaps any private owner had hitherto brought together, provided the artist with a thousand new incentives. Of these the most exciting to his taste was the large and admirable collection of drawings by the great masters. He was affected by those of Jacopo Bassano; and still more so by the studies of Rubens and Van Dyck. He was charmed by the fine inventions, the exquisite landscape backgrounds, the foliage, revealing so much taste and understanding, of Titian and Campagnola, whose secrets he was able to explore in these drawings. And, since it is natural to consider things in relation to their possible usefulness, it was to these last qualities that he most readily gave attention, rather than to those other qualities of arrangement, composition and expression in the works of the great history painters whose talents and purposes were so remote from his own. These he was content to admire without seeking to adapt himself to them by any special course of study, from which, indeed, he would have derived scant advantage.

It was here that I and M. Henin, the friend to whom I have referred, were able to assist him by preparing copies of drawings by the best Flemish masters and by those two great Italian landscape painters, copies which we carried just sufficiently far for him to capture the finished effect himself by the addition of a few touches. This was to serve him as he would have wished; in everything he required rapidity. And I shall always maintain that, in painting, it was to effects of rapidity that he was most sensitive.

The painting of small pictures facilitates the achievement of such effects. The most trifling adjustment makes or mars their expressive quality. Indeed, there are instances when the principal credit for their success should be assigned to chance. Wateau, in order to stimulate rapidity both of effect and execution, liked to apply his paint thickly. This device has always been widely employed, and the greatest masters have had recourse to it. But to practise it successfully, elaborate and adroit preparations are required, and Wateau hardly ever made them. As some sort of remedy for this omission, he had the habit, when wishing to correct a picture, of heedlessly rubbing it with thick oil and then repainting. The momentary advantage he gained in this way subsequently caused considerable damage to his pictures, damage to which a certain untidiness in his procedure, that must have injured his colour, also greatly contributed. It was very rarely that he cleaned his palette, and he sometimes went for several days without doing so. The pot of thick oil, of which he made so much use, was full

of dirt and dust and mixed with all sorts of colours which adhered to his brushes when he dipped them into it. How remote was this method of procedure from the exceptional precautions that certain Dutch painters used to take in order to work cleanly! In this respect, Gerard Dow, among others, has often been quoted; and it has been observed how he ground his colours on a mirror, that he took infinite precautions to prevent their corruption by a single atom of dust, and that he always cleaned his palette himself and even the handles of his brushes...

I do not suppose that you, however, would look upon these details as mere trifles. It seemed to me necessary to record them as a recommendation of that care and cleanliness in the use of colour which is a too essential condition of the preservation and survival of pictures for me to refrain from emphasizing the consequences of its neglect for the benefit of any who may have so utterly disregarded it as Wateau. It was listlessness and laziness that prompted this disregard, even more than that vivacity which may be inspired by an eager need to transfer at once to the canvas some effect conceived in the imagination. It was a need that seized him at times, but it was less compelling than his pleasure in drawing. The exercise of drawing had infinite charms for him and although sometimes the figure on which he happened to be at work was not a study undertaken with any particular purpose in view, he had the greatest imaginable difficulty in tearing himself away from it.

I must insist that in general he drew without a purpose. For he never made an oil sketch nor noted down the idea, in however slight or summary a form, for any of his pictures. It was his habit to do his drawings in a bound book, so that he always had a large number that were readily available. He possessed cavalier's and comedian's costumes in which he dressed up such persons as he could find, of either sex, who were capable of posing adequately, and whom he drew in such attitudes as nature dictated and with a ready preference for those that were the most simple. When it took his fancy to paint a picture, he resorted to his collection of studies, choosing such figures as suited him for the moment. These he usually grouped so as to accord with a landscape background that he had already conceived or prepared. He rarely made use of them in any other way.

This method of composing, which is certainly not one to be followed, is the real reason for that uniformity with which Wateau's pictures may be reproached. Without being aware of it, he repeated, on many occasions, the same figure; and it is this also which gives engravings after his work a kind of monotony, a kind of general similarity which prohibits the production of any quantity of them. In a word, with the exception of one or two of his pictures, such as 'L'Accordée de village' (or 'La Noce de village') ['The Village Betrothal' or 'The Village Marriage'], 'Le Bal' ['The Ball'], the trade sign painted for the sieur Gersaint, and 'L'Embarquement de Cythère' ['The Embarkation for Cythera'], which he painted for his reception into our Academy and which he has repeated, his compositions have no precise object. They do not express the activity of any passion, and are thus deprived of one of the most affecting aspects of the art of painting, that is, of action. Action alone, as you are aware, gentlemen, may animate your compositions, particularly in the heroic vein, with that sublime fire which speaks to the spirit, takes possession of it, transports it and fills it with wonder and admiration.

I should not forget to observe here that Wateau was not received as a member of your Academy until five years after his candidature had been approved; that is to say, on 28 August 1717. His dilatoriness in executing and supplying the picture required by the conditions of membership was the only cause of this delay. It even proved necessary to issue two summonses before he complied with this rule.

IIB
Imagination and Understanding

1 John Locke (1632–1704) 'Of the Association of Ideas' from *An Essay Concerning Human Understanding*

John Locke was a formative influence on the development of British empiricism. His *Essay Concerning Human Understanding* brought about a profound change towards subjectivism, giving priority to sensation as the basic or most fundamental unit of human knowledge. In opposition to the rationalism of Descartes, with its emphasis on innate ideas and the deductive power of reason, Locke placed a new emphasis on the data of the senses. His starting-point was not general truths of reason, but the information given through sensation. This new approach had an enormous impact on the subsequent development of aesthetics, though Locke himself did not write directly on the subject. The influence of his ideas can be seen in the work of figures such as Du Bos (IIB6), Hutcheson (IIB7), Hume (IIIB5) and Burke (IIIB6). His writings also contributed to awakening a new interest in psychology and the workings of the mind. The first edition of *An Essay Concerning Human Understanding* was published in 1690. In a chapter added to the fourth edition of the book in 1700, Locke addressed the phenomenon of the association of ideas, arguing that through sufficiently powerful or repeated experiences we can develop likings or aversions which are 'accidental' and bear no necessary connection to the objects themselves. Later theorists such as Archibald Alison (VA11) subsequently developed this idea in relation to questions of art and beauty. For these 'Associationists', beauty is not a quality of objects but a feeling in the perceiver's mind, the origin of which is to be traced to the connection between ideas which arises on the basis of experience. The following excerpt is taken from the edition of Locke's *Essay Concerning Human Understanding* edited by Peter H. Nidditch, Oxford: Clarendon Press, 1975, chapter XXXIII, 'Of the Association of Ideas', pp. 395–400.

§5. Some of our *Ideas* have a natural Correspondence and Connexion one with another: It is the Office and Excellency of our Reason to trace these, and hold them together in that Union and Correspondence which is founded in their peculiar Beings. Besides this there is another Connexion of *Ideas* wholly owing to Chance or Custom; *Ideas* that in themselves are not at all of kin, come to be so united in some Mens Minds, that 'tis very hard to separate them, they always keep in company, and

the one no sooner at any time comes into the Understanding but its Associate appears with it; and if they are more than two which are thus united, the whole gang always inseparable shew themselves together.

§6. This strong Combination of *Ideas*, not ally'd by Nature, the Mind makes in it self either voluntarily, or by chance, and hence it comes in different Men to be very different, according to their different Inclinations, Educations, Interests, *etc*. Custom settles habits of Thinking in the Understanding, as well as of Determining in the Will, and of Motions in the Body; all which seems to be but Trains of Motion in the Animal Spirits, which once set a going continue on in the same steps they have been used to, which by often treading are worn into a smooth path, and the Motion in it becomes easy and as it were Natural. As far as we can comprehend Thinking, thus *Ideas* seem to be produced in our Minds; or if they are not, this may serve to explain their following one another in an habitual train, when once they are put into that tract, as well as it does to explain such Motions of the Body. A Musician used to any Tune will find that let it but once begin in his Head, the *Ideas* of the several Notes of it will follow one another orderly in his Understanding without any care or attention, as regularly as his Fingers move orderly over the Keys of the Organ to play out the Tune he has begun, though his unattentive Thoughts be elsewhere a wandering. Whether the natural cause of these *Ideas*, as well as of that regular Dancing of his Fingers be the Motion of his Animal Spirits, I will not determine, how probable soever by this Instance it appears to be so: But this may help us a little to conceive of Intellectual Habits, and of the tying together of *Ideas*.

§7. That there are such Associations of them made by Custom in the Minds of most Men, I think no Body will question who has well consider'd himself or others; and to this, perhaps, might be justly attributed most of the Sympathies and Antipathies observable in Men, which work as strongly, and produce as regular Effects as if they were Natural, and are therefore called so, though they at first had no other Original but the accidental Connexion of two *Ideas*, which either the strength of the first Impression, or future Indulgence so united, that they always afterwards kept company together in that Man's Mind, as if they were but one *Idea*. I say most of the Antipathies, I do not say all, for some of them are truly Natural, depend upon our original Constitution, and are born with us; but a great part of those which are counted Natural, would have been known to be from unheeded, though, perhaps, early Impressions, or wanton Phancies at first, which would have been acknowledged the Original of them if they had been warily observed. A grown Person surfeiting with Honey, no sooner hears the Name of it, but his Phancy immediately carries Sickness and Qualms to his Stomach, and he cannot bear the very *Idea* of it; other *Ideas* of Dislike and Sickness, and Vomiting presently accompany it, and he is disturb'd, but he knows from whence to date this Weakness, and can tell how he got this Indisposition: Had this happen'd to him, by an over dose of Honey, when a Child, all the same Effects would have followed, but the Cause would have been mistaken, and the Antipathy counted Natural. [...]

§9. This wrong Connexion in our Minds of *Ideas* in themselves, loose and independent one of another, has such an influence, and is of so great force to set us awry in our Actions, as well Moral as Natural, Passions, Reasonings, and Notions

themselves, that, perhaps, there is not any one thing that deserves more to be looked after.

§10. The *Ideas* of *Goblines* and *Sprights* have really no more to do with Darkness than Light; yet let but a foolish Maid inculcate these often on the Mind of a Child, and raise them there together, possibly he shall never be able to separate them again so long as he lives, but Darkness shall ever afterwards bring with it those frightful *Ideas*, and they shall be so joined that he can no more bear the one than the other.

§11. A Man receives a sensible Injury from another, thinks on the Man and that Action over and over, and by ruminating on them strongly, or much in his Mind, so cements those two *Ideas* together, that he makes them almost one; never thinks on the Man, but the Pain and Displeasure he suffered comes into his Mind with it, so that he scarce distinguishes them, but has as much an aversion for the one as the other. Thus Hatreds are often begotten from slight and almost innocent Occasions, and Quarrels propagated and continued in the World.

§12. A Man has suffered Pain or Sickness in any Place, he saw his Friend die in such a Room; though these have in Nature nothing to do one with another, yet when the *Idea* of the Place occurs to his Mind, it brings (the Impression being once made) that of the Pain and Displeasure with it, he confounds them in his Mind, and can as little bear the one as the other.

§13. When this Combination is settled and whilst it lasts, it is not in the power of Reason to help us, and relieve us from the Effects of it. *Ideas* in our Minds, when they are there, will operate according to their Natures and Circumstances; and here we see the cause why Time cures certain Affections, which Reason, though in the right, and allow'd to be so, has not power over, nor is able against them to prevail with those who are apt to hearken to it in other cases. The Death of a Child, that was the daily delight of his Mother's Eyes, and joy of her Soul, rends from her Heart the whole comfort of her Life, and gives her all the torment imaginable; use the Consolations of Reason in this case, and you were as good preach Ease to one on the Rack, and hope to allay, by rational Discourses, the Pain of his Joints tearing asunder. Till time has by disuse separated the sense of that Enjoyment and its loss from the *Idea* of the Child returning to her Memory, all Representations, though never so reasonable, are in vain; and therefore some in whom the union between these *Ideas* is never dissolved, spend their Lives in Mourning, and carry an incurable Sorrow to their Graves.

§14. A Friend of mine knew one perfectly cured of Madness by a very harsh and offensive Operation. The Gentleman, who was thus recovered, with great sense of Gratitude and Acknowledgment, owned the Cure all his Life after, as the greatest Obligation he could have received; but whatever Gratitude and Reason suggested to him, he could never bear the sight of the Operator: That Image brought back with it the *Idea* of that Agony which he suffer'd from his Hands, which was too mighty and intolerable for him to endure. [. . .]

§16. Instances of this kind are so plentiful every where, that if I add one more, it is only for the pleasant oddness of it. It is of a young Gentleman, who having learnt to Dance, and that to great Perfection, there happened to stand an old Trunk in the Room where he learnt. The *Idea* of this remarkable piece of Household–stuff, had so mixed it self with the turns and steps of all his Dances, that though in that Chamber

he could Dance excellently well, yet it was only whilst that Trunk was there, nor could he perform well in any other place, unless that, or some such other Trunk had its due position in the Room. If this Story shall be suspected to be dressed up with some comical Circumstances, a little beyond precise Nature; I answer for my self, that I had it some Years since from a very sober and worthy Man, upon his own knowledge, as I report it; and I dare say, there are very few inquisitive Persons, who read this, who have not met with Accounts, if not Examples of this Nature, that may parallel, or at least justify this.

§17. Intellectual Habits and Defects this way contracted are not less frequent and powerful, though less observed. Let the *Ideas* of Being and Matter be strongly joined either by Education or much Thought, whilst these are still combined in the Mind, what Notions, what Reasonings, will there be about separate Spirits? Let custom from the very Childhood have join'd Figure and Shape to the *Idea* of God, and what Absurdities will that Mind be liable to about the Deity?

2 Anthony Ashley Cooper, third Earl of Shaftesbury (1671–1713) from 'The Moralists, a Philosophical Rhapsody'

The early education of Anthony Ashley Cooper, third Earl of Shaftesbury, was carried out by the philosopher John Locke (see IIB1) who was a member of the household of his grandfather, the first Earl of Shaftesbury. Although Shaftesbury, like his grandfather, initially entered into politics, ill-health obliged him to retire from active life. From 1702 he pursued the interests of an intellectual and a connoisseur. His most important contributions were in the domain of moral philosophy. He was one of the first to propound that we have a 'moral sense', an innate capacity to distinguish virtue from vice. His philosophy owes as much to Neoplatonism as to Locke's empiricism, and much of its complexity arises from his attempt to combine these two seemingly incompatible approaches. Shaftesbury himself describes his treatise 'The Moralists' as a 'philosophical rhapsody'. It is subtitled a 'recital of conversations on natural and moral subjects'. In the excerpt reproduced here, Theocles seeks to awaken in Philocles admiration and awe for the works of nature. Theocles' celebrated hymn to the natural world is informed both by a pantheistic admiration for nature's divine order and harmony and by a recognition of the terror which its more 'sublime' aspects can induce. (For Burke on the sublime, see IIIB6.) Significantly, Theocles maintains that the enjoyment of beauty is quite distinct from any desire to possess the thing which we admire. Passages such as these have encouraged later thinkers to recognize Shaftesbury as the founder of the modern notion of disinterested pleasure. However, it is important to note that Shaftesbury does not distinguish between beauty and goodness; moral and aesthetic pleasure are seen to arise from the same basic source. 'The Moralists' was first published in 1709. It was reprinted in 1711 in Shaftesbury's own collection of his writings entitled *Characteristics of Men, Manners, Opinions and Times*. We have used the edition edited by John M. Robertson, Indianapolis: Bobbs-Merrill, 1964, pp. 97–9, 110–12, 122–4, 125–8.

Here, Philocles, we shall find our sovereign genius, if we can charm the genius of the place (more chaste and sober than your Silenus) to inspire us with a truer song of Nature, teach us some celestial hymn, and make us feel divinity present in these solemn places of retreat.

Haste then, I conjure you, said I, good Theocles, and stop not one moment for any ceremony or rite. For well I see, methinks, that without any such preparation some divinity has approached us and already moves in you. We are come to the sacred groves of the Hamadryads, which formerly were said to render oracles. We are on the most beautiful part of the hill, and the sun, now ready to rise, draws off the curtain of night and shows us the open scene of Nature in the plains below. Begin: for now I know you are full of those divine thoughts which meet you ever in this solitude. Give them but voice and accents; you may be still as much alone as you are used, and take no more notice of me than if I were absent.

Just as I had said this, he turned away his eyes from me, musing awhile by himself; and soon afterwards, stretching out his hand, as pointing to the objects round him, he began:—

'Ye fields and woods, my refuge from the toilsome world of business, receive me in your quiet sanctuaries, and favour my retreat and thoughtful solitude. Ye verdant plains, how gladly I salute ye! Hail all ye blissful mansions! known seats! delightful prospects! majestic beauties of this earth, and all ye rural powers and graces! Blessed be ye chaste abodes of happiest mortals, who here in peaceful innocence enjoy a life unenvied, though divine; whilst with its blessed tranquillity it affords a happy leisure and retreat for man, who, made for contemplation, and to search his own and other natures, may here best meditate the cause of things, and, placed amidst the various scenes of Nature, may nearer view her works.

'O glorious nature! supremely fair and sovereignly good! all-loving and all-lovely, all-divine! whose looks are so becoming and of such infinite grace; whose study brings such wisdom, and whose contemplation such delight; whose every single work affords an ampler scene, and is a nobler spectacle than all which ever art presented! O mighty Nature! wise substitute of Providence! impowered creatress! Or thou impowering Deity, supreme creator! Thee I invoke and thee alone adore. To thee this solitude, this place, these rural meditations are sacred; whilst thus inspired with harmony of thought, though unconfined by words, and in loose numbers, I sing of Nature's order in created beings, and celebrate the beauties which resolve in thee, the source and principle of all beauty and perfection.

'Thy being is boundless, unsearchable, impenetrable. In thy immensity all thought is lost, fancy gives over its flight, and wearied imagination spends itself in vain, finding no coast nor limit of this ocean, nor, in the widest tract through which it soars, one point yet nearer the circumference than the first centre whence it parted. Thus having oft essayed, thus sallied forth into the wide expanse, when I return again within myself, struck with the sense of this so narrow being and of the fulness of that immense one, I dare no more behold the amazing depths nor sound the abyss of Deity.

'Yet since by thee, O sovereign mind, I have been formed such as I am, intelligent and rational, since the peculiar dignity of my nature is to know and contemplate thee, permit that with due freedom I exert those faculties with which thou hast adorned

me. Bear with my venturous and bold approach. And since nor vain curiosity, nor fond conceit, nor love of aught save thee alone inspires me with such thoughts as these, be thou my assistant and guide me in this pursuit, whilst I venture thus to tread the labyrinth of wide Nature and endeavour to trace thee in thy works.'

Here he stopped short, and starting as out of a dream: now, Philocles, said he, inform me, how have I appeared to you in my fit? Seemed it a sensible kind of madness, like those transports which are permitted to our poets? or was it down-right raving?

I only wish, said I, that you had been a little stronger in your transport, to have proceeded as you began, without ever minding me. For I was beginning to see wonders in that Nature you taught me, and was coming to know the hand of your divine Artificer. But if you stop here I shall lose the enjoyment of the pleasing vision. And already I begin to find a thousand difficulties in fancying such a universal genius as you describe.

* * *

Thus I continue then, said Theocles, addressing myself as you would have me, to that guardian deity and inspirer whom we are to imagine present here, but not here only. For, 'O mighty Genius! sole animating and inspiring power! author and subject of these thoughts! thy influence is universal, and in all things thou art inmost. From thee depend their secret springs of action. Thou movest them with an irresistible unwearied force, by sacred and inviolable laws, framed for the good of each particular being, as best may suit with the perfection, life, and vigour of the whole. The vital principle is widely shared and infinitely varied, dispersed throughout, nowhere extinct. All lives, and by succession still revives. The temporary beings quit their borrowed forms and yield their elementary substance to new-comers. Called in their several turns to life, they view the light, and viewing pass, that others too may be spectators of the goodly scene, and greater numbers still enjoy the privilege of Nature. Munificent and great, she imparts herself to most and makes the subjects of her bounty infinite. Nought stays her hastening hand. No time nor substance is lost or unimproved. New forms arise, and when the old dissolve, the matter whence they were composed is not left useless, but wrought with equal management and art, even in corruption, Nature's seeming waste and vile abhorrence. The abject state appears merely as the way or passage to some better. But could we nearly view it, and with indifference, remote from the antipathy of sense, we then perhaps should highest raise our admiration, convinced that even the way itself was equal to the end. Nor can we judge less favourably of that consummate art exhibited through all the works of Nature, since our weak eyes, helped by mechanic art, discover in these works a hidden scene of wonders, worlds within worlds of infinite minuteness, though as to art still equal to the greatest, and pregnant with more wonders than the most discerning sense, joined with the greatest art or the acutest reason, can penetrate or unfold.

'But 'tis in vain for us to search the bulky mass of matter, seeking to know its nature; how great the whole itself, or even how small its parts.

'If, knowing only some of the rules of motion, we seek to trace it further, 'tis in vain we follow it into the bodies it has reached. Our tardy apprehensions fail us, and can reach nothing beyond the body itself, through which it is diffused. Wonderful

being (if we may call it so), which bodies never receive except from others which lose it, nor ever lose, unless by imparting it to others. Even without change of place it has its force, and bodies big with motion labour to move, yet stir not, whilst they express an energy beyond our comprehension.

'In vain, too, we pursue that phantom time, too small, and yet too mighty for our grasp, when, shrinking to a narrow point, it escapes our hold, or mocks our scanty thought by swelling to eternity, an object unproportioned to our capacity, as is thy being, O thou ancient cause! older than time, yet young with fresh eternity.

'In vain we try to fathom the abyss of space, the seat of thy extensive being, of which no place is empty, no void which is not full.

'In vain we labour to understand that principle of sense and thought, which seeming in us to depend so much on motion, yet differs so much from it and from matter itself as not to suffer us to conceive how thought can more result from this than this arise from thought. But thought we own pre-eminent, and confess the realest of beings, the only existence of which we are made sure by being conscious. All else may be only dream and shadow. All which even sense suggests may be deceitful. The sense itself remains still; reason subsists, and thought maintains its eldership of being. Thus are we in a manner conscious of that original and eternally existent thought whence we derive our own. And thus the assurance we have of the existence of beings above our sense and of thee (the great exemplar of thy works) comes from thee, the all true and perfect, who hast thus communicated thyself more immediately to us, so as in some manner to inhabit within our souls, thou who art original soul, diffusive, vital in all, inspiriting the whole.

'All Nature's wonders serve to excite and perfect this idea of their author. 'Tis here he suffers us to see, and even converse with him in a manner suitable to our frailty. How glorious is it to contemplate him in this noblest of his works apparent to us, the system of the bigger world!'

* * *

...The wildness pleases. We seem to live alone with Nature. We view her in her inmost recesses, and contemplate her with more delight in these original wilds than in the artificial labyrinths and feigned wildernesses of the palace. The objects of the place, the scaly serpents, the savage beasts, and poisonous insects, how terrible soever, or how contrary to human nature, are beauteous in themselves, and fit to raise our thoughts in admiration of that divine wisdom, so far superior to our short views. Unable to declare the use or service of all things in this universe, we are yet assured of the perfection of all, and of the justice of that economy to which all things are subservient, and in respect of which things seemingly deformed are amiable, disorder becomes regular, corruption wholesome, and poisons (such as these we have seen) prove healing and beneficial.

'But behold! through a vast tract of sky before us, the mighty Atlas rears his lofty head covered with snow above the clouds. Beneath the mountain's foot the rocky country rises into hills, a proper basis of the ponderous mass above, where huge embodied rocks lie piled on one another, and seem to prop the high arch of heaven....See! with what trembling steps poor mankind tread the narrow brink of the deep precipices, from whence with giddy horror they look down, mistrusting even the ground which bears them, whilst they hear the hollow sound of torrents

underneath, and see the ruin of the impending rock, with falling trees which hang with their roots upwards and seem to draw more ruin after them. Here thoughtless men, seized with the newness of such objects, become thoughtful, and willingly contemplate the incessant changes of this earth's surface. They see, as in one instant, the revolutions of past ages, the fleeting forms of things, and the decay even of this our globe, whose youth and first formation they consider, whilst the apparent spoil and irreparable breaches of the wasted mountain show them the world itself only as a noble ruin, and make them think of its approaching period.... But here, mid-way the mountain, a spacious border of thick wood harbours our wearied travellers, who now are come among the ever green and lofty pines, the firs, and noble cedars, whose towering heads seem endless in the sky, the rest of the trees appearing only as shrubs beside them. And here a different horror seizes our sheltered travellers when they see the day diminished by the deep shades of the vast wood, which, closing thick above, spreads darkness and eternal night below. The faint and gloomy light looks horrid as the shade itself; and the profound stillness of these places imposes silence upon men, struck with the hoarse echoings of every sound within the spacious caverns of the wood. Here space astonishes; silence itself seems pregnant, whilst an unknown force works on the mind, and dubious objects move the wakeful sense. Mysterious voices are either heard or fancied, and various forms of deity seem to present themselves and appear more manifest in these sacred silvan scenes, such as of old gave rise to temples, and favoured the religion of the ancient world. Even we ourselves, who in plain characters may read divinity from so many bright parts of earth, choose rather these obscurer places to spell out that mysterious being, which to our weak eyes appears at best under a veil of cloud....'

Here he paused a while and began to cast about his eyes, which before seemed fixed. He looked more calmly, with an open countenance and free air, by which, and other tokens, I could easily find we were come to an end of our descriptions, and that whether I would or no, Theocles was now resolved to take his leave of the sublime, the morning being spent and the forenoon by this time well advanced.

* * *

'Tis true, said I, Theocles, I own it. Your genius, the genius of the place, and the Great Genius have at last prevailed. I shall no longer resist the passion growing in me for things of a natural kind, where neither art nor the conceit or caprice of man has spoiled their genuine order by breaking in upon that primitive state. Even the rude rocks, the mossy caverns, the irregular unwrought grottos and broken falls of waters, with all the horrid graces of the wilderness itself, as representing Nature more, will be the more engaging, and appear with a magnificence beyond the formal mockery of princely gardens.... But tell me, I entreat you, how comes it that, excepting a few philosophers of your sort, the only people who are enamoured in this way, and seek the woods, the rivers, or seashores, are your poor vulgar lovers?

Say not this, replied he, of lovers only. For is it not the same with poets, and all those other students in nature and the arts which copy after her? In short, is not this the real case of all who are lovers either of the Muses or the Graces?

However, said I, all those who are deep in this romantic way are looked upon, you know, as a people either plainly out of their wits, or overrun with melancholy and enthusiasm. We always endeavour to recall them from these solitary places. And I

must own that often when I have found my fancy run this way, I have checked myself, not knowing what it was possessed me, when I was passionately struck with objects of this kind.

No wonder, replied he, if we are at a loss when we pursue the shadow for the substance. For if we may trust to what our reasoning has taught us, whatever in Nature is beautiful or charming is only the faint shadow of that first beauty. So that every real love depending on the mind, and being only the contemplation of beauty either as it really is in itself or as it appears imperfectly in the objects which strike the sense, how can the rational mind rest here, or be satisfied with the absurd enjoyment which reaches the sense alone?

From this time forward then, said I, I shall no more have reason to fear those beauties which strike a sort of melancholy, like the places we have named, or like these solemn groves. No more shall I avoid the moving accents of soft music, or fly from the enchanting features of the fairest human face.

If you are already, replied he, such a proficient in this new love that you are sure never to admire the representative beauty except for the sake of the original, nor aim at other enjoyment than of the rational kind, you may then be confident. I am so, and presume accordingly to answer for myself. However, I should not be ill satisfied if you explained yourself a little better as to this mistake of mine you seem to fear. Would it be any help to tell you, 'That the absurdity lay in seeking the enjoyment elsewhere than in the subject loved'? The matter, I must confess, is still mysterious. Imagine then, good Philocles, if being taken with the beauty of the ocean, which you see yonder at a distance, it should come into your head to seek how to command it, and, like some mighty admiral, ride master of the sea, would not the fancy be a little absurd?

Absurd enough, in conscience. The next thing I should do, 'tis likely, upon this frenzy, would be to hire some bark and go in nuptial ceremony, Venetian-like, to wed the gulf, which I might call perhaps as properly my own.

Let who will call it theirs, replied Theocles, you will own the enjoyment of this kind to be very different from that which should naturally follow from the contemplation of the ocean's beauty. The bridegroom-Doge, who in his stately Bucentaur floats on the bosom of his Thetis, has less possession than the poor shepherd, who from a hanging rock or point of some high promontory, stretched at his ease, forgets his feeding flocks, while he admires her beauty. But to come nearer home, and make the question still more familiar. Suppose (my Philocles) that, viewing such a tract of country as this delicious vale we see beneath us, you should, for the enjoyment of the prospect, require the property or possession of the land.

The covetous fancy, replied I, would be as absurd altogether as that other ambitious one.

O Philocles! said he, may I bring this yet a little nearer, and will you follow me once more? Suppose that, being charmed as you seem to be with the beauty of those trees under whose shade we rest, you should long for nothing so much as to taste some delicious fruit of theirs; and having obtained of Nature some certain relish by which these acorns or berries of the wood became as palatable as the figs or peaches of the garden, you should afterwards, as oft as you revisited these groves, seek hence the enjoyment of them by satiating yourself in these new delights.

The fancy of this kind, replied I, would be sordidly luxurious, and as absurd, in my opinion, as either of the former.

Can you not then, on this occasion, said he, call to mind some other forms of a fair kind among us, where the admiration of beauty is apt to lead to as irregular a consequence?

I feared, said I, indeed, where this would end, and was apprehensive you would force me at last to think of certain powerful forms in human kind which draw after them a set of eager desires, wishes, and hopes; no way suitable, I must confess, to your rational and refined contemplation of beauty. The proportions of this living architecture, as wonderful as they are, inspire nothing of a studious or contemplative kind. The more they are viewed, the further they are from satisfying by mere view. Let that which satisfies be ever so disproportionable an effect, or ever so foreign to its cause, censure it as you please, you must allow, however, that it is natural. So that you, Theocles, for aught I see, are become the accuser of Nature by condemning a natural enjoyment.

Far be it from us both, said he, to condemn a joy which is from Nature. But when we spoke of the enjoyment of these woods and prospects, we understood by it a far different kind from that of the inferior creatures, who, rifling in these places, find here their choicest food. Yet we too live by tasteful food, and feel those other joys of sense in common with them. But 'twas not here (my Philocles) that we had agreed to place our good, nor consequently our enjoyment. We who were rational, and had minds, methought, should place it rather in those minds which were indeed abused, and cheated of their real good, when drawn to seek absurdly the enjoyment of it in the objects of sense, and not in those objects they might properly call their own, in which kind, as I remember, we comprehended all which was truly fair, generous, or good.

So that beauty, said I, and good with you, Theocles, I perceive, are still one and the same.

'Tis so, said he. And thus are we returned again to the subject of our yesterday's morning conversation. Whether I have made good my promise to you in showing the true good, I know not. But so, doubtless, I should have done with good success had I been able in my poetic ecstasies, or by any other efforts, to have led you into some deep view of Nature and the sovereign genius. We then had proved the force of divine beauty, and formed in ourselves an object capable and worthy of real enjoyment.

3 Anthony Ashley Cooper, third Earl of Shaftesbury (1671–1713) 'A Notion of the Historical Draught of the Tablature of the Judgement of Hercules'

Shaftesbury's notional sketch of an exemplary history painting sets virtue and pleasure in competition, in a context sanctioned by classical authority. The theme is the young Hercules, faced at the crossroads of his life with the choice between 'Virtus' (Virtue) and 'Voluptas' (Pleasure or Vice), each represented by a woman of appropriate aspect who

invites him to follow the path she indicates. (Shaftesbury's text is taken from the Sophist Prodicus as represented in Xenophon's *Memorabilia*. We have omitted the lengthy footnote in which Prodicus' account is given.) Shaftesbury writes as though engaged in the thorough imagination of an appropriate painted composition or 'tablature' – somewhat disingenuously, since his 'invention' follows closely on the precedent of Annibale Carracci's painting on the theme made for the Farnese Palace in Florence (1596–7, now Naples, Capodimonte Museum), which was engraved in a widely circulated set by Petrus Aquila. The subject was also treated by Poussin in a painting owned in the early eighteenth century by James Brydges, later Duke of Chandos (now National Trust, Stourhead). In fact, Shaftesbury's aim seems to have been less to achieve the 'invention' of a painting than to discourse upon the proper conditions and functions of elevated history painting in general, supported by the authority of various previous writers whom he cites in quotations. He did give his treatise practical effect, however, making it the basis for a commission from the Italian painter Paolo de Matteis (1662–1728), who painted three versions of *Hercules at the Crossroads between Virtue and Vice* (now Leeds, Temple Newsam House, dated 1712; Munich, Alte Pinakothek; and Oxford, Ashmolean Museum). We have included Shaftesbury's introduction and chapter I, which is concerned with matters of consistency and priority in the interpretation of the chosen theme, together with chapter V, on such stylistic matters as drapery and scene-setting. Chapters II, III and IV, omitted here, are concerned with the manners in which the three principal figures should be represented. Shaftesbury's treatise was the product of conversation with French littérateurs and painters. It was originally written in French and was published in the *Journal des Sçavans* in November 1712. An English version was printed the following year, and a German translation in 1759. Shaftesbury also intended the treatise for inclusion in a collection under the title *Second Characters, or the Language of Forms*, which remained unpublished at the time of his death. This volume was finally edited by Benjamin Rand and published by Cambridge University Press in 1914. Our text is taken from the reprint of this edition, New York: Greenwood Press, 1969, pp. 30–8 and 49–56.

Introduction

(1) Before we enter on the examination of our historical sketch, it may be proper to remark, that by the word Tablature (for which we have yet no name in English, besides the general one of picture) we denote, according to the original word Tabula, a work not only distinct from a mere portraiture, but from all those wilder sorts of painting which are in a manner absolute, and independent; such as the paintings in fresco upon the walls, the ceilings, the staircases, the cupola's, and other remarkable places either of churches or palaces.

(2) Accordingly we are to understand, that it is not merely the shape or dimension of a cloth, or board, which denominates the piece or tablature; since a work of this kind may be composed of any coloured substance, as it may of any form; whether square, oval or round. But it is then that in painting we may give to any particular work the name of Tablature, when the work is in reality 'a single piece, comprehended in one view, and formed according to one single intelligence, meaning, or design; which constitutes a real whole, by a mutual and necessary relation of its parts, the same as of the members in a natural body.' So that one may say of a picture composed of any number of figures differently ranged, and without any regard to this correspondency or union described, that it is no more a real piece or tablature than a

picture would be a man's picture, or proper portraiture, which represented on the same cloth, in different places, the legs, arms, nose, and eyes of such a person, without adjusting them according to the true proportion, air, and character which belonged to him.

(3) This regulation has place even in the inferior degrees of painting; since the mere flower-painter is, we see, obliged to study the form of festoons and to make use of a peculiar order, or architecture of vases, jars, cannisters, pedestals, and other inventions, which serve as machines, to frame a certain proportionate assemblage, or united mass, according to the rules of perspective; and with regard as well to the different shapes and sizes of his several flowers, as to the harmony of colours resulting from the whole: this being the only thing capable of rendering his work worthy the name of a composition or real piece.

(4) So much the more, therefore, is this regulation applicable to history-painting, where not only men, but manners, and human passions are represented. Here the unity of design must with more particular exactness be preserved, according to the just rules of poetic art; that in the representation of any event, or remarkable fact, the probability, or seeming truth (which is the real truth of art) may with the highest advantage be supported and advanced: as we shall better understand in the argument which follows on the historical tablature of the Judgment of Hercules; who being young, and retired to a solitary place in order to deliberate on the choice he was to make of the different ways of life, was accosted (as our historian relates) by the two goddesses, Virtue and Pleasure. It is on the issue of the controversy between these two, that the character of Hercules depends. So that we may naturally give to this piece and history, as well the title of The Education, as the Choice or Judgment of Hercules.

Chapter I

Of the general constitution or ordinance of the tablature

(1) THIS fable or history may be variously represented, according to the order of time:

Either in the instant when the two goddesses (Virtue and Pleasure) accost Hercules;

Or when they are entered on their dispute;

Or when their dispute is already far advanced, and Virtue seems to gain her cause.

(2) According to the first notion, Hercules must of necessity seem surprized on the first appearance of such miraculous forms. He admires, he contemplates; but is not yet engaged or interested. According to the second notion, he is interested, divided, and in doubt. According to the third, he is wrought, agitated, and torn by contrary passions. It is the last effort of the virtuous one, striving for possession over him. He agonizes, and with all his strength of reason endeavours to overcome himself:

Et premitur ratione animus, vincique laborat.

['And the first thing to be considered is the work that surrounds me.']

(3) Of these different periods of time, the latter has been chosen; as being the only one of the three, which can well serve to express the grand event, or consequent resolution of Hercules, and the choice he actually made of a life full of toil and hardship, under the conduct of Virtue, for the deliverance of mankind from tyranny and oppression. And it is to such a piece, or tablature, as represents this issue of the balance, in our pondering hero, that we may justly give the title of the Decision or Judgment of Hercules.

(4) The same history may be represented yet according to a fourth date or period: as at the time when Hercules is entirely won by Virtue. But then the signs of this resolute determination reigning absolutely in the attitude, and air of our young hero; there would be no room left to represent his agony, or inward conflict, which indeed makes the principal action here; as it would do in a poem, were this subject to be treated by a good poet. Nor would there be any more room left in this case, either for the persuasive rhetoric of Virtue (who must have already ended her discourse) or for the insinuating address of Pleasure, who having lost her cause, must necessarily appear displeased, or out of humour: a circumstance which would no way suit her character.

(5) In the original story or fable of this adventure of our young Hercules, it is particularly noted, that Pleasure, advancing hastily before Virtue, began her plea, and was heard with prevention; as being first in turn. And as this fable is wholly philosophical and moral, this circumstance in particular is to be considered as essential.

(6) In this third period therefore of our history (dividing it, as we have done, into four successive dates or points of time) Hercules being auditor, and attentive, speaks not. Pleasure has spoken. Virtue is still speaking. She is about the middle, or towards the end of her discourse; in the place where, according to just rhetoric, the highest tone of voice and strongest action are employed.

(7) It is evident, that every master in painting, when he has made choice of the determinate date or point of time, according to which he would represent his history, is afterwards debarred the taking advantage from any other action than what is immediately present, and belonging to that single instant he describes. For if he passes the present only for a moment, he may as well pass it for many years. And by this reckoning he may with as good right repeat the same figure several times over, and in one and the same picture represent Hercules in his cradle, struggling with the serpents; and the same Hercules of full age, fighting with the Hydra, with Anteus, and with Cerberus: which would prove a mere confused heap, or knot of pieces, and not a single entire piece, or tablature, of the historical kind.

(8) It may however be allowable, on some occasions, to make use of certain enigmatical or emblematical devices, to represent a future time: as when Hercules, yet a mere boy, is seen holding a small club, or wearing the skin of a young lion. For so we often find him in the best antiques. And though history had never related of Hercules, that being yet very young, he killed a lion with his own hand; this representation of him would nevertheless be entirely conformable to poetic truth; which not only admits, but necessarily presupposes prophecy or prognostication, with regard to the actions, and lives of heroes and great men. Besides that as to our subject, in particular, the natural genius of Hercules, even in his tenderest youth,

might alone answer for his handling such arms as these, and bearing, as it were in play, these early tokens of the future hero.

(9) To preserve therefore a just conformity with historical truth, and with the unity of time and action, there remains no other way by which we can possibly give a hint of any thing future, or call to mind any thing past, than by setting in view such passages or events as have actually subsisted, or according to nature might well subsist, or happen together in one and the same instant. And this is what we may properly call the rule of consistency.

(10) How is it therefore possible, says one, to express a change of passion in any subject, since this change is made by succession; and that in this case the passion which is understood as present, will require a disposition of body and features wholly different from the passion which is over, and past? To this we answer, That notwithstanding the ascendency or reign of the principal and immediate passion, the artist has power to leave still in his subject the tracts or footsteps of its predecessor: so as to let us behold not only a rising passion together with a declining one: but, what is more, a strong and determinate passion, with its contrary already discharged and banished. As for instance, when the plain tracts of tears new fallen, with other fresh tokens of mourning and dejection, remain still in a person newly transported with joy at the sight of a relation or friend, who the moment before had been lamented as one deceased or lost.

(11) Again, by the same means which are employed to call to mind the past, we may anticipate the future: as would be seen in the case of an able painter, who should undertake to paint this history of Hercules according to the third date or period of time proposed for our historical tablature. For in this momentary turn of action, Hercules remaining still in a situation expressive of suspense and doubt, would discover nevertheless that the strength of this inward conflict was over, and that victory began now to declare herself in favour of virtue. This transition, which seems at first so mysterious a performance, will be easily comprehended, if one considers, that the body, which moves much slower than the mind, is easily outstripped by this latter; and that the mind on a sudden turning itself some new way, the nearer situated and more sprightly parts of the body (such as the eyes, and muscles about the mouth and forehead) taking the alarm, and moving in an instant, may leave the heavier and more distant parts to adjust themselves, and change their attitude some moments after.

(12) This different operation may be distinguished by the names of anticipation and repeal.

(13) If by any other method an artist should pretend to introduce into this piece any portion of time, future or past, he must either sin directly against the law of truth and credibility, in representing things contrary and incompatible; or against that law of unity and simplicity of design, which constitutes the very being of his work. This particularly shews itself in a picture, when one is necessarily left in doubt, and unable to determine readily, which of the distinct successive parts of the history or action is that very one represented in the design. For even here the case is the same as in the other circumstances of poetry and painting: 'That what is principal or chief, should immediately shew itself, without leaving the mind in any uncertainty.'

(14) According to this rule of the unity of time, if one should ask an artist, who had painted this history of the Judgment of Hercules, 'Which of these four periods or dates of time above proposed he intended in his picture to represent?' and it should happen that he could not readily answer, It was this, or that: it would appear plainly he had never formed a real notion of his workmanship, or of the history he intended to represent. So that when he had executed even to a miracle all those other beauties requisite in a piece, and had failed in this single one, he would from hence alone be proved to be in truth no history-painter, or artist in the kind, who understood not so much as how to form the real design of a historical piece.

* * *

Chapter V

Of the ornaments of the piece; and chiefly of the drapery, and perspective

(1) IT is sufficiently known, how great a liberty painters are used to take, in the colouring of their habits, and of other draperies belonging to their historical pieces. If they are to paint a Roman people, they represent them in different dresses; though it be certain the common people among them were habited very near alike, and much after the same colour. In like manner, the Egyptians, Jews, and other ancient nations, as we may well suppose, bore in this particular their respective likeness or resemblance one to another, as at present the Spaniards, Italians, and several other people of Europe. But such a resemblance as this would, in the way of painting, produce a very untoward effect; as may easily be conceived. For this reason the painter makes no scruple to introduce philosophers, and even apostles, in various colours, after a very extraordinary manner. It is here that the historical truth must of necessity indeed give way to that which we call poetical, as being governed not so much by reality, as by probability, or plausible appearance. So that a painter, who uses his privilege or prerogative in this respect, ought however to do it cautiously, and with discretion. And when occasion requires that he should present us his philosophers or apostles thus variously coloured, he must take care at least so to mortify his colours, that these plain poor men may not appear, in his piece, adorned like so many lords or princes of the modern garb.

(2) If, on the other hand, the painter should happen to take for his subject some solemn entry or triumph, where, according to the truth of fact, all manner of magnificence had without doubt been actually displayed, and all sorts of bright and dazzling colours heaped together and advanced, in emulation, one against another; he ought on this occasion, in breach of the historical truth, or truth of fact, to do his utmost to diminish and reduce the excessive gaiety and splendour of those objects, which would otherwise raise such a confusion, oppugnancy, and riot of colours, as would to any judicious eye appear absolutely intolerable.

(3) It becomes therefore an able painter in this, as well as in the other parts of his workmanship, to have regard principally, and above all, to the agreement or correspondency of things. And to that end it is necessary he should form in his mind a certain note or character of unity, which being happily taken, would, out of the many colours of his piece, produce (if one may say so) a particular distinct species of an

original kind: like those compositions in music, where among the different airs (such as sonatas, entries, or sarabands) there are different and distinct species, of which we may say in particular, as to each, 'that it has its own proper character or genius, peculiar to itself.'

(4) Thus the harmony of painting requires, 'that in whatever key the painter begins his piece, he should be sure to finish it in the same.'

(5) This regulation turns on the principal figure, or on the two or three which are eminent, in a tablature composed of many. For if the painter happens to give a certain height or richness of colouring to his principal figure; the rest must in proportion necessarily partake this genius. But if, on the contrary, the painter should have chanced to give a softer air, with more gentleness and simplicity of colouring, to his principal figure; the rest must bear a character proportionable, and appear in an extraordinary simplicity; that one and the same spirit may, without contest, reign through the whole of his design.

(6) Our historical draught of Hercules will afford us a very clear example in the case. For considering that the hero is to appear on this occasion retired and gloomy; being withal in a manner naked, and without any other covering than a lion's skin, which is itself of a yellow and dusky colour; it would be really impracticable for a painter to represent this principal figure in any extraordinary brightness or lustre. From whence it follows, that in the other inferior figures or subordinate parts of the work, the painter must necessarily make use of such still quiet colours, as may give to the whole piece a character of solemnity and simplicity, agreeable with itself. Now should our painter honestly go about to follow his historian, according to the literal sense of the history, which represents Virtue to us in a resplendent robe of the purest and most glossy white, it is evident he must after this manner destroy his piece. The good painter in this, as in all other occasions of like nature, must do as the good poet; who undertaking to treat some common and known subject, refuses however to follow strictly, like a mere copyist or translator, any preceding poet or historian; but so orders it, that his work in itself becomes really new and original

(7) As for what relates to the perspective or scene of our historical piece, it ought so to present itself, as to make us instantly conceive that it is in the country, and in a place of retirement, near some wood or forest, that this whole action passes. For it would be impertinent to bring architecture or buildings of whatever kind in view, as tokens of company, diversion, or affairs, in a place purposely chosen to denote solitude, thoughtfulness, and premeditated retreat. Besides, that according to the poets (our guides and masters in this art) neither the goddesses, nor other divine forms of whatever kind, cared ever to present themselves to human sight, elsewhere than in these deep recesses. . . .

(8) As to the fortress, temple, or palace, of Virtue, situated on a mountain, after the emblematical way, as we see represented in some pieces formed upon this subject; there is nothing of this kind expressed by our historian. And should this or any thing of a like nature present itself in our design, it would fill the mind with foreign fancies, and mysterious views, no way agreeable to the taste and genius of this piece. Nor is there any thing, at the same time, on Pleasure's side, to answer, by way of opposition, to this palace of Virtue; which, if expressed, would on this account destroy the just simplicity and correspondency of our work.

(9) Another reason against the perspective part, the architecture, or other studied ornaments of the landscape kind, in this particular piece of ours, is, that in reality there being no occasion for these appearances, they would prove a mere incumbrance to the eye, and would of necessity disturb the sight, by diverting it from that which is principal, the history and fact. Whatsoever appears in a historical design, which is not essential to the action, serves only to confound the representation, and perplex the mind: more particularly, if these episodic parts are so lively wrought, as to vie with the principal subject, and contend for precedency with the figures and human life. A just design, or tablature, should, at first view, discover, what nature it is designed to imitate; what life, whether of the higher or lower kind, it aims chiefly to represent. The piece must by no means be equivocal or dubious; but must with ease distinguish itself, either as historical and moral, or as perspective and merely natural. If it be the latter of these beauties, which we desire to see delineated according to its perfection, then the former must give place. The higher life must be allayed, and in a manner discountenanced and obscured; whilst the lower displays itself, and is exhibited as principal. Even that which according to a term of art we commonly call still-life, and is in reality of the last and lowest degree of painting, must have its superiority and just preference in a tablature of its own species. It is the same in animal pieces, where beasts or fowl are represented. In landscape, inanimates are principal: it is the earth, the water, the stones and rocks which live. All other life becomes subordinate. Humanity, sense, manners, must in this place yield, and become inferior. It would be a fault even to aim at the expression of any real beauty in this kind, or go about to animate or heighten in any considerable degree the accompanying figures of men, or deities which are accidentally introduced, as appendices, or ornaments, in such a piece. But if, on the contrary, the human species be that which first presents itself in a picture; if it be the intelligent life, which is set to view; it is the other species, the other life, which must then surrender and become subservient. The merely natural must pay homage to the historical or moral. Every beauty, every grace must be sacrificed to the real beauty of this first and highest order. For nothing can be more deformed than a confusion of many beauties: and the confusion becomes inevitable, where the subjection is not complete.

(10) By the word moral are understood, in this place, all sorts of judicious representations of the human passions; as we see even in battle pieces; excepting those of distant figures, and the diminutive kind; which may rather be considered as a sort of landscape. In all other martial pieces, we see expressed in lively action, the several degrees of valour, magnanimity, cowardice, terror, anger, according to the several characters of nations, and particular men. It is here that we may see heroes and chiefs (such as the Alexanders or Constantines) appear, even in the hottest of the action, with a tranquillity and sedateness of mind peculiar to themselves: which is, indeed, in a direct and proper sense, profoundly moral.

(11) But as the moral part is differently treated in a poem, from what it is in history, or in a philosophical work; so must it, of right, in painting be far differently treated, from what it naturally is, either in the history, or poem. For want of a right understanding of this maxim, it often happens that by endeavouring to render a piece highly moral and learned, it becomes thoroughly ridiculous and impertinent.

(12) For the ordinary works of sculpture, such as the low-relieves, and ornaments of columns and edifices, great allowance is made. The very rules of perspective are here wholly reversed, as necessity requires, and are accommodated to the circumstance and genius of the place or building, according to a certain oeconomy or order of a particular and distinct kind... But for the completely imitative and illusive art of painting, whose character it is to employ in her works the united force of different colours; and, who surpassing by so many degrees, and in so many privileges, all other human fiction, or imitative art, aspires in a directer manner towards deceit, and a command over our very sense; she must of necessity abandon whatever is over-learned, humorous, or witty; to maintain herself in what is natural, credible, and winning of our assent: that she may thus acquit herself of what is her chief province, the specious appearance of the object she represents...

(13) We are therefore to consider this as a sure maxim or observation in painting, 'that a historical and moral piece must of necessity lose much of its natural simplicity and grace, if any thing of the emblematical or enigmatic kind be visibly and directly intermixed.' As if, for instance, the circle of the Zodiac, with its twelve signs, were introduced. Now this being an appearance which carries not any matter of similitude or colourable resemblance to any thing extant in real nature; it cannot possibly pretend to win the sense, or gain belief, by the help of any poetical enthusiasm, religious history, or faith. For by means of these, indeed, we are easily induced to contemplate as realities those divine personages and miraculous forms, which the leading painters, ancient and modern, have speciously designed, according to the particular doctrine or theology of their several religious and national beliefs. But for our tablature in particular, it carries nothing with it of the mere emblematical or enigmatic kind: since for what relates to the double way of the vale and mountain, this may naturally and with colourable appearance be represented at the mountain's foot. But if on the summit or highest point of it, we should place the fortress, or palace of virtue, rising above the clouds, this would immediately give the enigmatical mysterious air to our picture, and of necessity destroy its persuasive simplicity, and natural appearance.

(14) In short, we are to carry this remembrance still along with us, 'that the fewer the objects are, besides those which are absolutely necessary in a piece, the easier it is for the eye, by one simple act and in one view, to comprehend the sum or whole.' The multiplication of subjects, though subaltern, renders the subordination more difficult to execute in the ordinance or composition of a work. And if the subordination be not perfect, the order (which makes the beauty) remains imperfect. Now the subordination can never be perfect, except 'when the ordinance is such, that the eye not only runs over with ease the several parts of the design (reducing still its view each moment on the principal subject on which all turns), but when the same eye, without the least detainment in any of the particular parts, and resting, as it were, immovable in the middle, or centre of the tablature, may see at once, in an agreeable and perfect correspondency, all which is there exhibited to the sight.'

4 Joseph Addison (1672–1719) 'On the Pleasures of the Imagination'

Playwright, poet, politician and journalist, Addison was one of the figures of his age. After a classical education at Charterhouse and Oxford, he travelled in Europe for four years from 1699 to 1703. The resulting book, *Remarks upon Several Parts of Italy* (1705) became the standard guide for English gentlemen undertaking the Grand Tour. Together with Richard Steele, Addison produced and wrote two magazines, *The Tatler* (1709–11), and *The Spectator* (1711–12 and 1714) which did much to establish modern periodical journalism. In effect, Addison became the premier arbiter of taste in England on issues ranging from gardening and manners to literature and art. 'The Pleasures of the Imagination' was his most influential piece of cultural journalism. Addision begins by claiming that sight is our most important sense, and the greatest stimulus to the imagination. He then distinguishes the pleasures of the imagination from those of understanding. For Addison, the imagination occupies a mid-point between the relatively crude pleasures of the senses, and the higher pleasures of rational understanding. But for all that it is in that sense inferior, the imagination can dominate the understanding, since its pleasures are more vivid and easier to acquire. Addison's third main point is to divide the pleasures of the imagination into two kinds, 'primary' and 'secondary': the former derived from objects before our sight, the latter from things or kinds of things we have seen and are then able to summon up in our memories. 'The Pleasures of the Imagination' appeared in eleven instalments in daily issues of *The Spectator*, in 1712. Our extracts are taken from Papers I (no. 411, Saturday 21 June); II (no. 412, Monday 23); IV (no. 414, Wednesday 25); and VI (no. 416, Friday 27). Our source was *The Spectator with a Biographical, Historical and Critical Preface by the Rev. Rob. Lynham in Six Volumes*, London: Cowie, Low and Co., 1826, vol. 4, pp. 377–84, and vol. 5, pp. 5–15.

Paper I.

Our sight is the most perfect and most delightful of all our senses. It fills the mind with the largest variety of ideas, converses with its objects at the greatest distance, and continues the longest in action without being tired or satiated with its proper enjoyments. The sense of feeling can indeed give us a notion of extension, shape, and all other ideas that enter at the eye, except colours; but at the same time it is very much straitened, and confined in its operations to the number, bulk, and distance of its particular objects. Our sight seems designed to supply all these defects, and may be considered as a more delicate and diffusive kind of touch, that spreads itself over an infinite multitude of bodies, comprehends the largest figures, and brings into our reach some of the most remote parts of the universe.

It is this sense which furnishes the imagination with its ideas; so that by 'the pleasures of the imagination,' or 'fancy' (which I shall use promiscuously), I here mean such as arise from visible objects, either when we have them actually in our view, or when we call up their ideas into our minds by painting, statues, descriptions, or any the like occasion. We cannot indeed have a single image in the fancy that did not make its first entrance through the sight; but we have the power of retaining, altering, and compounding those images which we have once received, into all the varieties of picture and vision that are most agreeable to the imagination: for by this

faculty, a man in a dungeon is capable of entertaining himself with scenes and landscapes more beautiful than any that can be found in the whole compass of nature.

There are few words in the English language which are employed in a more loose and uncircumscribed sense than those of the fancy and the imagination. I therefore thought it necessary to fix and determine the notion of these two words, as I intend to make use of them in the thread of my following speculations, that the reader may conceive rightly what is the subject which I proceed upon. I must therefore desire him to remember, that by 'the pleasures of the imagination,' I mean only such pleasures as arise originally from sight, and that I divide these pleasures into two kinds: my design being first of all to discourse of those primary pleasures of the imagination, which entirely proceed from such objects as are before our eyes; and in the next place to speak of those secondary pleasures of the imagination which flow from the ideas of visible objects, when the objects are not actually before the eye, but are called up into our memories, or formed into agreeable visions of things that are either absent or fictitious.

The pleasures of the imagination, taken in their full extent, are not so gross as those of sense, nor so refined as those of the understanding. The last are indeed more preferable, because they are founded on some new knowledge or improvement in the mind of man; yet it must be confessed, that those of the imagination are as great and as transporting as the other. A beautiful prospect delights the soul as much as a demonstration; and a description in Homer has charmed more readers than a chapter in Aristotle. Besides, the pleasures of the imagination have this advantage above those of the understanding, that they are more obvious, and more easy to be acquired. It is but opening the eye, and the scene enters. The colours paint themselves on the fancy, with very little attention of thought or application of mind in the beholder. We are struck, we know not how, with the symmetry of any thing we see, and immediately assent to the beauty of an object, without inquiring into the particular causes and occasions of it.

A man of a polite imagination is let into a great many pleasures that the vulgar are not capable of receiving. He can converse with a picture, and find an agreeable companion in a statue. He meets with a secret refreshment in a description, and often feels a greater satisfaction in the prospect of fields and meadows, than another does in the possession. It gives him, indeed, a kind of property in every thing he sees, and makes the most rude uncultivated parts of nature administer to his pleasures; so that he looks upon the world as it were in another light, and discovers in it a multitude of charms, that conceal themselves from the generality of mankind.

There are indeed but very few who know how to be idle and innocent, or have a relish of any pleasures that are not criminal; every diversion they take is at the expense of some one virtue or another, and their very first step out of business is into vice or folly. A man should endeavour, therefore, to make the sphere of his innocent pleasures as wide as possible, that he may retire into them with safety, and find in them such a satisfaction as a wise man would not blush to take. Of this nature are those of the imagination, which do not require such a bent of thought as is necessary to our more serious employments, nor, at the same time, suffer the mind to sink into that negligence and remissness, which are apt to accompany our more sensual delights, but, like a gentle exercise to the faculties, awaken them from sloth and idleness, without putting them upon any labour or difficulty. [. . .]

Paper II.

I shall first consider those pleasures of the imagination which arise from the actual view and survey of outward objects: and these, I think, all proceed from the sight of what is great, uncommon, or beautiful. There may, indeed, be something so terrible or offensive, that the horror or loathsomeness of an object may overbear the pleasure which results from its greatness, novelty, or beauty; but still there will be such a mixture of delight in the very disgust it gives us, as any of these three qualifications are most conspicuous and prevailing.

By greatness, I do not only mean the bulk of any single object, but the largeness of a whole view, considered as one entire piece. Such are the prospects of an open champaign country, a vast uncultivated desert, of huge heaps of mountains, high rocks and precipices, or a wide expanse of waters, where we are not struck with the novelty or beauty of the sight, but with that rude kind of magnificence which appears in many of these stupendous works of nature. Our imagination loves to be filled with an object, or to grasp at any thing that is too big for its capacity. We are flung into a pleasing astonishment at such unbounded views, and feel a delightful stillness and amazement in the soul at the apprehension of them. The mind of man naturally hates every thing that looks like a restraint upon it, and is apt to fancy itself under a sort of confinement, when the sight is pent up in a narrow compass, and shortened on every side by the neighbourhood of walls or mountains. On the contrary, a spacious horizon is an image of liberty, where the eye has room to range abroad, to expatiate at large on the immensity of its views, and to lose itself amidst the variety of objects that offer themselves to its observation. Such wide and undetermined prospects are as pleasing to the fancy as the speculations of eternity or infinitude are to the understanding. But if there be a beauty or uncommonness joined with this grandeur, as in a troubled ocean, a heaven adorned with stars and meteors, or a spacious landscape cut out into rivers, woods, rocks, and meadows, the pleasure still grows upon us, as it arises from more than a single principle.

Every thing that is new or uncommon raises a pleasure in the imagination, because it fills the soul with an agreeable surprise, gratifies its curiosity, and gives it an idea of which it was not before possessed. We are indeed so often conversant with one set of objects, and tired out with so many repeated shows of the same things, that whatever is new or uncommon contributes a little to vary human life, and to divert our minds for a while with the strangeness of its appearance. It serves us for a kind of refreshment, and takes off from that satiety we are apt to complain of, in our usual and ordinary entertainments. It is this that bestows charms on a monster, and makes even the imperfections of nature please us. It is this that recommends variety, where the mind is every instant called off to something new, and the attention not suffered to dwell too long, and waste itself on any particular object. It is this, likewise, that improves what is great or beautiful, and makes it afford the mind a double entertainment. Groves, fields, and meadows, are at any season of the year pleasant to look upon, but never so much as in the opening of the spring, when they are all new and fresh, with their first gloss upon them, and not yet too much accustomed and familiar to the eye. For this reason, there is nothing that more enlivens a prospect than rivers,

jetteaus, or falls of water, where the scene is perpetually shifting, and entertaining the sight every moment with something that is new. We are quickly tired with looking upon hills and valleys, where every thing continues fixed and settled in the same place and posture, but find our thoughts a little agitated and relieved at the sight of such objects as are ever in motion, and sliding away from beneath the eye of the beholder.

But there is nothing that makes its way more directly to the soul than beauty, which immediately diffuses a secret satisfaction and complacency through the imagination, and gives a finishing to any thing that is great or uncommon. The very first discovery of it strikes the mind with an inward joy, and spreads a cheerfulness and delight through all its faculties. There is not perhaps any real beauty or deformity more in one piece of matter than another, because we might have been so made, that whatsoever now appears loathsome to us might have shewn itself agreeable; but we find by experience that there are several modifications of matter, which the mind, without any previous consideration, pronounces at first sight beautiful or deformed. Thus we see that every different species of sensible creatures has its different notions of beauty, and that each of them is most affected with the beauties of its own kind. This is no where more remarkable than in birds of the same shape and proportion, where we often see the male determined in his courtship by the single grain or tincture of a feather, and never discovering any charms but in the colour of its species. [. . .]

There is a second kind of beauty that we find in the several products of art and nature, which does not work in the imagination with that warmth and violence as the beauty that appears in our proper species, but is apt however to raise in us a secret delight, and a kind of fondness for the places or objects in which we discover it. This consists either in the gaiety or variety of colours, in the symmetry and proportion of parts, in the arrangement and disposition of bodies, or in a just mixture and concurrence of all together. Among these several kinds of beauty the eye takes most delight in colours. We no where meet with a more glorious or pleasing show in nature, than what appears in the heavens at the rising and setting of the sun, which is wholly made up of those different stains of light that shew themselves in clouds of a different situation. For this reason we find the poets, who are always addressing themselves to the imagination, borrowing more of their epithets from colours, than from any other topic.

As the fancy delights in every thing that is great, strange, or beautiful, and is still more pleased the more it finds of these perfections in the same object, so it is capable of receiving a new satisfaction by the assistance of another sense. Thus, any continued sound, as the music of birds, or a fall of water, awakens every moment the mind of the beholder, and makes him more attentive to the several beauties of the place that lie before him. Thus, if there arises a fragrancy of smells or perfumes, they heighten the pleasures of the imagination, and make even the colours and verdure of the landscape appear more agreeable; for the ideas of both senses recommend each other, and are pleasanter together than when they enter the mind separately: as the different colours of a picture, when they are well disposed, set off one another, and receive an additional beauty from the advantage of their situation.

Paper IV.

If we consider the works of nature and art as they are qualified to entertain the imagination, we shall find the last very defective, in comparison of the former; for though they may sometimes appear as beautiful or strange, they can have nothing in them of that vastness and immensity, which afford so great an entertainment to the mind of the beholder. The one may be as polite and delicate as the other, but can never shew herself so august and magnificent in the design. There is something more bold and masterly in the rough careless strokes of nature, than in the nice touches and embellishments of art. The beauties [of] the most stately garden or palace lie in a narrow compass; the imagination immediately runs them over, and requires something else to gratify her; but in the wide fields of nature, the sight wanders up and down without confinement, and is fed with an infinite variety of images, without any certain stint or number. For this reason we always find the poet in love with the country life, where nature appears in the greatest perfection, and furnishes out all those scenes that are most apt to delight the imagination. [. . .]

But though there are several of those wild scenes, that are more delightful than any artificial shows, yet we find the works of nature still more pleasant, the more they resemble those of art: for in this case our pleasure rises from a double principle; from the agreeableness of the objects to the eye, and from their similitude to other objects. We are pleased as well with comparing their beauties, as with surveying them, and can represent them to our minds, either as copies or originals. Hence it is that we take delight in a prospect which is well laid out, and diversified with fields and meadows, woods and rivers; in those accidental landscapes of trees, clouds, and cities, that are sometimes found in the veins of marble; in the curious fret-work of rocks and grottos; and, in a word, in any thing that hath such a variety or regularity as may seem the effect of design in what we call the works of chance.

If the products of nature rise in value according as they more or less resemble those of art, we may be sure that artificial works receive a greater advantage from their resemblance of such as are natural; because here the similitude is not only pleasant, but the pattern more perfect. [. . .]

We have before observed, that there is generally in nature something more grand and august than what we meet with in the curiosities of art. When, therefore, we see this imitated in any measure, it gives us a nobler and more exalted kind of pleasure than what we receive from the nicer and more accurate productions of art. On this account our English gardens are not so entertaining to the fancy as those in France and Italy, where we see a large extent of ground covered over with an agreeable mixture of garden and forest, which represent every where an artificial rudeness, much more charming than that neatness and elegancy which we meet with in those of our own country. It might indeed be of ill consequence to the public, as well as unprofitable to private persons, to alienate so much ground from pasturage and the plough, in many parts of a country that is so well peopled, and cultivated to a far greater advantage. But why may not a whole estate be thrown into a kind of garden by frequent plantations, that may turn as much to the profit as the pleasure of the owner? A marsh overgrown with willows, or a mountain shaded with oaks, are not

only more beautiful, but more beneficial, than when they lie bare and unadorned. Fields of corn make a pleasant prospect; and if the walks were a little taken care of that lie between them, if the natural embroidery of the meadows were helped and improved by some small additions of art, and the several rows of edges set off by trees and flowers that the soil was capable of receiving, a man might make a pretty landscape of his own possessions.

Writers who have given us an account of China, tell us the inhabitants of that country laugh at the plantations of our Europeans, which are laid out by the rule and line; because, they say, any person may place trees in equal rows and uniform figures. They choose rather to shew a genius in works of this nature, and therefore always conceal the art by which they direct themselves. They have a word, it seems, in their language, by which they express the particular beauty of a plantation that thus strikes the imagination at first sight, without discovering what it is that has so agreeable an effect. Our British gardeners, on the contrary, instead of humouring nature, love to deviate from it as much as possible. Our trees rise in cones, globes, and pyramids. We see the marks of the scissars upon every plant and bush. I do not know whether I am singular in my opinion, but for my own part, I would rather look upon a tree in all its luxuriancy and diffusion of boughs and branches, than when it is thus cut and trimmed into a mathematical figure; and cannot but fancy that an orchard in flower looks infinitely more delightful than all the little labyrinths of the most finished parterre. But, as our great modellers of gardens have their magazines of plants to dispose of, it is very natural for them to tear up all the beautiful plantations of fruit-trees, and contrive a plan that may most turn to their own profit, in taking off their evergreens, and the like moveable plants, with which their shops are plentifully stocked.

Paper VI.

I at first divided the pleasures of the imagination into such as arise from objects that are actually before our eyes, or that once entered in at our eyes, and are afterward called up into the mind either barely by its own operations, or on occasion of something without us, as statues or descriptions. We have already considered the first division, and shall therefore enter on the other, which, for distinction sake, I have called 'The Secondary Pleasures of the Imagination.' When I say the ideas we receive from statues, descriptions, or such-like occasions, are the same that were once actually in our view, it must not be understood that we had once seen the very place, action, or person, that are carved or described. It is sufficient that we have seen places, persons, or actions in general, which bear a resemblance, or at least some remote analogy, with what we find represented; since it is in the power of the imagination, when it is once stocked with particular ideas, to enlarge, compound, and vary them at her own pleasure.

Among the different kinds of representation, statuary is the most natural, and shews us something *likest* the object that is represented. To make use of a common instance: let one who is born blind take an image in his hands, and trace out with his fingers the different furrows and impressions of the chisel, and he will easily conceive how the shape of a man, or beast, may be represented by it; but should he draw his

hand over a picture, where all is smooth and uniform, he would never be able to imagine how the several prominences and depressions of a human body should be shewn on a plain piece of canvas, that has in it no unevenness or irregularity. Description runs yet farther from the things it represents than painting; for a picture bears a real resemblance to its original, which letters and syllables are wholly void of. Colours speak all languages, but words are understood only by such a people or nation. For this reason, though men's necessities quickly put them on finding out speech, writing is probably of a later invention than painting; particularly we are told that in America, when the Spaniards first arrived there, expresses were sent to the Emperor of Mexico in paint, and the news of his country delineated by the strokes of a pencil, which was a more natural way than that of writing, though at the same time much more imperfect, because it is impossible to draw the little connexions of speech, or to give the picture of a conjunction or an adverb. It would be yet more strange to represent visible objects by sounds that have no ideas annexed to them, and to make something like description in music. Yet it is certain, there may be confused imperfect notions of this nature raised in the imagination by an artificial composition of notes; and we find that great masters in the art are able, sometimes to set their hearers in the heat and hurry of a battle, to overcast their minds with melancholy scenes and apprehensions of deaths and funerals, or to lull them into pleasing dreams of groves and elysiums.

In all these instances, this secondary pleasure of the imagination proceeds from that action of the mind which compares the ideas arising from the original objects with the ideas we receive from the statue, picture, description, or sound, that represents them. It is impossible for us to give the necessary reason why this operation of the mind is attended with so much pleasure, as I have before observed on the same occasion; but we find a great variety of entertainments derived from this single principle; for it is this that not only gives us a relish of statuary, painting, and description, but makes us delight in all the actions and arts of mimicry. It is this that makes the several kinds of wit pleasant, which consists, as I have formerly shewn, in the affinity of ideas: and we may add, it is this also that raises the little satisfaction we sometimes find in the different sorts of false wit; whether it consists in the affinity of letters, as an anagram, acrostic; or of syllables, as in doggrel rhymes, echoes; or of words, as in puns, quibbles; or of a whole sentence or poem, as wings and altars. The final cause, probably of annexing pleasure to this operation of the mind, was to quicken and encourage us in our searches after truth, since the distinguishing one thing from another, and the right discerning betwixt our ideas, depend wholly upon our comparing them together, and observing the congruity or disagreement that appears among the several works of nature. [...]

5 Jean-Pierre de Crousaz (1663–1750) from *Treatise on Beauty*

Jean-Pierre de Crousaz was born in Lausanne in Switzerland, where he was educated in the Calvinist faith. As a minister of the Church he suffered persecution for his enthusiasm for Descartes and for his vigorous pursuit of Enlightenment ideals. As late as 1680, the canton of Bern prohibited the teaching of Descartes' philosophy. Crousaz was the author of a

Logic (1712) as well as a major treatise on Pyrrhonism, and in 1725 he was made an associate member of the Academy of Sciences in Paris. His *Treatise on Beauty* of 1714 is generally considered the earliest French treatise on aesthetics. Although written in the spirit of Cartesian rationalism, much of its interest resides in the new significance which it accords to feeling (*sentiment*). Instead of relying on the authority of the ancients, Crousaz begins with the question 'What is beauty?' He seeks to convince his readers that a proper understanding of beauty is a task which still lies ahead of them. The central problem is that knowledge of beauty is gained through two different faculties, feeling and reason. The first gives rise to pleasure, the second to approbation or approval. But the two are not always in accord: something can please me even though I withhold my approval and vice versa. True to the principles of Cartesian rationalism, Crousaz elects to pursue the path of speculation rather than of sentiment. Although he acknowledges pleasure as a constituent element in the appreciation of beauty, he trusts to the superior authority of reason; the true character of beauty is to be established *independently* of feeling. It is not until the Abbé du Bos (see IIB6) that sentiment is given priority over rational deliberation. The *Traité du Beau* was first published in Paris in 1714. The following excerpt has been taken from the edition published in Amsterdam: Françoise L'Honoré, 1715, pp. 1–11. It has been translated for the present volume by Katerina Deligiorgi.

Aim of the work

I. There are, without doubt, very few words used more often than the word 'beautiful'. Yet nothing is as unclear as its meaning or as vague as its idea. Although we use it all the time, we lack a definition for it and do not agree about the meaning it ought to have.

At various times and in various matters people call things beautiful to which others refuse the name. It seems that we must conclude from this either that all men do not have the same idea of the beautiful or that their senses are far less similar than we suppose and that they perceive things very differently. For if an object makes the same impression upon someone who finds it beautiful and upon someone who does not, then certainly the idea of beauty they have in their heads cannot be the same. And if the idea remains invariable, then the same object must be sensed differently by the person who finds it beautiful and by him who does not recognize it as such.

Whereas for some the beautiful is that which pleases, at least generally speaking, others immediately oppose this definition, claiming that it is contradicted by experience. Every day, they say, we discover people who, though charmed by certain objects, recognize in good faith that these objects lack beauty and that they cannot be called beautiful without exaggeration. On the other hand, there are beauties which are not at all striking and which fail to delight even those who admit that they are beautiful. Sometimes, therefore, we call 'beautiful' that which does not please and we refuse this name to that which does please.

II. Is the idea of the beautiful, then, but a figment of the imagination? Is the use of the word ruled by caprice alone? Do we find beautiful whatever we please? I find it difficult to believe this and the very examples I have just given show the contrary. Sometimes we recognize as particularly beautiful an object which does not touch us sensibly and at other times we love and contemplate with pleasure something of little

or no beauty. Therefore, we have an idea of the beautiful which does not at all depend on feeling alone and which we cannot attach as firmly as we would like to that which most pleases us, while refusing it to that which pleases us less.

It is this idea which we seek to discover. Everybody possesses it, but since it hardly ever appears alone we do not reflect upon it and fail to distinguish it from the tangle of other ideas which appear alongside it. Above all, the attendant feelings seize hold of our attention and prevent us from dwelling sufficiently upon this idea to observe it clearly. Because of this the idea of the beautiful remains vague and in a state of confusion, which generates an infinity of misunderstandings.

III. I will endeavour to write with precision on this vague idea and to establish agreement on a subject that seems to divide people so much.

To this end, I will carefully avoid building upon doubtful principles. I shall proceed with as much order and precaution as is possible. I shall not introduce a subsequent thought without having first appropriately established the previous one. And I would rather burden my discourse with a few superfluous reflections than advance falsehoods that seem true or leave any of my propositions half-proven.

IV. My readers will probably have the same experience as I. Given the vastness of the topic, a great number of ideas will occur to them at once and a thousand difficulties will cross their mind which will at first stop them from seeing the force of my proofs. But I beg my readers to suspend their judgement and to have the patience to read this discourse through to the end. If they give it their attention, I hope that they will not encounter any difficulties which cannot easily be resolved from my principles.

The general idea of the beautiful

I. When we ask what is beautiful, we do not mean to speak of an object which exists outside us and is separate from other objects, as when we ask what is a horse or what is a tree. A tree is a tree and a horse is a horse absolutely and in themselves; there is no need to compare them with any of the other things contained in the universe. This is not the case with beauty. This term is not absolute but expresses a relation between the objects we call beautiful and our ideas, or our feelings, or our understanding, or our heart, or, finally, other objects different from ourselves. To fix the idea of beauty, therefore, it is necessary to determine and to examine in detail the relations we call beautiful.

II. Human language is full of similar terms. Words such as 'truth' and 'probity', for instance, are of a like nature. They are not substances placed who knows where, each with its own rank and discrete existence. A proposition is true on account of the relation between the ideas it contains or the relation between the ideas and the things to which they are applied. A triangle has three corners, wood is flammable, glass is solid and breakable. All these propositions are true because the things of which I speak are in fact such as I conceive and describe them. Both the objects of which I speak and the ideas which I gather are mutually connected with each other.

Similarly, when I say that such an action is just, or that such a conduct shows probity, I mean that the action or the conduct accords with ideas we have of justice and of probity.

In the same way, it is said of a food or of a way of life that they are healthy, meaning that they maintain or restore our health, that they preserve or impart vigour, sustain our forces and prolong our life.

I admit that there is as much controversy and disagreement about these matters as there is about the beautiful. However, this makes these examples better suited to the subject I seek to explain and allows them to throw further light on it. Some consider a falsehood what others hold as an incontestable truth. Some consider unjust what others believe to be entirely legitimate. Some give dietary advice which others find pernicious and some prescribe as a medicine what others claim to be a poison.

Yet no matter how opposed they might be in their use of these terms, all agree on the general idea. When my feeling differs from another's, it is precisely because that person's ideas seem to me not to accord with the things themselves, whereas that person believes that they do. We both, however, take truth to consist in the relation between thought and object. Believing that it is in accordance with the idea of equity, someone may approve of something which I find inequitable and therefore condemn it. We agree, however, that an action is just when it conforms to ideas of rectitude. In a similar manner, we agree that a medicine is health-giving when it helps us recover or conserve our forces and our life, even if some attribute this property to something which, according to others, has quite contrary properties. These three general ideas are the same in all men and are in themselves invariable even if we use them very differently. This is because not everybody has the same ideas and the same know-ledge of the things to which they apply these ideas.

Could we then not base on the same principle and determine in a similar way the idea of beauty? Even if it were more vague than the three ideas I have just used in my examples, as long as all could come to an agreement we could discover a principle and use it to go further. All that would be required then would be to take care to apply this principle correctly and precisely.

III. Those who are not content to fall back on habitual usage but who are willing to look inside themselves, to pay attention to what occurs within themselves and to examine what they feel and think when they say 'this is beautiful,' will notice that they use this word to express a certain relation between an object and agreeable feelings or ideas of approbation. They will agree that to say 'this is beautiful' is to say 'I perceive something of which I approve, or something that pleases me.'

We see from this that the idea we attach to the word beautiful is a double one and that this is what renders it equivocal. We become confused because we fail to disentangle the two meanings. This is one of the principal causes of our disagree-ments about the beautiful.

IV. I shall invoke here a principle I have established elsewhere and which can be accepted without difficulty once it is properly understood. I distinguish between two sorts of perceptions: I call the first 'ideas' and the others 'feelings'. When I think of a circle, a triangle, two decades, three decades, or the numbers five or eight, a bird or a

house, I form ideas in my head. But when I eat, when I sit by the fire, when I raise a flower to my nose, the perceptions of flavour, of warmth and of scent which strike and take possession of me belong to what I call feelings and not to simple ideas.

Ideas occupy the spirit, feelings interest the heart. Ideas amuse us, exercise and sometimes tire our attention, depending on whether or not they are composite and on the degree to which they are combined with each other. Feelings, on the other hand, dominate and take hold of us, determine our predilections and render us happy or sad according to whether they are sweet or vexing, agreeable or disagreeable. Whereas we express ideas easily, it is very difficult to describe feelings. It is moreover impossible to communicate them exactly with words to those who have not experienced anything similar.

We exert a certain control over our ideas and stimulate them ourselves. One idea is born from another and, as long as no feeling holds them fast or pushes them away, our attention stays fixed for as long as we wish and leaves them as soon as we decide. However, feelings depend both on external objects and on certain inner dispositions which are not in our power. This is why we cannot always feel what pleases us, nor can we always avoid that which displeases us.

We are more or less happy with our ideas, depending on how clear, simple, composite or ordered they are, and on whether or not the objects which they represent seem to us worthy of our attention. Our feelings, however, animate or irritate us depending on their intensity or dullness. This, I think, is enough to explain my thoughts on this matter and the distinction which I have drawn.

V. Let us take someone who considers an object, but who seeks only to form an idea about it, aiming to know and to judge the object accurately. It is possible that, on such an occasion, he will perceive nothing which moves him, because he discovers nothing that interests him or disturbs his tranquillity. He will then say that there is nothing in this object that touches and delights him, even though he recognizes the object to be beautiful. From this we can establish that something can be recognized as beautiful even if it fails to please and that for this reason it is wrong to define the beautiful as that which pleases. However, even if the idea of the object is not accompanied by any agreeable feeling, it is possible that we can discover something in it that merits our approbation and that it has attributes to which we could not refuse our favourable opinion. Such an object then both pleases and does not please: it pleases the idea but not the feeling.

By contrast . . . there are objects whose idea contains nothing laudable, but which excite agreeable and enjoyable feelings. We say then that the objects are pleasant without being beautiful. There are, then, different kinds of beauty and different kinds of pleasure and we should not confuse them, or else we shall remain entangled. Let us distinguish that which pleases the spirit from that which pleases the heart, and that which gains our approval simply as an idea from that which gains our approval as a cause of a feeling.

Sometimes ideas and feelings are in agreement with each other and an object merits the qualification 'beautiful' on both counts. Sometimes, however, ideas and feelings are at war with each other and then an object pleases and at the same time it does not: from one perspective it is beautiful, while from another it lacks beauty.

Some speculative thinkers, accustomed to judging objects coolly and from ideas only, count feelings for nothing and consider all that is built upon them and all that follows from them as capricious or wayward. In contrast others, who are more numerous, do not reason at all, or hardly at all, and deliver themselves over entirely to their feelings. Since these latter are unable to trace the origins of their feelings and the causes of their differences with each other, in order to give some account of such differences and have done with it, they attribute them to chance, to some *je ne sais quoi*, or to pure caprice, thus confounding taste with fancy. However, we ought to avoid equally both confusion and excess.

Let us therefore examine first which principles regulate our approbation when we judge something from ideas only and find it beautiful independently of feeling.

VI. It is certain that instances like the following occur. Take someone with knowledge of painting and of mathematics and ask him to look at excellent paintings, or at circles, triangles, polygons, and other figures drawn with perfect regularity. If this person is preoccupied by something else or his heart is swayed by some violent passion, if, for example, he is anxious about the proceedings of a trial and happens to look at all these objects in the waiting-rooms of a judge whose verdict he awaits impatiently, then, it is certain that he will look at them fleetingly, simply out of politeness. He will not be touched by them in any way and every moment they demand of his attention will be painful and unrelieved by any feeling of pleasure. He would, however, be able to agree that all these objects are beautiful and well-wrought. There is, therefore, a beauty that is independent of feeling, and our mind contains the speculative principles which enable us to decide coolly whether an object is beautiful or not.

6 Abbé Jean-Baptiste du Bos (1670–1742) from *Critical Reflections on Poetry and Painting*

Jean-Baptiste du Bos was born in Beauvais, but underwent his theological training in Paris. He travelled widely and was familiar with the intellectual and cultural life of England, Italy and the Netherlands. He was strongly influenced by the empiricist philosophy of Locke (IIB1), whom he met while in England, and, to a lesser extent, by the work of Addison (IIB4) and Shaftesbury (IIB2 and 3). His *Critical Reflections on Poetry and Painting* met with enormous success on its publication in 1719. This was due, at least in part, to the fact that the book is written from the standpoint of the interested amateur rather than that of the philosopher or the practising artist. It found a wide readership amongst the ever growing number of those who took a non-professional interest in the arts. The new concern with the role of feeling and imagination which had surfaced in the work of Bouhours (ID7) and Crousaz (IIB5) is now made into a powerful attack on the authority of reason to judge works of art. Insisting on the primacy of sensation or 'sentiment', Du Bos maintains that it is the individual's subjective response before a work of art which is of central importance. This concern with the effects which art works have upon their audience leads him to consider the different means of representation proper to poetry and painting. In an argument which prefigures that developed by Lessing in the *Laocoön* (IIIA10), he contrasts poetry with

painting, pointing out that whereas poetry can depict a sequence of events, painting is restricted to a single moment in time. The *Réflexions critiques sur la poésie et sur la peinture* was first published in Paris, by J. Mariette, in 1719. We have used the English translation by Thomas Nugent, made from the fifth French edition, which encompasses all the changes and subsequent additions which Du Bos made to the work in his lifetime: *Critical Reflections on Poetry, Painting and Music*, London: John Nourse, 1748, vol. I, pp. 1–4, 21–5, 43–7, 56–9, 69–72, 74–5.

That a sensible pleasure arises from poems and pictures, is a truth we are convinced of by daily experience; and yet 'tis a difficult matter to explain the nature of this pleasure, which bears so great a resemblance with affliction, and whose symptoms are sometimes as affecting, as those of the deepest sorrow. The arts of poetry and painting are never more applauded, than when they are most successful in moving us to pity.

The pathetic representation of the sacrifice of Jephtha's daughter, set in a frame, is one of the most elegant ornaments of a sumptuous cabinet. The several grotesque figures, and most smiling compositions of painters of the gayest fancies, pass unobserved, to attend to this tragical picture. A poem, the chief subject whereof is the violent death of a young princess, graces the most august solemnity; and the tragedy is marked out for one of the principal amusements of a company assembled for their diversion. 'Tis observable, that we feel in general a greater pleasure in weeping, than in laughing at a theatrical representation.

In short, the more our compassion would have been raised by such actions as are described by poetry and painting, had we really beheld them; the more in proportion the imitations attempted by those arts are capable of affecting us. These actions are universally allowed to be the happiest and noblest subjects. It must be therefore a secret charm that draws our attention to the imitations made by those arts, whilst our nature feels an inward dread and repugnance at the sight of its own pleasure.

I shall venture to undertake to clear up this paradox, and explain the origin of that pleasure, which we receive from poems and paintings. Attempts of a less arduous nature have been frequently charged with temerity. 'Tis an attempt to unfold to man the causes of his approbation and dislike: an attempt to instruct him concerning the nature of his own sentiments, how they rise and are formed within him. I cannot therefore flatter myself with the hopes of my reader's approbation, unless I succeed in endeavouring to lay open to him what passes within himself; that is, in one word, the most inward motions of his heart. 'Tis natural to reject as untrue the glass, wherein we perceive no resemblance of our own features.

Those who write on subjects of a less sensible nature, have it frequently in their power to err with impunity. To detect their mistakes, a great deal of reflection, and sometimes inquiry, is necessary, but the subject which comes under my examination, is most obvious and intelligible. Every man is possessed of a standard rule applicable to my arguments, so as to discover easily the least deviation they may have from truth.

On the other hand, 'tis rendering an important service to those two arts, (arts, that are ranked amongst the most accomplished ornaments of polite society) to inquire philosophically into the nature and manner of the effects arising from their productions. A book which could lay open the heart of man, when moved by a poem, or

affected with a picture, would give our artists a very just and extensive view of the general effect of their works, whereof they seem to have so imperfect an idea. I must beg the indulgence of those gentlemen, for giving them so frequently, in the course of this work, the appellation of artists. The regard which, upon all occasions, I express for their respective arts, will be sufficient to convince them, that my not adding 'illustrious', or some other proper epithet to 'artist', proceeds only from my apprehension of falling into repetition. The desire of rendering them service is one of my inducements to publish these reflections, which I offer as the observations of a plain fellow-citizen, drawn from the examples of past ages, in order to enable their republic to be more upon its guard against future inconveniencies. If at any time I happen to assume a legislative tone, the reader will please to excuse it, as proceeding from inadvertency, rather than from any notion I entertain of my legislative authority.

* * *

That the principal merit of poems and pictures consists in the imitation of such objects as would have excited real passions. The passions which those imitations give rise to, are only superficial.

Since the most pleasing sensations that our real passions can afford us, are balanced by so many unhappy hours that succeed our enjoyments, would it not be a noble attempt of art to endeavour to separate the dismal consequences of our passions from the bewitching pleasure we receive in indulging them? Is it not in the power of art to create, as it were, beings of a new nature? Might not art contrive to produce objects that would excite artificial passions, sufficient to occupy us while we are actually affected by them, and incapable of giving us afterwards any real pain or affliction?

An attempt of so delicate a nature was reserved for poetry and painting. I do not pretend to say, that the first painters and poets, no more than other artists, whose performances may not perhaps be inferior to theirs, had such exalted ideas, or such extensive views, upon their first sitting down to work. The first inventers of bathing never dreamt of its being a remedy proper for the curing of certain distempers; they only made use of it as a kind of refreshment in sultry weather, though afterwards it was discovered to be extreamly serviceable to human bodies in several disorders: In like manner, the first poets and painters had nothing more in view perhaps, than to flatter our senses and imagination; and in labouring with that design, they found out the manner of exciting artificial passions. The most useful discoveries in society, have been commonly the effect of hazard: Be that as it will, those imaginary passions which poetry and painting raise artificially within us, by means of their imitations, satisfy that natural want we have of being employed.

Painters and poets raise those artificial passions, within us, by presenting us with the imitations of objects capable of exciting real passions. As the impression made by those imitations is of the same nature with that which the object imitated by the painter or poet would have made; and as the impression of the imitation differs from that of the object imitated only in its being of an inferior force, it ought therefore to raise in our souls a passion resembling that which the object imitated would have excited. In other terms, the copy of the object ought to stir up within us a copy of the passion which the object itself would have excited. But as the impression made by the

imitation is not so deep as that which the object itself would have made; moreover, as the impression of the imitation is not serious, inasmuch as it does not affect our reason, which is superior to the illusory attack of those sensations, as we shall presently explain more at large: Finally, as the impression made by the imitation affects only the sensitive soul, it has consequently no great durability. This superficial impression, made by imitation, is quickly therefore effaced, without leaving any permanent vestiges, such as would have been left by the impression of the object itself, which the painter or poet hath imitated.

The reason of the difference between the impression made by the object, and that made by the imitation, is obvious. The most finished imitation hath only an artificial existence, or a borrowed life; whereas the force and activity of nature meet in the object imitated. We are influenced by the real object, by virtue of the power which it hath received for that end from nature. *In things which we propose for imitation*, says Quintilian, *there is the strength and efficacy of nature, whereas in imitation there is only the weakness of fiction*.

Here then we discover the source of that pleasure which poetry and painting give to man. Here we see the cause of that satisfaction we find in pictures, the merit whereof consists in setting before our eyes such tragical adventures, as would have struck us with horror, had we been spectators of their reality. For as Aristotle in his Poetics says, *Tho' we should be loth to look at monsters, and people in agony, yet we gaze on those very objects with pleasure when copied by painters; and the better they are copied, the more satisfaction we have in beholding them*.

The pleasure we feel in contemplating the imitations made by painters and poets, of objects which would have raised in us passions attended with real pain, is a pleasure free from all impurity of mixture. It is never attended with those disagreable consequences, which arise from the serious emotions caused by the object itself.

A few examples will illustrate, better than all my arguments, an opinion, which, methinks, I can never set in too clear a light. The massacre of the innocents must have left most gloomy impressions in the imaginations of those, who were real spectators of the barbarity of the soldiers slaughtering the poor infants in the bosom of their mothers, all imbrued with blood. Le Brun's picture, where we see the imitation of this tragical event, moves indeed our humanity, but leaves no troublesome idea in our mind; it excites our compassion, without piercing us with real affliction. A death like that of Phædra, a young princess expiring in the midst of the most frightful convulsions, and accusing herself of the most flagitious crimes, which she has endeavoured to expiate with poison; such a death, I say, as that, would be one of the most frightful and most disagreable objects. We should be a long time before we could get rid of the black and gloomy ideas which such a spectacle would undoubtedly imprint in our imagination. The tragedy of Racine, wherein the imitation of that event is represented, touches us most sensibly, without leaving any permanent seed of affliction. We are pleased with the enjoyment of our emotion, without being under any apprehension of its too long continuance. This piece of Racine draws tears from us, though we are touched with no real sorrow; for the grief that appears is only, as it were, on the surface of our heart, and we are sensible, that our tears will finish with the representation of the ingenious fiction that gave them birth.
* * *

Of the nature of those subjects which painters and poets treat of. That they cannot chuse for imitation too engaging a subject.

Since the principal charm of poetry and painting, even the very power of moving and pleasing, proceeds from the imitations of objects capable of engaging us; the greatest imprudence a poet or painter can commit, is to chuse for a principal object of imitation, such things as we should look upon with an eye of indifference in nature; or to employ their art in the description of such actions, as would draw only a midling attention, were we really to behold them. How is it possible for us to be touched with the copy of an original, when the original itself is incapable of moving us? How shall our attention be engaged by a picture representing a peasant driving a couple of beasts along the highway, if the very action which this picture imitates, has no power of affecting us? A tale in verse, describing an adventure, which we have seen unconcernedly, will be much less able to give us any concern. *The imitation operates always with less force*, as Quintilian observes, *than the object imitated*. The imitation therefore is incapable of moving us, when the object imitated can have no effect upon us. The subjects which the Teniers, Wowermans, and other painters of the same rank have chosen for imitation, would have very little engaged our attention. There is nothing in the action of a country feast, or in the amusements of a parcel of soldiers in a guard-house, that is capable of moving us. The imitation therefore of those objects, may possibly amuse us some few moments, may even draw from us an applause of the artist's abilities in imitating, but can never raise any emotion or concern. We commend the painter's art in copying nature so well, but we disapprove of his choice of objects that have so little in them to engage us.

The finest landskip, were it even Titian's or Caraccio's, does not affect us more, than the prospect of a frightful or agreable spot of land; there is nothing in such a picture that can be called really entertaining, and, as it strikes us but little, so as little it engages us. The most knowing painters have been so thoroughly convinced of this truth, that it is very rare to find any mere landskips of theirs without an intermixture of figures. They have therefore thought proper to people them, as it were, by introducing into their pieces a subject composed of several personages, whereof the action might be capable of moving, and consequently of engaging us. 'Tis thus that Poussin, Rubens, and several other great masters, have employed their art. They are not satisfied with giving a place in their landskips to the picture of a man going along the high road, or of a woman carrying fruit to market; they commonly present us with figures that think, in order to make us think; they paint men hurried with passions, to the end that ours may be also raised, and our attention fixed by this very agitation: In fact, the figures of those pieces are much more talked of than the trees or terrasses. The famous landskip, so often drawn by Poussin, and which is commonly called the *Arcadia*, would not have been so highly esteemed, had it not been embellished with figures.

The fame of those blissful regions is universally known, which were fancied to have been once inhabited by the happiest race of men that ever the earth produced; men engaged in an uninterrupted series of pleasures, and strangers to all disquiets or cares, except such as are attributed in romances to those chimerical shepherds, whose

situation is represented to us as an object worthy of our desires. The picture above-mentioned exhibits a landskip of that delightful country: In the middle thereof you see the monument of a young maid snatched away in the flower of her age; which appears from her statue lying on the tomb, after the manner of the antients. The sepulchral inscription contains those few Latin words, *Et in Arcadia ego: And I was once an inhabitant of Arcadia.* But this short inscription draws the most serious reflections from two youths and two young virgins decked with garlands, who seem to be struck with their having thus accidentally met with so melancholy a scene, in a place where one might naturally suppose they had not been in pursuit of an object of sorrow. One of them points with his finger to the inscription, to make the rest observe it, whilst the remains of an expiring joy may yet be discerned through the gloominess of grief which begins to diffuse itself over their countenances. Here you imagine yourself listening to the reflections of those youthful persons upon death, which spares neither age nor beauty, and against the attacks of which the most happy climates can afford no sanctuary. Your fancy now suggests to you, the affecting speeches they are going to make to each other upon recovering from their first surprize, which you will naturally apply to yourself, and to those whom you have a concern for.

What has been said with regard to painting, is equally applicable to poetry; since the imitations which the latter makes of nature, affect us only in proportion to the impression made by the thing imitated. The best versified tale imaginable, the subject whereof hath nothing in its nature ridiculous, will never be capable of exciting laughter. A satire, which does not set in a clear light some truth, whereof I had already a confused idea, nor contains none of those maxims, whose conciseness of expression, and sublimity of thought, render them worthy of being dignified as proverbs; such a satire perhaps may be commended as a well-written piece, but makes no impression, nor leaves no desire of a second perusal in the mind of the reader. An epigram without any vivacity of thought, or on such a subject as would not bear listening to with pleasure in prose, let the versification and rhyme be ever so well finished, will never fix itself in your memory. A dramatic poet, whose personages appear in characters of so little concernment, as I should not be uneasy to see my most intimate acquaintances acting those very characters in real life; is very far from engaging me in favor of his personages. 'Tis impossible for the copy to affect me, if I cannot be touched with the original.

* * *

Objection drawn from pictures, to prove that the art of imitation is more engaging than the very subject of imitation.

It may be here objected, that some pictures, wherein we only see the imitation of different objects, which would have no way affected us, had we seen them in their real nature, engage notwithstanding our attention a long time. We take much more notice of fruits and animals represented in a picture, than we should of the reality of those very objects. The copy here engages us more than the original.

To this I reply, that when we contemplate curiously any pictures of this kind, our principal attention is not fixt on the object imitated, but upon the art of the imitator.

'Tis not so much the object, as the artist's abilities, that draws our curiosity; we bestow no more attention on the object imitated in the picture, than we should on that same object in real nature. This kind of pictures does not engage our curiosity half so long as those, wherein the merit of the subject is joined with that of the execution. No body stands as long gazing at a basket of flowers done by Baptist, or at a country feast done by Teniers, as he would on one of Poussin's seven sacraments, or some other historical composition executed with as much ability and art, as is displayed by Baptist and Teniers in theirs. An historical piece drawn with as much dexterity, as a guard-house by Teniers, would engage our attention much more than the guard-house.

Here we are always to suppose, as it is reasonable we should, that the painter's art has been equally successful in both; for it is not sufficient that the pictures be drawn by the same hand. For instance, we behold with more pleasure one of Tenier's country feasts, than one of his historical pieces; but this is no argument at all against us. Everybody knows that Teniers miscarried always in his serious compositions, as he generally succeeded in his grotesque ones.

Thus, by distinguishing the attention which is given to the art, from that which is given to the object imitated, the truth of my proposition will appear manifest; that the imitation never makes a greater impression on us, than the object imitated could have made. This is even true in pictures, that are only valuable for the merit of the execution.

The art of painting is so extremely delicate and attacks us by means of a sense, which has so great an empire over our soul, that a picture may be rendered agreable by the very charms of the execution, independent of the object which it represents: but I have already observed, that our attention and esteem are fixt then upon the art of the imitator, who knows how to please, even without moving us. We admire the pencil that has been so capable of counterfeiting nature. We inquire how it was possible for an artist to deceive our eyes to that degree, as to make us take colors laid on a surface for real fruit. A painter, therefore, may pass for a great artist, considered as an elegant designer, or as so skilled in colors as to rival nature, though he does not even know how to make use of his talents in the representation of affecting objects, or to give his pictures that spirit and resemblance of life that are conspicuous in those of Raphael and Poussin. The pictures of the Lombard school are admired, though the painters thereof have frequently confined themselves to the flattering of the eyes, with the richness and exactness of their colors, without reflecting, perhaps, that their art was capable of moving us: but their most zealous sticklers agree, that there is yet one great beauty wanting in the pictures of this school; and that those of Titian, for instance, would be infinitely more valuable, if he had pitched upon affecting subjects, and if he had joined more frequently the talents of his own school with those of the Roman. The picture of this great painter, which represents Peter Martyr, a Dominican friar, massacred by the Vaudois, is not perhaps the most valuable of his pieces for the richness of local colors, notwithstanding its being so admirable, even in this respect; and yet Cavalier Ridolfi, the historian of the painters of the school of Venice, acknowledges that this, of all his pieces, is the most generally known, and the most universally applauded. The reason thereof is, because the action of this picture is

more engaging, and Titian has treated it with a greater resemblance of truth, and a more elaborate expression of the passions, than any of his other pieces.

* * *

That there are some subjects particularly adapted to poetry, and others specially proper for painting. Of the manner of distinguishing them.

The subject of imitation ought not only to be interesting of its own nature, but moreover should be adapted to painting, if intended for the pencil; and proper for poetry, if designed for verse. There are some subjects that are much more suitable to painters than poets, and others that are fitter for poets than painters. I shall endeavour to explain this more at large; but as I have thought proper to be a little diffused, in order to render myself more intelligible, I am afraid I shall stand in need of the reader's indulgence for the prolixity of this discussion.

A poet can tell us several things, which a painter would find impossible to exhibit. He can express several of our thoughts and sentiments, which a painter cannot represent, by reason of their not being attended with any proper motion, particularly marked in our attitude, or precisely characterised in our countenance. The speech of Cornelia to Cæsar, where she discovers to him the conspiracy, that was just ripe for his destruction,

L'exemple que tu dois periroit avec toi!

[*May Rome the last example see in thee!*]

cannot be expressed by a painter. He may, indeed, by drawing Cornelia's countenance suitable to her situation and character, give us some idea of her sentiments, and make us sensible, that she is speaking with a dignity that becomes her; but the thought of this Roman lady, who desires the death of the oppressor of the republic, as a punishment that may deter others from making any future attempts upon liberty, and not as a detestable crime, cannot be imaged by the pencil. There is no picturesque expression that can articulate, as it were, the words of old Horatius, where he answers the person, who had asked him, what his son was able to do alone against three antagonists? *Qu'il mourût, That he could die.* A painter may indeed let us see, that a man is moved with a particular passion, tho' he does not draw him in the action of venting it, because there is no one passion of the mind, that is not at the same time a passion of the body. But it is extremely rare, that a painter can express, so as to be sufficiently understood, the particular thoughts produced by anger, according to the proper character and circumstances of each person; or the sublime which it throws out in words adapted to the situation of the personage that speaketh.

For example, Poussin could, in his piece of the death of Germanicus, express all the different sorts and degrees of affliction, wherewith his friends and family were penetrated, when they saw him poisoned, and expiring in their arms; but he was incapable of giving us an account of the last sentiments of this prince, which are so extremely moving. This is left for the poet, who can make him say, *If a death so untimely as mine had snatched me away, even through some mistake of nature, I should yet*

have a right to complain of the severity of my destiny; but as I fall a victim to treachery and poison, I must exhort you, my friends, to be the avengers of my death, and not to blush to turn informers, to obtain my injured manes satisfaction: The public pity will certainly join with such accusers. A painter cannot express the greatest part of these thoughts, nor can he exhibit, in a single piece, more than one of such sentiments as he is capable of expressing. 'Tis true, that in order to make us understand the suspicion which Germanicus had of Tiberius's being the author of his death, he can draw Germanicus, shewing to his wife Agrippina, a figure of Tiberius, exhibited in a gesture and air proper for the distinguishing of such a thought; but he is then obliged to employ his whole piece in expressing this single sentiment.

As the picture, which represents an action, shews only an instant of its duration, it is impossible for the painter to express the sublime, which those things, that are previous to its present situation, throw sometimes into an ordinary sentiment. Poetry, on the contrary, describes all the remarkable incidents of the action it treats of, and that which precedes reflects frequently the marvellous upon a very ordinary thing, which is said or done in the sequel. 'Tis thus poetry may employ the marvellous that arises from circumstances, which may be called a relative sublime. [. . .]

I have oftentimes wondered why painters, who have so great an interest in making those personages known, by whose figures they intend to move us, and who find it so vastly difficult to distinguish them sufficiently by the sole aid of the pencil, why, I say, they do not accompany always their historical pieces with a short inscription. The greatest part of the spectators, who are in other respects capable of doing justice to the work, are not learned enough to guess at the subject of the picture. 'Tis to them sometimes an agreable person that strikes them, but talks a language they do not understand. People soon grow tired of looking at such pictures, by reason that pleasures, wherein the mind has no share, are of a very short duration.

The Gothic painters, rude and coarse as they were, had sense enough to know the utility of inscriptions, in order to render the subject of their pictures more intelligible. True it is, that they made as barbarous a use of that knowledge as of their pencils. They had the odd precaution to draw their figures with rolls coming out of their mouths, whereon they wrote whatever they would have these heavy inactive figures express; which was really making them speak. Tho' the rolls here mentioned, disappeared together with the Gothic taste; yet sometimes the greatest masters have judged two or three words necessary, in order to render their subjects intelligible: Nay, several have not even scrupled to write them on some part of the plan of their pieces, where they could be of no prejudice to the work. Raphael and Caraccio have acted thus; and Coypel has inscribed even several scraps of verses from Virgil, in the gallery of *Palace Royal*, in order to render those subjects more intelligible, which he had borrowed of the Æneid. Painters, whose works are ingraved, begin to grow sensible of the utility of these inscriptions; wherefore they put them at the bottom of such Prints, as are copied from their drawings.

7　Francis Hutcheson (1694–1746) 'Preface' to *An Inquiry into the Original of our Ideas of Beauty and Virtue*

Francis Hutcheson was born in Ireland of Scottish descent and was educated in Glasgow. He was licensed to preach by the Presbyterian Church of Ireland and went on to establish a successful private academy in Dublin. In 1729 he was made professor of moral philosophy at Glasgow University, lecturing on natural religion, morals, jurisprudence and government. He is one of the principal representatives of the moral-sense doctrine in ethics, which he inherited from Shaftesbury (see IIB2). However, his account of the role of feelings or sensations in the formation of our 'ideas' owes more to the philosophy of Locke (see IIB1). His *Inquiry into the Original of our Ideas of Beauty and Virtue* was published in two volumes in 1725. The first volume, entitled 'An Inquiry Concerning Beauty, Order, Harmony and Design', is given over to demonstrating the existence of an 'inner sense' of beauty. Just as involuntary feelings of pleasure and pain are 'caused' in us by properties of external objects and remain beyond our will, so the idea of beauty arises in direct response to the presence of features such as regularity, order, and harmony. Beauty is to be found in geometrical shapes and mathematical theorems just as much as in works of art or objects of natural beauty. The second volume of the treatise is given over to establishing the existence of a parallel moral sense which responds to virtuous actions with the same causal immediacy. As the 'Preface' to the *Inquiry* makes clear, Hutcheson sees both the inner sense of beauty and the moral sense as independent of rational deliberation. They are 'natural' attributes which are identical in every human being and which allow us to judge spontaneously and immediately. Hutcheson's arguments were subjected to vigorous criticism by Berkeley (see IIB8), but his theory of beauty remains important for having inaugurated a shift towards the perceptual and emotional responses of the individual subject. We have used the fourth, corrected edition, *An Inquiry into the Original of our Ideas of Beauty and Virtue in Two Treatises*, London, 1738, pp. ix–xvii.

There is no Part of *Philosophy* of more Importance, than a just *Knowledge of Human Nature*, and its various Powers and Dispositions. Our late Inquirys have been very much employ'd about our *Understanding*, and the several Methods of obtaining *Truth*. We generally acknowledge, that the Importance of any Truth is nothing else than its Moment, or Efficacy to make Men happy, or to give them the greatest and most lasting Pleasure; and *Wisdom* denotes only a Capacity of pursuing this End by the best Means. It must surely then be of the greatest Importance, to have distinct Conceptions of this End itself, as well as of the Means necessary to obtain it; that we may find out which are the greatest and most lasting Pleasures, and not employ our Reason, after all our laborious Improvements of it, in trifling Pursuits. It is to be fear'd indeed, that most of our Studys, without this Inquiry, will be of very little Use to us; for they seem to have scarce any other Tendency than to lead us into *speculative Knowledge* itself. Nor are we distinctly told how it is that *Knowledge* or *Truth* is pleasant to us.

This Consideration put the *Author* of the following Papers upon inquiring into the various Pleasures which *Human Nature* is capable of receiving. We shall generally find in our modern philosophick Writings, nothing farther on this Head, than some bare Division of them into *Sensible*, and *Rational*, and some trite Common-place

Arguments to prove the *latter* more valuable than the *former*. Our *sensible Pleasures* are slightly pass'd over, and explain'd only by some Instances in *Tastes, Smells, Sounds*, or such-like, which Men of any tolerable Reflection generally look upon as very trifling Satisfactions. Our *rational Pleasures* have had much the same kind of Treatment. We are seldom taught any other Notion of rational Pleasure than that which we have upon reflecting on our Possession or Claim to those Objects, which may be Occasions of Pleasure. Such Objects we call *advantageous*; but *Advantage*, or *Interest*, cannot be distinctly conceiv'd, till we know what those Pleasures are which advantageous Objects are apt to excite; and what Senses or Powers of Perception we have with respect to such Objects. We may perhaps find such an Inquiry of more Importance in *Morals*, to prove what we call the *Reality of Virtue*, or that it is the *surest Happiness* of the *Agent*, than one would at first imagine.

In reflecting upon our *external Senses*, we plainly see, that our Perceptions of Pleasure or Pain do not depend directly on our *Will*. Objects do not please us, according as we incline they should. The Presence of some Objects necessarily pleases us, and the Presence of others as necessarily displeases us. Nor can we, by our *Will*, any otherwise procure Pleasure, or avoid Pain, than by procuring the former kind of Objects, and avoiding the latter. By the very *Frame* of our *Nature* the one is made the Occasion of Delight, and the other of Dissatisfaction.

The same Observation will hold in all our other Pleasures and Pains. For there are many other sorts of Objects, which please, or displease us as necessarily, as material Objects do when they operate upon our Organs of Sense. There is scarcely any Object which our Minds are employ'd about, which is not thus constituted the necessary Occasion of some Pleasure or Pain. Thus we find ourselves pleas'd with a *regular Form*, a Piece of *Architecture* or *Painting*, a Composition of *Notes*, a *Theorem*, an *Action*, an *Affection*, a *Character*. And we are conscious that this Pleasure necessarily arises from the Contemplation of the Idea, which is then present to our Minds, with all its Circumstances, altho' some of these Ideas have nothing of what we commonly call sensible Perception in them; and in those which have, the Pleasure arises from some *Uniformity, Order, Arrangement, Imitation;* and not from the simple Ideas of *Colour*, or *Sound*, or Mode of *Extension* separately consider'd.

These *Determinations* to be pleas'd with any Forms, or Ideas which occur to our Observation, the *Author* chooses to call *Senses*; distinguishing them from the Powers which commonly go by that Name, by calling our Power of perceiving the *Beauty* of *Regularity, Order, Harmony*, an *Internal Sense*; and that *Determination* to approve *Affections, Actions*, or *Characters* of *rational Agents*, which we call *virtuous*, he marks by the Name of a *Moral Sense*.

His principal Design is to shew, 'That *Human Nature* was not left quite indifferent in the Affair of Virtue, to form to itself Observations concerning the *Advantage*, or *Disadvantage* of Actions, and accordingly to regulate its Conduct.' The Weakness of our Reason, and the Avocations arising from the Infirmities and Necessitys of our Nature, are so great, that very few Men could ever have form'd those long Deductions of Reason, which shew some Actions to be in the whole *advantageous* to the *Agent*, and their Contrarys *pernicious*. The *Author* of *Nature* has much better furnish'd us for a virtuous Conduct, than our *Moralists* seem to imagine, by almost as quick and powerful Instructions, as we have for the Preservation of our Bodys. He

has given us *strong Affections* to be the Springs of each virtuous Action; and made Virtue a lovely Form, that we might easily distinguish it from its Contrary, and be made happy by the Pursuit of it.

This *Moral Sense* of *Beauty* in *Actions* and *Affections*, may appear strange at first View. Some of our Moralists themselves are offended at it in my *Lord Shaftesbury*; so much are they accustomed to deduce every Approbation, or Aversion, from rational Views of private *Interest*, (except it be merely in the Simple Ideas of the external Senses) and have such a Horror at *innate Ideas*, which they imagine this borders upon. But this *moral Sense* has no relation to innate Ideas, as will appear in the second Treatise.

Our Gentlemen of *good Taste*, can tell us of a great many *Senses, Tastes*, and *Relishes* for *Beauty, Harmony*, Imitation in *Painting* and *Poetry*; and may not we find too in Mankind a *Relish* for a *Beauty* in *Characters*, in *Manners*? It will perhaps be found, that the greater Part of the Ingenious *Arts* are calculated to please some Natural Powers, pretty different either from what we commonly call *Reason*, or the External Senses.

In the first Treatise, the *Author* perhaps in some Instances has gone too far, in supposing a greater Agreement of Mankind in their *Sense* of *Beauty*, than Experience will confirm; but all he is sollicitous about is to shew, 'That there is some *Sense* of *Beauty natural* to Men; that we find as great an Agreement of Men in their Relishes of *Forms*, as in their external Senses, which all agree to be *natural*; and that Pleasure or Pain, Delight or Aversion, are *naturally* join'd to their Perceptions.' If the Reader he convinc'd of this, it will be no difficult matter to apprehend another *superior Sense*, *natural* also to Men, determining them to be pleas'd with *Actions, Characters, Affections*. This is the *moral Sense*, which makes the Subject of the second Treatise.

The proper Occasions of Perception by the external Senses, occur to us as soon as we come into the World; whence perhaps we easily look upon these Senses to be *natural*: but the Objects of the superior Senses of *Beauty* and *Virtue* generally do not. It is probably some little time before Children reflect, or at least let us know that they reflect upon *Proportion* and *Similitude*; upon *Affections, Characters, Tempers;* or come to know the external Actions which are Evidences of them. Hence we imagine that their *Sense* of *Beauty*, and their *moral Sentiments* of Actions, must be entirely owing to *Instruction* and *Education*; whereas it is as easy to conceive, how a *Character*, a *Temper*, as soon as they they are observ'd, may be constituted by *Nature* the necessary Occasion of Pleasure, or an Object of Approbation, as a *Taste* or a *Sound*; tho' these Objects present themselves to our Observation sooner than the other.

8 George Berkeley, Bishop of Cloyne (1685–1753) 'Third Dialogue' from *Alciphron, or the Minute Philosopher*

Berkeley was born near Kilkenny in Ireland. He was made a Fellow of Trinity College Dublin in 1707 and was ordained in the Anglican Church in 1709. The works upon which his reputation rests were largely written at this time, including his *Essay Towards a New*

Theory of Vision (1709) and *A Treatise concerning the Principles of Human Knowledge* (1710). He vigorously criticized the theories of Locke (see IIB1) and Shaftesbury (see IIB2 and 3), but his own claim that the contents of the material world are 'ideas' that exist only when a mind perceives them was much misunderstood by his contemporaries. The long philosophical dialogue, *Alciphron*, belongs to his later work. It is an attempt to defend the tenets of Anglican orthodoxy against various manifestations of 'free-thinking' and deism. The 'Third Dialogue' contains a sustained criticism of Hutcheson's arguments for the existence of an innate sense of beauty (see IIB7). Hutcheson's claim that we possess a natural and immediate capacity to discern what is beautiful is put into the mouth of Alciphron. As Alciphron's speech makes clear, however, Berkeley's real worry is the use of such arguments in support of claims for the existence of a parallel moral sense which would obviate the need for the precepts and instruction of the established Church. He seeks to counter such views with the figure of Euphranor, who is made the spokesman of his own opinions. Through a strategy of Socratic questioning, Euphranor brings Alciphron to recognize that the perception of beauty also depends upon recognition of the object's fitness or usefulness for its intended end or purpose. Since this involves the use of reason, our response to beauty cannot be sheerly sensuous or immediate. Beauty is thus to be regarded as not only an object of the eye but of the mind. The dialogue was first published in London by J. Tonson in 1732. The following excerpts are taken from the modern reprint edited by David Berman, *Alciphron, or the Minute Philosopher in Focus*, London and New York: Routledge, 1993, pp. 59–61, 65–70.

ALCIPHRON: [...] To go to the bottom of things, to analyse virtue into its first principles, and fix a scheme of duty on its true basis, you must understand that there is an idea of beauty natural to the mind of man. This all men desire, this they are pleased and delighted with for its own sake, purely from an instinct of nature. A man needs no arguments to make him discern and approve what is beautiful; it strikes at first sight, and attracts without a reason. And as this beauty is found in the shape and form of corporeal things; so also is there analogous to it a beauty of another kind, an order, a symmetry, and comeliness, in the moral world. And as the eye perceiveth the one, so the mind doth, by a certain interior sense, perceive the other; which sense, talent, or faculty is ever quickest and purest in the noblest minds. Thus, as by sight I discern the beauty of a plant or an animal, even so the mind apprehends the moral excellence, the beauty, and decorum of justice and temperance. And as we readily pronounce a dress becoming, or an attitude graceful, we can, with the same free untutored judgment, at once declare whether this or that conduct or action be comely and beautiful. To relish this kind of beauty there must be a delicate and fine taste; but, where there is this natural taste, nothing further is wanting, either as a principle to convince, or as a motive to induce men to the love of virtue. And more or less there is of this taste or sense in every creature that hath reason. All rational beings are by nature social. They are drawn one towards another by natural affections. They unite and incorporate into families, clubs, parties, and commonwealths by mutual sympathy. As, by means of the sensitive soul, our several distinct parts and members do consent towards the animal functions, and are connected in one whole; even so, the several parts of these rational systems or bodies politic, by virtue of this moral or interior sense, are held together, have a fellow feeling, do succour and protect each other, and jointly

co-operate towards the same end. Hence that joy in society, that propension towards doing good to our kind, that gratulation and delight in beholding the virtuous deeds of other men, or in reflecting on our own. By contemplation of the fitness and order of the parts of a moral system, regularly operating, and knit together by benevolent affections, the mind of man attaineth to the highest notion of beauty, excellence, and perfection. Seized and rapt with this sublime idea, our philosophers do infinitely despise and pity whoever shall propose or accept any other motive to virtue. Interest is a mean ungenerous thing, destroying the merit of virtue; and falsehood of every kind is inconsistent with the genuine spirit of philosophy.

CRITO: The love therefore that you bear to moral beauty, and your passion for abstracted truth, will not suffer you to think with patience of those fraudulent impositions upon mankind, providence, the immortality of the soul, and a future retribution of rewards and punishments; which, under the notion of promoting, do, it seems, destroy all true virtue, and at the same time contradict and disparage your noble theories, manifestly tending to the perturbation and disquiet of men's minds, and filling them with fruitless hopes and vain terrors.

ALC: Men's first thoughts and natural notions are the best in moral matters. And there is no need that mankind should be preached, or reasoned, or frightened into virtue, a thing so natural and congenial to every human soul. Now, if this be the case, as it certainly is, it follows that all the ends of society are secured without religion, and that an infidel bids fair to be the most virtuous man, in a true, sublime, and heroic sense.

* * *

EUPHRANOR: Pray tell me, Alciphron, are all mankind agreed in the notion of a beauteous face?

ALC: Beauty in humankind seems to be of a mixed and various nature; forasmuch as the passions, sentiments, and qualities of the soul, being seen through and blending with the features, work differently on different minds, as the sympathy is more or less. But with regard to other things is there no steady principle of beauty? Is there upon earth a human mind without the idea of order, harmony, and proportion?

EUPH: O Alciphron, it is my weakness that I am apt to be lost in abstractions and generalities, but a particular thing is better suited to my faculties. I find it easy to consider and keep in view the objects of sense: let us therefore try to discover what their beauty is, or wherein it consists; and so, by the help of these sensible things, as a scale or ladder, ascend to moral and intellectual beauty. Be pleased then to inform me, what is it we call beauty in the objects of sense?

ALC: Everyone knows beauty is that which pleases.

EUPH: There is then beauty in the smell of a rose, or the taste of an apple?

ALC: By no means. Beauty is, to speak properly, perceived only by the eye.

EUPH: It cannot therefore be defined in general [as] that which pleaseth?

ALC: I grant it cannot.

EUPH: How then shall we limit or define it?

Alciphron, after a short pause, said that beauty consisted in a certain symmetry or proportion pleasing to the eye.

EUPH: Is this proportion one and the same in all things, or is it different in different kinds of things?

ALC: Different, doubtless. The proportions of an ox would not be beautiful in a horse. And we may observe also in things inanimate, that the beauty of a table, a chair, a door, consists in different proportions.

EUPH: Doth not this proportion imply the relation of one thing to another?

ALC: It doth.

EUPH: And are not these relations founded in size and shape?

ALC: They are.

EUPH: And, to make the proportions just, must not those mutual relations of size and shape in the parts be such as shall make the whole complete and perfect in its kind?

ALC: I grant they must.

EUPH: Is not a thing said to be perfect in its kind when it answers the end for which it was made?

ALC: It is.

EUPH: The parts, therefore, in true proportions must be so related, and adjusted to one another, as that they may best conspire to the use and operation of the whole?

ALC: It seems so.

EUPH: But the comparing parts one with another, the considering them as belonging to one whole, and the referring this whole to its use or end, should seem the work of reason: should it not?

ALC: It should.

EUPH: Proportions, therefore, are not, strictly speaking, perceived by the sense of sight, but only by reason through the means of sight.

ALC: This I grant.

EUPH: Consequently, beauty, in your sense of it, is an object, not of the eye, but of the mind.

ALC: It is.

EUPH: The eye, therefore, alone cannot see that a chair is handsome, or a door well proportioned.

ALC: It seems to follow; but I am not clear as to this point.

EUPH: Let us see if there be any difficulty in it. Could the chair you sit on, think you, be reckoned well proportioned or handsome, if it had not such a height, breadth, wideness, and was not so far reclined as to afford a convenient seat?

ALC: It could not.

EUPH: The beauty, therefore, or symmetry of a chair cannot be apprehended but by knowing its use, and comparing its figure with that use; which cannot be done by the eye alone, but is the effect of judgment. It is, therefore, one thing to see an object, and another to discern its beauty.

ALC: I admit this to be true.

EUPH: The architects judge a door to be of a beautiful proportion, when its height is double of the breadth. But if you should invert a well-proportioned door, making its breadth become the height, and its height the breadth, the figure would still be the same, but without that beauty in one situation which it had in another. What can be the cause of this, but that, in the forementioned supposition,

the door would not yield convenient entrances to creatures of a human figure? But, if in any other part of the universe there should be supposed rational animals of an inverted stature, they must be supposed to invert the rule for proportion of doors; and to them that would appear beautiful which to us was disagreeable.

ALC: Against this I have no objection.

EUPH: Tell me, Alciphron, is there not something truly decent and beautiful in dress?

ALC: Doubtless, there is.

EUPH: Are any likelier to give us an idea of this beauty in dress than painters and sculptors, whose proper business and study it is to aim at graceful representations?

ALC: I believe not.

EUPH: Let us then examine the draperies of the great masters in these arts: how, for instance, they use to clothe a matron, or a man of rank. Cast an eye on those figures (said he, pointing to some prints after Raphael and Guido, that hung upon the wall): what appearance do you think an English courtier or magistrate, with his Gothic, succinct, plaited garment, and his full-bottomed wig; or one of our ladies in her unnatural dress, pinched and stiffened and enlarged, with hoops and whale-bone and buckram, must make, among those figures so decently clad in draperies that fall into such a variety of natural, easy, and ample folds, that cover the body without encumbering it, and adorn without altering the shape?

ALC: Truly I think they must make a very ridiculous appearance.

EUPH: And what do you think this proceeds from? Whence is it that the eastern nations, the Greeks, and the Romans, naturally ran into the most becoming dresses; while our Gothic gentry, after so many centuries racking their inventions, mending, and altering, and improving, and whirling about in a perpetual rotation of fashions, have never yet had the luck to stumble on any that was not absurd and ridiculous? Is it not from hence that, instead of consulting use, reason, and convenience, they abandon themselves to irregular fancy, the unnatural parent of monsters? Whereas the ancients, considering the use and end of dress, made it subservient to the freedom, ease, and convenience of the body; and, having no notion of mending or changing the natural shape, they aimed only at showing it with decency and advantage. And, if this be so, are we not to conclude that the beauty of dress depends on its subserviency to certain ends and uses?

ALC: This appears to be true.

EUPH: This subordinate relative nature of beauty, perhaps, will be yet plainer, if we examine the respective beauties of a horse and a pillar.... Now, I would fain know whether the perfections and uses of a horse may not be reduced to these three points: courage, strength, and speed; and whether each of the beauties enumerated doth not occasion or betoken one of these perfections? After the same manner, if we inquire into the parts and proportions of a beautiful pillar, we shall perhaps find them answer to the same idea. Those who have considered the theory of architecture tell us, the proportions of the three Grecian orders were taken from the human body, as the most beautiful and perfect production of nature. Hence were derived those graceful ideas of columns, which had a character of strength without clumsiness, or of delicacy without weakness. Those beautiful proportions were, I say, taken originally from nature, which, in her creatures, as

hath been already observed, referreth them to some end, use, or design. The *gonfiezza* also, or swelling, and the diminution of a pillar, is it not in such proportion as to make it appear strong and light at the same time? In the same manner, must not the whole entablature, with its projections, be so proportioned, as to seem great but not heavy, light but not little; inasmuch as a deviation into either extreme would thwart that reason and use of things wherein their beauty is founded, and to which it is subordinate? The entablature, and all its parts and ornaments, architrave, frieze, cornice, triglyphs, metopes, modiglions, and the rest, have each a use or appearance of use, in giving firmness and union to the building, in protecting it from the weather and casting off the rain, in representing the ends of beams with their intervals, the production of rafters, and so forth. And if we consider the graceful angles in frontispieces, the spaces between the columns, or the ornaments of their capitals, shall we not find, that their beauty riseth from the appearance of use, or the imitation of natural things, whose beauty is originally founded on the same principle? which is, indeed, the grand distinction between Grecian and Gothic architecture; the latter being fantastical, and for the most part founded neither in nature nor in reason, in necessity nor use, the appearance of which accounts for all the beauty, grace, and ornament of the other.

9 Jonathan Richardson (1665–1745) 'Of the Sublime'

For the second edition of his *Essay on the Theory of Painting*, Richardson added a new final chapter on the Sublime. Taking up some suggestions by the French author Nicolas Boileau, he began to explore a concept which was to achieve wide currency during the eighteenth century, and to become an important influence on the later Romantic movement. Richardson is obviously uncertain of the matter before him, seeming sometimes to think of the Sublime simply as 'the most excellent of what is excellent'. Indeed, after a lengthy attempt to pin down the nature of the Sublime in literature he confesses that 'after all it cannot be said with certainty what is and what is not Sublime'. However, when he goes on to the Sublime in Painting, it turns out that something like this is precisely the point: the Sublime cannot be pinned down. Richardson senses that its hallmark is the excessive, the drive to go beyond what is given in the rules. It is as if, from the very centre of the disposition to specify and codify what art was in terms of gentlemanly competence and national profitability, the notion of the Sublime gave a glimpse of what art would become at a later stage. Although he does not quite know what to do with it, the hallmark of transgression is there in Richardson's language: 'tempests', 'vastness', '*plus ultra*', and 'bliss'. Our brief extracts are taken from the second edition of Richardson's *Essay on the Theory of Painting*, London: 'A. C.' 1725, pp. 248–9 and 256–63.

[. . .] [H]ere I take the Sublime to be the Greatest, and most Beautiful Ideas, whether Corporeal, or not, convey'd to us the most Advantageously.

By Beauty I do not mean that of Form, or Colour, Copy'd from what the Painter sees; These being never so well Imitated, I take not to be Sublime, because These require little more than an Eye, and Hand, and Practice. An Exalted Idea of Colour in a Humane Face, or Figure might be judg'd to be Sublime, could That be had, and

convey'd to Us, as I think it cannot, since even Nature has not yet been Equall'd by the Best Colourists; Here she keeps Art at a Distance whatever Courtship it has made to her. In Forms 'tis Otherwise as we find in the Antique Statues, which therefore I allow to have a Sublimity in them: And should do the same in regard to the same Kind, and Degree of Beauty if it were to be found in any Picture, as I believe it is not. Tho' in Pictures is seen a Grace, and Greatness, whether from the Attitude, or Air of the Whole, or the Head only, that may justly be Esteem'd Sublime.

'Tis to these Properties therefore as also to the Invention, Expression and Composition, that I confine the Sublime in Painting, and that as they are found in Histories and Portraits. [. . .]

When we see the Sublime it Elevates the Soul, gives her a higher Opinion of her Self, and fills her with Joy, and a Noble kind of Pride, as if her self had produc'd what she is Admiring. It Ravishes, it Transports, and creates in us a certain Admiration, mix'd with Astonishment. And like a Tempest drives all before it. [. . .]

In the foregoing Treatise I have been shewing what I take to be the Rules of Painting, and tho' Any one had understood, and practis'd them all, I must yet say One thing is wanting, Go, and Endeavour to attain the Sublime. For a Painter should not Please only, but Surprize.

Plus ultra was the Motto of the Emperour Charles V. whose Actions were of the Sublime kind, and, as Monsieur St. Evremont finely distinguishes, rather Vast, than Great: And this should be the Motto of all that apply themselves to any Noble Art, particularly of a Painter [. . .] He must be perpetually Advancing. And whatever Rules are given as Fundamental of the Art *Plus ultra* like a Golden Thread should be woven in, and run throughout the whole piece. [. . .]

When we propose only an exact Imitation of Nature we shall certainly fall short of it; So when we aim no higher than what we find in any One, or more Masters, we shall never reach their Excellence: He that would rise to the Sublime must form an Idea of Something beyond all we have yet seen; or which Art, or Nature has yet produc'd. [. . .]

This is the Great Rule for the Sublime; not to be given however 'till those Fundamental of the Art have been well Known, and Practised; 'tis to be Open'd when a Man has got far on his way, as the Commissions of Admirals, or Generals going on some great Expedition frequently are. The Sublime disdains to be Trammell'd, it knows no Bounds, 'tis the Sally of Great Genius's, and the Perfection of Humane Nature; but like Milton's Paradise *Wild, above Rule, or Art, Enormous Bliss!*

10 Lambert Hermanson ten Kate (1674–1732) 'The Beau Ideal'

Ten Kate was a widely read Dutch scholar with an interest in philology and Antiquity, as well as the contemporary theory of art. In 1728, in company with A. Rutgers, he published in Amsterdam a three-volume French translation of works by Jonathan Richardson under the collective title *Traité de la Peinture*. To the third volume, Ten Kate appended his own short treatise 'Un Discourse Preliminaire sur le Beau Idéal, des Peintres, Sculpteurs et Poètes'. This had apparently been written before he encountered Richardson's writings on painting. Be that as it may, Ten Kate's text complements the chapter on the Sublime which

Richardson added to the second edition of his *Theory of Painting* in 1725 (see IIB9). Although slight, and far from clear, Ten Kate's text helps to underline the link between the earlier concepts of 'grace' and the *je ne sais quoi* (see ID) and a concept of the Sublime as relating to those aspects of art which appear to defy logical judgement and measure. The text was translated into English and published posthumously as a separate pamphlet of 21 pages. Our short extract is taken from pp. 2–3 of the translation by James Christopher Le Blon, London: James Bettenham, 1732.

The most considerable Authors that treat of the sublime Part and Ideal of the Art of Painting, commonly used the Name of Beau; or a thing well proportion'd, natural, sublime, and of an high Taste: Terms that, in my Opinion, might be more illustrated than they have been; I am determin'd upon the Occasion of this Book of Messieurs Richardsons to publish this my Treatise of the Beau Ideal, with a View to enrich the Art, and to facilitate the Undertakings of the best Authors.

The Ideal is properly a judicious Choice only and an ingenious Representation of Objects in order to have every thing excellent in its kind, and so chosen from intire Nature, as to attract the Eyes and captivate the Attention of Connoisseurs; the whole nevertheless different throughout, according to the Exigence of the Case and the Subject. This Ideality is extended through all the principal Parts of Art, not only in the different Choice of Ordonnance, or Disposition of the whole of the Chiaro Obscuro, the Coloritto, the Draperies, the Attitudes, the Characters of Personages; but also through the Subjects of pleasant Landskips, of fine Flowers and of exquisite Fruits, in such a manner that in every Composition a particular Harmony reigns, and a certain Union of the Whole; just as in a fine Piece of Musick, the Key or Tone reigns upon which the Musick is compos'd.

But seeing the different Reflections of Authors have a Respect to the Ideal of the Personages, either of Fables, or of sacred and prophane History, or of Allegories; and seeing, when the most difficult part of any thing is comprehended, the more easy parts are soon comprehended, we may confine ourselves here to the Ideal, with respect to Personages or Figures, especially to one of the most sublime parts of the Ideal, which is more admirably well executed in the finest antique Statues and in the principal Works of Raphael.

The sublime Part that I so much esteem, and of which I have begun to speak, is a real *Je ne sçai quoi*, or an unaccountable Something to most People, and it is the most important part to all the Connoisseurs: I shall call it an harmonious Propriety, which is a touching or moving Unity, or a pathetick Agreement or Concord, not only of each Member to its Body, but also of each Part to the Member of which it is a Part: It is also an infinite Variety of Parts, however conformable, with respect to each different Subject, so that all the Attitude, and all the Adjustment of the Draperies of each Figure ought to answer or correspond to the Subject chosen. Briefly, it is a true Decorum, a *Bienséance* or a congruent Disposition of Ideas, as well for the Face and Stature, as for the Attitudes. A bright Genius, in my Opinion, who aspires to excel in the Ideal, should propose this to himself, as what has been the principal Study of the most famous Artists. 'Tis in this Part that the great Masters cannot be imitated or copied but by themselves, or by those that are advanced in the Knowledge of the Ideal, and who are as knowing as those Masters in the Rules or Laws of the

Pittoresque and Poetical Nature, altho' inferior to the Masters in the high Spirit of Invention.

11 Pierre de Marivaux (1688–1763) from *The Philosopher's Cabinet*

The French dramatist, novelist and essayist Marivaux was born in Paris. His numerous plays reflect the spirit of 'preciosity' which reigned in the Parisian salons where he was most at home. Through the use of disguise and the construction of false situations, Marivaux investigates the disparity between what is said and what is thought in 'the game of love'. His plays have sometimes been compared to the paintings of Watteau (see IIA12), whose *fêtes galantes* are animated by a similar spirit of grace and refinement. In the work of both artists there is a tone of melancholy seriousness beneath the apparent gaiety. Marivaux was also a prolific essayist. In 1722 he founded the *Spectateur Français*, inspired by Addison's journal, *The Spectator* (see IIB4). *Le Cabinet du philosophe* was also published as a weekly journal, although it seems that the work was conceived as a whole prior to the appearance of the first issue in January 1734. In the excerpt reproduced here, Marivaux constructs an ingenious allegory in which he describes the respective abodes of 'beauty' and of the *je ne sais quoi*. Each is identified with a different form of garden design. That of beauty is formal and symmetrical, that of the *je ne sais quoi*, free and informal. Although the personification of beauty commands respect and admiration, she has become mute and inexpressive. By contrast, the *je ne sais quoi* remains elusive, invisible to the gaze but everywhere present as an animating spirit. Marivaux's admiration for disorder, fantasy and irregularity owes much to the work of Addison, but also draws on the writing of earlier figures such as Bouhours (see ID7). *Le Cabinet du philosophe* was first published in Paris, by Prault, in 1734. The following excerpt has been translated for this volume by Katerina Deligiorgi from the facsimile edition, Geneva; Slatkine Reprints, 1970, 'Deuxième feuille', pp. 35–48.

Rarely are beauty and the *je ne sais quoi* found together.

By *je ne sais quoi* I mean the diffuse charm of a face or a figure which renders someone lovely but which is impossible to locate.

I have read somewhere a rather singular story on this subject about a man who thought that he had found the dwelling-place of Beauty and of the *je ne sais quoi*.

And here is more or less what he said. The account is short, for I relate here only the summary of the story.

One day, said the man, I was strolling in the countryside when I came across one of the most beautiful women in the world, a woman I had encountered before over the eight days I had already spent there. The first time I saw her I had looked upon her with admiration, the second time I was less moved, until finally I was able to look at her with indifference even though I still found her beautiful – and indeed so she was. I asked myself why this beauty, so deserving of admiration, seemed now insipid to me, and, in general, why Beauty itself fails to inspire more enduring feelings.

I was still pondering this when I found myself between two gardens, one magnificent, the other gay and cheerful. The doors of the two gardens were facing each other. On the door of the magnificent garden was written with golden letters: 'The Abode of Beauty'. On that of the cheerful garden, painted in many-coloured letters so

that one could not make out for certain the precise hue, was: 'The Abode of the *je ne sais quoi*'.

'The abode of Beauty!' I thought to myself, 'Oh! that is what I want to see! For who says "beauty" says something more important than "*je ne sais quoi*" and certainly more worth seeing.'

As if pulled by the force of the very word 'beauty' I did not hesitate. Choosing the garden of Beauty, I left behind the garden of the *je ne sais quoi* to which I would return later to amuse myself.

Resolved as I was in favour of the former, I nonetheless glanced once more at the other which seemed so cheerful. I wished then it were possible to see them both at once. But in truth there was no comparison to be made and I had to start with the most attractive. This is what I did.

As I entered the garden of beauty I noticed the footsteps of many men who had gone before – though I also noticed that just as many had left.

I stepped forward and the more I discovered, the more I admired.

I will not describe to you all the beautiful things I saw there. An account of these grounds is beyond me, but I was amazed and awe-struck. Imagine all that is grand, superb and magnificent in a single garden, all the astonishing effects that the most exact symmetry and the most intelligent arrangement can create – and you will hardly have formed an image of what I saw.

How, too, can I describe that palace which I discovered after having walked a while? I give up.

I would rather say something about the woman I saw there. She was sitting on a kind of throne around which several men were gathered. From what they told me, they had arrived there only an hour before me. They were all motionless, as if in ecstasy before this woman sitting on the throne.

Judge for yourself whether they were wrong: it was Beauty in person they were looking at. From time to time, she let her gaze fall nonchalantly on each one of us, making us cry: 'Ah! The beautiful eyes!' and the next moment, 'Ah! The beautiful mouth! Ah! The beautiful turn of the face, the beautiful figure!'

Hearing these exclamations, Beauty would smile, lower her eyes a little, and assume a countenance that was modest rather than disconcerted. Without saying a word, she would start again to look at each one of us, as if to confirm in us the feelings of admiration we had for her. After a short while, she would lift her head and assume a haughty stance that seemed to say: 'Join respect to your admiration.' That was her only language.

In the first quarter of an hour the pleasure of contemplating her made us forget her silence. In the end, however, I became aware of it and so did the others.

'What!' we said amongst ourselves, 'Nothing but smiles and airs and not a single word. That is hardly enough. Is it only our eyes that may be contented? Do we live only for the pleasures of seeing?'

Thereupon, one of us stepped forward to present Beauty with a fruit he had picked in the garden. She smiled and picked it with the most beautiful hand of the world but never opened her mouth. She thanked him with a comely gesture and we had to limit ourselves to looking at her.

Each one of us apparently grew weary of this, for, little by little, our gathering diminished. I saw my companions disappear and soon, from all the admirers amongst whom I had found myself, I was the only one remaining and withdrew in my turn.

As I was walking along an alley, retracing my steps, I encountered another woman who looked very proud and noble. I bowed deeply as I crossed her path.

'What did you see?' she asked with a disdainful and vexed air. 'I have just been admiring Beauty,' I said, 'and now I withdraw.' 'And why withdraw?' she replied. 'Should you not be transfixed by Beauty? What else is there to see, once you have seen her?'

'Nothing for sure,' I said, 'but I saw her enough. I know her features by heart. They are always the same. The beautiful face always repeats itself, it says nothing to the spirit, it speaks only to the eyes, telling them always the same thing. I learn nothing new. If Beauty entertained her admirers a little, if the movements of her soul were reflected on her face, rendering it less uniform and more affecting, then her face would please the heart as well as the eyes. But we are only to look at its beauty, without feeling it. Beauty should take the trouble to speak and to show the wit she doubtless possesses.'

'And what does it matter whether she has any or none at all?' the woman said. 'Does she need any, made the way she is? Go away, you understand nothing. If this were an ordinary face, I would agree with you. Then it would gain from being animated by wit and this would do it a great deal of good and would supplement the graces which it lacked. But to wish that wit animated a beautiful face is to wish to alter its charms. Wit improves uneven features, but harms beautiful ones – it disturbs them. A beautiful face is perfectly finished. The best it can do is to remain as it is. The play of wit would trouble its economy because it is precisely as it should be and it cannot leave that state without harming itself. Your criticisms are therefore lacking in judgement. It is I who tell you this, the unmoving Pride of the beautiful and the companion of Beauty. I never leave her side and take great care to keep her spirit cold and tranquil, so that her face stays calm and retains its noble reserve. Fortunately, it is true that I have no great difficulty in tempering her spirit, for it is usually placid and calm. Or, at least, her spirit is well aware of how important it is to remain grave and not to disturb the beautiful face, whose interests concern it far more than its own.'

This is what this woman claimed and her discourse seemed to me so extraordinary that I responded with a bow, after which I left promptly to reach the abode of the *je ne sais quoi* where I found all those who had left me alone in the abode of beauty.

There was nothing eye-catching in this place and, what is more, nothing arranged. All was as if thrown together by chance. Disorder reigned, but a disorder of the best possible taste, producing a charming effect, the cause of which could neither be unravelled nor shown.

We wanted for nothing and yet nothing can have been finished there, or at least, whatever the final design was, it remained incomplete, for every moment we saw something new added.

And despite the fable which allows for only three Graces, there was an infinity of Graces there striding along in the garden, working and transforming everything. I say 'striding' because this is all they did: they came and went, they passed quickly in

front of us, followed by others, without giving us the time to know them well. They were there, we scarcely had a chance to see them, and they were there no more. Others took their place, moving on in their turn to make room for others. In a word, they were everywhere and stood nowhere. We never saw one but a thousand.

'Ah well, Gentlemen,' I said then, to those who were there with me, 'this is a charming garden, and I would gladly spend a lifetime here, but where is its inhabitant, the *je ne sais quoi?* Bring me to him for you must certainly have encountered him.'

'Not yet,' they replied, 'we have been looking for him since we arrived without having succeeded in finding him yet. It is true that our search is agreeable in itself, for even though we have the greatest desire to see him, we are not in the least impatient to find where he is and were we never to find him we would still be determined to search for ever.'

'He must nonetheless be here,' I replied. Hardly had I uttered these words, than we heard a voice declaring 'Here I am.'

We turned around, for we could see nothing before us. We turned in vain, for we saw nothing there either.

'Where are you then, lovely *je ne sais quoi?*' we all asked together.

'Here I am, I say,' replied the same voice.

And we turned again, again expecting to see him and still seeing nothing.

'You tell us "here I am",' I replied, 'and you do not present yourself to us.' 'But you see no one else but me,' he replied. 'In this infinite number of Graces who pass incessantly in front of your eyes, who come and go and are all so different and yet equally lovely, some virile and some tender: take a good look at them, for there I am. I am what you see, I alone. In these paintings that you like so, in these objects of every kind which so delight you, in the entire expanse of the grounds, in all that you perceive, here simple, here untended, irregular even, sometimes ornate, sometimes not, I am there and I show myself. I bestow my charm on everything, I surround you. In the figure of the Graces, I am the *je ne sais quoi* that belongs to both sexes. Here I am the *je ne sais quoi* which pleases in painting, there the *je ne sais quoi* which pleases in architecture, in furniture, in gardens, in everything that makes an object of taste. Do not look for me in any single shape; I have a thousand and not a single one that is fixed. This is why I am seen but not known and why I remain impossible to grasp or to define. I disappear from sight even while being watched; I am perceived but cannot be unravelled. You look at me and for me and you shall never find me in any other way. Thus you shall never tire of me.

12 Jonathan Edwards (1703–1758) 'The Beauty of the World'

Edwards was born in East Windsor, Connecticut, the son of the village pastor. At the age of 13 he went to Yale College. Having discovered the 'new learning' – principally the work of Locke and Newton – he went on to gain his MA degree, and was appointed as a tutor there in 1724. He had already undergone a profound religious conversion, and shortly followed his father into the Church, being ordained as a pastor in 1727. He was a leading figure in the religious revivalism which swept New England in the middle years of the eighteenth century,

and as a result of controversies which arose in this period, he was dismissed from his living in 1750. Thereafter he spent six years as a missionary to the Housatonic Indians at the frontier outpost of Stockbridge, Massachusetts. It was here, in almost complete isolation, that he produced his best-known works. In 1757 he was invited to take up the presidency of the College of New Jersey, subsequently Princeton University, but died in an epidemic before he could assume the post. He is now regarded as the first American intellectual to have gained an international reputation. His writings display a remarkable tension between acute observation of the natural world, fuelled by his interest in Newtonian science, and an all-pervading mysticism. The present text, long unpublished, was part of a folio of writings to which Edwards added throughout his life, and which drew together these two sides of his intellect. Called *The Images or Shadows of Divine Things*, it consists of over 200 entries, each of which 'reads' the world as the image of a divine truth. *The Beauty of the World* is a self-contained text of the same kind, included within the larger work. For Edwards, it is as if the world itself is an aesthetic totality, yet this is a sense of the aesthetic which is suffused by far more than worldly pleasure. Edwards himself did not write on art. However, many seventeenth- and eighteenth-century attempts to address elusive and ineffable aspects of experience, under rubrics such as the *je ne sais quoi* and 'grace', seem clearly to prefigure a later, modernist sense of the aesthetic. In this connection, it is of some interest that a meditation by Edwards was employed in 1967 as the epigraph to Michael Fried's passionate defence of artistic modernism, 'Art and Objecthood' (see *Art in Theory 1900–1990* VIIA6). Likewise, Fried's famous claim that 'we are all literalists most or all of our lives; presentness is grace,' clearly carries echoes of the eighteenth-century tradition we find at work in Edwards, with its sense of aesthetic experience lifting the sympathetic viewer out of a world of accident and contingency into a realm of immediacy and truth. The text, which is reproduced here in full, is taken from Jonathan Edwards, *Images or Shadows of Divine Things*, ed. Perry Miller, New Haven: Yale University Press, 1948, pp. 135–7.

The beauty of the world consists wholly of sweet mutual consents, either within itself or with the supreme being. As to the corporeal world, though there are many other sorts of consents, yet the sweetest and most charming beauty of it is its resemblance of spiritual beauties. The reason is that spiritual beauties are infinitely the greatest, and bodies being but the shadows of beings, they must be so much the more charming as they shadow forth spiritual beauties. This beauty is peculiar to natural things, it surpassing the art of man.

Thus there is the resemblance of a decent trust, dependence and acknowledgment in the planets continually moving round the sun, receiving his influences by which they are made happy, bright and beautiful: a decent attendance in the secondary planets, an image of majesty, power, glory, and beneficence in the sun in the midst of all, and so in terrestrial things, as I have shown in another place.

It is very probable that that wonderful suitableness of green for the grass and plants, the blues of the skie, the white of the clouds, the colours of flowers, consists in a complicated proportion that these colours make one with another, either in their magnitude of the rays, the number of vibrations that are caused in the atmosphere, or some other way. So there is a great suitableness between the objects of different senses, as between sounds, colours, and smells; as between colours of the woods and flowers and the smells and the singing of birds, which it is probable consist in a certain proportion of the vibrations that are made in the different organs. So there are innumerable other agreeablenesses of motions, figures, etc. The gentle motions of

waves, of [the] lily, etc., as it is agreeable to other things that represent calmness, gentleness, and benevolence, etc. the fields and woods seem to rejoice, and how joyfull do the birds seem to be in it. How much a resemblance is there of every grace in the field covered with plants and flowers when the sun shines serenely and undisturbedly upon them, how a resemblance, I say, of every grace and beautifull disposition of mind, of an inferiour towards a superiour cause, preserver, benevolent benefactor, and a fountain of happiness.

How great a resemblance of a holy and virtuous soul is a calm, serene day. What an infinite number of such like beauties is there in that one thing, the light, and how complicated an harmony and proportion is it probable belongs to it.

There are beauties that are more palpable and explicable, and there are hidden and secret beauties. The former pleases, and we can tell why; we can explain the particular point for the agreement that renders the thing pleasing. Such are all artificial regularities; we can tell wherein the regularity lies that affects us. [The] latter sort are those beauties that delight us and we cannot tell why. Thus, we find ourselves pleased in beholding the colour of the violets, but we know not what secret regularity or harmony it is that creates that pleasure in our minds. These hidden beauties are commonly by far the greatest, because the more complex a beauty is, the more hidden is it. In this latter fact consists principally the beauty of the world, and very much in light and colours. Thus mere light is pleasing to the mind. If it be to the degree of effulgence, it is very sensible, and mankind have agreed in it: they all represent glory and extraordinary beauty by brightness. The reason of it is either that light or our organ of seeing is so contrived that an harmonious motion is excited in the animal spirits and propagated to the brain. That mixture we call white is a proportionate mixture that is harmonious, as Sir Isaac Newton has shown, to each particular simple colour, and contains in it some harmony or other that is delightfull. And each sort of rays play a distinct tune to the soul, besides those lovely mixtures that are found in nature. Those beauties, how lovely is the green of the face of the earth in all manner of colours, in flowers, the colour of the skies, and lovely tinctures of the morning and evening.

Corollary: Hence the reason why almost all men, and those that seem to be very miserable, love life, because they cannot bear to lose sight of such a beautiful and lovely world. The ideas, that every moment whilst we live have a beauty that we take not distinct notice of, brings a pleasure that, when we come to the trial, we had rather live in much pain and misery than lose.

Part III
Judgement and the Public Sphere

III
Introduction

The next three sections together cover different aspects of the same chronological span: the second half of the eighteenth century. In Western Europe this was experienced at the time as a period of great change. Indeed, momentous change did occur, economically as well as politically, in the leading nation-states of France and England. In a very real sense, the modern world was born in the twin revolutions of the later eighteenth century: the Industrial Revolution in England, and the political revolution in France. We shall postpone discussion of the political crisis of the late century, and of the artistic changes it brought in its wake, until the introduction to Part IV. Here we will concentrate on the period of entrenchment and stabilization which preceded the upheavals of the American and French Revolutions. Despite these different phases and emphases, certain themes pervade the whole period. The principal motif of Parts III and IV is the consolidation of art as a matter for *public* discourse: as something with which the cultivated urban middle class might be expected to concern itself, and no longer the specialized interest of a patrician or intellectual elite.

The second half of the eighteenth century saw Britain established as the dominant nation in world terms. The Spanish and Portuguese empires, founded on the first wave of global exploration in the sixteenth century, and its associated 'primitive accumulation' of exotic wares and sheer plunder, had long been in decline. The Dutch established a trading empire in the seventeenth century, but lost out to British naval strength. The eighteenth century then saw prolonged conflict between Britain and France. These were not only the strongest European states, but the superpowers of the period. The outcome of the Seven Years War (1756–63), in which both were leading protagonists, did much to shape world history for the next 150 years. The outcome of the war was a pointer to the way things would continue to go. Though the English had good generals and admirals and well-trained armies, their ultimate triumph was due not merely to soldierly élan, but to the development of a stronger economic base than their adversaries. Global hegemony was underwritten by industrial strength allied with finance capital at its most advanced: the mines and factories of the Midlands and North combined with the City of London and the Bank of England. The only war the British lost in the period was with their colonists in North America in the mid-1770s. But by then, following the defeat of the French in

1760, the North American continent was already decisively Anglicized in cultural and linguistic terms, if not in its political character. Britain also vanquished France in the East, establishing dominance over India at the same time in the early 1760s. The newly discovered southern continent of Australia was British by 1778. And the 1790s saw the British take control of southern Africa from the Dutch and begin to expand their influence across the rest of the continent.

The nineteenth century was to be British as decisively as the twentieth was to become American. But Britain in the eighteenth century was a paradox. Its industrial strength and political liberty were never translated into artistic pre-eminence in quite the way that might have been expected. The question of an English school, and of the pros and cons of an Academy on the French model, dragged on throughout the middle of the century (see below, section IVA). We have already commented (in the introduction to Part II) on the lack of artistic advance in France at the time, with Watteau's work standing out in its intensity against a quantity of run-of-the-mill history painting. Likewise in England, with the exception of Hogarth's work, there was little really interesting art to talk *about*. Portraiture (demeaningly tagged 'face-painting') dominated, along with landscape. These are discussed in the introductions to Parts IV and V. England remained a predominantly literary culture, with a pronounced empiricist bent. And in the field of the visual arts, English-language debate at the mid-century centred less on practice than on the reception of art: on how it was to be judged, and on what the cultivated might expect to derive from it. There seems, in truth, to have been something of a lull in artistic achievement right across Western Europe at this point. Perhaps for this reason, the question of art's relationship to the past continued to dominate art-theoretical discussion – somewhat paradoxically, however, given that this was the moment at which the leading nations were making a decisive leap into modern social and economic forms.

For those who turned once more to discuss the legacy of the ancients, a principal objective was the education of taste (IIIA1, 6). For George Turnbull in particular, the primary importance of the classics was educative. Art was less something to be studied for its own reward than for the pointers it provided towards conduct and leadership in the here and now. This was the function of the Grand Tour, that system whereby the social leaders of the next generation were to be allowed off the leash while simultaneously getting acquainted with their cultivated heritage. That said, genuine interest in the past continued apace, and increasingly the mere scrutiny of classical quotations gave way to practical archaeology. The excavations at Herculaneum (IIIA4) proved a mixed blessing, insofar as they showed the Romans to have been rather less than the austere paragons fondly imagined by so many modern Augustans. For whatever reason, the mid-eighteenth century witnessed a shift in the balance of modern attitudes to the past. Since the time of the Renaissance, Rome had symbolized classical virtue. Now, however, its status increasingly came to be seen as a legacy of the true original, Athens. This was a crucial shift in the balance of power where the Antique was concerned. From this point on, for purposes of both intellectual and practical enquiry, Greece became established as the fountain-head of the Western canon (IIIA5, 7 and 8).

There was a further shift on this terrain of debate about the art of the past, and it was one which was to have even more far-reaching consequences. In 1939–40, the

emerging American critic Clement Greenberg wrote his two ground-breaking essays on avant-garde art (see *Art in Theory 1900–1990* IVD10 and VA1). In these he claimed that the defining element of modernism was its autonomy. The title he chose for the second essay was revealing: 'Towards a Newer Laocoon'. In the mid-eighteenth century, German-language scholarship was making its first impact on European debate about art. The period from the Renaissance up to the mid-eighteenth century had been dominated by the motif of art's elevation. *Ut pictura poesis*, the doctrine of the Sister Arts, stood behind everything that was being claimed on behalf of visual art. Painting could do what poetry could do. However, painting's equivalence to poetry tended to be predicated on the relationship of both to narrative. The claim was that painting, once granted its learned status, could tell the classical stories with as much impact as poetry. But what also became clear was that it told the stories differently; that is, paintings' *effects* were different. And the registration of this pointed to something new: the perception that the visual arts were equal to but distinct from literature. In the early eighteenth century, writers like De Piles and Du Bos had begun to establish the particularity of visual art (cf. IIA2, IIB6). But the *locus classicus* for this perception is Gotthold Lessing's meditation on the antique Laocoön sculpture, published in 1766 (IIIA10). The theory of the Sister Arts had done its job, so to speak. The visual arts had been elevated from craft status to Liberal Art. Now art could stand on its own feet. By weakening the doctrine of the Sister Arts and emphasizing instead the particularity of the visual, Lessing blazed a trail along which lay forms of artistic independence as yet inconceivable to the eighteenth-century mind.

The notion of an 'eighteenth-century mind' is of course an abstraction; but it serves to differentiate a set of intellectual and moral habits from our own. Cultivated social intercourse in the period was largely preoccupied with questions of virtue and decorum and with the maintenance of all kinds of public standards and proprieties. It is this which makes the eighteenth century at once so close to and so remote from our contemporary world. Postmodern theory has decisively located the origins of the modern in the second half of the eighteenth century: in its technological dynamism, its secularization, its discovery of the individual, of reason, of feeling, of alienation even. Yet it was also an age of wigs and cravats, of bowing and scraping, of the most grovelling homilies by artists of every kind to their esteemed patrons, in other words, of the most stultifying obsession with rank and protocol. Mid-eighteenth-century reflection on the arts was dominated by the concept of 'Taste'. This was a complex notion, responding on the one hand to a democratizing impulse rooted in the development of empiricist philosophy and the pre-eminence of individual judgement; yet on the other hand steeped in connotations of class and social hierarchy. We include several examples from an extensive literature in both Britain and France, composed by lawyers and political figures no less than philosophers and artists themselves (see IIIB4, 5, 7, 8, 9, 13, 15).

It is as if what was at issue in all the circling around the classical heritage was whose canon it provided, and what lessons it might teach. For Turnbull, as we have remarked, the culture of the past was a kind of handbook for his prospective Grand Tourist. In their concern with gentlemanly competence and good sense, authors repeatedly returned to questions about the nature of judgement: whether it was

innate, whether it could be learned, and what were its limits. One of the most intriguing features of this discourse, attracting mention from figures as dissimilar as Joshua Reynolds and Voltaire, was the relation of the classical heritage to non-Western standards of beauty (see IIIB8 and 9). In general, however, 'taste' was associated with the concept of a 'Grand Manner', embodied in the argument of figures such as Reynolds in England and Winckelmann's ally Anton Raphael Mengs on the continent (IIIB13; for Reynolds' mature statement, see below IVA7). We do not mean to imply that the discourse on taste and on canons of beauty represented some kind of a brake on development and innovation in the arts. There was certainly a potential for conservatism, but at the same time the very preoccupation with these questions led to the emergence of modern aesthetics as such. In due course, reflection upon art and its appropriate modes of response came to be considered as a field of study in itself, not only in England and France, but also in Germany, where a distinct range of philosophical concerns gave rise to some of the most challenging forms of art-theoretical reflection (see IIIB1, 2, and below, VA10).

The very concentration on rational standards of beauty and taste, made manifest in a suitably 'grand manner' indebted to the classical ideal, simultaneously gave rise to various divergent interests and counter-tendencies. Hogarth, for example, drew inspiration from the Dutch in his recording of the manners and mores of contemporary English life. The other side of the preoccupation with imitating classical models and the cultivation of public taste was a growing emphasis on the individual response. The mid-eighteenth century saw the emergence of a recognizably modern interest in the linked concepts of originality and genius. 'Genius' had played a role in the theory of art since the Renaissance. In the early sixteenth century Albrecht Dürer recognized that a rapid sketch by an artist possessed of genius would eclipse even the most laborious production of an uninspired hack. But in the period covered by the present section, the notion began to take on a characteristically modern inflection in respect of its relationship to the idea of rule. For Reynolds, Mengs and others, 'genius' in art had essentially come to mean mastery of the rules. Increasingly, however, from the mid-eighteenth century, the individual imagination began to claim its place (see IIIB10), and genius came to be associated with the transgression, or transcendence, of rules.

This sense of art as potentially disruptive of the status quo, rather than continually confirming it, can also be seen at work in formulations of the concept of the sublime. With its roots in seventeenth-century notions of grace and the *je ne sais quoi*, the sublime takes on a central role in eighteenth-century aesthetics (see IIIB6), leading rapidly out of academic decorum to the preoccupations of Romanticism. In Germany, the field of theory was already dominated by a certain systematizing tendency in the work of Baumgarten, and later of Kant, Winckelmann and Lessing. Yet even here, in the almost wilfully eccentric aesthetic writings of Georg Hamann in the early 1760s, an entirely different note can be heard prefiguring Romanticism (IIIB12). In France, Voltaire remained sceptical of overarching claims for a standard of beauty (IIIB14). So an interest in individualism and subjective judgement, in ungovernability and genius, appears in both the practice and theory of the arts in the mideighteenth century. Yet the ruling protocols were still, arguably, established on a

different kind of basis: taste as a standard; virtue as incontestable; civic responsibility as the goal of education and cultivation.

The mid-eighteenth century, then, saw the emergence of both what P. O. Kristeller called 'the modern system of the arts' and the modern modes of philosophical reflection upon the arts, namely aesthetics and art history. A fourth and no less important element in the modern constellation of the arts also emerged at this time, in debate about the *public* role of art: that is, the discourse of art criticism. In 1737, after a period of neglect, the Salons were revived in Paris. Beginning in 1747, a debate took place on standards in art, and on the rights and responsibilities attendant upon the maintenance of those standards. The discussion of the 1747 Salon by La Font de St Yenne, and the discussion to which it gave rise, provides a convenient marker for the birth of modern art criticism (see IIIC1, 2, 3).

This critical discourse around the practice of art may be seen as part of the wider climate of intellectual inquiry conventionally known by its own sobriquet of 'Enlightenment'. In the contemporary intellectual world, haunted by the apparent failure of the promise of emancipation, the so-called Enlightenment 'grand narratives' have been subject to relentless questioning. Yet it is worth underlining that Enlightenment thinkers were motivated by a commitment to combat far more confining myths than those of human reason and virtue: in essence, superstition in the form of organized religion, and inherited privilege in the form of the aristocracy. The beginnings of the Enlightenment may be seen in the late seventeenth-century thought of Locke, Newton and others, and its practical apotheosis was reached in the French Revolution of 1789. It was motivated by a belief 'that unassisted human reason, not faith or tradition, was the principal guide to human conduct . . . that science and the conquest of superstition and ignorance provided the prospect for endless improvement and reformation of the human condition' (Kramnick, 1995, pp. xi–xii). However, the Enlightenment was a more complex and internally differentiated movement than has sometimes been recognized. It included, for example, the figure of Jean-Jacques Rousseau, whose critical and polemical writings struck at many of the certainties and practical ideals which were upheld by his fellow *philosophes*. Rousseau's suggestion that the 'progress' of civilization may in fact have led to the corruption of our natural goodness, called into question the early Enlightenment's confidence in the emancipatory power of unaided reason. He also placed a new emphasis on the role of feeling or 'sentiment', and established new ideals of fulfilled human existence which were to have an important impact throughout the second half of the eighteenth century. In fact his ideas continued to influence Romanticism, and may even be seen as standing behind conceptions such as the 'nobility' of 'primitive' life, which pervaded sections of the late nineteenth- and early twentieth-century avant-garde (IIIA2, 3).

The defining intellectual project of the Enlightenment was the French *Encyclopédie*. Growing out of a plan to translate Ephraim Chambers' *Cyclopedia* (IIA10), the result far outstripped the inspiration. Led by D'Alembert and Diderot, the *Encyclopédie* offered an overview of the entire field of human knowledge, composed in twenty-eight volumes by a small army of scholars, and published in Paris between 1751 and 1765. Here we reprint extracts from several contributions relevant to the practice of art (IIIC7, 8, 9) as well as one by the sculptor Falconet, intended for the

Encyclopédie, but first published separately (IIIC11). This French milieu of debate around the Salon and the *Encyclopédie* project gave rise to art criticism's first major figure, Denis Diderot. Diderot's Salon reviews (IIIC12, 13, 14) stand at the head of a tradition extending well into the nineteenth century, a tradition which would exert increasing influence on the actual practice of art. In some of its more esoteric reaches, art theory has often seemed detached from the actual practice of art, not least when it takes the form of philosophical aesthetics. Not so criticism. The antagonism to critics felt by so many modern artists is witness to the fact that, from Diderot onwards, the voice of the critic counted for something.

IIIA
Classical and Contemporary

1 George Turnbull (1698–1748) From *A Treatise on Ancient Painting*

Turnbull was one of the earliest representatives of the eighteenth-century Scottish school of philosophers. His *Principles of Moral Philosophy*, which was later to have an influence on Thomas Reid (see IIIB15), was published in 1740, the same year as the *Treatise on Ancient Painting* itself. Indeed the hallmark of the *Treatise* is Turnbull's resolutely ethical approach to art. Turnbull is not interested in art as an object of study in itself. As he puts it in his conclusion, he has written about painting because of its potential 'of impressing on the mind some useful rules and maxims for our conduct' (p. 180). The bulk of Turnbull's text consisted of a survey of the arts in Antiquity, and the social and moral roles they played. A hundred years after Junius (IA1), remarkably little seems to have altered. What has changed is less the story itself than the way it is told. Unlike Junius, Turnbull's study of ancient painting is chronological. It concludes with a survey of the modern inheritors of the classical tradition, from Raphael and Michelangelo to Rubens and Poussin. The *Treatise* is illustrated with fifty engravings of classical works of art, drawn by the Italian artist Camillo Paderni. (These were reissued with an extended commentary the following year as *A Curious Collection of Ancient Paintings*, London 1741.) A second important difference concerns the audience. Junius wrote for an elite group of humanist scholars, originally in Latin. Turnbull addressed the parents of well-off young men, the future leaders of eighteenth-century society. The *Treatise* was, in part at least, homework for the potential Grand Tourist. Turnbull's argument is that in the shaping of human nature, and in the inculcation of an ethical sensibility, the work of art can play a role akin to that of an experiment in teaching the natural sciences. Our extracts, which emphasize this educative purport of the *Treatise*, are drawn from the preface, 'Concerning Education, Travelling and the Fine Arts', and from chapter VII, on 'the Usefulness of the Fine Arts in a Liberal Education'. They are taken from *A Treatise on Ancient Painting, containing Observations on the Rise, Progress and Decline of that Art amongst the Greeks and Romans... to which are added some Remarks on the peculiar Genius, Character and Talents of Raphael, Michael Angelo, Nicholas Poussin and other Celebrated Modern Masters*, London: A. Millar 1740, pp. xv–xvi, 144, 145–7, 148.

There are Subjects of a more important Nature than Paintings and Sculptures, in whatever light they are considered, that ought principally to employ the Thoughts of a Traveller, who has it in his View to qualify himself for the Service of his own Country, by visiting foreign ones. But one Point aimed at in this Treatise is to shew

how mean, insipid, and trifling the fine Arts are when they are quite alienated from their better and nobler, genuine Purposes, which, as well as those of their Sister Poetry, are truly philosophical and moral: that is, to convey in an agreeable manner into the Mind the Knowledge of Men and Things; or to instruct us in Morality, Virtue, and human Nature. And it necessarily follows, that the chief Design of travelling must be somewhat of greater moment than barely to learn how to distinguish an original Medal from a counterfeit one, a *Greek* from a *Roman* Statue, or one Painter's Hand from another's; since it is here proved, that even with regard to the Arts of Design that kind of Knowledge is but idle and trivial; and that by it alone one has no better title to the Character of a Person of good Taste in them, than a mere verbal Critick hath to that of a polite Scholar in the Classicks.

Let us consider a little the pretended Reasons for sending your Gentlemen to travel: They may be reduced to these two. 'That they may see the Remains of ancient Arts, and the best Productions of modern Sculptors and Painters;' and 'That they may see the World and study Mankind.'

Now as for the first, how it should be offered as a Reason for sending young Gentlemen abroad, is indeed very unaccountable, when one considers upon what footing Education is amongst us at present; unless it could be thought that one may be jolted by an *Italian* Chaise into the Knowledge and Taste that are evidently prerequisite to travelling with advantage, even in that view; or that such Intelligence is the necessary, mechanical Effect of a certain Climate upon the Understanding; and will be instantaneously infused into one at his Arrival on Classick Ground. For in our present Method of educating young Gentlemen either in publick Schools or by private Tutors, what is done that can in any degree prepare them for making proper and useful Reflexions upon the fine Arts, and their Performances? Are not the Arts of Design quite sever'd in modern Education not only from Philosophy, their Connexion with which is not so obvious, or at least so generally acknowledged; but likewise from classical Studies, where not only their Usefulness must be readily owned by all who have the slighest Notion of them, but where the want of proper Helps from ancient Statues, Bas-reliefs and Paintings for understanding ancient Authors, the Poets in particular, is daily felt by Teachers and Students? It is not more ridiculous to dream of one's acquiring a strange Language merely by sucking in foreign Air, than to imagine that those who never have been directed at home into the right manner of considering the fine Arts; those who have no Idea of their true Beauty, Scope, and Excellence (not to mention such as have not the least notion of Drawing) that such should all at once so soon as they tread *Italian* Soil become immediately capable of understanding these Arts, and of making just Reflexions upon their excellent Productions. And yet this is plainly the case with regard to the greater part of our young Travellers. And for that reason I have endeavoured in the following Essay to lead young Gentlemen and those concerned in their Education, into a juster Notion of the Fine Arts than is commonly entertained even by the Plurality of their professed Admirers; by distinguishing the fine Taste of them from the false Learning that too frequently passes for it; and by shewing in what respects alone the Study of them belongs to Gentlemen, whose high Birth and Fortune call them to the most Important of all Studies; that, of Men, Manners and Things, or Virtue and publick Good.
* * *

The Ancients considered Education in a very extensive View, as comprehending all the Arts and Sciences, and employing them all to this one End; to form, at the same time, the Head and the Heart, the Senses, the Imagination, Reason, and the Temper, that the whole Man might be made truly virtuous and rational. And how they managed it, or thought it ought to be managed, to gain this noble Scope, we may learn from their way of Handling any one of the Arts, or of Discoursing on Morals: Whatever is the more immediate Subject of their Enquiries, we find them, as it hath been observed, calling upon all the Arts and Sciences for its Embellishment and Illustration. Let us therefore consider a little the natural Union and close Dependence of the liberal Arts, and enquire how these were explain'd by the Ancients. [...]

If Pictures of natural Beauties are exact Copies of some particular Parts of Nature, or done after them, as they really happened in Nature; they are in that case no more than such Appearances more accurately preserved by Copies of them, than they can be by Imagination and Memory, in order to their being contemplated and examined as frequently and as seriously as we please. 'Tis the same as preserving fine Thoughts and Sentiments by Writing, without trusting to Memory, that they may not be lost. This is certainly too evident to be insisted upon. On the other hand, if Landscapes are not copied from any particular Appearances in Nature, but imaginary; yet, if they are conformable to Nature's Appearances and Laws, being composed by combining together such scattered Beauties of Nature as make a beautiful Whole; even in this case, the Study of Pictures is still the Study of Nature itself: For if the Composition be agreeable to Nature's settled Laws and Proportions, it may exist: And all such Representations shew what Nature's Laws would produce in supposed Circumstances. The former Sort may therefore be called a Register of Nature, and the latter a Supplement to Nature, or rather to the Observers and Lovers of Nature. And in both Cases Landscapes are Samples or Experiments in natural Philosophy: Because they serve to fix before our Eyes beautiful Effects of Nature's Laws, till we have fully admired them, and accurately considered the Laws from which such visible Beauties and Harmonies result.

Tho' one be as yet altogether unacquainted with Landscapes (by which I would all along be understood to mean all Views and Prospects of Nature) he may easily comprehend what superior Pleasures one must have, who hath an Eye formed by comparing Landscapes with Nature, in the Contemplation of Nature itself, in his Morning or Evening Walks, to one who is not at all conversant in Painting. Such a one will be more attentive to Nature, he will let nothing escape his Observation; because he will feel a vast Pleasure in observing and chusing picturesque Skies, Scenes, and other Appearances, that would be really beautiful in Pictures. He will delight in observing what is really worthy of being painted; what Circumstances a good Genius would take hold of; what Parts he would leave out, and what he would add, and for what Reasons. The Laws of Light and Colours, which, properly speaking, produce all the various Phænomena of the visible World, would afford to such an inexhaustible Fund of the most agreeable Entertainment; while the ordinary Spectator of Nature can hardly receive any other Satisfaction from his Eye, but what may be justly compared with the ordinary Titillation a common Ear feels, in respect of the

exquisite Joy a refined Piece of Musick gives to a skilful, well-formed one, to a Person instructed in the Principles of true Composition, and inured to good Performance.

Nor is another Pleasure to be passed by unmentioned, that the Eye formed by right Instruction in good Pictures, to the accurate and careful Observance of Nature's Beauties, will have, in recalling to mind, upon seeing certain Appearances in Nature, the Landscapes of great Masters he has seen, and their particular Genius's and Tastes. He will ever be discerning something suited to the particular Turn of one or other of them; something that a Titian, a Pousin, a Salvator Rosa, or a Claud Lorrain, hath already represented, or would not have let go without imitating, and making a good Use of in Landscape. Nature would send such a one to Pictures, and Pictures would send him to Nature: And thus the Satisfaction he would receive from the one or the other would be always double.

In short, Pictures which represent visible Beauties, or the Effects of Nature in the visible World, by the different Modifications of Light and Colours, in Consequence of the Laws which relate to Light, are Samples of what these Laws do or may produce. And therefore they are as proper Samples and Experiments to help and assist us in the Study of those Laws, as any Samples or Experiments are in the Study of the Laws of Gravity, Elasticity, or of any other Quality in the natural World. They are then Samples or Experiments in natural Philosophy. The same Observation may be thus set in another Light: Nature hath given us a Sense of Beauty and Order in visible Objects; and it hath not certainly given us this or any other Sense, for any other Reason, but that it might be improv'd by due Culture and Exercise. Now in what can the Improvement of this Sense and Taste consist, but in being able to chuse from Nature such Parts, as being combined together according to Nature's Laws, would make beautiful Systems? This is certainly its proper Business and Entertainment: And what else is this but Painting, or a Taste of Painting? For Painting aims at visible Harmony, as Musick at Harmony of Sounds. But how else can either the Eye or the Ear, the Sense of visible or audible Harmony, be formed and improved to Perfection, but by Exercise and Instruction about these Harmonies, by means of proper Examples? Pictures, therefore, in whatever Sense they are considered, have a near Relation to Philosophy, and a very close Connexion with Education, if it be any Part of its Design to form our Taste of Nature, and improve our Sense of visible Harmonies and Beauties, or to make us intelligent Spectators and Admirers of the visible World.

But I proceed to consider historical or moral Pictures, which must immediately be acknowledged, in Consequence of the very Definition of them, to be proper Samples and Experiments in teaching human Nature and moral Philosophy. For what are historical Pictures, but Imitations of Parts of human Life, Representations of Characters and Manners? And are not such Representations Samples or Specimens in moral Philosophy, by which any Part of human Nature, or of the moral World, may be brought near to our View, and fixed before us, till it is fully compared with Nature itself, and is found to be a true Image, and consequently to point out some moral Conclusion with complete Force of Evidence? Moral Characters and Actions described by a good Poet, are readily owned to be very proper Subjects for the Philosopher to examine, and compare with the human Heart, and the real Springs and Consequences of Actions. [...] But moral Pictures must be for the same Reason

proper Samples in the School of Morals: For what Passions or Actions may not be represented by Pictures; what Degrees, Tones, or Blendings of Affections; what Frailties, what Penances, what Emotions in our Hearts; what Manners, or what Characters, cannot the Pencil exhibit to the Life? Moral Pictures, as well as moral Poems, are indeed Mirrours in which we may view our inward Features and Complexions, our Tempers and Dispositions, and the various Workings of our Affections. 'Tis true, the Painter only represents outward Features, Gestures, Airs, and Attitudes; but do not these, by an universal Language, mark the different Affections and Dispositions of the Mind? What Character, what Passion, what Movement of the Soul, may not be thus most powerfully expressed by a skilful Hand? The Design of moral Pictures is, therefore, by that Means, to shew us to ourselves; to reflect our Image upon us, in order to attract our Attention the more closely to it, and to engage us in Conversation with ourselves, and an accurate Consideration of our Make and Frame.

As it hath been observed, with respect to Landscapes, so in this Case likewise, Pictures may bring Parts of Nature to our View, which could never have been seen or observed by us in real Life; and they must engage our Attention more closely to Nature itself, than mere Lessons upon Nature can do, without such Assistance; nothing being so proper to fix the Mind, as the double Employment of comparing Copies with Originals. And in general, all that hath been said to shew that Landscapes are proper Samples or Experiments in natural Philosophy, as being either Registers or Supplements to Nature, is obviously applicable to moral Pictures, with relation to moral Philosophy. We have already had Occasion to remark, that it is because the Poet and Painter have this Advantage, that whereas the Historian is confined to Fact, they can select such Circumstances in their Representations as are fittest to instruct or move; that it is for this Reason Aristotle recommends these Arts as better Teachers of Morals than the best Histories, and calls them more catholick or universal. I shall only add upon this Head, that as certain delicate Vessels in the human Body cannot be discerned by the naked Eye, but must be magnified, in order to be rendered visible; so, without the Help of Magnifiers, not only several nice Parts of our moral Fabrick would escape our Observation, but no Features, no Characters of whatever kind, would be sufficiently attended to. Now the Imitative Arts become Magnifiers in the moral way, by means of chusing those Circumstances which are properest to exhibit the Workings and Consequences of Affections, in the strongest Light that may be, or to render them most striking and conspicuous. All is Nature that is represented, if all be agreeable to Nature: What is not so, whether in Painting or Poetry, will be rejected, even by every common Beholder.... But a Fiction that is consonant to Nature, may convey a moral Lesson more strongly than can be done by any real Story, and is as sure a Foundation to build a Conclusion upon; since from what is conformable to Nature, no erroneous or seducive Rule can be inferred.

Thus, therefore, 'tis evident that Pictures, as well as Poems, have a very near relation to Philosophy, a very close Connexion with moral Instruction and Education. [...] The Conclusion I have now chiefly in View is, that good moral Paintings, whether by Words, or by the Pencil, are proper Samples in moral Philosophy, and ought therefore to be employed in teaching it, for the same Reason that Experiments

are made use of in teaching natural Philosophy. And this is as certain, as that Experiments or Samples of Manners, Affections, Actions, and Characters, must belong to moral Philosophy, and be proper Samples for evincing and enforcing its Doctrines; for such are moral Paintings.

2 Jean-Jacques Rousseau (1712–1778) from 'Discourse on the Arts and Sciences'

Though Jean-Jacques Rousseau is now known primarily as a political philosopher, he worked for much of his life as a composer, music-copyist and dramatist. His *The Village Soothsayer* (1752) was presented at court and remained in the repertory of the Paris Opera for fifty years. He also published one of the most widely read and influential novels of the eighteenth century, *Julie, or the new Héloïse (1760)*, which has been seen as an important source for later Romanticism. He was born in Geneva, where he was brought up by various relations and received little formal education. He was apprenticed to an engraver, but in 1728 he ran away to Italy and Savoy where he lived with Baronne Louise de Warens. In 1741 he moved to Paris, where he was drawn into the circle of Diderot and his collaborators on the project of the *Encyclopédie*. In contrast to the beliefs normally associated with the Enlightenment, however, Rousseau argued that the regulated manners of sophisticated societies lead to the concealment of emotion and the inhibiting of passion, and to an increasing divorce between private and public forms of virtue. He thus associated the possibility of sincere and direct human expression with an ideal 'state of nature', measuring the health of society more in terms of its moral vigour than its achievements in the arts or sciences. If art had a defensible function in his eyes, it was not to arouse pleasant emotions, but rather to provide images of right action that its audience might emulate. The more corrupt and inequitable the society, the more likely it would be that the arts would be conscripted in defence of its vices. Rousseau's was a strong voice in that criticism of *ancien régime* culture that gathered force in the years leading up to the Revolution. His major work of political philosophy was *Le Contrat social* (The Social Contract), published in 1762. This document is widely understood as having furnished a philosophical justification for the politics of the French Revolution, and is the source of the slogan 'liberty, equality, fraternity'. In the 1790s, when Jacques-Louis David and his followers argued for a morally strenuous form of classicism to replace the culture of the *ancien régime*, Rousseau's name was frequently invoked in support. In 1794 his ashes were installed next to those of Voltaire in the Pantheon in Paris (see IVB12). The 'Discourse on the Arts and Sciences' was originally submitted for a prize announced by the Academy of Dijon in 1749. On his own later account, Rousseau read the announcement while on his way to Vincennes to visit Diderot, then in prison for offending the censor. The question proposed by the Academy was: 'Has the Restoration of the Arts and Sciences had a purifying Effect upon Morals?' Rousseau was awarded the prize (which he declined to collect), and the discourse was published as *Discours sur les sciences et les arts* in November 1750, arousing considerable controversy. It was translated by G. D. H. Cole, with the full title 'A Discourse on the Moral Effects of the Arts and Sciences', in Jean-Jacques Rousseau, *The Social Contract and the Discourses*, London: Everyman, 1913, pp. 115–42. Our extract is taken from pp. 119–35 of this edition. (See also IIIA3.)

The question before me is: 'Whether the Restoration of the arts and sciences has had the effect of purifying or corrupting morals.' Which side am I to take? That, gentlemen, which becomes an honest man, who is sensible of his own ignorance, and thinks himself none the worse for it.

* * *

The First Part

[...] So long as government and law provide for the security and well-being of men in their common life, the arts, literature, and the sciences, less despotic though perhaps more powerful, fling garlands of flowers over the chains which weigh them down. They stifle in men's breasts that sense of original liberty, for which they seem to have been born; cause them to love their own slavery, and so make of them what is called a civilized people.

Necessity raised up thrones; the arts and sciences have made them strong. Powers of the earth, cherish all talents and protect those who cultivate them. Civilized peoples, cultivate such pursuits: to them, happy slaves, you owe that delicacy and exquisiteness of taste, which is so much your boast, that sweetness of disposition and urbanity of manners which make intercourse so easy and agreeable among you – in a word, the appearance of all the virtues, without being in possession of one of them.

It was for this sort of accomplishment, which is by so much the more captivating as it seems less affected, that Athens and Rome were so much distinguished in the boasted times of their splendour and magnificence: and it is doubtless in the same respect that our own age and nation will excel all periods and peoples. An air of philosophy without pedantry; an address at once natural and engaging, distant equally from Teutonic clumsiness and Italian pantomime; these are the effects of a taste acquired by liberal studies and improved by conversation with the world. What happiness would it be for those who live among us, if our external appearance were always a true mirror of our hearts; if decorum were but virtue; if the maxims we professed were the rules of our conduct; and if real philosophy were inseparable from the title of a philosopher! But so many good qualities too seldom go together; virtue rarely appears in so much pomp and state.

Richness of apparel may proclaim the man of fortune, and elegance the man of taste; but true health and manliness are known by different signs. It is under the homespun of the labourer, and not beneath the gilt and tinsel of the courtier, that we should look for strength and vigour of body.

External ornaments are no less foreign to virtue, which is the strength and activity of the mind. The honest man is an athlete, who loves to wrestle stark naked; he scorns all those vile trappings, which prevent the exertion of his strength, and were, for the most part, invented only to conceal some deformity.

Before art had moulded our behaviour, and taught our passions to speak an artificial language, our morals were rude but natural; and the different ways in which we behaved proclaimed at the first glance the difference of our dispositions. Human nature was not at bottom better then than now; but men found their security in the ease with which they could see through one another, and this advantage, of which we no longer feel the value, prevented their having many vices.

In our day, now that more subtle study and a more refined taste have reduced the art of pleasing to a system, there prevails in modern manners a servile and deceptive conformity; so that one would think every mind had been cast in the same mould. Politeness requires this thing; decorum that; ceremony has its forms, and fashion its laws, and these we must always follow, never the promptings of our own nature.

We no longer dare seem what we really are, but lie under a perpetual restraint; in the meantime the herd of men, which we call society, all act under the same circumstances exactly alike, unless very particular and powerful motives prevent them. Thus we never know with whom we have to deal; and even to know our friends we must wait for some critical and pressing occasion; that is, till it is too late; for it is on those very occasions that such knowledge is of use to us.

What a train of vices must attend this uncertainty! Sincere friendship, real esteem, and perfect confidence are banished from among men. Jealousy, suspicion, fear, coldness, reserve, hate, and fraud lie constantly concealed under that uniform and deceitful veil of politeness; that boasted candour and urbanity, for which we are indebted to the light and leading of this age. We shall no longer take in vain by our oaths the name of our Creator; but we shall insult Him with our blasphemies, and our scrupulous ears will take no offence. We have grown too modest to brag of our own deserts; but we do not scruple to decry those of others. We do not grossly outrage even our enemies, but artfully calumniate them. Our hatred of other nations diminishes, but patriotism dies with it. Ignorance is held in contempt; but a dangerous scepticism has succeeded it. Some vices indeed are condemned and others grown dishonourable; but we have still many that are honoured with the names of virtues, and it is become necessary that we should either have, or at least pretend to have them. Let who will extol the moderation of our modern sages, I see nothing in it but a refinement of intemperance as unworthy of my commendation as their artificial simplicity.

Such is the purity to which our morals have attained; this is the virtue we have made our own. Let the arts and sciences claim the share they have had in this salutary work. I shall add but one reflection more; suppose an inhabitant of some distant country should endeavour to form an idea of European morals from the state of the sciences, the perfection of the arts, the propriety of our public entertainments, the politeness of our behaviour, the affability of our conversation, our constant professions of benevolence, and from those tumultuous assemblies of people of all ranks, who seem, from morning till night, to have no other care than to oblige one another. Such a stranger, I maintain, would arrive at a totally false view of our morality.

Where there is no effect, it is idle to look for a cause: but here the effect is certain and the depravity actual; our minds have been corrupted in proportion as the arts and sciences have improved. Will it be said, that this is a misfortune peculiar to the present age? No, gentlemen, the evils resulting from our vain curiosity are as old as the world. The daily ebb and flow of the tides are not more regularly influenced by the moon than the morals of a people by the progress of the arts and sciences. As their light has risen above our horizon, virtue has taken flight, and the same phenomenon has been constantly observed in all times and places.

* * *

It is not through stupidity that the people have preferred other activities to those of the mind. They were not ignorant that in other countries there were men who spent their time in disputing idly about the sovereign good, and about vice and virtue. They knew that these useless thinkers were lavish in their own praises, and stigmatized other nations contemptuously as barbarians. But they noted the morals of these people, and so learnt what to think of their learning.

Can it be forgotten that, in the very heart of Greece, there arose a city as famous for the happy ignorance of its inhabitants, as for the wisdom of its laws; a republic of demi-gods rather than of men, so greatly superior their virtues seemed to those of mere humanity? Sparta, eternal proof of the vanity of science, while the vices, under the conduct of the fine arts, were being introduced into Athens, even while its tyrant was carefully collecting together the works of the prince of poets, was driving from her walls artists and the arts, the learned and their learning!

The difference was seen in the outcome. Athens became the seat of politeness and taste, the country of orators and philosophers. The elegance of its buildings equalled that of its language; on every side might be seen marble and canvas, animated by the hands of the most skilful artists. From Athens we derive those astonishing performances, which will serve as models to every corrupt age. The picture of Lacedaemon is not so highly coloured. There, the neighbouring nations used to say, 'men were born virtuous, their native air seeming to inspire them with virtue.' But its inhabitants have left us nothing but the memory of their heroic actions: monuments that should not count for less in our eyes than the most curious relics of Athenian marble.

It is true that, among the Athenians, there were some few wise men who withstood the general torrent, and preserved their integrity even in the company of the muses. But hear the judgment which the principal, and most unhappy of them, passed on the artists and learned men of his day.

'I have considered the poets,' says he, 'and I look upon them as people whose talents impose both on themselves and on others; they give themselves out for wise men, and are taken for such; but in reality they are anything sooner than that.'

'From the poets,' continues Socrates, 'I turned to the artists. Nobody was more ignorant of the arts than myself; nobody was more fully persuaded that the artists were possessed of amazing knowledge. I soon discovered, however, that they were in as bad a way as the poets, and that both had fallen into the same misconception. Because the most skilful of them excel others in their particular jobs, they think themselves wiser than all the rest of mankind. This arrogance spoilt all their skill in my eyes, so that, putting myself in the place of the oracle, and asking myself whether I would rather be what I am or what they are, know what they know, or know that I know nothing, I very readily answered, for myself and the god, that I had rather remain as I am.

'None of us, neither the sophists, nor the poets, nor the orators, nor the artists, nor I, know what is the nature of the *true*, the *good*, or the *beautiful*. But there is this difference between us; that, though none of these people know anything, they all think they know something; whereas for my part, if I know nothing, I am at least in no doubt of my ignorance. So the superiority of wisdom, imputed to me by the oracle, is reduced merely to my being fully convinced that I am ignorant of what I do not know.'

Thus we find Socrates, the wisest of men in the judgment of the god, and the most learned of all the Athenians in the opinion of all Greece, speaking in praise of ignorance. Were he alive now, there is little reason to think that our modern scholars and artists would induce him to change his mind. No, gentlemen, that honest man would still persist in despising our vain sciences. He would lend no aid to swell the flood of books that flows from every quarter: he would leave to us, as he did to his disciples, only the example and memory of his virtues; that is the noblest method of instructing mankind.

Socrates had begun at Athens, and the elder Cato proceeded at Rome, to inveigh against those seductive and subtle Greeks, who corrupted the virtue and destroyed the courage of their fellow-citizens: culture, however, prevailed. Rome was filled with philosophers and orators, military discipline was neglected, agriculture was held in contempt, men formed sects, and forgot their country. To the sacred names of liberty, disinterestedness, and obedience to law, succeeded those of Epicurus, Zeno, and Arcesilaus. It was even a saying among their own philosophers that since learned men appeared among them, honest men had been in eclipse. Before that time the Romans were satisfied with the practice of virtue; they were undone when they began to study it.

What would the great soul of Fabricius have felt, if it had been his misfortune to be called back to life, when he saw the pomp and magnificence of that Rome, which his arm had saved from ruin, and his honourable name made more illustrious than all its conquests. 'Ye gods!' he would have said, 'what has become of those thatched roofs and rustic hearths, which were formerly the habitations of temperance and virtue? What fatal splendour has succeeded the ancient Roman simplicity? What is this foreign language, this effeminacy of manners? What is the meaning of these statues, paintings, and buildings? Fools, what have you done? You, the lords of the earth, have made yourselves the slaves of the frivolous nations you have subdued. You are governed by rhetoricians, and it has been only to enrich architects, painters, sculptors, and stage-players that you have watered Greece and Asia with your blood. Even the spoils of Carthage are the prize of a flute-player. Romans! Romans! make haste to demolish those amphitheatres, break to pieces those statues, burn those paintings; drive from among you those slaves who keep you in subjection, and whose fatal arts are corrupting your morals. Let other hands make themselves illustrious by such vain talents; the only talent worthy of Rome is that of conquering the world and making virtue its ruler. [...]

Thus it is that luxury, profligacy, and slavery have been, in all ages, the scourge of the efforts of our pride to emerge from that happy state of ignorance, in which the wisdom of providence had placed us. That thick veil with which it has covered all its operations seems to be a sufficient proof that it never designed us for such fruitless researches. But is there, indeed, one lesson it has taught us, by which we have rightly profited, or which we have neglected with impunity? Let men learn for once that nature would have preserved them from science, as a mother snatches a dangerous weapon from the hands of her child. Let them know that all the secrets she hides are so many evils from which she protects them, and that the very difficulty they find in acquiring knowledge is not the least of her bounty towards them. Men are perverse;

but they would have been far worse, if they had had the misfortune to be born learned.

How humiliating are these reflections to humanity, and how mortified by them our pride should be! What! it will be asked, is uprightness the child of ignorance? Is virtue inconsistent with learning? What consequences might not be drawn from such suppositions? But to reconcile these apparent contradictions, we need only examine closely the emptiness and vanity of those pompous titles, which are so liberally bestowed on human knowledge, and which so blind our judgment. Let us consider, therefore, the arts and sciences in themselves. Let us see what must result from their advancement, and let us not hesitate to admit the truth of all those points on which our arguments coincide with the inductions we can make from history.

The Second Part

AN ancient tradition passed out of Egypt into Greece, that some god, who was an enemy to the repose of mankind, was the inventor of the sciences.[1] What must the Egyptians, among whom the sciences first arose, have thought of them? And they beheld, near at hand, the sources from which they sprang. In fact, whether we turn to the annals of the world, or eke out with philosophical investigations the uncertain chronicles of history, we shall not find for human knowledge an origin answering to the idea we are pleased to entertain of it at present. Astronomy was born of superstition, eloquence of ambition, hatred, falsehood, and flattery; geometry of avarice; physics of an idle curiosity; and even moral philosophy of human pride. Thus the arts and sciences owe their birth to our vices; we should be less doubtful of their advantages, if they had sprung from our virtues.

Their evil origin is, indeed, but too plainly reproduced in their objects. What would become of the arts, were they not cherished by luxury? If men were not unjust, of what use were jurisprudence? What would become of history, if there were no tyrants, wars, or conspiracies? In a word, who would pass his life in barren speculations, if everybody, attentive only to the obligations of humanity and the necessities of nature, spent his whole life in serving his country, obliging his friends, and relieving the unhappy? Are we then made to live and die on the brink of that well at the bottom of which Truth lies hid? This reflection alone is, in my opinion, enough to discourage at first setting out every man who seriously endeavours to instruct himself by the study of philosophy.

If our sciences are futile in the objects they propose, they are no less dangerous in the effects they produce. Being the effect of idleness, they generate idleness in their turn; and an irreparable loss of time is the first prejudice which they must necessarily cause to society. To live without doing some good is a great evil as well in the political as in the moral world; and hence every useless citizen should be regarded as a pernicious person. Tell me then, illustrious philosophers, of whom we learn the ratios in which attraction acts *in vacuo*; and in the revolution of the planets, the relations of spaces traversed in equal times; by whom we are taught what curves have conjugate points, points of inflexion, and cusps; how the soul and body correspond, like two clocks, without actual communication; what planets may be inhabited; and what insects reproduce in an extraordinary manner. Answer me, I say, you from

whom we receive all this sublime information, whether we should have been less numerous, worse governed, less formidable, less flourishing, or more perverse, supposing you had taught us none of all these fine things.

Reconsider therefore the importance of your productions; and, since the labours of the most enlightened of our learned men and the best of our citizens are of so little utility, tell us what we ought to think of that numerous herd of obscure writers and useless *littérateurs*, who devour without any return the substance of the State.

Useless, do I say? Would God they were! Society would be more peaceful, and morals less corrupt. But these vain and futile declaimers go forth on all sides, armed with their fatal paradoxes, to sap the foundations of our faith, and nullify virtue. They smile contemptuously at such old names as patriotism and religion, and consecrate their talents and philosophy to the destruction and defamation of all that men hold sacred. Not that they bear any real hatred to virtue or dogma; they are the enemies of public opinion alone; to bring them to the foot of the altar, it would be enough to banish them to a land of atheists. What extravagancies will not the rage of singularity induce men to commit!

The waste of time is certainly a great evil; but still greater evils attend upon literature and the arts. One is luxury, produced like them by indolence and vanity. Luxury is seldom unattended by the arts and sciences; and they are always attended by luxury. I know that our philosophy, fertile in paradoxes, pretends, in contradiction to the experience of all ages, that luxury contributes to the splendour of States. But, without insisting on the necessity of sumptuary laws, can it be denied that rectitude of morals is essential to the duration of empires, and that luxury is diametrically opposed to such rectitude? Let it be admitted that luxury is a certain indication of wealth; that it even serves, if you will, to increase such wealth; what conclusion is to be drawn from this paradox, so worthy of the times? And what will become of virtue if riches are to be acquired at any cost? The politicians of the ancient world were always talking of morals and virtue; ours speak of nothing but commerce and money. One of them will tell you that in such a country a man is worth just as much as he will sell for at Algiers: another, pursuing the same mode of calculation, finds that in some countries a man is worth nothing, and in others still less than nothing; they value men as they do droves of oxen. According to them, a man is worth no more to the State than the amount he consumes; and thus a Sybarite would be worth at least thirty Lacedaemonians. Let these writers tell me, however, which of the two republics, Sybaris or Sparta, was subdued by a handful of peasants, and which became the terror of Asia.

The monarchy of Cyrus was conquered by thirty thousand men, led by a prince poorer than the meanest of Persian Satraps: in like manner the Scythians, the poorest of all nations, were able to resist the most powerful monarchs of the universe. When two famous republics contended for the empire of the world, the one rich and the other poor, the former was subdued by the latter. The Roman empire in its turn, after having engulfed all the riches of the universe, fell a prey to peoples who knew not even what riches were. The Franks conquered the Gauls, and the Saxons England, without any other treasures than their bravery and their poverty. A band of poor mountaineers, whose whole cupidity was confined to the possession of a few sheep-skins, having first given a check to the arrogance of Austria, went on to crush

the opulent and formidable house of Burgundy, which at that time made the potentates of Europe tremble. In short, all the power and wisdom of the heir of Charles the Fifth, backed by all the treasures of the Indies, broke before a few herring-fishers. Let our politicians condescend to lay aside their calculations for a moment, to reflect on these examples; let them learn for once that money, though it buys everything else, cannot buy morals and citizens. What then is the precise point in dispute about luxury? It is to know which is most advantageous to empires, that their existence should be brilliant and momentary, or virtuous and lasting. I say brilliant, but with what lustre? A taste for ostentation never prevails in the same minds as a taste for honesty. No, it is impossible that understandings, degraded by a multitude of futile cares, should ever rise to what is truly great and noble; even if they had the strength, they would want the courage.

Every artist loves applause. The praise of his contemporaries is the most valuable part of his recompense. What then will he do to obtain it, if he have the misfortune to be born among a people, and at a time, when learning is in vogue, and the superficiality of youth is in a position to lead the fashion; when men have sacrificed their taste to those who tyrannize over their liberty, and one sex dare not approve anything but what is proportionate to the pusillanimity of the other;[2] when the greatest masterpieces of dramatic poetry are condemned, and the noblest of musical productions neglected? This is what he will do. He will lower his genius to the level of the age, and will rather submit to compose mediocre works, that will be admired during his life-time, than labour at sublime achievements which will not be admired till long after he is dead. Let the famous Voltaire tell us how many nervous and masculine beauties he has sacrificed to our false delicacy, and how much that is great and noble, that spirit of gallantry, which delights in what is frivolous and petty, has cost him.

It is thus that the dissolution of morals, the necessary consequence of luxury, brings with it in its turn the corruption of taste. Further, if by chance there be found among men of average ability, an individual with enough strength of mind to refuse to comply with the spirit of the age, and to debase himself by puerile productions, his lot will be hard. He will die in indigence and oblivion. This is not so much a prediction as a fact already confirmed by experience! Yes, Charles and Pierre Vanloo, the time is already come when your pencils, destined to increase the majesty of our temples by sublime and holy images, must fall from your hands, or else be prostituted to adorn the panels of a coach with lascivious paintings. And you, inimitable Pigalle, rival of Phidias and Praxiteles, whose chisel the ancients would have employed to carve them gods, whose images almost excuse their idolatry in our eyes; even your hand must condescend to fashion the belly of an ape, or else remain idle.

We cannot reflect on the morality of mankind without contemplating with pleasure the picture of the simplicity which prevailed in the earliest times. This image may be justly compared to a beautiful coast, adorned only by the hands of nature; towards which our eyes are constantly turned, and which we see receding with regret. While men were innocent and virtuous and loved to have the gods for witnesses of their actions, they dwelt together in the same huts; but when they became vicious, they grew tired of such inconvenient onlookers, and banished

them to magnificent temples. Finally, they expelled their deities even from these, in order to dwell there themselves; or at least the temples of the gods were no longer more magnificent than the palaces of the citizens. This was the height of degeneracy; nor could vice ever be carried to greater lengths than when it was seen, supported, as it were, at the doors of the great, on columns of marble, and graven on Corinthian capitals.

As the conveniences of life increase, as the arts are brought to perfection, and luxury spreads, true courage flags, the virtues disappear; and all this is the effect of the sciences and of those acts which are exercised in the privacy of men's dwellings. When the Goths ravaged Greece, the libraries only escaped the flames owing to an opinion that was set on foot among them, that it was best to leave the enemy with a possession so calculated to divert their attention from military exercises, and keep them engaged in indolent and sedentary occupations.

[1] It is easy to see the allegory in the fable of Prometheus: and it does not appear that the Greeks, who chained him to the Caucasus, had a better opinion of him than the Egyptians had of their god Theutus. The Satyr, says an ancient fable, the first time he saw a fire, was going to kiss and embrace it; but Prometheus cried out to him to forbear, or his beard would rue it. It burns, says he, everything that touches it.

[2] I am far from thinking that the ascendancy which women have obtained over men is an evil in itself. It is a present which nature has made them for the good of mankind. If better directed, it might be productive of as much good, as it is now of evil. We are not sufficiently sensible of what advantage it would be to society to give a better education to that half of our species which governs the other. Men will always be what women choose to make them. If you wish then that they should be noble and virtuous, let women be taught what greatness of soul and virtue are. The reflections which this subject arouses, and which Plato formerly made, deserve to be more fully developed by a pen worthy of following so great a master, and defending so great a cause.

3 Jean-Jacques Rousseau (1712–1778) from 'Discourse on the Origins of Inequality'

Following the publication of his 'Discourse on the Arts and Sciences' (IIIA2) Rousseau turned his attention to the origins of human civilization, and to the question of the role of language in the formation of human societies. On the one hand, it seemed inconceivable that language could have developed without some kind of social organization that required and encouraged it, on the other, language itself seemed a necessary condition for the development of society. Rousseau's solution was to take an evolutionary approach to both language and society: to see humans as developing from solitary animals into basic forms of community, and as gradually increasing their linguistic competence in the process. There was a price to be paid, however. As social forms became increasingly sophisticated, forms of human expression were more liable to be corrupted. Indeed, Rousseau raised a powerful challenge to Enlightenment notions of perfectibility and progress, questioning the relative priority given to established dichotomies between nature and society, and between the natural and the artificial. He contends provocatively that man is by nature good, but that he is corrupted by society and by the effects of civilization. Like the 'Discourse on the Arts and Sciences', Rousseau's 'Discourse on the Origins of Inequality' was written on a subject

proposed by the Academy of Dijon: 'What is the Origin of Inequality among Men, and is it authorized by Natural Law?' It was originally published as *Discours sur l'origine et les fondements de l'inégalité parmi les hommes* in 1755. It was translated by G. D. H. Cole, with the full title 'A Dissertation on the Origin and Foundation of the Inequality in Mankind' in Jean-Jacques Rousseau, *The Social Contract and the Discourses*, London: Everyman, 1913, pp. 143–229. Our extract is taken from pp. 174–80 of this edition.

[. . .] Let it be considered how many ideas we owe to the use of speech; how far grammar exercises the understanding and facilitates its operations. Let us reflect on the inconceivable pains and the infinite space of time that the first invention of languages must have cost. To these reflections add what preceded, and then judge how many thousand ages must have elapsed in the successive development in the human mind of those operations of which it is capable.

I shall here take the liberty for a moment, of considering the difficulties of the origin of languages, on which subject I might content myself with a simple repetition of the Abbé Condillac's investigations, as they fully confirm my system, and perhaps even first suggested it. But it is plain, from the manner in which this philosopher solves the difficulties he himself raises, concerning the origin of arbitrary signs, that he assumes what I question, viz. that a kind of society must already have existed among the first inventors of language. While I refer, therefore, to his observations on this head, I think it right to give my own, in order to exhibit the same difficulties in a light adapted to my subject. The first which presents itself is to conceive how language can have become necessary; for as there was no communication among men and no need for any, we can neither conceive the necessity of this invention, nor the possibility of it, if it was not somehow indispensable. I might affirm, with many others, that languages arose in the domestic intercourse between parents and their children. But this expedient would not obviate the difficulty, and would besides involve the blunder made by those who, in reasoning on the state of nature, always import into it ideas gathered in a state of society. Thus they constantly consider families as living together under one roof, and the individuals of each as observing among themselves a union as intimate and permanent as that which exists among us, where so many common interests unite them: whereas, in this primitive state, men had neither houses, nor huts, nor any kind of property whatever; every one lived where he could, seldom for more than a single night; the sexes united without design, as accident, opportunity, or inclination brought them together, nor had they any great need of words to communicate their designs to each other; and they parted with the same indifference. The mother gave suck to her children at first for her own sake; and afterwards, when habit had made them dear, for theirs: but as soon as they were strong enough to go in search of their own food, they forsook her of their own accord; and, as they had hardly any other method of not losing one another than that of remaining continually within sight, they soon became quite incapable of recognizing one another when they happened to meet again. It is further to be observed that the child, having all his wants to explain, and of course more to say to his mother than the mother could have to say to him, must have borne the brunt of the task of invention, and the language he used would be of his own device, so that the number of languages would be equal to that of the individuals speaking them, and the variety would be

increased by the vagabond and roving life they led, which would not give time for any idiom to become constant. For to say that the mother dictated to her child the words he was to use in asking her for one thing or another, is an explanation of how languages already formed are taught, but by no means explains how languages were originally formed.

We will suppose, however, that this first difficulty is obviated. Let us for a moment then take ourselves as being on this side of the vast space which must lie between a pure state of nature and that in which languages had become necessary, and, admitting their necessity, let us inquire how they could first be established. Here we have a new and worse difficulty to grapple with; for if men need speech to learn to think, they must have stood in much greater need of the art of thinking, to be able to invent that of speaking. And though we might conceive how the articulate sounds of the voice came to be taken as the conventional interpreters of our ideas, it would still remain for us to inquire what could have been the interpreters of this convention for those ideas, which, answering to no sensible objects, could not be indicated either by gesture or voice; so that we can hardly form any tolerable conjectures about the origin of this art of communicating our thoughts and establishing a correspondence between minds: an art so sublime, that far distant as it is from its origin, philosophers still behold it at such an immeasurable distance from perfection, that there is none rash enough to affirm it will ever reach it, even though the revolutions time necessarily produces were suspended in its favour, though prejudice should be banished from our academies or condemned to silence, and those learned societies should devote themselves uninterruptedly for whole ages to this thorny question.

The first language of mankind, the most universal and vivid, in a word the only language man needed, before he had occasion to exert his eloquence to persuade assembled multitudes, was the simple cry of nature. But as this was excited only by a sort of instinct on urgent occasions, to implore assistance in case of danger, or relief in case of suffering, it could be of little use in the ordinary course of life, in which more moderate feelings prevail. When the ideas of men began to expand and multiply, and closer communication took place among them, they strove to invent more numerous signs and a more copious language. They multiplied the inflexions of the voice, and added gestures, which are in their own nature more expressive; and depend less for their meaning on a prior determination. Visible and movable objects were therefore expressed by gestures, and audible ones by imitative sounds: but, as hardly anything can be indicated by gestures, except objects actually present or easily described, and visible actions; as they are not universally useful – for darkness or the interposition of a material object destroys their efficacy – and as besides they rather request than secure our attention; men at length bethought themselves of substituting for them the articulate sounds of the voice, which, without bearing the same relation to any particular ideas, are better calculated to express them all, as conventional signs. Such an institution could only be made by common consent, and must have been effected in a manner not very easy for men whose gross organs had not been accustomed to any such exercise. It is also in itself still more difficult to conceive, since such a common agreement must have had motives, and speech seems to have been highly necessary to establish the use of it.

It is reasonable to suppose that the words first made use of by mankind had a much more extensive signification than those used in languages already formed, and that ignorant as they were of the division of discourse into its constituent parts, they at first gave every single word the sense of a whole proposition. When they began to distinguish subject and attribute, and noun and verb, which was itself no common effort of genius, substantives were at first only so many proper names; the present infinitive was the only tense of verbs; and the very idea of adjectives must have been developed with great difficulty; for every adjective is an abstract idea, and abstractions are painful and unnatural operations.

Every object at first received a particular name without regard to genus or species, which these primitive originators were not in a position to distinguish; every individual presented itself to their minds in isolation, as they are in the picture of nature. If one oak was called A, another was called B; for the primitive idea of two things is that they are not the same, and it often takes a long time for what they have in common to be seen: so that, the narrower the limits of their knowledge of things, the more copious their dictionary must have been. The difficulty of using such a vocabulary could not be easily removed; for, to arrange beings under common and generic denominations, it became necessary to know their distinguishing properties: the need arose for observation and definition, that is to say, for natural history and metaphysics of a far more developed kind than men can at that time have possessed.

Add to this, that general ideas cannot be introduced into the mind without the assistance of words, nor can the understanding seize them except by means of propositions. This is one of the reasons why animals cannot form such ideas, or ever acquire that capacity for self-improvement which depends on them. When a monkey goes from one nut to another, are we to conceive that he entertains any general idea of that kind of fruit, and compares its archetype with the two individual nuts? Assuredly he does not; but the sight of one of these nuts recalls to his memory the sensations which he received from the other, and his eyes, being modified after a certain manner, give information to the palate of the modification it is about to receive. Every general idea is purely intellectual; if the imagination meddles with it ever so little, the idea immediately becomes particular. If you endeavour to trace in your mind the image of a tree in general, you never attain to your end. In spite of all you can do, you will have to see it as great or little, bare or leafy, light or dark, and were you capable of seeing nothing in it but what is common to all trees, it would no longer be like a tree at all. Purely abstract beings are perceivable in the same manner, or are only conceivable by the help of language. The definition of a triangle alone gives you a true idea of it: the moment you imagine a triangle in your mind, it is some particular triangle and not another, and you cannot avoid giving it sensible lines and a coloured area. We must then make use of propositions and of language in order to form general ideas. For no sooner does the imagination cease to operate than the understanding proceeds only by the help of words. If then the first inventors of speech could give names only to ideas they already had, it follows that the first substantives could be nothing more than proper names.

But when our new grammarians, by means of which I have no conception, began to extend their ideas and generalize their terms, the ignorance of the inventors must have confined this method within very narrow limits; and, as they had at first gone

too far in multiplying the names of individuals, from ignorance of their genus and species, they made afterwards too few of these, from not having considered beings in all their specific differences. It would indeed have needed more knowledge and experience than they could have, and more pains and inquiry than they would have bestowed, to carry these distinctions to their proper length. If, even to-day, we are continually discovering new species, which have hitherto escaped observation, let us reflect how many of them must have escaped men who judged things merely from their first appearance! It is superfluous to add that the primitive classes and the most general notions must necessarily have escaped their notice also. How, for instance, could they have understood or thought of the words matter, spirit, substance, mode, figure, motion, when even our philosophers, who have so long been making use of them, have themselves the greatest difficulty in understanding them; and when, the ideas attached to them being purely metaphysical, there are no models of them to be found in nature?

But I stop at this point, and ask my judges to suspend their reading a while, to consider, after the invention of physical substantives, which is the easiest part of language to invent, that there is still a great way to go, before the thoughts of men will have found perfect expression and constant form, such as would answer the purposes of public speaking, and produce their effect on society. I beg of them to consider how much time must have been spent, and how much knowledge needed, to find out numbers, abstract terms, aorists, and all the tenses of verbs, particles, syntax, the method of connecting propositions, the forms of reasoning, and all the logic of speech. For myself, I am so aghast at the increasing difficulties which present themselves, and so well convinced of the almost demonstrable impossibility that languages should owe their original institution to merely human means, that I leave, to any one who will undertake it, the discussion of the difficult problem, which was most necessary, the existence of society to the invention of language, or the invention of language to the establishment of society. But be the origins of language and society what they may, it may be at least inferred, from the little care which nature has taken to unite mankind by mutual wants, and to facilitate the use of speech, that she has contributed little to make them sociable, and has put little of her own into all they have done to create such bonds of union. It is in fact impossible to conceive why, in a state of nature, one man should stand more in need of the assistance of another, than a monkey or a wolf of the assistance of another of its kind: or, granting that he did, what motives could induce that other to assist him; or, even then, by what means they could agree about the conditions. I know it is incessantly repeated that man would in such a state have been the most miserable of creatures; and indeed, if it be true, as I think I have proved, that he must have lived many ages, before he could have either desire or an opportunity of emerging from it, this would only be an accusation against nature, and not against the being which she had thus unhappily constituted. But as I understand the word 'miserable,' it either has no meaning at all, or else signifies only a painful privation of something, or a state of suffering either in body or soul. I should be glad to have explained to me, what kind of misery a free being, whose heart is at ease and whose body is in health, can possibly suffer. I would ask also, whether a social or a natural life is most likely to become insupportable to those who enjoy it. We see around us hardly a creature in civil society, who does not lament his

existence: we even see many deprive themselves of as much of it as they can, and laws human and divine together can hardly put a stop to the disorder. I ask, if it was ever known that a savage took it into his head, when at liberty, to complain of life or to make away with himself. Let us therefore judge, with less vanity, on which side the real misery is found. On the other hand, nothing could be more unhappy than savage man, dazzled by science, tormented by his passions, and reasoning about a state different from his own. It appears that providence most wisely determined that the faculties, which he potentially possessed, should develop themselves only as occasion offered to exercise them, in order that they might not be superfluous or perplexing to him, by appearing before their time, nor slow and useless when the need for them arose. In instinct alone, he had all he required for living in the state of nature; and with a developed understanding he has only just enough to support life in society.

* * *

4 Jérôme-Charles Bellicard (1726–1786) and Charles-Nicolas Cochin fils (1715–1790) from *Observations upon the Antiquities of the Town of Herculaneum*

Despite, or perhaps because of the excessive admiration in which Antiquity had been held for much of the seventeenth and the early eighteenth centuries, the reception awarded to the frescos uncovered by the excavations at Herculaneum and Pompeii was remarkably critical. The *Observations upon the Antiquities of the Town of Herculaneum*, published by Jérôme-Charles Bellicard and Charles-Nicolas Cochin in 1753, did much to establish the unfavourable opinion in which the frescos were held well into the 1780s. Bellicard was a French writer and engraver who became involved with the antiquarian movement in Rome whilst a scholar at the Académie de France. Charles-Nicolas Cochin, the son of a celebrated engraver, pursued the same career as his father. He received a large number of royal commissions and illustrated more than 200 books, including a frontispiece to the 1764 edition of Diderot's *Encylopédie* (see IIIC7–9). Both men were invited to accompany the Marquis de Marigny on his official visit to the site of the excavations in 1750–1. The resulting volume was the first illustrated account of the archaeological sites and proved highly popular. Three English-language editions were published in London in 1753, 1756 and 1758. French editions were published in Paris in 1754, 1755 and 1757. The following excerpts are taken from the first English edition, *Observations on the Antiquities of the Town of Herculaneum*, London: D. Wilson and T. Durham, 1753, pp. 60–6, 70–2, 74–5, 78–80, 84–6, 91–3, 101–5.

Historical Pictures

The most important pictures which have been found in the subterranean city of Herculaneum, are upon some historical subjects, and the figures as large, or nearly as large, as the life.

The first picture represents Theseus victorious over the Minotaur. Theseus stands upright, and naked, except on the shoulder and left arm, which are covered with a piece of drapery. Young children of Athens are represented kissing his hands and feet. The Minotaur exhibited under the figure of a man with the head of a bull, appears overthrown at his feet. On a cloud is represented the figure of a woman, who has a quiver at her back, and a great affinity with the usual description of Diana. The composition of this picture is very cold: the principal figures (especially that of Theseus) seem to be copied from statues. The two children who embrace his right and left arm, appear in attitudes which are very common in the basso relievo of the ancients. The others are not so much in this taste, particularly the Minotaur, who appears fore-shortned. Theseus is tolerably drawn, though without art or understanding, yet there is a very good character in the head. Nor are the other figures designed with better taste. – We may nevertheless affirm, that the manner in these pictures is generally grand and the pencil easy. Otherwise this performance is unfinished, and cannot be considered in any other light than that of a forward sketch.

PICTURE II. The figures of this picture are as big as the life: it represents a woman sitting and leaning upon the right arm, and holding a staff in her other hand. She is crowned with flowers and leaves, intermixed with some ears of corn, and at her right side appears a basket of flowers, from which she is supposed to represent the goddess Flora. Behind her is a fawn, holding a flute composed of seven pipes, and a staff bent in form of a crosier. A man standing upright with his back towards the spectator is placed before her, and is supposed to be Hercules, on account of the lion's skin that covers his quiver. He is looking at a child, who in the lower part of the picture, is represented sucking a hind, which caresses him, and lifts up her hind leg that he may suck with more ease. Between Hercules and this child is an eagle with his wings half display'd. On the other side of Hercules, is a lion asleep; and above in a cloud, the figure of a woman representing a divinity. This picture seems to be nothing more than a Camaieu [monochrome picture] of red colour, the draperies of which are nearly of the same tint with the flesh; yet this last has a variety of tones, and seems to approach the true colouring of nature. The picture is poorly designed, and shews very little knowledge in drawing and expression. The heads are middling, the hand ill executed, and the feet altogether as incorrect. The child is lame, opens his thighs to an unnatural width, and his loins are a great deal too large. The woman has great eyes, which are neither fellows, nor opposite to each other: the whites of them are too much sunk and ill-rounded. The head of the fawn is well enough drawn, and has character in it: as for the animals, they are very ill expressed, especially the eagle and the lion. In a word, this picture seems to be painted by the very same hand that produced the other; for it has the same ease, the same boldness of touches, and is altogether as unfinished.

PICTURE III. Represents the centaur Chiron teaching Achilles. The centaur sits upon his buttocks, embracing the young man. He is tuning the lyre, which Achilles touches at the same time, and which is hung round his neck. Behind these figures, in the back ground, is a plan of architecture, the mouldings of the cornishes of which are very ill executed, and painted with red, so as to resemble a piece of stuff. The manner of this picture is pretty much the same with those I have already mentioned, and altogether

as poorly designed. The muscles of the stomach, and legs of the centaur, are neither just, nor well expressed. Besides, the arms are ill drawn, with regard to the outlines, and the hind legs, which are bent under him are ill chosen, consequently have an ill effect. The figure of Achilles has more symmetry, and the outlines are more flowing; because, without doubt, copied from some good statue; for the attitude gives us reason to suppose that was the case. However, the figure is not ill-painted; the semi-tints make a pretty soft gradation from the light to the shade; and though of a very grey tone, have a good deal of truth and nature.

* * *

There is besides, a number of other pictures which I do not recollect, though the figures are pretty much of the same size; but those I have mentioned are the most important, and what the most solid judgment may be founded upon.

Their colouring in general, has neither art, beauty nor variety: the great lights are well enough coloured; but the semi-tints being nearly the same from head to foot, are of a yellowish grey or olive colour, without grace or variety. The red predominates in the shades, the tone of which is of a duskish hue. Nor is there any strength in the shadows of the drapery, an inconvenience that usually attends painting in fresco and distemper. Another fault which is visible in a great number of fresco's, even by the best Italian masters, is, that the colour of the shades is not broken down, but continues nearly the same with that of the lights, there being no other difference than that the colour of the shades, has a little less white in it. – I do not think the weakness of the colouring in those pictures, can be attributed to the effect of time; at least they seem perfectly fresh and well preserved in that respect. The manner of painting is generally by hatchings, and sometimes melted: almost all the pieces are unfinished, and painted pretty much like our decorations of the theatre. The manner is grand enough and the touches easy, but on the whole denote more boldness than skill.

* * *

Pictures Containing Figures of a Middling Size.

There are several pictures composed of figures of half the natural size, or less; the greatest part of which are indifferent: though the heads are generally the best parts of them, and discover something of a greater character, which savours of what we call the antique. The touches in these are bolder, and sustained by a more vivid colouring than that which we find in the rest. The subject of the most and best of these pieces, is a woman seized by a satyr. There is besides, a picture of Ariadne forsaken. The figures, which are about a foot high, are well coloured, correctly drawn, and have a good effect.

* * *

Pictures of Animals.

They have likewise discovered at Herculaneum, a great number of pictures of animals, birds, fishes, fruits, &c. of the natural size. These pieces are the best of any yet found, being executed with taste and ease; yet they are for the most part

unfinished, and have not always the necessary rounding and exactness. I will mention some that seem to be pretty true in colour and effect, though they want strength in both.

One of these represents an earthen bottle, on the neck of which is a glass reversed, of the same form with our goblets, but shorter.

In another appears a glass with two handles half filled with white wine, and a glass bottle holding some water, which cannot be better expressed.

In a third we find a book, composed of two rolls, and another utensil, which appears to be a Portefeuille, resembling those which are now in use. These are three very good pieces.

Some pictures represent game; and among others is a wild duck extremely natural, together with fruits, and a loaf of the same shape with that which was actually found, &c.

There are also small pieces representing animals, and among the rest, elephants; but that which is the most distinguished for the delicacy of execution, is a tyger about five or six inches long.

There is another picture which has nothing worth notice, but the singularity of the subject; representing a bird like a perroquet, yoked to a little car, upon the forepart of which sits a grashopper, holding the reins in the capacity of driver: this, however, is none of the best executed.

* * *

Paintings of Architecture.

There is a very considerable number of these pictures of architecture or ruins; but they scarce deserve notice: for, they are altogether out of the proportion of the Grecian architecture. Generally speaking, the pillars are double or triple the length of the natural dimensions: the profil of the mouldings of the cornishes, chapiters and bases, is of a wretched Gothic taste; and most of the Arabic mixture in the architecture, is as ridiculous as any of the Chinese designs. Nevertheless, we must except two or three pieces which are agreeably coloured, though not true, and in which the landskip is touched with ease: we may allow the same advantage to some other pieces of ornament twined with vine leaves or ivy. In general, what they have taken from nature, is good: but, we cannot say so much for their works of imagination. There is gradation and distance in these pictures, and the architecture is represented in a kind of perspective, which plainly proves, however, that the authors of these compositions did not understand the rules of that art. The receding figures do not tend towards the points, where they ought to unite. Some objects are seen above, and some below; so that several distant horizons are required to arrange them. In a word, we perceive some notion of the diminution of objects, but without any knowledge of the invariable rules, to which it ought to be subject; or a right understanding of the effects of light.

* * *

Marble Statues Found in Herculaneum.

The sculpture found in this subterranean city, is much superior to the painting.

The principal and finest piece hitherto discovered, is the equestrian statue of white marble, representing Nonnius Balbus. This is a young man, armed with a cuirass, which scarce descends to his loins: Under this cuirass, is a sort of shirt without sleeves, that covers his shoulders; then passing under the cuirass, comes down as far as one third of his thighs. A cloak which he wears upon the shoulder and left arm, does not conceal the hand with which he holds the horse's bridle, which is very short. His thighs and legs are naked, except so much as is covered with the buskins, that scarce reach above the instep, over which they are tied with strings.

This figure is extremely beautiful, on account of the simplicity with which it hath been designed; it is not so striking or fair at first sight, as it will appear after an attentive examination. The head is admirable, the figure surprizingly correct, the contour just and delicate, and the composition equally grand and simple. Although the horse be likewise very beautiful, and his head full of fire and spirit, it is nevertheless inferior to the figure of the man, and the work performed in a peculiar manner; indeed that manner is beautiful and grand: yet the canons of the forelegs, together with the hoof and joint of the foot, seem to be too long in proportion. Another equestrian statue of marble was also discovered, but I could not see it, as they were at work in repairing it.

* * *

Reflections upon the State of Painting at Herculaneum.

One would imagine, that such a numerous collection of antique paintings would ascertain the degree of perfection to which the ancients carried the different parts of that art; nevertheless, I do not believe, that they convey a distinct idea of the excellence of ancient painting. And indeed it is probable that these pieces were not painted by the best masters of those days. For how can we suppose, that in such an age, abounding with excellent sculptors, any consideration could be had to painters so weak in point of design. It seems probable therefore, that these are the works of painters belonging to this ancient city, which in itself was but very inconsiderable. They are painted upon the walls of a theatre, and other publick places, and doubtless, were at that time regarded only as simple embellishments, for which they were unwilling to be at such an expense as would attend the choice of abler artists.

Be that as it will, the Theseus and other pictures as big as the life, are too feeble in point of colour and design. There is very little genius in the composition; and all the parts of the art are expressed in an equal degree of poverty and weakness. The colouring has no variety of tones, and shews no knowledge of the clair obscur; that is, the change which the colours undergo from the distance of the objects; the reflection of the contiguous bodies, and the privation of light. In a word, these works display none of the graces of the art of composing the lights and shades; so as that being assembled and aggrouped, they become more grand, and produce a more sensible effect. Every figure has its own light and shade, and I have not observed one overshadowing another; nor is there one that does not look like the first elements of a composition. The shades are either not at all reflected, or they are reflected equally from head to foot. The colours are too glaring, without being broken down, as

they ought to be, by a privation of light: and they do not partake of the reflection of the adjacent objects. In fine, we observe nothing which can prove, that the ancients had carried the knowledge of light to that degree which it hath attained in these latter ages. As to the composition of the figures, it is cold, and seems to be rather treated in the taste of sculpture than with that heat of imagination of which painting is susceptible. Yet as some of the figures are a little fore-shortened, we may suppose that art was carried farther by the able painters of those days. But nothing has been discovered which determines, whether the ancients knew the fine effect which the richness and variety of stuffs have in painting. We can, however, perceive that the manner of painting drapery in small folds, as practised in statuary, was not general among them, and that they had another manner more large and full. Indeed of this circumstance we were already fully assured by several pieces of antique sculpture; the draperies of which were of coarser stuffs, and folded in larger masses.

* * *

5 Johann Joachim Winckelmann (1717–1768) from *Reflections on the Imitation of Greek Works in Painting and Sculpture*

Winckelmann is generally regarded as the father of modern art history. The son of a poor cobbler in a village in Prussia, he nonetheless received a classical education, going on to study theology and medicine at university. He did not encounter classical art as such until after the age of 30, when, in 1748, he took up a research post in the library of Count von Bünau at Nöthnitz near Dresden. In 1754 he moved into Dresden itself and was involved in the intellectual and artistic circle of the court of the Elector of Saxony. His reflections on Greek painting and sculpture were published in 1755. Although originally published in an edition of only fifty copies, they achieved immediate success, and were quickly translated into French, Italian and English. (Henry Fuseli's *Reflections on the Painting and Sculpture of the Greeks with Instructions for the Connoisseur* appeared in London in 1765, with a second edition in 1767. An anonymous translation also appeared in Glasgow in 1766.) Part of the reason for this was, of course, the apparently inexhaustible contemporary interest in the classical heritage, stimulated not least by the new discoveries at Pompeii and Herculaneum. But above all, the book's success can be attributed to the fact that, despite the vast deposit of words that had settled over Antiquity, Winckelmann had something new to say. Until the middle of the eighteenth century, the focus of classical scholarship had been Rome. But Winckelmann's short text was both symptom of and stimulus to a sea-change. Rome, for so long pre-eminent as the centre of Western culture, was now regarded as having inherited the mantle from Athens. Greece was beginning to be perceived as the true original, its achievement captured in Winckelmann's resonant description of its *Edle Einfalt und stille Grösse* ('noble simplicity and quiet grandeur'). Winckelmann's essay has seven sections: I. Natural Beauty; II. Contour; III. Drapery; IV. Noble Simplicity and Quiet Grandeur; V. Working Methods; VI. Painting; VII. Allegory. Winckelmann went on to compose the first genuinely art-historical study of ancient art (see IIIA8). The *Reflections*, however, is less a work of history proper than an argument: first, for the priority of Greece over Rome, but also for the emulation of the Greek ideal as the only hope for the Moderns. Our extracts, from sections I and IV, are taken from *Reflections on the Imitation of Greek*

Works in Painting and Sculpture, translated (with the original German in parallel) by Elfriede Heyer and Roger C. Norton, La Salle, Illinois: Open Court, 1987, pp. 3–25 and 33–9.

I. Natural Beauty

Good taste, which is becoming more prevalent throughout the world, had its origins under the skies of Greece. Every invention of foreign nations which was brought to Greece was, as it were, only a first seed that assumed new form and character here. We are told that Minerva chose this land, with its mild seasons, above all others for the Greeks in the knowledge that it would be productive of genius.

The taste which the Greeks exhibited in their works of art was unique and has seldom been taken far from its source without loss. Under more distant skies it found tardy recognition and without a doubt was completely unknown in the northern zones during a time when painting and sculpture, of which the Greeks are the greatest teachers, found few admirers. [. . .]

The only way for us to become great or, if this be possible, inimitable, is to imitate the ancients. What someone once said of Homer – that to understand him well means to admire him – is also true for the art works of the ancients, especially the Greeks. One must become as familiar with them as with a friend in order to find their statue of Laocoon just as inimitable as Homer. In such close acquaintance one learns to judge as Nicomachus judged Zeuxis' Helena: 'Behold her with my eyes,' he said to an ignorant person who found fault with this work of art, 'and she will appear a goddess to you.'

With such eyes did Michelangelo, Raphael, and Poussin see the works of the ancients. They partook of good taste at its source, and Raphael did this in the very land where it had begun. We know that he sent young artists to Greece in order to sketch for him the relics of antiquity.

The relationship between an ancient Roman statue and a Greek original will generally be similar to that seen in Virgil's imitation of Homer's Nausicaa, in which he compares Dido and her followers to Diana in the midst of her Oreads.

Laocoon was for the artist of old Rome just what he is for us – the demonstration of Polyclitus' rules, the perfect rules of art. [. . .]

In the masterpieces of Greek art, connoisseurs and imitators find not only nature at its most beautiful but also something beyond nature, namely certain ideal forms of its beauty, which, as an ancient interpreter of Plato teaches us, come from images created by the mind alone.

The most beautiful body of one of us would probably no more resemble the most beautiful Greek body than Iphicles resembled his brother, Hercules. The first development of the Greeks was influenced by a mild and clear sky; but the practice of physical exercises from an early age gave this development its noble forms. Consider, for example, a young Spartan conceived by a hero and heroine and never confined in swaddling clothes, sleeping on the ground from the seventh year on and trained from infancy in wrestling and swimming. Compare this Spartan with a young Sybarite of our time and then decide which of the two would be chosen by the artist as a model for young Theseus, Achilles, or even Bacchus. Modelled from the latter it would be a Theseus fed on roses, while from the former would come a Theseus fed

on flesh, to borrow the terms used by a Greek painter to characterize two different conceptions of this hero.

The grand games gave every Greek youth a strong incentive for physical exercise, and the laws demanded a ten-month preparation period for the Olympic Games, in Elis, at the very place where they were held. The highest prizes were not always won by adults but often by youths, as told in Pindar's odes. To resemble the god-like Diagoras was the fondest wish of every young man.

Behold the swift Indian who pursues a deer on foot – how briskly his juices must flow, how flexible and quick his nerves and muscles must be, how light the whole structure of his body! Thus did Homer portray his heroes, and his Achilles he chiefly noted as being 'swift of foot'.

These exercises gave the bodies of the Greeks the strong and manly contours which the masters then imparted to their statues without any exaggeration or excess. [. . .]

Moreover, everything that was instilled and taught from birth to adulthood about the culture of their bodies and the preservation, development, and refinement of this culture through nature and art was done to enhance the natural beauty of the ancient Greeks. Thus we can say that in all probability their physical beauty excelled ours by far.

The most perfect creations of nature would, on the other hand, have become only partially and imperfectly known to the artists in a country where nature was hindered by rigid laws, as in Egypt, the reputed home of the arts and sciences. In Greece, however, where people dedicated themselves to joy and pleasure from childhood on, and where there was no such social decorum as ours to restrict the freedom of their customs, the beauty of nature could reveal itself unveiled as a great teacher of artists.

The schools for artists were the gymnasia, where young people, otherwise clothed for the sake of public modesty, performed their physical exercises in the nude. The philosopher and the artist went there – Socrates to teach Charmides, Autolycus, and Lysias; Phidias to enrich his art by watching these handsome young men. There one could study the movement of the muscles and body as well as the body's outlines or contours from the impressions left by the young wrestlers in the sand. The nude body in its most beautiful form was exhibited there in so many different, natural, and noble positions and poses not attainable today by the hired models of our art schools.

Truth springs from the feelings of the heart, and the modern artist who wants to impart truth to his works cannot preserve even a shadow of it unless he himself is able to replace that which the unmoved and indifferent soul of his model does not feel or is unable to express by actions appropriate to a certain sensation or passion.

Many of Plato's dialogues, beginning in the gymnasia of Athens, portray to us the noble souls of these youths and at the same time suggest a uniformity of action and outward carriage developed in these places and in their physical exercises.

The most beautiful young people danced nude in the theaters, and Sophocles, the great Sophocles, was the first who in his youth presented such dramas for his fellow-citizens. Phryne bathed before the eyes of all the Greeks during the Eleusinian Games, and, as she emerged from the water, became for the artists the prototype of Venus Anadyomene. It is also known that girls from Sparta danced completely

naked before the eyes of the young people at certain festive occasions. What might seem strange to us here becomes more acceptable when considering that the early Christians, both men and women, were totally unclothed when they were submersed in the same baptismal font.

Thus every festival of the Greeks was an opportunity for the artists to become intimately acquainted with the beauty of nature. [. . .]

These frequent opportunities to observe nature prompted Greek artists to go still further. They began to form certain general ideas of the beauty of individual parts of the body as well as of the whole – ideas which were to rise above nature itself; their model was an ideal nature originating in the mind alone.

Thus did Raphael conceive Galatea, as we can see in his letter to Count Baldassare Castiglione: 'Since beauty is so rare among women, I avail myself of an ideal image.'

Following such concepts the Greeks gave their gods and men forms that transcended the common shapes of matter. In their figures of gods and goddesses, the forehead and nose formed nearly a straight line. Similar profiles of famous women can be seen on Greek coins, which were intentionally modelled after idealized concepts. Perhaps this profile was as peculiar to the ancient Greeks as flat noses are to the Kalmucks, and small eyes to the Chinese. The large eyes of the Greek faces on gems and coins tend to support this supposition. The Roman empresses depicted on coins by the Greek artists were similarly conceived; the head of Livia or of Agrippina has exactly the same profile as that of Artemisia or Cleopatra.

We observe, nevertheless, that the law prescribed by the Thebans to their artists – 'To imitate nature as best as you can or suffer penalty' – was also obeyed by artists in other parts of Greece. In cases where the smooth Greek profile could not be used without endangering the resemblance, they followed nature, as can be seen in the beautiful head of Julia, the daughter of Emperor Titus, done by Euodus.

The highest law recognized by Greek artists was 'to create a just resemblance and at the same time a more handsome one'; it assumes of necessity that their goal was a more beautiful and more perfect nature. Polygnotus constantly observed this law.

Thus, when various artists reportedly followed the example of Praxiteles, who modeled his Cnidian Aphrodite after his mistress, Cratina, or of certain painters who took Lais as a model for the Graces, it is to be understood that this was done without neglecting the great and universal laws of art. Sensual beauty provided the artist with all that nature could give; ideal beauty provided him with sublimity – from the one he took the human element, from the other the divine.

A person enlightened enough to penetrate the innermost secrets of art will find beauties hitherto seldom revealed when he compares the total structure of Greek figures with most modern ones, especially those modelled more on nature than on Greek taste.

In most modern figures, where the skin on certain parts of the body is pressed, one can observe small but all too obvious individual wrinkles. In Greek figures, however, there is, in such a case, a gentle curvature of rippling folds coming one from the other in such a way that they appear as a whole and make but one noble impression. These masterpieces never display a skin tensely stretched, but rather, gently drawn over flesh which fills it firmly but without turgid protrusions, harmoniously following the

directions of any flexions of the body. The skin never forms, as in modern bodies, individual small wrinkles distinct from the flesh beneath them.

Modern works are also distinguished from the Greek by their multitude of small indentations and much too visible dimples. In the works of the ancients, these are subtly distributed with sparing sagacity, of a size appropriate to the more perfect and complete nature of the Greeks, and often are discernible only to an educated eye.

The probability is that in the beautiful bodily forms of the Greeks as well as in the works of their masters there was a greater unity of the entire structure, a nobler connection of parts, and a greater fullness of form, without the emaciated tensions and depressions of our bodies.

We can, of course, do no more than establish a probability. But this probability deserves the attention of our artists and connoisseurs – all the more so since the veneration and imitation of Greek monuments of art is, regrettably, often prompted not by their quality but by prejudice attached to their great age.

This point, concerning which there is a difference of opinion among artists, would require a more detailed treatment than is possible in the present study.

It is known that the great Bernini was one of those who refused to grant the Greeks the virtue of portraying either a more perfect nature or an ideal beauty in their figures. He was, furthermore, of the opinion that nature was capable of bestowing on all its parts the necessary amount of beauty, and that the skill of art consisted in finding it. He prided himself in having to overcome his earlier prejudice concerning the charms of the Medicean Venus, since, after painstaking study, he had been able to perceive occasionally these very charms in nature.

It was this Venus therefore that taught him to discover beauties in nature which he had previously seen only in the statue and which, without the Venus, he would not have sought in nature. Does it not follow then that the beauty of Greek statues is easier to discover than beauty in nature and that thus the former is more inspiring, less diffuse and more harmoniously united than the latter? So the study of nature must be at best a longer and more difficult way to gain knowledge of perfect beauty than the study of antiquity, and Bernini, by directing young artists primarily toward the most beautiful in nature, was not showing them the shortest way.

The imitation of beauty in nature either directs itself toward a single object or it gathers observations of various individual objects and makes of them a whole. The first method means making a similar copy, a portrait; this leads to the forms and figures of the Dutch artists. The second, however, is the way to general beauty and to ideal images of it; and this was the way chosen by the Greeks. But the difference between them and us is that the Greeks could arrive at their portrayals, if not from more beautiful bodies, then from a daily opportunity to observe beauty in nature – an opportunity which we do not have every day, and rarely in the manner that an artist would desire.

Our nature will not easily bring forth such a perfect body as that of Antinoüs Admirandus nor our minds conceive anything beyond the more than human proportions of a beautiful deity such as that of the Vatican Apollo. What nature, genius, and art have been capable of producing is here revealed to us.

I believe that the imitation of the Greeks can teach us to become knowledgeable more quickly, for it shows us on the one hand the essence of what is otherwise dispersed through all of nature, and, on the other, the extent to which the most perfect nature can boldly, yet wisely, rise above itself. Imitation will teach the artist to think and to draw with confidence, since he finds established in it the highest limits of that which is both humanly and divinely beautiful.

If the artist builds upon this groundwork and allows the Greek rules of beauty to guide his hand and mind, he will be on the path which will lead him safely to the imitation of nature. The concepts of unity and completeness in the nature of antiquity will purify and make more meaningful the concepts of those things that are divided in our nature. By discovering their beauties he will be able to bring them into harmony with perfect beauty and, with the help of the noble forms that are constantly in his awareness, he will become a rule unto himself. [...]

Nothing would demonstrate more clearly the advantages of the imitation of antiquity over the imitation of nature than to take two young people of equal talent and to have one of them study antiquity and the other nature alone. The latter would depict nature as he finds her; if he were an Italian he would perhaps paint figures like those of Caravaggio; or if he were Dutch, he might paint like Jacob Jordaens; if a Frenchman, like Stella. The former, however, would depict nature as it should be, and would paint figures like those of Raphael.

IV. Noble Simplicity and Quiet Grandeur

The general and most distinctive characteristics of the Greek masterpieces are, finally, a noble simplicity and quiet grandeur, both in posture and expression. Just as the depths of the sea always remain calm however much the surface may rage, so does the expression of the figures of the Greeks reveal a great and composed soul even in the midst of passion.

Such a soul is reflected in the face of Laocoon – and not in the face alone – despite his violent suffering. The pain is revealed in all the muscles and sinews of his body, and we ourselves can almost feel it as we observe the painful contraction of the abdomen alone without regarding the face and other parts of the body. This pain, however, expresses itself with no sign of rage in his face or in his entire bearing. He emits no terrible screams such as Virgil's Laocoon, for the opening of his mouth does not permit it; it is rather an anxious and troubled sighing as described by Sadoleto. The physical pain and the nobility of soul are distributed with equal strength over the entire body and are, as it were, held in balance with one another. Laocoon suffers, but he suffers like Sophocles' Philoctetes; his pain touches our very souls, but we wish that we could bear misery like this great man.

The expression of such nobility of soul goes far beyond the depiction of beautiful nature. The artist had to feel the strength of this spirit in himself and then impart it to his marble. [...]

All movements and poses of Greek figures not marked by such traits of wisdom, but instead by passion and violence, were the result of an error of conception which the ancient artists called *parenthyrsos*.

The more tranquil the state of the body the more capable it is of portraying the true character of the soul. In all positions too removed from this tranquillity, the soul is not in its most essential condition, but in one that is agitated and forced. A soul is more apparent and distinctive when seen in violent passion, but it is great and noble when seen in a state of unity and calm. The portrayal of suffering alone in Laocoon would have been *parenthyrsos*; therefore the artist, in order to unite the distinctive and the noble qualities of soul, showed him in an action that was closest to a state of tranquillity for one in such pain. But in this tranquillity the soul must be distinguished by traits that are uniquely its own and give it a form that is calm and active at the same time, quiet but not indifferent or sluggish.

The common taste of artists of today, especially the younger ones, is in complete opposition to this. Nothing gains their approbation but contorted postures and actions in which bold passion prevails. This they call art executed with spirit, or *franchezza* [sincerity, frankness]. Their favorite term is *contrapposto*, which represents for them the essence of a perfect work of art. In their figures they demand a soul which shoots like a comet out of their midst; they would like every figure to be an Ajax or a Capaneus.

The arts themselves have their infancy as do human beings, and they begin as do youthful artists with a preference for amazement and bombast. Such was the tragic muse of Aeschylus; his hyperbole makes his Agamemnon in part far more obscure than anything that Heraclitus wrote. Perhaps the first Greek painters painted in the same manner that their first good tragedian wrote.

Rashness and volatility lead the way in all human actions; steadiness and composure follow last. The latter, however, take time to be discovered and are found only in great matters; strong passions can be of advantage to their students. The wise artist knows how difficult these qualities are to imitate.

> ut sibi quivis
> Speret idem, sudet multum frustraque laboret
> Ausus idem.
>
> <div align="right">HORACE</div>

['so that everyone thinks he can do it too; yet however hard he sweats and strives, his attempt is in vain.']

La Fage, the great draughtsman, was unable to match the taste of the ancients. His works are so full of movement that the observer's attention is at the same time attracted and distracted, as at a social gathering where everyone tries to talk at once.

The noble simplicity and quiet grandeur of the Greek statues is also the true hallmark of Greek writings from their best period, the writings of the Socratian school. And these are the best characteristics of Raphael's greatness, which he attained through imitation of the Greeks.

So great a soul in so handsome a body as Raphael's was needed to first feel and to discover in modern times the true character of the ancients.

6 Daniel Webb (1719?–1798) from *An Inquiry into the Beauties of Painting*

By the second half of the eighteenth century it was becoming widely recognized in England that painting was possessed of both a classical heritage and a respectable modern tradition, and thus deserved to be considered alongside poetry as a fit subject of study for the cultivated amateur. Webb's *Inquiry* is one of a number of works written with the declared aim of educating taste. His further intention was to provide a thorough account of the virtues of Greek painting, and by this means to contribute towards an elevation of modern standards in the art. The problem that lay in the way of this enterprise – as of others like it – was the complete absence of any surviving Greek painting. Webb's solution was not original, though he pursued it with some industry and scholarship. He extrapolated an understanding of Greek painting from what were widely if mistakenly seen at the time as surviving examples of classical Greek sculpture (the Apollo Belvedere, the Laocoön group, the Daughter of Niobe, the Medici Venus and the Borghese Gladiator); and he combed Greek and Latin authors for any mention of specific Greek artists and for descriptions of their works, as others had done before him. On this basis he constructed an ideal and gentlemanly prototype for the modern artist to emulate. Beside the imaginary achievements attributed to Apelles, Zeuxis, Polygnotus, Euphranor, Parrhasius, Nicias and Nicophanes, even Raphael and Correggio appear wanting. It is significant of an anticlerical tendency in the enlightened culture of the time that Webb could write disparagingly (in Dialogue VII) of the patronage of the Church, that he could describe the Christian religion as one whose 'characters are borrowed from the lowest spheres of life', and that he could conceive of the 'genius of painting wasting its powers on crucifixions, holy families, last suppers, and the like'. The *Inquiry* is written in dialogue form, and is copiously referenced with quotations from the original Greek, Latin and Italian (omitted in our version). Our excerpts are taken from the first edition, published as *An Inquiry into the Beauties of Painting and into the Merits of the most Celebrated Painters, Ancient and Modern*, London: R. and J. Dodsley, 1760, pp. 39–43, 51–5, 99–108, 144–7.

Dialogue IV. of Design

A: We are told by Pliny, that all the statues before the time of Dædalus, were represented stiff and motionless with winking eyes, closed feet, and arms hanging in right lines to their sides: These were the rude essays of design, Dædalus, and his immediate followers, unfolded these embarassed figures; they threw motion into the limbs, and life into the countenance. In the progress of the art, and in abler hands, motion was fashioned into grace, and life was heightened into character. Now, too, it was, that beauty of form was no longer confined to mere imitation, which always falls short of the object imitated; to make the copy equal in its effect, it was necessary to give it some advantage over its model. The artist, therefore, observing, that nature was sparing of her perfections, and that her efforts were limited to parts, availed himself of her inequality, and drawing these scattered beauties into a more happy and compleat union, rose from an imperfect imitative,

to a perfect ideal beauty. We are informed, that the painters of Greece pressed in crowds to design the bosom and breasts of Thais: Nor were the elegant proportions of Phryne less the object of their study. By this constant contemplation of the beautiful, they enriched their imagination and confirmed their taste; from this fund they drew their systems of beauty; and though we should consider them but as imitators as to the parts, we must allow them to have been inventors in the compositions. And indeed, when we reflect on the taste and judgment requisite to form these various ideas into such a wonderful agreement, we cannot set too high a value on their productions. The poets and writers of antiquity acknowledge this superiority of invented to real beauty. –

Ovid thus describes Cyllarus the Centaur, –

> A just proportion, and a manly grace,
> Spread thro' his limbs, and kindled in his face.
> Nature for once assum'd the sculptor's part,
> And in a faultless beauty rivall'd art. –

And Philostratus, speaking of the beauty of Neoptolemus, remarks, that it was as much inferior to that of his father Achilles, as the handsomest men are to the finest statues. Should we still doubt of the truth or justness of the descriptions, let us observe the works which gave occasion to them. Let us contemplate the fine proportions, the style of drawing in the Laocoon and Gladiator. Let us mark the sublime of the art, in the expressive energy, the divine character of the Apollo. Let us dwell on the elegant beauties of the Venus of Medicis. These are the utmost efforts of design: It can reach no farther than a full exertion of grace, character, and beauty.

* * *

A: The design of the ancients is distinguished by an union in the proportions, a simplicity of Contour, and excellence of character. Of the first I have said as much as I might do, without venturing too far into the mechanic of the art: But, as I have only hinted at the others, some more particular remarks may not be improper. There is no one excellence of design, from which we receive such immediate pleasure, as from a gracefulness of action: If we observe the attitudes and movements of the Greek statues, we shall mark that careless decency, and unaffected grace, which ever attend the motions and gestures of men unconscious of observation. There is a prodigious difference, between those movements which flow from nature, and those which are directed by art.

The ancients knew this well; and hence followed that singular simplicity which characterises their works: For, though at times, as in the Venus of Medicis, and daughters of Niobe, they rise to an assumed gracefulness; and even profess a desire to please; yet this is confin'd to so simple a contour; it is so little above the measure of ordinary action, that it appears less the effect of study, than the natural result of a superior character, or an habitual politeness.

B: Raphael has, in this particular, been wonderfully happy in his imitation of the antique. The most courtly imagination cannot represent to itself an image of a

more winning grace, than is to be seen in his Sta. Cæcilia: Indeed, an elegant simplicity is the characteristic of his design; we no where meet in him the affected contrasts of Mic. Angelo, or the studied attitudes of Guido; the true difference between those, may be best conceived, in a supposed comparison of the real characters of the Drama, with the actors who personate them; in Raphael, and the antique, we see Alexander and Hamlet, in Mic. Angelo and Guido —— And, ——

A: Though in treating of grace and beauty, character, so far as it is determined by them, has been naturally included; yet there remains still a more essential part; I mean, that expression of a mind, conveyed in the air of the head, and intelligence of the countenance. If, in the other branches of design, the ancients are to be admired; in this they are wonderful. However enlightened we may be by the most elegant observance of nature, or warmed by the most poetic descriptions, the Belvedere Apollo, and daughter of Niobe still give us new ideas of nobleness, energy, and beauty. The statuaries of Greece, were not mere mechanicks; men of education and literature, they were more the companions than servants of their employers: Their taste was refined by the conversation of courts, and enlarged by the lecture of their poets: Accordingly, the spirit of their studies breathes through their works. We see no such influence in the productions of the moderns; their greatest merit is a servile imitation of the antique; the moment they lose sight of them they are lost. In the elegant, they are little; in the great, charged; character they have none; their beauty is the result of measure, not idea: And if, mistaking extravagance for spirit, they aim at the sublime, it ends in the blusterings of Bernini, or caricatures of Michael Angelo.

B: From all that you have offered on the design of the ancients, we may define grace to be the most pleasing conceivable action, expressed with the utmost simplicity each occasion will admit of.

A: So far as a definition of Grace can go, yours gives a just idea of it; for, it implies the highest degree of elegance in the choice; of propriety in the application and of ease in the execution.

* * *

Dialogue VI. of the Clear Obscure

A: [. . .] Now, in treating of the Clear obscure of the ancients, we have neither the works nor writings of their painters to guide us. Happily, their classic authors, men of parts and erudition, were universally admirers of this art. Hence their frequent allusions to it; their metaphors borrowed from it; with the descriptions of particular paintings, and their effects. In these last we cannot be deceived; like effects, in picture, as in nature, must proceed from uniform causes: And when we find these to correspond exactly with our own observations on the works of the moderns, this analogy leads us into a certainty, as to the similitude of the means by which they were produced.

B: Such inferences as these, when they are natural and unforced, are more con-
clusive than positive assertions; for we are more apt to be deceived by authority,
than by the reason of things.

A: Longinus observes, that, 'if we place in parallel lines, on the same plane, a bright
and an obscure colour, the former springs forward, and appears much nearer to the
eye.' Hence we may remark, that when painters would give a projection to any part
of a figure, as the breasts of a virgin, and the like, they throw its extremities into
shade; that these retiring from the eye, the intermediate parts may have their just
relief. From this simple law of nature, springs all the magic of the Clear obscure;
not only parts are distinguished, but intire figures are detached from their fond;
seem surrounded by air; and meet the imagination with all the energy of life. Thus
Philostratus prettily describes the picture of a Venus, 'The goddess will not seem
to be painted, but springs from the canvass as if she would be pursued.' The same
writer tells us, that Zeuxis, Polygnotus, and Euphranor, were, above all things,
attentive, to shade happily, and animate their figures; by which he insinuates, that
animation, or the soul of painting, owes its being to a just conduct of lights and
shades: And hence it was, no doubt, that the paintings of Parrhasius were termed
realities; they being possessed of such a force of Clear obscure, as to be no longer
the imitations of things, but the things themselves: Agreeable to this, is the
observation of an ancient writer, 'That in painting, the contour of the illumined
part, should be blended with and lost in the shade; for on this, joined to the
advantage of colouring, depend animation, tenderness, and the similitude to truth.'

B: Ovid thus marks this transition of colours in his description of the rainbow.

> *A thousand colours gild the face of day,*
> *With sever'd beauties, and distinguish'd ray;*
> *Whilst in their contact they elude the sight,*
> *And lose distinction in each others light.*

A: A remark made by Petronius Arbiter, on certain paintings of Apelles, points out
the happy effects of this delicacy of pencil. 'With such subtilty, such a likeness to
nature, were the extremities of the figures blended with their shades, that you
must have taken what was before you for real life.' Nicias the Athenian is praised
by Pliny, for his knowledge in the Clear obscure; 'He preserved the lights and
shades, and was particularly careful, that his paintings should project from the
canvass.' But, the greatest effect in this kind, is by the same attributed to the
Alexander of Apelles, in the character of Jupiter the thunderer: 'The fingers (says
he) seem to shoot forward, and the thunder to be out of the picture.' This passage
is too striking to need a comment. Let us compare the idea we receive from this,
with the happiest productions of the modern artists; what could we expect more
from the magic pencil of Correggio? I mean as to the effect of clear obscure; for, I
am at a loss, from whom to expect, the beauty and grace of an Alexander, united to
the majesty and splendor of a Jove. If it appears from what I have offered, that the
painter can by a nice conduct of light and shade, give to the characters he brings on

the scene a kind of real existence: So can he, by a partial distribution of this advantage, give them an evident preference one to the other; and by adding a degree of splendor to each character, proportioned to its importance in the drama, he becomes master of a beautiful gradation, no less satisfactory to the understanding, than pleasing to the eye.

Since I cannot offer you an example of this in any of the ancient paintings now to be seen, I shall remind you of a piece of poetic painting, in which you will find every circumstance of dignity and beauty, set off with the finest effect of Clear obscure, that, perhaps, ever entered into the imagination of either poet or painter. It is, where Virgil introduces Æneas into the presence of Dido.

> Scarce had he spoke, when lo! the bursting cloud
> Melts into air: Confess'd the hero stood,
> Mark'd by the form and splendor of a god;
> The rays maternal round his temples play,
> And gild his beauties with a brighter day;
> These the fond mother studious to improve,
> Breath'd on his person all the powers of love;
> Thro' his long winding locks the magic flows,
> Beams from his eyes, and in each feature glows.

There is something in this description so truly picturesque, it breaks upon the imagination with such a sudden energy of Clear obscure, that I am persuaded, the poet must have had in his eye, some celebrated picture in this style. It is easy to distinguish, when the arts borrow their ideas one from another, and the lights which they so communicate and receive, reverberate, and prove reciprocally their beauties.

B: I could never read the passage you have just quoted, without being struck with the beauty of this image; but you have supplied me with an adventitious pleasure: The correspondence of these sister arts, acts, in some degree, like the harmony of consenting voices; the idea, which they express, is the same, but the effect is doubled in their agreement. When warmed by the description of Virgil's Laocoon, we gaze on that at the Vatican, his cries are more piercing, his pains more exquisite, and the ideas of the poet are as unisons to those of the statuary. [...]

Dialogue VII. of Composition

B: ... let us proceed to what you call the drama of painting.

A: It was with great propriety so termed by the ancients; because, like a dramatic poem, it contains, first, a subject, or fable: secondly, its order, or contrivance; thirdly, characters, or the manners: Fourthly, the various passions which spring from those characters. Philostratus, speaking of the composition of a picture, calls it in express terms the drama of the painter: Pliny has the same idea, in his commendation of Nichophanes. But, we shall be better satisfied of the justness of this application, by examples, than by authorities. It was the opinion of Nicias,

one of the greatest of the Greek painters, that the subject was of no less consequence in painting, than the fable in poetry; and, of course, that great and noble actions tended to elevate and enlarge, as the contrary must humble and contract the genius of the painter. The ancients had great advantages in this particular; they had, not only their profane history, rich in the most glorious and interesting events; but their sacred, whilst it furnished them with new ideas of the sublime, gave no check to the pathetic. Their gods, superior in grace, majesty and beauty, were yet subject to all the feelings and passions of humanity. How unequal is the lot of the modern artists? employed by priests, or princes who thought like priests, their subjects are, for the most part, taken from a religion, which professes to banish, or subdue the passions: Their characters are borrowed from the lowest spheres of life: Men, in whom, meanness of birth, and simplicity of manners, were the best titles to their election. Even their divine master, is no where, in painting, attended with a great idea; his long strait hair, Jewish beard, and poor apparel, would undignify the most exalted nature, humility and resignation, his characteristics, are qualities extremely edifying, but by no means picturesque. Let us, for example, compare (I must be understood to mean only as subjects for painting) a Christ armed with a scourge, driving the money-changers out of the temple, to an Alexander, the thunder in his hand, ready to dart it on the rebellious nations. It is not in the sublime alone, that their subjects are deficient; they are equally so in the pathetic: The sufferings, which they mostly represent, are in obedience to prophecies and the will of heaven; they are often the choice of the sufferers; and a tenfold premium is at hand. When St. Andrew falls down to worship the cross, on which he is soon after to be nailed; we may be improved by such an example of piety and zeal; but we cannot feel for one, who is not concerned for himself. We are not so calm at the sacrifice of Iphigenia; beautiful, innocent, and unhappy; we look upon her as the victim of an unjust decree; she might live the object of universal love; she dies the object of universal pity. This defect in the subject, and of habitude in the painters, accounts for the coldness, with which, we look in general on their works in the galleries and churches; the genius of painting wasting its powers on crucifixions, holy families, last suppers, and the like, wants nerves, if at any time the subject calls for the pathetic or sublime. [...]

7 James Stuart (1713–1788) and Nicholas Revett (1720–1804) from *The Antiquities of Athens*

Stuart and Revett met each other in Rome in the 1740s, having travelled there independently from England in 1742. Both were young architects attracted to the centre of Western civilization, and, in particular, of its architectural heritage. Whilst in Rome, they conceived the idea that the hitherto relatively overlooked Greeks were the true source from which Rome had derived its position. While travelling in Italy they met the British Resident in Venice, Sir James Grey. Grey was a prominent member of the Society of Dilettanti, of which his brother was secretary. In 1748 the society in London published Stuart and Revett's 'Proposals for publishing an accurate Description of the Antiquities of Athens'. Members of the society then funded an expedition to Greece. The authors were in Athens

for over two years, from early 1751 to the autumn of 1753, during which time they carefully measured and recorded all the surviving works of classical architecture. After their return to England in 1755, they began the publication of their findings in the form of large albums of meticulous engravings. However, delays in publication allowed the French architect Julien-David Le Roy to pre-empt their efforts with his *Les Ruines des plus beaux monuments de la Grèce*, published in Paris in 1758. Le Roy's work was both less extensive and less accurate than Stuart and Revett's, being based on no more than three months' work. But partly because of Le Roy's enterprise, and partly also because they had chosen to survey the Greek architectural orders by illustrating a series of relatively minor constructions, Stuart and Revett's first volume, which appeared in 1762, was initially regarded as something of a disappointment. The second volume, however, dealt with the Acropolis, and the complete four-volume work is now regarded as second only to Winckelmann (see IIIA5 and 8) in establishing the priority of Greece as the fountain-head of the Western classical tradition. Our selection is taken from the preface to the first volume of *The Antiquities of Athens measured and delineated by James Stuart FRS and FSA and Nicholas Revett, painters and architects*, London 1762, pp. i–iv. Punctuation and spelling have been slightly modified.

The ruined edifices of Rome have for many years engaged the attention of those who apply themselves to the study of architecture, and have generally been considered as the Models and Standard of regular and ornamental building. Many representations of them drawn and engraved by skilful artists have been published, by which means the study of the art has been everywhere greatly facilitated, and the general practice of it improved and promoted; insomuch that what is now esteemed the most elegant manner of decorating buildings was originally formed, and has been since established, on examples which the antiquities of Rome have furnished.

But although the world is enriched with collections of this sort already published, we thought it would be a work not unacceptable to the lovers of Architecture if we added to those collections some examples drawn from the antiquities of Greece; and we were confirmed in our opinion by this consideration principally, that as Greece was the great Mistress of the Arts, and Rome in this respect no more than her disciple, it may be presumed all the most admired buildings which adorned that imperial city were but imitations of Graecian originals.

Hence it seemed probable that if accurate representations of these Originals were published, the world would be enabled to form not only more extensive but juster ideas than have hitherto been obtained concerning Architecture, and the state in which it existed during the best ages of Antiquity. It even seemed that a performance of this kind might contribute to an improvement of the Art itself, which at present appears to be founded on too partial and too scanty a system of ancient examples.

For during those ages of violence and barbarism, which began with the declension and continued long after the destruction of the Roman empire, the beautiful edifices which had been erected in Italy with such labour and expense, were neglected or destroyed; so that, to use a very common expression, it may truly be said that Architecture lay for ages buried in its own ruins; and although from these ruins it has Phoenix-like received a second birth, we may nevertheless conclude that many of the beauties and elegancies which enhanced its ancient splendour are still wanting, and that it has not yet by any means recovered all its former perfection.

This conclusion becomes sufficiently obvious when we consider that the great Artists by whose industry this noble art has been revived, were obliged to shape its present Form after those Ideas only which the casual remains of Italy suggested to them; and these remains are so far from furnishing all the materials necessary for a complete restoration of Architecture in all its parts that the best collections of them, those published by Palladio and Desgodetz, cannot be said to afford a sufficient variety of examples for restoring even the three Orders of columns, for they are deficient in what relates to the Doric and Ionic, the two most ancient of these Orders.

If from what has been said it should appear that Architecture is reduced and restrained within narrower limits than could be wished, for want of a greater number of Ancient examples than have hitherto been published, it must then be granted that every such example of beautiful Form or Proportion, wherever it may be found, is a valuable addition to the former stock, and does, when published, become a material acquisition to the Art.

But of all the countries which were embellished by the Ancients with magnificent buildings, Greece appears principally to merit our attention; since if we believe the Ancients themselves, the most beautiful Orders and Dispositions of columns were invented in that country, and the most celebrated works of Architecture were erected there; to which may be added that the most excellent Treatises on the Art appear to have been written by Grecian architects.

The city of Greece most renowned for stately edifices, for the Genius of its inhabitants, and for the culture of every art, was Athens. We therefore resolved to examine that spot rather than any other, flattering ourselves that the remains we might find there would excel in true Taste and Elegance every thing hitherto published. How far indeed these expectations have been answered must now be submitted to the opinion of the Public.

Yet since the authorities and reasons which engaged us to conceive so highly of the Athenian buildings may serve likewise to guard them in some measure from the over-hasty opinions and unadvised censures of the inconsiderate, it may not be amiss to produce some of them in this place. And we the rather wish to say something a little more at large on this subject, as it will be at the same time an apology for ourselves and perhaps the best justification for our undertaking.

After the defeat of Xerxes, the Grecians, secure from invaders and in full possession of their Liberty, arrived at the height of their Prosperity. It was then they applied themselves with the greatest assiduity and success to the culture of the Arts. They maintained their Independency and their Power for a considerable space of time and distinguished themselves by a pre-eminence and universality of Genius unknown to other Ages and Nations.

During this happy period their most renowned Artists were produced. Sculpture and Architecture attained their highest degree of excellence at Athens in the time of Pericles, when Phidias distinguished himself with such superior ability that his works were considered as wonders by the Ancients, so long as any knowledge or taste remained among them. His statue of Jupiter Olympus, we are told, was never equalled; and it was under his inspection that many of the most celebrated buildings of Athens were erected. Several Artists of most distinguished talents were his contemporaries, among whom we may reckon Callimachus, an Athenian, the

inventor of the Corinthian capital. After this, a succession of excellent Painters, Sculptors and Architects appeared, and these arts continued in Greece at their highest perfection till after the death of Alexander the Great.

Painting, Sculpture and Architecture, it should be observed, remained all that time in a very rude and imperfect state among the Italians.

But when the Romans had subdued Greece, they soon became enamoured of these delightful Arts. They adorned their City with Statues and Pictures, the spoils of that conquered Country; and adopting the Grecian style of Architecture they now first began to erect Buildings of great Elegance and Magnificence. They seem not however to have equalled the Originals from whence they had borrowed their Taste, either for Purity of Design or delicacy of Execution.

For although these Roman edifices were most probably designed and executed by Grecians, as Rome never produced many extraordinary Artists of her own, yet Greece herself was at that time greatly degenerated from her former excellence, and had long since ceased to display that superiority of Genius which distinguished her in the Age of Pericles and of Alexander. To this a long series of misfortunes had reduced her, for having been oppressed by the Macedonians first, and afterwards subdued by the Romans, with the loss of her Liberty, that love of glory likewise and that sublimity of Spirit which had animated her artists, as well as her warriors, her statesmen and her philosophers and which had formed her peculiar character, were now extinguished, and all her exquisite Arts languished and were near expiring.

They were indeed at length assiduously cherished and cultivated at Rome. That City being now Mistress of the World, and possessed of unbounded Wealth and Power, became ambitious also of the utmost embellishments which these Arts could bestow. They could not however, though assisted by Roman munificence, reascend to that height of Perfection which they had attained in Greece during the happy period we have already mentioned. And it is particularly remarkable that when the Roman authors themselves celebrate any exquisite production of Art, it is the work of Phidias, Praxiteles, Myron, Lysippus, Zeuxis, Apelles, or in brief of some Artist who adorned that happy period, and not of those who had worked at Rome, or had lived nearer to their own times than the age of Alexander.

It seemed therefore evident that Greece is the place where the most beautiful edifices were erected, and where the purest and most elegant examples of ancient architecture are to be discovered.

But whether or no it be allowed that these edifices deserved the encomiums which have been bestowed on them, it will certainly be a study of some delight and curiosity to observe wherein the Grecian and Roman style of building differ; for differ they certainly do; and to decide, by a judicious examination, which is the best. It is as useful to attend to the progress of an Art while it is improving as to trace it back towards its first perfection, when it has declined. In one of these lights therefore, the performance which we now offer to the public will, it is hoped, be well received.

8 Johann Joachim Winckelmann (1717–1768) from *A History of Ancient Art*

Winckelmann moved from Dresden to Rome in 1755. The earliest plans for what was to be his major work, the *Geschichte der Kunst des Alterthums*, date from the following year. The manuscript was complete by 1761 and the book appeared in 1764, less than a decade after his initial, ground-breaking foray into classical art (see IIIA5). It is on the *History of Ancient Art* that Winckelmann's reputation rests as the initiator of the modern tradition of art history. He was able to synthesize existing treatments of classical art, such as those of Junius (IA1) and Turnbull (IIIA1), with a chronologically based history informed by recent developments in archaeology and his own highly individual responses to particular works. The result was an account of ancient art based not on subject-matter or the rehearsal of classical quotations, but on the development of a sequence of period styles. These followed a model of birth, maturity and decay, moving from an archaic period, through to a high or classical phase in the fifth and fourth centuries BC, exemplified by artists such as Phidias and Apelles, and then declining in the Hellenistic and Roman periods. In his preface, Winckelmann made much of the fact that, unlike his predecessors, he had actually seen the works he was writing about. For the most part these were later Greek works, or even Roman copies, but it still marked an advance over the earlier, predominantly literary approaches to writing about the art of the past. Winckelmann accordingly enriched his overarching historical schema with insightful responses to particularly significant works; responses which, in sharp contrast to much of the subsequent art-historical academicism he legitimated, are marked by a passionate and even erotic feeling for the art he described. Among the most interesting features of Winckelmann's *History* for the contemporary reader is the way in which, even here, in the founding text of objective, stylistic analysis, figures of race and sex hover in the margins. The *History of Ancient Art* is an extensive book, moving by turns from detailed meditations on particular works to historical generalizations and wide-ranging philosophical reflections on the place of art in human existence. The selections here are therefore restricted to a small number of key issues: Winckelmann's systematic aims, and the practical difficulties he faced; his speculations about the reasons for Greece's artistic eminence, particularly its climate and its political freedom; and his analysis of ideal beauty and artistic expression. The extracts are taken from the *History of Ancient Art*, translated by G. Henry Lodge (4 vols. 1849–72), New York: Frederick Ungar, 1968, pp. 3–4, 10–11, 176–9, 198–203, 210–11, 215, 227–8, 245–6, 250–1.

Preface

The History of Ancient Art which I have undertaken to write is not a mere chronicle of epochs, and of the changes which occurred within them. I use the term History in the more extended signification which it has in the Greek language; and it is my intention to attempt to present a system. [...]

The History of Art is intended to show the origin, progress, change, and downfall of art, together with the different styles of nations, periods, and artists, and to prove the whole, as far as it is possible, from the ancient monuments now in existence.

A few works have been published under the title of a *History of Art*. Art, however, had but a small share in them, for their authors were not sufficiently familiar with it, and therefore could communicate nothing more than what they had learned from

books or hearsay. There is scarcely one who guides us to the essential of art, and into its interior; and those who treat of antiquities either touch only on those points in which they can exhibit their learning, or, if they speak of art, they do so either in general terms of commendation, or their opinion is based on strange and false grounds. [...]

In this *History of Art* I have exerted myself to discover the truth, and, as I have had every desirable opportunity of leisurely investigating the works of the ancients, and have spared no pains to obtain the requisite kinds of knowledge, I believed myself competent to undertake it. From youth upward, a love for art has been my strongest passion; and though education and circumstances led me in quite another direction, still my natural inclination was constantly manifesting itself. All the pictures and statues, as well as engraved gems and coins, which I have adduced as proofs, I have myself seen, and seen frequently, and been able to study; but for the purpose of aiding the reader's conception, I have cited, besides these, both gems and coins from books, whenever the engravings of them were tolerably good.

It must not occasion surprise that I have omitted to notice some few works of ancient art bearing the name of the artist, and some which have become remarkable from other circumstances. Those which I have silently passed by are objects which either afford no help in determining a style or a period in art, or else they are no longer in Rome, or are entirely destroyed; for, in modern times, this misfortune has befallen very many glorious pieces, – as I have remarked in several places. I would have described the torso of a statue with the name Apollonius of Athens, son of Nestor, upon it, which was formerly in the Massimi palace; but it is lost. A painting of the goddess Roma, – not the known one in the Barberini palace, – which is adduced by [Jacob] Spon, is also no longer in Rome. The Nymphæum described by Holstein has gone to decay, through negligence, it is asserted, and is no longer shown. The relievo on which Painting was making a portrait of Varro, which belonged to the celebrated Ciampini, is likewise no longer in Rome, lost without the slightest further information in regard to it. The Hermæ of the head of Speusippus, the head of Xenocrates, and several others, bearing either the name of the person or of the artist, have had a similar fate. It is impossible to read, without sorrow, notices of so many antique monuments of art, which were destroyed, both in Rome and elsewhere, in the days of our forefathers; and of many no information even has been preserved. [...] Who could believe that in our day, from the torso of a statue of which the head is in existence, two other statues were made? Yet this has been the case at Parma, in the very year in which I write, with the colossal trunk of a Jupiter, the beautiful head of which is in the Academy of Painting in that city. The two new figures cut out of the antique one, of a sort that can easily be imagined, stand in the ducal garden. A nose has been affixed to the head in the most bungling manner; and the modern sculptor, intending to improve the forms which the ancient master gave to the forehead, cheeks, and beard, has removed what seemed to him superfluous. I forgot to state that this Jupiter was found in the buried city of Velleia, in the Parmesan territory, of which the discovery has recently been made. Moreover, within the memory of man, indeed since my residence in Rome, many celebrated pieces have been carried to England, where, as Pliny expresses it, they are exiled to remote country-seats.
* * *

Book IV

The superiority which art acquired among the Greeks is to be ascribed partly to the influence of climate, partly to their constitution and government, and the habits of thinking which originated therefrom, and, in an equal degree also, to respect for the artist, and the use and application of art.

The influence of climate must vivify the seed from which art is to be produced; and for this seed Greece was the chosen soil. The talent for philosophy was believed by Epicurus to be exclusively Greek; but this preëminence might be claimed more correctly for art. The Greeks acknowledged and prized the happy clime under which they lived, though it did not extend to them the enjoyment of a perennial spring; for, on the night when the revolt against the Spartan government broke out in Thebes, it snowed so violently as to confine every one to the house. Moderateness of temperature constituted its superiority, and is to be regarded as one of the more remote causes of that excellence which art attained among the Greeks. The climate gave birth to a joyousness of disposition; this, in its turn, invented games and festivals; and both together fostered art, which had already reached its highest pinnacle at a period when that which we call Learning was utterly unknown to the Greeks. At this time they attached a peculiar signification to the honorable title of Author, who was regarded with a certain degree of contempt; and Plato makes Socrates say, that distinguished men, in Greek cities, had not drawn up or left behind them any writings, for fear of being numbered among the Sophists.

Much that might seem ideal to us was natural among them. Nature, after having passed step by step through cold and heat, established herself in Greece. Here, where a temperature prevails which is balanced between winter and summer, she chose her central point; and the nigher she approaches it, the more genial and joyous does she become, and the more general is her influence in producing conformations full of spirit and wit, and features strongly marked and rich in promise. Where clouds and heavy mists rarely prevail, but Nature acts in a serene and gladsome atmosphere, such as Euripides describes the Athenian, she imparts an earlier maturity to the body; she is distinguished for vigorous development, especially of the female form; and it is reasonable to suppose that in Greece she perfected man to the highest degree...

The Greeks were conscious of this, and, as Polybius says, of their superiority generally to other nations; and among no people has beauty been prized so highly as among them. [...]

To the same influence, in an equal degree, which the atmosphere and climate exercised upon the physical conformation, – which, according to the testimony of all travellers, is of superior excellence even among the Greeks of the present day, and could inspire their artists in former times, – are to be ascribed their kindly natures, their gentle hearts, and joyous dispositions, – qualities that contributed fully as much to the beautiful and lovely images which they designed, as nature did to the production of the form. History convinces us that this was their character. The humanity of the Athenians is as well known as their reputation in the arts. Hence a poet says, that Athens alone knows the feeling of pity; for it appears that, from the times of the oldest wars of the Argives and Thebans, the oppressed and persecuted always found

refuge and received help there. This same genial disposition was the origin of theatrical representations, and other games, – for the purpose, as Pericles says, of chasing sadness from life.

This is more easily understood by contrasting the Greeks with the Romans. The inhuman, sanguinary games, and the agonizing and dying gladiators, in the amphitheatres of the latter, even during the period of their greatest refinement, were the most gratifying sources of amusement to the whole people. The former, on the contrary, abhorred such cruelty; and, when similar fearful games were about to be introduced at Corinth, some one observed, that they must throw down the altar of Mercy and Pity, before they could resolve to look upon such horrors. [...]

The independence of Greece is to be regarded as the most prominent of the causes, originating in its constitution and government, of its superiority in art. Liberty had always held her seat in this country, even near the throne of kings, – whose rule was paternal, – before the increasing light of reason had shown to its inhabitants the blessings of entire freedom. [...]

We ourselves differ as to beauty, – probably more than we do even in taste and smell, – whenever our ideas respecting it are deficient in clearness. It will not be easy to find a hundred men who would agree as to all the points of beauty in any one face, – I speak of those who have not thought profoundly on the subject. The handsomest man that I have seen in Italy was not the handsomest in the eyes of all, not even of those who prided themselves on being observant of the beauty of our sex. But those who have regarded and selected beauty as a worthy subject of reflection cannot differ as to the truly beautiful, for it is one only, and not manifold; and when they have studied it in the perfect statues of the ancients, they do not find, in the beautiful women of a proud and wise nation, those charms which are generally so much prized, – because they are not dazzled by the fairness of their skin. Beauty is felt by sense, but is recognized and comprehended by the understanding, which generally renders, and ought to render, sense less susceptible, but more correct. Most nations, however, and among them the most cultivated, not only of Europe, but of Asia and Africa, invariably agree as to the general form; consequently their ideas of it are not to be considered as arbitrarily assumed, although we are not able to account for them all.

Color assists beauty; generally, it heightens beauty and its forms, but it does not constitute it; just as the taste of wine is more agreeable, from its color, when drunk from a transparent glass, than from the most costly golden cup. Color, however, should have but little share in our consideration of beauty, because the essence of beauty consists, not in color, but in shape, and on this point enlightened minds will at once agree. As white is the color which reflects the greatest number of rays of light, and consequently is the most easily perceived, a beautiful body will, accordingly, be the more beautiful the whiter it is, just as we see that all figures in gypsum, when freshly formed, strike us as larger than the statues from which they are made. A negro might be called handsome, when the conformation of his face is handsome. A traveller assures us that daily association with negroes diminishes the disagreeableness of their color, and displays what is beautiful in them; just as the color of bronze and of the black and greenish basalt does not detract from the beauty of the antique heads. The beautiful female head in the latter kind of stone, in the villa Albani, would not appear more beautiful in white marble. The head of the elder Scipio, of

dark-greenish basalt, in the palace Rospigliosi, is more beautiful than the three other heads, in marble, of the same individual. These heads, together with other statues in black stone, will meet with approbation even from the unlearned, who view them as statues. It is manifest, therefore, that we possess a knowledge of the beautiful, although in an unusual dress and of a disagreeable color. But beauty is also different from pleasingness or loveliness. [. . .]

Wise men who have meditated on the causes of universal beauty have placed it in the harmony of the creature with the purposes of its being, and of the parts with each other and with the whole, because they have investigated it in the works of creation, and have sought to reach even the source of the highest beauty. But, as this is synonymous with perfection, of which humanity is not a fit recipient, our idea of universal beauty is still indefinite; and it is formed within us by single acquisitions of knowledge, which, when they are collected and united together, give us, if correct, the highest idea of human beauty, – which we exalt in proportion as we are able to elevate ourselves above matter. Since, moreover, this perfection has been bestowed by the Creator on all his creatures, in a degree suitable to them, and every idea originates from a cause which must be sought, not in the idea itself, but in something else, so the cause of beauty cannot be found *out* of itself, since it exists *in* all created things. From this circumstance, and – as all our knowledge is made up of ideas of comparison – from the impossibility of comparing beauty with anything higher than itself, arises the difficulty of a general and clear explanation of it.

The highest beauty is in God; and our idea of human beauty advances towards perfection in proportion as it can be imagined in conformity and harmony with that highest Existence which, in our conception of unity and indivisibility, we distinguish from matter. This idea of beauty is like an essence extracted from matter by fire; it seeks to beget unto itself a creature formed after the likeness of the first rational being designed in the mind of the Divinity. The forms of such a figure are simple and flowing, and various in their unity; and for this reason they are harmonious, just as a sweet and pleasing tone can be extracted from bodies the parts of which are uniform. [. . .]

From unity proceeds another attribute of lofty beauty, the absence of individuality; that is, the forms of it are described neither by points nor lines other than those which shape beauty merely, and consequently produce a figure which is neither peculiar to any particular individual, nor yet expresses any one state of the mind or affection of the passions, because these blend with it strange lines, and mar the unity. According to this idea, beauty should be like the best kind of water, drawn from the spring itself; the less taste it has, the more healthful it is considered, because free from all foreign admixture. As the state of happiness – that is, the absence of sorrow, and the enjoyment of content – is the very easiest state in nature, and the road to it is the most direct, and can be followed without trouble and without expense, so the idea of beauty appears to be the simplest and easiest, requiring no philosophical knowledge of man, no investigation and no expression of the passions of his soul.

Since, however, there is no middle state in human nature between pain and pleasure, even according to Epicurus, and the passions are the winds which impel our bark over the sea of life, with which the poet sails, and on which the artist soars, pure beauty alone cannot be the sole object of our consideration; we must place it also

in a state of action and of passion, which we comprehend in art under the term *Expression*. We shall, therefore, in the first place, treat of the shape of beauty, and in the second place, of expression.

The shape of beauty is either *individual*, – that is, confined to an imitation of one individual, – or it is a selection of beautiful parts from many individuals, and their union into one, which we call *ideal*, yet with the remark that a thing may be ideal without being beautiful. The form of the Egyptian figures, in which neither muscles, tendons, nor veins are indicated, is ideal, but still it shapes forth no beauty in them; neither can the drapery of Egyptian female figures – which can only be imagined, and consequently is ideal – be termed beautiful. [...]

The gymnasia and other places where the young exercised naked in athletic and other games, and which were the resort of those who desired to see beautiful youth, were the schools wherein the artist saw beauty of structure; and, from the daily opportunity of seeing it nude and in perfection, his imagination became heated, the beauty of the forms he saw became his own, and was ever present to his mind. At Sparta, even the young virgins exercised naked, or nearly so, in the games of the arena.

To each age, even as to the goddesses of the seasons, there belongs its peculiar beauty, but differing in degree. It is associated especially with youth, which it is the great effort of art to represent. Here, more than in manhood, the artist found the cause of beauty, in unity, variety, and harmony. The forms of beautiful youth resemble the unity of the surface of the sea, which at some distance appears smooth and still, like a mirror, although constantly in movement with its heaving swell. The soul, though a simple existence, brings forth at once, and in an instant, many different ideas; so it is with the beautiful youthful outline, which appears simple, and yet at the same time has infinitely different variations, and that soft tapering which is difficult of attainment in a column is still more so in the diverse forms of a youthful body. Among the innumerable kinds of columns in Rome, some appear pre-eminently elegant on account of this very tapering; of these I have particularly noticed two of granite, which I am always studying anew: just so rare is a perfect form, even in the most beautiful youth, which has a stationary point in our sex still less than in the female.

The forms of a beautiful body are determined by lines the centre of which is constantly changing, and which, if continued, would never describe circles. They are, consequently, more simple, but also more complex, than a circle, which, however large or small it may be, always has the same centre, and either includes others, or is included in others. This diversity was sought after by the Greeks in works of all kinds; and their discernment of its beauty led them to introduce the same system even into the form of their utensils and vases, whose easy and elegant outline is drawn after the same rule, that is, by a line which must be found by means of several circles, for all these works have an elliptical figure, and herein consists their beauty. The greater unity there is in the junction of the forms, and in the flowing of one out of another, so much the greater is the beauty of the whole.

From this great unity of youthful forms, their limits flow imperceptibly one into another, and the precise point of height of many, and the line which bounds them, cannot be accurately determined. This is the reason why the delineation of a youthful

body, in which everything is and is yet to come, appears and yet does not appear, is more difficult than that of an adult or aged figure. In the former of these two, the adult, nature has completed, and consequently determined, her work of formation; in the latter, she begins again to destroy the structure; in both, therefore, the junction of the parts is clearly visible. In youth, on the contrary, the conformation is, as it were, suspended between growth and maturity. To deviate from the outline in bodies having strongly developed muscles, or to strengthen or exaggerate the prominence of muscles or other parts, is not so great an error as the slightest deviation in youthful figures, in which even the faintest shadow, as it is commonly said, becomes a body, just as a rule, though shorter or narrower than the requisite dimensions, still has all the properties of a rule, but cannot be called so if it deviates from a straight line; whoever misses the centre-white has missed as much as though he had not hit the target at all. [. . .]

Book V

The most beautiful forms, thus selected, were, in a manner, blended together, and from their union issued, as by a new spiritual generation, a nobler progeny, of which no higher characteristic could be conceived than never-ending youth, – a conclusion to which the consideration of the beautiful must necessarily lead. For the mind, in rational beings, has an innate tendency and desire to rise above matter into the spiritual sphere of conceptions, and its true enjoyment is in the production of new and refined ideas. The great artists among the Greeks – who regarded themselves almost as creators, although they worked less for the understanding than for the senses – sought to overcome the hard resistance of matter, and, if possible, to endue it with life, with soul. This noble zeal on their part, even in the earlier periods of art, gave rise to the fable of Pygmalion's statue. For their hands produced those objects of devout respect, which, to inspire veneration, must necessarily appear to be images taken from a more elevated order of beings. The first founders of the religion – who were poets – attached to these images exalted ideas, and these in their turn excited the imagination to elevate her work above herself, and above sense. To human notions, what attribute could be more suitable to sensual deities, and more fascinating to the imagination, than an eternal youth and spring-time of life, when the very remembrance of youth which has passed away can gladden us in later years? It was conformable to their idea of the immutability of the godlike nature; and a beautiful youthful form in their deities awakened tenderness and love, transporting the soul into that sweet dream of rapture, in which human happiness – the object and aim of all religions, whether well or ill understood – consists. [. . .]

As the ancients had mounted gradually from human to divine beauty, each of the steps of beauty remained through which they passed in their ascent.

Near the divinities stand the Heroes and Heroines of fable. To the artist, the latter as well as the former were objects of beauty. In Heroes, that is, in men to whom antiquity attributed the highest excellence of human nature, he advanced even to the confines of the divine nature, without passing beyond them, and without blending the very nice distinctions which separated the two. Battus, on medals of Cyrene, might easily be made to represent a Bacchus, by a single expression of tender delight,

and an Apollo, by one trait of godlike nobleness. Minos, on coins of Gnossus, if it were not for a proud, regal look, would resemble a Jupiter, full of graciousness and mercy.

The artist shaped the forms of Heroes heroically, and gave to certain parts a preternatural development; placed in the muscles quickness of action and of motion; and in energetic efforts brought into operation all the motive powers of nature. The object which he sought to attain was variety in its utmost extent; and in this respect, Myron exceeded all his predecessors. It is visible even in the Gladiator, erroneously so called, of Agasias of Ephesus, in the villa Borghese, whose face is evidently copied after that of some particular individual. The serrated muscles on the sides, as well as others, are more prominent, active, and contractile than is natural. The same thing is yet more clearly seen, in the same muscles, in the Laocoön, – who is an ideally elevated being, – if this portion of the body be compared with the corresponding portion in deified or godlike figures, as the Hercules and Apollo of the Belvedere. The action of these muscles, in the Laocoön, is carried beyond truth to the limits of possibility; they lie like hills which are drawing themselves together, – for the purpose of expressing the extremest exertion in anguish and resistance. In the torso of Hercules deified, there is a high ideal form and beauty in these same muscles; they resemble the undulations of the calmed sea, flowing though elevated, and rising and sinking with a soft, alternate swell. In the Apollo, an image of the most beautiful of the gods, these muscles are smooth, and, like molten glass blown into scarce visible waves, are more obvious to touch than to sight.

In all these respects, beauty was uniformly the principal object at which the artist aimed.

* * *

Next to a knowledge of beauty, expression and action are to be considered as the points most essential to an artist, just as Demosthenes regarded action as the first, second, and third requisite in an orator. Action alone may cause a figure to appear beautiful; but it can never be considered so, if the action is faulty. An observance of propriety in expression and action ought, therefore, to be inculcated at the same time with the principles of beautiful forms, – because it is one of the constituents of grace. For this reason, the Graces are represented as the attendants of Venus, the goddess of beauty. Consequently the phrase, *to sacrifice to the Graces*, signifies among artists to be attentive to the expression and action of their figures.

In art, the term *expression* signifies imitation of the active and passive states of the mind and body, and of the passions as well as of the actions. In its widest sense it comprehends action; but in its more limited meaning, it is restricted to those emotions which are denoted by looks and the features of the face. Action relates rather to the movements of the limbs and the whole body; it sustains the expression. [...]

Expression, in its limited as well as more extended signification, changes the features of the face, and the posture, and consequently alters those forms which constitute beauty. The greater the change, the more unfavorable it is to beauty. On this account, stillness was one of the principles observed here, because it was regarded, according to Plato, as a state intermediate between sadness and gayety; and, for the same reason, stillness is the state most appropriate to beauty, just as it is

to the sea. Experience also teaches that the most beautiful men are quiet in manners and demeanor. In this view, even abstraction is required in an image not less than in him who designs it; for the idea of lofty beauty cannot be conceived otherwise than when the soul is wrapt in quiet meditation, and abstracted from all individuality of shape. Besides, a state of stillness and repose, both in man and beast, is that state which allows us to examine and discover their real nature and characteristics, just as one sees the bottom of a river or lake only when their waters are still and unruffled, and consequently even Art can express her own peculiar nature only in stillness.

Repose and equanimity, in their highest degree, are incompatible with action. The most elevated idea of beauty, therefore, can neither be aimed at, nor preserved, even in figures of the deities, who must of necessity be represented under a human shape. But the expression was made commensurate, as it were, with the beauty, and regulated by it. With the ancient artists, therefore, beauty was the chief object of expression, just as the cymbal guides all the other instruments in a band, although they seemingly overpower it. A figure may, however, be called beautiful even though expression should preponderate over beauty, just as we give the name of wine to a liquor of which the larger portion is water. Here we also see an indication of the celebrated doctrine of Empedocles relative to discord and harmony, by whose opposing actions the things of this world are arranged in their present situation. Beauty without expression might properly be termed insignificant, and expression without beauty, unpleasing; but, from the action of one upon the other, and the union of the two opposing qualities, beauty derives additional power to affect, to persuade, and to convince.

Repose and stillness are likewise to be regarded as a consequence of the propriety which the Greeks always endeavored to observe both in feature and action, insomuch that even a quick walk was regarded as, in a certain measure, opposed to their ideas of decorum. It seemed to involve a kind of boldness. Demosthenes reproaches Nicobulus with such a mode of walking; and he connects impudent talking with quick walking. In conformity to this mode of thinking, the ancients regarded slow movements of the body as characteristic of great minds. [. . .]

The Greek artists were convinced that, as Thucydides says, greatness of mind is usually associated with a noble simplicity. Even Achilles presents himself to us in this aspect; for, though prone to anger and inexorable in wrath, his character is ingenuous, and without dissimulation or falseness. The ancient artists accordingly modelled the faces of their heroes after the truth thus taught them by experience. No look of subtlety is there, nor of frivolity, nor craft, still less of scorn, but innocence is diffused over them, blended with the calmness of a trustful nature.

In representing heroes, the artist is allowed less license than the poet. The latter can depict them according to their times, when the passions were as yet unrestrained by social laws or the artificial proprieties of life, because the qualities ascribed to a man have a necessary relation to his age and standing, but none necessarily to his figure. The former, however, being obliged to select the most beautiful parts of the most beautiful conformations, is limited, in the expression of the passions, to a degree which will not conflict with the physical beauty of the figure which he models.

The truth of this remark is apparent in two of the most beautiful works of antiquity. One of them is a representation of the fear of death; the other, of extreme

suffering and pain. The daughters of Niobe, at whom Diana has aimed her fatal shafts, are represented in that state of indescribable anguish, their senses horror-struck and benumbed, in which all the mental powers are completely overwhelmed and paralyzed by the near approach of inevitable death. The transformation of Niobe into a rock, in the fable, is an image of this state of deathlike anguish; and for this reason Æschylus introduced her as a silent personage in his tragedy on this subject. A state such as this, in which sensation and reflection cease, and which resembles apathy, does not disturb a limb or a feature, and thus enabled the great artist to represent in this instance the highest beauty just as he has represented it; for Niobe and her daughters are beautiful according to the highest conceptions of beauty.

Laocoön is an image of the most intense suffering. It manifests itself in his muscles, sinews, and veins. The poison introduced into the blood, by the deadly bite of the serpents, has caused the utmost excitement in the circulation; every part of the body seems as if straining with agony. By this means the artist brought into action all the natural motive powers, and at the same time displayed the wonders of his science and skill. But in the representation of this intense suffering is seen the determined spirit of a great man who struggles with necessity and strives to suppress all audible manifestations of pain. [...]

9 Francesco Algarotti (1712–1764) 'Of the Camera Obscura' from *An Essay on Painting*

Algarotti was a wealthy, Venetian-born collector, connoisseur and man of letters. Following an education which combined science and culture, he spent his adult life in a succession of major European cities, involved with a variety of projects ranging from building up the art collection of the Elector of Saxony to publishing popular expositions of Newton's optics. In London his portrait was drawn by Jonathan Richardson; in Paris he stayed with Voltaire; in Prussia he was ennobled by Frederick the Great. Towards the end of his life he prepared a complete edition of his writings which, when published posthumously in Venice in the 1790s, ran to seventeen volumes. His *Saggio sopra la pittura* was published in Bologna in 1762. An English translation followed in 1764, dedicated to 'The Society Instituted in London for Promoting Arts, Manufactures and Commerce' (now known as the Royal Society of Arts). The book is essentially an instruction manual for the young artist, taking the reader in an easygoing but informed fashion through the conventionally recognized requirements of the practice: anatomy, perspective, colouring, drapery, expression and so forth. Algarotti's text is liberally sprinkled with references to the most eminent artists of the past and present, and draws on a wide range of theorists from Pliny and Leonardo to near contemporaries such as De Piles, Du Fresnoy and Le Brun. One chapter, however, is more innovative, combining as it does Algarotti's knowledge of classicist art theory with his enthusiasm for modern science, and in particular, optics. 'Of the Camera Obscura' forms chapter VI of Algarotti's *An Essay on Painting*, London: L. Davis and C. Reymers, 1764, pp. 60–6.

We may well imagine, that, could a young painter but view a picture by the hand of Nature herself, and study it at his leisure, he would profit more by it, than by the

most excellent performances by the hand of man. Now, nature is continually forming such pictures in our eye. The rays of light coming from exterior objects, after entering the pupil, pass through the crystalline humour, and being there refracted, in consequence of the lenticular form of that part, proceed to the retina, which lies at the bottom of the eye, and stamp upon it, by their union, the image of the object, towards which the pupil is directed. The consequence of which is, that the soul, by means as yet unknown to us, receives immediate intelligence of these rays, and comes to see the objects that sent them. But this grand operation of Nature, the discovery of which was reserved for our times, might have remained an idle amusement of physical curiosity, without being of the least service to the painter, had not means been happily found of imitating it. The machine, contrived for this purpose, consists of a lens and a mirror so situated, that the second throws the picture of any thing properly exposed to the first, and that too of a competent largeness, on a clean sheet of paper, where it may be seen and contemplated at leisure.

As this artificial eye, usually called a Camera Optica or Obscura, gives no admittance to any rays of light, but those coming from the thing whose representation is wanted, there results from them a picture of inexpressible force and brightness; and, as nothing is more delightful to behold, so nothing can be more useful to study, than such a picture. For, not to speak of the justness of the contours, the exactness of the perspective and of the chiaroscuro, which exceeds conception; the colours are of a vivacity and richness that nothing can excell; the parts, which stand out most, and are most exposed to the light, appear surprisingly loose and resplendent; and this looseness and resplendency declines gradually, as the parts themselves sink in, or retire from the light. The shades are strong without harshness, and the contours precise without being sharp. Wherever any reflected light falls, there appears, in consequence of it, an infinite variety of tints, which, without this contrivance, it would be impossible to discern. Yet there prevails such a harmony amongst all the colours of the piece, that scarce any one of them can be said to clash with another.

After all, it is no way surprising, that we should, by means of this contrivance, discover, what otherwise we might justly despair of ever being acquainted with. We cannot look directly at any object, that is not surrounded by so many others, all darting their rays together into our eyes, that it is impossible we should distinguish all the different modulations of its light and colours. At least we can only see them in so dull and confused a manner, as not to be able to determine any thing precisely about them. Whereas, in the Camera Obscura, the visual faculty is brought wholly to bear upon the object before it; and the light of every other object is, as it were, perfectly extinguished.

Another most astonishing perfection in pictures of this kind is the diminution of the size, and of the intenseness of light and colour, of the objects and all their parts, in proportion to their distance from the eye. At a greater distance the colours appear more faint, and the contours more obscure. The shades likewise are a great deal weaker in a less intense or more remote light. On the other hand, those objects, which are largest in themselves, or lie nearest to the eye, have the most exact contours, the strongest shades, and the brightest colours: all which qualities are requisite to form that kind of perspective, which is called aerial, as though the air between the eye and

external objects, not only veiled them a little, but in some sort gnawed, and preyed upon, them. This kind of perspective constitutes a principal part of that branch of painting, which regards the foreshortening of figures, and likewise the bringing them forward, and throwing them back in such a manner, as to make us lose sight of the ground upon which they are drawn. It is, in a word, this kind of perspective, from which, assisted by linear perspective, arise

Dolci cose a vedere, e dolci inganni

[Things sweet to see, and sweet deceptions].

Nothing proves this better than the Camera Obscura, in which nature paints the objects, which lie near the eye, as it were, with a hard and sharp pencil, and those at a distance with a soft and blunt one.

The best modern painters among the Italians have availed themselves greatly of this contrivance; nor is it possible they should have otherwise represented things so much to the life. It is probable, too, that several of the Tramontane Masters, considering their success in expressing the minutest objects, have done the same. Every one knows of what service it has been to Spagnoletto of Bologna, some of whose pictures have a grand and most wonderful effect. I once happened to be present where a very able master was shewn this machine for the first time. It is impossible to express the pleasure he took in examining it. The more he considered it, the more he seemed to be charmed with it. In short, after trying it a thousand different ways, and with a thousand different models, he candidly confessed, that nothing could compare with the pictures of so excellent and inimitable a master. Another, no less eminent, has given it as his opinion, that an academy, with no other furniture than the book of da Vinci, a critical account of the excellencies of the capital painters, the casts of the finest Greek statues, and the pictures of the Camera Obscura, would alone be sufficient to revive the art of painting. Let the young painter, therefore, begin as early as possible to study these divine pictures, and study them all the days of his life, for he never will be able sufficiently to contemplate them. In short, Painters should make the same use of the Camera Obscura, which Naturalists and Astronomers make of the Microscope and Telescope, for all these instruments equally contribute to make known, and represent Nature.

10 Gotthold Ephraim Lessing (1729–1781) from *Laocoön: An Essay on the Limits of Painting and Poetry*

The German dramatist, critic and philosopher Gotthold Ephraim Lessing was born in Kamenz, in Saxony. He studied theology for a short period in Leipzig before moving to Berlin where he wrote his first plays. He was one of the leading figures in the protest against the dominance of French taste and in his *Hamburg Dramaturgy* (1767–9) he sought to establish the superiority of Shakespeare to classical French tragedy. His important essay, *Laocoön*, first published in 1766, addresses the limits and possibilities inherent in the different media of poetry and the visual arts. His point of departure is a

disagreement with the German art historian, Johann Joachim Winckelmann (see IIIA5), over his interpretation of the antique sculpture, *Laocoön*, now in the Vatican. Against Winckelmann, Lessing argues that it was not a general refusal to depict suffering which led the artist to restrain Laocoön's cries, but a law of beauty specific to the visual arts. The constraints upon poetry and drama are different from those upon painting and sculpture. These differences, in turn, are traced back to differences in the media through which the respective arts operate. Since poetry uses words which follow one another in time, its proper subject-matter is actions or events. Painting and sculpture, however, work with shapes and surfaces which coexist in space, and their proper subject is objects or bodies. Painting and sculpture are restricted to a single, highly charged moment, whereas poetry and drama deal with sequences of events. Lessing struck to the heart of the doctrine of poetry and painting as sister arts, expressed in the motto, *ut pictura poesis*, and initiated a new concern with the expressive possibilities of the different media of artistic representation. He intended to complete the *Laocoön* with two further parts, devoted to music and dance, but left the work unfinished. *Laokoon: oder über die Grenzen der Malerei und Poesie* was first published in Berlin in 1766. The following excerpts are taken from the edition edited and translated by Edward Allen McCormick, Baltimore and London: Johns Hopkins University Press, 1984, pp. 3–5, 7–11, 12, 15–17, 19–20, 23–4, 78–9, 85–6, 91.

Preface

The first person to compare painting with poetry was a man of fine feeling who observed that both arts produced a similar effect upon him. Both, he felt, represent absent things as being present and appearance as reality. Both create an illusion, and in both cases the illusion is pleasing.

A second observer, in attempting to get at the nature of this pleasure, discovered that both proceed from the same source. Beauty, a concept which we first derive from physical objects, has general rules applicable to a number of things: to actions and thoughts as well as to forms.

A third, who examined the value and distribution of these general rules, observed that some of them are more predominant in painting, others in poetry. Thus, in the one case poetry can help to explain and illustrate painting, and in the other painting can do the same for poetry.

The first was the amateur, the second the philosopher, and the third the critic.

The first two could not easily misuse their feelings or their conclusions. With the critic, however, the case was different. The principal value of his observations depends on their correct application to the individual case. And since for every one really discerning critic there have always been fifty clever ones, it would have been a miracle if this application had always been made with the caution necessary to maintain a proper balance between the two arts.

If Apelles and Protogenes, in their lost writings on painting, confirmed and explained its laws by applying already established rules of poetry, we may be certain that they did so with the same moderation and accuracy with which the principles and lessons of painting are applied to eloquence and poetry in the works of Aristotle, Cicero, Horace, and Quintilian. It is the prerogative of the ancients never to have done too much or too little in anything.

But in many respects we moderns have considered ourselves far superior when we transformed their pleasant little lanes into highways, even though shorter and safer highways themselves become mere footpaths as they lead through wildernesses.

The brilliant antithesis of the Greek Voltaire[1] that painting is mute poetry and poetry a speaking painting was doubtless not to be found in any textbook. It was a sudden fancy – among others that Simonides had – and the truth it contains is so evident that one feels compelled to overlook the indefinite and untrue statements which accompany it.

The ancients, however, did not overlook them. In restricting Simonides' statement to the effect achieved by the two arts, they nevertheless did not forget to stress that, despite the complete similarity of effect, the two arts differed both in the objects imitated as well as in the manner of imitation ($\H{\upsilon}\lambda\eta$ $\kappa\alpha\acute{\iota}$ $\tau\rho\acute{o}\pi o\iota s$ $\mu\iota\mu\acute{\eta}\sigma\epsilon\omega$s).

Still, many recent critics have drawn the most ill-digested conclusions imaginable from this correspondence between painting and poetry, just as though no such difference existed. In some instances they force poetry into the narrower limits of painting; in others they allow painting to fill the whole wide sphere of poetry. Whatever one is entitled to must be permitted to the other also; whatever pleases or displeases in one must necessarily please or displease in the other. And so, full of this idea, they pronounce the shallowest judgments with the greatest self-assurance and, in criticizing the work of a poet and a painter on the same subject, they regard the differences of treatment observed in them as errors, which they blame on one or the other, depending on whether they happen to prefer painting or poetry.

Indeed, this spurious criticism has to some degree misled even the masters of the arts. In poetry it has engendered a mania for description and in painting a mania for allegory, by attempting to make the former a speaking picture, without actually knowing what it could and ought to paint, and the latter a silent poem, without having considered to what degree it is able to express general ideas without denying its true function and degenerating into a purely arbitrary means of expression.

To counteract this false taste and these unfounded judgments is the principal aim of the following chapters. They were written as chance dictated and more in keeping with my reading than through any systematic development of general principles. Hence they are to be regarded more as unordered notes for a book than as a book itself.

* * *

Chapter One

The general and distinguishing characteristics of the Greek masterpieces of painting and sculpture are, according to Herr Winckelmann, noble simplicity and quiet grandeur, both in posture and in expression. 'As the depths of the sea always remain calm,' he says 'however much the surface may be agitated, so does the expression in the figures of the Greeks reveal a great and composed soul in the midst of passions.'

Such a soul is depicted in Laocoön's face – and not only in his face – under the most violent suffering. The pain is revealed in every muscle and sinew of his body, and one

can almost feel it oneself in the painful contraction of the abdomen without looking at the face or other parts of the body at all. However, this pain expresses itself without any sign of rage either in his face or in his posture. He does not raise his voice in a terrible scream, which Virgil describes his Laocoön as doing; the way in which his mouth is open does not permit it. Rather he emits the anxious and subdued sigh described by Sadolet. The pain of body and the nobility of soul are distributed and weighed out, as it were, over the entire figure with equal intensity. Laocoön suffers, but he suffers like the Philoctetes of Sophocles; his anguish pierces our very soul, but at the same time we wish that we were able to endure our suffering as well as this great man does.

Expressing so noble a soul goes far beyond the formation of a beautiful body. This artist must have felt within himself that strength of spirit which he imparted to his marble. In Greece artists and philosophers were united in one person, and there was more than one Metrodorus. Philosophy extended its hand to art and breathed into its figures more than common souls....

The remark on which the foregoing comments are based, namely that the pain in Laocoön's face is not expressed with the same intensity that its violence would lead us to expect, is perfectly correct. It is also indisputable that this very point shows truly the wisdom of the artist. Only the ill-informed observer would judge that the artist had fallen short of nature and had not attained the true pathos of suffering.

But as to the reasons on which Herr Winckelmann bases this wisdom, and the universality of the rule which he derives from it, I venture to be of a different opinion.

* * *

High as Homer raises his heroes above human nature in other respects, he still has them remain faithful to it in their sensitiveness to pain and injury and in the expression of this feeling by cries, tears, or invectives. In their deeds they are beings of a higher order, in their feelings true men.

I know that we more refined Europeans of a wiser, later age know better how to govern our mouths and our eyes. Courtesy and propriety force us to restrain our cries and tears. The aggressive bravery of the rough, early ages has become in our time a passive courage of endurance. Yet even our ancestors were greater in the latter than the former. But our ancestors were barbarians. To master all pain, to face death's stroke with unflinching eye, to die laughing under the adder's bite, to weep neither at the loss of one's dearest friend nor at one's own sins: these are the traits of old Nordic heroism. Palnatoko decreed that his Jomsburghers were not to fear anything nor even so much as mention the word 'fear.'

Not so the Greek! He felt and feared, and he expressed his pain and grief. He was not ashamed of any human weakness, but it must not prevent him from attaining honor nor from fulfilling his duty. The Greek acted from principles whereas the barbarian acted out of his natural ferocity and callousness. In the Greek, heroism was like the spark hidden in the flint, which sleeps quietly as long as no external force awakens it, and robs it of its clarity or its coldness. In the barbarian, heroism was a bright, consuming, and ever-raging flame which devoured, or at least blackened, every other fine quality in him. When Homer makes the Trojans march to battle with wild cries, while the Greeks go in resolute silence, the commentators rightly observe

that the poet thereby intends to depict the former as barbarians and the latter as civilized peoples. [. . .]

It is worthy of note that among the few tragedies which have come down to us from antiquity there are two in which physical pain is not the least part of the misfortune that befalls the suffering heroes, Philoctetes and the dying Hercules. And Sophocles lets even the latter wail and moan, weep and cry out. Thanks to our well-mannered neighbors, those masters of propriety, a wailing Philoctetes or a bawling Hercules today would be the most ridiculous and unbearable figure on stage. One of their most recent poets has, to be sure, ventured on a Philoctetes, but did he dare to show his audience the *true* Philoctetes?

There is even a Laocoön among the lost plays of Sophocles. If only fate had saved this one for us! From the slight references of some of the ancient grammarians we cannot determine how the poet treated his subject. But of this much I am certain: he did not portray Laocoön as more stoical than Philoctetes and Hercules. Stoicism is not dramatic, and our sympathy is in direct proportion to the suffering of the object of our interest. If we see him bearing his misery with nobility of soul, he will, to be sure, excite our admiration; but admiration is only a cold sentiment whose barren wonderment excludes not only every warmer passion but every other clear conception as well.

I come now to my conclusion: if, according to the ancient Greeks, crying aloud when in physical pain is compatible with nobility of soul, then the desire to express such nobility could not have prevented the artist from representing the scream in his marble. There must be another reason why he differs on this point from his rival the poet, who expresses this scream with deliberate intention.

Chapter Two

Whether it be fact or fiction that Love inspired the first artistic effort in the fine arts, this much is certain: she never tired of guiding the hands of the old masters. Painting, as practiced today, comprises all representations of three-dimensional bodies on a plane. The wise Greek, however, confined it to far narrower limits by restricting it to the imitation of beautiful bodies only. The Greek artist represented only the beautiful, and ordinary beauty, the beauty of a lower order, was only his accidental subject, his exercise, his relaxation. The perfection of the object itself in his work had to give delight, and he was too great to demand of his audience that they be satisfied with the barren pleasure that comes from looking at a perfect resemblance, or from consideration of his skill as a craftsman. Nothing in his art was dearer to him or seemed nobler than its ultimate purpose.

* * *

. . . Among the ancients beauty was the supreme law of the visual arts. Once this has been established, it necessarily follows that whatever else these arts may include must give way completely if not compatible with beauty, and, if compatible, must at least be subordinate to it.

Let us consider expression. There are passions and degrees of passion which are expressed by the most hideous contortions of the face and which throw the whole body into such unnatural positions as to lose all the beautiful contours of its natural

state. The ancient artists either refrained from depicting such emotions or reduced them to a degree where it is possible to show them with a certain measure of beauty.

Rage and despair did not degrade any of their works. I venture to say that they never depicted a Fury. Wrath was reduced to seriousness. In poetry it was the wrathful Jupiter who hurled the thunderbolt; in art it was only the stern Jupiter.

Anguish was softened into sadness. Where this softening was impossible, where anguish would have been disparaging as well as distorting – what did Timanthes do? We know the answer from his painting of the sacrifice of Iphigenia: he imparted to each bystander the particular degree of sadness appropriate to him but concealed the face of the father, which should have shown the most intense suffering. Many clever things have been said about this. One critic, for instance, says that he had so exhausted himself in depicting the sorrowful faces of the bystanders that he despaired of his ability to give a still more sorrowful one to the father. Another says that by so doing he admitted that the anguish of a father in such circumstances is beyond expressing. For my part, I see no incapacity on the part of either the artist or his art. The intensity of the emotions intensifies the corresponding expression in the features of the face; the highest degree will cause the most extreme expression, and nothing is easier in art than to express this. But Timanthes knew the limits which the Graces had set for his art. He knew that the anguish appropriate to Agamemnon as the father would have to be expressed through distortions, which are always ugly. He went as far as he could in combining beauty and dignity with the expression of anguish. He would have preferred to pass over the ugly or to soften it, but since his composition did not permit him to do either, there was nothing left him but to veil it. What he might not paint he left to conjecture. In short, this concealment is a sacrifice that the artist has made to beauty; it is an example, not of how one pushes expression beyond the limits of art, but how one should subject it to the first law of art, the law of beauty.

If we apply this now to the Laocoön, the principle which I am seeking becomes apparent. The master strove to attain the highest beauty possible under the given condition of physical pain. The demands of beauty could not be reconciled with the pain in all its disfiguring violence, so it had to be reduced. The scream had to be softened to a sigh, not because screaming betrays an ignoble soul, but because it distorts the features in a disgusting manner. Simply imagine Laocoön's mouth forced wide open, and then judge! Imagine him screaming, and then look! From a form which inspired pity because it possessed beauty and pain at the same time, it has now become an ugly, repulsive figure from which we gladly turn away. For the sight of pain provokes distress; however, the distress should be transformed, through beauty, into the tender feeling of pity.

* * *

Chapter Three

As I have already said, art has been given a far wider scope in modern times. It is claimed that representation in the arts covers all of visible nature, of which the

beautiful is but a small part. Truth and expression are art's first law, and as nature herself is ever ready to sacrifice beauty for the sake of higher aims, so must the artist subordinate it to his general purpose and pursue it no farther than truth and expression permit. It is enough that truth and expression transform the ugliest aspects of nature into artistic beauty.

But even if we were willing to leave these ideas for the moment unchallenged as to their value, we would still have to consider, quite independently of these ideas, why the artist must nevertheless set certain restraints upon expression and never present an action at its climax.

The single moment of time to which art must confine itself by virtue of its material limitations will lead us, I believe, to such considerations.

If the artist can never make use of more than a single moment in ever-changing nature, and if the painter in particular can use this moment only with reference to a single vantage point, while the works of both painter and sculptor are created not merely to be given a glance but to be contemplated – contemplated repeatedly and at length – then it is evident that this single moment and the point from which it is viewed cannot be chosen with too great a regard for its effect. But only that which gives free rein to the imagination is effective. The more we see, the more we must be able to imagine. And the more we add in our imaginations, the more we must think we see. In the full course of an emotion, no point is less suitable for this than its climax. There is nothing beyond this, and to present the utmost to the eye is to bind the wings of fancy and compel it, since it cannot soar above the impression made on the senses, to concern itself with weaker images, shunning the visible fullness already represented as a limit beyond which it cannot go. Thus, if Laocoön sighs, the imagination can hear him cry out; but if he cries out, it can neither go one step higher nor one step lower than this representation without seeing him in a more tolerable and hence less interesting condition. One either hears him merely moaning or else sees him dead.

Furthermore, this single moment, if it is to receive immutable permanence from art, must express nothing transitory. According to our notions, there are phenomena, which we conceive as being essentially sudden in their beginning and end and which can be what they are only for a brief moment. However, the prolongation of such phenomena in art, whether agreeable or otherwise, gives them such an unnatural appearance that they make a weaker impression the more often we look at them, until they finally fill us with disgust or horror. La Mettrie, who had himself portrayed in painting and engraving as a second Democritus, seems to be laughing only the first few times we look at him. Look at him more often and the philosopher turns into a fop. His laugh becomes a grin. The same holds true for screaming. The violent pain which extorts the scream either soon subsides or else destroys the sufferer. When a man of firmness and endurance cries out he does not do so unceasingly, and it is only the seeming perpetuity of such cries when represented in art that turns them into effeminate helplessness or childish petulance. This, at least, the artist of the Laocoön had to avoid, even if screaming had not been detrimental to beauty, and if his art had been allowed to express suffering without beauty.

* * *

Chapter Four

I review the reasons given why the master of the Laocoön was obliged to exercise moderation in expressing physical pain and find that all of them have been derived from the special nature of the visual arts, their limitations, and their requirements. Hence any one of those causes could scarcely be applied to poetry.

Without investigating here the extent to which the poet is able to depict physical beauty, we may accept this much as unquestionable: since the whole infinite realm of perfection lies open to his description, this external form, beneath which perfection becomes beauty, can at best be only one of the least significant means by which he is able to awaken our interest in his characters. Often he ignores it entirely, being convinced that once his hero has won our favor his other qualities will either occupy us to such a point that we do not think of his physical form or, if we do think of it, we will be so captivated that we give him of our own accord if not a beautiful form, at least an ordinary one.

Least of all will he have to consider the sense of sight in any single trait that is not expressly intended to appeal to it. When Virgil's Laocoön screams, does it occur to anyone that a wide-open mouth is necessary in order to scream, and that this wide-open mouth makes the face ugly? Enough that *clamores horrendos ad sidera tollit*[2] has a powerful appeal to the ear, no matter what its effect on the eye! He who demands a beautiful picture here has failed to understand the poet.

Moreover, there is nothing to compel the poet to compress his picture into a single moment. He may, if he so chooses, take up each action at its origin and pursue it through all possible variations to its end. Each variation which would cost the artist a separate work costs the poet but a single pen stroke; and if the result of this pen stroke, viewed by itself, should offend the hearer's imagination, it was either anticipated by what has preceded or is so softened and compensated by what follows that it loses its individual impression and in combination achieves the best effect in the world. Thus, if it were really improper for a man to cry out in the violence of pain, what prejudice can this slight and transitory impropriety create in us against a man whose other virtues have already inclined us in his favor?

Virgil's Laocoön cries out, but this screaming Laocoön is the same man whom we already know and love as a prudent patriot and loving father. We do not relate his cries to his character, but solely to his unbearable suffering. It is this alone which we hear in them, and it was only by this means that the poet could convey it clearly to our senses.

* * *

Chapter Sixteen

But I shall attempt now to derive the matter from its first principles.

I reason thus: if it is true that in its imitations painting uses completely different means or signs than does poetry, namely figures and colors in space rather than articulated sounds in time, and if these signs must indisputably bear a suitable relation to the thing signified, then signs existing in space can express only objects

whose wholes or parts coexist, while signs that follow one another can express only objects whose wholes or parts are consecutive.

Objects or parts of objects which exist in space are called bodies. Accordingly, bodies with their visible properties are the true subjects of painting.

Objects or parts of objects which follow one another are called actions. Accordingly, actions are the true subjects of poetry.

However, bodies do not exist in space only, but also in time. They persist in time, and in each moment of their duration they may assume a different appearance or stand in a different combination. Each of these momentary appearances and combinations is the result of a preceding one and can be the cause of a subsequent one, which means that it can be, as it were, the center of an action. Consequently, painting too can imitate actions, but only by suggestion through bodies.

On the other hand, actions cannot exist independently, but must be joined to certain beings or things. Insofar as these beings or things are bodies, or are treated as such, poetry also depicts bodies, but only by suggestion through actions.

Painting can use only a single moment of an action in its coexisting compositions and must therefore choose the one which is most suggestive and from which the preceding and succeeding actions are most easily comprehensible.

Similarly, poetry in its progressive imitations can use only one single property of a body. It must therefore choose that one which awakens the most vivid image of the body, looked at from the point of view under which poetry can best use it. From this comes the rule concerning the harmony of descriptive adjectives and economy in description of physical objects.

* * *

Chapter Seventeen

But the objection will be raised that the symbols of poetry are not only successive but are also arbitrary; and, as arbitrary symbols, they are of course able to represent bodies as they exist in space. Examples of this might be taken from Homer himself. We need only to recall his shield of Achilles to have the most decisive instance of how discursively and yet at the same time poetically a single object may be described by presenting its coexistent parts.

I shall reply to this twofold objection. I call it twofold because a correct deduction must hold good even without examples; and, conversely, an example from Homer is of importance to me even when I am unable to justify it by means of deduction.

It is true that since the symbols of speech are arbitrary, the parts of a body may, through speech, be made to follow one another just as readily as they exist side by side in nature. But this is a peculiarity of speech and its signs in general and not as they serve the aims of poetry. The poet does not want merely to be intelligible, nor is he content – as is the prose writer – with simply presenting his image clearly and concisely. He wants rather to make the ideas he awakens in us so vivid that at that moment we believe that we feel the real impressions which the objects of these ideas would produce on us. In this moment of illusion we should cease to be conscious of the means which the poet uses for this purpose, that is, his words. This was the substance of the definition of a poetical painting given above. But the poet is always

supposed to paint, and we shall now see how far bodies with their coexistent parts adapt themselves to this painting.

How do we arrive at a clear conception of an object in space? We first look at its parts singly, then the combination of parts, and finally the totality. Our senses perform these various operations with such astonishing rapidity that they seem to us to be but one single operation, and this rapidity is absolutely necessary if we are to receive an impression of the whole, which is nothing more than the result of the conception of the parts and of their combination. Now let us assume that the poet takes us from one part of the object to the other in the best possible order; let us assume that he knows how to make the combination of these parts ever so clear to us; how much time would he use in doing this? That which the eye takes in at a single glance he counts out to us with perceptible slowness, and it often happens that when we arrive at the end of his description we have already forgotten the first features. And yet we are supposed to form a notion of the whole from these features. To the eye, parts once seen remain continually present; it can run over them again and again. For the ear, however, the parts once heard are lost unless they remain in the memory. And even if they do remain there, what trouble and effort it costs to renew all their impressions in the same order and with the same vividness; to review them in the mind all at once with only moderate rapidity, to arrive at an approximate idea of the whole!

* * *

Chapter Eighteen

[. . .] It remains true that succession of time is the province of the poet just as space is that of the painter.

It is an intrusion of the painter into the domain of the poet, which good taste can never sanction, when the painter combines in one and the same picture two points necessarily separate in time, as does Fra Mazzuoli when he introduces the rape of the Sabine women and the reconciliation effected by them between their husbands and relations, or as Titian does when he presents the entire history of the prodigal son, his dissolute life, his misery, and his repentance.

It is an intrusion of the poet into the domain of the painter and a squandering of much imagination to no purpose when, in order to give the reader an idea of the whole, the poet enumerates one by one several parts of things which I must necessarily survey at one glance in nature if they are to give the effect of a whole.

1 Simonides of Ceos (died 469 BC).
2 *Aeneid* I. 222: 'He lifted up his voice in horrible cries to the heavens.'

IIIB
Aesthetics and the Sublime

1 Alexander Gottlieb Baumgarten (1714–1762) from *Reflections on Poetry*

The first use of the term 'aesthetics' in its modern sense is to be found in the concluding sections of the inaugural dissertation of Alexander Gottlieb Baumgarten, the *Meditationes philosophicae de nonnullis ad poema pertinentibus* (Philosophical Meditations on some Matters pertaining to Poetry), published in Latin in 1735. He was Professor of Philosophy at the University of Frankfurt an der Oder. His *Metaphysica* of 1739 and his *Ethica* of 1740 were widely used as textbooks and he played a considerable role in transmitting the tradition of philosophical rationalism associated with the work of Leibniz (see ID9) and Christian Wolff. Baumgarten's conception of a new science of aesthetics arises out of this tradition, whilst at the same time initiating an important revision in its most basic assumptions. Rationalism held that knowledge gained through the senses was a confused and imperfect form of knowing. It attached no intrinsic value to such knowledge other than as providing material for the sciences. Baumgarten sought to show, however, that cognition through the senses has its own significance and that the study of its perfection constituted an important area of enquiry subordinate to the established discipline of logic. The perfection of sensory knowledge is achieved in beauty and in the realization of works of art. In the *Meditationes* he restricted himself to the study of poetry, which he defines as 'perfect sensate discourse'. In its closing sections, however, he looks forward to a complete science of perception, or aesthetics, a project which he began but never completed with the publication of his *Aesthetica* in 1750 (see IIIB2). The following excerpts are taken from the translation of the *Meditationes*, published together with the original text, by Karl Aschenbrenner and William B. Holther as *Reflections on Poetry*, Berkeley and Los Angeles: University of California Press, 1954, pp. 38–9, 77–8.

* * *

§3. By **sensate representations** we mean representations received through the lower part of the cognitive faculty.

Since desire, so far as it derives from a confused representation of the good, is called sensate, and since, on the other hand, a confused representation, along with an obscure one, is received through the lower part of the cognitive faculty,

we can apply the same name to confused representations, in order that they may be distinguished from concepts distinct at all possible levels.

§4. By **sensate discourse** we mean discourse involving sensate representations.

Just as no philosopher attains to such profundity that he can see through all things, aided only by pure intellect, without becoming entangled somewhere or other in confused thinking, so, too, practically no discourse can be so purely scientific and intellectual that no sensate idea at all occurs in the whole context. Likewise, if one is especially looking for evidences of distinct thinking, one may find distinct representations here and there in sensate discourse; yet the discourse remains sensate, as the other remains abstract and intellectual.

§5. Connected sensate representations are to be apprehended from sensate discourse.

§6. The various parts of sensate discourse are: (1) sensate representations, (2) their interrelationships, (3) the words, or the articulate sounds which are represented by the letters and which symbolize the words.

§7. By **perfect sensate discourse** we mean discourse whose various parts are directed toward the apprehension of sensate representations.

§8. A sensate discourse will be the more perfect the more its parts favor the awakening of sensate representations.

§9. By **poem** we mean a perfect sensate discourse, by **poetics** the body of rules to which a poem conforms, by **philosophical poetics** the science of poetics, by **poetry** the state of composing a poem, and by **poet** the man who enjoys that state.

* * *

§115. Philosophical poetics is by §9 the science guiding sensate discourse to perfection; and since in speaking we have those representations which we communicate, philosophical poetics presupposes in the poet a lower cognitive faculty. It would now be the task of logic in its broader sense to guide this faculty in the sensate cognition of things, but he who knows the state of our logic will not be unaware how uncultivated this field is. What then? If **logic** by its very definition should be restricted to the rather narrow limits to which it is as a matter of fact confined, would it not count as the science of knowing things philosophically, that is, as the science for the direction of the higher cognitive faculty in apprehending the truth? Well, then. Philosophers might still find occasion, not without ample reward, to inquire also into those devices by which they might improve the lower faculties of knowing, and sharpen them, and apply them more happily for the benefit of the whole world. Since psychology affords sound principles, we have no doubt that there could be available a science which might direct the lower cognitive faculty in knowing things sensately.

§116. As our definition is at hand, a precise designation can easily be devised. The Greek philosophers and the Church fathers have already carefully distinguished between *things perceived* [αισθητα] and *things known* [νοητα]. It is entirely evident that they did not equate *things known* with things of sense, since they honored with this name things also removed from sense (therefore, images). Therefore, *things known* are to be known by the superior faculty as the object of logic; *things perceived* [are to be known by the inferior faculty, as the object] of the science of perception, or **aesthetic**.

* * *

2 Alexander Gottlieb Baumgarten (1714–1769) 'Prolegomena' to *Aesthetica*

Baumgarten published the first volume of his *Aesthetica* in 1750, and a second volume in 1758, but it remained uncompleted by the time of his death in 1769. It was to have two halves, dealing with theoretical and practical aesthetics respectively. The first half was then further subdivided into three parts – heuristics, methodology and semiotics – of which only the first five chapters on heuristics were ever published (of an intended six). The *Aesthetica* went through only one printing and few seem to have read Baumgarten's Latin text at first hand. However, his principal ideas were widely disseminated by his students, including Georg Friedrich Meier, who produced a popularized German version even before the publication of the *Aesthetica* itself. The term 'aesthetics' is derived from the Greek *aisthesis*, meaning 'perception' or 'sensation'. Baumgarten begins by defining the new discipline of aesthetics as the 'science of sensible knowledge'. As such, aesthetics forms a counterpart to the science of logic which brings clarity and coherence to the realm of thought. However, Baumgarten recognizes that the particular character of sensory knowledge lies in the richness and vividness of its representations. The perfection of sense cognition as this is realized in works of beauty is to be developed for its own sake. Whereas logic undertakes the abstract analysis of complex ideas into simple parts, aesthetics recognizes plenitude and complexity as valuable characteristics within its own domain. The 'Prolegomena' of the *Aesthetica* has been translated for this volume by Susan Halstead from a facsimile edition, Hildesheim: Georg Olms Verlagsbuchhandlung, 1961, pp. 1–5.

§1. Aesthetics (the theory of the liberal arts, the lower study of perception, the art of thinking in the fine style, the art of analogical reasoning) is the science of perception that is acquired by means of the senses.

§2. The natural condition of the lower cognitive faculties, developed only by use rather than training and culture, may be termed *natural aesthetics*, and divided, as natural logic generally is, into two types: the innate (as in a fine talent which is inborn) and the acquired, which in its turn is divided between teaching and practising.

§3. The most important uses of theoretical aesthetics (§1) as a support for natural aesthetics are, among others, these: (1) providing suitable material for those sciences which primarily depend upon perception by means of the intellect, (2) adapting

scientifically ascertained facts to anyone's level of comprehension, (3) improving knowledge and extending it beyond the current boundaries of what is known to us, (4) providing a sound basis for all study of culture and the liberal arts, and (5) giving a surpassing distinction to all matters pertaining to everyday life, all things being equal.

§4. From this proceed these special applications: (1) philological, (2) hermeneutical, (3) exegetical, (4) rhetorical, (5) homiletical, (6) poetical, (7) musical, etc.

§5. The following objections may be raised against our science (§1): (1) it is too extensive to be exhaustively treated in one short book or lecture. I reply by conceding this point, but anything is better than nothing. (2) It is the same as rhetoric and poetry. I reply that (a) it is more extensive, and (b) it embraces objects which both these disciplines have in common and share between themselves; considering this (and this is one convenient place to do so), any and every art may cultivate its own plot more successfully. (3) It is the same thing as criticism. I reply (a) there is also critical logic, (b) a certain type of criticism is an element of aesthetics, (c) for this a previous knowledge of the rest of aesthetics is almost indispensable, if one does not wish to discuss the matter simply on the basis of tastes in judging the excellence of thought, of spoken and written material.

§6. These objections may be raised against our science: (4) that impressions received from the senses, fantasies, emotional disturbances, etc., are unworthy of philosophers and beneath the scope of their consideration. I reply (a) that the philosopher is a man amongst men and it is not good for him to think that so great a part of human perception has nothing to do with him, (b) that the general theory of good thinking is here confused with particular practice and execution.

§7. Objection (5): Confusion is the mother of error. I reply (a) that it is an indispensable precondition for the discovery of truth, since nature does not make a leap from darkness into clarity of thought. Noon comes from night by way of dawn. And (b) for this very reason confusion too must receive attention, so that errors do not result as they so frequently do amongst the curious, (c) confusion should not be commended but perception corrected, inasmuch as some element of confusion still remains in it.

§8. Objection (6): Distinct perception is the highest form. I reply (a) that this is only valid for more important matters within the limited sphere of human thought, (b) the positing of one does not exclude the other, and (c) for that reason we proceed according to the clearly recognized basic rules of thought to that perception which has beauty as its goal, so that from it clear distinction may emerge more perfectly at some future time (§3, 7).

§9. Objection (7): It is to be feared that strictly rational perception may be disadvantaged by the cultivation of analogical thinking on the part of reason. I reply (a) that this argument belongs rather to those who seek to prove our position to be right, for they are in danger, whenever they seek composite perfection, of

urging caution and not persuading others to neglect true perfection. And (b) if the analogon neglects reason and rather becomes corrupted, it is no less harmful to logical thinking.

§10. Objection (8): Aesthetics is an art, not a science. I reply (a) that these fields are not the opposites of each other. How many subjects which were once only arts have now also become sciences? (b) Experience will demonstrate that our art can be subjected to proof; it is clear a priori, because psychology, etc. provide a sure foundation; and the uses mentioned in §3 and §4, amongst others, show that aesthetics deserves to be elevated to the rank of a science.

§11. Objection (9): Aestheticians are, like poets, born and not made. I reply with Horace, *Ars Poetica*, 408; Cicero, *De Oratore*, I. II: 60; Bilfinger, *In dilucid.*, §268; Breitinger, *Von den Gleichnissen*, p. 6: A more comprehensive theory, more commendable through the authority of reason, more exact, less confused, more certain, less unsure, is helpful to the born aesthetician. §3.

§12. Objection (10): The lower faculties, and the flesh, should be combated rather than aroused and strengthened. I reply (a) that the lower faculties require control and not tyranny, (b) that aesthetics, as far as this can be achieved by natural means, in fact leads them towards this condition by the hand, as it were, and (c) that the lower faculties, as long as they are corrupt, should not be aroused or strengthened by aestheticians, but rather directed by them, so that they should not become even further corrupted by inexpert practice, or lest the use of a talent bestowed by God be abolished on the easy pretext of avoiding its misuse.

§13. Our aesthetics, like logic its elder sister, is Part I: *theoretical*, with teaching in general and offering guidance concerning matters and thinking; *heuristics* (Chapter 1, 2) on clear order; *methodology* (Chapter 2, 3) on the expression of what is well thought out and ordered; *semiotics* (Chapter 3). Part II: *practical aesthetics*, concerned with practice in application to specific cases. In both cases, 'He who chooses his material with care will not lack verbal ability or clear order. Let the matter be your first concern, clear order your second, and, in the third place, pay due attention to expression' [Horace, *Epistles*, 2, 3, 40 ff.].

3 William Hogarth (1697–1764) from *The Analysis of Beauty*

Hogarth remains best known for his painted and engraved serial depictions of eighteenth-century social mores, *A Harlot's Progress* (1732), *A Rake's Progress* (1735) and *Marriage à la Mode* (1743). Largely self-taught as a painter, he began his career as an engraver, and was in business on his own account as early as 1720. Throughout his career Hogarth was deeply preoccupied by the need to maintain financial independence from aristocratic patrons. He was one of the prime movers in the campaign leading to the Copyright Act of 1735, which protected engravers for fourteen years after the initial publication of their work. Hogarth was also committed to the development of an English school of painting

independent of both continental and antique models. Partly as a result, his career was dogged by controversy, as he engaged variously with theorists of the Ideal, or with those who looked to royal patronage to underwrite the development of painting in England. Hogarth wrote much, and polemically, about Academies of art, about the status of art in England, and about his own career (see IVA2). His major theoretical statement, *The Analysis of Beauty*, was published in November 1753 to a mixed reception. Its arguments were critically discussed by fellow-artists, including Allan Ramsay and Joshua Reynolds (see IIIB4 and 9), but it was also well enough regarded to go into German and Italian editions (in 1754 and 1761 respectively). In his preface, Hogarth claims that 'mere men of letters' (he probably had in mind figures such as Shaftesbury and Hutcheson), are incapable of grasping beauty in painting, and that practical knowledge is required for a proper treatment of the subject. His main claim is that grace is the property of compositions employing a 'serpentine line', and that even though this quality is to be found in the best works of Antiquity and the Renaissance, nonetheless the achievement of beauty in art arises from the study of nature, not the following of academic authority. The self-portrait he mentions, inclusive of the serpentine line, is now in the collection of the Tate Gallery, London. Hogarth's closing remark about the serpentine line mentions the Italian concept of *il poco piu*, 'the little more'. This notion, derived from music, was part of the discourse of 'grace' and the *je ne sais quoi* (see ID passim). Our selections are taken from the preface, the introduction, and chapters VII, IX and X of *The Analysis of Beauty*, edited with an Introduction and Notes by Ronald Paulson, New Haven and London: Yale University Press, 1997, pp. 1–6, 17–19, 41–2, 48–9, 50–6. We have included a small number of Hogarth's illustrations, retaining his original numbering.

Preface

If a preface was ever necessary, it may very likely be thought so to the following work; the title of which (in the proposals publish'd some time since) hath much amused, and raised the expectation of the curious, though not without a mixture of doubt, that its purport could ever be satisfactorily answered. For though beauty is seen and confessed by all, yet, from the many fruitless attempts to account for the cause of its being so, enquiries on this head have almost been given up; and the subject generally thought to be a matter of too high and too delicate a nature to admit of any true or intelligible discussion. Something therefore introductory ought to be said at the presenting a work with a face so entirely new; especially as it will naturally encounter with, and perhaps may overthrow, several long received and thorough establish'd opinions: and since controversies may arise how far, and after what manner this subject hath hitherto been consider'd and treated, it will also be proper to lay before the reader, what may be gathered concerning it, from the works of the ancient and modern writers and painters.

It is no wonder this subject should have so long been thought inexplicable, since the nature of many parts of it cannot possibly come within the reach of mere men of letters; otherwise those ingenious gentlemen who have lately published treatises upon it (and who have written much more learnedly than can be expected from one who never took up the pen before) would not so soon have been bewilder'd in their accounts of it, and obliged so suddenly to turn into the broad, and more beaten path of moral beauty; in order to extricate themselves out of the difficulties they seem to

have met with in this: and withal forced for the same reasons to amuse their readers with amazing (but often misapplied) encomiums on deceased painters and their performances; wherein they are continually discoursing of effects instead of developing causes; and after many prettinesses, in very pleasing language, do fairly set you down just where they first took you up; honestly confessing that as to GRACE, the main point in question, they do not even pretend to know any thing of the matter. And indeed how should they? when it actually requires a practical knowledge of the whole art of painting (sculpture alone not being sufficient) and that too to some degree of eminence, in order to enable any one to pursue the chain of this enquiry through all its parts: which I hope will be made to appear in the following work.

It will then naturally be asked, why the best painters within these two centuries, who by their works appear to have excelled in grace and beauty, should have been so silent in an affair of such seeming importance to the imitative arts and their own honour? to which I answer, that it is probable, they arrived at that excellence in their works, by the mere dint of imitating with great exactness the beauties of nature, and by often copying and retaining strong ideas of graceful antique statues; which might sufficiently serve their purposes as painters, without their troubling themselves with a farther enquiry into the particular causes of the effects before them. It is not indeed a little strange, that the great Leonardo da Vinci (amongst the many philosophical precepts which he hath at random laid down in his treatise on painting) should not have given the least hint of any thing tending to a system of this kind; especially, as he was cotemporary with Michael Angelo, who is said to have discover'd a certain principle in the trunk only of an antique stature, (well known from this circumstance by the name of Michael Angelo's Torso, or Back,) which principle gave his works a grandeur of gusto equal to the best antiques. Relative to which tradition, Lomazzo who wrote about painting at the same time, hath this remarkable passage:

'And because in this place there falleth out a certaine precept of *Michael Angelo* much for our purpose, I will not conceale it, leaving the farther interpretation and understanding thereof to the judicious reader. It is reported then that *Michael Angelo* upon a time gave this observation to the Painter *Marcus de Sciena* his scholler; *that he should alwaies make a figure Pyramidall, Serpentlike, and multiplied by one two and three*. In which precept (in mine opinion) the whole mysterie of the arte consisteth. For the greatest grace and life that a picture can have, is, that it expresse *Motion*: which the Painters call the *spirite* of a picture: Nowe there is no forme so fitte to express this *motion*, as that of the flame of fire, which according to *Aristotle* and the other Philosophers, is an elemente most active of all others: because the forme of the flame thereof is most apt for motion: for it hath a *Conus* or sharpe pointe wherewith it seemeth to divide the aire, that so it may ascende to his proper sphere. So that a picture having this forme will bee most beautifull.'

Many writers since Lomazzo have in the same words recommended the observing this rule also; without comprehending the meaning of it: for unless it were known systematically, the whole business of grace could not be understood.

Du Fresnoy, in his art of painting, says 'large flowing, gliding outlines which are in waves, give not only a grace to the part, but to the whole body; as we see in the Antinous, and in many other of the antique figures: a fine figure and its parts ought always to have a serpent-like and flaming form: naturally those sort of lines have I

know not what of life and seeming motion in them, which very much resembles the activity of the flame and of the serpent.' Now if he had understood what he had said, he could not, speaking of grace, have expressed himself in the following contradictory manner. – 'But to say the truth, this is a difficult undertaking, and a rare present, which the artist rather receives from the hand of heaven than from his own industry and studies.' But De Piles, in his lives of the painters, is still more contradictory, where he says, 'that a painter can only have it (meaning grace) from nature, and doth not know that he hath it, nor in what degree, nor how he communicates it to his works: and that grace and beauty are two different things; beauty pleases by the rules, and grace without them.'

All the English writers on this subject have eccho'd these passages; hence *Je ne sçai quoi*, is become a fashionable phrase for grace.

By this it is plain, that this precept which Michael Angelo deliver'd so long ago in an oracle-like manner, hath remain'd mysterious down to this time, for ought that has appear'd to the contrary. The wonder that it should do so will in some measure lessen when we come to consider that it must all along have appeared as full of contradiction as the most obscure quibble ever deliver'd at Delphos, because, *winding lines are as often the cause of deformity as of grace*. [. . .]

There are also strong prejudices in favour of straight lines, as constituting true beauty in the human form, where they never should appear. A middling connoisseur thinks no profile has beauty without a very straight nose, and if the forehead be continued straight with it, he thinks it is still more sublime. I have seen miserable scratches with the pen, sell at a considerable rate for only having in them a side face or two . . . The common notion that a person should be straight as an arrow, and perfectly erect is of this kind. If a dancing-master were to see his scholar in the easy and gracefully-turned attitude of the Antinous, he would cry shame on him, and tell him he looked as crooked as a ram's horn, and bid him hold up his head as he himself did.

The painters, in like manner, by their works, seem to be no less divided upon the subject than the authors. The French, except such as have imitated the antique, or the Italian school, seem to have studiously avoided the serpentine line in all their pictures, especially Anthony Coypel, history painter, and Rigaud, principal portrait painter to Lewis the 14th.

Rubens, whose manner of designing was quite original, made use of a large flowing line as a principle, which runs through all his works, and gives a noble spirit to them; but he did not seem to be acquainted with what we call the *precise line*; which hereafter we shall be very particular upon, and which gives the delicacy we see in the best Italian masters; but he rather charged his contours in general with too bold and S-like swellings.

Raphael, from a straight and stiff manner, on a sudden changed his taste of lines at sight of Michael Angelo's works, and the antique statues; and so fond was he of the serpentine line, that he carried it into a ridiculous excess, particularly in his draperies: though his great observance of nature suffer'd him not long to continue in this mistake.

Peter de Cortone form'd a fine manner in his draperies of this line.

We see this principle no where better understood than in some pictures of Corregio, particularly his Juno and Ixion: yet the proportions of his figures are sometimes such as might be corrected by a common sign painter.

Whilst Albert Durer, who drew mathematically, never so much as deviated into grace, which he must sometimes have done in copying the life, if he had not been fetter'd with his own impracticable rules of proportion.

But that which may have puzzled this matter most, may be, that Vandyke, one of the best portrait painters in most respects ever known, plainly appears not to have had a thought of this kind. For there seems not to be the least grace in his pictures more than what the life chanced to bring before him. [...]

Nor have the painters of the present times been less uncertain and contradictory to each other, than the masters already mentioned, whatever they may pretend to the contrary: of this I had a mind to be certain, and therefore, in the year 1745, published a frontispiece to my engraved works, in which I drew a serpentine line lying on a painter's pallet, with these words under it, THE LINE OF BEAUTY. [...]

Introduction

[...] I must confess, I have but little hopes of having a favourable attention given to my design in general, by those who have already had a more fashionable introduction into the mysteries of the arts of painting, and sculpture. Much less do I expect, or in truth desire, the countenance of that set of people, who have an interest in exploding any kind of doctrine, that may teach us to *see with our own eyes*. [...]

To those, then, whose judgments are unprejudiced, this little work is submitted with most pleasure; because it is from such that I have hitherto received the most obligations, and now have reason to expect most candour.

Therefore I would fain have such of my readers be assured, that however they may have been aw'd, and over-born by pompous terms of art, hard names, and the parade of seemingly magnificent collections of pictures and statues; they are in a much fairer way, ladies, as well as gentlemen, of gaining a perfect knowledge of the elegant and beautiful in artificial, as well as natural forms, by considering them in a systematical, but at the same time familiar way, than those who have been prepossess'd by dogmatic rules, taken from the performances of art only: nay, I will venture to say, sooner, and more rationally, than even a tolerable painter, who has imbibed the same prejudices.

The more prevailing the notion may be, that painters and connoisseurs are the only competent judges of things of this sort; the more it becomes necessary to clear up and confirm, as much as possible, what has only been asserted in the foregoing paragraph: that no one may be deterr'd, by the want of such previous knowledge, from entering into this enquiry.

The reason why gentlemen, who have been inquisitive after knowledge in pictures, have their eyes less qualified for our purpose, than others, is because their thoughts have been entirely and continually employ'd and incumber'd with considering and retaining the various *manners* in which pictures are painted, the histories, names, and characters of the masters, together with many other little circumstances belonging to

the mechanical part of the art; and little or no time has been given for perfecting the ideas they ought to have in their minds, of the objects themselves in nature: for by having thus espoused and adopted their first notions from nothing but *imitations*, and becoming too often as bigotted to their faults, as their beauties, they at length, in a manner, totally neglect, or at least disregard the works of nature, merely because they do not tally with what their minds are so strongly prepossess'd with. [. . .]

VII Of lines

[. . .] The constant use made of lines by mathematicians, as well as painters, in describing things upon paper, hath establish'd a conception of them, as if actually existing on the real forms themselves. This likewise we suppose, and shall set out with saying in general – That *the straight line*, and *the circular line*, together with their different combinations, and variations, &c. bound, and circumscribe all visible objects whatsoever, thereby producing such endless variety of forms, as lays us under the necessity of dividing, and distinguishing them into general classes; leaving the intervening mixtures of appearances to the reader's own farther observation.

First, [fig. 23] objects composed of straight lines only, as the cube, or of circular lines, as the sphere, or of both together, as cylinders and cones, &c.

Secondly, [fig. 24] those composed of straight lines, circular lines, and of lines partly straight, and partly circular, as the capitals of columns, and vases, &c.

Thirdly, [fig. 25] those composed of all the former together with an addition of the waving line, which is a line more productive of beauty than any of the former, as in flowers, and other forms of the ornamental kind: for which reason we shall call it the line of beauty.

Fourthly, [fig. 26] those composed of all the former together with the serpentine line, as the human form, which line hath the power of super-adding grace to beauty. Note, forms of most grace have least of the straight line in them.

It is to be observed, that straight lines vary only in length, and therefore are least ornamental.

That curved lines as they can be varied in their degrees of curvature as well as in their lengths, begin on that account to be ornamental.

That straight and curv'd lines join'd, being a compound line, vary more than curves alone, and so become somewhat more ornamental.

That the waving line, or line of beauty, varying still more, being composed of two curves contrasted, becomes still more ornamental and pleasing, insomuch that the hand takes a lively movement in making it with pen or pencil.

And that the serpentine line, by its waving and winding at the same time different ways, leads the eye in a pleasing manner along the continuity of its variety, if I may be allowed the expression; and which by its twisting so many different ways, may be said to inclose (tho' but a single line) varied contents; and therefore all its variety cannot be express'd on paper by one continued line, without the assistance of the imagination, or the help of a figure [see fig. 26]; where that sort of proportion'd, winding line, which will hereafter be call'd the precise serpentine line, or *line of grace*, is represented by a fine wire, properly twisted round the elegant and varied figure of a cone.

IX Of Composition with the Waving-Line

There is scarce a room in any house whatever, where one does not see the waving-line employ'd in some way or other. How inelegant would the shapes of all our moveables be without it? how very plain and unornamental the mouldings of cornices, and chimney-pieces, without the variety introduced by the *ogee* member, which is entirely composed of waving-lines.

Though all sorts of waving-lines are ornamental, when properly applied; yet, strictly speaking, there is but one precise line, properly to be called the line of *beauty*, which in the scale of them [fig. 49] is number 4: the lines 5, 6, 7, by their bulging too much in their curvature becoming gross and clumsy; and, on the contrary, 3, 2, 1, as they straighten, becoming mean and poor; as will appear in the next figure [50], where they are applied to the legs of chairs.

A still more perfect idea of the effects of the precise waving-line, and of those lines that deviate from it, may be conceived by the row of stays, figure [53], where number 4 is composed of precise waving-lines, and is therefore the best shaped stay. Every whale-bone of a good stay must be made to bend in this manner: for the whole stay, when put close together behind, is truly a shell of well-varied contents, and its surface of course a fine form; so that if a line, or the lace were to be drawn, or brought from the top of the lacing of the stay behind, round the body, and down to the bottom peak of the stomacher; it would form such a perfect, precise, serpentine-line, as has been shewn, round the cone, figure 26.——For this reason all ornaments obliquely contrasting the body in this manner, as the ribbons worn by the knights of the garter, are both genteel and graceful. The numbers 5, 6, 7, and 3, 2, 1, are deviations into stiffness and meanness on one hand, and clumsiness and deformity on the other. The reasons for which disagreeable effects, after what has been already said, will be evident to the meanest capacity.

It may be worth our notice however, that the stay, number 2, would better fit a well-shaped man than number 4; and that number 4, would better fit a well-form'd woman, than number 2; and when on considering them, merely as to their forms, and comparing them together as you would do two vases, it has been shewn by our principles, how much finer and more beautiful number 4 is, than number 2: does not this our determination enhance the merit of these principles, as it proves at the same time how much the form of a woman's body surpasses in beauty that of a man?

From the examples that have been given, enough may be gathered to carry on our observations from them to any other objects that may chance to come in our way, either animate or inanimate; so that we may not only *lineally* account for the ugliness of the toad, the hog, the bear and the spider, which are totally void of this waving-line, but also for the different degrees of beauty belonging to those objects that possess it.

X Of Compositions with the Serpentine-Line

The very great difficulty there is in describing this line, either in words, or by the pencil (as was hinted before, when I first mention'd it) will make it necessary for me to proceed very slowly in what I have to say in this chapter, and to beg the reader's patience whilst I lead him step by step into the knowledge of what I think the sublime in form, so remarkably display'd in the human body; in which, I believe, when he is once acquainted with the idea of them, he will find this species of lines to be principally concern'd.

First, then, let him consider fig. 56, which represents a straight horn, with its contents, and he will find, as it varies like the cone, it is a form of some beauty, merely on that account.

Next let him observe in what manner, and in what degree the beauty of this horn is increas'd, [in fig. 57], where it is supposed to be bent two different ways.

And lastly, let him attend to the vast increase of beauty, even to grace and elegance, in the same horn, [fig. 58], where it is supposed to have been twisted round, at the same time, that it was bent two different ways. [...]

I have chosen this simple example, as the easiest way of giving a plain and general idea of the peculiar qualities of these serpentine-lines, and the advantages of bringing them into compositions, where the contents you are to express, admit of grace and elegance.

And I beg the same things may be understood of these serpentine-lines, that I have said before of the waving-lines. For as among the vast variety of waving-lines that may be conceiv'd, there is but one that truly deserves the name of *the line of beauty*, so there is only one precise serpentine-line that I call *the line of grace*. Yet, even when they are made too bulging, or too tapering, though they certainly lose of their beauty and grace, they do not become so wholly void of it, as not to be of excellent service in compositions, where beauty and grace are not particularly design'd to be express'd in their greatest perfection.

Though I have distinguish'd these lines so particularly as to give them the titles of *the lines of beauty and grace*, I mean that the use and application of them should still be confined by the principles I have laid down for composition in general; and that they should be judiciously mixt and combined with one another, and even with those I may term *plain* lines, (in opposition to these) as the subject in hand requires. Thus the cornu-copia, [fig. 59], is twisted and bent after the same manner, as the last figure of the horn; but more ornamented, and with a greater number of other lines of the same twisted kind, winding round it with as quick returns as those of a screw. [...]

Almost all the muscles, and bones, of which the human form is composed, have more, or less of these kind of twists in them; and give in a less degree, the same kind of appearance to the parts which cover them, and are the immediate object of the eye: and for this reason it is that I have been so particular in describing these forms of the bent, and twisted, and ornamented horn.

There is scarce a straight bone in the whole body. Almost all of them are not only bent different ways, but have a kind of twist, which in some of them is very graceful; and the muscles annex'd to them, tho' they are of various shapes, appropriated to their particular uses, generally have their component fibres running in these serpentine-lines, surrounding and conforming themselves to the varied shape of the bones they belong to: more especially in the limbs. Anatomists are so satisfied of this, that they take a pleasure in distinguishing their several beauties. I shall only instance in the thigh-bone, and those about the hips.

The thigh-bone [fig. 62] has the waving and twisted turn of the horn, 58: but the beautiful bones adjoining, call'd the ossa innominata [fig. 60], have, with greater variety, the same turns and twists of that horn when it is cut; and its inner and outward surfaces are exposed to the eye.

How ornamental these bones appear, when the prejudice we conceive against them, as being part of a skeleton, is taken off, by adding a little foliage to them, may be seen in fig. [61],——such shell-like winding forms, mixt with foliage, twisting about them, are made use of in all ornaments; a kind of composition calculated merely to please the eye. Divest these of their serpentine twinings and they immediately lose all grace, and return to the poor gothic taste they were in an hundred years ago [fig. 63].

Fig. [64] is meant to represent the manner, in which most of the muscles, (those of the limbs in particular) are twisted round the bones, and conform themselves to their

length and shape; but with no anatomical exactness. As to the running of their fibres, some anatomists have compared them to skains of thread, loose in the middle, and tight at each end, which, when they are thus consider'd as twisted contrary ways round the bone, gives the strongest idea possible of a composition of serpentine-lines. [. . .]

I cannot be too long, I think, on this subject, as so much will be found to depend upon it; and therefore shall endeavour to give a clear idea of the different effect such anatomical figures have on the eye, from what the same parts have, when cover'd by the fat and skin; by supposing a small wire (that has lost its spring and so will retain every shape it is twisted into) to be held fast to the out-side of the hip and thence brought down the other side of the thigh obliquely over the calf of the leg, down to the outward ancle (all the while press'd so close as to touch and conform itself to the shape of every muscle it passes over) and then to be taken off. If this wire be now examined it will be found that the general uninterrupted flowing twist, which the winding round the limbs would otherwise have given to it, is broke into little better than so many separate plain curves, by the sharp indentures it every where has receiv'd on being closely press'd in between the muscles.

Suppose, in the next place, such a wire was in the same manner twisted round a living well-shaped leg and thigh, or those of a fine statue; when you take it off you will find no such sharp indentures, nor any of those regular *engralings* (as the heralds express it) which displeased the eye before. On the contrary, you will see how *gradually* the changes in its shape are produced; how imperceptibly the different curvatures run into each other, and how easily the eye glides along the varied wavings of its sweep. To enforce this still further, if a line was to be drawn by a pencil exactly where these wires have been supposed to pass, the point of the pencil, in the muscular leg and thigh, would perpetually meet with stops and rubs, whilst in the others it would flow from muscle to muscle along the elastic skin, as pleasantly as the lightest skiff dances over the gentlest wave.

This idea of the wire, retaining thus the shape of the parts it passes over, seems of so much consequence, that I would by no means have it forgot; as it may properly be consider'd as one of the threads (or outlines) of the shell (or external surface) of the human form: and the frequently recurring to it will assist the imagination in its

conceptions of those parts of it, whose shapes are most intricately varied: for the same sort of observations may be made, with equal justice, on the shapes of ever so many such wires twisted in the same manner in ever so many directions over every part of a well made man, woman, or statue.

And if the reader will follow in his imagination the most exquisite turns of the chissel in the hands of a master, when he is putting the finishing touches to a statue; he will soon be led to understand what it is the real judges expect from the hand of such a master, which the Italians call, the little more, Il poco piu, and which in reality distinguishes the original master-pieces at Rome from even the best copies of them.

4 Allan Ramsay (1713–1784) 'Dialogue on Taste'

A son of the Scottish poet Allan Ramsay, Ramsay the Younger rose to become the leading portraitist of his generation and Principal Painter to the King, George III. Throughout his career he made extended trips to Rome (1736–8, 1754–7, 1775–7 and 1782–4), but despite a thorough grounding in classical principles, his work from the mid-century onwards was characterized by a refreshing commitment to naturalism. As well as his royal commissions, he painted enduring portraits of leading intellectual figures of the day, including David Hume and Jean-Jacques Rousseau (both painted in 1766, and now in the collections of the Scottish National Portrait Gallery and the National Gallery of Scotland, Edinburgh, respectively). His *Dialogue on Taste* was composed during his third period in Rome, and was first published as a pamphlet in London in 1755. Set at the country seat of Lord Modish, it takes the form of a conversation between the slightly dim-witted and fashion-conscious aristocrat, his rather more acute wife Lady Modish, her sister Lady Harriot, and their no-nonsense friend Colonel Freeman. The discussion turns on a distinction between taste and judgement. Through his empirically minded protagonist Freeman, Ramsay argues that taste is subjective and beauty relative (against, amongst others, Shaftesbury and Hogarth, see IIB2 and IIIB3). The reason for a broad consensus about what is or is not good in art – as opposed to food, drink, clothing, etc. – is that whereas the exercise of taste is purely subjective, in art there is an objective standard available, namely imitation. Thus, evaluating art is strictly speaking a matter of judgement, a mental operation involving comparison of the picture with its original, rather than of taste as such. For Ramsay, where non-imitative arts like music are concerned, subjective pleasure reigns, and dispute on that 'must be no less absurd than when cookery is the subject of controversy'. Our extracts are taken from the text as printed in *The Investigator*, number CCCXXII, London: A. Millar, 1755, pp. 3–11, 28–9, 54–8.

LORD MODISH: And so you prefer HUDIBRAS to VIRGIL?

COL. FREEMAN: I do indeed, my Lord.

LORD MODISH: But why, my noble Colonel?

COL. FREEMAN: Because he gives me most pleasure.

LORD MODISH: Then allow me to tell you, George, you are with all your reading an absolute Goth, and have no manner of taste.

COL. FREEMAN: So you told me last night, my Lord, when I preferred Canary to Champaign.

LORD MODISH: No doubt, for that was just such another instance of your Gothickness.

COL. FREEMAN: I agree with your Lordship that the cases are very parallel, and for that reason I mention your last night's observation. The word taste originally belongs to the palate, and it is not amiss to have that always in view, when we suspect a misapplication of it in the way of metaphor. It is by taste, no doubt, that we are able to distinguish salt from sugar, and mustard from apple-pie, its proper office being upon all such occasions to inform us what is what. But allow me to ask your Lordship, why you said I had no taste in wine, when it was plain, by my preference of one of the bottles, that I could very well distinguish it from the rest.

LORD MODISH: You certainly now affect to misunderstand me. By saying you had no taste, I did not mean that you was not capable of distinguishing, but, according to the usual application of the phrase, that you had a bad taste, and preferred the worst.

COL. FREEMAN: This is, my Lord, an application of the word taste, that, however usual, somewhat deviates from its original and proper sense. For, according to that, good taste can signify no more than a greater than ordinary accuracy in determining, in certain cases, that two separate things are of the same or of different kinds, and when of different kinds in assigning the proper name to each. Take a man so endowed into your cellar, and without seeing the labels, he will tell you not only that this hogshead is Port and that Claret, but amongst the Clarets that this is of such a growth and such a year, that of such another. I am very sensible that your Lordship's application of the phrase is nevertheless usual: but if all the phrases that convey no distinct and uniform meaning were banished out of the world, we should be deprived, among the rest, of a great many that are very usual and fashionable. But, a propos of our last night's liquor, did you mean by the worst the least wholesome? If so, I am afraid my taste can hardly be defended.

LORD MODISH: No, faith; I believe the Champaign is the worst of the two in that respect. No; I meant that which had the worst flavour.

COL. FREEMAN: Then I suppose you think me insincere in my declaration of liking Canary.

LORD MODISH: I have known you too long, George, to lay insincerity to your charge. No; I make no doubt of your having really a very bad taste in your potations.

COL. FREEMAN: You mean, then, I dare say, that it is not your taste.

LORD MODISH: No; nor of any of your acquaintance, I'll be sworn.

COL. FREEMAN: So then the goodness or badness of one's taste is to be determined by the taste of the majority.

LORD MODISH: Certainly; and were it otherwise what confusion must ensue? for when men are to drink jovially together, it is highly reasonable that the few should yield in the choice of the liquor to the many.

COL. FREEMAN: My Lord, I will allow your consequence: But what necessity is there for this society in drink, by which the conformity becomes necessary? When soldiers are to attack the enemy, such an union must be absolutely necessary; else one platoon might retire whilst another advanced. It is no less necessary where more pacific people are met to dance country dances; else the man might be footing corners whilst his partner was figuring in. Unless all fight and dance with one accord, the purposes of fighting and dancing would be entirely frustrated. But

there is nothing in the nature of drinking, that hinders it from being performed as effectually, and to as good purpose, by a single person, as by one that has thirty legions at his command. When you can make it appear that a man ought to take physic because his companion is sick, or to drink because he is dry, it may then appear reasonable in him to drink of a particular kind of liquor because his companions happen to be pleased with the flavour of it. An extraordinary stretch of complaisance, from which no person seems to reap any advantage. For my own part, I profess myself an entire friend to toleration and liberty of conscience, and think it little better than popery and the inquisition to compel any man to swallow what goes against his stomach, on pretence of preserving unity in public drinking.

LORD MODISH: Thou art an odd fellow, George, that is certain.

COL. FREEMAN: I am indeed, my Lord; for I always deliver my own sentiments, and in my own words.

LORD MODISH: So then you reckon religion and drinking to be of the same nature. I think I have known you sometimes more lucky in your comparisons.

COL. FREEMAN: I don't pretend, my Lord, that the parallel will hold in every respect; but with regard to the subject of our present conversation they are certainly very much akin: being both matters of private concern and advantage only; and, of course, the objects only of taste or private opinion. But when I speak of religion, I would be understood of what is speculative and ritual, and not at all of the moral duties: So when I speak of drinking, I mean drinking for pleasure, without taking any of its medicinal effects into consideration, for as by these society may be affected, they are very properly the objects of general concern and enquiry.

LORD MODISH: Then you don't allow the moral duties to be the objects of taste. My Lord Shaftesbury is of a very different opinion.

COL. FREEMAN: That may be; but his Lordship stands not for divine authority with me. I know, my Lord, that there has been much unfortunate pains employed, by many authors from Plato down to Sir Harry Beaumont, in order to confound the objects of judgment with those of taste and feeling; than which nothing can be more vulgar and unphilosophical.

LORD MODISH: I fancy it is not an easy matter to separate them; and, as I know you have turned your mind pretty much to such enquiries, I should be glad to know what touchstone you recommend for that purpose.

COL. FREEMAN: It does not appear to me so difficult as it seems to those refined philosophers; and thus I distinguish them. Whatever has a rule or standard to which it may be referred, and is capable of comparison, is not the object of taste, but of reason and judgment. The proper objects of taste or feeling are such as are relative to the person only who is actuated by them, who is the sole judge whether those feelings be agreeable or otherwise; and being informed of this simple fact from himself, no farther consequence can be drawn from it, neither does it admit of any dispute. Thus when a man tells me that venison eats better with currant than with gravy sauce, he only informs me of his private opinion concerning it. It admits of no reasoning, pro or con. There it must rest, and he must have the like patience to hear me, in my turn, declare that gravy sauce is far before currant; and this without making any reply, if he has a grain of sense. It is quite otherwise when either he or I assert that Westminster hall is longer than Westminster bridge, or

that oak is specifically heavier than copper; for in each of those cases there is a standard to apply, to wit, a foot rule in one case, and a pair of scales in the other, which entirely exclude opinion from having any share in the debate. With regard to one thing's being comparatively better than another, there is likewise a standard of another kind, which leaves the preference to be decided by the judgment; and that is the relation which such things bear to the use for which they are both supposed to be intended. As for instance, if it should become the subject of enquiry which of two swords is the best, the intention of fighting being supposed, the preference will be reasonably given to that which by its superior strength, lightness, sharpness, and perhaps length, is the fittest for fight. If for the same purpose the comparison happens between a sword and a pair of scissars, the preference will no doubt fall to the sword for very obvious reasons. But vary the circumstances of the intended combat, and explain that it is not to be fought in a field, but in a post chaise or a centry box, and you will be obliged to rejudge the cause by a new standard, which will infallibly declare a pair of scissars to be a more fatal, and consequently a better, weapon than any Toledo in the world. It is possible, by thus supposing certain circumstances, to bring the most different and most remote objects in nature to be compared by a common standard; but where this is not provided, reason must be pleased to leave the bench, and refer the matter entirely to taste, or private inclination. [...]

LORD MODISH:　I must own, Colonel, that the notion of an universal standard for the beauty of natural objects, would be very contradictory to that almost self-evident truth, that whatever is is right; since in the great variety of forms which God has contrived, the benign end of pleasing would have been frustrated, if he had not ordained a like variety to exist in the apprehensions and feelings of different men and different animals concerning those things.

COL. FREEMAN:　It is most certainly so, my Lord; and it is surprizing that so many ingenious men should have lost their time in a search, the vanity of which is so obvious. Hogarth owns that his line of beauty and grace is not to be seen in a toad; which if true, ought to have convinced him, either that there was no such line, or universal receipt for beauty; or else that he had not yet hit upon it: since it hardly admits of a doubt, that a blooming she toad is the most beautiful sight in the creation, to all the crawling young gentlemen of her acquaintance; and that her crawl, or as they may possibly call it, her *pas grave*, is far before the minuet step, with all its wavings. An analysis or dissection can never be begun of any subject till the subject itself is ascertained, and consequently no analysis can be made of abstract beauty, nor of any abstraction whatsoever. Till a real something is discovered, which we are sure by experience is universally the source of pleasure, any attempt to discover the universal principle of pleasure by analysis must be fruitless; and the philosopher who engages in such a business, after finding that he has been gravely measuring a dream with a pair of compasses, will probably return at last to the *je ne scay quoy*, upon which he had at first disdainfully turned his back. [...]

LORD MODISH:　I begin to be afraid that taste, at last, must content himself with ruling over the finer arts. There I think you will hardly try to pull him from his throne.

COL. FREEMAN:　What arts does your Lordship comprehend under that title?

LORD MODISH: Musick, poetry, and painting; or, as they call them, the sister arts,

COL. FREEMAN: I know they are often so called; and indeed there is so great a likeness betwixt two of them, poetry and painting, that their sisterhood will be readily allowed: but betwixt musick and painting there is no likeness at all; and I am apt to suspect that musick passes for the sister of poetry, rather from their being often seen in company, than from any resemblance they bear to each other. For this reason, when I examine how far taste is concerned in these arts, I shall consider musick by itself. But either the distinction betwixt taste and judgment, which I gave your Lordship some time ago, is false, or else taste is totally excluded from being a determiner in works of art, and must leave that talk for judgment to perform. An art has been thus defined by one of the most sagacious of the ancients, *a system of rules acquired by study, and reduced to practice, for some usefull purpose.* Now wherever there is a rule or rules, by which any work is supposed to be conducted, that rule, being known, must serve equally for a standard to those who would determine with propriety concerning its merit or degree of excellence. An art, then, and whatever pretends to a standard, is an object of judgment and not of taste. As to musick, it is certainly an art, so far as geometry is concerned in it; but as the mathematical part of musick is totally unknown to 999 in a thousand of those who set up for connoisseurs in musick, including the performers, we may venture to say that it is, with regard to them, no art at all. These virtuosos, therefore, have nothing but their own taste, that is, their own private liking, to set up for a standard, or, what is little more mathematical, the liking which those of their club, city, or nation have acquired by habit, that is, by the daily repetition of a certain strain of musick. What disputes therefore happen upon that subject must be no less absurd, than when cookery is the subject of controversy. With regard to the sister arts of painting and poetry, the case is very different: for in these arts there is not only a standard, but one so level to the common sense of mankind, that the most ignorant are acquainted with it; and, if it is unknown or mistaken by any, it is by the half-learned, who from their own conceit, or a respect for the authority of coxcombs, have tried to undervalue common sense, in order to substitute something which they thought better, in its stead.

LORD MODISH: There is no doubt, Colonel, that there are rules for poetry and painting, and that there have been many ingenious books written both in prose and verse concerning these rules. But I fancy they are not so universally known as you would have us believe.

COL. FREEMAN: Pardon me, my Lord; I have reason to be convinced by a thousand experiments, that the leading principle of criticism in poetry and painting, and that of all the learned principles which is the most unexceptionably true, is known to the lowest and most illiterate of the people. Those experiments are easily made. Your Lordship has only to hide yourself behind the screen in your drawing-room, and order Mrs. Hannah to bring in one of your tenant's daughters, and I will venture to lay a wager that she shall be struck with your picture by La Tour, and no less with the view of your seat by Lambert, and shall, fifty to one, express her approbation by saying, they are vastly natural. When she has said this, she has shewn that she knew the proper standard, by which her approbation was to be directed, as much, at least, as she would have done, if she had got Aristotle by heart

and all his commentators. He has defined those arts, arts of imitation, and his definition, though often obscured and confounded by more modern connoisseurs, has never been contradicted by any. The same country girl, who applauds the exact representation of a man and a house which she has seen, will, for the same reason, be charmed with Hogarth's march to Finchly, as that is a representation, though not of persons, yet of general manners and characters, with which we may suppose her to be acquainted. And if she is less struck with the historical pictures of distant ages and countries, though equally well painted, it is not because her critical standard is not equally applicable to them, but because the subject and manners, there meant to be represented, are to her unknown, and must pass with as little observation and remark as a good portrait of a person whom she had never seen. In all this I see no pretension taste has to be consulted. It requires first eyes to see, and then judgment to compare the exhibited image with that of the absent object, which is stored up in the remembrance, and is plainly a reflective and compound operation of the mind. It is indeed so quick and instantaneous, that it often passes for a simple feeling or sentiment; and is sometimes mentioned as such by criticks of no mean reputation, for want of having considered the nature of the mental faculties with that accuracy which they deserve. The general standard of poetry is exactly the same, and equally obvious with that of painting, and any experiment you make in that art upon a farmer's daughter, will be found to have a like event.

5 David Hume (1711–1776) 'Of the Standard of Taste'

The Scottish essayist, philosopher and historian David Hume was born in Edinburgh into a Calvinist family. He attended Edinburgh University where he studied classics, mathematics and philosophy. His *Treatise of Human Nature* was composed in his early twenties at La Flèche in France, but failed to make any impact. According to Hume's own account of his life, it 'fell dead-born from the press'. However, in 1748 he published a more popular and lively account of his ideas, *An Enquiry concerning Human Understanding*, which received a much greater measure of success. Hume sought to extend the scientific understanding of the natural world into a new domain of inquiry – human nature. The 'science of man' should be founded on experience and observation. It consisted of three parts, devoted to the 'understanding', the 'passions', and 'morals'. Hume was one of the consummate stylists of the eighteenth century, and his essays on moral, literary and political subjects were warmly received both in Britain and on the Continent. His essay 'Of the Standard of Taste' has long been recognized as one of the most important contributions to the subject. Though strongly influenced by Hutcheson's doctrine of an 'inner sense' of beauty (see IIB7), Hume maintains that we must first 'pave the way' if we are to experience the right sensation. The sentiments which arise in us in answer to works of art are educable and responsive to reasoning. Indeed, in matters of taste we should recognize the superiority of those who have the most refined powers of discrimination and the greatest practice in judging works of art. 'Of the Standard of Taste' was first published in 1757 as one of Hume's *Four Dissertations*. It was then incorporated in volume 1 of the 1758 edition of his *Essays and Treatises on Several Subjects*, 'Essays, Moral, Political, and Literary'. We have used the edition edited by Eugene F. Miller, based on the posthumous 1777 edition, which

incorporates all of Hume's changes and corrections, *Essays, Moral, Political, and Literary*, Indianapolis: Liberty Classics, 1985, pp. 226–7, 229–44.

The great variety of Taste, as well as of opinion, which prevails in the world, is too obvious not to have fallen under every one's observation. Men of the most confined knowledge are able to remark a difference of taste in the narrow circle of their acquaintance, even where the persons have been educated under the same government, and have early imbibed the same prejudices. But those, who can enlarge their view to contemplate distant nations and remote ages, are still more surprized at the great inconsistence and contrariety. We are apt to call *barbarous* whatever departs widely from our own taste and apprehension: But soon find the epithet of reproach retorted on us. And the highest arrogance and self-conceit is at last startled, on observing an equal assurance on all sides, and scruples, amidst such a contest of sentiment, to pronounce positively in its own favour.

As this variety of taste is obvious to the most careless enquirer; so will it be found, on examination, to be still greater in reality than in appearance. The sentiments of men often differ with regard to beauty and deformity of all kinds, even while their general discourse is the same. There are certain terms in every language, which import blame, and others praise; and all men, who use the same tongue, must agree in their application of them. Every voice is united in applauding elegance, propriety, simplicity, spirit in writing; and in blaming fustian, affectation, coldness, and a false brilliancy: But when critics come to particulars, this seeming unanimity vanishes; and it is found, that they had affixed a very different meaning to their expressions. In all matters of opinion and science, the case is opposite: The difference among men is there oftener found to lie in generals than in particulars; and to be less in reality than in appearance. An explanation of the terms commonly ends the controversy; and the disputants are surprized to find, that they had been quarrelling, while at bottom they agreed in their judgment.

* * *

It is natural for us to seek a *Standard of Taste*; a rule, by which the various sentiments of men may be reconciled; at least, a decision, afforded, confirming one sentiment, and condemning another.

There is a species of philosophy, which cuts off all hopes of success in such an attempt, and represents the impossibility of ever attaining any standard of taste. The difference, it is said, is very wide between judgment and sentiment.

All sentiment is right; because sentiment has a reference to nothing beyond itself, and is always real, wherever a man is conscious of it. But all determinations of the understanding are not right; because they have a reference to something beyond themselves, to wit, real matter of fact; and are not always conformable to that standard. Among a thousand different opinions which different men may entertain of the same subject, there is one, and but one, that is just and true; and the only difficulty is to fix and ascertain it. On the contrary, a thousand different sentiments, excited by the same object, are all right: Because no sentiment represents what is really in the object. It only marks a certain conformity or relation between the object and the organs or faculties of the mind; and if that conformity did not really exist, the sentiment could never possibly have being. Beauty is no quality in things themselves:

It exists merely in the mind which contemplates them; and each mind perceives a different beauty. One person may even perceive deformity, where another is sensible of beauty; and every individual ought to acquiesce in his own sentiment, without pretending to regulate those of others. To seek the real beauty, or real deformity, is as fruitless an enquiry, as to pretend to ascertain the real sweet or real bitter. According to the disposition of the organs, the same object may be both sweet and bitter; and the proverb has justly determined it to be fruitless to dispute concerning tastes. It is very natural, and even quite necessary, to extend this axiom to mental, as well as bodily taste; and thus common sense, which is so often at variance with philosophy, especially with the sceptical kind, is found, in one instance at least, to agree in pronouncing the same decision.

But though this axiom, by passing into a proverb, seems to have attained the sanction of common sense; there is certainly a species of common sense which opposes it, at least serves to modify and restrain it. Whoever would assert an equality of genius and elegance between OGILBY[1] and MILTON, or BUNYAN and ADDISON, would be thought to defend no less an extravagance, than if he had maintained a mole-hill to be as high as TENERIFFE, or a pond as extensive as the ocean. Though there may be found persons, who give the preference to the former authors; no one pays attention to such a taste; and we pronounce without scruple the sentiment of these pretended critics to be absurd and ridiculous. The principle of the natural equality of tastes is then totally forgot, and while we admit it on some occasions, where the objects seem near an equality, it appears an extravagant paradox, or rather a palpable absurdity, where objects so disproportioned are compared together.

It is evident that none of the rules of composition are fixed by reasonings *a priori*, or can be esteemed abstract conclusions of the understanding, from comparing those habitudes and relations of ideas, which are eternal and immutable. Their foundation is the same with that of all the practical sciences, experience; nor are they any thing but general observations, concerning what has been universally found to please in all countries and in all ages. Many of the beauties of poetry and even of eloquence are founded on falsehood and fiction, on hyperboles, metaphors, and an abuse or perversion of terms from their natural meaning. To check the sallies of the imagination, and to reduce every expression to geometrical truth and exactness, would be the most contrary to the laws of criticism; because it would produce a work, which, by universal experience, has been found the most insipid and disagreeable. But though poetry can never submit to exact truth, it must be confined by rules of art, discovered to the author either by genius or observation. If some negligent or irregular writers have pleased, they have not pleased by their transgressions of rule or order, but in spite of these transgressions: They have possessed other beauties, which were conformable to just criticism; and the force of these beauties has been able to overpower censure, and give the mind a satisfaction superior to the disgust arising from the blemishes. ARIOSTO pleases; but not by his monstrous and improbable fictions, by his bizarre mixture of the serious and comic styles, by the want of coherence in his stories, or by the continual interruptions of his narration. He charms by the force and clearness of his expression, by the readiness and variety of his inventions, and by his natural pictures of the passions, especially those of the gay and amorous kind: And

however his faults may diminish our satisfaction, they are not able entirely to destroy it. Did our pleasure really arise from those parts of his poem, which we denominate faults, this would be no objection to criticism in general: It would only be an objection to those particular rules of criticism, which would establish such circumstances to be faults, and would represent them as universally blameable. If they are found to please, they cannot be faults; let the pleasure, which they produce, be ever so unexpected and unaccountable.

But though all the general rules of art are founded only on experience and on the observation of the common sentiments of human nature, we must not imagine, that, on every occasion, the feelings of men will be conformable to these rules. Those finer emotions of the mind are of a very tender and delicate nature, and require the concurrence of many favourable circumstances to make them play with facility and exactness, according to their general and established principles. The least exterior hindrance to such small springs, or the least internal disorder, disturbs their motion, and confounds the operation of the whole machine. When we would make an experiment of this nature, and would try the force of any beauty or deformity, we must choose with care a proper time and place, and bring the fancy to a suitable situation and disposition. A perfect serenity of mind, a recollection of thought, a due attention to the object; if any of these circumstances be wanting, our experiment will be fallacious, and we shall be unable to judge of the catholic and universal beauty. The relation, which nature has placed between the form and the sentiment, will at least be more obscure; and it will require greater accuracy to trace and discern it. We shall be able to ascertain its influence not so much from the operation of each particular beauty, as from the durable admiration, which attends those works, that have survived all the caprices of mode and fashion, all the mistakes of ignorance and envy.

The same HOMER, who pleased at ATHENS and ROME two thousand years ago, is still admired at PARIS and at LONDON. All the changes of climate, government, religion, and language, have not been able to obscure his glory. Authority or prejudice may give a temporary vogue to a bad poet or orator; but his reputation will never be durable or general. When his compositions are examined by posterity or by foreigners, the enchantment is dissipated, and his faults appear in their true colours. On the contrary, a real genius, the longer his works endure, and the more wide they are spread, the more sincere is the admiration which he meets with. Envy and jealousy have too much place in a narrow circle; and even familiar acquaintance with his person may diminish the applause due to his performances: But when these obstructions are removed, the beauties, which are naturally fitted to excite agreeable sentiments, immediately display their energy; and while the world endures, they maintain their authority over the minds of men.

It appears then, that, amidst all the variety and caprice of taste, there are certain general principles of approbation or blame, whose influence a careful eye may trace in all operations of the mind. Some particular forms or qualities, from the original structure of the internal fabric, are calculated to please, and others to displease; and if they fail of their effect in any particular instance, it is from some apparent defect or imperfection in the organ. A man in a fever would not insist on his palate as able to decide concerning flavours; nor would one, affected with the jaundice, pretend to

give a verdict with regard to colours. In each creature, there is a sound and a defective state; and the former alone can be supposed to afford us a true standard of taste and sentiment. If, in the sound state of the organ, there be an entire or a considerable uniformity of sentiment among men, we may thence derive an idea of the perfect beauty; in like manner as the appearance of objects in day-light, to the eye of a man in health, is denominated their true and real colour, even while colour is allowed to be merely a phantasm of the senses.

Many and frequent are the defects in the internal organs, which prevent or weaken the influence of those general principles, on which depends our sentiment of beauty or deformity. Though some objects, by the structure of the mind, be naturally calculated to give pleasure, it is not to be expected, that in every individual the pleasure will be equally felt. Particular incidents and situations occur, which either throw a false light on the objects, or hinder the true from conveying to the imagination the proper sentiment and perception.

One obvious cause, why many feel not the proper sentiment of beauty, is the want of that *delicacy* of imagination, which is requisite to convey a sensibility of those finer emotions. This delicacy every one pretends to: Every one talks of it; and would reduce every kind of taste or sentiment to its standard. But as our intention in this essay is to mingle some light of the understanding with the feelings of sentiment, it will be proper to give a more accurate definition of delicacy, than has hitherto been attempted. And not to draw our philosophy from too profound a source, we shall have recourse to a noted story in DON QUIXOTE.

It is with good reason, says SANCHO to the squire with the great nose, that I pretend to have a judgment in wine: This is a quality hereditary in our family. Two of my kinsmen were once called to give their opinion of a hogshead, which was supposed to be excellent, being old and of a good vintage. One of them tastes it; considers it; and after mature reflection pronounces the wine to be good, were it not for a small taste of leather, which he perceived in it. The other, after using the same precautions, give also his verdict in favour of the wine; but with the reserve of a taste of iron, which he could easily distinguish. You cannot imagine how much they were both ridiculed for their judgment. But who laughed in the end? On emptying the hogshead, there was found at the bottom, an old key with a leathern thong tied to it.

The great resemblance between mental and bodily taste will easily teach us to apply this story. Though it be certain, that beauty and deformity, more than sweet and bitter, are not qualities in objects, but belong entirely to the sentiment, internal or external; it must be allowed, that there are certain qualities in objects, which are fitted by nature to produce those particular feelings. Now as these qualities may be found in a small degree, or may be mixed and confounded with each other, it often happens, that the taste is not affected with such minute qualities, or is not able to distinguish all the particular flavours, amidst the disorder, in which they are presented. Where the organs are so fine, as to allow nothing to escape them; and at the same time so exact as to perceive every ingredient in the composition: This we call delicacy of taste, whether we employ these terms in the literal or metaphorical sense. Here then the general rules of beauty are of use; being drawn from established models, and from the observation of what pleases or displeases, when presented singly and in a high degree: And if the same qualities, in a continued composition and

in a smaller degree, affect not the organs with a sensible delight or uneasiness, we exclude the person from all pretensions to this delicacy. To produce these general rules or avowed patterns of composition is like finding the key with the leathern thong; which justified the verdict of SANCHO'S kinsmen, and confounded those pretended judges who had condemned them. Though the hogshead had never been emptied, the taste of the one was still equally delicate, and that of the other equally dull and languid: But it would have been more difficult to have proved the superiority of the former, to the conviction of every by-stander. In like manner, though the beauties of writing had never been methodized, or reduced to general principles; though no excellent models had ever been acknowledged; the different degrees of taste would still have subsisted, and the judgment of one man been preferable to that of another; but it would not have been so easy to silence the bad critic, who might always insist upon his particular sentiment, and refuse to submit to his antagonist. But when we show him an avowed principle of art; when we illustrate this principle by examples, whose operation, from his own particular taste, he acknowledges to be conformable to the principle; when we prove, that the same principle may be applied to the present case, where he did not perceive or feel its influence: He must conclude, upon the whole, that the fault lies in himself, and that he wants the delicacy, which is requisite to make him sensible of every beauty and every blemish, in any composition or discourse.

It is acknowledged to be the perfection of every sense or faculty, to perceive with exactness its most minute objects, and allow nothing to escape its notice and observation. The smaller the objects are, which become sensible to the eye, the finer is that organ, and the more elaborate its make and composition. A good palate is not tried by strong flavours; but by a mixture of small ingredients, where we are still sensible of each part, notwithstanding its minuteness and its confusion with the rest. In like manner, a quick and acute perception of beauty and deformity must be the perfection of our mental taste; nor can a man be satisfied with himself while he suspects, that any excellence or blemish in a discourse has passed him unobserved. In this case, the perfection of the man, and the perfection of the sense or feeling, are found to be united. A very delicate palate, on many occasions, may be a great inconvenience both to a man himself and to his friends: But a delicate taste of wit or beauty must always be a desirable quality; because it is the source of all the finest and most innocent enjoyments, of which human nature is susceptible. In this decision the sentiments of all mankind are agreed. Wherever you can ascertain a delicacy of taste, it is sure to meet with approbation; and the best way of ascertaining it is to appeal to those models and principles, which have been established by the uniform consent and experience of nations and ages.

But though there be naturally a wide difference in point of delicacy between one person and another, nothing tends further to encrease and improve this talent, than *practice* in a particular art, and the frequent survey or contemplation of a particular species of beauty. When objects of any kind are first presented to the eye or imagination, the sentiment, which attends them, is obscure and confused; and the mind is, in a great measure, incapable of pronouncing concerning their merits or defects. The taste cannot perceive the several excellencies of the performance; much less distinguish the particular character of each excellency, and ascertain its quality

and degree. If it pronounce the whole in general to be beautiful or deformed, it is the utmost that can be expected; and even this judgment, a person, so unpractised, will be apt to deliver with great hesitation and reserve. But allow him to acquire experience in those objects, his feeling becomes more exact and nice: He not only perceives the beauties and defects of each part, but marks the distinguishing species of each quality, and assigns it suitable praise or blame. A clear and distinct sentiment attends him through the whole survey of the objects; and he discerns that very degree and kind of approbation or displeasure, which each part is naturally fitted to produce. The mist dissipates, which seemed formerly to hang over the object: The organ acquires greater perfection in its operations; and can pronounce, without danger of mistake, concerning the merits of every performance. In a word, the same address and dexterity, which practice gives to the execution of any work, is also acquired by the same means, in the judging of it.

So advantageous is practice to the discernment of beauty, that, before we can give judgment on any work of importance, it will even be requisite, that that very individual performance be more than once perused by us, and be surveyed in different lights with attention and deliberation. There is a flutter or hurry of thought which attends the first perusal of any piece, and which confounds the genuine sentiment of beauty. The relation of the parts is not discerned: The true characters of style are little distinguished: The several perfections and defects seem wrapped up in a species of confusion, and present themselves indistinctly to the imagination. Not to mention, that there is a species of beauty, which, as it is florid and superficial, pleases at first; but being found incompatible with a just expression either of reason or passion, soon palls upon the taste, and is then rejected with disdain, at least rated at a much lower value.

It is impossible to continue in the practice of contemplating any order of beauty, without being frequently obliged to form *comparisons* between the several species and degrees of excellence, and estimating their proportion to each other. A man, who has had no opportunity of comparing the different kinds of beauty, is indeed totally unqualified to pronounce an opinion with regard to any object presented to him. By comparison alone we fix the epithets of praise or blame, and learn how to assign the due degree of each. The coarsest daubing contains a certain lustre of colours and exactness of imitation, which are so far beauties, and would affect the mind of a peasant or Indian with the highest admiration. The most vulgar ballads are not entirely destitute of harmony or nature; and none but a person, familiarized to superior beauties, would pronounce their numbers harsh, or narration uninteresting. A great inferiority of beauty gives pain to a person conversant in the highest excellence of the kind, and is for that reason pronounced a deformity: As the most finished object, with which we are acquainted, is naturally supposed to have reached the pinnacle of perfection, and to be entitled to the highest applause. One accustomed to see, and examine, and weigh the several performances, admired in different ages and nations, can alone rate the merits of a work exhibited to his view, and assign its proper rank among the productions of genius.

But to enable a critic the more fully to execute this undertaking, he must preserve his mind free from all *prejudice*, and allow nothing to enter into his consideration, but the very object which is submitted to his examination. We may observe, that every

work of art, in order to produce its due effect on the mind, must be surveyed in a certain point of view, and cannot be fully relished by persons, whose situation, real or imaginary, is not conformable to that which is required by the performance. An orator addresses himself to a particular audience, and must have a regard to their particular genius, interests, opinions, passions, and prejudices; otherwise he hopes in vain to govern their resolutions, and inflame their affections. Should they even have entertained some prepossessions against him, however unreasonable, he must not overlook this disadvantage; but, before he enters upon the subject, must endeavour to conciliate their affection, and acquire their good graces. A critic of a different age or nation, who should peruse this discourse, must have all these circumstances in his eye, and must place himself in the same situation as the audience, in order to form a true judgment of the oration. In like manner, when any work is addressed to the public, though I should have a friendship or enmity with the author, I must depart from this situation; and considering myself as a man in general, forget, if possible, my individual being and my peculiar circumstances. A person influenced by prejudice, complies not with this condition; but obstinately maintains his natural position, without placing himself in that point of view, which the performance supposes. If the work be addressed to persons of a different age or nation, he makes no allowance for their peculiar views and prejudices; but, full of the manners of his own age and country, rashly condemns what seemed admirable in the eyes of those for whom alone the discourse was calculated. If the work be executed for the public, he never sufficiently enlarges his comprehension, or forgets his interest as a friend or enemy, as a rival or commentator. By this means, his sentiments are perverted; nor have the same beauties and blemishes the same influence upon him, as if he had imposed a proper violence on his imagination, and had forgotten himself for a moment. So far his taste evidently departs from the true standard; and of consequence loses all credit and authority.

It is well known, that in all questions, submitted to the understanding, prejudice is destructive of sound judgment, and perverts all operations of the intellectual faculties: It is no less contrary to good taste; nor has it less influence to corrupt our sentiment of beauty. It belongs to *good sense* to check its influence in both cases; and in this respect, as well as in many others, reason, if not an essential part of taste, is at least requisite to the operations of this latter faculty. In all the nobler productions of genius, there is a mutual relation and correspondence of parts; nor can either the beauties or blemishes be perceived by him, whose thought is not capacious enough to comprehend all those parts, and compare them with each other, in order to perceive the consistence and uniformity of the whole. Every work of art has also a certain end or purpose, for which it is calculated; and is to be deemed more or less perfect, as it is more or less fitted to attain this end. The object of eloquence is to persuade, of history to instruct, of poetry to please by means of the passions and the imagination. These ends we must carry constantly in our view, when we peruse any performance; and we must be able to judge how far the means employed are adapted to their respective purposes. Besides, every kind of composition, even the most poetical, is nothing but a chain of propositions and reasonings; not always, indeed, the justest and most exact, but still plausible and specious, however disguised by the colouring of the imagination. The persons introduced in tragedy and epic poetry, must be

represented as reasoning, and thinking, and concluding, and acting, suitably to their character and circumstances; and without judgment, as well as taste and invention, a poet can never hope to succeed in so delicate an undertaking. Not to mention, that the same excellence of faculties which contributes to the improvement of reason, the same clearness of conception, the same exactness of distinction, the same vivacity of apprehension, are essential to the operations of true taste, and are its infallible concomitants. It seldom, or never happens, that a man of sense, who has experience in any art, cannot judge of its beauty; and it is no less rare to meet with a man who has a just taste without a sound understanding.

Thus, though the principles of taste be universal, and nearly, if not entirely the same in all men; yet few are qualified to give judgment on any work of art, or establish their own sentiment as the standard of beauty. The organs of internal sensation are seldom so perfect as to allow the general principles their full play, and produce a feeling correspondent to those principles. They either labour under some defect, or are vitiated by some disorder; and by that means, excite a sentiment, which may be pronounced erroneous. When the critic has no delicacy, he judges without any distinction, and is only affected by the grosser and more palpable qualities of the object: The finer touches pass unnoticed and disregarded. Where he is not aided by practice, his verdict is attended with confusion and hesitation. Where no comparison has been employed, the most frivolous beauties, such as rather merit the name of defects, are the object of his admiration. Where he lies under the influence of prejudice, all his natural sentiments are perverted. Where good sense is wanting, he is not qualified to discern the beauties of design and reasoning, which are the highest and most excellent. Under some or other of these imperfections, the generality of men labour; and hence a true judge in the finer arts is observed, even during the most polished ages, to be so rare a character: Strong sense, united to delicate sentiment, improved by practice, perfected by comparison, and cleared of all prejudice, can alone entitle critics to this valuable character; and the joint verdict of such, wherever they are to be found, is the true standard of taste and beauty.

But where are such critics to be found? By what marks are they to be known? How distinguish them from pretenders? These questions are embarrassing; and seem to throw us back into the same uncertainty, from which, during the course of this essay, we have endeavoured to extricate ourselves.

But if we consider the matter aright, these are questions of fact, not of sentiment. Whether any particular person be endowed with good sense and a delicate imagination, free from prejudice, may often be the subject of dispute, and be liable to great discussion and enquiry: But that such a character is valuable and estimable will be agreed in by all mankind. Where these doubts occur, men can do no more than in other disputable questions, which are submitted to the understanding: They must produce the best arguments, that their invention suggests to them; they must acknowledge a true and decisive standard to exist somewhere, to wit, real existence and matter of fact; and they must have indulgence to such as differ from them in their appeals to this standard. It is sufficient for our present purpose, if we have proved, that the taste of all individuals is not upon an equal footing, and that some men in general, however difficult to be particularly pitched upon, will be acknowledged by universal sentiment to have a preference above others.

But in reality the difficulty of finding, even in particulars, the standard of taste, is not so great as it is represented. Though in speculation, we may readily avow a certain criterion in science and deny it in sentiment, the matter is found in practice to be much more hard to ascertain in the former case than in the latter. Theories of abstract philosophy, systems of profound theology, have prevailed during one age: In a successive period, these have been universally exploded: Their absurdity has been detected: Other theories and systems have supplied their place, which again gave place to their successors: And nothing has been experienced more liable to the revolutions of chance and fashion than these pretended decisions of science. The case is not the same with the beauties of eloquence and poetry. Just expressions of passion and nature are sure, after a little time, to gain public applause, which they maintain for ever. ARISTOTLE, and PLATO, and EPICURUS, and DESCARTES, may successively yield to each other: But TERENCE and VIRGIL maintain an universal, undisputed empire over the minds of men. The abstract philosophy of CICERO has lost its credit: The vehemence of his oratory is still the object of our admiration.

Though men of delicate taste be rare, they are easily to be distinguished in society, by the soundness of their understanding and the superiority of their faculties above the rest of mankind. The ascendant, which they acquire, gives a prevalence to that lively approbation, with which they receive any productions of genius, and renders it generally predominant. Many men, when left to themselves, have but a faint and dubious perception of beauty, who yet are capable of relishing any fine stroke, which is pointed out to them. Every convert to the admiration of the real poet or orator is the cause of some new conversion. And though prejudices may prevail for a time, they never unite in celebrating any rival to the true genius, but yield at last to the force of nature and just sentiment. Thus, though a civilized nation may easily be mistaken in the choice of their admired philosopher, they never have been found long to err, in their affection for a favourite epic or tragic author.

But notwithstanding all our endeavours to fix a standard of taste, and reconcile the discordant apprehensions of men, there still remain two sources of variation, which are not sufficient indeed to confound all the boundaries of beauty and deformity, but will often serve to produce a difference in the degrees of our approbation or blame. The one is the different humours of particular men; the other, the particular manners and opinions of our age and country. The general principles of taste are uniform in human nature: Where men vary in their judgments, some defect or perversion in the faculties may commonly be remarked; proceeding either from prejudice, from want of practice, or want of delicacy; and there is just reason for approving one taste, and condemning another. But where there is such a diversity in the internal frame or external situation as is entirely blameless on both sides, and leaves no room to give one the preference above the other; in that case a certain degree of diversity in judgment is unavoidable, and we seek in vain for a standard, by which we can reconcile the contrary sentiments.

* * *

1 John Ogilby (1600–76) published verse translations of Homer and Virgil and of *Aesop's Fables*.

6 Edmund Burke (1729–1797) from *A Philosophical Inquiry into the Origin of our Ideas of the Sublime and the Beautiful*

Edmund Burke was born in Ireland and was educated at Trinity College, Dublin. In 1750 he went to London to study for the Bar, but subsequently abandoned a career in law for literary work. His *Philosophical Inquiry into the Origin of our Ideas of the Sublime and the Beautiful* was published in 1757 when the author was just 28 years old. It was an enormous popular success both in Britain and on the Continent, where it influenced figures such as Lessing (IIIA10) and Kant (VA10). The subject of the sublime had already been addressed by Addison (IIB4) and Richardson (IIB9) and was a fashionable topic by the time Burke took it up. However, Burke's lively and vigorous style, and the wide range of his interests, helped to establish the sublime as a key category of eighteenth-century aesthetics. Burke shares Hutcheson's insistence on the immediacy of our aesthetic responses (see IIB7), but extends his investigation to include a much wider range of emotional and affective states. Much of the *Inquiry* is given over to identifying and categorizing the different emotions attendant on the sublime and the beautiful. Whereas beauty gives rise to a positive pleasure, the sublime depends upon the 'removal or diminution of pain', which he terms 'delight'. We can take pleasure in what terrifies or overwhelms us, as long as we know ourselves at a safe distance from actual harm. Burke criticizes Berkeley's claim that beauty is connected to an object's fitness or usefulness (see IIB8), arguing that if this were the case, the 'wedge-like snout of a swine', which is so well adapted to digging, must be considered beautiful. It is not rational reflection, but rather the intrinsic properties of the object which 'cause' in us the corresponding emotions. Just as the sublime belongs to what is vast, rugged, gloomy, and negligent, beauty belongs to what is small, smooth, light, and delicate. We have used the edition edited by Adam Philips, *A Philosophical Inquiry into the Origin of our Ideas of the Sublime and the Beautiful*, Oxford and New York: Oxford University Press, 1990, pp. 36–7, 53–6, 59–61, 66–8, 75, 83–6, 95–7, 102–4, 113–14. For criticism of Burke's ideas by Mary Wollstonecraft see IVB6.

Of the Sublime

Whatever is fitted in any sort to excite the ideas of pain, and danger, that is to say, whatever is in any sort terrible, or is conversant about terrible objects, or operates in a manner analogous to terror, is a source of the *sublime*; that is, it is productive of the strongest emotion which the mind is capable of feeling. I say the strongest emotion, because I am satisfied the ideas of pain are much more powerful than those which enter on the part of pleasure. Without all doubt, the torments which we may be made to suffer, are much greater in their effect on the body and mind, than any pleasures which the most learned voluptuary could suggest, or than the liveliest imagination, and the most sound and exquisitely sensible body could enjoy. Nay I am in great doubt, whether any man could be found who would earn a life of the most perfect satisfaction, at the price of ending it in the torments, which justice inflicted in a few hours on the late unfortunate regicide in France. But as pain is stronger in its operation than pleasure, so death is in general a much more affecting idea than

pain; because there are very few pains, however exquisite, which are not preferred to death; nay, what generally makes pain itself, if I may say so, more painful, is, that it is considered as an emissary of this king of terrors. When danger or pain press too nearly, they are incapable of giving any delight, and are simply terrible; but at certain distances, and with certain modifications, they may be, and they are delightful, as we every day experience. The cause of this I shall endeavour to investigate hereafter.

* * *

Of the passion caused by the Sublime

The passion caused by the great and sublime in *nature*, when those causes operate most powerfully, is Astonishment; and astonishment is that state of the soul, in which all its motions are suspended, with some degree of horror. In this case the mind is so entirely filled with its object, that it cannot entertain any other, nor by consequence reason on that object which employs it. Hence arises the great power of the sublime, that far from being produced by them, it anticipates our reasonings, and hurries us on by an irresistible force. Astonishment, as I have said, is the effect of the sublime in its highest degree; the inferior effects are admiration, reverence and respect.

Terror

No passion so effectually robs the mind of all its powers of acting and reasoning as fear. For fear being an apprehension of pain or death, it operates in a manner that resembles actual pain. Whatever therefore is terrible, with regard to sight, is sublime too, whether this cause of terror, be endued with greatness of dimensions or not; for it is impossible to look on any thing as trifling, or contemptible, that may be dangerous. There are many animals, who though far from being large, are yet capable of raising ideas of the sublime, because they are considered as objects of terror. As serpents and poisonous animals of almost all kinds. And to things of great dimensions, if we annex an adventitious idea of terror, they become without comparison greater. A level plain of a vast extent on land, is certainly no mean idea; the prospect of such a plain may be as extensive as a prospect of the ocean; but can it ever fill the mind with any thing so great as the ocean itself? This is owing to several causes, but it is owing to none more than this, that the ocean is an object of no small terror. Indeed terror is in all cases whatsoever, either more openly or latently the ruling principle of the sublime. [...]

Obscurity

To make any thing very terrible, obscurity seems in general to be necessary. When we know the full extent of any danger, when we can accustom our eyes to it, a great deal of the apprehension vanishes. Every one will be sensible of this, who considers how greatly night adds to our dread, in all cases of danger, and how much the notions of ghosts and goblins, of which none can form clear ideas, affect minds, which give credit to the popular tales concerning such sorts of beings. Those despotic governments, which are founded on the passions of men, and principally upon the passion

of fear, keep their chief as much as may be from the public eye. The policy has been the same in many cases of religion. Almost all the heathen temples were dark. Even in the barbarous temples of the Americans at this day, they keep their idol in a dark part of the hut, which is consecrated to his worship. For this purpose too the druids performed all their ceremonies in the bosom of the darkest woods, and in the shade of the oldest and most spreading oaks. [. . .]

Of the difference between Clearness and Obscurity with regard to the passions

It is one thing to make an idea clear, and another to make it *affecting* to the imagination. If I make a drawing of a palace, or a temple, or a landscape, I present a very clear idea of those objects; but then (allowing for the effect of imitation which is something) my picture can at most affect only as the palace, temple, or landscape would have affected in the reality. On the other hand, the most lively and spirited verbal description I can give, raises a very obscure and imperfect *idea* of such objects; but then it is in my power to raise a stronger *emotion* by the description than I could do by the best painting. This experience constantly evinces. The proper manner of conveying the *affections* of the mind from one to another, is by words; there is a great insufficiency in all other methods of communication; and so far is a clearness of imagery from being absolutely necessary to an influence upon the passions, that they may be considerably operated upon without presenting any image at all, by certain sounds adapted to that purpose; of which we have a sufficient proof in the acknowledged and powerful effects of instrumental music. In reality a great clearness helps but little towards affecting the passions, as it is in some sort an enemy to all enthusiasms whatsoever.

* * *

Power

Besides these things which *directly* suggest the idea of danger, and those which produce a similar effect from a mechanical cause, I know of nothing sublime which is not some modification of power. And this branch rises as naturally as the other two branches, from terror, the common stock of every thing that is sublime. The idea of power at first view, seems of the class of these indifferent ones, which may equally belong to pain or to pleasure. But in reality, the affection arising from the idea of vast power, is extremely remote from that neutral character. For first, we must remember, that the idea of pain, in its highest degree, is much stronger than the highest degree of pleasure; and that it preserves the same superiority through all the subordinate gradations. From hence it is, that where the chances for equal degrees of suffering or enjoyment are in any sort equal, the idea of the suffering must always be prevalent. And indeed the ideas of pain, and above all of death, are so very affecting, that whilst we remain in the presence of whatever is supposed to have the power of inflicting either, it is impossible to be perfectly free from terror. Again, we know by experience, that for the enjoyment of pleasure, no great efforts of power are at all necessary; nay we know, that such efforts would go a great way towards destroying our satisfaction: for pleasure must be stolen, and not forced upon us; pleasure follows the will; and

therefore we are generally affected with it by many things of a force greatly inferior to our own. But pain is always inflicted by a power in some way superior, because we never submit to pain willingly. So that strength, violence, pain and terror, are ideas that rush in upon the mind together. Look at a man, or any other animal of prodigious strength, and what is your idea before reflection? Is it that this strength will be subservient to you, to your ease, to your pleasure, to your interest in any sense? No; the emotion you feel is, lest this enormous strength should be employed to the purposes of rapine and destruction. That power derives all its sublimity from the terror with which it is generally accompanied, will appear evidently from its effect in the very few cases, in which it may be possible to strip a considerable degree of strength of its ability to hurt. When you do this, you spoil it of every thing sublime, and it immediately becomes contemptible. An ox is a creature of vast strength; but he is an innocent creature, extremely serviceable, and not at all dangerous; for which reason the idea of an ox is by no means grand. A bull is strong too; but his strength is of another kind; often very destructive, seldom (at least amongst us) of any use in our business; the idea of a bull is therefore great, and it has frequently a place in sublime descriptions, and elevating comparisons. Let us look at another strong animal in the two distinct lights in which we may consider him. The horse in the light of an useful beast, fit for the plough, the road, the draft, in every social useful light the horse has nothing of the sublime; but is it thus that we are affected with him, *whose neck is cloathed with thunder, the glory of whose nostrils is terrible, who swalloweth the ground with fierceness and rage, neither believeth that it is the sound of the trumpet?* In this description the useful character of the horse entirely disappears, and the terrible and sublime blaze out together. We have continually about us animals of a strength that is considerable, but not pernicious. Amongst these we never look for the sublime: it comes upon us in the gloomy forest, and in the howling wilderness, in the form of the lion, the tiger, the panther, or rhinoceros. Whenever strength is only useful, and employed for our benefit or our pleasure, then it is never sublime; for nothing can act agreeably to us, that does not act in conformity to our will; but to act agreeably to our will, it must be subject to us; and therefore can never be the cause of a grand and commanding conception. The description of the wild ass, in Job, is worked up into no small sublimity, merely by insisting on his freedom, and his setting mankind at defiance; otherwise the description of such an animal could have had nothing noble in it. *Who hath loosed* (says he) *the bands of the wild ass? whose house I have made the wilderness, and the barren land his dwellings. He scorneth the multitude of the city, neither regardeth he the voice of the driver. The range of the mountains is his pasture.*

* * *

Vastness

Greatness of dimension, is a powerful cause of the sublime. This is too evident, and the observation too common, to need any illustration; it is not so common, to consider in what ways greatness of dimension, vastness of extent, or quantity, has the most striking effect. For certainly, there are ways, and modes, wherein the same quantity of extension shall produce greater effects than it is found to do in others. Extension is either in length, height, or depth. Of these the length strikes least; an

hundred yards of even ground will never work such an effect as a tower an hundred yards high, or a rock or mountain of that altitude. I am apt to imagine likewise, that height is less grand than depth; and that we are more struck at looking down from a precipice, than at looking up at an object of equal height, but of that I am not very positive. A perpendicular has more force in forming the sublime, than an inclined plane; and the effects of a rugged and broken surface seem stronger than where it is smooth and polished. It would carry us out of our way to enter in this place into the cause of these appearances; but certain it is they afford a large and fruitful field of speculation. However, it may not be amiss to add to these remarks upon magnitude; that, as the great extreme of dimension is sublime, so the last extreme of littleness is in some measure sublime likewise; when we attend to the infinite divisibility of matter, when we pursue animal life into these excessively small, and yet organized beings, that escape the nicest inquisition of the sense, when we push our discoveries yet downward, and consider those creatures so many degrees yet smaller, and the still diminishing scale of existence, in tracing which the imagination is lost as well as the sense, we become amazed and confounded at the wonders of minuteness; nor can we distinguish in its effect this extreme of littleness from the vast itself. For division must be infinite as well as addition; because the idea of a perfect unity can no more be arrived at, than that of a compleat whole to which nothing may be added.

Infinity

Another source of the sublime, is *infinity*; if it does not rather belong to the last. Infinity has a tendency to fill the mind with that sort of delightful horror, which is the most genuine effect, and truest test of the sublime. There are scarce any things which can become the objects of our senses that are really, and in their own nature infinite. But the eye not being able to perceive the bounds of many things, they seem to be infinite, and they produce the same effects as if they were really so. We are deceived in the like manner, if the parts of some large object are so continued to any indefinite number, that the imagination meets no check which may hinder its extending them at pleasure.

Whenever we repeat any idea frequently, the mind by a sort of mechanism repeats it long after the first cause has ceased to operate. After whirling about; when we sit down, the objects about us still seem to whirl. After a long succession of noises, as the fall of waters, or the beating of forge hammers, the hammers beat and the water roars in the imagination long after the first sounds have ceased to affect it; and they die away at last by gradations which are scarcely perceptible. If you hold up a strait pole, with your eye to one end, it will seem extended to a length almost incredible. Place a number of uniform and equidistant marks on this pole, they will cause the same deception, and seem multiplied without end. The senses strongly affected in some one manner, cannot quickly change their tenor, or adapt themselves to other things; but they continue in their old channel until the strength of the first mover decays. This is the reason of an appearance very frequent in madmen; that they remain whole days and nights, sometimes whole years, in the constant repetition of some remark, some complaint, or song; which having struck powerfully on their disordered imagination, in the beginning of their phrensy, every repetition reinforces it with

new strength; and the hurry of their spirits, unrestrained by the curb of reason, continues it to the end of their lives.

* * *

Colour considered as productive of the Sublime

Among colours, such as are soft, or cheerful, (except perhaps a strong red which is cheerful) are unfit to produce grand images. An immense mountain covered with a shining green turf, is nothing in this respect, to one dark and gloomy; the cloudy sky is more grand than the blue; and night more sublime and solemn than day. Therefore in historical painting, a gay or gaudy drapery, can never have a happy effect: and in buildings, when the highest degree of the sublime is intended, the materials and ornaments ought neither to be white, nor green, nor yellow, nor blue, nor of a pale red, nor violet, nor spotted, but of sad and fuscous colours, as black, or brown, or deep purple, and the like. Much of gilding, mosaics, painting or statues, contribute but little to the sublime. This rule need not be put in practice, except where an uniform degree of the most striking sublimity is to be produced, and that in every particular; for it ought to be observed, that this melancholy kind of greatness, though it be certainly the highest, ought not to be studied in all sorts of edifices, where yet grandeur must be studied; in such cases the sublimity must be drawn from the other sources; with a strict caution however against any thing light and riant; as nothing so effectually deadens the whole taste of the sublime.

* * *

Of Beauty

It is my design to consider beauty as distinguished from the sublime; and in the course of the enquiry, to examine how far it is consistent with it. But previous to this, we must take a short review of the opinions already entertained of this quality; which I think are hardly to be reduced to any fixed principles; because men are used to talk of beauty in a figurative manner, that is to say, in a manner extremely uncertain, and indeterminate. By beauty I mean, that quality or those qualities in bodies by which they cause love, or some passion similar to it. I confine this definition to the merely sensible qualities of things, for the sake of preserving the utmost simplicity in a subject which must always distract us, whenever we take in those various causes of sympathy which attach us to any persons or things from secondary considerations, and not from the direct force which they have merely on being viewed. I likewise distinguish love, by which I mean that satisfaction which arises to the mind upon contemplating any thing beautiful, of whatsoever nature it may be, from desire or lust; which is an energy of the mind, that hurries us on to the possession of certain objects, that do not affect us as they are beautiful, but by means altogether different. We shall have a strong desire for a woman of no remarkable beauty; whilst the greatest beauty in men, or in other animals, though it causes love, yet excites nothing at all of desire. Which shews that beauty, and the passion caused by beauty, which I call love, is different from desire, though desire may sometimes operate along with it; but it is to this latter that we must attribute those violent and tempestuous passions,

and the consequent emotions of the body which attend what is called love in some of its ordinary acceptations, and not to the effects of beauty merely as it is such.

Proportion not the cause of Beauty in Vegetables

Beauty hath usually been said to consist in certain proportions of parts. On considering the matter, I have great reason to doubt, whether beauty be at all an idea belonging to proportion. Proportion relates almost wholly to convenience, as every idea of order seems to do; and it must therefore be considered as a creature of the understanding, rather than a primary cause acting on the senses and imagination. It is not by the force of long attention and enquiry that we find any object to be beautiful; beauty demands no assistance from our reasoning; even the will is unconcerned; the appearance of beauty as effectually causes some degree of love in us, as the application of ice or fire produces the ideas of heat or cold. To gain something like a satisfactory conclusion in this point, it were well to examine, what proportion is; since several who make use of that word, do not always seem to understand very clearly the force of the term, nor to have very distinct ideas concerning the thing itself. Proportion is the measure of relative quantity. Since all quantity is divisible, it is evident that every distinct part into which any quantity is divided, must bear some relation to the other parts or to the whole. These relations give an origin to the idea of proportion. They are discovered by mensuration, and they are the objects of mathematical enquiry. But whether any part of any determinate quantity be a fourth, or a fifth, or a sixth, or a moiety of the whole; or whether it be of equal length with any other part, or double its length, or but one half, is a matter merely indifferent to the mind; it stands neuter in the question: and it is from this absolute indifference and tranquillity of the mind, that mathematical speculations derive some of their most considerable advantages; because there is nothing to interest the imagination; because the judgment sits free and unbiassed to examine the point. All proportions, every arrangement of quantity is alike to the understanding, because the same truths result to it from all; from greater, from lesser; from equality and inequality. But surely beauty is no idea belonging to mensuration; nor has it any thing to do with calculation and geometry. If it had, we might then point out some certain measures which we could demonstrate to be beautiful, either as simply considered, or as related to others; and we could call in those natural objects, for whose beauty we have no voucher but the sense, to this happy standard, and confirm the voice of our passions by the determination of our reason. But since we have not this help, let us see whether proportion can in any sense be considered as the cause of beauty, as hath been so generally, and by some so confidently affirmed.

* * *

Fitness not the cause of Beauty

It is said that the idea of utility, or of a part's being well adapted to answer its end, is the cause of beauty, or indeed beauty itself. If it were not for this opinion, it had been impossible for the doctrine of proportion to have held its ground very long; the world would be soon weary of hearing of measures which related to nothing, either of a

natural principle, or of a fitness to answer some end; the idea which mankind most commonly conceive of proportion, is the suitableness of means to certain ends, and where this is not the question, very seldom trouble themselves about the effect of different measures of things. Therefore it was necessary for this theory to insist, that not only artificial, but natural objects took their beauty from the fitness of the parts for their several purposes. But in framing this theory, I am apprehensive that experience was not sufficiently consulted. For on that principle, the wedge-like snout of a swine, with its tough cartilage at the end, the little sunk eyes, and the whole make of the head, so well adapted to its offices of digging, and rooting, would be extremely beautiful. The great bag hanging to the bill of a pelican, a thing highly useful to this animal, would be likewise as beautiful in our eyes. The hedgehog, so well secured against all assaults by his prickly hide, and the porcupine with his missile quills, would be then considered as creatures of no small elegance. There are few animals, whose parts are better contrived than those of a monkey; he has the hands of a man, joined to the springy limbs of a beast; he is admirably calculated for running, leaping, grappling, and climbing: and yet there are few animals which seem to have less beauty in the eyes of all mankind. I need say little on the trunk of the elephant, of such various usefulness, and which is so far from contributing to his beauty. How well fitted is the wolf for running and leaping? how admirably is the lion armed for battle? But will any one therefore call the elephant, the wolf, and the lion, beautiful animals? I believe nobody will think the form of a man's legs so well adapted to running, as those of an horse, a dog, a deer, and several other creatures; at least they have not that appearance: yet I believe a well-fashioned human leg will be allowed far to exceed all these in beauty. If the fitness of parts was what constituted the loveliness of their form, the actual employment of them would undoubtedly much augment it; but this, though it is sometimes so upon another principle, is far from being always the case. A bird on the wing is not so beautiful as when it is perched; nay, there are several of the domestic fowls which are seldom seen to fly, and which are nothing the less beautiful on that account; yet birds are so extremely different in their form from the beast and human kinds, that you cannot on the principle of fitness allow them any thing agreeable, but in consideration of their parts being designed for quite other purposes. I never in my life chanced to see a peacock fly; and yet before, very long before I considered any aptitude in his form for the aerial life, I was struck with the extreme beauty which raises that bird above many of the best flying fowls in the world; though for any thing I saw, his way of living was much like that of the swine, which fed in the farmyard along with him. The same may be said of cocks, hens, and the like; they are of the flying kind in figure; in their manner of moving not very different from men and beasts. To leave these foreign examples; if beauty in our own species was annexed to use, men would be much more lovely than women; and strength and agility would be considered as the only beauties. But to call strength by the name of beauty, to have but one denomination for the qualities of a Venus and Hercules, so totally different in almost all respects, is surely a strange confusion of ideas, or abuse of words. The cause of this confusion, I imagine, proceeds from our frequently perceiving the parts of the human and other animal bodies to be at once very beautiful, and very well adapted to their purposes; and we are deceived by a sophism, which makes us take that for a cause which is only a

concomitant; this is the sophism of the fly; who imagined he raised a great dust, because he stood upon the chariot that really raised it. The stomach, the lungs, the liver, as well as other parts, are incomparably well adapted to their purposes; yet they are far from having any beauty. Again, many things are very beautiful, in which it is impossible to discern any idea of use. And I appeal to the first and most natural feelings of mankind, whether on beholding a beautiful eye, or a well-fashioned mouth, or a well-turned leg, any ideas of their being well fitted for seeing, eating, or running, ever present themselves. What idea of use is it that flowers excite, the most beautiful part of the vegetable world? It is true, that the infinitely wise and good Creator has, of his bounty, frequently joined beauty to those things which he has made useful to us; but this does not prove that an idea of use and beauty are the same thing, or that they are any way dependent on each other.

* * *

The real cause of Beauty

Having endeavoured to shew what beauty is not, it remains that we should examine, at least with equal attention, in what it really consists. Beauty is a thing much too affecting not to depend upon some positive qualities. And, since it is no creature of our reason, since it strikes us without any reference to use, and even where no use at all can be discerned, since the order and method of nature is generally very different from our measures and proportions, we must conclude that beauty is, for the greater part, some quality in bodies, acting mechanically upon the human mind by the intervention of the senses. We ought therefore to consider attentively in what manner those sensible qualities are disposed, in such things as by experience we find beautiful, or which excite in us the passion of love, or some correspondent affection.

Beautiful objects small

The most obvious point that presents itself to us in examining any object, is its extent or quantity. And what degree of extent prevails in bodies, that are held beautiful, may be gathered from the usual manner of expression concerning it. I am told that in most languages, the objects of love are spoken of under diminutive epithets. It is so in all the languages of which I have any knowledge. In Greek the ιον, and other diminutive terms, are almost always the terms of affection and tenderness. These diminutives were commonly added by the Greeks to the names of persons with whom they conversed on terms of friendship and familiarity. Though the Romans were a people of less quick and delicate feelings, yet they naturally slid into the lessening termination upon the same occasions. Anciently in the English language the diminishing *ling* was added to the names of persons and things that were the objects of love. Some we retain still, as darling, (or little dear) and a few others. But to this day in ordinary conversation, it is usual to add the endearing name of *little* to every thing we love; the French and Italians make use of these affectionate diminutives even more than we. In the animal creation, out of our own species, it is the small we are inclined to be fond of; little birds, and some of the smaller kinds of beasts. A great beautiful thing, is a manner of expression scarcely ever used; but that of a great ugly thing, is very

common. There is a wide difference between admiration and love. The sublime, which is the cause of the former, always dwells on great objects, and terrible; the latter on small ones, and pleasing; we submit to what we admire, but we love what submits to us; in one case we are forced, in the other we are flattered into compliance. In short, the ideas of the sublime and the beautiful stand on foundations so different, that it is hard, I had almost said impossible, to think of reconciling them in the same subject, without considerably lessening the effect of the one or the other upon the passions. So that attending to their quantity, beautiful objects are comparatively small.

Smoothness

The next property constantly observable in such objects is *Smoothness*. A quality so essential to beauty, that I do not now recollect any thing beautiful that is not smooth. In trees and flowers, smooth leaves are beautiful; smooth slopes of earth in gardens; smooth streams in the landscape; smooth coats of birds and beasts in animal beauties; in fine women, smooth skins; and in several sorts of ornamental furniture, smooth and polished surfaces. A very considerable part of the effect of beauty is owing to this quality; indeed the most considerable. For take any beautiful object, and give it a broken and rugged surface, and however well formed it may be in other respects, it pleases no longer. Whereas let it want ever so many of the other constituents, if it wants not this, it becomes more pleasing than almost all the others without it. This seems to me so evident, that I am a good deal surprised, that none who have handled the subject have made any mention of the quality of smoothness in the enumeration of those that go to the forming of beauty. For indeed any ruggedness, any sudden projection, any sharp angle, is in the highest degree contrary to that idea.

* * *

The Sublime and Beautiful compared

On closing this general view of beauty, it naturally occurs, that we should compare it with the sublime; and in this comparison there appears a remarkable contrast. For sublime objects are vast in their dimensions, beautiful ones comparatively small; beauty should be smooth, and polished; the great, rugged and negligent; beauty should shun the right line, yet deviate from it insensibly; the great in many cases loves the right line, and when it deviates, it often makes a strong deviation; beauty should not be obscure; the great ought to be dark and gloomy; beauty should be light and delicate; the great ought to be solid, and even massive. They are indeed ideas of a very different nature, one being founded on pain, the other on pleasure; and however they may vary afterwards from the direct nature of their causes, yet these causes keep up an eternal distinction between them, a distinction never to be forgotten by any whose business it is to affect the passions. In the infinite variety of natural combinations we must expect to find the qualities of things the most remote imaginable from each other united in the same object. We must expect also to find combinations of the same kind in the works of art. But when we consider the power of an object upon our passions, we must know that when any thing is intended to affect the mind by the

force of some predominant property, the affection produced is like to be the more uniform and perfect, if all the other properties or qualities of the object be of the same nature, and tending to the same design as the principal;

> *If black, and white blend, soften, and unite,*
> *A thousand ways, are there no black and white?*

If the qualities of the sublime and beautiful are sometimes found united, does this prove, that they are the same, does it prove, that they are any way allied, does it prove even that they are not opposite and contradictory? Black and white may soften, may blend, but they are not therefore the same. Nor when they are so softened and blended with each other, or with different colours, is the power of black as black, or of white as white, so strong as when each stands uniform and distinguished.

* * *

7 Charles-Louis de Secondat, Baron de Montesquieu (1689–1755) 'An Essay on Taste'

Born into the French nobility, Montesquieu embarked on a legal and political career, but after about the age of 30 he turned increasingly to writing. *The Spirit of Laws*, his major work in the field of political and legal theory, was published in 1750, and led to his being regarded as the Newton of the social sciences. He had been at the centre of intellectual life in Paris since the success of his *Persian Letters*, a satire on the age of Louis XIV, published in 1721. He was elected to the Académie Française in 1727. In the late 1720s and early 1730s he travelled throughout Europe, visiting Vienna, Hungary, Germany and Holland, but with particularly extended stays in Italy and England. Towards the end of his life he enjoyed international fame (or notoriety in some quarters: the *Spirit of Laws* was placed on the *Index Librorum Prohibitorum* by the Vatican in 1751), and he was accordingly invited in 1753 to contribute to the *Encyclopédie* (see IIIC7–9). D'Alembert had asked him to write on democracy and despotism, but feeling he had already said all he had to say on those subjects, Montesquieu wrote instead on Taste. The *Essai sur le goût* was his last work. For Montesquieu, taste is a faculty by which we derive pleasure from the perception of certain objects or actions, including works of art. He investigates why and how these things produce pleasure and concludes that it is to do with the combinations of order and variety they present to the contemplating mind. Along with two other French 'Dissertations' by D'Alembert and Voltaire, Montesquieu's 'Essay on Taste' was translated and published as an addition to Alexander Gerard's *An Essay on Taste*, London and Edinburgh: A. Millar, 1759, pp. 257–314. Our extracts are from pp. 257–60 and 272–85 of this edition.

The constitution of human nature in it's present state, opens to the mind three different sources of pleasure; one in it's internal faculties and essence, another in it's union with the body, and a third in those impressions and prejudices, that are the result of certain institutions, customs, and habits.

These different pleasures of the mind constitute the proper objects of taste, those objects which we term beautiful, good, agreeable, natural, delicate, tender, graceful,

elegant, noble, grand, sublime, and majestick, as also the qualities to which we give the name of *Je ne sçai quoi*. When, for instance, the pleasure we enjoy in the contemplation of any object is accompanied with a notion of it's utility to us, we call that object good; but when an object appears merely agreeable, without being advantageous, we then term it beautiful. [...]

Let us then turn the eye of the mind upon itself, examine it's inward frame, consider it in it's actions, and it's passions, and contemplate it in it's pleasures in which it's true nature is best discovered. It derives pleasure from poetry, painting, sculpture, architecture, musick, dancing, in a word, from the various productions of nature and art. Let us, therefore, inquire into the reasons that render these objects pleasing, as also into the manner of their operation, and the times and circumstances in which they produce their agreeable effects, and thus give an account of our various feelings. This will contribute to the formation of taste, which is nothing more than the faculty of discovering with quickness and delicacy the degree of pleasure, which we should receive from each object that comes within the sphere of our perceptions.

* * *

Concerning the pleasures, which arise from order.

It is not sufficient to exhibit to the mind a multiplicity of objects; it is farther requisite that they be exhibited with order and arrangement, for then it retains what it has seen, and also forms to itself some notion of what is to follow. One of the highest mental pleasures is that which we receive from a consciousness of the extent of our views, and the depth of our penetration; but in a production void of order this pleasure is impeded; the mind, desirous to supply from its own ideas this want of regularity, is perplexed in the vain attempt; it's plan mingles itself with that which the author of the work had formed, and this produces a new confusion. It retains nothing, foresees nothing; it is dejected by the confusion that reigns in it's ideas, and by the comfortless void that succeeds the abundance and variety of it's vain recources. It's fatigue is without it's effect, and efforts are unsuccessful. Hence the judicious artist always introduces a certain order, even amidst confusion, where confusion is not the main object, the principal thing to be expressed. Hence the painter throws his figures into groups; and when he draws a battle, represents, as it were, in the front of his piece, the principal objects which the eye is to distinguish, and casts at a distance, by the magick of perspective, the groups where confusion and disorder reign.

Concerning the pleasure that arises from variety.

If order be thus necessary in all sorts of productions, variety is no less so; without variety the mind falls into a lifeless inactivity and languor; for similar objects appear to it as if they were wholly the same; so that if a part of a piece of painting was disclosed to our view, which carried a striking resemblance of another part of the same piece that we had already seen, this second part would be really a new object without appearing such, and would be contemplated without the least sensation of

pleasure. The beauties we discern in the productions of art, as well as in the works of nature, consisting entirely in the pleasure they administer, it is necessary so to modify these beauties as to render them the means of diversifying our pleasures as far as is possible. We must employ our industry in offering to the eye of the mind objects which it has not as yet seen, and in exciting within it feelings different from those which it may have already experienced.

Thus History pleases by the variety of facts and relations which it contains; Romance by the variety of prodigies it invents; and Dramatic Poetry by the variety of passions which it excites. Thus also they who are well versed in the art of education endeavour to introduce as much diversity as they can amidst that tedious uniformity which is inseparable from a long course of instruction.

Uniformity carried on to a certain length renders every thing insupportable. The same arrangement of periods continued for a long time fatigues in a piece of eloquence. The same numbers and cadences become extremely tedious in a long poem. If the accounts given of the famous Vista or alley that extends from Moscow to Petersburg be true, the traveller, pent up between these two seemingly endless rows of trees, must feel the most disagreeable lassitude and satiety in the continuance of such a dull uniformity. Nay, even prospects which have the charm of variety, cease to please, if they be repeated without much alteration, and are for a long time present to the mind. Thus the traveller, who has been long wandering through the Alps, will descend satiated with the most extensive views, the most romantick and delightful landscapes.

The human mind loves variety, and the reason is, as we have already observed, that it is naturally framed for contemplation and knowledge. If then the love of variety is subordinate and adapted to the attainment of knowledge, it is requisite, that variety, whether in the productions of nature or art, be such as will facilitate knowledge; or, in other words, an object must be sufficiently simple to be perceived with ease, and sufficiently diversified to be contemplated with pleasure.

There are certain objects, which have the appearance of variety, without the reality; and others, that seem to be uniform, but are, in effect, extremely diversified.

The Gothic architecture appears extremely rich in point of variety, but it's ornaments fatigue the eye by their confusion and minuteness. Hence we cannot easily distinguish one from the other, nor fix our attention upon any one object, on account of the multitude that rush at once upon the sight; and thus it happens that this kind of architecture displeases in the very circumstances that were designed to render it agreeable.

A Gothic structure is to the eye what a riddle is to the understanding; in the contemplation of it's various parts and ornaments the mind perceives the same perplexity and confusion in it's ideas, that arise from reading an obscure poem.

The Grecian architecture, on the contrary, appears uniform; but as the nature, and the number also of it's divisions are precisely such as occupy the mind without fatiguing it, it has consequently that degree of variety, that is pleasing and delightful.

Greatness in the whole of any production requires of necessity the same quality in the parts. Gigantic bodies must have bulky members; large trees must have large branches, &c. Such is the nature of things.

The Grecian architecture, whose divisions are few, but grand and noble, seems formed after the model of the great and the sublime. The mind perceives a certain majesty which reigns through all it's productions.

Thus the painter distributes the figures, that are to compose his work, into various groups; and in this he follows nature and truth, for a crowd is almost always divided into separate companies. In the same manner in every complex piece of painting we see the lights and shades distributed into large masses, which strike the eye at a distance, before the whole composition is distinctly perceived.

Concerning the pleasure that arises from symmetry.

We have already observed that variety is pleasing to the human mind; and we must farther remark, that a certain degree of Symmetry produces also an agreeable effect, and contributes to the beauty of the greatest part of those complex productions, which we behold with admiration and delight. How shall we reconcile this seeming contradiction! It will vanish if we attend to the following observations.

One of the principal causes of the pleasure, which the mind receives in the contemplation of the various objects that are presented to it, is the facility with which it perceives them. Hence Symmetry is rendered agreeable, as it's similar arrangements relieve the mind, aid the quickness of it's comprehension, and enable it, upon a view of the one half of an object, to form immediately an idea of the whole.

Upon this observation is founded the following general rule, That where Symmetry is thus useful to the mind, by aiding it's comprehension, and facilitating it's operations and it's perceptions, there it is, and must always be agreeable; but where it does not produce this effect, it becomes flat and insipid, because, without any good purpose, it deprives an object of that variety to which nature has given superior charms. In those objects which are viewed successively, variety is requisite, because they are distinctly perceived without the least difficulty. On the contrary, where a multitude of objects are presented to us in one point of view, and rush in at once upon the eye, there Symmetry is necessary to aid us in forming quickly an idea of the whole. Thus Symmetry is observed in the front of a building, in a parterre, in a temple; and there it pleases extremely for the reason now mentioned, it's aiding the mind to take in immediately the whole object without pain, perplexity, or confusion.

The object which the mind views not successively, but, as it were, by one effort, must be simple and one; all it's parts must unite in forming one design, and must relate to one end. This is another consideration, that renders symmetry pleasing, as it alone properly constitutes what we call a whole, or the effect of a variety of parts that center in one general design.

There is yet another consideration that pleads in favour of symmetry, and that is the desire, so natural to the mind, of seeing every thing finished and brought to perfection. In all complex objects there must be a sort of counterballance, or equilibrium between the various parts that terminate in one whole; and an edifice only with one wing, or with one wing shorter than the other, would be as unfinished and imperfect a production as a body with only one arm, or with two of unequal length.

Concerning contrasts.

If the mind takes pleasure in symmetry, it is also agreeably affected by contrasts. This requires explication, and a few examples will serve for that purpose.

If painters and sculptors, in obedience to the directions of nature, are careful to observe a certain symmetry in their compositions; the same nature requires that the attitudes which they represent should contrast each other; and thus exhibit an agreeable variety, a pleasing opposition to the eye of the spectator. One foot placed precisely in the same position with the other, or any two of the corresponding parts of the body placed exactly in the same direction, disgust a judicious observer, because this studied symmetry produces a perpetual and insipid sameness of attitude, such as we observe in the Gothic figures, which all resemble each other in this respect. Besides, this uniformity of attitude is contrary to our natural frame and constitution; nature has not designed that we should imitate in our gestures the stupid uniformity that is observable in the Indian Pagods: no; she has given us the power of self-motion and consequently the liberty of modifying our air and our posture as we please. And if stiffness and affectation be unsupportable in the human form, can they be pleasing in the productions of art?

The attitudes therefore, particularly of such figures as are represented in sculpture, must be contrasted in order to give them an agreeable air of variety and ease. What renders this more especially necessary in sculpture is, that of all the arts it is naturally the most cold and lifeless, and can only affect and enflame by the force of it's contrasts and the boldness of it's postures.

But as, according to an observation already made, the variety which the Gothic architects were studious to introduce into their structures gave them an insipid air of uniformity; so has it happened that the variety, which other artists proposed effectuating by the means of contrasts, has degenerated also into a vicious symmetry. [...]

Several painters have fallen into this vicious custom of multiplying contrasts beyond measure in all their compositions, so that the view of one single figure will enable the acute observer to guess at the disposition of all those that are contiguous to it. This perpetual study of diversity produces uniformity, as has been observed above. Besides, this passion for multiplying contrasts has no example in nature, which operates, on the contrary, with a seeming disorder, void of all affectation, and, so far from giving to all bodies a determinate and uniform motion, gives to a great number no motion at all. The hand of nature diversifies truly her multifarious productions; some bodies she holds in repose, while she impresses upon others an infinite variety of tendencies and movements.

If the merely intellectual faculties of our nature determine us to take pleasure in variety, our feeling powers are not less agreeably affected by it. The mind cannot long bear the same objects, the same pleasures, the same situations, if I may use that term, because it is united to a body to which they are insupportable. The activity of the mind, and it's sensations and feelings depend upon the course of the animal spirits that circulate in the nerves; there are, of consequence, two circumstances that suspend their vigour, viz. the lassitude of the nerves, and the dissipation of the animal spirits, or their entire cessation.

Thus every thing fatigues us after a certain time; this, at least, is undoubtedly true with respect to those pleasures that are extremely intense; we quit them always with the same satisfaction with which we embraced them; the fibres which were their instruments have need of repose; we must therefore employ others that are in a condition to serve us, and thus distribute equally to the various parts of our frame the functions they are to perform in rendering us active and happy.

The soul finds it's vigour exhausted by any long and intense feeling. But to be destitute of sentiment or feeling, is to fall into a void which sinks and overwhelms our better part. We remedy this disorder, or rather prevent this disagreeable alternative by diversifying the modifications and pleasures of the mind, and then it feels without weariness.

8 Voltaire (François-Marie Arouet, 1694–1778) 'Essay on Taste'

Voltaire was born in Paris and educated by the Jesuits. After study of the law he turned to writing and pursued a prominent and turbulent career as critic, dramatist, novelist, aesthetician and *philosophe*. He combined a relatively conservative taste in art with a powerful commitment to the righting of social injustices. Rewards for his work included periods of imprisonment and exile at one extreme, and at the other the patronage of Frederick the Great of Prussia and an appointment as royal historiographer to the French court. Like Jean-Jacques Rousseau, he contributed substantially to the intellectual background of the French Revolution. In his 'Essay on Taste', Voltaire distinguishes between a merely physical taste, such as the preference for one flavour over another, which he calls 'fancy', and what he refers to as 'intellectual taste'. This latter has for him an objective aspect, such that it can be true or false. It is salutary to note that, revolutionary liberalism notwithstanding, from Voltaire's point of view as expressed in the present essay, 'taste' is an entirely Eurocentric attribute. Voltaire's 'Essay on Taste', like that by Montesquieu (IIIB7), was translated into English and published as a supplement to Alexander Gerard's *Essay on Taste*, Edinburgh and London: A. Millar, 1759, pp. 213–22. Our extract is from pp. 218–22 of this edition.

[...] It is a common saying, that there is no disputing about tastes: And if by taste here be understood the palate, which loaths certain aliments and relishes others, the maxim is just; because it is needless to dispute about what cannot be corrected, or to attempt reforming the constitution and mechanism of organs merely corporeal. But the maxim is false and pernicious, when applied to that intellectual taste, which has for it's objects the arts and sciences. As these objects have real charms, so there is in reality a good taste which perceives them, and a bad one which perceives them not; and there are certain methods, by which we may often correct those mental defects which produce a depraved *taste*. But it must be granted, at the same time, that there are certain phlegmatick spirits, which nothing can enflame, and also certain distorted intellects, which it is impossible to rectify; with such therefore, it is in vain to dispute about tastes, because they have none at all.

In many things Taste seems to be of an arbitrary nature, and without any fixed or uniform direction, such as in the choice of dress and equipage, and in every thing that

does not come within the circle of the finer arts. In this low sphere it should be distinguished, methinks, by the name of fancy; for it is fancy rather than taste, that produces such an endless variety of new and contradictory modes.

The taste of a nation may degenerate and become extremely depraved; and it almost always happens that the period of it's perfection is the forerunner of it's decline. Artists through the apprehension of being regarded as mere imitators, strike out into new and uncommon paths, and turn aside from the beautiful simplicity of nature, which their predecessors invariably kept in view. In these efforts there is a certain degree of merit, which arises from industry and emulation, and casts a veil over the defects which accompany their productions. The publick, fond of novelty, applauds their invention; but this applause is soon succeeded by satiety and disgust. A new set of artists start up, invent new methods to please a capricious taste, and depart still further from nature than those who first ventured from it's paths into the wilds of fancy. Thus the taste of a people degenerates into the grossest corruption. Overwhelmed with new inventions, which succeed and efface each other with incredible rapidity, they scarcely know where they are, and cast back their eager and anxious desires towards the period, when true taste reigned under the empire of nature. But they implore it's return in vain; that happy period cannot be recalled, it deposits however in the custody of certain choice spirits the sublime pleasures of true taste, which they cherish and enjoy in their little circle, remote from the profane eye of the depraved and capricious multitude.

There are vast countries, where taste has not yet been able to penetrate. Such are those uncultivated wastes, where civil society has never been brought to any degree of perfection, where there is little intercourse between the sexes, and where all representations of living creatures in painting and sculpture are severely prohibited by the laws of religion. Nothing renders the mind so narrow, and so little, if I may use that expression, as the want of social intercourse; this confines it's faculties, blunts the edge of genius, damps every noble passion, and leaves in a state of languor and inactivity every principle, that could contribute to the formation of true taste. Besides, where several of the finer arts are wanting, the rest must necessarily languish and decay, since they are inseparably connected together, and mutually support each other. This is one reason, why the Asiaticks have never excelled in any of the arts, and hence also it is that true taste has been confined to certain countries in Europe.

9 Joshua Reynolds (1723–1792) Letters to 'The Idler'

Joshua Reynolds enjoyed the grandest career that English art has had to offer. The Founder-President of the Royal Academy, he dominated the scene for thirty years, and the *Discourses* he delivered annually to that institution have a deserved place in the forefront of the literature of art (see IVA7). Reynolds was at the heart of a group which, in effect, constituted the component of the Enlightenment in England: Burke, Goldsmith, Gibbon, Garrick among others, and, first among equals, Samuel Johnson. These early papers took the form of Letters contributed to 'The Idler' in 1759. 'The Idler' was a weekly series of essays appearing every Saturday in the *Universal Chronicle*, the vast majority of them written by Johnson. The concept of the detached observer implicit in the title marks

an interesting prefiguration of the idea of the *flâneur*, which would come to play such an important role in the constitution of the mid-nineteenth century avant-garde (see *Art in Theory 1815–1900* IIID7, 8). The 'Idler' essays were Reynolds' first published literary works. He begins by disparaging a petty adherence to rules in art, both in making it and judging it, although Rule as such is not his target, merely its mechanical following. (His foolish connoisseur's invocation of a 'flowing line of grace and beauty' is assumed to have been a dig at Hogarth – see IIIB3.) In his second letter he again criticizes the mechanic aspect of art, this time with regard to Imitation, and emphasizes instead the need of Grand Style if painting is to maintain its place as a liberal art. The third letter is a meditation on beauty, which it defines as a product of generality rather than particularity (and thus celebrates the Italian school at the expense of the Dutch) while simultaneously conceding a measure of cultural relativity. The extracts are taken from the letters as reprinted in Reynolds' *Discourses*, edited with an introduction and notes by Pat Rogers, Harmondsworth: Penguin Classics, 1992, Appendix B, pp. 347–58.

The Idler Number 76 *Saturday, September 29 1759*

Sir,

I was much pleased with your ridicule of those shallow Criticks, whose judgement, though often right as far as it goes, yet reaches only to inferior beauties; and who, unable to comprehend the whole, judge only by parts, and from thence determine the merit of extensive works. But there is another kind of Critick still worse, who judges by narrow rules, and those too often false, and which though they should be true, and founded on nature, will lead him but a very little way towards the just estimation of the sublime beauties in works of Genius; for whatever part of an art can be executed or criticised by rules, that part is no longer the work of Genius, which implies excellence out of the reach of rules. For my own part, I profess myself an Idler, and love to give my judgement, such as it is, from my immediate perceptions, without much fatigue of thinking; and I am of opinion, that if a man has not those perceptions right, it will be vain for him to endeavour to supply their place by rules; which may enable him to talk more learnedly, but not to distinguish more acutely. Another reason which has lessened my affection for the study of Criticism is, that Criticks, so far as I have observed, debar themselves from receiving any pleasure from the polite arts, at the same time that they profess to love and admire them: for these rules being always uppermost, give them such a propensity to criticise, that instead of giving up the reins of their imagination into their author's hands, their frigid minds are employed in examining whether the performance be according to the rules of art.

To those who are resolved to be Criticks in spite of nature, and at the same time have no great disposition to much reading and study, I would recommend to assume the character of Connoisseur, which may be purchased at a much cheaper rate than that of a Critick in poetry. The remembrance of a few names of Painters, with their general characters, and a few rules of the Academy, which they may pick up among the Painters, will go a great way towards making a very notable Connoisseur.

With a Gentleman of this cast, I visited last week the Cartoons at Hampton-Court; he was just returned from Italy, a Connoisseur, of course, and of course his mouth

full of nothing but the Grace of Raffaelle, the Purity of Domenichino, the Learning of Poussin, the Air of Guido, the greatness of Taste of the Caraccis, and the Sublimity and grand Contorno of Michael Angelo; with all the rest of the cant of Criticism, which he emitted with that volubility which generally those orators have, who annex no ideas to their words.

As we were passing through the rooms, in our way to the Gallery, I made him observe a whole length of Charles the First, by Vandyck, as a perfect representation of the character as well as the figure of the man: He agreed it was very fine, but it wanted spirit and contrast, and had not the flowing line, without which a figure could not possibly be graceful. When we entered the Gallery, I thought I could perceive him recollecting his Rules by which he was to criticise Raffaelle. I shall pass over his observation of the boats being too little, and other criticisms of that kind, till we arrived at St *Paul preaching*. 'This,' says he, 'is esteemed the most excellent of all the Cartoons: what nobleness, what dignity there is in that figure of St Paul! and yet what an addition to that nobleness could Raffaelle have given, had the art of Contrast been known in his time; but above all, the flowing line, which constitutes Grace and Beauty. You would not then have seen an upright figure standing equally on both legs, and both hands stretched forward in the same direction, and his drapery, to all appearance, without the least art of disposition.' [. . .]

I shall trouble you no longer with my friend's observations, which, I suppose, you are now able to continue by yourself. It is curious to observe, that at the same time that great admiration is pretended for a name of fixed reputation, objections are raised against those very qualities by which that great name was acquired.

These Criticks are continually lamenting that Raffaelle had not the Colouring and Harmony of Rubens, or the Light and Shadow of Rembrandt, without considering how much the gay harmony of the former, and affectation of the latter, would take from the Dignity of Raffaelle; and yet Rubens had great Harmony, and Rembrandt understood Light and Shadow; but what may be an excellence in a lower class of Painting, becomes a blemish in a higher; as the quick, sprightly turn, which is the life and beauty of epigrammatick compositions, would but ill suit with the majesty of heroic Poetry.

To conclude; I would not be thought to infer from any thing that has been said, that Rules are absolutely unnecessary, but to censure scrupulosity, a servile attention to minute exactness, which is sometimes inconsistent with higher excellence, and is lost in the blaze of expanded genius. [. . .]

The Idler Number 79 *Saturday, October 20 1759*

Your acceptance of a former letter on Painting, gives me encouragement to offer a few more sketches on the same subject.

Amongst the Painters and the writers on Painting, there is one maxim universally admitted and continually inculcated. *Imitate Nature*, is the invariable rule; but I know none who have explained in what manner this rule is to be understood; the consequence of which is, that every one takes it in the most obvious sense, – that objects are represented naturally, when they have such relief that they seem real. It may appear strange, perhaps, to hear this sense of the rule disputed; but it must be

considered, that if the excellency of a Painter consisted only in this kind of imitation, Painting must lose its rank, and be no longer considered as a liberal art, and sister to Poetry; this imitation being merely mechanical, in which the slowest intellect is always sure to succeed best; for the Painter of genius cannot stoop to drudgery, in which the understanding has no part; and what pretence has the art to claim kindred with Poetry, but by its power over the imagination? To this power the Painter of genius directs his aim; in this sense he studies Nature, and often arrives at his end, even by being unnatural, in the confined sense of the word.

The grand style of Painting requires this minute attention to be carefully avoided, and must be kept as separate from it as the style of Poetry from that of History. Poetical ornaments destroy that air of truth and plainness which ought to characterise History; but the very being of Poetry consists in departing from this plain narration, and adopting every ornament that will warm the imagination. To desire to see the excellencies of each style united, to mingle the Dutch with the Italian School, is to join contrarieties which cannot subsist together, and which destroy the efficacy of each other. The Italian attends only to the invariable, the great and general ideas which are fixed and inherent in universal Nature; the Dutch, on the contrary, to literal truth and a minute exactness in the detail, as I may say, of Nature modified by accident. The attention to these petty peculiarities is the very cause of this naturalness so much admired in the Dutch pictures, which, if we suppose it to be a beauty, is certainly of a lower order, that ought to give place to a beauty of a superior kind, since one cannot be obtained but by departing from the other.

If my opinion were asked concerning the works of Michael Angelo, whether they would receive any advantage from possessing this mechanical merit, I should not scruple to say, they would lose, in a great measure, the effect which they now have on every mind susceptible of great and noble ideas. His works may be said to be all genius, and soul; and why should they be loaded with heavy matter, which can only counteract his purpose by retarding the progress of the imagination?

If this opinion should be thought one of the wild extravagances of enthusiasm, I shall only say, that those who censure it are not conversant in the works of the great Masters. It is very difficult to determine the exact degree of enthusiasm that the arts of Painting and Poetry may admit. There may perhaps be too great an indulgence, as well as too great a restraint of imagination; and if the one produces incoherent monsters, the other produces what is full as bad, lifeless insipidity. An intimate knowledge of the passions and good sense, but not common sense, must at last determine its limits. It has been thought, and I believe with reason, that Michael Angelo sometimes transgressed those limits; and I think I have seen figures by him, of which it was very difficult to determine, whether they were in the highest degree sublime or extremely ridiculous. Such faults may be said to be the ebullition of Genius; but at least he had this merit, that he never was insipid; and whatever passion his works may excite, they will always escape contempt.

What I have had under consideration is the sublimest style, particularly that of Michael Angelo, the Homer of Painting. Other kinds may admit of this naturalness, which of the lowest kind is the chief merit; but in Painting, as in Poetry, the highest style has the least of common nature. [. . .]

The Idler Number 82 *Saturday, November 10 1759*

Discoursing in my last letter on the different practice of the Italian and Dutch Painters, I observed that 'the Italian Painter attends only to the invariable, the great, and general ideas, which are fixed and inherent in universal nature.'

I was led into the subject of this letter by endeavouring to fix the original cause of this conduct of the Italian Masters. If it can be proved that by this choice they selected the most beautiful part of the creation, it will show how much their principles are founded on reason, and, at the same time, discover the origin of our ideas of beauty.

I suppose it will be easily granted, that no man can judge whether any animal be beautiful in its kind, or deformed, who has seen only one of that species; this is as conclusive in regard to the human figure; so that if a man, born blind, were to recover his sight, and the most beautiful woman were brought before him, he could not determine whether she was handsome or not; nor if the most beautiful and most deformed were produced, could he any better determine to which he should give the preference, having seen only those two. To distinguish beauty, then, implies the having seen many individuals of that species. If it is asked, how is more skill acquired by the observation of greater numbers? I answer, that, in consequence of having seen many, the power is acquired, even without seeking after it, of distinguishing between accidental blemishes and excrescences which are continually varying the surface of Nature's works, and the invariable general form which Nature most frequently produces, and always seems to intend in her productions.

Thus amongst the blades of grass or leaves of the same tree, though no two can be found exactly alike, the general form is invariable: a Naturalist, before he chose one as a sample, would examine many; since if he took the first that occurred, it might have, by accident or otherwise, such a form as that it would scarce be known to belong to that species; he selects as the Painter does, the most beautiful, that is, the most general form of nature.

Every species of the animal as well as the vegetable creation may be said to have a fixed or determinate form, towards which Nature is continually inclining, like various lines terminating in the centre; or it may be compared to pendulums vibrating in different directions over one central point: and as they all cross the centre, though only one passes through any other point, so it will be found that perfect beauty is oftener produced by nature than deformity; I do not mean than deformity in general, but than any one kind of deformity. To instance in a particular part of a feature; the line that forms a ridge of the nose is beautiful when it is straight; this then is the central form, which is oftener found than either concave, convex, or any other irregular form that shall be proposed. As we are then more accustomed to beauty than deformity, we may conclude that to be the reason why we approve and admire it, as we approve and admire customs and fashions of dress for no other reason than that we are used to them; so that though habit and custom cannot be said to be the cause of beauty, it is certainly the cause of our liking it; and I have no doubt but that if we were more used to deformity than beauty, deformity would then lose the idea now annexed to it, and take that of beauty: as if the whole world should

agree, that *yes* and *no* should change their meaning; *yes* would then deny, and *no* would affirm.

Whoever undertakes to proceed further in this argument, and endeavours to fix a general criterion of beauty respecting different species, or to show why one species is more beautiful than another, it will be required from him first to prove that one species is really more beautiful than another. That we prefer one to the other, and with very good reason, will be readily granted; but it does not follow from thence that we think it a more beautiful form; for we have no criterion of form by which to determine our judgement. He who says a swan is more beautiful than a dove, means little more than that he has more pleasure in seeing a swan than a dove, either from the stateliness of its motions, or its being a more rare bird; and he who gives the preference to the dove, does it from some association of ideas of innocence which he always annexes to the dove; but if he pretends to defend the preference he gives to one or the other by endeavouring to prove that this more beautiful form proceeds from a particular gradation of magnitude, undulation of a curve, or direction of a line, or whatever other conceit of his imagination he shall fix on, as a criterion of form, he will be continually contradicting himself, and find at last that the great Mother of Nature will not be subjected to such narrow rules. Among the various reasons why we prefer one part of her works to another, the most general, I believe, is habit and custom; custom makes, in a certain sense, white black, and black white; it is custom alone determines our preference of the colour of the Europeans to the Ethiopians, and they, for the same reason, prefer their own colour to ours. I suppose no body will doubt, if one of their Painters were to paint the Goddess of Beauty, but that he would represent her black, with thick lips, flat nose, and woolly hair; and, it seems to me, he would act very unnaturally if he did not: for by what criterion will any one dispute the propriety of his idea! We indeed say, that the form and colour of the European is preferable to that of the Ethiopian; but I know of no other reason we have for it, but that we are more accustomed to it. It is absurd to say, that beauty is possessed of attractive powers, which irresistibly seize the corresponding mind with love and admiration, since that argument is equally conclusive in favour of the white and the black philosophers.

The black and white nations must, in respect of beauty, be considered as of different kinds, at least a different species of the same kind; from one of which to the other, as I observed, no inference can be drawn.

Novelty is said to be one of the causes of beauty. That novelty is a very sufficient reason why we should admire, is not denied; but because it is uncommon, it is therefore beautiful? The beauty that is produced by colour, as when we prefer one bird to another, though of the same form, on account of its colour, has nothing to do with the argument, which reaches only to form. I have here considered the word Beauty as being properly applied to form alone. There is a necessity of fixing this confined sense; for there can be no argument, if the sense of the word is extended to every thing that is approved. A rose may as well be said to be beautiful, because it has a fine smell, as a bird because of its colour. When we apply the word Beauty, we do not mean always by it a more beautiful form, but something valuable on account of its rarity, usefulness, colour, or any other property. A horse is said to be a beautiful

animal; but had a horse as few good qualities as a tortoise, I do not imagine that he would then be deemed beautiful.

A fitness to the end proposed, is said to be another cause of beauty; but supposing we were proper judges of what form is the most proper in an animal to constitute strength or swiftness, we always determine concerning its beauty, before we exert our understanding to judge of his fitness.

From what has been said, it may be inferred, that the works of Nature, if we compare one species with another, are all equally beautiful, and that preference is given from custom or some association of ideas; and that, in creatures of the same species, beauty is the medium or centre of all its various forms.

To conclude, then, by way of corollary: if it has been proved that the Painter, by attending to the invariable and general ideas of Nature, produce beauty, he must, by regarding minute particularities, and accidental discriminations, deviate from the universal rule, and pollute his canvass with deformity.

10 Edward Young (1683–1765) from *Conjectures on Original Composition*

Young was a poet and dramatist as well as a writer on the arts. He was best known in his lifetime for the long poem he wrote on death, called *The Complaint, or Night Thoughts* (1742–5). He knew Samuel Johnson well, and was also a friend of Joshua Reynolds' father. His *Conjectures on Original Composition*, which had some success in Europe as well as England, were addressed to another of his literary friends, the novelist Samuel Richardson. The notion of originality was becoming fashionably controversial in the mid-eighteenth century. At this time, the unquestioning invocation of rules and decorum laid down in the Renaissance and Antiquity began to be moderated by the more individualistic spirit which would ultimately give rise to Romanticism. In some of his early *Discourses* Reynolds appears to take issue quite directly with Young's celebration of originality. The *Conjectures on Original Composition in a Letter to the Author of Sir Charles Grandison* [i.e. Richardson] were published in London in 1759. The selections are from the facsimile edition, Leeds: Scolar Press, 1966, pp. 9–13, 17–20, 48–56, 71–5.

[...] The mind of a man of Genius is a fertile and pleasant field, pleasant as Elysium, and fertile as Tempe; it enjoys a perpetual Spring. Of that Spring, Originals are the fairest Flowers: Imitations are of quicker growth, but fainter bloom. Imitations are of two kinds; one of Nature, one of Authors: The first we call Originals, and confine the term Imitation to the second. I shall not enter into the curious enquiry of what is, or is not, strictly speaking, Original, content with what all must allow, that some Compositions are more so than others; and the more they are so, I say, the better. Originals are, and ought to be, great Favourites, for they are great Benefactors; they extend the Republic of Letters, and add a new province to its dominion: Imitators only give us a sort of Duplicates of what we had, possibly much better, before; increasing the mere Drug of books, while all that makes them valuable, Knowlege and Genius, are at a stand. The pen of an Original Writer, like Armida's wand, out of a barren waste calls a blooming spring: Out of that blooming spring an Imitator is a

transplanter of Laurels, which sometimes die on removal, always languish in a foreign soil.

But suppose an Imitator to be most excellent (and such there are), yet still he but nobly builds on another's foundation; his Debt is, at least, equal to his Glory; which therefore, on the ballance, cannot be very great. On the contrary, an Original, tho' but indifferent (its Originality being set aside,) yet has something to boast; it is something to say with him in Horace,

Meo sum Pauper in œre;

['I am poor in money.']

and to share ambition with no less than Cæsar, who declared he had rather be the First in a Village, than the Second at Rome.

Still farther: An Imitator shares his crown, if he has one, with the chosen Object of his Imitation; an Original enjoys an undivided applause. An Original may be said to be of a vegetable nature; it rises spontaneously from the vital root of Genius; it grows, it is not made: Imitations are often a sort of Manufacture wrought up by those Mechanics, Art, and Labour, out of pre-existent materials not their own.

Again: We read Imitation with somewhat of his languor, who listens to a twice-told tale: Our spirits rouze at an Original; that is a perfect stranger, and all throng to learn what news from a foreign land: And tho' it comes, like an Indian Prince, adorned with feathers only, having little of weight; yet of our attention it will rob the more Solid, if not equally New: Thus every Telescope is lifted at a new-discovered star; it makes a hundred Astronomers in a moment, and denies equal notice to the sun. But if an Original, by being as excellent, as new, adds admiration to surprize, then are we at the Writer's mercy; on the strong wing of his Imagination, we are snatched from Britain to Italy, from Climate to Climate, from Pleasure to Pleasure; we have no Home, no Thought, of our own; till the Magician drops his Pen: And then falling down into ourselves, we awake to flat Realities, lamenting the change, like the Beggar who dreamt himself a Prince. [. . .]

But why are Originals so few? not because the Writer's harvest is over, the great Reapers of Antiquity having left nothing to be gleaned after them; nor because the human mind's teeming time is past, or because it is incapable of putting forth unprecedented births; but because illustrious Examples engross, prejudice, and intimidate. They engross our attention, and so prevent a due inspection of ourselves; they prejudice our Judgment in favour of their abilities, and so lessen the sense of our own; and they intimidate us with the splendor of their Renown, and thus under Diffidence bury our strength. Nature's Impossibilities, and those of Diffidence, lie wide asunder.

Let it not be suspected, that I would weakly insinuate any thing in favour of the Moderns, as compared with antient Authors; no, I am lamenting their great Inferiority. But I think it is no necessary Inferiority; that it is not from divine Destination, but from some cause far beneath the moon: I think that human Souls, thro' all periods, are equal; that due care, and exertion, would set us nearer our immortal Predecessors than we are at present; and he who questions and confutes this, will show abilities not a little tending toward a proof of that Equality, which he denies.

After all, the first Ancients had no Merit in being Originals: They could not be Imitators. Modern Writers have a Choice to make; and therefore have a Merit in their power. They may soar in the Regions of Liberty, or move in the soft Fetters of easy Imitation; and Imitation has as many plausible Reasons to urge, as Pleasure had to offer to Hercules. Hercules made the Choice of an Hero, and so became immortal.

Yet let not Assertors of Classic Excellence imagine, that I deny the Tribute it so well deserves. He that admires not antient Authors, betrays a secret he would conceal, and tells the world, that he does not understand them. Let us be as far from neglecting, as from copying, their admirable Compositions: Sacred be their Rights, and inviolable their Fame. Let our Understandings feed on theirs; they afford the noblest nourishment: But let them nourish, not annihilate, our own. When we read, let our Imagination kindle at their Charms; when we write, let our Judgment shut them out of our Thoughts; treat even Homer himself, as his royal Admirer was treated by the Cynic; bid him stand aside, nor shade our Composition from the beams of our own Genius; for nothing Original can rise, nothing Immortal can ripen, in any other Sun. [...]

As great, perhaps, greater than those mentioned (presumptuous as it may sound) may, possibly, arise; for who hath fathomed the mind of man? Its bounds are as unknown, as those of the creation; since the birth of which, perhaps, not One has so far exerted, as not to leave his Possibilities beyond his Attainments, his Powers beyond his Exploits. Forming our judgments, altogether by what has been done, without knowing, or at all inquiring, what possibly might have been done, we naturally enough fall into too mean an opinion of the human mind. If a sketch of the divine Iliad before Homer wrote, had been given to mankind, by some superior being, or otherwise, its execution would, probably, have appeared beyond the power of man. Now, to surpass it, we think impossible. As the First of these opinions would evidently have been a mistake, why may not the Second be so too? Both are founded on the same bottom; on our ignorance of the possible dimensions of the mind of man.

Nor are we only ignorant of the dimensions of the human mind in general, but even of our own. That a Man may be scarce less ignorant of his own powers, than an Oyster of its pearl, or a Rock of its diamond; that he may possess dormant, unsuspected abilities, till awakened by loud calls, or stung up by striking emergencies; is evident from the sudden eruption of some men, out of perfect obscurity, into publick admiration, on the strong impulse of some animating occasion; not more to the world's great surprize, than their own. Few authors of distinction but have experienced something of this nature, at the first beamings of their yet unsuspected Genius on their hitherto dark Composition: The writer starts at it, as at a lucid Meteor in the night; is much surprized; can scarce believe it true. During his happy confusion, it may be said to him, as to Eve at the Lake,

> *What there thou seest, fair creature*
> *is thyself.*
>
> Milt.

Genius, in this view, is like a dear Friend in our company under disguise; who, while we are lamenting his absence, drops his mask, striking us, at once, with equal surprize and joy. [...]

Since it is plain that men may be strangers to their own abilities; and by thinking meanly of them without just cause, may possibly lose a name, perhaps, a name immortal; I would find some means to prevent these Evils. Whatever promotes Virtue, promotes something more, and carries its good influence beyond the moral man: To prevent these evils, I borrow two golden rules from Ethics, which are no less golden in Composition, than in life. 1. Know thyself; 2dly, Reverence thyself. [...]

Therefore dive deep into thy bosom; learn the depth, extent, biass, and full fort of thy mind; contract full intimacy with the Stranger within thee; excite, and cherish every spark of Intellectual light and heat, however smothered under former negligence, or scattered through the dull, dark mass of common thoughts; and collecting them into a body, let thy Genius rise (if a Genius thou hast) as the sun from Chaos; and if I should then say, like an Indian, worship it, (though too bold) yet should I say little more than my second rule enjoins, (viz.) Reverence thyself.

That is, let not great Examples, or Authorities, browbeat thy Reason into too great a diffidence of thyself: Thyself so reverence as to prefer the native growth of thy own mind to the richest import from abroad; such borrowed riches make us poor. The man who thus reverences himself, will soon find the world's reverence to follow his own. His works will stand distinguished; his the sole Property of them; which Property alone can confer the noble title of an Author; [...]

This is the difference between those two Luminaries in Literature, the well-accomplished Scholar, and the divinely-inspired Enthusiast; the First is, as the bright morning star; the Second, as the rising sun. The writer who neglects those two rules above will never stand alone; he makes one of a group and thinks in wretched unanimity with the throng: Incumbered with the notions of others, and impoverished by their abundance, he conceives not the least embryo of new thought; opens not the least vista thro' the gloom of ordinary writers, into the bright walks of rare Imagination, and singular Design; while the true Genius is crossing all publick roads into fresh untrodden ground; he, up to the knees in Antiquity, is treading the sacred footsteps of great examples, with the blind veneration of a bigot saluting the papal toe; comfortably hoping full absolution for the sins of his own understanding, from the powerful charm of touching his idol's Infallibility.

Such meanness of mind, such prostration of our own powers, proceeds from too great admiration of others. Admiration has, generally, a degree of two very bad ingredients in it; of Ignorance, and of Fear; and does mischief in Composition, and in Life. [...]

If thoughts of this nature prevailed; if Antients and Moderns were no longer considered as masters and pupils, but as hard-match'd rivals for renown; then moderns, by the longevity of their labours, might, one day, become antients themselves: And old Time, that best weigher of merits, to keep his balance even, might have the golden weight of an Augustan age in both his scales: Or rather our scale might descend; and antiquity's (as a modern match for it strongly speaks) might kick the beam. [...]

What a rant, say you, is here? – I partly grant it: Yet, consider, my Friend! knowledge physical, mathematical, moral, and divine, increases; all arts and sciences are making considerable advance; with them, all the accommodations, ornaments,

delights, and glories of human life; and these are new food to the Genius of a polite writer; these are as the root, and composition, as the flower; and as the root spreads, and thrives, shall the flower fail? As well may a flower flourish, when the root is dead. It is Prudence to read, Genius to relish, Glory to surpass, antient authors; and Wisdom to try our strength in an attempt in which it would be no great dishonour to fail.

11 Charles François Tiphaigne de la Roche (1722–1774) from *Giphantia*

Tiphaigne de la Roche was a French doctor and author who wrote a number of scientific treatises as well as several novels. His fantastic tale *Giphantie* was published in Paris in 1760 (though the title-page says Babylon, a frequent ploy to evade censorship). It was translated into English the following year as *Giphantia. Giphantie*, which is an anagram of the author's own name, purports to be the memoirs of a traveller who journeys through the world, passing through many strange lands and observing their inhabitants (not unlike Swift's Gulliver, whose *Travels* were published in 1726). Giphantia itself was a fertile island in the desert 'given to the elementary spirits the day before the Garden of Eden was allotted to the parent of mankind' (p. 15). The Prefect of Giphantia conducts the author on a tour of the country and provides him with a magical rod and a mirror which enable him to see into every part of the world. He is then taken down a flight of stairs and along a tunnel before being brought into the light again. What follows amounts to a remarkable imaginative anticipation of the process of photography, almost eighty years before it was actually realized (see also VIIA5). We reprint chapter XVII, 'The Storm' from *Giphantia: or A View of What has Passed, What is now Passing, and, during the Present Century, what Will Pass in the World*, London: Robert Horsfield, 1761, pp. 93–8.

Some paces from the noisy globe, the earth is hollowed, and there appears a descent of forty or fifty steps of turf; at the foot of which there is a beaten subterraneous path. We went in; and my guide, after leading me through several dark turnings, brought me at last to the light again.

He conducted me into a hall of a middling size, and not much adorned, where I was struck with a sight that raised my astonishment. I saw, out of a window, a sea which seemed to me to be about a quarter of a mile distant. The air, full of clouds, transmitted only that pale light which forebodes a storm: the raging sea ran mountains high, and the shore was whitened with the foam of the billows which broke on the beach.

By what miracle (said I to myself) has the air, serene a moment ago, been so suddenly obscured? By what miracle do I see the ocean in the center of Africa? Upon saying these words, I hastily ran to convince my eyes of so improbable a thing. But in trying to put my head out of the window, I knocked it against something that felt like a wall. Stunned with the blow, and still more with so many mysteries, I drew back a few paces.

Thy hurry (said the Prefect) occasions thy mistake. That window, that vast horizon, those thick clouds, that raging sea, are all but a picture.

From one astonishment I fell into another: I drew near with fresh haste; my eyes were still deceived, and my hand could hardly convince me that a picture should have caused such an illusion.

The elementary spirits (continued the Prefect) are not so able painters as naturalists; thou shalt judge by their way of working. Thou knowest that the rays of light, reflected from different bodies, make a picture and paint the bodies upon all polished surfaces, on the retina of the eye, for instance, on water, on glass. The elementary spirits have studied to fix these transient images: they have composed a most subtile matter, very viscous, and proper to harden and dry, by the help of which a picture is made in the twinkle of an eye. They do cover with this matter a piece of canvas, and hold it before the objects they have a mind to paint. The first effect of the canvas is that of a mirrour; there are seen upon it all the bodies far and near, whose image the light can transmit. But what the glass cannot do, the canvas, by means of the viscous matter, retains the images. The mirrour shows the objects exactly; but keeps none; our canvases show them with the same exactness, and retains them all. This impression of the images is made the first instant they are received on the canvas, which is immediately carried away into some dark place; an hour after, the subtile matter dries, and you have a picture so much the more valuable, as it cannot be imitated by art nor damaged by time. We take, in their purest source, in the luminous bodies, the colours which painters extract from different materials, and which time never fails to alter. The justness of the design, the truth of the expression, the gradation of the shades, the stronger or weaker strokes, the rules of perspective, all these we leave to nature, who, with a sure and never-erring hand, draws upon our canvases images which deceive the eye and make reason to doubt, whether, what are called real objects, are not phantoms which impose upon the sight, the hearing, the feeling, and all the senses at once.

The Prefect then entered into some physical discussions, first, on the nature of the glutinous substance which intercepted and retained the rays; secondly, upon the difficulties of preparing and using it; thirdly, upon the struggle between the rays of light and the dried substance; three problems, which I propose to the naturalists of our days, and leave to their sagacity.

Mean while, I could not take off my eyes from the picture. A sensible spectator, who from the shore beholds a tempestuous sea, feels not more lively impressions: such images are equivalent to the things themselves.[. . .]

12 Johann Georg Hamann (1730–1788) *from Aesthetica in nuce*

Hamann cut a strange figure in the Age of Reason, significantly at odds with most of his contemporaries in the German Enlightenment. Born and educated at Königsberg in East Prussia, he was based there again from 1759 onwards. But in between there occurred the decisive spiritual event of his life. He worked in commerce after university, and in 1757 went on a business trip to London. A worldly period there was interrupted by religious conversion to a mystical kind of Christianity, and it was this that gave his subsequent writing its distinctive character. These writings include esoteric linguistics (*Crusades of the Philologist* 1762) and an attack on the work of Kant (*Metacritique on the Purism of Reason*

1781). *Aesthetica in nuce* (Aesthetics in a Nutshell), his principal statement on poetry and literature, appeared in 1762, with the subtitle 'A rhapsody in cabbalistic prose'. Opposed to the dominance of Reason during the Enlightenment period, he emphasized the dimension of the pre-rational, the senses and the emotions: qualities which made him an influential figure upon the *Sturm und Drang* movement, and latterly on the German Romantics. Hamann adopted a dense, elliptical, deliberately non-rationalistic style, the opacity of which does not seem to have impeded his impact on the Romantic generation, though it acts as an undeniable obstacle to any subsequent non-specialist appreciation of his work. The short passages selected here demonstrate his claims for poetry and the language of the emotions over rationalistic, scientific analysis and the pretensions of academic learning. Elsewhere in the text, Hamann attacks Winckelmann and Lessing, but in the present selection the particular target of his criticism is Voltaire, and the effects of the French Enlightenment in general. Our selection is taken from 'Aesthetica in nuce', translated by Joyce P. Crick, in *German Aesthetic and Literary Criticism: Winckelmann, Lessing, Hamann, Herder, Schiller, Goethe*, edited and introduced by H. B. Nisbet, Cambridge and London: Cambridge University Press, 1985, pp. 140–50; our extracts are taken from pp. 141 and 144–7. We have retained six of the editor's explanatory footnotes.

Poetry is the mother-tongue of the human race; even as the garden is older than the ploughed field, painting than script; as song is more ancient than declamation; parables older than reasoning; barter than trade. A deep sleep was the repose of our farthest ancestors; and their movement a frenzied dance. Seven days they would sit in the silence of deep thought or wonder; – and would open their mouths to utter winged sentences.

The senses and passions speak and understand nothing but images. The entire store of human knowledge and happiness consists in images. [. . .]

Bacon represented mythology as a winged boy of Aeolus, the sun at his back, and with clouds for his footstool, fleeting away the time piping on a Grecian flute.

But Voltaire, High Priest in the Temple of Taste, can draw conclusions as compellingly as Caiaphas, and thinks more fruitfully than Herod. For if our theology is not worth as much as mythology, then it is simply impossible for us to match the poetry of the Heathens, let alone excel it[1] – which would be most appropriate to our duty and to our vanity. But if our poetry is worthless, our history will look leaner than Pharaoh's kine; but fairy-tales and court gazettes will take the place of our historians. And it is not worth the trouble of thinking of philosophy; all the more systematic calendars instead! – more than spider-webs in a ruined castle. Every idle fellow who can just about manage dog-Latin or Switzer-German, but whose name is stamped by the whole number M or half the number of the academic beast[2] is a blatant liar, and the benches and the clods sitting on them would have to cry 'outrage!' if the former only had ears, and the latter, ironically called listeners, only exercised their ears to listen with [. . .]

Nature works through the senses and the passions. But whoso maims these instruments, how can he feel? Are crippled sinews fit for movement?

Your lying, murderous philosophy has cleared Nature out of the way, and why do you demand that we should imitate her? – So that you can renew the pleasure by murdering the young students of Nature too.

Verily, you delicate critics of art, go on asking what is truth, and make for the door, because you cannot wait for an answer to this question. Your hands are always washed, whether you are about to eat bread, or whether you have just pronounced a death-sentence. Do you not also ask: what means did you employ to clear Nature out of the way? Bacon accuses you of flaying her with your abstractions. If Bacon is a witness to the truth, well then, stone him – and cast clods of earth or snowballs at his shade ——

If one single truth, like the sun, prevaileth, it is day. But if you behold instead of this One truth, as many as the sands of the seashore; and here close by, a little light which excels in brightness a whole host of suns; that is a night beloved of poets and thieves. The poet at the beginning of days is the same as the thief at the end of days.

All the colours of the most beautiful world grow pale if once you extinguish that light, the firstborn of Creation. If the belly is your god, then even the hairs on your head are under his guardianship. Every created thing becomes alternately your sacrifice and your idol. Cast down against its will, but hoping still, it groans beneath your yoke, or at your vanity; it does its best to escape your tyranny, and longs even in the most passionate embrace for that freedom with which the beasts paid Adam homage, when GOD brought them unto man to see what he would call them; for whatsoever man would call them, that was the name thereof.

This analogy of man to the Creator endows all creatures with their imprint and their stamp, on which faithfulness and faith in all Nature depends. The more vividly this idea of the image of the invisible GOD dwells in our heart, the more able we are to perceive his loving-kindness in his creatures; and to taste, and see it and grasp it with our hands. Every impression of Nature in man is not only a memorial, but also a warrant of fundamental truth: who is the LORD. Every counter-effect of man in GOD's created world is charter and seal that we partake of the divine nature, and that we are his offspring.

Oh for a muse like a refiner's fire, and like a fuller's soap!—She will dare to purify the natural use of the senses from the unnatural use of abstractions, which distorts our concepts of things, even as it suppresses the name of the Creator and blasphemes against Him. [. . .] Behold, the scribes of worldly wisdom, great and small, have overwhelmed the text of Nature, like the Great Flood. Were not all its beauties and riches bound to turn into water? But you perform far greater miracles than ever delighted the gods, with oak-trees and pillars of salt, with petrifactions, alchemical transformations and fables, to convince the human race. You make Nature blind, that she might be your guide! Or rather, you have with your Epicureanism[3] put out the light of your own eyes, that you might be taken for prophets who spin your inspirations and expositions out of your own heads. Oh, you would have dominion over Nature, and you bind your own hands and feet with your Stoicism,[4] that you may warble all the more movingly in your Poetic Miscellanies at the diamond fetters of fate.

If the passions are limbs of dishonour, do they therefore cease to be weapons of virility? Have you a wiser understanding of the letter of reason than that allegorical chamberlain of the Alexandrian Church had of the letter of the

Scriptures when he castrated himself in order to reach heaven?[5] The prince of this aeon takes his favourites from among the greatest offenders against themselves; his court fools are the worst enemies of Nature in her beauty; true, she has Corybants and Gauls as her pot-bellied priests, but *esprits forts* as her true worshippers.[6] [. . .]

Why should I paraphrase *one* word for you with an infinity of them, you readers whose estate, honour, and dignity make you so ignorant? For they can observe for themselves the phenomena of passion everywhere in human society; even as everything, however remote, can touch our hearts in a particular direction; even as each individual feeling extends over the range of all external objects; even as we can make the most general instances our own by applying them to ourselves personally, and expand any private circumstance into the public spectacle of heaven and earth. Each individual truth grows into the foundation of a design more miraculously than the fabled cow-hide grew into the extent of a state, and a plan greater than the hemisphere comes together in the focus of perception. In short, the perfection of the design, the strength of the execution – the conception and birth of new ideas and new expressions – the labour and the rest of the wise man, the consolation and the loathing he finds in them, lie hidden from our senses in the fruitful womb of the passions. [. . .]

1 A reference to the *querelle des anciens et des modernes*.
2 Typically oblique reference to the academic degrees of Master (M) and Doctor (D, the Roman numeral for 500, and half of M or 1,000).
3 A reference to such secular philosophers and freethinkers of the Enlightenment as Gassendi, La Mettrie, and Frederick the Great (who much admired the Epicurean philosophy of Lucretius).
4 A reference to modern scientific determinism, as a counterpart to the determinism of the ancient Stoics.
5 An allusion to Matthew 19:12 and to the Church Father Origen ($c.185$–$c.254$), who castrated himself for the sake of religion.
6 The 'prince of this aeon' is Frederick the Great; the 'court fools', 'Gauls', and *esprits forts* are the French freethinkers (La Mettrie, Voltaire, etc.) with whom Frederick associated.

13 Anton Raphael Mengs (1728–1779) from *Reflections upon Beauty and Taste in Painting*

Mengs was born in Bohemia, and his childhood was spent in Dresden. By the age of 21 he had already had two extended stays in Italy, his first between the ages of 12 and 16. He studied antique and Renaissance works, and back in Dresden in the early 1750s, built a career as a portraitist. One of the formative moments of his career came in 1755, when he met Winckelmann, while on a third trip to Rome. Winckelmann profoundly influenced Mengs' views on Antiquity and the theory of art, and for his part, believed the painter to be 'the greatest artist of his own and probably of the coming age also . . . like a phoenix new-born out of the ashes of the first Raphael' (Winckelmann, 1968, p. 297). Mengs' artistic reputation has not survived as high as this, but in his day he was regarded as one of the foremost painters in Europe. In the second half of the 1750s he was in Rome and Naples, where he undertook major mural commissions as well as portraits of the royal family. In 1761 he was summoned by Charles III to the court in Madrid (see IVA4). His most extended work of art theory was composed around this time in the form of a handbook for painters,

the *Gedanken über die Schönheit und über den Geschmack in der Malerei*, dedicated to Winckelmann and published in Zurich in 1762. Mengs argues that beauty is a visible manifestation of perfection. Since true perfection is divine and cannot be found in nature or mankind, neither can beauty in its fullest sense. However, despite the fact that art's supposed business is to imitate nature, it can surpass it in respect of beauty by synthesizing particulars into an ideal. Perhaps the most interesting implication of Mengs' argument is that the purpose of art lies not in the fidelity of imitation as such, but in the achievement of this harmonious ordering of pictorial elements, akin to words in a poem or sounds in a musical composition. Our extracts are taken from the English translation, published as *Reflections upon Beauty and Taste in Painting* in *The Works of Anthony Raphael Mengs*, by the Chevalier Don Joseph Nicholas D'Azara, London: R. Faulder 1796, pp. 7 and 14–25.

Explanation of beauty.

Since perfection is not allotted to mankind, and is only to be found in God, and as nothing is comprehensible to our nature except that which falls under the conviction of the senses; thus the Omnipotent has thought fit to imprint a visible idea of that perfection, which is what we call beauty.

This Beauty is found in all things, whenever our ideas and intellectual senses cannot carry the imagination beyond the perfection which we behold in the thing created.[...]

The effects of beauty.

Beauty consists in the perfection of matter according to our ideas. Since God alone is perfect, Beauty is for that reason a thing divine. The more beautiful a thing is, the more it is animated. Beauty is the soul of matter. As the soul of man is the cause of his being, thus also is Beauty the soul of figures; and that which is not beautiful is like death in man. This Beauty has a power which delights and enchants; and being of a spirit, moves the soul of man, encreases, if we may so say, its strength, and makes it in some moments forget that it is confined within the narrow centre of the body. From this is derived the attractive power of Beauty. As soon as the eye beholds a beautiful object, the soul is awakened, and wishes to unite itself with it; man therefore seeks to approach, and accost it. Beauty transports the senses of man beyond what is human: all is changed and in commotion in him; so much so, that if the enthusiasm is of some duration he falls silently into a kind of sadness: then it is that the soul of man is no more than the mere appearance of perfection.

Nature has for that reason produced many gradations of Beauty, in order to hold the human spirit, by the variety, in equal and continued commotion. Beauty attracts every one, because its power is uniform, and sympathetic with the soul of man. He who seeks it, finds it in every thing and every where, since it is the light of all matter, and the similitude of the same Divinity.

It would be possible to find perfection in nature, although it is not found there.

Although Beauty is never found in Nature in a degree truly perfect, one ought not therefore to believe, that properly it is not there to be found, and that to wish to imitate it one has to transgress the laws of truth. Nature has made all things in such a manner, that every thing may be perfect according to its destiny; but since perfection participates so much of Divinity, for that reason few things in Nature are found perfect, and many things imperfect. The perfect is that which one sees full of reason; and since each figure has only one centre, or middle point, thus has also all Nature, in every kind, one only centre, in which is contained all the perfection of its circumference. The Centre is a sole point, and in the circumference of the figure it comprehends an infinity of points, which are all imperfect in comparison to that of the centre. As among stones, one only kind is perfect, which is the diamond, among all metals only gold, and among animated creatures here below is man alone; thus there is likewise a distinction in each species apart, and few are those which are truly perfect. Since man does not originate of himself, but depends first to see the light, and then to take his form from extraneous accidents, thus it is almost impossible that he should be perfectly beautiful. That man is scarce ever to be found who is not subject to passions, which, in a lesser or greater degree affect his being; nor is there to be found one who has not his predilectual, and predominant affections. The human body has all these affections, and passions, in different parts, on which they operate and influence particularly. The same happens in women, who, scarce gravid, are tormented and oppressed by their passions and affections, even to the injury of their health, and that of the infant which they bear; from whence the soul of the embryo is not at liberty to finish the formation of its body to perfection; for if it could operate without impediment, it would form the body certainly perfect, and in consequence beautiful. This is the motive by which, from the beauty and body of a person one judges of his strength, and of the quality of his spirit, forming easily a good opinion of him who is beautiful and well made; but because the soul is thus impeded in the womb, we see but few persons born beautiful. What contributes besides to this is, the diversity of people, of climate, of passions, and of vices which predominate in different countries, and are the cause why entire nations are distinguishable by their aspect. To prove that we should otherwise find man a perfect Beauty is deducted from this, that almost every one has some parts of his body beautiful, and these parts are more conformable than the others to the utility and object of the whole structure. Man therefore would be beautiful, if the accidents which are natural to him did not spoil him. I speak of man in being the part of all Nature, in which, more than in any other appears true Beauty.

Art can surpass nature in beauty.

The Art of painting is said to be an imitation of Nature; from whence it appears, that in its perfection it ought to be inferior to it; but this subsists conditionally. There are things in Nature which Art cannot entirely imitate, and where the one appears feeble

and weak in comparison to the other, as, for instance, in imitating light or darkness. To the contrary Art has one thing very important, in which it by far surpasses Nature, which is in Beauty. Nature, in its productions, is subject to a variety of accidents; Art therefore operates freely, since it avails itself of materials entirely flexible, and which nothing resists. The Art of Painting is, to choose of all the subjects of Nature, the most beautiful, gathering, and placing together the materials of different places, and the beauty of various persons: to the contrary, for instance, Nature, to form man, is constrained to take the material part of the mother only, subject to all its accidents; from whence it is visible that a portrait might be more beautiful than man in Nature. Whenever is there found united in one man, greatness of soul, harmony and proportion of the body; a virtuous mind, and members pliant and robust? And what man finds himself in such a perfect state of health, as never to be agrieved by his occupations, employments, and pursuits? But in Painting, one can unite and express every good quality of him: it is sufficient to observe, and to express, exactness in the design, grandeur in the figure, ease in the posture, beauty in the members, force in the breast, agility in the legs, strength in the shoulders and arms, sincerity on the front and brow, prudence in the eyes, health on the cheek, and grace and loveliness on the lips; carrying itself thus throughout all the parts, from the greatest to the smallest, as much in the figure of man, as in that of woman, and by adapting these modifications according to the diversity of their aspects and expressions, one may see that Art can easily surpass Nature; for since no flower produces honey from every part, the Bee visits that only from which it can extract the richest sweets; thus can also the skilful painter gather from all the creation the best and most beautiful parts of nature, and produce by this Artifice the greatest expression and sweetness.

That by a good choice one may meliorate the things in Nature, becomes clear from the two charming and agreeable arts of Poetry and Music. The latter of which is not more than a collection of all the tones which are found in Nature, put in measure, and which from a good choice receives a motive, and acquires a spirit capable of moving the soul of man; and this spirit is called Harmony. Thus, therefore, Poetry is no more than the ordinary discourse of men; by whom is put in measured order, first the sentiments, and then the words; and by a choice of the most sonorous and grateful of these and by means of a kind of harmony, is found the measure of the syllable. Then, since Music and Poetry have a force infinitely greater than that of tones and words mixed together without any order, thus, therefore, Painting, worthy sister of the same Arts, receives from the order in which it is placed, and from the good choice which refuses that which is superfluous, and insignificant, an additional force, or one might say its whole being. [. . .]

This is what I have wished to say of Beauty, which is therefore the formed and visible perfection of Matter; because absolute perfection is a spirit invisible. The perfection of Matter consists in its conformity with our ideas, the which likewise consist in the cognition of its destiny. A thing is perfect when it expresses an idea conformable to itself. Perfections are distributed in Nature like so many offices. That thing which is most capable, and best adapted to fill its office, is in its kind the most perfect; for this reason also, that which is ugly sometimes becomes beautiful on account of the character it represents. That thing which has only one motive

conformable to its being, is of a higher rank of Beauty than that which has more spirit, and is more sublime than that which has more matter. The spiritual has the power to administer its perfection to the material, which can receive it. It is therefore necessary that the virtuoso who would wish to produce any thing beautiful, should propose to rise gradually from matter; to attempt nothing without reason, nothing superflous, and nothing which is lifeless, or without expression, since that destroys every thing in which it enters: his genius ought to seek to give perfection to matter, by means of a good choice. Genius is the Reason of Painters: this Reason ought to have an empire over Matter, and its principal diligence ought to be to determine the motives of things, and to follow in an entire work one principal motive, so that it may appear one motive only, the which should be distributed even in the smallest parts of matter. It is then necessary that he chooses the best adapted parts of Nature, to render clear and intelligible his idea to those who view it. As nature has distributed her perfections in different degrees, thus ought likewise the painter in giving different things their significations, apply different expressions; but all should be directed towards the principle signification; then the spectator distinguishes in each the idea, and in the whole together the motive of the work, which he will praise as perfect, when the quality of the materials of each part is conformable to his ideas; then it is that his affection will be moved by the beauty which appears in all its parts; because each part, having its motive and spirit, all the work will be full of it, and for that reason will please, and will have the highest degree of perfection.

As the Creator of Nature has given a perfection to every thing, and has made all Nature to appear beautiful, admirable, and worthy of him; thus ought also the painter to apply, and leave in each expression, and from each little stroke of the pencil, a countersign of his genius and wisdom, to the end that his work may be ever esteemed as worthy of a rational being.

14 Voltaire (François-Marie Arouet, 1694–1778) 'Beautiful, beauty' from *Philosophical Dictionary*

Voltaire's definition of the beautiful is taken from his characteristically sceptical *Dictionnaire philosophique*, published in Paris in 1764. His argument that beauty is ever in the eye of the beholder is presented as a caution against lengthy metaphysical speculations and universal aesthetic theories. He may also have intended a reference to Diderot's article 'Beau' (Beauty), widely acclaimed in 1752 on its publication in the second volume of the *Encyclopédie*, and subsequently reprinted in separate form as 'Traité du beau' (1772). The following translation has been made for the present volume by Katerina Deligiorgi from the reprint of the *Dictionnaire philosophique* in *Les Oeuvres complètes de Voltaire*, vol. 35, Oxford: Voltaire Foundation, 1994, pp. 407–10. (For previous material on Voltaire, see IIIB8.)

Beautiful, Beauty

Ask a toad what is beauty, the greatly beautiful, the *to kalon*? He will reply that it is a female toad with two big round eyes coming out of its little head, a large flat mouth, a

yellow belly and a brown back. Ask a Negro from Guinea and for him the beautiful is oily black skin, deep-set eyes and a broad nose.

Ask the devil and he will tell you that the beautiful is a pair of horns, four claws and a tail. Ask, finally, the philosophers and they will reply with a torrent of abstraction; they seek something conforming with the archetypal essence of the beautiful, with the *to kalon*.

One day I was watching a tragedy in the company of a philosopher. He was saying: 'How beautiful that is!' 'What do you find beautiful in it?' I asked. 'The fact that the author has attained his aim,' he replied. The following day, he took some medicine which did him a great deal of good. 'It has attained its aim,' I said, 'What a beautiful medicine!' He understood that we cannot call a medicine beautiful and that in order to give something this name it must produce in us a feeling of admiration and pleasure. He agreed that the tragedy had inspired in him these two feelings and that therein lies the *to kalon*, the beautiful.

On a trip to England, we saw a performance of the same play, perfectly translated: it made everybody in the audience yawn. 'Oh!' he said, 'The *to kalon* is not the same for the English and the French.' After considerable reflection, he concluded that the beautiful is often very relative, just as what is decent in Japan is indecent in Rome and what is fashionable in Paris is not in Peking. Thus he saved himself the trouble of having to compose a long treatise on the beautiful.

15 Thomas Reid (1710–1796) 'Of Taste' from *Essays on the Intellectual Powers of Man*

Born in Kincardineshire in central Scotland, Reid went on to study philosophy at Aberdeen University. For over a decade he was a Presbyterian minister before taking up academic posts, first in Aberdeen, and later as Professor of Moral Philosophy at the University of Glasgow. His main enterprise was to discover a way out of the consequences of Hume's scepticism, which he achieved through a reliance on common sense and the suppositions implied by our ordinary use of language: a position which has won favour in twentieth-century Anglo-American philosophy. His *Essays on the Intellectual Powers of Man* were first published in 1785. The long essay 'Of Taste' discussed, among other things, 'Novelty', 'Grandeur' and 'Beauty'; the present extracts are taken from the first section, 'Of Taste in General'. In conformity with his wider philosophical position, Reid appeals to our ordinary use of language to argue that beauty is a property of the objects we ascribe it to, and not a mere feature of the subjective workings of the mind. Hence Taste, the faculty of mind with which we apprehend beauty, also has an objective aspect: it can be true or false, accurate or misguided. In contrast to Ramsay (see IIIB4), Reid conceives of taste as a matter of judgement, and not as distinct from it. Our selection has been made from 'Of Taste' as reprinted in the expanded edition of Reid's writings, *Essays on the Powers of the Human Mind*, 3 volumes, Edinburgh: Bell & Bradfute, 1803, pp. 495–567. Our extracts are from pp. 495–6, 500–4.

That power of the mind by which we are capable of discerning and relishing the beauties of Nature, and whatever is excellent in the fine arts, is called *taste*.

The external sense of taste, by which we distinguish and relish the various kinds of food, has given occasion to a metaphorical application of its name to this internal power of the mind, by which we perceive what is beautiful, and what is deformed or defective in the various objects that we contemplate.

Like the taste of the palate, it relishes some things, is disgusted with others; with regard to many, is indifferent or dubious, and is considerably influenced by habit, by associations, and by opinion. These obvious analogies between external and internal taste, have led men, in all ages, and in all or most polished languages, to give the name of the external sense to this power of discerning what is beautiful with pleasure, and what is ugly and faulty in its kind with disgust. [...]

The taste of the palate may be accounted most just and perfect, when we relish the things that are fit for the nourishment of the body, and are disgusted with things of a contrary nature. The manifest intention of Nature in giving us this sense, is, that we may discern what it is fit for us to eat and to drink, and what it is not. Brute animals are directed in the choice of their food merely by their taste. Led by this guide, they choose the food that Nature intended for them, and seldom make mistakes, unless they be pinched by hunger, or deceived by artificial compositions. In infants likewise the taste is commonly sound and uncorrupted, and of the simple productions of Nature they relish the things that are most wholesome.

In like manner, our internal taste ought to be accounted most just and perfect, when we are pleased with things that are most excellent in their kind, and displeased with the contrary. The intention of Nature is no less evident in this internal taste than in the external. Every excellence has a real beauty and charm that makes it an agreeable object to those who have the faculty of discerning its beauty; and this faculty is what we call a good taste.

A man, who, by any disorder in his mental powers, or by bad habits, has contracted a relish for what has no real excellence, or what is deformed and defective, has a depraved taste, like one who finds a more agreeable relish in ashes or cinders than in the most wholesome food. As we must acknowledge the taste of the palate to be depraved in this case, there is the same reason to think the taste of the mind depraved in the other.

There is therefore a just and rational taste, and there is a depraved and corrupted taste. For it is too evident, that, by bad education, bad habits, and wrong associations, men may acquire a relish for nastiness, for rudeness, and ill breeding, and for many other deformities. To say that such a taste is not vitiated, is no less absurd than to say, that the sickly girl who delights in eating charcoal and tobacco-pipes, has as just and natural a taste as when she is in perfect health.

The force of custom, of fancy, and of casual associations, is very great both upon the external and internal taste. An Esquimaux can regale himself with a draught of whale-oil, and a Canadian can feast upon a dog. A Kamschatkadale lives upon putrid fish, and is sometimes reduced to eat the bark of trees. The taste of rum, or of green tea, is at first as nauseous as that of ipecacuanha, to some persons, who may be brought by use to relish what they once found so disagreeable.

When we see such varieties in the taste of the palate produced by custom and associations, and some perhaps by constitution, we may be the less surprised that the same causes should produce like varieties in the taste of beauty; that the African

should esteem thick lips and a flat nose; that other nations should draw out their ears, till they hang over their shoulders; that in one nation ladies should paint their faces, and in another should make them shine with grease.

Those who conceive that there is no standard in nature by which taste may be regulated, and that the common proverb, *That there ought to be no dispute about taste*, is to be taken in the utmost latitude, go upon slender and insufficient ground. The same arguments might be used with equal force against any standard of truth.

Whole nations by the force of prejudice are brought to believe the grossest absurdities; and why should it be thought that the taste is less capable of being perverted than the judgment? It must indeed be acknowledged, that men differ more in the faculty of taste than in what we commonly call judgment; and therefore it may be expected that they should be more liable to have their taste corrupted in matters of beauty and deformity, than their judgment in matters of truth and error.

If we make due allowance for this, we shall see that it is as easy to account for the variety of tastes, though there be in nature a standard of true beauty, and consequently of good taste; as it is to account for the variety and contrariety of opinions, though there be in nature a standard of truth, and consequently of right judgment.

Nay, if we speak accurately and strictly, we shall find, that, in every operation of taste, there is judgment implied.

When a man pronounces a poem or a palace to be beautiful, he affirms something of that poem or that palace; and every affirmation or denial expresses judgment. For we cannot better define judgment, than by saying that it is an affirmation or denial of one thing concerning another. I had occasion to show, when treating of judgment, that it is implied in every perception of our external senses. There is an immediate conviction and belief of the existence of the quality perceived, whether it be colour, or sound, or figure; and the same thing holds in the perception of beauty or deformity.

If it be said that the perception of beauty is merely a feeling in the mind that perceives, without any belief of excellence in the object, the necessary consequence of this opinion is, that when I say Virgil's Georgics is a beautiful poem, I mean not to say any thing of the poem, but only something concerning myself and my feelings. Why should I use a language that expresses the contrary of what I mean?

My language, according to the necessary rules of construction, can bear no other meaning but this, that there is something in the poem, and not in me, which I call beauty. Even those who hold beauty to be merely a feeling in the person that perceives it, find themselves under a necessity of expressing themselves, as if beauty were solely a quality of the object, and not of the percipient.

No reason can be given why all mankind should express themselves thus, but that they believe what they say. It is therefore contrary to the universal sense of mankind, expressed by their language, that beauty is not really in the object, but is merely a feeling in the person who is said to perceive it. Philosophers should be very cautious in opposing the common sense of mankind; for, when they do, they rarely miss going wrong.

III C
The Practice of Criticism

1 Etienne La Font de Saint-Yenne (1688–1771) from *Reflections on some Causes of the Present State of Painting in France*

La Font was a courtier who had been a member of the Academy in Lyons before coming to Paris. Apart from some work on designs for tapestries, his experience of art was that of an amateur. He had seen collections of art in Flanders and Holland and had been friendly with the painter François Lemoyne while at Versailles between 1729 and 1737. However he may have been prompted, he had formed strong views on the current state of French painting. He believed there had been a decline in civic standards and in public life, and he saw the arts as implicated. The platform he chose for the expression of these views was an extensive review of the 1746 Salon, published the following year. This was a remarkable publication in several respects. The first was in claiming the right of the amateur critic to intervene in a debate about the maintenance of standards which the professionals of the Académie Royale had conducted as a virtual monopoly for the past century. The second was in doing so in the name of the public (albeit the public La Font had in mind would not have extended far down the social ladder). The third was in levelling an accusation of decadence at the painters of his own time, whose work he compared unfavourably with the art of the Old Masters and of the seventeenth century. And finally La Font's publication was remarkable in the explanation offered for this decadence. Serious painting had been displaced from the walls of the fashionable by a vogue for mirrors and rococo plasterwork. This was the unkindest cut of all, for it implied that the remedy was out of the painters' own hands. In effect he was looking not simply for a return to previous standards on the part of the painters themselves, but for a redirection in the relationship between painting and public life, which would have to come from the state. Among other recommendations, he suggested that the Louvre should be opened as a public picture gallery where the royal collections could be displayed for the benefit of young artists and for the education of amateurs. Two years later, in a text with the telling title, *L'Ombre du grand Colbert*, he expressed his dismay at the condition into which the Louvre had been allowed to decline. La Font's *Reflections* had two immediate consequences. The first was to provoke further publications, some written in defence of the Academy and of judgements approved by the state (see IIIC2), others joining what had rapidly become a public controversy (see IIIC3). The second and more long-term consequence was to initiate a pattern of extensive Salon reviews by critics independent of the Academy, to which writers as distinguished as Denis Diderot (IIIC12–14), Stendhal (see *Art in Theory 1815–1900*, IA4), Heinrich Heine (see *Art*

in Theory 1815–1990, IA14, IIA7), Charles Baudelaire (see *Art in Theory 1815–1900*, IIC9, IID13, IIID6), Théophile Thoré (see *Art in Theory 1815–1900*, IIA12, IIB11, IIIC9) and Emile Zola (see *Art in Theory 1815–1900*, IVA6) were to contribute over the next 120 years. La Font's Salon was originally published anonymously as *Réflexions sur quelques causes de l'état présent de la peinture en France. Avec un examen des principaux Ouvrages exposés au Louvre le mois d'Août 1746*, The Hague: Jean Neaulme, 1747. Our text is taken from the opening section of the work, pp. 1–24 of this edition, which contains La Font's more general observations. The translation is by Belinda Thomson, made originally for the Open University, with passages omitted from that version translated for the present volume by Christopher Miller.

Love of painting and the fine arts and zeal for their advancement are the only motives that have led to the publication of these sentiments concerning the works exhibited this year at the Louvre. There is no intention whatever of presenting them as verdicts. Nothing could be more absurd, in our view, than to seek to subordinate others' opinions to our own. At the same time, the progress of the arts, and indeed of literature, might, we felt, be much assisted if certain reflections were put forward, reflections critical but modest, devoid alike of passion and of personal interest, which might enable authors to perceive their failings, and encourage them to attain still greater perfection.

An exhibited picture is the same as a book on the day of publication, and as a play performed in the theatre: everyone has the right to make his own judgement. We have gathered together the judgements of the public which showed the greatest amount of agreement and fairness, and we now present *them*, and not at all our own judgement, to the artists, in the belief that this same public whose judgements are so often bizarre and unjustly damning or hasty rarely errs when all its voices unite on the merit or weakness of any particular work.

It is by taking scrupulous pains and with the genuine intention of offending no-one that we present the judgements of discerning connoisseurs, men enlightened by principles and still more by that natural light that we call feeling, because it makes one feel from the first glance the dissonance or the harmony of a work; indeed it is this feeling which is the basis of taste, I mean of that steady and unalterable taste for true beauty which can almost never be acquired where it is not the endowment of a fortunate birth.

Few artists will attain a reputation of the first order without the help of advice and criticism, not only from their colleagues most of whom only judge the beauties and faults of their art in relation to a cold, dry set of rules or by a routine of comparison with their own often dull and repetitive style, but also from a disinterested and enlightened spectator who, although not a practising painter himself, judges with natural taste and without a servile adherence to the rules. These are the people one cannot consult too frequently about the suitability of the tones, the choice of the details and their particular and general effects and about the harmony of that beautiful whole which charms the eye.

A number of painters have not yet arrived at the reputation of first order to which I referred, because they are wanting in their choice of subjects. This is a peril frequently incurred by painters who have only a limited knowledge of history. The

same risk is run by those who, overestimating their abilities and blind to the limits of their talent, seek pre-eminence in every genre. Some are motivated by overweening vanity, others by base envy of the successes reaped by their colleagues in genres other than their own. How many authors have been seduced by this odious daughter of pride, this jealousy so contemptible in a man of genius, into undertaking all kinds of subjects and passing themselves off as universal geniuses! One of the foremost minds of the previous century [Monsieur de Fontenelle], who has lived to adorn the present one, has distinguished himself in every genre; in doing so, he has inspired many inferior imitators, who might themselves have been models, had they but had the wit to confine themselves to their spheres of competence.

I return to the choice of subject, on which the success of a painting frequently depends. Though history sacred and profane, along with fable, affords an almost infinite number of subjects, every day we see indolent authors, born to plagiary, restrict themselves to such as have been treated over and over again. Are they unaware that our minds are swayed by novelty? That it frequently does duty for merit in our writings? It is given only to the most vast and penetrating genius to discover a host of new and interesting circumstances in subjects that the vulgar mind perceives as exhausted. When these circumstances are linked to the principal action, and presented under new and ingenious aspects, they can rejuvenate apparently worn-out subjects, by the choice of a more striking moment and a new interest. In painting as in poetry, an author must choose his subject according to his strengths, or he will fall into the error of certain painters, who flatter themselves that they can disguise with the charms of novelty subjects long since defunct. Their imagination fails them; no new beauty distinguishes their compositions. They seek, nonetheless, to maintain a well-deserved reputation for intelligence – on which they pride themselves. They are too sensible to add irrelevant episodes, especially in subjects sacred or of inviolable historicity. Instead, they weaken the essential action, and substitute violent or exaggerated attitudes; they impart to faces, and particularly to the eyes, an exaggerated expression, whose grimacing effect is as offensive in the sacred as it is comical in the profane.

Of all the genres of painting, history is without question the most important. The history painter alone is the painter of the soul, the others only paint for the eye. He alone can bring into play that enthusiasm, that divine spark which makes him conceive his subjects in a powerful, sublime manner; he alone can create heroes for posterity, through the great actions and the virtues of the famous men he presents; so the public does not coldly read about but actually sees the performers and their deeds. Who does not know the advantage the faculty of sight has over all the others, and the power it has over our soul to bring about the deepest, most sudden impression?

But where shall our young pupils find the heat and fire of those eloquent expressions, the source of those great ideas, of those striking or interesting features that characterize true history painting? Why, in the same sources that have always been drawn upon by our greatest poets. In the great writers of Antiquity: in the *Iliad* and *Odyssey* of Homer, so rich in sublime images; in the *Aeneid*, so rich in heroic actions, pathetic narratives and grand sentiments; in Horace's *Ars Poetica*, an inexhaustible treasure of good sense for arranging the composition of an epic or tragic painting, and

in Despréaux[1] his imitator; in Tasso,[2] in Milton. These are the men who have unlocked the human heart and known how to read it, to render its troubles, its rages, its torments for us with an eloquence and truth which both teach us and fill us with pleasure.

What if the history painter is religious and wishes to devote his brush to subjects of piety? What an abundant source of great events, supernatural and yet true and respectable, of majestic pathos is to be found in our sacred books, and above all in the five great prophets, Isaiah, Ezekiel, Jeremiah, Daniel, and the Prophet King....

Everyone knows the perfect relationship the painter has with the poet. He will lack passion and life, and his inspiration will quickly cool unless he fires it by repeated intercourse with those great men I have just spoken of. When I advise such study for our history painters, I presume it to have been preceded and backed up by the study of our most famous painters in this genre, both past and present. Raphael, Domenichino, the Carracci, Giulio Romano, Pietro da Cortona, etc., and closer to home, Rubens, Poussin, Le Sueur, Le Brun, [Antoine] Coypel, Le Moine in his ceiling at Versailles, which is a masterpiece of art and comparable to the most beautiful of its kind, both in France and in Italy: in short all the excellent works whose economy, arrangement, effects produced by skilled composition he will have had to consider deeply, and to copy the pieces most admired for their drawing or colour. Without a plentiful collection of this excellent material, he will never manage to construct the solid and durable edifice of a great reputation.

After having given history painters the standing and praise they deserve, would that I could lavish praise on those of today, and raise them, or at least compare them to those of the last century! O blessed century, when the progress and perfection in all the Arts made France a rival to Italy! I am, however, far from thinking that France's genius has been extinguished or her vigour lost. The celebrated painters of our school I have just mentioned, who raised the century of Louis XIV to the level of Leo X[3] in the Fine Arts, and surpassed it even by the great number, would still find admirers today, were it not that the taste of the nation has greatly changed, and had there not been, to accompany the upheavals that passing years and the sway of novelty necessarily bring to States and minds, an excessive taste for ornamentation, the success of which has been extremely harmful to painting.

An account of the effects of mirrors, which form pictures in which the imitation is so perfect, that our eyes have an illusion equal to nature, would sound like a fairy-tale and a figment of the imagination, if the reality was not already too well known to us; these mirrors which were comparatively rare in the last century and are extremely abundant in this have dealt a fatal blow to art, and have been one of the principal causes of its decline in France, banishing the great history subjects which were its triumph from their former positions and monopolizing the decoration of salons and galleries. I admit that the miraculous-sounding advantages of these mirrors deserved the fashionable success they have had, in many respects. Breaking through walls to enlarge apartments and adjoin others to them; reflecting the rays of light from the sun or from candles with increased brilliance; how could man, the born enemy of darkness and everything suggesting its horror, prevent himself loving a form of embellishment which brightens as well as lightens his room and which, while deceiving his eyes, does not deceive him as to the genuine pleasure he receives?

How could he prefer to it the ideal beauties of painting which is often dark, where the enjoyment depends solely upon the illusion to which one must submit, and which often has no effect on the vulgar or ignorant man?

We should not then be surprised by the rapid success of a discovery so favourable to the general pleasure and to the particular taste of a nation greedy for all that is sparkling and new, although its charms are strictly material and entirely limited to the delight of the eye. Everything possible has been done to perfect its manufacture and to increase their number ad infinitum.[4] But since it was impossible to entirely line the walls of large apartments with mirrors, either because of the considerable cost involved or lest such uniformity should have led to surfeit, the idea came about of filling the intervals with panels, sometimes enriched with gilding and coated with colour varnishes; the brilliance and polish of these attractive varnishes being the next best means, after mirrors, of reflecting light.

And so the science of the brush has been forced to yield to the brilliance of glass; its abundance and the mechanical facility of its perfection have banished the finest of the arts from our apartments; the only refuge left to it being to fill in a few miserable gaps, overdoors, overmantels and the tops of a few pier-glasses reduced in height for the sake of economy.[5] In this way, restricted by lack of space to paltry little subjects which are in any case far above eye level, painting is reduced in these large rooms, to cold, insipid, totally uninteresting representations: the four Elements, the Seasons, the Senses, the Arts, the Muses and other commonplaces which are the triumph of the plagiarist journeyman painter, requiring neither genius nor imagination, pitifully worked and reworked for more than twenty years in a hundred thousand ways.

I ought to pass over in silence, for the honour of this fine art, the unworthy places in which painting has taken refuge since its expulsion from our apartments. Could our fathers have foreseen that one day art lovers would come to admire the beauties of a skilful brush in such vile hovels, in dusty sheds and filthy coach-houses? Nothing is more true, nevertheless, than that up until the time when camaieux[6] became the most popular form of carriage decoration, for several years one saw in their place paintings, of a price and quality superior to, or at least equal to those decorating the apartments of the masters of those houses. These paintings were only brought out of their shameful stores to be dragged through the streets, to suffer the ravages of the mud, to be defenselessly exposed every day to the danger of being knocked to pieces by the dirtiest rubbish-wagons, by carts, or by the innumerable hazards of the public highway, unavoidable in such a large city. What must foreigners find the most incomprehensible: our shameful disregard and ridiculous abuse of this fine art, or the excess and eccentricity of our ornament, carried to such a high degree of extravagance?

For mythological and historical subjects, there did remain one fruitful area, favourable to the painter whose great talent lay in illusionism and foreshortening, which gave full scope to the magical art of perspective – and that was the ceiling. But, accustomed to the brilliance of mirrors – which unfortunately have so far been impossible to install in new ceilings, where, I am quite convinced, I shall one day see them admired, the public rejected embellishments of an intellectual character, requiring some consideration and knowledge, in favour of the material whiteness of

plaster carved into filigree work at the base of the coving and in the corners and at the central point carved into ornaments of the same substance, often gilded, sometimes painted, imperceptible grotesques for the most part, that Voltaire so aptly criticized in his *Temple du Goût:*[7]

I will cover ceilings, canopies, covings with a hundred singeries[8] carefully worked,
An inch or two large so they can be seen from afar.

And elsewhere:

The whole thing glazed, varnished, whitewashed, gilded;
And admired, for sure, by idle gazers.

These, then, are the main causes of the present decline in painting; I am in no doubt that they have forced several pupils, into whose hands the gods had placed paint-brushes, to abjure their talent and abandon themselves, like our writers have done to works of wit, to the futile subjects of fashion and of the day; or else to the most lucrative genre of this art, which is, and has been for several years, the portrait.

A painter today, obstinately attached to history painting through the elevation of his thoughts and the nobility of his expressions, will see himself reduced to a few works for churches, for the Gobelins,[9] or to a very small number of easel paintings which have been almost entirely banished from decorative schemes because, it is said, they spoil the silk tapestries whose lustre and uniformity is at present preferred to the skilful variations of the brush and to all the products of the imagination. What resource will be left to the history painter if he is not in a position to feed his family on more solid fare than glory? He will sacrifice his personal tastes and natural talents to his needs, in order not to see his fortunes waning, despite his skill and efforts, in contrast to the rapid financial gains made by his colleagues the portrait painters, especially those working in pastel. He will suppress his inner callings and divert his brush from the path to glory to follow that of material well-being. He will, in all honesty, suffer for a time to see himself forced to flatter a simpering, often misshapen or aged face, which almost always lacks physiognomy; reproducing obscure, characterless people, without name, without position, without merit; people who are often despised, sometimes even hateful, or at the very least indifferent to the public, to their posterity, even to their heirs who will abandon their features to the dust of the attic and the teeth of mice; or who will coldly watch them pass from an auction sale to hang in furnished rooms and render the householder more illustrious. We should not then be surprised that today the portrait is the genre of painting in readiest supply, the most cultivated and the most advantageous to even the most mediocre talent. Its credit is of long standing, and based on several good reasons.

Although the present widespread taste for the beauties of a damask tapestry,[10] picked up by richly gilded and attractively sculpted frames, has banished history paintings from apartments, as if they were boring and superfluous ornaments, portraits have managed to replace them and secure from the caprices of fashion an exception in their favour.

Self-love, whose rule is even more imperious than that of fashion, has had the art of presenting to the eyes, of ladies especially, mirrors of themselves that are all the more beguiling for being false and which, for that reason, are preferred by most people to real mirrors which are too truthful. In effect, what sight can be compared, either for a real or for an imaginary beauty, to that of eternally seeing herself endowed with the grace and the cup of Hebe, the goddess of youth? Or to that of displaying every day, beneath the apparel of Flora, the budding charms of spring of which she is the image? Then again, seeing herself decked out with the attributes of the goddess of the forests, a quiver on her back, her hair attractively dishevelled, an arrow in her hand, how could she not believe herself to be the rival of that charming god who wounds all hearts?[11] [...]

This is how a taste for divine disguises is suddenly kindled in the majority of women. The immediate success won by pretty women makes a strong impression – be it envy or jealousy – on the less well endowed. They eagerly seek the agent of this metamorphosis, and hasten to his door. He finds it easy to persuade them of his miraculous capacities, of which they are more convinced than he. A list of the members of the celestial court is presented. The divinity is chosen, sketched, completed. Finally, it makes its entry into the temple where it is to be adored; it has no sooner arrived than applause is universal, and everyone exclaims 'It's you to a T! Only speech is lacking!' It is no small lack. How else is the divinity to explain who she is? The ecstasy and delight are completed by that of the painter, who returns to his studio famous, admired, and well paid.

These few light-hearted reflections will not, I think, lead to my impeachment by today's practitioners of this genre, nor weary the public of their talents. While they are able to flatter their originals with sufficient skill to persuade them that they do nothing of the kind, the vanity of either sex is a sure warrant of their continued success and more than average prosperity.

To the latter must be attributed the emulation and superabundant production that we daily encounter in this genre. Messieurs Nattier, Tocqué, La Tour, Aved, Nonotte and many others (not to mention the older masters whose reputation is already made) will perhaps console us for the loss of such as Rigaud, Largillière and de Troye. In all of these we find an agreeable touch, vivid and truthful flesh tones, and particularly fine imitation of fabrics of all kinds. Certain of them also exhibit a fine ordering of the composition, along with a mastery of local colour, details and the distribution of the parts of the background.

[1] Despréaux: Nicolas Boileau-Despréaux (1636–1711). Playwright, poet and theorist. Boileau's *Art poétique* (1674) was based on Horace's *Ars Poetica* and laid down many of the principles on which French literary classicism was based.

[2] Torquato Tasso (1544–95). Italian poet. ... his best-known works are the narrative poem *Rinaldo* (1562) and the epic poem *Gerusalemme Liberata* (1574).

[3] Leo X's papacy, 1513–21, coincided with high points in the careers of Raphael and Michelangelo.

[4] Whereas at Versailles' Galerie de Glaces several sheets of mirror had been needed to fill the enormous frames, by the mid-eighteenth century the technique of making large mirrors had been mastered.

[5] Panelling and mirrors tended to form the main part of eighteenth-century wall decoration, but an architect would leave a number of clearly defined spaces, above doorways, mirrors and mantelpieces to be filled with suitable paintings.

6 Camaieux: a type of painting used particularly in interior decoration, made up of different tones of the same colour.
7 Voltaire's *Temple du Goût, c.* 1732, was an essay in criticism composed in verse and prose which attacked all that was false or feeble in the arts – in particular, the Rococo.
8 Singeries: a form of grotesque ornamentation incorporating monkeys into the design.
9 Gobelins: the royal Gobelins tapestry factory was set up by Colbert in 1667, during the reign of Louis XIV. It depended upon painters for its designs. Technical advances made in the eighteenth century enabled weavers to make tapestries resemble paintings more and more closely.
10 Silk tapestries – damasks – imported from the Orient, were becoming a fashionable form of wall covering.
11 Flattering portraits of aristocratic ladies dressed up to look like goddesses were popularized by such painters as J.-M. Nattier (1685–1766) and L.-M. Van Loo (1707–71). They inherited the genre from N. Largillière (1656–1746).

2 Abbé Jean-Bernard Le Blanc (1707–1781) from 'Letter on the Exhibition of Works of Painting, Sculpture etc., of 1747, and in general on the utility of such exhibitions'

Though he had taken holy orders, the Abbé Le Blanc pursued a career as a writer and critic in Paris. Through the patronage of Mme de Pompadour he gained the position of Historiographer of the Royal Buildings (the department of government responsible for administration of the arts), devoting himself thenceforth to the defence of state patronage and of official policy on the arts. His letter on the 1747 Salon exhibition was the first of two lengthy publications written to disparage La Font de Saint-Yenne (see IIIC1) and to support the prevailing policy of the Academy. The second was published in 1753 as *Observations sur les ouvrages de l'Académie de peinture et de sculpture.* In the present text Le Blanc's tactic is to condescend to La Font's apparent good intentions and patriotic zeal, while effectively damning him for naivety and inexperience in matters of judgement. What is unwittingly revealed is the concern that La Font must have caused in claiming to speak on behalf of a significant public. It is this claim, above any other, that Le Blanc seeks to undermine, accusing La Font of self-deception brought about by self-importance. He further objects to the very thoroughness of La Font's survey of the works on exhibition, and to the relative indiscriminateness of his praise. Reading between the lines, we can assume that, prompted or not, Le Blanc was speaking on behalf of those senior members of the Academy who were accustomed to being singled out for special attention, and who may have felt affronted at being assessed on level terms with their juniors. An experienced critic, he implies, should *know* which are the artists to praise. Le Blanc's text was originally published as *Lettre sur l'exposition des ouvrages de peinture, sculpture, etc., de l'Année 1747, Et en général sur l'utilité de ces sortes d'Expositions,* Paris, 1747. The following translation has been taken from pp. 1–20 of this edition and has been made for the present volume by Christopher Miller. (See also IIIC3.)

Since you desire it, I am delighted to write and tell you what I think of the criticism that made last year's Salon an object of curiosity for the public.[1] In doing so, my only goal is to disabuse those who, being anxious to learn, read in good faith, and believe what they read because it is printed. I shall also tell you my opinion of the pictures exhibited this year in the Galerie d'Apollon and the Salon du Louvre; then I shall talk about the benefit that the public, and more particularly, painters, can derive from such exhibitions. I take this opportunity to convey to you some *Reflections on*

Painting, which will, I hope, please both those who profess this excellent art and those anxious to know something about it. [. . .]

I come now to the little work containing an *Examination of the Pictures* of last year's Salon, which so fluttered the painters. You know and like painting, and therefore strongly approved the author's intentions; but you were far from happy with his execution. You accuse him of presenting his own prejudices as the verdict of the public. You condemn him for lamenting the decadence of painting in France, whereas readers who have only his detailed encomiums of the various academicians to go by, must inevitably conclude that French painting is thriving as never before. When, you ask, have we ever had so many painters worthy of the name as are admitted to his catalogue? What trust can we place in an author who contradicts himself so clearly? How can his panegyrics and jeremiads be reconciled? Painting, like poetry, has its Despréaux and its Cottins. How can a sentient man place both on the same footing?

Allow me, Monsieur, to accuse *you* of being too hard on this author. His work is difficult to defend overall, but it is, in many respects, excusable; I am convinced his intentions were good. In anyone who writes, as he does, out of no other motive than love of the fine arts and zeal for their advancement, one must pardon much. Let us be grateful for his undertaking; though he is more amateur than connoisseur, he is, at least, a citizen zealous for the glory of the fatherland. Those who, like him, attend to the common good, should never be discouraged; praiseworthy though his attitude be, it is not often encountered in this country.

Your criticisms of his style seem to me entirely unfounded. He has indeed, though rarely, made use of technical terms. Though familiar to the practitioner, these do not convey to the general reader the precise idea to which they refer. The adepts have their own language; unless one writes exclusively for them, it should be used as little as possible; few readers are likely to understand it, and most are sure to hate it. Like you, I reprove the use, in a book written for everyone, of words confined to painters and amateurs; it is an affectation. But I do not find it as noticeable in the author of the *Examination* as you do. Certain writers about art are prone to this vice, in particular, those who seek less to instruct than to parade the very limited knowledge they have acquired. By this means, so they flatter themselves, the average reader will be convinced that they understand what, in fact, they do not. In the arts, *semi-connoisseurs* are worse than the completely ignorant; they stock their memories with all these terms, and, unable to use them correctly, apply them at random. They are like Sganerelle, who takes his admirers for simpletons, because they cannot understand what he says. But the more intelligent reader, wearied rather than deceived, laughs them to scorn.

Monsieur Coypel, whose paintings and writings are notable for their wit and veracity, offers, in his *Dialogue sur la connaissance de la peinture* [Dialogue on Discernment in Painting, 1732], a very telling portrait of one of these absurd characters. 'See,' he has him say, 'what authority in the eyebrows! The contrasts in the brow, all full-pigment, then the *pentimenti* in thick creamy strokes, piff, paff, piff! Ah, they could really hold a brush, those fellows! And what a finish to it, eh? Ah, Monsieur, splendid! Quite splendid.' What on earth can you say to rubbish like that? Not a word; you're confounded, but not convinced.

Félibien, in his *Entretiens sur les vies des Peintres* [Conversations on the Lives of the Painters], very properly used technical language to teach the rudiments of painting; but he wrote principally as a master addressing other artists. Necessity in his case prescribed what in others is affectation. Monsieur l'Abbé du Bos has subsequently treated almost the same subject, and he carefully avoided all the words that men of the world (his intended audience) might fail to grasp. Yet his discussion of the various departments of painting is clear and intelligent. The very precepts he lays down for poets and painters are within the grasp of any reader endowed with common sense. Those who would appeal to persons of taste must follow his example. A man of talent can, if he must, speak of an art without recourse to its terminology. It is not difficult to convey what you know well.

Such a talent does, though, require two rare things, knowledge and wit, whereas the desire to kick up a stir is common; as common, indeed, as talent is rare. Many authors are neither better-informed nor more intelligent than the average; they just want to write a book.

As to the mistakes, if any, made by the author of these new *Reflections on Painting*, their source is clear. People often suppose that they speak for the public; with the best faith in the world, they attribute to the public the sentiments of themselves or their friends. It is a consequence of vanity. The most common error men make is to suppose that all right-thinking persons necessarily think as they do. More intolerable is the vanity of those who, believing that they alone see things in the proper light, must always be prescribing for others' tastes.

Any writer seeking credit for his views lays claim to the authority of the public; but as there is more than one society, so there is more than one public, and everyone cites their own. Only the public, they say, can decide; but the infallible arbiter thus cited is merely the public one knows. So it is not surprising that the reader is sometimes misinformed about its judgements. Here, the misleading author is often more deserving of pity than criticism; he is entangled in the errors he propounds.

In justice to the author of *Reflections on Painting*, he did, I believe, conceive himself to be 'scrupulously respectful'; he truly intended 'no offence to anyone' in citing those he believed were 'judicious connoisseurs'. Everything bespeaks his sincerity and his love of the arts. Indeed, certain of our artists could do worse than follow the sage advice he bestows on them.

He believed himself duty-bound to speak of all the pictures exhibited in the Louvre; perhaps out of the kindness of his heart, he felt that he owed a garland of praise to each of the painters. Ardently though one desires the glory of the arts, one prefers to make no enemies; in his own words, one at least *intends* 'no offence to anyone' . . . But the enlightened public is not so tender-hearted; it exercises its rights as a sovereign judge, and bestows its votes on those who merit them. Implacable or indulgent, it judges equitably. It may, in a work where beauty prevails, pardon certain weaknesses; where talent is lacking, on the other hand, it has no regard for rules coldly observed. In short, where no praise is deserved, it bestows none.

At one time, there was but a single paper, whose uninterrupted prerogative it was to lavish, in the name of the public, its debased praises on authors and artists of every kind. Its very frivolity excused it. Today, people complain that the most serious journals, which might be of the greatest service, do no otherwise. There is, doubtless,

nothing immoral about this tendency to praise good and bad indiscriminately, but it is very bad for literature and art. The author of *Reflections on Painting* seems to have realized this; praise can seem insipid, and he seasons his with critical remarks. Despite his circumspection, some of these are rather tart, and though he tries always to be just, some of his remarks are not.

Generally speaking, it is the way in which he distributes praise and blame that sets him furthest from public opinion. The principal weakness of his work is to praise and criticize every painter in succession, and, as it were, in the same degree. The non-connoisseur relying on the author's verdicts can hardly guess which are the eminent painters in any genre; since they cannot all be eminent, he may believe that none are, and this is quite wrong. The effect that the work may have abroad, should any copies leave the country, is something the author should have thought of. The first-class painters, like Monsieur Boucher and Monsieur Natoire, may rightly reproach him with exaggerating any putative defects in their style, and failing to convey their real excellence. By thus balancing his praise and blame of each painter's works, he seems to place them all on the same footing, and thus departs from both truth and public opinion. Like praise, criticism cannot be universal; he who deserves no praise merits no reproof. Félibien, in the preface to his *Entretiens sur les vies des peintres* [Conversations on the Lives of the Painters], says 'One cannot, I think, demonstrate either the abilities of a worker or the beauty of his work, without pointing to both the good and the bad; objection to one part of it in some measure shows one's esteem for the rest.' For that, though, there must be some parts worthy of admiration. Among those who cannot resist writing books, many should be passed over in silence, without so much as a reproach. There are men who paint, who are yet not painters. It would be churlish, indeed barbaric, to signal, and more so to name, the unfortunates of whom this is true. The public must make up its own mind; only that estimable judge can pronounce such implacable verdicts. On the other hand, habitual encomiasts need to lay hold of the idea that when everyone is praised, no one is.

The author evidently sought to give everyone his due, and is widely thought to have failed; persons of discernment blame him for according too much to some and too little to others. One should not delude oneself, that one can judge equitably of persons and genres against which one is prejudiced; injustice is in that case unavoidable. I shall not cite the painters whom he has over-praised; they would be mortified if I did, and such is not my intention. But it is true that everyone was surprised at the injustice that he did to some, in particular those whom I have just named, whose long-standing reputations should have given the author of the *Reflections* pause. If a painter lacks certain qualities, one should dwell on those he has. Poussin is not so great a colourist as Rubens, but does anyone dare to suggest that he is not a great painter? The author of the *Reflections* seems, as yet, unaware of the many talents needed to paint a fine portrait, which seems to him a negligible genre. Titian and Van Dyke thought otherwise. In no department of painting can one excel without outstanding talent. The author of the *Examination* was wrong to understate the merits of a portrait painter who consoles us for the loss of Rigaut, and whose name is already spoken throughout Europe. A painter who excels all others in his genre should not be relegated to the crowd. [. . .]

Our author allocates praise and blame to every painter as he thinks fit, and this method has another drawback, one that he did not, perhaps, foresee: he has contented neither the public nor the individual. Unjustified eulogies repel the public, and individuals resent the most justified critique. These are truths confirmed by experience. It is a commonplace that the most mediocre artists and authors are often excessively vain. Most of those discussed in his work have complained bitterly of the treatment they received, and a number of them, as we said, had reason to. The author pointed out faults that no one could miss, while praising beauties entirely lacking in the paintings where he discovered them; I feel sure that the artists who least deserved his praise felt more resentment at the former than gratitude at the latter. True, they should not; but such is the nature of mankind. What one bestows on vanity, it takes as its due, while detraction is perceived as injustice.

1 Réflexions sur quelques causes de l'état présent de la Peinture en France, avec un Examen des principaux Ouvrages exposés au Louvre le mois d'Août 1747 [IIIC1].

3 Louis-Guillaume Baillet de Saint-Julien (active 1748–1783) from 'Letter on Painting, Sculpture and Architecture, With an Examination of the Principal Works Exhibited at the Louvre in August 1748'

Baillet de Saint-Julien's review of the 1748 Salon was written in explicit acknowledgement of the commentaries offered by La Font and Le Blanc on the 1746 and 1747 Salons respectively (see IIIC1 and 2). Significantly, he distinguishes between the acclaim accorded to certain works by an undiscriminating public and the judgements of connoisseurs – those 'able to justify the praise they award'. Like Le Blanc, he credits La Font for his patriotism, but admonishes him for his inexperience. (Since the paintings and sculptures shown in the 1746 Salon are now 'lost to sight', the only specific works on which he takes issue with the *Reflections* are three architectural works available to view in Paris.) On the other hand, he questions Le Blanc's assumption that one can be a competent connoisseur without a practical knowledge of painting, flaunting his own reading of Du Fresnoy (see IC4), Du Bos (IIB6) and Félibien (IB9,10) to strengthen his case. Baillet's review is marked by the interest he shows in landscape painting endowed with naturalistic atmosphere. He was to comment regularly on the Salons over the next nine years and to pay an unusual degree of attention to those artists who worked in genres other than history painting, among them Chardin, Vernet and Oudry. The review was originally published as *Lettre sur la peinture, sculpture et architecture, Avec un examen des principaux Ouvrages exposés au Louvre au mois d'Août*, Paris, 1748, dedicated to M. ***. Our excerpt is taken from pp. 1–6 and 66–71 of this edition, translated for the present volume by Christopher Miller.

To Monsieur . . .
You have good reason, Monsieur, to regret the fact that you were forced to leave Paris almost immediately after the opening of the Salon; a week was indeed too short a time for you to admire at your ease the many beautiful things that it contained. But far away as you are now, your memories of the Salon must, I think, be pleasant ones, since you ask for an account of the public's view of the works currently exhibited

there. If it were only a matter of informing you which works have earned the greatest general approval, I could easily make you happy. In this respect, paintings and sculpture are like plays. When one sees the public hastening to a comedy or tragedy, hears it lavish on the performance such spontaneous applause as seems wrung from it by the sustained nobility of the characters, the interest of the situations and the beauty of the catastrophe, this flattering unanimity is a reliable guarantee of its worth.

Something similar is true if, on entering the Salon, one is struck by a picture's coloration, captivated by its draughtsmanship and enchanted by the elegance of its composition; the allure it exerts so pleasantly is a sure sign that our preference is rightly bestowed. The public is not easy to deceive; its sole guide is feeling, and by feeling one is rarely deceived.

If, therefore, you simply wish to know which works of painting and sculpture were most favourably received by the public, I would answer: those which you yourself saw the public show the greatest enthusiasm for.

But you require something more. You wish me to expound the views of that estimable portion of the public, the connoisseurs: persons apprised of the principles of art, and able to justify the praise that they award, in whom feeling is refined and justified by intellect. You could hardly have caught me at a more favourable moment. I have spent the last few days at a gathering of connoisseurs, whose exact, weighty and impartial judgements seemed entirely to merit that title. To meet your request, I need only repeat exactly what I heard.

The merits of the works exhibited this year were much discussed, and comparison with those of preceding Salons occasioned a critical review of the two brochures about this distributed last year. You know the ones I mean: one is entitled *Reflections on Certain Causes of the Current State of Painting in France*, the other *Letter on Painting*.

Here, then, are the observations made at my gathering; I have only the merit of writing them down. They will interest you particularly for the light they cast on observations about works in the current Salon, for which they offer a kind of preparation. To set these different purposes in order, I shall divide my letter into three parts. The first will constitute a response to the *Reflections on Certain Causes of the Current State of Painting in France*.

The second will contain some critical notes on Monsieur l'Abbé Le Blanc's *Letter on Painting*.

Finally, the third part will comprise an examination of the main works of painting and sculpture exhibited at the Salon this year.

Response to the Reflections on Certain Causes of the Current State of Painting in France

There is little sign in the *Reflections* that the author is well acquainted with the subject that he has undertaken. But one is bound to praise his zealous assault on the various abuses that so lower the nation in the eyes of foreigners.

For example, nothing could be more apt than his remark on the ruinous state in which the old Louvre has been left – that rich monument of architecture, which would be worthy of Rome itself, were it complete.

The general principles of Sieur L.F. thus met with approval, but they do not seem to have informed his specific criticisms. I shall not record his views on many things now lost to sight, as a discussion of them would, by definition, be tedious. It would simply be a good thing if he went as often as possible to the Salon, there to acquire the knowledge that he lacks, by the aid of an eye alien, impartial and discerning. Thus, confining myself to what anyone can now see, I shall speak of three major works of architecture that the author has excessively praised or scorned. They are first M. Bouchardon's fountain in rue de Grenelle; second the church of Saint-Louis-du-Louvre; and third that of Saint-Sulpice.

* * *

The particular sentiments of Monsieur l'Abbé Le Blanc on the acquisition of knowledge in painting and the selection of subjects to paint

According to this author, one can quite reasonably assess a painting using nothing more than 'a pair of eyes and a little practice'. To refute this system, one has only to contrast it with his other statements. We shall not easily be convinced that nothing more than 'eyes' and 'practice' are required, as he puts it, to discern 'whether the sentiment expressed by each figure is well observed. Whether their various attitudes are natural. Whether those in the middle ground are, in terms of degradation of light and of scale, where they should be in order to maintain the illusion.' No, say what he will, it requires more than eyes and practice to discern all this, even in those who do not aspire to be either authors or amateurs.

He who judges a painting, must, as it were, have in common with the painter everything of a speculative nature, and differ only in the matter of application.

It is therefore insufficient to know that painting is in general the art of imitation of all visible things through line and colour on a flat surface. He must also know the general principles of the three parts of painting, which are drawing, colour and composition.

He must be apprised that drawing requires knowledge of perspective, by means of which the outlines of objects can be accurately rendered. A knowledge of anatomy is also required, as least as far as this concerns the movements allowed by the bones and the functions performed by the muscles. Lastly, he needs to know that nature does not always afford perfect models, and one must therefore choose carefully the forms of beauty one finds in it; this is done by studying fine proportions in the ablest masters, and above all in Antiquity, where examples are most commonly found.

He should be apprised that colour is divided into parts: that is, local colour, which is nothing more than accurately reproducing the colour proper to any object, and chiaroscuro, which consists in the accurate distribution of light and shade, in relation not only to individual objects but to the work in general. 'By this consonance and affinity, skin tone should be neatly set off by draperies, and the draperies by one

another; the figures should harmonize with both one another, the landscape and the distance. In short, everything should appear so artfully connected that the whole painting seems to have been painted at one and the same time, and, as it were, from the same palette' (Félibien: *Conversations on Painters*).

He should also know that there is a mixed element, which combines drawing and colour. This is 'the art of disappearance' or aerial perspective, by means of which objects seem to grow more distant from the spectator; their scale is reduced and their colours are degraded in proportion to the place they occupy in the painting.

Finally, composition: the last and most important part of painting,[1] which requires such passion and knowledge in the painter. Anyone wishing to judge a painting at all sensibly must at least be acquainted with the essential points of composition. For example, unity of place must be scrupulously observed. One cannot attain the right effect in a painting if more than a certain number of groups is represented. The main protagonist must dominate all the others, and catch the eye before any of the others. The positions of all the figures must be natural; their attitudes must be agreeably contrasted, and their bearing and character properly rendered, as must the objects accessory to the subject.

Such then is the knowledge of painting and its various component parts that one should bring to the Salon if one comes not as a simple spectator, but as a judge. Our famous artists have spent many years working hard to perfect their art, and it would be a great shame if they had blindly to submit to the verdict of the ignorant; if those lacking all principles, and knowing no other counsel than that 'of their eyes, and some practice (a little more, or a little less) in looking at pictures' were set up as their judges.

Another sentiment expressed by Monsieur l'Abbé Le Blanc seems likewise doomed to oblivion, since it appears to proscribe any flight of imagination on the part of the painter. It is this: 'Nature should only ever be painted in a state of perfect repose.' [. . .]

But did Monsieur l'Abbé Le Blanc not realize that his system contains its own contradiction? To prove that nature should be painted only in repose, he cites the example of landscape painting; these pieces are much more widely liked, he says, than action pictures. This is because one sees nature in repose in the landscape, and the verisimilitude so dear to his heart is consequently not violated, or so he says, whereas in other paintings it is. But this example proves just the contrary. For if ever a subject had the potential for action and variety, it is landscape, where one cannot imagine nature remaining the same even for an instant. The landscape alters and varies with every refraction of the sunlight that illuminates it. Now we see nature bright and luminous; everything gives way before the brilliance of the sun. A moment later a storm blows up, the sky darkens, and the houses that were lacklustre before grow luminous compared with the clouds. Supposing the sky now clears, and you try to seize the moment, capturing the splendid ray of light illuminating the depths of the landscape; the foreground, meanwhile, is in shadow, and the objects in the background accordingly look distant. But no; a cloud intercepts the ray and transforms the effect. It flies in the face of probability to suppose nature in repose in a landscape; that would require something utterly impossible, immutable light.

1 See *The Art of Painting* by C. A. du Fresnoy, and the *Critical Reflections on Poetry and Painting* by Monsieur l'Abbé Dubos, one of the very best books that a painter can consult for composition.

4 Anne-Claude-Philippe de Tubières, Comte de Caylus (1692–1765) 'On Composition'

This lecture on composition was originally delivered at the Académie Royale des Beaux-Arts on 5 September 1750. (For previous lectures by Caylus, see texts IIA11, 12.) As Michael Fried has argued, an increasing interest in the unity and independence of compositions was significant of the growing independence of the painted 'tableau' in mid-eighteenth-century France (Fried 1980). (For Shaftesbury's earlier thoughts on the composition of a 'Tablature', see IIB3.) In a longer view, the idea of composition that Caylus here proposes foreshadows later attempts to identify expressive content and aesthetic experience with the total form of the work of art, and to equate unity with instantaneousness. (See, for instance, the sense given to composition in Henri Matisse's 'Notes of a Painter', or the concept of 'significant form' advanced by Clive Bell in 1914; *Art in Theory 1900–1990*, IB5, 15.) To this end Caylus distinguishes between 'ordinary composition', which may be organized according to rules, and the composition of genius. When it comes to defining the latter, however, he is reliant, as all subsequent writers were to be, upon a combination of circular argument – the composition of genius is recognized by its ineffable effect upon the mind of the observer – with appeals to an established canon. In the second part of his lecture, omitted here, Caylus considers certain works by Raphael as exemplary of genius in composition. The lecture is published in Comte de Caylus, *Vies d'artistes du XVIIIe siècle, Discours sur la peinture et la sculpture, Salons de 1751 et de 1753 – Lettre à Lagrenée*, ed. A Fontaine, Paris: Librairie Renouard, H. Laurens, 1910, pp. 160–74. Our excerpt is taken from pp. 160–6 of this edition, translated for the present volume by Christopher Miller.

Generally speaking, composition is the poetry of painting, and, more precisely, this poetry is the expression of genius at the service of its object. So complete and extensive is the precision required for such expression that the difficulty is only too apt to prove deterrent. Yet it has no other principle than that of genius combined with good sense; what the one produces with passion and abundance, the other, consistently logical, moderates and retrenches. Expression both general and particular must then, as a consequence of this same principle, be completely concealed, invisible behind the simplest, most natural and unaffected appearance.

This is not the only difficulty such poetry must overcome; for its object is a single instant, to which everything must relate and contribute so perfectly, that adulteration of this relation is inexcusable, and even the most clement eye cannot but condemn it. The moment the latter perceives the painting, it must grasp it in its entirety, and nothing is more painful to it than to be detained by some insignificant trifle that disrupts the order and propriety of the work. The eye must, in short, be instructed, attracted and captivated. The requirement that these impressions be imparted at first glance derives not from any self-imposed law, but from the essence of painting: from one mind's duty at that instant to speak directly to another.

Sublime composition arises from the mind, and no rules can be given for it; there are general rules that apply to ordinary composition, and which are known to everyone. Yet both are merely a means by which the painter inscribes and renders the impression made on him by a story or action. To this means he brings the assistance of all that he has perceived in nature, in which everything is grouped and composed. It must be confessed that the composition of which I speak is susceptible of indefinable distinctions that pertain to the mind alone. Before we proceed further, allow me the following consideration.

Mankind has never begun by making rules for a thing before it was invented; instead, they have taken for rules, especially in the various departments of poetry, the productions of the first genius to appear. Study and meditation on these productions then gave rise to the rules of epic and of all the other genres of poetry. There is no doubt that the mind proceeded similarly in painting. Homer was preceded by Giottos and Peruginos, now, it is true, unknown; but Homer appeared and was imitated by Virgil, and more recently by Tasso, Milton and many others. Finally, the successors of these first geniuses of poetry and painting have been deemed great men insofar as their procedure suggests that they would have invented their art, had they come first.

At all events, such reflections – this form of imitation drawing on Homer or Raphael – have in some sense established themselves as rules of composition for both painters and poets. But they cannot impart genius, and should not be considered on a par with those governing chiaroscuro and draughtsmanship. The latter exist, and are based on the imitation of nature; it may even be said that they are intimately linked to composition. To conclude, one can become a poet without Homer and a painter without Raphael, but these great men should always be present to the minds of those who devote themselves to the furtherance of their talents.

On this subject, then, what I have to say amounts to little more than examining the abuse of this operation of the mind, and of the very high proportion of even the greatest masters who have offended against painting (or rather poetry). To this end, I will necessarily cite examples of a kind that we cannot bring to mind too often.

My project is the following: having first analysed, or rather described composition in its common and practical form, such as it has been utilized by all painters since the renaissance of the arts, I shall turn to the composition of genius. Only the latter can lead the painter to the sublime, making him the equal of the greatest poets and even, perhaps, in certain respects, their superior, a pre-eminence that not everyone admits. The conclusions to be drawn will therefore emerge clearly enough from the criticism and the praise that I bestow, while acting as a constant reminder of the true object and sublimity of this great art. I hope that this method will allow me to demonstrate these great truths, and persuade the reader that, especially in noble and heroic subjects, they should never be lost to sight; and though all possible compositions are subject to this same propriety, I have confined myself to the latter, since they are the most difficult and encompass all others.

Ordinary composition is for the most part what one might call a geometrical reminiscence, insofar as it follows in the most obvious way from certain rules, and is, in a sense, subordinate to the prevailing taste. It is all too commonly encountered; it grates on the mind, and the reproach to which it leaves painting open brings the latter into disrepute; for every tradition, even the most famous Italian schools,

abounds with such paintings. They are much praised and highly valued, but this is no reason why we should neglect the attentions art, by its very nature, requires.

In every national school, then, composition, or rather grouping, is undertaken in this way: a figure is found, appropriate and striking in its development and the beauties it elicits by contrast; this is made the dominant figure, and from it all others derive. This figure may be accurately represented by the mechanical standards of art, and yet its movement will be too emphatic, or its stillness inappropriate; in short, its overall attitude may very easily fail to suit the subject intended. No matter: the figure is handsome, notions of suitability that might constitute an impediment are set aside, and laziness activates certain motives in us with complete success. So far from being guided by the spirit of the subject, which is the only means by which truth may be attained, we do all that we can to make this figure fit the subject.

Whatever the figure, we retain it. Our only thought is to patch up the holes; we do not see them as holes, as infractions of rules that we have adopted. And we succeed in patching things up with draperies or other foreign bodies, for the most part introduced without the slightest necessity; or, what is worse, with frigid figures or heads of which neither the development nor the action is clear. Examples from any country could be cited to authorize these capital sins, which are committed without the slightest remorse.

Light is distributed, directed and more or less recalled, depending on one's needs; we are not afraid to extend it beyond the limits set by nature, and we forget that it must be weightless and subject to degradation. The pyramid has been constructed, the figures are contrasted; true, certain of them lie in the foreground, often facing away from the one that they should be looking at, while others in the middle ground are arranged or inclined so that they lead to the main figure. In short, the chain of connection is consistent, but it is made without regard for the median emotions, or more exactly, the emotions that should be felt by the second-order or accessory figures who must be made to take part in the event. Yet the richness of a subject lies precisely in these secondary figures, since they enrich the dominant figure, and are a source of charm when the admiration of the first glance is complete, and the eye seeks to discover in the painting's details a justification for more general admiration. But let us turn back to our picture.

The surface of the painting is divided to encourage the glance to wander and to create contrasts of richness, but in doing so no regard has been shown for the nature of the land or the buildings placed on it, and these things are never a matter of indifference.

This composition once established, a drawing is made after nature, but in the studio, where the light and background are unvarying. More, each individual part receives due study, though the natural models selected for these are rather undifferentiated and their suitability more a matter of community of age than anything else. Finally, when everything has been prepared in this fashion, we paint the heads; they go together nicely, the contrast of their general position has been carefully considered; but they are expressive of no passion, there is no trace of character in them, they are just heads; they have eyes, noses and mouths, but absolutely no relation to the poetry or expression that the mind always begins by looking for in the dominant parts. We think well of ourselves if we have drawn some pretty women; but the forms

of the faces and the attitudes of the heads could equally well appear in a completely different scene. And this criticism would continue to apply, even if it were not true that prettiness is only ever fitting in pastoral scenes, and that noble subjects require beauty; you know as well as I do, gentlemen, that beauty is found only in grand forms. In short, approximation in the heads is unforgivable, and the severity required in studying them is the more valuable in that a general exactitude inevitably follows.

Let us not lose sight of our work. Having dealt thus with the women, we weigh down the heroes, loading them with muscle, and forgetting that as princes or demigods they must be several degrees more beautiful and better proportioned than other men, and invariably more delicate. At all events, the flesh tones are silky, the draperies are true to life and appropriately coloured; care has been taken to divide them up to enhance the overall effect and to create passage work. Now the harmony is perfectly comprehended and observed; the site of the action looks as it was intended it should, that is, such as the needs of the action require, in terms of light, harmony and effect. Often enough, the scene's horizon has been raised or lowered to an absurd degree, if it is a landscape; or extreme licence has been taken with the construction of a piece of architecture, whose surfaces are perfectly implausible, and whose overall mass and profile alike show no regard for perspective; local colour and aerial perspective have been neglected. No matter; this place seems to the author at once accurately rendered and appropriately coloured. And one cannot even contradict him in relation to his picture, as one might relative to truth in nature. Everything, then, is finished, and we think that we have made a picture, and indeed, in several ways, we may justifiably claim to have done so. We present the said work: it is admired, since the public does not invariably judge equitably at the first glance. And lastly, the author is content with his payment.

That, I think, is all that one could desire in terms of care taken and approbation received; yet one might also say that all these details have not produced a painting so much as a more or less extensive agglomeration of the parts of painting. The reasons why it is not a painting are as follows: first, it is lacking in genius at the service of an object; secondly, it is devoid of that accuracy of expression required if one is to communicate with the mind; thirdly, there is no hint of the unity by which one should be struck in even the smallest details; fourthly, the essence of the composition has not, it might be said, been clearly presented, and so nothing has been done for the subject.

In a word, if the painting that I have described is sought out and admired, its colour, draughtsmanship, or harmony, as I have already said, must have constituted its attraction. But, given that painting is so extensive and lofty an art, would a painter of burning passion, full of the spirit of painting, be satisfied with praises based merely on components of that art? Commendable as these parts may be, they are merely ancillary. No; he will find the parts in themselves mediocre; painting demands more of those who devote their lives to practising it, and are so strongly motivated to bring its every perfection to light.

Far from granting men knowledge of their faults and limitations, nature seems rather to have blinded them to what concerns themselves; though jealousy and criticism give them the most penetrating insight into the works of their colleagues.

Any painter can therefore make use of these reflections in relation to paintings already in existence, and if ever he should turn his gaze on himself, as justice requires, and apply to his own works the remarks that he has made along these lines, he will soon attain perfection; that is, he will contrive to unite the other parts of art with those very properly demanded by mind and common sense. Many men who have brought habit into nature itself, and draw a muscle not because they see it, but because they imagine it must be there or thereabouts (all of which they do in order to produce a clear and structured drawing), many such men will, I say, tell me, out of indolence or vanity, that these procedures in art will necessarily result in frigidity. Far be it from me to speak at length of that subject, and take the part of anything so inimical, in general and in particular, to any species of poetry whatsoever. But accuracy and truth of expression should be and are as far removed from frigidity as they are from exaggeration. Finally, it should be remembered that, while recommending them both, I have taken care never to set genius and good sense at variance.

There can be no doubt, gentlemen, that the observations I have taken the liberty of imparting to you concern the most difficult part of art. But, since they undoubtedly afford considerable satisfaction to their author, and redound to the greater praise of painting, one can hardly bear them too often in mind, nor too often recommend to one's friends the reflection and attention they deserve.

5 Abbé Marc-Antoine Laugier (1713–1769) *from Essay on Architecture*

Laugier was a Jesuit priest and an amateur observer of the art of architecture. The avowed aim of his treatise was to raise the level of relevant discussion and theory and to establish what he regarded as the authentic tradition, as founded by the Greeks, copied by the Romans, continued in the Italian Renaissance by Bramante, Michelangelo and Vignola, and graced in the previous century by the architect and theorist Claude Perrault. He was opposed to eclecticism and shared the widespread opinion of the time that Gothic architecture was barbaric. The *Essay* offers both an exposition of the elements of classical architecture and a critique of current practice in France. Laugier thus brought to discussion of architecture in the 1750s both the kind of informed and instructive categorization typical of contributions to the *Encyclopédie*, and the kind of independent critical voice that La Font de Saint-Yenne had exercised regarding the Salon (see IIIC1). Like La Font, but unlike the Encyclopedists in general, he looked back to the age of Louis XIV as a relative high point in the arts. In his 'On German Architecture' (VA4) Goethe was to take issue with Laugier, objecting to the rigidity of his classicism and his dismissal of the Gothic, and questioning his equation of the primitive dwelling with the origins of the Greek architectural system. Laugier's text was originally published as *Essai sur l'architecture*, Paris: Chez Duchesne, 1753. A second edition was published two years later. Our excerpts are taken from the English translation of the first edition, London: T. Osborne and Shipton, 1755, pp. 1–10.

Preface

We have various treatises of Architecture, which explain with sufficient exactness the measures and proportions which enter into the detail of the different orders, and

which furnish models for all kind of buildings. We have not as yet any work, which establishes in a solid manner the principles of it, which manifests the true spirit of it, or which proposes rules proper to direct the talent and to fix the taste. It appears to me that in those arts that are not purely mechanical, it is not sufficient to know how to work only, we ought to learn how to think upon them. An artist ought to give a reason for everything he does. For this end he has occasion for fixt principles to determine his judgement and justify his choice so that he may tell if a thing be good or bad, not purely by instinct, but by reasoning, and as a man instructed in the fine paths of beauty.

Observations have been carried to a great extent in all the liberal arts: abundance of people of talents have applied themselves to make us sensible of the delicacies of them. They have wrote very learnedly of poetry, painting and music. The mysteries of these ingenious arts have been so nicely examined, that there remains very few discoveries to be made in them. There are such judicious criticisms and reflected precepts of them, that determine their real beauties. Imagination has put them on the way, and served as reins to restrain them in their proper limits. The just rate is fixed upon the merit of their sallies and the disorders of their wandrings. If we want good poets, good painters or good musicians, it could not be for want of theory, it would be the defect of their talents.

Architecture alone has hitherto been abandoned to the caprice of Architects, which have given us precepts of it without discernment. They have determined its rules at hazard upon the bare inspection of ancient buildings. They have copied their defects with the same scruples as their beauties, wanting principles to distinguish their difference, they have imposed on themselves the obligation of confounding them – vile imitators of all that has been declared legitimate: limiting all their inquiries by consulting the fact, they have wrongfully concluded the right, and their lessons have only been a fountain of errors.[. . .]

It is then to be wished that some great architect may undertake to protect Architecture from the caprice of opinions, in discovering to us the fixt and determined laws thereof. Every art, all sciences have a determined object. To arrive at this object, all the paths cannot be equally good, there is but one that leads directly to the end, and it is that road only that we ought to be acquainted with. In all things there is but one manner of doing well. What then is this art? but that established manner upon evident principles, and applied to the object by invariable principles.

In expectation that some one much more able then myself, may undertake to clear up this chaos of the rules of Architecture, that none of them may remain hereafter, but for which a solid reason may be given. I am endeavouring to produce an inconsiderable ray of light for that end. In considering with attention our great and fine edifices, my soul hath experienced various impressions. Sometimes the charm was so strong that it produced in me a pleasure mixed with transport and enthusiasm: at other times without being so lively drawn away, I found myself employed in an agreeable manner; it was indeed a less pleasure, but nevertheless a true pleasure. Often I remained altogether insensible; often also I was surfeited, shocked, and mutinied. I reflected a long time upon all these different effects. I repeated my observations until I was assured that the same objects always made the same impressions upon me. I have consulted the taste of others, and putting them to the

same proof, I found in them all my sensibilities more or less lively, according as their souls had received from nature a less or greater degree of heat. From thence I concluded first that there were in Architecture essential beauties independent of the habitude of the senses, or of the agreement of them. Secondly, that the composition of a piece of Architecture was as all the operations of the mind, susceptible of coldness or vivacity, of exactness and disorder. Thirdly, that there should be for this art as for all others a talent which is not acquired, a measure of genius that is given by nature, and that this talent, this genius, ought nevertheless to be subjected and confined by laws.

In meditating always more upon the various impressions that the different compositions of Architecture made upon me, I was desirous of searching into the cause of their effect. I have called upon self for an account of my own sentiments. I was willing to know why such a thing ravished me, another only pleased me; this was without agreements; that were to me insupportable. This inquiry at first presented to me nothing but darkness and uncertainties. I was not discouraged, I have fathomed the abyss, until I believed I had discovered the bottom. I have not ceased to interrogate my soul until it had rendered me a satisfactory answer. All at once it has given to my eyes a great light. I have beheld distinct objects, where before I could not see anything but mists and clouds: I have seized these objects with ardour, and in making use of their light I have discovered by little and little my doubts to disappear, my difficulties to vanish, and I am at last able to demonstrate to myself, by principles and consequences, the necessity of all the effects; the causes of which I was ignorant. [...]

Introduction

Architecture of all the useful arts is that which requires the most distinguished talents, as well as the most extensive knowledge. Perhaps as much genius, spirit and taste is required therein as for the forming a Painter or a Poet of the first rank. It is a great mistake to think that mechanism only is required; that all is confined to laying foundations, and building walls, all according to rules; the practice of which supposes eyes accustomed to judge of a line, and hands to manage the travel.

When we speak of the art of building, of the confused heaps of troublesome rubbish, of heaps of shapeless materials, dangerous scaffolds, a frightful game of machines, a multitude of ragged labourers; this is all that presents itself to the imagination of the vulgar, it is the rind, the least agreeable of any art, the ingenious mysteries of which are understood by few, and excite the admiration of all who discern them. Therein are discovered inventions, the boldness of which intimates an extensive and most fruitful genius. Proportions, the use of which declares a severe and systematic precision. Ornaments, the elegance of which discloses a most excellent and delicate thought. Whoever is capable of discerning such a variety of beauties, far from confounding architecture with the lesser arts, will be tempted to place it in the rank of the most profound sciences.

The sight of an edifice, built with all the perfection of art, creates a pleasure and enchantment, which becomes irresistible. This view raises in the soul noble and most affecting ideas. We experience therein that sweet emotion, and that agreeable trans-

port that such works excite, which bear the impression of true superiority of genius. A fine building speaks most eloquently for its architect. Mons. Perrault in his writings only appears a knowing man; the colonade of the Louvre determines him the great one.

Architecture owes all that is perfect in it to the Greeks, a free nation, to which it was reserved not to be ignorant of any thing in the arts and sciences. The Romans, worthy of admiring, and capable of copying the most excellent models that the Greeks helped them to, were desirous there to join their own, and did no less then show the whole universe, that when perfection is arrived at, there only remains to imitate or decay.

The barbarity of succeeding ages having buried the liberal arts under the ruins of that empire, which alone retained its taste and principles, created a new system of Architecture, wherein unskilful proportions, ornaments ridiculously connected and heaped together, presented stones as paper work, unformed, ridiculous, and super-fluous. This modern architecture hath been but too long the delight of all Europe. Most of our great churches are unfortunately destined to preserve the traces of it to the remotest posterity. To say the truth, with numberless blemishes, this architecture hath had some beauties, and altho' there governs in its most magnificent productions a heavy and gross spirit of invention, we may yet admire the bold traces, the delicacy of the chisel, the majestic and disengaged air that one beholds in certain pieces, which through all their ways have something forlorn and inimitable. But at length more happy genius's discovered from the ancient monuments proofs of the universal wandrings, and also resources to return from them; made to taste the wonders that had in vain been exposed to every eye for so many ages. They meditated on the reports of them, they imitated their skill, and by the force of inquiry, examination, and trial, they again revived the study of good rules, and re-established Architecture in all its rights. They abandoned the ridiculous geugaws of the Goths and Arabians, and substituted in their room manly and elegant appearances of the Doric, Ionic and Corinthian. The French slow of invention, but quick to improve happy imaginations, envied Italy the glory of reviving the magnificent creations of Greece. Every place is full now of monuments that attest the ardour, that established the success of our fathers emulation. We have had our Bramanti, our Michael Angelos, our Vigniolis. The past age, an age where in regard to talents, nature amongst us, hath displayed, and perchance exhausted, all its fruitfulness. The past age has produced in feats of Architecture performers worthy of the best times. But at the moment that we arrive at perfection, as if barbarity had not lost all its rights with us, we are fallen again into the base and defective: every thing seems to threaten at last an entire downfall.

This danger that approaches every day nearer, which may yet be prevented, engages me to propose herein modestly my reflections upon an art for which I have always had the greatest love. In the design I propose, I am not moved by the passion of censure; a passion I detest; nor by the desire of telling new things, a desire I think at least frivolous. Full of esteem for our artists, many of whom are of known abilities: I confine myself to communicate to them my ideas and my doubts, of which I desire them to make a serious examination. If I bring to mind real abuses, as certain usages universally received amongst them, I do not pretend that they should refer themselves to my opinion only, which I submit frankly to their critical judgment. I

only request, they will divest themselves of certain prejudices too common, and always hurtful to the progress of the arts.

Don't let them say that not being of their profession I cannot speak of it with sufficient knowledge: it is assuredly the most vain of difficulties. We daily judge of tragedies without having ever made verses. The knowledge of rules is not prohibited to any body, altho' the execution is given but to some. Let them not oppose me with respectable authorities, without being infallible. It would undo all only to judge of what ought to be by what is. The greatest have sometimes erred. It is not therefore a sure means of avoiding error to take always their example for a rule. Don't let them interrupt me by pretended impossibilities: idleness finds many of them, when reason sees none. I am persuaded that those of our architects that have a true zeal for the perfection of their art, will accept of my good-will. They will find, perchance in this writing, reflections that had escaped them. If they make a solid judgement of them they will not disdain to make use of them: this is all I ask of them. [...]

Chapter I.

General principles of Architecture.

It is with Architecture as with all other arts; its principles are founded upon simple nature, and in the proceedings of this are clearly shown the rules of that. Let us consider man in his first origin without any other help, without other guide, than the natural instinct of his wants. He wants an abiding place. Near to a gentle stream he perceives a green turf, the growing verdure of which pleases his eye, its tender down invites him, he approaches, and softly extended upon this enameled carpet, he thinks of nothing but to enjoy in peace the gifts of nature: nothing he wants, he desires nothing; but presently the Sun's heat which scorches him, obliges him to seek a shade. He perceives a neighbouring wood, which offers to him the coolness of its shades: he runs to hide himself in its thickets and behold him there content. In the mean time a thousand vapours raised by chance meet one another, and gather themselves together; thick clouds obscure the air, a frightful rain throws itself down as a torrent upon this delicious forest. The man badly covered by the shade of these leaves, knows not how to defend himself from this invading moisture that penetrates on every part. A cave presents itself to his view, he slides into it, and finding himself dry applauds his discovery. But new defects make him dislike his abode, he sees himself in darkness, he breathes an unhealthful air; he goes out of it resolved to supply by his industry the inattentions and neglects of nature. The man is willing to make himself an abode which covers but not buries him. Some branches broken down in the forest are the proper materials for his design. He chooses four of the strongest, which he raises perpendicularly and which he disposes into a square. Above he puts four others across, and upon these he raises some that incline from both sides. This kind of roof is covered with leaves put together, so that neither the sun nor the rain can penetrate therein; and now the man is lodged. Indeed cold and heat will make him sensible of their inconveniences in his house, open on every part; but then he will fill up between the space of the pillars, and will then find himself secure. Such is the step of simple nature: It is to the imitation of her proceedings, to

which art owes its birth. The little rustic cabin that I have just described, is the model upon which all the magnificences of architecture have been imagined, it is in coming near in the execution of the simplicity of this first model, that we avoid all essential defects, that we lay hold on true perfection. Pieces of wood raised perpendicularly give us the idea of columns. The horizontal pieces that are laid upon them, afford us the idea of entablatures. In fine the inclining pieces which form the roof give us the Idea of the pediment. See then what all the masters of art have confessed. But then we ought here to be very much on our guard. Never principle was more fruitful in consequences. It is easy from hence to distinguish the part that enters essentially into the composition of an order of architecture, from those which are introduced only by necessity, or which have not been added thereto but by caprice. It is in the essential parts that all the beauties consist; in the part, added thereto by caprice, consist all the defects [. . .].

6 Jean-Baptiste de La Curne de Sainte-Palaye (1696–1781) 'Letter to M. de Bachaumont on Taste in the Arts and Letters'

La Curne de Sainte-Palaye was born in Auxerre in France and made his name as the discoverer and publicist of neglected national documents, such as the *Chroniques de Saint Denis* and the *Vie de Charlemagne*, which he found in the archives of the monastery of Saint-Yves. He stimulated a new appreciation of the literature of the Middle Ages and wrote important studies on the history of the French language. He was also an influential connoisseur and critic. His 'Letter to M. de Bachaumont' stages a familiar form of argument between the 'sister arts' of poetry and painting. La Curne accords himself the role of *littérateur* and antiquary, enraptured by the beauties of a Greek epigram, while his friend M. de Bachaumont is addressed as a lover of art, devoted to his portfolio of drawings by Raphael, Michelangelo and the Carracci, his Egyptian sculpture and his Etruscan vase. (Louis Petit de Bachaumont was a prominent and wealthy connoisseur and collector, whose own *Essai sur la peinture, la sculpture et l'architecture* was also published in 1751.) The particular interest of La Curne's text lies in the account of his own awakening to the feelings aroused by works of art. This is effected by a visit to Eustace Le Sueur's paintings of the Life of St Bruno in the Charterhouse of Paris, painted between 1645 and 1648 (now in the Louvre, Paris). The implication of the 'letter' is that good taste in all the arts may be identified with a quality of simplicity and purity of means. *Lettre de M. de S. P. à M. de B. sur le bon goût dans les arts & dans les lettres* was originally published in Paris in 1751. Our text is taken from the facsimile reprint of this edition, Geneva: Minkoff, 1972, pp. 1–10, translated for the present volume by Christopher Miller.

You, Sir, love the arts, and I literature. These tastes differ little, and I have often noticed how similarly we feel the things that affect us. Yet it has often happened, when we mutually confide our private thoughts, that each considers the other somewhat fantastical. This I confess; you will be no less sincere with me. You have sometimes found me reading a fat volume, full of Greek, which I called the *Anthology*; I was in ecstasies over a Greek epigram, and was tireless in my praise of the beauties I perceived in it. What man is so sterile as to wax laconic when he speaks of his passion? These beauties seemed to you utterly insipid. [. . .] I could not help but

notice this, though you tried hard to enthuse and appear of one mind with me; such are the deceptions practised among friends. It would be well, if none but such deceits were practised, and these more often! Men would the sooner recognize their errors, and hate each other less. After many words which convinced you not at all, you left my house shrugging your shoulders, and if you did not say, with Molière 'By my troth, the man is mad indeed,' you at least said: 'His judgement is impaired on certain topics.'

In either case, I was fully revenged when next I visited you; I found you at your fireside, contemplating a portfolio full of horribly torn sheets. I could see nothing on them but a monstrous scribbling of half-drawn figures, which looked to me like a sorcerer's book of spells, and which you, otherwise inclined, called 'the magic of the art of drawing'. What I thus scorned was nothing less than the work of Raphael, Michelangelo and the Carracci brothers, men whom I have so often heard you praise as immortal and divine. Whilst you put aside your habitual impassivity and expressed the most intense admiration, I remained stonily indifferent. I could not conceive how these unconnected lines carelessly and haphazardly drawn, these few pen-strokes hastily and randomly set down on paper, made such a strong impression on you; how, indeed they could convey to you what these clever people had intended, when, in the heat of composition, they had thus expressed their thoughts. Still less was I convinced that such trifling sketches should be dignified with the grave title of 'studies'.

You no doubt remember the Egyptian statuette which stood on your mantelpiece; what you would never have sold for all the gold in the world, generous to a fault, you ceded to the entreaties of a friend, and presented it to him. Your ape (as I then thought it) was squatting in a rather graceless posture, the head tolerably sketched out; the rest of it seemed to me as formless as those quaint little figures that idle country shepherds make with a knife and a piece of wood. The arms and legs sticking out of the corners of the figure were all stiff and dry, but you always exclaimed on the fine overall effect, its noble composition, and the precision and elegance of its proportions. It all seemed to you admirably outlined, the limbs well-fitting (forgive me, if the terms have not stuck in my memory); not a muscle was forgotten, and they were all at work. You even saw beneath the skin, and perceived the structure and action of the bones. [. . .] In your imagination, the statue became a masterpiece no less of anatomy and osteology than of sculpture. You supplied whatever the sculptor had omitted, as if he sought merely to suggest things, whereas I felt that he had no more thought of these things than I did.

You will still less have forgotten an Etruscan vase that was your pride and joy; you sacked an excellent valet, who unfortunately broke it. I was often startled by the eloquence – you never repeated yourself – with which you praised its beautiful form, its flowing harmonious outline, and a thousand other perfections of the kind. A few figures on the vase, such as we sometimes make by cutting them out of card or paper, you found, you said, ravishing in the naturalness of their attitudes, the regularity of their profiles and the magnificent simplicity of their garments. Often we have parted rather coldly, a little disappointed in one another.

Summer, and the walks that we took in the Charterhouse, reconciled us. When we entered the handsome cloisters, and meditated on those marvellous paintings of Le Sueur, we were rather more at one; you had a hundred and one things to tell me, and

I, though I had nothing to say myself, at least found nothing to contradict in what you said. I was almost always of the same mind; an intuition that I could not articulate made me think, I know not why, as you did. Nightfall would eventually part us, and leave me to my reflections.

Then I was no longer disappointed in you, but in myself. I was irritated that I could not, in my own eyes, justify a feeling whose principle remained a mystery to me, but whose intensity was not on that account diminished. In my impatience, I somewhat regretted the pleasure this feeling had given me.

As we often repeated our walks and visits to the cloister, the veil fell from my eyes, and I saw.

When I considered these incomparable pictures, which, more than any others, give me my idea of what Greek painting was like, and of the taste that they brought to the arts, as they did to purely intellectual works, I noticed that two or three figures in a cell, or in a landscape as simple as that cell, formed the whole of their subject. There were none of those forced attitudes, which nature disavows, and which the painter so unnecessarily includes, merely to show how well he draws; none of those exaggerated and invariably botched expressions, those draperies whose richness consists entirely in the bizarre superabundance of folds, and in superfluous ornaments; none of those fairy palaces reaching up into the inflamed heavens; no contrasts in the ordering of the groups, or in the arrangement of light and shade: no rackety 'machinery'.

Our cloister shows a few solitary devotees standing, kneeling, or in other positions – each as the state of his soul dictates – in meditation, prayer, or in silent penitential or devotional exercises. A long white garment of serge covers these devotees from head to foot. Most of them have their hands covered by their sleeves; their arms are crossed or fall casually by their sides, as chance would have it, or perhaps as nature presented them to the artist; for he always studied Nature, and she will always be the only mistress of the arts and taste. A small number of colours enlivens the pictures, without any effect of false brilliance. Everything exudes extreme simplicity. The compositions seem to have presented themselves to the artist just as they are, and to have cost him no effort. Yet the more I considered them, the more they delighted me. I then began to think, that the more we discover the efforts that are made to move us, the less effective they are; and the better artifice is concealed from us, the more successfully it attracts and touches us. I next concluded, that the fewer the means employed to produce a particular effect, the greater the merit of its production, and the more willingly the spectator or reader receives the impression that we sought to impart. The simplicity of these means, which were, it seems, visible and accessible to all men (though they make so little use of them), is what has created masterpieces in every genre, as if to serve eternally as our models. Here then, is that much discussed thing, the sublime.

And since that time, Sir, I have had no further quarrel with your bulging portfolios, your sketches, your Egyptian statues, and your Etruscan vases. I confess that the gulf between our opinions is a result of my trying to begin, not at the beginning, but at the end. I wanted to penetrate the mysteries of painting, and I am the merest neophyte. Like many another, I looked without seeing. To bring me back to the truth, I needed things that were absolutely complete, and which left nothing to be desired; above all, works that spoke to the mind; I have found them. [...]

7 Denis Diderot (1713–1784) 'Art' from the *Encyclopédie*

In mid-eighteenth-century France the questioning of received dogma proceeded in the face of official censorship. This censorship was rigid insofar as the interests of religious and civil authority converged, and unpredictable where their powers diverged. In 1746 Diderot's book *Pensées philosophiques* (Philosophical Thoughts) was burned by decree of the Parlement of Paris on the grounds that the ideas it expressed were anti-Christian. Three years later the publication of his *Lettre sur les aveugles* (Letter on the Blind) led to a three-month period of imprisonment in the Bastille. In 1750 he published the prospectus for an ambitious encyclopaedia. The expressed aim of this work was 'to collect all the knowledge scattered over the face of the earth, to present its general outlines and structure to the men with whom we live, and to transmit this to those who will come after us, so that the work of the past centuries may be useful to the following centuries, that our children, by becoming more educated, may at the same time become more virtuous and happier, and that we may not die without having deserved well of the human race.' This optimistic belief in the power of knowledge and education to counter dogma and to produce virtue and happiness typifies what subsequently came to be called 'the project of Enlightenment'. The *Encyclopédie* of 1751–76 was that project's definitive expression. Diderot and Jean Le Rond d'Alembert, a mathematician, had been involved in plans to produce a French translation of Ephraim Chambers' *Cyclopaedia, or Universal Dictionary of Arts and Sciences*, first published in England in 1728 (see IIA10). In the event they became the editors of a new and independent publication, coordinating the contributions of some 200 collaborators, named or unnamed according to the vagaries of religious opposition and state censorship as the work progressed over the course of twenty-five years to its final tally of seventeen folio volumes (followed by eleven volumes of plates and five further supplementary volumes). Besides Diderot and D'Alembert themselves, those known to have been involved as authors include the Marquis de Condorcet, Baron d'Holbach, Charles-Marie La Condamine, Jean-François Marmontel, Charles Montesquieu (see IIIB7), Jean-Jacques Rousseau (see IIIA 2,3), Jean-François Saint-Lambert (see IIIC8), Voltaire (see IIIB8, 14) and Claude-Henri Watelet (see IVA15). The *Encyclopédie* attracted some 4,000 subscribers in France, both representing and informing that professional middle class whose rise to the forefront of public life was to be decisively marked by the Revolution of 1789. Diderot's article on 'Art' serves to make clear that the Arts as the editors understood them were not restricted to the 'Fine Arts' of polite culture, but embraced all forms of productive activity and practice, as distinguished from the contemplative and observational activities of the 'Sciences'. This was not an unaccustomed usage for the time. What *was* unusual was that anyone who concerned himself with the 'mechanical arts' should also be versed in the more refined problems and possibilities of painting and sculpture. The very breadth of the Encyclopaedists' interests and sympathies ensured that their writing would be challenging to the restricted artistic culture of the *ancien régime* – as Diderot's criticism was to prove after 1759, when he turned his full attention to the work exhibited in the Salon (see IIIC12–14 and IVA11). 'Art' was originally published in the *Mercure de France* in 1751, attracting interest in advance of its inclusion in the first volume of the *Encyclopédie* later in the same year. Our version is taken from *Encyclopedia, Selections*, translated by N. S. Hoyt and T. Cassirer, Bobbs-Merrill, 1965, as reprinted in S. Eliot and B. Stern eds., *The Age of Enlightenment*, vol. 2, London: Ward Lock Educational in association with the Open University Press, 1979, pp. 144–53. (See also IIIC12–14, IVA11.)

ART. Abstract metaphysical term. Men began by collecting observations on the nature, function, use and qualities of beings and their symbols. Then they gave the name of science or art to the center or focal point to which they linked the observations they had made, in order to create a system of instruments, or of rules which were all directed toward the same object. That is the most general meaning of art. To give an example: Men reflected on the usage and function of words and subsequently invented the word 'grammar.' Grammar is the name of a system of instruments and rules that relate to a specific object; this object is articulated sound. The same is true of the other arts and sciences.

Origin of the arts and sciences. In pursuit of his needs, luxury, amusement, satisfaction of curiosity, or other objectives, man applied his industriousness to the products of nature and thus created the arts and sciences. The focal points of our different reflections have been called 'science' or 'art' according to the nature of their 'formal' objects, to use the language of logic. If the object leads to action, we give the name of 'art' to the compendium of the rules governing its use and to their technical order. If the object is merely contemplated under different aspects, the compendium and technical order of the observations concerning this object are called 'science.' Thus metaphysics is a science and ethics is an art. The same is true of theology and pyrotechnics.

Speculative and practical aspects of an art. From the preceding it is evident that every art has its speculative and its practical aspect: the former consists in knowing the principles of an art, without their being applied, the latter in their habitual and unthinking application. It is difficult if not impossible to go far in the practice of an art without speculation, and, conversely, to have a thorough knowledge of the speculative aspects of an art without being versed in its practice. In every art there are many particulars concerning its material, its instruments, and its application which can only be learned through practice. It is the function of practice to present difficulties and phenomena, while speculation must explain the phenomena and solve the difficulties. Consequently, only an artist who can think logically can talk well about his art.

Division of the arts into liberal and mechanical arts. When men examined the products of the arts, they realized that some were primarily created by the mind, others by the hands. This is *part* of the cause for the preeminence that some arts have been accorded over others, and of the distinction between liberal and mechanical arts. This distinction, although it is quite justified, has led to bad consequences because it has given a low name to people who are very worthy and useful, and encouraged us in a certain natural laziness. We are all too inclined to believe that it is beneath the dignity of the human spirit to apply oneself diligently and continuously to specific and concrete experiments and objects, and that our mind forfeits its dignity when it descends to the study, let alone the practice, of the mechanical arts; the mind here stoops to questions in which research is laborious, reflection inglorious, and exposition difficult; such questions are dishonorable to deal with, countless in number, and of scarcely any value. *Minui majestatem mentis humanae, si in experimentis et rebus*

particularibus,[1] *etc.* (Bacon, *Novum Organum*). This prejudice has tended to fill the cities with useless spectators and with proud men engaged in idle speculation, and the countryside with petty tyrants who are ignorant, lazy, and disdainful. Such was not the thinking of Bacon, one of the foremost geniuses of England, nor of Colbert,[2] one of the greatest ministers of France, nor, in a word, of the right-thinking and sensible men of all times. Bacon considered the history of the mechanical arts the most important branch of true philosophy; therefore he certainly did not scorn its practice. Colbert considered the industry of the people and the founding of manufactures the most reliable resource of a kingdom. In the opinion of those who today can discern true worth, the state benefited no less from a man who filled France with engravers, painters, sculptors, and artists of all types, who wrested from the English the secret of the machine for producing hosiery, from the Genoese their velvet, from the Venetians their mirrors, than it benefited from those who vanquished the enemies of France and took their fortresses. In the eyes of a philosopher a sovereign may deserve more praise if he has encouraged men like Le Brun, Le Sueur, and Audran,[3] if he has had the battles of Alexander painted and engraved, and the victories of our generals represented in tapestry, than he would for having gained those victories. Place on one side of the scales the actual advantages of the most sublime sciences and the most honored arts, and on the other side the advantages of the mechanical arts, and you will find that esteem has not been accorded to the one and to the other in just proportion to the benefits they bring. You will discover that far more praise has been heaped on those men who spend their time making us believe that we are happy, than on those who actually bring us happiness. How strangely we judge! We expect everyone to pass his time in a useful manner, and we disdain useful men.

General purpose of the arts. Man is only the minister or interpreter of nature: he can only understand or act insofar as he has knowledge of the beings that surround him, either by means of experiment or reflection. His bare hand can only achieve a small number of effects, however robust, tireless, and supple it may be; it succeeds in great enterprises only with the help of instruments and rules. The same is true of the understanding. It is as if instruments and rules provided additional muscles for the arms, and additional energy for the mind. The general purpose of any art, or of any system of instruments and rules concurring toward the same end, is to impress specific forms onto the basic element provided by nature. This element can be either matter, or spirit, or some function of the soul, or some product of nature. However, I shall devote most of my attention to the mechanical arts, particularly because other authors have written little about them. In these arts *man's power is limited to moving natural objects closer or farther away. Man is capable of everything or nothing, depending on whether it is or is not possible to bring objects closer or move them farther away* (see Bacon, *Novum Organum*).

* * *

Of the geometry of the arts. Everyone will readily agree that there are few artists who can dispense with the elements of mathematics. Yet here we have a paradox, although its truth is not immediately obvious: in many situations knowledge of these elements would actually hamper an artist if, in practice, the precepts of mathematics were not

corrected by an extensive knowledge of physical circumstances; such as location, position, irregular figures, materials and their qualities, elasticity, rigidity, friction, consistency, duration, as well as the effects of air, water, cold, heat, dryness, and so forth. It is clear that the elements of academic geometry constitute only the simplest and least complex elements of workshop geometry. There exists not one lever in nature that is the same as the one which Varignon[4] presupposes in his propositions; there exists not one lever in nature whose factors can all be calculated. Among these factors we find a great number, some of them very essential in practice, which cannot even be subjected to the mathematical operations by which we determine the slightest discernible differences of quantity. Hence a man who knows only theoretical geometry is usually not skilful, and an artist who knows only experimental geometry is very limited as a worker. But, in my opinion, experience shows us that it is easier for an artist to get along without theoretical geometry than for any man to get along without some experimental geometry. In spite of calculus the entire subject of friction has remained the province of experimental and practical mathematics. It is remarkable how far we can go with only this mathematics. How many bad machines are suggested every day by men who imagine that levers, wheels, pulleys, and cables perform in a machine as they do on paper! Because they have not taken part in practical work, they have never learned the difference between the effects of the machine itself and of its section. We will add a second observation since the subject suggests it: there are machines that are successful on a small scale but not on a large scale. Of some others the opposite is true. I believe that the latter should include all the machines whose effect depends principally on the considerable weight of their component parts, on the force of reaction in a fluid, or on a great volume of elastic matter upon which these machines have to act. If one constructs them on a small scale, the weight of the parts is reduced to nothing, the reaction of the fluid is almost nonexistent, the forces on which one has counted disappear and the machine is ineffective. However, just as there is a point, if we may use the term, a limit that stands in relation to the size of the machine, where it ceases to be effective, there is another below or beyond which the potential of its mechanism does not produce its maximum effect. Every machine has, in the language of geometry, a *maximum* size. When we consider each part in relation to its most perfect functioning, it has a size that is determined by the other parts. Similarly, from the point of view of its most perfect functioning, the whole has a size determined by the machine, by its intended use, and by an infinity of other matters. But where, you will ask, is the limit in the dimensions of a machine, beyond or below which it is either too large or too small? Which is the actual and absolute size of an excellent watch, a perfect mill, or a ship of the best possible construction? To give us an approximate solution to these problems, we need the experimental and practical geometry of several centuries, assisted by the most subtle theoretical geometry. I am convinced that it is impossible to obtain any satisfactory result when these types of geometry are kept separate, and that it is very difficult to do so even when they are combined.

Of the language of the arts. I have found the language of the arts to be very imperfect for two reasons: the scarcity of proper nomenclature and the frequency of synonyms. Some tools have several different names while others have only the generic name

'engine' or 'machine,' without any additional name to distinguish them. At times an insignificant difference is enough to make artists invent specific names to substitute for the generic name. At other times a tool that is distinctive because of its form and use either has no name or is given the name of another tool with which it has nothing in common. One would wish for more attention to analogy of form and use. Geometers do not have as many names as they have figures, but in the arts a hammer, a pair of tongs, a bucket, a shovel, etc., have almost as many names as there are arts. A good part of the language changes from manufacture to manufacture. Yet I am convinced that the most unusual operations and the most complex machines could be explained by a rather small number of familiar, well-known terms, if it were decided to use technical terms only when they communicate a distinctive idea. What I am saying must carry conviction for anyone who considers that complex machines are only combinations of simple machines, that there are few simple machines, and that in the description of any operation all the movements can be reduced, without any significant error, to rectilinear and circular movements. It would be desirable if a good logician, well versed in the arts, undertook to describe the elements of a 'grammar of the arts.' For a first step he would have to determine the value of the correlatives 'big,' 'large,' 'average,' 'thin,' 'thick,' 'slight,' 'small,' 'light,' 'heavy,' etc. For this purpose one must seek a constant measure in nature or evaluate the height, width, and average force of man, and relate to it all indeterminate expressions of quantity, or at the least set up tables to which artists would be asked to make their language conform. The second step would be to decide on the differences and similarities between the form and the use of one instrument and another, between one operation and another, in order to determine when these should keep the same name and when they should be given different names. I do not doubt that anyone who undertakes this task will find it necessary to eliminate synonyms rather than to introduce new terms. I am also sure that it is more difficult to give a good definition of common terms, such as 'elegance' in painting, 'knot' in trimming, 'hollow' in several arts, than it is to explain the most complicated machines. It is the lack of precise definitions and the great number, not the diversity, of movements in various operations that makes it difficult to speak clearly about the arts. The only remedy for the second problem is to familiarize oneself with the objects: they are well worth the trouble whether we think of the advantages they bring us or of the fact that they do honor to the human mind. In what physical or metaphysical system do we find more intelligence, discernment, and consistency than in the machines for drawing gold or making stockings, and in the frames of the braid-makers, the gauze-makers, the drapers, or the silk workers? What mathematical demonstration is more complicated than the mechanism of certain clocks or the different operations to which we submit the fiber of hemp or the chrysalis of the silkworm before obtaining a thread with which we can weave? What projection is more beautiful, more subtle, and more unusual than the projection of a design onto the threads of a simple and from there onto the threads of a warp? What can conceivably be more subtle than the art of shadowing velvet? I could never enumerate all the marvels that amaze anyone who looks at factories, unless his eyes are closed by prejudice or stupidity.

I shall follow the example of the English philosopher and mention three inventions that were unknown to the ancients. It is to the shame of modern history and poetry

that the names of their inventors are scarcely known. I am speaking of the art of printing, the discovery of gunpowder, and the properties of the magnetic needle. What a revolution these discoveries have brought about in the republic of letters, in military art, and in seafaring! The magnetic needle has led our ships to the most remote regions, typographic characters have created enlightened communication between learned men of all countries and all future time, and gunpowder has occasioned all the architectural masterpieces that defend our frontiers as well as those of our enemies; these three arts have almost transformed the face of the earth.

Let us finally render artists the justice that is their due. The liberal arts have sung their own praise long enough; they should now raise their voice in praise of the mechanical arts. The liberal arts must free the mechanical arts from the degradation in which these have so long been held by prejudice, while royal protection must save them from the indigent state in which they still languish. The artisans have thought they deserved disdain because they were in fact disdained; let us teach them to think better of themselves, only then can we obtain more perfect products from them! We would wish that from the halls of the academies there would emerge a man who would go into the workshops, record everything noteworthy about the arts, and set it forth in a work that would induce the artists to read, the philosophers to think usefully, and the nobles to begin exercising their authority and their munificence in a useful manner.

If we may give some advice to learned men, we would suggest that they practice what they teach, namely not to judge too hastily nor to condemn an invention as useless because in its early stages it does not bring all the advantages that could be expected of it. [...]

On the other hand we invite the artists to take counsel with learned men and not to allow their discoveries to perish with them. The artists should know that to lock up a useful secret is to render oneself guilty of theft from society. It is just as despicable to prefer the interest of one individual to the common welfare in this case as in a hundred others where the artists themselves would not hesitate to decide for the common good. If they communicate their discoveries they will be freed of several preconceptions and especially of the illusion, which almost all of them hold, that their art has reached its ultimate perfection. Because they have so little learning they are often inclined to blame the nature of things for a defect that exists only in themselves. Obstacles seem insuperable to them whenever they do not know the means of overcoming them. Let them carry out experiments and let everyone make his contribution to these experiments: the artist should contribute his work, the academician his knowledge and advice, the rich man the cost of materials, labor, and time; soon our arts and our manufactures will be as superior as we could wish to those of other countries.

[1] Diderot is quoting from Francis Bacon's Latin work *Novum Organum* (1620), which discusses, in a series of aphorisms, the methods of acquiring knowledge. In the aphorism here quoted (Book I, Aphorism LXXXIII) Bacon is quoting the common view that 'the dignity of the human mind is lowered by long and frequent intercourse with experiments and particulars.'

[2] Jean-Baptiste Colbert (1619–83), Minister of Finance to Louis XIV, did a great deal to encourage French industry and technology and was instrumental in founding the French Academy of Sciences in 1666.

[3] Charles Le Brun (1619–90) and Eustache Le Sueur (1616–55) were painters; Gerard Audran (1640–1703) was an engraver who engraved many of their paintings.

[4] Pierre Varignon (1654–1722), French mathematician, author of *Nouvelle mécanique et statique* (1725).

8 Jean-François, Marquis de Saint-Lambert (1716–1803) 'Genius' from the *Encyclopédie*

Saint-Lambert contributed articles to the *Encyclopédie* on government and military history as well as art. Though his authorship of the article on Genius is now generally accepted, it has sometimes been attributed to Diderot, whose thought is certainly reflected in it. The separation of genius from taste is significant of a growing impatience with art's regulation by forms of decorum, whether imposed in the name of religion, of custom or of common sense. In this as in many other respects the contributors to the *Encyclopédie* give early expression to attitudes normally associated with the Romantic movement at the end of the century. 'Génie' was first published in the seventh volume of the *Encyclopédie*, issued in 1757. Our version is taken from the text printed in *Denis Diderot's The Encyclopedia*, ed. and trans. Stephen J. Gendzier, New York, Evanston and London: Harper & Row, 1967, pp. 118–24.

GENIUS (*Philosophy and Literature*). Range of mind, power of imagination, and responsiveness of soul: this is *genius*. The manner in which ideas are received determines those that are remembered. Man thrust into the universe receives with more or less vivid feelings the ideas of all beings. Most men only have vivid feelings from the impression of objects bearing directly on their needs, their tastes, etc. Everything which is foreign to their passions, everything which is not analogous to their way of existing, either is not perceived by them or is only seen for a moment without being felt and is forever forgotten.

The man of *genius* has a soul with greater range, can, therefore, be struck by the feelings of all beings, is concerned with everything in nature, and never receives an idea that does not evoke a feeling: everything stirs him and everything is retained within him.

When the soul has been moved by an object itself, it is even more affected by the memory of the object. But in a man of *genius* imagination goes further: it recalls ideas with a more vivid feeling than it received them, because to these ideas are connected a thousand others more appropriate to arouse the feeling.

The *genius* surrounded with objects that preoccupy him does not remember: he sees but does not restrict himself to seeing: he is moved; in the silence and obscurity of his room he enjoys the smiling and fertile countryside; he is chilled by the whistling of the winds; he is burned by the sun; he is frightened of storms. The soul often takes pleasure in these momentary affections; they give him enjoyment that is precious to him. The soul gives itself to everything that can increase its scope; with true colors and indelible strokes it would like to give body to the phantasms that are its work, that transport or amuse it.

When he wishes to paint a few objects that excite him, things and people sometimes shed their imperfections; only what is sublime or pleasant finds its way into his

paintings; then *genius* paints the bright side of everything: sometimes he sees in the most tragic events only the most terrible of circumstances; and in this moment *genius* spreads the most somber colors, powerful expressions of lament and sorrow; he animates matter, colors thought; in the heat of enthusiasm he neither orders nature nor arranges the sequence of his ideas; he is transported into the situation of the personages he invents; he has taken on their character: if he feels heroic passions to the highest degree, such as the confidence of a noble soul in full possession of its power rising above all danger, such as love of country carried to the point of forgetting oneself, then he produces the sublime . . .

This force of enthusiasm inspires the proper word which is striking but often sacrificed for bold figures of speech; it inspires imitative harmony, images of all kinds, the most delicate motions and imitating sounds, embodied in the words that characterize people.

Imagination can assume different forms: it borrows them from the different qualities that form the character of the soul. Some passions, the diversity of circumstances, and certain qualities of the mind give a particular turn to the imagination: it does not recall all of its ideas with feeling, because there is not always a relationship between it and all beings.

Genius is not always *genius*; sometimes it is more amiable than sublime; it feels and paints what is graceful more than what is beautiful in things; it experiences and makes us experience gentle emotions more than ecstasy.

Sometimes in a man of *genius* the imagination is gay concerning itself with the slight imperfections of humanity, with ordinary faults and follies. The opposite of order is only ridiculous to it, but in a manner which is so new that it seems the view of the man of *genius* is responsible for treating the object with ridicule which he has only just discovered there. The gay imagination of a *genius* enlarges the field of ridicule, and while the common people see and feel it in that which offends established practice, *genius* discovers and feels it in what is offensive to universal order.

Taste is often separate from *genius*. *Genius* is a pure gift of nature; what he produces is the work of a moment; taste is the product of study and time; it depends on the knowledge of a multitude of established or assumed rules; it brings about the creation of beauty that is merely conventional. For a thing to be beautiful according to the rules of taste, it must be elegant, perfect, worked on without seeming so: to be of *genius*, it must sometimes be untidy with an irregular, abrupt, savage appearance. *Genius* and the sublime sparkle in Shakespeare as flashes of lightning in a long night, and Racine is always beautiful: Homer is full of *genius*, and Virgil of elegance.

The rules and laws of taste would place shackles on *genius*: he breaks them to soar to what is sublime, pathetic, or noble. The taste of a man of *genius* is defined by his love of this eternal beauty that characterizes nature and by a passion to make his tableaux conform to some kind of model that he has created and according to which he has an idea and a sense of the beautiful. The need to express the passions that move him is continually obstructed by grammar and usage: often the idiom in which he writes hinders the expression of an image that would be sublime in another idiom. Homer could not find in a single dialect the expressions necessary for his *genius*;

Milton constantly violates the rules of his language and goes in search of powerful expressions from three or four different idioms. Finally strength and abundance, a certain kind of roughness, irregularity, the sublime, and the pathetic – this is the character of *genius* in the arts; he does not touch lightly, he does not please without astonishment, he even astonishes by his imperfections. [...]

The *genius* is struck with everything, and as soon as he is not possessed by his thoughts and subjugated by enthusiasm, he studies, so to speak, without being aware of it; he is forced by the impressions that objects make on him to enrich himself continually with knowledge that costs him nothing; he casts an ample eye on nature and pierces its abyss. He gathers in his breast the seeds of thought that enter there imperceptibly and that produce in time some results that are so astonishing that he is tempted to believe himself inspired: he nevertheless has a taste for observation, but he rapidly observes a great distance, a multitude of beings.

Movement, which is his natural state, is sometimes so gentle that he hardly notices it; but most often this movement stirs up a tempest, and the *genius* is rather carried away by a torrent of ideas than inclined to follow in an unstrained manner his calm reflections. In a man dominated by imagination ideas are tied together by circumstances and feeling: he often sees abstract ideas only in their relationship to perceptible ideas. He gives to abstractions an existence independent of the mind that made them; he gives reality to his phantasms, his enthusiasm increases at the sight of his creations, that is to say, of his new combinations, the only creations of man; carried away by a host of thoughts, possessed by the gift of combining them, forced to produce, he finds a thousand specious articles of evidence and is not certain of any of them; he builds audacious structures in which reason would not dare to dwell and which please him by their proportions and not by their solidity; he admires his systems as he would admire the plan of a poem, and he embraces them as objects of beauty while believing that he loves them as the truth.

Truth and falsehood, in philosophic works, are not distinct characteristics of *genius*.

There are very few errors in Locke and too few truths in Shaftesbury. The first, nevertheless, is only a far-reaching, penetrating, and judicious mind; and the second is a *genius* of the first order. Locke saw; Shaftesbury created, constructed, built: we owe to Locke some great truths coldly perceived, methodically sustained, boldly proclaimed, and to Shaftesbury some brilliant systems, often unfounded, filled nevertheless with sublime truths; and in his moments of error he pleases and even persuades by the charm of his eloquence.

The *genius* hastens, nevertheless, the progress of philosophy by the most fortunate and the least expected discoveries: he rises with the flight of an eagle toward a luminous truth, the source of a thousand truths at which the timid crowd of wise observers will subsequently arrive by crawling. And beside this luminous truth he will place the works of his imagination: incapable of following a normal course in life and of successively covering the intervals, he starts from one point and springs toward his goal; he draws a fruitful principle from out of the darkness; it is rare that he follows the chain of inferences; he is *spontaneous* [*primo-sautier*], to use the expression of Montaigne. He imagines more than he has seen; he produces more than he discovers; he sweeps along more than he leads the way: he incites the Platos, the

Descartes, the Malebranches, the Bacons, and the Leibnizes; and according to whether imagination has been more or less dominant in these great men, he causes brilliant systems to be developed or great truths to be discovered.

In the arts, the sciences, and the affairs of state the *genius* changes the nature of things; his character spreads over everything he touches, and the light of his reason flashes beyond the past and the present to illuminate the future: he surpasses the people of his century who cannot follow him; he leaves far behind him those minds who rightly criticize him but who proceed along a steady path and never depart from the uniformity of nature. The person who wishes to define him has more of a feeling and less actual knowledge about him: it is incumbent on him to speak about himself; and this article, which I should not have written, ought to be the work of one of those extraordinary men who reflect honor on this century and who would only have to look inside themselves to know the *genius*.

9 Anonymous: 'Observation' from the *Encyclopédie*

In its full text, this article betrays its author's particular interest in the areas of metallurgy and medicine. In the distinction it draws between observation and experiment or experience, however, it reveals the wider influence of natural-scientific research and of empirical philosophy on the principles of inquiry in general. It thus helps to define the larger intellectual framework within which the arts and sciences were considered by the Encyclopædists. 'Observation' was first published in 1765, when the last ten volumes of the *Encyclopédie* were issued, together with the fourth of eleven volumes of plates. Our version is taken from the text printed in *Denis Diderot's The Encyclopedia*, ed. and trans. Stephen J. Gendzier, New York, Evanston and London: Harper & Row, 1967, pp. 175–9.

OBSERVATION (*Gram. Physic. Med.*) is the attention of the soul focused on objects offered by nature. An experiment is the result of this same attention directed toward phenomena produced by the labors of man. We must, therefore, include within the meaning of the generic noun *observation* the examination of all natural effects, not only of those that present themselves at once and without intermediary to our sight but also those we would not be able to discover without the hand of a worker, provided that this hand has not changed, altered, or disfigured them. [...]

Observation is the primary foundation of all the sciences, the most reliable way to arrive at one's goal, the principal means of extending the periphery of scientific knowledge and of illuminating all its points. The facts, whatever they are, constitute the true wealth of the philosopher and the subject of *observation*: the historian collects them, the theoretical physicist combines them, and the experimenter verifies the results of their synthesis. Several facts taken separately appear dry, sterile, and unfruitful. The moment we compare them, they acquire a certain power, assume a vitality that everywhere results from the mutual harmony, from the reciprocal support, and from a chain that binds them together. The connection of these facts and the general cause that links them together are some of the objects of reasoning, theories, and systems, while the facts are the materials. The moment a certain number of them have been gathered, some people hasten to construct; and the

building is the more solid as the materials are more numerous and each one of them finds a more appropriate place. It sometimes happens that the imagination of the architect compensates for the deficiency found in the number and relation of the materials, and he manages to make them serve his plans, however defective they may be. This is the case of those audacious and eloquent theorists who, devoid of the necessary patience to observe, are content to have gathered a few facts, immediately tie them together by some ingenious system, and render their opinions plausible and attractive by the richness of their stylistic devices, the variety and force of some colorful writing, and striking and sublime images with which they know how to present their ideas. How can one resist admiring and almost believing Epicurus, Lucretius, Aristotle, Plato, and M. de Buffon? But when one is in too much of a hurry (a common shortcoming) to create a chain of all the facts that have been collected by *observation*, one constantly runs the risk of encountering some facts that cannot fit, that force a change in the system or destroy it entirely. And as the field of discovery is extremely vast, and its limits extend further as knowledge increases, it appears impossible to establish a general system that is always true. We should not be astonished to see some of the great men of antiquity attached to opinions that we find ridiculous, because there is every reason to presume that in times past those opinions took full account of all the *observations* already made and were in complete agreement with them. If we could live several centuries from now, we would see our principal systems, which appear the most ingenious and the most reliable, destroyed, scorned, and replaced by others that would then be subject to the same vicissitudes.

Observation has produced the history or the science of the facts that concern God, man, and nature. *Observation* of the works of God, of miracles, of religions, etc. has created sacred history. *Observation* of life, deeds, customs, and mankind has given rise to secular history. *Observation* of nature, of the movement of heavenly bodies, of the vicissitudes of seasons, meteors, elements, animals, vegetables, and minerals, of the mistakes of nature, of its use, of arts and crafts have all furnished the materials for the different branches of natural history....

Observation and experiment[1] are the only paths that we have to knowledge, if one recognizes the truth of the axiom: *we have nothing in our minds that did not originally come from the senses.*[2] At least these are the only means by which one can attain knowledge of objects that fall within the province of the senses. It is only through them that we can cultivate physics, and it is not doubtful that *observation* even in the physics of inorganic bodies infinitely surpasses experimentation in certainty and usefulness, although inanimate bodies, without life and almost without action, only offer the observer a certain number of phenomena that are relatively uniform and in appearance easy to recognize and combine. Although one cannot overlook the fact that experiments, especially those in chemistry, have shed a great light on that science, we see that the parts of physics, which are entirely within the province of *observation*, are the best known and perfected. It is by *observation* that the laws of motion have been determined, that the general properties of bodies have been known. It is to *observation* that we owe the discovery of gravity, attraction, acceleration of heavy bodies, and the system of Newton; on the other hand, Descartes' system was based on experience. Finally it is *observation* that created astronomy and carried it to this point of perfection in which we see it today, and which is such that it surpasses in

certainty all the other sciences. The immense distance of the heavenly bodies, which prevented all experimentation, seemed bound to be an obstacle to our knowledge. But *observation*, to which astronomy was totally delivered, cleared this and all other obstacles. One can also say that celestial physics is the fruit and triumph of *observation*. In chemistry *observation* opened a vast field of experimentation: it threw light on the nature of air, water, fire, on fermentation, on the decomposition and spontaneous degeneration of bodies. [...]

Man ultimately, from whatever angle one considers him, is the least appropriate subject for *experimentation*. He is the most suitable, lofty, and interesting object of *observation*; and it is only by means of this method that a certain amount of progress can be made in the sciences related to man. *Experimentation* here is often more than useless. Man can be considered from two principal points of view: either in regard to the moral or in connection with the physical. The *observations* made on *moral* man are, or should be, the basis of secular history, morality, and all the sciences which are derived from it. ... *Observations* made on man considered from the physical aspect comprise the noble and divine science called *medicine*, which is concerned with the knowledge of man, health, illness, and the means to relieve and prevent one and to conserve the other.

1 *Expérience* means 'experience' as well as 'experiment' in French. Sometimes one translation seems more appropriate than another, although a French writer might have both in mind.
2 See John Locke, *An Essay Concerning Human Understanding*, ed. Alexander Campbell Fraser (Oxford, 1894), I, 124–5, for the source of the author's apparent paraphrase.

10 Friedrich Melchior Grimm (1723–1807) from the *Correspondence littéraire*

The German critic and journalist Friedrich Melchior Grimm was born in Ratisbon and educated in Leipzig. He was in Paris by the later 1740s, where he was on close terms with Diderot and Rousseau. In 1753 he assumed the role of confidential correspondent to the brothers of Frederick II, King of Prussia, employed to keep them informed about literary and artistic matters in France. His communications took the form of a privately circulated manuscript journal, the *Correspondence littéraire, philosophique et critique*, which he edited until 1773, gradually enlarging its small list of subscribers amongst the royalty and senior aristocracy of Germany, Poland, Sweden and Russia. Both through the journal and through more direct forms of agency and advice he was responsible for recommending numerous purchases of French art to buyers abroad, among them Catherine the Great of Russia. He reviewed the Salons of 1753, 1755 and 1757, and persuaded Diderot to succeed him in 1759 (see IIIC 12–14 and IVA11). He was thenceforward to appear in Diderot's Salons as a frequent interlocutor, actual or imagined. In the following passage, he offers a trenchant critique of the kind of ambitious but rule-governed painting that was generally regarded as the highest form of the art, both within the Academy and by the representatives of the state. It was originally included in the *Correspondence littéraire* for 15 December 1756, and was first printed in *Correspondence littéraire, philosophique, et critique par Grimm, Diderot, Raynal, etc.*, ed. M. Tourneux, Paris, 1877–82, vol. III, pp. 317–21. The present translation by Michael Fried is taken from his *Absorption and*

Theatricality: Painting and Beholder in the Age of Diderot, Berkeley, Los Angeles and London: University of California Press, 1980, Appendix A, pp. 164–6.

I have always disliked enormous constructions in painting and in poetry. If it is true that in imitating nature the arts have no other aim than to move and to please, one must admit that the artist strays from his aim as often as he undertakes epic poems, painted ceilings, immense galleries, in a word, those complicated works that throughout the ages have received such injudicious praise. Simplicity of subject and unity of action are not only what is most difficult when it comes to genius and invention, but also what is most indispensable as regards overall effect. Our mind cannot embrace many objects or many situations at the same time. It gets lost in that infinity of details with which you believe you enrich your work. It wants to be struck at first glance by a certain ensemble, without hindrance and in a strong manner. If you miss this first instant, you will obtain nothing but those reasoned and tranquil praises that constitute the satire and the despair of genius. One thinks that one justifies those enormous constructions by saying that they are meant less to touch us than to arouse our admiration. But admiration is a rapid feeling, a sudden thrill that does not last and that becomes tiresome and cold as soon as one wants to prolong it. It is always produced by the simplicity and sublimity of a thought or a work of poetry, in painting and in music, whereas those complicated works can only cause a kind of cold astonishment. The most artistically arranged brilliance soon bores and repels. This is not to mention the numerous added ornaments and inevitably out of place accessories that a composed work of a certain size necessarily entails. The least evil that can be said of them is that they distract the mind from the principal object and that they complete the destruction of the effect of the whole. For all the praise that has been lavished on unity of action and on the subordination of details and their relation to the principal subject in all the great works of poetry and painting, there is none from which two-thirds would not be removed if it were a question of keeping only those bound essentially to the subject. How many episodes make us lose sight of the true personages of the action and introduce us to people whom we had no reason to expect and who should not occupy us! As for me, I frankly admit that I have never seen a gallery or a ceiling nor read an epic poem without a certain weariness and without feeling a diminution of that vivacity with which we receive impressions of beauty.

These reflections necessarily lead to another. It is incredible how much havoc and harm have been wrought in all the arts by imitation. Imitation alone is responsible for the audacity and the success of mediocre people, the timidity of men of true genius, and the discouragement the latter feel. Homer, obeying the divine flame that he felt burning within him, composed the story of the famous quarrel between the Greeks and the Trojans. The sublimity of his imagination, the simplicity of his soul and of his age, give all the details of his poem, however diffuse they may be, an inexpressible charm. But in listening to the muse who inspired him to sing Achilles' anger, he certainly did not intend to leave to his successors the model for an epic poem. Raphael and the great painters of his time, obliged to fill the whole length of a ceiling or a vast gallery, gave themselves over to the abundance of ideas, to the fecundity of their imagination, and, imparting to all their figures the divine inspiration by which

they themselves were animated, they left us monuments of their genius and of their glory. But they did not intend to give, through their works, the rules and theories of immense constructions in painting. Perhaps one should have admired in them only the difficulty overcome by the artist's genius. How contagious their example has been, and how high a price has been paid for their success! Their example has become so authoritative that the boldest and most determined genius would not dare to stray from it past a certain point, while the most mediocre man, by imitating them servilely, readily persuades himself that he is their equal and that he shares in their glory. Taste and criticism have completed the process of making the works of the greatest men dangerous for their successors by declaring what ought to please and by dictating the means by which to succeed in pleasing. Because of rules, genius, turned shy and timid, no longer dares to soar. It is imposed upon by authority and by examples. Men without talent, on the other hand, have become bold. They do not doubt that, to equal the achievement of a great architect, to construct edifices similar to those which excite admiration, they have only to study the scaffolding that was used to erect them. Bad copies have been made and, in spite of all the countless repetitions, the first models have remained unequalled. In that sense one can say that there has been but one epic poem, that of Homer. The most remarkable poetic genius, Virgil himself, did nothing but copy him, and the moderns have imitated him even more slavishly. Homer's construction has been used by all his successors. All epic poems resemble each other so strongly that they can only be considered reproductions of the *Iliad* and the *Odyssey*. This childish uniformity led to Dr. Swift's amusing idea of writing recipes for epic poems as one would write a medical prescription. It is certain that it would be unbecoming for an epic poem to appear without combats, without an account of some dangerous journey and frightful perils, without a descent into hell, without predictions and prophecies, etc. The most effective satire on all these puerilities is an epic poem on a comic subject. Why do *Le Lutrin* and *The Rape of the Lock* give us so much pleasure? Not because of their main subject, which is nothing, but because apart from the details that lend themselves to laughter, the poet seems to be ceaselessly mocking the construction and the scaffolding of the epic that the successors of Homer managed to render ridiculous. One does not make good jokes about something that does not lend itself to joking. Even if one wished to ridicule tragedy by parodies and by burlesque tragedies, one would never create anything but farces and insipid buffooneries, whereas the idea of comic epic poems has become a source of much amusement. The same applies to ceilings and galleries – they can be written out as recipes, and their construction is fully as puerile and even less well made than that of epic poems. Wise and enlightened criticism would have examined these works in quite a different way from that of our professional Aristarchuses. Instead of confusing the author's merit with that of his genre, of crediting the one with what belongs only to the other, it would have carefully distinguished what the *Iliad* owes to Homer's genius from what it owes to the merit of the epic in general, it would have distinguished what a gallery becomes under the brush of Raphael or Annibale Carracci from the beauty of the genre. Moreover, it is a well-known fact that a man of genius remains himself under any circumstances, that he remains great even when he errs or is put in shackles. But a genre does not become good in itself for having been treated by a great man, and in

order to appreciate it with a certain accuracy one must see what is made of it by a mediocrity. Had this method been followed in examining the genre of galleries and of ceilings in painting, perhaps enough drawbacks would have been found to have led to its abandonment.

Apart from the general reflections that we have just made, I shall conclude these remarks with two or three specific observations concerning the drawbacks of this genre. As regards galleries, the painter is almost always obliged to take a subject from history or fable and to treat it in a certain series of paintings. Now, few subjects have more than one pictorial moment; they rarely have two; almost never three or four. To get one excellent painting, the painter runs the risk of making several bad ones. Often the whole subject is poorly chosen, as in the Rubens gallery at the Luxembourg. It is the insipid story of Marie de Medici to which this great man was obliged to devote the poetry and the magic of his color. Another drawback of these grand constructions is that it was necessary to have recourse to allegory, so cold in poetry, so obscure and so unbearable in painting. Fools willingly call allegory the poetry of painters; for my part, I think that nothing so testifies to an artist's lack of genius as resorting to allegory. They have sought another resource in the supernatural, which is no less absurd. The supernatural must always be imperceptible; to bring it into view is to make it ridiculous. Thus the Assumption of the Virgin is a very bad subject, because it would be impossible to treat it without including many of those imaginary subjects that painters should never represent.

11 Etienne Falconet (1716–1791) 'Reflexions on Sculpture'

After a long apprenticeship with Jean-Baptiste Lemoyne, Falconet was received into the Académie Royale in 1754 and was made a professor seven years later. Like other approved sculptors of the time, he received occasional commissions to decorate royal buildings and gardens. The patronage of Mme de Pompadour led to his appointment in 1757 as director of the sculpture studios at the Sèvres porcelain factory, and much of his output for the next ten years took the form of models for statuettes and groups, either from his own designs or from drawings by Boucher. Between 1766 and 1778 he was in Russia, where the Empress Catherine had awarded him the most important of his commissions, for a giant equestrian statue of Peter the Great to be installed in St Petersburg. For much of this period he maintained a correspondence with Diderot, defending his belief in the immediacy and autonomy of the artist's practice against the writer's view that even a vanished work could be accorded status in posterity if it survived in the form of a literary account. Diderot left a memorable pen-portrait of his friend in the *Salon of 1765*, and was no doubt indebted to him for many of the views contained in his own essay on sculpture (see IIIC13). Falconet's extensive writings were published in his *Oeuvres complètes* in 1781. The 'Réflexions sur la sculpture' was composed at the request of Diderot for inclusion in the *Encyclopédie*. It was printed in 1761, and thirty years later was still regarded as sufficiently authoritative to be reprinted in Watelet's *Dictionnaire des arts*. Prior to publishing his text Falconet delivered it as a lecture at the French Academy on 7 June 1760. He must have taken a copy of his lecture with him to Russia, for it was in this original form that the 'Réflexions' was translated into English by William Tooke, Chaplain to the Factory at St Petersburg. This version was printed under the title *Pieces written by*

Mons. Falconet and Mons. Diderot on Sculpture in General, and particularly on The Celebrated Statue of Peter the Great now finishing by the former at St. Petersburg, London: printed by Bowyer and Nichols, 1777. Our text is taken from pp. 9–26 of this edition.

Gentlemen,

No one is more attentive to the admonitions of the Academy than I am. Artists have often been encouraged to communicate here the reflexions they might make on our arts. It has also been sometimes said, that an artist should not speak but with the pencil or chissel in his hand, leaving to enlightened admirers the task of discoursing on our talents.

Now, though I am very much of the latter opinion, I have one motive which determines me not to conform to it at present. I have been asked for some reflexions on Sculpture; which I think it my duty not to give to the world till they have been submitted to your judgment.

I am indebted for them partly to the lessons of my master M. Le Moyne; and if, among the rest, I should present some that stand in need of correction, to what tribunal more just and more enlightened can I submit them? It is to him that I should principally look for the correction of my mistakes.

Sculpture, next to History, is the most durable depositum of the virtues and weaknesses of men. If in the statue of Venus we have the object of a ridiculous and dissolute worship, that of Marcus Aurelius affords a famous monument of the homage paid to the benefactor of the human race.

This art, in discovering to us the deification of vices, more forcibly represents the horrible catastrophes of history; while, on the other side, the precious memorials of those uncommon mortals, who ought to have lived as long as their statues, keep alive in our hearts the sentiment of a noble emulation, animating the soul to the cultivation of those virtues which have embalmed their names. On seeing the statue of Alexander, Cæsar falls into a profound reverie; and, with eyes bathed in tears, exclaims: *How great was thy happiness! at my age thou hadst already subjugated a part of the earth; and I have yet done nothing for my glory.* – What a glory was his! – he destroyed his country.

The most noble end of Sculpture, in viewing it on the sentimental side, is that of perpetuating the memory of illustrious men, and of giving models of virtue, so much the more efficacious, as the owners of it are no longer the objects of envy. We possess the portrait of Socrates, and we reverence it. Who will answer for it that we should have the courage to love him, if he lived amongst us?

Sculpture has another object, seemingly less useful than the foregoing; I mean when it is employed on subjects of ornament or grace: it is here however no less capable of inciting the soul to good or evil propensities. Sometimes the sensations it raises are indifferent. The Sculptor, as well as the Writer, is praiseworthy or reprehensible, only as the subjects he treats of are becoming or licentious.

When the surface of the human body is the object of imitation, the powers of Sculpture are not to be confined to a cold resemblance, such as man might have been before the breath of God was blown into his nostrils. This sort of representation, although well expressed by its very exactitude, could only excite a commendation as

cold as the resemblance, and the soul of the spectator would be totally unmoved. It is living, animated, impassioned Nature, that the Sculptor is to express, in marble, in bronze, or in stone.

Whatever the Sculptor takes for the object of his imitation, ought to be the continual subject of his study. This study, enlightened by genius, conducted by taste and reason, executed with precision, encouraged by the munificent attention of sovereigns, and by the advice and elogies of excellent artists, will not fail to produce master-pieces equal to those precious monuments which have triumphed over the barbarism of ages. In like manner such Sculptors as, not confining themselves to the payment of their share in that tribute of applause, so justly due to these sublime performances, make them the object of their profoundest study, and the rule of their labours, must arrive at that superiority which we admire in the Grecian statues. If I might be allowed to quote, as a proof of this, examples from the works of living artists, I could find them at Paris, in the gardens of Choisi [a statue of Cupid by Bouchardon], and those of Sans-souci [a Mercury and a Venus by M. Pigalle].

The mind of the Sculptor is not to dwell only on the famous statues of antiquity, but on all the productions of genius whatever they may be. – The reading of Homer, that sublime painter, will exalt the soul of the artist, and impress the ideas of grandeur and majesty so forcibly upon it, that the generality of objects which surround him will appear to him but as atoms.

Whatever the imagination of the Sculptor can create of the most majestic, of the most sublime, of the most uncommon, ought to be only the expression of the possible appearances of Nature, of her effects, of her sports, of her accidents. I mean, that the Beautiful, even the ideal Beautiful, in Sculpture, as in Painting, should be nothing else than the result of the real Beautiful of Nature. An essential Beautiful undoubtedly exists, but dispersed through the different parts of the universe. To feel, to collect, to assort, to chuse, even to imagine different parts of this Beautiful, whether in the character of a figure, as the Apollo, or in the ordonnance of a composition, like the boldnesses of Lanfranc, Correggio, and Rubens, this is to display by art, that ideal Beautiful which has its source in Nature.

Above all things, Sculpture is the enemy of those forced attitudes which Nature disavows, and which some artists have employed without necessity, and only to shew that they could sport with Design. It is the professed enemy also of those draperies whose only elegance consists in the superfluous ornaments of a confused arrangement of folds. Lastly, it abhors over-refined contrasts in composition, and an affected distribution of lights and shades. In vain will it be pretended that it is the machine: at the bottom it will be found to be only confusion, and an unfailing cause of embarassment to the spectator, and of the little effect the performance will produce upon his soul. The more the efforts that are made to move us are discoverable, the less are we moved by them. Whence we are to conclude, that the fewer means an artist employs to produce an effect, the greater is his merit in producing it, and the spectator delivers himself up the more implicitly to the impression which it was intended to make upon him. It is by the simplicity of these means, that the master-pieces of Greece were so perfectionated as to become the models for artists to the end of time.

Sculpture has fewer objects than Painting has; but those which come within her province, and which are common to the two arts, are the most difficult to be

represented: these are, expression, the science of contours, the difficult art of disposing of draperies, and of distinguishing the different kinds of stuffs of which they are composed.

Sculpture has, moreover, difficulties which are peculiar to it. In the first place, a Statuary is not eased of any part of his work by the advantage of shades, of backgrounds, of roundings, and of fore-shortnings. Secondly, if he have well composed, and well expressed one view of his work, he has only performed a part of his business; since that work has as many points of view as there are points of space which surround it. Thirdly, a Statuary ought to possess an imagination, I do not say as abundant, but as strong as that of the Painter. Besides this, he must have a constancy of genius to put him above that disgust which the mechanism, the fatigue, and the slowness of his operations must necessarily occasion. Genius is not to be acquired; it unfolds, extends, and strengthens itself by exercise. A Statuary has not such frequent opportunities for the display of his genius as the Painter has, which is an additional difficulty, since genius must be shewn in a statue, as well as in a picture. Fourthly, the Sculptor, being deprived of the seducing charms of colours, what knowledge ought he not to have in the means of attracting attention? – To fix it, what precision, what truth, what choice of expression must he not put into his work?

We require then of the Sculptor not only the interest which results from the work entire, but also from every part of this whole; his work being generally composed of but one figure, in which it is not possible for him to unite the different causes productive of interest in a picture. Painting, independently of the variety of colours, interests by the different groups, the attributes, the ornaments, and the expressions, of the several personages which compose the subject. It interests by the ground, by the place of the scene, by the general effect: in a word, by the whole assemblage. But the Sculptor has often only one word to say: there is the more need that that word should be sublime. It is by that that he must touch the springs of the soul, in proportion to its own sensibility and to the skill which he has discovered.

Not but that many able Statuaries have borrowed that assistance which Painting draws from colours: Rome and Paris furnish examples of it. Doubtless, materials of different colours, employed with judgement, ought to produce pittoresque effects; but, when distributed without harmony, that assemblage renders Sculpture disagreeable, and even disgustful. The glare of gilding, the clashing of the discordant colours of different marbles, will doubtless dazzle the eye of the vulgar, always captivated by glitter; but the man of taste will turn from it in disgust. Gilding, bronze, and different-coloured marbles, ought only to be employed by way of decoration, never in order to rob Sculpture of its true character for the sake of substituting one that is false; or, at best, but equivocal. Thus, Sculpture will lose none of its advantages by being confined within the bounds prescribed by Nature; which it would certainly do, if all the advantages of Painting were employed. Either of these arts has her peculiar means of imitation: colour is by no means of that number which belongs to Sculpture.

Nevertheless, though colouring, which belongs properly to Painting, be of great advantage to her; yet how many difficulties has she to struggle with, which are entirely unknown to Sculpture! The facility with which the illusion is to be produced by colours, is itself a very formidable difficulty. The rare appearance of that talent is

but too convincing a proof of it. By how much more numerous the objects are which Painting has to represent, by so much must her particular studies be more numerous. A just imitation of different skies, of waters, of prospects, the different instants of the day, the various effects of light, and that law by which a picture is to be inlightened by only one sun, require a knowledge and an industry from which the Sculptor is intirely dispensed. Although there be studies and labours which belong exclusively to each of the two arts, it would betray a consummate ignorance to deny their relation. It would be an error to give preference to one of them at the expence of the other, because of their peculiar difficulties.

Painting is still agreeable, even when deprived of that enthusiasm and genius which characterise her; but, without the support of these two bases, the productions of Sculpture are lifeless and insipid. When equally inspired by genius, nothing disturbs their intimate union, notwithstanding there be some diffcrences in their progress. If these sisters have not a resemblance in every thing, a family likeness is always to be perceived. [. . .]

The artist whose means are simple, is free and open; he gives up himself to be judged the more easily, since he uses no sleights and evasions for escaping examination, which are only assumed as a mask to ignorance. Let us then never call those *beauties* in any work whatever, which serve only to dazzle the eyes, and tend to the corruption of taste. That taste so justly boasted of among the productions of the human mind, is only the effect of good sense operating upon our ideas: when too lively, it puts a bridle on them, and restrains their career; when too languid, it animates and inspires them. It is to this happy temperament, that Sculpture, as well as all the arts invented to please, owes its true beauties; the only ones that are lasting.

As Sculpture demands the most austere exactitude, a negligent design is less supportable in that than in Painting. I do not mean, that Rafaël and Dominichino were not very correct as well as very able designers, and that all capital Painters do not look upon this as an essential part of their art; but, strictly speaking, there may be pictures, where it does not reign, which yet are interesting by other beauties. A proof of it is in several women painted by Rubens, which, in spite of the Flemish incorrect character, will always inchant by the charm of the colouring. Execute them in Sculpture on the same character of design, the charm will be considerably diminished, if not intirely destroyed. The attempt would be worse, if made on certain figures of Rembrandt.

Why is it still less allowable to the Sculptor than to the Painter, to neglect any of the parts of his art? Perhaps it may be owing to three particulars: To the time that an artist must give to his work; for we cannot endure that a man should employ a number of years, only to produce an indifferent performance: To the value of the matter employed; – what comparison is there between a piece of canvas and a block of marble? Lastly, To the duration of the piece: every thing that is about the marble will fall to decay and ruin; but the marble remains. Break it into pieces, the very fragments shall deliver down to posterity its excellences and defects.

Having thus pointed out the object and the general system of Sculpture; we must now consider it as subject to particular laws, which the artist ought to understand, lest he should infringe their jurisdiction, or extend it beyond the limits of its power.

It would be to widen too much the extent of these laws, to say that Sculpture cannot give herself up to a daring flight in her compositions, by the constraint with which she is held down to the dimensions of a block of marble. We need only to behold the Gladiator and the Atalanta; these Grecian figures prove sufficiently, that marble will readily obey, when Sculpture knows how to command.

This liberty, however, which the Sculptor has over the marble, should not extend so far as to comprehend the exterior forms of his figures, by details exceeding and contrary to the action and motion represented. The work, by detaching itself, as it were, on a back-ground of air, of a tree, or of architecture, plainly declares itself to be what it is intended to represent, from the greatest distance at which it can be distinguished. The lights and shades, copiously distributed, concur also in determining the principal forms and the general effect. From whatever distance you perceive the Gladiator and the Apollo, their action is never doubtful.

Amongst the difficulties of Sculpture, there is one very generally known, and which requires the utmost attention of the artist; and this is the impossibility of going over again and rectifying any bad touches he may have made, or of making any essential alteration in the composition, or in any one of its parts: a very good reason for obliging him to make his model, and to fix it in such a manner as to enable him to proceed with the greatest accuracy in his labour on the marble. For which reason, the generality of Sculptors make their models, or at least sketch them out, on the spot where the statue is to be placed. By this method they are invariably sure of their lights and shades, and of the proper effect of the composition; which otherwise might have a very good effect in the light of the work-shop, but a very bad one where it is to be fixed.

But this difficulty reaches farther yet. The model being at length perfectly well finished, let us suppose the Sculptor to have but one moment of drowziness or absence of mind. If he go on with his work in that instant, he is sure to maim some important part of his figure, while he thinks he is following his model, or perhaps even rendering it more perfect. The next day, with his head in better order, he finds out the mischief, without being able to remedy it.

Happy advantage for the Painter! – Not subject to this rigorous law, he changes, corrects, and does it over again to his mind; at the very worst, he reprimes it, or he takes another. Can the Sculptor dispose thus of his marble? If it be necessary that he begin his work again, the loss of time, the fatigue, and the expence which he must suffer, are not to be compared with those of the other.

Moreover, if the Painter have traced his lines properly, placed his lights and shades as they ought to be; a different aspect, or a different light, will not entirely rob him of the fruit of his ingenuity and his pains. But, in a work of Sculpture, intended to produce a harmony of light and shade, cause only the light to strike it on the right-side, which did come from the left; or from below, that which came from above; you will find it deprived of every effect, or productive of only disagreeable ones, unless the artist have taken care to dispose them for different lights. It often happens also, that the Sculptor, in endeavouring to make every point of view agree, risks the omission of positive beauties, and at length effects but an indifferent harmony. Happy, if his repeated cares and attention do not cause him to grow cold over his work, and arrive at perfection in that particular!

To set this reflexion in a clearer light, I will relate one made by the Count de Caylus. 'Painting,' says he, 'has, out of three lights, the choice of that which will best inlighten the surface. Sculpture is dispensed from this choice; she has them all; and this abundance only occasions her an infinity of trouble and study, being obliged to consider and reflect upon all the parts of her figure, and then to make them conformable; it is she, in some sort, that inlightens herself; it is her composition which gives and which distributes her lights. In this respect the Sculptor is more a creator than the Painter; but this vanity is only satisfied at the expence of numberless reflexions and fatigues.' [From the *Mercure de France*, for April, 1759]

When a Sculptor has once overcome these difficulties, artists and true connoisseurs are, without doubt, much obliged to him. But, how many people are there, that are very agreeably affected by our arts, who, not knowing their difficulties, are not judges of the glory of having surmounted them?

The *Naked* is the proper study of the Sculptor. The principles of this study consist in the knowledge of the bones, the exterior anatomy, and an assiduous imitation of all the parts, with every possible movement of the human body. The schools of Paris and Rome require this practice, and provide their pupils with the means of acquiring it. But, as Nature herself may have her defects, the young student, by often seeing and repeatedly copying them, will be apt to transfer them to his works; he must therefore be placed under the conduct of some sure guide, to give him the knowledge of just proportions and of fine forms.

The Grecian statues are the most certain guide; they are, and will ever be, the rule of precision, of grace and elegance, as being the most perfect representations of the human body. To a man satisfied with a superficial examination of them, these statues will not appear to be very extraordinary things, nor even difficult to imitate: but the intelligent and attentive artist will discover in some of them the most profound knowledge of design, joined to all the energy of Nature. Thus those Sculptors who have most studied, with choice, the antique figures, have ever been the most distinguished in their profession. I say, *with choice*; and I believe the remark to be well founded.

However fine the statues of antiquity may be, they are still but human productions, and consequently susceptible of the imperfections of humanity: it would therefore be dangerous for an artist to bestow his admiration indifferently on every thing that bears the name of *antique*. It might happen, that, having admired the pretended wonders of certain antiques, and which they do not possess, he would make efforts to render them his own, and would fail of being admired. It is a discernment, inlightened, judicious, and unprejudiced, that must discover to him the beauties and the defects of the ancients; and, having once learned how to appreciate them, he will tread in their steps with so much the more confidence, as being convinced that they will conduct him to whatever is great and sublime. It is in this judicious discernment that a delicacy of taste appears; and the talents of the Sculptor are always in proportion to this delicacy. A very moderate knowledge of the state of our arts among the Greeks is sufficient to convince us that they too had their moments of drowziness and languor. The same taste reigned, but an equal knowledge was not imparted alike to every artist: the pupil of an excellent Sculptor may possess the manner of his master, without having the same head. An example shall

decide whether or not this be a rash observation. We will take it from the works of Puget.

In what piece of Grecian Sculpture do we perceive the implications of the skin, the softness of the carnations, or the fluidity of the blood, so well expressed as in the works of this celebrated modern Sculptor? – It is impossible not to perceive the blood circulate in the veins of the Milo at Versailles. What man of sentiment would not be apt to be mistaken on seeing the carnations of the Andromeda? while one may produce many fine antiques in which these expressions are not to be found. It would then be a sort of ingratitude, if, while acknowledging the sublimity of the Grecian Sculptors on so many other accounts, we were to refuse our homage to a merit which is regularly superior to them in the works of a French artist.

A scandalous passion for exposing the defects of celebrated pieces is not the source of this observation. The artist, who should not know how far superior the beauties are to the negligences and defects of these invaluable monuments of antiquity, must be the child of ignorance or frenzy, or checked by that exactitude which mediocrity establishes without the participation of genius.

We have seen that it is the imitation of natural objects, in subjection to the rules of the ancients, which constitutes the true beauties of Sculpture. But the most earnest contemplation of the antique figures, the most perfect knowledge of the muscles, the greatest precision of character, even the art of expressing the concurrent action of the skin; in short, all the springs of the human body; this knowledge, I say, is only for the eyes of artists, and a very small number of connoisseurs. But, as Sculpture is not exercised for the sake of those who practise the art, or such as have acquired intelligence in it; the Sculptor, that he may catch the applause of others, must join to these necessary studies still one more talent superior to them all. This talent, so essential and so uncommon, and which nevertheless appears to be within the comprehension of every artist, is Sentiment. It must be inseparable from all his productions. It is that which gives life to them: if other studies be the basis of Statuary, it is Sentiment alone which is the soul of it. Acquired knowledge is the property of some particular people; Sentiment belongs to all mankind: and, in respect of Sentiment, all mankind are the judges of our labours.

To express the forms of bodies, and to give no Sentiment to the expression, is doing work by halves. To endeavour at distributing it throughout with regard to precision, is only making sketches or producing dreams, the impression of which is erased the moment you cease to behold them; and, if for any length of time, even while you behold them. – The union of these two properties (but how hard to bring them in conjunction!) is the sublime in Sculpture.

12 Denis Diderot (1713–1784) from the 'Salon of 1763'

At the invitation of Melchior Grimm (see IIIC10), Diderot reviewed the biennial Salons for the *Correspondence littéraire* between 1759 and 1771. At the time of the 1773 Salon he was en route to St Petersburg with Grimm. He contributed a brief review for the year 1775 and a final one at Grimm's behest in 1781 (see IVA11). Taken together, Diderot's 'Salons' constitute a remarkable contribution to the modern development of art criticism. They are

distinguished by the variety of his approaches, by the vividness of his descriptions, and by the forthrightness of his judgements. The high point of his development as a reviewer of contemporary art is reached with the Salons of 1763, 1765 and 1767, each of which is longer than the last. It should be borne in mind that these were far from being public productions. By the end of the 1750s, the printing of independent Salon reviews was being officially discouraged. The *Correspondence littéraire* circulated in manuscript, its sale was prohibited in Paris, and while its readership may have been highly select, its subscription list barely reached double figures. On the other hand, it was free from censorship. Diderot was thus able to express opinions that would have been prohibited in a printed text. His 'Salons' were not in fact issued in printed form until the appearance of Jacques-André Naigeon's *Oeuvres de Denis Diderot publiés sur les manuscrits de l'auteur*, in fifteen volumes, Paris, 1798. Our excerpts from the 'Salon of 1763' are taken from *Diderot oeuvres IV: Esthétique-Théâtre*, ed. Laurent Versini, Paris: Robert Laffont, 1996, pp. 246–7, 264–5 and 275–8. Boucher's art represented all that Diderot disapproved of in the rococo art of the *ancien régime*. The work of Chardin and of Greuze, on the other hand, prompted him to some of his most effective passages of advocacy. It is noticeable that he adapts the manner of his writing to the work under consideration. In the case of Chardin he concentrates upon the quality of colour and the substantial properties of the paint, while Greuze's work stimulates him to acts of imaginative engagement with its represented subject. The excerpts have been translated for this edition by Kate Tunstall. (See also IIIC7, 13, 14 and IVA11.)

Boucher

Pastoral Scene

Imagine in the background a vase on a pedestal crowned with a bunch of heavily drooping branches; beneath it, a shepherd asleep in the lap of his shepherdess. Arrange around them a shepherd's crook, a little hat full of roses, a dog, some sheep, a bit of countryside and countless other objects piled on top of each other. Paint the lot in the brightest colours, and there you have Boucher's *Pastoral Scene*.

What a misuse of talent! How much time gone to waste! You could have had twice the effect for half the effort. With so many details all equally carefully painted, the eye doesn't know where to look. No air. No rest. And yet the shepherdess does have the right face for her station. And this bit of countryside surrounding the vase does have a delicacy, a freshness, a surprising charm. But what does this vase and its pedestal mean? What's the meaning of those heavy branches on top of it? When one writes, does one have to write everything? And when one paints, does one have to paint everything? For pity's sake, leave something to my imagination. But if you say that to a man who has been corrupted by praise and who is convinced of his own talent, he'll just nod his head in disdain; you'll say your piece and we'll move on. *Jussum se suaque solum amare* [Condemned to love nothing but himself and his own works]. It's a shame nonetheless.

When he first came back from Italy, this man did some very beautiful pieces. His sense of colour was strong and true. His compositional skill was sound but full of warmth, his style was generous and great. I know some of his early pieces which today he refers to as daubs and would happily buy back to burn.

He has old portfolios full of admirable pieces which he scorns and new ones stuffed full of sheep and shepherds *à la* Fontenelle which he is ecstatic about.

This man is the ruination of all young apprentice painters. Barely able to handle a brush and hold a palette, they torture themselves stringing together infantile garlands, painting chubby crimson bottoms, and hurl themselves headlong into all kinds of follies which cannot be redeemed by originality, fire, tenderness nor by any magic in their models. For they lack all of these.

Chardin

Here's the real painter, here's the real colourist.

There are many small pictures by Chardin at the Salon, almost all of them depicting fruit with the accoutrements for a meal. This is nature itself. The objects stand out from the canvas and they are so real that my eyes are fooled by them.

The one you can see as you go up the stairs [*The Jar of Olives*, Louvre, Paris] is particularly worthy of note. The artist has placed on a table a vase of old porcelain china, two biscuits, a jar full of olives, a basket of fruit, two glasses half full of wine, a bitter orange and a pie.

In order to look at other people's pictures, I feel as though I need different eyes; but to look at Chardin's, I need only keep the ones nature gave me and use them properly.

If I had painting in mind as a career for my child, I'd buy this one. 'Copy that for me,' I'd say, 'copy it for me again.' Yet nature itself may be no more difficult to copy.

That porcelain vase really is made of porcelain; those olives really are seen through the water they are floating in; you could simply take those biscuits and eat them; break open that bitter orange and squeeze it; pick up that glass of wine and drink it; peel that fruit; and cut a piece of that pie.

This is the man who really understands the harmony of colour and reflections. O Chardin, it's not white, red or black pigment that you grind on your palette but rather the very substance of objects; it's real air and light that you take onto the tip of your brush and transfer onto the canvas.

Once my child had copied that piece and then copied it again, I'd set her to work on *The Dead Skate* [*The Rayfish*, Paris, Louvre] by the same master. The object is revolting; but this is the real meat of the fish. Its skin, its blood; the sight of the real thing would affect you in just the same way. Mr Pierre, take a good look at this picture when you go to the Academy and if you can, learn the secret of using artistic talent to redeem the revolting aspect of certain subjects.

It's magic, one can't understand how it's done: thick layers of colour, applied one on top of the other, each one filtering through from underneath to create the effect. At times, it looks as though the canvas has misted over from someone breathing on it; at others, as though a thin film of water has landed on it. Rubens, Berghem, Greuze and Loutherbourg could explain this technique better than I; they would all describe the effect as you see it. Close up, everything blurs, goes flat and disappears. From a distance, everything comes back to life and reappears.

They say that when Greuze came to the Salon and saw the Chardin I've just described, he looked at it and gave a deep sigh. This brief praise is more valuable than mine.

Who will reward Chardin's paintings when this rare man is gone? You should also know that the artist is a man of sound judgement and can talk wonderfully about his art.

Ah! my friend, spit on Apelles' curtain and Zeuxis' grapes. An impatient artist is easily fooled and animals are bad judges of painting. Haven't we seen the birds in the King's Garden go crashing into the most unconvincing of *trompe-l'œils*? But it's you and me that Chardin will fool, any time he likes.

Greuze

That Greuze really is my kind of man. Putting to one side for a moment his small compositions which will give me some nice things to say to him, I'm going straight to his painting of *Filial Piety*, a better title for which would be *On the Rewards of a Good Education*.

To begin with, I like the genre. It's moral painting. What? Hasn't the painter's brush been given over to sin and vice often enough and for far too long? Shouldn't we be pleased to see it at last competing with dramatic verse to move us, teach us, improve us and invite us to be virtuous? Keep it up, Greuze, my friend! Put moral lessons in your paintings, and keep on doing it like this. When your time comes to leave this world, there won't be a single composition you won't be pleased to look back on. If only you had heard that young girl exclaim in a lively, charming way as she was looking at the face of your *Paralytic*: 'Ah, my God, how moved I am by him; if I look at him any longer though, I think I'll cry.' And if only that young girl were mine. I would have known her to be mine by that outburst. When I saw that pathetic, eloquent, old man, I too felt my soul moved to pity and I was ready to shed tears.

Filial Piety

This painting is 4 feet 6 inches wide and 3 feet high

The main figure, occupying centre stage, and who captures our attention, is a paralysed old man, stretched out in his armchair, his head on a pillow and his feet on a stool. He is fully dressed. His feeble legs are wrapped in a blanket. He is surrounded by his children and grandchildren, most of them anxious to attend to him. His lovely face has such a touching character; he seems so moved by the help he is being given; he has such difficulty speaking, his voice is so weak, his eyes so tender, his complexion so pale, that you would have to be devoid of all feeling not to be moved by him.

To his right, one of his daughters is raising his head on his pillow.

In front of him, on the same side, his son–in–law has come to give him some food. The son-in-law is listening to what his father-in-law says, and looks very moved.

To the left, on the other side of him, a young boy is bringing him something to drink. You should see the distress in his whole body. His grief is not only to be seen in his face, it's in his legs, in every inch of his body.

A small boy's head is visible from behind the old man's armchair. He is coming closer to him; he would also very much like to listen to his grandpa, to see him and help him; the children are dutiful. You can see his little fingers on the top of the armchair.

Another older boy is at his feet, arranging the blanket.

In front of him, a very young boy has slipped in between the son-in-law and his father-in-law and is presenting him with a goldfinch. Look at the way he is holding the bird! Look at the way he is offering it to him! He thinks it'll cure his grandpa.

Further away, to the right of the old man, is his married daughter. She is listening with joy to what her father is saying to her husband. She is sitting on a stool; she is leaning her head on her hand. She has the Holy Scripture on her lap. She has stopped reading it to the old man.

Next to the daughter is her mother and the paralytic's wife. She too is seated, on a wicker chair. She is darning a shirt. I am sure she is hard of hearing. She has stopped her work, and is leaning forward to listen.

On the same side, at the far edge of the painting, a servant has abandoned her work and is also listening.

Everything relates back to the main figure, both what everyone is doing now in the present moment and what everyone was doing in the previous moment.

Even the background reveals the way the old man is being cared for. There is a large sheet hanging to dry on a rope. This sheet is well thought out both in relation to the subject of the painting and for the artistic effect it produces. You would be right in thinking that the painter has not omitted to give it ample space.

Every figure in the picture shows precisely the right degree of interest for their age and character. The number of figures assembled in quite a small space is very large; but there is no confusion, for this master excels above all else at creating order in his scene. The skin colours are true. The fabrics are very carefully done. There is no awkwardness in any of the movements. Everyone is involved in what they are doing. The youngest children are happy because they are not yet old enough to have feelings. Compassion is clearest on the faces of the older figures. The son-in-law seems to be the most deeply moved because the sick man is speaking and looking at him. The married daughter seems to be listening with pleasure rather than with pain. Sympathy is, if not absent, then invisible in the old mother; and all this is true to life. *Iam proximus ardet Ucalegon*.[1] Very soon now, her only consolation will be that same tenderness being displayed by her children. And anyway, age hardens the heart and toughens the soul.

Some say the paralytic is leaning too far back and that it is impossible for him to eat in such a position. He is not eating, he is speaking and someone is ready to lift his head for him.

Some say it should be his daughter giving him the food and his son-in-law lifting his head and pillow, since the first task requires skill and the second strength. This observation is not as well-founded as it first appears. The painter wanted his paralytic to receive particular help from the person he had the least right to expect it from.

This justifies the choice he has made for his daughter; this is the real source of the emotion shown in his face, his eyes and in the words he is saying to him. To place this figure somewhere else would have been to change the subject of the picture. To put the daughter in the place of the son-in-law would have been to undermine the whole composition; it would have meant four women's heads next to each other and the series of all those heads would have been unbearable.

They also say that the degree of consideration shown by the figures is unnatural; that some should indeed be involved with the old man, but that the rest should be getting on with their own tasks; that the scene would thereby have been simpler and truer, and that that is how it was, they are sure of it. – Those people *faciant ut nimis intelligendo nihil intelligant*.[2] The moment they are asking for is a general moment, without interest; the one the painter has chosen is particular. By chance it happened that day that it was the son-in-law who was bringing him his food, and the old man was moved and showed his gratitude in such a lively and profound manner that it made the rest of the family abandon their activities and fix their attention on him.

They also say that the old man is dying, that his face is that of a man breathing his last – Doctor Gatti says that those critics have never seen a sick man and that this one has a good three years left in him.

They say that the daughter who is looking up from her book lacks expression or that she has the wrong expression – I agree in part.

They say that the arms of this otherwise charming figure are stiff, scrawny, badly painted and lacking in detail. – Well, that's certainly true.

That the pillow is brand new and that it would be more natural if it had been used before. – Perhaps.

That this artist is devoid of creativity; and that all the heads in the scene are the same as those in his painting of *The Betrothal* and that the heads in *The Betrothal* are the same ones as the ones in his *Peasant Reading to his Children*. – Fine, but supposing the painter wanted it this way? Supposing he has traced the history of the same family?

That ... damn those critics and me with them! This painting is beautiful, very beautiful, and woe betide anyone who is able to look at it for a single moment and remain unmoved! The old man's character is unique; the child who is bringing him a drink is also unique. The old lady, unique. Wherever you look, you are enchanted. The background, the blankets, the clothes are all perfectly finished; and furthermore, this man draws like a god. His use of colour is beautiful and strong, though it is not quite up to Chardin's. I'll say it again, this painting is beautiful, or I don't know what is. Moreover, it pulls in crowds of spectators; you can't get close to it. You are transported by it, and when you see it again, you realize you were right to be transported by it.

It would be very surprising if this artist did not excel. He has intelligence and sensibility. He is enthusiastic about his art; he is forever producing studies. He spares no expense and goes out of his way to get the models he needs. If he sees a striking face, he would happily go down on his knees in front of its wearer to persuade it to come into his studio. He is always observing people, in streets, in churches, in markets, in theatres, in promenades, in public assemblies. If he is thinking about a subject, he is obsessed by it, it follows him everywhere. It infiltrates his

own personality. He adopts that of his painting: he is brusque, gentle, guileful, acerbic, flirtatious, sad, gay, cold, serious or insane, depending on the subject he is preparing.

Besides the genius of his art, which you cannot deny him, you can see that he is intelligent by his choice and arrangement of secondary figures. In the painting of the *Peasant Reading the Holy Scripture to his Children*, he had placed on the floor in one corner a small child, amusing himself by pulling faces at a dog. In his *The Betrothal*, he had introduced a mother hen with her brood. In the former, next to the boy bringing a drink to his sick father, he had placed a big dog, a bitch, suckling her puppies while standing still with her nose in the air; not to mention the sheet stretched out on a rope which forms the backdrop to this painting.

He used to be criticized for painting in rather grey tones, but he has stopped making this mistake. Whatever people say, Greuze is the painter for me.

[1] Virgil, *Æneid*, II, v. 311–12: 'The house of Ucalegon is already ablaze nearby.' Said when misfortune is at hand, here with reference to the mother's death following on from the father's.

[2] Terence, *Andria*, Prologue, v. 17 (slightly misquoted): 'They see to it that by understanding too much, they understand nothing.'

13 Denis Diderot (1713–1784) from the 'Salon of 1765' and 'Notes on Painting'

Diderot's 'Salon of 1765' was a far more extensive affair than its predecessor, though on his own account it was written in little more than two weeks. Many of the individual works on view drew him to expansive passages of description and speculation. He wrote at length on several works by Greuze, and included a long and virtuoso excursus on 'Plato's Cave', couched in the form of a dialogue with Grimm, which was occasioned by Fragonard's painting of *Corésus and Callirhoé*. The 'Salon' also contains a short self-contained essay on Sculpture, written to preface Diderot's account of the sculptures on show in 1765, among which were a group of works by his friend Etienne Falconet (see IIIC11). We reproduce the first part of this here, together with the opening and concluding sections from the extensive 'Notes on Painting'. Diderot added these to his 'Salon of 1765' 'to serve as an Appendix', and no doubt to give expression to general thoughts and conclusions provoked by his work as a reviewer. (The 'Notes on Painting' were to be translated by Goethe and published with a commentary in the journal *Proplyaën* in 1799.) In the first of these sections, on drawing, Diderot attributes unnatural and mannered effects to academic practices and priorities, and makes a case for what would later be described as realism. (See also his discussion of 'Mannerism' in IIIC14.) In the last section he inquires into the nature of aesthetic experience and aesthetic value, and into the relationship of both to taste and to genius. The 'Salon de 1765' and 'Essais sur la peinture, pour fair suite au Salon de 1765' were originally written for Grimm's *Correspondence littéraire* and were first printed in Naigeon (op. cit. IIIC12). The English versions are taken from *Diderot on Art – I: The Salon of 1765 and Notes on Painting*, translated by John Goodman, New Haven and London: Yale University Press, 1995, pp. 156–9, 191–6, 237–40. The notes are Goodman's. (See also IIIC7, 11, 12 and IVA11.)

Sculpture

I'm fond of fanatics, not the ones who present you with an absurd article of faith and who, holding a knife to your throat, scream at you: 'Sign or die,' but rather those who, deeply committed to some specific, innocent taste, hold it to be beyond compare, defend it with all their might, who go into street and household, not with a lance but with their syllogistic decree in hand, calling on everyone they meet to either embrace their absurd view or to avow that the charms of their Dulcinea surpass those of every other earthly creature. People like this are droll; they amuse me, sometimes they astonish me. When they've happened upon some truth, they advocate it with an energy that shatters and demolishes all before it. Courting paradox, piling image on image, exploiting all the resources of eloquence, figurative expressions, daring comparisons, turns of phrase, rhythmic devices, appealing to sentiment, imagination, attacking soul and sensibility from every conceivable angle, the spectacle of their efforts is always beautiful. Such a one is Jean-Jacques Rousseau when he lashes out against the literature he's cultivated all his life, the philosophy he himself professes, the society of our corrupt cities in the midst of which he burns to reside and whose acknowledgement, approbation, tribute he craves. It's all very well for him to close the window of his country retreat that faces towards Paris, but it's still the only spot in the world for which he has eyes; in the depths of his forest he's elsewhere, he's in Paris. Such a one is Winckelmann when he compares the productions of ancient artists with those of modern artists. What doesn't he see in this stump of a man we call the *Torso*? The swelling muscles of his chest, they're nothing less than the undulations of the sea; his broad bent shoulders, they're a great concave vault that, far from being broken, is strengthened by the burdens it's made to carry; and as for his nerves, the ropes of ancient catapults that hurled large rocks over immense distances are mere spiderwebs in comparison. Inquire of this charming enthusiast by what means Glycon, Phidias, and the others managed to produce such beautiful, perfect works and he'll answer you: by the sentiment of liberty which elevates the soul and inspires great things; by rewards offered by the nation, and public respect; by the constant observation, study, and imitation of the beautiful in nature, respect for posterity, intoxication at the prospect of immortality, assiduous work, propitious social mores and climate, and genius . . . There's not a single point of this response one would dare contradict. But put a second question to him, ask him if it's better to study the antique or nature, without the knowledge and study of which, without a taste for which ancient artists, even with all the specific advantages they enjoyed, would have left us only mediocre works: The antique! he'll reply without skipping a beat; The antique! . . . and in one fell swoop a man whose intelligence, enthusiasm, and taste are without equal betrays all these gifts in the middle of the Toboso.[1] Anyone who scorns nature in favor of the antique risks never producing anything that's not trivial, weak, and paltry in its drawing, character, drapery, and expression. Anyone who's neglected nature in favor of the antique will risk being cold, lifeless, devoid of the hidden, secret truths which can only be perceived in nature itself. It seems to me one must study the antique to learn how to look at nature.

Modern artists have rebelled against study of the antique because amateurs have tried to force it on them; and modern men of letters have defended study of the antique because it's been attacked by the *philosophes*.

It seems to me, my friend, that sculptors are more attached to the antique than painters. Could this be because the ancients left behind some beautiful statues while their paintings are known to us only through the descriptions and accounts of writers? There's a considerable difference between the most beautiful line by Pliny and the *Gladiator* of Agasias.

It also seems to me that it's more difficult to judge sculpture than painting, and this opinion of mine, if it's valid, should make me more circumspect. Few people other than practitioners of the art can distinguish a very beautiful work of sculpture from an ordinary one. Certainly the *Dying Athlete* will touch you, move you, perhaps even make so violent an impression on you that you can neither look away nor stop looking at it; still, if you had to choose between this statue and the *Gladiator*, whose action, while beautiful and true certainly, is nonetheless incapable of touching your soul, you'd make Pigalle[2] and Falconet laugh if you preferred the former to the latter. A large single figure that's all white is so simple, it has so few of the particulars that would facilitate a comparison of the work of art with that of nature! Paintings remind me a hundred times over of what I see, of what I've seen; this is not true of sculpture. I'd take the chance of buying a picture on the basis of my own taste, my own judgment; if it were a statue, I'd ask an artist's advice.

So you think, you say to me, it's more difficult to sculpt than to paint? – I don't say that. Judging is one thing and making is another. There's the block of marble, the figure is within it, it must be extracted. There's the canvas, it's flat, it's on this surface that one must create. The image must spring forth, advance, take on relief so that I can move around it; if not I myself, then my eye; it must take on life. But if it's modelled, it must live through its modelling, without resorting to the life-bestowing resources of the palette. – But these same resources, is it easy to use them? The sculptor has everything when he has drawing, expression, and facility with the chisel; with these resources he can successfully essay a nude figure. Painting requires still more. As for the difficulties inherent in more complex subjects, it seems to me they increase more for the painter than for the sculptor. The art of composing groups is the same, the art of draping is the same; but lighting, overall composition, the sense of place, skies, trees, water, accessories, backgrounds, color, the full array of accidents? 'Sed non nostrum inter vos tantas componere lites.'[3] Sculpture is made for both the blind and those who can see; painting addresses itself only to the eyes. On the other hand, the first certainly has fewer objects and fewer subjects than the second: one can paint whatever one wants; sculpture – severe, grave, chaste – must choose. Sometimes it makes play with an urn or a vase, even in the grandest, most moving compositions: one sees reliefs of frolicking children on bowls about to collect human blood; but this play maintains a certain dignity: it is serious, even when striking a light note. Undoubtedly it exaggerates; exaggeration might even suit it better than it does painting. The painter and the sculptor are both poets, but the latter never makes jokes. Sculpture can't bear the facetious, the burlesque, the droll, and can sustain the comic only rarely. But it delights in fauns and sylphs; without strain it can help satyrs put the aging Silenus back on his mount or bear up the

tottering steps of a disciple. It is voluptuous but never lewd. In a voluptuous mode it retains something that's refined, rarefied, exquisite, which alerts me to how protracted, laborious, difficult the work is, and that while it's possible to brush onto the canvas a frivolous idea that can be created in an instant and painted out in the same breath, such is not true of the chisel, which, instilling the artist's idea into material that's hard, resistant, and eternal, should be governed by choices that are original and unusual. The pencil is more licentious than the brush and the brush more licentious than the chisel. Sculpture requires an enthusiasm that's more obstinate and deep-seated, more of a kind of verve that seems strong and tranquil, more of this covered, hidden fire that burns within; its muse is violent, but secretive and silent.

If sculpture cannot tolerate ordinary ideas, it's even less tolerant of middling execution; a slight imperfection in drawing that's scarcely noticeable in a painting is unforgivable in a statue. Michelangelo knew this well; when he despaired of achieving flawless perfection he preferred to leave the marble rough-hewn. – But this is proof that because sculpture can do fewer things than painting, we're more demanding with regard to what we have a right to expect of it. – My thought exactly.

* * *

My Bizarre Thoughts About Drawing

Nature does nothing that is not correct. Every form, whether beautiful or ugly, has its cause, and of all extant beings there isn't a single one that's not just as it should be.

Look at this woman who's lost her eyes while still young. The progressive deepening of her sockets hasn't increased the extent of the surrounding pockets. They've sunk into the cavities hollowed out by the organs' absence; they've shrunk. Above, a portion of her brow has been pulled in; below, her cheeks have been slightly lifted. Her upper lip, responding to this movement, has risen somewhat. These alterations have affected all parts of her face, in proportion to their proximity or distance from the principal site of the accident. But do you think that the deformity has been restricted to this oval? Do you think her neck has been completely unaffected? And her shoulders and throat? Yes, to your eyes and mine. But summon nature, show her this neck, these shoulders, this throat, and nature will tell you; this is the neck, these the shoulders, and this the throat of a woman who's lost her eyes while still young.

Direct your glance towards this man whose back and chest are hunched over. As the cartilage in front of his neck grew longer, his vertebrae bent over. His head fell forward, his hands closed into fists, his elbows pushed backwards: all his bodily members conspired to locate a center of gravity consistent with this irregular arrangement. As a result, his face assumed an air of constraint and discomfort. Cover this figure and show nature no more than its feet, and nature will pronounce, without hesitation, these feet belong to a hunchback.

If causes and effects were readily apparent to us, we'd have only to represent beings just as they are. The more perfect an imitation, the more analogous to its causes, the more it would satisfy us.

Despite our ignorance of cause and effect, and the rules of convention entailed by this ignorance, I suspect that any artist who dared neglect these rules, opting instead

for rigorous imitation of nature, would often find justification for oversized feet, short legs, swollen knees, and heavy, cumbersome heads in that refined awareness deriving from continuous observation of phenomena that makes us sensitive to secret relationships, to the natural concatenations between such deformities.

A crooked nose in nature does not offend because everything is of a piece. One arrives at this deformity by way of little adjacent alterations that sustain and redeem it. Twist the nose of the *Antinous*, leaving the rest as it is, and this nose will be unfortunate. Why? Because the *Antinous'* nose wouldn't be twisted at all, but rather broken.

We say of a man passing by in the street that he's ill made. Yes, according to our poor rules; but according to nature? That's something else again. We say of a statue that it's beautifully proportioned. Yes, according to our poor rules; but according to nature?

Allow me to transfer the veil covering my hunchback to the *Medici Venus*, leaving only the tip of her foot exposed. If nature, summoned once again, set out to complete the figure on the basis of the tip of this foot, perhaps you'd be surprised to see it sketch in a hideous, deformed monster. But as for myself, I'd be surprised if the result were otherwise.

A human figure is a system that's too carefully composed for the consequences of a tiny adjustment, apparently of little effect, not to remove the most perfect artistic production a thousand leagues from the work of nature.

If I were initiated into art's mysteries, perhaps I'd know to what extent the artist should conform to accepted proportions, and I'd tell you; I do know, however, that they don't stand up against the despotism of nature, and that age and social condition dictate that they be sacrificed in a hundred different ways. I've never heard a figure dismissed as badly drawn when its exterior organization revealed its age and its capacity and custom of fulfilling its daily tasks. It is these tasks that determine both a figure's overall stature and the true proportions of its bodily members and their mutual consistency. It's from these that I see emerge the child, and the adult, and the old man; the savage, and the civilized man; the magistrate, and the soldier, and the porter. If ever a figure would be difficult to capture, it would be that of a twenty-five-year-old suddenly formed out of clay, and who'd never done anything; but this man is a chimera.

Childhood is almost a caricature, and I'd say the same of old age. The child is a shapeless, fluid mass striving to develop; the old man is also a shapeless mass, but dried out, turning inward, tending to reduce itself to nothing. It's only in the interval between these two ages, from the beginning of perfect adolescence to the end of maturity, that the artist submits to a purity and rigorous precision of line, and that the *poco piu* or *poco meno*, the precise placement of a stroke, can make for blemish or beauty.

You'll say to me that age and customary tasks alter the forms but don't abolish the inner organs. Very well... One must become familiar with them... I agree. This is why one should study the *écorché*.[4]

Study of the *écorché* doubtless has its advantages; but is it not to be feared that this *écorché* might remain in the imagination forever; that this might encourage the artist to become enamored of his knowledge and show it off; that his vision might be

corrupted, precluding attentive scrutiny of surfaces; that despite the presence of skin and fat, he might come to perceive nothing but muscles, their beginnings, attachments, and insertions; that he might over-emphasize them, that he might become hard and dry, and that I might encounter this accursed *écorché* even in his figures of women? Since only the exterior is exposed to view, I'd prefer to be trained to see it fully, and spared treacherous knowledge I'd only have to forget.

It is said the *écorché* is studied only to learn to observe nature, but experience suggests that after such study it's very difficult to see her in any other terms.

No one but yourself, my friend, will read these pages, so I can write exactly what I please. These seven years drawing after the model at the Academy, do you consider them well spent, and would you like to know what I think about them? It's here, during these seven cruel and difficult years, that one's draftsmanship becomes mannered. All these studied, artificial, carefully arranged academic poses, all these movements coldly and ineptly imitated by some poor devil, and always the same poor devil, who's paid to appear, undress, and let himself be manipulated by a professor three times a week, what do they have in common with postures and movements in nature? What does the man drawing water in the well in your courtyard have in common with another who, not pulling the same burden, awkwardly mimics this action, his two arms raised, on the school's posing platform? What does a person pretending to die have in common with another expiring in his bed or beaten to death in the street? What does an artificial wrestler have in common with the one on my street corner? This man who begs, prays, sleeps, reflects, and faints upon request, what does he have in common with a peasant stretched out on the ground from fatigue, with a philosopher meditating at his fireside, with a suffocating man who faints in the crowd? Nothing, my friend, nothing. To complete this absurdity, students might just as well be packed off to Vestris or Gardel, or whatever dancing master you like, to learn about graceful movement. The truth of nature is forgotten, while the imagination is filled with gestures, postures, and figures that are false, forced, ridiculous, and cold. There they're stored away, re-emerging for application to the canvas. Whenever the artist takes up his chalks or brushes, these limp phantoms revive and present themselves to him; they're a perpetual distraction, and he who managed to exorcise them from his head would be a prodigy indeed. I once knew a young man of excellent taste who, before making the smallest stroke on his canvas, would get down on his knees and say, dear Lord, deliver me from the model. If today one rarely sees a picture composed of a certain number of figures without observing, here and there, a few of the academic figures, poses, movements, and attitudes so mortally disagreeable to men of taste, and convincing only to those to whom truth is foreign, blame the eternal study of the academic model.

It's not in the school that one learns about the general coordination of movements, a coordination that's sensed, that's seen, that extends, winding its way, from head to foot. If a woman allows her head to fall forward, all her bodily members acknowledge its weighty pull; if she lifts and holds it erect, there's a similar acknowledgement from the rest of the machine.

What an art, and a great one, is the posing of the model; one need only observe how proud of it is Monsieur le Professeur. No need to fear that he might say to the poor salaried devil, my friend, strike a pose on your own, do what you like. Rather

than allow him to assume a simple natural posture, he much prefers to assign him some eccentric one. And currently one has no choice but to put up with this.

A hundred times I've been tempted to say to young students I encountered on their way to the Louvre with their portfolios under their arms: My friends, how long is it you've been drawing there? Two years? Why, that's too long. Leave this shop of mannered tics. Go to the Carthusians',[5] and there you'll see real attitudes of piety and compunction. Today is the eve of a high holy day; go to a parish church, prowl around the confessionals there, and you'll see real postures of meditation and repentance. Tomorrow go to a tavern, and you'll see the real movement of an angry man. Seek out public gatherings; be observant in the street, in public gardens, at the market, in private homes, and you'll obtain an accurate idea of true movement as it is in the activity of life. Look at your two comrades arguing with one another; note how, without their realizing it, it's the dispute that determines the placement of their limbs. Examine them carefully, and you'll take pity on your insipid professor's lessons and your insipid model's imitations. How I'll pity you, my friends, when one day you find yourselves obliged to replace all the falsehoods you've learned with the simplicity and truth of Le Sueur; and you'll certainly have to do this if you intend to amount to anything.

Posturing is one thing, action another. All posturing is false and trivializing; all action is beautiful and true.

Contrast that's poorly understood is one of the most deadly causes of mannerism. Genuine contrast derives exclusively from an action's essence, or from a diversity of agents or interests. Look at Raphael and Le Sueur; they sometimes place three, four, or five standing figures next to one another, and the effect is sublime. At Mass or Vespers at the Carthusian monastery forty or fifty monks are to be seen in two long parallel lines, with the stalls, actions, and vestments all identical, and yet no two of these monks resemble one another. No contrast should be sought out other than what's needed to individuate them; so much is genuine, any more would be shabby and false.

If these students should be inclined to profit further from my advice, I'd say to them: Hasn't it been long enough for you to see only a portion of the objects you copy? Try, my friends, to imagine that the entire figure is transparent, and that your eyes look out from its center. From there you'll observe the complete exterior disposition of the machine; you'll see how some parts are extended while others are contracted, how the former stretch out while the latter expand; and, consistently preoccupied by the overall effect, by the whole, you'll succeed in showing in that part of the object presented in your drawing everything that would correspond with it but that's not visible, and though displaying only one of its views to me you'll oblige my imagination to envision the opposite view as well; and it's then that I'll write that you're a surprising draftsman.

But it's not enough to evoke the whole successfully; the challenge lies in introducing details without destroying the mass. This is the work of verve, of genius, of feeling, and extremely delicate feeling at that.

Here, then, is how I'd like to see a drawing school run. When the student was able to draw after prints and reliefs with ease, I'd place him before male and female academic models for two years. Then I'd expose him to children, adults, mature men,

old men, subjects of all ages, of both sexes, drawn from all walks of life – in a word, to every kind of nature. The prospective models would come in droves to the door of my academy, if I paid them well; if I was in a country with slaves, I'd compel them to come too. The professor would make a point of noting in all these different models how their habitual daily tasks, their way of life, their social station, and their age had introduced accidental features into their forms. Thereafter my student would see the academic model but once every fifteen days, and the professor would allow the model to strike poses on his own. After the drawing sessions a trained anatomist would explain the *écorché* to my student, with constant references to the living, animated nude body; and he'd draw from the *écorché* no more than a dozen times a year. That would be sufficient for him to acquire a sense of how flesh supported by bone and flesh that lacks such support should not be drawn in the same way, that here the outline should be rounded, and there angular; and that if he neglects such details, the whole will seem like an inflated bladder or a ball of cotton.

There would be no mannerism, in either drawing or color, if nature were scrupulously imitated. Mannerism derives from teachers, from the academy, from drawing schools, and even from the antique.

A little corollary to the preceding

But what's the point of all these principles if taste is capricious, and if beauty is not subject to eternal, immutable rules?

If taste is capricious, if there are no rules determining beauty, then what is it that prompts these delicious feelings that arise so suddenly, so involuntarily, so tumultuously in the depths of our souls, dilating or constricting them, forcing our eyes to shed tears of joy, pain, and admiration, whether in response to some grand physical phenomenon or to an account of some great moral action? *Apage, Sophista*:[6] You'll never convince my heart that it's mistaken in skipping a beat, nor my entrails that they're wrong to contract from profound emotion.

The true, the good, and the beautiful are very closely allied. Add some unusual, striking circumstance to one of the first two qualities and truth becomes beauty, or beauty truth. If the solution to the problem posed by three bodies is as simple as the movement of three points inscribed on a scrap of paper, this is nothing; it's a purely speculative truth. But if one of these three bodies is the star that lights up our days, another the orb that shines through our nights, and the third the globe we inhabit, suddenly the truth becomes grand and beautiful.

One poet said of another poet: He won't go far, he doesn't know the secret. What secret? That of focusing on things of inherent interest, on fathers, mothers, women, and children.

I see a high mountain covered by a deep, dark, ancient forest. I see and hear descending from it, very noisily, a stream whose rushing waters crash against steep outcrops of rock. The sun is setting; it transforms the droplets of water clinging to the rough surface of the stone into so many diamonds. But after having cleared these obstacles, the water is collected into a large, broad canal that leads to a machine. It's there that, under enormous blocks of stone, the basic material of human subsistence is ground and prepared. I glimpse the machine. I glimpse its wheels whitened by

foam. I glimpse the top of the owner's cottage through the branches of a willow. I look into myself, and I dream.

Without doubt the forest that makes me reflect on the origin of the world is a beautiful thing. Without doubt the rock that's an image of constancy and perseverance is a beautiful thing. Without doubt the droplets of water transformed by the sun's rays, broken and refracted into so many brilliant, liquid diamonds are beautiful. Without doubt the noise, the roar of the rushing stream that breaks the vast silence and solitude of the mountain, giving my soul a violent shock, instilling in it a secret terror, is also beautiful.

But these willows, this cottage, these animals grazing nearby, this spectacular display of utility, does it add nothing to my pleasure? And what of the different feelings it evokes in an ordinary man and a philosopher? It's the latter who reflects, seeing in each forest tree a mast that will one day lift high its head against wind and storm; in the mountain's bowels the raw metal that one day will boil in blast furnaces, prior to transformation into machines for cultivating the earth or destroying its inhabitants; in the rock, blocks of stone that will be used to construct the palaces of kings, the temples of the gods; in the rushing water, at one moment the source of life, at another the ravage of the countryside; then thinking on its fusion with larger streams and rivers; on commerce, the inhabitants of the universe connected to one another, their treasures transported from bank to bank, from where they're dispersed into the continental depths; and his volatile soul will pass rapidly from a tender, voluptuous feeling of pleasure to a sensation of terror, if his imagination proceeds to summon up the waves of the ocean.

It's in this way that pleasure increases proportionally with imagination, sensitivity, and knowledge. Nature and the art that copies it have nothing to say to a man who's stupid or cold, and very little to a man who's ignorant.

So what, then, is taste? A capacity, acquired through reiterated experience, to sense the true or the good, along with the circumstances rendering it beautiful, and to be promptly, vividly moved by it.

If the experiences that shape judgment remain clear in the memory, one's taste will be enlightened. If there are no such distinct memories, only vague impressions, one's taste will be instinctive.

Michelangelo gave the dome of Saint Peter's in Rome the most beautiful form possible. The geometer La Hyre, impressed by this form, plotted its arc and found that this curve was the one that offered the greatest resistance. What is it that inspired Michelangelo to use this curve, among the infinite number from which he could choose? The experience of everyday life. It's this that suggests to a master carpenter, just as surely as to the sublime Euler,[7] the angle of support best suited to prop up a wall threatening collapse. It's this that teaches him how to give the sails on a windmill the pitch most favorable to rotation. It's this that sometimes prompts us to introduce subtle elements into our calculations that find no justification in the academy's rules of geometry.

Experience and study: these are the fundamentals of those who execute as well as those who judge. I'd be inclined to add sensitivity to the list. But as we see men acting with justice, benevolence, and virtue solely through a proper understanding of their own best interests, through intelligence and a taste for order, without deriving any

pleasure or gratification from it, it follows that there can be taste without sensitivity, just as there can be sensitivity without taste. In its extreme form sensibility is not discerning; it's moved by everything. The first will tell you coldly, That is beautiful; the other will be moved, transported, inebriated. 'Saliet tundet pede terram, ex oculis stillabit amicis rorem.'[8] He'll stammer; he'll be unable to find words to describe the state of his soul.

The happier of the two is undoubtedly the latter. The better judge? That's another matter. Cold, austere men who are tranquil observers of nature are often better able to articulate their views. They simultaneously are and are not enthusiasts; they're both man and animal.

Reason sometimes rectifies a rapid judgment made by sensibility; it appeals against it. Thus the large number of works quickly applauded but as quickly forgotten, and the many others that, while initially either unnoticed or disdained, with passing time, advancing intelligence and sensitivity, and closer attention, come to be valued at their true worth.

Such is the uncertain prospect for any work of genius. It stands alone. It can be appreciated only by immediate comprehension of its relation to nature. And who is the only one capable of grasping this relation? Another man of genius.

[1] Toboso was a small town outside Toledo in which Cervantes [in *Don Quixote*] placed the residence of Dulcinea. . . . Diderot here seems to suggest an image of Toboso as a river in which Winckelmann, having begun to cross, stops in midstream.

[2] Jean-Baptiste Pigalle (1714–85). Student of J.-B. II Lemoyne. Granted provisional membership in the Royal Academy on November 4, 1741; received as a full academician on July 30, 1744.

[3] 'It is not our place to compose such great strife': based on Virgil, *Eclogues*, IV, v. 108 ('non nostrum inter vos tantas componere lites').

[4] 'Flayed figure': a male mannequin with skin and fat removed to facilitate study of the muscles.

[5] The Carthusian monastery behind the Luxembourg Palace, now destroyed, which housed one of the most admired works of the French seventeenth century, the *Life of Saint Bruno* cycle by Eustache Le Sueur (now in the Louvre, Paris). Diderot is known to have admired these paintings; here, however, he is advising his imaginary auditors/artists to observe both the canvases and the real monks there.

[6] 'Back, sophist!'

[7] Leonard Euler (1707–83). Swiss physicist and mathematician.

[8] 'He'll bounce about, he'll stamp his feet, he'll weep fervently': Horace, *Ars Poetica*, vv. 429–30 (Diderot's citation is approximate).

14 Denis Diderot (1713–1784) from 'Salon of 1767'

The 'Salon of 1767' is a *tour de force* which took Diderot over a year to complete, amounting in its finished extent to the equivalent of an entire year's normal output of the *Correspondence littéraire*. Following the listings in the official Salon booklet, he found something to say about virtually every one of some 250 works on display, no more than a dismissive sentence in a few cases, in others a lengthy excursus of several pages. Interspersing the individual commentaries are occasional passages of exposition and speculation on issues raised by them. We reproduce three characteristic passages from a work that occupies 330 pages in its modern printed form. The first serves as a conclusion to an extensive discussion of paintings by Louis-Jean-François Lagrenée. Diderot represents himself as engaged in dialogue with Grimm (see IIIC10) on the question

of wealth (or luxury) and its influence on the arts – a matter on which opinions had been publicly divided since the 1720s. The second passage concerns the work of Claude-Joseph Vernet (1714–89), a painter specializing in marine landscapes who received considerable support from Diderot. We reproduce the introductory discussion and the first of seven 'sites'. In each of these the writer describes his own peregrinations through an extensive landscape which, it transpires, is actually a composition painted by Vernet. Each of these accounts offers a remarkable demonstration of the writer's imaginative engagement. In each case it is the specific organization and detail of the picture observed, rather than the gratuitous self-projection of the observer, that decides the elaboration of episode and detail. The final excerpt from the 'Salon' contains Diderot's most sustained critique of mannerism (the French word *manière* embraces the meanings of both 'manner' and 'mannerism'). The 'Salon de 1767' was orginally written for Grimm's *Correspondence littéraire* and was first printed in Naigeon (*op. cit.* IIIC12). The English versions are taken from *Diderot on Art – II: The Salon of 1767*, translated by John Goodman, New Haven and London: Yale University Press, 1995, pp. 75–8, 86–91, 320–4.

On Luxury

DIDEROT: Aren't you tired of roaming through this immense Salon? For my part, my legs are about to give out: let's head for the Galerie d'Apollon, which will be empty; we'll be able to relax there as we like, and I'll tell you about a few ideas I've had concerning a question of some importance.

GRIMM: And what is this important question?

DIDEROT: Luxury's influence on the fine arts. You'll agree that everybody's wonderfully confused over this question.

GRIMM: Wonderfully.

DIDEROT: They've seen that the fine arts owe their birth to riches. They've seen that this same cause that produced them, strengthened them, and brought them to a level of perfection finished by degrading them, corrupting them, and destroying them. And two different factions have formed! One presents a picture of the fine arts as begotten, perfected, and capable of astonishment and defends luxury, while the other faction takes them to task, attacking the fine arts as corrupted, degraded, impoverished, and debased.

GRIMM: While still others, and not the least credible, have exploited luxury and its consequences to denigrate the fine arts.

DIDEROT: And in this dark night in which they wage war . . .

GRIMM: The aggressors and defenders have worked about equal damage, such that neither party has scored a clear victory.

DIDEROT: It's because they've been dealing with only one kind of luxury.

GRIMM: Ah! You want to talk politics.

DIDEROT: And why not? Suppose there was a prince who had the good sense to understand that everything comes from the earth and that everything returns there; that accordingly he lent his support to agriculture and ceased to be the father and maker of great usurers.

GRIMM: I understand; and that he dismissed all the tax farmers, replacing them with painters, poets, sculptors, and musicians. Is that it?

DIDEROT: Yes, Monsieur, and determined to have good ones, and only good ones. Agriculture being so favored, men would pursue their best interests into her sphere, and all phantasy, passion, prejudice, and opinion concerning it would vanish. The earth would be as well cultivated as possible; its productions being so diverse, abundant, and various, great wealth would result, and this great wealth would engender great luxury: for seeing that one can't eat gold, what good is it, if not to increase pleasure, to underwrite the infinite means of attaining happiness, namely poetry, painting, sculpture, music, mirrors, tapestries, gilding, porcelain, and eccentric objects. Painters, poets, sculptors, musicians, and the crowd of related arts are born of the earth; they too are offspring of the good Ceres. And I tell you that wherever they have their origin in this kind of luxury they'll flourish forever.

GRIMM: You think so?

DIDEROT: More than that; I'll prove it to you. But first, allow me to say, from the bottom of my heart: Cursed forever be he who first put government offices up for sale.

GRIMM: And he who first advocated the superiority of industry, and its right to flourish on the ruins of agriculture!

DIDEROT: Amen.

GRIMM: And he who, after having degraded agriculture, encumbered free exchange with all kinds of fetters!

DIDEROT: Amen.

GRIMM: And he who created the first of the great extortionists and their number-less clan!

DIDEROT: Amen.

GRIMM: And he who facilitated the taking of ruinous loans by foolish, spendthrift sovereigns!

DIDEROT: Amen.

GRIMM: And he who suggested to them how they might rupture the most sacred ties holding them together by yielding to the irresistible lure of increasing their fortunes two, three, even ten times!

DIDEROT: Amen, amen, amen. At the very moment in which the nation was struck by these various scourges, the breasts of the common mother dried up, and a small portion of the nation was swimming in wealth while the remainder languished in indigence.

GRIMM: Education was lacking in vision, unmotivated, without solid foundation, without an encompassing public goal.

DIDEROT: Money, which purchases anything, became the measure of all things. It became necessary to have money, and then what? More money. And when it ran out, it was necessary to keep up appearances and create the illusion that one was still well supplied.

GRIMM: Giving birth to appalling ostentation in some cases, and in others to a kind of epidemic of hypocrisy regarding one's resources.

DIDEROT: Which is to say to another kind of luxury, and it's this kind that degrades and destroys the fine arts, for their continued health and progress require genuine opulence, whereas this brand of luxury does nothing but fatally mask a

misery that's almost general, which it aggravates and encourages. It's under the tyranny of this luxury that talents are wasted or sidetracked. It's in such circumstances that the fine arts must make do with the dregs left to those of inferior social status; it's in such extraordinary, perverse circumstances that they're either subordinated to the phantasy and caprice of a handful of rich, bored, fastidious men, their taste as corrupt as their morals, or they're abandoned to the mercy of the indigent multitude, which strives, with poor work in all genres, to take on some of the credit and the lustre associated with wealth. In the present century and under the present reign the impoverished nation has framed not a single grand enterprise, no great works, nothing that might nourish the spirit and exalt the soul. At present great artists don't develop at all or are compelled to endure humiliation to avoid dying of hunger. At present there are a hundred easel paintings for every large composition, a thousand portraits for every history painting; mediocre artists proliferate and the nation is flooded with them.

GRIMM: Such that the Belles, the Bellengers, the Voiriots, and the Brenets brush shoulders with the Chardins, the Viens, and the Vernets.

DIDEROT: And their tiresome works cover the walls of the Salon.

GRIMM: And blessed be the Belles, the Bellengers, the Voiriots, the Brenets, bad poets, bad painters, bad sculptors, picture dealers, jewelers, and prostitutes.

DIDEROT: Very good, my friend, for it is through these people that we have our revenge. They're the vermin who prey upon and destroy our vampires, and who give us back, drop by drop, the blood they've extracted from us.

GRIMM: And shamed be any minister who ventures, while surrounded by vast, fruitful stretches of soil, to create sumptuary laws, to annihilate an existing luxury, instead of supporting another kind rooted in the bowels of the earth.

DIDEROT: And who prevents the free circulation of works of art, rather than encouraging artists. It's not I alone who've arrived at this point, for you've led me here; and if there's any logic in what's preceded, it follows, as I said at the beginning, that there are two kinds of luxury: one born of wealth and general affluence, and another of ostentation and misery; and that the first kind is as favorable to development and progress of the fine arts as the second is detrimental to them . . .

* * *

Vernet

I'd inscribed this artist's name at the head of my page and was about to review his works with you, when I left for a country close to the sea and celebrated for the beauty of its sites. There, while some spent the day's most beautiful hours, the most beautiful days, their money, and their gaiety on green lawns, and others, shotguns over their shoulders, overcame their exhaustion to pursue their dogs through the fields, and others still wandered aimlessly through the remote corners of a park whose trees, happily for their young consorts in delusion, are models of discretion; while a few serious people, as late as seven o'clock in the evening, still made the dining room resound with their tumultuous discussion of the new principles of the economists, the utility or uselessness of philosophy, religion, morals, actors, actresses, govern-

ment, the relative merits of the two kinds of music, the fine arts, literature, and other important questions, the solutions to which they sought at the bottom of bottles, and returned, staggering and hoarse, to their rooms, whose doors they found only with difficulty, and, having relaxed in an armchair, began to recover from the intensity and zeal with which they'd sacrificed their lungs, their stomachs, and their reason in the hope of introducing the greatest possible order into all branches of administration; there I went, accompanied by the tutor of the children of the household and his two charges, my cane and writing pad in hand, to visit the most beautiful sites in the world. My intention is to describe them to you, and I hope that these descriptions will prove worth the trouble. My companion for these walks was thoroughly familiar with the lie of the land, and knew the best time to take in each rustic scene, and the places best viewed in the morning hours, which were most charming and interesting at sunrise and which at sunset, as well as the coolest, shadiest areas in which to seek refuge from the burning midday sun. He was the *cicerone* of this region; he did the honors for newcomers, and no one knew better than he how to maximize the impact of the spectator's first glance. We were off, and we chatted as we walked. I was moving along with my head lowered, as is my custom, when I felt my movement suddenly checked and was confronted with the following site.

First Site

To my right, in the distance, a mountain summit rose to meet the clouds. At this moment chance had placed a traveller there, upright and serene. The base of the mountain was obscured from us by an intervening mass of rock; the foot of this rock stretched across the view, rising and falling, such that it severed the scene's foreground from its background. To the far right, on an outcropping of rock, I saw two figures which could not have been more artfully placed to maximize their effect; they were two fishermen; one was seated towards the bottom of the rock, his legs dangling; the other, his catch slung over his back, bent over the first and conversed with him. On the rugged embankment formed by the extension of the lower portion of the rock, where it extended into the distance, a covered wagon driven by a peasant descended towards a village beyond the embankment: another incident which art would have suggested. Passing over the crest of this embankment, my gaze encountered the tops of the village houses and continued on, plunging into and losing itself in a landscape prospect that merged with the sky.

Who among your artists, my *cicerone* asked me, would have imagined breaking up the continuity of this rugged embankment with a clump of trees? – Perhaps Vernet. – Right, but would your Vernet have imagined such elegance and charm? Would he have been able to render the intense, lively effect of the play of light on the trunks and their branches? – Why not? – Depict the vast distances taken in by the eye? – He's done it on occasion in the past. You don't know just how conversant this man is with natural phenomena . . . I responded distractedly, for my attention was focused on a mass of rocks covered with wild shrubs which nature had placed at the other end of the rugged mound. This mass was masked in turn by a closer rock that, separate from the first one, formed a channel through which flowed a torrent of water that, having completed its violent descent, broke into foam among detached rocks . . . Well! I say

to my *cicerone*: Go to the Salon, and you'll see that a fruitful imagination, aided by close study of nature, has inspired one of our artists to paint precisely these rocks, this waterfall, and this bit of landscape. – And also, perhaps, this piece of rough stone, and the seated fisherman pulling in his net, and the tools of his trade scattered on the ground around him, and his wife standing with her back to us. – You have no idea what a jokester you are, Abbé . . . The space framed by the rocks in the torrent, the rugged embankment, and the mountains to the left contained a lake along whose shore we walked. From there we contemplated the whole of this marvellous scene; however, towards the part of the sky visible between the clump of trees on the rugged strip and the rocks with the two fishermen a wispy cloud was tossed by the wind. I turned to the Abbé: Do you believe in good faith, I said to him, that an intelligent artist could have done otherwise than place this cloud exactly where it is? Do you see that it establishes a new level of depth for the eye, that it signals expanses of space before and beyond it, that it makes the sky recede and makes other things seem closer? Vernet would have grasped all of this. Others, in darkening their skies with clouds, dream only of avoiding monotony, but Vernet wants his skies to have movement and magic like what's in front of us. – You can say Vernet, Vernet all you want, but I won't abandon nature to run after an image of it; however sublime a man might be, he's not God. – All right, but if you'd spent more time with the artist, perhaps he'd have taught you to see in nature what you don't see now. How many things you'd find there that needed altering! How many of them his art would omit as they spoiled the overall effect and muddled the impression, and how many he'd draw together to double our enchantment! – What, you believe in all seriousness that Vernet would have better things to do than rigorously transcribe this scene? – I believe so. – Then tell me how he'd embellish it. – I don't know, and if I did I'd be a greater poet and a greater painter than he; but if Vernet had taught you to see nature better, nature, for her part, would have taught you to see Vernet better. – But Vernet will always remain Vernet, a mere man. – Yes, and all the more astonishing for that, and his work all the more worthy of admiration. The universe is a grand thing, without question, but when I compare it with the energy of the cause which generated it, what seems marvellous to me is that it's not still more beautiful and more perfect. It's quite otherwise when I reflect on the weakness of man, on his limited capacities, on the travail and brevity of his life, and consider certain things which he has undertaken and achieved. Abbé, may I put a question to you? Here it is: Which would you find the more remarkable, a mountain whose peak touched and held up the sky, or a pyramid covering several square miles and whose summit disappeared into the clouds? . . . You hesitate. It's the pyramid, my dear Abbé, and the reason is that nothing coming from God, the mountain's author, is astonishing, while the pyramid would be an incredible human phenomenon.

The conversation proceeded by fits and starts. Such was the beauty of the site that from time to time we were overcome with admiration; I spoke without paying much attention to what I was saying, and my listener was equally distracted; in addition, the Abbé's young charges ran from left to right and clambered up the rocks, such that their instructor was in perpetual fear of their becoming lost or falling or drowning in the lake. He advised that next time we should leave them behind at the house, but I disagreed with him.

I was inclined to linger on in this spot, spending the rest of the day there; but the Abbé having assured me that the country was so rich in such sites that we need not economize our pleasures in this way, I allowed myself to be led further on, though not without stealing a backward glance from time to time.

The youngsters went on ahead of their teacher, while I trailed behind him. We followed narrow, twisting paths, and I complained a bit about this to the Abbé, but he, having turned around, stopped directly in front of me and, looking me straight in the eye, said to me with considerable emphasis: Monsieur, the work of man is sometimes more admirable than that of God! – Monsieur l'Abbé, I answered him, have you seen the *Antinous*, the *Medici Venus*, the *Callipygian Venus*, and other antique statues? – Yes. – Have you ever encountered figures in nature that were as beautiful, as perfect as those? – No, I can't say that I have. – Have your students never said things to you that evoked greater admiration and pleasure than the most profound sentence in Tacitus? – That has happened on occasion. – And how is that? – I'm deeply interested in them; their remarks seemed to me to indicate great sensibility, a kind of shrewdness and astute intelligence beyond their years. – Abbé, let's apply these observations. If I had a cup full of dice, and I emptied the cup, and they all landed showing the same number, would this astonish you? – Very much. – And if all the dice were loaded, would you still be astonished? – No. – Abbé, let's apply these observations. The world is but a heap of loaded molecules of infinite variety. There's a law of necessity that governs all the works of nature without design, without effort, without intelligence, without progress, and without resistance. If one were to invent a machine capable of producing paintings like Raphael's, would such paintings continue to be beautiful? – No. – And the machine? Should it become commonplace, it would be no more beautiful than the paintings. – But doesn't it follow from this that Raphael was himself such a machine? – Yes, it's true; but Raphael the machine was never commonplace; the productions of this machine were never as widespread and numerous as the leaves of an oak; but by a natural, almost irresistible inclination we attribute will, intelligence, purpose, and liberty to this machine. Suppose Raphael was eternal, fixed in front of the canvas, painting ceaselessly and of necessity. Imagine these machines to be everywhere, producing paintings in nature like the plants, trees, and fruit depicted in them, and tell me what would become of your admiration then. The beautiful order in the universe that you find so enchanting cannot be other than it is. Only one such order is known to you, the one you inhabit; you'll find it beautiful or ugly, according to whether the terms of your coexistence with it are agreeable or difficult; things would have to be quite otherwise than they are for it to seem equally beautiful or ugly independent of the pleasure or pain with which one lived in it. An inhabitant of Saturn transported to earth would feel his lungs dry up and would perish cursing nature; an inhabitant of earth transported to Saturn would feel choked, suffocated, and would perish cursing nature . . .

At this point a western wind sweeping across the landscape enveloped us in a thick, swirling cloud of dust. It momentarily blinded the Abbé, who rubbed his eyes. As he did this, I added: Although this cloud seems to you like a chaos of haphazardly dispersed molecules, in fact, my dear Abbé, it's as perfectly ordered as the world . . . I was about to demonstrate my case to him, which he was hardly in a condition to

enjoy, when the view of a new site, one no less admirable than the first, left me astonished and mute, my voice broken and my ideas thrown into confusion.

On Mannerism

A difficult subject, perhaps too difficult for one who knows no more than I; a matter calling for concise, profound reflection, for a vast range of knowledge, and above all a freedom of spirit that I lack . . .

Mannerism is a vice common to all the fine arts. Its sources are even more hidden than those of beauty. There's something intangible about it that seduces children, that impresses the crowd, and that sometimes corrupts an entire nation; but it is more unbearable to the man of taste than ugliness; for ugliness is natural, in itself it entails no pretension, nothing that's ridiculous, nothing inconsistent with common sense.

A *mannered* savage, peasant, shepherd, or artisan is a kind of monster unimaginable in nature.

It seems to me first of all, then, that *mannerism*, whether in morals, discourse, or the arts, is a vice of regulated society.

At the origin of societies one finds art that's crude, discourse that's barbaric, and morals that are countrified; but these things tend to work together in favor of perfection, until the grand style [*grand goût*] is born; but this grand style is like the edge of a razor on which it's difficult to maintain one's footing. Very soon morals decline; the empire of reason extends its boundaries; discourse becomes epigrammatic, clever, laconic, sententious; the arts are corrupted through refinement. The ancient routes are found to be blocked by sublime models one despairs of ever equalling. Poetics are composed; new genres are envisioned; the singular, the bizarre, and the *mannered* make their appearance; from which it would appear that *mannerism* is a vice that occurs in a regulated society, one in which good taste tends towards decadence.

When good taste has been carried to its highest point of development, there is much debate over the merits of the ancients, who are less read than ever before. The small number of people who meditate, who reflect, who think, who adopt the true, the good, and the useful as their sole measure of worth – in a word, the *philosophes* – have only scorn for fiction, poetry, harmony, and antiquity. Those who are sensitive, who respond to beautiful images, who have refined, delicate ears protest against this blasphemy, this impiety. The greater the contempt expressed for their idol, the greater their deference to it. If a truly original man appears, one with a subtle, inquiring, analytic, deconstructive frame of mind, corrupting poetry with philosophy and philosophy with a few poetic sallies, a *mannerism* is born that can infect an entire nation. There follows a crowd of imitators insipidly aping a bizarre model, an imitator of whom it could be said, in the words of the healer Procopius: 'Those, hunchbacks? You must be joking; they're just badly made.'

These copyists of a bizarre model are insipid because their singularity is secondhand; their vice is not their own; they're the apes of Seneca, Fontenelle, and Boucher.

The word *mannerism* can be construed favorably or unfavorably; it is usually understood as unfavorable when it is alone. It is said: *Mannerism, to be mannered* is

a vice. But it is also said: His *manner* is grand; it's the *manner* of Poussin, Le Sueur, Guido Reni, Raphael, and the Carracci.

I only cite painters here, but *mannerism* occurs in all media: in sculpture, in music, in literature. [...]

If *mannerism* is an affectation, what component of painting is not susceptible to this flaw?

Drawing? But there are draftsmen who favor rounded forms and those who favor squared ones. Some make their figures tall and slender; others make them short and heavy; their component parts are either too articulated or not at all. Those who've studied anatomy always see and depict what's beneath the skin. Some barren artists have only a small number of body poses at their disposition, only one foot, one hand, one arm, one back, one leg, and one head, which they use everywhere. Here I recognize a slave to nature, there a slave to the antique.

Light and shadow? But what is this affectation of directing all the light on a single object, leaving all the rest of the composition in shadow? It seems that these artists have never seen anything save looking through a hole. Others use more light and make their shadows weaker, but they fall endlessly into the same pattern, their sun is immobile. If you've ever observed the little curved marks thrown onto a gallery ceiling by light reflected in a canal, you'll have a pretty good idea of light's flicker effects.

Color? But art's sun is not the same as nature's sun; the painter's light as the sky's; the flesh of the palette as my own; the artist's eye as any other; how could there not be *mannerism* in color? How could one hue not be too brilliant, another too grey, a third completely wan and dark? How could there not be technical flaws resulting from misjudged juxtapositions; flaws in the school or in the teacher; flaws in the organs themselves, if different colors don't affect them all in the same way?

Expression? But it's she who's most accused of being *mannered*. In effect, expression can be *mannered* in a hundred different ways. In art, as in society, there's false grace, affectation, preciousness, artificiality, ignobility, false dignity or arrogance, false gravity or pedantry, false pain, false piety; all virtue, all vice, all passion is made to grimace; these grimaces sometimes occur in nature, but they're always unpleasant when imitated; we require that one remain human, even when suffering the most violent torture.

It rarely happens that a being less than fully committed to what it's doing is not *mannered*.

Every individual who seems to say to you: 'Look how well I weep, how well I get angry, how well I entreat,' is false and *mannered*.

Every individual who diverges from the comportment appropriate to his social position or emotional state, an elegant magistrate, a woman in distress who carefully composes her arms, a man who plays the dandy as he walks, is false and *mannered*. [...]

Because there are compulsory groupings, conventionalized masses, dispositions dictated by technical considerations, often in contradiction with the nature of the subject, exaggerated contrasts between figures, and similarly exaggerated contrasts between the limbs of a given figure, there exists a *mannerism* of composition, of the organization of a painting.

Think about it a while, and you'll concede that paltriness, shabbiness, meanness, and *mannerism* can occur even in the handling of drapery.

Rigorous imitation of nature makes art paltry, mean, and shabby, but never false or *mannered*.

It's the imitation of nature, but exaggerated or embellished, that's the basis of the beautiful and the true, the *mannered* and the false; for then the artist gives rein to his own imagination; he remains without any precise model.

* * *

Part IV
A Public Discourse

Part IV
A Public Discourse

IV
Introduction

During a period in the second half of the eighteenth century, British culture was possessed of an unmistakable dynamism. Behind this lay the development of industry on an unprecedented scale. The production of textiles was becoming mechanized, Wedgwood's pottery was getting under way, there were key technological developments in the production of iron and steel, and above all there was one epoch-making invention: between 1765 and 1775 James Watt developed the steam engine. After that, it was a case of 'tomorrow, the world'. Britain was becoming the dominant imperial power, while London emerged as the first crucible of modernity (see below, VB7). We have become accustomed, perhaps too accustomed, to considering modernity as a nineteenth-century phenomenon. But Hogarth's London has a fair claim to priority as the urban birthplace of a new commodity-oriented culture. It is important that we write 'British' rather than 'English' here, because although London was the great metropolis – a magnet for that amalgam of the ambitious, the unscrupulous and the talented who made modernity – there was a flourishing provincial culture in places such as Bath and Derby, and there was also a significant dimension to the British Enlightenment that was not 'English' at all. Scottish philosophy flourished; Edinburgh and Glasgow were centres of advanced work in science, medicine and economics. And there were keynote Irish voices involved, notably those of Burke and Barry.

British intellectual life was animated by an empiricist, practical attitude, and seemed to flourish in the culture that had emerged from the revolutions of the seventeenth century. It was a culture that mixed violence with opportunity in equal measures, and conferred a sinewy resilience on its best products. The impression is one of a situation far removed from the protocols of Continental absolutism. For all that, art in England remained a problem, particularly the vexed question of a national school. For decades in the middle of the eighteenth century, argument went backwards and forwards about the desirability of a national collection of art and of an Academy on the French model, royal patronage and all. Attitudes to this question differed widely. Hogarth, as the dominant English artistic figure of the mid-century, was committed to the idea of an institution where art could be taught – and in fact ran one himself for many years – while yet being deeply opposed to patronage by royalty

(IVA2). By the 1760s, however, Hogarth was in the minority. Four years after his death, a Royal Academy was indeed constituted in London. The Academy quickly gave rise to a mini-tradition which, before it was over, had come to represent a high point of eighteenth-century academic art theory. This was the series of lectures, initially delivered annually, then from 1774 biennially, by the President, Sir Joshua Reynolds. Reynolds usually considered central theoretical issues, such as the contrasting demands of imitation and genius, of good taste and the grand style, and the competing claims of feeling and reason in the arts (IVA7). On the occasion of the Academy's move into new premises in 1780, however, he briefly addressed the more practical, even polemical, question of art's place in the national culture (IVA8). He thus entered into a wide-ranging debate in which the question of the role of art in the civilizing process intersected with more contingent, economic considerations. In the other contributions selected here, James Barry and Valentine Green introduce a polemical edge of national rivalry generally absent from Reynolds' measured argument (IVA13, 16).

The question of the public role of art and of the aims and conduct of academies was not of course restricted to England. It had long been an issue in France (see IIIC *passim*), and contrasting views also emerged in Spain (IVA4 and 14). Patronage and history painting were themes of particular concern. Patronage was a pressing issue in England, where contrasts were often drawn with the situation in France, as can be seen from the comments of both Barry and Green (IVA10, 13). William Shenstone's letter to his friend Graves offers an insight into both the self-image of the patron and the power relations in play between the patron and his artist. (Further comments on the artist–patron relationship can be found in VA1.) Traditionally, it was through the genre of history painting that art was established as a forum in which matters of public moment could be rehearsed. Once again, the paradigm came from France, though the existence of a well-supported school of history painting does not necessarily ensure vivid artistic results. In England, history painting seemed unable to gain a secure foothold, as Barry once more trenchantly points out. Among those few artists who did make an impact in history painting in England, the Americans Benjamin West and John Singleton Copley and the Swiss Angelica Kauffmann had all received their art education in Italy (IVA5, 6, 9).

England had finally got its Academy in 1768, a hundred and twenty years after the French, though the system never acquired either the status or indeed the bureaucratic apparatus that it did in France. Ironically, in 1768, the Académie Royale had only another twenty-five years left. In France, the system of the arts was embedded in the wider structures of the absolutist state, and in its forms of official and aristocratic patronage. Absolutism had served a purpose in helping to centralize the nation-state in the late seventeenth century. But by the later eighteenth century French and English societies had diverged. England's flexible mercantile capitalism and its emergent industrial base gave it a decisive advantage in the struggle for global imperial domination. By contrast, the absolutism of the French state was becoming a brake on development. A story of two very different social orders emerges from the *grandes machines* of academic history painting on the one hand and the taste for portraiture and landscape on the other.

England had undergone its political transformation from feudalism in the seventeenth century. In the eighteenth it was, in effect, a fully bourgeois society, albeit the bourgeois was in alliance with the landed remnant of the old order. The necessary triumph of the bourgeoisie in France, for so long held back by absolutism, was all the more cataclysmic when it finally came. An indication that new political forces were at work in eighteenth-century society had already come from across the Atlantic. For the English, defeating the French in North America had been an expensive business. After the treaty with France in 1763, the government's subsequent attempt to make its colonists pay for their security led to a smouldering resentment over taxation and the administration of life in the new world. Things went from bad to worse in the decade or so after the end of the Seven Years War, and the calling of a Continental Congress of the American colonies in 1774, and again in 1775, led the English king to declare the existence of a state of rebellion. Fighting broke out in 1775, and on 4 July 1776 the erstwhile colonists signed their Declaration of Independence. This was only the beginning. The French joined in against the English in 1778, followed by the Spanish and Dutch. Victory and defeat alternated, until in 1781 the English were decisively defeated at Yorktown. Finally, in the Treaty of Paris in 1783, twenty years after the last treaty of Paris in which the loss of New France had been acknowledged, the existence of the United States of America was ratified by the contending parties. These events, accompanied as they were by a rhetoric of Liberty and Common Sense, had profound implications for artists' and intellectuals' sense of the nature of their calling. Nowhere is this made clearer than in the letter written by the American painter John Trumbull to Thomas Jefferson, then acting as his country's Ambassador to Paris (IVB5).

In France itself the cost of intervention in the American war put added strains on a system that was already moving into crisis. At the most basic level, the people were being inadequately fed and clothed, obviously leeched off by the institutionalized Church and the aristocracy. The bourgeoisie resented their exclusion from political power. The burgeoning radical intelligentsia, sustained by ideals of Reason and Enlightenment, found itself an expanding constituency. And now there was a financial squeeze. In 1787 and 1788, a combination of popular unrest and disaffection of the 'notables' led to an unprecedented call – for the first time in no less than 175 years – to convene the States General: the one countervailing force to the power of the monarchy. This body duly met in the early summer of 1789, was followed immediately by the Tennis Court Oath in which delegates pledged not to stand down until a new constitution was in place, and then in July by open insurrection. The Bourbon dynasty, which had been in power for 200 years, now tottered. The French Revolution had begun.

Ever since, there have been those who interpret the Revolution as a catastrophe which reached its logical conclusion in the 'Terror' of the early 1790s. There were many at the time, as there have been many since, who believe quite the opposite: that the fall of the Bastille was – and remains – a potent symbol of the fate of all structures of repression. On 26 August the Assembly adopted the Declaration of the Rights of Man and of the Citizen. Taken together with the American Declaration of Independence, the Declaration of the Rights of Man represents an attempt to realize in practice the ideals of the Enlightenment. The prospect of a new kind of world suddenly

seemed to be opening up. William Wordsworth was moved to write, 'Bliss was it in that dawn to be alive'. Three years later, after the defeat of the Prussians by the French revolutionary army at Valmy on 20 September 1792, no less a figure than Goethe remarked that 'From this place and from this day forth commences a new era in the world's history' (Fuller, 1970, p. 58). The totalizing scope of the revolution is nowhere more vividly symbolized than in two simple facts. The revolutionaries overthrew the entire traditional system of weights and measures on which economic exchange was based, and introduced a new, scientifically based system, in the metre and the gramme. And, in what had been the Christian 1793, they instituted a new calendar, beginning at Year I, with ten-day weeks and new names for the months.

No series of events on the scale of the French Revolution (as of the Russian one over a century later), could be without consequence for the arts. Already in the 1780s Jacques-Louis David had begun to compose large history paintings redolent of austerely republican sympathies, a world away from the confections of Boucher and Fragonard, or indeed of court portraitists such as Elisabeth Vigée-Lebrun (see VIIA14). From 1789 onwards David was at the forefront of attempts to realign the practice of the arts in France with the priorities of the new order. The anxiety felt by the status quo over the potential impact of his painting is revealed by a letter of August 1789 to the painter Vien, the President of the Academy (IVB2). The other side of the coin is demonstrated by the 'Demand' of students at the Academy, made in the wake of the exhibition of David's *Brutus* (IVB4). In brief, the Revolution polarized opinion among artists and intellectuals no less than among citizens in other walks of life, and abroad no less than in France itself. In England, the conservative Edmund Burke composed a condemnation of the Revolution which was published in November 1790. Within days the radical feminist Mary Wollstonecraft was composing a reply, as remarkable for its criticism of Burke's underlying theoretical assumptions as for its opposition to his politics (IVB6).

In Paris, David led the criticism of the Academy, which was eventually abolished in August 1793. He did not restrict his activity to artistic politics, however. He was a member of the Jacobin Club from September 1790, a Deputy of the Convention from September 1792, and in January 1793 voted for the execution of Louis XVI. As an artist, his services to the Revolution ranged from the staging of public festivals to the commemoration of revolutionary martyrs such as Lepelletier, Bara, and above all, Marat (IVB8–12). After the fall of Robespierre in the summer of 1794, David was lucky to escape with his life. It was while he was in prison at this time that he began work on a major painting representative of reconciliation, the *Intervention of the Sabine Women*, not completed until 1799 (see below VIIB2). By then, David's position had changed. From 1795 the term 'revolutionary' was banned from descriptions of the government. The late 1790s saw the rise of Napoleon, culminating in his assumption of power as 'First Consul' on 18 Brumaire, Year VIII (9 November 1799). If the revolution of 1789 and the Declaration of the Rights of Man represented a kind of fulfilment of Enlightenment ideals of social progress and emancipation, then the anti-aristocratic Terror of the early 1790s, and, more seriously, Napoleon's imperial ambition, no less certainly represented their defeat. From the late 1790s onwards, David effectively became Napoleon's court painter, and was appointed

Premier Peintre in December 1804. Bathetically, after Napoleon's final defeat he went into exile in Belgium. Today, in the National Gallery in Brussels, his *Hommage à Marat* of 1793 hangs adjacent to his late, classicizing *Mars Disarmed by Venus* of 1824. If a picture is worth a thousand words, the gulf between these two expresses with soundless eloquence the shipwreck of the French Revolution.

IVA
Consolidation and Instruction

1 William Shenstone (1714–1763) Letter to Richard Graves

Shenstone was a poet and man of letters, the quintessential, genial, eighteenth-century 'man of taste'. He was born and died on the family estate, the Leasowes, in Shropshire. From 1743 Shenstone devoted much of his time to the development of his garden at the Leasowes. He was at the forefront of the English 'landscape garden' movement (see VB1). The present letter, written to a friend of many years standing, concerns a portrait of himself, set on a terrace at the Leasowes, with a view behind him out on to the landscape. It is of interest for what it tells us about the eighteenth-century relation between artist and patron. Shenstone is in control of the picture. He determines the classical allusions, in the form of a representation of a carved figure of Pan, and a Latin inscription. At the other end of the scale of values, his favourite dog is to be included, and he takes quite a detailed interest in the placement of this, and indeed all the other pictorial elements. In fact he has had his artist make a sketch of the picture, which he has altered for his friend's benefit, the better to indicate what he has in mind, and to seek the friend's approval or any suggestions for improvement. In a letter written the previous November, Shenstone describes the artist, Edward Alcock, as being 'esteemed to shine among the painters of Birmingham'. The finished portrait depicts Shenstone full-length and facing the viewer. In his right hand he holds a scroll as he leans on a stone plinth, the front face of which is carved with a figure of Apollo. On the plinth lie some large leather-bound volumes, above it, the head of Pan. The dog, a kind of whippet, sits at his feet in the bottom right, gazing up at him. Behind them both, across a tiled floor, a balustrade and classical arch frame the vista. The picture now hangs in the National Portrait Gallery in London. The letter, written on 8 January 1760, was published in volume 3 of Shenstone's *Works*, edited by Robert Dodsley under the title *Letters to Particular Friends*, London 1769. Our extract is from pp. 307–9 of the 1777 edition.

The Leasowes, Jan. 8, 1760

Dear Mr. Graves,

[. . .] You must not judge of my painter's abilities by the small sketch I inclose. – I desired him to give me a *slight* one; and have, perhaps, ruined even *that* by endeavouring to bring it nearer to what the picture now is, *myself*. It will give you a tolerable idea in most points, except the Pan, which has his face turned towards the front; and

is not near so considerable. – I chose to have this *term* introduced, not only as he carries my favourite reeds, but as he is the principal *sylvan* deity. – The water-nymph below has the word 'Stour' on the mouth of her urn; which, in some sort, rises at The Leasowes. On the scroll is, 'Flumina amem sylvasque inglorius,' ['The woods and streams inglorious let me haunt!'] alluding to them *both*. – The Pan, you will perhaps observe, hurts the *simplicity* of the picture – not much, as we have managed him; and the intention here is, I think, a balance.

The dog on the other side is my faithful Lucy, which you perhaps remember; and who *must* be *nearer* the *body* than she perhaps would if we had more room. However, I believe, I shall cause her head to cut off that little cluster of angles, where the balustrade joins the base of the arch. The balustrade is an improvement we made the other day: it is, I think, a great one; not only as it gives a symmetry or balance to the curtain of which you complained, but as it extends the *area* on which I stand, and shortens the *length* of this *half-arch*. The painter objected to a tree; I know not why; unless that we could introduce no *stem* without encroaching too much upon the landscape: but the reason he gave was, it would be an injury to the face. The console is an Apollo's head. The impost does not go further than the pilaster, which ends the corner; and here the drawing is erroneous. We are, I think, to have a carpet, though we know not well how to manage it.

And now, I must tell you the dimensions. The figure itself is three feet three inches and a half; the whole picture four feet eleven inches, by three feet two inches and three quarters. – The colour of the gown, a sea-green; waistcoat and breeches, buff-colour; stockings white, or rather pearl-colour; curtain a terra-sienna, or very rich reddish brown. – I think the whole will have a good effect; but beseech you to send me your opinion *directly*. There are some things we can alter; but there are others we must not.

You shall have one of the size you desire in the spring; but will you not calculate for some one place in your room? The painter takes very strong likenesses; is young; rather daring than delicate in his manner, though he paints well in enamel; good-natured; slovenly; would improve much by application. Adieu!

W. S.

2 William Hogarth (1697–1764) 'Of Academies'

Considerable confusion surrounds Hogarth's late writings. He was helped by literary friends to clarify and polish the prose of his *Analysis of Beauty* (IIIB3), which went through several drafts before its publication in 1753. None of the texts he wrote thereafter was ever brought to completion. These include a Supplement to the *Analysis*, his largely autobiographical 'Apology for Painters', and his reflections on the question of an Academy. Instead, after his death, the unpublished manuscripts passed to John Ireland, who subsequently edited them into a work known as the 'Anecdotes of William Hogarth'. This was first published by Ireland in 1798 as *A Supplement to Hogarth Illustrated*. Modern art-historical scholarship has shown that Ireland's intervention was more active than he implied. Hogarth's manuscripts were fragmentary, repetitive and discontinuous, some more so than others: the autobiographical notes are particularly splenetic and disjointed. The

reflections on the academy are rather less so, but there is still a considerable gap between Ireland's flowing prose and Hogarth's own staccato text. Nonetheless, Ireland does not actually misrepresent Hogarth, and we have chosen to reprint the comments on academies as he rendered them. The first academy to be organized in England was run by Kneller from 1711 to 1718. Others, mentioned by Hogarth, were then run by Cheron and Vanderbanck, and by Thornhill in the 1720s. Hogarth himself took over the running of the St Martin's Lane Academy from 1734, and this remained the main focus for art in London for the next twenty years. Hogarth split from it in the early 1750s, for reasons he gives in his text, and for a while he became involved with the Society for the Encouragement of Arts, Manufactures and Commerce, founded in 1754. This became the Society of Arts, and in April 1760, following a joint initiative, St Martin's Lane artists and the Society organized what has been seen as the first genuinely public art exhibition to take place in England. The situation continued confused until the Royal Academy was finally founded in December 1768, four years after Hogarth's death. Kitson (1968) argues persuasively that Hogarth's comments on academies were written in $c.1760-1$. Our selections have been made from chapter III of the 1833 edition of Ireland's *Anecdotes of William Hogarth, written by himself*, London: J. B. Nichols and Son, pp. 24–7, 30–1.

Much has been said about the immense benefit likely to result from the establishment of an Academy in this country, but as I do not see it in the same light with many of my contemporaries, I shall take the freedom of making my objections to the plan on which they propose forming it; and as a sort of preliminary to the subject, state some slight particulars concerning the fate of former attempts at similar establishments.

The first place of this sort was in Queen-street, about sixty years ago; it was begun by some gentlemen-painters of the first rank, who in their general forms imitated the plan of that in France, but conducted their business with far less fuss and solemnity; yet the little that there was, in a very short time became the object of ridicule. Jealousies arose, parties were formed, and the president and all his adherents found themselves comically represented, as marching in ridiculous procession round the walls of the room. The first proprietors soon put a padlock on the door; the rest, by their right as subscribers, did the same, and thus ended this academy.

Sir James Thornhill, at the head of one of these parties, then set up another in a room he built at the back of his own house, now next the playhouse, and furnished tickets gratis to all that required admission; but so few would lay themselves under such an obligation, that this also soon sunk into insignificance. Mr. Vanderbank headed the rebellious party, and converted an old Presbyterian meeting-house into an academy, with the addition of a woman figure, to make it the more inviting to subscribers. This lasted a few years; but the treasurer sinking the subscription money, the lamp, stove, &c. were seized for rent; and that also dropped.

Sir James dying, I became possessed of his neglected apparatus; and thinking that an Academy conducted on proper and moderate principles had some use, proposed that a number of artists should enter into a subscription for the hire of a place large enough to admit thirty or forty people to draw after a naked figure. This was soon agreed to, and a room taken in St. Martin's Lane. To serve the society, I lent them the furniture which had belonged to Sir James Thornhill's academy; and as I attributed the failure of that and Mr. Vanderbank's to the leading members assuming a superiority which their fellow-students could not brook, I proposed that every

member should contribute an equal sum to the establishment, and have an equal right to vote in every question relative to the society. As to electing presidents, directors, professors, &c. I considered it as a ridiculous imitation of the foolish parade of the French Academy, by the establishment of which Louis XIV. got a large portion of fame and flattery on very easy terms. But I could never learn that the arts were benefited, or that members acquired any other advantages than what arose to a few leaders from their paltry salaries, not more I am told than fifty pounds a year; which, as must always be the case, were engrossed by those who had most influence, without any regard to their relative merit. As a proof of the little benefit the arts derived from this Royal Academy, Voltaire asserts that, after its establishment, no one work of genius appeared in the country; the whole band, adds the same lively and sensible writer, became mannerists and imitators. It may be said in answer to this, that all painting is but imitation: granted; but if we go no further than copying what has been done before, without entering into the spirit, causes, and effects, what are we doing? If we vary from our original, we fall off from it, and it ceases to be a copy; and if we strictly adhere to it, we can have no hopes of getting beyond it; for if two men ride on a horse, one of them must be behind.

To return to our own Academy; by the regulations I have mentioned of a general equality, &c., it has now subsisted near thirty years; and is, to every useful purpose, equal to that in France, or any other; but this does not satisfy. The members finding his present Majesty's partiality to the arts, met at the Turk's Head in Gerrard-street, Soho; laid out the public money in advertisements, to call all sorts of artists together; and have resolved to draw up and present a ridiculous address to King, Lords, and Commons, to do for them, what they have (as well as it can be) done for themselves. Thus to pester the three great estates of the empire, about twenty or thirty students drawing after a man or a horse, appears, as it must be acknowledged, foolish enough; but the real motive is, that a few bustling characters, who have access to people of rank, think they can thus get a superiority over their brethren, be appointed to places, and have salaries as in France, for telling a lad when an arm or a leg is too long or too short.

Not approving of this plan, I opposed it; and having refused to assign to the society the property which I had before lent them, I am accused of acrimony, ill nature, and spleen, and held forth as an enemy to the arts and artists. How far their mighty project will succeed, I neither know nor care; certain I am it deserves to be laughed at, and laughed at it has been. The business rests in the breast of Majesty, and the simple question now is, – whether he will do, what Sir James Thornhill did before him, i.e. establish an Academy, with the little addition of a royal name, and salaries for those professors who can make most interest and obtain the greatest patronage. As his Majesty's beneficence to the arts will unquestionably induce him to do that which he thinks most likely to promote them, would it not be more useful, if he were to furnish his own gallery with one picture by each of the most eminent painters among his own subjects? This might possibly set an example to a few of the opulent nobility; but, even then, it is to be feared that there never can be a market in this country for the great number of works which, by encouraging parents to place their children in this line, it would probably cause to be painted. The world is already glutted with these commodities, which do not perish fast enough to want such a supply. [...]

Portrait painting ... *ever* has, and ever will succeed better in this Country than in any other; the demand will be as constant as new faces arise; and with this we must be contented, for it will be in vain to attempt to force what can never be accomplished; or at least can never be accomplished by such institutions as Royal Academies on the system now in agitation. Upon the whole, it must be acknowledged that the artists and the age are fitted for each other. If hereafter the times alter, the arts, like water, will find their level.

Among other causes that militate against either painting or sculpture succeeding in this nation, we must place our religion; which, inculcating unadorned simplicity, doth not require, nay absolutely forbids, images for worship, or pictures to excite enthusiasm. Paintings are considered as pieces of furniture, and Europe is already overstocked with the works of other ages. These, with copies, countless as the sands on the sea shore, are bartered to and fro, and are quite sufficient for the demands of the curious; who naturally prefer scarce, expensive, and far-fetched productions, to those which they might have on low terms at home. Who can be expected to give forty guineas for a modern landscape, though in ever so superior a style, when he can purchase one, which, for little more than double the sum, shall be sanctioned by a sounding name, and warranted original by a solemn-faced connoisseur? This considered, can it excite wonder that the arts have not taken such deep root in this soil as in places where the people cultivate them from a kind of religious necessity, and where proficients have so much more profit in the pursuit? Whether it is to our honour or disgrace, I will not presume to say, but the fact is indisputable, that the public encourage trade and mechanics, rather than painting and sculpture. Is it then reasonable to think, that the artist, who, to attain essential excellence in his profession, should have the talents of a Shakespeare, a Milton, or a Swift, will follow this tedious and laborious study merely for fame, when his next door neighbour, perhaps a porter-brewer, or an haberdasher of small wares, can without any genius accumulate an enormous fortune in a few years, become a Lord Mayor, or a Member of Parliament, and purchase a title for his heir? Surely no; – for, as very few painters get even moderately rich, it is not reasonable to expect, that they should waste their lives in cultivating the higher branch of the art, until their country becomes more alive to its importance, and better disposed to reward their labours.

These are the true causes that have retarded our progress; and for this, shall a nation which has, in all ages, abounded in men of sound understanding, and the brightest parts, be branded with incapacity, by a set of pedantic dreamers, who seem to imagine that the degrees of genius are to be measured like the degrees on a globe, – determine a man's powers from the latitude in which he was born, – and think that a painter, like certain tender plants, can only thrive in a hot-house? Gross as are these absurdities, there will always be a band of profound blockheads ready to adopt and circulate them; if it were only upon the authority of the great names by which they are sanctioned.

3 Frans Hemsterhuis (1721–1790) from 'Letter on Sculpture'

The Dutch philosopher and aesthetician, Frans Hemsterhuis, was born in Franecker in Frisia, the son of a noted philologist and professor of Greek, Tiberius Hemsterhuis (1685–1766). He spent most of his life in The Hague and from 1755 to 1780 held the post of secretary to the Council of State. He developed a strong interest in the natural sciences, especially optics, and was a keen amateur draughtsman, taking lessons from Etienne Falconet (see IIIC11) and Lorenz Natter. In his *Lettre sur la Sculpture* his initial concern is with the psychological conditions of imitation in the arts. He notes that perception is dependent upon both point of view and the possession of appropriate concepts. He also observes that while simple and coherent forms are more readily perceived, the human mind relishes variety, so that the most successful compositions will be those in which separate parts are so well unified that they can be instantaneously perceived. In the following passage he considers how complexity of subject and clarity of formal organization may be combined to maximal effect in the art of sculpture. Hemsterhuis wrote his *Lettre sur la Sculpture* in French, addressed it from The Hague and dated it 1765. It was first published in Amsterdam in 1769. Our excerpt is taken from pp. 9–12 of the original edition, translated for the present volume by Jonathan Murphy.

[...] Beauty in the arts is that which should furnish us with the greatest possible number of ideas in the smallest possible lapse of time. It follows from this that an artist can arrive at the beautiful by two different means: through the finesse and facility of his contours he can give me, in a single second, for example, the idea of beauty at rest as in the Medici Venus or in Galatea; or through a freer and more mobile line he might show me Andromeda, with all her hope and fear written on her body, and thus he could show me in the same second not only the idea of beauty but also an idea of the danger that she faces, which would set in motion not only my admiration, but almost my faculty of commiseration. It is perhaps the case that the expression of any passion in a figure diminishes slightly the freedom of the line, which makes it so easy for our eyes to scan the picture; but through the addition of action and passion to a figure there is a consequently greater concentration of ideas in the same lapse of time. Michelangelo, in his *Hercules and Antaeus* group, was attempting to reach this optimum by maximizing the number of ideas, through the perfect expression of the action of Hercules and the passion of Antaeus, rather than by reducing to a minimum the amount of time that we require to appreciate the group, through a great facility in the lines, so that our gaze is never arrested by a particular point. The opposite procedure is used by Giambologna, in the *Rape of the Sabine Women*, who sought this optimum by reducing the time lapse to a minimum through the facility of the contours, which enclose as great a number of highly contrasting members as it is possible to imagine in a composition that involves only three figures. When one examines the two groups at any distance, the *Hercules and Antaeus* is far inferior, as the magic wrought by the expression fails to work from afar, and all that remains is the relatively small number of ideas that can be achieved through a small number of contrasting poses: whereas the *Rape of the Sabine Women* has precisely the opposite effect.

What is most harmful to this optimum in all art is the idea of internal contradiction, either between different aspects of the line or between those lines which express action and those which express passion. [...]

To understand what I mean by contradiction in expression, one need only imagine the *Farnese Hercules*, and think of any of the overly tight muscles, which trouble the harmony and repose which was Glycon's aim. Or indeed think of any of the limbs in the Laocoön group, or any physiognomy expressing joy. [...]

Artists fall into this error for the reasons I have outlined above: the soul needs time, and succession of the various parts when through either words or actions it desires to convey or execute a beautiful idea that it has conceived.

It will be understood from this that it is entirely possible where the beautiful is concerned to surpass nature herself; for it would indeed be an unusual happenstance that gathered together a sufficient quantity of constituent parts to result in this *optimum* that I describe, analogous not to the essence of things themselves, but to the rapport between objects in the world and the nature of our sense organs. One may choose different objects, but the nature of our ideas concerning the beautiful will remain unchanged. But if the nature or construction of our sense organs were to change, the nature of our current ideas concerning beauty would immediately be destroyed.

There remains one observation to be made, and a humiliating one at that, but one that proves incontrovertibly that in itself beauty has no reality. One need only take a vase or group of figures which by all our standards can only be considered ugly, and a second object which meets all our standards for the beautiful. The objects should then be examined from all sides for several hours each day. The first response to this unpleasant experiment will be one of disgust; but as we continue to compare the objects, we will be amazed to find that our sensitivity to the differing degrees of beauty will swiftly diminish, and soon their nature will appear to have changed. With time we will be unable to choose between the two objects, which nonetheless differ radically from each other. The reason for the disgust derives from a property of the soul which I shall investigate in greater detail at a later date: but the reason for the change in our judgement is that our eye, during this experience, has become so accustomed to following the lines of the group whose composition was ugly, that it now completes its journey in almost exactly the same lapse of time as is required by the other object for us to have a different idea of it: what has happened in fact is that through glancing many times over the beautiful object, the eye has discovered the tiny flaws and imperfections that it passed over at first glance, and now stops to consider them in the course of each glance. An identical effect may be observed in any of the arts.

From nature, we have learnt to know things: from use of them, we learn to tell them apart; but our idea of the beauty of things is no more than a necessary consequence of the singular property of the soul that I demonstrated above.

In closing this somewhat metaphysical section of the letter, I would remark in passing that through this property, it would seem incontestable that there is some element of our soul which strongly resists the manner in which events succeed each other in our consciousness, and also resists the prolongation of any mental state.

4 Anton Raphael Mengs (1728–1799) 'A Discourse upon the Academy of Fine Art at Madrid'

In 1761 Mengs (see IIIB13) was commissioned by Charles III to work on frescos for the Palacio Real in Madrid, remaining in the city until 1769. For the last three years he enjoyed the official title of First Painter to the King. The Real Academia de Bellas Artes (Royal Academy of Fine Arts) de San Fernando had been founded in Madrid in 1752 under the patronage of Ferdinand VI, closely following the example of the French Academy, with outstanding students rewarded by scholarships to study in Rome. Within two years of his arrival in Madrid, Mengs was involved in moves to reform the Academy. He had met Winckelmann in Rome in 1755 and had been profoundly influenced by the art historian in his approach to the legacy of classical art (see IIIA5, 8). As the following text makes clear, his own concept of reform involved a reassertion of the importance of classical example and a strengthening of the established academic regime. The discourse on the Academy was originally published in Madrid in 1766 under the title *Ragionamento su l'Accademia delle Belle Arti di Madrid*. (A second discourse published in the same year concerned the means by which the fine arts might be made to flourish in Spain.) Mengs' recommendations were finally to be implemented in 1773. Twenty-four years later the Spanish painter Goya was to offer his own very different advice for the conduct of the Academy (IVA14). Mengs' writings were collected after his death and edited by G. N. d'Azara as *Opere di Antonio Raffaelo Mengs, primo pittore della Maestà di Carlo III, Re di Spagna*, 2 vols, Parma, 1780; revised 4 vols., Rome, 1787. English, French, German and Spanish editions followed during the next two decades, establishing a wide reputation for Mengs as a theorist. The following text is taken from the English translation included in *The Works of Anton Raphael Mengs*, London: R. Faulder, 1796, vol. III, pp. 69–83.

By an *academy* is understood an assembly of men the most expert in science or in art, their object being to investigate truth, and to find fixed rules always conducing to progress and perfection. It is very different from a school in which able masters teach the elements of sciences or of arts. The fine arts, as liberal ones, have their fixed rules founded in reason and on experience, by which means they join to obtain their end, which is the perfect imitation of nature; from whence an academy of these arts ought not to comprehend alone the execution, but ought to apply principally to the theory and to the speculation of rules, since indeed these arts terminate in the operation of the hand; but if this is not directed by good theory, they will be deprived of the title of liberal arts.

Some erroneously think that practice alone is of more importance than all the rules together, and without them there have been great artists. False are such ideas, and so false that they merit not a confutation. Whatever is done without reason and without rules is all hazard. How is it possible to arrive to a determinate end without a sure guide to conduct us? Painting and sculpture are arts similar to poetry; and as in this last art, sensibility, imagination and genius, can never produce, without rules and knowledge, any thing but dreams and monstrous productions, the same must happen in the two first. Therefore, as the poet, without knowing profoundly the subject which he has to treat and the language in which he is to explain himself, can never produce a perfect work, neither will the painter or sculptor know how to perform a

work worthy these professions, if they know not the forms of the bodies which they imitate, and the diversity of manners with which they present them to our sight; and the same will happen if they know not the theory of the art.

I do not, however, say that theory alone ought to exclude the exercise of the hand; on the contrary, I infinitely recommend it: both ought always to be united; and in this sense ought to be understood the oracle of Michael Angelo, who was wont to say that all the art consisted in the *obedience of the hand to the conception*. This great man well understood that images ought to be well imprinted on the mind, and the idea of every thing which the hand ought to execute. From whence it is necessary always to have practice, but with the knowledge of why and wherefore.

The able professors of an academy ought to endeavour, by conferring together, to find out certain rules, by which students may be able to abbreviate the course of arts so extensive. These rules will be prescribed to youth as fundamental laws, explaining to them reasons by clear demonstrations, which not only may convince, but persuade, since without persuasion one is not capable of doing any thing perfect.

All academies of arts have begun from being schools, and afterwards have been transformed into what we call academies, that is to say, societies of professors, who by their conferences and discourses promote instructions, and have merited the protection of princes. In this manner have begun the academies of Rome, Bologna, Florence and Paris, &c. &c.

The utility of such establishments consists in the advancement of arts, and in the influence which they occasion in a nation by disseminating there a good taste: since it is the intelligence of design which directs all arts treating of figures or of forms. This utility cannot possibly be obtained by any academy, if good reasoning and the aforesaid theory of design are not publicly taught; because, without theory, design is only a practical and material action which produces the figure alone that one circumscribes, without giving to it a general intelligence, or instructing how to judge of the forms. For which reason, every academy which follows not the above-mentioned maxims, will have material designers and artisans, but not illuminated and excellent artists; and in consequence will operate against its principal end, and will waste the time that it employs in bad instructions.

* * *

Considering now the academy of Madrid as a school, it is necessary to make some reflections. Even to these latter times good examples of the arts were here wanting. In this, however, they have at last been supplied, the academy being now possessed of the best and most copious collection of casts of the antique statues that are in Europe. From this one now is in a capacity to learn proportions, the art of expressing anatomy without harshness, a selection of fine forms, and the true character of beauty. Yet according to my belief much time is wanted to acquire an uniform system of design, and some necessary parts of art which they either do not teach, or teach improperly. Upon these matters I will speak my opinion ingenuously.

Although there are found in Madrid many professors of merit, one cannot deny but there have been, and that there are now elsewhere, schools more reputable. One ought not, therefore, to give as an example to youth the particular works of the artists of this academy, but one ought to take the best works of every school, and of all the

most celebrated professors. In this manner boys, from their most tender age, will accustom themselves to a good style. Another very great advantage will result from it, which is, that the masters of the academy will be able to speak with freedom, not being led away by self-love or by human prejudices, which prevent a man from speaking frankly his sentiments, there where he speaks of his own work, or of his associates, having themselves many reasons to palliate their own opinions.

It would be also very convenient that professors should give a good example in designing and of modelling together with their scholars in the modelling room, by this means animating the youth and the professors themselves in the inferior classes: this study being much more useful to the advanced than to scholars. Above all it would be necessary that one should examine with the greatest attention every thing proposed to youth; not submitting to the caprice of particulars the introductions of vicious examples, since it is much more difficult to undo a vice acquired in early years, than to learn a thousand good things.

The time that is destined in the academy for study is neither sufficient or proper, because the hours of the night are few for a study so extensive; and the spirits of a youth, distracted by the occupations of the day, have not the necessary activity for learning, and for fixing in the memory the things that are taught him. It would be therefore necessary, since the academy is to be also a school, to do that which is practised in the schools of other branches, that is to say, to employ in study the later hours of the day, with the assistance of professors of an inferior rank, and those should give an account to the superior of the progress and of the mode of teaching. This exercise would be, besides that, very useful to themselves; and the principal masters ought to review the studies of youth, in order to change the classes according to their progress.

The exercise of night ought to serve only for those who, being already advanced in the theory of the art, have occasion to augment the practice by frequent use, because otherwise, with the solicitude with which they ought to work at night, pupils accustom themselves to an incorrectness which degenerates into a vicious negligence, there not being time to observe well the rules and the reasons of art; and those who being to copy rudiments have not sufficient time to see the fruit of their application, whence many discourage themselves and abandon the study already begun. In short, if the academy is to be a school, it is necessary to practise there all that which a vigilant and good master ought privately to do for his own disciples; otherwise it will never become an useful school.

If laws, and the maxims of public lectures, are not fixed in a manner that youth learn as if they studied under one master only, they will confuse the disciple by following different, and sometimes contradictory rules.

For that reason it would be necessary, that professors congregate themselves and well examine matters: they should consult and determine the method which ought to be followed, weighing well reasons, pro and contra, reserving nevertheless to amend them, whenever experience and reason may indicate the necessity.

The things which ought to be taught with a greater diligence are, linear and aërial perspective, selecting notwithstanding a short method. Then comes anatomy, not as physicians and surgeons learn it, but as it is suitable to the arts, which have for their

object the imitation of the exterior forms of things: and as amongst all the bodies of nature there is not for man any thing more noble, and more worthy than the human figure, it is very necessary for him to know it exactly, both in the whole and in its parts, and this is taught us by anatomy. Whence it is that perspective shews to us the manner of imitating the appearance of forms, which one cannot execute without knowing it anatomically. For this reason, this science is equally necessary to the sculptor and the painter.

Nor is less precious the study of symmetry, that is to say, of the proportions of the human body, without which it is not possible to know how to select from nature the most perfect bodies. By this the ancient Greeks distinguished themselves so superiorly from us; and they derived beauty, grace and animation from the knowledge of proportions.

The art of light and shade, which is called clare obscure, ought to be taught with the same accuracy, since without it painting cannot have any relief: therefore it is necessary to consider it as an essential part, so much the more as painters have not always the opportunity of seeing things according to nature; and when even they have, it is not so easy to understand the reasons of them, and to keep fast to truth by not permitting themselves to be transported by any practical rules followed by ignorant people, and learned without reflection from their masters. Finally, clare obscure is a part doubly useful, because it pleases the intelligent as well as those who are not so.

I know not if lessons of colouring have ever been given, notwithstanding it is a part so principal in painting, that it has its rules founded on science and reason. Without such study, it is impossible that youth can acquire a good taste in colouring, or understand harmony.

In the same manner it is necessary to teach invention and composition without omitting the art of composing drapery. All these have equally their fixed rules; rules necessary to be learned, to understand what one sees in nature. I will not say that with these rules alone, and without talents, it is possible to acquire the arts: I say, however, that without them, no one will ever arrive to be an excellent artist; and if even all the rules are not susceptible of demonstration, those indeed which respect imitation they absolutely admit, and those of election have their reasons almost evident.

Some possibly will say, that all this study that I propose for an academy, could be done by some master professor in his own house to his disciples. To me it appears otherwise, believing it impossible that any one man can know equally well so many things; and if indeed he knew them, I know not if he would have time or convenience to teach them. Besides which it might happen, that amongst those who study under a particular master one would find some of talents, which by defect of good instruction, or from some other motive, cannot arrive to make him a man of great merit; whilst in a public school he will have occasion to develop his own ingenuity, and to distinguish himself by emulation, and from a poor unhappy man render himself an artist, who may give honour to the art, and glory to his country.

5 Benjamin West (1738–1820) and John Singleton Copley (1738–1815) Correspondence 1766–7

West and Copley were both born in America, in Pennsylvania and Boston respectively, and both travelled to Italy to study before settling permanently in London. Though they were contemporaries, West's career advanced a great deal faster than Copley's, thanks in part to the early support of American patrons. He spent three years in Italy between 1760 and 1763, studying with Anton Raphael Mengs in Rome and gaining membership of academies in Bologna, Florence and Parma. He arrived in London with qualifications as a neo-classical history painter that no English artist could match, and was soon to draw attention to himself through works shown at the Society of Arts. He was among those who would serve as founder members of the Royal Academy in 1768. By the time of his correspondence with Copley he was thus already well established in professional circles, using his position to the advantage of other American artists as the opportunity arose. Copley, on the other hand, was not to leave for Europe until 1774. During his time in America he was largely restricted to the study of prints for his exemplars, and to the painting of portraits for a living, there being no market for history paintings (see ID8). By the 1760s he was established as the foremost portrait painter in the Boston area. In 1765 he sent *Boy with a Squirrel* (now in the Museum of Fine Arts, Boston) for exhibition at the Society of Arts in London the following year, consigning it to the care of his friend Captain Bruce. The painting was well received, and West took it upon himself both to encourage his compatriot and to pass on his own and Joshua Reynolds' advice and criticism, initiating the correspondence represented here. Copley's move to England was finally triggered by the American Revolution. After spending a year in Italy in 1774–5 he embarked on a second career in London. His first history painting, *Watson and the Shark*, was shown at the Royal Academy in 1779, the year of his election to membership. In *The Death of the Earl of Chatham* (1779–81), his next historical subject, he followed the precedent of West's *Death of General Wolfe* (see IVA6) in treating a modern theme in modern dress. Our text of the correspondence is taken from *Letters and Papers of John Singleton Copley and Henry Pelham, 1739–1776*, Boston: Massachusetts Historical Society, no. 71, 1914, pp. 43–5, 50–2, 56–8.

Benjamin West to Copley

London, August 4th, 1766.

Sir,

On Seeing a Picture painted by you and meeting with Captain Bruce, I take the liberty of writeing to you. The great Honour the Picture has gaind you hear in the art of Painting I dare say must have been made known to You Long before this Time. and as Your have made So great a Progr[e]ss in the art I am Persuaded You are the more desierous of hearing the remarks that might have been made by those of the Profession, and as I am hear in the Midst of the Painting world have the greater oppertunity of hearing them. Your Picture first fell into Mr. Reynolds' hands to have it Put into the Exhibition as the Proformanc of a Young American: he was Greatly Struck with the Piec, and it was first Concluded to have been Painted by one Mr. Wright [Joseph Wright of Derby], a young man that has just made his appearance in the art in a sirprising Degree of Merritt. as Your Name was not given with the

Picture it was Concluded a mistake, but before the Exhibition opened the Perticulers was recevd from Capt. Bruce. while it was Excibited to View the Criticizems was, that at first Sight the Picture struck the Eye as being to liney, which was judgd to have arose from there being so much neetness in the lines, which indeed as fare as I was Capable of judgeing was some what the Case. for I very well know from endevouring at great Correctness in ones out line it is apt to Produce a Poverty in the look of ones work. when ever great Desition [decision] is attended to they lines are apt to be to fine and edgey. This is a thing in works of great Painter[s] I have remark[ed] has been strictly a voyded, and have given Correctness in a breadth of out line, which is finishing out into the Canves by no determind line when Closely examined; tho when seen at a short distanc, as when one looks at a Picture, shall appear with the greatest Bewty and freedom. for in nature every thing is Round, or at least Partakes the most of that forme which makes it imposeble that Nature, when seen in a light and shade, can ever appear liney.

As we have every April an Exhibition where our works is exhibited to the Publick, I advise you to Paint a Picture of a half figure or two in one Piec, of a Boy and Girle, or any other subject you may fancy. And be shure take your Subjects from Nature as you did in your last Piec, and dont trust any resemblanc of any thing to fancey, except the dispositions of they figures and they ajustments of Draperies, So as to make an agreable whole. for in this Consists the work of fencey and Test [taste].

If you should do anything of this kind, I begg you may send it to me, when you may be shure it shall have the greatest justice done it. lett it be Painted in oil, and make it a rule to Paint in that way as much as Posible, for Oil Painting has the superiority over all other Painting. As I am from America, and know the little Opertunities is to be had their in they way of Painting, made the inducement the more in writeing to you in this manner, and as you have got to that lenght in the art that nothing is wanting to Perfect you now but a Sight of what has been done by the great Masters, and if you Could make a viset to Europe for this Porpase for three or four years, you would find yourself then in Possession of what will be highly valuable. if ever you should make a viset to Europe you may depend on my friendship in eny way thats in my Power to Sarve.

Your Friend and Humble Servent,

B. West.

my direction is Castle Street Leicester Fields. [...]

Copley to Benjamin West

Boston, Novr. 12, 1766.

Sir,

Your kind favour of Augst. 4, 1766, came to hand. It gave me great pleasure to receive without reserve Your Criticisms on the Picture I sent to the Exibition. Mr. Powell informed me of Your intention of wrighting, and the handsom things You was pleas'd say in praise of that little performance, which has increased my estamation of it, and demands my thanks which previous to the receipt of Your favour I acknowledged in a letter forwarded by Mr. Powell. It was remarkd the Picture was too lind. this I confess I was concious of my self and think with You that it is the natural result

of two great presition in the out line, which in my next Picture I will indeavour to avoid, and perhaps should not have fallen into it in that, had I not felt two great timerity at presenting a Picture to the inspection of the first artists in the World, and where it was to come into competition with such masterly performancess as generally appear in that Collection. In my last I promis'd to send another peace. the subject You have sence pointed out, but I fear it will not be in my power to comply with Your design, the time being two short for the exicution of two figures, not having it in my power to spend all my time on it, and the Days short and weither cold, and I must ship it by the middle of Feby. at farthest, otherwise it will come too late for the exibition. but I shall do somthing near what you propose. Your c[a]utioning me against doing anything from fancy I take very kind, being sensable of the necessity of attending to Nature as the fountain head of all perfection, and the works of the great Masters as so many guides that lead to the more perfect imitation of her, pointing out to us in what she is to be coppied, and where we should deviate from her. In this Country as You rightly observe there is no examples of Art, except what is to [be] met with in a few prints indiferently exicuted, from which it is not possable to learn much, and must greatly inhanch the Value of free and unreserved Criticism made with judgment and Candor.

It would give me inexpressable pleasure to make a trip to Europe, where I should see those fair examples of art that have stood so long the admiration of all the world. the Paintings, Sculptors and Basso Releivos that adourn Italy, and which You have had the pleasure of making Your Studies from would, I am sure, annimate my pencil, and inable me to acquire that bold free and gracefull stile of Painting that will, if ever, come much slower from the mere dictates of Nature, which has hither too been my only instructor. I was allmost tempted the last year to take a tour to Philadelphia, and that chiefly to see some of Your Pictures, which I am informd are there. I think myself peculiarly unlucky in Liveing in a place into which there has not been one portrait brought that is worthy to be call'd a Picture within my memory, which leaves me at a great loss to gess the stile that You, Mr. Renolds, and the other Artists practice. I shall be glad when you write next you will be more explicit on the article of Crayons, and why You dis[ap]prove the use of them, for I think my best portraits done in that way. and be kind anough to inform me what Count Allgarotti means by the five points that he recommends for amusement and to assist the invention of postures, and weither any prints after Corregios or Titianos are to be purchased. I fear I shall tire Your patience and mak you repent your wrighting to one who makes so many requests in one letter.

But I shall be exceeding glad to know in general what the present state of Painting in Italy is, weither the Living Masters are excellent as the Dead have been. it is not possable my curiossity can be sattisfied in this by any Body but Yourself, not having any corraspondance with any whose judgment is sufficent to sattisfy me. I have been painting the head of a Decenting Cleargyman and his friends are desireous to subscribe for it to be scraped in mezzotinto in the common size of 14 inches by ten, but I cannot give them the terms till I know the price. I shall take it kind if when you see any artist that You approve You menshon it to him, and Let me know. I have seen a well exicuted print by Mr. [William] Pether of a Jew Rabbi. if You think him a good hand, be kind anough to desire him to let me know by a few lines (as soon as

convenient) his terms, as the portrait weits only for that in my hands, and I shall send it immediately with the mony to defray the expence when I know what it is.

I am Sir with all Sinceri[t]y Your friend and Humble Sert.

<div align="right">J: S: Copley. [...]</div>

Benjamin West to Copley

<div align="right">London, June 20th, 1767.</div>

Sir,

Dont impute the long Omition of my not writeing to you [to] any forgetfullness or want of that Friendship I first Shewd on seeing your works. My having been so much ingaged in the Study of my Bussiness, in perticuler that of history Painting, which demands the greates Cear and intelegance in History amaginable, has so intierly Prevented my takeing up the Penn to answer your Several Agreable favours, and the reception of your Picture of the little Gairl you Sent for the exhibition. It came safe to hand in good time. And as I am Persuaded you must be much interested in reguard to the reception it mett with from they artists and Publicks opinion in General, I as a Friend Take this oppertunity to Communicate it to you.

In regard to the Artists they Somewhat differ in Opinion from Each Other, Some Saying they thought your First Picture was the Best, others Say the last is Superior (which I think [it] is as a Picture in point of Exhecution, tho not So in Subject). But of those I shall give this of Mr. Reynolds when he saw it he was not so much Pleased with it as he was with the first Picture you Exhibited, that he thougt you had not mannaged the general Affect of it so Pleasing as the other. This is what the Artists in General has Criticised, and the Colouring of the Shadows of the flash wants transperency. Those are thing[s] in General that have Struck them. I Cant say but the Above remarks have some justness in them, for the Picture being at my house some time gave me an oppertunity of Examining it with more Exectness.

The General Affect as Mr. Reynolds justly Observes is not quite so agreable in this as in the other; which arrises from Each Part of the Picture being Equell in Strenght of Coulering and finishing, Each Making to much a Picture of its silf, without that Due Subordanation to the Principle Parts, viz they head and hands. For one may Observe in the great works of Van dyke, who is the Prince of Portrait Painter[s], how he has mannaged by light and shedow and the Couler of Dreperys made the face and hands apear allmost a Disception. For in Portrait Painting those are they Parts of Most Consiquence, and of Corse ought to be the most distinguished. Thare is in Historical Painting this Same attention to be Paid. For if the Principl Carrictors are Suffred to Stand in the Croud, and not distinguished by light and shadow, or made Conspicuous by some Pece of art, So that the Eye is first Caut by the Head Carrictor of the History, and So on to the next as he bears Proportion to the head Carrictor, if this is not observed the whole is Confusion and looses that dignity we So much admier in Great works. Your Picture is in Possession of Drawing to a Correctness that is very Surpriseing, and of Coulering very Briliant, tho this Brilantcy is Somewhat missapplyed, as for instance, the Gown too bright for the flesh, which over Came it in Brilency. This made them Critisise they Shadows of the Flesh without knowing from whence this defect arose; and so in like manner the dog and Carpet to

Conspichious for Excesry things, and a little want of Propriety in the Back Ground, which Should have been Some Modern orniment, as the Girle was in a Modern dress and modern Cherce [skirt?]. The Back Ground Should have had a look of this time. These are Critisisms I should not mak was not your Pictures very nigh upon a footing with the first artists who now Paints, and my being sensible that Observations of this nature in a friendly way to a man of Your Talents must not be Disagreable. I with the greater Freedom give them, As it is by this assistance the art is reasd to its hight. I hope I shall have the Pleasur of Seeing you in Europe, whare you will have an oppertunity of Contemplateing the great Productions of art, and feel from them what words Cannot Express. For this is a Scorce the want of which (I am senseble of) Cannot be had in Ameri[c]a; and if you should Ever Come to London my house is at Your Service, or if you should incline to go for Italy, if you think letters from me Can be of any Service, there are much at your Service. And be asshurd I am with greatest Friendship, Your Most obediant Humble Servent

Benjn West.

PS. I have Spoke to Several of our Mezzotinto Scrappers, and there Prices for a Plate after a Picture of that Sise is from fifteen Guines to Twenty Guines. Thare is Scrapers of a less Price thin that, but they are reather indefirent. I hope you will fevour us with a Picture the next Exhibition. In Closed I Send you a Copy of our Royal Charter and list of fellows, amongst whom you are Chosen one. The next which will be printed your name is to be inserted.

6 Benjamin West (1738–1820) on *The Death of General Wolfe*

Having achieved success within a few years after his arrival from Italy (see IVA5), West decided to stay and to pursue a career in England. By the late 1760s he had gained a position as a leading painter of histories in a neo-classical style and was appointed as history painter to George III. Substantial commissions followed for canvases on historical themes to decorate the Royal Chapel and King's Audience Room at Windsor Castle. For his best-known work, however, West portrayed an event from recent military history. He was 33 when he painted *The Death of General Wolfe* (now in the National Gallery of Canada, Ottawa). As an American, he may be expected to have had a particular interest in the subject, since the battle in which Wolfe died did much to determine the balance of power between the French and the English on the North American continent. Wolfe had defeated Montcalm at the Heights of Abraham outside Quebec. His death at the very moment of triumph provided a ready-made subject for an ambitious modern history painting. What made the picture so pivotal, however, was not its subject, but its treatment. West decided to clothe his heroes, not in the draperies of classical Antiquity, but in the modern dress they wore on the field. This was the first time such a procedure had been followed. His decision effectively reanimated the genre of history painting by according it the potential to engage directly with matters of present and public concern. Initial opposition to the plan came from members of the Royal Academy and from King George III, in his role as the leading patron of the arts. However, West's performance won them over, and the painting was widely acclaimed on its exhibition in 1771. Together with its successor, *William Penn's Treaty with the Indians* (1771–2, Academy of Fine Arts, Philadelphia), it was to bring West both financial reward and an international reputation through the wide circulation of engravings

in Europe and America. It was cited by David as a precedent for the exhibition of his *Sabines* in 1799 (see VIIB2). West's account of his triumph appears in *The Life and Works of Benjamin West*. As its subtitle indicated, this account of West's life was in part 'composed from materials furnished by himself'. There is no indication as to when the passage in question was written, but it purports to be a verbatim account of the exchange which took place in West's studio sometime in 1771, between the artist himself, the Archbishop of York, and Joshua Reynolds, then President of the Royal Academy. We have included a paragraph by Galt which sets the scene. The extract is taken from John Galt, *The Life and Works of Benjamin West Esq.*, London: T. Cadell and W. Davies, and Edinburgh: W. Blackwood, 1820, pp. 46–50.

About this period, Mr. West had finished his Death of Wolfe, which excited a great sensation, both on account of its general merits as a work of art, and for representing the characters in the modern military costume. The King mentioned that he heard much of the picture, but he was informed that the dignity of the subject had been impaired by the latter circumstance; observing that it was thought very ridiculous to exhibit heroes in coats, breeches, and cock'd hats. The Artist replied, that he was quite aware of the objection, but that it was founded in prejudice, adding, with His Majesty's permission, he would relate an anecdote connected with that particular point.

'When it was understood that I intended to paint the characters as they had actually appeared in the scene, the Archbishop of York called on Reynolds and asked his opinion, the result of which was that they came together to my house. For His Grace was apprehensive that, by persevering in my intention, I might lose some portion of the reputation which he was pleased to think I had acquired by his picture of Agrippina, and Your Majesty's of Regulus;[1] and he was anxious to avert the misfortune by his friendly interposition. He informed me of the object of their visit, and that Reynolds wished to dissuade me from running so great a risk. I could not but feel highly gratified by so much solicitude, and acknowledged myself ready to attend to whatever Reynolds had to say, and even to adopt his advice, if it appeared to me founded on any proper principles. Reynolds then began a very ingenious and elegant dissertation on the state of the public taste in this country, and the danger which every attempt at innovation necessarily incurred of repulse or ridicule; and he concluded with urging me earnestly to adopt the classic costume of antiquity, as much more becoming the inherent greatness of my subject than the modern garb of war. I listened to him with the utmost attention in my power to give, but could perceive no principle in what he had delivered; only a strain of persuasion to induce me to comply with an existing prejudice, – a prejudice which I thought could not be too soon removed. When he had finished his discourse, I begged him to hear what I had to state in reply, and I began by remarking that the event intended to be commemorated took place on the 13th of September, 1758, in a region of the world unknown to the Greeks and Romans, and at a period of time when no such nations, nor heroes in their costume, any longer existed. The subject I have to represent is the conquest of a great province of America by the British troops. It is a topic that history will proudly record, and the same truth that guides the pen of the historian should govern the pencil of the artist. I consider myself as undertaking to tell this great event to the eye of the world; but if, instead of the facts of the

transaction, I represent classical fictions, how shall I be understood by posterity! The only reason for adopting the Greek and Roman dresses, is the picturesque forms of which their drapery is susceptible; but is this an advantage for which all the truth and propriety of the subject should be sacrificed? I want to mark the date, the place, and the parties engaged in the event; and if I am not able to dispose of the circumstances in a picturesque manner, no academical distribution of Greek or Roman costume will enable me to do justice to the subject. However, without insisting upon principles to which I intend to adhere, I feel myself so profoundly impressed with the friendship of this interference, that when the picture is finished, if you do not approve of it, I will consign it to the closet, whatever may be my own opinion of the execution. They soon after took their leave, and in due time I called on the Archbishop, and fixed a day with him to come with Reynolds to see the painting. They came accordingly, and the latter without speaking, after his first cursory glance, seated himself before the picture, and examined it with deep and minute attention for about half an hour. He then rose, and said to His Grace, Mr. West has conquered. He has treated his subject as it ought to be treated. I retract my objections against the introduction of any other circumstances into historical pictures than those which are requisite and appropriate; and I foresee that this picture will not only become one of the most popular, but occasion a revolution in the art.'

1 *Agrippina with the Ashes of Germanicus* (1767), and *Regulus* (1769).

7 Joshua Reynolds (1723–1792) from *Discourses on Art, III, VI and XI*

Reynolds' *Discourses* represent the summation of eighteenth-century art theory in English. In them he offered a grand synthesis of the existing knowledge of the arts in the classical tradition: the Ancients, mediated by authors such as Junius; the Renaissance, as represented in the writings of Alberti and Leonardo; French academic theory, represented by the likes of Du Fresnoy, De Piles and Le Brun; and eighteenth-century British philosophical discussion of the arts, represented by thinkers such as Richardson from the previous generation, and Hume and Burke from his own. After a long, wrangling debate, the Royal Academy was finally founded in December 1768, and Reynolds was immediately elected its first President. His first Discourse was delivered at the opening of the new institution on 2 January 1769. After that, the Discourses were delivered in December, on the occasion of the Academy's prize-giving ceremony. Discourses II–V were given annually between 1769 and 1772. Thereafter they took place every two years until the final one, the fifteenth on 10 December 1790. The single exception to this was the additional short Discourse IX, delivered in October 1780 on the occasion of the Academy's move to new, permanent premises at Somerset House on the Strand. The Discourses were an immediate success. The first seven were published in book form as early as 1778, since when there have been well over thirty English editions. Several were translated into French, German and Italian in Reynolds' own lifetime. The present selections have been made from three Discourses: III, from 14 December 1770; VI, from 10 December 1774; XI, from 10 December 1782. (Discourse IX is included as a separate selection below, at IVA8.) The principal themes addressed in Discourse III, VI and XI are the need for a Grand Style, the pursuit of Ideal

beauty rather than mechanical imitation, and a reiteration of the status of painting as a Liberal Art. Reynolds' changing views on imitation and innovation are also represented. Thus in Discourse VI he challenges the type of argument advanced by Young regarding originality and genius (see IIIB10). But by the time of Discourse XI he lays greater emphasis on genius, arguing that the main work of art is not imitation as such, but the production of effects through an integrated aesthetic totality. The extracts have been taken from Reynolds' *Discourses*, edited with an introduction and notes by Pat Rogers, Harmondsworth: Penguin Classics, 1992. Our selections are from Discourse III: pp. 102–4, 105–7, 109–13; Discourse VI: pp. 152–5, 156–8; Discourse XI: pp. 247–50, 255–6.

Discourse III

[. . .] The first endeavours of a young Painter, as I have remarked in a former discourse, must be employed in the attainment of mechanical dexterity, and confined to the mere imitation of the object before him. Those who have advanced beyond the rudiments, may, perhaps, find in reflecting on the advice which I have likewise given them, when I recommended the diligent study of the works of our great predecessors; but I at the same time endeavoured to guard them against an implicit submission to the authority of any one master however excellent: or by a strict imitation of his manner, precluding themselves from the abundance and variety of Nature. I will now add, that Nature herself is not to be too closely copied. There are excellencies in the art of painting beyond what is commonly called the imitation of nature; and these excellencies I wish to point out. The Students who, having passed through the initiatory exercises, are more advanced in the art, and who, sure of their hand, have leisure to exert their understanding, must now be told, that a mere copier of nature can never produce any thing great; can never raise and enlarge the conceptions, or warm the heart of the spectator.

The wish of the genuine painter must be more extensive: instead of endeavouring to amuse mankind with the minute neatness of his imitations, he must endeavour to improve them by the grandeur of his ideas; instead of seeking praise, by deceiving the superficial sense of the spectator, he must strive for fame, by captivating the imagination.

The principle now laid down, that the perfection of this art does not consist in mere imitation, is far from being new or singular. It is, indeed, supported by the general opinion of the enlightened part of mankind. The poets, orators, and rhetoricians of antiquity, are continually enforcing this position; that all the arts receive their perfection from an ideal beauty, superior to what is to be found in individual nature. They are ever referring to the practice of the painters and sculptors of their times, particularly Phidias, (the favourite artist of antiquity,) to illustrate their assertions. As if they could not sufficiently express their admiration of his genius by what they knew, they have recourse to poetical enthusiasm: they call it inspiration; a gift from heaven. The artist is supposed to have ascended the celestial regions, to furnish his mind with this perfect idea of beauty. 'He,' says Proclus, 'who takes for his model such forms as nature produces, and confines himself to an exact imitation of them, will never attain to what is perfectly beautiful. For the works of nature are full of disproportion, and fall very short of the true standard of beauty. So that Phidias, when he formed his Jupiter, did not copy any object ever presented to his

sight; but contemplated only that image which he had conceived in his mind from Homer's description.' And thus Cicero, speaking of the same Phidias: 'Neither did this artist,' says he, 'when he carved the image of Jupiter or Minerva, set before him any one human figure, as a pattern, which he was to copy; but having a more perfect idea of beauty fixed in his mind, this is steadily contemplated, and to the imitation of this, all his skill and labour were directed.'

The Moderns are not less convinced than the Ancients of this superior power existing in the art; nor less sensible of its effects. Every language has adopted terms expressive of this excellence. The *gusto grande* of the Italians, the *beau ideal* of the French, and the *great style, genius*, and *taste* among the English, are but different appellations of the same thing. It is this intellectual dignity, they say, that ennobles the painter's art; that lays the line between him and the mere mechanick; and produces those great effects in an instant, which eloquence and poetry, by slow and repeated efforts, are scarcely able to attain. [. . .]

It is not easy to define in what this great style consists; nor to describe, by words, the proper means of acquiring it, if the mind of the Student should be at all capable of such an acquisition. Could we teach taste or genius by rules, they would be no longer taste and genius. But though there neither are, nor can be, any precise invariable rules for the exercise, or the acquisition of these great qualities, yet we may truly say, that they always operate in proportion to our attention in observing the works of nature, to our skill in selecting, and to our care in digesting, methodizing, and comparing our observations. There are many beauties in our art, that seem, at first, to lie without the reach of precept, and yet may easily be reduced to practical principles. Experience is all in all; but it is not every one who profits by experience; and most people err, not so much from want of capacity to find their object, as from not knowing what object to pursue. This great ideal perfection and beauty are not to be sought in the heavens, but upon the earth. They are about us, and upon every side of us. But the power of discovering what is deformed in nature, or in other words, what is particular and uncommon, can be acquired only by experience; and the whole beauty and grandeur of the art consists, in my opinion, in being able to get above all singular forms, local customs, particularities, and details of every kind.

All the objects which are exhibited to our view by nature, upon close examination will be found to have their blemishes and defects. The most beautiful forms have something about them like weakness, minuteness, or imperfection. But it is not every eye that perceives these blemishes. It must be an eye long used to the contemplation and comparison of these forms; and which by a long habit of observing what any set of objects of the same kind have in common, has acquired the power of discerning what each wants in particular. This long laborious comparison should be the first study of the painter, who aims at the greatest style. By this means, he acquires a just idea of beautiful forms; he corrects nature by herself, her imperfect state by her more perfect. His eye being enabled to distinguish the accidental deficiencies, excrescences, and deformities of things, from their general figures, he makes out an abstract idea of their forms more perfect than any one original; and what may seem a paradox, he learns to design naturally by drawing his figures unlike to any one object. This idea of the perfect state of nature, which the Artist calls the Ideal Beauty, is the great leading principle by which works of genius are conducted. [. . .]

When the Artist has by diligent attention acquired a clear and distinct idea of beauty and symmetry; when he has reduced the variety of nature to the abstract idea; his next task will be to become acquainted with the genuine habits of nature, as distinguished from those of fashion. For in the same manner, and on the same principles, as he has acquired the knowledge of the real forms of nature, distinct from accidental deformity, he must endeavour to separate simple chaste nature, from those adventitious, those affected and forced airs or actions, with which she is loaded by modern education.

Perhaps I cannot better explain what I mean, than by reminding you of what was taught us by the Professor of Anatomy, in respect to the natural position and movement of the feet. He observed, that the fashion of turning them outwards was contrary to the intent of nature, as might be seen from the structure of the bones, and from the weakness that proceeded from that manner of standing. To this we may add the erect position of the head, the projection of the chest, the walking with straight knees, and many such actions, which we know to be merely the result of fashion, and what nature never warranted, as we are sure that we have been taught them when children.

I have mentioned but a few of those instances, in which vanity or caprice have contrived to distort and disfigure the human form; your own recollection will add to these a thousand more of ill-understood methods, which have been practised to disguise nature among our dancing-masters, hair-dressers, and tailors, in their various schools of deformity.

However the mechanick and ornamental arts may sacrifice to fashion, she must be entirely excluded from the Art of Painting; the painter must never mistake the capricious challenging for the genuine offspring of nature; he must divest himself of all prejudices in favour of his age or country; he must disregard all local and temporary ornaments, and look only on those general habits which are every where and always the same; he addresses his works to the people of every country and every age, he calls upon posterity to be his spectators, and says with Zeuxis, *in æternitatem pingo* [I paint for eternity].

The neglect of separating modern fashions from the habits of nature, leads to that ridiculous style which has been practised by some painters, who have given to Grecian Heroes the airs and graces practised in the court of Lewis the Fourteenth; an absurdity almost as great as it would have been to have dressed them after the fashion of that court.

To avoid this error, however, and to retain the true simplicity of nature, is a task more difficult than at first sight it may appear. The prejudices in favour of the fashions and customs that we have been used to, and which are justly called a second nature, make it too often difficult to distinguish that which is natural from that which is the result of education; they frequently even give a predilection in favour of the artificial mode; and almost every one is apt to be guided by those local prejudices, who has not chastised his mind, and regulated the instability of his affections by the eternal invariable idea of nature.

Here then, as before, we must have recourse to the Ancients as instructors. It is from a careful study of their works that you will be enabled to attain to the real simplicity of nature; they will suggest many observations which would probably

escape you, if your study were confined to nature alone. And, indeed, I cannot help suspecting, that in this instance the ancients had an easier task than the moderns. They had, probably, little or nothing to unlearn, as their manners were nearly approaching to this desirable simplicity; while the modern artist, before he can see the truth of things, is obliged to remove a veil, with which the fashion of the times has thought proper to cover her.

Having gone thus far in our investigation of the great style in painting; if we now should suppose that the artist has found the true idea of beauty, which enables him to give his works a correct and perfect design; if we should suppose also, that he has acquired a knowledge of the unadulterated habits of nature, which gives him simplicity; the rest of his task is, perhaps, less than is generally imagined. Beauty and simplicity have so great a share in the composition of a great style, that he who has acquired them has little else to learn. It must not, indeed, be forgotten, that there is a nobleness of conception, which goes beyond any thing in the mere exhibition even of the perfect form; there is an art of animating and dignifying the figures with intellectual grandeur, of impressing the appearance of philosophick wisdom, or heroick virtue. This can only be acquired by him that enlarges the sphere of his understanding by a variety of knowledge, and warms his imagination with the best productions of ancient and modern poetry.

A hand thus exercised, and a mind thus instructed, will bring the art to a higher degree of excellence than perhaps it has hitherto attained in this country. Such a student will disdain the humbler walks of painting, which, however profitable, can never assure him a permanent reputation. He will leave the meaner artist servilely to suppose that those are the best pictures, which are most likely to deceive the spectator. He will permit the lower painter, like the florist or collector of shells, to exhibit the minute discriminations, which distinguish one object of the same species from another; while he, like the philosopher, will consider nature in the abstract, and represent in every one of his figures the character of its species.

If deceiving the eye were the only business of the art, there is no doubt, indeed, but the minute painter would be more apt to succeed; but it is not the eye, it is the mind which the painter of genius desires to address; nor will he waste a moment upon those smaller objects which only serve to catch the sense, to divide the attention, and to counteract his great design of speaking to the heart.

This is the ambition which I wish to excite in your minds; and the object I have had in my view, throughout this discourse, is that one great idea which gives to painting its true dignity, which entitles it to the name of a Liberal Art, and ranks it as a sister of poetry.

Discourse VI

The subject of this discourse will be Imitation, as far as a painter is concerned in it. By imitation, I do not mean imitation in its largest sense, but simply the following of other masters, and the advantage to be drawn from the study of their works.

Those who have undertaken to write on our art, and have represented it as a kind of inspiration, as a gift bestowed upon peculiar favourites at their birth, seem to insure a much more favourable disposition from their readers, and have a much more

captivating and liberal air, than he who attempts to examine, coldly, whether there are any means by which this art may be acquired; how the mind may be strengthened and expanded, and what guides will show the way to eminence.

It is very natural for those who are unacquainted with the cause of any thing extraordinary, to be astonished at the effect, and to consider it as a kind of magick. They, who have never observed the gradation by which art is acquired; who see only what is the full result of long labour and application of an infinite number and infinite variety of acts, are apt to conclude, from their entire inability to do the same at once, that it is not only inaccessible to themselves, but can be done by those only who have some gift of the nature of inspiration bestowed upon them.

The travellers into the East tell us, that when the ignorant inhabitants of those countries are asked concerning the ruins of stately edifices yet remaining amongst them, the melancholy monuments of their former grandeur and long-lost science, they always answer, that they were built by magicians. The untaught mind finds a vast gulph between its own powers, and those works of complicated art, which it is utterly unable to fathom; and it supposes that such a void can be passed only by supernatural powers.

And, as for artists themselves, it is by no means their interest to undeceive such judges, however conscious they may be of the very natural means by which their extraordinary powers were acquired; though our art, being intrinsically imitative, rejects this idea of inspiration, more perhaps than any other.

It is to avoid this plain confession of truth, as it should seem, that this imitation of masters, indeed almost all imitation, which implies a more regular and progressive method of attaining the ends of painting, has ever been particularly inveighed against with great keenness, both by ancient and modern writers.

To derive all from native power, to owe nothing to another, is the praise which men, who do not much think on what they are saying, bestow sometimes upon others, and sometimes on themselves; and their imaginary dignity is naturally heightened by a supercilious censure of the low, the barren, the groveling, the servile imitator. It would be no wonder if a student, frightened by these terrifick and disgraceful epithets, with which the poor imitators are so often loaded, should let fall his pencil in mere despair; (conscious as he must be, how much he has been indebted to the labours of others, how little, how very little of his art was born with him;) and consider it as hopeless, to set about acquiring by the imitation of any human master, what he is taught to suppose is matter of inspiration from heaven.

Some allowance must be made for what is said in the gaiety of rhetorick. We cannot suppose that any one can really mean to exclude all imitation of others. A position so wild would scarce deserve a serious answer; for it is apparent, if we were forbid to make use of the advantages which our predecessors afford us, the art would be always to begin, and consequently remain always in its infant state; and it is a common observation, that no art was ever invented and carried to perfection at the same time.

But to bring us entirely to reason and sobriety, let it be observed, that a painter must not only be of necessity an imitator of the works of nature, which alone is sufficient to dispel this phantom of inspiration, but he must be as necessarily an imitator of the works of other painters: this appears more humiliating, but is

equally true; and no man can be an artist, whatever he may suppose, upon any other terms.

However, those who appear more moderate and reasonable, allow, that our study is to begin by imitation; but maintain that we should no longer use the thoughts of our predecessors, when we are become able to think for ourselves. They hold that imitation is as hurtful to the more advanced student, as it was advantageous to the beginner.

For my own part, I confess, I am not only very much disposed to maintain the absolute necessity of imitation in the first stages of the art; but am of opinion, that the study of other masters, which I here call imitation, may be extended throughout our whole lives, without any danger of the inconveniences with which it is charged, of enfeebling the mind, or preventing us from giving that original air which every work undoubtedly ought always to have.

I am on the contrary persuaded that by imitation only, variety, and even originality of invention, is produced. I will go further; even genius, at least what generally is so called, is the child of imitation. But as this appears to be contrary to the general opinion, I must explain my position before I enforce it.

Genius is supposed to be a power of producing excellencies, which are out of the reach of the rules of art; a power which no precepts can teach, and which no industry can acquire.

This opinion of the impossibility of acquiring those beauties, which stamp the work with the character of genius, supposes that it is something more fixed, than in reality it is; and that we always do, and ever did agree in opinion, with respect to what should be considered as the characteristick of genius. But the truth is, that the degree of excellence which proclaims Genius is different, in different times and different places; and what shows it to be so is, that mankind have often changed their opinion upon this matter.

When the Arts were in their infancy, the power of merely drawing the likeness of any object, was considered as one of its greatest efforts. The common people, ignorant of the principles of art, talk the same language even to this day. But when it was found that every man could be taught to do this, and a great deal more, merely by the observance of certain precepts; the name of Genius then shifted its application, and was given only to him who added the peculiar character of the object he represented; to him who had invention, expression, grace, or dignity; in short, those qualities, or excellencies, the power of producing which, could not then be taught by any known and promulgated rules.

We are very sure that the beauty of form, the expression of the passions, the art of composition, even the power of giving a general air of grandeur to a work, is at present very much under the dominion of rules. These excellencies were, heretofore, considered merely as the effects of genius; and justly, if genius is not taken for inspiration, but as the effect of close observation and experience. [...]

What we now call Genius, begins, not where rules, abstractedly taken, end; but where known vulgar and trite rules have no longer any place. It must of necessity be, that even works of Genius, like every other effect, as they must have their cause, must likewise have their rules; it cannot be by chance, that excellencies are produced with any constancy or any certainty, for this is not the nature of chance; but the rules by

which men of extraordinary parts, and such as are called men of Genius, work, are either such as they discover by their own peculiar observations, or of such a nice texture as not easily to admit being expressed in words; especially as artists are not very frequently skilful in that mode of communicating ideas. Unsubstantial, however, as these rules may seem, and difficult as it may be to convey them in writing, they are still seen and felt in the mind of the artist; and he works from them with as much certainty, as if they were embodied, as I may say, upon paper. It is true, these refined principles cannot be always made palpable, like the more gross rules of art; yet it does not follow, but that the mind may be put in such a train, that it shall perceive, by a kind of scientifick sense, that propriety, which words, particularly words of unpractised writers, such as we are, can but very feebly suggest.

Invention is one of the great marks of genius; but if we consult experience, we shall find, that it is by being conversant with the inventions of others, that we learn to invent; as by reading the thoughts of others we learn to think.

Whoever has so far formed his taste, as to be able to relish and feel the beauties of the great masters, has gone a great way in his study; for, merely from a consciousness of this relish of the right, the mind swells with an inward pride, and is almost as powerfully affected, as if it had itself produced what it admires. Our hearts, frequently warmed in this manner by the contact of those whom we wish to resemble, will undoubtedly catch something of their way of thinking; and we shall receive in our own bosoms some radiation at least of their fire and splendour. That disposition, which is so strong in children, still continues with us, of catching involuntarily the general air and manner of those with whom we are most conversant; with this difference only, that a young mind is naturally pliable and imitative; but in a more advanced state it grows rigid, and must be warmed and softened, before it will receive a deep impression.

From these considerations, which a little of your own reflection will carry a great way further, it appears, of what great consequence it is, that our minds should be habituated to the contemplation of excellence; and that, far from being contented to make such habits the discipline of our youth only, we should, to the last moment of our lives, continue a settled intercourse with all the true examples of grandeur. Their inventions are not only the food of our infancy, but the substance which supplies the fullest maturity of our vigour.

The mind is but a barren soil; a soil which is soon exhausted, and will produce no crop, or only one, unless it be continually fertilized and enriched with foreign matter.

When we have had continually before us the great works of Art to impregnate our minds with kindred ideas, we are then, and not till then, fit to produce something of the same species. We behold all about us with the eyes of those penetrating observers whose works we contemplate; and our minds, accustomed to think the thoughts of the noblest and brightest intellects, are prepared for the discovery and selection of all that is great and noble in nature. The greatest natural genius cannot subsist on its own stock: he who resolves never to ransack any mind but his own, will be soon reduced, from mere barrenness, to the poorest of all imitations; he will be obliged to imitate himself, and to repeat what he has before often repeated. When we know the subject designed by such men, it will never be difficult to guess what kind of work is to be produced.

It is vain for painters or poets to endeavour to invent without materials on which the mind may work, and from which invention must originate. Nothing can come of nothing. [...]

Discourse XI

The highest ambition of every Artist is to be thought a man of Genius. As long as this flattering quality is joined to his name, he can bear with patience the imputation of carelessness, incorrectness, or defects of whatever kind.

So far indeed is the presence of Genius from implying an absence of faults, that they are considered by many as its inseparable companions. Some go such lengths as to take indication from them, and not only excuse faults on account of Genius, but presume Genius from the existence of certain faults.

It is certainly true, that a work may justly claim the character of Genius, though full of errors; and it is equally true, that it may be faultless, and yet not exhibit the least spark of Genius. This naturally suggests an inquiry, a desire at least of inquiring, what qualities of a work and of a workman may justly entitle a Painter to that character.

I have in a former discourse [Discourse III] endeavoured to impress you with a fixed opinion, that a comprehensive and critical knowledge of the works of nature is the only source of beauty and grandeur. But when we speak to Painters, we must always consider this rule, and all rules, with a reference to the mechanical practice of their own particular Art. It is not properly in the learning, the taste, and the dignity of the ideas, that Genius appears as belonging to a Painter. There is a Genius particular and appropriated to his own trade, (as I may call it,) distinguished from all others. For that power, which enables the Artist to conceive his subject with dignity, may be said to belong to general education; and is as much the Genius of a Poet, or the professor of any other liberal Art, or even a good critick in any of those arts, as of a Painter. Whatever sublime ideas may fill his mind, he is a Painter only as he can put in practice what he knows, and communicate those ideas by visible representation.

If my expression can convey my idea, I wish to distinguish excellence of this kind by calling it the Genius of mechanical performance. This Genius consists, I conceive, in the power of expressing that which employs your pencil, whatever it may be, as a whole; so that the general effect and power of the whole may take possession of the mind, and for a while suspend the consideration of the subordinate and particular beauties or defects.

The advantage of this method of considering objects, is what I wish now more particularly to enforce. At the same time I do not forget, that a Painter must have the power of contracting as well as dilating his sight; because, he that does not at all express particulars, expresses nothing; yet it is certain, that a nice discrimination of minute circumstances, and a punctilious delineation of them, whatever excellence it may have, (and I do not mean to detract from it,) never did confer on the Artist the character of Genius. [...]

The detail of particulars, which does not assist the expression of the main characteristick, is worse than useless, it is mischievous, as it dissipates the attention,

and draws it from the principal point. It may be remarked, that the impression which is left on our mind even of things which are familiar to us, is seldom more than their general effect; beyond which we do not look in recognising such objects. To express this in Painting, is to express what is congenial and natural to the mind of man, and what gives him by reflection his own mode of conceiving. The other pre-supposes nicety and research, which are only the business of the curious and attentive, and therefore does not speak to the general sense of the whole species; in which common, and, as I may so call it, mother tongue, every thing grand and comprehensive must be uttered.

I do not mean to prescribe what degree of attention ought to be paid to the minute parts; this it is hard to settle. We are sure that it is expressing the general effect of the whole, which alone can give to objects their true and touching character; and wherever this is observed, whatever else may be neglected, we acknowledge the hand of a Master. We may even go further, and observe, that when the general effect only is presented to us by a skilful hand, it appears to express the object represented in a more lively manner than the minutest resemblance would do.

These observations may lead to very deep questions, which I do not mean here to discuss; among others, it may lead to an inquiry, Why we are not always pleased with the most absolute possible resemblance of an imitation to its original object. Cases may exist in which such a resemblance may be even disagreeable. I shall only observe that the effect of figures in Wax-work, though certainly a more exact representation than can be given by Painting or Sculpture, is a sufficient proof that the pleasure we receive from imitation is not increased merely in proportion as it approaches to minute and detailed reality; we are pleased, on the contrary, by seeing ends accomplished by seemingly inadequate means.

To express protuberance by actual relief, to express the softness of flesh by the softness of wax, seems rude and inartificial, and creates no grateful surprise. But to express distances on a plain surface, softness by hard bodies, and particular colouring by materials which are not singly of that colour, produces that magic which is the prize and triumph of art.

Carry this principle a step further. Suppose the effect of imitation to be fully compassed by means still more inadequate; let the power of a few well-chosen strokes, which supersede labour by judgment and direction, produce a complete impression of all that the mind demands in an object; we are charmed with such an unexpected happiness of execution, and begin to be tired with the superfluous diligence, which in vain solicits an appetite already satiated. [. . .]

Those who are not conversant in works of art, are often surprised at the high value set by connoisseurs on drawings which appear careless, and in every respect unfinished; but they are truly valuable; and their value arises from this, that they give the idea of an whole; and this whole is often expressed by a dexterous facility which indicates the true power of a Painter, even though roughly exerted: whether it consists in the general composition, or the general form of each figure, or the turn of the attitude which bestows grace and elegance. [. . .]

Excellence in every part, and in every province of our art, from the highest style of history down to the resemblances of still-life, will depend on this power of extending the attention at once to the whole, without which the greatest diligence is vain.

I wish you to bear in mind, that when I speak of an whole, I do not mean simply an whole as belonging to composition, but an whole with respect to the general style of colouring; an whole with regard to the light and shade; an whole of every thing which may separately become the main object of a Painter.

* * *

8 Joshua Reynolds (1723–1792) *Discourse IX*

For the first dozen years of its existence the Royal Academy shared accommodation in Somerset House. Though this included teaching rooms and a library, the annual exhibition had to be held elsewhere, at Lambe's auction rooms in Pall Mall. Following plans presented in 1776 by the architect Sir William Chambers (1726–96), work began on new premises including an exhibition space. These were ready by 1780. Reynolds painted a ceiling decoration representing an allegorical female figure of 'Theory'. He also delivered a special Discourse, the ninth in his series of fifteen, on the occasion of the opening on 16 October 1780. Paradoxically, this was the least 'theoretical' of his addresses. Discourse IX represents a different set of concerns from those which usually preoccupied Reynolds in his lectures. He used the inauguration of the new establishment not to discuss relatively abstract matters of theory and criticism, but rather to raise the question of an English School of art, and the role art could be expected to play in raising the level of public culture in the nation as a whole. These were issues of considerable moment in late eighteenth century England (cf. IVA2, 13). We reprint Reynolds' brief text in full, from *Discourses*, edited with an introduction and notes by Pat Rogers, Harmondsworth: Penguin Classics, 1992, pp. 228–31.

The honour which the Arts acquire by being permitted to take possession of this noble habitation, is one of the most considerable of the many instances we have received of His Majesty's protection; and the strongest proof of his desire to make the Academy respectable.

Nothing has been left undone, that might contribute to excite our pursuit, or to reward our attainments. We have already the happiness of seeing the Arts in a state to which they have never before arrived in this nation. This Building, in which we are now assembled, will remain to many future ages an illustrious specimen of the Architect's abilities. It is our duty to endeavour that those who gaze with wonder at the structure, may not be disappointed when they visit the apartments. It will be no small addition to the glory which this nation has already acquired from having given birth to eminent men in every part of science, if it should be enabled to produce, in consequence of this institution, a School of English Artists. The estimation in which we stand in respect to our neighbours, will be in proportion to the degree in which we excel or are inferior to them in the acquisition of intellectual excellence, of which Trade and its consequential riches must be acknowledged to give the means; but a people whose whole attention is absorbed in those means, and who forget the end, can aspire but little above the rank of a barbarous nation. Every establishment that tends to the cultivation of the pleasures of the mind, as distinct

from those of sense, may be considered as an inferior school of morality, where the mind is polished and prepared for higher attainments.

Let us for a moment take a short survey of the progress of the mind towards what is, or ought to be, its true object of attention. Man, in his lowest state, has no pleasures but those of sense, and no wants but those of appetite; afterwards, when society is divided into different ranks, and some are appointed to labour for the support of others, those whom their superiority sets free from labour, begin to look for intellectual entertainments. Thus, whilst the shepherds were attending their flocks, their masters made the first astronomical observations; so musick is said to have had its origin from a man at leisure listening to the strokes of a hammer.

As the senses, in the lowest state of nature, are necessary to direct us to our support, when that support is once secure there is danger in following them further; to him who has no rule of action but the gratification of the senses, plenty is always dangerous: it is therefore necessary to the happiness of individuals, and still more necessary to the security of society, that the mind should be elevated to the idea of general beauty, and the contemplation of general truth; by this pursuit the mind is always carried forward in search of something more excellent than it finds, and obtains its proper superiority over the common senses of life, by learning to feel itself capable of higher aims and nobler enjoyments. In this gradual exaltation of human nature, every art contributes its contingent towards the general supply of mental pleasure. Whatever abstracts the thoughts from sensual gratifications, whatever teaches us to look for happiness within ourselves, must advance in some measure the dignity of our nature.

Perhaps there is no higher proof of the excellency of man than this, – that to a mind properly cultivated whatever is bounded is little. The mind is continually labouring to advance, step by step, through successive gradations of excellence, towards perfection, which is dimly seen, at a great though not hopeless distance, and which we must always follow because we never can attain; but the pursuit rewards itself: one truth teaches another, and our store is always increasing, though nature can never be exhausted. Our art, like all arts which address the imagination, is applied to somewhat a lower faculty of the mind, which approaches nearer to sensuality; but through sense and fancy it must make its way to reason; for such is the progress of thought, that we perceive by sense, we combine by fancy, and distinguish by reason: and without carrying our art out of its natural and true character, the more we purify it from every thing that is gross in sense, in that proportion we advance its use and dignity; and in proportion as we lower it to mere sensuality, we pervert its nature, and degrade it from the rank of liberal art; and this is what every artist ought well to remember. Let him remember also, that he deserves just so much encouragement in the state as he makes himself a member of it virtuously useful, and contributes in his sphere to the general purpose and perfection of society.

The Art which we profess has beauty for its object; this it is our business to discover and to express; the beauty of which we are in quest is general and intellectual; it is an idea that subsists only in the mind; the sight never beheld it, nor has the hand expressed it: it is an idea residing in the breast of the artist, which he is always labouring to impart, and which he dies at last without imparting; but which he is yet

so far able to communicate as to raise the thoughts, and extend the views of the spectator; and which, by a succession of art, may be so far diffused, that its effects may extend themselves imperceptibly into publick benefits, and be among the means of bestowing on whole nations refinement of taste: which, if it does not lead directly to purity of manners, obviates at least their greatest depravation, by disentangling the mind from appetite, and conducting the thoughts through successive stages of excellence, till that contemplation of universal rectitude and harmony which began by Taste, may, as it is exalted and refined, conclude in Virtue.

9 Various Reviewers, on exhibitions by Angelica Kauffmann at the Royal Academy

On at least three counts, Angelica Kauffmann (1741–1807) was the exception that proves a rule. She was a female history painter, with a successful career, in England. Swiss by birth, she spent her early twenties in Florence and Rome, where she painted a portrait of Winckelmann, among others, and generally imbibed the ideal of the classically inspired history painter. Her later years, from 1781 to her death, were also passed in Italy, but her middle years, from 1766 to 1781, were spent in highly successful practice in England. She was a founder member of the Royal Academy in 1768, where she exhibited on a regular basis from the inaugural exhibition of 1769 until the 1790s. London at this time was second only to Rome as a centre of neo-classical art, and the establishment of the Academy offered Kaufmann the chance to pursue the history painting she had learned in Italy, alongside the portrait commissions that seemed more congenial to the English. Despite working in what was conventionally regarded as the most elevated and intellectual of the artistic genres, Kauffmann left no theoretical statement about her work. Nonetheless, run-of-the-mill reviews of her Academy exhibitions offer a telling insight into eighteenth-century suppositions about gender and art. The last, written after Kauffmann had moved to Italy (when she continued to send pictures to London), is no less indicative of contemporary cultural chauvinism. Selections (i), (ii), (iv) and (v) have been made from Wendy Wassyng Roworth, 'Kauffmann and the Art of Painting in England' in *Angelica Kauffmann. A Continental Artist in Georgian England*, London: Reaktion, 1992, pp. 83, 84, 86, 93. Selection (iii) is taken from Gill Perry, 'Women in Disguise', in Gill Perry and Michael Rossington eds., *Femininity and Masculinity in 18th century Art and Culture*, Manchester: Manchester University Press, 1994, p. 20. We are indebted to Perry and Roworth for our bibliographical information.

(i) 'This lady has, for years, stood deservedly high in the most difficult, yet most liberal line of her profession – History Painting. She has not, in general, receded from this character in the above pictures [*Ariadne Abandoned by Theseus, Paris and Helen Directing Cupid to Inflame each other's Hearts with Love*], though we would beg leave to observe there is too great a monotony of beauty in all her principal figures.'
'A Friend to the Arts', *Morning Chronicle*, 27 April 1772, p. 2.

(ii) 'This artist, considering her sex, is certainly possessed of very great merit. She is endued with that bold and daring genius which leads her to employ her pencil upon historical paintings which are as much superior to portraits and landscapes as an

epic poem is to a pastoral, or a tragedy to a farce.'
Anon. *The London Chronicle*, 3 May 1774 (discussing *Penelope Invoking Minerva's Aid* and *Calypso Calling to Heaven to Witness her Sincere Affection to Ulysses*).

(iii) 'Some philosophers have asserted that women have no souls. Others have maintained, and with greater probability, that they have souls but that the only difference between their souls and the souls of men depends on the greater delicacy of the bodily organs. Miss Kauffmann's genius seems to favour strongly this latter opinion; for though a woman, she is possessed of that bold and masculine spirit which aims at the grand and sublime in painting, as well as in Poetry, and a History painter is as much superior to a mere Portrait or Landscape painter as an Epic or Tragic poet is to the simple author of a Sonnet or an Epigram.'
Anon. *The London Chronicle*, 4–6 May 1775 (discussing *The Despair of Achilles*).

(iv) 'It is surely somewhat singular, that while so many of our male artists are employed upon portraits, landscapes, and other inferior species of painting, this lady should be almost uniformly carried, by the boldness and sublimity of her genius, to venture upon historical pieces; which is as great a phenomenon in the painting as it would be if our poets dealt in nothing but sonnets and epigrams while our poetesses aspired to the highest and most difficult department of their art, the producing of epic and heroic compositions. But though Miss Kauffmann possesses this masculine and daring spirit, she still retains so much of the softness natural to her sex that she always pitches upon such historical subjects as have in them a strong mixture of the tender and pathetic.'
Anon. *The London Chronicle*, 29 April 1777, p. 413.

(v) 'These pictures possess that character which usually constitutes her works, but they do not appear to be either so beautifully conceived, or so tasteful in their execution, as to drawing, characters or colour, as those which she painted in England. They seem to be done from memory of her former works, and no new beauties have been added to her style by her late tour to Italy. Here perhaps it may be proper to remark that there is now established in this country a school of art much superior to what is to be found on any part of the Continent, there being at this moment in England a greater number of living artists, excelling in different branches, envious of each other, and striving with a spirit of enthusiasm, which has left our neighbours far behind. Amongst other foreign artists this country is certainly much indebted to *Signora Angelica*. She has enriched the cabinets of the curious with many elegant performances, composed and executed in her best time; and though she has withdrawn herself from us, her best works and her taste remain with us.'
Anon. *The Public Advertiser*, 22 May 1786, p. 2 (discussing *Vergil Writing his own Epitaph at Brundisium, Pliny the Younger with his Mother at Misaenum* and *Cornelia, the Mother of the Gracchi, Pointing to her Children as her Treasures*).

10 James Barry (1741–1806) from *An Inquiry into the Real and Imaginary Obstructions to the Acquisition of the Arts in England*

Barry was an outsider who nonetheless rose to become Professor of Painting at the Royal Academy, only to be expelled at the age of 58 in 1799. He was cantankerous, suffered from a persecution complex, and publicly criticized his colleagues in the Academy. But the fact that he was also Irish, Catholic and Republican cannot have endeared him to the English establishment during the French revolutionary wars. Something else which made life difficult for him in the late eighteenth-century English art world was an unswerving commitment to history painting. It was for this that he had enjoyed precocious success in Dublin at the age of 22. Barry's early work drew him to the attention of Edmund Burke, who found employment for him in London, working as an assistant on *The Antiquities of Athens* with Stuart and Revett (see IIIA7), and subsequently funded an extended visit to Europe between 1765 and 1771. Barry was elected to the Academy two years after his return, but the English market could support little more than portraiture, and his most ambitious essay in history painting was an expensive loss. This was the gigantic mural commission he voluntarily undertook between 1777 and 1784 for the Great Room of the Society of Arts, Manufactures and Commerce in the Adelphi in London. Artists had been invited to take up this challenge in 1774, but nothing came of it until Barry put himself forward in 1777. He worked alone on the project for the next seven years. Six large canvases, two of them over 12 metres wide, depicted the Enlightenment theme of the *Progress of Human Culture*. Ancient Greece and eighteenth-century England were prominent, along with a Heaven populated by over a hundred geniuses who had contributed significantly to the evolution from barbarity to civilization. In line with these commitments, Barry's first book asserted the importance of a school of history painting in the consolidation of the national culture. The present extracts review specious criticisms of the English by Continental theorists, and offer a brief historical explanation for the retardation of history painting in the country. They end with a general exhortation to improve things, and a more specific invitation to some patron to underwrite the Adelphi commission. The selections are drawn from *An Inquiry into the Real and Imaginary Obstructions to the Acquisition of the Arts in England*, London: T. Beckett, 1775, pp. 3–6, 9–10, 121–5, 144–8.

There are many people who seem to have persuaded themselves, and are desirous of persuading others, that the arts of painting, sculpture, and architecture, are naturally and inevitably confined to particular ages; and further, that they are, like plants, only the growth of certain soils and climates. If all that they have advanced upon this head be admitted as true and decisive, it must be acknowledged that the people of the British dominions are labouring in the arts to little purpose, and they must in the end find themselves disappointed in their aims, and that they had been endeavouring to do what the order of nature and the situation of their climate had pre-determined they should not do. Opinions of this kind make no disagreeable figure in works of imagination; we often find a playful and beautiful use made of them by poets, ancient as well as modern. See Virgil, Milton, Addison, &c. but as they might be converted to a sort of weapon in the hands of national prejudice, they will be occasionally and pertinently adopted; and they have been virulently applied in plain, cool prose, with no inconsiderable amplification.

Abbé du Bos, president Montesquieu, and Abbé Wincleman, have followed one another in assigning limits to the genius of the English; they pretend to point out a certain character of heaviness and want of fancy, which they deduce from physical causes. They have either wilfully taken advantage of, or they have been ignorantly deceived by, certain impediments which happened accidentally to prevent or retard us in keeping pace with other nations, in an acquisition of some of the fine arts: because we have not hitherto done it, they chuse to find out that the thing is impossible to us; and that we are eternally incapacitated by the clouds that hang over our heads, the nervous system of our bodies, our soil, our food. They say that we can have no imagination, taste, or sensibility: that we are cold and unfeeling to the powers of music: that we can succeed in nothing that requires genius; that if ever we are worth admiring, it is for the hand and execution of the workman, and not for the design of the artist: that our climate is so distempered, that we disrelish every thing, nay even life itself; that we are naturally and constitutionally addicted to suicide; that it is a consequence of the filtration of our nervous juices; that it is in consequence of a north-east wind, that our poets cannot arrive at that particular kind of delicacy that springs from taste; that they cannot arrive at any true imagery; that they strike the ear with a great noise, and present nothing to the mind; and that our natural capacity for the fine arts, amounts to very little, to nothing at all. [. . .]

It may seem that such opinions, and the distorted methods of reasoning that produce them, being so little calculated to prove and to convince, the refutation of them will be proportionably unentertaining and useless. But no: I flatter myself that the discussion of this matter will lead to considerations of a weightier nature; and by developing the accidental causes that have hitherto retarded our progress in the arts, we might, besides making our apology with foreigners, hope to be also an occasion of some future advantage to our own people. In the course of this work, I hope to make it evident, that the obstructions that have hitherto lain in the way of our acquiring art, were not naturally connected with our climate, but arose from mere accident, the fluctuation of opinions, and of those things that depend upon opinions; and consequently, that although these difficulties might lie before us at one time, they might possibly be removed at another.

* * *

It appears that until the time of Edward VI. and queen Elizabeth, that whatever little painting was practised in England was of a historical nature, taken from the legends of the saints, or from the Old and New Testament. These were, as many as could be come at, destroyed, and the practice of all such things interdicted for the future. The taste of the public, and the labours of the artist, was, from this period, turned into a new chanel, and has spent itself upon portraits, landscapes, and other inanimate matters, in which the human mind, and consequently the genius of the artists, if there was any, had little or nothing to employ itself upon: so that historical painting was proscribed just at the time we were going to receive the qualifications that would have enabled us to succeed in it; at the time when Spenser, Fairfax, and numbers of other ingenious men, were cultivating and gathering in knowledge of all kinds, ancient and foreign; and when lord Bacon, like another Columbus, was leading us to the discovery of new worlds in the regions of knowledge.

It is a misfortune, never entirely to be retrieved, that painting was not suffered to grow up amongst us, at the same time with poetry and the other arts and sciences, whilst the genius of the nation was yet forming its character in strength, beauty, and refinement; it would then have received a strength and a polish; and it would, in its turn, have given to our poetry a greater perfection in one of its master features, in which (Milton and Spenser excepted) it is rather somewhat defective. But the nation is now formed, and perhaps more than formed; and there is cause to fear that it may be too late to expect the last degree of perfection in the arts, from what we are now likely to produce, in an age when perhaps frothy affectations and modish, corrupt, silly opinions, of foreign as well as of domestic growth, have but too generally taken place of that masculine vigour and purity of taste, so necessary both for the artist and for his employer.

* * *

When we reflect upon the great variety of useful institutions, which do so much honour to the public virtue of this country, it is really a matter of surprize that the arts only should have lain so long unheeded, and that no means have been yet devised, of extricating historical painting out of the confused mass of meaner arts with which it is indiscriminately jumbled. The members of the Royal Academy, conscious of the necessity of making some effort of this kind, did, with the consent of the dean and chapter, select six painters to execute each a large picture of Scripture-history, which he had the liberty of presenting to the cathedral of St. Paul: but obstacles arose which prevented its taking effect. Some time after this, the society for the encouragement of Arts and Manufactures formed another plan of placing historical pictures, of the most eminent native artists, in their new room at the Adelphi; they elected, for this purpose, the former six selected members of the Royal Academy, to whom they added four others. The design of this plan was every way worthy of that society, which had been, in great measure, the nurse of national art. It would have afforded an equitable display of whatever abilities those artists were in possession of, as they were to be ranged side by side, without any intervening pictures of landscape, portraits, fish, dogs, or other dissimilar subjects, which, in our annual exhibitions, are sometimes so introduced as to distract the eye, and in a great measure to take away the opportunity of forming any well digested comparative judgments, during the short time of their exposition. But this excellent plan, (which is so much wanting) from some defect in the manner of it, went off in smoke like the other. There is however great reason to hope that something will yet be done, and that amongst all our different societies of connoisseurs, dilettanti, colleges, corporations, and parishes, a noble public spirit will somewhere step forward, especially as it may be brought about with very little expence.

There is to be sure but few artists whose personal interests happen to be embarked in the same bottom with the dignity of the art, and consequently with the interest and wishes of the public: but there is a few, and as to the many who can have no part in this exertion of superior art, they ought in conscience to content themselves with those greater profits which in this commercial country must ever follow from the practice of the lower branches, especially as they cannot expect to keep up for ever, that false weight and importance which they have assumed in consequence of those greater gettings; for the public ignorance of these arts, behind which they have been

hitherto entrenched, is much battered and shaken, and now lets in the light at many places. It is therefore to be hoped that they will no longer find it practicable to play the part of the dog in the manger, as they have hitherto done; for indeed a great many of the blocks and impediments that were thrown in the way of superior art, have been greatly owing to the secret workings and machinations of these interested men: and, if they can do nothing else, they will at least endeavour to turn the attention of dilettanti towards the breeding up of history-painters for the next age, in hopes to prevent the necessary means of exertion being given to the present historical artists: and I will with plainness and freedom again repeat it, that any public spirited man or men, who may wish to put forth a hand towards the calling out of historical-painting amongst us, ought for every reason, to pay no manner of regard to the counsels and insinuations of those artists who can have no part in this exertion.

11 Denis Diderot (1713–1784) from 'Disconnected Thoughts on Painting, Sculpture and Poetry'

Diderot's last 'Salon' was written in 1781, after an interval of six years. An inclination to synthesize his various thoughts about art had been clearly declared both in the 'Notes on Painting' appended to the 'Salon of 1765' (IIIC13) and in the lengthy theoretical digressions in the 'Salon of 1767' (IIIC14). The extensive 'Disconnected Thoughts' were appended to the 'Salon of 1781' 'to serve as a continuation of the Salons'. They thus provide a form of summation of Diderot's writing on art. About a fifth of the individual 'thoughts' are derived from the *Betrachtungen über die Mahlerey* (Reflections on Painting) of Christian von Hagedorn, originally published in Leipzig in 1762, and itself much indebted to Gérard de Lairesse's *Groot schilderboek* (see IIA1). A French translation of von Hagedorn's work appeared in 1775 (as *Réflexions sur la peinture*). Though Diderot was already acquainted with the author, it may have been this publication that first prompted him to conceive a summary publication of his own. In the event the 'Disconnected Notes' remained just that, the fragmentary observations for a work that Diderot was never able to complete. They are nevertheless instinct with the fruits of his observation, of his reading, and of his own extensive experience as a writer on the art of his time. They were originally issued under the title *Pensées détachées sur la Peinture, la Sculpture et la Poésie pour servir de suite aux Salons*, and were printed by Naigeon (see IIIC12) from an incomplete manuscript. We have referred to the version published in *Diderot oeuvres IV: Esthétique-Théâtre*, ed. Laurent Versini, Paris: Robert Laffont, 1996, which is based on a more complete manuscript preserved in St Petersburg. Our excerpts are taken from this edition pp. 1017–24, 1034–5, 1040–1, 1051, translated for the present volume by Kate Tunstall.

On composition and on the choice of subjects

There can be no beauty without unity; and there can be no unity without subordination. This appears contradictory; but it is not.

The unity of the whole is born of the subordination of the parts; and of this subordination is born harmony which presupposes variety.

Unity is to uniformity what a beautiful melody is to continuous sound.

Symmetry is the equality of all the corresponding parts in a whole. Symmetry, which is essential in architecture, is proscribed in every genre of painting. Symmetry in the human body is always destroyed by variety in actions and positions; it does not exist even in a figure seen from the front with its arms outstretched. The life and the action of a figure are two very different things. Life is represented in a figure at rest. Artists have given the word *movement* a particular meaning. They say of a figure at rest that it possesses *movement*; that is, it is about to move.

The harmony of the most beautiful painting is but a pale imitation of the harmony of nature. Often the hardest task for the artist is not to elude the difficulty.

It is this effect that characterizes for the most part the technique or style of every master.

The more someone commissioning a painting gives details of the subject-matter, the worse the painting is sure to be. They have no idea how far they limit art in the most talented master. [. . .]

Go ahead and be terrifying; but let the terror you inspire in me be tempered by some great moral idea.

If all the pictures of martyrs so subtly painted by our great masters were passed down to a generation in the distant future, what would they take us for? Either wild animals or savages.

Why are the works of the ancient artists so great? Because they had all been to the schools of the ancient philosophers.

Every sculpture or painting should express a great maxim, convey a lesson to the spectator; without this, it is mute.

Two qualities which are essential in the artist are morality and perspective.

The most beautiful thought cannot appeal to the mind if the ear is offended by it.[1] That is why line and colour are necessary. [. . .]

In every work of art that imitates nature, there is technique and morality. Every man of taste can judge morality; only an artist can judge technique.

Wherever you look in nature, whether the place is wild or cultivated, rich or poor, deserted or populated, you will always find two magical qualities: truth and harmony.

Transport Salvator Rosa to the icy regions of the North Pole, and his genius will make them beautiful.

Proceed soberly when inventing new allegorical personæ for fear of being enigmatic.[2]

Give preference, whenever possible, to real characters over symbolic beings.

Allegory is rarely sublime; it is almost always cold and obscure.

Nature is more interesting to the artist than it is to me; for me, it is merely a spectacle; for him, it is also a model. [. . .]

Like dramatic verse, art has its three unities: time, either sunrise or sunset; place, in a temple, a thatched cottage, on the edge of a forest or in a public square; action, either Christ carrying the cross on his way to be crucified, or Christ rising from the dead, or Christ appearing to the pilgrims on the road to Emmaus.

The unity of time is even stricter for the painter than for the poet; the former has only a single, almost indivisible moment.

The moments which follow on one from the other in the poet's descriptions would furnish a long gallery of paintings. How many subjects there are from the moment when Jephthah's daughter goes against her father's will to the moment when that same cruel father thrusts the dagger into her breast! [. . .]

Lairesse claims that the artist is allowed to have the spectator enter the scene of his painting. I don't think so at all; and there are so few exceptions that I would gladly make a general rule of the opposite. That would seem to me to be equal in bad taste as an actor playing to the stalls. The canvas is self-contained, and there is no one beyond it. When Susannah exposes her naked body to my eyes, protecting herself against the elders' gaze with all the veils she had been wrapped in, Susannah is chaste and so is the painter; neither of them knew I was there. [. . .]

In general, silent scenes appeal to us more than noisy ones. Christ in the garden at Gethsemane, his soul laden with a great sadness, forsaken by his disciples asleep around him, has a very different effect on me to the same figure being whipped, wearing a crown of thorns and abandoned to the jeers, insults and shrieks of the Jewish mob.

If you take the magic of art away from Flemish and Dutch painting, they would be atrocious daubs. But Poussin could lose all his harmony, and the *Testament of Eudamidas* [Statens Museum for Kunst, Copenhagen] would still be sublime.

What do we see in the picture of Eudamidas? The dying man on the bed; to one side, there is the doctor feeling his pulse and also the notary taking down his last requests; at the foot of the bed, there is Eudamidas' wife sitting with her back to her husband; and his daughter is on the ground between her mother's knees, her head leaning on her lap. There is no overcrowding here. Multiple figures or crowds are

akin to disorder. What accessories are there here? Nothing more than the sword and shield of the main character, hanging on the back wall. A large number of accessories is akin to mediocrity. It is called staffage in painting and padding in poetry.

Silence, majesty and dignity in a scene are things rarely felt by the common spectator. Almost all the *Holy Families* by Raphael, or the most beautiful ones at least, are situated in pastoral, solitary and wild places; and when he chose such places, he knew exactly what he was doing.

All delightful scenes depicting love, friendship, charity, generosity, outpourings of emotion are set in remote places at the ends of the earth.

Paint as people spoke in Sparta.

In dramatic verse as in painting, there should be as few characters as possible. [...]

On colour, on understanding light and on chiaroscuro

[...] How many surprising things, both beautiful and flawed, are brought to life or made to disappear by the painter's brush!

Only a musician, writer or consummate artist can say 'I know what that will be.'

Truth in nature is the basis for the verisimilitude in art.

Colour is what attracts the spectator and action is what keeps him enthralled; these are the two qualities that can make us forgive the artist any minor inaccuracies in his drawing, I say the artist, not the sculptor, for drawing is essential in sculpture; one limb, even only slightly distorted, strips a statue of almost all its value.

Daphne's hands, the fingers of which Lemoyne has painted growing out of laurel leaves, are full of charm; the leaves are arranged with an elegance that I cannot describe. I doubt he has ever done anything with Lycaon changed into a wolf.[3] The antlers sprouting on Actaeon's head would have posed him fewer difficulties. It is easier to feel the difference between these two subjects than to explain it.

Lairesse gives the name *second colour* to the half-tone placed on the light side of the outline, a technique that makes the convex parts of the body fall away into the background, making them rounded.[4]

There are the tones of light and the half-tones of light; the tones of shadow and the half-tones of shadow: this system is to be found under the general heading of *the diminution of light*, running from the greatest light to the strongest shadow.

There are various technical ways of weakening and strengthening, speeding up or slowing down the path of this gradation: using accidental shadows, reflections, passing shadows or intermediary bodies; but whichever of these means you use, the gradation persists nonetheless, whether you strengthen or weaken it, speed it up or slow it down. In art as in nature, there can be no gaps; *nihil per saltum*; otherwise you run the risk of creating black holes of shadow or bright circles of light and of things looking like cut-outs.

Aren't these black holes of shadow and bright circles of light to be found in nature? I think they are. But who told you to imitate nature strictly?

What is a background? Either it is an infinite space in which all the colours of the objects merge in the distance, ultimately producing the sensation of a greyish-white; or it is a vertical plane which absorbs either direct or reflected light, and in both cases, it is subject to the rules governing diminution.

The terms *tone* and *half-tone* which we applied to light and shadow can also be applied to a single colour.

The tone which forms the bridge between light and shadow, the final term in the shading off of light, is wider than the tone of light found next to the edge of an object on its light side. Lairesse calls it a *half-tone*.[5]

All these theoretical precepts can only be properly understood by the artist who, walking round a gallery, cane in hand, should point out where they have been put into practice in different works of art.

It is a very clever piece of artistry to borrow from a reflection that half-tone which seems to lead the eye beyond the visible part of the outline. Then it really is magic, for the spectator feels the effect without being able to work out its cause.

Nothing could be more certain than the following: the constant habit of looking at near and distant objects and of using our sense of sight to measure how far away they are, has created in our eyes an enharmonic scale of tones, semi-tones and quarter-tones, which is set out very differently but which is just as strict as that of music in our ears. Things can look wrong to the eye, just as they can sound wrong to the ear.

The accord between reflections in a large composition or the action and reaction of lit bodies on each other seems to be impossibly difficult to understand owing to both the large number and the scale of their causes. On this point, I think the greatest painters owe a great deal to our ignorance. [. . .]

On the naïve and on flattery

To say what I mean, I need to make up a word or at least to broaden the accepted meaning of an existing word: the word is *naïve*. Beyond the simplicity that it used to

express, we must extend it to include the innocence, truth and purity of a happy childhood, free of constraints; and as such, the naïve will be essential to every work of art. The naïve will be discernible in every inch of a Raphael canvas; the naïve will be very close to the sublime; the naïve will be found in all that is very beautiful; in an attitude, a movement, a drapery, an expression. It's the real thing, absolutely the pure thing itself, without the slightest alteration. Art is no longer present.

Everything true is not naïve, but everything naïve is true, and not just true, but of a truth that is enticing, original and rare. Almost all Poussin's figures are naïve, that is, they are what they must be, perfectly and purely. Almost all Raphael's old men, his women, children and angels are naïve, that is, they have a certain natural purity, a grace they were born with, that was not given to them by education.

Manner in art is like hypocrisy in morals. Boucher is the greatest hypocrite I know; there is not one of his figures to whom you could not say: 'You want to be true, but you're not.' Naïvety applies to all kinds of people: you can be a naïve hero, a naïve villain, naïvely religious, naïvely beautiful, a naïve orator or a naïve philosopher. Without naïvety, there can be no real beauty. One may naïvely be a tree, a flower, a plant or an animal. I could almost say that water is naïvely water, and if it isn't, it is more like polished steel or crystal. Naïvety means a great resemblance between the imitation and the thing, along with a great fluency of style: it means water taken from the stream and splashed straight onto the canvas.

I've been too harsh on Boucher; I take it back. I think I've seen some children of his that are very naïvely childlike.

The naïve, according to my definition, is in violent emotions as it is in calm emotions, in action as it is in rest. It depends on something almost intangible; often the artist is very close to it; but he is not there.

1 Boileau, *Art poétique*, v. 111–12.
2 'A painting should not be an enigma,' Abbé Dubos, *Réflexions critiques sur la poésie et la peinture*, 1715, vol. 1, section 24.
3 Hagedorn, *Réflexions sur la peinture*, I, pp. 176–7. Diderot has added the reference to Lemoyne.
4 *Ibid.*, II, p. 171. Diderot has copied Hagedorn word for word.
5 Hagedorn, *Réflexions sur la peinture*, II, p. 171.

12 Jean-Etienne Liotard (1702–1789) from *Treatise on the Principles and Rules of Painting*

The Swiss pastellist, painter and printmaker Jean-Etienne Liotard published his short *Treatise on the Principles and Rules of Painting* at the age of 80 after a long and varied career which had taken him to many of the principal courts of Europe. He was born in Geneva, where he was apprenticed to the miniature painter and enamellist, Daniel Gardelle.

He completed his studies in Paris, but subsequently travelled to Naples and then to Rome. He spent several formative years in Constantinople (now Istanbul) from 1738 to 1742. On his return, he continued to wear Turkish dress and a long beard, which won him the sobriquet of *le peintre turc*. The succeeding years found him in Vienna, Amsterdam, The Hague, Paris and London. He produced a large number of highly successful portraits, many of them in pastel. His work is characteristically uncluttered and simple and is marked by a strong emphasis on truthfulness of depiction. The *Treatise* dates from the end of his life, when his popularity had begun to wane. Its principal interest resides in his violent attack on *touches*, the application of pastel or paint in such a way that the marks or 'touches' remain visible on the surface of the canvas. It has been suggested that Liotard's criticisms were motivated in part by rivalry with his contemporary, Maurice de Latour, whose pastel portraits reveal an extreme vivacity of handling. The following extracts are taken from the edition edited by Pierre Cailler, *Traité des principes et des règles de la peinture*, Geneva: Vésenaz, 1945, pp. 81–8, 92–4, 127–9. They have been translated for the present volume by Jonathan Murphy. For further discussion of 'touch' in painting see IVA15.

Rule VII – Avoidance of touch

We arrive now at one of the principal objectives of this book, and I am not ashamed to say that it is the part which will require the most courage on my part, for there are so many received ideas and ingrained half-truths where the subject is concerned, so many examples propagated by a number of great masters, and so many reasons for maintaining the status quo that it will perhaps be impossible for me to destroy it alone. But I will at least have done what I think best, and shown the truth and the incontestable nature of the principle I advance; I will have done my duty, and that must suffice. Let us proceed then to the quick of the matter.

Nature, which we must always take as our model, never demonstrates the shocking inequalities that are the ruin of so many masterpieces by the great painters. The sublime picture of nature forms a harmonious whole, where all parts, even the most disparate, are imperceptibly linked; we see no touches in the work of nature, and what stronger case could there be for their absence in painting? We should never paint what we do not see. But before going into detail where touch is concerned I must explain exactly what I understand by this term.

A *touch* is a brushstroke of clear or dark colour applied on one or other of these two tones; it will lighten a pale colour, or deepen a dark one. The more perceptible a touch is, the harsher it becomes, and the more it will shock the sharp eye of anyone filled with the true beauties of nature, who is desirous of finding their reproduction in the copies presented by the artist. Such ugliness shocks even those who have no appreciation of the arts. Touch is the most ugly manner, and the one most distant from nature. Touch owes not its credit (as truly great artists have never used it), but the acceptability that it has been accorded, to an idea common to almost all European painters: that it gives strength, vigour, relief and life to painting. My intention is to try and destroy such false and dangerous prejudices, which have only been universally adopted and accredited on account of the fact that a touch is always a short cut, and a time-saving device for the painter. It is then the result of self-interest, impatience and an inability to finish paintings. All artists who have allowed

themselves to abuse touch without really considering the consequences of their actions agree that a painting with many touches is disagreeable when examined close up; but they claim that at the appropriate distance the eye will no longer notice the touches, which will blend together and lend the painting a finished effect of strength, vigour, relief and life. A prejudice that develops naturally out of the first one; once one has lost the way, every step we make takes us further from our true destination. Like stray sheep, such painters should be brought back to the fold, that they might see the simple, luminous principles that prove the uselessness, ugliness and danger of their methods.

If a painting with many touches is disagreeable when examined close up, it is even more so when examined from afar; nothing can and nothing does change regardless of the distance. The appearance may alter, but the nature of the painting remains the same, for even when one believes one can no longer see the touches they are still in place.

I would admit that from a certain distance the painting is apt to lose that shocking asperity that the abuse of touch will lend it, but touches will always be faintly distinguishable and will never disappear altogether. But I sense that this line of argument will establish the truth of my principles too slowly, and their truth will be more manifest through the following comparison.

If one places a truly finished painting side by side with a painting in which touch is the distinguishing feature, and one observes both paintings from a distance, we might think that the touches would no longer be visible, but in practice the finished quality of the first picture will be easily distinguished from the clumsiness of the other. If one takes a painting by Correggio or Raphael, and places it beside a Rubens, a Rembrandt or a Ribera [L'Espagnolet] then even at a distance from which touch can no longer be distinguished, one can see the Rubens, Rembrandt and Ribera are clumsily executed. Such paintings will always be ugly, and they are no less ugly for being at a distance; the finished quality can never come simply from distance alone.

But, I hear my detractors object, if you admit that both pictures, one finished and one touched, produce approximately the same effect from a distance, why should artists not take the infinitely shorter route to arrive at almost exactly the same point, for a fraction of the effort required by the longer method? The objection may seem fair, but I would answer as follows:

The painting may indeed be less ugly when seen from afar, but being less ugly through being less visible is hardly a victory. Consequently a touched painting gains nothing from distance, and certainly not a finished quality; more important still, in nature there are a thousand beauties which can never be conveyed through touch, and even if one were to allow that distance (since you seem to wish to judge from afar) established some apparent equivalence between us (a point that, needless to say, I do not in fact concede), how could it possibly be the case that your painting could ever convey the fine and light touches of nature, that uniform quality of human skin, the translucency of bodies, the colour of flowers or the velvet quality that characterizes fruit, in short, the charming details which when captured well truly imitate nature, and make painting her happy rival?

This you believe possible through touch? Come! Its inadequacy should be frankly acknowledged. Touches are heavy and ugly, and are the fruit of impatience, laziness,

self-interest and ignorance. Touch, it is claimed, lends strength and vigour, but this is simply wrong. These qualities are the result of the difficult art of painting the appreciable difference between light and shade, and of ensuring that inside the painting there are no pale tints as dark as the shadow, and no shadow as light as the faintest clear tone; the dark and the light must be clearly distinguished.

* * *

When oil painting first came into favour and was almost universally adopted, the great ease with which colours may subtly be mixed with each other, and its capacity to imitate tiny variations in colour and almost imperceptible nuances, led to its being favoured above all other forms of painting; this great advantage of subtleness, unique to painting in oils, is entirely lost through the abuse of touch.

The only occasions when it should be allowed, when it is actually a useful technique for the artist, is when a painter wishes to depict actions of very short duration in nature. Then he should use touches in order to paint more quickly, and make the best use of the space of time that the model affords; but the resulting sketch should never be passed off to real connoisseurs as a finished product. Seen from a distance, great paintings have no need of marked or exaggerated touches. Such paintings demand solely an equivalence between the masses of dark and light, and above all, as I have already noted, that the light tones be clearly distinguished from the dark. A touch on carnations, having no relation to the real colour of the object it represents, is like a burn mark, a cut or a scar. A face, or any figure, painted with an excess of touches, resembles the ugliest or most defective parts of nature. In a great painting, by contrast, all the different tints blend together as they do in nature, and such paintings have a softness and a quality of vigour and truth that immediately renders them more agreeable to our sight. There are of course great painters whose touch is highly expressive and conveys nature well, but as such works lack the most precious quality of all, the finish of the masters, they are apt to satisfy only painters themselves. In all arts perfection must be the sole goal of the artist, insofar as it is possible for imperfect humanity to attain it, for perfection alone is the unique source of true glory.

Good painting should please all in equal measure; those who aim for anything else are mistaken, for painting by the use of touch is a kind of falsification, adopted and followed only by the impatient idle, who are eager for facile gains; such painters are incapable of finish, and their work never progresses beyond the sketch. But painters who achieve a high degree of finish in their work, and attain the same degree of expression without having recourse to touch, deserve high praise; for there are few things more difficult in painting than the combination of a high degree of finish with full expression.

* * *

Rule XVIII – Seek to achieve effect

Effect is the part of painting which is most striking, and the first to catch the attention of the spectator, so much so that it is a waste of time to try and attain a finished quality in a painting if one has not sought the correct effect. If in a painting one half is light and the other is dark, and if there is the same proportional distance between the

light and the dark in the painting as there is in nature, then the painting will achieve the desired effect.... To attain a beautiful and grand effect, chiaroscuro must be used, by the correct grouping of the light and dark colours. The example that Titian used to demonstrate the chiaroscuro effect for his pupils was a bunch of grapes, where the light colours on one side of each grape are linked together and form a group, and the same effect is also visible with the dark colours, and thus they learnt to balance the two. All patient painters, who desire to achieve a true finish in their paintings, should study effect most carefully, if their aim is to please. Impatient painters, overly enamoured of touch, who rarely achieve the finished state, should also take note and use more effect. I have on occasion seen paintings which were badly drawn and badly coloured, which were little more than sketches, yet which caught the eye of all spectators and were greatly appreciated from afar, simply on account of their mastery of effect.

* * *

13 Valentine Green (1739–1813) from *A Review of the Polite Arts in France*

Green was an engraver and draughtsman. After apprenticeship and an early career in Worcester, he moved to London in 1765. He became established as a member of the Royal Academy and mezzotint engraver to King George III. Among his most successful productions were engravings of historical pictures by Benjamin West and of contemporary portraits by Joshua Reynolds. He also achieved success in Europe, becoming engraver to the Elector Palatine. A major project to engrave the paintings in the Düsseldorf collection proved unprofitable, and Green's later career was clouded by financial difficulties. In 1782 he wrote a lengthy pamphlet, addressed to Reynolds in his capacity as President of the Academy, contrasting the fortunes of art in France and England. In parallel with James Barry, to whom he explicitly referred in the argument, Green set out to refute charges that the English were temperamentally unsuited to the practice of the arts (see IVA10); rather, the relatively lowly status of art in England was a matter of historical circumstance which could be, and indeed should be, corrected as a matter of urgency. Green detailed the organization and ambition of the French Royal Academy not as something beyond the scope of English aspiration, but as a model for emulation. The nub of his argument was that the persistent weakness of English patronage had to be remedied if England's advance as a leading civilized nation was not to be compromised. Our selection is taken from *A Review of the Polite Arts in France at the Time of their Establishment under Louis XIV compared with their Present State in England*, London: T. Cadell, 1782, pp. 11–13, 25–7, 31–5, 65–6.

The great figure the French Academy has made in the commonwealth of the Arts, has been chiefly owing to its government being placed in the hands of Noblemen of the first rank, and in possession of the first employments of the State; and the good consequences of that system, are evident in it to the present moment. The Patron, and the Artist, were distinct characters: it was the province of the first to guide and guard; it was the wish of the last to deserve and receive Protection. Both were under the eye of the Sovereign, whose care had been not to mock the Arts, by putting them under the direction of Ignorance, or Indifference; either of which must be fatal to

their existence; but added to the Royal, they received Ministerial Protection, uncontaminated by political distinction, or the bias of party; and honoured by the Affection of the Prince, they enjoyed also the Personal Regard of his most confidential Servants. Above the littleness of contrivance to suppress Genius; too much the friend of his Country to palm pretenders on its esteem, under the shelter of his influence; the decided Patron of the Arts, its Professors had perfect repose in his counsels, and perfect reliance on his justice. Their desires made known to their Prince through such a medium, excited no jealousy, alarmed no suspicion; open and accessible to all its Members, no cabal dared to misrepresent the wishes, or impede the interest of an individual. Competent to decide, no matter was suffered to appear before the Sovereign, but had, in aid to its own propriety, the countenance of the *Protecteur* added to its recommendation and support; and the ungracious trouble of investigating their concerns, farther than an Assent to their public undertakings, or an Approbation of their finished labours, never approached the Royal Breast. The Minister stood the Palladium of rising Genius, an impracticable boundary, separating a Royal Academy from a Company of Painters, by which all combination was broke, all professional bickerings silenced, and a local tyranny, inimical to every generous principle, destroyed. To have suffered such Abilities as were enrolled in the first records of the Parisian Academy, to have remained inactive, would have been a reproach too severe for its *Protecteur* to have sustained; to have employed them on trivial objects, would have been equally disgraceful. It was a duty which had devolved on his shoulders from the nature of the Institution, and must be fulfilled without personal regard. But in the hands appointed to guide their movements, nothing of doubt remained of the most flattering issue. And so well were these points attended to, with such ardour and spirit were they entered upon, that in a very short period, so numerous were the proofs of the Ability and Industry of the French Artists; so different an aspect had the Metropolis put on; so much was the public taste improved, and private life embellished, that to the present hour it has the appearance of the Work of Ages, and has descended from them a miracle of exertion, and a national benefit. [. . .]

The Parisian Academy is now assembling the works of all their great masters; and by a thorough renovation of them, in whatsoever parts they may have been impaired by time, or accident, they will set them before an applauding people with all their original splendour, and by their ability, and care, in that useful operation, be preserved, to the benefit and admiration of future ages. To give honourable reception to those Pictures and Statues, the upper apartments of the New Louvre are under preparation; and through the whole extent of that magnificent palace, a length of upwards of 1300 feet, possessing half of the whole space between Pont Royal, and Pont Neuf, new lights are introducing from its roof and sides, in addition to those it originally possessed, some of which, will also, necessarily, undergo a reform, in order to produce a regular, impartial, and equal distribution of light, through the whole range of the gallery. In addition to those works of the French School, will be collected, the numerous and valuable Pictures, which for want of room, are huddled together in the most unfavourable manner, in and about the Palace of Versailles, to the amount of some thousands, by the best Italian, and other Masters, and of the first order. The whole suite of the Luxembourg Gallery, by Rubens, together with the

most select of those that are arranged on the floors of those apartments, among which, those of the French Ports, by Vernet, will be restored to the rank they so eminently deserve. That choice and inestimable work of Le Sueur, the life of St. Bruno, lately in the Cloister of the Chartreux, are removed, and under preparation for their re-appearance in this grand assemblage of Arts. The Battles of Alexander, by Le Brun; jointly with all such fugitive works as may be found dispersed in the different depots of the Royal Palaces, whose merits, in the opinion of the Academy, may entitle them to so honourable a distinction, will assist in forming this magnificent collection. And, in further addition, the best and most perfect Statues, Busts, and other Sculptures, of their own, and other Masters, will be selected, and with the Pictures arranged, and classed under their several and distinct Schools, affording, at one view, to the eye of the Connoisseur, the various principles and systems, on which the different Professors have founded their practice, fully illustrated, by some of their most capital productions. This resurrection of their ancient spirit, will form an epoch in the Academy of Paris, and infuse into its abated powers, an energy that may prove beneficial to future undertakings; and make its influence operate through all its classes, in a degree flattering to the importance of the Profession, [...].

We can, with temper, hear the Church of St. Peter at Rome extolled as the first Structure in the world, while St. Paul's ranks as second, and is so little short of the perfections of the first. We can, with patience, hear of the Rialto at Venice, and the vain-boasting of the grandeur of the lumber of Pont Neuf, threatning to dam up the meandering of the Seine, while we have a bridge of iron binding the rapid Severn within its arch, and those of Westminster, and Black-Friars, stretching themselves over the majestic tide of the Thames. L'Hotel Royal des Invalides, at Paris, may exult in its beautiful dome, and glory in the munificence of its foundation, without hurting our feelings, while the Royal Hospital of Greenwich, can vie with their Palaces in magnificence, and its ample revenues can so comfortably supply the wants of our naval defenders, worn out in the service of their country. The parallel may be carried on with advantage to Britain, in the learned Sciences, Poetry, Philosophy, the œconomical Arts, and various other instances; but in the Polite Arts, we are struck dumb, and scarcely a paltry city on the continent but insults our weakness in that vulnerable part, and looks upon the arguments of Montesquieu as irrefragable, the irony of the Abbé du Bois as founded, and the deductions of the Abbé Winckelman, to prove that nature never meant the heavy atmosphere of Britain to be productive of Original Genius, as a doctrine incontrovertibly established, notwithstanding Mr. Professor Barry has so incontestibly refuted them in his able reply to the disquisitions of the philosopher, and the heterogeneous and visionary arguments of the speculating Fathers. But why this stigma is still suffered to remain upon us, and why it has not hitherto received radical refutation, is the point towards which I am now verging; namely, a review of the pursuits the English School has been forced upon, since its establishment amongst us. [...]

The annual Exhibitions of the result of the practice of the Artists, may be fairly understood as the barometer of their supposed importance; and the subjects which have so uniformly filled them, may be estimated as the highest idea the Public entertain of their powers. It is then, evident, from what has appeared in those Exhibitions, that they have never had the advantages in this country, which those of

others have enjoyed to the fullest extent, in the most ample practice, and under the most liberal Patronage. To what public exertion have they ever been called, or in what instance have they been invited to a trial that could put them on a scale of comparison with those of other nations? What Churches, Palaces, or other Public Edifices, have been opened to them? What King's, or Hero's Actions have they recorded, to which the Public can be referred to contemplate? What monuments of the Worth, or the Wisdom, the Patriotism, or the Virtues of Individuals, or Communities, have they been called forth to give to our imitation, or our notice? Is it the want of Subjects in the history of our country deserving to be perpetuated? Is it that we have had neither Patriot Kings, Princes, or Heroes to celebrate? Is it that our Churches, or other Public Edifices, are not suited for the reception of ornamental embellishment? Is it not, rather, the want of national policy, in not opening a free passage to a current which has been too long obstructed by the blindest of prejudices, and the most hateful of Gothic barbarisms? a current forcing its way over every impediment, impatient to fertilize the barrenness of a soil which has so long lain waste, a reproach to itself, and a bye-word among the nations.

Those Walks the Arts have been permitted to use, have been so ably filled, that the solicitude of expectation has been fully answered. But, as they have been wholly directed to local purposes, and the gratification of private taste, they assist not towards forming an object, to which the general eye can be again turned, after they have once passed the ordeal of Exhibition. And as far as Protection has been extended to those limited operations, it has been liberal; but its bounds are of too contracted dimension for the great body of Arts to revolve in. [...]

I proposed to myself in the Plan of this Address, not to draw inferences from the reputed Abilities of either School, but simply to state what has been the result of the two foundations from the Patronage they originally received.

In the French School, we find its Patronage was warm, fervent, and dignified; partaking of every stimulating principle that could invigorate, enliven, and cherish its objects, and place them on a permanent basis, beyond the reach of caprice to assail, or fashion to impair; it saw them of too much importance to be trifled with, and of too much value to be abandoned. – And the result has been a National Honour.

In the English School, Public Patronage is seen to have been attracted more by the novelty of the undertaking, than the importance of the pursuit. Engaged in an experiment, which if it failed, nothing was lost, nothing being expected. Employed on a forlorne hope, of which all the world had said, we were not to expect the fruition, and we ourselves were persuaded to believe it a presumption to attempt. – It has consequently terminated in a National Disgrace.

14 Francisco de Goya (1746–1828) 'Address to the Royal Academy of San Fernando regarding the method of teaching the visual arts'

After study in Saragossa, Goya entered competitions for the Real Academia in Madrid in 1764 and again in 1766, failing on both occasions to gain entry. He went to Rome instead, remaining there until 1771, when he returned to Saragossa. In 1774 he was called to Madrid to produce painted cartoons for the Royal Tapestry Factory, a function which he

continued to fulfil for the next eighteen years. His election to the Real Academia came in 1780. In 1785 he was appointed deputy director of painting and the following year he was made Painter to the King. During the 1780s he was much in demand as a portrait painter. His submission to the Academy was made in 1792 at a time when his intellectual interests were becoming increasingly hard to reconcile with the expectations of commissioned work, and when he felt the weight of his official success impinging on his independence as an artist. Ten years earlier he had protested at the demand that he submit his tapestry cartoons to 'correction', asserting the priority of individual imagination in the making of an artist. In the following text he defends a similar position in response to a request from the Real Academia that he state his views on the teaching of art. The contrast with Mengs' earlier discourse (IVA4) testifies to a considerable difference in temperament and approach between the two artists. It also serves to illustrate the developments in thought about art that had taken place during the intervening quarter-century, particularly in those ideas concerning individual genius and imagination that linked the Enlightenment to the Romantic movement. Our text of Goya's address is taken from the translation in J. A. Tomlinson, *Goya in the Twilight of the Enlightenment*, New Haven and London: Yale University Press, 1992, Appendix 1, pp. 193–4.

Most Excellent Sir

Fulfilling on my behalf Your Excellency's order that each of us explain what he thinks opportune about the Study of the Arts, I say: That the Academies should not be exclusive, or serve more than as an aid to those who freely wish to study in them, banishing all servile subjection of the primary school, mechanical precepts, monthly prizes, financial aid, and other trivialities that degrade, and effeminate an Art as liberal and noble as Painting; nor should a time be predetermined that they study Geometry, or Perspective to overcome difficulties in drawing, for this itself will necessarily demand them in time of those who discover an aptitude, and talent, and the more advanced in it, the more easily they attain knowledge in the other Arts, as seen from the examples of those who have risen highest in this aspect, who I do not cite since they are so well known. I will give a proof to demonstrate with facts, that there are no rules in Painting, and that the oppression, or servile obligation of making all study or follow the same path, is a great impediment for the Young who profess this very difficult art, that approaches the Divine more than any other, since it makes known all that God has created; he who has most closely approached will be able to give few rules concerning the profound operations of the understanding that are needed for it, nor explain why he has been happier perhaps with a work where less care has been taken, than with one of greater finish; What a profound and impenetrable arcanum is encompassed in the imitation of divine nature, without which there is nothing good, not only in Painting (that has no other task than its exact imitation) but in the other sciences.

Annibale Carracci, revived Painting that since the time of Raphael had fallen into decline, with the liberality of his genius, he gave birth to more disciples, and better than as many practitioners as there has been, leaving each to proceed following the inclination of his spirit, without determining for any to follow his style, or method, putting only those corrections intended to attain the imitation of the truth, and thus is seen the different styles, of Guido, Guercino, Andrea Sacchi, Lanfranco, Albano, etc.

I cannot omit another clearer proof. Of the Painters known to us of greatest ability, and who have taken the greatest pains to teach the method of their tired styles (according to what they have told us). How many students have resulted? Where is the progress? the rules? the method? From what they have written, has any more been attained than to arouse the interest of those that are not, nor cannot be Artists, with the object of more greatly enhancing their own [that is, the Artist's] works, and giving them broad authority to decide even in the presence of those versed in this very sacred Science that demands so much study (even of those who were born for it) to understand and discern what is best.

It is impossible to express the pain that it causes me to see the flow of the perhaps licentious, or eloquent pen (that so attracts the uninitiated) and fall into the weakness of not knowing in depth the material of which he writes; What a scandal to hear nature deprecated in comparison to Greek statues by one who knows neither the one nor the other, without acknowledging that the smallest part of Nature confounds and amazes those who know most! What statue, or cast of it might there be, that is not copied from Divine Nature? As excellent as the artist may be who copied it, can he not but proclaim that placed at its side, one is the work of God, and the other of our miserable hands? He who wishes to distance himself, to correct it [nature] without seeking the best of it, can he help but fall into a reprehensible [and] monotonous manner, of paintings, of plaster models, as has happened to all who have done this exactly? It seems that I stray from my original subject, but there is nothing more necessary, if there were to be a remedy for the actual decadence of the Arts but to know that they must not be dragged down by the power of knowledge of other sciences, but rather be governed by their own merit, as has always been the case when talents have flourished: then the despotic enthusiasts cease, and prudent lovers are born, who appreciate, venerate and encourage those who excel, providing them with work that can further advance their talent, helping them with greater force to produce all that their inclination promises: this is the true protection of the Arts, and it has always been shown that the works have made the men great. In conclusion, sir, I do not see any other means of advancing the Arts, nor do I believe there is one, than to reward and protect he who excels in them; to hold in esteem the true Artist, to allow free reign to the genius of students who wish to learn them, without oppression, nor imposition of methods that twist the inclination they show to this or that style, of Painting.

I have given my opinion in response to Your Excellency's charge, but if my hand doesn't govern the pen as I might wish, to explain that which I understand, I hope that your Excellency will excuse it, for my entire life has been spent in attaining the fruit of that of which I am now speaking.

Madrid 14 October 1792.

15 Claude-Henri Watelet (1718–1786) and Pierre-Charles Lévesque (1736–1812) from the *Dictionnaire des arts de peinture, sculpture et gravure*

Watelet was a wealthy civil servant, collector and amateur of the arts, with an extensive acquaintance among the artists and writers of his time. He had a particularly fine collection

of prints and was himself a competent engraver. In 1760 he published *L'Art de Peindre. Poëme, avec des Réflexions sur les différents parties de la peinture* (Paris and 1761 Amsterdam), which won him election to the Académie Française. (The 'Reflections' contains an extensive section on 'Grace' – the prototype for the passage given below, in which Watelet refers to his own poem and commentary. Amongst the papers left by William Hogarth there is a partial English translation of the former text in manuscript form.) Watelet contributed several articles on the fine arts to the *Encyclopédie*, using these as the basis for a collection issued under his own name in 1784. Intended as a supplement to the *Encyclopédie*, his *Dictionnaire des Beaux-Arts* was originally published in two posthumous volumes in 1788 and 1791. It was subsequently completed by Lévesque and published in five volumes as *Dictionnaire des arts de peinture, sculpture et gravure*, Paris: Fuchs, 1792. It was to be cited as a repository of authority on technical and conceptual matters well into the nineteenth century. Our excerpts are taken from the facsimile reprint of the 1792 edition, Geneva: Minkoff, 1972, vol. I, pp. 1–11, 247–9, 478–80; vol. II, pp. 450–6; vol. IV, pp. 783–8, translated for the present volume by Jonathan Murphy.

Academy [*Académie*] (noun, feminine). What is known in artistic language as an *academy* is the drawn, painted or modelled imitation of a living model. The particular aim of this imitation is the study of the form and shape of the human body, either as a means of perfecting the imitation, or as preparation for a larger work.

One *draws*, *paints*, or *models* an academy. Students whose chosen career is painting or sculpture, and artists who already practise these arts, draw or model these imitations of the human figure in studios and in the academic schools.

Natural light or artificial light from lamps is used, depending upon the circumstances.

The drawing master poses a naked man in an attitude that he will then keep for a time proportional to the discomfort occasioned by the pose.

In the public schools, the draughtsmen sit upon steeply raked benches as in an amphitheatre, and endeavour to capture the lines and the overall effect that the model presents. The masters preside over this exercise, and assist students with words of advice, correcting the studies that they are presented with.

The origin of the word is doubtless from the place where such studies are often carried out; as such it is an example of a word taking on a particular meaning in artistic language, totally at odds with its normal sense in the rest of the language.

A good academy is one that is carried out with *easy execution*, without negligence; *fine correction*, neither too dry nor too mean; *with feeling*, finely captured; *with taste*, in an unmannered fashion; with *thoroughness*, with great care and attention; and neither too *laboured* nor too *cold*.

As the aim of the painter is ultimately to provide an imitation of the figure through the use of brush and colours, if he becomes accustomed to drawing in too painstaking a manner, he will experience great difficulty when he comes to hold a brush laden with colour, as that will come to seem less easy, less comfortable and less precise than the use of pencil.

If he is indecisive when drawing, and *lacks care for line and shape*, he will be equally undetermined, and lack correction all the more when faced with colour and *the handling of the brush*.

If his touch is heavy, affected or mannered, these faults will be all the more evident in the manner in which he paints. Unless he forces himself to acquire the precision and care in his drawing necessary to render his work agreeable, his tints will ever be muddy and unclear, and his painting will never have the bright freshness required for the imitation of nature.

If, on the other hand, the care and precision in his drawings goes so far as coldness, it may well be feared that he will develop an overly facile style, which flatters the eyes but leaves the spirit unsatisfied, and never moves the soul.

To sum up, the draughtsmen, through his academies, must demonstrate the system that he will follow once he moves on to painting.

He must have foremost in his mind the relation between the means he employs at present and the means that he will employ at a later date.

For this reason, when drawing, he must strive to indicate whenever possible the effect that colour has on his eyes, as well as the touch that he will soon use with the aid of a brush.

There are several different ways of drawing an academy, but the ones to be preferred are those which have the greatest affinity with the final aim of the artist.

The use of blue or grey coloured paper is consequently more widespread amongst those who are determined to paint; and with their use of lead pencils, *stump* is more common, to prepare shadows, form blocks and half-tones, to spread and soften the pencil strokes. Such practices have a tangible rapport with the means of employing colour, through the production of graded tones, and through the manner in which tones fade into each other.

Stump drawing, which makes strokes wider, softer and abrupt, is similar in that respect to working with a brush; and the whiteness spread by the stump adds nuance to the spread of light inside the drawing, and accustoms the practitioner to the use of luminous colour on the objects in the composition or the parts of a figure, whose place is determined by the laws of chiaroscuro. This manner of drawing is also swifter than others, and as such is particularly suitable to studies done from life, as living models can only remain immobile for a limited period of time.

Academies drawn on white paper in sanguine or pencil, with hatching or shading, demand more preparation. These manners are slower in execution as the half-tones must all be worked out, whereas blue or grey coloured paper offers them ready formed. Moreover, the overly obvious colour contrast between the red or black of the crayons and the white of the background demands long and painstaking preparation in order for it to be toned down.

The colouring of the background, which artists are obliged to do with great care, often requires a considerable amount of time, and the care required to achieve that end, in the desire to offer to view a clear and agreeable picture, can easily lead the artist into too cold a manner.

A number of masters of the first rank, from whose number one might single out Bouchardon, have executed *patient* and *clear* academies and studies skilful and artful enough to merit our admiration; but such artists are either not really destined to be painters, or worse, are wasting valuable time in this manner that they have adopted and which evidently pleases them; they would be better employed in other more important engagements. Servile imitation is particularly dangerous when one lacks

the talent of those that one imitates, and serves only to produce cold copyists, or artists whose work is overly mannered.

To return to the relationship of ideas that should be established between the manner of drawing and the projected intention to paint, I would add to what I said above that the more the artist becomes accustomed to imagining some emotion in the mind of his model fitting to the pose he has adopted, the better he will get into the habit of never representing a figure without thinking about the idea that animates it. There is no position or pose that does not reflect some state of mind or some nuance of affection. The custom, when choosing a pose for a model for an academy, is to *pose the model* in what is imagined to be a picturesque mode, with no intention other than that of arranging limbs and bodies in an agreeable or piquant aspect. The model is then drawn in similar fashion, and the result is a work which is overly mechanical and is accordingly a soulless and lifeless imitation, where even the defects of the model are reproduced, as well as his almost inevitable fatigue, and his understandably bored or indifferent countenance, whose reproduction serves no purpose whatsoever.

When the student follows such a path, there is every chance that he will wind up a journeyman.

But to become a true artist, he must not be satisfied with the reproduction of shapes and traits: he must add the truly picturesque qualities of passion and emotion, and learn to make these legible to the viewer.

A free man, who is not overburdened with excessive civilization, will never strike a pose or attitude that is not a reflection of the events that are taking shape in his soul; and it follows from this that the disposition of his limbs and features is an inevitable reflection or sign of the level of his morality or state of mind.

The artist who considers his art in depth never loses sight of this principle, and it is through accustoming himself early to these observations and to this practice that the draughtsman will oblige himself never to forget, when imitating the human form, that this form is animated with life and sentiment.

Seemliness [*Bienséance*] (noun, feminine). *Seemliness*, in painting and in all of the arts, forms part of what are more generally known as the *proprieties*.

Conformity to *good custom* is for all painters a law of propriety, and this law bears a particular relation to the ideas that we have of seemliness. The question that I will address here will be above all that of seemliness: related issues will be addressed under the entry for the proprieties.

The origin of the word in question is to be found in all that is *seemly*. Doubtless the word, in earlier times, did not carry the heavy burden of responsibility that it now bears. The meaning that it has today is largely the expression of a duty or obligation, an obligation composed of various diverse elements of modesty, shame, wisdom and reason.

Unseemliness is not merely a question of that which is unfitting for our age, our estate or our figure, but also involves our behaviour, our speech, our gestures and actions, and all that defines us. Seemliness, for obvious and related reasons, concerns modesty and honesty, and when we apply such an idea to painting, it covers not merely the nature of the work in which the artist is engaged, and the place and person

for whom the work in question is designated, but also the relation between the artist's general mores and his occupation.

Seemliness in general, where the nature of the subject-matter of painting is concerned, requires that painting should not obtrude upon public sensibility. As such it is a relation between art and nature, and between nature and ourselves.

Where artists are concerned, seemliness supposes that their profession, as is fitting, given the consideration that it is accorded when men distinguish themselves in it, is quite reciprocally engaged in a similar contract with public sensibility, which must not be offended in any manner. The public attention that artists attract to themselves when executing their work with the seemliness that will ensure success should oblige them to behave in such a manner as is likely to ensure that this consideration is not lost. It is a time-honoured principle that all men whose occupation or function places them in the public eye of the society in which they live are obliged to honour that position through whichever forms of virtue or seemliness are most appropriate to their estate.

One distinctive prerogative that artists owe to the nature of their occupation is that art customarily uplifts all those who practise it, and heightens their sensibilities, through the deep thought that is required, through the solitude and the retreat from the world that it often entails, and through the idea of perfection that artists are obliged to cherish unceasingly.

It is therefore unlikely that a republic of artists would erect public monuments in celebration of vice or barbarism. In accordance with the sentiments which motivate so many of them and fill them with enthusiasm, we might even go so far as to say that it would rather be great acts of virtue and evidence of the grandeur of the soul which would inspire their etchers' needles, their brushes and chisels. But while artists as a body are by nature republicans, and while they are virtuous through the liberating effects that their art has brought them, it is unfortunately all too often the case that they are also the slaves of circumstance, and of the requirement to earn their keep from their work.

Conventions [*Conventions*]. If the arts employed exactly the same means as nature, they would be nature itself, and the merit of their production would rest on the same basis. The arts imitate nature, they do not reproduce it; we might even claim that painting is only capable of feigning imitation, as it is one of the arts which has illusion and convention at its very heart. Such arts, which do not truly create, in order to achieve the desired effect, are obliged to employ means born out of deep consideration and perfected through much practice and hard labour, but in themselves these means would not suffice; they must be supplemented by a series of conventions, some secret, some openly avowed, which have gradually come to be established between the producers of art and its audience. The first of these conventions for those considering a painting is that they should forget for a few moments, insofar as such a thing is possible, that the painted representation is an imitation. For his part, the artist, when exhibiting his canvas, should remind his public that although he would be very pleased if they were taken in for a moment, they should never lose sight of the fact that the illusion that seduces them is an artistic effect and that it is his own work, and that they would do well to consider the preparation and care that has been

necessary for such illusionism to be possible. Such mutual pacts are indispensable: if spectators could be wholly fooled, artists would lose the one thing that they find most flattering, which is the admiration of their talent; and spectators would lose one of the principal pleasures that the arts produce, for the central aim of art, for many people, is the momentary error that it produces. Artist and spectator here must both willingly submit to this law, and even desire that painting should not deceive them entirely; but that they should deliberately allow themselves to be deceived only momentarily. If the deception is total at the outset, which may indeed arise under certain circumstances, in order for the success to be complete it is indispensable, as I have remarked above, that the error should be acknowledged to be the result of invented means deployed with great intelligence. For it is from that knowledge that the agreeable sensation effected by the arts springs, a feeling which, unbeknown to us, compounded with our admiration, is then shared between the painting, the artist, the art form itself, and even the real object behind the imitation, if it has been selected with sufficient care.

It is also often the case that the spectator joins to this pleasure a separate one, his pleasure in the foreknowledge that he possesses of the nature of the experience that he is about to undergo when looking at the imitation, in the same manner that we feel an agreeable sensation of anticipation before rereading a book that we know will satisfy our heart or our mind. A further satisfaction still is the pleasure felt by people who share the joy experienced by others in a work that they have themselves provided, and who watch again the same sensations that they themselves have already experienced.

All of which leads us to conclude that certain highly developed conventions are inseparable from the art of painting, just as they are essentially inseparable from the other liberal arts. The spectator, for instance, in order to experience exactly what the artist desires, must agree to position himself at the correct distance from the canvas and in the ideal viewpoint to allow that momentary deception to take place; he must agree to concentrate his attention on the canvas alone, which is customarily bounded by a frame, whose major advantage is to circumscribe the object, and to provide a barrier to any distraction that may be caused by nearby objects, or by comparison with real objects in nature, which may act to the detriment of the imitation.

Grace [*Grace*] (noun, feminine). If grace is born out of the harmony between the feelings of the soul and the actions of the body, the painter, in order to represent it, must learn through observation and meditation to recognize this correspondence between feeling and movement; a correspondence which at times is obvious, but on other occasions difficult to seize, either through a lack of frankness in the expression or because the feeling itself is strained or insincere.

The word in question here is one of those whose meaning is almost identical in the arts and in ordinary usage. It is a term of general theory, and it is precisely through such terms that the links between the different arts are forged, and through such common preoccupations that they form a harmonious whole.

The grace of a painted or sculpted figure, of a figure described in verse or prose, or the grace of a musical air all springs from the same principle.

At this point I must beg the reader's leave, for my intention is to reproduce here the chapter on grace to be found at the end of the poem on the art of painting [i.e. Watelet's own poem]; my thoughts and words on the subject have been confirmed by further observation that I have carried out, and have been adopted by a number of other writers on the subject, and here I shall merely provide a new formulation for ideas with which the reader is perhaps already familiar.

Grace, like beauty, seeks perfection. The two qualities come together in our minds. Their common effect is to please. At times we confuse them, at times they can be easily distinguished; they compete in our minds for supremacy and turn about are accorded pride of place.

Beauty can withstand constant and repeated attention; hence a prize may be disputed, as was the case for the three goddesses; grace by contrast flees examination, and the very project of examining it closely will cause it to disappear.

Beauty, as I have said above, is a perfect conformity among the appropriate movements.

Grace is the concordance between such movements and those of the soul.

In childhood and youth, the soul acts in a free and easy manner on all forms of expression.

The child's movements are simple, and his limbs flexible and supple. A pleasing unity and honesty results from this.

Consequently, childhood and youth are the age of grace. Flexibility and suppleness are essential requirements for grace; in maturity they begin to fade, and in old age they are lost altogether.

Simplicity and honesty in the movements of the soul are so essential for graceful movement that it is rarely the product of indecisive or complex passions.

Naivety, ingenuous curiosity, the desire to please, spontaneous joy, regret, and the suffering and tears occasioned by the loss of something much loved can all produce grace, as they are all simple movements.

Uncertainty, reserve, constraint, complex agitations of the soul, and violent passions whose movements are often compulsive do not lend themselves to the production of grace.

The female sex, suppler in its movements, more sensitive in its affections, where the desire to please arises as though of its own accord, as part of nature's great system, renders beauty more interesting, and when it escapes artifice and affectation, conveys grace in the most comely manner that it is given to us to imagine.

Overly cultivated youth causes grace to flee, while unconstrained youth possesses it without having wished to acquire it. The coming of knowledge retards or hinders the sudden movements of the soul or the body. Reflection renders them more complicated. As reason takes hold and begins to direct the spirit, and as experience grows, then the empire of spontaneous movements diminishes, relinquishing the grip it held on expressions, gestures and actions.

Maturity, which ordinarily sees the perfecting of reason and experience, also bears witness to a gradual loss of suppleness and physical control.

In old age, the fire in the soul is quenched; its orders are obeyed but haltingly, as our steps begin to falter.

Then do expression and grace both vanish, for grace takes its infinite value from that perfect conformity so absent from old age.

Yet not all simple movements of the soul are matched with an exact physical manifestation; on occasion, there is no absolute rapport between the perfection of a body and the appropriate internal state.

For that reason childhood, which one often regards as an age at which the body is unformed and imperfect, is rightly the age of grace, but is an age to which we only lend ideas of beauty by convention.

What I say here presupposes an equilibrium between the life principles that result in good health. Such a state, common to all ages, is most favourable to grace, and adds lustre to beauty.

For the rest, this accord between simple movements of the soul and those of the body can undergo an infinite variety of modifications and produce many varied effects.

For that reason there is often so much confusion that surrounds grace, and it is on that account that we speak of a certain *je ne sais quoi*, a commonly repeated but ultimately meaningless expression.

Grace is perceived and felt in varying degrees, in accordance with the extent to which the observer is disposed to remark upon its effect.

How could it not be the case that when we are highly sensitive to grace, there is some concord between our interior sensation and that which has brought about such a state? Let us explore this idea a little more fully.

Imagine a disinterested observer watching a young girl, whose perfect proportions agree exactly with the freedom and suppleness in her demeanour characteristic of her age. The young girl, who, for instance, we might imagine moved by a feeling of curiosity, receives that simple impression from her soul, and it results in a charm in her demeanour which would immediately strike the observer.

Such would be an example of natural grace, independent of any external modification.

Imagine then in the place of the disinterested observer the father of the same girl, who watches his beautiful daughter catch sight of him and walk towards him. Instead of curiosity guiding the girl's steps, we might imagine a less vague emotion which lent a more decided movement to her demeanour and her stride; what a resultant increase in grace! The object would become altogether more interesting and more lively: on the one side there would be a feeling of tender haste, and on the other the paternal perceptiveness, one hundred times more attentive to the grace than the disinterested man!

These nuances may be refined further still.

Imagine that this was neither a disinterested man nor even a father but an amorous young man, waiting and being rewarded with the arrival of the object of his affections that he cherished so, and if this were no young girl but a tender and naive lover who hurried her step the moment she caught sight of her swain; suppose the place where the two lovers met to be the most agreeable corner that nature may offer, and imagine that nature had decorated the trysting place with all the fresh green flowers of the season. Think of the charms of youth, of the perfection of its beauty, of the lusty health and the lively and natural agitation of these two souls moved by the simplest,

most direct and least constrained emotions, and imagine then the infinite variety of nuances in the representation of grace, inspired and involuntary, imprinted on their features, and expressed in their slightest action and their every movement.

Thus, amongst all the impressions of the soul depicted in our movements, when one reflects upon the various passions that we have examined here, love itself, the one most favoured by nature, produces the most agreeable and most universal expression, more easily perceived than any other. In love the relation between body and soul is most harmonious, most intimate, and most complete; and hence here more than anywhere else is grace the result.

For that reason the ancients always joined and never separated Venus, Love, and the Graces; and the mysterious belt described by Homer is perhaps nothing other than this feeling of love so productive of grace, which occupied Venus so, and which the charm of beauty alone would not have provided.

Touch [*touche*] (noun, feminine), or **to Touch**[1] [*toucher*] (verb, transitive). One speaks of a *bold* touch, a *fine* touch, a *spiritual* touch, a *heavy* or *light* touch, etc.

One also says to *touch flesh with feeling, to touch cloth faithfully*, to *touch a landscape with spirit*, to *touch animal paintings* or *still life proudly*.

These two expressions have quite different meanings which I will attempt to explore here.

Touch in drawing and painting is a means of illustrating chance irregularities or particular circumstances regarding the visible appearance of bodies, accidents or circumstances occasioned by their nature, their position, or their movements.

When a touch is *placed*, *pronounced*, or *underlined* by an artist, it is because he is particularly or unusually affected by such circumstances or chance effects.

In a representation that an artist might make of the human figure, if the touch he employs is determined solely by the outlines of the contour, which would mean that certain parts of that contour or line are less lit or are in shadow, then there is no relation to the impression made on the soul or to the passions, which inspire the most spiritual and ultimately the most interesting aspects of the touch.

If by contrast touch is marked by the artist in accordance with the impression that he has of the correct movement of the figure that he is drawing or painting, it may be fine or spiritual, and it might rightly have the aim of conveying grace or strength, according to the artist's impression.

This is not the same as an *expressive touch*, but if the touch is pronounced or insisted upon by the painter, inspired by his imagination, which provides him with a strong impression of the accidents that great passions provoke in the appearance of bodies, or if better still his touch is like that of nature itself, then his touch will be that of the great masters. That is the unmistakable sign that they imprint on their work, the sign by which they are recognized, which immediately distinguishes their original from any copy.

A trait is a line of equal weight throughout its length, with the help of which one may draw the outline of a body, as the basis of a representation in drawing or painting.

When we term such a line an even trait, we acknowledge that there is nothing in such a manner that we may term a touch. In like fashion, if when painting we

depicted a body with one uniform colour throughout, the painting would be a mere illustration offering neither character nor touch; but if, when directing his pencil, the artist takes note of particular accidents caused by the chiaroscuro effects of relief and illumination, and if, once he has observed these accidents or effects, he presses harder in certain areas to break the uniformity of the trait, and if the trait is accordingly more pronounced in some areas than others, wherever the draughtsman wished to express the shadow more fully, then he has begun to use what is known as touch, which will eventually give character to his art.

We may pursue the argument further. If from a figure at rest, showing no particular emotion, the curves, contours and habitual accidents produced by the articulations can all be captured through touch, how much more expressive will the touch of the painter or draughtsman be when more colourful movements heighten such accidents in the contours? If the quick and obedient hand captures that excitement, and follows the impression received from it in the correct manner in order to transmit it through the work, and if the pressure applied by the artist renders the trace of the pencil more significant still, and if that effect is achieved without dryness, in a generous manner, then that artist will show that touch is one of the most important elements that he has at his disposal, one that lies at the heart of all that is spiritual in art.

One notes from such details that touch is in no way arbitrary, and is not a result of what we improperly term taste, as too many young artists today seem to believe, in their thoughtless imitation of the models placed before them, or indeed as a number of so-called connoisseurs would try to convince us, with their superficial familiarity with artistic terminology.

I address myself here instead to those who wish to learn more about the degree of touch necessary in all forms of painting.

What is to be conveyed above all is the idea that touch, as it is designated here, is at once an imitative sign taken from nature, and a communicative sign demonstrating all that the artist has seen and felt, of which he then attempts an illustration.

Touch, if taken beyond a certain point, becomes a sign itself rather than a precise imitation; but it should also be noted that that perfect point beyond which exaggeration begins, and which thus forms the boundary of good taste, is perhaps never obtained in any representation.

First, because as touch is the instantaneous effect of the impression that the painter or draughtsman receives, it is susceptible to the many vagaries of imagination.

Secondly, for the reason that for that exact measure of touch to be gauged and perfectly accorded, one would also need to consider the precise distance of the object of imitation.

Most commonly, touch in drawing is overdone, either through regard to the feeling which inspired it, or through the effects of bad habits acquired over time.

This fault, which often passes unnoticed, frequently produces a superficially pleasing effect, in harmony with a number of well-established artistic conventions regarding certain elements of art; for touch, as a means of expression, is often immediately striking, and when it is artfully exaggerated, it is undoubtedly more forceful than when it is overly timid or generally insipid.

In painting as opposed to drawing, touch is inevitably more measured as its exaggeration is too obviously detrimental to the truth of the colour in the picture, and to its harmony; such exaggeration is permissible only in miniatures, or in paintings which do not have polished completion as their aim.

Yet another meaning of the word *touch* becomes apparent if one considers the verb from which it derives; the verb *to touch*, in painting, has a meaning slightly different to that of the noun.

When we say a painter perfectly *touches* flesh, fabric, landscape, trees, earth, plants, water or accessories we are speaking of the physical manner in which he applies colour in his representation of objects.

So touch, which is the means of applying colour, becomes a manner of referring to the objects themselves, different from line and colour, and taken in its own right.

Painting is not a complete imitation, but a feigned one: it does not actually reproduce relief, but rather pretends to. In this it is quite different to sculpture, where once colour is removed, it imitates in a quite palpable manner the shape of the object that it is intended to represent.

It is thus most commonly in the art of feigning the representation of objects, by whichever means they see fit, that painters are engaged; and in following that truly liberal route, in a free and ingenuous manner, that they arrive at all that is great in their art. The aim of art is not a painstakingly minute reproduction of the world; for in any case, no reproduction could ever hope to equal the majesty of nature.

When one examines closely the flesh painted by Rubens, Rembrandt or any other great master, or indeed any other aspect such as their fabrics, trees or earth, one sees only the magic signs that have been employed, the visible trace of their handling of the paint, their spiritual touch, the wise strokes of their brush, placed side by side, and not mixed; for it is distance which serves to unite and blend their nuances.

1 In French the verb *toucher*, translated here as 'to touch' in order to maintain the similarity with the noun, is almost an exact synonym for the verb 'to paint', but for the fact that in the verb *toucher* the accent is on the feeling conveyed through the depiction, rather than on the representation itself or on the act of depiction [translator's note].

16 James Barry (1741–1806) *A Letter to the Dilettanti Society*

Barry's last publication appeared a year before his expulsion from the Academy. He continued his criticism of the state of patronage in England and the effect this was having on history painting (see IVA10). He also argued that the Academy was in default of its obligations in this regard, a claim that was shortly to be turned against him. In the present extract he appeals to the gentlemen of the Society of Dilettanti to use their influence to bring about the establishment of a national collection of art. Barry holds that the state of English painting will be improved only through familiarity with actual examples of the best work. In a passage that must have been deeply uncongenial to the majority of his English contemporaries, he goes out of his way to praise the efforts of Jacques-Louis David to build up a school of classically grounded history painting in revolutionary France (see IVB2–4, 8 and 10–12). These short extracts are taken from *A Letter to the Dilettanti Society respecting certain Matters essentially necessary for the Improvement of Public Taste, and*

for accomplishing the original Views of the Royal Academy of Great Britain, London: J. Walker, 1798, pp. 5–6, 24–6.

I have long seen, and from my situation as Lecturer on Painting in the Academy, have often pressed it on the attention of my hearers, that without some proper public collection of ancient art, to refer to occasionally, both our pupils and the public would be in the same bewildered situation, so emphatically alluded to in the New Testament, of the people without guides, exposed to every imposture of 'Lo! here is Christ. Lo! there is Christ.' – This is Titian's manner. – No, that was his manner. – Old Giacomo Bassano, did he do his works after this or after the other way? – How far is scumbling necessary in the production of the true Venetian tones? – Upon what basis, and how much and what should be done before, after it, or with it? There is no need to mention that discernment and taste must govern in the application and conduct; but with respect to the mechanic desideratum, these questions go all the length; and to obtain satisfactory oracular answers, we had best recur to the familiar inspection of the original pictures of these ancient masters; and as nothing else can satisfactorily determine researches of this kind, and prevent or detect mistakes or imposition so well as this frequent familiar inspection, I could much wish that what I have so often had occasion in the Academy to urge on this subject, was known to his Majesty; for this end I brought it forward, as it is so much and so easily in his power to gratify the wishes of the public, and complete the views of his own Institution, by graciously conferring on them this remaining favour. His royal countenance, and a very small matter, would be sufficient to begin with. But as I am not likely ever to have the honour of a hearing from his Majesty, and if I had, would unfortunately for the art and for the country have probably but little weight, I must content myself, and think it a sufficient discharge of conscience and duty, to lay the whole matter before you and your friends, who happily can have all the opportunity, weight, and consideration, that is wanting to me. You may then either lay this letter before his Majesty, as a testimony of the best discharge of humble duty within the knowledge of his Professor, or you may put the matter in any other form more agreeable and proper, without any regard to me or to what I have written. You will partly see, by what follows, how long I have laboured under the weight of this business, how far it has been carried, and through what an ordeal I have passed: my patience is now quite exhausted, and almost like the traveller mentioned somewhere in Horace, who, when with all his pains and care, he could not prevent his ass from continually going to the edge of the precipice, was at last so transported with rage and indignation, as to stretch out his hands and push him down. Before any such matter as this happens with me, I shall feel happy and delivered from a world of anxiety in placing this business under the care and direction of the Gentlemen of your Society; you can easily manage it, and will henceforward be answerable to the art and to the public for its safety and success; carry this point, and all will be done that I wish done, as, I thank God, there is nothing to ask for myself. But … gentlemen like those of the Dilettanti Society, possessed of all the advantages of education and foreign travel, can want no information from me respecting the importance, nature, and extent, of that collection of exemplars and materials of information and study, so absolutely and

indispensably necessary for advancing and perfecting the arts of Painting and Sculpture in a National Academy [. . .].

This national collection of all the materials of art, is absolutely necessary for the formation of the pupils and of the public (who ought to grow up with them), whatever style of art may be likely to obtain a settled credit, so as to be considered as constituting the taste, whether we may content ourselves with adopting the manly plan of art pursued by the Carraches, and their school at Bologna, in uniting the perfections of all the other schools, of which there remains a masterly, elegant record, in a beautiful little poem of Agostino, or whether (which I rather hope) we look further into that most essential article, the style of design, and endeavour to form it altogether in conformity with the taste of the Greeks, in which Annibal made such an illustrious beginning on his coming to Rome, as may be seen in many parts of the Farnese Gallery. Whichever of these plans of art the nation might fix in, the materials necessary towards succeeding can only be found in the collection which it has been the main object of this letter to obtain: there, and there only, shall we be enabled to find that which can qualify us to succeed, when used with genius, and superinduced upon our own (never to be lost sight of) studies after nature. [. . .]

[A]ccording to all the late accounts of the state of arts in France, a higher and a much better order of things has been recently substituted in the place of their former corruptions; and the sublime, venerable, majestic, genuine simplicity of the Grecian taste, utterly estranged from all mean affectation, from the *précieuse* or the grimace and blustering, and incorporated with all that might be derived from the illustrious moderns towards forming a complete and perfect totality, is now renovated, or indeed rather created, and for the first time brought into existence in that country: since it is certain that, on the one hand, Annibal Caracci, and Domenichino, had but made a beginning, and did not go far enough in the gusto of Grecian design; and on the other hand, that (every thing fairly considered and acknowledged), from all that remains of the ancient painting, it is highly probable that even the works of their best painters were very defective in some essential parts of the art, where many of the illustrious moderns have left us nothing to wish for. With hands lift up to Heaven, and a heart full of exultation, I then hail the generous exertion of David and his noble fellow-labourers in that glorious undertaking, wishing it a long and a prosperous carriere. How happy am I to think, that they have a public who will meet their work with correspondent feelings, who will give it the same generous, becoming, patriotic reception, which has ever so peculiarly and so exemplarily characterised that gallant nation! As this new style of painting, founded upon the Grecian character of design, is of such recent introduction in France, is so utterly the reverse of every pursuit of art that was in use with them in my time, it would be a great satisfaction (to me at least an exceeding great one) to know by what artist this revolution in the style of design was first introduced; in what picture it was first shewn; when, where, and whether the first suggestion of the idea of this revolution in the taste of art, had no other circumstance connected with it, than the general spirit of reform, and the desire of preparing and adapting art to the purity and feelings of those descendants of Brutus, Dion, and Cato, who would be likely to come forward in the cause of the public and of virtue.

IV B
Revolution

1 Anonymous: Salon Reviews from *Mémoires secrets*

The *Mémoires secrets* contains a chronological collection of carefully dated notices, reviews and items of gossip, covering the theatrical, literary, artistic and political events in France during the years from 1762 to 1789 – which is to say during the final stages of the *ancien régime*, when censorship was liable to prevent the open publication of sceptical and dissenting views (see also IIIC7 and 13). It was published in England in thirty-six volumes between 1777 and 1789, with the full title, *Mémoires secrets pour servir à l'histoire de la république des lettres en France, depuis 1762 jusqu'à nos jours, ou Journal d'un observateur* (Secret Memoirs to Serve the History of the Republic of Letters in France, from 1762 until the Present, or Journal of an Observer), London: John Adamson. Volume 13, published in 1780, contains a succession of six unsigned Salon reviews, covering the years 1767 to 1779. Further 'Salons' are spread throughout the remaining volumes. Their traditional attribution to M. de Bachaumont, the addressee of La Curne de Sainte-Palaye's *Lettre sur le bon goût* (IIIC6), has been shown to be erroneous (other considerations apart, he died in 1771). Bernadette Fort has made the point that the 'Salons' themselves both invoke and represent a multiplicity of voices and views and thus tend to evade identification with any individual author (Fort, 1999). What can be said is that the 'Salons' reveal a considerable familiarity both with the canonical art-theoretical texts of the previous hundred years and with the priorities of academic practice, albeit the ensuing commentaries are far from respectful of those priorities. The earlier reviews tend to be critical of the authority of the Academy and of its luminaries, holding them to account for the stultification of French painting. In 1781, however, the reviewer greets the positive contributions of a new generation, notably of Jacques-Louis David, who exhibited his *Belisarius receiving Alms* (Louvre, Paris) and *Socrates taking the Hemlock* (Metropolitan Museum of Art, New York) in the Salon of that year. We reproduce excerpts from the 'Salons' of 1783 and 1785. The first is remarkable for the somewhat arch attention given to the work of Elisabeth Vigée-Lebrun, the second for the author's condemnation of Boucher's influence and for his interest in David's *Oath of the Horatii* (Louvre, Paris). Our excerpts are taken from the text of the 'Salons' in Bernadette Fort ed., *Les Salons des 'Mémoires Secrets'*, Paris: Ecole Nationale Supérieure des Beaux-Arts, 1999, pp. 249–54, 283–4, 295–6, translated for this volume by Kate Tunstall.

On the paintings, sculptures and engravings exhibited in the Louvre Salon
on 25th August 1783

Since the imitative arts, however perfect they may be, Sir, can never be equal to the
inexhaustible fecundity and infinite variety of their model, nature, the fear for the
historian of the works of the former would seem to be that in returning too often to
the same objects, he might eventually become monotonous and tiresome. Until
now, however, the Salon has always offered us some unexpected event, various
new combinations of events and above all, the odd anecdote to add excitement and
interest to the diary of this periodical collection. Today, for instance, in spite of the
unprecedented abundance of history paintings to be found in this place and in spite
of the excellence of the numerous masters competing in the arena of the grand genre,
would you believe it, – and is it not a blasphemy? – Apollo's sceptre seems to have
become a distaff and a woman has carried off the palm. Let me explain: this does not
mean that there is more genius in a painting of two or three three-quarter-length
figures than there is in a vast composition with ten or twelve life-size figures, nor that
there is more genius in a painting based on an utterly simple idea than in one whose
complicated structure is equivalent to a whole poem; it only means that the works by
the modern Minerva attract the spectator's attention first, call it back constantly,
seize it, take it over and wring from him those cries of pleasure and admiration that
artists are so eager for and which are usually the mark of superior works. The
paintings in question are also the most highly praised, the most talked about, the
ones most discussed in court and in town, at dinner parties, in clubs, even in artists'
studios. When someone says they have just returned from the Salon, the first
questions people ask are: did you see Madame Lebrun? What do you think of
Madame Lebrun? And at the same time, they suggest the answer: Madame Lebrun
is an astonishing woman, isn't she? Such, Sir, is the name of the woman I am
thinking of, who has risen to fame in such a short space of time, for it was only a
few months ago that she was swiftly made an Academician and given the right to one
of the four places that are specially reserved for women.

Anyway, what has in no small measure helped to increase Madame Lebrun's
reputation is the fact that she is a pretty young woman, very pleasant, witty and
charming, who keeps the best company in Paris and Versailles, gives fine dinner
parties to artists, writers and persons of quality, and that her house is a refuge for the
Polignacs, the Vandreuils, the Polastrons, the most respected and refined courtiers, a
retreat from the troubles of the court and a place where they can find the happiness
that eludes them elsewhere. Only with such powerful protection was she able to cross
the threshold of the Academy which would not have allowed her in, despite her
merits, because her husband degrades art with his commercial activities and this is
sufficient reason to exclude her. But having introduced you to her person, it is now
time to analyse her works.

I don't know in which class the Academy has put Madame Lebrun, history, genre
or portraits, but she is worthy of any of them, even the first. I consider the painting
for which she was received into the Academy [her *tableau de réception*] very likely to
gain her admission into the first class. It is *Peace restoring Plenty* [Louvre, Paris], an

allegory as natural as it is ingenious: one could have chosen no better in terms of the details. The first figure, noble, proper and modest like the peace which France has just signed, is characterized by the olive, her favourite tree: she is holding a branch of it in her right hand as she places her right arm gently round the second figure who is looking at her with a kind expression and seeming to give in to her influence without any resistance. The second figure is shown with a bundle of ears of corn in her left hand that she is ready to scatter on the ground. With the other hand, she is generously pouring the different fruits of the land out of a cornucopia. Finally, goatskin gourds filled with wine complete the basic pleasures required to meet the needs of the people upon whom the blessings of peace are principally bestowed.

Moreover, the figure representing Plenty is a superb woman, in the style of Rubens, in those robust proportions which are the mark of health, strength and happiness. The flesh is firm and supple and her breast is rising up, as it were, underneath the canvas. Her complexion has a freshness, a radiance which we find more beautiful than real life because we compare this woman to our Parisian coquettes and because the model, by contrast, has doubtlessly been drawn, as she should be, from the healthiest and strongest aspects of rural women, and then adapted nonetheless with a kind of art that has nothing fake about it, and embellished with those true charms that a good bourgeois townswoman calls upon when she is at her toilet.

If one goes on to examine these figures as an artist, one judges them to be grouped in a superior manner; one admires the ample forms, the smooth outlines, the picturesque attitude of the skilfully posed Plenty; whilst Peace, daughter of heaven, is drawn with a more precise line. Spread across her face, we see that gentleness, that calm, that repose of the inhabitants of Olympus; her simple and severe clothing contrasts wonderfully with the shiny fabrics that her wholly earthly companion is casually draped in. The latter has a more elegant headdress; she is wearing a thousand flowers in her hair, whilst the former wears only a crown of olive leaves. These various contrasts produce a harmony in this painting which induces in the spectator that pleasure whose origins are unknown to the vulgar man but are soon grasped by the connoisseur.

If this composition, Sir, were still not enough to earn Madame Lebrun the honour of a seat amongst the history painters, it would be difficult to resist granting it to her for another painting the motif of which, taken from Homer, proves that she is able, like her masters, to derive enthusiasm from the divine works of the prince of poets and painters, for the latter do not cease to take him as their inspiration. The subject is *Juno Borrowing the Belt of Venus*. There are three figures in this subject, in which Cupid has a part and enjoys playing with this belt, which has already been handed over to the Queen of Olympus. It pains him to let it go, as though he is aware of its full importance and fears that his mother will lose her most precious charms along with it. In fact, either as a development of this idea or as an act of homage, the artist has thought she should make the chief goddess her principal figure, preferring Juno to Venus as no amateur would do in these circumstances. The former, a brunette, brings all the excitement of beauty to the majesty of the throne; the latter is a blonde, with nothing of a goddess's nobility, even verging on the grisette, a bit dull and consequently unenticing. Except for this flaw in the face, which is a serious error

with regard to the classical story, her body is very alluring; she is a nude in the style of Boucher, painted very lovingly and using his colour tone. To judge by the price it fetched, this painting must be of a very high quality, since the Count d'Artois was advised to pay 15,000 francs for it; he did so and His Royal Highness is now the owner.

What confirms to me that Madame Lebrun had the idea of subordinating Venus to Juno and of drawing the spectator's attention to the latter in the painting of which I have just spoken is the fact that in her third piece, *Venus Binding Cupid's Wings*, the mother of the little god is clearly divine. Her face looks more noble and her body is of richer proportions. The artist felt that she had to dignify the maternal act being performed in an appropriate manner, for in painting, as in poetry, it is not enough to express a person's general character, it must be modified by local character, that is, by the kind of emotion the person is feeling. Thus Cupid, usually represented as a sweet, naughty, laughing, sprightly child, has something sulky and sullen about him here. Viewed in the right way, this pretty allegory is charming, and the criticism of the cold expression on the face of one figure and of the scowl on the face of the other is found to be unfair and no longer stands up.

In addition to these three pieces, Madame Lebrun has exhibited three *Portraits* of the Royal Family, those of *The Queen*, of *Monsieur* and of *Madame*. The two princesses are *en chemise*, a form of dress recently created by women. Quite a number of people have thought it out of place to show these august personages in public in a form of dress which is reserved for the privacy of the palace; it is to be presumed, however, that the artist was authorized to do so and would not have taken such a liberty of her own accord. Whatever the case may be, Her Majesty is very good; she has that alert and assured look, that ease that she prefers to the discomfort of a public performance, and which does no harm to the nobility of her role. Some critics find her neck too long and thin: that may be a slight mistake in the drawing. Apart from that, there is much freshness in her face, elegance in her bearing and naturalness in her pose which make this a portrait a success. It even attracts those who would not, at first glance, recognize it as the queen.

Madame has something more severe, more reserved, more serious about her; these attributes are her dominant characteristics. She is also a very good likeness; one might wish only that her arms moved and that they were not stuck on to her body, making her look like a puppet. As for the Prince, to judge by the gaiety his face is exuding, something which is very rare in portraits, he was not ill at ease when he was being painted. That is easy to believe when you see her *Self-Portrait*. Nevertheless, there she has tried less to show off her charms than to display her artistic talents.

She is wearing a hat with a very wide, turned-down brim, the shadow of which is skilfully arranged to fall on her face, leaving us to imagine her rather than see her, though this involves a momentary lack of common sense, given the kind of occupation she is currently engaged in, as indicated by the palette and paintbrush she is holding, which would require her to be able to see in an unencumbered way. Nor does the short cape she is wearing go with the freedom of movement that her hands and arms would also require to the full at this moment. But that, so painters have told me, is more picturesque and moreover, it is not about conventions but artistic *tours de force*. Madame Lebrun was not in need of any when she painted *Madame la Marquise*

de la Guiche Dressed as a Gardener. Such figures serve the artist very well. And the accessories are no less charming; the flowers, the clothes, the arrangement of her fichu alone is delightful, and the bright colour of this painting, which one would at first be tempted to view as being out of place in this rustic subject, is a subtlety revealing, beneath this simple disguise, if one were deceived by it, a noble woman's fancy.

In finishing this article on Madame Lebrun, on which I would not have spent so much time, had I not known your liking for the opposite sex and were it not really a phenomenon worthy of remark, I will not conceal from you a rumour which is given credit amongst her fellow artists: people insinuate that she does not paint her paintings or at least that she does not finish them, and that an artist who is in love with her helps her. I will admit that his living arrangements, the fact that he lives under the same roof as her, greatly strengthens these suspicions, but it should be added that the painters are excessively jealous, sometimes even to the point of slandering others. Jealousy might therefore play a large part in this anecdote and even be the inspiration for it. Whatever the case may be, Madame Lebrun's paintings will belong to her as long as the real accomplice does not contest them, and it is up to her to justify her reputation and to deny these shameful claims by defending herself with new masterpieces and, if possible, by surpassing herself.

On the paintings, sculptures and engravings exhibited in the Louvre *Salon* on 25th August 1785

Artists, Sir, are like certain sick men who, unable to overcome their revulsion at the sight of a particular cure, choose suffering and sometimes even death over a momentary unpleasantness. They are lucky if they meet some relations or a friend interested enough in keeping them alive to exercise some salutary constraint and save them in spite of themselves. With regard to artists, criticism is that supreme cure, though loathsome to their pride, and yet how infinitely they have gained by it! In fact, is it not criticism that, by protesting against the unworthiness of the room, the ridiculously named Salon which has for a long time been the theatre of their rivalries, has succeeded in having it converted into a nobler, more appropriate place, equal to that lavish name. Is it not criticism that, in relentlessly groaning at the huge numbers of obscure portraits, puerile *bambochades*[1] and at worthy genre paintings that stifle genius, has awakened the government's zeal, provoked its munificence and given birth to that host of history painters that is the pride of the French School today? Is it not criticism that, in mercilessly hounding bad taste, artificiality and the dazzling but out of place and always exaggerated manner for which Boucher instilled a passion in his pupils, has brought the young athletes back to the true principles of the grand genre and to the beautiful and male ideals of Antiquity? Finally, in short, is it not criticism that is responsible for producing the current Salon, cited as the most magnificent and by all accounts the most impressive Salon in its history? No trivialities, no fripperies, no grotesqueries, no caricatures, none of those feeble and effeminate scenes the usual effect of which is to debilitate the talent while corrupting the heart. A severe tone reigns there which makes it less agreeable to frivolous and superficial people, but which appeals to the true friends of art and the supporters of

morals that uplift and expand the soul, that provide something for genius to meditate on, perfecting it through exercise. This is certainly the aim of more than thirty history paintings, the majority of which are vast machines, fourteen of them commissioned by the king. One would wish only that in accordance with what had been agreed, the subjects had been chosen from our annals, and one is sorry to find only one of this kind: anyway, it is time that the Romans, Greeks, Egyptians and Jews who have held centre stage for 4,000 years made way for figures who are closer to us, whose customs are more like ours and are more interesting to the French. Still, at least I can see elements of heroism, patriotic actions and sweet virtues, social or religious, everywhere. [...]

I was going to finish and seal this letter about history paintings, Sir, when, back at the Salon to visit it once again and to examine scrupulously whether I had left anything out of this genre that could be of interest to you, I see the crowd of spectators that had until then been so dispersed and restless, reduced to, as it were, a stupefied mass, united in admiration of a masterpiece that had just been hung. You will not be surprised when I tell you that it comes from Italy, but make no mistake: it is not a Raphael, nor a Guido, nor a Titian nor a Correggio but a David. This young painter is in Rome and has composed his work, *The Oath of the Horatii between the Hands of their Father*, for the king. Once they return to their senses, everyone pours forth praise and extols what they found most beautiful: 'What a simple and sublime composition,' says the man of letters! 'What a noble design! What elevated ideas in the father's mind! How steadfastly patriotic the first of the young men is!' 'What drawing!' the artist replies. 'How skilfully those muscles have been accentuated and how intelligently those of the father's legs differ from the son's! What energy! What harmony! What colour! This painting crushes all the others.' 'I like the architecture above all,' one of our Vitruvii says; 'it fills the background well, it is in a grand style, with no ornaments, as the fashions of the time demanded, deriving all its beauty from its exact proportions.' 'What a good person the sister is!' a young man adds, 'what gentleness, how moving she is in her sadness! What beautiful eyes, though they are full of tears! *Si dolci nei pianti che savan nel riso!*' 'The poor mother!' an old lady replies tearfully. 'How painful for her to watch her sons leave for a battle they may be going to die in!' 'Yes, but it's a Roman woman's pain,' says a man of a philosophical mind standing next to her, who is used to dissecting and nuancing the passions. Finally, the connoisseur goes into ecstasies over the draperies and the clothing which are all he could ask for. A hundred times this concert of praise is repeated, but when it is over, I hear envy say in muffled tones, its snakes hissing: 'The painting is rather yellow in colour, the groups are disjointed; the most prominent of the Horatii swears his oath with his legs apart as if he were about to start fencing. There is something uneasy about the outstretched arms of the three brothers, and in particular, the profile of the last brother's hand is drawn badly. Yes, I repeat, there is a general confusion in those arms and it is hard to work out which body each one belongs to. The elder Horatius, rather than presenting the swords to his sons, keeps them held tight, seeming to fear handing them over. The swords are not overly well done, there is too dark a shadow on one of them; the father's left leg that, despite being set back, should be in the foreground, seems to be in the middle ground, making the old man

lose his balance and appear unsteady; the painting is in general too light; there is not enough contrast in the shadows. Mr David paints daylight so as best to bring out the brilliance of his talents, not as it is in nature. The architecture is too well proportioned for the time of the Horatii, the stage is too bare; the action would have been more persuasive if one had seen the two armies in the background, the Roman army at least...' It may be that there is some truth in these criticisms, but even if there were Mr David's painting would, I repeat, be no less of a masterpiece, which does not mean a work without flaws, but a work that enchants, transports and so delights the spectator that he does not notice the flaws at first, seeing them only afterwards in discussion.

1 From the Italian *bambocciata*: 'childish action or remark' [translator's note].

2 Charles-Étienne-Gabriel Cuvillier (active 1780s) Letter to Joseph-Marie Vien

Cuvillier's letter is that of a functionary, written on 10 August 1789 according to the instructions of the General Director of Fine Arts, the royalist Comte d'Angiviller. The painter Joseph Vien (1716–1809) was President of the Académie Royale, with responsibility for the Salon exhibition of 1789, due to take place at a moment of utter precariousness in the political fortunes of the country. The date of the composition of the letter is between the fall of the Bastille on 14 July and the Declaration of the Rights of Man and Citizens on 26 August. It has been described by Robert L. Herbert as 'the key document for the interpretation of David's *Brutus*' (Herbert 1972). It should be acknowledged, however, that the text reveals more about the anxieties attendant on the exhibition of the painting, and about the reasons for its subsequent effect, than it does about David's intentions. His *Oath of the Horatii* had been the success of the 1785 Salon (see IVB1), and the *Brutus* was planned in response to a request from d'Angiviller that the painter should submit a subject for a further royal commission. For all that the painting invokes an extreme republican patriotism, it seems unlikely that it was planned as an anti-royalist demonstration. It is clear, however, that d'Angiviller had reasons to be nervous. At the time the letter was written the authorities responsible for control of the theatre were already under pressure from the radical press. On the one hand, Cuvillier makes clear that the Academy is expected to ensure wholesale support for the exhibition; on the other, he transmits d'Angiviller's concern about the potential for provocation of public opinion if certain actual or imagined images were to appear. The portrait of the chemist Lavoisier and his wife had been painted by David in 1788 (Metropolitan Museum of Art, New York). As Commissioner for Gunpowder, Lavoisier had recently been suspected of acting to equip aristocrats in exile. M. de Tollendahl's 'terrifying painting' was *The Marquis de Lally-Tollendahl unveiling the Bust of his Father* (by J. B. C. Robin). The father in question was a military leader and a victim of royal injustice whose honour the son had eventually been able to vindicate. David's *Brutus* (Louvre, Paris) was finally delivered to the Salon two weeks after the opening (see IVB3). His politically innocuous *Paris and Helen* (Louvre, Paris) was also shown, though without reference to its owner, the king's brother, the Comte d'Artois. The letter was originally published in M. Furcy-Raynaud ed., 'Correspondance de M. d'Angiviller avec Pierre', *Nouvelles Archives de l'Art Français*, volumes 20 and 22, 1906, no. 763,

pp. 263–5. It is translated in full in Robert L. Herbert, *David: Brutus*, London: Allen Lane, The Penguin Press, 1972, pp. 124–5, from which our text is taken.

Versailles, 10 August 1789

At our last meeting, Monsieur, about the coming opening of the Salon, the idea of which preoccupies Monsieur the General Director almost as much as making use of the waters, I expressed to you the justified and entire confidence he places in the prudence and caution of the Academy in organizing this Salon. I will not repeat here the reasons and the motives that unhesitatingly determine Monsieur the General Director to deprive neither the capital nor the artists of an event interesting for the pleasures of the former, valuable for the glory of the latter, and which, in the present moment, can serve morale as a useful diversion. None of that will have escaped your notice and will be equally understood by Messieurs of the Academy, hence it is only in a certain measure to complete the instructions prepared by Monsieur the General Director that I will offer a few observations here.

Monsieur the General Director thinks that one could not exercise too much caution in the choice of subjects which will be exhibited, relative to the interpretations which might escape from an observer and which could be awakened by others. The theatre provides us each day with the most unexpected examples. I only feel all the more how difficult it is to predict all that might be imagined, and my unique aim is to urge the committee to use all possible precaution.

The heading of portraits lets one more readily put oneself on guard, because in general the sitters being known, one is in the position of measuring public opinion and of not risking anything; I imagine that concerning this, M. Lavoisier will be the first to wish not to show his portrait. It is not that he could in any sense be ranked among those whom one could think badly of, but one can let him judge that. On the subject of portraits I am inclined to fear that Monsieur de Tollendal might renew the project of exhibiting this terrifying painting which it was so difficult to set aside in 1787; but, at the same time, I am reassured by the very virtue of Monsieur de Tollendal and by the loftiness of his views which will let him see at a glance the danger of furnishing more food to the fermentation. It is in this regard that I am comforted, as much as I could be, by learning that Monsieur David's painting is still far from finished; and, à propos this artist, I think as you, Monsieur, that his painting of *Paris and Helen* can be exhibited without remaining fears, by suppressing the owner's name. In this the only concern I see is the glory of the Academy and that of the artist.

I ought to express very particularly to you, Monsieur, the really deep distress which Monsieur the General Director would feel at the decision some of the artists might take not to contribute to the exhibition, and Monsieur the General Director urges you to press them on his behalf not to follow that course. In case there were too much empty space, the precise wish of Monsieur the General Director is that it be occupied by paintings sent to previous exhibitions that were not seen, or poorly seen. Messieurs *Roslin* and *Durameau* are in a position to respond to both cases, and I rely on them to be ready for the next committee meeting.

I have the honor, etc.

CUVILLIER

P.S. – Will you permit me to make the personal observation that it will perhaps be well to arrange the pictures so that the little ones will not be within reach of certain hands?

3 Comte de Mende Maupas (active 1780s) Review of the Salon of 1789

The title of the painting exhibited by David in the 1789 Salon is *The Lictors returning to Brutus the Bodies of his Sons* (Louvre, Paris). The Brutus referred to is not the more familiar Marcus Brutus, assassin of Julius Caesar, but Lucius Junius Brutus, credited by the Latin historian Livy with a decisive role in ending the rule of the Tarquins and in establishing the Roman republic as a community of free citizens living under the rule of law. In the episode on which David based his painting, Brutus had found his sons guilty of a royalist conspiracy against the new republic, and had himself condemned them to death. Brutus' extraordinary expression at the moment of execution is remarked on by both Livy and Plutarch. David made the hero's stern but troubled features the focus of his composition, but shifted the moment represented to an imagined aftermath of the actual execution. This allowed him to set the scene in an interior and to include a tragic female chorus. It also provided the context for his most original imaginative move. In the normal conventions of history painting, the effects of light would be organized so as to pick out the main player in the pictorial drama, who could also be expected to occupy the centre of the pictorial space. David locates Brutus at the extreme left foreground of his composition and sets him in deep shadow, thereby engaging the spectator more immediately with the emotional content of the painting. This was just the point that caught the attention of one writer on the 1789 Salon, the Comte de Mende Maupas, who presumably added the following supplement to his review in order to take account of the late delivery of David's work. While he pays due credit to the originality of the composition, he is noticeably very cagey in drawing conclusions from its historical theme. *Supplément aux remarques sur les ouvrages exposés au Salon par le C. de M. M.* (Comte de Mende Maupas), is preserved in the *Collection Deloynes*, volume 16, no. 414. The English version is taken from Robert L. Herbert, *David: Brutus*, London: Allen Lane, The Penguin Press, 1972, p. 127.

To appreciate the sublime beauties of this composition, one must go back to the time when Rome built its liberty on the coarseness of its customs, when would-be citizens only dethroned kings in order to reign themselves, when natural feelings gave way to ardent ambition, when a republican phantom consoled the people for the tyranny of its consuls. Then one will understand the merits of M. David's painting: strength of composition, nobility of expression, decisiveness of movement, agony of pose and, more than all that, originality of conception, because the principal subject is found in the dark portion of the picture, as though to mark the suffering of a being whom the republican morgue cannot prevent from being a father. In effect this production is more that of a great poet than of a painter, and the reproach that I heard *of seeing two paintings in the subject* is the very cause of my admiration. I think I see J. Brutus, removing himself from this family, but not yet reproaching himself for his severity; I think I see him wavering between nature and ambition, hence I admire this painting. But, since my enthusiasm never blinds me, I think I should remark to the celebrated

M. David that the uncertainty of the light in this painting could serve as pretext for the criticism of envious and malicious mediocrity.

4 Students of the Académie Royale des Beaux-Arts: 'Artists' Demand'

The 'Vœu des Artistes' was published as a pamphlet addressed to the Assembly on 12 September 1789, a few days after David's *Brutus* had appeared at the Salon. David's initial participation in revolutionary politics was less a cause of his work than a consequence of its reception. It is clear, however, that his opposition to authority within the Academy had already made him a figurehead for dissident students. If he did not actually have a hand in composition of the pamphlet, it is likely that the radical demands expressed in it came from those who had been closest to him. Our complete text is taken from the original edition, issued in Paris, Chez Gueffier jeune, 4 pp., translated for this volume by Akane Kawakami.

At this happy time when the regeneration of the nation is taking place, when she has just announced solemnly that henceforth only merit will lead to high places, will the artists, who hold such a distinguished rank in the nation, be the only ones not to enjoy the happy revolution which has come to pass; and is it not time for them to have at last, at their head, a man whose knowledge of the arts has placed him there? The public knows that artists are governed by a head known as the Director of His Majesty's Buildings, Arts and Manufactures. This pompous title would seem to require, in him who is graced by it, a meeting of knowledge and wisdom which would make him worthy of giving orders to men whose works do honour to their century and their country. For many years, kings regarded these qualities as completely useless, and favour alone guided their choice. Thus, since Colbert, ignorance, ineptitude, and that haughtiness which is such a convenient mask for the nullity of the nobility, have been the only qualities constantly displayed by the Directors of Buildings. Some, having arrived in their new position, and wishing to ape the Ministers, sketched out a code of laws, in which only justice, reason and common sense were lacking, but in which everything favoured their greed and despotism; others, blind protectors of rampant mediocrity, would pitilessly crush those artists who, permeated by the nobility of their art and their independence, scorned to pay them court assiduously; but all of them, in general, driven by a ridiculous pride, and incapable of comprehending the honour of their task, distanced themselves from the artists, and broke off all communication with them; and, left with a collection of base subalterns, ceased to give any signs of their existence, save by the ridiculous orders which emanated from their offices.

The class of artists, abundant and respectable as they are, thus invokes the National Assembly; the artists ask that it employ its good offices to deliver them from a yoke which is as ridiculous as it is unbearable. The king has had the goodness and justice to follow the wishes of the nation for the nomination of his new Ministers; may he now complete his creation, and finally bestow upon the artists a Leader worthy of them. Their deference for noble birth, if supported by personal merit and a

solid knowledge of the arts, would lead them to desire the choice of the prince to fall on a member of the noble order of Citizens, who have recently made so many sacrifices for the country; and it is also the case that their merits, their thorough studies in painting and architecture, their travels and assiduous projects, have resulted in their most distinguished members sitting in the artists' seats at the Academy; it is a nomination from their ranks that would do honour to the justice and wisdom of his Majesty, at the same time as being infinitely agreeable to the artists, with whom they have always shared the most intimate links of brotherhood.

5 John Trumbull (1756–1843) Letter to Thomas Jefferson

Trumbull's principal claim to fame as an artist lies in his series of large contemporary history paintings of the American Revolution: images such as the *Battle of Bunker's Hill* and the *Declaration of Independence*, painted only about a decade after the events they depicted. Trumbull came from an affluent New England family and his choice of a career in art was strongly opposed by his father, with the result that he was, at first, largely self-taught as a painter. In 1780, however, he came to Europe on family business and when in London sought out Benjamin West, who agreed to become his tutor. Trumbull was actually imprisoned and deported as a spy, and may only have been spared because of West's personal intercession with the king. He returned in 1784 to study both with West and at the Royal Academy. It was at this time that he came into contact with Thomas Jefferson, then American Ambassador in Paris, who suggested the series of paintings based on the War of Independence. The occasion of the present letter was Jefferson's invitation to Trumbull to become his personal secretary. Trumbull declined, and speaks of his dedication to commemorating the events of the Revolution in an art worthy of its epoch rather than one that merely offered frivolous entertainment. Later in 1789 Trumbull returned to America, where his plan to make money from engravings of his paintings failed. He gave up art for a while, but eventually recovered to become a leading portrait painter and a pillar of the American art establishment. Ironically, the conservatism he brought to his role as President of the Academy of Fine Arts led in 1830 to the secession of the National Academy of Design. The latter claimed for itself the American tradition of independence and condemned Trumbull's Academy for its allegiance to Old World tradition (see *Art in Theory 1815–1900*, IID3). We have taken Trumbull's letter from the text reprinted in John W. McCoubrey ed., *American Art 1700–1960*, Englewood Cliffs, New Jersey: Prentice-Hall, 1965, pp. 40–3.

London, June 11th, 1789

Dear Sir:

I have received yours of the 1st, by the last post, and am happy that you find the account correct; since writing that, you will have received by Mr. Broome, the bill of exchange. You will receive by the diligence to-morrow, Stern's Sermons, Tristram Shandy, and the Sentimental Journey, unbound; being all of his works which have been published by Wenman, in his very small size; they cost eight shillings, sixpence.

If my affairs were in other respects as I could wish them, I should have given at once a positive answer to your proposition. It would have been an answer of thankfulness and acceptance, for nothing could be proposed to me more flattering to my pride, or more consonant, at least for a time, to my favorite pursuit. The

greatest motive I had or have for engaging in, or for continuing my pursuit of painting, has been the wish of commemorating the great events of our country's revolution. I am fully sensible that the profession, as it is generally practiced, is frivolous, little useful to society, and unworthy of a man who has talents for more serious pursuits. But, to preserve and diffuse the memory of the noblest series of actions which have ever presented themselves in the history of man; to give to the present and the future sons of oppression and misfortune, such glorious lessons of their rights, and of the spirit with which they should assert and support them, and even to transmit to their descendants, the personal resemblance of those who have been the great actors in those illustrious scenes, were objects which gave a dignity to the profession, peculiar to my situation. And some superiority also arose from my having borne personally a humble part in the great events which I was to describe. No one lives with me possessing this advantage, and no one can come after me to divide the honor of truth and authenticity, however easily I may hereafter be exceeded in elegance. Vanity was thus on the side of duty, and I flattered myself that by devoting a few years of life to this object, I did not make an absolute waste of time, or squander uselessly, talents from which my country might justly demand more valuable services; and I feel some honest pride in the prospect of accomplishing a work, such as had never been done before, and in which it was not easy that I should have a rival.

With how much assiduity, and with what degree of success, I have pursued the studies necessarily preparatory to this purpose, the world will decide in the judgment it shall pass on the picture (of Gibraltar) which I now exhibit to them; and I need not fear that this judgment will deceive me, for it will be biased here, to a favorable decision, by no partiality for me, or for my country.

But, while I have done whatever depended upon my personal exertions, I have been under the necessity of employing, and relying upon the exertions of another. The two paintings which you saw in Paris three years ago, (Bunker's Hill and Quebec,) I placed in the hands of a print-seller and publisher, to cause to be engraved, and as the prospect of profit to him was considerable, I relied upon his using the utmost energy and dispatch; instead of which, three years have been suffered to elapse, without almost the smallest progress having been made in the work. Instead therefore of having a work already far advanced to submit to the world and to my countrymen, I am but where I was three years since, with the deduction from my ways and means of three years' expenses, with prospects blighted, and the hope of the future damped by the experience of past mismanagement. And the most serious reflection is, that the memory and enthusiasm for actions however great, fade daily from the human mind; that the warm attention which the nations of Europe once paid to us, begins to be diverted to objects more nearly and immediately interesting to themselves; and that France, in particular, from which country I entertained peculiar hopes of patronage, is beginning to be too much occupied by her own approaching revolution, to think so much of us as perhaps she did formerly.

Thus circumstanced, I foresee the utter impossibility of proceeding in my work, without the warm patronage of my countrymen. Three or four years more must pass before I can reap any considerable advantage from what I am doing in this country,

and as I am far from being rich, those years must not be employed in prosecuting a plan, which, without the real patronage of my country, will only involve me in new certainties of great and immediate expense, with little probability of even distant recompense. I do not aim at opulence, but I must not knowingly rush into embarrassment and ruin.

I am ashamed to trouble you with such details, but without them, I could not so well have explained my reason for not giving you at once a decided answer. You see, sir, that my future movements depend entirely upon my reception in America, and as that shall be cordial or cold, I am to decide whether to abandon my country or my profession. I think I shall determine without much hesitation; for although I am secure of a kind reception in any quarter of the globe, if I will follow the general example of my profession by flattering the pride or apologizing for the vices of men, yet the ease, perhaps even elegance, which would be the fruit of such conduct, would compensate but poorly for the contempt which I should feel for myself, and for the necessity which it would impose upon me of submitting to a voluntary sentence of perpetual exile. I hope for better things. Monuments have been in repeated instances voted to her heroes; why then should I doubt a readiness in our country to encourage me in producing monuments, not of heroes only, but of those events on which their title to the gratitude of the nation is founded, and which by being multiplied and little expensive, may be diffused over the world, instead of being bounded to one narrow spot?

Immediately therefore upon my arrival in America, I shall offer a subscription for prints to be published from such a series of pictures as I intend, with the condition of returning their money to subscribers, if the sum received shall not prove to be sufficient to justify me in proceeding with the work; and I shall first solicit the public protection of Congress.

I am told that it is a custom in France, for the king to be considered as a subscriber for one hundred copies of all elegant works engraved by his subjects; that these are deposited in the Bibliothèque du Roi, and distributed as presents to foreigners of distinction and taste, as specimens of the state of the fine arts in France. Would this be a mode of diffusing a knowledge of their origin, and at the same time a lesson on the rights of humanity, improper to be adopted by the United States? And if the example of past greatness be a powerful incentive to emulation, would such prints be improper presents to their servants? The expense would be small, and the purpose of monuments and medals as rewards of merit, and confirmations of history, would receive a valuable support, since perhaps it may be the fate of prints, sometimes to outlast either marble or bronze.

If a subscription of this sort should fill in such a manner as to justify me, I shall proceed with all possible diligence, and must of course pass some years in Europe; and as I have acquired that knowledge in this country which was my only object for residing here, and shall have many reasons for preferring Paris hereafter, I shall in that case be happy and proud to accept your flattering proposal. But if, on the contrary, my countrymen should not give me such encouragement as I wish and hope, I must give up the pursuit, and of course I shall have little desire to return for any stay in Europe. In the mean time, viewing the absolute uncertainty of my situation, I must beg you not to pass by any more favorable subject which may

offer, before I have the happiness to meet you in America, which I hope will be ere long.

I have the honor to be, very gratefully,
Dear sir, your most faithful servant,
John Trumbull

6 Mary Wollstonecraft (1759–1797) Response to Edmund Burke

Wollstonecraft was part of a radical circle of English intellectuals active at the end of the eighteenth century, which included William Godwin, Thomas Paine and William Blake. Although radicalized by the French Revolution, she had already written on women's place in society before 1789. Burke's hostile *Reflections on the Revolution in France* appeared in November 1790. Wollstonecraft immediately began to compose a reply, which was printed by the page as she wrote it, and which was published in December. Wollstonecraft took issue not just with Burke's condemnation of the Revolution but with his wider scale of values as manifest in his earlier *Enquiry into the Origin of our Ideas of the Sublime and the Beautiful* (see IIIB6). For Wollstonecraft, Burke's gendered language – in which beauty was a feminine attribute while the sublime was masculine – was evidence of a value system which excluded women from the sphere of moral action and truth by aestheticizing them. Indeed she goes further, and argues that the consistent application of Burke's principles would effectively dehumanize men too. Wollstonecraft's text thus offers an early example of reading aesthetic categories for evidence of the material and political interests lying behind them. The extract is taken from *A Vindication of the Rights of Men in a Letter to the Right Honourable Edmund Burke* (1790), as reprinted in *The Works of Mary Wollstonecraft*, volume 5, edited by Janet Todd and Marilyn Butler, London: Pickering and Chatto 1989, pp. 29–30, 45–7. We have included one of the editors' explanatory footnotes.

It is an arduous task to follow the doublings of cunning, or the subterfuges of inconsistency; for in controversy, as in battle, the brave man wishes to face his enemy, and fight on the same ground. Knowing, however, the influence of a ruling passion, and how often it assumes the form of reason when there is much sensibility in the heart, I respect an opponent, though he tenaciously maintains opinions in which I cannot coincide; but, if I once discover that many of those opinions are empty rhetorical flourishes, my respect is soon changed into that pity which borders on contempt; and the mock dignity and haughty stalk, only reminds me of the ass in the lion's skin.

A sentiment of this kind glanced across my mind when I read the following exclamation. 'Whilst the royal captives, who followed in the train, were slowly moved along, amidst the horrid yells, and shrilling screams, and frantic dances, and infamous contumelies, and all the unutterable abominations of the furies of hell, in the abused shape of the vilest of women.' Probably you mean women who gained a livelihood by selling vegetables or fish, who never had had any advantages of education; or their vices might have lost part of their abominable deformity, by losing part of their grossness. The queen of France – the great and small vulgar, claim our pity; they have almost insuperable obstacles to surmount in their progress towards true dignity of character; still I have such a plain downright understanding that I do

not like to make a distinction without a difference. But it is not very extraordinary that *you* should, for throughout your letter you frequently advert to a sentimental jargon, which has long been current in conversation, and even in books of morals, though it never received the *regal* stamp of reason. [. . .]

Where is the dignity, the infallibility of sensibility, in the fair ladies, whom, if the voice of rumour is to be credited, the captive negroes curse in all the agony of bodily pain, for the unheard of tortures they invent? It is probable that some of them, after the sight of a flagellation, compose their ruffled spirits and exercise their tender feelings by the perusal of the last imported novel. How true these tears are to nature, I leave you to determine. But these ladies may have read your Enquiry concerning the origin of our ideas of the Sublime and Beautiful, and, convinced by your arguments, may have laboured to be pretty, by counterfeiting weakness.

You may have convinced them that *littleness* and *weakness* are the very essence of beauty; and that the Supreme Being, in giving women beauty in the most super-eminent degree, seemed to command them, by the powerful voice of Nature, not to cultivate the moral virtues that might chance to excite respect, and interfere with the pleasing sensations they were created to inspire. Thus confining truth, fortitude, and humanity, within the rigid pale of manly morals, they might justly argue, that to be loved, women's high end and great distinction! they should 'learn to lisp, to totter in their walk, and nick-name God's creatures' [*Hamlet*]. Never, they might repeat after you, was any man, much less a woman, rendered amiable by the force of those exalted qualities, fortitude, justice, wisdom, and truth; and thus forewarned of the sacrifice they must make to those austere, unnatural virtues, they would be authorized to turn all their attention to their persons, systematically neglecting morals to secure beauty. – Some rational old woman indeed might chance to stumble at this doctrine, and hint, that in avoiding atheism you had not steered clear of the mussulman's creed;[1] but you could readily exculpate yourself by turning the charge on Nature, who made our idea of beauty independent of reason. Nor would it be necessary for you to recollect, that if virtue has any other foundation than worldly utility, you have clearly proved that one half of the human species, at least, have not souls; and that Nature, by making women *little, smooth, delicate, fair* creatures, never designed that they should exercise their reason to acquire the virtues that produce opposite, if not contradictory, feelings. The affection they excite, to be uniform and perfect, should not be tinctured with the respect which moral virtues inspire, lest pain should be blended with pleasure, and admiration disturb the soft intimacy of love. This laxity of morals in the female world is certainly more captivating to a libertine imagination than the cold arguments of reason, that give no sex to virtue. If beautiful weakness be interwoven in a woman's frame, if the chief business of her life be (as you insinuate) to inspire love, and Nature has made an eternal distinction between the qualities that dignify a rational being and this animal perfection, her duty and happiness in this life must clash with any preparation for a more exalted state. So that Plato and Milton were grossly mistaken in asserting that human love led to heavenly, and was only an exaltation of the same affection; for the love of the Deity, which is mixed with the most profound reverence, must be love of perfection, and not compassion for weakness.

To say the truth, I not only tremble for the souls of women, but for the good natured man, whom every one loves. The *amiable* weakness of his mind is a strong argument against its immateriality, and seems to prove that beauty relaxes the *solids* of the soul as well as the body.

It follows then immediately, from your own reasoning, that respect and love are antagonist principles; and that, if we really wish to render men more virtuous, we must endeavour to banish all enervating modifications of beauty from civil society. We must, to carry your argument a little further, return to the Spartan regulations, and settle the virtues of men on the stern foundation of mortification and self-denial; for any attempt to civilize the heart, to make it humane by implanting reasonable principles, is a mere philosophic dream. If refinement inevitably lessens respect for virtue, by rendering beauty, the grand tempter, more seductive; if these relaxing feelings are incompatible with the nervous exertions of morality, the sun of Europe is not set; it begins to dawn, when cold metaphysicians try to make the head give laws to the heart.

But should experience prove that there is a beauty in virtue, a charm in order, which necessarily implies exertion, a depraved sensual taste may give way to a more manly one – and *melting* feelings to rational satisfactions. Both may be equally natural to man; the test is their moral difference, and that point reason alone can decide.

Such a glorious change can only be produced by liberty. Inequality of rank must ever impede the growth of virtue, by vitiating the mind that submits or domineers; that is ever employed to procure nourishment for the body, or amusement for the mind. And if this grand example be set by an assembly of unlettered clowns, if they can produce a crisis that may involve the fate of Europe, and 'more than Europe,' you must allow us to respect unsophisticated reason, and reverence the active exertions that were not relaxed by a fastidious respect for the beauty of rank, or a dread of the deformity produced by any *void* in the social structure.

[1] The very low status of woman in Muslim countries gave rise to the widespread Christian misconception that Islam denied that women had souls.

7 Antoine Quatremère de Quincy (1755–1849) 'On the System of Teaching' from *Considerations on the Arts of Design in France*

Quatremère de Quincy trained as a sculptor after leaving the study of law, though much of his written work was devoted to the subject of architecture. He eventually became an eminent administrator of the arts. He spent much of the period 1776–84 in Rome and in 1779 was in Naples with David. On the basis of recent archaeological discoveries, he later came to see classical Greek style as an ideal expression of 'character' in the society that produced it, and in that sense as a model to be followed in the present. He put these ideas into effect in the remodelling of the church of Ste Geneviève in Paris in the early 1790s, when it was renamed the Pantheon and transformed into a temple to the martyrs and heroes of the Revolution. His *Considerations on the Arts of Design in France* was offered to the National Assembly at a time when the question of the continuing existence of the (formerly royal) academies was under discussion but as yet unresolved. The question

Quatremère addressed was 'Does France need to maintain the expense of a public academy or school of Design? And what would be the most advantageous method to adopt in such an institution?' (p. viii). In response, he argued for a post-revolutionary renewal of the arts along neo-classical lines. He made two proposals of particular significance: that the exclusive Royal Academy of Painting and Sculpture should be liberalized through reform of its teaching programme; and that there should be an end to the monopoly by which only members of the Academy were permitted to exhibit in the official Salon. His arguments were generally well received. A decision to open the Salon to all comers was formalized by the Assembly in August 1791, with effect from the Salon of 1793, while the royal academies were dissolved by decree in 1793. However, Quatremère was soon to become detached from the cultural politics of the Revolution. He was briefly imprisoned during the Terror in 1794 and grew increasingly anti-republican, opposing the removal of art from Italy for the Louvre and from the French provinces for Lenoir's Musée des Monuments Français (see IVB13). He was eventually exiled to Germany, returning in 1800 at the time of the Consulate. *Considérations sur les arts du dessin en France, Suivies d'un plan d'Académie, ou d'Ecole publique, et d'un système d'encouragemens*, was originally published in Paris: Chez Desenne, in 1791. Our text is taken from this edition, Part II, chapter III, pp. 121–37, translated for the present volume by Jonathan Murphy. (For excerpts from Quatremère's later work, *An Essay on the Nature, the End and the Means of Imitation in the Fine Arts*, 1823, see *Art in Theory 1815–1900*, IB5.)

On the Teaching System

Under this title I do not include the organizational and disciplinary requirements that will no doubt be necessary from a legal point of view, but which have no place in a preliminary study. My subject instead will be the ideas that lie behind the teaching, and its methodology.

The spirit of teaching

There is no one spirit that informs all teaching: teaching should vary according to the different types of institution, their nature and objectives, and their means. An art school, by which I mean a place where one teaches the imitation of the beautiful and the true, in accordance with principles which depend on the intelligence, and methods that aim at both the head and the heart; a school whose students, once they have arrived at the age of reason, should be allowed to follow the inspiration that reason brings, and should only be subjected to public teaching if that teaching brings a desire to learn and spurs on ambition. Such a school should have as its principle a spirit of great liberty in all its procedures and in all the forms of teaching that it offers. All that might remind the students of the scholastic regime of a children's school should be removed, so that the students instead should be inspired to all forms of emulation, and teaching itself through this free and simple instruction will in itself be ennobled. Such an institution should resemble more the Lyceum of the ancients than it should a modern school.

All men filled with the desire for the passion and glory of a career in the most noble of the arts should find here all that they require to facilitate their progress and speed

them on their way, and our school should present students with all the necessary lessons and examples, so that they should never be in a position to reproach it for any lack of culture nor for the teaching of any practice that might ultimately be harmful to their nature. Thus the school must teach neither too much nor too little, and it is in this idea of balance that the true spirit of our institution should be found.

The errors at the present Academy

The main problem at the present academy is that it teaches both too much and too little. It teaches too much in that it has reduced teaching to a series of exclusive procedures, outside which the students receive almost no assistance whatsoever, and it thus clips the wings of the students who are forced to suffer under a monotonous and quite forbidding regime. It teaches too much in that it relies on an extremely narrow ideal of emulation, towards which there is only one path, which all students are forced to follow. It teaches too much in that it controls too tightly the direction that talent might take, instituting a multitude of irrelevant fine distinctions, all of which in its opinion must be mastered if the student is to arrive at a peak of perfection, and be accorded the title of Academician. Perhaps I am wrong to say it teaches too much; closer to my meaning is the idea that it regulates too closely the activities of the pupils.

But I am clear in my mind that it teaches too little. We might even go so far as to say that there is very little true teaching at all.

All individual teaching by the masters is carried out by a dozen or so teachers and assistants who take turns to choose the pose for the model for a month, and in practice watch over the students far more than they actually correct their work. However zealously the teachers may desire to correct the students' work, the large numbers of students and the short hours kept by the school reduce the act of teaching itself to an extremely brief encounter.

The action of teaching, such as it is carried out by the academic body, is reduced to little more than the act of judging the periodic competitions between the students, which were originally introduced to bolster the enthusiasm of the students. Thus their role is to adjudicate places and distribute medals and prizes. No shadow of theory haunts these puerile proceedings, and the whole enterprise is flawed from the outset and overly fastidious throughout. One could teach thus for thirty years without ever making a single useful suggestion, and this leads to a form of teaching which is both passive and wordless.

So much for the teachers. Where the students are concerned, the only assistance they receive from this public teaching is the free study of the model. This is the sole object of their work and their only means of advancement, as it is only on this form of imitation that the majority of the competitions are founded. This means of learning is so exclusive that one might claim that this model posed on the table, like the rule of Polytectes, is the whole academy, and that one might as well simply dispense with the masters altogether.

Misuse of the study of the model

Doubtless some of these drawing masters would reply that the lessons of nature are far more valuable than any teaching they themselves might bring. In principle I agree with this view, but we need to be quite clear about what we understand by the study of nature, as it is clearly one of the most essential elements in the art of drawing.

They are strangely mistaken if they take the study of the model to be the study of nature. The model is part of nature, but it does not necessarily follow that all of nature is in the model; nature is species, while the model is no more than a specimen. The study of nature should always be the study of the species itself. Thus the study can never be limited by a single specimen, unless that individual could somehow encapsulate all types of beauty and perfection. Such perfection of course can exist nowhere other than in a work of art, and there only in a certain measure. Nature, in the creation of beings, is subject to too many accidents. Join to those the accidents of education and all the circumstances which surround man and society, and one quickly has proof that the idea of a perfect model is a chimera of the imagination. Only art can bring such a chimera into being, by reuniting these parts scattered throughout nature in different specimens, and this search for the perfect form that might reunite these disparate elements is what the true study of nature really is.

That being the case, any other form of study, and any study whose aim is simply the copying of one particular individual form, is inevitably the study of imperfection.

The great cause of the superiority of the Greeks in the imitative arts was the facility that they had to study perfection in nature. All their monuments demonstrate tremendous resourcefulness in this area. Looking at their art, one never gets the impression that it was ever the copy of one particular isolated individual, as is regrettably so often the case when one examines modern figures.

The difference between the Greeks and ourselves in that respect is that they had nature for a model, whereas we have only a model for nature.

The results of this study of the figure, where so much of the students' energies are at present concentrated, serve to demonstrate its inadequacy and insufficiency. It would be pointless to begin to draw up a list of the damage done by this exclusive study, and it may well be that no single student ever escapes its ravages. Independent of this aberrant principle, we should also note that the practice of copying and recopying ceaselessly the same individual, who is paid to contort himself into the most bizarre and improbable positions, serves to pervert the faculties of imagination and invention, when it does not severely reduce them. From this endless copying of lifeless figures devoid of character and expression results the style empty of truth, character and expression, which artists themselves have identified with a word that indicates the cause – the *academic style*.

The reform and improvement of figure drawing

One of the first things to be improved in our new school, both in terms of the spirit that will lie behind it and the methods used to propagate the ideas, is then this study of the model.

As artists are deprived of the habitual sight of nature, the school must provide the answer, and use all the imperfect means at its disposal to fill this lack. My intention is not to suppress figure study at all, but to improve it, and there are principally two means of bringing about this improvement.

The first is to increase several-fold the number of models used, and to ensure that a wide variety of models, both male and female, young and old, of all character types pass before the students' eyes. Is it not ridiculous to believe oneself to be well instructed in nature simply on account of having studied one man for nearly a decade? The same man, moreover, that successive generations of artists have studied, and will otherwise continue to do until he passes on from old age. Why should one particular man be the universal model for all the gods, the heroes and all the men painted? For in turn he plays the role of Apollo, Mars, Jupiter, Adonis, Hercules, Narcissus, etc. The art of a whole half-century can be identified simply through the portrait of one man.

It is my contention that the choice and variation of models should be one of the responsibilities devolved to those whose task it is to teach the drawing of the model in question. There is no reason for them all to be employed for the whole year, or even to be salaried employees of the Academy.

The second means of removing the disadvantages of the present system without harming the students' taste or individuality would be to remove one of the particularities which characterize it, and reorganize the internal competitions. In place of the puerile scholastic competitions on which the pupils squander so much of their energy, other competitions should be instituted, which would serve as a corrective to the present over-used formula.

Classical study

Until now the students have been forced to study a single model, and this has led to an often biased and usually incomplete form of imitation. The only sure means of expanding the students' capabilities would be to offer them far greater access to the spectacle of antique monuments and classical models. For it is there that nature seems most clearly to have imprinted her timeless proportions, and writ large the principles of beauty and the elements of perfection.

A gallery of antique statuary

It is my desire to create a gallery of original antique statuary, for in these original monuments there is to be found an ineffable beauty impossible to characterize, together with an immutable quality of authenticity most fruitful for study and quite absent from any plaster models taken of such statues. The gallery could be instituted for a relatively small sum, simply through the bringing together of monuments which are at present dispersed and forgotten throughout the country. I have drawn up a list of a number of such monuments which could be gathered together in the space of three months, and it is my belief that, without any expenditure whatsoever, more than a hundred original classical statues could be brought together, not including numerous other antique monuments which have largely been forgotten or

allowed to fall into a state of disrepair obscuring their real value, through the negligence of our forebears.

A gallery of antique plaster casts

A gallery of plaster casts taken from classical figures and other objects of value apt to instruct the pupils would admittedly require a certain outlay. Out of the powdery debris which at present fills the present so-called antique gallery barely five or six whole figures could be salvaged, and no greater number than that will be found anywhere else inside the Academy. This expense could perhaps be met through a few simple savings on revenues at present destined to go to the school in Rome; but it must be recognized that this gallery will have a fundamental role to play in the formation of our new school.

A gallery of classical ornamentation

An equally indispensable source of models to be presented to the students would be a collection of classical ornamentation, with a selection of the most beautiful foliated scrolls, volutes, capitals, architectural friezes, vases, candelabra and other objects relating to decoration and of general use to those who study ornamentation. Such a gallery would be invaluable to students of drawing: at present ornamentation is learnt through the copying of other drawings, and the original models are quite unknown both to those whose task it is to teach drawing and to those who take the lessons.

The architectural school which forms part of our institution would profit even more directly from the immediate improvement in the students' abilities brought about by their increased study of nature and antique models. I have written elsewhere of how the two parts which make up this art should be brought closer together under a single leadership, and the only changes that I would envisage for the school of architecture would be those naturally engendered by this general change in the spirit that informs our teaching methods in the arts.

Five types of practical classes

The main body of the teaching would thus be divided into five different types of study, which we might usefully term practical classes.

- The study of nature and the figure
- The study of Antiquity
- The study of ornamentation
- The study of architecture
- The study of composition.

I use the term practical classes because the students who follow the classes will want to try the practices for themselves, and they are thus manual exercises; they will proceed through the imitation of examples rather than through instructions that are to be retained.

Despite the improvements in all these different fields, the school would still be quite incomplete if such practical courses were not accompanied by a series of theoretical lectures, for which the establishment of a certain number of professorships would almost certainly be required.

Such an innovation is all the more necessary, given that the practice of the arts is founded upon a certain stock of knowledge, the acquisition of which requires a certain amount of assistance, together with solid advice and an often not inconsiderable period of time, a combination which, left alone, many students are unable to find. It is often objected that the study required for such knowledge is sometimes prejudicial to the practical study of the arts; our institution must therefore come to the assistance of the students and ensure that they are spared these often fruitless efforts.

Five types of theoretical classes

There should also be five types of theoretical classes, to run in parallel with the above improvements. These classes would require a smaller number of masters, as they would only take place on certain days each week.

History

The first class would be the history class. This would consist of an accelerated course through the learning of peoples both ancient and modern, particularly where that learning had a bearing on the arts of the time, or on the content of that art. The historical component of the arts should be quite developed here.

Costume and Antiquity

The second class would cover costume and Antiquity. Here the master would be required to make a study of all ancient art, and garner a collection of the different clothing of different peoples. The costumes should then be recreated and demonstrated with various different cloths on models. The study of costume is not simply limited to clothing, but should also include a knowledge of the customs of the time, of religious and civil ceremonies, of furniture and tools, of different tastes in architecture, and of all that which is often the cause of error and anachronism in the work of the artists of today.

Optics and perspective

The third class would be for optics and perspective. To demonstrate the necessity of this one need look no further than the work of some of the best painters of the present time, who through a lack of learning in this area often find themselves caught between two alternatives. Either they are forced to sin against the most elementary principles, as they do in all but a few of their pictures, or they call in a different artist to draw the lines on the buildings which form the background in their pictures. Unfortunately no one can deny that this is the truth of the present situation.

Anatomy

An anatomy class would also be a requirement. The need for this is all too apparent. The course should be divided up into practical study, which would take place for part of the year, and theoretical study with lessons and demonstrations which could run the whole year long, using works of art, anatomical copies, and books and learned writings upon the subject.

Geometry and mathematics

Geometry and mathematics would be the object of study in the last class, disciplines which might well be accorded pride of place if the subjects were to be ranked in order of their true importance. These sciences are one of the foundations of the art of drawing. The nature of their relationship with sculpture is quite unequivocal; as we already study architecture in our institution, there is no necessity to demonstrate their relevance here.

Each of these classes would be accorded a particular day and hour, and should be combined so that the students could link their lessons with the practical studies mentioned above.

The Academy of the Arts of Design would thus propose two sorts of classes or types of study, and would be a mixture of the practical and the theoretical. The practical classes demand much closer supervision, and would require a greater number of teachers, who could rotate each month or each quarter. The other classes, which would depend more directly on oral communication, would require only one teacher whose lessons could take place on one or several fixed occasions each week or month, in accordance with the nature of the discipline.

A public school, along the lines that I have drawn up here, has as its purpose the supplementing of insufficient resources available at any given moment, either where teaching or learning is concerned. I hope I have demonstrated clearly that there has rarely been a more pressing moment for the creation of such an institution.

Once more I must stress that such an institution requires as much liberty within its confines as the law may allow. Nothing should constrict the students in their choice of studies, in the lessons that they prefer, or in how they choose to spend their time.

As mentioned above, the constant internal competitions to which students are subjected at present should be abolished, as such competitions serve only to make schoolchildren rather than men. They may foster competitiveness, but they inspire too little else besides, and encourage students too early in their careers to care only for a form of public recognition, and learn to use the art of their peers as the sole standard against which their own art should be measured, leading to excessive ambition and petty jealousies and diverting the true course of learning merely to satisfy the forces of vanity and pride. In such a manner the soul will never be rightly proud of genuinely excellent execution.

The Prix de Rome

One competition must nonetheless be maintained, and that is the greatest prize of all. It is highly laudable as an institution, and fits its purpose in an admirable fashion. The Prix de Rome is the best of all possible recompenses, offering young artists the means to grow and strengthen their painting. Few changes are necessary here: one might only extend the competition slightly by opening it to a wider audience. This might be brought about by a small change in the regulations, enabling anyone who applied several days in advance to be considered for a sort of preliminary competition. The winners of the first competition, who might number a dozen or more, would then be allowed to enter the main competition and compete for the great prize. There are of course other detailed points to be taken into consideration here, but this memoir is not the place to address them.

The Ecole de Rome

The main point to make about the Ecole de Rome is that it should be left largely untouched, so that its unique authenticity should remain. Although some small economies could be made they would be quite out of place. Time itself will no doubt expedite them. But while I do feel that we must keep our institution in Rome, we should find a way of enabling our students to study elsewhere in Italy too. Each should be allowed, in accordance with the taste and style that he has developed, to select a number of Italian cities to visit, providing that there be some sort of affinity between his style and choice of town. To this end, rather than being attached to the academy in Rome, as is the case at the present time, each student should be allowed to transport his emoluments to a destination of his choice. The task of the director of the academy in Rome would be to ensure that his individual requirements were met. The influence of the director on students' studies at present counts for little in any case, and the student's own personal interest would be a far more important tool in assisting his progress. He would thus be obliged to submit each year one work, enabling the authorities to check on his progress: the maintaining of the bursary accorded would depend on the manner in which these obligations were met.

I would also note that it would be fitting if each subject were given one additional year of funding, at least equal to what he received in Italy, on his return to France, to begin immediately he came back. The reasons for this need no further explanation.

8 Jacques-Louis David (1748–1825) on his picture of Le Peletier

In the Salon of 1791, David was represented by *The Oath of the Horatii*, *The Death of Socrates*, the *Brutus* and his sketch for *The Oath in the Tennis Court*, which recorded the National Assembly's formal act of resistance to the authority of the king. Much as the most notable among his predecessors had been designated Painters to the King, David was now clearly if informally identified as painter and designer to the Revolution. In the spring of 1792 he directed a public Festival of Liberty and during the same year became a

representative on the Convention's Committee of Public Instruction – effectively a member of the Revolution's general staff. Michel Le Peletier (or Lepelletier) de Saint-Fargeau was among those who had voted for the execution of Louis XVI (as was David himself). On the day before the execution took place in January 1793 he was stabbed to death by a member of the former royal guard. At the request of the National Convention, David stage-managed a public display of Le Peletier's corpse, presenting him in classical style as a martyr to the cause of liberty. Two months later, in March, he offered the Convention his own painting of Le Peletier, represented as he had been posed in death. (The work was subsequently destroyed by Le Peletier's family.) That summer David was to paint the posthumous picture of another assassinated hero of the Revolution, his still surviving and better-known *Death of Marat* (Musée Royaux des Beaux-Arts, Brussels). On the day of Marie-Antoinette's execution, 16 October 1793, the two paintings were set up on sarcophagi in the courtyard of the Louvre, where a funeral service for the two martyrs was held as the climax to a procession of the Museum Section through the streets of Paris. David's *Discours prononcé à la Convention Nationale le 29 Mars 1793* was issued by the Imprimerie Nationale, Paris, in 1793. It was reprinted in J.-L. Jules David, *Le Peintre Louis David 1748–1825*, Paris: Victor-Havard, 1880, p. 117, from which the following translation has been made for this volume by Akane Kawakami.

Representative Citizens,

Each one of us is accountable to our country for the talents that we have received from nature; the forms they take may differ, but their goal should be the same for all of us. The true patriot must seize eagerly every opportunity to enlighten his fellow citizens, and ceaselessly proffer the sublime features of heroism and virtue to their eyes.

This is what I have attempted to do in the homage that I offer today to the National Convention, in this painting of Michel Lepelletier who was basely assassinated for having voted for the death of the tyrant.

Citizens, God, who divided up His gifts amongst all His children, willed that I should express my soul and my thoughts through the medium of painting, and not through that persuasive eloquence whose sublime accents resound amongst you, issuing from the energetic sons of freedom. Filled with respect for His immutable decrees, I will be silent, and I will have achieved my task, if one day I cause an aged father, surrounded by the numerous members of his family, to say: 'Come, my children, come and see the first of your representatives who died to give you your freedom; see his features, see how serene they are; when one dies for one's country one has nothing with which to reproach oneself. Do you see that sword above his head, hanging by nothing but a hair? My children, that is a sign of the fortitude shown by Michel Lepelletier and his brave companions when they sent to his death the odious tyrant who had oppressed us for so long; for the slightest hesitation, breaking the hair, would have destroyed them all.

'Do you see that deep wound? You are crying, my children, you are looking away! But look too at that crown, it is the crown of the immortals; it is kept in readiness by our country for each one of her children; learn to become worthy of it; opportunities are never lacking for noble souls. If ever, for instance, an ambitious scoundrel were to come to you about a dictator, a tribunal, a regulator, or to attempt to usurp the tiniest portion of the sovereignty of the people, or if a coward dared to offer a king to you, do

battle and die as did Michel Lepelletier, rather than consent to it; then, my children, the crown of the immortals shall be your reward.'

I humbly ask the National Convention to accept the homage of my meagre talent. I will think myself too happy if it deigns to receive it.

9 Gazat, Minister of the Interior/Anonymous: preliminary statement to the Official Catalogue of the Salon of 1793

Following the execution of Louis XVI, the Salon of 1793 opened in a Louvre redesignated the Palais National des Arts. With the dissolution of the Academy already decided, its organization was undertaken by a General Commune of Artists, formed along lines proposed by David. Open as it was to all comers of all nationalities, the size of the exhibition exceeded that of any previous Salon, with over 1,400 separate entries. This was the only Salon to take place under the regime of the Committee for Public Safety, during the period of the Terror. The inclusion of an introduction to the official catalogue was an innovation in line with the times, serving to remind artists of their obligation to the state. The introduction is preserved in the *Collection Deloynes*. Our text is taken from the English version printed in Elizabeth Gilmore Holt ed., *The Triumph of Art for the Public 1785–1848*, Princeton, New Jersey: Princeton University Press, (1979) 1983, pp. 45–7.

Introduction:

The forms of the arts, like the political system, must change: art should return to its first principle – to the imitation of nature, that unique model for which unfaithful copies have so long been substituted. Genius, once more, should no longer drag itself along the beaten track, but, flying with its own wings, should offer us its productions with an originality of character suitable to it. If this is accomplished we shall no longer see a long succession of artists who copy each other in servile fashion, but a varied imitation of nature, according to the diversity of the genius of nature's imitators. There will no longer be style or academic manner, but in their place the true and the natural in a thousand forms, in a thousand different characters, multiplied to the infinite from an inexhaustible source.

The arts should never limit themselves to the single aim of pleasing by faithful imitation. The artist must remember that the goal which he has set before him is, like that of all work of genius, to instruct men, inspire in them the love of goodness and to encourage them to honorable living. The artist should not abuse his gift of charming the eye in order to let slip into his heart the poison of vice and the fires of passion: he will rather set himself to extinguish these and to light instead the enthusiasm of generous and social virtues.

This is the moment when we must bring back the arts to the memory of their noble beginnings, when the nation should once more turn her gaze upon them, when she should use them as powerful instruments to bring about the moral regeneration essential to her happiness and her new Constitution. Let her raise statues to the great men who have deserved well of their country: following the example of the Greeks and the Romans, let her gardens and her public walks be filled with these, so that in the place of the unreal, sometimes insignificant and often immoral monuments we

have seen, we shall behold those of greater worth, that shall continually place before our eyes the events of our national history and those of ancient peoples worthy to serve us as examples. May the arts speak to us always of the love of country, of humanity and of virtue; may these cold marbles warm in every heart the seeds of good that we have received from nature. May our warriors, following the example of the Athenians, come to the tombs of our heroes who have died for their country, and there sharpen the iron destined to avenge them. Mothers shall bring their children, so that their hearts may early be formed by the sentiments of magnanimity and of courage, and like new Hannibals swear, from earliest infancy, an eternal hatred for the devastators of the world. . . .

It may seem strange to austere republicans that we occupy ourselves with the arts, while Europe in coalition assails the territory of Liberty. Artists do not fear at all the reproach of heedlessness of the interests of their country. They are free by their very nature. Independence is the property of Genius. Surely we have seen them, in this memorable Revolution, as the most zealous partisans of a regime which gives to man the dignity long refused by the class that was the protectress of the ignorance which flattered it.

We do not accept the well-known adage: 'At the rattle of arms the arts fall silent.'

More willingly we would remember Protogenes, tracing a masterpiece during the siege of Rhodes, or Archimedes meditating upon a problem during the sack of Syracuse. Such deeds have the sublimity of character which belongs to Genius; and Genius must always soar over France and raise herself to the level of liberty. Wise laws shall prepare her for new flights; the National Convention has just enlarged her field, she is now free at last. With enlightenment, Liberty is no longer bound. The Usurper alone fears this light. He commands us to forget science, but a free government encourages and honors it. A Decree of September 1, 1791, sufficiently proves that the legislators understood this eternal truth. But they desired that mediocrity, often reckless, not lay claim to national rewards where merit alone has place and that the artists, following the public judgment of their peers, be charged to produce works which are a part of the exhibition and for which the artists have been paid by the nation: these are the ones that are referred to under the title of Works Belonging to the Nation. The public will judge.

10 Jacques-Louis David (1748–1825) 'The Jury of Art'

With the abolition of the Academy and the Prix de Rome, there was now no formal mechanism for rewarding those French students who showed particular merit. On 15 November 1793 David presented to the Convention his recommendations for the composition of a jury to award prizes for competitions in sculpture, painting and architecture. The recommendations were accepted and the jury was duly assembled. No prize was awarded for sculpture. The prize for painting was awarded to a pupil of David's, for a work on the theme of *The Death of Brutus*. The *Rapport fait au nom du Comité d'instruction publique par David sur la nomination des cinquante membres du Jury* was printed in J.-L. Jules David, *Le Peintre Louis David 1748–1825*, Paris: Victor-Havard, 1880, pp. 149–51, from which the following translation has been made for this volume by Akane Kawakami.

Citizens,

In decreeing that those works of art entered into competitions for national awards be judged by a jury named by the Representatives of the People, you have paid homage to the unity and indivisibility of the Republic. You commissioned your Committee of Public Instruction to present you with a list of candidates; your Committee then considered the arts in the light of all the ways in which they could help to spread the progress of the human spirit, to propagate and pass on to posterity the striking example of an immense people's sublime efforts, guided by reason and philosophy, restoring to earth the reign of liberty, equality and the law.

The arts should therefore contribute forcefully to the instruction of the public, but through their own regeneration; artistic genius must be worthy of the people it enlightens; it must always walk in the company of philosophy, which counsels it with great and useful ideas.

For too long, tyrants, who fear the very image of the virtues, had encouraged licentious mores by enchaining even our thoughts; art served only to satisfy the pride and whims of a few sybarites gorged with gold, and despotic corporations circum-scribed genius in the narrow circle of their thought, proscribing anyone who came forward with pure ideas of morality and philosophy. How many nascent geniuses have been smothered in their cradles! How many have fallen victim to the arbitrari-ness, prejudices and passions of those schools that caprice and fashion perpetuated! Let us examine what principle should regenerate good taste in the arts, and from that we shall conclude who should be their judge.

The arts are the imitation of nature in those aspects of it which are most beautiful and most perfect; a natural sentiment in man attracts him to the same objective.

It is not only in charming the eyes that works of art have achieved their end; it is in penetrating the soul, in making a profound impression on the mind, like that of reality. It is then that the traits of heroism, and of the civic virtues, offered to the eyes of the people, will electrify their souls and bring forth in them the passion for glory, for devotion to the good of the nation. The artist, therefore, must have studied all the qualities of mankind; he must have a great knowledge of nature; he must, in a word, be a philosopher. Socrates, an able sculptor; Jean-Jacques [Rousseau], a fine musi-cian; and the immortal Poussin, tracing on his canvas the most sublime lessons of philosophy, are witnesses enough to prove that genius must have no other guide than the torch of reason. And if the artist must be imbued with these sentiments, the judge must be even more so.

Your Committee has decided that in this epoch of ours, when the arts need to be regenerated along with morality, to leave the judgement of works of genius to artists alone would be to abandon them in the rut of routine, the rut through which they once crawled on their knees, singing the praises of despotism. It is for the hardy souls, those who have a sense of the true and the great derived from the study of nature, to give a new impulse to the arts by restoring to them the principles of true beauty. Thus the philosopher, the poet, the scholar, that is, the man with a naturally fine sensibility in the different realms that make up the art of judging the artist, the student of nature, will be the most capable of representing the taste and knowledge of an entire people when, in the name of these people, the palms of glory are to be awarded to Republican artists. It is in accordance with these views that your

Committee has charged me to present to you the following list, to form the national jury of the arts.

Dufourny, member of the department;
Monvel, actor;
Fragonard, painter;
Fragonard, anatomist;
Julien, sculptor;
Pache;
Varon, man of letters;
David-Leroy, architect;
Fleuriot, assistant public prosecutor;
Pasquier, sculptor;
Rondelet, architect;
Topino-Lebrun, painter;
Cietty, artist;
Monge;
Naigeon, painter;
Balzac, architect;
Gérard, painter;
Lussault, architect;
Lebrun, man of letters;
Hazard, shoemaker;
Hubert, architect;
Belle, fils, painter;
Prud'hon, painter;
Haroux-Romain, architect;
Neveu, painter;
Thouin, gardener;

Bonvoisin, painter;
Dardel, sculptor;
Taillasson, painter;
Boichot, sculptor;
Lesueur, painter;
Dupré, engraver;
Ronsin, general commander of the
 Revolutionary Army;
Caraffe, painter;
Laharpe, man of letters;
Hébert, assistant prosecutor of the
 Commune;
Delannoy, architect;
Hassenfratz;
Chaudet, sculptor;
Lebrun, seller of paintings;
Cels, agriculturalist;
Poidevin, architect;
Michallon, sculptor;
Dorat-Cubières, man of letters;
Ramey, sculptor;
Laïs, actor;
Goust, architect;
Seguy, doctor;
Lesueur, sculptor;
Allais, architect.

Deputies:
Talma, doctor;
Desroches, painter;
Vic d'Azir, anatomist;
Merceray, engraver;
Michot, actor;

Arni, man of letters;
Dejoux, sculptor;
Boullé, architect;
Willemin, painter;
Toucaty, engraver.

11 Jacques-Louis David (1748–1825) Proposal for a monument to the French people

On 10 August 1793 David organized a fête of Republican Reunion on the first anniversary of the storming of the Tuileries, an event in which many citizens had lost their lives. Like other artists charged in later historical moments with propagandizing in the interests of the state, he tended to idealize the people in the image of a massive body. In the course of two sessions of the Convention that November he presented proposals for a giant monument to the French people, to be sited on the Ile de la Cité in Paris and to be erected on the rubble from dismantled royal monuments. (For more on the consequences of revolutionary iconoclasm see IVB13.) A competition would be held and judged in two stages, the first for the conception of the monument and the second for its execution. During the same month David was responsible for the design of a Festival of Reason in Paris. His proposals for the monument and the subsequent supporting decree were enshrined in the records of the Convention, though the project was never put into effect. The documents were reproduced in full in J.-L. Jules David, *Le Peintre Louis David 1748–1825*, Paris: Victor-Havard, 1880, pp. 154–8, from which the following translation, including David's editorial comment, has been made for this volume by Akane Kawakami.

The kings of yore, being unable to usurp the place of Divinity in the temples, took possession of the porticos; there they placed their own effigies, doubtless so that the adoration of the people would stop at them before reaching the sanctuary. It was thus that, accustomed to invade everywhere and everything, they even dared to compete with God for His incense.

You have overthrown the insolent usurpers; at this very moment they lie stretched out on the earth that they sullied with their crimes, objects of the laughter of the people, who have finally been cured of their long superstition.

Citizens, let us make eternal this triumph of reason over prejudice; let a monument raised in the heart of the Commune of Paris, not far from that same church which they had turned into their Pantheon, pass on to our descendants the first trophy erected by the sovereign people, in memory of their immortal victory over the tyrants; let disorderly piles of the truncated debris of their statues form a lasting monument to the glory of the people and to their debasement, so that he who travels through this new land with a didactic purpose, will say: 'I once saw kings in Paris, the objects of a humiliating idolatry; I went there again, and they were there no more.'

I propose to place this monument, composed of the broken-up pieces of these statues, on the square of the Pont-Neuf, and to seat above it the image of the giant people, the French People. Let this imposing image, imposing by its character of strength and simplicity, have *Light* written in large characters on its forehead; on its breast, *Nature* and *Truth*; on its arms, *Strength*; on its hands, *Labour*. Let there be placed on one of its hands the figures of Liberty and Equality, standing close together and ready to set forth into the world, proving to all that they depend wholly on the genius and virtue of the people. Let this image of the people, *standing upright*, hold in its other hand that true and terrifying truncheon, of which the ancient Hercules' club was but a symbol. Such are the monuments worthy of us; all those who have

worshipped freedom have erected them; not far from the battlefield of Granson, there lie still the bones of the slaves and tyrants who wished to suffocate Swiss liberty; they are *there*, raised up into a pyramid, to menace the foolhardy kings who would dare to violate the land of free men.

Thus, in Paris, the effigies dreamt up and deified by royalty and superstition over a period of 1400 years will be made up into rough piles and serve as pedestals for the emblem of the people.

Following this speech, the Assembly adopted the proposal presented by David, barring some editing; on 27th Brumaire, the project, edited thus, was submitted to the Convention:

Citizens,
You have recently decreed that there be erected a monument to the glory of the French People, a monument which will pass on to farthest posterity the memory of its triumph over despotism and superstition, the two cruellest enemies of the human race.

You have given your consent to the idea of building a foundation for this monument out of the debris of the double tyranny of kings and priests.

When I explained to you that the Parisian authorities had taken down from the raised section of the portico of this church, this church which has now become the temple of Reason, the long line of kings of all races, who still seemed to reign over the whole of France; when I explained this to you, you decided, together with your Committee of Public Instruction, that these worthy predecessors of Capet, who had until this very moment escaped the law with which you struck down royalty and all that reminds us of it, should undergo, in the form of their Gothic effigies, the terrible and revolutionary judgement of posterity. You decided that their statues, mutilated by national justice, could for the first time today serve the cause of liberty and equality by becoming the foundation of the monument suggested to you by patriotism; you thought that the National Convention of France, penetrated by the greatness of its mission, and of the epoch in which Fate has placed it, should hold up the torch of Reason at its proper height and let it shine forth in all its splendour; finally, you decided that this Assembly, in the impetuous torrent of its liberating energy, should free the present, the future, even the past; complete its task of clearing France's name of the opprobrium of a long slavery, inasmuch as it is still possible to free even our ancestors, that is to say to plant the tree of liberty on their tombs, and above all to obliterate from their white hairs the images of their oppressors.

The idea of the monument seemed to you, Citizens, to be great and useful; the opinion that you formed of it became for you yet another motive for giving to this idea all the support that it could receive from patriotic enthusiasm; it was for this purpose that, having decreed that the monument be erected, you ordered your Committee of Public Instruction to examine the means of its execution. It is the result of this examination, for which the Committee enlisted artists as enlightened as they are patriotic, that I bring to you in its name.

Your Committee was of the opinion that everything in the proposed monument, both in the material and the form, should express the great memories of our revolution in a forceful yet sensitive fashion, and especially to consecrate the victory

of the French People over despotism and superstition, its inseparable companion; that the people, trampling underfoot the debris of tyranny, should be represented by a colossal statue in bronze, carrying various inscriptions and emblems destined to remind us of the regenerative principles that we have made our own.

With regard to the material for the statue, we hesitated for a moment to deprive the Republic of a precious metal necessary for its defence, a metal intended to bring terror and death to the enemy ranks; but having made some calculations concerning both the period in which this project, after a double competition, could definitively be executed, and the infallible and glorious result of the courage of your Republican legions, the Committee concluded that bronze would do honour both to the artists and to your glory; it did not allow itself to doubt for a moment that the intrepid French soldiers would bring you a sufficient quantity of it for the construction of the monument; it felt that it was equally worthy of those who represent the country as of those who defend it, to set your brave warriors the task of obtaining all the necessary bronze from the allied despots.

It is up to each one of our Republican armies, each one of our soldiers in the armies, to work together towards this monument and to co-operate through their generous efforts: *it will represent a proportion of all the victories.*

This statue that you will raise to the French People, Citizens, will in some way make our glory one and indivisible like the Republic itself: each citizen, each defender of the nation, will be able to see in it an honourable monument to his courageous and patriotic perseverance. A bundle, which brings together disparate parts, is a symbol of union; the statue, through fusion, will be the symbol of unity; at the same time it will be, dare I say it, its guarantee and its means of conservation.

If it is the task of courage to furnish the material of the monument, it is the task of artistic and patriotic genius to imprint upon it form and life.

Since it is a kind of representation of the nation, it is not possible for it to be too imposing or too beautiful. To this end every Republican artist must be called upon, only too happy for this new occasion to repair the wrongs of the arts, which have too often comforted tyranny.

A competition must first be set up for the model. Working on the premises offered to them by the decreed project, the artists will give life to their subject through adornments suggested to them by their imagination, a suitable attitude and character, and the choice of forms that are both calm and bold.

But he who has the best idea is not always he who will execute it best. Genius conceives rapidly, the instant of creation is imperceptible, it is a flash of light, a sudden illumination. In its execution, by contrast, what is needed is a continuous ardour, a passionate slowness, an enthusiasm fixed by patience, which will often spend six months rendering faithfully the idea of a moment. The talent for execution must therefore be inflamed by a second competition set up solely for this object: this is also the recommendation of the Committee of Public Instruction.

But in the second competition, the number of participants will be limited by the Committee to the four artists who will have been most successful in the first competition for the model. To judge their merit in execution, they will be called to execute a certain part of the monument; this part will be determined by one of the articles of the project that we submit to you, and it will suffice to reveal the talent of

the artists. The one who is most successful in this work will definitely be chosen to execute the statue. As these attempts will require of those artists who are not ultimately victorious a sacrifice of time and payment, it has seemed just to your Committee to promise these artists an indemnity which will compensate them honourably for this sacrifice.

These, Citizens, are the thoughts of your Committee of Public Instruction on this subject. I feel that I ought to end this report on a point of instruction, one which your wisdom and patriotism cannot fail to appreciate: slaves did everything for the tyrants; the genius of liberty should do everything for the people.

Decree

FIRST ARTICLE. – The people have triumphed over tyranny and superstition; a monument will consecrate this memory.

ARTICLE II. – The monument will be colossal.

ARTICLE III. – The people will be represented by a statue.

ARTICLE IV. – Victory will furnish the bronze.

ARTICLE V. – It will hold in one hand the figures of Liberty and Equality; it will lean, with the other hand, on its truncheon; on its forehead will be the word Light; on its breast, Nature and Truth; on its arms, Strength; on its hands, Labour.

ARTICLE VI. – The statue will be 15 metres or 46 feet tall.

ARTICLE VII. – It will be erected on the debris of the idols of tyranny and superstition, built up to create a foundation.

ARTICLE VIII. – The monument will be erected at the westernmost point of the Ile de Paris.

ARTICLE IX. – The nation calls on all the artists of the Republic to present, within two months, models which will give an idea of the form, the attitude and the character of this statue, following the decrees which will serve as a plan.

ARTICLE X. – These models will be sent to the Minister of the Interior, who will deposit them in the Museum, where they will be exhibited for twenty days.

ARTICLE XI. – A jury, nominated by the Assembly of the Representatives of the People, will publicly judge the competition, in the ten days following the exhibition.

ARTICLE XII. – The four competitors who are most successful in the competition will compete with each other for the execution.

ARTICLE XIII. – The statue, made in plaster or clay in the proportions prescribed by Article VI, will be the required test for the second competition.

ARTICLE XIV. – A new jury will pronounce publicly on the result after an exhibition lasting twenty days.

ARTICLE XV. – He who wins the prize will be entrusted with the execution.

ARTICLE XVI. – The other three competitors will be indemnified by the state.

ARTICLE XVII. – The declaration of rights, the constitutional Act engraved on steel, the medal of 10 August and this decree will be deposited in the truncheon of the statue.

ARTICLE XVIII. – This decree, as well as the report, will be inserted in the Bulletin and sent to the armies.

12 Jacques-Louis David (1748–1825) Project for the apotheoses of Barra and Viala

In April 1794, as the Terror intensified in Paris, the ashes of Jean-Jacques Rousseau were moved to the Pantheon to join those of Voltaire, installed three years before. In June Robespierre instituted a Festival of the Supreme Being in celebration of the revolutionary religion by which the people were to be bound together. David was responsible for the design of the programme. This involved the construction of an artificial mountain and the orchestration of mothers and daughters on one side, fathers and sons on the other. For the following month David proposed a further festival to serve as a commemoration and apotheosis of two young 'martyrs of the Revolution', Barra and Viala. (His unfinished painting of the former is now in the Musée Calvet, Avignon.) On acceptance of the proposal by the Convention it was decreed that it should be printed and that copies should be circulated to Convention members, to primary schools, to popular organizations and to the armies of the revolution. This was to be the artist's last initiative on behalf of the revolutionary regime, and it came too late to be put into effect. During the same month Robespierre fell from power. His execution followed on the day before the proposed fête. As a close associate, David was also arrested and was imprisoned for two separate periods between August 1794 and August 1795. He was fortunate to escape with his life. A year later a decree was promulgated forbidding the use of the word 'revolutionary' in reference to the government. David's proposal is printed as *Plan de la Fête qui aura lieu le 10 Thermidor* [28 July] *pour décerner les honneurs du Panthéon à Barra et à Viala*, in J. -L. Jules David, *Le Peintre Louis David 1748–1825*, Paris: Victor-Havard, 1880, pp. 149–51, from which the following translation has been made for this volume by Akane Kawakami.

At three o'clock in the afternoon, an artillery salvo will be discharged from the easternmost point of the Ile de Paris; this announces the beginning of the ceremony.

The people immediately assemble in the National Garden; the members of the Convention make their entry into the amphitheatre, attired in their official garb as Representatives of the People; each member carries in his hands the symbol of his mission. They are preceded by martial music; the musicians sing a refrain mirroring the spirit of the occasion.

After the song, the President of the Convention ascends the tribune and delivers a speech in which he describes to the people the heroic traits of Barra and Agricol Viala, their filial piety; in a word, the reasons for which they have been deemed worthy of the honours of the Pantheon. He then hands the urn containing Viala's ashes to a deputation of children, selected from all the sections of Paris and of the same age as our young Republicans, that is to say between 11 and 13 years old.

The mortal remains of Barra, sealed in the other urn, are to be put into the hands of the mothers whose children have died gloriously in defence of our liberty: it will be the task of these respectable Citizens, also from the different sections of Paris, to carry the precious remains, an eternal pledge of the filial tenderness which this heroic child demonstrated so perfectly.

At precisely five o'clock, a second artillery salvo is heard. The deputations of mothers and children begin to march, divided into two columns. The procession is preceded by a large number of drums, whose lugubrious and majestic sounds are

expressive of both the movement and emotion of a great people assembled for this most august of ceremonies.

Each column is to be headed by paintings of Barra and Viala, depicting their actions.

The column on the right will consist of the deputations of children; that on the left, of the deputations of mothers.

The space in between the columns will be occupied by artists of the theatre, arranged in six groups, which will process in the following order:

The first group is to consist of instrumental musicians, the second of male singers, the third of male dancers, the fourth of female singers, the fifth of female dancers, the sixth of poets who will recite verses composed by them in honour of the young heroes.

Next follow the Representatives of the People, surrounded by courageous soldiers, wounded in the defence of their country. The President of the Convention gives his right hand to one of them, who has been chosen by lot, his left hand to the mother of Barra and her daughters.

The people bring up the rear of the march.

From time to time, there will be a funeral drum roll, and the music will wail. The singers will express our grief in plaintive tones, the dancers with lugubrious or warlike mime.

Suddenly, everyone stops; all is silent; all at once, the people raise their voices in unison and cry out three times: *They have died for their country*.

On arriving at the Pantheon in this order, the two columns will group themselves into two semicircles, in order to leave a space in the centre through which the members of the Convention will pass to take their places on the steps of the Temple. The children, musicians, male singers and dancers, and poets will stand on the side of Viala; the mothers, the women singers and dancers on the side of Barra.

In the meantime, the two urns are to be placed on an altar erected in the middle of the square. Around this altar, the young female dancers will perform funeral dances expressive of deepest grief; they will scatter cypress branches on the urns. At the same time, the musicians and the singers will deplore, through their music, the ravages of fanaticism which have deprived us of these young Republicans.

The cries of grief are followed by a new silence. The President of the Convention steps forward, kisses the urns, and, raising his eyes to the heavens, proclaims in the presence of the Supreme Being and of the people that the honour of immortality be bestowed upon Barra and Agricol Viala. In the name of the grateful nation, he places them in the Pantheon, whose doors are thrown open at this instant.

Suddenly, everything changes; grief disappears and is replaced by public rejoicing, and thrice the people let loose this cry: *They are immortal!*

The great bell booms, and the games commence.

The drums make the very air resound with their warlike rumblings, the female dancers, dancing joyously, scatter flowers on the urn, covering up the cypress branches. The male dancers strike martial attitudes to the accompaniment of the music, celebrating the glory of the two heroes; the poets recite verses in their honour, and the young soldiers display their military flourishes.

The President of the Convention steps forward into the crowd; he gives a speech, after which the mothers carry Barra's urn into the Pantheon, and the children that of Viala.

The President closes the doors of the temple, and gives the signal to depart. The same order is observed for the departure as for the entrance.

Upon arriving at the National Garden, the Convention takes up its place again in the amphitheatre; the President gives another speech, in which he recounts to the mothers the lessons of virtue with which they are to inspire their children from an early age, so that one day they too may be worthy of the glorious honours that the nation has just bestowed on Barra and Viala. He exhorts the young soldiers to avenge their death swiftly, and to show themselves to be, like them, ever ready to devote themselves to the defence of the nation.

The people end this memorable and moving ceremony with repeated cries: *Long live the Republic!*

The Committee of Public Instruction is charged with the execution of the fête.

13　Alexandre Lenoir (1761–1839) Foreword to the 'Historical and Chronological Description of the Monuments of Sculpture'

In November 1789 the French Church was nationalized by the revolutionary government. The closure of the religious houses followed. In 1790 the revolutionary Commission des Arts established that confiscated objects should be housed in Paris in the Hôtel de Nesles and the former convent of the Petits Augustins. Alexandre Lenoir was appointed keeper of the latter depot in June 1791 and set about making inventories of paintings and statues as they arrived. In the same month it was decreed that objects of value should be sold and metal objects melted down. Though the decree was not to be put into systematic effect, revolutionary iconoclasm led to the partial or wholesale destruction of a large number of monuments, statues and tombs. On his own account Lenoir worked heroically to salvage what he could, Michelangelo's two *Slaves* among them (now in the Louvre). He was also increasingly motivated by his desire to assemble a survey of monumental sculpture and religious art from the Middle Ages to the recent past, along chronological lines influenced by his reading of Winckelmann's *History of Ancient Art* (IIIA8). In 1795 he was officially appointed 'Conservateur' of what a year later was to be named the Musée des Antiquités et Monuments Français. Under the circumstances of the time no clear line distinguished salvage from appropriation, and by one means or another, latterly by purchase and exchange, the collection grew from 250 items recorded in 1793 to the several thousand which the museum housed by the time of its dissolution in 1816. Once the Terror was over and a measure of stable government had been restored, travellers from all over Europe visited Lenoir's museum. His installations were influential in two important respects. In arranging the assembled artefacts in separate areas by centuries, he initiated the tradition of organizing artefacts into period rooms which was thereafter to be widely followed in major museums of the fine and decorative arts; and in grouping a number of removed and reconstructed tombs in a 'Jardin Elysée', he provided an ideal location for the meeting of sculptural interests with romantic antiquarianism. Lenoir was also responsible for a considerable programme of publications. The first of these to be started was the four-volume *Description historique* of 1795–1806. A catalogue in five volumes was issued between 1800 and 1805, the first being translated into English in 1803, and a historical survey of

sculptures and tombs in 1810. There were studies of painted and stained glass, and of Egyptian hieroglyphs, and an engraved volume of decorative arabesques. The museum had its opponents, among them Quatremère de Quincy and Chateaubriand, who each for their separate reasons argued against the displacement of the monuments from their original locations. After the restoration of the monarchy Louis XVIII decreed that objects taken from French churches should be restored, and the museum was closed. The principles underlying its organization were to be pursued when Alexandre du Sommerard opened his collection in Paris in 1832 in what was to become the Musée de Cluny. Lenoir's 'Avant-propos' was originally published in *Description historique et chronologique des Monumens de Sculpture, réunis au Musée des Monuments français*, volume 1, Paris: Musée de Monumens, 1795. Our excerpt is taken from the fourth edition, revised and corrected, 1797, pp. 1–17, translated for the present volume by Jason Gaiger.

The culture of the arts amongst a people increases its commerce and its resources, purifies its morals, and renders it more gentle and pliant in following the laws which govern it. Convinced by this maxim and having decreed that the possessions of the clergy belonged to the *public property*, the National Assembly charged its committee of alienation to oversee the conservation of those monuments of the arts which were contained within these domains. 'The Athenians found themselves in more favourable circumstances. After the expulsion of the tyrants they changed their form of government and declared a democracy. Henceforth all of the people participated in public affairs, the character of every inhabitant grew stronger, and Athens was raised above all the other cities of Greece. Good taste having become universal and the wealthy citizens having attracted the esteem of their fellow citizens by erecting superb public monuments, all the different talents flourished at one and the same time, just as many rivers flow into the sea. The arts were joined to the sciences which formed their centre, and it was from here that they spread out into other countries. The prosperity of the state was the principal cause of the progress of taste. Florence attests to the truth of this proposition in modern times: once it became wealthy this city saw the shadows of ignorance disappear and the arts and sciences flourish.' (Winckelmann, *History of Ancient Art*, volume 1).

The philanthropist, La Rochefoucauld, president of the aforesaid committee, selected a group of learned individuals and artists whom he united under the title of the *Commission des savants*. This commission distinguished itself by its assiduous labours, by the number of its inquiries and, soon enough, by the quantity of monuments which were transported and preserved in the building in the rue des Petits-Augustins which the commission had chosen to receive them. The National Convention also gave proof of its love for the arts by making several decrees in their favour. Its Committee of Public Instruction created a commission formed of men of letters and artists of different kinds, distinguished by their work, to oversee the conservation of artistic monuments. This esteemed group of individuals soon produced a considerable number of memoranda, petitions and reports which brought reason to the departments and succeeded in arresting the arm of that idiocy which was toppling statues, tearing up the most precious paintings and melting down the most beautiful bronzes.

In 1790 I was charged with the administration of the depot at Petits-Augustins. This became a place of asylum for the monuments of our history which, at certain

periods, barbarians have pursued with axes in their hands. I was fortunate to be able to take in a large number of these monuments. I obtained from the Committee of Public Instruction, and then from the Ministry of the Interior, permission to establish the depot as the Museum of French Monuments. This was organized under the dual aspect of history and of the history of art in respect of France. It is with gratitude that I mention here the Director of Public Instruction (Citizen Ginguené) whose kindness has been of great help to me in establishing this museum, which I have sought to classify in a methodical way, since this alone is useful for study. His intelligence and his love for the arts are unequivocal and his goodwill towards artists is boundless. It is undoubtedly the case that if the services which the present government and its administration have rendered to the arts and sciences over the last three years are examined impartially and compared with those of the regime which is not missed, we will no longer be embarrassed to have to judge which way the balance will tip.

How great will be the astonishment of people from abroad when they see how many precious objects have been preserved and that in one and the same place it is possible to move successively from one century to another. The Museum of French Monuments has been erected under the auspices of a government which is devoted to the arts and to the prosperity of the people. Despite the envy and jealousy of others, it has been given a form which is useful; and with the greatest economy, I have succeeded in rebuilding and restoring more than 200 monuments. Already three centuries have been finished, each with their own respective rooms fitted with the features appropriate to each century. These are the XIIIth, the XVIth and the XVIIth centuries. At present I am working on the XIVth and the XVth centuries, and for the last three years the museum has remained open permanently to students and lovers of the arts. I have just augmented the collection, which is unique in Europe, with a burial chamber in which the tomb of the Restorer of letters and of the arts, erected in 1550, has been restored under my direction. [...] The chamber has been constructed with freestone in accordance with the architecture of the time, by Citizen Peyre, the architect ... He has been charged with ensuring that the construction remains solid and with verifying the accuracy of the reports. The erection and the location of the monuments is carried out in accordance with my designs and under my direction. Since the distribution of the different locations, the colours and all those things which give to each century its proper character are the object of my special attention, this artist is obliged to consult me on this aspect of his work. Such an agreement serves the general good.

Certain reasons, which I could publish if necessary, have led me to confirm in writing these facts concerning the history of the museum. If one were obliged to read or to listen to the projects and plans of the innovators which emerge in a government, nothing would ever get finished. The mania for novelty and the spirit of versatility which for too long have governed the arts is the reason why so many of our public monuments have yet to be completed. Life passes with the rapidity of a river and the public good that an honest man can achieve in a short period of time offers gentle consolation to his soul.

* * *

It is this chronological sequence of statues in marble and bronze, the bas-reliefs and the tombs of famous men and women – monuments which have escaped the axe of the destroyers and the scythe of time – which I propose to describe in this work. I have also added an exact description of the antique monuments which no longer belong to this museum, which is given over exclusively to French monuments, and which have recently been returned to their respective museums. These include statues and bas-reliefs from which I have drawn archetypes to be placed in a special room devoted to the chronology of art, which I consider the principal foundation of my work. This precious continuation of the museum is composed of an Egyptian monument seen from two sides, a series of antique tombs brought to France by Ambassador Nointel, who travelled to Greece and its archipelago on behalf of Louis XIV, and several antique statues which Robert Strozzi gave to François I.

In the first part of the *Museum of French Monuments*, I give a description of the monuments of ancient Gaul, followed by those erected to the kings of the first race, such as those of Dagobert, Clovis, Fredegond, Childebert, and so forth.

Continuous wars and ignorance have left a long interval in the culture of the arts. We will pass on to the thirteenth century when timid artists, servile copiers of nature and of the costumes of the time, began to establish some sort of unity and to give form to their statues. Here we find the origins of Moorish architecture in France, introduced after the Crusades.

The fourteenth century witnessed the interesting monuments to wise Charles V, to the good constable (Duguesclin), to the brave Sancerre, to Isabeau de Bavière, and so forth.

The tombs of Orléans, of Juvenal des Ursins, of Philippe de Commines, of Pierre de Navarre and of Tannegui du Châtcl form the introduction to the fifteenth century.

The second part is composed of monuments from the sixteenth century through to the beginning of the nineteenth.

Before François I created the arts in France, our school was plunged into the most hideous barbarism. Painting and sculpture were already flourishing in Italy; and Albrecht Dürer had founded a school of art in Germany whilst we were dominated by superstition and did not dare even to draw a line. On the tomb of Louis XII we find the beginnings of worked-out forms and of good taste. Next comes that of François I, who established the first epoch of the restoration of the arts in France. The monument erected by Catherine de Médicis to the Valois family, carried out by Germain Pilon after designs by Philibert de l'Orme, also represents a great achievement.

You, Gougeon and Cousin, worthy founders of the French school, you too helped the arts to develop, and the erection of your tombs is a debt that I would like to pay to the centuries to come. These monuments have been executed according to my plans and designs along with a large number of other monuments which are kept in this museum, which I was obliged to rebuild and to adapt according to their age because of the terrible mutilations which they had suffered.

Without doubt, a benevolent genius gave birth to the seventeenth century for the honour of the French nation: warriors, poets, statesmen, painters, sculptors and engravers all marched in the same rank towards immortality. Undoubtedly we will recover with interest the monuments of Richelieu, Mazarin, Turenne, Condé,

Bignon, Lully, Le Brun and Mignard, and the statues of Le Sueur, Sarrazin, and Pujet, and of Nicolas Poussin, the painter of poets and of philosophers.

The eighteenth century, too, has its own particular character and although its art degenerated somewhat through the introduction of a false taste, it presents features which are of interest to the historian. Costou, Bouchardon, Lemoine and Pigalle have left us monuments which remain of interest for the persons they represent and it will undoubtedly be with pleasure that we see Crébillon, Maupertius, Chevett and Caylus adorn our collection.

Oh Drouais! son of an estimable artist, you too render your century illustrious! You no longer live to contribute to the arts, but you have left your name to posterity and your *Woman of Cana* and your *Marius*. Yes, your tomb will honour this work and those who are sufficiently sensitive will recognize the friendship which guides its author.

The third and last part of the work offers a historical dissertation on painting on glass and a chronology of the principal stained-glass windows which have been made since the origin of this art, especially those made after designs by Raphael, Primaticcio, Albrecht Dürer, Jean Cousin, the Belgian Elia and so forth.

Lovers of art and letters should hope to find in this collection several monuments from our history scattered throughout the departments, which until now it has been impossible to preserve from the mutilations of time and of ill-will.

* * *

At this time, a peace which is glorious for the French Republic is in the process of reuniting all the peoples of Europe under the sanctuary of liberty (France) and which leads those who admire the arts to our great city. It has become a duty on those who cultivate the arts to exert themselves to make their studios active and to give a new life to their work which can only be advantageous to society and which must necessarily honour a great nation and stimulate trade. [...]

An Elysium seemed to me to suit the character which I have given to this establishment, and the garden in the courtyard offered everything I needed to carry out my project. In this calm and peaceful garden more than forty statues can be seen; tombs placed here and there upon a green lawn stand with dignity in the midst of the silence and tranquillity. Some pines, some cypresses and some poplars keep them company; funerary urns placed upon the walls give to this place of happiness that sweet melancholy which speaks to the sensitive soul. Finally, there is a stone, a fragment of the tomb of Héloïse, on which I have had engraved the names of this unfortunate couple; there are the cenotaphs and the reclining statues of the good Constable and of Sancerre, his illustrious friend; further back a vase atop a column contains the heart of Jacques Rohault, worthy rival of Descartes. Next to the heart of this philanthropist is the touching and modest epitaph of Jean-Baptiste Brizard, the favourite of Melpomene who made the French stage popular.

In this work you will find careful engravings of the most interesting points of view which give onto this Elysium.

Part V
Nature and Human Nature

V
Introduction

The closing decades of the eighteenth century formed a period of transition, marked above all by the final stages of the European Enlightenment and by the impact of the American and French Revolutions. Enlightenment confidence in the power of reason, the inevitability of historical progress and the universality of the ideals of freedom, tolerance and rational perspicuity gave way to an increasingly self-critical and self-reflective tendency. This should not be understood to mean that the Enlightenment was in any sense complete or that its goals and aspirations had been fulfilled. Rather, the fundamental values and assumptions underlying the very project of Enlightenment were increasingly subject to question. This process of revision was given powerful impetus by the French Revolution. Much of the revolutionary rhetoric was drawn from Enlightenment ideals of popular sovereignty, equality before the law and freedom from arbitrary abuse of power. As the Revolution descended into the Terror, and as the revolutionary wars spread to neighbouring states, the legitimacy and practical application of these ideals were cast into doubt. By 1793 France was at war with Britain, Austria, Prussia, the Dutch Republic, Spain, Portugal and the Kingdoms of Sardinia and Naples. In 1792 French armies had invaded the territories of the Holy Roman Empire, and by the end of 1794 all of Germany west of the Rhine was under French rule. Though the French forces thought of themselves as 'liberators', freeing oppressed peoples from the burden of aristocratic rule, they appeared to the victims of military conquest as unwanted invaders whose real goal was the territorial extension of a French empire.

Many early supporters of the Revolution came to reconsider their views when faced by the turmoil that followed. During September 1792 over a thousand people were killed at the hands of the crowds, and during 1793 revolutionary violence became incorporated into the apparatus of state power. Special courts were established to try those suspected of disloyalty. It has been estimated that between 11,000 and 18,000 people died in France in the period now known as the Terror, up to the fall of Robespierre in the summer of 1794. News of these events had a marked effect on the support for the Revolution among foreign radicals. In England, Coleridge abandoned his Jacobinism and subsequently turned back to religion, whilst Wordsworth was disappointed in his early hopes for social and political justice (see VIA5, 6, 11).

In Germany, Friedrich Schiller (see VA12 and 13) initially welcomed the Revolution as the practical instantiation of the ideas of the *philosophes*, as did many of his contemporaries. However, he subsequently declared himself 'sickened by these abominable butchers' and feared that the events in France would plunge Europe back into 'barbarism and slavery'. He saw the violence of the Terror as a symptom of the failure of the Enlightenment. It showed that the education of reason alone was not sufficient to ensure humanity's progress to moral and political freedom. The 'urgent need of the age' was the 'development of man's capacity for feeling'. By pitting duty against inclination, the Enlightenment had created a disastrous separation between the demands of rationality and of sensibility. Schiller's radical solution to this problem was to propose the 'Aesthetic Education of Man' as the means to reconcile the divided aspects of human nature. (Though the German *Mensch* of Schiller's original title is normally translated as 'Man', its reference is to human beings in general, and not specifically to the male sex.) It is only through beauty that true freedom can be realized since beauty alone provides a *sensuous* image of human freedom and wholeness. Similar thoughts are echoed by the author of the 'Earliest System Programme of German Idealism', who contrasts the 'mechanical' character of the state with a living ideal of genuine 'humanity'. For Hegel, the presumed author of this fragment, 'the highest act of reason . . . is an aesthetic act and . . . *truth and goodness only become sisters in beauty*' (VA15).

An earlier expression of protest against the perceived deficiencies of the 'age of reason' is to be found in the *Sturm und Drang* (Storm and Stress) movement in Germany. Taken from the title of a play by a now-forgotten author, the term 'Sturm und Drang' has come to stand for the new spirit of exuberance and extravagance which flourished in German literature in the brief period from 1771 to 1778. Through a series of literary and theoretical writings, Johann Gottfried Herder (VA7), the young Goethe (VA4 and VB7) and others developed a powerfully anti-rationalistic aesthetic. In opposition to the prevailing spirit of classicism, they exalted the freedom of individual and national 'genius' to break with fixed rules and conventions, emphasizing all that is 'sensuous, vital, powerful, immense, tangible and independent'. The true model for artistic creativity is to be found in the creativity of nature herself. Karl Philipp Moritz was later to claim that the beauty of the work of art should be seen as a microcosm of the rationally ordered whole of nature (VA9). The 'Sturm und Drang' also led to the 'discovery' of indigenous folk songs and poetry, which were valued for their apparent spontaneity and immediacy. In an essay on Strasbourg cathedral, published in the movement's 'manifesto', *Von deutscher Art und Kunst*, Goethe sought to awaken appreciation for the Gothic art of his own country, identifying it with the expression of *feeling* rather than calculation (VA4).

Despite these heady declarations of artistic freedom, the reality for most practising artists in the last decades of the eighteenth century was one of dependence upon the wishes of noble patrons or, if they chose the path of independence, of exposure to the inconsistencies and insecurities of the open market. It was still a hazardous enterprise to seek to support oneself through the sale of works of art and there was a genuine risk of falling into penury. Thomas Gainsborough was obliged to neglect his landscape studies for the more profitable business of 'face painting', or portraiture. As his

letters reveal, he was heavily dependent even here upon the wishes of his patrons (see VA1). In the case of the German artist Asmus Jacob Carstens, an irreconcilable clash of views followed from his belief that his obligations to art and to humanity took priority over the requirements of his paymasters in the royal household of the Prussian state (VA14). Despite the receipt of a stipend which funded his studies in Rome, he insisted upon the right to retain and to display his work as he wished. In asserting the moral independence of the artist's role, Carstens took support from the ideas of Immanuel Kant (VA8 and 10), to which he had been introduced by his friend and biographer Carl Ludwig Fernow (see VIIA6). However, if one's point of departure was Kant's formal analysis of those powers of the mind which constitute genius, some distance still remained to be travelled before one arrived at social and economic conditions granting full freedom of self-expression to artists.

It was both a symptom and a consequence of the secularization of art during the later eighteenth century that claims for the independence of the artist's practice tended to coincide with appeals to the natural world. With increasing emphasis, notably in Germany and in England, nature was regarded both as a source of significant motifs and as the final arbiter of art's moral value. Under these circumstances discussion of landscape served to focus debate both about the artist's role in the representation of the natural world and about the aesthetic properties of natural scenery. In their separate ways, Salomon Gessner (VB3) and Thomas Gainsborough (VA1, 2) both worked to establish landscape painting as a branch of art capable of conveying significant content. There was considerable variance in the styles of work that developed in separate European countries, as might be expected given that the respective artists were working under very different circumstances, both geographically and culturally. On the other hand, there was some exchange of ideas through the circulation of translations. Gessner's writing was well known in England in the early nineteenth century, and was studied by John Constable among others, while the taste for rustic scenes that Gainsborough did much to establish was transmitted to both French and German readers through versions of William Gilpin's essays (VB2, 11).

The art of landscape served as the focus for one particular issue that was to remain central to art-theoretical debate through the entire modern period. It concerned the relationship between responses to nature and responses to art. Among German writers, this issue was typically addressed through argument about the possibility of a moral response to natural scenery. Thus Sulzer argued that landscape painting was capable of eliciting ethical responses not only through the artist's insertion of moralizing elements, but because natural scenery could itself be morally elevating (VB6), a view which Goethe opposed on the grounds that nature has no moral aspect (VB7). In England debate focused on the nature of the Picturesque, a concept given particular currency by Gilpin. His argument was that the distinction between the Sublime and the Beautiful as advanced by Burke (IIIB6) was insufficient for the purposes of aesthetic categorization, since it failed to recognize that, while a particular motif might appear neither Sublime nor Beautiful, it might yet be highly suitable as material for an artistic picture. The idea of the picturesque was in turn referred back to the natural landscape (VB5). Scenery was self-consciously viewed for its potential to generate pleasing pictures, and differences of taste in pictures became

implicated in exchanges between members of the English landed gentry, who argued over the best means to 'improve' their estates (VB13–15).

The debate over the picturesque generated a considerable literature and provided some rich material for satire (VB19). Yet at the heart of both English and German writing on the relationship of art to nature there lay the same fundamental issue. On what basis was the value of artistic representations to be established, and how great a degree of autonomy was to be accorded to their emotional effects? In the principally French theory of the early and mid-eighteenth century, the concept of the 'tableau' had served to mark a requirement of formal virtue in composition, more or less independent of any moral content that might be conveyed by subject-matter (see IIIC4). In other words, a painting could in principle be assessed as a good or bad composition, irrespective of its particular narrative or moral content. For Reynolds the capacity to abstract general principles from painted particulars was the sign of a properly qualified public (IVA7, 8). In practice, however, it was virtually assumed by all concerned that a 'tableau' deserving of the name would be instilled with some elevated theme – that it would not merely serve to reflect a given natural scene. But what was now at issue was whether the merit of a painted landscape was dependent ultimately upon the scene it pictured, or whether its virtue might be said to reside in its own achieved effects (VB11). A discourse surrounding what has subsequently come to be termed the 'autonomy' of art thus preceded the relevant application of the concept. The central issue at stake was nonetheless the degree of independence to be accorded to artistic effects, and the extent to which these could be considered in abstraction from any edifying content.

Whatever might have been the merits of the case for art's independence in this respect, we should note one significant implication of its being advanced at all. So long as the value of art was inextricably connected to the themes it illustrated, effective authority in aesthetic judgement was always liable to lie with a constituency competent in the relevant areas of reference, whether a religious authority versed in the scriptures, an aristocracy versed in the mythology of its own lineage, or an educated nobility versed in the classics. But if art was to be measured in terms of its emotional effect, then any sensitive subject could in principle claim to be a competent judge – so long, that is, as they had leisure to devote to the experience (see Alison, VA11) and could find words in which to communicate the effect in question.

Major cultural developments tend to entail significant changes in the relationship between art and its audience. Since the mid-seventeenth century the development of a literate middle class in Europe had been a factor of growing influence in the development of artistic culture. In the second half of the eighteenth century the modern form of art's relationship to its audience finally came to dominate in the cultures of the principal European countries. One telling expression of this relationship was the growth of a market in which works of art could be traded as commodities. Another was the growth of a sophisticated aesthetic literature addressed primarily to the emotional effects of works of visual art, rather than to their religious or historical or mythological references. It was in its capacity both to make significant choices between comparable goods and to articulate a range of emotional effects that the constituency in question established its distinctive competences.

In doing so, that constituency marked the clear alignment of its interests with those basic material and economic forces which bore directly upon the circumstances and character of modern artistic production. These were such as to reveal a growing contradiction between the traditional values cited in support of art's cultural standing and the actual conditions under which works of art were now produced and paid for. However central Christian mythology remained to notions of elevated subject-matter, the Church was virtually inconsiderable as a source of patronage in late eighteenth-century France, Germany and England, while however determinedly the status of history painting was upheld in the academies, it formed only a small percentage of the wares on show in their exhibitions and had little effective presence in the market-place. As Gainsborough knew only too well, the one secure means for a painter to earn a living was through commissions for portraits. Insofar as the painter could afford to work speculatively, it would make sense to concentrate on relatively modest and portable pictures which might attract in an increasingly open market by virtue of their decorative properties. It would also make sense to ensure some accompanying written justifications. As might be expected under these conditions, the artists themselves were among those who argued for the relative independence of artistic value. Though it would be some time before these arguments were taken to their logical conclusion, there is a clear sequence of developments connecting late eighteenth-century debates over the picturesque to the theoretical justifications of abstract art, and to the formalist tendencies of twentieth-century art criticism.

VA
The Human as Subject

1 Thomas Gainsborough (1727–1788) Letters

Along with Reynolds, Gainsborough was one of the two most significant English artists of his time. In many ways they form a contrasting pair. Where Reynolds was intellectual, elevated and academic, Gainsborough's approach leaned more to the spontaneous and informal; where Reynolds composed the *Discourses* which are a cornerstone of academic art theory, Gainsborough left nothing except letters to friends and patrons. He is said to have loved music and disliked reading. Nonetheless, the letters reveal an acute consciousness that is by turns charming, witty and self-deprecating, and very down-to-earth about the practical business of making art. Gainsborough is known both as a landscapist and for his portraits. The majority of the letters we have selected concern the business of portrait painting, throwing interesting light on the artist–patron relationship. They vividly represent the portrait painter as a singular combination of sought-after purveyor of a scarce commodity and a virtual servant required to adhere to his master's dictates. Nowhere is this combination more evident than in the letter to Stratford about the inclusion of a dog in his wife's portrait. In the letter to the Earl of Dartmouth, Gainsborough also discusses the fashion for dressing up portrait subjects in historical clothes and the difficulties this caused for the achievement of a likeness. In two further letters (those of 13 March 1758 and 29 January 1773) Gainsborough touches on questions of technique: issues which are further explored by Reynolds in his Discourse on Gainsborough (see VA2). Gainsborough also comments on Reynolds in a brief discussion of his fourth Discourse. That letter is undated, but given that the Discourse was delivered on 10 December 1771, it is most likely to have been written in 1772. Our selections have been made from *The Letters of Thomas Gainsborough*, ed. Mary Woodall, Birmingham: Cupid Press, 1961–3. In the chronological order in which we have reproduced them they are letters 25 (to Edgar, pp. 61–3); 73, 74, 75 (to Stevens, pp. 135, 139); 91 (to Unwin, p. 167); 16, 17, 18 (to Dartmouth, pp. 49–53); 46 (to Hoare, pp. 95–7); 77, 78 (to Stratford, pp. 141, 143); 103 (to Jackson, pp. 177–9).

To Robert Edgar, Ipswich, 13 March 1758

Sir,

I am favor'd with your obliging letter, and return you many thanks for your kind intention; I thought I should have been at Colchester by this time, as I promis'd my

sister I would the first opportunity, but business comes in and being chiefly in the Face way, I'm afraid to put people off when they are in the mind to sit. You please me much by saying that no other fault is found in your picture than the roughness of the surface, for that part being of use in giving force to the effect at a proper distance, and what a judge of painting knows an original from a copy by; in short being the touch of the pencil, which is harder to preserve than smoothness. I am much better pleas'd that they should spy out things of that kind, than to see an eye half an inch out of its place, or a nose out of drawing when viewed at a proper distance. I don't think it would be more ridiculous for a person to put his nose close to the canvas and say the colours smell offensive, than to say how rough the paint lies; for one is just as material as the other with regard to hurting the effect and drawing of a picture. Sir Godfrey Kneller used to tell them that pictures were not made to smell of: and what made his pictures more valuable than others with the connoisseurs was his pencil or touch. I hope, Sir you'll pardon this dissertation upon pencil and touch, for if I gain no better point than to make you and Mr. Clubb laugh when you next meet at the sign of the Tankard, I shall be very well contented. [...]

I am,

Sir, your most obedt & obliged hum. servt.

Tho. Gainsborough

To Richard Stevens, MP, Bath, 13 September 1767

Sir,

The least I can do when told of my faults in a genteal and friendly manner, is to acknowledge them, and ask pardon: I was tempted to exceed the bounds of good manners in keeping Mrs. Awse so long as my situation now requires all the *sail* I can crowd: the truth is Sir, I suffered some hardships in the first part of my Voyage and fancying now that I see *Land* makes me forget myself. I will send it immediately and happy I shall be if you think the care & pains I have taken in the finishing part at all compensates for my faults in other respects.

I had the Frames made at the time I received your first Letter with the Drawing, and though doubtless there may appear some small difference upon immediate comparison with that it is design'd to match, yet the dimensions being pretty exact, I hope it will pass, especially Sir whilst the Eyes of your Friends are employ'd in admiring the Excellence of my Performances. I wish I could make you laugh till you forget how deficient I have been in point of good manners. [...]

I am

(hoping Mrs. Awse is well)

Sir your Obedient humble Serv-

Tho. Gainsborough

To Richard Stevens, MP, Bath, 2 October 1767

Sir,

I hope by this time you have received Mrs. Awse's Picture, and that it meets with your approbation. I this morning paid the Frame-maker, and am sorry to say that I

think it a dear one, but he says the trouble he had in working after a limited scale and pattern in Drawing Occupied the additional charge; he set it at four Guineas, and for 3 Guineas & $\frac{1}{2}$ I have the Burnish'd Gold sort. However if you, Sir, think it dear too I shall be willing to become a fellow sufferer as My Profits in the Portrait way is a little upon apothecray order – I shall be glad to hear it comes safe to hand, and suits pretty well with the other.

<div style="text-align: right">I am Sir your most obedient Servt
Tho. Gainsborough</div>

PS. Packing Case cost me 7 shillings which my Wife desires me always to remember and I often forget voluntarily because I'm afraid to mention it.

To Richard Stevens, MP, Bath, 28 January 1768

Sir,

I have recd. the favor of your inclosing a Bill Value £15 which when pd. I acknowledge to be in full for Mrs. Awse's Picture and Frame & all Demands.

I am sorry Sir I have not been so happy in Mrs. Awse's Picture as to give satisfaction to yourself & Friends, but I believe nobody can always succeed alike at all times. I can only say it was not for want of either pains or Inclination; & as to the Frame it was done after the Drawing you sent, by the best frame-maker at Bristol. If at any time you should have a convenience of bringing Mrs. Awse's Picture with you to Bath I shall very willingly make any alterations which you or Mrs. Awse may think proper, without any additional charge – and am Sir Your most Obedient & humble Servant

<div style="text-align: right">Tho. Gainsborough</div>

To James Unwin, Bath, 10 July 1770

My Dear Friend, – Ever since the receipt of your last *undeserv'd* favor, I have been tossed about like a ship in a storm: I went by appointment only to spend two or three Days at Mr. George Pitt's Country House, by way of taking leave of him, as a staunch Friend of mine before his going to Spain, and behold he had got two whole length canvasses, and his son and daughter, *Lord & Lady Ligonier*, in readiness to take me prisoner for a month's work – you'l say I might have wrote to you from thence, and so I certainly should but that I left your Letter at home, and forgot your direction. [...]

I have been just going to write to your Brother many times for your direction, but have been always prevented by the curs'd Face Business – If you'l believe me, my Dear Friend, there is not a man in the World who has less time to call his own, and that would so willingly spend some of it in the enjoyment of an Old Acquaintance. My Regard for you was originally built upon such a foundation that you know no time can shake, nor ought not; but the nature of face painting is such, that if I was not *already cracked*, the continual hurry of one fool upon the back of another, just when the magot bites, would be enough to drive me crazy. [...]

I'm so ashamed to mention Mrs. Unwin's Picture that D——m me, I wish I was a Razor-grinder – I'll begin a new one of Her and you together if you'l come. Poor Mrs. Saumarez too, O Lord – that I should behave worst to my best friends and best to my worst – I hate myself for this, tho' even my Enemies say I have some good qualities. If there is any one Devil uglier than another, 'tis the appearance of Ingratitude join'd to such a Face as mine. Let me before I get more out of patience with myself, tell you that my Wife and Daughters desire their best Respects to yourself and Mrs. Unwin; and hope you'l agree to my proposal.

<div style="text-align:right">

Believe me, Dear Sir, Yours Affectionately,

Tho. Gainsborough
</div>

To the Earl of Dartmouth, Bath, 8 April 1771

My Lord

I recd the honour of your Lordships letter acquainting me that I am to expect Lady Dartmouth's Picture at Bath, but it is not yet arrived – I shall be extremely willing to make any alterations your Lordship shall require, when Her ladyship comes to Bath for that purpose, as I cannot (without taking away the likeness) touch it unless from the Life.

I would not be thought by what I am going to observe that I am at all unwilling to do anything your Lordship requires to it or even to paint an entire new picture for the money I received for that, as I shall always take pleasure in doing anything for Lord Dartmouth, but I should fancy myself a great blockhead if I was capable of painting such a Likeness as I did of your Lordship, and not have sense enough to see why I did not give the same satisfaction in Lady Dartmouths Picture; & I believe your Lordship will agree with me in this point, that next to being able to paint a tollerable Picture, is having judgment enough to see what is the matter with a bad one. I don't know if your Lordship remembers a few *impertinent* remarks of mine upon the ridiculous use of fancied Dresses in Portraits about the time that Lord North made us laugh in describing a *Family Piece* His Lordship had seen somewhere, but whether your Lordship's memory will reach this trifling circumstance or not, I will venture to say that had I painted Lady Dartmouths Picture, dressed as her Ladyship goes, no fault (more than in my Painting in general) would have been found with it. Believe me, My Lord, 'tho I may appear conceited in saying it so confidently.

I never was far from the mark, but I was able before I pull'd the trigger to see the cause of my missing and nothing is so common with me as to give up my own sight in my Painting room rather than hazard giving offence to my best Customers. You see, my Lord, I can speak plainly when there is no danger of having my bones broke, and if your Lordship encourages my giving still a free opinion upon the matter, I will do it in another Line.

<div style="text-align:right">

I am your Lordships most obliged & obedient

humble servant

Tho. Gainsborough
</div>

To the Earl of Dartmouth, Bath, 13 April 1771

My Lord

I can see plainly your Lordships good nature in not taking amiss what I wrote in my last, 'tho 't is not so clear to me but your Lordship has some suspicion that I meant it to spare myself the trouble of painting another Picture of Lady Dartmouth which time & opportunity may convince your Lordship was not the intention, and I here give it under my hand that I will most willingly begin upon a new Canvas. But I only for the present beg your Lordship will give me leave to try an Experiment upon that Picture to prove the amazing Effect of dress – I mean to treat it as a cast off Picture and dress it (contrary I know to Lady Dartmouths taste) in the modern way; the worst consequence that can attend it will be Her Ladyships being angry with me for a time – I am vastly out in my notion of the thing if the Face does not immediately look like; but I must know if Lady Dartmouth Powders or not in common: I only beg to know that, and to have the Picture sent down to me – I promise this, my Lord, that if I boggle a Month by way of Experiment to please myself, it shall not in the least abate my desire of attempting another to please your Lordship when I can be in London for that purpose or Lady Dartmouth comes to Bath.

I am
your Lordships
most obedient humble
servant
Tho. Gainsborough

My Lord I am very well aware of the Objection to modern dresses in Pictures, that they are soon out of fashion & look awkward; but as that misfortune cannot be helpd we must set it against the unluckiness of fancied dresses taking away Likenesses, the principal beauty and intention of a Portrait.

To the Earl of Dartmouth, Bath, 18 April 1771

Here it is then – nothing can be more absurd than the foolish custom of painters dressing people like Scaramouches, and expecting the likeness to appear. Had a picture voice, action, etc. to make itself known as Actors have upon the Stage, no disguise would be sufficient to conceal a person; but only a face confined to one view and not a muscle to move to say, 'Here I am' falls very hard upon the poor Painter who perhaps is not within a mile of the truth in painting the Face only. Your Lordship I'm sure, will be sensible of the effect of the dress thus far, but I defy any but a Painter of some sagacity (and such you see I am, my Lord) to be well aware of the different Effects which one part of a picture has upon another, and how the Eye may be cheated as to the appearance of size, and by an artful management of the accompanyments. A Tune may be so confused by a false Bass – that is if it is ever so plain, simple and full of meaning, it shall become a jumble of nonsense, and just so shall a handsome face be overset by a fictitious bundle of trumpery of the foolish Painter's own inventing. For my part (however your Lordship may suspect my

Genius for Lying) I have that regard for truth, that I hold the finest invention as a mere slave in Comparison, and believe I shall remain an ignorant fellow to the end of my days, because I never could have patience to read Poetical impossibilities, the very food of a Painter; especially if he intends to be KNIGHTED in this land of Roast Beef, so well do serious people love froth. But, where am I, my Lord? this my free Opinion in another Line with a witness – forgive me my Lord, I'm but a wild goose at best – all I mean is this, Lady Dartmouth's Picture will look more like and not so large when dressed properly; and if it does not, I'll begin another.

To Mr. Hoare [undated]

Mr. Gainsborough's Respects to Mr. Hoare, and is much obliged for the sight of Sir Joshua's Discourse which he thinks amazingly clever, and cannot be too much admired (together with its Ingenious Author) by every candid lover of the Art. The truth of what he observes concerning Fresco, and the Great style, Mr. G. is convinced of by what he has often heard Mr. Hoare say of the works of Rafaelle and Michel Angelo – But betwixt Friends Sir Joshua either forgets, or does not chuse see that his Instruction is all adapted to form the History Painter, which he must know there is no call for in this country. The Ornamental style (as he calls it) seems form'd for Portraits. Therefore he had better come *down to Watteau* at once (who was a very fine Painter taking away the french conceit) and let us have a few Tints; or else why does Sir Joshua put tints equal to Painted Glass, only to make the People talk of Colors flying when the great style would do. Every one knows that the grand style must consist in plainness & simplicity, and that silks & satins, Pearls and trifling ornaments would be as hurtfull to simplicity, as flourishes in a Psalm Tune; but Fresco would no more do for Portraits than an Organ would please Ladies in the hands of Fischer; there must be variety of lively touches and surprizing Effects to make the Heart dance, or else they had better be in a Church – so in Portrait Painting there must be a Lustre and finishing to bring it up to individual Life.

As Mr. G. hates of all things the least tendency to the sour Critic, hopes to talk over the affair some Evening over a Glass, as there is no other Friendly or sensible way of settling these matters except upon *Canvas*.

To Edward Stratford, Bath, 1 May 1772

Dear Sir,

When you mention *Exhibition Pictures*, you touch upon a string, which once broke, all is at an End with me; but I do assure you, nay I swear by Saint Luke's Pencil, I have not dress'd nor sent a finished half length out of my doors since yours have been in hand so that I beg you to have patience to hear me, and I beg Mrs. Stratford to keep you in good nature for a moment, I do solemnly promise you to finish your Pictures in my best manner before any other from this time. I was obliged to cobble up something for the Exhibition or else (so far from being knighted) I should have been expel'd the Society, and have been look'd upon as a deserter, unworthy my *Diploma* sign'd with the King's own hand, which I believe you have seen most beautifully framed & hung up in my Painting-Room, *behind the Door*. Do good Sir let me know

for certain when you think of returning home from abroad and if I disappoint you of *seeing* your Pictures hung in their Places *with my own Eyes*, I'll give you leave to boil me down for Painters Drying oil, and shiver my Bones into Pencil Sticks – could Shakespeare with his Mother Madam fancy say more – I wish you would recollect that Painting & Punctuality mix like Oil & Vinegar, & that Genius & regularity are utter Enemies, & must be to the end of Time – I would not insinuate that *I* am a genius any further than as I resemble one in your Opinion, who think I have no such thing as punctuality about me – In short Sir, I throw myself at your Feet, & thank God most sincerely that I am not any nearer to them, for surely you could not help kicking me – However Sir depend upon this, that I am most sincerely,

Your ever obedient & humble Servant
Tho. Gainsborough

To Edward Stratford [undated]

Mr. Gainsborough presents his compts to Mr. Stratford; He does not understand whether Mr. Stratford means to have the Dog painted separate by Monsieur Dupont, or again put into Mrs. Stratford's Picture to spoil it; so cannot say anything about it to Day.

But with regard to Mrs. Stratford's Drawing, Mr. G– will expect the honor of seeing Mrs. Stratford to morrow Evening (*Dress'd*) at any hour agreeable to Mrs. Stratford.

To William Jackson, Bath, 29 January 1773

Dear Jackson of Exeter

There is not a man living that you can mention (besides *yourself* and one more, living) that shall ever know my secret of making those studies you mention – I have a real regard for you, and would tell you anything except one [word erased, fact ?] in the world & that shall die with me.

You may acquaint your Friend that you tried your strength with me for the secret, but the *fixing the white chalk* previous to tinging the Drawing with waterColors, you find I am determined never to tell to anybody; and here you'l get off, for no Chalk is used, and so keep it close for your own use; and when you can make a Drawing to please your self by my direction send it to me, & I'll tell you if they are right.

Mind now – take half a sheet of blotting paper such as the Clerks and those that keep books put upon writing instead of sand; 'tis a spongy purple paper, paste that and half a sheet of white paper, of the same size, together, let them dry, and in that state keep them for use – take a Frame of deal about two Inches larger every way, and paste, or glue, a few sheets of very large substantial paper, no matter what sort, thick brown, blue, or any; then cut out a square half an Inch less than the size of your papers for Drawing; so that it may serve for a perpetual stretcing Frame for your Drawings; that is to say after you have dipt your drawing as I shall by & by direct in a liquid, in that wet state you are to take, and run some hot glue and with a brush run round the border of your stretcher, gluing about half an Inch broad, which is to receive your half an Inch extraordinary allow'd for that purpose in your drawing

paper, so that when that dries, it may be like a drum. Now before you do anything by way of stretching, make the black and white of your drawing, the Effect I mean, and disposition in rough, Indian Ink shadows & your lights of *Bristol* made *white lead* which you buy in lumps at any house painters; saw it the size you want for your white chalk; the Bristol is harder and more the temper of chalk than the London. When you see your effect, dip it all over in skim'd milk; put it wet on your Frame just glued as before observed let it dry; and then you correct your Effects with Indian Ink when dry & if you want to add more lights or alter, do it and dip again, til all your effect is to your mind; then tinge in your greens, your browns with sap green & Bistre, your yellows with Gall stone & blues with fine Indigo [word illegible] – when this is done, float it all over with Gum water, 3 ounces of Gum Arabic to a pint of water with a Camels pencil let that dry & varnish it 3 times with spirit varnish such as I sent you; tho only Mastic & Venice Turpentine is suffcent, then cut out your drawing but observe it must be varnished both sides to keep it flat trim it round with a pen knife & Ruler, and let any body produce the like if they can; stick them upon a white paper leaving a Margin of an Inch and half round.

Swear now never to impart my secret to any one living –

Yours sincerely
Tho. Gainsborough

2 Joshua Reynolds (1723–1792) on Thomas Gainsborough

Gainsborough died on 2 August 1788. That year Reynolds chose to dedicate his Royal Academy Discourse to an appreciation of his deceased colleague. His Discourse, the fourteenth in what was to be a series of fifteen, was delivered on 10 December 1788. Reynolds gives interesting information about Gainsborough's technique, particularly with regard to his landscape painting. He also comments on Gainsborough's lack of involvement with the classical tradition, and on his gravitation towards alternative northern models. His remarks on the surfaces of Gainsborough's portraits complement the painter's own letter of March 1758, reproduced above. The following extracts are taken from Reynolds' *Discourses*, edited with an introduction and notes by Pat Rogers, Harmondsworth: Penguin Classics, 1992, pp. 301, 303–5, 306–8, 312–14.

[...] We have lately lost Mr Gainsborough, one of the greatest ornaments of our Academy. It is not our business here, to make panegyricks on the living, or even on the dead who were of our body. The praise of the former might bear appearance of adulation; and the latter, of untimely justice; perhaps of envy to those whom we have still the happiness to enjoy, by an oblique suggestion of invidious comparisons. In discoursing therefore on the talents of the late Mr Gainsborough, my object is, not so much to praise or to blame him, as to draw from his excellencies and defects, matter of instruction to the Students in our Academy. If ever this nation should produce genius sufficient to acquire to us the honourable distinction of an English School, the name of Gainsborough will be transmitted to posterity, in the history of the Art, among the very first of that rising name. [...]

It may not be improper to make mention of some of the customs and habits of this extraordinary man; points which come more within the reach of an observer; I however mean such only as are connected with his art, and indeed were, as I apprehend, the causes of his arriving to that high degree of excellence, which we see and acknowledge in his works. Of these causes we must state, as the fundamental, the love which he had to his art; to which, indeed, his whole mind appears to have been devoted, and to which every thing was referred; and this we may fairly conclude from various circumstances of his life, which were known to his intimate friends. Among others he had a habit of continually remarking to those who happened to be about him whatever peculiarity of countenance, whatever accidental combination of figure, or happy effects of light and shadow, occurred in prospects, in the sky, in walking the streets, or in company. If, in his walks, he found a character that he liked, and whose attendance was to be obtained, he ordered him to his house: and from the fields he brought into his painting-room, stumps of trees, weeds, and animals of various kinds; and designed them, not from memory, but immediately from the objects. He even framed a kind of model of landscapes on his table; composed of broken stones, dried herbs, and pieces of looking glass, which he magnified and improved into rocks, trees and water. How far this latter practice may be useful in giving hints, the professors of landscape can best determine. Like every other technical practice, it seems to me wholly to depend on the general talent of him who uses it. Such methods may be nothing better than contemptible and mischievous trifling; or they may be aids. I think upon the whole, unless we constantly refer to real nature, that practice may be more likely to do harm than good. I mention it only, as it shows the solicitude and extreme activity which he had about every thing that related to his art; that he wished to have his objects embodied as it were, and distinctly before him; that he neglected nothing which could keep his faculties in exercise, and derived hints from every sort of combination.

We must not forget whilst we are on this subject, to make some remarks on his custom of painting by night, which confirms what I have already mentioned, – his great affection to his art; since he could not amuse himself in the evening by any other means so agreeable to himself. I am indeed much inclined to believe that it is a practice very advantageous and improving to an artist; for by this means he will acquire a new and a higher perception of what is great and beautiful in Nature. By candle-light, not only objects appear more beautiful, but from their being in a great breadth of light and shadow, as well as having a greater breadth and uniformity of colour, nature appears in a higher style; and even the flesh seems to take a higher and richer tone of colour. Judgement is to direct us in the use to be made of this method of study; but the method itself is, I am very sure, advantageous. [...]

When such a man as Gainsborough arrives to great fame, without the assistance of an academical education, without travelling to Italy, or any of those preparatory studies which have been so often recommended, he is produced as an instance, how little such studies are necessary; since so great excellence may be acquired without them. This is an inference not warranted by the success of any individual; and I trust it will not be thought that I wish to make this use of it.

It must be remembered that the style and department of art which Gainsborough chose, and in which he so much excelled, did not require that he should go out of his

own country for the objects of his study; they were every where about him; he found them in the streets, and in the fields; and from the models thus accidentally found, he selected with great judgement such as suited his purpose. As his studies were directed to the living world principally, he did not pay a general attention to the works of the various masters, though they are, in my opinion, always of great use, even when the character of our subject requires us to depart from some of their principles. It cannot be denied, that excellence in the department of the art which he professed may exist without them; that in such subjects, and in the manner that belongs to them, the want of them is supplied, and more than supplied, by natural sagacity, and a minute observation of particular nature. If Gainsborough did not look at nature with a poet's eye, it must be acknowledged that he saw her with the eye of a painter; and gave a faithful, if not a poetical, representation of what he had before him.

Though he did not much attend to the works of the great historical painters of former ages, yet he was well aware that the language of the art – the art of imitation – must be learned somewhere; and as he knew that he could not learn it in an equal degree from his contemporaries, he very judiciously applied himself to the Flemish School, who are undoubtedly the greatest masters of one necessary branch of art; and he did not need to go out of his own country for examples of that school: from that he learnt the harmony of colouring, the management and disposition of light and shadow, and every means which the masters of it practised, to ornament and give splendour to their works. And to satisfy himself as well as others, how well he knew the mechanism and artifice which they employed to bring out that tone of colour which we so much admired in their works, he occasionally made copies from Rubens, Teniers, and Vandyck, which it would be no disgrace to the most accurate connoisseur to mistake, at the first sight, for the works of those masters. What he thus learned, he applied to the originals of nature, which he saw with his own eyes; and imitated, not in the manner of those masters, but in his own.

Whether he most excelled in portraits, landscapes, or fancy-pictures, it is difficult to determine: whether his portraits were most admirable for exact truth of resemblance, or his landscapes for a portrait-like representation of nature, such as we see in the works of Rubens, Ruysdaal, and others of those schools. In his fancy-pictures, when he had fixed on his object of imitation, whether it was the mean and vulgar form of a wood-cutter, or a child of an interesting character, as he did not attempt to raise the one, so neither did he lose any of the natural grace and elegance of the other; such a grace, and such an elegance, as are more frequently found in cottages than in courts. This excellence was his own, the result of his particular observation and taste; for this he was certainly not indebted to the Flemish School, nor indeed to any School; for his grace was not academical or antique, but selected by himself from the great school of nature [. . .].

A novelty and peculiarity of manner, as it is often a cause of our approbation, so likewise it is often a ground of censure; as being contrary to the practice of other painters, in whose manner we have been initiated, and in whose favour we have perhaps been prepossessed from our infancy, for, fond as we are of novelty, we are upon the whole creatures of habit. However, it is certain, that all those odd scratches and marks, which on a close examination, are so observable in Gainsborough's

pictures, and which even to experienced painters appear rather the effect of accident than design; this chaos, this uncouth and shapeless appearance, by a kind of magick, at a certain distance assumes form, and all the parts seem to drop into their proper places, so that we can hardly refuse acknowledging the full effect of diligence, under the appearance of chance and hasty negligence. That Gainsborough himself considered this peculiarity in his manner, and the power it possesses of exciting surprise, as a beauty in his works, I think may be inferred from the eager desire which we know he always expressed, that his pictures, at the Exhibition, should be seen near, as well as at a distance.

The slightness which we see in his best works cannot always be imputed to negligence. However they may appear to superficial observers, painters know very well that a steady attention to the general effect takes up more time, and is much more laborious to the mind, than any mode of high finishing, or smoothness, without such attention. His *handling, the manner of leaving the colours*, or, in other words, the methods he used for producing the effect, had very much the appearance of the work of an artist who had never learned from others the usual and regular practice belonging to the art; but still, like a man of strong intuitive perception of what was required, he found out a way of his own to accomplish his purpose.

It is no disgrace to the genius of Gainsborough, to compare him to such men as we sometimes meet with, whose natural eloquence appears even in speaking a language which they can scarce be said to understand; and who, without knowing the appropriate expression of almost any one idea, contrive to communicate the lively and forcible impressions of an energetick mind.

I think some apology may reasonably be made for his manner without violating truth, or running any risk of poisoning the minds of the younger students, by propagating false criticism, for the sake of raising the character of a favourite artist. It must be allowed, that this hatching manner of Gainsborough did very much contribute to the lightness of effect which is so eminent a beauty in his pictures; as on the contrary, much smoothness, and uniting the colours, is apt to produce heaviness. Every artist must have remarked, how often that lightness of hand which was in his dead-colour, or first painting, escaped in the finishing, when he had determined the parts with more precision; and another loss he often experiences, which is of greater consequence; whilst he is employed in the detail, the effect of the whole together is either forgotten or neglected. The likeness of a portrait, as I have formerly observed, consists more in preserving the general effect of the countenance, than in the most minute finishing of the features, or any of the particular parts. Now Gainsborough's portraits were often little more, in regard to finishing, or determining the form of the features, than what generally attends a dead colour; but as he was always attentive to the general effect, or whole together, I have often imagined that this unfinished manner contributed even to that striking resemblance for which his portraits are so remarkable. Though this opinion may be considered as fanciful, yet I think a plausible reason may be given, why such a mode of painting should have such an effect. It is pre-supposed that in this undetermined manner there is the general effect; enough to remind the spectator of the original; the imagination supplies the rest, and perhaps more satisfactory to himself, if not more exactly, than the artist, with all his care, could possibly have done.

3 William Duff (1732–1815) 'Of the Effects of Genius'

Duff graduated from the University of Aberdeen in 1750 at a time when the college was celebrated for having revived the study of classical literature in Scotland. Five years later he was licensed by the presbytery and spent the rest of his career as a minister of religion in Aberdeenshire. During his lifetime he published six books on a variety of subjects, ranging from 'the hermit of Mount Ararat' to the 'moral character of women'. Two of them were on the subject of Genius in philosophy and the fine arts. Questions of imagination, genius and originality came to play an increasingly prominent role in debate about the arts in the late eighteenth century (see IIIB10 and IVA7 for different approaches to the question). The present extracts on the personality of the genius are taken from the final chapter, 'Of the Effects of Genius on the Temper and Character', of Duff's book *Critical Observations on the Writings of the Most Celebrated Original Geniuses in Poetry*, London: T. Becket and P. A. de Hont, 1770, pp. 339–47, 355–9.

A man of Genius is really a kind of different being from the rest of his species. The bent of his disposition, the complexion of his temper, the general turn of his character, his passions and his pursuits are for the most part very dissimilar from those of the bulk of mankind. Hence partly it happens that his manners appear ridiculous to some, and disagreeable to others; that most people, though they treat him with a ceremonious respect, behave in his presence with an uneasy restraint; and that his company is seldom courted, except by those persons who have penetration enough to discern his merit, as well as candour to acknowledge it, or by those others who hope to derive some credit to themselves from their acquaintance with him. These consequences indeed, likewise, partly arise from *Envy*, that despicable passion of little minds; but as Genius is not an object of *Envy* to every one, we cannot suppose this passion the sole cause of that indifference and neglect which it meets with from many: we must therefore attribute the mortifications to which it is exposed, in a considerable measure, to those peculiar manners which generally distinguish it, and to its being unfit for entering with any degree of order or relish, into those amusements and occupations which engross the attention of a great part of mankind, promote a kind of social intercourse, and form those bonds of attachment which render men necessary and agreeable to each other. [...]

True Genius, we may observe, naturally produces a warmth and sensibility of temper. It is indeed incompatible with a cold, or plegmatic constitution of mind. All its sensations, and all its affections are ardent, lively and exquisite. Neither its pleasures, nor its pains are of the common kind: there is a delicacy and refinement in its sensibility of either, which is utterly unknown and inconceivable by the vulgar. This extreme sensibility is the effect of a vivacity and strength of fancy, which throws an additional lustre of its own on every object it contemplates with pleasure, as it casts a dark shade on such as are calculated to excite disquietude and pain, by which means the feeling of either is rendered more intensely affecting. [...]

At the same time that Genius has a natural tendency to produce a chearful and sanguine temper of mind, which is its usual attendant, and which, if not saddened by reiterated disappointments, it studiously preserves, it is distinguished by another more remarkable and invariable characteristic, a sublime, soothing, and pensive

melancholy. This disposition is indeed the inseparable concomitant of true Genius. Perhaps, it may at first view be imagined, that such a temper of mind is inconsistent with that ardor and chearfulness which we have above observed to be an usual attendant of Genius; but it is by no means really so. We may observe, that as the minds of the more unfeeling part of mankind, who are not susceptible of very high degrees of pain or pleasure, are however at different times in very different dispositions; sometimes pleased with themselves, and with all around them, at other times oppressed with sadness, of which they know not the cause, and experiencing a deplorable vacancy of thought which they are utterly at a loss to supply, so the mind of a man of Genius is subjected to the same kind of vicissitudes, though he feels them more intensely; and while at one time he rises in his enjoyments to a degree of rapture, at another he relapses into a pensive, but pleasing melancholy. This last mentioned disposition, as it is the constant attendant of Genius, so it becomes the predominating feature of the mind, and gives a tincture to the whole character, rendering it rather serious than gay, rather thoughtful than desultory.

That pensive melancholy which so remarkably characterizes exalted Genius, appears to be produced by a sublimity of imagination united with a contemplative turn of mind, both co-operating with a tender and sympathetic sense of human misery. Objects that are in themselves great and awful, as well as dismal and terrific, whether they are the works of nature or of art, are peculiarly calculated to sooth and gratify the disposition of which we are treating. Thus the mouldering towers, the rocking battlements, the roaring billows, the howling wilderness, and the dreary waste, as they are objects awfully grand, at the same time that they are attended with circumstances of calamity and danger, are for these reasons perfectly suited to the indulgence of a sublime melancholy. [. . .]

Having considered the influence of Genius on the temper and character, we shall now point out some of the peculiarities or foibles which usually attend it.

Among these we may reckon its powerful bent to project romantic and ideal schemes of future felicity. It is difficult to determine whether this strange disposition, which retains its tendency and much of its strength after many fatal disappointments, is upon the whole desirable or otherwise. It provides indeed in the mean time a delicious repast to the mental appetite, but unthinkingly prepares along with it a bitter draught, arising from the anguish of deceived hope. This tendency to contrive visionary schemes, it is obvious, arises from imagination, but from an imagination irregular and unchastised.

Precipitate temerity in judgment and conduct is likewise in some instances annexed to the possession of Genius. A man endued with this quality is sometimes apt to say and to do things which to the rest of mankind appear ridiculous, and are really so. This foible, by no means a necessary effect of the quality above mentioned, proceeds from a volatility of imagination, untamed by the chastening power of the reasoning faculty.

We may farther remark that Genius is sometimes debased by an unbecoming union with *Irresolution* and *Inconstancy* of mind. These qualities, it must be confessed, are none of its constant attendants. They are often the effects of a too pliant temper, discovering a disposition to oblige, devising expedients for reconciling different views and interests, hesitating concerning the means of accomplishing its

purposes, making concessions, and repenting of the concessions it has made. Thus they may sometimes be resolved into goodnature; but it is goodnature degenerating into weakness. When these qualities are connected with Genius, they are effects of a volatility of imagination, and a natural imbecillity of the mind.

Abstraction of thought may be considered as another more usual concomitant of Genius. It is commonly very conspicuous in the behaviour of persons distinguished by this quality while they are in company. One can perceive from their fixed and thoughtful looks a certain alienation of mind from the subject of conversation, and a continued employment of the thoughts on one particular object, without attending to any thing else. This peculiarity appears to be the offspring of imagination, united with a contemplative turn of mind, which is generally the attendant of Genius, and often discovers itself very remarkably both in the Poet and Philosopher, though their minds are differently employed; that of the former being busied in creating the images of Poetry, that of the latter in devising solutions of the phænomena of nature; while perhaps the rest of the company, regardless of both, are engaged in learned disputes concerning a case in quadrille, the comparative excellence of hounds and horses, or other subjects of like importance. We need not at all wonder while such topics are discussed that they should both sometimes choose to indulge their own reveries, and leave it to others who are better qualified for it to support the spirit of the conversation.

The last peculiarity of Genius of which we shall take notice, is an ignorance of and indifference to the common affairs of life. These qualities, though not universally connected with Genius, are however its ordinary attendants, and indeed naturally enough result from the particular pursuits in which it is engaged. The taste and manner of life of a man of Genius being generally so different from that of the rest of mankind, it is impossible he should enter with any degree of relish into their favourite occupations, or that he should adopt their maxims, and conform to their mode of living, without doing the utmost violence to his own inclinations. [...]

4 Johann Wolfgang Goethe (1749–1832) 'On German Architecture'

Goethe was born in Frankfurt am Main and studied at the University of Leipzig. His early writing on art forms part of an emerging Romantic reaction against the traditional view of the classical heritage. He was by no means indifferent to the art of the Greeks, but he followed other German writers, Herder, Winckelmann and Lessing foremost among them, in conceiving of it as a guide to fullness of expression rather than as a model of rationalism. This revision in the understanding of classical art went hand in hand with a reconsideration of past cultural forms that had previously been disparaged as barbaric – or 'Gothic' – simply because they were unclassical. As Goethe was later to write, 'What we must do is recognize achievement in whatever shape or form it may appear, always remembering not to expect roses in winter and grapes in spring.' His essay 'On German Architecture' is written as though addressed to Erwin von Steinbach, architect of the first stage of Strasbourg Cathedral (actually founded not in 1318, but in 1277. The 'D.M.' is short for *Divis Manibus*, an invocation to the spirits found on Roman tombs). Goethe affirms a defiant pride in the Gothic art of his own country, arguing that it derives from feeling rather than

calculation and is therefore a *natural* achievement. In the process he takes issue with the Abbé Laugier's *Essai sur l'architecture* (see IIIC5). Goethe was to make two further pilgrimages to Erwin's grave, the second of which, in 1775, gave rise to a brief text published the following year, in which he referred back to 'a pamphlet which seemed less inwardly felt than it was, which few read, and those few did not understand it, though some good spirits saw glimmerings of what made them inexpressibly happy.' 'On German Architecture' was originally published as *Von deutscher Baukunst* in November 1772 by Johann Conrad Deinet in Frankfurt (dated 1773). It was reprinted alongside essays by Herder, Frisi and Möser in *Von Deutscher Art und Kunst* (Hamburg: Bode, 1773), a publication which is widely recognized as the 'manifesto' of the *Sturm und Drang*. The English text is taken from *Goethe on Art*, edited and translated by John Gage, London: Scolar Press, 1980, pp. 103–12; some of Gage's footnotes have been omitted. (See also VB7, VIIA9.)

<div align="center">

D. M.

Ervini a Steinbach

</div>

As I wandered about your tomb, noble Erwin, looking for the stone which should have told me *Anno domini* 1318 *XVI Kal. Febr. obiit Magister Ervinus, Gubernator Fabricae Ecclesiae Argentinensis,* and could not find it, and none of your fellow-townsmen could show it to me, so that I could pour out my veneration at that holy place – then was I deeply grieved in my soul, and my heart, younger, warmer, more innocent, better than now, vowed to you a memorial of marble or sandstone (according to what I could afford) as soon as I should come into the quiet enjoyment of my inheritance.

Yet what need you a memorial! You have erected the most magnificent one for yourself, and although your name does not bother the ants who crawl about it, you have the same destiny as that Architect who piled up his mountains to the clouds.

It was given to few to create the idea of Babel in their souls, whole, great, and with the beauty of necessity in every smallest part, like trees of God. To even fewer has it been granted to encounter a thousand willing hands to carve out the rocky ground, to conjure up steeps on it, and when they die, to tell their sons, 'I am still with you in the creations of my spirit; complete what is begun, up to the clouds.'

What need have you of a memorial! And from me! When the rabble utters holy names, it is superstition or blasphemy. The feeble aesthete will forever be dizzied by your Colossus, and those whose spirits are whole will recognize you without need of an interpreter.

Now then, excellent man, before I risk my patched-up little ship on the ocean again, and am more likely to meet death than profit, look at this grove where all about the names of my loved ones are still green.[1] I cut yours on a beech tree, reaching upwards like one of your slender towers, and hang this handkerchief of gifts by its four corners on it. It is not unlike the cloth that was let down to the Holy Apostle out of the clouds, full of clean and unclean beasts;[2] also flowers, blossoms, leaves and dried grass and moss, and night-sprung toadstools – all of which I gathered, botanizing to pass the time, on a walk through some place or other, and now dedicate to your honour until they rot away.

'It is in a niggling taste,' says the Italian, and passes on. 'Puerilities,' babbles the Frenchman childishly after him, and triumphantly snaps open his snuffbox, *à la grecque*.[3] What have you done, that you should dare to look down your noses?

Has not the genius of the Ancients risen from its grave to enslave yours, you dagoes? You scramble over the ruins to cadge a system of proportions, you cobble together your summer-houses out of the blessed rubble, and think yourselves the true guardians of the secrets of art if you can reckon the inches and minutest lines of past buildings. If you had rather felt than measured, if the spirit of the pile you so admire had come upon you, you would not simply have imitated it because *they* did it and it is beautiful; you would have made your plans because of truth and necessity, and a living, creative beauty would have flowed from them.

You have given your practical considerations a colour of truth and beauty. You were struck by the splendid effect of columns, you wanted to make use of them, and walled them in. You wanted colonnades, too, and ringed the forecourt of St Peter's with alleys of marble which lead nowhere, so that mother nature, who despises and hates the inappropriate and unnecessary, drove the rabble to convert your splendour into public cloaca, and men avert their eyes and hold their noses before the wonder of the world.[4]

That is the way it goes. The whim of the artist serves the obsession of the rich: the travel writer gapes, and our *bels esprits*, called philosophers, spin out of the raw stuff of fairy tales the history of art up to our times, and the evil genius murders true men in the forecourt of the sanctuary.

Rules are more damaging to the genius than examples. Before he arrives on the scene, some individuals may have worked out some parts, but he is the first from whose soul those parts emerge as an everlasting whole. But school and rule fetter all power of perceiving and acting. What does it matter to us, you new-fangled French philosophizing connoisseurs, that the first man – whose needs made him ingenious – hammered in four stakes, lashed four posts over them, and put branches and moss on the top?[5] From this you deduce the needs of today, and it is just as if you wanted to rule your new Babylon[6] according to the feelings of simple patriarchal societies.

It is also wrong to think that your hut was the first. Two stakes at each end, crossed at their apex, with another as ridgepole are, as you may daily see in the huts of field and vineyard, a far more basic invention, from which you could not even extract a principle for your pig-sty.

So none of your conclusions can rise to the sphere of truth. They all swim in the atmosphere of your system. You want to teach us what we should use, because what we do use cannot be justified according to your principles.

The column is close to your heart, and in another part of the world you would be a prophet. You say, 'The column is the first and most important component of the building, and the most beautiful. What sublime elegance of form, what pure and varied greatness, when they stand in rows!'[7] Only be careful not to use them out of turn: their nature is to stand free. Woe to those wretches who have wedded their slender growth to lumpish walls! And yet it seems to me, my dear Abbé, that the frequent repetition of this impropriety of walling columns in, by which the moderns even stuff the intercolumnia of ancient temples with masonry, might have given you

pause. If your ear was not deaf to truth, these stones at least might have preached it to you.

The column is, on the contrary, no part of our dwellings; rather it contradicts the essence of all our buildings. Our houses do not arise from four columns in four corners, but from four walls as four sides, which are in place of columns, and exclude them, and where you tack them on, they are a tiresome excrescence. That goes, too, for our palaces and churches, except for a few instances which I need not notice. So your buildings present surfaces which, the more extensive they are, and the higher they soar, the more they oppress the soul with intolerable monotony. It would be a sad day for us if the genius of Erwin von Steinbach did not come to our rescue: 'Diversify the enormous walls; you should so build towards heaven that they rise like a sublimely towering, wide-spreading tree of God which, with its thousand branches, millions of twigs and leaves more numerous than the sands of the sea, proclaims to the surrounding country the glory of its master, the Lord.'

The first time I went to the Minster, my head was full of the common notions of good taste. From hearsay I respected the harmony of mass, the purity of forms, and I was the sworn enemy of the confused caprices of Gothic ornament. Under the term Gothic, like the article in a dictionary,[8] I threw together all the synonymous misunderstandings, such as undefined, disorganized, unnatural, patched-together, tacked-on, overloaded, which had ever gone through my head. No less foolish than the people who call the whole of the foreign world barbaric, for me everything was Gothic that did not fit my system, from the lathe-turned gaudy dolls and paintings with which our *bourgeois gentilshommes* decorate their homes to the sober remains of early German architecture, on which, on the pretext of one or two daring curlicues, I joined in the general chorus: 'Quite smothered with ornament!' And so I shuddered as I went, as if at the prospect of some mis-shapen, curly-bristled monster.

How surprised I was when I was confronted by it! The impression which filled my soul was whole and large, and of a sort that (since it was composed of a thousand harmonizing details) I could relish and enjoy, but by no means identify and explain. They say it is thus with the joys of heaven, and how often have I gone back to enjoy this heavenly-earthly joy, and to embrace the gigantic spirit of our ancient brothers in their works. How often have I returned, from all sides, from all distances, in all lights, to contemplate its dignity and his magnificence. It is hard on the spirit of man when his brother's work is so sublime that he can only bow and worship. How often has the evening twilight soothed with its friendly quiet my eyes, tired-out with questing, by blending the scattered parts into masses which now stood simple and large before my soul, and at once my powers unfolded rapturously to enjoy and to understand. Then in hinted understatements the genius of the great Master of the Works revealed itself to me. 'Why are you so surprised?' he whispered to me. 'All these shapes were necessary ones, and don't you see them in all the old churches of my city? I have only elevated their arbitrary sizes to harmonious proportions. How the great circle of the window opens above the main door which dominates the two side ones: what was otherwise but a hole for the daylight now echoes the nave of the church! How, high above, the belfry demands the smaller windows! All this was necessary, and I made it beautiful. But ah! if I float through the dark and lofty openings at the side that seem

to stand empty and useless, in their strong slender form I have hidden the secret powers which should lift those two towers high in the air – of which, alas! only one stands mournfully there, without its intended decoration of pinnacles, so that the surrounding country would pay homage to it and its regal brother.'

And so he left me, and I sank into a sympathetic melancholy until the dawn chorus of the birds who lived in the thousand openings rejoiced at the rising sun and woke me from my slumber. How freshly the Minster sparkled in the early morning mist, and how happily I could stretch out my arms towards it and gaze at the harmonious masses, alive with countless details. Just as in the eternal works of nature, everything is perfectly formed down to the meanest thread, and all contributing purposefully to the whole. How the vast building rose lightly into the air from its firm foundations; how everything was fretted, and yet fashioned for eternity! Genius, it is to your teaching that I owe it that I am no longer dazzled by your profundities, that a drop of the rapturous quiet of the spirit sinks into my soul, which can look down over such a creation and say, as God said, 'It is good.'

And now I ought not to be angry, holy Erwin, if the German art expert, on the hearsay of envious neighbours, fails to recognize his advantage and belittles your work with that misunderstood word 'Gothic'. For he should thank God that he can proclaim that this is German architecture, our architecture. For the Italian has none he can call his own, still less the Frenchman. And if you do not wish to admit this advantage yourself, at least prove to us that the Goths already built like this: you will find it difficult. And if in the end you cannot demonstrate that there was a Homer before Homer, we will willingly leave you the story of lesser efforts that succeed or fail, and come to worship before the work of the master who first welded the scattered elements into a living whole. And you, my dear spiritual brother in the search for truth and beauty, shut your ears to all the blather about fine art; come, look, and enjoy. Take care that you do not profane the name of your noblest artist, and hasten here to see his excellent work. If it makes an unpleasant impression on you, or none at all, good luck to you, harness your horses and be off to Paris!

But it is to you, beloved youth, that I feel closest, for, standing there, you are moved and cannot reconcile the conflicting feelings in your soul. At one moment you feel the irresistible power of this vast whole, and the next chide me for being a dreamer since I see beauty where you see only rugged strength. Do not let us be divided by a misunderstanding. Do not let the effete doctrine of modern pretty-prettyness spoil you for roughness that is full of meaning, so that in the end your sickly sensibility can only tolerate meaningless polish. They would have us believe that the fine arts arise from our desire to beautify the objects around us.[9] This is not true! For not the philosopher, but the man in the street and the artisan use the word in the only way it could be true.

Art is formative long before it is beautiful, and it is still true and great art, indeed often truer and greater than 'fine art' itself. For in man's nature there is a will to create form which becomes active the moment his survival is assured. As soon as he does not need to worry or to fear, like a demi-god, busy even in his relaxation, he casts around for a material into which he can breathe his spirit. And so the savage articulates his coconut shell, his feathers, his body with fantastical lines, hideous

forms and gaudy colours. And even if this making visibly expressive is made up of the most arbitrary forms, they will still harmonize without any obvious relationship between them, for a single feeling has created a characteristic whole.

Now this characteristic art is the only true art. If it becomes active through inner, unified, particular and independent feeling, unadorned by, indeed unaware of, all foreign elements, whether it be born of savagery or of a cultivated sensibility, it is a living whole. Hence among different nations and individuals you will see countless different degrees of it. The more the soul is raised to a feeling for those proportions which alone are beautiful and eternal, whose principal harmonies may be proved but whose secrets can only be felt, in which alone the life of godlike genius is whirled around to the music of the soul – the more, I say, this beauty penetrates the being of the mind, so that it seems to be born within that mind, so that nothing satisfies the mind but beauty, so that the mind creates nothing but beauty out of itself, so much the happier is the artist, and the more magnificent, and the lower we prostrate ourselves and worship the Lord's anointed.

And no one will remove Erwin from his high place. Here is his creation. Come up and acknowledge the deepest feeling for truth and beauty of proportion, brought about by the strong, rugged German soul on the narrow, gloomy, priest-ridden stage of the *medii aevi*.

And our *aevum*? That has renounced his genius, has driven its sons about after strange growths, to its ruin. The frivolous Frenchman who gleans far worse at least has the wit to pull his loot into a single whole; he does build a magic temple of a Madeleine for his Greek columns and German vaults. But I have seen one of our artists, when he was asked to devise a porch to an old German church, prepare a model with stately Antique columns.

I do not wish to rehearse how much I hate our tarted-up doll-painters. With their stagey poses, false complexions and gaudy clothes they have caught the eye of the ladies. Your wood-carved face, O manly Dürer, whom these novices mock, is far more welcome to me.

And you yourselves, excellent people, to whom it was given to enjoy the highest beauty, and now step down to proclaim your happiness; even you harm genius, for it will be raised and moved on no other wings than its own, not even the wings of the morning. It is our own power, unfolded in a childhood dream, and developed in youth until it is strong and agile like the mountain lion as he rushes on his prey. Hence nature is the best teacher, for your pedagogues can never create the diversity of situations in which genius may exert and enjoy its present powers.

Hail to you, youth, with your sharp eye for proportion, born to adapt yourself easily to all sorts of form! When, little by little, joy in the life around you wakes and you feel a jubilant and human pleasure after the fears and hopes of toil: the delighted shout of the wine-harvester when the fulness of autumn swells his vats, the lively dance of the mower when he hangs his sickle, now idle, on the beam. If the strong nerve of desire and suffering becomes more manfully alive in your brush, then you have striven and lived enough, and enjoyed enough, and are sated with earthly beauty; you are worthy to rest in the arms of the goddess, worthy to feel at her breast that by which the deified Hercules was reborn. Receive him, heavenly Beauty,

you mediatrix between gods and men, so that he may, more than Prometheus, bring down the bliss of the gods upon earth.

1 In the woods at Sesenheim, near Strasbourg, Goethe had fixed a tablet with the names of himself and his friends on a tree.
2 *Acts*, X, II ff.
3 Goethe is alluding to the Abbé M. A. Laugier, *Essai sur l'architecture*, 1753, p. 3, where Gothic ornaments were described as *puérillement entassés*.
4 This example is also from Laugier (*Nouvelles Observations sur l'Architecture*, 1765, pp. 74, 76).
5 Cf. Laugier, *Essai*, p. 9. The source is Vitruvius, *Ten Books on Architecture*, II, i, 3–5.
6 i.e. Paris.
7 Cf. Laugier, *Essai*, p. II., 288.
8 i.e. J. G. Sulzer, *Allgemeine Theorie der Schönen Künste*, 1771, I, p. 489.
9 See Sulzer, p. 609.

5 Georg Christoph Lichtenberg (1742–1799) on London, from Letter to Baldinger

Lichtenberg studied mathematics and natural science at the University of Göttingen, and from 1770 was a professor there. He taught physics and mathematics but is now best known as a writer, winning the subsequent acclaim of figures as eminent as Goethe, Schopenhauer, and Nietzsche. His most lasting work has been the *Aphorisms*, which he began writing as a student and continued until the end of his life. They were first published after his death, in 1800–6, and are now often seen as a key text of the German Enlightenment. Before taking up his professorial appointment, Lichtenberg had acted as a private tutor to a group of wealthy young Englishmen who were studying in Germany. This in turn led to his visiting England in the early summer of 1770. He developed a lifelong Anglophilia which was fuelled by a second, longer visit in 1774–5. This gave rise to his *Letters from England*, published in Germany in 1776 and 1778, and later to an extensive study of Hogarth which appeared in parts between 1784 and 1796. Lichtenberg's treatment of Hogarth evolves a coherent and powerful overall narrative from minutely detailed descriptions of the subjects of individual prints. In effect, he proposes Hogarth as a visual equivalent of Shakespeare, narrowing the distinction between visual art and narrative literature which so much modern criticism has been concerned to emphasize. The same powers of description are evident in the present letter, a compelling evocation of late eighteenth-century modernity as witnessed on the streets of London in 1775. Lichtenberg's correspondent, Ernst Gottfried Baldinger, was a colleague at Göttingen University. Our extract is taken from the text of the letter as published in *Lichtenberg's Visits to England*, translated and annotated by Margaret L. Mare and W. H. Quarrell, Oxford: Clarendon Press, 1938, pp. 61 and 63–5.

Kew, 10 January 1775.
My dear Sir,
[. . .] I will make you a hasty sketch of an evening in the streets of London; I will not merely paint it for you in words, but fill in my picture with some groups, which one does not care to paint with such a lasting pigment as ink. For this purpose I will take Cheapside and Fleet Street, as I saw them last week, when I was going from Mr. Boydell's house to my lodging in the evening rather before 8 o'clock. Imagine a street

about as wide as the Weender in Göttingen, but, taking it altogether, about six times as long. On both sides tall houses with plate-glass windows. The lower floors consist of shops and seem to be made entirely of glass; many thousand candles light up silverware, engravings, books, clocks, glass, pewter, paintings, women's finery, modish and otherwise, gold, precious stones, steel-work, and endless coffee-rooms and lottery offices. The street looks as though it were illuminated for some festivity: the apothecaries and druggists display glasses filled with gay-coloured spirits, in which Dieterich's lackey could bathe; they suffuse many a wide space with a purple, yellow, verdigris-green, or azure light. The confectioners dazzle your eyes with their candelabra and tickle your nose with their wares, for no more trouble and expense than that of taking both into their establishments. In these hang festoons of Spanish grapes, alternating with pineapples, and pyramids of apples and oranges, among which hover attendant white-armed nymphs with silk caps and little silk trains, who are often (here's the devil to pay) too little attended. Their masters wisely associate them with the cakes and tarts, to make the mouth of even the most replete water, and to strip the poor purse of its last shilling but one; for to entice the hungry and rich, the cakes and their brilliant surroundings would suffice. All this appears like an enchantment to the unaccustomed eye; there is therefore all the more need for circumspection in viewing all discreetly; for scarcely do you stop than, crash! a porter runs you down, crying 'By your leave,' when you are lying on the ground. In the middle of the street roll chaises, carriages, and drays in an unending stream. Above this din and the hum and clatter of thousands of tongues and feet one hears the chimes from church towers, the bells of the postmen, the organs, fiddles, hurdy-gurdies, and tambourines of English mountebanks, and the cries of those who sell hot and cold viands in the open at the street corners. Then you will see a bonfire of shavings flaring up as high as the upper floors of the houses in a circle of merrily shouting beggar-boys, sailors, and rogues. Suddenly a man whose handkerchief has been stolen will cry: 'Stop thief,' and every one will begin running and pushing and shoving – many of them not with any desire of catching the thief, but of prigging for themselves, perhaps, a watch or purse. Before you know where you are, a pretty, nicely dressed miss will take you by the hand: 'Come, my Lord, come along, let us drink a glass together,' or 'I'll go with you if you please.' Then there is an accident forty paces from you; 'God bless me,' cries one, 'Poor creature,' another. Then one stops and must put one's hand into one's pocket, for all appear to sympathize with the misfortunes of the wretched creature: but all of a sudden they are laughing again, because some one has lain down by mistake in the gutter; 'Look there, damn me,' says a third, and then the procession moves on. Suddenly you will, perhaps, hear a shout from a hundred throats, as if a fire had broken out, a house fallen down, or a patriot were looking out of the window. In Göttingen one hastens thither and can see from at least forty yards off what has happened; here a man is fortunate (especially by night and in this part of the town – the City) if he can weather the storm unharmed in a side street. Where it widens out, all hasten along, no one looking as though he were going for a walk or observing anything, but all appearing to be called to a deathbed. That is Cheapside and Fleet Street on a December evening.

Up to this point I have written without taking breath, as they say, with my thoughts more on those streets than here. Pray excuse me, therefore, if it is at

times harsh and difficult reading, for that is the manner of Cheapside. I have exaggerated nothing; on the contrary, I have omitted a great deal which might have heightened the effect of my picture, so that, among other things, I have said nothing about the ballad singers who, forming circles at every corner, dam the stream of humanity which stops to listen and steal. Moreover, I have only once put on the stage the lewd females who should really have appeared in every scene and in all the intervals. Every ten yards one is beset, even by children of twelve years old, who by the manner of their address save one the trouble of asking whether they know what they want. They attach themselves to you like limpets, and it is often impossible to get rid of them without giving them something. Often they seize hold of you after a fashion of which I can give you the best notion by the fact that I say nothing about it. On that account the passers-by never look about them, and that is 'liberty' and 'property'. [...]

6 Johann Kaspar Lavater (1741–1801) from *Essays on Physiognomy*

One of the enduring preoccupations of artists has been to invest their pictures with more life than can be conveyed by mimesis pure and simple. In the seventeenth century, drawing on Descartes' study of the passions, Charles Le Brun codified an entire range of facial expressions for the use of artists (IB14). By the late eighteenth century the relation between inner feeling and outward manifestation was increasingly the subject of scientific enquiries. The most notable of these was Lavater's 'physiognomy', a kind of pseudo-science which purported to read character and personality from physical characteristics, notably those of the human head. Although discredited by subsequent developments in science and medicine, not least by psychoanalysis, Lavater's physiognomy overlapped with crucial areas of art practice such as observation, and proved of considerable interest to artists in the nineteenth century (see *Art in Theory 1815–1900* IVA8). Lavater was a Swiss writer and cleric with an abiding interest in art, which ran to a well-known collection of paintings and drawings. He had eminent friends in the world of art, notably Henry Fuseli, though he also had a deep and long-running feud with Goethe, whom he kept trying to convert in order to save his 'heathen soul'. His *Physiognomische Fragmente* were published in four volumes in 1775–8, illustrated with engravings by the Polish-German artist Daniel Nikolaus Chodowiecki (1726–1801). The publication was an immediate success and translation into other languages followed rapidly, both in full and in a variety of abridged, paraphrased and pirated versions: it has been calculated that by 1810 over fifty editions had appeared, including twenty in English. We have made three selections from the English edition of 1789: an emphatic assertion of the human as the proper subject of study; a lament on the rarity of precise and accurate observation; and a group of case studies in which Lavater deduces character from the close scrutiny of a range of facial and cranial types. We have retained the appropriate illustrations for the case studies. They are taken from *Essays on Physiognomy for the Promotion of the Knowledge and the Love of Mankind*, translated by Thomas Holcroft, London: G. G. J. Robinson, 1789, pp. 10–12, 106–7, 110–15.

Of all earthly creatures man is the most perfect, the most imbued with the principles of life.

Each particle of matter is an immensity; each leaf a world; each insect an inexplicable compendium. Who then shall enumerate the gradations between insect and man? In him all the powers of nature are united. He is the essence of creation. The son of earth, he is the earth's lord; the summary and central point of all existence, of all powers, and of all life, on that earth which he inhabits.

Of all organized beings with which we are acquainted, man alone excepted, there are none in which are so wonderfully united the three different kinds of life, the animal, the intellectual, and the moral. Each of these lives is the compendium of various faculties, most wonderfully compounded and harmonized.

To know – to desire – to act – Or accurately to observe and meditate – To perceive and to wish – To possess the powers of motion and of resistance – These, combined, constitute man an animal, intellectual, and moral being.

Man endowed with these faculties, with this triple life, is in himself the most worthy subject of observation, as he likewise is himself the most worthy observer. Considered under what point of view he may, what is more worthy of contemplation than himself? In him each species of life is conspicuous; yet never can his properties be wholly known, except by the aid of his external form, his body, his superficies. How spiritual, how incorporeal soever, his internal essence may be, still is he only visible and conceivable from the harmony of his constituent parts. From these he is inseparable. He exists and moves in the body he inhabits, as in his element. This material man must become the subject of observation. All the knowledge we can obtain of man must be gained through the medium of our senses.

This threefold life, which man cannot be denied to possess, necessarily first becomes the subject of disquisition and research, as it presents itself in the form of body, and in such of his faculties as are apparent to sense.

There is no object in nature the properties and powers of which can be manifest to us in any other manner than by such external appearances as affect the senses. By these all beings are characterized. They are the foundations of all human knowledge. Man must wander in the darkest ignorance, equally with respect to himself and the objects that surround him, did he not become acquainted with their properties and powers by the aid of their externals; and had not each object a character peculiar to its nature and essence, which acquaints us with what it is, and enables us to distinguish it from what it is not.

All bodies which we survey appear to sight under a certain form and superficies. We behold those outlines traced which are the result of their organization. I hope I shall be pardoned the repetition of such common-place truths, since on these are built the science of physiognomy, or the proper study of man.

* * *

Nothing can appear more easy than to observe, yet nothing is more uncommon. By observe I mean to consider a subject in all its various parts: first to consider each part separately, and, afterwards, to examine its analogy with contiguous or other possible objects; to conceive and retain the various properties which delineate, define, and constitute the essence of the thing under consideration; to have clear ideas of these properties, individually and collectively, as contributing to form a whole, so as not to confound them with other properties, or things, however great the resemblance.

We need only attend to the different judgments of a number of men, concerning the same portrait, to be convinced of the general want of a spirit of accurate observation: nor has any thing so effectually, so unexpectedly convinced me, of the extreme rarity of the true spirit of observation, even among men of genius, in famed, and fame-worthy, observers, in far greater physiognomists than I can ever hope to become, nothing, I say, has so perfectly convinced me of the rarity of this spirit, as the confounding of widely different portraits and characters, which, notwithstanding their difference, have been mistaken for the same. To make erroneous remarks is a very common thing; and, probably, has often befel myself. This all tends to prove how uncommon an accurate spirit of observation is, and how often it forsakes even those who have been most assiduous in observing. [...]

II

These four caricature profiles, of broken Grecian busts, will, to many hasty observers, though they should not be wholly destitute of physiognomonical sensation, seem nearly alike in signification. Yet are they essentially different. The nose excepted, the first has nothing in common with the rest. The manly closing, and firmness, of the mouth, as little permits the physiognomonical observer to class this countenance with the others, as would the serious aspect, the arching, and motion, of the forehead, and its descent to the nose. Let any one, further, consider this descent of the forehead to the nose; afterward, the nose itself, and the eye, in 2, 3, and 4. Let

4 3 2 1

him compare them, and the scientific physiognomist will develope characters almost opposite. In the nose of 3, he will perceive more taste and understanding than in the rest. The whole under part of the countenance, the general traits of voluptuousness excepted, is, in each of them, different. 4 is the most sensual and effeminate of the whole, although it is deprived of much of its grace by the ill drawn mouth. [. . .]

VII. VIII.

However similar these two shades of the same person may appear; to the physiognomist, that is, to a rare and accurate observer, they are not so. In the forehead, the bones above the eye, and the descent to the nose, in VIII. there is something more of understanding than in the same parts of VII. although the difference is scarcely that of a hair's breadth. How few will find in the bending and point of the nose of VIII. a quicker perception of sensual beauty; and superiour understanding in VII.! Yet this does not escape the physiognomist, to whom, likewise, the mouth, in VIII. betokens firm powers. The descent of the under lip, at the corner, of VII. is, by a hair's breadth, more pure and noble, than VIII.

VII

VIII

XI.

Four additional profiles, in the Grecian style, a few remarks on which may show the enquiring reader how minute are traits which have great signification; and how difficult it is, to the inexperienced eye, not to confound things in themselves very dissimilar. [*See overleaf.*]

The two upper have a great resemblance to each other; as likewise, have the two lower. Physiognomonical sensation would generally pronounce them to be four sisters. All will find the two upper more noble than the two lower. The forehead of 2 will be found to possess a small superior degree of delicacy over that of 1; the forehead of 3 much inferior to 2, and the forehead of 4 still inferior to 3. The physiognomist will read more of affection in 4 than in 3, and something less of delicacy; and more of voluptuousness, in 3 than in 4.

The converse of the proposition we have hitherto maintained will, in certain countenances, be true. The observer will perceive similarity in a hundred countenances which, to the inexperienced, appear entirely dissimilar.

XI

7 Johann Gottfried Herder (1744–1803) from *Sculpture: Some Observations on Form and Shape from Pygmalion's Creative Dream*

The German critic and poet Johann Gottfried Herder was a key figure of the *Sturm und Drang*, helping to shape its characteristic interests in folk poetry and the role of language. His writings contributed to a growing awareness of the importance of national and historical influences in the formation of aesthetic experience. He was born in Mohrungen in East Prussia and studied at Königsberg, where he met Hamann (see IIIB12) and Kant (see VA8 and 10). In 1764 he moved to Riga on the Baltic coast to take up an appointment as a schoolteacher and an assistant pastor. It was here that he began writing his essay, *Sculpture*, intended as an extension of the 'analytic method' of the natural sciences into the domain of aesthetics. As in his earlier *Fragmente* (1767) and *Kritische Wäder* (1769), Herder sought to analyse the complex experience of beauty into its more basic parts.His principal aim is to establish the primacy of our sense of touch where sculpture is concerned and to show that this fundamentally distinguishes it from the art of painting. He starts out from Lessing's identification of the different laws governing poetry and painting

in his *Laocoön* (see IIIA10), but critically evises and extends this account, arguing that sculpture should be recognized as a separate art form with its own laws and principles. Painting can only give us images arrayed across a surface, whereas sculpture works 'in depth', treating objects in the round. The one is the art of dream and 'illusion', the other of 'truth' and tactile physical presence. Herder's *Plastik: Einige Wahrnehmungen über Form und Gestalt aus Pygmalions bildendem Traume* was first published by Johann Friedrich Hartknoch in Riga in 1778. The following excerpt has been translated for this volume by Jason Gaiger from *Herders Sämtliche Werke*, ed. Bernard Suphan, vol. 8, Berlin: Weidmannsche Buchhandlung, 1892, pp. 14–18.

If we are to allow ourselves to speak about *works of art* and to *philosophize about art*, then our philosophy must at least be exact and, where possible, extend to the *simplest concepts*. When it was still fashionable to philosophize about the fine arts, I sought to discover the *specific concept* by which *beautiful forms* and *beautiful colours, sculpture* and *painting*, could be *distinguished* from one another – but I could not find it. Painting and sculpture are always confused with one another; they are placed under a *single* sense, under a *single* organ of the soul, which is supposed to register and to create the same beauty in both. A *single type* of beauty is recognized, which *operates* through the *same natural signs*, placed alongside one another in the same physical space, the one on surfaces, the other in forms. I confess that I understand but little of this. Two art forms which belong to the domain of a *single* sense must be bound by the *same subjective laws* of truth and beauty, for they enter through the same portal, just as they must both leave by it, both existing only for a *single sense*. Painting should be able to sculpt, and sculpture to paint, as much as each will, and the result must be *beautiful*. Both are supposed to serve a single sense and to touch just one point in our soul. Nothing can be falser than this! I have closely considered both art forms and have found that no *single* law, no observation, no effect of the one fits the other without some difference or delimitation. I discovered that the more something is *proper* to a particular art form, the more *native* it is to the most powerful effects of that art, the less it can simply be carried over and applied to a different art form without the most dreadful consequences. I found wretched examples of this in the execution of art works, but it is incomparably worse in the theory and philosophy of art, which is often written by those who know nothing about either art or science. Here everything is curiously mixed up; the two art forms are regarded not as sisters or half-sisters but simply as a *doubled unity* and no nonsense is said about the one that is not also imposed upon the other. From this arises that miserable criticism, that wretched attempt to impose *censorious* and *restrictive* rules, that bitter-sweet nonsense about *universal* beauty, which corrupts the young and appals the master craftsman, but which is taken up in the mouths of the informed masses as if it were true wisdom. Finally I arrived at my own idea of the matter, which seemed to me so true and to conform so accurately to the nature of our senses and to the two art forms, and to a hundred other aspects of our experience, that, like a subjective boundary stone, it was able to distinguish in the most delicate way between these two *arts* and their corresponding *effects* and *rules*. I discovered a point from which I could identify what was proper and what was foreign to each of these arts, their potentials and their requirements, what was a dream and what was the truth. It was as if I acquired a *sense*

which could allow me, fearfully and from a distance, to understand the nature of beauty, where . . . but I say too much and too soon. Here is the bare outline of how, in my opinion, the different *arts of beauty* are related to one another:

We have one sense which perceives *external* things *alongside one another*; a second sense perceives things in *succession*; a third sense perceives things *in depth*. These senses are: *sight, hearing, and touch*.

Things *alongside one another* constitute a *surface*. Things in *succession* in their purest and simplest form constitute *sounds*. Things *in depth* are *bodies* or *forms*. Thus it is that we have distinct senses for surfaces, sounds, and forms; and when it comes to beauty, we have three senses relating to three different *genres of beauty* which must be distinguished from one another, just as we distinguish *surfaces, sounds, and bodies*. And if there are art forms whose proper domain is to be found in one of these genres of beauty, then we know both their internal and external fields of application: on the one hand, *surfaces, sounds, and bodies*, on the other, *sight, hearing, and touch*. These limits or boundaries are imposed by *nature* herself. They are not a matter of convention or agreement, and no decision can be made to alter them without nature taking its revenge. Music which paints, a painting which produces sounds, a sculptor who uses colour, a painter who carves stone, these are monstrosities whether or not they employ false effects. All three arts are related to one another as *surface, sound, and body*, or as *space, time, and force*, the three great media of the Creation, which encompasses and embraces everything.

Let us now consider a second consequence which concerns the way in which *sculpture* and *painting* are related to each other in general.

If painting is the art directed to the eye, and if it is true that the eye can only perceive *surfaces*, if it sees *everything* as a plane, as a picture, then a painting is indeed a *tabula*, a *tavola*, a *tableau*, an image on a panel, on which the artist's creation stands like a dream, in which everything depends upon *appearance*, upon things placed *alongside one another*. It is here that invention and composition, unity and multiplicity begin (together with the rest of the litany of artistic terms), and here that they return; no matter how many chapters and volumes may be written on the subject, the artist can easily see that this follows from a *very simple principle*, that is, from the *nature of his art*. This forms the artist's royal command, beyond which he knows no other, the divine goddess to whom he pays homage. In the faithful execution of his work, all philosophy on this subject must appear to him as something so *elementary* and so *simple* that it does not merit so much discussion.

Sculpture creates *in depth*, it creates *one* living thing, an animate *work*, which *stands there* and which endures. Sculpture cannot imitate shadows or the light of dawn, it cannot imitate lightning or thunder, rivers or flames, any more than the feeling hand can grasp them. But why on this account should these subjects be denied to the painter? The painter follows another law, possesses different powers and a different vocation; why should he not be able to paint the *great panel of nature* in all its different *aspects*, in its *vast, beautiful visibility*? And with what magic he does so! Those who hold landscape painting in contempt, with its depiction of the great *unity* of nature, belittling its achievements and even, with ridiculous gravity, forbidding its practice, lack intelligence. A painter who is forbidden to be a painter? A descriptive artist who is forbidden to describe? The painter is required to turn out sculptures with his brush

and to embellish them with colour as the true taste for Antiquity would have it. It is considered ignoble to depict the panel of Creation; as if the sky and the earth were something worse and of less importance than the cripple who drags himself between them, whose effigy is, by force, to be made the *sole* subject worthy of painting.

Sculpture creates *beautiful forms*, it forms *shapes in depth* and *places* the object *there before us*. Of necessity, it must create that which merits such presentation and which possesses *independent existence*. It cannot gain anything by placing objects *alongside one another*, so that one object assists another and the *whole* profits thereby. For in sculpture the *one object* is the whole and the whole is *one object*. If this object is unworthy, lifeless, ill-chosen, irrelevant, all the worse for the marble and chisel! Nothing is gained from sculpting toads and frogs, rocks and mattresses, if they do not serve some higher work as accessories without raising any *claim* to be the principal subject. What sculpture should create, and what it has succeeded in creating, is forms in which the living soul animates the entire body, forms in which art can compete in the task of representing the *embodied soul*, that is to say, gods, human beings, and noble animals. – But whoever, driven by the high idealistic rigour of this law, seeks to impose it on *depiction*, on *painting the great panel of nature*, is obliged to ask himself how he would go about depicting this.

Finally, we may say that sculpture is *truth*, whereas painting is a *dream*. The former is all *presentation*, the latter story-telling *magic*. What a difference! How little the two stand upon a common ground! A sculpture before which I kneel can embrace me, it can become my friend and companion: it is *present, it is there*. The most beautiful painting is a magnificent story, the dream of a dream. It can transport me, making other moments present, and, like an angel dressed in light, lead me away with it. But the impression of the one is quite different from that of the other. The ray of light wanes, it is *brilliance, image, thought, colour*. – I can think of no theorist, who responds as a human being, who can believe that these two things derive from a *single ground*.

* * *

8 Immanuel Kant (1724–1804) 'What is Enlightenment?'

The German philosopher Immanuel Kant was born to parents of modest means in Königs-berg and spent his entire life in East Prussia. He studied at the university before being appointed a lecturer, and then, in 1770, a full professor. His most important works were all published relatively late in life, including the *Critique of Pure Reason* in 1781 and the *Critique of Practical Reason* in 1788. Kant sought to preserve what was sound in ration-alism and empiricism by constructing a new epistemological framework which emphasized the importance both of sensory knowledge and of the active role played by the mind. In his moral writings he insisted on the autonomy of the will and on the possibility of action based on respect for the moral law. Kant's assertion of the independence of the individual from external authority and on the irreducibility of human freedom have been connected with the ideas behind the American and French Revolutions. In his political writings he sought to establish rational principles for a secular national order and for the achievement of 'perpetual peace' on the international stage. His essay *'Was heißt Aufklärung?'* was first published in the *Berlinische Monatsschrift* in December 1783. It should be seen as a

contribution to a widespread debate about the exact meaning and character of the Enlightenment. Kant himself describes the Enlightenment as an ongoing and dynamic process which is still in the course of unfolding. He takes as its motto the Horatian tag *Sapere aude* (literally, 'dare to be wise'): we should learn to think for ourselves rather than following custom or authority. However, he also distinguishes between the private and the public use of reason, and refuses to countenance revolution as a legitimate political instrument. The ruler to whom he refers on a number of occasions is Frederick the Great, who ruled Prussia from 1740 to 1786. This translation of the complete essay is by H. B. Nisbet. It has been taken from *Kant's Political Writings*, ed. Hans Reiss, Cambridge: Cambridge University Press, 1970, pp. 54–60.

Enlightenment is man's emergence from his self-incurred immaturity. Immaturity is the inability to use one's own understanding without the guidance of another. This immaturity is *self-incurred* if its cause is not lack of understanding, but lack of resolution and courage to use it without the guidance of another. The motto of enlightenment is therefore: *Sapere aude!* Have courage to use your *own* understanding!

Laziness and cowardice are the reasons why such a large proportion of men, even when nature has long emancipated them from alien guidance (*naturaliter maiorennes*), nevertheless gladly remain immature for life. For the same reasons, it is all too easy for others to set themselves up as their guardians. It is so convenient to be immature! If I have a book to have understanding in place of me, a spiritual adviser to have a conscience for me, a doctor to judge my diet for me, and so on, I need not make any efforts at all. I need not think, so long as I can pay; others will soon enough take the tiresome job over for me. The guardians who have kindly taken upon themselves the work of supervision will soon see to it that by far the largest part of mankind (including the entire fair sex) should consider the step forward to maturity not only as difficult but also as highly dangerous. Having first infatuated their domesticated animals, and carefully prevented the docile creatures from daring to take a single step without the leading-strings to which they are tied, they next show them the danger which threatens them if they try to walk unaided. Now this danger is not in fact so very great, for they would certainly learn to walk eventually after a few falls. But an example of this kind is intimidating, and usually frightens them off from further attempts.

Thus it is difficult for each separate individual to work his way out of the immaturity which has become almost second nature to him. He has even grown fond of it and is really incapable for the time being of using his own understanding, because he was never allowed to make the attempt. Dogmas and formulas, those mechanical instruments for rational use (or rather misuse) of his natural endowments, are the ball and chain of his permanent immaturity. And if anyone did throw them off, he would still be uncertain about jumping over even the narrowest of trenches, for he would be unaccustomed to free movement of this kind. Thus only a few, by cultivating their own minds, have succeeded in freeing themselves from immaturity and in continuing boldly on their way.

There is more chance of an entire public enlightening itself. This is indeed almost inevitable, if only the public concerned is left in freedom. For there will always be a few who think for themselves, even among those appointed as guardians of the

common mass. Such guardians, once they have themselves thrown off the yoke of immaturity, will disseminate the spirit of rational respect for personal value and for the duty of all men to think for themselves. The remarkable thing about this is that if the public, which was previously put under this yoke by the guardians, is suitably stirred up by some of the latter who are incapable of enlightenment, it may subsequently compel the guardians themselves to remain under the yoke. For it is very harmful to propagate prejudices, because they finally avenge themselves on the very people who first encouraged them (or whose predecessors did so). Thus a public can only achieve enlightenment slowly. A revolution may well put an end to autocratic despotism and to rapacious or power-seeking oppression, but it will never produce a true reform in ways of thinking. Instead, new prejudices, like the ones they replaced, will serve as a leash to control the great unthinking mass.

For enlightenment of this kind, all that is needed is *freedom*. And the freedom in question is the most innocuous form of all – freedom to make *public use* of one's reason in all matters. But I hear on all sides the cry: *Don't argue!* The officer says: Don't argue, get on parade! The tax-official: Don't argue, pay! The clergyman: Don't argue, believe! (Only one ruler in the world says: *Argue* as much as you like and about whatever you like, *but obey!*) All this means restrictions on freedom everywhere. But which sort of restriction prevents enlightenment, and which, instead of hindering it, can actually promote it? I reply: The *public* use of man's reason must always be free, and it alone can bring about enlightenment among men; the *private use* of reason may quite often be very narrowly restricted, however, without undue hindrance to the progress of enlightenment. But by the public use of one's own reason I mean that use which anyone may make of it *as a man of learning* addressing the entire *reading public*. What I term the private use of reason is that which a person may make of it in a particular *civil* post or office with which he is entrusted.

Now in some affairs which affect the interests of the commonwealth, we require a certain mechanism whereby some members of the commonwealth must behave purely passively, so that they may, by an artificial common agreement, be employed by the government for public ends (or at least deterred from vitiating them). It is, of course, impermissible to argue in such cases; obedience is imperative. But in so far as this or that individual who acts as part of the machine also considers himself as a member of a complete commonwealth or even of cosmopolitan society, and thence as a man of learning who may through his writings address a public in the truest sense of the word, he may indeed argue without harming the affairs in which he is employed for some of the time in a passive capacity. Thus it would be very harmful if an officer receiving an order from his superiors were to quibble openly, while on duty, about the appropriateness or usefulness of the order in question. He must simply obey. But he cannot reasonably be banned from making observations as a man of learning on the errors in the military service, and from submitting these to his public for judgement. The citizen cannot refuse to pay the taxes imposed upon him; presumptuous criticisms of such taxes, where someone is called upon to pay them, may be punished as an outrage which could lead to general insubordination. Nonetheless, the same citizen does not contravene his civil obligations if, as a learned individual, he publicly voices his thoughts on the impropriety or even injustice of such fiscal measures. In the same way, a clergyman is bound to instruct his pupils and his congregation in

accordance with the doctrines of the church he serves, for he was employed by it on that condition. But as a scholar, he is completely free as well as obliged to impart to the public all his carefully considered, well-intentioned thoughts on the mistaken aspects of those doctrines, and to offer suggestions for a better arrangement of religious and ecclesiastical affairs. And there is nothing in this which need trouble the conscience. For what he teaches in pursuit of his duties as an active servant of the church is presented by him as something which he is not empowered to teach at his own discretion, but which he is employed to expound in a prescribed manner and in someone else's name. He will say: Our church teaches this or that, and these are the arguments it uses. He then extracts as much practical value as possible for his congregation from precepts to which he would not himself subscribe with full conviction, but which he can nevertheless undertake to expound, since it is not in fact wholly impossible that they may contain truth. At all events, nothing opposed to the essence of religion is present in such doctrines. For if the clergyman thought he could find anything of this sort in them, he would not be able to carry out his official duties in good conscience, and would have to resign. Thus the use which someone employed as a teacher makes of his reason in the presence of his congregation is purely *private*, since a congregation, however large it is, is never any more than a domestic gathering. In view of this, he is not and cannot be free as a priest, since he is acting on a commission imposed from outside. Conversely, as a scholar addressing the real public (i.e. the world at large) through his writings, the clergyman making *public use* of his reason enjoys unlimited freedom to use his own reason and to speak in his own person. For to maintain that the guardians of the people in spiritual matters should themselves be immature, is an absurdity which amounts to making absurdities permanent.

But should not a society of clergymen, for example an ecclesiastical synod or a venerable presbytery (as the Dutch call it), be entitled to commit itself by oath to a certain unalterable set of doctrines, in order to secure for all time a constant guardianship over each of its members, and through them over the people? I reply that this is quite impossible. A contract of this kind, concluded with a view to preventing all further enlightenment of mankind for ever, is absolutely null and void, even if it is ratified by the supreme power, by Imperial Diets and the most solemn peace treaties. One age cannot enter into an alliance on oath to put the next age in a position where it would be impossible for it to extend and correct its knowledge, particularly on such important matters, or to make any progress whatso-ever in enlightenment. This would be a crime against human nature, whose original destiny lies precisely in such progress. Later generations are thus perfectly entitled to dismiss these agreements as unauthorised and criminal. To test whether any partic-ular measure can be agreed upon as a law for a people, we need only ask whether a people could well impose such a law upon itself. This might well be possible for a specified short period as a means of introducing a certain order, pending, as it were, a better solution. This would also mean that each citizen, particularly the clergyman, would be given a free hand as a scholar to comment publicly, i.e. in his writings, on the inadequacies of current institutions. Meanwhile, the newly established order would continue to exist, until public insight into the nature of such matters had progressed and proved itself to the point where, by general consent (if not unan-

imously), a proposal could be submitted to the crown. This would seek to protect the congregations who had, for instance, agreed to alter their religious establishment in accordance with their own notions of what higher insight is, but it would not try to obstruct those who wanted to let things remain as before. But it is absolutely impermissible to agree, even for a single lifetime, to a permanent religious constitution which no-one might publicly question. For this would virtually nullify a phase in man's upward progress, thus making it fruitless and even detrimental to subsequent generations. A man may for his own person, and even then only for a limited period, postpone enlightening himself in matters he ought to know about. But to renounce such enlightenment completely, whether for his own person or even more so for later generations, means violating and trampling underfoot the sacred rights of mankind. But something which a people may not even impose upon itself can still less be imposed on it by a monarch; for his legislative authority depends precisely upon his uniting the collective will of the people in his own. So long as he sees to it that all true or imagined improvements are compatible with the civil order, he can otherwise leave his subjects to do whatever they find necessary for their salvation, which is none of his business. But it is his business to stop anyone forcibly hindering others from working as best they can to define and promote their salvation. It indeed detracts from his majesty if he interferes in these affairs by subjecting the writings in which his subjects attempt to clarify their religious ideas to governmental supervision. This applies if he does so acting upon his own exalted opinions – in which case he exposes himself to the reproach: *Caesar non est supra Grammaticos* [Caesar is not above the grammarians] – but much more so if he demeans his high authority so far as to support the spiritual despotism of a few tyrants within his state against the rest of his subjects.

If it is now asked whether we at present live in an *enlightened* age, the answer is: No, but we do live in an age of *enlightenment*. As things are at present, we still have a long way to go before men as a whole can be in a position (or can even be put into a position) of using their own understanding confidently and well in religious matters, without outside guidance. But we do have distinct indications that the way is now being cleared for them to work freely in this direction, and that the obstacles to universal enlightenment, to man's emergence from his self-incurred immaturity, are gradually becoming fewer. In this respect our age is the age of enlightenment, the century of *Frederick*.

A prince who does not regard it as beneath him to say that he considers it his duty, in religious matters, not to prescribe anything to his people, but to allow them complete freedom, a prince who thus even declines to accept the presumptuous title of *tolerant*, is himself enlightened. He deserves to be praised by a grateful present and posterity as the man who first liberated mankind from immaturity (as far as government is concerned), and who left all men free to use their own reason in all matters of conscience. Under his rule, ecclesiastical dignitaries, notwithstanding their official duties, may in their capacity as scholars freely and publicly submit to the judgement of the world their verdicts and opinions, even if these deviate here and there from orthodox doctrine. This applies even more to all others who are not restricted by any official duties. This spirit of freedom is also spreading abroad, even where it has to struggle with outward obstacles imposed by governments which

misunderstand their own function. For such governments can now witness a shining example of how freedom may exist without in the least jeopardising public concord and the unity of the commonwealth. Men will of their own accord gradually work their way out of barbarism so long as artificial measures are not deliberately adopted to keep them in it.

I have portrayed *matters of religion* as the focal point of enlightenment, i.e. of man's emergence from his self-incurred immaturity. This is firstly because our rulers have no interest in assuming the role of guardians over their subjects so far as the arts and sciences are concerned, and secondly, because religious immaturity is the most pernicious and dishonourable variety of all. But the attitude of mind of a head of state who favours freedom in the arts and sciences extends even further, for he realises that there is no danger even to his *legislation* if he allows his subjects to make *public* use of their own reason and to put before the public their thoughts on better ways of drawing up laws, even if this entails forthright criticism of the current legislation. We have before us a brilliant example of this kind, in which no monarch has yet surpassed the one to whom we now pay tribute.

But only a ruler who is himself enlightened and has no fear of phantoms, yet who likewise has at hand a well-disciplined and numerous army to guarantee public security, may say what no republic would dare to say: *Argue as much as you like and about whatever you like, but obey!* This reveals to us a strange and unexpected pattern in human affairs (such as we shall always find if we consider them in the widest sense, in which nearly everything is paradoxical). A high degree of civil freedom seems advantageous to a people's *intellectual* freedom, yet it also sets up insuperable barriers to it. Conversely, a lesser degree of civil freedom gives intellectual freedom enough room to expand to its fullest extent. Thus once the germ on which nature has lavished most care – man's inclination and duty to *think freely* – has developed within this hard shell, it gradually reacts upon the mentality of the people, who thus gradually become increasingly able to *act freely*. Eventually, it even influences the principles of governments, which find that they can themselves profit by treating man, who is *more than a machine*, in a manner appropriate to his dignity.

9　Karl Philipp Moritz (1756–1793) from 'On the Creative Imitation of Beauty'

Karl Philipp Moritz was born into poverty in Hameln, in Germany, and educated in Hannover. He originally served an apprenticeship as a hatter, and later worked as a schoolmaster in Berlin. He escaped the hardship of his upbringing to become a writer, publishing memoirs of his travels in England and France and the important, semi-autobiographical *Anton Reiser* (1785–90), subtitled 'a psychological novel'. Between 1783 and 1793 he edited a pioneering psychological periodical, *Know Thyself; or, Magazine of Experimental Psychology*. He wrote two short but influential treatises on aesthetics, 'On the Concept of That Which is Perfect in Itself' (1785) and 'On the Creative Imitation of Beauty' (1788). In 1789 he was appointed professor of the Theory of Fine Arts in Berlin, but died just four years later from tuberculosis. 'On the Creative Imitation of Beauty' was written under the influence of Goethe, whom Moritz met in Italy late in 1786. Goethe himself published part of

the treatise in his *Italian Journey*, where he observes that it was the result of conversations the two men enjoyed together at that time. The thesis of Moritz's essay is that the creative genius produces in the work of art a beautiful whole which is, at the same time, a microcosm of the rationally ordered whole of nature. This quasi-religious interpretation of artistic activity establishes a metaphysical correspondence between artistic creation and the work of the Creator. However, the conception of nature which underpins Moritz's account is closer to the pantheistic vision celebrated in Christof Tobler's essay of 1783 on nature (see VB8), which was long thought to be by Goethe himself. *Über die bildende Nachahmung des Schönen* was first published in Braunschweig in 1788. The following passages are taken from the excerpt reproduced by Goethe in his *Italian Journey*, translated by Robert R. Heitner, Princeton: Princeton University Press, 1994, pp. 431–3.

In the case of a creative genius, however, the horizon of his active power must be as broad as nature itself: that is, his organic structure must be so finely textured and offer so many points of contact with all-circumfluent nature that, so to speak, the outermost ends of all relations in nature on the grand scale, placed beside each other here on a small scale, have room enough not to crowd each other out.

Now if an organic structure of this finer texture, when fully developed, suddenly, in dim awareness of its active power, grasps a whole entity that came in neither through its eye nor its ear, neither through its imagination nor its thoughts, then a commotion, a tension, will necessarily arise between the swaying forces, until they regain their balance.

If a mind, with dim presentiment, has already grasped the grand, noble entirety of nature solely with its active power, then its clearly discerning power of thought, its still more vividly graphic power of imagination, and its most brightly mirroring external sense can no longer be satisfied with viewing individual things in nature's continuum.

All the relations of that great whole that are only dimly sensed by the active power must necessarily in some way become either visible, audible, or, at any rate, comprehensible to the imagination; and in order for this to happen the active power, in which they slumber, must form them in its own fashion, out of itself. – This power must take all the relations of the great whole and bring the highest beauty in them, as though from the point of its rays, into focus – Out of this focus, within the precise range of the eye, a fragile, yet faithful image of the highest beauty must be rounded out and include in its small compass the most complete relations of the great whole of nature, just as truly and accurately as nature itself does.

Now, however, because this image of the highest beauty must necessarily adhere to something, the creative power, determined by its individuality, chooses some object that is visible, audible, or, at any rate, comprehensible to the imagination, onto which it transfers, on a reduced scale, the reflection of the highest beauty. – And again, because if this object were really what it represents it could not go on existing in the continuum of nature, which tolerates no really independent whole outside itself, this leads us to the point where we were before: namely, that the inner essence must always first be transformed into phenomenon before it can be shaped by art into an independently existing whole and mirror unhindered and in their full scope the relations of the great whole of nature.

Since, however, those great relations, in whose complete compass beauty resides, lie outside the jurisdiction of the power of thought, the living concept of the creative imitation of beauty can only emerge when one is conscious of the active power producing the imitation, in the first moment of origin, when the work, as though already completed, suddenly, in dim presentiment, appears before the mind in all the degrees of its gradual development, and, in this moment of its first conception, is there, so to speak, before it really exists. From this, then, springs that inexpressible charm which impels the creative genius to continue producing art perpetually.

Thanks to our reflections on the creative imitation of beauty, combined with our pure pleasure in the beautiful artworks themselves, something like that living concept can, to be sure, arise in us and enhance our enjoyment of the beautiful artworks. – But nevertheless, since our highest enjoyment of beauty cannot possibly depend on our own power for its genesis, the only supreme enjoyment of it always belongs to the creative genius who produces it; and therefore beauty has already attained its highest goal in its emergence, in its becoming. Our subsequent enjoyment of it is simply a result of its existence – and, consequently, in the great plan of nature the creative genius exists first for his own sake, and only then for ours. For, of course, there are other beings besides him, who themselves do not create and produce art, but nevertheless can grasp the work with their imagination, once it is produced.

The nature of beauty consists in the very fact that its inner essence lies in its emergence and becoming, outside the boundaries of the power of thought. Beauty is beautiful for the very reason that the power of thought cannot inquire of it *why* it is beautiful. – For the power of thought completely lacks a point of comparison by which it could judge and view beauty. What other point of comparison is there for true beauty except the sum of all the harmonious relations of the great whole of nature, which no power of thought can grasp? Every individual beauty strewn here and there in nature is only beautiful insofar as this sum of all the relations of the great whole is more or less revealed in it. Therefore it can never serve as the point of comparison for the beauty of the fine arts, nor as a model for the true imitation of beauty; because the highest beauty in individual things in nature is still not beautiful enough for the proud imitation of the grand and majestic relations of the all-inclusive whole of nature. Consequently, beauty is not discerned, it must be produced – or felt.

Because beauty, with its total lack of a point of comparison, is not a matter for the power of thought, and since we cannot produce it ourselves, we would have to forgo enjoyment of it altogether, for we could never be certain of what was more beautiful, or less so – if the productive power were not replaced in us by something that comes as close to it as is possible without actually being it – this, now, is what we call taste, or the ability to *feel* beauty. When this remains within its bounds, it can replace our lack of the higher pleasure of producing beauty with the undisturbed peace of quiet contemplation.

That is to say, if our organic structure is not textured finely enough to offer the inflowing whole of nature as many points of contact as are needed to mirror completely all its great relations in miniature, and we lack one point for complete closure of the circle, then all we can have, instead of the creative power, is the ability

to feel beauty; our every attempt to represent it outside ourselves would fail and make us the more dissatisfied with ourselves, the more closely our ability to feel beauty borders on the creative ability we lack.

That is to say, because the essence of beauty consists in its being complete within itself, the last missing point damages it as much as a thousand, for this shifts all the other points out of the position where they belong. – And if this point of completion is missing, then an artwork is not worth the trouble of beginning it and the time of its formation; it descends below inferiority to uselessness, and its existence is inevitably canceled out again by the oblivion into which it sinks.

10 Immanuel Kant (1724–1804) from *Critique of Judgement*

Kant published the *Critique of Judgement* in 1790 as the third and last of his three great *Critiques* (see the introduction to VA8). In the first part of this work, entitled the 'critique of aesthetic judgement', he turns to problems of taste and beauty. His principal concern is to establish the independent significance and validity of judgement of taste in distinction from both cognitive and moral judgements. Our first set of excerpts is taken from his discussion of the two 'pecularities of the judgement of taste'. Here Kant summarizes his own arguments concerning the distinctive character of aesthetic judgement. In contrast to a mere expression of liking or preference, when we claim that something is beautiful we speak in a 'universal voice', asserting something that we hold to be valid for everyone else. A judgement of taste raises a claim to 'subjective universality'. Kant further develops this idea in relation to the notion of a *sensus communis*, or 'common sense'. Our second set of excerpts is taken from his discussion of the fine arts. A work of art is the product of genius, an innate capacity to create new rules rather than follow existing ones. Kant represents 'aesthetic ideas' as promoting a rich train of associations but as incapable of being captured by any determinate thought or concept. This account was highly influential on later thinkers, emerging, for example, in Karl Ludwig Fernow's writing on landscape painting (see VIIA6). Kant's *Kritik der Urtheilskraft* was first published in Berlin and Libau in 1790. A second edition was published in 1793 and a third, with only minor modifications in 1799. We have used the translation of the second edition by J. H. Bernard, *Kant's Critique of Judgement*, London: Macmillan, 1914, pp. 154–9, 169–73, 185–90, 197–202.

§32. First peculiarity of the judgement of Taste

The judgement of taste determines its object in respect of satisfaction (in its beauty) with an accompanying claim for the assent of *every one*, just as if it were objective.

To say that 'this flower is beautiful' is the same as to assert its proper claim to satisfy every one. By the pleasantness of its smell it has no such claim. A smell which one man enjoys gives another a headache. Now what are we to presume from this except that beauty is to be regarded as a property of the flower itself, which does not accommodate itself to any diversity of persons or of their sensitive organs, but to which these must accommodate themselves if they are to pass any judgement upon it? And yet this is not so. For a judgement of taste consists in calling a thing beautiful

just because of that characteristic in respect of which it accommodates itself to our mode of apprehension.

Moreover, it is required of every judgement which is to prove the taste of the subject, that the subject shall judge by himself, without needing to grope about empirically among the judgements of others, and acquaint himself previously as to their satisfaction or dissatisfaction with the same object; thus his judgement should be pronounced *a priori*, and not be a mere imitation because the thing actually gives universal pleasure. One would think, however, that an *a priori* judgement must contain a concept of the Object, for the cognition of which it contains the principle; but the judgement of taste is not based upon concepts at all, and is in general not a cognitive but an aesthetical judgement.

Thus a young poet does not permit himself to be dissuaded from his conviction that his poem is beautiful, by the judgement of the public or of his friends; and if he gives ear to them he does so, not because he now judges differently, but because, although (in regard to him) the whole public has false taste, in his desire for applause he finds reason for accommodating himself to the common error (even against his judgement). It is only at a later time, when his Judgement has been sharpened by exercise, that he voluntarily departs from his former judgements; just as he proceeds with those of his judgements which rest upon Reason. Taste merely claims autonomy. To make the judgements of others the determining grounds of his own would be heteronomy.

That we, and rightly, recommend the works of the ancients as models and call their authors classical, thus forming among writers a kind of noble class who give laws to the people by their example, seems to indicate *a posteriori* sources of taste, and to contradict the autonomy of taste in every subject. But we might just as well say that the old mathematicians, – who are regarded up to the present day as supplying models not easily to be dispensed with for the supreme profundity and elegance of their synthetical methods, – prove that our Reason is only imitative, and that we have not the faculty of producing from it in combination with intuition rigid proofs by means of the construction of concepts. There is no use of our powers, however free, no use of Reason itself (which must create all its judgements *a priori* from common sources) which would not give rise to faulty attempts, if every subject had always to begin anew from the rude basis of his natural state, and if others had not preceded him with their attempts. Not that these make mere imitators of those who come after them, but rather by their procedure they put others on the track of seeking in themselves principles and so of pursuing their own course, often a better one. Even in religion – where certainly every one has to derive the rule of his conduct from himself, because he remains responsible for it and cannot shift the blame of his transgressions upon others, whether his teachers or his predecessors – there is never as much accomplished by means of universal precepts, either obtained from priests or philosophers or got from oneself, as by means of an example of virtue or holiness which, exhibited in history, does not dispense with the autonomy of virtue based on the proper and original Idea of morality (*a priori*), or change it into a mechanical imitation. *Following*, involving something precedent, not 'imitation,' is the right expression for all influence that the products of an exemplary author may have upon others. And this only means that we draw from the same sources as our

predecessor did, and learn from him only the way to avail ourselves of them. But of all faculties and talents Taste, because its judgement is not determinable by concepts and precepts, is just that one which most needs examples of what has in the progress of culture received the longest approval; that it may not become again uncivilised and return to the crudeness of its first essays.

§33. Second peculiarity of the judgement of Taste

The judgement of taste is not determinable by grounds of proof, just as if it were merely *subjective*.

If a man, *in the first place*, does not find a building, a prospect, or a poem beautiful, a hundred voices all highly praising it will not force his inmost agreement. He may indeed feign that it pleases him in order that he may not be regarded as devoid of taste; he may even begin to doubt whether he has formed his taste on a knowledge of a sufficient number of objects of a certain kind (just as one, who believes that he recognises in the distance as a forest, something which all others regard as a town, doubts the judgement of his own sight). But he clearly sees that the agreement of others gives no valid proof of the judgement about beauty. Others might perhaps see and observe for him; and what many have seen in one way, although he believes that he has seen it differently, might serve him as an adequate ground of proof of a theoretical and consequently logical judgement. But that a thing has pleased others could never serve as the basis of an aesthetical judgement. A judgement of others which is unfavourable to ours may indeed rightly make us scrutinise our own with care, but it can never convince us of its incorrectness. There is therefore no empirical *ground of proof* which would force a judgement of taste upon any one.

Still less, *in the second place*, can an *a priori* proof determine according to definite rules a judgement about beauty. If a man reads me a poem of his or brings me to a play, which does not after all suit my taste, he may bring forward in proof of the beauty of his poem *Batteux* or *Lessing* or still more ancient and famous critics of taste, and all the rules laid down by them; certain passages which displease me may agree very well with rules of beauty (as they have been put forth by these writers and are universally recognised): but I stop my ears, I will listen to no arguments and no reasoning; and I will rather assume that these rules of the critics are false, or at least that they do not apply to the case in question, than admit that my judgement should be determined by grounds of proof *a priori*. For it is to be a judgement of Taste and not of Understanding or Reason.

It seems that this is one of the chief reasons why this aesthetical faculty of judgement has been given the name of Taste. For though a man enumerate to me all the ingredients of a dish, and remark that each is separately pleasant to me and further extol with justice the wholesomeness of this particular food – yet am I deaf to all these reasons; I try the dish with *my* tongue and my palate, and thereafter (and not according to universal principles) do I pass my judgement.

In fact the judgement of Taste always takes the form of a singular judgement about an Object. The Understanding can form a universal judgement by comparing the Object in point of the satisfaction it affords with the judgement of others upon it: *e.g.* 'all tulips are beautiful.' But then this is not a judgement of taste but a logical

judgement, which takes the relation of an Object to taste as the predicate of things of a certain species. That judgement, however, in which I find an individual given tulip beautiful, *i.e.* in which I find my satisfaction in it to be universally valid, is alone a judgement of taste. Its peculiarity consists in the fact that, although it has merely subjective validity, it claims the assent of *all* subjects, exactly as it would do if it were an objective judgement resting on grounds of knowledge, that could be established by a proof.

* * *

§40. Of Taste as a kind of sensus communis

We often give to the Judgement, if we are considering the result rather than the act of its reflection, the name of a sense, and we speak of a sense of truth, or of a sense of decorum, of justice, etc. And yet we know, or at least we ought to know, that these concepts cannot have their place in Sense, and further, that Sense has not the least capacity for expressing universal rules; but that no representation of truth, fitness, beauty, or justice, and so forth, could come into our thoughts if we could not rise beyond Sense to higher faculties of cognition. *The common Understanding of men*, which, as the mere sound (not yet cultivated) Understanding, we regard as the least to be expected from any one claiming the name of man, has therefore the doubtful honour of being given the name of common sense (*sensus communis*); and in such a way that by the name *common* (not merely in our language, where the word actually has a double signification, but in many others) we understand *vulgar*, that which is everywhere met with, the possession of which indicates absolutely no merit or superiority.

But under the *sensus communis* we must include the Idea of a *communal* sense, *i.e.* of a faculty of judgement, which in its reflection takes account (*a priori*) of the mode of representation of all other men in thought; in order *as it were* to compare its judgement with the collective Reason of humanity, and thus to escape the illusion arising from the private conditions that could be so easily taken for objective, which would injuriously affect the judgement. This is done by comparing our judgement with the possible rather than the actual judgements of others, and by putting ourselves in the place of any other man, by abstracting from the limitations which contingently attach to our own judgement. This, again, is brought about by leaving aside as much as possible the matter of our representative state, *i.e.* sensation, and simply having respect to the formal peculiarities of our representation or representative state. Now this operation of reflection seems perhaps too artificial to be attributed to the faculty called *common* sense; but it only appears so, when expressed in abstract formulae. In itself there is nothing more natural than to abstract from charm or emotion if we are seeking a judgement that is to serve as a universal rule.

The following Maxims of common human Understanding do not properly come in here, as parts of the Critique of Taste; but yet they may serve to elucidate its fundamental propositions. They are: $1°$ to think for oneself; $2°$ to put ourselves in thought in the place of every one else; $3°$ always to think consistently. The first is the maxim of *unprejudiced* thought; the second of *enlarged* thought; the third of *consecutive* thought. The first is the maxim of a Reason never *passive*. The tendency to such

passivity, and therefore to heteronomy of the Reason, is called *prejudice*; and the greatest prejudice of all is to represent nature as not subject to the rules that the Understanding places at its basis by means of its own essential law, *i.e.* is *superstition*. Deliverance from superstition is called *enlightenment*; because although this name belongs to deliverance from prejudices in general, yet superstition specially (*in sensu eminenti*) deserves to be called a prejudice. For the blindness in which superstition places us, which it even imposes on us as an obligation, makes the need of being guided by others, and the consequent passive state of our Reason, peculiarly noticeable. As regards the second maxim of the mind, we are otherwise wont to call him limited (*borné*, the opposite of *enlarged*) whose talents attain to no great use (especially as regards intensity). But here we are not speaking of the faculty of cognition, but of the *mode of thought* which makes a purposive use thereof. However small may be the area or the degree to which a man's natural gifts reach, yet it indicates a man of *enlarged thought* if he disregards the subjective private conditions of his own judgement, by which so many others are confined, and reflects upon it from a *universal standpoint* (which he can only determine by placing himself at the standpoint of others). The third maxim, viz. that of *consecutive* thought, is the most difficult to attain, and can only be attained by the combination of both the former, and after the constant observance of them has grown into a habit. We may say that the first of these maxims is the maxim of Understanding, the second of Judgement, and the third of Reason.

I take up again the threads interrupted by this digression, and I say that Taste can be called *sensus communis* with more justice than sound Understanding can; and that the aesthetical Judgement rather than the intellectual may bear the name of a communal sense, if we are willing to use the word 'sense' of an effect of mere reflection upon the mind: for then we understand by sense the feeling of pleasure. We could even define Taste as the faculty of judging of that which makes *universally communicable*, without the mediation of a concept, our feeling in a given representation.

The skill that men have in communicating their thoughts requires also a relation between the Imagination and the Understanding in order to associate intuitions with concepts, and concepts again with those concepts, which then combine in a cognition. But in that case the agreement of the two mental powers is *according to law*, under the constraint of definite concepts. Only where the Imagination in its freedom awakens the Understanding, and is put by it into regular play without the aid of concepts, does the representation communicate itself not as a thought but as an internal feeling of a purposive state of the mind.

Taste is then the faculty of judging *a priori* of the communicability of feelings that are bound up with a given representation (without the mediation of a concept).

If we could assume that the mere universal communicability of a feeling must carry in itself an interest for us with it (which, however, we are not justified in concluding from the character of a merely reflective Judgement), we should be able to explain why the feeling in the judgement of taste comes to be imputed to every one, so to speak, as a duty.

* * *

§44. Of beautiful Art

There is no Science of the Beautiful, but only a Critique of it; and there is no such thing as beautiful Science, but only beautiful Art. For as regards the first point, if it could be decided scientifically, *i.e.* by proofs, whether a thing was to be regarded as beautiful or not, the judgement upon beauty would belong to science and would not be a judgement of taste. And as far as the second point is concerned, a science which should be beautiful as such is a nonentity. For if in such a science we were to ask for grounds and proofs, we would be put off with tasteful phrases (bon-mots). – The source of the common expression, *beautiful science*, is without doubt nothing else than this, as it has been rightly remarked, that for beautiful art in its entire completeness much science is requisite; *e.g.* a knowledge of ancient languages, a learned familiarity with classical authors, history, a knowledge of antiquities, etc. And hence these historical sciences, because they form the necessary preparation and basis for beautiful art, and also partly because under them is included the knowledge of the products of beautiful art (rhetoric and poetry), have come to be called beautiful sciences by a confusion of words.

If art which is adequate to the *cognition* of a possible object performs the actions requisite therefor merely in order to make it actual, it is *mechanical* art: but if it has for its immediate design the feeling of pleasure, it is called *aesthetical* art. This is again either *pleasant* or *beautiful*. It is the first, if its purpose is that the pleasure should accompany the representations [of the object] regarded as mere *sensations*; it is the second if they are regarded as *modes of cognition*.

Pleasant arts are those that are directed merely to enjoyment. Of this class are all those charming arts that can gratify a company at table; *e.g.* the art of telling stories in an entertaining way, of starting the company in frank and lively conversation, of raising them by jest and laugh to a certain pitch of merriment; when, as people say, there may be a great deal of gossip at the feast, but no one will be answerable for what he says, because they are only concerned with momentary entertainment, and not with any permanent material for reflection or subsequent discussion. (Among these are also to be reckoned the way of arranging the table for enjoyment, and, at great feasts, the management of the music. This latter is a wonderful thing. It is meant to dispose to gaiety the minds of the guests, regarded solely as a pleasant noise, without any one paying the least attention to its composition; and it favours the free conversation of each with his neighbour.) Again, to this class belong all games which bring with them no further interest than that of making the time pass imperceptibly.

On the other hand, beautiful art is a mode of representation which is purposive for itself, and which, although devoid of [definite] purpose, yet furthers the culture of the mental powers in reference to social communication.

The universal communicability of a pleasure carries with it in its very concept that the pleasure is not one of enjoyment, from mere sensation, but must be derived from reflection; and thus aesthetical art, as the art of beauty, has for standard the reflective Judgement and not sensation.

§45. Beautiful Art is an art, in so far as it seems like nature

In a product of beautiful art we must become conscious that it is Art and not Nature; but yet the purposiveness in its form must seem to be as free from all constraint of arbitrary rules as if it were a product of mere nature. On this feeling of freedom in the play of our cognitive faculties, which must at the same time be purposive, rests that pleasure which alone is universally communicable, without being based on concepts. Nature is beautiful because it looks like Art; and Art can only be called beautiful if we are conscious of it as Art while yet it looks like Nature.

For whether we are dealing with natural or with artificial beauty we can say generally: *That is beautiful which pleases in the mere act of judging it* (not in the sensation of it, or by means of a concept). Now art has always a definite design of producing something. But if this something were bare sensation (something merely subjective), which is to be accompanied with pleasure, the product would please in the act of judgement only by mediation of sensible feeling. And again, if the design were directed towards the production of a definite Object, then, if this were attained by art, the Object would only please by means of concepts. But in both cases the art would not please *in the mere act of judging; i.e.* it would not please as beautiful, but as mechanical.

Hence the purposiveness in the product of beautiful art, although it is designed, must not seem to be designed; *i.e.* beautiful art must *look* like nature, although we are conscious of it as art. But a product of art appears like nature when, although its agreement with the rules, according to which alone the product can become what it ought to be, is *punctiliously* observed, yet this is not *painfully* apparent; the form of the schools does not obtrude itself – it shows no trace of the rule having been before the eyes of the artist and having fettered his mental powers.

§46. Beautiful Art is the art of genius

Genius is the talent (or natural gift) which gives the rule to Art. Since talent, as the innate productive faculty of the artist, belongs itself to Nature, we may express the matter thus: *Genius* is the innate mental disposition (*ingenium*) *through which* Nature gives the rule to Art.

Whatever may be thought of this definition, whether it is merely arbitrary or whether it is adequate to the concept that we are accustomed to combine with the word *genius* (which is to be examined in the following paragraphs), we can prove already beforehand that according to the signification of the word here adopted, beautiful arts must necessarily be considered as arts of *genius*.

For every art presupposes rules by means of which in the first instance a product, if it is to be called artistic, is represented as possible. But the concept of beautiful art does not permit the judgement upon the beauty of a product to be derived from any rule, which has a *concept* as its determining ground, and therefore has at its basis a concept of the way in which the product is possible. Therefore, beautiful art cannot itself devise the rule according to which it can bring about its product. But since at the same time a product can never be called Art without some precedent rule, Nature

in the subject must (by the harmony of its faculties) give the rule to Art; *i.e.* beautiful Art is only possible as a product of Genius.

We thus see (1) that genius is a *talent* for producing that for which no definite rule can be given; it is not a mere aptitude for what can be learnt by a rule. Hence *originality* must be its first property. (2) But since it also can produce original nonsense, its products must be models, *i.e. exemplary*; and they consequently ought not to spring from imitation, but must serve as a standard or rule of judgement for others. (3) It cannot describe or indicate scientifically how it brings about its products, but it gives the rule just as nature does. Hence the author of a product for which he is indebted to his genius does not himself know how he has come by his Ideas; and he has not the power to devise the like at pleasure or in accordance with a plan, and to communicate it to others in precepts that will enable them to produce similar products. (Hence it is probable that the word genius is derived from *genius*, that peculiar guiding and guardian spirit given to a man at his birth, from whose suggestion these original Ideas proceed.) (4) Nature by the medium of genius does not prescribe rules to Science, but to Art; and to it only in so far as it is to be beautiful Art.

* * *

§49. Of the faculties of the mind that constitute Genius

We say of certain products of which we expect that they should at least in part appear as beautiful art, they are without *spirit*; although we find nothing to blame in them on the score of taste. A poem may be very neat and elegant, but without spirit. A history may be exact and well arranged, but without spirit. A festal discourse may be solid and at the same time elaborate, but without spirit. Conversation is often not devoid of entertainment, but yet without spirit: even of a woman we say that she is pretty, an agreeable talker, and courteous, but without spirit. What then do we mean by spirit?

Spirit, in an aesthetical sense, is the name given to the animating principle of the mind. But that whereby this principle animates the soul, the material which it applies to that [purpose], is that which puts the mental powers purposively into swing, *i.e.* into such a play as maintains itself and strengthens the [mental] powers in their exercise.

Now I maintain that this principle is no other than the faculty of presenting *aesthetical Ideas*. And by an aesthetical Idea I understand that representation of the Imagination which occasions much thought, without, however, any definite thought, *i.e.* any *concept*, being capable of being adequate to it; it consequently cannot be completely compassed and made intelligible by language. – We easily see that it is the counterpart (pendant) of a *rational Idea*, which conversely is a concept to which no *intuition* (or representation of the Imagination) can be adequate.

The Imagination (as a productive faculty of cognition) is very powerful in creating another nature, as it were, out of the material that actual nature gives it. We entertain ourselves with it when experience proves too commonplace, and by it we remould experience, always indeed in accordance with analogical laws, but yet also in accordance with principles which occupy a higher place in Reason (laws too which are just as natural to us as those by which Understanding comprehends empirical nature). Thus we feel our freedom from the law of association (which attaches to the empirical em-

ployment of Imagination), so that the material which we borrow from nature in accordance with this law can be worked up into something different which surpasses nature.

Such representations of the Imagination we may call *Ideas*, partly because they at least strive after something which lies beyond the bounds of experience, and so seek to approximate to a presentation of concepts of Reason (intellectual Ideas), thus giving to the latter the appearance of objective reality, – but especially because no concept can be fully adequate to them as internal intuitions. The poet ventures to realise to sense, rational Ideas of invisible beings, the kingdom of the blessed, hell, eternity, creation, etc; or even if he deals with things of which there are examples in experience, – *e.g.* death, envy and all vices, also love, fame, and the like, – he tries, by means of Imagination, which emulates the play of Reason in its quest after a maximum, to go beyond the limits of experience and to present them to Sense with a completeness of which there is no example in nature. It is, properly speaking, in the art of the poet, that the faculty of aesthetical Ideas can manifest itself in its full measure. But this faculty, considered in itself, is properly only a talent (of the Imagination).

If now we place under a concept a representation of the Imagination belonging to its presentation, but which occasions solely by itself more thought than can ever be comprehended in a definite concept, and which therefore enlarges aesthetically the concept itself in an unbounded fashion, – the Imagination is here creative, and it brings the faculty of intellectual Ideas (the Reason) into movement; *i.e.* a movement, occasioned by a representation, towards more thought (though belonging, no doubt, to the concept of the object) than can be grasped in the representation or made clear.

Those forms which do not constitute the presentation of a given concept itself but only, as approximate representations of the Imagination, express the consequences bound up with it and its relationship to other concepts, are called (aesthetical) *attributes* of an object, whose concept as a rational Idea cannot be adequately presented. Thus Jupiter's eagle with the lightning in its claws is an attribute of the mighty king of heaven, as the peacock is of its magnificent queen. They do not, like *logical attributes*, represent what lies in our concepts of the sublimity and majesty of creation, but something different, which gives occasion to the Imagination to spread itself over a number of kindred representations, that arouse more thought than can be expressed in a concept determined by words. They furnish an *aesthetical Idea*, which for that rational Idea takes the place of logical presentation; and thus as their proper office they enliven the mind by opening out to it the prospect into an illimitable field of kindred representations. But beautiful art does this not only in the case of painting or sculpture (in which the term 'attribute' is commonly employed): poetry and rhetoric also get the spirit that animates their works simply from the aesthetical attributes of the object, which accompany the logical and stimulate the Imagination, so that it thinks more by their aid, although in an undeveloped way, than could be comprehended in a concept and therefore in a definite form of words. [. . .]

In a word the aesthetical Idea is a representation of the Imagination associated with a given concept, which is bound up with such a multiplicity of partial representations in its free employment, that for it no expression marking a definite concept can be found; and such a representation, therefore, adds to a concept much ineffable thought, the feeling of which quickens the cognitive faculties, and with language, which is the mere letter, binds up spirit also.

The mental powers, therefore, whose union (in a certain relation) constitutes *genius* are Imagination and Understanding. In the employment of the Imagination for cognition it submits to the constraint of the Understanding and is subject to the limitation of being conformable to the concept of the latter. On the other hand, in an aesthetical point of view it is free to furnish unsought, over and above that agreement with a concept, abundance of undeveloped material for the Understanding; to which the Understanding paid no regard in its concept, but which it applies, though not objectively for cognition, yet subjectively to quicken the cognitive powers and therefore also indirectly to cognitions. Thus genius properly consists in the happy relation [between these faculties], which no science can teach and no industry can learn, by which Ideas are found for a given concept; and on the other hand, we thus find for these Ideas the *expression*, by means of which the subjective state of mind brought about by them, as an accompaniment of the concept, can be communicated to others. The latter talent is properly speaking what is called spirit; for to express the ineffable element in the state of mind implied by a certain representation and to make it universally communicable – whether the expression be in speech or painting or statuary – this requires a faculty of seizing the quickly passing play of Imagination and of unifying it in a concept (which is even on that account original and discloses a new rule that could not have been inferred from any preceding principles or examples), that can be communicated without any constraint of rules.

* * *

11 Archibald Alison (1757–1839) from *Essays on the Nature and Principles of Taste*

Archibald Alison was born in Scotland and educated at Glasgow and Oxford. After taking orders in the Church of England he received his first preferment at Brancepeth in Durham. He later held two ecclesiastical sinecures and a prebend at Salisbury, which allowed him to pursue his interest in natural history and in questions of taste and beauty. His *Essays on the Nature and Principles of Taste* attempts to explain the 'pleasures of the imagination' on rigorously empiricist and associationist principles, following the work of Locke (see IIB1). His chief concern is the 'state of mind' which allows us to appreciate beauty and sublimity. The simple perception of an object is not sufficient to explain our aesthetic responses. Rather, the emotions of sublimity and beauty are attendant upon the awakening of a 'train of thought' in our imagination, that is to say, a series of associations which are kindled in us by the object. To respond in this way, however, requires the right sort of attention. Someone who is in pain or grief, or even the critic who reasons, will remain insufficiently sensitive to such experiences. Alison concludes that 'It is upon the vacant and unemployed, accordingly, that the objects of taste make the strongest impression.' For this reason, his theory has been seen as an important precursor of the idea of a specific 'aesthetic attitude'. The following excerpts are taken from the first chapter of Essay 1, 'Of the Effect produced upon the Imagination, by objects of Sublimity and Beauty' and from the third chapter of Essay 2, 'Of the Sublimity and Beauty of the Objects of Sight', which discusses the associative beauty of colours. We have used the first edition, *Essays on the Nature and Principles of Taste*, Edinburgh: J. J. G. and G. Robinson, 1810, pp. 1–9, 15–18, 29–30, 204–10.

Essay I. Chapter I. Section I

The emotions of sublimity and beauty are uniformly ascribed, both in popular and in philosophical language, to the imagination. The fine arts are considered as the arts which are addressed to the imagination, and the pleasures they afford, are described, by way of distinction, as the Pleasures of the Imagination. The nature of any person's taste, is, in common life, generally determined from the nature or character of his imagination, and the expression of any deficiency in this power of mind, is considered as synonymous with the expression of a similar deficiency in point of taste.

Although, however, this connection is so generally acknowledged, it is not perhaps as generally understood in what it consists, or what is the nature of that effect which is produced upon the imagination, by objects of sublimity and beauty. I shall endeavour, therefore, in the first place, to state, what seems to me the nature of this effect, or, in what that exercise of imagination consists, which is so generally supposed to take place, when these emotions are felt.

When any object, either of sublimity or beauty, is presented to the mind, I believe every man is conscious of a train of thought being immediately awakened in his imagination, analogous to the character or expression of the original object. The simple perception of the object, we frequently find, is insufficient to excite these emotions, unless it is accompanied with this operation of mind, unless, according to common expression, our imagination is seized, and our fancy busied in the pursuit of all those trains of thought, which are allied to this character or expression.

Thus, when we feel either the beauty or sublimity of natural scenery, the gay lustre of a morning in spring, or the mild radiance of a summer evening, the savage majesty of a wintry storm, or the wild magnificence of a tempestuous ocean, we are conscious of a variety of images in our minds, very different from those which the objects themselves can present to the eye. Trains of pleasing or of solemn thought arise spontaneously within our minds, our hearts swell with emotions, of which the objects before us seem to afford no adequate cause; and we are never so much satiated with delight, as when, in recalling our attention, we are unable to trace either the progress or the connection of those thoughts, which have passed with so much rapidity through our imagination.

The effect of the different arts of taste is similar. The landscapes of Claude Lorrain, the music of Handel, the poetry of Milton, excite feeble emotions in our minds, when our attention is confined to the qualities they present to our senses, or when it is to such qualities of their composition that we turn our regard. It is then, only, we feel the sublimity or beauty of their productions, when our imaginations are kindled by their power, when we lose ourselves amid the number of images that pass before our minds, and when we waken at last from this play of fancy, as from the charm of a romantic dream. [...]

Section II

That unless this exercise of imagination is excited, the emotions of beauty or sublimity are unfelt, seems capable of illustration, from many instances of a very familiar kind.

I

If the mind is in such a state, as to prevent this freedom of imagination, the emotion, whether of sublimity or beauty, is unperceived. In so far as the beauties of art or nature affect the external senses, their effect is the same upon every man who is in possession of these senses. But to a man in pain or in grief, whose mind, by these means, is attentive only to one object or consideration, the same scene, or the same form, will produce no feeling of admiration, which, at other times, when his imagination was at liberty, would have produced it, in its fullest perfection. Whatever is great or beautiful in the scenery of external nature, is almost constantly before us; and not a day passes, without presenting us with appearances, fitted both to charm and to elevate our minds; yet it is in general with a heedless eye that we regard them, and only in particular moments that we are sensible of their power. There is no man, for instance, who has not felt the beauty of sunset; yet every one can remember many instances, when this most striking scene had no effect at all upon his imagination; and when he has beheld all the magnificence with which nature generally distinguishes the close of day, without one sentiment of admiration or delight. There are times, in the same manner, when we can read the Georgics, or the Seasons, with perfect indifference, and with no more emotion, than what we feel from the most uninteresting composition in prose; while in other moments, the first lines we meet with, take possession of our imagination, and awaken in it such innumerable trains of imagery, as almost leave behind the fancy of the poet. In these, and similar cases of difference in our feelings, from the same objects, it will always be found, that the difference arises from the state of our imaginations; from our disposition to follow out the train of thought, which such objects naturally produce, or our incapacity to do it, from some other idea, which has at that time taken possession of our minds, and renders us unable to attend to any thing else. That state of mind, every man must have felt, is most favourable to the emotions of taste, in which the imagination is free and unembarrassed, or in which the attention is so little occupied by any private or particular object of thought, as to leave us open to all the impressions, which the objects that are before us, can create. It is upon the vacant and the unemployed, accordingly, that the objects of taste make the strongest impression. It is in such hours alone, that we turn to the compositions of music, or of poetry, for amusement. The seasons of care, of grief, or of business, have other occupations, and destroy, for the time at least, our sensibility to the beautiful or the sublime, in the same proportion, that they produce a state of mind unfavourable to the indulgence of imagination.

II

The same thing is observable in criticism. When we sit down to appreciate the value of a poem, or of a painting, and attend minutely to the language or composition of the one, or to the colouring or design of the other, we feel no longer the delight which they at first produce. Our imagination in this employment is restrained, and instead of yielding to its suggestions, we studiously endeavour to resist them, by fixing our attention upon minute and partial circumstances of the composition. How much this

operation of mind tends to diminish our sense of its beauty, every one will feel, who attends to his own thoughts on such an occasion, or who will recollect how different was his state of mind, when he first felt the beauty either of the painting or the poem. It is this, chiefly, which makes it so difficult for young people, possessed of imagination, to judge of the merits of any poem or fable, and which induces them so often to give their approbation to compositions of little value. It is not, that they are incapable of learning in what the merits of such compositions consist, for these principles of judgment are neither numerous nor abstruse. It is not, that greater experience produces greater sensibility, for this every thing contradicts; but it is, because every thing, in that period of life, is able to excite their imaginations, and to move their hearts, because they judge of the composition, not by its merits, when compared with other works, or by its approach to any abstract or ideal standard, but by its effect in agitating their imaginations, and leading them into that fairy land, in which the fancy of youth has so much delight to wander. It is their own imagination, which has the charm, which they attribute to the work, that excites it; and the simplest tale, or the poorest novel, is, at that time, as capable of awakening it, as afterwards the eloquence of Virgil or Rousseau. All this, however, all this flow of imagination, in which youth, and men of sensibility, are so apt to indulge, and which so often brings them pleasure at the expence of their taste, the labour of criticism destroys. The mind, in such an employment, instead of being at liberty to follow whatever trains of imagery the composition before it can excite, is either fettered to the consideration of some of its minute and solitary parts; or pauses amid the rapidity of its conceptions, to make them the objects of its attention and review. In these operations, accordingly, the emotion, whether of beauty, or sublimity, is lost, and if it is wished to be recalled, it can only be done by relaxing this vigour of attention, and resigning ourselves again, to the natural stream of our thoughts. The mathematician who investigates the demonstrations of the Newtonian philosophy, the painter who studies the design of Raphael, the poet who reasons upon the measure of Milton, all, in such occupations, lose the delight which these several productions can give; and when they are willing to recover their emotion, must withdraw their attention from those minute considerations, and leave their fancy to expatiate at will, amid all the great or pleasing conceptions, which such productions of genius can raise.

* * *

Section III

There are many other instances equally familiar, which are sufficient to shew, that whatever increases this exercise or employment of Imagination, increases also the emotion of beauty or sublimity.

I

This is very obviously the effect of all Associations. There is no man, who has not some interesting associations with particular scenes, or airs, or books, and who does not feel their beauty or sublimity enhanced to him, by such connections. The view of the house where one was born, of the school where one was educated, and where the

gay years of infancy were passed, is indifferent to no man. They recal so many images of past happiness, and past affections, they are connected with so many strong or valued emotions, and lead altogether to so long a train of feelings and recollections, that there is hardly any scene which one ever beholds with so much rapture. There are songs also, that we have heard in our infancy, which, when brought to our remembrance in after years, raise emotions, for which we cannot well account; and which, though perhaps very indifferent in themselves, still continue from this association, and from the variety of conceptions which they kindle in our minds, to be our favourites through life. The scenes which have been distinguished by the residence of any person, whose memory we admire, produce a similar effect. [...] The scenes themselves may be little beautiful; but the delight with which we recollect the traces of their lives, blends itself insensibly with the emotions which the scenery itself, excites; and the admiration which these recollections afford, seems to give a kind of sanctity to the place where they dwelt, and converts every thing into beauty which appears to have been connected with them. There are scenes, undoubtedly, more beautiful than Runnymede, yet to those who recollect the great event which passed there, there is no scene, perhaps, which so strongly seizes upon the imagination; and although the emotions this recollection produces, are of a very different kind from those which the mere natural scenery can excite, yet they unite themselves so well with these inferior emotions, and spread so venerable a charm over the whole, that one can hardly persuade one's self, that the scene itself is not entitled to this admiration. [...]

The Sublime is increased, in the same manner, by whatever tends to increase this exercise of imagination. The field of any celebrated battle becomes sublime from this association. No man, acquainted with English history, can behold the field of Agincourt, without some emotion of this kind. The additional conceptions which this association produces, and which fill the mind of the spectator on the prospect of that memorable field, diffuse themselves in some measure over the scene, and give it a sublimity which does not naturally belong to it. The majesty of the Alps themselves is increased by the remembrance of Hannibal's march over them; and who is there, that could stand on the banks of the Rubicon, without feeling his imagination kindle, and his heart beat high?

* * *

II

The effect which is thus produced, by Associations, in increasing the emotions of sublimity or beauty, is produced also, either in nature, or in description, by what are generally termed Picturesque Objects. Instances of such objects are familiar to every one's observation. An old tower in the middle of a deep wood, a bridge flung across a chasm between rocks, a cottage on a precipice, are common examples. If I am not mistaken, the effect which such objects have on every one's mind, is to suggest an additional train of conceptions, beside what the scene or description itself would have suggested; for it is very obvious, that no objects are remarked as picturesque, which do not strike the imagination by themselves. They are, in general, such circumstances, as coincide, but are not necessarily connected, with the character of the scene

or description, and which at first affecting the mind with an emotion of surprise, produce afterwards an increased or additional train of imagery. The effect of such objects, in increasing the emotions either of beauty or sublimity, will probably be obvious from the following instances.

The beauty of sunset, in a fine autumnal evening, seems almost incapable of addition from any circumstance. The various and radiant colouring of the clouds, the soft light of the sun, that gives so rich a glow to every object [on] which it falls, the dark shades with which it is contrasted, and the calm and deep repose that seems to steal over universal nature, form altogether a scene, which serves perhaps better than any other in the world, to satiate the imagination with delight: Yet there is no man who does not know how great an addition this fine scene is capable of receiving from the circumstance of the evening bell. In what, however, does the effect of this most picturesque circumstance consist? Is it not in the additional images which are thus suggested to the imagination? images indeed of melancholy and sadness, but which still are pleasing, and which serve most wonderfully to accord with that solemn and pensive state of mind, which is almost irresistibly produced by this charming scene.

Essay 2. Chapter III

Of the Object of Sight

The greatest part of the external objects, in which we discover Sublimity or Beauty, are such as are perceived by the Sense of Sight. It has even been imagined by some Philosophers, that it is to such objects only that the name of Beauty is properly applied, and that it is only from analogy that the same term is applied, to the objects of our other Senses. This opinion, however, seems at first sight ill founded. The terms Beauty and Sublimity are applied by all men to Sounds, and even sometimes to Smells. In our own experience, we very often find, that the same Emotion is produced by Sounds, which is produced by Forms or Colours; and the nature of language sufficiently shows, that this is conformable also to general experience. There seems no reason therefore for limiting the objects of Sublimity or Beauty to the sole class of visible objects.

It must, however, be acknowledged, that by far the greatest number of these objects are such as we discover by means of this Sense; nor does it seem difficult to assign the reason of this superiority. By the rest of our senses, we discover only single qualities of objects; but by the Sense of Seeing, we discover all that assemblage of qualities which constitute, in our imaginations, the peculiar nature of such objects. By our other senses, we discover, in general, such qualities, only when the bodies are in contact with us; but the Sense of Sight affords us a very wide field of observation, and enables us to make them the objects of attention, when they are at very considerable distances from ourselves. It is natural, therefore, that the greater power of this Sense should dispose us to greater confidence in it, and that the qualities of bodies which we discover by means of it, should more powerfully impress

themselves upon our imagination and memory, than those single qualities which we discover by the means of our other Senses. The visible qualities of objects, accordingly, become to us not only the distinguishing characteristics of external bodies, but they become also in a great measure the Signs of all their other qualities; and by recalling to our minds the qualities signified, affect us in some degree with the same Emotion which the objects themselves can excite. Not only the smell of the Rose, or the Violet, is expressed to us by their Colours and Forms; but the utility of a Machine, the elegance of a Design; the proportion of a Column, the speed of the Horse, the ferocity of the Lion, even all the qualities of the human mind are naturally expressed to us by certain visible appearances; because our experience has taught us, that such qualities are connected with such appearances, and the presence of the one immediately suggests to us the idea of the other. Such visible qualities, therefore, are gradually considered as the Signs of other qualities, and are productive to us of the same Emotions with the qualities they signify.

But, besides this, it is also to be observed, that by this sense, we not only discover the nature of individual objects; and therefore naturally associate their qualities with their visible appearance; but that by it also we discover the relation of objects to each other; and that hence a great variety of objects in nature become expressive of qualities which do not immediately belong to themselves, but to the objects with which we have found them connected. Thus, for instance, it is by this sense we discover that the Eagle inhabits among Rocks and Mountains; that the Red-breast leaves the Woods in Winter, to seek shelter and food among the dwellings of Men; that the song of the Nightingale is peculiar to the Evening and the Night, &c. In consequence of this permanent connection, these animals acquire a character from the scenes they inhabit, or the seasons in which they appear, and are expressive to us in some measure of the character of these seasons and scenes. It is hence that so many objects become expressive, which perhaps in themselves would never have been so; that the Curfew is so solemn from accompanying the close of day, the twitter of the Swallow so cheerful, from its being heard in the Morning, the bleating of Sheep, the call of the Goat, the lowing of Kine, so beautiful from their occurring in pastoral or romantic Situations; in short, that the greatest number of natural objects acquire their expression from their connection with particular or affecting scenes.

As, in this way, the visible qualities of objects become expressive to us of all the qualities which they possess; and besides, in so many cases receive expression from their connection with other objects, it is extremely natural, that such qualities should form the greatest and most numerous class of the objects of Material Beauty.

I proceed to a more particular investigation of the Sublimity and Beauty of some of the most remarkable Classes of these Qualities.

Of the Beauty of Colours.

The greatest part of Colours are connected with a kind of established Imagery in our Minds, and are considered as expressive of many very pleasing and affecting Qualities.

These Associations may perhaps be included in the following Enumeration: 1st, Such as arise from the nature of the objects thus permanently coloured. 2dly, Such as

arise from some analogy between certain Colours, and certain Dispositions of Mind; and, 3dly, Such as arise from accidental connections, whether national or particular.

1. When we have been accustomed to see any object capable of exciting Emotion, distinguished by some fixed or permanent Colour, we are apt to extend to the Colour the Qualities of the object thus coloured; and to feel from it, when separated, some degree of the same Emotion which is properly excited by the object itself. Instances of this kind are within every person's observation. White, as it is the colour of Day, is expressive to us of the Cheerfulness or Gaiety which the return of Day brings. Black, as the colour of Darkness, is expressive of Gloom and Melancholy. The Colour of the Heavens, in serene Weather, is Blue: Blue therefore is expressive to us of somewhat of the same pleasing and temperate character. Green is the colour of the Earth in Spring: It is consequently expressive to us of some of those delightful Images which we associate with that Season. The colours of Vegetables and Minerals acquire, in the same manner, a kind of character from the character of the species which they distinguish. The expression of those colours, which are the signs of particular passions in the human Countenance, and which, from this connection, derive their effect, every one is acquainted with.

2. There are many Colours which derive expression from some analogy we discover between them and certain affections of the human Mind. Soft or Strong, Mild or Bold, Gay or Gloomy, Cheerful or Solemn, &c. are terms in all Languages applied to Colours; terms obviously metaphorical, and the use of which indicates their connection with particular qualities of Mind. In the same manner, different degrees or shades of the same Colour have similar characters, as Strong, or Temperate, or Gentle, &c. In consequence of this Association, which is in truth so strong that it is to be found among all Mankind, such Colours derive a character from this resemblance, and produce in our Minds some faint degree of the same Emotion, which the qualities they express are fitted to produce.

3. Many Colours acquire character from accidental Association. Purple, for instance, has acquired a character of Dignity, from its accidental connection with the dress of Kings. The colours of Ermine have a similar character from the same cause. The colours in every country which distinguish the dress of Magistrates, Judges, &c. acquire dignity in the same manner. Scarlet, in this country, as the Colour which distinguishes the dress of the Army, has, in some measure, a character correspondent to its employment; and it was perhaps this Association, (though unknown to himself,) that induced the blind man, mentioned by Mr Locke, to liken his notion of Scarlet to the Sound of a Trumpet. Every person will, in the same manner, probably recollect particular Colours which are pleasing to him, from their having been worn by People whom we loved, or from some other accidental Association.

In these several ways, Colours become significant to us of many interesting or affecting Qualities, and excite in us some degree of the Emotions which such qualities in themselves are fitted to produce.

12 Friedrich Schiller (1759–1805) from *Letters on the Aesthetic Education of Man*

The German poet, dramatist, historian and philosopher Friedrich Schiller was born in Marbach on the Neckar. His first play, *The Robbers* (1781), has been described as 'the great revolutionary drama' of German literature and as the first political tragedy of the *Sturm und Drang*. This impassioned protest against tyranny brought him into disfavour and he was obliged to flee Württemberg. In hiding in Bauerbach, he finished the plays *Fiesko* and *Kabale und Liebe* (1783). On the basis of his work on the Thirty Years War, he was appointed professor of history at Jena in 1788. But three years later he suffered a breakdown in his health. It was at this time that he began a close reading of Kant (see VA8 and 10), temporarily abandoning creative work for the study of philosophy. Perhaps the most significant product of this period is his *Letters on the Aesthetic Education of Man*. The letters are addressed to the Duke of Augustenberg, who supported Schiller's work through a three-year stipend. The *Letters* are, in part, a reaction to the events of the French Revolution and its descent into the Terror. Schiller defends his decision to write on problems of aesthetics at a time of political crisis, insisting that the only way to achieve true freedom is through beauty. He offers a powerful criticism of the fragmentary and dehumanizing qualities of modern society, in which the individual is reduced to a mere part in an 'ingenious clockwork'. For Schiller, rational enlightenment alone is not enough to ensure the proper development of humanity. It is necessary to educate the heart as well as the head. As the bridge between our sensuous and our rational nature, beauty offers a model of human wholeness. The 'aesthetic education of man' is thus an education to unity and completeness. The letters were first published in a series of three instalments in Schiller's own journal, *Die Horen*, between 1795 and 1796 under the title *Über die Ästhetische Erziehung des Menschen in einer Reihe von Briefen*. The following excerpts are taken from the translation by Elizabeth M. Wilkinson and L. A. Willoughby, *On the Aesthetic Education of Man in a Series of Letters*, Oxford: Clarendon Press, 1967, pp. 3, 7–9, 31–7, 49–53, 161–9.

First Letter

I have, then, your gracious permission to submit the results of my inquiry concerning Art and Beauty in the form of a series of letters. Sensible as I am of the gravity of such an undertaking, I am also alive to its attraction and its worth. I shall be treating of a subject which has a direct connexion with all that is best in human happiness, and no very distant connexion with what is noblest in our moral nature. I shall be pleading the cause of Beauty before a heart which is as fully sensible of her power as it is prompt to act upon it, a heart which, in an inquiry where one is bound to invoke feelings no less often than principles, will relieve me of the heaviest part of my labours.

* * *

Second Letter

* * *

I would not wish to live in a century other than my own, or to have worked for any other. We are citizens of our own Age no less than of our own State. And if it is deemed unseemly, or even inadmissible, to exempt ourselves from the morals and customs of the circle in which we live, why should it be less of a duty to allow the needs and taste of our own epoch some voice in our choice of activity?

But the verdict of this epoch does not, by any means, seem to be going in favour of art, not at least of the kind of art to which alone my inquiry will be directed. The course of events has given the spirit of the age a direction which threatens to remove it ever further from the art of the Ideal. This kind of art must abandon actuality, and soar with becoming boldness above our wants and needs; for Art is a daughter of Freedom, and takes her orders from the necessity inherent in minds, not from the exigencies of matter. But at the present time material needs reign supreme and bend a degraded humanity beneath their tyrannical yoke. Utility is the great idol of our age, to which all powers are in thrall and to which all talent must pay homage. Weighed in this crude balance, the insubstantial merits of Art scarce tip the scale, and, bereft of all encouragement, she shuns the noisy market-place of our century. The spirit of philosophical inquiry itself is wresting from the imagination one province after another, and the frontiers of art contract the more the boundaries of science expand.

Expectantly the gaze of philosopher and man of the world alike is fixed on the political scene, where now, so it is believed, the very fate of mankind is being debated. Does it not betray a culpable indifference to the common weal not to take part in this general debate? If this great action is, by reason of its cause and its consequences, of urgent concern to every one who calls himself man, it must, by virtue of its method of procedure, be of quite special interest to every one who has learnt to think for himself. For a question which has hitherto always been decided by the blind right of might, is now, so it seems, being brought before the tribunal of Pure Reason itself, and anyone who is at all capable of putting himself at the centre of things, and of raising himself from an individual into a representative of the species, may consider himself at once a member of this tribunal, and at the same time, in his capacity of human being and citizen of the world, an interested party who finds himself more or less closely involved in the outcome of the case. It is, therefore, not merely his own cause which is being decided in this great action; judgement is to be passed according to laws which he, as a reasonable being, is himself competent and entitled to dictate.

How tempting it would be for me to investigate such a subject in company with one who is as acute a thinker as he is a liberal citizen of the world! And to leave the decision to a heart which has dedicated itself with such noble enthusiasm to the weal of humanity. What an agreeable surprise if, despite all difference in station, and the vast distance which the circumstances of the actual world make inevitable, I were, in the realm of ideas, to find my conclusions identical with those of a mind as unprejudiced as your own! That I resist this seductive temptation, and put Beauty before Freedom, can, I believe, not only be excused on the score of personal

inclination, but also justified on principle. I hope to convince you that the theme I have chosen is far less alien to the needs of our age than to its taste. More than this: if man is ever to solve that problem of politics in practice he will have to approach it through the problem of the aesthetic, because it is only through Beauty that man makes his way to Freedom. But this cannot be demonstrated without my first reminding you of the principles by which Reason is in any case guided in matters of political legislation.

* * *

Sixth Letter

* * *

Closer attention to the character of our age will, however, reveal an astonishing contrast between contemporary forms of humanity and earlier ones, especially the Greek. The reputation for culture and refinement, on which we otherwise rightly pride ourselves *vis-à-vis* humanity in its merely natural state, can avail us nothing against the natural humanity of the Greeks. For they were wedded to all the delights of art and all the dignity of wisdom, without however, like us, falling a prey to their seduction. The Greeks put us to shame not only by a simplicity to which our age is a stranger; they are at the same time our rivals, indeed often our models, in those very excellences with which we are wont to console ourselves for the unnaturalness of our manners. In fullness of form no less than of content, at once philosophic and creative, sensitive and energetic, the Greeks combined the first youth of imagination with the manhood of reason in a glorious manifestation of humanity.

At that first fair awakening of the powers of the mind, sense and intellect did not as yet rule over strictly separate domains; for no dissension had as yet provoked them into hostile partition and mutual demarcation of their frontiers. Poetry had not as yet coquetted with wit, nor speculation prostituted itself to sophistry. Both of them could, when need arose, exchange functions, since each in its own fashion paid honour to truth. However high the mind might soar, it always drew matter lovingly along with it; and however fine and sharp the distinctions it might make, it never proceeded to mutilate. It did indeed divide human nature into its several aspects, and project these in magnified form into the divinities of its glorious pantheon; but not by tearing it to pieces; rather by combining its aspects in different proportions, for in no single one of their deities was humanity in its entirety ever lacking. How different with us Moderns! With us too the image of the human species is projected in magnified form into separate individuals – but as fragments, not in different combinations, with the result that one has to go the rounds from one individual to another in order to be able to piece together a complete image of the species. With us, one might almost be tempted to assert, the various faculties appear as separate in practice as they are distinguished by the psychologist in theory, and we see not merely individuals, but whole classes of men, developing but one part of their potentialities, while of the rest, as in stunted growths, only vestigial traces remain.

I do not underrate the advantages which the human race today, considered as a whole and weighed in the balance of intellect, can boast in the face of what is best in the ancient world. But it has to take up the challenge in serried ranks, and let whole

measure itself against whole. What individual Modern could sally forth and engage, man against man, with an individual Athenian for the prize of humanity?

Whence this disadvantage among individuals when the species as a whole is at such an advantage? Why was the individual Greek qualified to be the representative of his age, and why can no single Modern venture as much? Because it was from all-unifying Nature that the former, and from the all-dividing Intellect that the latter, received their respective forms.

It was civilization itself which inflicted this wound upon modern man. Once the increase of empirical knowledge, and more exact modes of thought, made sharper divisions between the sciences inevitable, and once the increasingly complex machinery of State necessitated a more rigorous separation of ranks and occupations, then the inner unity of human nature was severed too, and a disastrous conflict set its harmonious powers at variance. The intuitive and the speculative understanding now withdrew in hostility to take up positions in their respective fields, whose frontiers they now began to guard with jealous mistrust; and with this confining of our activity to a particular sphere we have given ourselves a master within, who not infrequently ends by suppressing the rest of our potentialities. While in the one a riotous imagination ravages the hard-won fruits of the intellect, in another the spirit of abstraction stifles the fire at which the heart should have warmed itself and the imagination been kindled.

This disorganization, which was first started within man by civilization and learning, was made complete and universal by the new spirit of government. It was scarcely to be expected that the simple organization of the early republics should have survived the simplicity of early manners and conditions; but instead of rising to a higher form of organic existence it degenerated into a crude and clumsy mechanism. That polypoid character of the Greek States, in which every individual enjoyed an independent existence but could, when need arose, grow into the whole organism, now made way for an ingenious clock-work, in which, out of the piecing together of innumerable but lifeless parts, a mechanical kind of collective life ensued. State and Church, laws and customs, were now torn asunder; enjoyment was divorced from labour, the means from the end, the effort from the reward. Everlastingly chained to a single little fragment of the Whole, man himself develops into nothing but a fragment; everlastingly in his ear the monotonous sound of the wheel that he turns, he never develops the harmony of his being, and instead of putting the stamp of humanity upon his own nature, he becomes nothing more than the imprint of his occupation or of his specialized knowledge. But even that meagre, fragmentary participation, by which individual members of the State are still linked to the Whole, does not depend upon forms which they spontaneously prescribe for themselves (for how could one entrust to their freedom of action a mechanism so intricate and so fearful of light and enlightenment?); it is dictated to them with meticulous exactitude by means of a formulary which inhibits all freedom of thought. The dead letter takes the place of living understanding, and a good memory is a safer guide than imagination and feeling.

When the community makes his office the measure of the man; when in one of its citizens it prizes nothing but memory, in another a mere tabularizing intelligence, in a third only mechanical skill; when, in the one case, indifferent to character, it insists

exclusively on knowledge, yet is, in another, ready to condone any amount of obscurantist thinking as long as it is accompanied by a spirit of order and law-abiding behaviour; when, moreover, it insists on special skills being developed with a degree of intensity which is only commensurate with its readiness to absolve the individual citizen from developing himself in extensity – can we wonder that the remaining aptitudes of the psyche are neglected in order to give undivided attention to the one which will bring honour and profit? True, we know that the outstanding individual will never let the limits of his occupation dictate the limits of his activity. But a mediocre talent will consume in the office assigned him the whole meagre sum of his powers, and a man has to have a mind above the ordinary if, without detriment to his calling, he is still to have time for the chosen pursuits of his leisure. Moreover, it is rarely a recommendation in the eyes of the State if a man's powers exceed the tasks he is set, or if the higher needs of the man of parts constitute a rival to the duties of his office. So jealously does the State insist on being the sole proprietor of its servants that it will more easily bring itself (and who can blame it?) to share its man with the Cytherean, than with the Uranian, Venus.

Thus little by little the concrete life of the Individual is destroyed in order that the abstract idea of the Whole may drag out its sorry existence, and the State remains for ever a stranger to its citizens since at no point does it ever make contact with their feeling. Forced to resort to classification in order to cope with the variety of its citizens, and never to get an impression of humanity except through representation at second hand, the governing section ends up by losing sight of them altogether, confusing their concrete reality with a mere construct of the intellect; while the governed cannot but receive with indifference laws which are scarcely, if at all, directed to them as persons. Weary at last of sustaining bonds which the State does so little to facilitate, positive society begins (this has long been the fate of most European States) to disintegrate into a state of primitive morality, in which public authority has become but one party more, to be hated and circumvented by those who make authority necessary, and only obeyed by such as are capable of doing without it.

* * *

Eighth Letter

Is Philosophy then to retire, dejected and despairing, from this field? While the dominion of forms is being extended in every other direction, is this, the most important good of all, to remain the prey of formless chance? Is the conflict of blind forces to endure for ever in the political world, and the law of sociality never to triumph over hostile self-interest?

By no means! Reason herself, it is true, will not join battle directly with this savage force which resists her weapons. No more than the son of Saturn in the *Iliad* will she descend to personal combat in this gloomy arena. But from the midst of the warriors she chooses the most worthy, equips him, as Zeus did his grandson, with divine weapons, and through his victorious strength decides the great issue.

Reason has accomplished all that she can accomplish by discovering the law and establishing it. Its execution demands a resolute will and ardour of feeling. If Truth is

to be victorious in her conflict with forces, she must herself first become a force and appoint some drive to be her champion in the realm of phenomena; for drives are the only motive forces in the sensible world. If she has hitherto displayed so little of her conquering power, this was due, not to the intellect which was powerless to unveil her, but to the heart which closed itself against her, and to the drive which refused to act on her behalf.

For whence comes this still so prevalent rule of prejudice, and this obscuring of minds in the face of all the light which philosophy and empirical science have kindled? Our Age is Enlightened; that is to say, such knowledge has been discovered and publicly disseminated as would suffice to correct at least our practical principles. The spirit of free inquiry has dissipated those false conceptions which for so long barred the approach to truth, and undermined the foundations upon which fanaticism and deception had raised their throne. Reason has purged herself of both the illusions of the senses and the delusions of sophistry, and philosophy itself, which first seduced us from our allegiance to Nature, is now in loud and urgent tones calling us back to her bosom. How is it, then, that we still remain barbarians?

There must, therefore, since the cause does not lie in things themselves, be something in the disposition of men which stands in the way of the acceptance of truth, however brightly it may shine, and of the adoption of truth, however forcibly it may convince. A Sage of old felt what it was, and it lies concealed in that pregnant utterance: *sapere aude*.

Dare to be wise! It is energy and courage that are required to combat the obstacles which both indolence of nature and cowardice of heart put in the way of our true enlightenment. Not for nothing does the ancient myth make the goddess of wisdom emerge fully armed from the head of Jupiter. For her very first action is a warlike one. Even at birth she has to fight a hard battle with the senses, which are loath to be snatched from their sweet repose. The majority of men are far too wearied and exhausted by the struggle for existence to gird themselves for a new and harder struggle against error. Happy to escape the hard labour of thinking for themselves, they are only too glad to resign to others the guardianship of their thoughts. And if it should happen that higher promptings stir within them, they embrace with avid faith the formulas which State and Priesthood hold in readiness for such an event. If these unhappy men deserve our compassion, we are rightly contemptuous of those others whom a kindlier fate has freed from the yoke of physical needs, but who by their own choice continue to bow beneath it. Such people prefer the twilight of obscure ideas, where feeling is given full rein, and fancy can fashion at will convenient images, to the rays of truth which put to flight the fond delusions of their dreams. It is on precisely these illusions, which the unwelcome light of knowledge is meant to dissipate, that they have founded the whole edifice of their happiness – how can they be expected to pay so dearly for a truth which begins by depriving them of all they hold dear? They would first have to be wise in order to love wisdom: a truth already felt by him who gave philosophy her name.

It is not, then, enough to say that all enlightenment of the understanding is worthy of respect only inasmuch as it reacts upon character. To a certain extent it also proceeds from character, since the way to the head must be opened through the heart. The development of man's capacity for feeling is, therefore, the more urgent

need of our age, not merely because it can be a means of making better insights effective for living, but precisely because it provides the impulse for bettering our insights.

* * *

Twenty-Third Letter

[...] The transition from a passive state of feeling to an active state of thinking and willing cannot ... take place except *via* a middle state of aesthetic freedom. And although this state can of itself decide nothing as regards either our insights or our convictions, thus leaving both our intellectual and our moral worth as yet entirely problematic, it is nevertheless the necessary pre-condition of our attaining to any insight or conviction at all. In a word, there is no other way of making sensuous man rational except by first making him aesthetic.

But, you will be tempted to object, can such mediation really be indispensable? Should truth and duty not be able, of and by themselves alone, to gain access to sensuous man? To which I must answer: they not only can, they positively must, owe their determining power to themselves alone; and nothing would be more at variance with my previous assertions than if they should seem to support the opposite view. It has been expressly proved that beauty can produce no result, neither for the understanding nor for the will; that it does not meddle in the business of either thinking or deciding; that it merely imparts the power to do both, but has no say whatsoever in the actual use of that power. In the actual use of it all other aid whatsoever is dispensed with; and the pure logical form, namely the concept, must speak directly to the understanding, the pure moral form, namely the law, directly to the will.

But for them to be able to do this at all, for such a thing as a pure form to exist for sensuous man at all, this, I insist, has first to be made possible by the aesthetic modulation of the psyche. Truth is not something which, like actuality or the physical existence of things, can simply be received from without. It is something produced by our thinking faculty, autonomously and by virtue of its freedom. And it is precisely this autonomy, this freedom, which is lacking in sensuous man. Sensuous man is already (physically speaking) determined, and in consequence no longer possesses free determinability. This lost determinability he will first have to recover before he can exchange his passive determination for an active one. But he cannot recover it except by either losing the passive determination which he had, or by already possessing within himself the active determination towards which he is to proceed. Were he merely to lose the passive determination, he would at the same time lose the possibility of an active one, since thought needs a body, and form can only be realized in some material. He will, therefore, need to have the active determination already within him, need to be at one and the same time passively, and actively, determined; that is to say, he will have to become aesthetic.

Through the aesthetic modulation of the psyche, then, the autonomy of reason is already opened up within the domain of sense itself, the dominion of sensation already broken within its own frontiers, and physical man refined to the point where spiritual man only needs to start developing out of the physical according to

the laws of freedom. The step from the aesthetic to the logical and moral state (i.e., from beauty to truth and duty) is hence infinitely easier than was the step from the physical state to the aesthetic (i.e., from merely blind living to form). The former step man can accomplish simply of his own free will, since it merely involves taking from himself, not giving to himself, fragmenting his nature, not enlarging it; the aesthetically tempered man will achieve universally valid judgements and universally valid actions, as soon as he has the will to do so. But the step from brute matter to beauty, in which a completely new kind of activity has to be opened up within him, must first be facilitated by the grace of Nature, for his will can exert no sort of compulsion upon a temper of mind which is, after all, the very means of bringing his will into existence. In order to lead aesthetic man to understanding and lofty sentiments, one need do no more than provide him with motives of sufficient weight. To obtain the same results from sensuous man we must first alter his very nature. Aesthetic man often needs no more than the challenge of a sublime situation (which is what acts most directly upon our will-power) to make of him a hero or a sage. Sensuous man must first be transported beneath another clime.

It is, therefore, one of the most important tasks of education to subject man to form even in his purely physical life, and to make him aesthetic in every domain over which beauty is capable of extending her sway; since it is only out of the aesthetic, not out of the physical, state that the moral can develop. If man is, in every single case, to possess the power of enlarging his judgement and his will into the judgement of the species as a whole; if out of his limited existence he is to be able to find the path which will lead him through to an infinite existence, out of every dependent condi-tion be able to wing his way towards autonomy and freedom: then we must see to it that he is in no single moment of his life a mere individual, and merely subservient to the law of nature. If he is to be fit and ready to raise himself out of the restricted cycle of natural ends towards rational purposes, then he must already have prepared himself for the latter within the limits of the former, and have realized his physical destiny with a certain freedom of the spirit, that is, in accordance with the laws of beauty.

And this he can indeed accomplish without in the least acting counter to his physical ends. The claims which nature makes upon him are directed merely to what he does, to the content of his actions; in the matter of how he does it, the form of his actions, the purposes of nature offer no directives whatsoever. The claims of reason, by contrast, are directed strictly towards the form of his activity. Necessary as it is, then, for his moral destiny that he should be purely moral, and display absolute autonomy, for his physical destiny it is a matter of complete indifference whether he is purely physical, and behaves with absolute passivity. In respect of the latter, it is left entirely to his own discretion whether he realizes it merely as sensuous being and natural force (i.e., as a force which only reacts as it is acted upon), or whether he will at the same time realize it as absolute force and rational being; and there should be no question as to which of these two ways is more in keeping with his human dignity. On the contrary, just as it debases and degrades him to do from physical impulse what he should have decided to do from pure motives of duty, so it dignifies and exalts him to strive for order, harmony, and infinite freedom in those matters where the common man is content merely to satisfy his legitimate desires. In a word: in the realm of

truth and morality, feeling may have no say whatsoever; but in the sphere of being and well-being, form has every right to exist, and the play-drive every right to command.

It is here, then, in the indifferent sphere of physical life, that man must make a start upon his moral life; here, while he is still passive, already start to manifest his autonomy, and while still within the limitations of sense begin to make some show of rational freedom. The law of his will he must apply even to his inclinations; he must, if you will permit me the expression, play the war against Matter into the very territory of Matter itself, so that he may be spared having to fight this dread foe on the sacred soil of Freedom. He must learn to desire more nobly, so that he may not need to will sublimely. This is brought about by means of aesthetic education, which subjects to laws of beauty all those spheres of human behaviour in which neither natural laws, nor yet rational laws, are binding upon human caprice, and which, in the form it gives to outer life, already opens up the inner.

* * *

13 Friedrich Schiller (1759–1805) from 'On Naive and Sentimental Poetry'

At first sight, Schiller's 'On Naive and Sentimental Poetry' appears to be a reprise of the themes which animated the French *querelle des anciens et des modernes* in the late seventeenth century (see IA6 and 7). German classicism is distinguished from that of seventeenth-century Italy and France, however, by its orientation towards an ideal vision of ancient Greece rather than of Rome. This vision was in large part inspired by the writings of Winckelmann (see IIIA5 and 8). It projected a notion of ideal harmony and simplicity prior to the divisions of modernity. As Lesley Sharpe has observed, whereas the values of ancient Rome were called upon to reinforce those of contemporary France, ancient Greece was consistently held up as a challenge to modern society (Sharpe, 1991). Although Schiller's distinction between the 'naive' and the 'sentimental' starts out as an opposition between two different historical periods, the tendency of his essay is to recognize these two categories as belonging to different psychological types. Indeed, Schiller believed that in Goethe he had encountered the naive poet of the modern age, gifted with an intuitive capacity to grasp the underlying unity beneath its divisions and conflicts. By contrast, Schiller saw himself as incorrigibly 'sentimental', forced to traverse the path of philosophy and reflection in order to return to nature and art. *Über naïve und sentimentalische Dichtung* was first published in a series of instalments in Schiller's journal, *Die Horen*, between 1795 and 1796. The following excerpts are taken from the translation by Helen Watanabe-O'Kelly, *On the Naive and Sentimental in Literature*, Manchester: Carcanet New Press, 1981, pp. 21–5, 31–5, 38–40. The reader should bear in mind that Schiller's use of 'naive' and 'sentimental' differs from our own, and that the meaning of these terms is closer to our 'immediate' and 'reflective'.

There are moments in our life when we accord to nature in plants, minerals, animals, landscapes, as well as to human nature in children, in the customs of country people and of the primitive world, a sort of love and touching respect, not because it pleases our senses nor because it satisfies our intellect or taste (the opposite of both can often

be the case) but merely *because it is nature*. Every sensitive person who is not wholly lacking in feeling experiences this when he wanders in the open air, when he lives in the country or lingers among the monuments of ancient times, in short, when in artificial conditions and situations he is surprised by a sight of simple nature. This interest, elevated quite often to a need, is what lies at the bottom of many of our fancies for flowers and animals, for simple gardens, for walks, for the country and its inhabitants, for many a product of distant antiquity and such like things; always presupposing that neither affectation nor any other accidental interest plays a part here. This sort of interest in nature, however, only comes to pass under two conditions. Firstly, it is absolutely necessary that the object which inspires it in us should be *natural* or at least should be held by us to be so; secondly, that it should (in the widest sense of the word) be *naive*, i.e., that nature should stand in contrast to art and put it to shame. As soon as the last is joined to the first and not before, the natural becomes the naive.

In this way of looking at things, nature for us is nothing other than voluntary existence, the continuation of things through themselves, existence according to its own unchangeable laws.

This concept is absolutely necessary if we are to take an interest in such phenomena. If one could give an artificial flower the appearance of nature so that it deceived completely, if one could push the imitation of the naive in manners and customs to the highest degree of illusion, then the discovery that it was imitation would completely destroy the feeling under discussion. From this it emerges that this sort of pleasure in nature is not an aesthetic but a moral one; for it is conveyed by means of an idea, not produced directly by observation; nor is it governed at all by the beauty of natural forms. What could a modest flower, a spring, a mossy stone, the twittering of the birds, the humming of the bees, etc. have in themselves that would be so pleasing to us? What could give them a claim on our love, even? It is not these objects, it is an *idea* represented by them which we love in them. In them we love the calm, creative life, the quiet functioning from within themselves, the existence according to their own laws, the inner necessity, the eternal unity with themselves.

They *are* what we *were*; they are what we *should become* again. We were natural like them and our culture should lead us back to nature along the path of reason and freedom. They are, therefore, at the same time a representation of our lost childhood, which remains eternally most precious to us and thus they fill us with a certain sadness. At the same time they are representations of our highest perfection in the ideal, so that they transport us into a state of elevated emotion.

But their perfection is no merit of their own, since it is not the product of their own choice. They accord us, therefore, the quite singular pleasure of being our models without putting us to shame. As a constant divine manifestation they surround us, but more to revive than to dazzle. The essence of their character is exactly that which is lacking to the perfection of our own; what distinguishes us from them is exactly what is lacking to the divinity of theirs. We are free and they are necessary; we change, they remain one. But only when both are combined, one with another – when the will freely follows the law of necessity and when reason enforces its rules in spite of all the flux of the imagination, then the divine or the ideal emerges. *In them*, therefore, we eternally see what eludes us, but for which we are

called upon to struggle and which we may hope to approach in a never-ending progression, although we never reach it. *In ourselves* we see a merit which they lack but which they can either never possess, like the unreasoning, or only if they travel on the same path *as us*, like children. They therefore provide us with the sweetest enjoyment of our humanity as an idea, even if they must necessarily humble themselves with regard to that *particular* condition of our humanity.

Since this interest in nature is based on an idea, it can only manifest itself in dispositions which are receptive to ideas, i.e. in moral ones. By far the greatest number of people only affect it, and the commonness of this sentimental taste in our day, which especially since the appearance of certain works expresses itself in sentimental journeys, sentimental gardens, walks and other fancies of this kind, is no proof of the commonness of this type of sentiment. Yet nature will always impress something of this effect even on the most insensitive, because that *predisposition* towards the moral which is common to all men conduces to it, and no matter how distant our *deeds* are from the simplicity and truth of nature we are all without exception impelled towards it *in the idea*. This sensitivity to nature is called forth especially strongly and in the most general way by those objects, for example children and childlike races, which stand in close connection with us and which encourage us to look at ourselves and what is *unnatural* in us. We are wrong if we think that it is merely the idea of helplessness which causes us in certain moments to linger among children with so much emotion. This may perhaps be the case with those who never feel anything else in the face of weakness except their own superiority. But the feeling of which I speak (it is only to be found in particular moral moods and is not to be confused with that which is evoked in us by the cheerful activity of children), rather humbles than flatters one's self-love; and even if there is a merit to be considered here, then it is not on our side. Not because we look down on the child from the height of our strength and perfection but because, from the *limitation* of our condition which is inseparable from the *determination* which we have reached, we *look up* to the limitless *indeterminable nature* of the child and to his pure innocence, we are moved and our emotion in such a moment is too obviously mingled with a certain sadness to allow us to mistake its source. The child represents *disposition* and *destiny*, we represent the *fulfilment* which always lags immeasurably far behind the former. For us, therefore, the child is a representation of the ideal, not the fulfilled but the abandoned one, and it is therefore in no way the concept of his insufficiency and limitations, it is on the contrary the concept of his pure, free strength, of his wholeness, of his boundlessness which touches us. To the moral and sensitive person for this reason the child will become a *sacred* object, an object which, by the power of an idea, destroys any power of experience and which will richly regain when judged by reason what it has lost when judged by common sense.

From just this contradiction between judgments of reason and common sense proceeds the unique phenomenon of the mixed feeling which is aroused in us by the *naive* way of thinking. It connects *child-like* and *childish* simplicity; through the latter it exposes itself to the common sense and calls forth that smile by which we bear witness to our (*theoretical*) superiority. As soon, however, as we have cause to believe that the childish simplicity is at the same time a child-like one, that consequently not lack of understanding, not lack of ability but a higher (*practical*) strength, a heart full

of innocence and truth is the source of it, a heart which despised the assistance of art from an inner greatness, then that triumph of the common sense is over, and mockery of foolishness turns into admiration of simplicity. We feel compelled to respect the object at which we previously smiled and, by taking a look into ourselves at the same time, to accuse ourselves of not being the same. In this way the unique phenomenon of an emotion which unites cheerful mockery, respect and sadness comes into existence. It is a prerequisite of the naive that nature is victorious over art, whether this happens without the knowledge and will of the person or in the full consequence of it. In the first case it is the naiveté of *surprise* and causes merriment; in the second it is the naiveté of disposition and moves one.

In the naiveté of surprise, the person must be *morally* capable of denying nature, in the naiveté of disposition he should not be so, yet we should not imagine him as *physically* incapable of it if it is to affect us as naive. The actions and speech of children, therefore, only give the pure impression of the naive as long as we do not remember their inability in the realm of art and only take account of the contrast between their naturalness and artificiality. The naive is a *childlike quality where it is no longer expected* and cannot therefore be attributed in the strictest sense to real childhood.

However, in both cases, in the naiveté of surprise as well as in the naiveté of disposition, nature must be right, art wrong.

Only with this last statement is the definition of the naive complete. Emotion is natural too and the rules of decorum are something artificial; yet the victory of emotion over decorum is not at all naive. If on the other hand the same emotion conquers affectation, false decorum, pretence, then we have no hesitation in calling it naive. It is therefore necessary that nature should not triumph over art through its blind power as a *dynamic* force but through its form as a *moral* force, in short, that it should triumph over art as an *inner necessity* not as an *outward need*. Not the *inadequacy* but the *invalidity* of art must have given nature the prize, for inadequacy is a deficiency and nothing which springs from a deficiency can call forth respect. Though in the case of the naiveté of surprise it is always the predominance of emotion and a *lack* of recollection which causes nature to betray itself, yet this lack and that predominance by no means constitute the naive by themselves but merely give nature an opportunity to follow *its moral disposition*, i.e. *to follow the law of harmony unhindered*.

* * *

The naiveté of disposition can, strictly speaking, only be attributed to man as a being not absolutely subject to nature, although only in so far as pure nature really still acts in him; but through an effect of the poeticising imagination, it is often transferred from the rational to the unreasoning. Thus we often ascribe to an animal, a landscape, a building, even to all nature in contrast to the arbitrariness and the fantastic ideas of man, a naive character. This, however, always demands that we, in our thoughts, provide what has no will with a will and notice its strict organisation according to the law of necessity. The dissatisfaction over our own badly-used moral freedom and the lack of moral harmony in our own actions easily puts us into a mood in which we address the inanimate like a person and, as though it had really had to fight a temptation towards the opposite, we make a virtue out of its eternal sameness and

envy its calm demeanour. In such a moment, we tend to consider the privilege of our reason a curse and an evil and, because of a lively feeling of the imperfection of our real achievements, we lose from sight a sense of justice towards our disposition and destiny.

We then see in irrational nature only a happier sister who remained behind in the parental home from which we rushed forth to foreign climes, in the arrogant high spirits of our freedom. With a painful longing we wish we were back there as soon as we begin to experience the afflictions of culture, and in the distant exile of art we hear the touching voice of our mother. As long as we were mere children of nature, we were happy and perfect; we have become free and have lost both. From this emerges a double and very unequal longing for nature, a longing for her *happiness* and a longing for her *perfection*. Only the sensual person laments the loss of the former. Only the moral person laments the loss of the latter.

Ask yourself therefore, tenderhearted friend of nature, whether your laziness thirsts for her peace, whether your offended moral code thirsts for her harmony? Ask yourself carefully, when art disgusts you and the abuses of society drive you to inanimate nature in solitude, whether it is society's deprivations, burdens and trials, or whether it is her moral anarchy, her arbitrariness, her disorder which you loathe in her. Your courage must throw itself joyfully into the former and your reward must be the very freedom from which they come. You may indeed set quiet happiness in nature up as a distant goal but only that happiness which is the reward of your worthiness. Therefore no complaints about the difficulty of life, about the inequality of conditions, about the pressure of circumstances, about the uncertainty of possession, about ingratitude, oppression, persecution; you must submit to all the *evils* of culture with voluntary resignation, you must respect them as the natural conditions of the sole Good; you must lament only the *evil* in it but not merely with weak tears. Take care rather that you act purely in the midst of that defilement, freely under that slavery, steadfastly under that capricious change, lawfully in the midst of that anarchy. Do not be afraid of the confusion around you but only of the confusion within you; strive for unity but do not seek it in monotony; strive for peace but through equilibrium, not by a cessation of activity. That nature for which you envy the unreasoning is not worthy of any respect, any longing. It lies behind you, it must always lie behind you. Abandoned by the ladder which carried you, there is now no other choice open to you than to seize the law consciously and voluntarily or to sink without hope of salvation into a bottomless pit.

But when you are comforted over the lost *happiness* of nature, then let her *perfection* serve your heart as a model. When you step out to her from your artificial circle, and she stands before you in her great stillness, in her naive beauty, in her childlike innocence and simplicity, then linger before this picture, cultivate this feeling; it is worthy of your best humanity. Think no more of *changing places* with her but receive her into yourself and strive to wed her endless superiority to your endless privilege and from the two conceive the divine. Let her surround you like a delightful *idyll* in which you always find yourself again after the aberrations of art, in which you gather courage and new confidence for the race and kindle anew in your heart the flame of the *ideal* which extinguishes itself so easily in the storm of life.

When one remembers the beauties of nature which surrounded the ancient Greeks; when one considers how intimately this people could live under its happy sky with free nature, how much nearer its way of imagining things, its way of feeling, its customs lay to simple nature and what a true impression of it its literary works are, then one is unpleasantly surprised to notice that one meets with so few signs of the *sentimental* interests with which we moderns cling to natural scenes and natural characters. The Greek is indeed in the highest degree exact, faithful, detailed in the description of nature, but yet no more and with no greater participation of the heart than in the description of a costume, a shield, a suit of armour, a household utensil or any mechanical product. In his love for the object he seems to make no difference between what exists through itself and what exists through art and the human will. Nature seems more to interest his understanding and his desire for knowledge than his moral sense; he does not cling with inwardness, with emotion, with sweet sorrow to her as we moderns do. Indeed, by personifying and deifying her individual phenomena and representing her effects as the actions of free beings, he does away with her calm necessity which is just what makes her so attractive to us. His impatient imagination carries him on past her to the drama of human life. Only what is alive and free, only characters, actions, fates and morals satisfy him and if *we* can wish in certain moral moods to substitute for the superiority of our freedom of will, which exposes us to so many struggles with ourselves, to so much unease and confusion, the choiceless but calm necessity of the irrational, the imagination of the Greek is preoccupied on the contrary with seeing the beginning of human nature already in the inanimate world and with seeing the influence of the will where blind necessity reigns.

Where does this dissimilarity of spirit come from? How does it come to pass that we, who are so immeasurably surpassed in everything that is nature by the ancients, at just this point can pay homage to nature to a higher degree, cling to her with fervour and embrace even the inanimate world with the warmest emotion? It comes *from this*, that nature for us has vanished from humanity and we only meet it in its true form outside of humanity in the inanimate world. Not our greater *accord with nature*, quite on the contrary our *opposition to nature* in our relationships, circumstances and customs, drives us to seek a satisfaction in the physical world which is not to be hoped for in the moral world, for the awakening desire for truth and simplicity which, like the moral disposition from which it comes, lies incorruptible and ineradicable in every human heart. For this reason, the feeling with which we cling to nature is so closely related to the feeling with which we lament the vanished age of childhood and childlike innocence. Our childhood is the only unmutilated piece of nature which we can still find in civilised humanity and therefore it is no wonder if every footprint of nature outside ourselves leads us back to our childhood.

It was very different with the ancient Greeks. With them culture had not degenerated so much that nature was abandoned for it. The whole structure of their social life was built on feelings, not on the inferior construction of art; even their theology was the inspiration of a naive feeling, the product of a happy imagination, not of brooding reason, as is the ecclesiastical belief of more modern nations. Since, therefore, the Greeks had not lost nature in humanity, they could not be astonished by it outside of humanity and had no such urgent need for objects in which they found it

again. United with themselves and happy in the feeling of their humanity, they had to stop at humanity as their highest value and try to bring everything else nearer to it, while *we*, in discord with ourselves and unhappy in our experience of humanity, have no more urgent interest than to flee out of it and to remove such an unsuccessful form from our eyes.

The feeling of which we are speaking here is, therefore, not that which the ancients had; it is rather one with that which we have *for the ancients*. They felt in a natural way, we feel the Natural. It was without doubt a quite different feeling which filled Homer's soul when he had his divine swineherd play host to Ulysses, from that which moved the soul of the young Werther when he read those verses after an irritating social gathering. Our feeling for nature is like that of the feeling of the sick man for health.

Just as nature began gradually to vanish from human life as *experience* and as the (active and feeling) *subjectivity*, so we see it emerge in the world of the poet as an *idea* and as *subject-matter*. That nation which has gone farthest towards unnaturalness and the consciousness of it would have to be the first to be touched the most strongly by the phenomenon of the *naive* and the first to put a name to it. This nation was, as far as I know, the *French*. But the experience of the naive and the interest in it is naturally much older and dates already from the beginning of moral and aesthetic corruption. This change in the kind of emotion is, for example, already very striking in *Euripides* when you compare him with his predecessors, especially with Aeschylus, and yet the former poet was the darling of his time. The same revolution can be shown among the ancient *historians*. *Horace*, the poet of a civilised and corrupt era, praises the calm contentment of his Tivoli and one could call him the true founder of this type of sentimental poetry, just as he is still the unsurpassed model for it. In *Propertius* and *Virgil*, among others, we also find traces of this way of feeling, less in *Ovid* who lacked the fullness of heart for it and who in his exile in Tomi misses painfully the contentment which Horace did without so gladly in his Tivoli.

Poets everywhere are by definition the *preservers* of nature. Where they can no longer be so completely and already experience in themselves the destructive influence of arbitrary and artificial forms or have even had to fight against them, then they appear as the *witnesses* and the *avengers* of nature. They therefore will either *be* nature or they will *look for* lost nature. From this stem two quite different types of poetry, by which the whole poetic territory is exhausted and measured. All poets who really are poets, according to the nature of the period in which they flourish or according to what accidental circumstances have an influence on their general education and on their passing mental state, will belong either to the *naive* or the *sentimental* type.

* * *

The poet, as I have said, either *is* nature or he will *seek* it. The former constitues the naive, the second the sentimental poet.

The poetic spirit is immortal and inalienable in humanity. It can be lost in no other way than together with humanity and with the disposition to it. For if man distances himself through the freedom of his fantasy and his understanding from the simplicity, truth and necessity of nature, then not only is the way back to nature always open but a powerful and ineradicable drive, the moral drive, impels him increasingly back to it, and it is with this drive that the poetic gift stands in the closest relation-

ship. This, therefore, is not lost at the same time as natural simplicity but simply takes effect in another direction.

Now, too, nature is still the only flame at which the poetic spirit is kindled. From nature alone it draws its whole power, to nature alone it speaks even in the artificial man involved in culture. Every other kind of effect is foreign to the poetic spirit. Therefore, by the way, all so-called works of wit are quite wrongly called poetic, although we have confused the two for a long time, led astray by French literature. Nature, I say, is still now, in the artificial state of culture, the force by which the poetic spirit is powerful; only that it now has quite a different relationship to nature.

As long as man consists of pure, not of course of crude, nature, then he gives the impression of an undivided sensual unit and of a harmonious whole. The senses and the reason, the receptive and the spontaneous capacity, have not yet separated in their function, much less are they in opposition to each other. His emotions are not the formless play of accident, his thoughts are not the meaningless play of the imagination; the former proceed from the law of *necessity*, the latter from *reality*. If man has entered into a state of culture and if art has placed her hand on him, then that *sensual* harmony has been removed from him and he can only express himself as a *moral* unit, i.e., as someone striving for unity. The correspondence between his feeling and his thinking which existed *in reality* in the first state, now only exists *as an ideal*; it is no longer in him but outside of him, as an idea which must first be realised, no longer as a fact of his life. If one now applies the concept of poetry, which means nothing else than *to give humanity its most complete expression possible*, to both of these states, then in the state of natural simplicity, where man still functions together with all his powers as a harmonious unit, where the whole of his nature expresses itself completely in reality, the result is that the most complete possible *imitation of the real* must constitute the poet – that, on the other hand, here in the state of culture where that harmonious cooperation of his whole nature is merely an idea, it is the elevation of reality to the ideal or, what comes to the same thing, the *representation of the ideal which must make the poet*. And these are the two sole possible ways in which the poetic spirit can ever express itself. They are, as one can see, extremely different from each other, but there is a higher concept which subsumes both of them and it should not surprise us when this concept coincides with the idea of humanity.

Here is not the place to pursue this idea which can only be displayed in its full light by a separate discussion. He who knows how to institute a comparison between ancient and modern poets according to some spiritual criterion and not just according to accidental forms will easily be able to convince himself of the truth of it. The older poets touch us through nature, through sensual truth, through the living present; the modern ones touch us through ideas.

This path on which the modern poets are moving is, moreover, the same one on which man individually and mankind as a whole must travel. Nature makes him one with himself, art separates and divides him, through the ideal he returns to that unity. Because, however, the ideal is an infinite one which he never attains, the cultivated man can never become perfect in *his* own way as the natural man is able to do in his. He would, therefore, necessarily be immeasurably inferior to the latter in perfection if one were only to consider the relationship of both to their type and to their maximum potential. If, on the other hand, one compares the types themselves with

each other, then it emerges that the goal for which man *strives* through culture is immeasurably preferable to that which he *reaches* through nature. One, therefore, has his value because of his absolute attainment of a finite greatness, the other because of his approximation to an infinite one. However, because only the latter has *degrees* and a *progression*, then the relative value of him who is caught up in culture is on the whole never determinable, although looked at individually he must always find himself at a disadvantage compared to him in whom nature is functioning in all her perfection. In so far, however, as the ultimate goal of humanity cannot be reached except by means of that progression and the natural man cannot progress except by cultivating himself and as a result merges with the former, then there is no question as to which of the two deserves greater merit with regard to that ultimate goal.

14 Asmus Jakob Carstens (1754–1798) Letter to Karl Friedrich von Heinitz

Asmus Jakob Carstens was born in Sanct Gürgen near Schleswig in what was then Denmark, but is now part of Germany. In 1776 he entered the Copenhagen Academy to study fine art, but showed an early resistance to academic training. After travelling to Rome in 1783, he returned to Berlin where was appointed as a teacher at the Academy. He was supported by the minister of education, Karl Friedrich von Heinitz, who commissioned him to provide murals for his own rooms and for those of the royal family. It was under Heinitz's auspices that Carstens was granted leave of absence from his teaching duties and a stipend from the Prussian government to travel to Rome. Once there, however, he neglected his obligations to the Academy, omitting to send the required reports and examples of his work. The ensuing correspondence with Heinitz forms a key document in changing conceptions of the artist's role and relation to the state. Carstens had been influenced by the ideas of Kant (see VA8 and 10), whose teachings were transmitted to him by his friend and biographer Carl Ludwig Fernow (see VIIA6). Challenging the prevailing assumption that the proper role of the artist is as a functionary of the royal household, he declares his independence as a private citizen whose only obligation is to art and to humanity. Indeed, Carstens maintains that by exhibiting his work to the public he has effectively repaid the money given to him. The exhibition referred to in the letter opened in Berlin in April 1795. It contained drawings as well as works in tempera and watercolour, but no oils, since Carstens was unwilling to compare himself with the great artists of the past. The exhibition was favourably received and was reviewed in the *Deutscher Merkur*. However, in a letter of 19 December, Heinitz wrote to Carstens demanding that he fulfil the conditions of their agreement and return immediately to Berlin. Carstens stayed on in Rome, but died just a few years later. The high seriousness which he brought to his work and his adoption of a rigorously linear neo-classical style influenced a subsequent generation of artists, including Bertel Thorvaldsen, Joseph Anton Koch and Peter Cornelius (see VIIB7). The correspondence with Heinitz is reproduced in Carl Ludwig Fernow, *Leben des Künstlers Asmus Jakob Carstens. Ein Beitrag zur Kunstgeschichte des 18. Jahrhunderts*, Leipzig: Johann Friedrich Hartknoch, 1806. The full text of this letter has been translated for the present volume by Jason Gaiger from pp. 199–206.

20 February 1796

From the letter which was sent to me by Your Most Noble Excellency on the 19th of December of last year, and which was delivered by Herr Rehberg on the 8th of this month, I learn that my canvases have been well received not only by the Academy but by the public as a whole. In your letter of the 23rd of February 1975 it is written:

'And afterwards (that is, after the examination of my paintings by Your Excellency, together with other experts) further details will follow as to whether your stipend can continue to be paid, or whether it is better for you henceforth to work on your own account.'

At the end of the same letter it is written:

'As has already been stated, it still remains the case that your stipend will come to an end *ultimo Mai* of this year, unless the paintings which you send on to us receive as appreciative a judgement as you yourself have passed on them.'

In accordance with this letter, then, and considering the warm reception which my paintings received, I should have expected a further extension of my pension rather than my discharge. In a letter of the 18th of July 1795 it is written:

'This will provide the hoped-for opportunity to present the paintings which were so highly praised in the above journal to his Royal Majesty Himself, and to your future advantage, to bring you, with your nobly born talent and ability, into closer acquaintance with His Majesty.'

However, what in fact took place was not only quite the opposite of my expectations, but I was treated with great injustice. I was even charged with having placed a burden upon the accounts of the Academy through the costs incurred in transporting my paintings, even though this took place in accordance with the will of Your Excellency, as can be seen from the aforementioned letter:

'If my assumption (that is, that my paintings had already been sent on) should prove ungrounded, then I must request that as soon as you receive this letter you send these works by the quickest means possible, so that they can arrive in time for the exhibition which is due to open here in the middle of September.'

Every impartial judge will see that I have done exactly what was demanded of me, and that the above charge cannot justly be made against me. Moreover, the considerate tone of this letter is quite different from that of the other two, which has led me to suspect that the Academy was seeking only to find a way to seize my paintings – as has now in fact taken place – before abandoning me to my fate.

In the last letter which was sent to me I was reproached with ingratitude towards the Curatorium. By this I can only understand ingratitude towards His Excellency, for to this day I do not know if it consists of any other members. Against this charge it

should be remembered that I have had to study here for one and a half years with weak eyes as a consequence of the service which I have already provided. Here I can allow the hall in the house of Field Marshal von Dorville which I painted for Your Excellency to speak for me. As I painted the first figure, Your Nobleness, out of Your Own free will promised to send me to Rome to develop my talent, and, once the considerable work in the hall had been completed, this was granted to me by His Most High Majesty. My presence here in Rome is testament to the truth of what I say. Whilst I have made useful and conscientious employment of the pension granted to me by His Royal Majesty, this is something which lies outside the concerns of Your Excellency as keeper of the state finances. That which His Majesty has given to me, no matter from which purse, cannot be demanded back from me by anyone; with what right does the Academy confiscate my paintings after it has already profited from them by putting them on display?

As concerns the depleted state of the academic fund, I have never had any knowledge of its income and expenditure. However, that this fund must be considerable is revealed by the number of subjects who are supported by it. And if Your Excellency treats others as I have been treated, the fund can surely only increase.

Since the talk is of mutual obligation, it is only appropriate for me to answer that I have never had obligations towards the Academy. As an independent employee of the Directorium I provided good lessons for a modest salary. Nor have I ever even been a member. If I have obligations, then it is to Your Excellency. But in this letter I have already shown how these mutual obligations are now dissolved and how this is required by the demands of justice to myself.

In Your letter there next follows an untruth, or at least an error. There it is written:

'After your repeated requests, you were appointed an official lecturer at the Academy.'

Is there a single line to prove that this is the case? On the contrary, I was obliged to turn down the appointment which was offered to my by Your Excellency. I had no desire to take up this position other than under the condition of independence from the Directorium which was promised to me by Professor Moritz. Your Excellency then enabled me to accept the position again by speaking to Professor Moritz and making proper arrangements; and this is what then in fact took place. But this can scarcely be termed making repeated requests.

And now, in the name of His Royal Majesty, I have received notification of my dismissal. I have been informed that the stipend to further my talents, for which I have worked with great zeal, and which was generously awarded by His Royal Majesty, has, as of the 19th of December of last year, been withdrawn. I am required to pay back to the account of the Academy 100 Taler which were lent me to cover my debts and for which my signature has been given. However, for the months of August, September, October and November, and up to the 19th of December, the Academy still owes me the sum of approximately 75 Taler from the stipend, bestowed on me for the furtherance of my artistic abilities by His Most High Majesty. Subtracted from 100 Taler this leaves 25 Taler, which I will pay back as soon as my paintings are returned to me without charges for transport. As long as this

does not take place, I must demand, in coinage, the sum of 300 zecchini from the Berlin Academy which has no right to my paintings and is entitled neither to take them into its possession nor to auction them off. I do not wish for them to be sold beneath this moderate price, and should this take place I will make a public complaint against the injustice of a public body against a private citizen.

Incidentally, I must inform Your Excellency that I do not belong to the Berlin Academy but to humanity. I have never thought of, nor have I ever promised, to put myself into bondage to the Academy for the rest of my life for a stipend which was given to me for a number of years for the progress of my talents. I can only develop as an artist here in Rome, amongst the greatest works of art in the world, and, as far as my strength allows, I will seek to justify myself to the world through my art. In order to remain true to my duty and calling as an artist I am prepared to relinquish all the privileges of the Academy and to choose instead poverty, an uncertain future and perhaps, considering my already weak condition, an invalid and helpless old age. God has bestowed upon me what talents I possess, and I must be a responsible house-keeper, so that when it is said: 'Give a good account of your housekeeping!' I need not reply: Lord, the Talers which you gave me I have buried in Berlin.

Since I have always known and valued Your Excellency as someone who values the truth I have not hesitated to write the truth frankly. If need be, I will declare this truth publicly in order to justify myself to the world as I am justified to myself.

With deepest respect I remain
Your Most Noble Excellency's
Wholly devoted
Carstens

15 Georg Wilhelm Friedrich Hegel (1770–1831) The 'Earliest System-Programme of German Idealism'

The authorship of the so-called 'Earliest System-Programme of German Idealism' remains a subject of dispute. The paper was first discovered amongst a bundle of Hegel's papers in his handwriting in 1917. However, although Hegel seems the most likely author, it has also been attributed to Friedrich Schelling (see VIA8), and to the poet Friedrich Hölderlin, both of whom studied with Hegel at the same theological seminary in Tübingen. This very uncertainty reveals the proximity between the ideas of these three thinkers at the time. What remains is only a fragment, but it provides a vivid expression of the nascent interests of German idealism at the end of the eighteenth century. The principal influences are Kant (see VA8 and 10) and Schiller (see VA12 and 13). Following Schiller's criticism of the dehumanizing and mechanical structure of the modern state, the author seeks to ground the idea of an ethical community in a new 'mythology of reason'. This is to be effected through the idea of beauty, which alone can reconcile the division of knowledge and morality which still characterizes Kant's philosophical system. The abstract ideas of philosophy first gain genuine motivating force when they are made into 'sensible truths', that is, when they are expressed in a form which appeals to the senses as well as to the mind. For the author, 'truth and goodness only become sisters in beauty – the philosopher must possess just as much aesthetic power as the poet.' In his later writings, Hegel sought to distinguish more clearly between art, religion and philosophy, ultimately claiming that

philosophy 'stands higher' than art (see *Art in Theory 1815–1900*, IA10). The following translation of the entire fragment is by H. S. Harris and is taken from his *Hegel's Development: Towards the Sunlight*, 1770–1801, Oxford: Clarendon Press, 1972, pp. 510–12.

[I] ... an *Ethics*. Since the whole of metaphysics falls for the future within *moral theory* – of which Kant with his pair of practical postulates has given only an *example*, and not *exhausted* it, – this Ethics will be nothing less than a complete system of all Ideas [*Ideen*] or of all practical postulates (which is the same thing). The first Idea is, of course, the presentation [*Vorst<ellung>*] *of my* self as an absolutely free entity [*Wesen*]. Along with the free, self-conscious essence there stands forth – out of nothing – an entire *world* – the one true and thinkable creation out of nothing – Here I shall descend into the realms of physics; the question is this: how must a world be constituted for a moral entity? I would like to give wings once more to our backward physics, that advances laboriously by experiments.

[2] Thus – if philosophy supplies the Ideas, and experience the data, we may at last come to have in essentials the physics that I look forward to for later times. It does not appear that our present-day physics can satisfy a creative spirit such as ours is or ought to be.

[3] From nature I come to the *work of man*. The Idea of mankind [being] premised – I shall prove that it gives us no Idea of the *State*, since the State is a mechanical thing, any more than it gives us an Idea of a *machine*. Only something that is an objective [*Gegenstand*] of *freedom* is called an *Idea*. So we must go even beyond the State – for every State must treat free men as cogs in a machine; and this it ought not to do; so it must *stop*. It is self-evident that in this sphere all the Ideas, of perpetual peace etc., are only *subordinate* Ideas under a higher one. At the same time I shall here lay down the principles for a *history of mankind*, and strip the whole wretched human work of State, constitution, government, legal system – naked to the skin. Finally come the Ideas of a moral world, divinity, immortality – uprooting of all superstition, the prosecution of the priesthood which of late poses as rational, at the bar of Reason itself. – Absolute freedom of all spirits who bear the intellectual world in themselves, and cannot seek either God or immortality outside themselves.

[4] Last of all the Idea that unites all the rest, the Idea of *beauty* taking the word in its higher Platonic sense. I am now convinced that the highest act of Reason, the one through which it encompasses all Ideas, is an aesthetic act, and that *truth and goodness only become sisters in beauty* – the philosopher must possess just as much aesthetic power as the poet. Men without aesthetic sense is what the philosophers-of-the-letter of our times [*unsre Buchstabenphilosophen*] are. The philosophy of the spirit is an aesthetic philosophy. One cannot be creative [*geistreich*] in any way, even about history one cannot argue creatively – without aesthetic sense. Here it ought to become clear what it is that men lack, who understand no ideas – and who confess honestly enough that they find everything obscure as soon as it goes beyond the table of contents and the index.

[5] Poetry gains thereby a higher dignity, she becomes at the end once more, what she was in the beginning – the *teacher of mankind*; for there is no philosophy, no history left, the maker's art alone will survive all other sciences and arts.

[6] At the same time we are told so often that the great mob must have a *religion of the senses*. But not only does the great mob need it, the philosopher needs it too. Monotheism of Reason and heart, polytheism of the imagination and of art, this is what we need.

[7] Here I shall discuss particularly an idea which, as far as I know, has never occurred to anyone else – we must have a new mythology, but this mythology must be in the service of the Ideas, it must be a mythology of *Reason*.

[8] Until we express the Ideas aesthetically, i.e. mythologically, they have no interest for the *people*, and conversely until mythology is rational the philosopher must be ashamed of it. Thus in the end enlightened and unenlightened must clasp hands, mythology must become philosophical in order to make the people rational, and philosophy must become mythological in order to make the philosophers sensible [*sinnl<ich>*]. Then reigns eternal unity among us. No more the look of scorn [of the enlightened philosopher looking down on the mob], no more the blind trembling of the people before its wise men and priests. Then first awaits us *equal* development of *all* powers, of what is peculiar to each and what is common to all. No power shall any longer be suppressed for universal freedom and equality of spirits will reign! – A higher spirit sent from heaven must found this new religion among us, it will be the last [and] greatest work of mankind.

VB

Landscape and the Picturesque

1 William Shenstone (1714–1763) 'Unconnected Thoughts on Gardening'

Besides being a poet and patron of art (see IVA1), Shenstone played a prominent part in the eighteenth-century English landscape-gardening movement. From the mid-1740s much of his effort was devoted to landscaping the family estate at the Leasowes in Shropshire, turning it into a *ferme ornée* (ornamental farm), offering a series of picturesque views over fields and waterways. Thomas Whately, author of *Observations on Modern Gardening* (1770), described the Leasowes as like Shenstone's mind, 'simple, elegant and amiable'. That is to say, it was an evocation of an arcadian landscape, and as such a departure from the formality of the prevailing neo-classical style. Shenstone drew on landscape descriptions by Virgil and Milton, as well as the classical landscape painting of Poussin and Claude, to produce varied prospects of the kind he approved in his 'Unconnected Thoughts on Gardening'. Shenstone considers the landscape painter to be the best potential composer of a garden, and uses Montesquieu's description of the avenue between Moscow and St Petersburg (see IIIB7) to exemplify what the English landscapist was to avoid. The point is, so to speak, that art should become natural, rather than that nature should be forced into the regularity of art (see also VB13–15). Yet for all that, Shenstone is scarcely a proto-romantic. Though he is critical of too much regularity and order, his sense of a humane variety is still nourished by the classical tradition; the gothic remains a step too far. 'Unconnected Thoughts on Gardening' was published in *The Works in Verse and Prose of William Shenstone* in two volumes, London: R. and J. Dodsley, 1764. Our extracts are taken from volume II, pp. 128–43.

In designing a house and gardens, it is happy when there is an opportunity of maintaining a subordination of parts; the house so luckily placed as to exhibit a view of the whole design. I have sometimes thought that there was room for it to resemble an epick or dramatick poem. It is rather to be wished than required, that the more striking scenes may succeed those which are less so.

Taste depends much upon temper. Some prefer Tibullus to Virgil, and Virgil to Homer – Hagley to Persfield, and Persfield to the Welsh mountains. This occasions the different preferences that are given to situations – A garden strikes us most, where the grand, and the pleasing succeed, not intermingle, with each other.

I believe, however, the sublime has generally a deeper effect than the merely beautiful.

I use the words landskip and prospect, the former as expressive of home scenes, the latter of distant images. Prospects should take in the blue distant hills; but never so remotely, that they be not distinguishable from clouds. Yet this mere extent is what the vulgar value.

Landskip should contain variety enough to form a picture upon canvas; and this is no bad test, as I think the landskip painter is the gardiner's best designer. The eye requires a sort of ballance here; but not so as to encroach upon probable nature. A wood, or hill, may ballance a house or obelisk; for exactness would be displeasing. We form our notions from what we have seen; and though, could we comprehend the universe, we might perhaps find it uniformly regular; yet the portions that we see of it, habituate our fancy to the contrary.

It is not easy to account for the fondness of former times for strait-lined avenues to their houses; strait-lined walks through their woods; and, in short, every kind of strait-line; where the foot is to travel over, what the eye has done before. This circumstance, is one objection. Another, somewhat of the same kind, is the repetition of the same object, tree after tree, for a length of way together. A third is, that this identity is purchased by the loss of that variety, which the natural country supplies every where; in a greater or less degree. To stand still and survey such avenues, may afford some slender satisfaction, through the change derived from perspective; but to move on continually and find no change of scene in the least attendant on our change of place, must give actual pain to a person of taste. For such an one to be condemned to pass along the famous vista from Moscow to Petersburg, or that other from Agra to Lahor in India, must be as disagreeable a sentence, as to be condemned to labour at the gallies. [. . .]

Let us examine what may be said in favour of that regularity which Mr. Pope exposes. Might he not seemingly as well object to the disposition of an human face, because it has an eye or cheek, that is the very picture of it's companion? Or does not providence who has observed this regularity in the external structure of our bodies and disregarded it within, seem to consider it as a beauty? The arms, the limbs, and the several parts of them correspond, but it is not the same case with the thorax and the abdomen. I believe one is generally sollicitous for a kind of ballance in a landskip, and, if I am not mistaken, the painters generally furnish one: A building for instance on one side, contrasted by a group of trees, a large oak, or a rising hill on the other. Whence then does this taste proceed, but from the love we bear to regularity in perfection? After all, in regard to gardens, the shape of ground, the disposition of

trees, and the figure of water, must be sacred to nature; and no forms must be allowed that make a discovery of art. [. . .]

Art should never be allowed to set a foot in the province of nature, otherwise than clandestinely and by night. Whenever she is allowed to appear here, and men begin to compromise the difference – Night, gothicism, confusion and absolute chaos are come again. [. . .]

Art, indeed, is often requisite to collect and epitomize the beauties of nature; but should never be suffered to set her mark upon them: I mean in regard to those articles that are of nature's province; the shaping of ground, the planting of trees, and the disposition of lakes and rivulets. [. . .]

Why, fantastically endeavor to humanize those vegetables, of which nature, discreet nature thought it proper to make trees? Why endow the vegetable bird with wings, which nature has made momentarily dependent upon the soil? Here art seems very affectedly to make a display of that industry, which it is her glory to conceal. The stone which represents an asterisk, is valued only on account of it's natural production: Nor do we view with pleasure the laboured carvings and futile diligence of Gothic artists. We view with much more satisfaction some plain Grecian fabric, where art, indeed, has been equally, but less visibly, industrious.

2 William Gilpin (1724–1804) 'The Principles of Painting considered, so far as they relate to prints'

William Gilpin was a clergyman, schoolteacher and amateur artist who became a leading theorist of the Picturesque movement. The following excerpt is taken from the first chapter of his *Essay upon Prints, containing remarks upon the Principles of picturesque Beauty; the Different Kinds of Prints; and the Characters of the most noted Masters*...Prints were the principal means of reproduction of paintings and drawings before the invention of photography and were also potentially collectable works of art in their own right. In this, his first substantial publication, Gilpin married his appreciation of prints to his reading in standard aesthetic treatises to establish general principles for an understanding of the 'picturesque'. At this stage in the development of his ideas, many of his points of reference were drawn from the established canon of paintings, Raphael's often-cited tapestry cartoons providing the majority of examples for his first chapter. In a context of debate largely conditioned by Burke's *Essay on the Sublime and the Beautiful*, published in 1757 (IIIB6), 'the picturesque' added a third term to those apparently required in establishing standards of taste. While a given scene might appear neither beautiful nor sublime to the ordinary perception, it might nevertheless provide material attractive to the eye of the painter or to the connoisseur of pictures. Of course, what then counted as picturesque in nature would be likely to be influenced by taste in paintings. Gilpin more than any other English writer was responsible for shifting the reference of the picturesque away from the classically harmonious landscape as represented by Poussin and for redefining it in terms of the rough, the rugged and the unshaped. His work is thus significant of a substantial shift in taste in the later eighteenth century, coinciding with Gainsborough's attempts to gain recognition for

pictures of rural scenes and subjects. In the end, however, Gilpin's most sustained influence was derived from his subsequent use of the picturesque as a category in the analysis and appreciation of natural scenery (see VB5, 11). The theme of the picturesque was taken up by Reynolds and by Uvedale Price and Richard Payne Knight (see VB13–15). The *Essay upon Prints*... was originally published anonymously, London: J. Robson, 1768 (though in a preface to the second edition Gilpin claimed that it had been written fifteen years earlier). It was translated into German in the year of its first publication and went through several editions in English. Our excerpts are taken from the second edition of 1768, pp. 1–8 and 15–21.

A Painting, or picture, is distinguished from a print only by the colouring, and the manner of execution. In other respects, the foundation of beauty is the same in both; and we consider a print as we do a picture, in a double light, with regard to the *whole*, and with regard to its *parts*. It may have an agreeable effect as a *whole*, and yet be very culpable in its *parts*. It may be likewise the reverse. A man may make a good appearance upon the *whole*; tho his *limbs*, examined separately, may be wanting in exact proportion. His *limbs*, on the other hand, may be exactly formed, and yet his person, upon the *whole*, disgusting.

To make a print agreeable as a *whole*, a just observance of those rules is necessary, which relate to *design, disposition, keeping*, and the *distribution of light*: to make it agreeable in its *parts*, of those which relate to *drawing, expression, grace*, and *perspective*.

We consider the whole before its parts, as it naturally precedes in practice. The painter first forms his general ideas; and disposes them, yet crude, in such a manner, as to receive the most beautiful form, and the most beautiful effect of light. His last work is to finish the several parts: as the statuary shapes his block, before he attempts to give delicacy to the limbs.

By *design*, (a term which painters sometimes use in a more limited sense) we mean the general conduct of the piece as a representation of such a particular story. It answers, in an historical relation of a fact, to a judicious choice of circumstances, and includes a *proper time, proper characters, the most affecting manner of introducing those characters*, and *proper appendages*.

With regard to a *proper time*, the painter is assisted by good old dramatic rules; which inform him, that *one* point of time only should be taken – the most affecting in the action; and that no other part of the story should interfere with it. [...]

With regard to *characters*, the painter must suit them to his piece by attending to historical truth, if his subject be history; or to heathen mythology, if it be fabulous.

He must farther *introduce them properly*. They should be ordered in so advantageous a manner, that the principal figures, those which are most concerned in the action, should catch the eye *first*, and engage it *most*. This is very essential to a well-told story. In the first place, they should be the least embarrassed of the group. This alone gives them distinction. But they may be farther distinguished, sometimes by a *broad light*; sometimes by a *strong shadow*, in the midst of a light; sometimes by a remarkable *action*, or *expression*; and sometimes by a combination of two or three of these modes of distinction.

The last thing included in *design* is the use of *proper appendages*. By *appendages* are meant animals, landskip, buildings, and in general, what ever is introduced into the piece by way of ornament. Every thing of this kind should correspond with the subject, and rank in a proper subordination to it. . . . We often see a landskip well adorned with a story in miniature. The *landskip* here is principal; but at the same time the figures, which tell the story, tho subordinate to the landskip, are the *principal figures.* . . .

When all these rules are observed, when a proper point of time is chosen; when characters corresponding with the subject are introduced, and these ordered so judiciously as to point out the story in the strongest manner; and lastly, when all the appendages, and underparts of the piece are suitable, and subservient to the subject, then the story is well told, and of course the *design* is perfect.

The second thing to be considered with regard to a *whole*, is *disposition*. By this word is meant the art of grouping the figures, and of combining the several parts of a picture. *Design* considers how each part, *separately taken*, concurs in producing a *whole – a whole*, arising from the *unity of the subject*, not the *effect of the object*. For the figures in a piece may be so ordered, as to tell the story in an affecting manner, which is as far as *design* goes, and yet may want that agreeable *combination*, which is necessary to please the eye. To produce such a combination is the business of *disposition*, In the cartoon of St. Paul *preaching at Athens*, the *design* is perfect; and the characters in particular, are so ordered, as to tell the story in a very affecting manner: yet the several parts of the picture are far from being agreeably combined. If Rubens had had the *disposition* of the materials of this picture, its effect as a *whole* had been very different.

* * *

A third thing to be considered in a picture, with regard to a *whole*, is *keeping*. This word implies the different degrees of strength and faintness, which objects receive from nearness and distance. A nice observance of the gradual fading of light and shade contributes greatly towards the production of a *whole*. Without it, the distant parts, instead of being connected with the objects at hand, appear like foreign objects, wildly introduced, and without meaning. Diminished in *size* only, they put you in mind of Lilliput and Brobdignag united in one scene. *Keeping* is generally found in great perfection in Della Bella's prints: and the want of it as conspicuously in Tempesta's.

Nearly allied to *keeping* is the doctrine of *harmony*, which equally contributes towards the production of a *whole*. In *painting*, it has amazing force. A judicious arrangement of according tints will strike even the unpracticed eye. The *effect* of every picture, in a great measure, depends on one principal and master-tint, which, like the key-tone in music, prevails over the whole piece. Sometimes the purple tint is chosen: sometimes the mellow, brown one; and in some subjects the greenish hue is most proper. Of this ruling tint, whatever it is, every object in the picture should in a degree participate. This theory is founded on principles of truth, and produces a fine effect from the *harmony*, in which it unites every object. Harmony is opposed to gaudy colouring, and glare. Yet the skilful painter fears not, when his subject allows it, to employ the greatest variety of tints; and tho he may depreciate their value in shadow, he will not scruple, in his lights, to give each its utmost glow. His art lies

deeper. He takes the glare from one vivid tint by introducing another; and from a nice assemblage of the brightest colours, each of which alone would stare, he creates an united glow, in the highest degree harmonious. He resolves even the most discordant tints into union, and makes them subservient to his grand effect; as the able musician will often dare to introduce notes foreign to his key, and even from apparent discord derive exquisite harmony. But these great effects of harmony are only to be produced by the magic of colours. The harmony of a print is a more simple production: and yet unless a print be harmonized by the same *tone of shadow*, if I may so express myself, there will always appear a great deficiency in it. By the same *tone of shadow*, I mean not only the *same manner* of execution, but an *uniform* degree of strength. We often meet with hard touches in a print, which, standing alone, are unharmonious; but when every contiguous part is touched up to that *tone*, the effect is harmony. – *Keeping* then proportions a proper degree of strength to the near and distant parts, in respect to *each other*. *Harmony* goes a step farther, and keeps each part quiet, with respect to itself, and the *whole*. I shall only add, that in sketches, and rough etchings no *harmony* is expected: it is enough, if *keeping* be observed. *Harmony* is looked for only in finished compositions. If you would see the want of it in the strongest light, examine a worn-print, harshly retouched by some bungler.

The last thing, which contributes to produce a *whole*, is a proper *distribution of light*. This, in a print especially, is most essential. An harmony in the colouring may, in some measure, supply its place in painting; but a print has no succedaneum. Were the *design, disposition*, and *keeping* ever so perfect, beautiful, and just, without this essential, instead of a whole, we should have only a piece of patch-work. Nay, such is the power of *light*, that by an artificial management of it we may even harmonize a bad disposition.

The general rule, which regards the distribution of *light*, is, that it should be spread in *large masses*. This gives the idea of a *whole*. Every grand object catches the light only upon one large surface. Where the light is in spots, we have the idea of several objects; or at least of an incoherent one, if the object be single; which the eye surveys with difficulty. It is thus in painting. When we see, upon a *comprehensive* view, *large masses* of light and shade, we have, of course, the idea of a *whole* – of *unity* in that picture. But where the light is scattered, we have the idea of several objects, or at least of one broken and confused. Titian's known illustration of this point by a bunch of grapes is beautiful, and explanatory. When the light falls upon the *whole bunch* together (one side being illumined, and the other dark) we have the representation of those large masses, which constitute a *whole*. But when the grapes are stripped from the bunch, and scattered upon a table (the light shining upon each separately) a *whole* is no longer preserved.

3 Salomon Gessner (1730–1788) 'Letter on Landscape Painting'

Salomon Gessner was born in Zurich, where his father was a bookseller. At the age of 19 he went to Berlin to study his father's trade, but returned to Zurich in 1750 to devote himself to writing, painting and engraving. His first written works were published at this

time and he subsequently achieved enormous success with his finely wrought prose descriptions of pastoral life. His collection of *Idylls* (1756 and 1772) was the most popular German book in Europe prior to Goethe's *Sorrows of Young Werther* and his epic prose poem *The Death of Abel* (1758), which mounted a moral critique of civilization, was widely translated into other European languages. Despite his literary success, Gessner retained his interest in the visual arts. He took up the study of painting and engraving with renewed vigour after 1757 when his friendship with his future wife, Judith Heidegger, gave him access to her father's art collection. His 'Letter on Landscape Painting' records his own evolution as a landscape painter and details the method he pursued to acquire the appropriate skills. It was frequently reprinted and exercised a considerable influence on artists such as Ferdinand Kobell and Johann Christian Reinhart, who were seeking to combine the achievements of the Dutch and Italian schools of landscape painting. The English painter John Constable is recorded as giving it his careful attention in 1816. Gessner himself achieved a certain renown as a painter and etcher, receiving praise from the art theorist and connoisseur, Christian Ludwig Hagedorn. The artists mentioned by Gessner in the text include: Antonie Waterloo (Dutch, *c*.1610–90), Herman van Swanefeld (Dutch, *c*.1600–55), Nicolaes Berchem (Dutch, 1620–83), Salvator Rosa (Italian, 1615–73), Felix Meyer (Swiss, 1653–1715), Johann Ermels (German, 1641–93), Jacob Philipp Hackert (German, 1737–1807), Claude Lorrain (French, 1600–82), Philips Wouverman (Dutch, 1619–68), Allaert van Everdingen (Dutch, 1621–75), Christian Dietrich (German, 1712–74), and Matthäus Merian (Swiss, 1593–1650). The addressee of the letter is the Swiss art historian, Johann Casper Füßli. Gessner's *Brief über die Landschaftsmahlerey* was first published as part of the preface to the third volume of his *Geschichte der besten Künstler in der Schweiz* (Zurich: Gessner, 1770). It was frequently reprinted in Gessner's own lifetime and was added to the 1772 edition of his *Idylls*. The following English translation by M. J. Hope is taken from *The Death of Abel in Five Books, Attempted from the German of Mr Gessner*, London: T. Heptinstall, 1797, pp. 235–49.

You think then, sir, that I may be entertaining, perhaps even useful, by pointing out the route I have taken to attain some proficiency in the arts of design, in an age but little favourable to great success. It certainly is to be wished that a project of this kind had been executed by some celebrated artists. What advantage should we not reap from an history of painters, if, with the events of their lives, it contained an account of the progress of their talents? We shou'd there see the different routes that lead to the same end; the obstacles there are to encounter, and the means of surmounting them; the developement of science, relative to the display of genius, and to the observations that arise from practice. Now, if these sorts of details had been wrote by the artists themselves, they wou'd undoubtedly have presented that important and useful truth, and that engaging entertainment which constantly attend it.

Perhaps, it is true, we shou'd not find in these simple recitals those profound researches which they labour to make, who descant on arts they never practise; but they who practise them would there find the resources and informations that experience alone can give.

Thus, the work of Lairesse, so useful to young practitioners, has justly acquired him the title of benefactor to those arts his labours have adorn'd. Thus, also, the work of Mengs may assist his rivals to equal him, by affording more opportunity for reflection, in a few lines, on the principles of painting, than is to be found in large works. If he sometimes give us occasion to wish that he had been more perspicuous as

a philosopher, what amends does he not make us as an artist, when he explains his method of proceeding, and his principles, and makes us admire the energy, the pure taste, and refined art which we ought to expect from him whom his cotemporaries call the Raphael of his age.

May I be permitted to descend to myself, after having soar'd thus high? Shall I dare to fulfil my promise? I, who have advanced only a few paces in the career, and, perhaps, shall find myself stopp'd by compulsive circumstances and occupations. But I am engaged. It is in the name of friendship, and friendship shall be my excuse.

You know that fortune did not seem to have intended me for the practice of painting. A natural inclination, however, shewn in early youth by continual essays, seem'd to indicate that Nature, in this matter, did not agree with those circumstances of situation that depend not on her. I drew, therefore, in my infancy, all objects that occur'd, without being then able to guess what this disposition meant, and without an attention being paid to it sufficient to render it useful. I made no progress, my taste declined, and my choicest days pass'd away; but the beauties of nature, and the excellent imitations of that grand model, made incessantly the most vivid impressions on my mind. I had abandon'd the pencil; a secret impulse made me take up the pen, and, by the aid of that which appear'd to me to have less difficulty in the practice, I imitated artless scenes and picturesque beauties; in a word, the charms of Nature that struck me most.

A select collection, however, that belonged to my father-in-law, awaken'd in me the passion for drawing; and, toward my thirtieth year, I attempted to deserve, in this sort of imitation, the indulgence, and if it might be, the approbation of artists and connoisseurs.

My natural inclination led me to landscapes; I sought with ardour, the means of satisfying my desire, and embarrassed in the route I should take, I said to myself; there is but one model, there is but one master; and I determined to draw after Nature. But I soon found, that this great and sublime master does not explain himself clearly but to those that have learnt to comprehend him. My precision in following him everywhere led me astray. I lost myself in those minute details that destroy the effect of the whole. I had not catch'd that manner which, without being servile or slight, expresses the true character of objects. My trees were dryly design'd, and not detach'd in masses. The whole was disturbed by a labour without taste. In a word, my eye, confined too closely to one point, was not accustomed to embrace a large extent. I was ignorant of that address which adds to or diminishes in the parts that art cannot equal. My first progress, therefore, was to discern what I was not able to perform; the second was, to have recourse to the great masters, and to the principles they have established by their precepts and their works; and is not this the natural progress in all arts? The first who practised them fell into that dryness with which they are reproach'd, by a too great accuracy in imitating nature, whose beauties they consider'd too much in detail. In fact, these details are executed by our first painters in a mannor sufficiently finish'd, as well in the subordinate objects as in the most striking parts. They that follow'd them remark'd these defects, and discovered that a characteristic imitation was more interesting than an imitation of parts. The ideas of masses, of effects and disposition, offer'd themselves; these ideas produced principles, and the great painters have aim'd at a general effect, as the poets have at a principal object.

I employed myself, therefore, in studying the great masters, in distinguishing them from each other; and, above all, in attaching myself to the best works only; for I perceived, that in the study of model, the most prejudicial quality is mediocrity. The bad strike and disgust; but those that are not good, nor absolutely bad, deceive us by offering a flattering and dangerous facility. It is for this reason that engraving, which may contribute to the progress of the arts, when it is employ'd on subjects that are judiciously chosen; and, in copying them justly, may become prejudicial by the indifferent works it multiplies without number. How many productions of that art have required the labour of a year, and do not deserve a moment's attention! But let Raphael be copy'd by skilful engravers, let a young artist profit by his labours, and works, without dignity and expression, will soon become intolerable to him; he will perceive to what an elevation the excellence of the art can raise him. The way to know and to avoid mediocrity, is by the study and imitation of beautiful productions; or, in want of them, of the most finished translations that have been made from them – for so we may call beautiful prints. Let a young draughtsman study the heads of Raphael, and he will not see without disgust, the sordid figures of indifferent painters. But if you first feed him with those insipid substances, he will soon lose the taste necessary to relish the excellence of Antinous and Apollo. In the one case, he will advance firmly in his career; in the other, he will continually totter, and even not be sensible of his own weakness.

It was from these reflections, that, following the steps of the masters, I dared to form a method of my own. My first precept was to pass from one principal part to another, without staying to attempt at once the numberless details that I perceiv'd in each of them. By this method I accustomed myself to design, or rather dispose the trees in masses, chusing Waterloo for my model; and the more I studied this artist, the more I found in his landscapes the true character of nature; and the more that discovery struck me, the more pleasure I found in imitating him: so that it was to him I owed at last the felicity of expressing my own ideas, but it was by borrowing his style. Then, to avoid what they call a manner, I ventured to insert more variety in my studies, and to associate with my first master those artists whose tastes differ from his; but who, at the same time, have, like him, nature and truth for their object.

Swanefeld and Berchem, by turns, presided over my labours. Like the bee, I search'd honey from many flowers. I consulted, I imitated – and, returning to nature, wherever I found a tree, a trunk, or foliage, that attracted my regard, that fix'd my attention, I made a sketch of it, more or less finish'd. By this method, I join'd to facility the idea of character, and I form'd a manner that became more personal to me. It is true, an original inclination frequently brought me back to my first guide; I return'd to Waterloo, when the disposition of the trees was to be regulated; but Berchem and Salvator Rosa obtain'd the preference in disposing the grounds, and characterising the rocks. Meyer, Ermels, and Hakert assisted me in distinguishing the truth of nature, and Lorrain instructed me in a happy choice of vistos, and a fine harmony of the grounds. I learnt, by studying him, to imitate the verdure of the fields, the soft distances, and admirable gradations, by the secret artifice of their shades. To conclude – I had recourse to Wouvermans for those light and sweet transient scenes that, illuminated with a moderate light, and cover'd with a tender verdure, have no defect, but the appearing sometimes too tufted.

Thus passing from various imitations to continual reflections, and then returning to nature, I found, at last, that my efforts became less laborious. The principal masses and forms laid themselves open to my sight. Effects, that I had not perceiv'd, struck me. I was at last able to express, by a single stroke, what art cou'd not detail without prejudice. My manner became expressive. How often, before this first progress, have I search'd, without finding them, objects favourable to imitation; and how often did they present themselves to my sight! Not, however, that every view, or every tree, contains all that picturesque beauty I sought after; but my experienced eye no longer beheld objects without distinguishing forms that pleased me, or characters that fix'd my attention. I saw no shade that had not some branch well disposed, some mass of foliage agreeably group'd, some part of a trunk whose singularity was not striking. A detach'd stone gave me the idea of a rock; I exposed it to the sun in the point of view that best agreed with my design, gave it in my mind a proportionable larger extent, and then discover'd the most brilliant effects in the clare obscure, the demi-tints, and the reflections. But when, in this manner, we investigate our subjects in nature, we shou'd take care not to let them lead us away by their singularity. Let us seek for the beautiful and noble in the forms, and manage with taste those that are merely fantastic. It is the idea of a noble simplicity in nature that must moderate a flight that wou'd carry the artist to a taste for the marvellous, to exaggeration, perhaps even to chimeras; and lead him away from that probability in which the truth of imitation consists.

With regard to the manner in which I executed my studies, they were not finished drawings, nor mere sketches. The more interesting any part of my subject appear'd, the more I finish'd it at the first attempt.

There are painters who content themselves with making, in haste, a mere sketch of a finish'd picture that nature presents them, and lay it aside to be finish'd at leisure. What is the consequence? Their accustomed manner takes place of the idea too lightly impress'd on the mind; the characteristic of the object disappears, and is lost. What can supply this? Neither the magic of the colouring, nor the effects of the clare obscure; they may amuse for a moment, but the critical eye will search for the true and natural, and, finding it not, will turn away from the work with disdain.

But when I wou'd have used my studies, made after nature, in the invention of a whole, I found myself embarrassed and intimidated. I fell into factitious details which wou'd not agree with the simplicity and truth of those parts I had taken from nature. I cou'd not find in my landscapes the great, the noble, the harmonious, and the striking effect of the whole. I was, therefore, obliged to have recourse to those masters who appear'd to me to excel in composition.

Everdinghen, whom I have not yet mentioned, frequently presented me with that rural simplicity, which pleases even in those countries where reigns the greatest variety. In his works I found impetuous torrents, rocks broken and cover'd with the thickest brambles, and rustic spots, where poverty finds a happy retreat in the most simple cottage. Though his bold and spirited touches were capable of inspiring me, I did not think that he was the only one whose example I should follow. It even appear'd to me not unprofitable to have learnt, before imitating him, to paint rocks in a better style. Dietrich taught me. The pieces he has composed of this kind are such, that one wou'd say they are Everdinghen's; but he has surpass'd himself.

Swanefeld, in his turn, offer'd me the dignity of ideas. I admired the prodigious effect of his execution, and that of his reflected lights, which dart in so striking a manner on the large masses of shades. Salvator Rosa often attracted me by the warmth and fury of his genius. Rubens, by the boldness of his compositions, by the brilliancy of his colours, and by the choice of his subjects. But the two Poussins, and Claud Lorrain, at last possess'd me entirely. It was in their works that I found dignity and truth united. Not a simple and servile imitation of nature, but a choice of the most sublime and interesting beauty. A poetic genius united in the two Poussins all that is great, all that is noble. They transport us to those times for which history, and especially poetry, fill us with veneration; into those countries where nature is not savage, but surprising in her variety; where, under the most happy sky, every plant acquires its utmost perfection. The buildings that adorn the pictures of those celebrated artists are in the true taste of the antique architecture. The figures have a noble air, and a firm attitude. It is thus the Greeks and Romans appear to us, when our imagination, render'd enthusiastic by their great actions, transports itself to the ages of their prosperity and glory. Repose and amenity reign throughout all the countries the pencil of Lorrain has created. The mere view of his pictures excites that sweet emotion, those delicious sensations that a well-chosen prospect has the power to produce in the mind. His fields are rich without confusion, and variegated without disorder; every object presents the idea of peace and prosperity; we continually behold a happy soil that pours its bounteous gifts on the inhabitants; a sky serene and bright, under which all things spring forth, and all things flourish.

Not content to fill my mind with the principles and beauties that the works of these great masters of the art presented me, I endeavour'd to draw from my memory, the principal parts that had struck me in these beautiful models. I sometimes copy'd one of their works, and I preserve these essays, as they bring to my mind the route I took, and the guides that conducted me to it. By forming this method, I have acquired the useful habit of tracing, in order to remember them the better, the compositions and plans of those works that have particularly engaged my attention. Perhaps this labour may be thought superfluous, as the engravings made after those beautiful pictures contain their exact representations. But the pains I have taken in copying them myself has imprinted a more durable idea on my mind. How many collections of prints and drawings resemble those large libraries, whose possessors reap not the least advantage from them!

I found, however, that when I apply'd myself too long in meditating on the masters I had chosen, a too great timidity. When I wou'd invent, overcharg'd, so to say, with the great ideas of the celebrated artists, I felt my weakness, and humbled by my want of strength, I perceiv'd how difficult it was to equal them. I observ'd how much a too continued imitation weakens the flight of fancy. Of this the celebrated Frey is an instance; and the greatest part of engravers confirm this observation. In reality, their own compositions are in general the most indifferent part of their works. Incessantly employed in expressing the ideas of others, and obliged to copy them with the most scrupulous exactitude, that boldness, that warmth of imagination, without which there can be no invention, is either enfeebled, or totally lost. Startled by these reflections, I abandon'd my originals, I left my guides, and deliver'd myself up to my own ideas. I prescrib'd myself subjects, and laid down problems for my solution,

and I thus endeavour'd to find out what might best agree with my feeble talents. I remark'd what I found most difficult, and discover'd to what studies I must for the future apply my greatest attention. Then the difficulties began to disappear. My courage encreased. I perceiv'd that my imagination was extended by perseverance. Wretched are the artists and poets who are the servile copiers of their models; they resemble the shadow that follows the body in its most trifling movements. I took care, however, not to forsake the practice of copying from nature, a sketch, or memorandum of any thing singular, striking, or agreeable. Constantly furnish'd with the necessary apparatus, and always attentive to every object that occurr'd, I was not asham'd to retire a moment in order to fill my tablets. A picture, a print, a view, an effect, a group, an aspect, all paid me tribute, and my sketches, or drawings, were a sort of cypher, that recall'd to my mind those ideas whose rapid and slight impressions wou'd have been otherwise infallibly lost. A thought conceiv'd in the first warmth, an effect with which we are struck at the first view, is never so well express'd as by the strokes that are drawn at that instant. In these first emotions, so important to be seized, a happy thought will not produce mediocrity merely. What poet has not sometimes conceiv'd a good verse, of which an indifferent one has given him the idea! The latter was a rough diamond, which he polished. The works of Merian, to which sufficient justice is not done, contain the most happy choice of truths taken from nature; what then can disguise their merit? The insipid tone of the execution. Give to his trees and his grounds the legerity of Waterloo; insert among his rocks, and the whole of his compositions, more variety, and you will see brilliant effects arise, whose splendour and harmony will do honour to genius, and of which the disposition and groundwork are all to be found in Merian.

But it is not sufficient to have always before our eyes both nature, and the finish'd works of the great masters. We shou'd also read the history of the art, and of the artists. This reading will extend the circle of our knowledge, and render us attentive to the different revolutions that have arrived in the empire of the arts. It will lead those who exercise the arts, to employ themselves more vigorously to what should be their principal object. How can we refrain from being interested in the fate of a man whose talents we admire? How can we avoid searching after, and beholding with attention, the works of a man whose character and fate has affected us? Can we perceive the veneration with which they talk of the great artists, and their immortal works, without conceiving the highest idea of the importance of the art? Can we be informed of the indefatigable ardour with which they labour'd to attain perfection, without being unconcern'd at the pains we have taken? Even their defects instruct us, and their misfortunes endear them to us.

But since I have digressed from the practice of the art, to theoretic ideas, and have indicated the means of improving the imagination, and elevating the genius, I must here recommend to the young artists the reading of the good poets. What can be of more use in refining their taste, exalting their ideas, and enriching their imagination? The poet and the painter, friends and rivals, draw from the same source; they both borrow from nature, and communicate their riches by rules that are analogous: variety without confusion. That is the grand principle of all their compositions. In short, the same delicacy of sensation and taste shou'd guide them in the choice of circumstances and images, the detail and the whole. How many artists wou'd be more

happy in their choice, how many poets wou'd put more truth in their pictures, and be more picturesque in their expressions, if the one and the other knew how to unite a profound knowledge of the two arts.

* * *

4 Salomon Gessner (1730–1788) and Konrad Gessner (1764–1826) Exchange of letters on landscape painting

Salomon Gessner's son, Konrad, was born in Zurich and from any early age he pursued his father's interests in painting and etching. In 1784 he travelled to Dresden to continue his studies under the Swiss artist, Adrian Zingg (1734–1816). At this time, Dresden had become a leading centre for landscape painting in Germany, attracting artists such as Anton Graff (1736–1813) and Johann Christian Klengel (1751–1824). Konrad Gessner left Dresden in 1786 and travelled to Rome before returning to Zurich. He enjoyed a successful career as a painter of landscapes and horse pictures, submitting works to the Royal Academy in London and living for a period in Scotland. The publication of this exchange of letters with his father provides an intimate glimpse into the practice of landscape painting pursued in Dresden at the time. It also reveals the existence of an interested public audience. The 'painter's mirror' described in one of the letters (sometimes known as a 'Claude glass') was a small tinted convex mirror which was used to give a painterly quality to the landscape by simplifying and reducing the colour and tonal range of the scene it reflected. The letters were first published by Salomon Gessner as *Briefwechsel mit seinem Sohne* in Berne in 1801. The following excerpts are taken from the English translation, *The Letters of Gessner and his Family*, London: Vernor and Hood, 1804, pp. 27–8, 40–6, 50–1, 112–16.

K. Gessner to his parents.

Dresden, July 29, 1784.

We returned yesterday from a little excursion to Hohenstein. It was a little tour, which four artists besides myself agreed to make for the purpose of sketching from nature. This country, covered with wood and intersected with mountains, is quite a paradise for landscape painters. Every step offers a romantic, or at least an interesting scene. At every turn you meet with a picturesque rock, or a pretty cottage, or a fine tree; and the ruins, which are scattered over the country, add a fresh charm by the great variety of objects. It is impossible to draw from nature here without having permission expressly for that purpose; and to this circumstance, which was very unpleasant in itself, we owe the satisfaction of becoming acquainted with the bailiff, who is a very amiable man; and the inhabitants, where we took up our quarters, shewed us every possible kindness. We made a rich harvest in this journey; and though all were equally industrious, each found time to contribute to the amusement of the rest of the party. Our return was attended with some whimsical circumstances. We did not limit ourselves to any hour, and even the bad weather, which overtook us, had no influence over our spirits. When we arrived at Königstein we were condemned to pass the night in a hayloft; we were wet to the skin, and the wind blew in

at every corner. Entertaining no hopes of getting any sleep in this situation, we endeavoured to dissipate our sorrows by acting a play: this was sufficient to confirm our landlord in the suspicion he had already formed, that we were actors. The report was soon spread through the country, and, during the whole of our voyage on the Elbe, the people ran in crowds to see us, whenever we stopped. I believe too, that I had the honour to be taken for the Punch of the party, for all the children seemed to view me with particular satisfaction. I intend shortly to return to that spot with all my apparatus, that I may paint from nature.

* * *

K. Gessner to his Parents.

<div align="right">Dresden, September 5, 1784.</div>

[...] I begin to dispose of my time so economically, that I think I can now give a tolerable account of myself. The proofs you give me of your satisfaction inspire me with the wish to deserve it more every day, by employing every moment to advantage. I will give you a sketch of my daily occupations. I begin by reading; then, after hastily taking a dish of coffee, I arrange my room, and employ myself in painting till the gallery opens. When I leave the latter, I go into the country to draw from nature, or return home to continue my painting. Now, that I am so fully aware of the importance of studying from nature, how much I regret having neglected those beauties, which Sihlwald and other delightful spots in my own country, daily presented to my eyes.

I have made some sketches in chalk, and a great number in colours; but the gallery has occupied so much of my time, that I have not yet been able to finish any. M. Graaf is of opinion, that it is useful to begin many things at once, and to finish them afterwards successively. I find this an excellent method, for, by fixing the attention a long time on the same object, we often fall into a style quite different from that, which was at first intended. When the gallery closes, I shall have sufficient leisure to finish what I have begun.

My room is already entirely covered with my works. The first picture, I painted here, represents a cannon on its carriage, and near it some peasants' horses with their saddles and harness; the second picture, four horses drinking at a cistern, and some grooms standing by them. These two are only sketches, done very hastily, but M. Graaf was so pleased with them, that he would not let me finish them more. I bestowed more care and attention on a little view of a stable, in which, in a distant perspective, another stable is distinguishable, filled with horses like the first. The principal object is a white horse, and near him is a groom preparing to put on his saddle; in the middle of the stable stands the officer, to whom the horse belongs; the light comes from the door and falls on these three figures alone. I do not mention some other pictures, which are much in the same style, because I wish to give you a description of a moonlight. The landscape of it is painted from nature; the moon, glittering through the trees, casts her beams on a pond where some horses have been bathing, and the trees are reflected in the water. A peasant's cottage appears on a little sandy hill. The sky is dark and stormy, like those which Ruysdael was so fond of

painting, but the cottage and hill have a strong light thrown on them. I am painting at present another picture, in which the warmth of the setting-sun is still discernible behind the mountains, and gilds some clouds scattered over the sky; in the distance, the eye loses itself in the bosom of a dark valley: the middle of the scene presents a forest, in which may be distinguished a group of sportsmen assembled round a large fire; and a skirmish between some hussars, is seen through the branches of the oaks and fir-trees in the foreground.

I must confess, that hitherto I have passed my time in the gallery more in looking at the pictures than in copying them, for I think, that the greatest advantage, which perhaps I can derive from this establishment, is the opportunity of seeing so many fine works, of comparing them with nature, and then consigning the result of my observations either to canvas or to paper. All, that I have copied, amounts to nothing more than some horses, from Blomaert, and a group from Wouverman. I intend very shortly to begin some more copies; M. Graaf is not dissatisfied with what I have done; and he approves of the method, which I have just now mentioned.

M. Klengel has had the goodness to accompany me sometimes to the gallery, and I am indebted to him for having made me observe several things, which, without him, would probably have escaped my notice, or which I should not have felt or understood so well. He has made me almost adore Wouverman. With what a wonderful facility every thing is grouped and arranged, as if without any trouble in his compositions! The most insignificant objects are expressed with neatness and taste, yet they never appear to be the productions of minute labour. His figures and horses possess all the delicacy of a miniature, yet are not wanting in fire and animation. I always feel very forcibly those sensations, which he must himself have experienced, when composing his works; yet my admiration of this great master does not render me blind to the merit of other artists, who have pursued the same style. Borgognone probably surpasses him in correctness, and in point of design. Rugendas is, in my opinion, the Raphael of horse painters; his are all in the same style, full of fire and character, and, abating only the fine colouring of Wouverman, I prefer them to the horses in his pictures. These, to be sure, possess a great share of grace and truth; but setting aside the elegant touch and magical colouring of Wouverman, it must be acknowledged, that the horses of Rugendas are drawn with more correctness and greater dignity. I have insisted so much the more on the observation, because M. Klengel, whose knowledge has in other respects been of so much assistance to me, wishes to persuade me to study Wouverman as my only model, even for the manner of painting horses. I cannot, in this respect, conform to his opinion. Why should I study Wouverman, or any one besides, and not attend to nature, by which Wouverman himself formed his style? Why should I undergo the slavery of copying his horses perpetually, without being able to give them that inimitable grace, which his pencil alone could bestow, and perhaps still more incorrectly than he has drawn them? No, in this respect I will not copy any master exclusively, neither Wouverman, nor even Rugendas; I will endeavour to acquire, as much as I can, the grace of the one and the correctness of the other, and profit from them as guides to assist me in discovering the best models in nature. I leave to those, who copy by profession, that scrupulous exactness, and the ambition to imitate, even the faults of their original. In

my mind he only deserves the name of a painter, who makes nature his great model, and attends to the impulse of those feelings, which are characteristically his own.

Most artists appear to me to be guilty of one common error, which is, that of forming a sort of arbitrary theory, which they adopt in their works, and which often seduces them from the truth of nature. This fault certainly cannot be attributed to Wouverman. He may be said to be free from art. His clouds are not geometrically carved into pyramids or other regular forms; his figures are grouped, as if by accident, and not arranged by the side of each other according to the prismatic order of colours. Generally speaking, I have never observed a striking contrast of colours in nature; all the tints are harmonized by an airy vapour and softly blended together as we see in the pictures of Ruysdael, of Claude Lorraine, and of Wouverman. How different from this is the usual system of landscape painters, who begin with a resplendent sky streaming with yellow and blue, then some beautiful blue mountains finely melting into grey; from grey to green, thus following every gradation of colour till they reach a fine coffee brown! and this is called harmony, and is the receipt to make a picture! You might suppose, after seeing one of this description, that they do not understand any other harmony than that of their pallet; or that their eyes can distinguish nothing but that false brilliancy, which in fact some artists have offered them as a model. A person must be totally dead to all feeling, not to observe in nature what a truly good picture represents. I am not surprised to meet with artists, who, after having tired themselves, as they describe it, in running after nature, at last stumble in the road, and overlook some of her most striking beauties; while others perhaps, who observe her, like painters, and contemplate every scene as a picture, draw some advantage from every object which presents itself.

* * *

S. Gessner to his son

<div align="right">Sihlwald, 5th September, 1784</div>

* * *

I am perfectly satisfied with the distribution of your time, and the plan you have laid down for pursuing your studies. I recommend to you, above all things, to make it your principal object to become familiarly acquainted with all the best examples of good painting, which the gallery affords. I do not mean by this, to advise the servile labour of a copyist; indeed your sentiments on that subject perfectly correspond with mine. The copyist, deprived of the animating stimulus of imagination, is obliged to tread with tedious exactness in the footsteps of his models. He is their slave, even when he wishes to do justice to his own ideas, and he will always remain below those whom he imitates, because he works without inspiration, without fire, and neither dares to think nor to act from the impulse of his own mind. I approve extremely of the rule, you intend to observe, of seeking in nature as much as possible for the originals of those objects, which are presented to you by art, and of comparing them with each other. When you are become familiar with the form and character of objects, you will never be led astray by any style; and you will adopt that only which will appear to you the best chosen, and most appropriate to the subject. Endeavour also to distinguish in each master those parts, in which he most excelled, and study

them with attention, until you have acquired perfect facility in the execution of them. It will frequently happen to you, even in your own works, to meet with difficulties, which will stop your progress. Observe thoroughly those objects, which are the cause of them; search both in nature and in works of art for such as are analogous, and study them without intermission, that you may thus combat with every difficulty, till you have overcome all that may arise.

You tell me, that in your drawings from nature, you endeavour not to fall into a stiff and finished style. I think you are perfectly right. Your drawings should be a faithful representation of every object, and they must be modified according to the nature of each. Exactness of imitation is too often sacrificed to composition. Endeavour as much as possible to unite them both, but be careful never to neglect that most essential point, of procuring in each object the truth and variety of its character, for any attainment of an inferior magnitude.

* * *

K. Gessner to his father

Dresden, October 12th, 1785.

Just at the moment, when Reinhard and myself were setting out on an expedition towards Leibthal, which is the very appropriate name of the valley I described to you in my last letter, I received the painters-mirror, which you have had the goodness to send me; it will henceforth be the constant companion of my picturesque excursions, and I improve daily in the use of it. I prefer it infinitely to all kinds of Camera-obscura, because it may be so easily carried in the pocket, and also because it reflects objects with perfect distinctness even in shade. I must now give you an account of our journey. Our persons being well packed up in a post-chaise, together with our colour boxes, and all the implements of our trade, we set out for our favorite retreat, which we explored in every direction, sometimes meeting with fine scenes in Ruysdael's style, but more frequently with views and perspectives, such as Everdingen delighted in. One would suppose, that the latter had made frequent visits to this spot, and had taken from it the subject of his best pictures. We established ourselves in a hut with some good honest peasants, whose habitation is situated amidst the trees of a fine orchard, which surround it with a pleasing shade. At break of day we left our bed of clean straw, where we had enjoyed a refreshing sleep, to descend into a valley where a little stream winds its course, and which, impeded in its progress by some fragments of rocks, falls here and there in a small cascade. At the bottom of the valley, in a recess formed by high rocks, large firs, and thick beech trees, the same stream precipitates itself from the top of a mass of rocks with the most picturesque effect. It was in this spot, truly worthy of a poet's eye, that we established our apparatus; the sun's rays in various parts pierced through the tufted foliage, and added fresh brilliancy to the objects which already wore all the different tints of autumn, and formed a mixed scene, which, in its confused variety, presented to the eye a softer harmony of colours. The tone of colouring, and the water, were precisely the same as in Ruysdael's pictures, and therefore, I studied them with particular attention.

We were agreeably surprised in the midst of our studies by a visit from Messrs. Graaf and Zingg. They applauded our courageous perseverance in working from nature, and admired our contrivance as a substitute for an easel, which we could not have made use of in the situation we were in, seated on pieces of rock in the middle of the river. I will tell you how we managed; we tired a string to two corners of the picture, and putting it over our necks, resting the picture on our knees, we painted with tolerable facility, although the attitude was not the most elegant. It was in this way that we passed our time from the dawn of day till night. As we had eaten a very small portion for dinner, we transferred all our appetite to the supper, which, added to our usual gaiety, furnished an excellent sauce to the frugal repast provided for us by our host.

It must be confessed, that it is very humiliating to an artist to work with nature immediately before his eyes; he then feels his insufficiency to represent it; and the difficulty of the task diminishes the pleasure. Thus, in a fit of too well-founded despair, I was going to efface what I had done, when M. Graaf arrived just in time to save it from destruction; and the satisfaction which he expressed, having reanimated my courage, I continued and finished my picture. Now that I see it in my room, I am better pleased with it than I was in the open air; I observe in it some touches of nature, and a tone of colouring which I could never have acquired, even with the greatest efforts, if I had painted it in my room. I am now more than ever convinced, that although this may be the most difficult mode, yet it is the most certain; and since I have employed myself in studying attentively the pictures in the gallery, instead of merely looking at them, I feel also how much that circumstance has improved me, by enabling me to study nature with more ease, and teaching me to distinguish and make choice of its principal beauties.

How rare are those artists, who excel in this respect! the greatest part of them do not begin to observe nature, until they are accustomed to a style of their own, which they blindly follow even in the imitation of nature; thus it is, that they always fail in the object of their wishes, that of expressing it with truth and accuracy. They indeed paint the stones and the trees, which present themselves to their eyes one after the other, and with such scrupulous exactness that you would suppose they had counted them; but they have not the least idea of giving the real character to each object; and notwithstanding their exactness in all the parts, their pictures do not possess any truth or effect. I confess I cannot endure any thing like mannerism. Claude Lorraine, Berghem, and Ruysdael, are the only painters, to whom I can turn with pleasure, even after examining nature, for they are the only ones, who admire it in all its purity, and who present it to my eyes chaste and undefiled. Each tree, each stone, each plant, in short every thing in their works, has its true and appropriate character; in my opinion, this is the excellence of the art, and it shall be, throughout my life, that which I shall be most ambitious to acquire. I praise your works, my dear father, as much as I do those of these great artists, and I assure you, my judgment is not biassed by partiality. I admire in your paintings those trees so full of life, if I may be allowed the expression, yet characterised by such a light and easy touch; those scenes so rich and varied, yet without a glaring profusion; in short, that attention to simple, unadorned nature, which must ever please, because it is true.

5 William Gilpin (1724–1804) from *Observations on the River Wye*

Having developed his concept of the picturesque and provided the general principles for its definition (see VB2), Gilpin proceeded to apply it in a series of summer tours made between 1768 and 1776 through the scenery of the British Isles. The results were published between 1782 and 1791 in a series of localized 'Observations relative to picturesque beauty', variously illustrated with aquatints of the kinds of pictures that might result. At a time when outdoor drawing and sketching were widely practised as polite and improving activities, this was a highly successful move. Equipped with Gilpin's directions and with his eloquent analyses, his readers could go out into the countryside and elevate sightseeing to the status of a high-cultural pursuit. They might even return with some sketches that would look like Art. Among those who made a 'picturesque tour' of the River Wye were Sir Uvedale Price (VB13, 15) and the landscape designer Humphry Repton (in 1790/1). Gilpin's various 'Observations' were to be continually reprinted over the next half-century. The tour of the River Wye was the first to be published, as *Observations on the River Wye, and several parts of South Wales, &c., relative chiefly to Picturesque beauty; made In the Summer of the Year 1770*, London: R. Blamire, 1782. Our excerpts are taken from the original edition, Section I, pp. 1–2 and Section II, pp. 7–14.

SECTION I.

We travel for various purposes; to explore the culture of soils; to view the curiosities of art; to survey the beauties of nature; to search for her productions; and to learn the manners of men; their different polities, and modes of life.

The following little work proposes a new object of pursuit; that of not barely examining the face of a country; but of examining it by the rules of picturesque beauty: that of not merely describing; but of adapting the description of natural scenery to the principles of artificial landscape; and of opening the sources of those pleasures, which are derived from the comparison.

Observations of this kind, through the vehicle of description, have the better chance of being founded in truth; as they are not the offspring of theory; but are taken warm from the scenes of nature, as they arise.

* * *

SECTION II.

The Wye takes its rise near the summit of Plinlimmon; and dividing the counties of Radnor, and Brecknoc, passes through Herefordshire. From thence becoming a second boundary between Monmouth, and Glocestershire, it falls into the Severn, a little below Chepstow. To this place from Ross, which is a course of near 40 miles, it flows in a gentle, uninterrupted stream; and adorns, through its various reaches, a succession of the most picturesque scenes.

The beauty of these scenes arises chiefly from two circumstances – the *lofty banks* of the river, and its *mazy course*; both which are accurately observed by the poet [Alexander Pope], when he describes the Wye, as *ecchoing* through its *winding* bounds. It could not well *eccho*, unless its banks were *lofty*.

From these two circumstances the views it exhibits, are of the most elegant kind of perspective; free from the formality of lines.

Every view on a river, thus circumstanced, is composed of four grand parts; the *area*, which is the river itself; the *two side-screens*, which are the opposite banks, and mark the perspective; and the *front-screen*, which points out the winding of the river.

If the Wye ran, like a Dutch canal, between parallel banks, there could be no front-screen: the two side-screens, in that situation, would lengthen to a point.

If a road were under the circumstance of a river winding like the Wye, the effect would be the same. But this is rarely the case. The road pursues the irregularity of the country. It climbs the hill; and sinks into the valley: and this irregularity gives the views it exhibits, a different character.

But the views on the Wye, though composed only of these *simple parts*, are yet *infinitely varied*.

They are varied, first, by the *contrast of the screens*. Sometimes one of the side-screens is elevated; sometimes the other; and sometimes the front. Or both the side-screens may be lofty; and the front either high, or low.

Again, they are varied by the *folding of the side-screens over each other*; and hiding more or less of the front. When none of the front is discovered, the folding-side either winds round, like an amphitheatre; or it becomes a long reach of perspective.

These *simple* variations admit still farther variety from becoming *complex*. One of the sides may be compounded of various parts; while the other remains simple: or both may be compounded; and the front simple: or the front alone may be compounded.

Besides these sources of variety, there are other circumstances, which, under the name of *ornaments*, still farther increase them. *Plain* banks will admit all the variations we have yet mentioned: but when this *plainness* is *adorned*, a thousand other varieties arise.

The *ornaments* of the Wye may be ranged under four heads – *ground* – *wood* – *rocks* – and *buildings*.

The *ground*, of which the banks of the Wye consists, (and which hath thus far been considered only in its *general effect*,) affords every variety, which ground is capable of receiving; from the steepest precipice, to the flattest meadow. This variety appears in the line formed by the summits of the banks; in the swellings, and excavations of their declivities; and in the unequal surfaces of the lower grounds.

In many places also the ground is *broken*; which adds new sources of variety. By *broken ground*, we mean only such ground, as hath lost its turf, and discovers the naked soil. Often you see a gravelly earth shivering from the hills, and shelving down their sides in the form of water-falls: or perhaps you see dry, stony channels, guttering down precipices; the rough beds of temporary torrents. And sometimes so trifling a cause, as the rubbing of sheep against the sides of little banks, or hillocs, will often occasion very beautiful breaks.

The *colour* too of the broken soil is a great source of variety; the yellow, or the red oker; the ashy grey; the black earth; or the marley blue. And the intermixtures of these with patches of verdure, blooming heath, and other vegetable tints, still increase that variety.

Nor let the fastidious reader think, these remarks descend too much into detail. Were an extensive distance described, a forest-scene, a sea-coast view, a vast semi-circular range of broken mountains, or some other grand display of nature, it would be trifling to mark these minute circumstances. But here the hills around exhibit little, except foregrounds; and it is necessary, where we have no distances, to be more exact in finishing objects at hand.

The next great ornament on the banks of the Wye, are its *woods*. In this country there are many works carried on by fire; and the woods being maintained for their use, are periodically cut down. As the larger trees are generally left, a kind of alternacy takes place: what is, this year, a thicket; may, the next, be an open grove. The woods themselves possess little beauty, and less grandeur; yet, as we consider them as the *ornamental*, not as the *essential* parts, of a scene, the eye must not examine them with exactness; but compound for a *general effect*.

One circumstance, attending this alternacy, is pleasing. Many of the furnaces, on the banks of the river, consume charcoal, which is manufactured on the spot; and the smoke, which is frequently seen issuing from the sides of the hills; and spreading its thin veil over a part of them, beautifully breaks their lines, and unites them with the sky.

The chief deficiency, in point of wood, is of large trees on the *edge of the water*; which, clumped here and there, would diversify the hills, as the eye passes them; and remove that heaviness, which always, in some degree, (though here as little as possible) arises from the continuity of ground. They would also give distance to the more removed parts; which, in a scene like this, would have peculiar advantage: for as we have here so little distance, we wish to make the most of what we have. – But trees *immediately on the foreground* cannot be suffered in these scenes; as they would obstruct the navigation of the river.

The *rocks*, which are continually starting through the woods, produce another *ornament on the banks of the Wye*. The rock, as all other objects, though more than all, receives its chief beauty from contrast. Some objects are beautiful in themselves. The eye is pleased with the tuftings of a tree: it is amused with pursuing the eddying stream; or it rests with delight on the shattered arches of a Gothic ruin. Such objects, independent of composition, are beautiful in themselves. But the rock, bleak, naked, and unadorned, seems scarcely to deserve a place among them. Tint it with mosses, and lychens of various hues, and you give it a degree of beauty. Adorn it with shrubs, and hanging herbage, and you still make it more picturesque. Connect it with wood, and water, and broken ground; and you make it in the highest degree interesting. Its colour, and its form are so accommodating, that it generally blends into one of the most beautiful appendages of landscape.

Different kinds of rocks have different degrees of beauty. Those on the Wye, which are of a greyish colour, are in general, simple, and grand; rarely formal, or fantastic. Sometimes they project in those beautiful square masses, yet broken and shattered in every line, which is the characteristic of the most majestic species of rock. Sometimes they slant obliquely from the eye in shelving diagonal strata: and sometimes they appear in large masses of smooth stone, detached from each other, and half buried in the soil. Rocks of this latter kind are the most lumpish, and the least picturesque.

The various *buildings*, which arise every where on the banks of the Wye, form the last of its *ornaments*; abbeys, castles, villages, spires, forges, mills, and bridges. One or other of these venerable vestiges of the past, or chearful habitations of the present times, characterize almost every scene.

These *works of art* are however of much greater use in *artificial*, than in *natural* landscape. In pursuing the beauties of nature, we range at large among forests, lakes, rocks, and mountains. The various scenes we meet with, furnish an inexhausted source of pleasure. And though the works of art may often give animation and contrast to these scenes; yet still they are not necessary. We can be amused without them. But when we introduce a scene on canvas – when the eye is to be confined within the frame of a picture, and can no longer range among the varieties of nature; the aids of art become more necessary; and we want the castle, or the abbey, to give consequence to the scene. And indeed the landscape-painter seldom thinks his view perfect, without characterizing it by some object of this kind.

6 Johann Georg Sulzer (1720–1779) 'Landscape (arts of design)' from *General Theory of the Fine Arts*

The Swiss aesthetician and philosopher Johann Georg Sulzer was born in Winterthur in Switzerland. He studied theology, philosophy, mathematics and botany in Zurich before taking up an appointment as a teacher of mathematics in Berlin in 1747. In 1750 he was elected to the Berlin Academy of Science, where he came into contact with the ideas of many of the leading figures of the Enlightenment. He was particularly influenced by the new study of psychology inaugurated sixty years earlier by Locke's empiricism (see IIB1). In 1755 he produced an annotated translation of David Hume's *Essay on Human Understanding*. Inspired by the *Encylopédie* of Diderot and D'Alembert (see IIIC7–9), he set out to produce a comprehensive and alphabetically ordered synthesis of the aesthetics of the period. Work was begun on the project in 1762, but the first volume of his *General Theory of the Fine Arts* did not appear until 1771. The second volume, covering the letters K–Z, was published in 1774. Sulzer provides essays on a vast range of topics, including general aesthetic concepts and processes, as well as articles on technical aspects of all the different branches of art. Some of the articles were later translated and included in the supplement to Diderot's *Encyclopédie* of 1776/7 and the book remained an influential reference work well into the nineteenth century. However, Sulzer was also criticized by leading figures of the *Sturm und Drang* for the prescriptive character of his writing and for his moral interpretation of art (see VB7). The essay on 'Landscape' is of particular interest for his treatment of the natural landscape not only as a source of spontaneous emotional responses but as a means of moral elevation. Our moral response to landscape painting can be heightened or reinforced through the representation of moral actions – such as the story of the Good Samaritan – but the effects of the landscape itself are already to be understood in emotional and ethical terms. This article has been translated for the present volume by Jason Gaiger from the first edition of Sulzer's *Allgemeine Theorie der schönen Künste*, Leipzig: M. G. Weidmanns Erben und Reich, 1774, pp. 653–5.

Among the arts of design, this branch, which presents us with so many agreeable views of inanimate nature, commands considerable respect. The fact that nearly

everyone takes pleasure in beautiful views already indicates that the beauties of nature stand in an intimate relation to the human soul. I have already discussed the general influence which this pleasure has on the formation of man's ethical character.[1] However, we need to consider this subject in more detail if we are to illuminate the particular branch of art which is under consideration here. Although painters do, of course, introduce ideas from the ethical domain into their landscapes, I want first of all to consider those ideas which are proper to inanimate nature and which, even on their own, possess a great diversity of aesthetic power.

Nowhere does our pleasure in the beautiful find so much satisfaction as in the contemplation of inanimate nature. Wherever we turn our eyes we are charmed by an infinite variety of colours, combined in the most delightful harmonies and pleasing tones; we meet every conceivable shape and form, whether pleasant, stimulating, or great and wondrous. Although a landscape is made up of a thousand different shapes in endlessly varied arrangements, these combine to form a whole in which everything is unified; each impression possesses its own character without conflicting with any other, and these are joined together in indescribable diversity. Here man feels for the first time that he does not merely respond as does an animal to the powerful impressions of his baser senses; he is made aware that he possesses a more noble feeling which penetrates his inner being and which has nothing in common with the material world. He learns to recognize needs other than hunger, thirst and the necessity of sustaining his purely material existence. He discovers an invisible essence within himself which takes pleasure in order, harmony and diversity. As yet unlearned in thinking, he is instructed by the beauties of nature to recognize that he is more than the mundane matter out of which he is formed.

Through the contemplation of inanimate nature man also develops more specific ethical and emotional responses. Nature reveals to us scenes in which we learn to admire what is great, original and extraordinary. There are aspects of nature which awaken fear and dread, others which invite us to silent prayer and to a festive elevation of our souls, and yet others which awaken quiet sadness or lively pleasure. Poets, pious hermits and other enthusiasts have long recognized this and in all ages have taken advantage of it. Who does not respond with a feeling of pious gratitude when he sees the richness of nature spread out before him in the fertile countryside? Who does not sense his weakness and his dependence on higher powers when he sees the powerful masses of overhanging cliffs, or when he hears the roaring of a mighty waterfall, the terrifying raging of the wind or the surge of the sea? Who does not register in these scenes the all-powerful force which steers the whole of nature? It is undoubtedly true that primitive man created his first concept of the divinity from such scenes.

A quiet and graceful spot, the gentle murmur of a stream, the sound of a small waterfall – such solitary spots unvisited by human beings awaken in us a gentle shudder of loneliness whilst at the same time filling us with a sense of awe for the invisible power at work in these abandoned places. In short, every sort of feeling is aroused in us by the variety of natural scenes. Philosophers, who find everywhere traces of an infinite wisdom and goodness, are convinced that these powers have not been given to nature without some higher purpose. They provide man's first education before he has learnt the language of reason. Through this education his character is gradually formed and his mind filled with concepts which are initially weak and

obscure but which subsequently develop and become clearer. The attentive contemplation of nature represents man's first step towards reason and the realization of his own proper character.

Thus painters find that inanimate nature offers them an inexhaustible store of material through which they can exercise a positive effect on men's character. A landscape painter can give us pleasure in a variety of beneficial ways. This is the case above all when a knowledge of the higher skills of his art allows him to combine the depiction of human passions and moral action with scenes of inanimate nature. Who is not affected in a salutary way when he sees someone who has been robbed and cruelly wounded by assassins in a desolate place helped onto his horse and taken back to his people by a Good Samaritan? What person of feeling can look upon the pleasures of simple shepherds in a rural scene marked by innocence and simplicity without experiencing the most joyful stirrings of the heart?

Through selecting appropriate actions from man's moral and ethical life and integrating them into his landscapes, the painter can give his landscapes a value which allows them to stand alongside the best history painting. Nicolas Poussin was entitled to be as proud of his Arcadian landscape as of the invention of a good history painting. I have observed elsewhere that the achievement of great effects does not always depend upon great events.[2] Something which initially appears to possess little significance can exercise a considerable effect upon a mind which is properly disposed. A single figure, such as Adam, who admires the beauty of creation in the midst of a paradisiacal landscape and who, through his posture and gesture, allows us to recognize that he is aware of the presence of the Creator, can awaken in a sensitive viewer powerful feelings of adoration for the all-bountiful Creator. Even the poorly drawn and badly engraved illustrations of fearsome places found in descriptions of journeys to Greenland or to Hudson's Bay awaken in us melancholy and dread. How much stronger these feelings would be and how much more support they would give to our moral ideas were they to be painted in nature's own proper colours and were they to depict appropriate historical events. From this it is easy to see that landscape too can achieve the greatest effects of which art is capable if only it is carried out by the hand of a master. As a great authority on art has rightly observed,[3] landscapes by Poussin, Salvator Rosa, and Everdingen possess such greatness that they awaken in us a sense of awe and terror which comes close to that of the sublime.

These observations provide us with the principles by which to judge the inner perfection of landscape, which derives from the value of the depicted object. Just as a history painting is to be considered good when it succeeds in depicting a scene from ethical life which awakens salutary feelings in us, stimulating and reinforcing our ethical beliefs, so a landscape is to be considered good when it depicts comparable scenes from inanimate nature, and, above all, when it improves these scenes with appropriate objects from the ethical domain. Just as we do not see in the human body a mere aggregate of dead forms arranged in contingent proportion, but register the existence of an inner force, a living soul which follows its own inclinations and can act according to principles, so a landscape should reveal more than mere dead matter. It should possess something which does not merely flatter our eyes but which awakens our ideas, animating our desires and our responsive capacity. This is the reason why nature has clothed her raw material in so many varied colours and forms. She speaks

a language which, though mute, can yet be understood by responsive souls, a language through which she educates and shapes mankind. We must be able to read some words of this language in every landscape to which we attach value:

> When Heaven and Earth, as if contending, vye
> To raise his Being, and serene his soul;
> Can he forbear the general Smile
> Of Nature? Can fierce passions vex his Breast
> While every Gale is Peace, and every Grove
> Is Melody?[4]

Nature is inexhaustible in such articulate scenes, and the landscape painter must seek them out for us. He must invite us to contemplative seriousness and then rouse us to joyousness, lead us into solitariness away from the din of the world and then rouse us from drowsy lethargy. Through the ever-active, universal power of nature, he should spur us on to contribute to the universal good. The painter who does not understand the language of nature and who seeks to delight us merely with a diversity of colours and forms, does not know the power of his art. If he does not, like Haller, Thomson and Kleist, lead us to the many different domains of the ethical world through the contemplation of nature, he achieves nothing with his use of line and colour.

* * *

[1] In the article on 'Architecture'.
[2] In the article on 'Song'.
[3] Friedrich von Hagedorn, *Betrachtungen über die Mahlerey*, p. 335.
[4] James Thomson (1700–48), from *Spring*. Sulzer provides a German translation in the text, but gives the original in a footnote.

7 Johann Wolfgang Goethe (1749–1832) Review of *The Fine Arts in their Origin, their True Nature and Best Application*, by J. G. Sulzer

In 1772 Johann Georg Sulzer published the key ideas behind his *General Theory of the Fine Arts* (see VB6) in a small booklet entitled *The Fine Arts in their Origin, their True Nature and Best Application*. Johann Heinrich Merck (1741–91), a close friend of Goethe's, had already written a highly negative review of the first volume of Sulzer's encyclopaedia in the same journal. Both authors reject the Enlightenment assumptions on which Sulzer's work rests. Goethe challenges the idea that nature is essentially benevolent, pointing out its violent and destructive aspects. He thereby resists the moralizing interpretation which Sulzer seeks to place upon the natural world. Above all, however, he is hostile to the notion that the arts can be systematically taught, rejecting the very idea of a lexicon of the arts. The figure of Pococurante, referred to in the text, is the rich Venetian senator described by Voltaire in *Candide*, who, despite being able to gratify any pleasure he wishes, remains unsatisfied with life. Goethe's review was published on 18 December 1772 in the *Frankfurter Gelehrte Anzeigen*. It is reprinted in Johann Wolfgang Goethe, *Schriften zur Kunst*, Gedenkausgabe, volume XIII, Zurich: Artemis Verlag, 1954. The following translation of the

complete review is taken from Timothy J. Chamberlain, *Eighteenth Century German Criticism*, New York: Continuum, 1992, pp. 175–9.

Very easy to translate into French, could also very well be translated from French. Sulzer, according to the testimony of one of our *famous* men just as great a philosopher as any from antiquity, seems in his theory, in the manner of the ancients, to fob the poor public off with an esoteric doctrine, and these sheets are, if possible, less significant than everything else he has written.

The *fine arts*, an article in his general theory, take central stage here, in order to put both amateurs and connoisseurs in a position to judge of the whole so much the sooner. Reading the great work until now we have already had many a doubt; but now that we investigate the very principles on which it is built, the lime that is supposed to stick together the scattered limbs of the lexicon, we find our opinion confirmed only too much: nothing is done for anyone here except the student seeking a basic primer, and the quite superficial fashionable dilettante.

We have already previously voiced our thoughts that a theory of the arts might not yet be ready for our times in Germany. We do not presume to expect such an opinion to be able to prevent the publishing of such a book; we can only, indeed we must, warn our good young friends against works of this kind. Anyone who lacks sensuous experience of the arts should rather leave them alone. Why should he occupy himself with them? Because it's fashionable? Let him consider that all theory bars his way to true enjoyment, for a more harmful nullity than theory has not been invented.

The *fine arts*, the fundamental article of Sulzer's theory. So there they are, of course, all together again, whether they're related or not. What doesn't stand listed in the lexicon? What cannot be connected by means of such a philosophy? Painting and dance, oratory and architecture, poetry and sculpture, all conjured by the magic light of a little philosophical lantern through a single hole onto the white wall, they dance up and down in the marvelous light, many-colored, and the delighted spectators pant for breath in their joy.

That some man who reasoned rather badly hit on the idea that certain human occupations and joys that became a labor and an effort for unspontaneous imitators without genius, could be classified under the rubric of arts, fine arts, for the benefit of theoretical sleight of hand – on account of its convenience this idea then remained the main theme for philosophy about the arts, even though they bear no closer relation to one another than the seven liberal arts of the old priestly schools.

We are astonished that Sulzer, even without reflecting on it, didn't become aware during the execution of his work of the great inconvenience that as long as one keeps to generalities one says nothing, and at most can conceal the lack of material from the inexperienced by means of declamation.

He wants to oust the indefinite principle of *imitation of nature*, and gives us in its place an equally meaningless one: *the embellishment of things*. He wants, in the traditional manner, to make inferences from nature to art: 'Everything in all creation is in harmony, to touch the eye and the other senses from all sides with pleasant impressions.' So does that which makes unpleasant impressions on us not belong just as much to nature's plan as her most lovely aspects? Are the raging storms, floods,

rains of fire, subterranean glow, and death in all the elements not just as much true witnesses of her eternal life as the sun rising in splendor over full vineyards, and fragrant orange groves? What would Sulzer say to the loving mother nature if it were to swallow into its belly a metropolis he had built up and populated with all the fine arts and their handmaidens?

This inference stands up just as little: 'In general, nature wanted to educate our hearts to gentleness and sensitivity by means of the pleasant impressions streaming in on us from all sides.' *In general* it never does that, rather, it hardens its genuine children, thank God, against the pains and evils it continually causes them, so that we can call that man the happiest who was able to encounter evils with the greatest strength, turn them away from him, and in defiance of them proceed according to his own will. Now that is too arduous, indeed impossible, for a great part of humankind; hence most of them, particularly the philosophers, beat a hasty retreat and retrench; which is why they then *in general* argue with such adequacy.

How selective and limited is the following observation, and how much it is supposed to prove! 'Above all, this tender mother has placed all the charms of attractiveness in those objects that are most necessary to our happiness, in particular in the blissful union in which the man finds a spouse.' We honor beauty with all our heart, have never been insensitive to its attractions; but to make it the prime mover in this sphere is only possible for one who has no inkling of the mysterious powers by which each is drawn to *its like*, and everything under the sun mates and is happy.

So even if it were true that the effect of the arts is the embellishment of things around us, it is nonetheless false to say that they do so following the example of nature.

What we see of nature is power, this power devours; nothing is present, everything passing, a thousand seeds are crushed, a thousand born each moment, it is great and significant, infinitely diverse; beautiful and ugly, good and evil, all exists side by side with equal right. And *art* is precisely the opposite; it arises from the endeavors of the individual to preserve itself from the destroying power of the whole. Even the animal by its artful instincts *sets itself apart, preserves itself*; the human being in all conditions fortifies himself against nature in order to avoid its thousandfold evils and enjoy only the measure of goodness it accords; until he finally succeeds as far as possible in encasing the circle of all his genuine and acquired needs within a palace, in holding all the scattered beauty and happiness spellbound within its glass walls, where he then becomes softer and softer, substitutes joys of the soul for joys of the body, and his powers, with nothing disagreeable to tauten them to natural uses, melt away into virtue, beneficence, sensibility.

Sulzer continues on his way, which we would rather not follow; he cannot lack a great troop of disciples, for he feeds them with milk, not strong foods; talks a lot about the essence of the arts, their purpose; and praises their great usefulness as a means to the furtherance of human happiness. Anyone who knows human nature just a little, and the arts, and happiness, will have little hope of this; the many kings will occur to him who were eaten to death by ennui in the midst of the glory of their splendor. For if only connoisseurship is envisaged, if one does not enjoy with active participation, hunger and disgust, the two most inimical drives, must soon combine to torment the wretched *Pococurante*.

Following this he embarks on a portrayal of the history of the fine arts and their present condition, projected imaginatively with the finest colors, just as good and no better than the histories of mankind to which we are so accustomed these days, in which the fairy tale of the four ages of the world always suffices; and told in the tone of history rewritten for practical application – as a novel.

Now Sulzer comes to our times and, as befits a prophet, scolds his own century roundly; admittedly doesn't deny that the fine arts have found more than enough promoters and friends, but because they have still not been used to the great end, the *moral improvement* of the people, our rulers have done nothing. He dreams, with others, that a wise legislature would both animate geniuses and be able to indicate the true goal to work towards, and more along those lines.

Finally he raises the question whose answer is supposed to open the way to the true theory: 'What initiatives can be taken so that man's innate sensual tendencies can be used to elevate his way of thinking and can be employed in specific cases as a means to attract him irresistibly to his duty?' As half- and misunderstood and vain as Cicero's wish to lead virtue to his son in the form of physical beauty. And Sulzer doesn't answer the question, but rather merely suggests what is important here – and we close his little book. His audience of disciples and petty connoisseurs may remain faithful to him, we know that all true artists and lovers of art are on our side, and will laugh at the philosopher just as until now they have complained about the academics. And to these listeners a few words more, confined to a few arts, which may apply to as many as it can.

If any speculative endeavor is to benefit the arts, it must address the artist directly, provide a draft to his natural fire, so that it can spread and prove active. For it's all a matter of the artist, that he feels no bliss in life but in his art, that he lives sunk in the instrument of his art, with all his feelings and powers. What does the gaping audience matter, what does it matter whether or not it can account for why it gaped, when it has done with gaping?

So anyone who in writing, speech, or by means of example – in ascending order – could raise the so-called amateur, the artist's only true audience, nearer and nearer to the spirit of the artist, so that his soul might also flow into the instrument of his art, would have done more than all psychological theorists. These gentlemen are so high up there in the empyrean of transcendental virtuous beauty that they don't care about petty details down here, which are all that matter. Which of us sons of the earth, on the other hand, doesn't see with deep regret how many good souls remain stuck with meticulous mechanical execution, e.g., in music, and perish beneath it?

May God preserve our senses, and preserve us from the theory of sensuousness, and give every beginner a good master! And since these are not to be had everywhere and always, and yet one has to write, let the artist and amateur give us a $\pi\epsilon\rho\grave{\iota}\ \dot{\epsilon}\alpha\upsilon\tau o\tilde{\upsilon}$ [report] of his endeavors, of the difficulties that delayed him most, the powers with which he overcame them, the chance events that helped him, the spirit that in certain moments came over him and gave him light for his life, until in the end, always growing, he swung himself up to mighty possession and as king and conqueror compelled the neighboring arts, indeed the whole of nature, to pay tribute.

In this way we would gradually assemble a living theory, passing from the mechanical to the intellectual, from the mixing of paints and the tuning of strings

to the true *influence of the arts on heart and mind*, would give the amateur joy and courage, and perhaps help the genius a little.

8 Georg Christof Tobler (1757–1812) 'Nature'

The fragment 'Nature' appeared in Goethe's *Tiefurter Journal* at the end of 1782 or early in 1783 and it has often mistakenly been assumed to be Goethe's own work. It was in fact written by the young Swiss theologian and classical scholar, Georg Christof Tobler. Tobler first met Goethe in Geneva in 1781 and between May and September of that year he visited Weimar, where the two became friends. Goethe was particularly impressed by Tobler's translations of Attic drama and Orphic hymns. The composition of the fragment dates from this time. Like Moritz's 'On the Creative Imitation of Beauty' (see VA9), it is the product of conversations with the poet, in this case on natural science and natural theology. When asked about the fragment in later years, Goethe agreed that it captured well a certain stage in his thinking. The piece is an emotional and pantheistic hymn to all-embracing nature. Whilst the form owes much to Tobler's translations from the Greek, the ideas are indebted to the spirit of pantheism which provided one of the animating forces of the *Sturm und Drang*. The lasting influence of these ideas is evidenced by Sigmund Freud's claim that his decision to study medicine rather than law was taken in response to the fragment, which he believed to be the work of Goethe. It is reprinted in Johann Wolfgang Goethe, *Naturwissenschaftliche Schriften*, Hamburger Goethe-Ausgabe, volume XIII, Hamburg: Christian Wegner Verlag, 1955, pp. 45–7. The complete text has been translated for this volume by Nicholas Walker.

Nature! We find ourselves at once surrounded and embraced by her – powerless to leave her, and powerless to fathom her more deeply. Unasked and unforewarned, she draws us into her dancing round, spins on and on with us until we are wearied and her arms can let us drop.

She creates ever new shapes for herself; what is there now was never there before, and what was there before never comes again – everything is new and yet forever ancient.

We live within her but are strangers to her. She speaks unceasingly to us but never once betrays her secret. We work upon her constantly yet over her possess no power.

She seems to strive for individuality in everything and brings all individuals to ruin. She builds unceasingly, destroys unceasingly, and her inner workshop is quite closed to us.

She lives in all her teeming children, but then where is this mother? – She is the one and only artist: she brings the simplest of material to the greatest contrasts, and without the slightest sign of effort to the greatest perfection – to the most precise articulation, though always with a gentle touch of delicacy. Each of her works has an essence of its own, each of her manifestations a singular concept peculiar to itself, but all still constitutes a single unity.

She playfully enacts a spectacle: whether she beholds all this herself we cannot know, although she plays it out before us in our little corner as we are.

There is in her eternal life and motion and becoming, although she also always stays unmoved. She transforms herself eternally and cannot rest for a moment. She

has no concept of the permanent, has cast her curse upon repose. She nonetheless stands firm. Her step is measured, her exceptions rare, her laws immutable.

She has taken thought and constantly reflects, although as Nature and not as man. She has retained a comprehensive meaning of her own, which no one can extract from her.

All human beings inhabit her and she inhabits them. She makes a friendly play with all of them, and rejoices all the more the more men gain from her. She plays in such mysterious ways with many and brings them to their end before they know it.

Even what is most unnatural is nature too. He who cannot see her working everywhere cannot find her rightly anywhere.

She loves herself and clings eternally to herself with countless hearts and eyes. She has parted herself the better to enjoy herself. She lets new creatures ceaselessly arise to enjoy and to share in her insatiably.

She delights in illusion. He who crushes this within himself or others, him she punishes as if she were the harshest tyrant. He who follows her in trust, him she presses to her heart as if he were a child.

Her children are without number. In general she is niggardly with none, but she has her favourites on whom she lavishly bestows her gifts and to whom she sacrifices much. She has expressly lent her protection to what is great.

She flings her creatures forth out of nothing, but never tells them whence they come or whither they are going; their task is but to run, she knows the course.

She has few springs of action but they are never worn away, are always active, always various in effect.

The spectacle she enacts is ever new because she constantly creates new onlookers for the play. Life is her fairest invention, and death her artful way of multiplying life.

She shrouds mankind in ignorance and spurs him ceaselessly towards the light. She makes him heavy and inert, dependent on the earth, and yet incites him constantly.

She bestows needs because she loves all movement. It is miraculous with what scarce means she has provoked such movement. Every need is a gift, quickly gratified, emerging quickly once again. When she bestows another need, this now becomes a novel source of pleasure. But she soon returns once more to equilibrium.

In each and every moment she starts upon the longest course and attains her goal in each and every moment.

She is vanity itself, though not to us, for whom she has made herself the most important thing of all.

She lets every child behave as it likes and every fool pass judgement on himself, lets thousands go obtusely on their way though understanding nothing, takes joy in all and makes her reckoning with all.

We obey her laws even when we strive to resist them; we work with her even when we want to go against her.

She turns everything she gives into an act of kindness for she makes it henceforth indispensable. She tarries that we might desire her, she hastens lest we ever tire of her.

She has neither language nor speech, but she creates tongues and hearts through which to feel and speak.

Her regal crown is love. Only through love can we approach her. She makes the sharpest division between all beings, yet everything desires to swallow up everything else into itself. She has individuated everything in order to draw everything together. She can recompense a life of ceaseless toil with a little draught from the goblet of love.

She is everything. She rewards herself and punishes herself, she delights in herself and tortures herself. She is harsh and gentle, lovely and terrifying, impotent and omnipotent. She harbours everything within herself for ever. She knows neither past nor future. To her the present is eternity. She is bountiful. I praise her and all her works. She is wise and calm. We can force no explanation from her, and exact from her no gifts that she does not willingly give. She is cunning, but to good purpose, and it is best of all to be ignorant of her cunning.

She is whole and yet ever incomplete. As she acts now, so she will always be able to act.

She appears to everyone in a unique shape. She conceals herself under a thousand names and titles and is always the same.

She has brought me here and she will likewise take me hence. I trust in her. She may scold me but she will not hate her own work. It was not I that have spoken of her. No, for what is true and what is false, she has spoken it all. She is to blame for everything, she is to thank for everything. [*Alles ist ihre Schuld, alles ist ihr Verdienst*.]

9 Alexander Cozens (1717–1786) from 'A New Method of Assisting the Invention in Drawing Original Compositions of Landscape'

Alexander Cozens' father was a master shipbuilder to Peter the Great, and much of his early life was spent in Russia. In 1746–8 he was in Italy, where he spent some time in the Roman studio of Claude-Joseph Vernet (see IIIC14). Though he studied oil painting with Vernet, the majority of his work was done in pencil, pen or ink wash and was based on landscape themes, actual or invented. For his remaining years he worked in England, earning his living principally as a drawing master. During his long career his pupils included orphans at Christ's Hospital, schoolboys at Eton and members of the royal family. In 1759 he published *An Essay to Facilitate the Invention of Landskips, Intended for Students in the Art*, setting out in brief his method for composing with the aid of ink blots and citing the precedent of Leonardo da Vinci, who had recommended looking for images in crumbling walls as a means of assisting the invention. He also worked on categorizing the types of landscape found in nature, leaving a list of sixteen 'Kinds of Composition' to each of which a particular range of moral effects was to be attached. The *New Method of Assisting the Invention* was his last publication and the most complete demonstration of his system for the use of ink blots. It was originally accompanied by sixteen aquatint plates. In Cozens' own eyes the potential of his method far exceeded its capacity to generate appealing novelties. In line with contemporary theories of the sublime and the picturesque, he believed that the resulting pictures would be stimulating to taste and understanding in the perception both of art and of nature. One of the most notable beneficiaries of Cozens' teaching was his own son, John Robert Cozens (1752–98), who accompanied Richard Payne Knight on a tour of the Alps in 1776 (see VB14), and whose landscapes in water-colour were admired by Fuseli, Turner and Constable, among others. *A New Method...* was first published in London by the author in 1785. It was reprinted in A. P. Oppé, *Alex-*

ander and John Robert Cozens, London: Adam and Charles Black, 1952, pp. 166–84. Our text is taken from the latter edition, pp. 167–77.

By way of introduction to the following treatise, I venture to avail myself of the just observation in the commentary on the first book of that beautiful poem, 'the English Garden' [by William Mason]; but at the same time, I take the liberty of altering the words in favour of composition of landscape by invention, that being, in great measure, the subject of the present work.

The powers of art and invention, impart picturesque beauty, and strength of character to the works of an artist in landscape painting; as a noble and graceful deportment confers a winning aspect on the human frame. Composing landscapes by invention, is not the art of imitating individual nature; it is more; it is forming artificial representations of landscape on the general principles of nature, founded in unity of character, which is true simplicity; concentring in each individual composition the beauties, which judicious imitation would select from those which are dispersed in nature.

I am persuaded, that some instantaneous method of bringing forth the conception of an ideal subject fully to the view (though in the crudest manner) would promote original composition in painting; and that the want of some such method has retarded the progress of it more than impotence of execution.

Hence proceeds the similarity, as well as weakness, of character, which may be seen in all compositions that are bad, or indifferently good: they may be also owing more particularly to the following causes;

1. To the deficiency of a stock of ideas originally laid up in the mind, from which might be selected such as suit any particular occasion;
2. To an incapacity of distinguishing and connecting ideas so treasured up;
3. To a want of facility, or quickness, in execution; so that the composition, how perfect soever in conception, grows faint and dies away before the hand of the artist can fix it upon the paper, or canvas.

To one or more of these causes may be imputed that want of nature and originality, which is visible in many productions.

How far the incapacity of combining our ideas with readiness and propriety in the works of art, may arise from neglecting to exercise the invention, or from not duely cultivating the taste and judgment, cannot perhaps be easily determined: but it cannot be doubted, that too much time is spent in copying the works of others, which tends to weaken the powers of invention; and I scruple not to affirm, that too much time may be employed in copying the landscapes of nature herself.

I here find myself tempted to communicate an accident that gave rise to the method now proposed of assisting the imagination in landscape composition, which I have constantly pursued, as well in my private studies as in the course of my teaching, ever since; and which I now lay before the public, after a full proof of its utility, from many years experience.

Reflecting one day in company with a pupil of great natural capacity, on original composition of landscape, in contradistinction to copying, I lamented the want of a

mechanical method sufficiently expeditious and extensive to draw forth the ideas of an ingenious mind disposed to the art of designing. At this instant happening to have a piece of soiled paper under my hand, and casting my eyes on it slightly, I sketched something like a landscape on it, with a pencil, in order to catch some hint which might be improved into a rule. The stains, though extremely faint, appeared upon revisal to have influenced me, insensibly, in expressing the general appearance of a landscape.

This circumstance was sufficiently striking: I mixed a tint with ink and water, just strong enough to mark the paper; and having hastily made some rude forms with it, (which, when dry, seemed as if they would answer the same purpose to which I had applied the accidental stains of the 'forementioned piece of paper) I laid it, together with a few short hints of my intention, before the pupil, who instantly improved the blot, as it may be called, into an intelligible sketch, and from that time made such progress in composition, as fully answered my most sanguine expectations from the experiment.

After a long time making these hints for composition with light ink, the method was improved by making them with black ink; and the sketches from these are produced by tracing them on transparent paper.

In the course of prosecuting this scheme, I was informed, that something of the same kind had been mentioned by Leonardo da Vinci, in his Treatise on Painting. It may easily be imagined how eagerly I consulted the book; and from a perusal of the particular passage which tended to confirm my own opinion, I have now an authority to urge in its favour; an authority, to which the ingenious will be disposed to pay some regard. The passage is as follows.

'Among other things I shall not scruple to deliver a new method of assisting the invention, which, though trifling in appearance, may yet be of considerable service in opening the mind, and putting it upon the scent of new thoughts; and it is this. If you look upon an old wall covered with dirt, or the odd appearance of some streaked stones, you may discover several things like landscapes, battles, clouds, uncommon attitudes, humorous faces, draperies, &c. Out of this confused mass of objects, the mind will be furnished with abundance of designs and subjects perfectly new.'

I presume to think, that my method is an improvement upon the above hint of Leonardo da Vinci, as the rude forms offered by this scheme are made at will; and should it happen, that a blot is so rude or unfit, that no good composition can be made from it, a remedy is always at hand, by substituting another. But, according to Leonardo, the rude forms must be sought for in old walls, &c. which seldom occur; consequently, the end of the composer may sometimes be defeated.

An artificial blot is a production of chance, with a small degree of design; for in making it, the attention of the performer must be employed on the whole, or the general form of the composition, and upon this only; whilst the subordinate parts are left to the casual motion of the hand and the brush.

But in making blots it frequently happens, that the person blotting is inclined to direct his thoughts to the objects, or particular parts, which constitute the scene or subject, as well as to the general disposition of the whole. The consequence of this is an universal appearance of design in his work, which is more than is necessary to a true blot. But this superabundance of design is of no disadvantage to the drawing that

is to be made from it, provided it is done with judgment and spirit; for if what is intended for a blot, proves to be a spirited sketch, the artist has only the less to invent in his drawing, when he is making it out.

A true blot is an assemblage of dark shapes or masses made with ink upon a piece of paper, and likewise of light ones produced by the paper being left blank. All the shapes are rude and unmeaning, as they are formed with the swiftest hand. But at the same time there appears a general disposition of these masses, producing one comprehensive form, which may be conceived and purposely intended before the blot is begun. This general form will exhibit some kind of subject, and this is all that should be done designedly.

It was thought necessary to give this particular description of a true blot, in order to compare it with one, in which too much attention has been paid to the constituent parts.

The blot is not a drawing, but an assemblage of accidental shapes, from which a drawing may be made. It is a hint, or crude resemblance of the whole effect of a picture, except the keeping and colouring; that is to say, it gives an idea of the masses of light and shade, as well as of the forms, contained in a finished composition. If a finished drawing be gradually removed from the eye, its smaller parts will be less and less expressive; and when they are wholly undistinguished, and the largest parts alone remain visible, the drawing will then represent a blot, with the appearance of some degree of keeping. On the contrary, if a blot be placed at such a distance that the harshness of the parts should disappear, it would represent a finished drawing, but with the appearance of uncommon spirit.

To sketch in the common way, is to transfer ideas from the mind to the paper, or canvas, in outlines, in the slightest manner. To blot, is to make varied spots and shapes with ink on paper, producing accidental forms without lines, from which ideas are presented to the mind. This is conformable to nature: for in nature, forms are not distinguished by lines, but by shade and colour. To sketch, is to delineate ideas; blotting suggests them. [...]

In order to produce the drawing, nothing more is required than to place a piece of paper, made transparent, upon the blot; or if the practitioner chooses to make the sketch upon paper not so transparent, he should procure a frame, made on purpose, with a glass for small drawings, and strained gauze for larger, to stand on a table, as is mentioned hereafter. The blot with the paper is to be put on it. The first operation in composing from the blot, is to make out the sketch, by giving meaning and coherence to the rude shapes, and aërial keeping to the casual light and dark masses of the blot.

I conceive, that this method of blotting may be found to be a considerable improvement to the arts of design in general; for the idea or conception of any subject, in any branch of the art, may be first formed into a blot. Even the historical, which is the noblest branch of painting, may be assisted by it; because it is the speediest and the surest means of fixing a rude whole of the most transient and complicated image of any subject in the painter's mind.

There is a singular advantage peculiar to this method; which is, that from the rudeness and uncertainty of the shapes made in blotting, one artificial blot will suggest different ideas to different persons; on which account it has the strongest tendency to enlarge the powers of invention, being more effectual to that purpose

than the study of nature herself alone. For instance, suppose any number of persons were to draw some particular view from a real spot; nature is so precise, that they must produce nearly the same ideas in their drawings; but if they were one after the other, to make out a drawing from one and the same blot, the parts of it being extremely vague and indeterminate, they would each of them, according to their different ideas, produce a different picture. One and the same designer likewise may make a different drawing from the same blot; as will appear from the three several landscapes taken from the same blot, which are given in the four last plates or examples.

To the practitioner in landscape it may be farther observed, that in finishing a drawing from a blot, the following circumstance will occur, viz. in compositions where there are a number of grounds or degrees of distance, several of them will be expressed in the sketch by little more than tracing the masses that are in the blot, the last ground of all perhaps requiring only an outline: for the greatest precision of forms will be necessary in the first or nearest ground; in the next ground the precision will be less, and so on.

There must doubtless be left a power of rejecting any part of the blot which may appear improper, or unnatural, while the sketch is making; for which no previous directions can be given: in this case imagination leads, while the judgment regulates.

However it is still evident, that, notwithstanding the variety which chance may suggest, and this discretionary power of rejecting any part of a blot, a very indifferent drawing may yet be produced from other causes, such as want of capacity, inattention, &c. the effects of which are not to be counteracted by any rules or assistance whatever.

It hath been already observed, that the want of variety and strength of character may be owing either, first;

To a scantiness of original ideas: or, secondly,

To an incapacity of distinguishing and connecting such as are capable of being properly united: or, thirdly,

To a want of facility and quickness in execution.

But to each of these defects, the art of blotting, here explained, affords, in some degree, a remedy. For it increases the original stock of picturesque ideas;

It soon enables the practitioner to distinguish those which are capable of being connected, from those which seem not naturally related; and

It necessarily gives a quickness and freedom of hand in expressing the parts of a composition, beyond any other method whatever.

It also is extremely conducive to the acquisition of a theory, which will always conduct the artist in copying nature with taste and propriety.

This theory is, in fact, the art of seeing properly; it directs the artist in the choice of a scene, and to avail himself of all those circumstances and incidents therein which may embellish or consolidate his piece.

But there is a farther, and a very material purpose that may be attained by it, which is, that of taking views from nature. In doing which, as well as composing landscapes by invention, the following principles are necessary, viz. A proper choice of the subject, strength of character, taste, picturesqueness, proportion, keeping, expression

of parts or objects, harmony, contrast, light and shade, effect, &c. All these may be acquired by the use of blotting; so that what remains necessary, for drawing landscapes from nature, is only a habit in the draughtsman, of imitating what he sees before him, which any one may learn through practice, assisted by some simple method.

In short, whoever has been used to compose landscapes by blotting, can also draw from nature with practice. But he cannot arrive at a power of composing by invention, by the means of drawing views from nature, without a much greater degree of time and practice.

In order to encourage those who wish to design original compositions, it may be remarked, that there is to be discerned, in all whole compositions in nature, a gradation of parts, which may be divided into several classes; for instance, the class of the smaller parts, the class of those of larger dimensions, and so on to the largest. The curious spectator of landscape insensibly acquires a habit of taking notice, or observing all the parts of nature, which is strengthened by exercise. It may be perceived, that the application of this notice in youth is directed to the smaller parts (which are also the most strongly retained in idea), from which it is gradually transferred to the larger as we approach to age, at which time we generally take notice of whole compositions. By the means of this propensity we lay up a store of ideas in the memory, from whence the imagination selects those which are best adapted to the nature of her operations. All the particular parts of each object may not be preserved in the memory, yet general ideas of the whole may be thrown as it were into the repository, and there retained.

Every one knows, that the youthful and the ignorant, as well as the mature and the refined, express their approbation (frequently from their own feelings) of performances that are worthy of praise. What can this proceed from? ... There must be an inward criterion by which they are led to judge and approve. This criterion is the store of ideas before-mentioned, which are in the possession of all who have been used to the proper subjects. Some of these ideas are drawn forth by the merits of such performances as are presented, and so become the scale or rule of judgment and taste, by which the operations of criticism are carried on.

Ideas may also be revived by recollection, whether casual or intended. To these may be added, the method of blotting now offered, which has a direct tendency to recal landscape ideas.

On the foregoing principles, very few can have reason to suspect in themselves a want of capacity sufficient to apply the use of blotting to the practice of drawing, nor can they be totally ignorant of the parts of composition in nature, for as they are previously prepared with ideas of parts, as before proved, so this art affords an opportunity of calling them forth, and likewise presents an ocular demonstration of the principles of composition. Previous ideas, however acquired (of which every person is possessed more or less) will assist the imagination in the use of blotting; and on the other hand, the exercise of blotting will strengthen and improve the ideas which are impaired for want of application.

I beg to consider this matter in a further light. It is probable, that all persons retain ideas of what they have seen, but that there are many who have no aptitude for imitating what they do see, in order to make a copy of it. So that in regard to

composing landscapes by invention, there is only required a method (as blotting) to bring out those ideas visibly on paper, &c. But no method can give an aptness, or an eye, for copying to a person who is not possessed of it from nature, which may be compared to a want of ear in music.

If it be said, that a person must have genius in order to be able to make out designs from blots; the truth of this assertion may be examined by enquiring what genius is, and to what principal purpose genius is indispensably necessary; and on the other hand, what are the requisites necessary to make designs from blots.

A definition of genius may be attempted as follows. Strength of ideas; power of invention; and ready execution. – So that a man of true genius conceives strongly, invents with originality, and executes readily.

It is to be suspected, that the world entertains but confused notions concerning genius. This probably arises from mistaking certain qualities for genius, which are totally distinct from it; as perception, judgement, imagination, partiality for an art, experience, memory, taste, perseverance, industry, attention, knowledge, &c. Any one of these, or any number, or even all of them together, cannot produce such transcendent beauties as are the fruits of genius, when furnished with proper materials. Yet much is, and may be done by the force of those qualities alone, without any proof of the existence of real and original genius.

When a person shews a very great inclination to any profession, employment, or art, &c. and pursues it with unremitting perseverance, and even enthusiasm; this is not really a proof of genius, but merely of a strong attachment.

When a person, by being inured to the perception of beauty, has acquired taste, suppose it in the greatest degree, so as to be a consummate judge of the highest style of beauty; this also is not a proof of genius.

But when a person frequently and readily performs works which are novel, and these with precision of meaning; this is a proof of genius; which, as beforementioned, consists of strength of ideas, with power of invention, and ready execution.

Lastly, when a person endued with genius has, from some incidental cause, directed his attention steadily to any pursuit, and feels a strong attachment to it; and has acquired taste, by inuring himself to the sight and perception of beauty; then enthusiasm and taste thus combined with genius, invest him with triple power, to create and execute works transcending in beauty and perfection.

The principal purpose to which genius is indispensably necessary is, the production of whole compositions new to the performer.

As to the requisites necessary for making out designs from blots, they may be seen in this treatise, where they are particularly set forth in many places. There it may be clearly understood, that it is in the power of most capacities to make designs from blots, to a considerable degree of perfection, and that genius is not indispensably necessary for that purpose. But it must be confessed, that if a person possesses genius, according to the definition, he will avail himself more of those accidental forms, &c. which the blot presents to him, and consequently will compose with greater facility and meaning from them, than one who has no genius. From this it may be presumed, that the use of blotting may be a help even to genius; and where there is latent genius, it helps to bring it forth.

10 Johann Kaspar Lavater (1741–1801) 'On Landscape Painting'

The Swiss poet, priest and theologian Johann Kaspar Lavater was a prolific writer in many genres, but he is principally known for his writings on physiognomy (see VA6). In 1790 he published two volumes of letters, composed in response to oral and written requests for help in religious, philosophical and moral matters. The following letter gives advice to a young landscape artist, addressed as Herr Steiner of Winterthur. As in the study of physiognomy, Lavater insists that close attention be paid to the determining character-istics of individual objects. No two blades of grass are alike and the idea of a tree in general is an empty abstraction that can have no place in painting. However, direct study of nature is to be combined with the recognition that the rules of composition and the means of attaining an overall effect are best derived from the work of other artists. Lavater repeatedly refers his correspondent to Claude Lorrain's *Liber Veritatis*, a collection of 200 compositions which Claude made from his own paintings to serve as a record of his work. Lavater's advice is remarkably similar to that given by Salomon Gessner in his 'Letter on Landscape Painting' (see VB3). Both men recommend close attention to nature, which is nonetheless guided by the practice of the great artists of the past. 'Ueber das Land-schaftsmalen. An Herrn Steiner in Winterthur' was first published in volume 2 of Lavater's *Antworten auf wichtige und würdige Briefe weiser und guter Menschen*, Zürich: Heinrich August Rottmann, 1790, pp. 536–9. The complete text has been translated for the present volume by Jason Gaiger.

A man such as you with so much talent and taste, with so much feeling and under-standing for art, has the divine vocation of bringing himself as near as possible to perfection! Never to stand still, but always to move forwards! Always to study nature herself, and to study nature through the medium of her most brilliant and exact imitators! What is most difficult for you is also the most necessary, or rather, the easiest is the most difficult: always to study with exactitude exactly one thing and to study this exhaustively. I strongly advise that you undertake a course of study just of trees, of their trunks, their branches, their boughs, and particularly of the point at which they connect with the earth and of the way in which the earth clothes each trunk as it rises up out of the ground; indeed, I advise a special course on each type of tree, on their particular skeletons and foliage, on the way in which they group together, how they stand alone, and how they appear when they grow alongside trees of another type.

To you, a man of taste, I do not need to say: always seek out the most beautiful groups of trees, well chosen and upright. It pleases me greatly that you take your easel into the fields and the woods and paint from nature with watercolours – this is what Aberlin does, who remains unsurpassed in the achievement of naturalness.

I also ask that you bridle your bold genius and do not seek to achieve too much with a single work; with every new attempt at enrichment ask yourself 'Will the beauty of the work remain the same? Will it lose? Or will it gain?'

That which damages the harmony and the manifold unity of the work should always be left undone, even if it is beautiful in itself and can easily be achieved.

In every landscape the character of the landscape painter should be clearly and immediately visible.

The *foreground* should be strongly worked in definite, large masses, but also delightful. Composition and firmness of execution will remove everything which is not unified. Alongside nature, both night and day, early and late, study the work of Claude Lorrain. It goes without saying that I would never tell you, 'Imitate him exactly.' For whoever is possessed of originality can never merely imitate.

Try to answer the following questions clearly and exactly – Do we not see here the superior plan of the whole? the gentle division of light and shadow? the exact distinction of foreground, middle ground and background? the strongly shadowed foreground, the lightly shadowed middle ground and the scarcely touched, light background? Do not the majority and the best of his landscapes oppose conspicuous masses against one another, which stand out clearly from the light in the centre, and are broken only by a slender tree, a ship, the arch of a bridge, a hill or some such?

Consider here his *Liber veritatis*, particularly numbers 1, 2, 3, 5, 17, 23, 27, 31, 43, 111, 122, 139.

How he loves the bright sun in the centre! He starts from the brightest point which he never hides from the viewer; he represents it as bright and gentle and does not blind us – and then proceeds to the darkest shadows in the foreground.

How impossible for him is all confusion and overworking! – and how far he is from any poverty of execution! what serenity he brings even to the most casually thrown off piece! how everything is clear! everything has been examined – and for that reason is easy to see! everything has been felt, and for that reason is easy to experience!

With what success he knows how to oppose areas of light against areas of shadow, as in 1, 31, 38, 58, 62; he knows how to lead us from the closest proximity to the most infinite distance through gentle progressions, as in 112, 113, 114, 122, 124. How is it that he manages to give his trees the effect of massiveness without making them massive? Look here at 7, 8, 13, 35, 40, 41, 56, 82, 83, 84.

Again and again I come back to the peculiar freedom from confusion which reigns in his landscapes! Everything is so light, so verdant, so free, so simple in nature and in Claude Lorrain. But enough of this.

One last thing: everything which is a mere mannerism for you is a sin! You must always know *what* you want to draw and *why* you draw it as you do. A mannerism which intrudes is as intolerable as declamation in speech, which makes the listener forget what is being spoken about.

You should always seek to achieve the greatest possible simplicity and the greatest possible harmony! No blade of glass is like any other, not to speak of any tree! – And yet every blade of grass bears the character of grass! and every tree is a tree, an individual tree in all its leaves and features. There is no such thing as a tree in general. – Every tree is a particular tree which possesses its own unique character or type. I see so many trees in paintings which are neither oaks nor pines, neither beeches nor limes. They are neither A nor B, nor X, Y, Z – therefore they are not trees. Enough for today.

11 William Gilpin (1724–1804) from 'On Picturesque Beauty' and 'On Picturesque Travel'

In 1792 Gilpin published *Three Essays: on Picturesque Beauty; on Picturesque Travel; and on Sketching Landscape: to which is added a poem on Landscape Painting* (London: R. Blamire), having completed a first draft some twenty years earlier. A French translation was published in 1799. In the first two of these essays, represented here, the ideas sketched out in Gilpin's 'Essay on Prints' (VB2) are developed with a confidence acquired during his series of 'Observations', and with specific reference to Burke's 'Essay on the Sublime and the Beautiful' (IIIB6). His argument is that those properties which lead us to see an object as beautiful are not necessarily consonant with those which might render it suitable and attractive as an object to be pictured – that is, which render it picturesque. While a Palladian villa might be the last word in taste and elegance, a picture of a Palladian villa might be thoroughly tedious. In noting that the beautiful was not necessarily an adequate measure of the picturesque, Gilpin revealed just how narrow was the set of positive aesthetic predicates generally admitted into academic discourse. By enlarging the range of terms available for describing naturalistic effects he encouraged the appreciation of landscape paintings – and by extension of other kinds of pictures as well – that were intentionally unclassical in style. Further, in proposing nature as the archetype of all picturesque experience, he offered a measure by which actual pictures were always in danger of falling short. It would not be appropriate, however, either to see Gilpin as a straightforward naturalist, or to associate him with the taste for experience of 'sublime' landscapes that fuelled Alpine travels of the kind Richard Payne Knight undertook in 1776. Knight was accompanied on that occasion by John Robert Cozens, who produced a pictorial record of the journey. Philippe de Loutherbourg and J. M. W. Turner were among the artists whose subsequent travels to the Alps resulted in pictures of lowering mountains, yawning chasms and raging torrents. In marked contrast to such scenes, the world Gilpin conceived of as picturesque was one in which 'the ruined tower, the Gothic arch, the remains of castles, and abbeys' might be contemplated in reasonable comfort. The debate on the 'picturesque', and on its relation to the 'sublime' and the 'beautiful', was taken up and pursued by a younger generation of English writers during the 1790s and early 1800s, among them Sir Uvedale Price (VB13, 15) and Richard Payne Knight (VB14). Our text is taken from the original edition of the *Three Essays*, pp. 1, 5–8, 15–21 and 41–6. Gilpin's footnotes have been omitted.

Essay I.

Disputes about beauty might perhaps be involved in less confusion, if a distinction were established, which certainly exists, between such objects as are *beautiful*, and such as are *picturesque* – between those, which please the eye in their *natural state*; and those, which please from some quality, capable of being *illustrated in painting*.

* * *

Mr. Burke, enumerating the properties of beauty, considers *smoothness* as one of the most essential. 'A very considerable part of the effect of beauty, says he, is owing to this quality: indeed the most considerable: for take any beautiful object, and give it a broken, and rugged surface, and however well-formed it may be in other respects, it pleases no longer. Whereas, let it want ever so many of the other constituents, if it

want not this, it becomes more pleasing, than almost all the others without it.'——
How far Mr. Burke may be right in making smoothness the *most considerable* source of
beauty, I rather doubt. A considerable one it certainly is.

Thus then, we suppose, the matter stands with regard to *beautiful objects in general*.
But in *picturesque representation* it seems somewhat odd, yet we shall perhaps find it
equally true, that the reverse of this is the case; and that the ideas of *neat* and *smooth*,
instead of being picturesque, in fact disqualify the object, in which they reside, from
any pretensions to *picturesque beauty*. – Nay farther, we do not scruple to assert, that
roughness forms the most essential point of difference between the *beautiful*, and the
picturesque; as it seems to be that particular quality, which makes objects chiefly
pleasing in painting. – I use the general term *roughness*; but properly speaking
roughness relates only to the surfaces of bodies: when we speak of their delineation,
we use the word *ruggedness*. Both ideas however equally enter into the picturesque;
and both are observable in the smaller, as well as in the larger parts of nature – in the
outline, and bark of a tree, as in the rude summit, and craggy sides of a mountain.

Let us then examine our theory by an appeal to experience; and try how far these
qualities enter into the idea of *picturesque beauty* and how far they mark that
difference among objects, which is the ground of our inquiry.

A piece of Palladian architecture may be elegant in the last degree. The proportion
of it's parts – the propriety of it's ornaments – and the symmetry of the whole, may
be highly pleasing. But if we introduce it in a picture, it immediately becomes a
formal object, and ceases to please. Should we wish to give it picturesque beauty, we
must use the mallet, instead of the chissel: we must beat down one half of it, deface
the other, and throw the mutilated members around in heaps. In short, from a *smooth*
building we must turn it into a *rough* ruin. No painter, who had the choice of the two
objects, would hesitate a moment.

Again, why does an elegant piece of garden-ground make no figure on canvas? The
shape is pleasing; the combination of the objects, harmonious; and the winding of the
walk in the very line of beauty. All this is true; but the *smoothness* of the whole, tho
right, and as it should be in nature, offends in picture. Turn the lawn into a piece of
broken ground: plant rugged oaks instead of flowering shrubs: break the edges of the
walk: give it the rudeness of a road: mark it with wheel-tracks; and scatter around a
few stones, and brushwood; in a word, instead of making the whole *smooth*, make it
rough; and you make it also *picturesque*. All the other ingredients of beauty it already
possessed.

* * *

The art of painting allows you all you wish. You desire to have a beautiful object
painted – your horse, for instance, led out of the stable in all his pampered beauty.
The art of painting is ready to accommodate you. You have the beautiful form you
admired in nature exactly transferred to canvas. Be then satisfied. The art of painting
has given you what you wanted. It is no injury to the beauty of your Arabian, if the
painter think he could have given the graces of his art more forcibly to your cart-
horse.

But does it not depreciate his art, if he give up a beautiful form, for one less
beautiful, merely because he could have given it *the graces of his art more forcibly* –
because it's sharp lines afford him a greater facility of execution? Is the smart touch of

a pencil the grand desideratum of painting? Does he discover nothing in *picturesque objects*, but qualities, which admit of being *rendered with spirit?*

I should not vindicate him, if he did. At the same time, a free execution is so very fascinating a part of painting, that we need not wonder, if the artist lay a great stress upon it. – It is not however intirely owing, as some imagine, to the difficulty of mastering an elegant line, that he prefers a rough one. In part indeed this may be the case; for if an elegant line be not delicately hit off, it is the most insipid of all lines: whereas in the description of a rough object, an error in delineation is not easily seen. However this is not the whole of the matter. A free, bold touch is in itself pleasing. In elegant figures indeed there must be a delicate outline – at least a line true to nature: yet the surfaces even of such figures may be touched with freedom; and in the appendages of the composition there must be a mixture of rougher objects, or there will be a want of contrast. In landscape universally the rougher objects are admired; which give the freest scope to execution. If the pencil be timid, or hesitating, little beauty results. The execution then only is pleasing, when the hand firm, and yet decisive, freely touches the characteristic parts of each object.

If indeed, either in literary, or in picturesque composition you endeavour to draw the reader, or the spectator from the *subject* to the *mode of executing* it, your affectation disgusts. At the same time, if some care, and pains be not bestowed on the *execution*, your slovenliness disgusts, as much. Tho perhaps the artist has more to say, than the man of letters, for paying attention to his *execution*. A truth is a truth, whether delivered in the language of a philosopher, or a peasant: and the *intellect* receives it as such. But the artist, who deals in lines, surfaces, and colours, which are an immediate address to the *eye*, conceives the *very truth itself* concerned in his *mode* of representing it. Guido's angel, and the angel on a sign-post, are very different beings; but the whole of the difference consists in an artful application of lines, surfaces, and colours.

It is not however merely for the sake of his *execution*, that the artist values a rough object. He finds it in many other respects accommodated to his art. In the first place, his *composition* requires it. If the history-painter threw all his draperies smooth over his figures, his groups, and combinations would be very awkward. And in *landscape-painting* smooth objects would produce no composition at all. In a mountain-scene what composition could arise from the corner of a smooth knoll coming forward on one side, intersected by a smooth knoll on the other; with a smooth plain perhaps in the middle, and a smooth mountain in the distance. The very idea is disgusting. Picturesque composition consists in uniting in one whole a variety of parts; and these parts can only be obtained from rough objects. If the smooth mountains, and plains were broken by different objects, the composition might be good, on a supposition the great lines of it were so before.

Variety too is equally necessary in his composition: so is *contrast*. Both these he finds in rough objects; and neither of them in smooth. Variety indeed, in some degree, he may find in the outline of a smooth object: but by no means enough to satisfy the eye, without including the surface also.

From *rough* objects also he seeks the *effect of light and shade*, which they are as well disposed to produce, as they are the beauty of composition. One uniform light, or one uniform shade produces no effect. It is the various surfaces of objects, sometimes turning to the light in one way, and sometimes in another, that give the painter his

choice of opportunities in massing, and graduating both his lights, and shades. – The *richness* also of the light depends on the breaks, and little recesses, which it finds on the surfaces of bodies. What the painter calls *richness* on a surface, is only a variety of little parts; on which the light shining, shews all it's small inequalities, and roughnesses; and in the painter's language, *inriches* it. – The beauty also of *catching lights* arises from the roughness of objects. What the painter calls a *catching light* is a strong touch of light on some prominent part of a surface, while the rest is in shadow. A smooth surface has no such prominences.

In *colouring* also, *rough* objects give the painter another advantage. Smooth bodies are commonly as uniform in their colour, as they are in their surface. In glossy objects, the smooth, the colouring may sometimes vary. In general however it is otherwise; in the objects of landscape, particularly. The smooth side of a hill is generally of one uniform colour; while the fractured rock presents it's grey surface, adorned with patches of greensward running down it's guttered sides; and the broken ground is every where varied with an okery tint, a grey gravel, or a leaden-coloured clay: so that in fact the rich colours of the ground arise generally from it's broken surface.

From such reasoning then we infer, that it is not merely for the sake of his *execution*, that the painter prefers *rough* objects to *smooth*. The very essence of his art requires it.

Essay II.

Enough has been said to shew the difficulty of *assigning causes:* let us then take another course, and amuse ourselves with *searching after effects*. This is the general intention of picturesque travel. We mean not to bring it into competition with any of the more useful ends of travelling: but as many travel without any end at all, amusing themselves without being able to give a reason why they are amused, we offer an end, which may possibly engage some vacant minds; and may indeed afford a rational amusement to such as travel for more important purposes.

In treating of picturesque travel, we may consider first it's *object*; and secondly it's sources of *amusement*.

It's *object* is beauty of every kind, which either art, or nature can produce: but it is chiefly that species of *picturesque beauty*, which we have endeavoured to characterize in the preceding essay. This great object we pursue through the scenery of nature; and examine it by the rules of painting. We seek it among all the ingredients of landscape – trees – rocks – broken-grounds – woods – rivers – lakes – plains – vallies – mountains – and distances. These objects *in themselves* produce infinite variety. No two rocks, or trees are exactly the same. They are varied, a second time, by *combination*; and almost as much, a third time, by different *lights, and shades*, and other aerial effects. Sometimes we find among them the exhibition of *a whole*; but oftener we find only beautiful *parts*.

That we may examine picturesque objects with more ease, it may be useful to class them into the *sublime*, and the *beautiful*; tho, in fact, this distinction is rather inaccurate. *Sublimity alone* cannot make an object *picturesque*. However grand the mountain, or the rock may be, it has no claim to this epithet, unless it's form, it's

colour, or it's accompaniments have *some degree of beauty*. Nothing can be more sublime, than the ocean: but wholly unaccompanied, it has little of the picturesque. When we talk therefore of a sublime object, we always understand, that it is also beautiful: and we call it sublime, or beautiful, only as the ideas of sublimity, or of simple beauty prevail.

The *curious*, and *fantastic* forms of nature are by no means the favourite objects of the lovers of landscape. There may be beauty in a *curious* object; and so far it may be picturesque: but we cannot admire it merely for the sake of it's curiosity. The *lusus naturæ* is the naturalist's province, not the painter's. The spiry pinnacles of the mountain, and the castle-like arrangement of the rock, give no peculiar pleasure to the picturesque eye. It is fond of the simplicity of nature; and sees most beauty in her *most usual* forms. The *Giant's causeway* in Ireland may strike it as a novelty; but the lake of Killarney attracts it's attention. It would range with supreme delight among the sweet vales of Switzerland; but would view only with a transient glance, the Glaciers of Savoy. Scenes of this kind, as unusual, may please *once*; but the great works of nature, in her simplest and purest stile, open inexhausted springs of amusement.

But it is not only the *form*, and the *composition* of the objects of landscape, which the picturesque eye examines; it connects them with the atmosphere, and seeks for all those various effects, which are produced from that vast, and wonderful storehouse of nature. Nor is there in travelling a greater pleasure, than when a scene of grandeur bursts unexpectedly upon the eye, accompanied with some accidental circumstance of the atmosphere, which harmonizes with it, and gives it double value.

Befides the *inanimate* face of nature, it's *living forms* fall under the picturesque eye, in the course of travel; and are often objects of great attention. The anatomical study of figures is not attended to: we regard them merely as the ornament of scenes. In the human figure we contemplate neither *exactness of form*; nor *expression*, any farther than it is shewn in *action:* we merely consider general shapes, dresses, groups, and occupations; which we often find *casually* in greater variety, and beauty, than any selection can procure.

In the same manner animals are the objects of our attention, whether we find them in the park, the forest, or the field. Here too we consider little more, than their general forms, actions, and combinations. Nor is the picturesque eye so fastidious as to despise even less considerable objects. A flight of birds has often a pleasing effect. In short, every form of life, and being has it's use as a picturesque object, till it become too small for attention.

But the picturesque eye is not merely restricted to nature. It ranges through the limits of art. The picture, the statue, and the garden are all the objects of it's attention. In the embellished pleasure-ground particularly, tho all is neat, and elegant – far too neat and elegant for the use of the pencil; yet, if it be well laid out, it exhibits the *lines*, and *principles* of landscape; and is well worth the study of the picturesque traveller. Nothing is wanting, but what his imagination can supply – a change from smooth to rough.

But among all the objects of art, the picturesque eye is perhaps most inquisitive after the elegant relics of ancient architecture; the ruined tower, the Gothic arch, the remains of castles, and abbeys. These are the richest legacies of art. They are

consecrated by time; and almost deserve the veneration we pay to the works of nature itself.

Thus universal are the objects of picturesque travel. We pursue *beauty* in every shape; through nature, through art; and all it's various arrangements in form, and colour; admiring it in the grandest objects, and not rejecting it in the humblest.

12 Friedrich Ramdohr (1752–1822) 'On Landscapes and Sea Pieces' from *Charis, or on Beauty and the Beautiful in the Imitative Arts*

Friedrich Ramdohr was born in Hoya, near Bremen, in Germany. From 1775 to 1778 he studied law and classical archaeology at Göttingen. As a young man he wrote and published a tragedy, *Kaiser Otto der dritte* (1783), and he remained a keen amateur painter and draughtsman throughout his life. Extensive travel in Germany, Denmark, France and Italy enabled him to extend his knowledge of art, and in 1787 he published a guide to the painting and sculpture of Rome (*Ueber Mahlerei und Bildhauerkunst in Rom*). His major work, *Charis, or on Beauty and the Beautiful in the Imitative Arts* (1793) was a more ambitious attempt to provide a theoretical account of beauty on the basis of a sensualistic theory of the drives, followed by a detailed study of the different domains of art. In a letter to Goethe (7 September 1794), Schiller criticized the abstract section of the book, but maintained that he had gained a great deal from the empirical parts, where the author discussed the different arts. However, Ramdohr's work became a target of attack for the early German Romantics, who sought to distance themselves from the normative aesthetics of the Enlightenment. Wilhelm Wackenroder, for example, offers his own *Confessions from the Heart of an Art-Loving Friar* as a self-conscious alternative to Ramdohr's 'cold, critical gaze' (see VIB1). Ramdohr was subsequently to become involved in a dispute over Caspar David Friedrich's painting, *The Cross in the Mountains* (see VIB12 and 13). The section of *Charis* devoted to landscape painting reveals a remarkable sensitivity to nature and to the distinctive qualities of landscape art. Ramdohr holds elevated or striking subject-matter to be less important than the overall effect, and maintains that our moral responses to nature are more likely to be awoken by a rapid sketch than by a finished work. The artists mentioned in the text include Johannes Glauber (Dutch, 1646–1726) and either Fredrick de Moucheron (German/Dutch, 1633–86) or Isaac de Moucheron (Dutch, 1667–1744). All three artists specialized in Italianate landscape views. The following translation has been made for this volume by Jason Gaiger from *Charis, oder ueber das Schöne und die Schönheit in den nachbildenden Künsten*, volume 2, Leipzig: Verlag der Deutschen Buchhandlung, 1793, pp. 124–31.

A landscape painting may only be considered beautiful when the viewer has the feeling that he has seen something similar before in nature or if he believes that something similar could exist in nature and that he would immediately recognize it as a real place. Here too, individuality is necessary. But if there is no unity or relation between the parts, and if beauty is to be found neither in the whole nor in the details, then we cannot speak of a beautiful painting. No matter how poetically composed the landscapes of Origonte, Moucheron and others, they cannot be considered beautiful.

Alongside individuality, care must be taken over the painterly effect. The profiles of the foreground, the middle ground and the background must clearly be distinguished from one another to form bands along which the eye runs gladly. The trees, buildings, rocks and mountains must form groups whose twists and turns the eye follows happily. The forms, the colours, the disposition of light and shadow must form groups which in turn are unified into a pleasing whole. Particular care must be taken over aerial perspective, so that we believe that we can walk deep into the place depicted. If, beyond this, the individual features are captured with striking truth and the execution is carried out with consummate skill, then the painting can be said to have spirit. If it awakens in us a festive mood, or one of tenderness or delight, then the painting also has expression and the whole may be considered beautiful.

A landscape is able to express festiveness, tenderness and delight solely through the character of the place it represents.

There are romantic places, such as those depicted by Poussin, Salvator Rosa, Everdingen, and others, with rocks, waterfalls, forest streams and so forth. There are also Arcadian places such as those painted by artists such as Claude Lorrain, with wind-ruffled groves, flower-strewn meadows, winding rivers and mirrored lakes. Finally, there are lively and amusing landscapes such as those which are often painted by Dutch artists, flat landscapes with plentiful staffage. Here I may be allowed to observe that the expression of a landscape depends as much on the handling, the tones of the colours, and the distribution of light across the entire canvas as it does on the character of the place depicted. Orizonte, Glauber, Moucheron, and all those others who have sought to make their landscapes romantic or Arcadian do not succeed in awakening in me either festive or tender feelings. By contrast, a place without any definite character when depicted by the hand of a great master takes on character. The light, the choice of colours, and even the handling of the brush – in places bold and vigorous, in others gentle and soft – contribute infinitely to achieving this.

A landscape painting is viewed in parts and success here depends far more on the particular forms given to the groups, on the truth of the colours, the faithful rendering of light, on the harmony of light and colour, and on aerial perspective, than it does on giving distinctness to the forms of individual objects in the landscape. For this reason, the drawing of individual figures and buildings, and even the exact representation of foliage, is scarcely seen. The greatest landscape painter who has ever lived, Claude Lorrain, had only an average gift for depicting these things. Exaggerated correctness in the drawing of details is counter-productive and easily leads to hardness. The detail does not need to be any truer than the view of the canvas as a whole requires. However, actual distortions constitute a fault. This is, perhaps, also true of the colouring. No tree or building should be coloured in a way that would be true only if it were seen in isolation. It is the colouring of everything as a whole, unified with the other objects, which must appear true. To expend more trouble on the details than on the truth of the whole is evidence of a meagre and fastidious style of landscape painting.

It is very dangerous to believe that a beautiful place in nature will necessarily provide a beautiful subject for a painting. Often the most beautiful natural sites cannot be captured in painting and it is rare that they are the occasion for a genuinely painterly effect. Often they lack either a beautiful middle ground, or a beautiful foreground or background. Very rarely do the objects form good groups of shapes

and it is even more rare for the colours and the light to be just right. I have already had occasion to observe elsewhere (in the first part of my study on Denmark) that some natural sites which are beautiful and interesting in nature, especially when looked down on from a height, lose this interest and this beauty when depicted in a painting. When we walk though a landscape our view constantly shifts from a vertical through to a horizontal and even to a perpendicular perspective. We twist our bodies around, make fine divisions, order the masses to compensate for something that is missing, often without thinking of the painterly effect. Richness and diversity make up for the lack of proper order.

The shape of the earth, the life and customs of its people, the scent of the plants and their individual forms, the aromatic breeze, the warmth of the sun, the cool of the shade, the melancholy groves, the murmuring of a stream, the spirit of nature as a whole, the expression of its benevolent love – all of this and yet more makes a place in nature into something beautiful. The painter cannot reproduce for me all that I experience before nature and all that I believe I see. Or, if he has tried, he will have produced an extremely compressed assemblage of quite heterogeneous things, which is, in general, cold and hard.

Still more dangerous for the painter is to attempt to depict those natural scenes which achieve their effect on us through their vastness or through the movement which animates them. Examples are the falls of the Rhine at Schaffhausen, the cascades at Tivoli, Mont Blanc, Lake Geneva and so forth. For what is genuinely great and breathtaking about these places can only be achieved inadequately in painting.

On these grounds too, I believe that the landscape painter should not rely too heavily on the morally beautiful influence which the actual countryside exercises upon us. This influence is also present in painting, but only to a subordinate degree. Feelings of gratitude and awe towards the Creator, a sense of calm, an indifference in the face of ambitious and selfish desires, an increased capacity to love and to be loved which delight in nature brings with it – alas! these can be awakened only rarely by the flat, painted surface of a canvas. For those who are able to transport themselves fully into the depicted scene and for those who have known such feelings before, this effect may still be possible. But powers of the imagination and memories such as these are too rare to be relied upon.

Images and memories such as we have spoken of are awakened just as effectively, and often more so, by quick sketches as by completely realized paintings. A sketch directs the mind towards what is not present; what is actually there serves only as an aid. In the case of a painting, however, our attention is drawn principally to the representation itself. A painting is too finished for it to offer us the opportunity for such activity.

Without doubt the landscape painter proceeds most securely when, like his brothers who are masters in the other genres of this art, he does not rely too heavily on the imagination and the sympathy of the viewer of his work. He should seek instead to engage and to satisfy the viewer's intelligence through the truth of his depiction.

If at the same time his work pleases the eye through its painterly effect, if his handling shows spirit, and if the tone of the whole has expression, then he will, without doubt, have produced a beautiful landscape painting. I have seen paintings

by Ruysdael, Claude Lorrain, Poussin and others, which depict a few trees, a farm, a section of a corn field, and a marshy lake, which yet awaken a feeling of beauty. By contrast, I have seen paintings of the Bay of Naples, Lake Geneva with Mont Blanc behind it, and other landscapes of great interest to the heart and to the imagination which do not contain any beauty surplus to their subject.

Nonetheless, if the artist, regardless of these preferences, is able to reveal to me a place which is already considered beautiful in nature; if he can represent the particular objects which adorn it, the buildings, the trees, the people, the mountains and so forth as individually beautiful; if he can give the place a romantic, tender or amusing character; and if he can add historical interest by making it the site of a significant event – all the better. I prefer to see the Bay of Naples, the gardens at Armida, the villa of Cicero, Dido occupied with the building of Carthage, and Marius sitting before its ruins. But only if all these sites of poetic and historical interest are made into beautiful landscapes. Otherwise, without a second thought, I will return directly to the marsh depicted by Ruysdael.

13 Uvedale Price (1747–1829) from 'An Essay on the Picturesque'

Price's essay was published in 1794 as a contribution to a debate for which Burke (IIIB6) and Gilpin (VB2, 5 and 11) had provided the principal terms of reference. Gilpin had employed principles derived from the study of pictures in order to extend the appreciation of natural scenery. If that appreciation was directed to any practical end, it was to be found in the *painted* landscapes that might ensue. To discover the picturesque in landscape, in other words, was to equip oneself to produce a painted representation. For Price, however, as for William Shenstone (see VB1), the purpose of studying pictures was to produce actual landscapes. Price's priorities are declared in the full title of his work: *An Essay on the Picturesque, as Compared with the Sublime and the Beautiful; and, on the Use of Studying Pictures, for the purpose of Improving Real Landscape* (London: J. Robson). Having inherited a large estate in Herefordshire on his father's death in 1761, he was in a position to give practical effect to his views on the improvement of natural scenery. He had known Gainsborough in his youth, the landscape architect Humphry Repton – a leading 'improver' – was an acquaintance and correspondent, and Richard Payne Knight (VB14) was a neighbour and fellow landowner, who shared his interests in both art and gardening. It should not be assumed that Price's taste lay with the kind of formalized parkland for which 'Capability' Brown had been responsible, and for which the paintings of Claude Lorrain had in the past been cited as prototypes. As the following passage makes clear, he was on the contrary concerned to argue that the landscapes of Claude's paintings were closer to reality than those of the improvers. It did not follow that he believed in leaving nature to its own devices. Rather, he opposed an aesthetic of benevolent dilapidation, of irregularity and of variety to the taste for organized clumps, for open prospects and for serpentine lines, associating the picturesque with an idealized rusticity at some remove from the material reality of rural existence. Price's clear writing style and his preference for straightforward contrasts made his writing on landscape approachable if not profound. The *Essay on the Picturesque* was frequently reprinted. A revised and expanded edition was issued as late as 1842. Our text is taken from the first edition of 1794, pp. 7–16. All footnotes but one have been deleted. Payne Knight's response to the publication of the essay was contained in the second edition of his poem *The Landscape* (see VB14). In

a 'Letter to Mr. Price', printed in July 1794, Repton responded to what he saw as criticism of his practice by both Price and Knight in the first edition of his poem.

Had the art of improving been cultivated for as long a time, and upon as settled principles, as that of painting, and were there extant various works of genius, which, like those of the other art, had stood the test of ages (though from the great change which the growth and decay of trees must produce in the original design of the artist, this is hardly possible) there would not be the same necessity of referring and comparing the works of reality to those of imitation; but as the case stands at present, the only models that approach to perfection, the only fixed and unchanging selections from the works of nature, united with those of art, are in the pictures and designs of the most eminent masters.

It may be objected, that there are many pleasing circumstances in nature, which, in painting, would appear flat and insipid, as there are others that have a striking effect in a picture, which yet in nature (by a common observer at least) would be unnoticed, or even disliked; but, however true this may be in particular instances, the great leading principles of the one art, as general composition – grouping the separate parts – harmony of tints – unity of character, are equally applicable to the other: I may add also, what is so very essential to the painter, though at first sight it seems hardly within the province of the improver – breadth and effect of light and shade.

Nothing can be more directly at war with all these principles (founded as they are in truth and in nature) than the present system of laying out grounds. A painter, or whoever views objects with a painter's eye,[1] looks with indifference, if not with disgust, at the clumps, the belts, the made water, and the eternal smoothness and sameness of a finished place; an improver, on the other hand, considers these as the most perfect embellishments, as the last finishing touches that nature can receive from art; and consequently must think the finest composition of Claude (and I mention him as the most ornamented of all the great masters) comparatively rude and imperfect; though he probably might allow, in Mr. Brown's phrase, that it had 'capabilities.'

No one, I believe, has yet been daring enough to improve a picture of Claude, or at least to acknowledge it; but I do not think it extravagant to suppose that a man, thoroughly persuaded, from his own taste, and from the authority of such a writer as Mr. Walpole, that an art, unknown to every age and climate, that of creating land-scapes, had advanced with master-steps to vigorous perfection; that enough had been done to establish such a school of landscape as cannot be found in the rest of the globe; and that Milton's description of Paradise seems to have been copied from some piece of modern gardening; – that such a man, full of enthusiasm for this new art, and with little veneration for that of painting, should chuse to shew the world what Claude might have been, had he had the advantage of seeing the works of Mr. Brown. The only difference he would make between improving a picture and a real scene, would be that of employing a painter instead of a gardener.

What would more immediately strike him would be the total want of that leading feature of all modern improvements, the clump; and of course he would order several of them to be placed in the most conspicuous spots, with, perhaps, here and there a patch of larches, as forming a strong contrast, in shape and colour, to the Scotch firs.

– His eye, which had been used to see even the natural groupes of trees in improved places made as separate and clump-like as possible, would be shocked to see those of Claude, some quite surrounded, some half concealed by bushes and thickets; others standing alone, but, by means of those thickets, or of detached trees, connected with other groupes of various sizes and shapes. All this rubbish must be cleared away, the ground made every where quite smooth and level, and each groupe left upon the grass perfectly distinct and separate. – Having been accustomed to whiten all distant buildings, those of Claude, from the effect of his soft vapoury atmosphere, would appear to him too indistinct; the painter of course would be ordered to give them a smarter appearance, which might possibly be communicated to the nearer buildings also. – Few modern houses or ornamental buildings are so placed among trees, and partially hid by them, as to conceal much of the skill of the architect, or the expence of the possessor; but in Claude, not only ruins, but temples and palaces, are often so mixed with trees, that the tops over-hang their balustrades, and the luxuriant branches shoot between the openings of their magnificent columns and porticos: as he would not suffer his own buildings to be so masked, neither would he those of Claude; and these luxuriant boughs, and all that obstructed a full view of them, the painter would be told to expunge, and carefully to restore the ornaments they had hid. – The last finishing both to places and pictures is water: in Claude it partakes of the general softness and dressed appearance of his scenes, and the accompaniments have, perhaps, less of rudeness, than in any other master; yet, compared with those of a piece of made water, or of an improved river, his banks are perfectly savage; parts of them covered with trees and bushes that hang over the water; and near the edge of it tussucks of rushes, large stones, and stumps; the ground sometimes smooth, sometimes broken and abrupt, and seldom keeping, for a long space, the same level from the water: no curves that answer each other; no resemblance, in short, to what he had been used to admire; a few strokes of the painter's brush would reduce the bank on each side to one level, to one green; would make curve answer curve, without bush or tree to hinder the eye from enjoying the uniform smoothness and verdure, and from pursuing, without interruption, the continued sweep of these serpentine lines; – a little cleaning and polishing of the fore-ground would give the last touches of improvement, and complete the picture.

There is not a person in the smallest degree conversant with painting, who would not, at the same time, be shocked and diverted at the black spots and the white spots, – the naked water, – the naked buildings, – the scattered unconnected groupes of trees, and all the gross and glaring violations of every principle of the art; and yet this, without any exaggeration, is the method in which many scenes, worthy of Claude's pencil, have been improved. Is it then possible to imagine that the beauties of imitation should be so distinct from those of reality, nay, so completely at variance, that what disgraces and makes a picture ridiculous, should become ornamental when applied to nature?

[1] When I speak of a painter, I do not mean merely a professor, but any man (artist or not) of a liberal mind, with a strong feeling for nature as well as art, who has been in the habit of comparing both together.

 A man of a narrow mind and little sensibility, in or out of a profession, is always a bad judge; and possibly (as that ingenious critic the Abbé du Bos has well explained) a worse judge for being an artist.

14 Richard Payne Knight (1751–1824) from *The Landscape: A Didactic Poem*

Richard Payne Knight was a wealthy collector and amateur of the arts with a good classical education and extensive experience of other cultures. Like his neighbour Uvedale Price (VB13, 15) he inherited a large estate and was responsible for planning both house and grounds. His poem was first published in 1794 and was dedicated to Price. Knight was on common ground with his friend in his advocacy of a 'natural' landscape for which the paintings of Claude provided the template. But in a second edition of his poem, published in 1795, he added two new passages of admonition specifically directed at Price (Book I, lines 257–70 and Book II, lines 200–25). In the first he makes the point that while the 'tattered rags' of miserable poverty are all very well in a painting, it does not follow that 'art' and 'nature' – or reality – can be altogether prised apart. In the second he cautions against the dangers of anti-utilitarianism and of affectation which attend on a taste for the picturesque. Knight's principal targets, however, were the 'improvers' Lancelot 'Capability' Brown and Humphry Repton (the 'ingenious professor'), whom he characterized as enemies alike of Nature and of Art. In his 'Letter to Mr. Price', Repton responded both to Price's *Essay on the Picturesque* and to the first edition of Knight's poem (Repton, 1794). In his turn Knight sharpened his attack on Repton in two lengthy footnotes added to the new edition. In the second of these he makes trenchant use of a notable passage from the novel *Tom Jones* (Book XVI, chapter 5), in which Fielding satirizes the errors of unsophisticated naturalism. Our text is taken from R. P. Knight, *The Landscape: A Didactic Poem. In three books. Addressed to Uvedale Price, Esq., The Second Edition*, London: G. Nicol, 1795. The following excerpts are from Books I and II of the poem and from the new footnotes added to lines 257–70 and 200–25 respectively. (See also VIIB13.)

Book I

The composition ranged in order true,
Brings every object fairly to the view;
And, as the field of vision is confined, 255
Shews all its parts collected to the mind.
Yet often still the eye disgusted sees
In nature, objects which in painting please;
Such as the rotting shed, or fungous tree,
Or tatter'd rags of age and misery: 260
But here restrain'd, the powers of mimic art
The pleasing qualities alone impart;
For nought but light and colour can the eye,
But through the medium of the mind, descry;
And oft, in filth and tatter'd rags, it views 265
Soft varied tints and nicely blended hues,
Which thus abstracted from each other sense,
Give pure delight, and please without offence:
But small attention these exceptions claim;
In general, art and nature love the same. 270

Hence then we learn, in real scenes, to trace
The tints of beauty, and the forms of grace;
To lop redundant parts, the coarse refine,
Open the crowded, and the scanty join.
But, ah! in vain: – See yon fantastic band, 275
With charts, pedometers, and rules in hand,
Advance triumphant, and alike lay waste
The forms of nature, and the works of taste!
To improve, adorn, and polish, they profess;
But shave the goddess, whom they come to dress; 280
Level each broken bank and shaggy mound,
And fashion all to one unvaried round;
One even round, that ever gently flows,
Nor forms abrupt, nor broken colours knows;
But, wrapt all o'er in everlasting green, 285
Makes one dull, vapid, smooth, unvaried scene.

V. 257 to 270 inclusive, have been added since the first edition. It is now, I believe, generally admitted, that the system of picturesque improvement, employed by the late Mr. Brown and his followers, is the very reverse of picturesque; all subjects for painting instantly disappearing as they advance; whence an ingenious professor, who has long practised under the title of *Landscape Gardener*, has suddenly changed his ground; and taking advantage of a supposed distinction between the picturesque and the beautiful, confessed that his art was never intended to produce landscapes, but some kind of *neat, simple, and elegant effects*, or non-descript beauties, which have not yet been named or classed. (See Letter to Mr. Price, p. 9.) '*A beautiful garden scene*,' he says, '*is not more defective because it would not look well on canvas, than a didactic poem, because it neither furnishes a subject for the painter or the musician.*' (ibid. p. 5 and 6.) Certainly not: – for such a poem must be void of imagery and melody; and therefore more exactly resembling one of this professor's improved places than he probably imagined when he made the comparison. It may, indeed, have all the *neatness, simplicity, and elegance of English gardening* (ibid. p. 9.); but it will also have its vapid and tiresome insipidity; and, however it may be esteemed by a professor or a critic, who judge every thing by rule and measure, will make no impression on the generality of readers, whose taste is guided by their feelings.

I cannot, however, but think that the distinction, of which this ingenious professor has thus taken advantage, is an imaginary one, and that the picturesque is merely that kind of beauty which belongs exclusively to the sense of vision; or to the imagination, guided by that sense. It must always be remembered in inquiries of this kind, that the eye, unassisted, perceives nothing but light variously graduated and modified: black objects are those which totally absorb it, and white those which entirely reflect it; and all the intermediate shades and colours are the various degrees in which it is partially absorbed or impeded, and the various modes in which it is reflected and refracted. Smoothness, or harmony of surface, is to the touch what harmony of colour is to the eye; and as the eye has learnt by habit to perceive form as instantaneously as colour, we perpetually apply terms belonging to the sense of touch to objects of sight; and

while they relate only to *perception*, we are guilty of no impropriety in so doing; but we should not forget that *perception* and *sensation* are quite different; the one being an operation of the mind, and the other an impression on the organs; and that therefore, when we speak of the pleasures and pains of each, we ought to keep them quite separate, as belonging to different classes, and governed by different laws.

Where men agree in facts, almost all their disputes concerning inferences arise from a confusion of terms; no language being sufficiently copious and accurate to afford a distinct expression for every discrimination necessary to be made in a philosophical inquiry, not guided by the certain limits of number and quantity; and vulgar use having introduced a mixture of literal and metaphorical meanings so perplexing, that people perpetually use words without attaching any precise meaning to them whatever. This is peculiarly the case with the word *beauty*, which is employed sometimes to signify that congruity and proportion of parts, which in composition pleases the understanding; sometimes those personal charms, which excite animal desires between the sexes; and sometimes those harmonious combinations of colours and smells, which make grateful impressions upon the visual or olfactory nerves. It often happens too, in the laxity of common conversation or desultory writing, that the word is used without any pointed application to either, but with a mere general and indistinct reference to what is any ways pleasing.

This confusion has been still more confounded, by its having equally prevailed in all the terms applied to the constituent properties both of beauty and ugliness. We call a still clear piece of water, surrounded by shaven banks, and reflecting white buildings, or other brilliant objects that stand near it, *smooth*, because we *perceive* its surface to be smooth and even, though the impression, which all these harsh and edgy reflections of light produce on the eye, is analogous to that which roughness produces on the touch; and is often so violently irritating, that we cannot bear to look at it for any long time together. In the same manner we call an agitated stream, flowing between broken and sedgy banks, and indistinctly reflecting the waving foliage that hangs over it, *rough*; because we know, from habitual observation, that its impression on the eye is produced by uneven surfaces; at the same time that the impression itself is all of softness and harmony; and analogous to what the most grateful and nicely varied smoothness would be to the touch. . . . The same analogy prevails between shaven lawns and tufted pastures, dressed parks and shaggy forests, neat buildings and mouldering walls, &c. &c. as far as they affect the senses only. In all, our landscape gardeners seem to work for the touch rather than the sight.

When harmony, either in colour or surface becomes absolute unity, it sinks into what, in sound, we call monotony; that is, its impression is so languid and unvaried, that it produces no further irritation on the organ than what is necessary for mere *perception*; which, though never totally free from either pleasure or pain, is so nearly neutral, that by a continuation it grows tiresome; that is, it leaves the organ to a sensation of mere existence, which seems in itself to be painful.

If colours are so harsh and contrasted, or the surface of a tangible object so pointed or uneven, as to produce a stronger or more varied impression than the organ is adapted to bear, the irritation becomes painful in proportion to its degree, and ultimately tends to its dissolution.

Between these extremes lies that grateful medium of grateful irritation, which produces the sensation of what we call *beauty*; and which in visible objects we call *picturesque beauty*, because painting, by imitating the visible qualities only, discriminates it from the objects of other senses with which it may be combined; and which, if productive of stronger impressions, either of pleasure or disgust, will overpower it; so that a mind not habituated to such discriminations, or (as more commonly expressed,) a person not possessed of a painter's eye, does not discover it till it is separated in the artist's imitation. Rembrandt, Ostade, Teniers, and others of the Dutch painters, have produced the most beautiful pictures, by the most exact imitations of the most ugly and disgusting objects in nature; and yet it is physically impossible that an exact imitation should exhibit qualities not existing in its original; but the case is, that, in the originals, animal disgust, and the nauseating repugnance of appetite, drown and overwhelm every milder pleasure of vision, which a blended variety of mellow and harmonious tints must necessarily produce on the eye, in nature as well as in art, if viewed in both with the same degree of abstracted and impartial attention.

In like manner, properties pleasing to the other senses often exist in objects disgusting or insipid to the eye, and make so strong an impression, that persons who seek only what is generally pleasing, confound their sensations, and imagine a thing beautiful, because they see in it something which gives them pleasure of another kind. I am not inclined, any more than Mr. Repton, *to despise the comforts of a gravel walk, or the delicious fragrance of a shrubbery*; (see his Letter to Mr. Price, p. 18.) neither am I inclined to despise the convenience of a paved street, or the agreeable scent of distilled lavender; but nevertheless, if the pavier and perfumer were to recommend their works as delicious gratifications for the eye, I might be tempted to treat them both with some degree of ridicule and contempt. Not only the fragrance of shrubs, but the freshness of young grass and green turf, and the coolness of clear water, however their disposition in modern gardens may be adverse to picturesque beauty, and disgusting to the sense of seeing, are things so grateful to the nature of man, that it is impossible to render them wholly disagreeable. Even in painting, where freshness and coolness are happily represented, scenes not distinguished by any beautiful varieties of tints or shadows, please through the medium of the imagination, which instantly conceives the comforts and pleasures which such scenes must afford; but still, in painting, they never reconcile us to any harsh or glaring discords of colour; wherefore I have recommended that art as the best criterion of the mere visible beauties of rural scenery, which are all that I have pretended to criticise.

If, however, an improver of grounds chooses to reject this criterion, and to consider picturesque beauty as not belonging to his profession, I have nothing more to do with him; the objects of our pursuit and investigation being entirely different. All that I beg of him is, that if he takes any *professional title*, it may be one really descriptive of his profession, such as that of *walk maker, shrub planter, turf cleaner*, or *rural perfumer*; for if *landscapes* are not what he means to produce, that of *landscape gardener* is one not only of *no mean*, but of *no true pretension*.

As for the beauties of congruity, intricacy, lightness, motion, repose, &c. they belong exclusively to the understanding and imagination; and though I have slightly

noticed them in the text, a full and accurate investigation of them would not only exceed the limits of a note, but of my whole work. The first great obstruction to it is the ambiguity of language, and the difficulty of finding distinct terms to discriminate distinct ideas. The next is the habit which men are in of flying for allusions to the inclination of the sexes towards each other; which, being the strongest of our inclinations, draws all the others into its vortex, and thus becomes the criterion of pleasures, with which it has no further connection than being derived from the same animal functions with the rest. All male animals probably think the females of their own species the most beautiful part of the creation; and in the various and complicated mind of civilized man, this original result of appetite has been so changed and diversified by the various modifications of mental sympathies, social habits, and acquired propensities, that it is impossible to analyze it: it can therefore afford no lights to guide us in exploring the general principles and theory of sensation.

Book II

To show the nice embellishments of art,
The foreground ever is the properest part;
For e'en minute and trifling objects near,
Will grow important and distinct appear:
No leaf of fern, low weed, or creeping thorn, 180
But, near the eye, the Landscape may adorn;
Either when tufted o'er the mouldering stone;
Or down the slope in loose disorder thrown;
Or, richly spread along the level green,
It breaks the tints and variegates the scene. 185
 But here again, ye rural nymphs, oppose
Nature's and Art's confederated foes!
Break their fell scythes, that would these beauties shave,
And sink their iron rollers in the wave!
Your favourite plants, and native haunts protect, 190
In wild obscurity, and rude neglect;
Or teach proud man his labour to employ
To form and decorate, and not destroy;
Teach him to place, and not remove the stone
On yonder bank, with moss and fern o'ergrown; 195
To cherish, not mow down, the weeds that creep
Along the shore, or overhang the steep;
To break, not level, the slow-rising ground,
And guard, not cut, the fern that shades it round.
 But let not still the o'erbearing pride of taste 200
Turn fertile districts to a forest's waste:
Still let utility improvement guide,
And just congruity in all preside.
While shaggy hills are left to rude neglect,
Let the rich plains with wavy corn be deck'd; 205

And while rough thickets shade the lonely glen,
Let culture smile upon the haunts of men;
And the rich meadow and the fertile field
The annual tribute of their harvests yield.
Oft pleased we see, in some sequester'd glade, 210
The cattle seek the aged pollard's shade;
Or, on the hillock's swelling turf reclined,
Snuff the cool breeze, and catch the passing wind:
Oft too, when shelter'd from the winter's cold,
In graceful groups they crowd the litter'd fold, 215
Their varied forms and blended colours gay
Mild scenes of simple elegance display,
And with faint gleams of social comfort charm
The humble beauties of the lonely farm.
But never let those humble beauties try 220
With the neat villa's tinsel charms to vie,
Or spoil their simple unaffected grace
With frippery ornaments and tawdry lace;
For still to culture should its use belong,
And affection's always in the wrong. 225

V. 200 to 225 inclusive have been added since the first edition.

After having recommended the preservation of inclosures and cottages (see Book II. v. 17 and 262), and condemned the practice of sacrificing extensive tracts of arable land to unproductive lawn (ibid. v. 73.), I did not expect that misrepresentation would have been carried so far as even to insinuate that my system of improvement tended *to turn this beautiful kingdom into one huge picturesque forest*; (Mr. Repton's Letter to Mr. Price, note in p. 1.) but persons who read to condemn, rather than to understand, will always interpret as best suits their own purposes.

What I have endeavoured to prove, and what I still assert, is, *that ground which is sacrificed to picturesque beauty ought to be really picturesque*; and, I think, it may be fairly presumed that the person who first dignified himself with the title of *Landscape Gardener*, meant to produce *landscapes*, and make picturesque places, when he assumed that title; whatever he may choose to profess, now that it has been proved that all his labours, as well as those of *the great self-taught master* who preceded him, have had a direct contrary tendency. In general, however, I believe that very small sacrifices are necessary; for, as I have stated in the text, (Book II. v. 176.) the foreground is the proper place for picturesque decoration, which need not therefore ever be extended far from the eye; and the kinds of ground best adapted to it are those least suited to the purposes of agriculture. Hedges are never very offensive to the eye, unless marked with lines of shreded elms, seen from great heights, in what are called bird's-eye views; or spread along the sides of mountains, where they give the inclosures the appearance of square divisions cut on the surface, than which nothing can be more harsh, meagre, and unpleasant. When seen horizontally in a flat country, they enrich and embellish, especially if their lines be occasionally broken by full-headed and well preserved trees. The custom of removing them to a great

distance from the house, in order to throw open to the eye a wide space of unbroken and undivided turf, may show magnificence and gratify vanity; but how it can add to the comfort or beauty of the dwelling, I cannot conceive.

The usual features of a cultivated country are the accidental mixtures of meadows, woods, pastures, and corn fields; interspersed with farm houses, cottages, mills, &c.; and I do not know that in this country better materials for middle grounds and distances can be obtained, or are to be wished for; and why they should be separated by a belt of plantation from the foreground, or even from the middle ground, when that is formed of smooth lawn or shrubbery, I cannot imagine. A *landscape painter* would, in all instances, wish to connect them; and it is to be hoped that the *landscape gardener* will some time or other be able to find better reasons than he has hitherto given for always separating them. Comfort and convenience are out of the question; for a fence which guards from trespass, affords all the separation that *they* require; and though the belt may conceal the materials of that useful boundary, and keep the spectator in doubt whether it be a hedge, a pale, or a wall, it so decidedly marks the line of it, that it renders it perceptible at a distance, where it would not otherwise be distinguishable from other adjoining fences. This line is exactly what an improver, who aimed at picturesque beauty and harmony of composition, would wish to hide: – why then is it so studiously, and often so expensively marked? By looking to a principle of improvement, which I have before glanced at, (Book I. v. 159.) and which Mr. Price has anticipated me in applying to the present subject, (Letter to Mr. Repton, p. 101.) we may, I believe, solve the difficulty without imputing any peculiar perversity of taste to its author. Mr. Brown, though ignorant of painting, and incapable of judging of picturesque effects, was a man of sense and observation, and had studied mankind attentively: he therefore knew that when a large sum of money had been expended in inclosing, levelling, and dressing (or rather undressing) a very extensive demesne, the proprietor would not dislike to have the great extent of his supposed improvements so distinctly marked, that all who came within sight of his place might form just notions of his taste and magnificence: for this purpose the belt is admirably contrived; and, if so intended, does honour to the sagacity and ingenuity of the inventor.

* * *

Scarcely any parts of our island are capable of affording the compositions of Salvator Rosa, Claude, and the Poussins; and only the most picturesque parts those of Rysdael, Berghem, and Pynaker; but those of Hobbima, Waterloe, and Adrian Vandervelde (which have also their beauties) are to be obtained every where. Pastures with cattle, horses or sheep grazing in them, and enriched with good trees, will always afford picturesque compositions; and inclosures of arable are never completely ugly, unless when lying in fallow, which, I believe, is very generally disused in the present improved state of husbandry. Clean and comfortable walks and rides may be made through fields, without any stiffness or formality; and by means of honeysuckles and creepers, even hedges may be made picturesque and beautiful. This is perhaps the best style of improvement for a tame flat country. The late Mr. Southgate's farm near Weybridge, though in many parts too finely dressed, is, both in design and execution, far preferable to any of the works of Kent or Brown; and is a proof of what may be done in this humble style: but in this, as in every other, picturesque effects can only be obtained by watching accidents, and profiting by

circumstances, during a long period of time. The line of a walk, the position of a seat, or limits of an inclosure, must often depend upon the accidental growth of a tree; and we must always make things, which we can command, conform to those which we cannot. The improver in his plan presupposes every thing to succeed as he chooses; and if he plants only clumps and belts of firs, he may certainly foresee the effect which they will have when arrived at maturity: but if he plants trees of less regular growth, and aims at picturesque effects in the distribution of them, he must watch the annual increase and variation in their forms; and cut down, prune, transplant, and vary his plan accordingly: the difference of a single branch in the foreground, or even in the middle distance, where the scene is on a small scale, may materially affect a whole composition.

Mr. Repton has observed that *there are a thousand scenes in nature to delight the eye, beside those which may be copied as pictures; and that one of the keenest observers of picturesque scenery (Mr. Gilpin), has often regretted that few are capable of being so represented, without considerable license and alteration.* (Letter to Mr. Price, p. 6.) I have heard many landscape painters express the same regret; but I must add, that it has always been in an inverse proportion to their merit. Unskilful artists, like unskilful musicians, are apt to omit whatever they cannot execute; and, what is worse, to supply its place with something of their own. Confirmed mannerists, both in music and painting, are apt to go still farther; and to substitute their own for the whole of what they pretend to execute or represent. The finest pieces of Italian scenery, as represented by many French and German, (and I am sorry to add) some English artists, have exactly the same resemblance to nature, as the finest pieces of Italian music executed by the performers of the *grand opera* at Paris have to the original works of the composer: yet all these artists (and I have conversed with many of them) insisted that they improved nature, and only altered such parts as were incapable of being advantageously represented in their genuine state. They made, however, a trifling mistake, which men of all professions, from statesmen to plough-men, are very apt to make. They attributed their own incapacity to the subject on which they were employed. This I often ventured to hint in the most delicate manner I could, by citing the example of Claude, whose landscapes are more highly esteemed than those of any other master, though always composed of parts copied from nature with the most minute and scrupulous exactitude, both in the forms and colours. Claude, however, was treated by them as a slow mechanic genius, void of spirit and invention, and incapable of any higher exertion than that of tamely copying what nature and accident placed before him. They aimed at a more exalted style of excellence, and by that means got into a *style*, which rendered them incapable of any kind of excellence in art.

I do not, however, mean to insinuate that the landscape painter is to confine himself to a servile imitation of the particular scenes that he finds in nature: on the contrary, I know that nature scarcely ever affords a complete and faultless composition; but nevertheless she affords the *parts* of which taste and invention may make complete and faultless compositions; and it is by accurately and minutely copying these parts, and afterwards skilfully and judiciously combining and arranging them, that the most perfect works in the art have been produced.

By working on the same principle; by carefully collecting and cherishing the accidental beauties of wild nature; by judiciously arranging them, and skilfully combining them with each other, and the embellishments of art; I cannot but think that the landscape gardener might produce complete and faultless compositions in nature, which would be as much superior to the imitations of them by art, as the acting of a Garrick or a Siddons is to the best representation of it in a portrait. Those, indeed, who think only of making *fine places*, in order to gratify their own vanity, or profit by the vanity of others, may call this mode of proceeding *a new system of improving by neglect and accident*; yet those who have tried it know, that, though to preserve the appearance of neglect and accident be one of its objects, it is not by leaving every thing to neglect and accident, that even that is to be obtained. *Profiting by accident*, is very different from *leaving every thing to accident*; and *improving by neglect*, very different from *neglecting*. Apelles by throwing his brush at the picture of Alexander's horse, which he was painting, marked the foam at his mouth more to his own satisfaction than he had been able to do by repeated trials in the regular process of his art; yet surely no one will think this an instance of negligence or inattention; but rather a proof of that refined taste and judgment which is always watchful to take advantage of every casual incident; and thus to catch those delicate graces of execution, which the regular efforts of art, however excellent, can never reach; and which persons wholly unskilled can never feel. The *ut sibi quivis speret idem, &c.* characterizes the highest degree of perfection in every art as well as that of poetry. Partridge thinks that he should look as Garrick did in Hamlet, if he saw a ghost; (Tom Jones, B. XVI. c. 5.) and I have known many a *young gentleman*, who had learned to draw a little, and thought himself a profound judge of the art, pass coldly by a brilliant sketch of Salvator Rosa or Rembrandt, without noticing it; but dwell with the warmest expressions of delight and approbation on a laboured drawing of Pillement or Worlidge. The refined delicacy of that art, which conceals itself in its own effects, is above the reach of such critics; who, looking only for the artifice of imitation, are pleased in proportion as that artifice is glaring and ostentatious; in the same manner as Partridge approves the actor most who never conceals his skill in the easy expression of nature, but performs his part throughout with such stiff pomposity that *every one might see that he was an actor*.

As this admirable scene in Fielding's most excellent novel has been misunderstood, and consequently misrepresented, by the best writer on art, as well as the best artist of the present age, I cannot resist the opportunity of vindicating it from what I consider as the unmerited censure of a person whose authority as a critic, both in art and literature, will always stand as high, as his memory as a man will be dear to those who had the happiness of knowing that his private virtues were equal to his professional talents. Partridge does not, as Sir Joshua Reynolds in one of his discourses supposes him to do, mistake, for a moment, the play for reality: on the contrary, he repeatedly says, *that he knows it is but a play, and that there is nothing at all in it*; and as *imitation* was all that he looked for, the most glaring and obvious imitation of the most dignified and imposing personage, was, to him, the most undoubted test of excellence in acting. The ghost he knows to be *only a man in a strange dress*, as he repeatedly observes; but, nevertheless, as the fear of ghosts is his predominant passion, when he sees that fear expressed by another in a manner so exactly consonant to his own

feelings, and with such unaffected truth and simplicity, that all the artifice of imitation disappears, his feelings overpower his understanding, and he sympathizes involuntarily with what he sees expressed, though he knows that all the circumstances which excite it are fictitious. This is a perfectly natural and exact picture of the effects which the different kinds of imitative expression have upon minds just cultivated enough to have their judgments perverted, without having their feelings destroyed. They admire extravagantly every artifice of imitation, which is sufficiently gross for them to perceive and comprehend; but when it is so refined as no longer to appear artifice, they entirely disregard it; unless when some strong expression happens to accord with some prominent, or ruling passion of their own, which being thus suddenly rouzed by a cause neither expected nor understood, so confounds and astonishes them, that it suspends, for the moment, the operation of every other faculty.

Theatrical amusements, indeed, have long been so general in this country that there are few, even among the lowest class of the people, whose judgment in them has not been corrected and refined by habitual exercise; but in landscape gardening, as well as landscape painting, there are many such critics as Partridge is represented to have been in acting; and, in *their* estimation, the stiff and tawdry glare of a modern improved place will appear as much preferable to the easy elegance and unaffected variety of natural scenery, as the stately strut and turgid declamation of the mock monarch of the stage did in *his*, to the easy dignity of deportment and grace of utterance, which a good actor would have given to the same character.

15 Uvedale Price (1747–1829) from 'A Dialogue on the Distinct Characters of the Picturesque and the Beautiful'

Price's dialogue was written in response to Knight's criticism, or at least to the principle that he believed was at issue: the question of the separability of the interests of art, as represented by the picturesque, and of nature, as represented by the beautiful. (In the context of this debate 'Nature' tends to carry a positive moral connotation; the 'beautiful' is therefore not simply that which is attractive but that which is seen as good in itself.) In his poem (VB14) Knight had argued that the eye may occasionally respond positively to 'artistic' arrangements of light and colour, in abstraction from those other senses which might attach meaning to the forms in question. These arrangements might be conceived of as picturesque rather than beautiful. On the other hand, he regarded such occasions as exceptions: 'In general, art and nature love the same,' which is to say that individuals normally find picturesque that which they are disposed to approve and to find agreeable in reality, so that the distinction between the picturesque and the beautiful tends to collapse. Price wished to maintain the distinction. In this dialogue Knight's words are put into the mouth of 'Mr. Howard', while Price's own arguments are voiced by 'Mr. Hamilton'. 'Mr. Seymour' acts as straight man, mostly to Mr. Hamilton. In face of such material, it is not hard to understand why the debate over the picturesque should have drawn the attention of literary satirists. And yet certain of the issues at stake were to remain matters of substantial controversy throughout the modern period, seriously dividing the advocates of opposed positions. Can we judge representations independently of our responses to that which they picture? Modernist theory has tended to say that we can and should. On the

other hand, the modern Mr Seymour feels a justifiable anxiety at the separation of aesthetic judgements from political positions and social concerns. Our text is taken from *A Dialogue on the Distinct Characters of The Picturesque and the Beautiful in answer to the Objections of Mr. Knight. Prefaced by An Introductory Essay on Beauty; with Remarks on the ideas of Sir Joshua Reynolds & Mr. Burke, upon that subject*, London: J. Robson, 1801, pp. 101–5, 107, 114–21.

Mr. Howard and Mr. Hamilton, two gentlemen remarkably fond of pictures, were on their return from a tour they had been making through the north of England. They were just setting out on their walk to a seat in the neighbourhood, where there was a famous collection of pictures, when a chaise drove to the inn door; and they saw, to their great delight, that the person who got out of it was Mr. Seymour, an intimate friend of their's. After the first rejoicings at meeting so unexpectedly, they told him whither ther they were going, and proposed to him to accompany them. You know, said he, how ignorant I am of pictures, and of every thing that relates to them; but, at all events, I shall have great pleasure in walking with you, and shall not be sorry to take a lesson of connoisseurship from two such able masters.

Mr. Hamilton had formerly been a great deal at the house they were going to, and undertook to be their guide: the three friends however conversed so eagerly together, that they missed their way, and got into a wild unfrequented part of the country; when, suddenly, they came to a ruinous hovel on the outskirts of a heathy common. In a dark corner of it, some gypsies were sitting over a half-extinguished fire, which every now and then, as one of them stooped down to blow it, feebly blazed up for an instant, and shewed their sooty faces, and black tangled locks. An old male gypsey stood at the entrance, with a countenance that well expressed his three-fold occupation, of beggar, thief, and fortune-teller; and by him a few worn-out asses: one loaded with rusty panniers, the others with old tattered cloaths and furniture. The hovel was propt and overhung by a blighted oak; its bare roots staring through the crumbling bank on which it stood. A gleam of light from under a dark cloud, glanced on the most prominent parts: the rest was buried in deep shadow; except where the dying embers

'Taught light to counterfeit a gloom.'

The three friends stood a long while contemplating this singular scene; but the two lovers of painting could hardly quit it: they talked in raptures of every part; of the old hovel, the broken ground, the blasted oak, gypsies, asses, panniers, the catching lights, the deep shadows, the rich mellow tints, the grouping, the composition, the effect of the whole; and the words beautiful, and picturesque, were a hundred times repeated. The uninitiated friend listened with some surprise; and when their raptures had a little subsided, he begged them to explain to him how it happened, that many of those things which he himself, and most others he believed, would call ugly, they called beautiful, and *picturesque* – a word, which those who were conversant in painting, might perhaps use in a more precise, or a more extended sense, than was done in common discourse, or writing. Mr. Howard told him that the picturesque, was merely that kind of beauty which belongs exclusively to the sense of vision, or to

the imagination guided by that sense. Then, said Mr. Seymour, as far as visible objects are concerned, what is picturesque is beautiful, and vice versâ; in short, they are two words for the same idea. I do not, however, entirely comprehend the meaning of *exclusively*, to the sense of vision.

* * *

'We have all learned to distinguish by the sight alone, not only form in general, but, likewise, its different qualities; such as hardness, softness, roughness, smoothness, &c. and to judge of the distance and gradation of objects: all these ideas, it is true, are originally acquired by the touch; but from use, they are become as much objects of the sight, as colours. *You* may possibly be able, so to abstract your attention from all these heterogeneous qualities, as to see light and colours only; but, for my part, I plainly see that old gypsey's wrinkles, as well as the colour of his skin; I see that his beard is not only grizzle, but rough and stubbed, and, in my mind, very ugly; I see that the hovel is rugged and uneven, as well as brown and dingy; and I cannot get these things out of my mind by any endeavours: in short, what I see and feel to be ugly, I cannot think, or call beautiful, whatever lovers of painting may do.'

* * *

'Tell me, then, how you account for this strange difference between an eye accustomed to painting, and that of such a person as myself? If those things which Howard calls beautiful, and those which I should call beautiful, are as different as light and darkness, would it not be better to have some term totally unconnected with that of beauty, by which such objects as we have just been looking at, should be characterised? By such means, you would avoid puzzling us vulgar observers with a term, to which we cannot help annexing ideas of what is soft, graceful, elegant, and lovely; and which, therefore, when applied to hovels, rags, and gypsies, contradicts and confounds all our notions and feelings.'

'The term you require,' answered Mr. Hamilton, 'has already been invented, for, according to my ideas, the word Picturesque, has exactly the meaning you have just described.'

'Then,' said Mr. Seymour, '*you* do not hold picturesque and beautiful to be synonymous.'

'By no means,' said he; 'and that is the only difference between Howard and me: in all the effects that arise from the various combinations of form, colour, and light and shadow, we agree; and I am truly sorry that we should disagree on this distinction.'

'No matter,' said Mr. Seymour; 'a friendly discussion of this kind, opens the road to truth; and, as I have no prejudice on either side, I shall take much delight in hearing your different opinions and arguments. Tell me, then, what is your idea of the picturesque?'

'That is no easy question,' said Mr. Hamilton, 'for to explain my idea of it in detail, would be to talk a volume; but, in reality, you have yourself explained a very principal distinction between the two characters: the set of objects we have been looking at, struck you with their singularity; but instead of thinking them beautiful, you were disposed to call them ugly: now, I should neither call them beautiful, nor ugly, but picturesque; for they have qualities highly suited to the painter and his art, but which are, in general, less attractive to the bulk of mankind; whereas the qualities of beauty, are universally pleasing and alluring to all observers.'

'I must own,' said Mr. Seymour, 'that it is some relief to me to find, that, according to your doctrine, I am not forced to call an ugly thing beautiful; yet, still, by the help of a middle term, may avoid the offence I must otherwise give to painters. But what most surprises me, and what I wish you to explain, is, that those objects which you and Howard so much admired, and which he called beautiful, not only appeared to me ugly, but very strikingly so: am I, then, to conclude that the more peculiarly and strikingly ugly an object is, the more charms it has for the painter?'

'You will be surprised,' said Mr. Hamilton, 'when I tell you, that what you have, perhaps ironically, supposed, is in great measure the case.'

Just at this time, a man, with something of a foreign look, passed by them on the heath, whose dress and appearance they could not help staring at. 'There,' said Mr. Seymour, after he had passed them, 'I hope, Hamilton, you are charmed with that figure! I hope he is sufficiently ugly for you: I shall not get his image out of my head for some time; what a singularly formed nose he has, and what a size! what eyebrows! how they, and his black raven hair, hung over his eyes, and what a dark designing look in those eyes! then the slouched hat that he wore on one side, and the sort of cloak he threw across him, as if he were concealing some weapon!'

'Need I now explain,' interrupted Mr. Hamilton, 'why an object peculiarly and strikingly ugly, is picturesque? Were this figure, just as you saw him, to be expressed by a painter with exactness and spirit, would you not be struck with it, as you were just now in nature, and from the same reasons? What indeed is the object of an artist, in whatever art? Not merely to represent the soft, the elegant, or the dignified and majestic; his point is to fix the attention; if he cannot by grandeur or beauty, he will try to do it by deformity: and indeed, according to Erasmus, 'quæ naturâ deformia sunt, plus habent et artis et voluptatis in tabulâ.' It is not ugliness, it is insipidity, however accompanied, that the painter avoids, and with reason; for if it deprives even beauty of its attractions, what must it do when united to ugliness? Do you recollect a person who passed by us, a little before you saw this figure that struck you so much? you must remember the circumstance, for he bowed to me as he passed, and you asked me his name, but made no further remark, or enquiry. I, who have often seen him, know that he is as ugly, if not uglier, than the other; a squat figure; a complexion like tallow; an unmeaning, pudding face, the marks of the small-pox appearing all over it, like bits of suet through the skin of a real pudding: a nose like a potatoe; and dull, heavy, oyster-like eyes, just suited to his face and person. A figure of this kind, dressed as he was, in a common coat and waistcoat, and a common sort of wig, excites little or no attention; and if you do happen to look at it, makes you turn away with mere disgust. Such ugliness, therefore, neither painters, nor others, pay any attention to; but the painter, from having observed many strongly marked peculiarities and effects, which, in the human species, though mixed with ugliness, attract in some degree the notice of all beholders, is led to remark similar peculiarities and effects in inanimate, and consequently less interesting objects; while those persons, who have not considered them in the same point of view, pass by them with indifference.'

16 Katherine Plymley (1758–1829) Notebook and diary entries

The diarist Katherine Plymley lived in the West Midlands near Shrewsbury. Her brother Joseph was Archdeacon for Shropshire, and her friends and acquaintances included the Wedgwood family, the Darwins, the Gilpins (VB2, 5 and 11), Archibald Alison (VA11) and his wife Dorothea, Richard Payne Knight and Thomas Pennant. Other contacts came from the world of science and industry and included Quaker industrialists from nearby Coalbrook-dale. She engaged in a systematic process of self-improvement, including the cultivation of her aesthetic awareness. Her extensive notebooks and diaries provide plentiful evidence of her familiarity with contemporary theories of taste and of the picturesque. We have included three short excerpts from her notebooks, which reflect her reading of theorists such as Archibald Alison and James Beattie (1735–1803). Two further excerpts from her diaries describe visits in 1794 to Coalbrookdale, where the Quaker ironmaster Richard Reynolds had made walks for his workers to enjoy the romantic scenery juxtaposed with dramatic effects of industry, and in 1797 to Downton in Herefordshire, where the grounds had been laid out by Richard Payne Knight (see VB14). Plymley's notebooks and diaries are kept in the Shropshire Research and Records Office. The following excerpts have been transcribed and edited by Jo Dahn, who also provided this introduction.

On imagination

The Human Soul is essentially active; & none of our faculties are more restless than this of Imagination... the right government of this faculty must be a matter of the greatest importance to all men. [One should] repress every disagreeable passion, as anger, revenge, envy, suspicion, & discontent; & cherish Piety, humanity, forgiveness, patience, & a lowly mind. For the latter bring along with them sweet & soothing ideas, as painful thoughts & misery are the inseparable companions of the former.

On the association of ideas

The Association of Ideas is commonly referred to imagination, but appears to be owing in part to habits affecting the memory, & the outward senses... a tune... will give pleasure when heard again, by recalling those ideas of delight that accompanied the first performance... A present, however trifling, preserved as the memorial of a friend, derives inestimable value from its power of enlivening our idea of the giver, & renewing those kind emotions, whereof that person is the object.

On the constituency of taste

... to be a person of taste, it seems necessary that one have 1st, a lively & correct imagination; which however, will avail but little if it is not regulated by the knowledge of nature, both external or material, & internal or moral; 2ly, the power of distinct apprehension; for obtaining which he recommends, to study with accuracy, & with method, everything we apply to, whether books or business. 3ly, the capacity of being easily, strongly, & agreeably affected, with sublimity, beauty, harmony, exact imitation, &c. these he calls secondary senses, & observes no person ever possessed

the faculty of being equally skilled in them all. 4ly, Sympathy, or that sensibility of heart, by which, on supposing ourselves in the condition of others, we are conscious in some degree of those very emotions, pleasant or painful, which would arise within us if we were really in that condition, & 5ly, judgement, or good sense, which is the principal thing, & may not very improperly be said to comprehend all the rest . . . no man will ever acquire good taste, unless nature has made him a man of senses.

Downton in Herefordshire

. . . here is charming natural scenery, & it is pleasant to see such places in the hands of taste, Mr Knight is contented not to interfere with its natural charms, all he does is only to shew it to advantage, the principal beauty is a river that winds beautifully in a narrow vale between rocky eminences wooded to their tops, walks are cut in the rock above the river, that rolls its clear water over a rocky bed, an elegant stone bridge of three arches over it, is one approach to the house; I lamented to find that the floods of last winter had destroy'd a wooden bridge of a very singular construction, it appear'd to be nothing more than some large trees fallen across the river, & had a most picturesque effect . . . when I crossed it in my walk about Downton Castle some years ago . . . I was greatly struck with it, the view up & down the river when you stood upon the bridge was highly picturesque & beautiful – In conformity with the rules he has given in his poem of the Landskip Mr Knight leaves his walks, even those near the house, in a very rude state, he is an enemy to all appearance of art in his grounds yet it may be urged that an house being an artificial object, it cannot be un[a]vailable to keep the walks & grounds about it in neat order – In further conformity to his own rules he has clear'd away the Firs, having a violent quarrel with that species of tree – [. . .] The situation is fine, & the view from the house remarkably well wooded. The smoke from Brinswood forge rising among trees has a good effect, & reminds me of the immense wealth that is sometimes acquired when industry & an invariable attention to self-interest are united with ability; for in this forge the founder of several families all possessing large estates, or immense monied fortunes, was originally a wheeler of charcoal, & rose to be the greatest Iron master of the kingdom, he was the grandfather of the present Mr Knight . . . We reach'd home the same evening, so well pleased with all we have seen as scarcely to allow us to reflect how much more beautiful the face of the country will appear a little while hence.

Coalbrookdale

. . . got to the Ironbridge Inn late in the evening, walked through part of the walks planted by Mr Reynolds, & which he permits the public to enjoy, till we reach'd the Rotunda placed on Lincoln Hill, the pillars of it are cast Iron – from whence we had a fine view of the Dale by night – the numerous fires have a fine effect, not only there in the Dale but several other works towards Broseley, Madeley &c. The next morning after a delightful walk through other plantations of Mr Reynolds we reach'd the Dale & look'd at the works of which though I have before seen them I am too ignorant to speak; it is wonderful to see the vivid green of the plantations so near the smoke of the

works, in the close walks it may be supposed that we are in a rural & retired spot, at convenient distances are placed seats which command views of a romantic country & discover how near we are to busy life; there is something in this contrast very pleasing – What pleases me much is a vast cavern of lime stone which they work under Lincoln Hill, as they take out the stone they leave massy pillars of it for support, they are formed into grand rude arches no caverns or made grottoes that I have seen can bear the least comparison with it. – what is striking is that it is seen by the light of day led in through some of the outward arches – there is light sufficient to look through these fine caverns & yet gloom sufficient to accord with the scene.

17 François-René, Comte de Chateaubriand (1768–1848) 'Letter on Landscape Painting'

The French writer and statesman Chateaubriand was born in Saint-Malo of a noble Breton family. After witnessing the beginnings of the Revolution, he set sail in 1791 for North America. His memoirs vividly reveal the contrast between his experiences of the end of the *ancien régime* and his encounter with the New World. He travelled as far west as Ohio and was greatly moved by the wildness and vastness of the natural landscape: 'Never has God more stirred me with his grandeur than in those nights, when I had immensity over my head and immensity under my feet.' On his return to France he joined the army of the royalist émigrés, but was severely wounded at the battle of Thionville. He managed to make his way to Jersey and from there to England, where he remained in exile from 1793 to 1800. Despite continuing problems with his health, he occupied himself with writing and translating. In 1797 he published his highly pessimistic *Essai sur les révolutions*. This was followed in 1801 by *Atala*, a Romantic epic of American Indian life, which established his literary reputation, and in 1803, *Génie du christianisme*, in which he sought to restore the role of the Catholic Church in the moral and intellectual life of post-revolutionary France (see VIIB4). The 'Letter on Landscape Painting' was written during his stay in England. The letter was first published by Chateaubriand himself in 1828 in volume 22 of his collected works (*Œuvres complètes*, Paris: Ladvocat, 31 vols, 1826–31). In 1795 he was actually in Beccles in Suffolk rather than London, and it is likely that he subsequently changed the address for its greater resonance abroad. Chateaubriand has been seen as an important precursor of Romanticism. This short letter adumbrates many of its principal concerns. The unknown addressee is urged to correct art by reference to nature and to trust to his own direct responses to the natural world. The complete letter has been translated for the present volume by Jason Gaiger from *Corréspondance générale, I, 1789–1807*, ed. B. d'Andlau, P. Christophorov and P. Riberette, Paris: Gallimard, 1977, pp. 69–73.

To Monsieur * * *

London, 1795

Here is the small landscape you asked me for. I have made you wait for it, but you know the sad circumstances which require that I devote myself to other studies. If the doctors are to be believed, however, this will not last long; I am ready when and however it may please God. These same studies have also caused me to abandon the large *prospect* of Canada which gave me such pleasure as a reminder of my travels.

What a difference between those times and these! When my thoughts return to the past my sorrows become so vivid that I do not know what will become of me. Forgive this baring of my soul. It is a great pleasure to speak of one's sufferings when you know that those who are listening can understand you. There are few people who understand me here.

The small drawing I am sending you encouraged me to develop some thoughts on the art of landscape which may be of some use to you. In any case, it is winter and you will have a fire lit – a great resource against scribblers.

Brought up amongst forests, I have been struck by the faults of the art and the dryness of landscapes ever since my childhood, without my being able to say wherein these faults consist. From the time when I myself began to draw, I was aware that something was wrong when I copied from models. I was better pleased with myself when I followed my own ideas. Imperceptibly, I was led to consider the cause of this strange state of affairs; for after all what I produced in accordance with the rules was worth more than what I created out of my own head. Here is what I gained from these deliberations; it is the most satisfactory solution to this problem that I have been able to find.

In general, landscape painters do not love nature sufficiently and they possess little knowledge of her. Here I do not refer to the great masters, about whom in any case there would be much more to say. I speak only of ordinary painters and of amateurs like ourselves. We are taught to intensify or to brighten shadows, to draw pure, clean lines, and so forth; but we are not taught to study the objects themselves which flatter us so agreeably in our paintings of nature. We are made only to observe features of the paintings which give us delight, to attend to the harmonies and the contrasts between old woods and bocage, or between dry rocks and meadows adorned with all the fresh youth of flowers. It seems as if the study of landscape consists in nothing but the study of pencil-marks and brushstrokes; the entire art is reduced to bringing together certain traits in such a way that the appearance is given of trees, houses, animals and other objects. The landscapist who draws in this fashion resembles a lace-maker who passes her small sticks on top of each other whilst chatting away or looking elsewhere; the result is something which is made up of holes and solid parts, and which forms a fabric of greater or lesser variety: this may be termed a craft, but not an art.

The first concern of students must be with the study of nature herself. Their first lessons should be taken in the open countryside. Let a young man be struck by the effect of a waterfall which cascades from the summit of a rock and by the way in which the water seethes and flows away. The movement, the noise, the shafts of light, the grouping of the shadows, the dishevelled plants, the froth which forms like snow at the bottom of the fall, the fresh grass which runs along the banks of the stream – all this will be engraved in the student's memory. These memories will pursue him to his studio; before he even picks up his brush he will burn with desire to reproduce what he has seen. The first thing he produces is a misshapen sketch; he is unhappy with what he has done; he starts all over again and then tears it up once more. He realizes that there are certain principles of which he is ignorant and he is forced to recognize that he needs a master. But such a student will not remain long at the level

of principles and he will proceed with the steps of a giant on a career in which inspiration will be his first guide.

The painter who seeks to represent human nature must study the passions: if we do not know a man's heart, we will not know his face. Landscape, too, has its moral and intellectual part just as a portrait does. It too must speak. Through the material execution of a landscape we must be made aware of the different sort of reveries and sentiments to which different locations give rise. It is not a matter of indifference, for example, if a landscape is depicted with oak trees or with willows: oak trees have a long life, *durando sæcula vincit*, with their rough bark, strong branches and tall peaks, *immota manet*, they inspire beneath their shade sentiments quite different from those produced by the light foliage of willows, which live for only a short time and which possess the freshness of the waters from which they draw their sap: *umbræ irrugui fontis amica salix*.[1]

For want of having studied nature, the landscape painter, like the poet, sometimes violates the character of her sites. He places pine trees on the banks of a stream and poplars on the side of a mountain; he scatters a basket of flowers taken from a garden across a meadow; the eglantine of a wild hedge bears a rose from one of our flower-beds – a crown which it cannot support.

In my opinion, the study of botany is useful for the landscape painter, even if only so that he learns to understand *foliage* and does not give the same outline and the same shape to the leaves of all the trees. The painter who wishes to express on his canvas the melancholy passions of man is obliged to use anatomy to study the organs of the body. The landscape painter, more fortunate, need only occupy himself with the innocent generation of flowers, the nodding of plants and the placid habits of rustic animals.

Once the student has made his way past these first stages, and once he has become sufficiently confident with his brush to allow him to follow the direction of his thoughts without a guide, he must take himself into solitude and abandon the fields which have been degraded by the proximity of towns. Otherwise, his imagination, which is greater than this small circle of nature, would end up despising nature herself; he would begin to believe that he can create something better than Creation: a dangerous error which would lead him far from the truth and into bizarre productions which he would take for genius.

Let us beware of believing that our imagination is richer and more fecund than nature herself. That which we call *great* in our minds is almost always disorder. Similarly in the art which forms the subject of this letter, when we imagine what is *great* we think of mountains piled up to the sky, torrents, precipices, the heaving ocean, waves so huge that we can see them only in the turbulence of our thoughts, wind and thunder. What else? A million things, incoherent and verging on the absurd, if we are to be honest and give a frank and clear account of our ideas.

Should all this not serve as proof of man's penchant for destruction? It is far easier for us to imagine chaos than the proper proportions of the universe. Unless it is combined with a memory of terror, it is only with great difficulty that we can picture to ourselves the calm of the sea. This can be seen from those descriptions of calm which are almost always accompanied by words such as *menacing, profound silence*, and so forth. When a landscape painter, full of these ridiculous ideas of the sublime,

arrives during a storm at the shore of the sea which he has never seen before, he is astonished to observe that the swelling waves approach and recede with order and majesty one after another, instead of the violence and chaos which he had imagined. He hears a dull noise mixed with clear and harsh sounds interspersed with short periods of silence instead of that din which our painter had imagined in his mind. Everywhere there are glaring colours, but these conserve their harmonies right up to the point at which they disappear. The dazzling spray of the waves splashes up against the black rocks; vast clouds roll before a dark horizon. But they are all pushed in the same direction; a thousand unchained winds do not fight against each other, nor do colours intermix or waves climb to the skies, with the light terrifying the dead through chasms hollowed out between the waves.

Our young poet or young painter will cry 'But I imagine it better than that!' and he will turn his back with disdain. But if his character is good, he will soon retreat from these extravagant ideas; he will correct his imagination and nothing will appear to him greater than the work which was formed by the first Great Power. He will topple over the mountains ranged up in his head in which every locale, every character and every plant are mixed up together. These ideal mountains will never reach up again to the stars, but snow will still cover the peaks of the Alps and torrents will pour from its summit; in a less elevated region, larks will begin to adorn the sides of the rocks; more fragile plants will end their sojourn amongst the tempests and gradually descend into the valleys; and the hut of the Swiss farmer and soldier will smile under greyish willows by the side of a stream.

Made strong by his studies and by this purification of his taste, the student will give himself up to his genius. He will lead the eyes of the amateur under pine trees or perhaps a tomb covered in ivy will call in vain for his favour. In a narrow valley surrounded by bare rocks he will place the ruins of an old château; through the fissures of the towers will be seen the trunk of a solitary tree which has invaded this place where once there was noise and battle; samphire will cover the fallen debris with its white crosses and ferns will carpet the pieces of wall which still remain upright. Perhaps a young herdsman will guard his goats there, and they will leap from ruin to ruin.

Cheerful landscapes, too, will receive their turn, even though such compositions are generally less engaging. This may be because happiness is little suited to man or because painting provides few resources for depicting rustic pleasures which are reduced for the most part to dancing and singing. There are, however, certain general features proper to these sorts of *prospects*: the foliage should be light and mobile, the distant view should be indeterminate without being hazy, shadows should not be emphasized too strongly, and over the whole scene there should reign a gentle light which softens the surfaces of objects.

The landscape painter will learn the effect of different horizons upon the colour of his paintings. Imagine two perfectly identical valleys, one of which faces south, the other north. The tone, the physiognomy and the moral expression of these two prospects will be completely different.

Aerial perspective is prodigiously difficult. Nonetheless, one must know how to situate linear perspective on the surface of the earth and how to capture the transient features of clouds which vary so much at different times of day. Night too has its

colours. It is not enough to make the moon pale to make it beautiful; chaste Diana too has her loves and the purity of the moon's rays should not take anything away from the inspiration of its light.

This letter is already of an extreme length and I have only begun to touch upon this inexhaustible subject. All that I wanted to say to you here is that landscape must be *drawn* from the *nude* if one wants to depict it accurately and to reveal, so to speak, its muscles, its bones, its forms. Studies after the work of others, copies of copies, can never replace study from nature herself. *Atticæ plurinam salutem.*[2]

[1] The first two Latin citations are from Virgil's *Georgics*, Book II, lines 294–5: ... *immola manet multosque nepotes/ Multa virum volvens durando saecula vincit* (... unmoved it abides, and many generations, many ages of men it outlives). The second quotation remains untraced, but means 'the willow loves the source which bathes the trees.'

[2] 'A thousand compliments to Attica' (Cicero, *Attica*, XIV, 20).

18 Mary Wollstonecraft (1759–1797) 'On Poetry, and our Relish for the Beauties of Nature'

Wollstonecraft remains best known for her *Vindication of the Rights of Women* (1792), and for her early writings on education. But she also wrote on a variety of other subjects, notably in the wide range of reviews she contributed to the *Analytical Review*. These tended to be on more broadly 'cultural' themes, such as novels, travel literature, collections of correspondence, poetry, drama and so on. She also wrote the present free-standing essay, 'On Poetry, and Our Relish for the Beauties of Nature' which appeared in the *Monthly Magazine* for April 1797 (pp. 279–82). Despite its title, the essay's concerns are restricted neither to poetry nor to nature. It has implications for the other arts, particularly the visual arts, and what it addresses is less nature per se than a certain myth or stereotype of nature entertained by modern town-dwellers. The paradox Wollstonecraft explores is that a taste for nature is an artificial sentiment, part of a would-be refined taste. Nonetheless, she is convinced of the virtue of an art which *really* draws its inspiration from nature, rather than from other art and polite convention – as did poetry in what she calls 'the infancy of society'. The qualities she values are those of spontaneity and truth rather than those of images 'selected from books'. The essay was included by William Godwin in volume IV of *Post-humous Works of the Author of a Vindication of the Rights of Women* (1797). We have taken our extracts from that text as reprinted in *The Works of Mary Wollstonecraft*, volume 7, edited by Janet Todd and Marilyn Butler, London: William Pickering, 1989, pp. 7–10.

A taste for rural scenes, in the present state of society, appears to be very often an artificial sentiment, rather inspired by poetry and romances, than a real perception of the beauties of nature. But, as it is reckoned a proof of refined taste to praise the calm pleasures which the country affords, the theme is never exhausted. Yet it may be made a question, whether this romantic kind of declamation, has much effect on the conduct of those, who leave, for a season, the crowded cities in which they were bred.

I have been led to these reflections, by observing, when I have resided for any length of time in the country, how few people seem to contemplate nature with their own eyes. I have 'brushed the dew away' in the morning; but, pacing over the

printless grass, I have wondered that, in such delightful situations, the sun was allowed to rise in solitary majesty, whilst my eyes alone hailed its beautifying beams. The webs of the evening have still been spread across the hedged path, unless some labouring man, trudging to work, disturbed the fairy structure; yet, in spite of this supineness, when I joined the social circle, every tongue rang changes on the pleasures of the country.

Having frequently had occasion to make the same observation, I was led to endeavour, in one of my solitary rambles, to trace the cause, and likewise to enquire why the poetry written in the infancy of society, is most natural: which, strictly speaking (for *natural* is a very indefinite expression) is merely to say, that it is the transcript of immediate sensations, in all their native wildness and simplicity, when fancy, awakened by the sight of interesting objects, was most actively at work. At such moments, sensibility quickly furnishes similes, and the sublimated spirits combine images, which rising spontaneously, it is not necessary coldly to ransack the understanding or memory, till the laborious efforts of judgment exclude present sensations, and damp the fire of enthusiasm.

The effusions of a vigorous mind, will ever tell us how far the understanding has been enlarged by thought, and stored with knowledge. The richness of the soil even appears on the surface; and the result of profound thinking, often mixing, with playful grace, in the reveries of the poet, smoothly incorporates with the ebullitions of animal spirits, when the finely fashioned nerve vibrates acutely with rapture, or when, relaxed by soft melancholy, a pleasing languor prompts the long-drawn sigh, and feeds the slowly falling tear.

The poet, the man of strong feelings, gives us only an image of his mind, when he was actually alone, conversing with himself, and marking the impression which nature had made on his own heart. – If, at this sacred moment, the idea of some departed friend, some tender recollection when the soul was most alive to tenderness, intruded unawares into his thoughts, the sorrow which it produced is artlessly, yet poetically expressed – and who can avoid sympathizing?

Love to man leads to devotion – grand and sublime images strike the imagination – God is seen in every floating cloud, and comes from the misty mountain to receive the noblest homage of an intelligent creature – praise. How solemn is the moment, when all affections and remembrances fade before the sublime admiration which the wisdom and goodness of God inspires, when he is worshipped in a *temple not made with hands* [Revelation 21–2], and the world seems to contain only the mind that formed, and the mind that contemplates it! These are not the weak responses of ceremonial devotion; nor, to express them, would the poet need another poet's aid: his heart burns within him, and he speaks the language of truth and nature with resistless energy.

Inequalities, of course, are observable in his effusions; and a less vigorous fancy, with more taste, would have produced more elegance and uniformity; but, as passages are softened or expunged during the cooler moments of reflection, the understanding is gratified at the expence of those involuntary sensations, which, like the beauteous tints of an evening sky, are so evanescent, that they melt into new forms before they can be analyzed. For however eloquently we may boast of our reason, man must often

be delighted he cannot tell why, or his blunt feelings are not made to relish the beauties which nature, poetry, or any of the imitative arts, afford.

The imagery of the ancients seems naturally to have been borrowed from surrounding objects and their mythology. When a hero is to be transported from one place to another, across pathless wastes, is any vehicle so natural, as one of the fleecy clouds on which the poet has often gazed, scarcely conscious that he wished to make it his chariot? Again, when nature seems to present obstacles to his progress at almost every step, when the tangled forest and steep mountain stand as barriers, to pass over which the mind longs for supernatural aid; an interposing deity, who walks on the waves, and rules the storm, severely felt in the first attempts to cultivate a country, will receive from the impassioned fancy 'a local habitation and a name' [*A Midsummer Night's Dream*].

It would be a philosophical enquiry, and throw some light on the history of the human mind, to trace, as far as our information will allow us to trace, the spontaneous feelings and ideas which have produced the images that now frequently appear unnatural, because they are remote; and disgusting, because they have been servilely copied by poets, whose habits of thinking, and views of nature must have been different; for, though the understanding seldom disturbs the current of our present feelings, without dissipating the gay clouds which fancy has been embracing, yet it silently gives the colour to the whole tenour of them, and the dream is over, when truth is grossly violated, or images introduced, selected from books, and not from local manners or popular prejudices.

In a more advanced state of civilization, a poet is rather the creature of art, than of nature. The books that he reads in his youth, become a hot-bed in which artificial fruits are produced, beautiful to the common eye, though they want the true hue and flavour. His images do not arise from sensations; they are copies; and, like the works of the painters who copy ancient statues when they draw men and women of their own times, we acknowledge that the features are fine, and the proportions just; yet they are men of stone; insipid figures, that never convey to the mind the idea of a portrait taken from life, where the soul gives spirit and homogeneity to the whole. The silken wings of fancy are shrivelled by rules; and a desire of attaining elegance of diction, occasions an attention to words, incompatible with sublime, impassioned thoughts. [...]

It may sound paradoxical, after observing that those productions want vigour, that are merely the work of imitation, in which the understanding has violently directed, if not extinguished, the blaze of fancy, to assert, that, though genius be only another world for exquisite sensibility, the first observers of nature, the true poets, exercised their understanding much more than their imitators. But they exercised it to discriminate things, whilst their followers were busy to borrow sentiments and arrange words. [...]

[T]hough it should be allowed that books may produce some poets, I fear they will never be the poets who charm our cares to sleep, or extort admiration. They may diffuse taste, and polish the language; but I am inclined to conclude that they will seldom rouse the passions, or amend the heart.

And, to return to the first subject of discussion, the reason why most people are more interested by a scene described by a poet, than by a view of nature, probably

arises from the want of a lively imagination. The poet contracts the prospect, and, selecting the most picturesque part in his *camera*, the judgment is directed, and the whole force of the languid faculty turned towards the objects which excited the most forcible emotions in the poet's heart; the reader consequently feels the enlivened description, though he was not able to receive a first impression from the operations of his own mind.

Besides, it may be further observed, that gross minds are only to be moved by forcible representations. To rouse the thoughtless, objects must be presented, calculated to produce tumultuous emotions; the unsubstantial, picturesque forms which a contemplative man gazes on, and often follows with ardour till he is mocked by a glimpse of unattainable excellence, appear to them the light vapours of a dreaming enthusiast, who gives up the substance for the shadow. It is not within that they seek amusement; their eyes are seldom turned on themselves; consequently their emotions, though sometimes fervid, are always transient, and the nicer perceptions which distinguish the man of genuine taste, are not felt, or make such a slight impression as scarcely to excite any pleasurable sensations. Is it surprising then that they are often overlooked, even by those who are delighted by the same images concentrated by the poet?

19 Jane Austen (1775–1817) from *Northanger Abbey*

Jane Austen wrote *Northanger Abbey* in 1798–9 and sold it to the publisher Richard Crosby in 1803. He failed to publish it, however, and it was not printed until 1818, a year after the author's death, when it was issued together with *Persuasion*. We include an excerpt here as a telling representation of contemporary conversation about the picturesque. In the later *Mansfield Park*, Austen's characters are given the best part of a chapter in which to reveal themselves through what they have to say about the 'improvement' of parks and gardens. *Northanger Abbey* was provoked in part by the contemporary taste for 'Gothic' novels, the most successful of these being *The Mysteries of Udolpho* by Mrs Radcliffe. Our text is taken from the Everyman's Library edition, London: Dent, (1906) 1966, pp. 89–90. Austen's disingenuous heroine, Catherine Morland, is staying in Bath and is befriended by the more sophisticated Mr Tilney and his sister Eleanor. In chapter XIV, the trio take a walk on Beechen Cliff, 'that noble hill, whose beautiful verdure and hanging coppice render it so striking an object from almost every opening in Bath'. After conversation about *The Mysteries of Udolpho* and novels in general, the Tilneys embark on another subject upon which Catherine is at a loss.

They were viewing the country with the eyes of persons accustomed to drawing, and decided on its capability of being formed into pictures, with all the eagerness of real taste. Here Catherine was quite lost. She knew nothing of drawing – nothing of taste: – and she listened to them with an attention which brought her little profit, for they talked in phrases which conveyed scarcely any idea to her. The little which she could understand however appeared to contradict the very few notions she had entertained on the matter before. It seemed as if a good view were no longer to be taken from the top of an high hill, and that a clear blue sky was no longer a proof of a

fine day. She was heartily ashamed of her ignorance. A misplaced shame. Where people wish to attach, they should always be ignorant. To come with a well-informed mind, is to come with an inability of administering to the vanity of others, which a sensible person would always wish to avoid. A woman especially, if she have the misfortune of knowing any thing, should conceal it as well as she can.

The advantages of natural folly in a beautiful girl have been already set forth by the capital pen of a sister author; – and to her treatment of the subject I will only add in justice to men, that though to the larger and more trifling part of the sex, imbecility in females is a great enhancement of their personal charms, there is a portion of them too reasonable and too well-informed themselves to desire any thing more in woman than ignorance. But Catherine did not know her own advantages – did not know that a good-looking girl, with an affectionate heart and a very ignorant mind, cannot fail of attracting a clever young man, unless circumstances are particularly untoward. In the present instance, she confessed and lamented her want of knowledge; declared that she would give any thing in the world to be able to draw; and a lecture on the picturesque immediately followed, in which his instructions were so clear that she soon began to see beauty in every thing admired by him, and her attention was so earnest, that he became perfectly satisfied of her having a great deal of natural taste. He talked of fore-grounds, distances, and second distances – side-screens and perspectives – lights and shades; – and Catherine was so hopeful a scholar, that when they gained the top of Beechen Cliff, she voluntarily rejected the whole city of Bath, as unworthy to make part of a landscape. Delighted with her progress, and fearful of wearying her with too much wisdom at once, Henry suffered the subject to decline, and by an easy transition from a piece of rocky fragment and the withered oak which he had placed near its summit, to oaks in general, to forests, the inclosure of them, waste lands, crown lands and government, he shortly found himself arrived at politics; and from politics, it was an easy step to silence.

Part VI
Romanticism

Part VI
Romanticism

VI
Introduction

As an artistic movement, Romanticism is characterized by its extraordinary diversity. Unlike neo-classicism, with which it is most often contrasted, Romanticism seems not to have been associated with a unifying visual language or a recognizable 'style' in painting. Indeed, if we consider the work of artists such as Friedrich (VIB13, 18), Runge (VIB5, VIIA8), Fuseli (VIB19), Goya (VIB3), Blake (VIB8, 9), Turner (VIIA10) and Constable (VIIA4), all of whom may with some justice be identified as Romantic artists, the most striking thing is the sheer variety of styles we encounter. Yet underlying the diversity of subject-matter and technique is a surprisingly unified set of concerns and preoccupations. These artists worked during a period when many long-standing assumptions about the role and status of the arts were subject to question, and when the concept of art itself underwent rapid and irreversible transformation. A new emphasis was placed on the expressive potential of the individual and on the seemingly limitless resources of the creative imagination. If there is a unity to be found beneath the apparent heterogeneity of Romantic art practice, then it resides in a shared body of beliefs and ideals concerning the possible emancipation of art from established rules and conventions. According to this view, the individual is bound by neither schools nor principles and possesses a sovereign right to pursue his or her own vision of art.

The origin of this 'Romantic aesthetic' can be traced to the last few years of the eighteenth century in Germany, in particular to the small university town of Jena. Although important precedents are to be found in the work of Rousseau (IIIA2, 3), Herder (VA7) and Schiller (VA12, 13), amongst others, it was the short-lived journal *Athenaeum* that first established the idea of 'Romantic poetry'. Published by Friedrich and August Wilhelm Schlegel from 1798 to 1800, the journal encouraged an extremely wide variety of literary and critical styles. The most characteristic of its forms was the 'fragment', developed as a medium of expression. Rather than a piece of some larger whole, the Romantic fragment is conceived as something independent and self-sufficient. At the same time, its very brevity and episodic character allow it to resist the appearance of completeness or 'closure' attendant upon a worked-out system. This same approach is carried through to the very definition of Romanticism itself. In fragment 116 of the *Athenäum*, Friedrich Schlegel defines Romantic poetry as 'a progressive, universal poetry' (VIA2). In place of the static model of artistic

'perfection' derived from Antiquity, Schlegel offers a model of artistic creativity based on the idea of constant becoming, or 'infinite perfectibility', which places no constraints upon the nature or form of the future work of art.

Throughout most of the period covered by this anthology, two assumptions remained in force. The first of these was that the goal of art is the imitation of nature, albeit informed by some ideal standard. And the second was that it is possible to establish a set of unchanging norms for the production and critical evaluation of works of art. In challenging both of these assumptions, the Romantic movement can be said to have introduced a new paradigm for understanding both the work of art and the role of the artist. Rather than explaining the task of the artist in terms of the *imitation* of external reality, Romanticism places new emphasis on the artist's capacity to *express* his or her own moods, feelings and responses. Primacy is accorded to what is unique, distinctive and authentic as opposed to what is necessary or universal. Much of the value of art is seen to reside in the privileged access it affords to an intensively cultivated domain of private experience. At the same time, theorists of Romanticism challenged the view that there is a fixed set of artistic forms or genres which stand in a hierarchical relation to one another. Equal value is accorded to different forms of art. Unstructured prose may surpass the most elaborately constructed poetry, and the hastiest pencil drawing or sketch may possess greater significance than the fully elaborated 'machine' of a history painting. Indeed, many Romantic artists overtly set out to break down the barriers between the different genres and to render them interchangeable. Rule is not something that can be imposed on the work of art from without. Rather, each individual work is capable of establishing a new form or mode of existence on the basis of its own inner unity and coherence.

These changes were accompanied by an acute awareness of the differences which separated the present from the past. When Goethe struggled belatedly to sustain the exemplary standing of Greek and Roman art by organizing a series of annual art competitions in Weimar, Philipp Otto Runge was roused to a powerful rejection of classicism (VIB5). For Runge, the 'highest point of perfection' is to be sought in a new kind of art which has yet to be developed and which 'will perhaps prove even more beautiful than what has gone before'. This renewed attempt to throw off the weight of the ancients may recall the *querelle des anciens et des modernes* which raged at the end of the seventeenth century (see section IA). However, the self-conscious modernity of the Romantics was informed by a new and different historical awareness: the recognition that human nature itself is subject to change and that the art of different cultures and historical periods needs to be judged according to the standards of its own time and place. In the writings of Wilhelm Wackenroder this characteristically Romantic insight issues in a recognition that 'artistic feeling is only one and the same divine ray of light which ... is refracted into a thousand different colours by the diversely polished glass of sensuality' and that Rome and Germany are 'situated on one Earth'. That is to say, each culture or form of expression possesses its own intrinsic value.

Wackenroder was one of the first German writers to express enthusiasm for the medieval period and for the art of his own native country, bestowing particular praise on the work of Dürer. In the early years of the nineteenth century this re-evaluation

of the importance of non-classical art developed into a veritable cult of the Middle Ages, finding further expression in the writings of Ludwig Tieck (VIB2), Novalis (VIB4) and Friedrich Schlegel (VIA7). It led directly to the founding of the Brotherhood of St Luke and to the artistic ideals of the Nazarenes (see VIIB5–7; and *Art in Theory 1815–1900*, IIB8, IIIC7, 8).

The Romantic period also saw the emergence of a cultural nationalism which frequently took the form of an interest in indigenous songs and folk-tales. Joseph Görres (VIA4) and Clemens Brentano (VIB15) were among those who formed important written collections of this predominantly oral tradition and helped to awaken a sense of regional cultural identity. There remained a strong literary emphasis to Romanticism in Germany. Many artists drew upon or illustrated themes from medieval romances and from collections of folk-tales.

In England too, some of the earliest proponents of the new ideas were writers and poets. Wordsworth had been in France at the time of the Revolution. His libertarian ideals of that period are exemplified in his composition of an elegy to Toussaint L'Ouverture, the leader of the Haitian slave revolt. However, Wordsworth's main contribution to early Romanticism in England is to be found in the small book he published with Coleridge in 1798: *Lyrical Ballads*. These poems, many of them on deliberately un- or anti-heroic subjects, such as 'The Female Vagrant', 'The Convict', or 'The Idiot Boy', were written in a style which approximated more closely to the rhythms and patterns of ordinary speech than had been the case in earlier, classically influenced verse. The two prose pieces Wordsworth wrote for this collection, a short 'Advertisement' for the first edition, and a longer 'Preface' to the second, in 1800, function as kinds of manifesto for the new aesthetic (VIA5 and 6). William Blake was another who found suitable material for Romantic poetry in the French Revolution: 'Gleams of fire streak the heavens / ... the peasant looks over the sea and wipes a tear; / Over his head the soul of Voltaire shone fiery, and over the army Rousseau his white cloud / Unfolded' (*The French Revolution*, 1791, lines 278–82). Blake's Romanticism pervades his entire output, from the poetry to his letters, from prose descriptions of his own works to the fierce marginalia in which he assaulted the legacy of Joshua Reynolds, the Academician par excellence (VIB7, 8, 9). Somewhat later another poet, Percy Bysshe Shelley, composed an enduring slogan applicable to the Romantic artist in every medium and genre, when he described poets as 'the unacknowledged legislators of the world' (VIA12).

It is scarcely surprising that uncompromising originality of this kind should have produced a reaction. Resistance to innovation in the visual arts is nowhere more clearly exemplified than in the debate surrounding Caspar David Friedrich's *The Cross in the Mountains*. Friedrich himself described the subject of the painting as: 'An upright cross, green ivy clinging around its stem, and surrounded by evergreen fir trees...on the summit of a rocky outcrop' (VIB13). What made this apparently innocuous image so challenging to the accepted conventions of classical landscape painting was, first, Friedrich's willingness to prioritize allegorical meaning over fidelity to the rules of composition and aerial perspective, and second, his intention that the painting be hung as a devotional altarpiece in a private chapel. Shortly after it was exhibited in Friedrich's studio in 1808, Friedrich Ramdohr published a coruscating attack in which he enumerated the failings of the work from the standpoint of

classical art theory (VIB12). Ramdohr rejects that 'mysticism which is now creeping into everything and enveloping art as well as science... with a haze of narcotic intoxication'. However, his detailed analysis of the painting is paradoxically sensitive to what is genuinely new in Friedrich's art. Read *ex negativo*, his account serves as a remarkable guide to the aims and ambitions of the younger generation of Romantic artists. That Friedrich's work continued to give rise to significant problems of interpretation is revealed by the incomprehension which greeted his *The Monk by the Sea* when it was exhibited in Berlin in 1810. Confronted by a painting which defies the rules of classical landscape composition and which invites the spectator to contemplate a seemingly infinite expanse of land, sea and sky, viewers were thrown upon their own often confused responses before the work itself (VIB14, 15).

Romanticism has been appositely described as an attempt to re-enchant the world and to invest it with a higher spiritual meaning. However, it would be unjust to the work of Friedrich, as of many other Romantics, to regard it as a retreat into apolitical subjectivism and mysticism. As his letter to Arndt reveals (VIB18), Friedrich was a committed patriot and supported his country's struggles against Napoleonic troops in the Wars of Liberation. Responses to the rise of Napoleon and to the subsequent course of the French Revolution were complex and ambiguous. Whilst there was continued opposition to French rule, the introduction of the Napoleonic Code and the abolition of serfdom in the occupied territories brought about much-needed social reform. In 1806 Napoleon formally dissolved the now essentially meaningless Holy Roman Empire, but occupied Europe still remained under French control and the newly created Confederation of the Rhine enjoyed little real autonomy.

Disillusionment with the intellectual and moral ideals of the Enlightenment and the frustration of the political ideals of the French Revolution are often cited as important factors in the genesis of Romanticism. However, as Ernst Behler has pointed out, there are remarkable parallels between the overthrow of the old social and political order by the Revolution in France, on the one hand, and the literary and artistic revolution brought about by Romanticism on the other (Behler, 1993). Romanticism's challenge to established rules and conventions, its dismantling of the hierarchy of the genres, its appreciation of popular forms of artistic expression and its emphasis on individual self-expression may be correlated with similar modes of political radicalism. This thought finds its definitive formulation in the words of Friedrich Schlegel, from the 'Critical Fragments' of 1798: 'Poetry is republican speech: a speech which is its own law and end unto itself, and in which all the parts are free citizens and have a right to vote' (VIA1).

VIA
Romantic Aesthetics

1 Friedrich Schlegel (1772–1829) from 'Critical Fragments'

Friedrich Schlegel was one of the leading figures of the movement of Early German Romanticism which flourished in Jena in the closing years of the eighteenth century. He was born in Hannover and studied law, philosophy and classics at the universities of Göttingen and Leipzig. His early works were devoted to classical Antiquity and it has been said that he sought to do for the history of Greek poetry what Winckelmann (see IIIA5 and 8) had done for Greek sculpture. Prompted by Schiller's 'On Naive and Sentimental Poetry' (see VA13) he later came to reject the idea that we should imitate the ancients, accepting that the distinctive character of modern art and literature requires new forms and categories if it is to be properly understood. In 1798 he joined his brother, August Wilhelm, in Jena, where he set about articulating his conception of 'romantic poetry'. The 'Critical Fragments' were first published in 1797 in the journal *Lyceum der Schönen Künste*. Schlegel's employment of the 'fragment' as a mode of writing was, in part, an attempt to block the moment of completion or closure and to sustain the dynamism and protean character which he attributed to Romanticism itself. Interpretation is an ongoing process which draws upon the creative powers of the reader or viewer. The following selection has been made from the translation by Peter Firchow in Friedrich Schlegel, *Philosophical Fragments*, Minneapolis and Oxford: University of Minnesota Press, 1991, pp. 1–16.

1. Many so-called artists are really products of nature's art.

4. There is so much poetry and yet there is nothing more rare than a poem! This is due to the vast quantity of poetical sketches, studies, fragments, tendencies, ruins, and raw materials.

9. Wit is absolute social feeling, or fragmentary genius.

12. One of two things is usually lacking in the so-called Philosophy of Art: either philosophy or art.

14. In poetry too every whole can be a part and every part really a whole.

16. Though genius isn't something that can be produced arbitrarily, it is freely willed – like wit, love, and faith, which one day will have to become arts and sciences. You should demand genius from everyone, but not expect it. A Kantian would call this the categorical imperative of genius.

20. A classical text must never be entirely comprehensible. But those who are cultivated and who cultivate themselves must always want to learn more from it.

21. Just as a child is only a thing which wants to become a human being, so a poem is only a product of nature which wants to become a work of art.

26. Novels are the Socratic dialogues of our time. And this free form has become the refuge of common sense in its flight from pedantry.

27. The critic is a reader who ruminates. Therefore he ought to have more than one stomach.

28. Feeling (for a particular art, science, person, etc.) is divided spirit, is self-restriction: hence a result of self-creation and self-destruction.

29. Gracefulness is life lived correctly, is sensuality intuiting and shaping itself.

34. A witty idea is a disintegration of spiritual substances which, before being suddenly separated, must have been thoroughly mixed. The imagination must first be satiated with all sorts of life before one can electrify it with the friction of free social intercourse so that the slightest friendly or hostile touch can elicit brilliant sparks and lustrous rays – or smashing thunderbolts.

40. In the sense in which it has been defined and used in Germany, aesthetic is a word which notoriously reveals an equally perfect ignorance of the thing and of the language. Why is it still used?

42. Philosophy is the real homeland of irony, which one would like to define as logical beauty: for wherever philosophy appears in oral or written dialogues – and is not simply confined into rigid systems – there irony should be asked for and provided. And even the Stoics considered urbanity a virtue. Of course, there is also a rhetorical species of irony which, sparingly used, has an excellent effect, especially in polemics; but compared to the sublime urbanity of the Socratic muse, it is like the pomp of the most splendid oration set over against the noble style of an ancient tragedy. Only poetry can also reach the heights of philosophy in this way, and only poetry does not restrict itself to isolated ironical passages, as rhetoric does. There are ancient and modern poems that are pervaded by the divine breath of irony through-out and informed by a truly transcendental buffoonery. Internally: the mood that surveys everything and rises infinitely above all limitations, even above its own art, virtue, or genius; externally, in its execution: the mimic style of an averagely gifted Italian *buffo*.

44. You should never appeal to the spirit of the ancients as if to an authority. It's a peculiar thing with spirits: they don't let themselves be grabbed by the hand and shown to others. Spirits reveal themselves only to spirits. Probably here too the best and shortest way would be to prove one's possession of the only true belief by doing good works.

47. Whoever desires the infinite doesn't know what he desires. But one can't turn this sentence around.

48. Irony is the form of paradox. Paradox is everything simultaneously good and great.

54. There are writers who drink the absolute like water; and books in which even the dogs refer to the infinite.

55. A really free and cultivated person ought to be able to attune himself at will to being philosophical or philological, critical or poetical, historical or rhetorical, ancient or modern: quite arbitrarily, just as one tunes an instrument, at any time and to any degree.

56. Wit is logical sociability.

57. If some mystical art lovers who think of every criticism as a dissection and every dissection as a destruction of pleasure were to think logically, then 'wow' would be the best criticism of the greatest work of art. To be sure, there are critiques which say nothing more, but only take much longer to say it.

60. All the classical poetical genres have now become ridiculous in their rigid purity.

63. Not art and works of art make the artist, but feeling and inspiration and impulse.

65. Poetry is republican speech: a speech which is its own law and end unto itself, and in which all the parts are free citizens and have the right to vote.

68. How many authors are there among writers? Author means creator.

70. People who write books and imagine that their readers are the public and that they must educate it soon arrive at the point not only of despising their so-called public but of hating it. Which leads absolutely nowhere.

73. What is lost in average, good, or even first-rate translations is precisely the best part.

84. From what the moderns aim at, we learn what poetry should become; from what the ancients have done, what it has to be.

90. Wit is an explosion of confined spirit.

93. In the ancients we see the perfected letter of all poetry; in the moderns we see its growing spirit.

96. A good riddle should be witty; otherwise nothing remains once the answer has been found. And there's a charm in having a witty idea which is enigmatic to the point of needing to be solved: only its meaning should be immediately and completely clear as soon as it's been hit upon.

100. The poetry of one writer is termed philosophical, of another philological, of a third, rhetorical, etc. But what then is poetical poetry?

103. Many works that are praised for the beauty of their coherence have less unity than a motley heap of ideas simply animated by the ghost of a spirit and aiming at a single purpose. What really holds the latter together is that free and equal fellowship in which, so the wise men assure us, the citizens of the perfect state will live at some future date; it's that unqualifiedly sociable spirit which, as the beau monde maintains, is now to be found only in what is so strangely and almost childishly called the great world. On the other hand, many a work of art whose coherence is never questioned is, as the artist knows quite well himself, not a complete work but a fragment, or one or more fragments, a mass, a plan. But so powerful is the instinct for unity in mankind that the author himself will often bring something to a kind of completion at least directly with the form which simply can't be made a whole or a unit; often quite imaginatively and yet completely unnaturally. The worst thing about it is that whatever is draped about the solid, really existent fragments in the attempt to mug up a semblance of unity consists largely of dyed rags. And if these are touched up cleverly and deceptively, and tastefully displayed, then that's all the worse. For then he deceives even the exceptional reader at first, who has a deep feeling for what little real goodness and beauty is still to be found here and there in life and letters. That reader is then forced to make a critical judgment to get at the right perception of it! And no matter how quickly the dissociation takes place, still the first fresh impression is lost.

108. Socratic irony is the only involuntary and yet completely deliberate dissimulation. It is equally impossible to feign it or divulge it. To a person who hasn't got it, it will remain a riddle even after it is openly confessed. It is meant to deceive no one except those who consider it a deception and who either take pleasure in the delightful roguery of making fools of the whole world or else become angry when they get an inkling they themselves might be included. In this sort of irony, everything should be playful and serious, guilelessly open and deeply hidden. It originates in the union of *savoir vivre* and scientific spirit, in the conjunction of a perfectly instinctive and a perfectly conscious philosophy. It contains and arouses a feeling of

indissoluble antagonism between the absolute and the relative, between the impossibility and the necessity of complete communication. It is the freest of all licenses, for by its means one transcends oneself; and yet it is also the most lawful, for it is absolutely necessary. It is a very good sign when the harmonious bores are at a loss about how they should react to this continuous self-parody, when they fluctuate endlessly between belief and disbelief until they get dizzy and take what is meant as a joke seriously and what is meant seriously as a joke. For Lessing irony is instinct; for Hemsterhuis it is classical study; for Hülsen it arises out of the philosophy of philosophy and surpasses these others by far.

112. The analytic writer observes the reader as he is; and accordingly he makes his calculations and sets up his machines in order to make the proper impression on him. The synthetic writer constructs and creates a reader as he should be; he doesn't imagine him calm and dead, but alive and critical. He allows whatever he has created to take shape gradually before the reader's eyes, or else he tempts him to discover it himself. He doesn't try to make any particular impression on him, but enters with him into the sacred relationship of deepest symphilosophy or sympoetry.

115. The whole history of modern poetry is a running commentary on the following brief philosophical text: all art should become science and all science art; poetry and philosophy should be made one.

117. Poetry can only be criticized by way of poetry. A critical judgment of an artistic production has no civil rights in the realm of art if it isn't itself a work of art, either in its substance, as a representation of a necessary impression in the state of becoming, or in the beauty of its form and open tone, like that of the old Roman satires.

123. It is thoughtless and immodest presumption to want to learn something about art from philosophy. There are many who start out that way as if they hope to find something new there, since philosophy, after all, can't and shouldn't be able to do more than order the given artistic experiences and the existing artistic principles into a science, and raise the appreciation of art, extend it with the help of a thoroughly learned history of art, and create here as well that logical mood which unites absolute tolerance with absolute rigor.

127. It's indelicate to be astonished when something is beautiful or great; as if it could really be any different.

2 Friedrich Schlegel (1772–1829) from 'Athenaeum Fragments'

Together with his brother, August Wilhelm, Friedrich Schlegel edited the journal *Athenäum* from 1798 to 1800. The journal embraced the work of the rich intellectual circle surrounding the two brothers in Jena. This included Dorothea Veit, Novalis (see VIA3 and VIB4),

Ludwig Tieck (see VIB2), Friedrich Schelling (see VIA8) and Friedrich Schleiermacher (see *Art in Theory 1815–1900*, IA11). The two brothers insisted on 'unity of spirit' rather than 'unity of content'. The journal covered a wide range of topics through an equally broad range of literary forms, including essays, dialogues, letters, discussions and, most characteristic of all, 'fragments'. The majority of the so-called 'Athenaeum Fragments' were written by Friedrich Schlegel, though some were by Novalis, Schleiermacher and August Wilhelm Schlegel. In fragment 116 Friedrich defines Romantic poetry as 'a progressive, universal poetry'. Whereas classicism strives for completion, romantic poetry is constantly in the process of becoming. Rather than aiming for stylistic purity it fuses together a variety of different genres. It offers a portrait of the age rather than an expression of timeless values and the only binding rules are those which are provided by the creative imagination of the author. Schiller took a strong dislike to the fragments, writing in a letter to Goethe (23 July 1798) that 'This pert, opinionated, sarcastic, one-sided manner makes me feel physically ill.' Goethe welcomed their polemical character, however, describing the Schlegels as a 'wasps' nest'. The fragments were first published in *Athenäum. Eine Zeitschrift von August Wilhelm Schlegel und Friedrich Schlegel*, volume I, part 2, Berlin: Friedrich Vieweg, 1798. The following selection is taken from the translation by Peter Firchow, *Philosophical Fragments*, Minneapolis and Oxford: University of Minnesota Press, 1991, pp. 18–24, 26–7, 30–5, 39, 41–2, 45–6, 51–4, 60, 75, 93. The fragments written by August Wilhelm Schlegel are marked with the initials AW in square brackets.

1. Nothing is more rarely the subject of philosophy than philosophy itself.

13. When young people of both sexes know how to dance to a lively tune, it doesn't in the least occur to them to try to make a critical judgment about music just for that reason. Why do people have less respect for poetry?

22. A project is the subjective embryo of a developing object. A perfect project should be at once completely subjective and completely objective, should be an indivisible and living individual. In its origin: completely subjective and original, only possible in precisely this sense; in its character: completely objective, physically and morally necessary. The feeling for projects – which one might call fragments of the future – is distinguishable from the feeling for fragments of the past only by its direction: progressive in the former, regressive in the latter. What is essential is to be able to idealize and realize objects immediately and simultaneously: to complete them and in part carry them out within oneself. Since transcendental is precisely whatever relates to the joining or separating of the ideal and the real, one might very well say that the feeling for fragments and projects is the transcendental element of the historical spirit.

24. Many of the works of the ancients have become fragments. Many modern works are fragments as soon as they are written.

32. One should have wit, but not want to have it. Otherwise, you get persiflage, the Alexandrian style of wit.

40. Notes to a poem are like anatomical lectures on a piece of roast beef. [AW]

51. Naive is what is or seems to be natural, individual, or classical to the point of irony, or else to the point of continuously fluctuating between self-creation and self-destruction. If it's simply instinctive, then it's childlike, childish, or silly; if it's merely intentional, then it gives rise to affectation. The beautiful, poetical, ideal naive must combine intention and instinct. The essence of intention in this sense is freedom, though intention isn't consciousness by a long shot. There is a certain kind of self-infatuated intuition of one's own naturalness or silliness that is itself unspeakably silly. Intention doesn't exactly require any deep calculation or plan. Even Homeric naiveté isn't simply instinctive; there is at least as much intention in it as there is in the grace of lovely children or innocent girls. And even if Homer himself had no intentions, his poetry and the real author of that poetry, Nature, certainly did.

68. The only true lover of art is the man who can renounce some of his wishes entirely whenever he finds others completely fulfilled, who can rigorously evaluate even what he loves most, who will, if necessary, submit to explanations, and has a sense for the history of art.

71. People always talk about how an analysis of the beauty of a work of art supposedly disturbs the pleasure of the art lover. Well, the real lover just won't let himself be disturbed!

73. Might it not be the same with the people as with the truth: where, as they say, the attempt is worth more than the result?

77. A dialogue is a chain or garland of fragments. An exchange of letters is a dialogue on a larger scale, and memoirs constitute a system of fragments. But as yet no genre exists that is fragmentary both in form and content, simultaneously completely subjective and individual, and completely objective and like a necessary part in a system of all the sciences.

109. A certain kind of micrology and belief in authority are characteristics of greatness – namely, the perfecting micrology of the artist, and the historical belief in the authority of nature.

110. It is a sublime taste always to like things better when they've been raised to the second power. For example, copies of imitations, critiques of reviews, addenda to additions, commentaries on notes. This taste is very characteristic of us Germans whenever it's a matter of making something longer; and of the French when it promotes brevity and vacuity. Their scientific education very likely tends to be an abbreviation of an extract, and the highest production of their poetical art, their tragedy, is merely the formula of a form. [AW]

111. The teachings that a novel hopes to instill must be of the sort that can be communicated only as wholes, not demonstrated singly, and not subject to exhaustive analysis. Otherwise the rhetorical form would be infinitely preferable.

114. A definition of poetry can only determine what poetry should be, not what it really was and is; otherwise the shortest definition would be that poetry is whatever has at any time and at any place been called poetry.

116. Romantic poetry is a progressive, universal poetry. Its aim isn't merely to reunite all the separate species of poetry and put poetry in touch with philosophy and rhetoric. It tries to and should mix and fuse poetry and prose, inspiration and criticism, the poetry of art and the poetry of nature; and make poetry lively and sociable, and life and society poetical; poeticize wit and fill and saturate the forms of art with every kind of good, solid matter for instruction, and animate them with the pulsations of humor. It embraces everything that is purely poetic, from the greatest systems of art, containing within themselves still further systems, to the sigh, the kiss that the poetizing child breathes forth in artless song. It can so lose itself in what it describes that one might believe it exists only to characterize poetical individuals of all sorts; and yet there still is no form so fit for expressing the entire spirit of an author: so that many artists who started out to write only a novel ended up by providing us with a portrait of themselves. It alone can become, like the epic, a mirror of the whole circumambient world, an image of the age. And it can also – more than any other form – hover at the midpoint between the portrayed and the portrayer, free of all real and ideal self-interest, on the wings of poetic reflection, and can raise that reflection again and again to a higher power, can multiply it in an endless succession of mirrors. It is capable of the highest and most variegated refinement, not only from within outwards, but also from without inwards; capable in that it organizes – for everything that seeks a wholeness in its effects – the parts along similar lines, so that it opens up a perspective upon an infinitely increasing classicism. Romantic poetry is in the arts what wit is in philosophy, and what society and sociability, friendship and love are in life. Other kinds of poetry are finished and are now capable of being fully analyzed. The romantic kind of poetry is still in the state of becoming; that, in fact, is its real essence: that it should forever be becoming and never be perfected. It can be exhausted by no theory and only a divinatory criticism would dare try to characterize its ideal. It alone is infinite, just as it alone is free; and it recognizes as its first commandment that the will of the poet can tolerate no law above itself. The romantic kind of poetry is the only one that is more than a kind, that is, as it were, poetry itself: for in a certain sense all poetry is or should be romantic.

119. Even those metaphors that seem simply arbitrary often have deep significance. What kind of analogy, one might wonder, exists between heaps of gold or silver and the accomplishments of the spirit that are so sure and so perfect they become arbitrary, and which sprang to life so casually they seem inborn? And yet it's obvious that one only has talents, owns them as if they were things, though they still retain their solid value even though they can't ennoble the possessor. But one can never really have genius, only be one. And there is no plural for genius, which in this case is already contained in the singular. For genius is actually a system of talents.

121. An idea is a concept perfected to the point of irony, an absolute synthesis of absolute antitheses, the continual self-creating interchange of two conflicting

thoughts. An ideal is at once idea and fact. If ideals don't have as much individuality for the thinker as the gods of antiquity do for the artist, then any concern with ideas is no more than a boring and laborious game of dice with hollow phrases, or, in the manner of the Chinese bronzes, a brooding intuition of one's own nose. Nothing is more wretched and contemptible than this sentimental speculation without any object. But one shouldn't call this mysticism, since this beautiful old word is so very useful and indispensable for absolute philosophy, from whose perspective the spirit regards everything as a mystery and a wonder, while from other points of view it would appear theoretically and practically normal. Speculation *en detail* is as rare as abstraction *en gros*, and yet it is these that beget the whole substance of scientific wit, these that are the principles of higher criticism, the highest rungs of spiritual cultivation. The great practical abstraction is what makes the ancients – among whom this was an instinct – actually ancients. In vain did individuals express the ideal of their species completely, if the species themselves, strictly and sharply isolated, weren't freely surrendered, as it were, to their originality. But to transport oneself arbitrarily now into this, now into that sphere, as if into another world, not merely with one's reason and imagination, but with one's whole soul; to freely relinquish first one and then another part of one's being, and confine oneself entirely to a third; to seek and find now in this, now in that individual the be-all and end-all of existence, and intentionally forget everyone else: of this only a mind is capable that contains within itself simultaneously a plurality of minds and a whole system of persons, and in whose inner being the universe which, as they say, should germinate in every monad, has grown to fullness and maturity.

125. Perhaps there would be a birth of a whole new era of the sciences and arts if symphilosophy and sympoetry became so universal and heartfelt that it would no longer be anything extraordinary for several complementary minds to create communal works of art. One is often struck by the idea that two minds really belong together, like divided halves that can realize their full potential only when joined. If there were an art of amalgamating individuals, or if a wishful criticism could do more than merely wish – and for that there are reasons enough – then I would like to see Jean Paul and Peter Leberecht combined. The latter has precisely what the former lacks. Jean Paul's grotesque talent and Peter Leberecht's fantastic turn of mind would, once united, yield a first-rate romantic poet.

167. Almost all criticisms of art are too general or too specific. The critics should look for the golden mean here, in their own productions, and not in the works of the poets.

178. If any work of German painting is worthy of being displayed in the forecourt of Raphael's temple, then certainly Albrecht Dürer and Holbein would be much closer to the inner sanctum than the scholarly Mengs. [AW]

182. To have a Diderot describe an art exhibition for you is a truly imperial luxury. [AW]

183. Hogarth painted ugliness and wrote about beauty. [AW]

190. Nature at its flattest and most monotonous is the best teacher of a landscape painter. Consider the wealth of Dutch art that comes under this heading. Poverty makes one thrifty: there comes from it a sense of frugality that is gladdened by even the slightest hint of higher life in nature. When later during his travels the artist gets to know romantic scenes, they make an even greater impression on him. The imagination too has its antitheses: the greatest painter of horrific wastelands, Salvator Rosa, was born in Naples. [AW]

206. A fragment, like a miniature work of art, has to be entirely isolated from the surrounding world and be complete in itself like a porcupine.

216. The French Revolution, Fichte's philosophy, and Goethe's *Meister* are the greatest tendencies of the age. Whoever is offended by this juxtaposition, whoever cannot take any revolution seriously that isn't noisy and materialistic, hasn't yet achieved a lofty, broad perspective on the history of mankind. Even in our shabby histories of civilization, which usually resemble a collection of variants accompanied by a running commentary for which the original classical text has been lost; even there many a little book, almost unnoticed by the noisy rabble at the time, plays a greater role than anything they did.

243. The mirage of a former golden age is one of the greatest obstacles to approximating the golden age that still lies in the future. If there once was a golden age, then it wasn't really golden. Gold can't rust or decompose: it emerges victoriously genuine from all attempts to alloy or decompose it. If the golden age won't last always and forever, then it might as well never begin, since it will only be good for composing elegies about its loss. [AW]

252. A real aesthetic theory of poetry would begin with the absolute antithesis of the eternally unbridgeable gulf between art and raw beauty. It would describe their struggle and conclude with the perfect harmony of artistic and natural poetry. This is to be found only among the ancients and would in itself constitute nothing but a more elevated history of the spirit of classical poetry. But a philosophy of poetry as such would begin with the independence of beauty, with the proposition that beauty is and should be distinct from truth and morality, and that it has the same rights as these: something that – for those who are able to understand it at all – follows from the proposition I = I. It would waver between the union and the division of philosophy and poetry, between poetry and practice, poetry as such and the genres and kinds of poetry; and it would conclude with their complete union. Its beginning would provide the principles of pure poetics; its middle the theory of the particular, characteristically modern types of poetry: the didactic, the musical, the rhetorical in a higher sense, etc. The keystone would be a philosophy of the novel, the rough outlines of which are contained in Plato's political theory. Of course, to the ephemeral, unenthusiastic dilettantes, who are ignorant of the best poets of all types, this kind of poetics would seem very much like a book of trigonometry to a child who just

wants to draw pictures. Only a man who knows or possesses a subject can make use of the philosophy of that subject; only he will be able to understand what that philosophy means and what it's attempting to do. But philosophy can't inoculate someone with experience and sense, or pull them out of a hat – and it shouldn't want to do so. To those who knew it already, philosophy of course brings nothing new; but only through it does it become knowledge and thereby assume a new form.

255. The more poetry becomes science, the more it also becomes art. If poetry is to become art, if the artist is to have a thorough understanding and knowledge of his ends and means, his difficulties and his subjects, then the poet will have to philosophize about his art. If he is to be more than a mere contriver and artisan, if he is to be an expert in his field and understand his fellow citizens in the kingdom of art, then he will have to become a philologist as well.

302. Jumbled ideas should be the rough drafts of philosophy. It's no secret how highly these are valued by connoisseurs of painting. For a man who can't draw philosophical worlds with a crayon and characterize every thought that has a physiognomy with a few strokes of the pen, philosophy will never be an art and consequently never a science. For in philosophy the way to science lies only through art, just as the poet, on the other hand, finds his art only through science.

366. Understanding is mechanical, wit is chemical, genius is organic spirit.

451. Universality is the successive satiation of all forms and substances. Universality can attain harmony only through the conjunction of poetry and philosophy; and even the greatest, most universal works of isolated poetry and philosophy seem to lack this final synthesis. They come to a stop, still imperfect but close to the goal of harmony. The life of the Universal Spirit is an unbroken chain of inner revolutions; all individuals – that is, all original and eternal ones – live in him. He is a genuine polytheist and bears within himself all Olympus.

3 Novalis (Friedrich von Hardenberg) (1772–1801) 'Fugitive Thoughts'

The German poet and novelist Friedrich von Hardenberg was born in Oberwiederstedt in Saxony. He was brought up in a strict pietistic household and was educated at home by private tutors. In 1790 he entered the University of Jena to study law, also attending the universities of Göttingen and Leipzig, where he made the acquaintance of Friedrich Schlegel (see VIA1 and 2). He first employed the pseudonym 'Novalis' for a collection of fragments entitled *Blütenstaub* (Pollen), published in the journal *Athenäum* in 1798. The early death of his fiancée, the 15-year-old Sophie von Kühn, initiated a profound spiritual and religious crisis, to which he gave literary expression in his *Hymnen an die Nacht* (Hymns to the Night), also published in the *Athenäum* in 1800. These were amongst the

few works which Novalis succeeded in completing before his own early death in 1801. He left behind a large body of writings and fragments which were edited and published shortly after his death by Friedrich Schlegel and Ludwig Tieck (*Schriften*, 2 volumes, 1802). Strongly influenced by the philosophy of German idealism, his writings encompass philosophical, scientific, mathematical and technical matters as well as issues connected with the transformative power of 'poesie'. His declared ambition was to 'poeticize the world' – to discover the original power behind the appearances of things and to invest them with a higher meaning. The following selection of fragments was made and translated by Mary Jane Hope, who gave them the title 'Fugitive Thoughts'. They most probably date from the period 1798–1801. Our excerpts are taken from Hope's *Novalis (Friedrich von Hardenberg). His Life, Thoughts and Work*, London: David Stott, 1891, pp. 175–8, 180–5, 188–9, 193–4, 198.

THE art of writing books has not yet been found out. It is, however, near at hand. The fragments which exist are literary seed-beds. Many of the seeds fail; but here and there one will spring up and bear fruit.

Perhaps I owe my happiest thoughts to the fact, that impressions do not strike me at once in their full completion, but first enter my brain in an uncertain and tentative form.

Every work of art is formed of spirit element.

The poet understands Nature better than the man of science.

The representation of feeling must be like the representation of nature, independent, complete, and original. Not as we find it, but as it ought to be.

Poetry heals the wounds given by reason. Its elements are of a totally opposite character, and may be described as elevated truth and agreeable illusion.

It is easy to be understood how all things tend to poetry. Is not the whole universe full of soul?

One must strive to maintain a ceaseless current of thought. If one has no time for a wide view of general literature, free thought, and calm reflection, even the most active imagination will grow dull, and the inward alertness cease. The poet must be alive to all the varying conditions of life with their special peculiarities, and have also a keen interest in all science and knowledge.

There are moments when even alphabets and books of reference may appear poetical.

All poetry forms a contrast to actual humdrum life; and real poetry revives the mind, even as sleep does the body. Illness, strange events, journeys, fresh acquaintances, influence us in the same way.

The past history of mankind is like an incomplete poem. Our belief in an ultimate reconciliation is in reality a confidence in the final poetic harmony of life. It is in our own power to tune our highest faculties, and infuse poetry into existence.

The artist rises above other men, as the statue does above its pedestal.

Poetry is creation. All poems must have a living individuality.

The power by which one throws oneself entirely into an extraneous individuality – not merely imitating it – is still quite unknown; it arises from keen perception and intellectual mimicry. The true artist can make himself anything that he likes.

Poetry is absolute truth. That is the gist of my philosophy. The more poetic, the more truthful.

This abundance of art essentials makes the few artists who arise among us so original, that we may be certain that the most splendid of all works of art will in time be produced by us, as no nation can compare with us in energy. If I understand our latest authors aright, they uphold the study of the ancients as a means of cultivation, not to make us slavish imitators, but to develop true artistic feeling.

No modern nation has such comprehension of art as the ancients.

By diligent and thoughtful study of the classics, we shall produce such a literature as never existed in classic ages. Goethe resembles classical writers in strength, but has a higher standard, which, however, is no merit of his. Goethe, however, will, and must, be surpassed; but only as the ancients have been, in power, in breadth of view, and reflection; not in the point of view of pure art, for his justness of observation and strength are even more perfect than they appear to be.

Arabesques and ornaments are embodied music.

All talents spring from intellect. Intellect sets the task, imagination chalks out the design, but intellect carries it out.

A romance must be like an English garden, every point must tell.

By invention and dexterity everything may be delineated gracefully on paper, either in writing or painting.

Poetry is only an active, productive use of our powers; thought is the same. Hence poetry and thought may be identical, for in thought the senses reproduce their accumulated impressions, transmuted into a fresh form, from which fresh ideas take their rise.

All purely comic characters must, as in the old plays, be roughly, broadly, sketched in; fine distinctions are prosaic. In the region of poetry, every touch must be incisive, every action full of animation and colour.

When we attentively consider the Laocoon, it may occur to us that there was a higher ideal than the ancients could grasp. Not that of wild defiance, but of resistance passing into resignation. Should not the sculptor always seize the moment of repose, and only that, for his art?

The poet's realm is the world compressed into the focus of his own times. He can make use of any topic, only he must do so with spirit. He must set forth both commonplace and extraordinary events; all effects are produced by contrast, and he is absolutely free to use whatever material he likes. Lifeless descriptions offer no interest; they do not touch either heart or soul; they must at least be symbolical, like nature herself, if they do not excite the deepest emotions. Above all, the poet must be no egotist. He is the representative prophet of nature, as the philosopher is the natural prophet of imagination. To the one all is objective, to the other all is subjective. The one is the voice of creation, the other the voice of the simple unit; one is song, the other talk.

The poet is ever true. He remains faithful to nature, and her recurrent cycles. All the poet's delineations must be symbolical or emotional. The symbolical does not touch the feelings at once, but it gives rise to spontaneous action. The one excites and rouses, the other touches and moves; the one affects the intellect, the other appeals to natural feeling; the one leads from appearances to actuality, the other from actuality to appearance.

Formerly the poet could be all things to all men; life's circle was so narrow, and men's experience, knowledge, customs, and character so much alike, their requirements so much simpler.

The most wonderful and eternal phenomenon is oneself. Man is the greatest of mysteries. The history of the world is the answer to this problem. Philosophy, science, and literature all seek to solve the riddle. Its attraction will never cease as long as men exist.

Dreams have a high degree of interest to the psychologist, also to the historian of humanity. Dreams have largely contributed to the culture and education of men – hence the great importance formerly attached to them.

We are united by closer bonds with the unseen, than with the seen.

The synthesis of body and soul is called person; the person is to the spirit what the body is to the soul. It fades away, but arises in a nobler form.

Commerce is the moving spirit of the world. It sets everything in motion, and unites everything, arouses countries and towns, nations and the arts, and is the spirit of culture, the perfection of human society.

The simplification and combination of science, and the transformation of all sciences into one, is an exercise for philosophy, which the love of science demands.

The individual soul must be brought into harmony with the soul of the universe.

Light in action; light is like life – a force; light makes fire – it is the genius of the fire.

With the ancients, religion certainly was what it ought to be with us – poetry.

There is no higher enjoyment than in learning; and the feeling of power is the source of all pleasure.

What attracts most is the unknown. The well known has no further attraction. The power of perception is in itself the greatest of charms.

Nothing is so great a perservative against folly as activity and technical work.

Real enjoyment is a *perpetuum mobile*; it is ever reproducing itself. The cessation of this activity is the cause of all the discontent and dissatisfaction in the world.

The life of a cultivated man should alternate between music and silence, as between day and night.

Christianity is an historical religion permeated by morality and poetry.

Intellect, soul, earnestness, and knowledge are inextricably associated with Divine things.

Science is only one half; faith is the completion.

Poetry permeates us with the individuality of another.

Nature has allegories of her own. The mists rising from the waters are like prayer.

4 Joseph Görres (1776–1848) from *Aphorisms on Art*

Born in Koblenz, Joseph Görres was an enthusiast for the French Revolution, an ardent supporter of republicanism and an advocate for the secession of the Rhineland. However, he was bitterly disappointed by what he saw when he visited France in 1799 and in 1800 he became a fervent nationalist. In 1806 he lectured on philosophy in Heidelberg where he came into contact with Georg Friedrich Creuzer (see VIIB10), Ludwig Achim von Arnim and Clemens Brentano (see VIB14). Inspired by Arnim's and Brentano's collection of folk-songs, *Des Knaben Wunderhorn* (1805–8), he published *Die teutschen Volksbücher* (1807) and the Middle High German poem *Lohengrin* (1813), confirming the increasingly nationalistic and philological orientation of German Romanticism. From 1814 to 1816 he edited the influential *Rheinischer Merkur*. He later became an ardent Catholic, leading a movement of religious awakening in Munich and publishing *Die christliche Mystik* (1836–42). His 'Aphorisms on Art' precede his Heidelberg years and form part of a larger work dedicated

to 'organonomy', physics, psychology and anthropology, as well as art. Although dense and confusing in places, they can be seen as sketching out a new set of categories through which to describe the visual language of Romanticism. Görres shares with Philipp Otto Runge (see VIB5 and VIIA8) an interest in the expressive potential of colour and in the coded meanings of hieroglyphs and arabesques. The following excerpt has been translated for the present volume by Nicholas Walker from *Aphorismen über die Kunst. Als Einleitung zu Aphorismen über Organonomie, Physik, Psychologie und Anthropologie*, Koblenz: Lassauln, 1802, pp. 47–61. The book is dated 'Year X', following the calendar of the French Revolution.

The language of images [*Bildersprache*] is the other branch of that river into which the inner capacity of the heart for art pours itself forth. The language of images, drawn from the realm of the cold, mute and mortified hieroglyph, of the symbol, and raised to the realm of warm, living, speaking presentation [*Darstellung*] – this is the object of all *formative art* [*der bildenden Kunst*].

Nature without paints shapes and forms images before our senses. Imagination clothes for us in shapes and forms and images the feeling which it would present in space for sensuous perception.

Images presented in external space initially distinguish themselves *mechanically* through the matter in which we fix them, and which we perceive as already formed by the images.

The matter which forms itself into an image is now either a *stuff*, namely *light*, and the art which speaks to our senses through the formation of light is *painting*.

Or the matter which forms itself into an image is all other *solid bodies*, and the art which speaks to our senses through the formation of the body is *plastic art*.

The artist who produces from himself presents effects, the artist who produces from out of matter presents sensations; every effect is a bundle of infinite effects, every sensation encompasses an infinity of simple sensations. The medium in which the artist reveals them both to us in an embodied form must therefore possess a similar infinity which can easily be evolved indefinitely.

Light is a bundle involving an infinity of colours; the prism and the structure of corporeal surfaces already effect the evolution of light. Light, therefore, is amongst all matters the most appropriate kind to meet this demand, and painting, by clothing its shapes in the stuff of light, opens up an unlimited field for its own creations.

For every tonal accordance a geometrical accordance in the length of a vibrating string, for every colour consonance and dissonance a spatial relationship within the spectrum, for each in turn a consonant and pleasing sensation, or a displeasing sensation, in the mind.

The light which art forms for us lies fettered in the *pigment*; pigments, therefore, are the *alphabet* of painting.

Grammar groups letters into words, and words into phrases; *composition* directs the grouping of pigments into a simple or variously organized picture according to rules of the understanding and perspective. *Composition*, therefore, is the *syntax* of painting.

The images expressed in pigments distinguish themselves *mathematically* through the closed determinate space which they delimit. *Drawing* constructs space that is delimited to form an image.

Images distinguish themselves *dynamically* through the strength or weakness of light, which thus gives rise to *illumination*.

Tones arrange themselves one after another in a regular and beautiful succession, which thus gives rise to melody; tones arrange themselves alongside one another in simultaneously sounding chords, and this gives rise to harmony.

Pigments likewise arrange themselves one after another spatially in a sequence of colour consonances in two dimensions; the rainbow is a colour scale, of which nature presents us with innumerable examples.

Insofar as painting arranges colours harmoniously with one another, works to produce consonance through distribution and mutual disposition of the latter and effects gradual transitions through the use of half-tones, thereby bringing truth, fidelity and nature into the painting, it is the art of *colourism*.

But the painting is not supposed to possess *surface* alone but also *depth*, and the magic of art brings this third dimension into play. Through the gradation of light and shade, through the distribution of light and its various reflections, through the use of half-shade and the feeling for colour, painting can highlight or withdraw the various parts of the picture and endow it thus with life and meaning. It is thus the art of chiaroscuro. *Chiaroscuro* here corresponds, therefore, to *melody* in the art of music, and *coloration* here corresponds to harmony there.

But in the art of music *melody* is a separate product elicited from nature, while *harmony* is only the later product of sentimental experimentation. In painting, on the other hand, *coloration* is the first thing that presents itself to perception, while *chiaroscuro* can only be a later product of reflection. In the painting of the battle of Marathon the figures of the generals stood in a row one after another.

Painting *drawn out from nature* is therefore coloration, and painting *produced from out of the artist* is chiaroscuro, though both flow together as *drawing*.

The colourist is the portrait painter of nature which stands warm, fresh and youthful before his eyes. The painter's task is to reproduce this warmth, freshness and youthfulness on canvas through glowing colour.

In the whole domain of nature *colour* is susceptible to the most delicate process of individualization, every unity can find a clear significance and designation in its manifold wealth of nuances, and colour as universal can present itself again in varied combinations. Passion reveals its different stages in changing colours, and the chemist interprets the latter as a reactive agent that registers even the slightest of changes within the body in question.

Colour speaks perceptibly even to the crudest of the senses. The latter understands what colour signifies: and sensation answers its call from the innermost depths of its being. Gladness gleams already in the eyes of a child in response to colour; after the mother's breast it is itself the first thing which entrances the child.

The first outpouring of artistic activity the very moment it awakes can only have been the *perception of colour*. What is received from the senses streams forth unchanged in the experience of colour; hence there can be no rules, no theory, for it, but only praxis.

Amongst all painters *Titian* stands unsurpassed for the use of colour. He may therefore serve to stand as representative of the eductive painter who draws from nature.

The productive painter brings something out of himself to the *surface* over which his brush hovers, namely *depth*.

An infinite depth, in each case limited only by the particular will of the artist, presents itself to the imagination, and employing all the arts of perspective, of drawing, of chiaroscuro, he represents within the painting just what he has himself produced.

His task is to reflect distance within proximity, to present the unlimited within the limited, to lend body to what is flat. The painting should deceptively present as existing to the senses what imagination alone has fashioned; the eye should believe it penetrates the furthest distance when in fact the impenetrable surrounds it.

If coloration astonishes us through the appearance of solid nature, through simplicity and innocence, and pleasing grace, then chiaroscuro moves the soul through the limitless and the immeasurable, through sublimity and an art drawn from the utmost depths. If coloration is already quite intelligible to the beginner here, chiaroscuro calls for culture and understanding in order to be grasped at all. One born blind with vision subsequently restored has long continued to perceive the objects in a painting as merely juxtaposed externally to one another in a single plane.

What coloration brings mutely and silently together side by side, first finds language, life and meaning when it is illuminated through and through by the idea which gives it sense, standing and soul.

As exemplary masters of productive painting we may name *Correggio* by virtue of his lively chiaroscuro and *Michelangelo* by virtue of his towering sublimity.

Landscape painting tends rather towards productive art; for infinite space, perspective and chiaroscuro are really properly at home here. The sphere of the painter is here extended up to the furthest mists of the horizon, and imagination bathes gladly in the distant airy blue.

Landscape painting stands initially at a point of transition between the language of images and formative art proper, like didactic poetry in the sphere of verbal language. The hieroglyph still reveals itself in purest form in the representation of foliage through shading. That is why the sentimental Gessner was also a sentimental landscape painter.

The portrait tends more towards eductive painting, where the sole and proper task is to represent to us an individual grasped at a single moment of life. Hence it was pre-eminently the *Venetian School* that excelled so much in portrait painting.

Productive painting without eductive painting is the form without the object, or *arabesque*, while eductive painting without productive painting is content without form, the slavish imitation of prosaic everyday life, or *still life*.

Productive and eductive painting without the preponderance of either, in harmonious balance with one another, give rise to the *ideal*.

Unity and outline is only characteristic of the mortified hieroglyph. The art which brings the latter to life necessarily divides this unity into coloration on the one hand and chiaroscuro on the other; the ideal brings unity back into division and restores

the outline of drawing through the inner connection between *colour* and the *clair-obscur*.

In coloration the artist breathes the gentle delicate play of shimmering colour from nature onto his canvas, pours the shapes of his imagination in their coloured haze into the effects of chiaroscuro, and from this form the ideal arises as his master-work.

For the ideal master nature possesses an imagination of her own; the finest thing to be found in reality was first called forth through this imagination, and the painter merely carries this perfect product over into his own homogeneous imagination.

Raphael flew closest to the illuminated centre of the ideal, and his painting of the *Transfiguration* has solved the problem of the total and harmonious balance of opposed forces in the purest possible manner.

Painting illuminates our senses by virtue of its shimmering light, while *plastic art* expresses itself through solid bodies.

In plastic art the effects are embodied in the domain of outer nature. What floats before the artist's soul in great ethereal masses here leaps over, like a spark, into the external world; thus it is that matter comes to clothe the little flame that has sprung forth from the burning ocean of the artist's imagination, and what is thereby clothed speaks lovingly to us in terms of form.

The rich abundance of our inner powers arranges itself into a state of equilibrium and the struggle of the battling elements of our nature has thus transformed itself into quiescence; the inner world now lies out there before us in the gentle happy light of a spring morning like a pure and distant cloudless sky. Just such a pure and distant cloudless sky shines back upon us from the marble statue of *Apollo Belvedere*.

Painful feelings rise within the breast, and gradually their coils embrace the soul, fetter and cripple our every power and capacity; trembling and suffocating with inexpressible anguish, the soul struggles with its final impulse against oppression but finally must submit; art receives the falling victim in her arms, and the catastrophic fate is captured for us in the *Laocoön*.

If you would feel how in such extremity the woman patiently endures while the husband struggles to his last breath with all-destroying fate and struggling falls; how, weeping, she beseeches nature for deliverance as her wounded husband, proud and unlamenting, is inwardly destroyed, then stand before the depiction of *Niobe*.

The Greek genius clothed every affect in the garments of myth, and form then crystallized around the latter in accordance with the corresponding laws of the plastic impulse.

Plastic art is thus the *petrifaction* of the soul.

Light decomposes into colour, and sound into tone; solid bodies are elements for our sensibility, and there can be no possible internal division within them that would effect the latter.

In the plastic product of art, therefore, there is no division, no sequential harmony of parts one after another, nothing that corresponds to coloration; it is impossible for it to represent melodic succession or anything resembling chiaroscuro. The single, homogeneous and undivided substance acquires differentiation only in relation to the external medium of space.

The depth which the painter transfers to the painting out of his own imagination, the breadth which the composer lends to song through his own inner and creative

capacity, both of these are also to be found in the plastic art of sculpture, and each is simultaneously given along with the other here.

If in painting the element of drawing decomposes into coloration and chiaroscuro, the solid form of plastic art, which characterizes the work of sculpture on every side, resists all such decomposition, but also renders it superfluous here for art.

In his domain the plastic artist already and immediately provides what the painter's highest striving only ever attains in infinity – namely to connect the uttermost extremes of art together in the ideal. But while unlimited paths stand open to the painter, the plastic artist must tread a narrow road, and any deviation in one direction or the other spells his downfall.

What the eductive artist wrests from nature for his art is merely the form; what the productive artist puts into nature out of himself is the selfsame form, the only possible garment in which the idea is clothed for him. The divided capacities for art are thus united in the image; in the image the points of contact between inner and outer nature, in which the soul and the organism are formed, are once again presented in external space.

The productive and the eductive capacities for art must assume, therefore, a perfect equilibrium in the artist if a single beautiful form is properly to arise. If the former is too prominent the contours are distorted into *caricature*, and if the latter is predominant the work of art *models* only what is *ordinary*.

The composer reproduces the same *theme* in a thousand different *variations*; the painter presents us with the same *image* from a hundred different views: the work of plastic art must express itself entirely from all sides and in every part, it stands before us ever finished and complete.

What the *harmonic scale* represents for music, *Antiquity* represents for the formative arts; as in the former the ideal seems to float towards us from the heavens, so here it rises forth to meet us from the clefts of earth as blocks of marble.

Monochromatic paintings in chiaroscuro without colour correspond to the *percussion* instruments in music; *coloured* paintings in the varied hues of light and shade correspond to the *wind* instruments in music; as the *string* instruments assume an intermediate position between both, so *plastic art* stands half-way between watercolour and painted picture, *bas-relief* marking the transition to the one and *mosaic* the transition to the other.

Landscape painting in the visual arts corresponds to the *art of garden design*, and the related art of *architecture*, in the plastic arts; both of the latter offer great scope for sentimental expression, whereas with the *bust* we must concentrate entirely upon the expression of individuality.

This is therefore how the scale of the formative arts is articulated: the manifestation of external nature presents itself to us in the *language of images* or symbols: it is only the heart that is capable of apprehending mere appearance; the inanimate *appearance of nature*, shining in upon the heart and represented in terms of solid bodies, is the art of *garden design*, while reflected in light and colour it is *landscape painting*; *living reality* expressed in solid form gives rise to *plastic art*, expressed in light itself to *figure painting*.

A duplex structure is therefore in the scale; a twofold character here as everywhere.

Mathematics, as the ideal in the realm of spirit, decomposes initially into a positive and a negative, into something produced and into something educed, into theoretical speculation and empirical experience, into science and manifestation.

The ideal in the realm of the heart, the summit of art, to which we here find ourselves driven, and which we have yet to demonstrate, decomposes in the same way into a positive and a negative, into something produced and something educed, into the arts of language and the formative arts.

The arts of language, in contrast to the formative arts, tend more towards the productive side; the tone, the word is a liquefied image which, unlike space, is not capable of the most precise external delimitation, but is shrouded, even more than light, in a kind of misty half-shade.

The formative arts, in contrast to the arts of language, tend more towards the eductive side; the images here represented in space acquire a sharply defined individuality; the eye grasps what is represented more sharply and clearly than the ear, and the imagination here finds itself confined within much narrower limits.

The highest and most primordial division in art thus reveals itself to us in the *sound* and in the *image*; at the next level the division itself will be divided in turn, and every opposition will disintegrate into new and further oppositions.

Thus the art of language divides into poetry and the musical art of tones; poetry, in contrast to music, will be the positive factor, while the latter provides the negative factor. Didactic poetry leads us into the brighter regions of the spirit, while music tarries below in the misty realm of feelings.

Formative art separates into *painting* and *sculpture*, the former being the productive moment, and the latter the eductive moment. We behold the imagination glimmering darkly towards us in the chiaroscuro of painting, whereas the sharply defined form of the sculpted work produces only sharply defined sensations in the senses.

The *single* great ideal of art will also divide into *two* further ideals; the oppositions of poetry and music are united in the ideal associated with the art of language, while the productive moment of painting and the eductive moment of plastic art are united in the ideal associated with formative art.

In the earliest childhood of their growth poetry and music played together trustingly like inseparable sisters; only later were the companions divided in order to meet again, when both had reached maturity, in the ideal.

Plastic art and painting would thus reveal themselves in the individual sculpture as the *colossal*, existing in every individual sculpture and uniting all of them together as a single, mighty, ideal *embodiment of art*.

5 William Wordsworth (1770–1850) 'Advertisement' from *Lyrical Ballads*

Wordsworth and Samuel Taylor Coleridge published their *Lyrical Ballads* in 1798. The book, which is regarded as marking the emergence of Romanticism in England, contained twenty-three poems, the great majority by Wordsworth. It also contained a short 'Advertisement', written between April and September 1798, after completion of the poems.

Poetry represents the principal focus of this 'Advertisement', as of the longer preface Wordsworth contributed to the second edition of 1800 (see VIA6). But it also encapsulates in concise form the wider Romantic move away from neo-classical decorum. Greater immediacy is to be achieved through a closer attention to nature and to daily life (in the case of poetry, to the patterns of ordinary speech). As if in anticipation of a persistent disposition in subsequent modern art, literary and visual alike, Wordsworth explicitly opposes the 'natural delineation' of feelings and incidents to the 'pre-established codes' of conventional taste. We have used the text of the Advertisement as published in *The Prose Works of William Wordsworth*, volume 1, edited by W. J. B. Owen and Jane Worthington Smyser, Oxford: Clarendon Press, 1974, pp. 116–17.

It is the honourable characteristic of Poetry that its materials are to be found in every subject which can interest the human mind. The evidence of this fact is to be sought, not in the writings of Critics, but in those of Poets themselves.

The majority of the following poems are to be considered as experiments. They were written chiefly with a view to ascertain how far the language of conversation in the middle and lower classes of society is adapted to the purposes of poetic pleasure. Readers accustomed to the gaudiness and inane phraseology of many modern writers, if they persist in reading this book to its conclusion, will perhaps frequently have to struggle with feelings of strangeness and aukwardness: they will look round for poetry, and will be induced to enquire by what species of courtesy these attempts can be permitted to assume that title. It is desirable that such readers, for their own sakes, should not suffer the solitary word Poetry, a word of very disputed meaning, to stand in the way of their gratification; but that, while they are perusing this book, they should ask themselves if it contains a natural delineation of human passions, human characters, and human incidents; and if the answer be favorable to the author's wishes, that they should consent to be pleased in spite of that most dreadful enemy to our pleasures, our own pre-established codes of decision.

Readers of superior judgment may disapprove of the style in which many of these pieces are executed: it must be expected that many lines and phrases will not exactly suit their taste. It will perhaps appear to them, that wishing to avoid the prevalent fault of the day, the author has sometimes descended too low, and that many of his expressions are too familiar, and not of sufficient dignity. It is apprehended, that the more conversant the reader is with our elder writers, and with those in modern times who have been the most successful in painting manners and passions, the fewer complaints of this kind will he have to make.

An accurate taste in poetry, and in all the other arts, Sir Joshua Reynolds has observed, is an acquired talent, which can only be produced by severe thought, and a long continued intercourse with the best models of composition. This is mentioned not with so ridiculous a purpose as to prevent the most inexperienced reader from judging for himself; but merely to temper the rashness of decision, and to suggest that if poetry be a subject on which much time has not been bestowed, the judgment may be erroneous, and that in many cases it necessarily will be so. [. . .]

6 William Wordsworth (1770–1850) from Preface to *Lyrical Ballads*

A second edition of *Lyrical Ballads* appeared two years after first publication, in 1800. It was now accompanied by a longer preface than the original short 'Advertisement' (see VIA5). In the new preface, Wordsworth further spelled out his aim to give more direct expression to the emotions. He calls these our 'elementary feelings', and regards them as capable of articulation only by an artist of 'organic sensibility'. For Wordsworth such an art is more likely to prosper in the face of nature, but in his conception, nature is not just a timeless idyll. It is, rather, historically situated. The experience of nature is a defence against forces which are at work to blunt what he calls the 'discriminating powers of the mind': the forces, that is, of an emergent modernity. These he specifies in particular as the turbulent political events of the period, the increasing pace of urban life, *and*, not least, the debased forms of mass culture to which the circumstances of urban life were already giving rise. Wordsworth writes in some detail of specifically literary matters, but we consider the inclusion of selections from his text to be justified because of the importance which technique as such came to assume across all the arts during the nineteenth century and later. Our extracts are taken from the 1800 preface to *Lyrical Ballads* as printed in *The Prose Works of William Wordsworth*, edited by W. J. B. Owen and Jane Worthington Smyser, volume 1, Oxford: Clarendon Press, 1974, pp. 122–30, 148–50.

[...] The principal object ... which I proposed to myself in these Poems was to make the incidents of common life interesting by tracing in them, truly though not ostentatiously, the primary laws of our nature: chiefly as far as regards the manner in which we associate ideas in a state of excitement. Low and rustic life was generally chosen because in that situation the essential passions of the heart find a better soil in which they can attain their maturity, are less under restraint, and speak a plainer and more emphatic language; because in that situation our elementary feelings exist in a state of greater simplicity and consequently may be more accurately contemplated and more forcibly communicated; because the manners of rural life germinate from those elementary feelings; and from the necessary character of rural occupations are more easily comprehended; and are more durable; and lastly, because in that situation the passions of men are incorporated with the beautiful and permanent forms of nature. The language too of these men is adopted (purified indeed from what appear to be its real defects, from all lasting and rational causes of dislike or disgust) because such men hourly communicate with the best objects from which the best part of language is originally derived; and because, from their rank in society and the sameness and narrow circle of their intercourse, being less under the action of social vanity they convey their feelings and notions in simple and unelaborated expressions. Accordingly such a language arising out of repeated experience and regular feelings is a more permanent and a far more philosophical language than that which is frequently substituted for it by Poets, who think that they are conferring honour upon themselves and their art in proportion as they separate themselves from the sympathies of men, and indulge in arbitrary and capricious habits of expression in order to furnish food for fickle tastes and fickle appetites of their own creation.

I cannot be insensible of the present outcry against the triviality and meanness both of thought and language, which some of my contemporaries have occasionally introduced into their metrical compositions; and I acknowledge that this defect where it exists, is more dishonorable to the Writer's own character than false refinement or arbitrary innovation, though I should contend at the same time that it is far less pernicious in the sum of its consequences. From such verses the Poems in these volumes will be found distinguished at least by one mark of difference, that each of them has a worthy *purpose*. Not that I mean to say, that I always began to write with a distinct purpose formally conceived; but I believe that my habits of meditation have so formed my feelings, as that my descriptions of such objects as strongly excite those feelings, will be found to carry along with them a *purpose*. If in this opinion I am mistaken I can have little right to the name of a Poet. For all good poetry is the spontaneous overflow of powerful feelings; but though this be true, Poems to which any value can be attached, were never produced on any variety of subjects but by a man who being possessed of more than usual organic sensibility had also thought long and deeply. For our continued influxes of feeling are modified and directed by our thoughts, which are indeed the representatives of all our past feelings; and as by contemplating the relation of these general representatives to each other, we discover what is really important to men, so by the repetition and continuance of this act feelings connected with important subjects will be nourished, till at length, if we be originally possessed of much organic sensibility, such habits of mind will be produced that by obeying blindly and mechanically the impulses of those habits we shall describe objects and utter sentiments of such a nature and in such connection with each other, that the understanding of the being to whom we address ourselves, if he be in a healthful state of association, must necessarily be in some degree enlightened, his taste exalted, and his affections ameliorated.

I have said that each of these poems has a purpose. I have also informed my Reader what this purpose will be found principally to be: namely to illustrate the manner in which our feelings and ideas are associated in a state of excitement. But speaking in less general language, it is to follow the fluxes and refluxes of the mind when agitated by the great and simple affections of our nature. [. . .]

[T]he human mind is capable of excitement without the application of gross and violent stimulants; and he must have a very faint perception of its beauty and dignity who does not know this, and who does not further know that one being is elevated above another in proportion as he possesses this capability. It has therefore appeared to me that to endeavour to produce or enlarge this capability is one of the best services in which, at any period, a Writer can be engaged; but this service, excellent at all times, is especially so at the present day. For a multitude of causes unknown to former times are now acting with a combined force to blunt the discriminating powers of the mind, and unfitting it for all voluntary exertion to reduce it to a state of almost savage torpor. The most effective of these causes are the great national events which are daily taking place, and the encreasing accumulation of men in cities, where the uniformity of their occupations produces a craving for extraordinary incident which the rapid communication of intelligence hourly gratifies. To this tendency of life and manners the literature and theatrical exhibitions of the country have conformed themselves. The invaluable works of our elder writers, I had almost

said the works of Shakespear and Milton, are driven into neglect by frantic novels, sickly and stupid German Tragedies, and deluges of idle and extravagant stories in verse. – When I think upon this degrading thirst after outrageous stimulation I am almost ashamed to have spoken of the feeble effort with which I have endeavoured to counteract it; and reflecting upon the magnitude of the general evil, I should be oppressed with no dishonorable melancholy, had I not a deep impression of certain inherent and indestructible qualities of the human mind, and likewise of certain powers in the great and permanent objects that act upon it which are equally inherent and indestructible; and did I not further add to this impression a belief that the time is approaching when the evil will be systematically opposed by men of greater powers and with far more distinguished success.

Having dwelt thus long on the subjects and aim of these Poems, I shall request the Reader's permission to apprize him of a few circumstances relating to their *style*, in order, among other reasons, that I may not be censured for not having performed what I never attempted. Except in a very few instances the Reader will find no personifications of abstract ideas in these volumes, not that I mean to censure such personifications: they may be well fitted for certain sorts of composition, but in these Poems I propose to myself to imitate, and, as far as is possible, to adopt the very language of men, and I do not find that such personifications make any regular or natural part of that language. I wish to keep my Reader in the company of flesh and blood, persuaded that by so doing I shall interest him. Not but that I believe that others who pursue a different track may interest him likewise: I do not interfere with their claim, I only wish to prefer a different claim of my own. There will also be found in these volumes little of what is usually called poetic diction; I have taken as much pains to avoid it as others ordinarily take to produce it; this I have done for the reason already alleged, to bring my language near to the language of men, and further, because the pleasure which I have proposed to myself to impart is of a kind very different from that which is supposed by many persons to be the proper object of poetry. [...]

If I had undertaken a systematic defence of the theory upon which these poems are written, it would have been my duty to develope the various causes upon which the pleasure received from metrical language depends. Among the chief of these causes is to be reckoned a principle which must be well known to those who have made any of the Arts the object of accurate reflection; I mean the pleasure which the mind derives from the perception of similitude in dissimilitude. This principle is the great spring of the activity of our minds and their chief feeder. From this principle the direction of the sexual appetite, and all the passions connected with it take their origin: It is the life of our ordinary conversation; and upon the accuracy with which similitude in dissimilitude, and dissimilitude in similitude are perceived, depend our taste and our moral feelings. It would not have been a useless employment to have applied this principle to the consideration of metre, and to have shewn that metre is hence enabled to afford much pleasure, and to have pointed out in what manner that pleasure is produced. But my limits will not permit me to enter upon this subject, and I must content myself with a general summary.

I have said that Poetry is the spontaneous overflow of powerful feelings: it takes its origin from emotion recollected in tranquillity: the emotion is contemplated till by a

species of reaction the tranquillity gradually disappears, and an emotion, similar to that which was before the subject of contemplation, is gradually produced, and does itself actually exist in the mind. In this mood successful composition generally begins, and in a mood similar to this it is carried on; but the emotion, of whatever kind and in whatever degree, from various causes is qualified by various pleasures, so that in describing any passions whatsoever, which are voluntarily described, the mind will upon the whole be in a state of enjoyment. Now if Nature be thus cautious in preserving in a state of enjoyment a being thus employed, the Poet ought to profit by the lesson thus held forth to him, and ought especially to take care, that whatever passions he communicates to his Reader, those passions, if his Reader's mind be sound and vigorous, should always be accompanied with an overbalance of pleasure. Now the music of harmonious metrical language, the sense of difficulty overcome, and the blind association of pleasure which has been previously received from works of rhyme or metre of the same or similar construction, all these imperceptibly make up a complex feeling of delight, which is of the most important use in tempering the painful feeling which will always be found intermingled with powerful descriptions of the deeper passions. This effect is always produced in pathetic and impassioned poetry; while in lighter compositions the ease and gracefulness with which the Poet manages his numbers are themselves confessedly a principal source of the gratification of the Reader. I might perhaps include all which it is *necessary* to say upon this subject by affirming what few persons will deny, that of two descriptions either of passions, manners, or characters, each of them equally well executed, the one in prose and the other in verse, the verse will be read a hundred times where the prose is read once.

7 Friedrich Schlegel (1772–1829 from *Description of Paintings in Paris and the Netherlands in the Years 1802–04*

After the dissolution of the Jena circle in 1800, Friedrich Schlegel (see VIA1 and 2) gave a series of lectures in Berlin, before travelling to Dresden and then to France. From January to May 1802 he was in Dresden, where he met Philipp Otto Runge (see VIB5 and VIIA8) and enjoyed extensive conversations on painting with Ludwig Tieck (see VIB2). On an earlier visit to Dresden in 1789 he had responded primarily to classical works of art, and had been particularly impressed by Mengs' collection of casts from the antique. However, his growing interest in the poetry of the Middle Ages helped to make him unusually receptive to early Renaissance painting, which he was one of the first to champion. From June 1802 to 1804 he lived in Paris, studying Sanskrit in the Bibliothèque Nationale and exploring the collections of the Musée Napoléon, recently expanded with works appropriated from abroad. From 1803 to 1805 he edited the journal *Europa* and it was here that he published his important series of 'Descriptions of Paintings'. Combining both critical and descriptive writing, these essays explore the historical and national roots of early German, Flemish and Italian painting. Schlegel conceives the true source of art as 'feeling' and passionately advocates a return to genuinely religious art. In 1808 he converted to Catholicism and entered into the employment of the Austrian government. Between 1822 and 1825 he oversaw a collected edition of his works, revising many of the essays in the process. The following excerpts were originally published in *Europa*, volume II, part 2, nos 1 and 6,

1805. We have used the English translation by E. J. Millington in *The Aesthetic and Miscellaneous Works of Friedrich von Schlegel*, London: Henry G. Bohn, 1849, pp. 72–4, 88–91, 113–19, 143–8. This was made from the version published by Schlegel in his *Sämmtliche Werke*, volume VI, Vienna, 1823. It has been conjectured that the engraving by Albrecht Dürer (1471–1528) of Sikkingen riding through the wood is *Knight, Death and the Devil*. The painting by Albrecht Altdorfer (*c.*1480–1529) is *The Battle of Issus (Alexander's Battle)* in the Alte Pinakothek in Munich.

The art of painting having gradually abandoned its early office of adorning the sacred edifices of the Christian faith, and placing the mysteries of our holy religion more clearly and beautifully before the eyes of men than could be effected by words alone, became ere long frivolous and unmeaning, till, vacillating between misconceptions of the ideal and a faulty struggle after mere effect, it wandered still farther from the high object to which it had been originally devoted, and eventually degenerated into uninteresting and commonplace generalities. Every attempt to separate the theory of the art from its practice will in the same manner lead invariably either to empty generalities or fantastic dreams of the imagination. In pursuing, therefore, my present attempt to develope the true and correct principles of the art, I shall, instead of confining myself to a theoretical outline alone, accompany my observations by such an uninterrupted description of various old paintings as may amply suffice to illustrate the ideas suggested. This description will form an appropriate introduction to my subsequent remarks, the results of which will thus rise naturally, and arrange themselves according to certain general principles whose innate affinity and connection will be easily perceived by every reflecting mind.

It is true that no contemplation of works of art can be throughout entirely systematic, more especially at the present time; still the unconnected character of these observations need not by any means interfere with the general unity of the views set forth in the minds of those who have already imbibed correct ideas of the art; and it may be in a certain degree advantageous, as serving continually to remind us of a fact in the history of art, which ought never to be forgotten. A fragmentary form is indeed the most appropriate for observations on an art which is in itself no more than a fragment, the ruined remains of by-gone times. The great body of Italian paintings is torn in pieces and dispersed, and rarely, very rarely, indeed, do we see any attention given to the older masters of the Italian school, or to the study of their works, although the original idea and object of the art is far more simply and naturally expressed in their compositions than in those of a later period. The old German school is in even a more deplorable state, although its preservation is of equal, perhaps even of greater importance than the other, on account of the decided superiority it evinces in principles and technicalities, because also it was more true to the object of religion, and besides remained always pure painting, not infringing the limits which properly divide that art from others. Yet, both German and Italian schools are now almost entirely unknown. The art, as a whole, no longer exists, and a few vanishing traces alone remain which may again furnish ideas for future development to those who, alive to the spirit of the past, are prepared to imbibe them. As we proceed in our survey of modern art, this dismemberment appears to us under a new light. The paintings at present existing are not only dispersed throughout all

lands, and formed into the most heterogeneous collections, not one of which is altogether satisfactory and complete, but pictures requiring to be viewed and studied together are, on the contrary, widely distant from each other. Christian art is in itself but a fragment, and probably will never be completed; and although this is less palpably evident in painting than in the ruined towers and churches of Gothic architecture, many of which have remained unfinished during the last thousand years, and have been suffered in that state to fall into decay and ruin, the observation is equally true of painting, and applicable to the Italian no less than to the German schools.

* * *

How strangely do artists of the present day appear to vacillate in their choice of subjects! Sometimes having recourse to classical fables, to modern French, or Celti-Ossianic figures and subjects: or possibly to such as have no existence at all, except in the brain of the bewildered artist, lost amid the mazes of false and erroneous theories. Were it not better to return at once to the beaten track of the old Italian and German masters? We should find in it no lack of materials, and those persons who imagine the circle of designs from Christian subjects would soon be exhausted, are most completely mistaken. Let them but examine attentively the series of Albert Dürer's engravings, – how rich a fund of new and profound ideas do these supply! I do not refer exactly to the apocalyptic wood-cuts, because, however profound the meaning they convey, these would, especially to the youthful artist, prove most dangerous guides. Yet, what originality is there in Dürer's treatment of ordinary subjects! His varied designs of the Crucifixion are familiar, and require no further notice here; so also his conceptions of the Virgin. Where, even among the greatest masters, can we find a Madonna superior to that of Dürer at Dresden, known by the name of the 'Immaculate Conception,' in which the Blessed Virgin is represented with the moon beneath her feet, the crown of heaven hovering as it were above her head, and her long hair flowing round her, like a veil, even to the hem of her garment? Where can you find a picture so truly and vividly representing the Queen of Heaven in all her divine majesty and loveliness, and at the same time so perfect as a work of art, and so entirely consonant with the symbolism of ancient Christianity? How rich, too, how finely imagined is his 'Madonna in the Garden,' the silent solitude of which, adorned with varied and beautiful plants, with here and there some curious animals, seems amplified into an abstract symbol of external nature! How vigorous, and at the same time incomparably true to nature, are his attempts to portray the Mother of God in her mortal condition, surrounded by domestic cares, – the infant Saviour, playing with angels in the workshop of his nominal earthly father! Where else can such pictures be found – and yet are they not almost necessary accompaniments of our belief? If the image of the star-crowned Madonna, with the planets at her feet, belongs intrinsically to the sphere of Christian ideas, her picture as the personification of spiritual love in the very heart and centre of the blooming garden of nature, lies surely very near to the same circle. Such paintings must undoubtedly be of great rarity, for we cannot point out one resembling either of these, in the collections of Dresden or Düsseldorf, Paris or Brussels, rich as those collections are in oil-paintings, and antique treasures. In the Salon of Ancient Paintings at Brussels, there is one very early picture of the Madonna, with the crown on her head and

the moon beneath her feet, but it is far from giving all the signification of which so lofty an idea is susceptible. Were there any painters of merit now to be found, who, emancipating themselves from the trammels of modern errors and innovations, had entered upon their course in the true spirit of ancient art, what could be a more worthy office for any noble and wealthy patron, than by a suitable and most invaluable gift to encourage the young artist to employ his genius on appropriate subjects, and with this object, to select for him some of the grandest and most beautiful of Dürer's unexecuted designs? Still, it must be remembered, leaving him at liberty to alter whatever is unpleasing to modern taste, or appears imperfect in form, or not essential to the general effect. It was probably in this hope, and with this intention, that our great master bequeathed to posterity the unbroken series of his designs: the outpouring of that inexhaustible activity, which yet could not suffice for the systematic development of all his profound ideas. These plates ought, therefore, to be considered as a collection of fragments of artistic thoughts, a store of creative art-ideas, and not merely as studies, nor as copies from paintings, uncoloured, and in every respect most imperfect. Engravings on copper merit the highest approbation and esteem as previous studies or sketches, preparatory to the execution of a perfect work; and Dürer's should undoubtedly be viewed in that light; hatched hard upon the copper, they will never please the eye at the first glance, yet the outline alone is amply sufficient to realise all that Dürer wished to effect. The engraving of the Sikkingen riding through the wood, shows sufficiently the perfection of Dürer's finished plates of this description. In this we are scarcely sensible of the absence of colour, but on the contrary return again and again to the study of a good impression, as we should do of a good picture; and although it seems impossible for colourless outlines to attain that inexhaustible individuality of character and expression, which is the privilege and property of the all-pervading elements of colour alone, yet the impossible is here attempted and almost attained; as many other great masters have been seen to carry their art to the utmost limit of its peculiar province, and even (feeling the path of return secure) venture for a moment daringly to overstep the boundary. It is this which makes the example of the great luminaries of the art so dangerous to feeble imitators, who venture thoughtlessly to tread a path in which they must find themselves unprepared. Thus Dürer, and many great Italian masters, innocently contributed to the diffusion of erroneous principles in the new school, and to that all-destroying separation between design and colouring, which is no less fatal to the theory of the art than to its mechanical execution. Thus the teaching of Socrates, who first distinguished between the beautiful and the necessary, laid the earliest foundation of inconsistency; thus the erroneous principles supported by Descartes, asserting the absolute distinction of soul and body, and setting an awful gulf between the two, necessarily gave birth to all the succeeding errors of philosophy; and thus also the prevailing error of dividing painting as an art into the distinct branches of design and colouring, has become the fruitful source of all subsequent errors and aberrations. Dürer especially, like so many of those old philosophers, set a far higher value on truth than on personal fame; and feeling it impossible to bring to perfection the entire abundance of his ideas, confidingly bequeathed the designs alone to the world at large. During a short period, some, among his contemporaries and followers employed them sometimes even without acknowledgment, till there

arose at last a feeble generation, incapable of completing or even of comprehending his ideas: ere long, they ceased to be esteemed, and in process of time were entirely forgotten. When after contemplating this splendid collection of Dürer's, I turn to all the throng of sketches and copper-plate designs among which we now live, he appears to me like the originator of a new and splendid system of thought, burning with the zeal of a first pure inspiration, eager to diffuse his deeply conceived, and probably true and noble views; and all the heap of frivolous sophists and sweet explainers succeeding him seem like those would-be connoisseurs, whose prattle is now to be heard in all markets both among the amateurs of art, and in every-day life.

* * *

[There is] a little composition of Altdorfer's with figures of one or two inches in height. I scarcely know whether to call it a landscape, an historical painting, or a battle-piece, – it is indeed all these combined, and much more. I cannot describe the astonishment I felt on first beholding this wonderful work. It was as if to one familiar only with the light, graceful verse of the Italians, and aware of no higher order of poetry, the magic world of Shakespeare's genius were suddenly unfolded in all its glorious creations. This simile, however, applies only to the depth and richness of the *poetry* in Altdorfer's painting, not to the romantic spirit which reigns supreme throughout it; so remarkably, indeed, that we might justly style it chivalric. It represents the victory of Alexander the Great over Darius. But there is no servile imitation of the Greek manner; it rather resembles the stories of old knight-errantry, as related in the romantic poetry of the middle ages. The costume is German and knightly; both men and horses clad in steel, with surcoats of gold and embroidery. The chamfrein on the heads of the horses, the glittering lances and stirrups, and the rich variety of the armour, form a scene of indescribable beauty and splendour. There is neither blood, nor any object likely to excite disgust and horror, – no severed or distorted limbs; only in the immediate foreground, if examined very closely, we discover under the feet of the charging hosts on either side, in their impetuous onset, many piles of corpses, lying thickly together, like a web, and forming, as it were, the groundwork to this world of war and arms, of glancing steel, and still more glittering fame and chivalry. It is, in truth, a little world comprised within a few square feet of canvas. The innumerable hosts of combatants advancing on all sides appear inexhaustible, and the distant landscape seems also to lose itself in immensity. The wide ocean stretches before us in the distance; an historical error, if you will, but which is made the vehicle of a lofty and speaking allegory. We see the sea, with lofty cliffs on either side, and a rugged island lying between them, ships of war and whole fleets of other vessels; on the left the sinking moon, and the sun rising on the right, form a striking and correct emblem of the event represented. The armies are arranged in rank and column, without any of the strange contrasts and distortions common in battle-pieces; indeed, with so vast a number of figures, this would have been impossible. It has the order, perhaps it may be termed formality, of the old school. The character and execution of the little figures is wonderful, and would not be unworthy even of Dürer. Let it be remarked, once for all, that the solidity of execution apparent in this picture, notwithstanding the injuries it has sustained, is superior to any we meet with even among *good* masters of the Italian school, and belongs only to the early German. What variety of expression is there, not in the

individual knights and warriors alone, but in the whole assembled armies! Here columns of black archers rush down the mountains, with the impetuosity of a sweeping torrent, while added numbers press on behind them. On the other side, high above, among the rocks, a scattered body of the flying is seen, turning into a narrow defile. Little can be distinguished except their helmets, glittering in the sun; and yet the whole scene, even in that remote distance, is most expressive. The point of highest interest stands out brilliantly in the centre, as the general focus of the composition, – Alexander and Darius, both glittering in armour of burnished gold. Alexander, mounted on Bucephalus, with lance in rest, and advancing far before his followers in eager pursuit of the flying Darius, whose charioteer has already fallen on his white horses, while Darius looks back upon his conqueror with all the rage and despair of a vanquished king. One may withdraw to so great a distance from this picture, that nothing else can be discerned, and yet this group is still clearly defined, and excites feelings of the deepest sympathy. It is a little Iliad on canvas, and by the mute language of its colouring, might instruct those who abandon the holy path of catholic symbolism in quest of new and grand subjects, and aim at producing really romantic compositions, how the stirring spirit of chivalry ought to be expressed.

[. . .] We can scarcely hope to see a revival of art in Germany until we possess some art-loving prince of German origin and temperament, or until some connoisseurs and investigators of the art arise, who being able to devote their lives to that sole object, seek to unite in one great body all the now-existing and widely-scattered compositions of the old German schools. The mingling rays of German art being thus concentrated in one focus, their effect would be inconceivably heightened, and they would prove at least as valuable and surprising as any exhibition of the assembled treasures of Greek or Italian art. The ancient Germans were peculiarly grand and original in their works, though modern ignorance is unacquainted with them; and a shallow rage for imitation, in bitter self-contempt, seeking the darkness, refuses to acknowledge it. But has this copying ever produced anything excellent in any art? Nothing, – nothing throughout! except what is either preposterous or completely shallow and useless. The poet who suffers his fancy to stray and luxuriate in distant regions, may perhaps be pardoned, yet even poetry must return from its quest of foreign treasures, and seek at home for what forms the closest point of union of feeling and of poetry among his own people and in his own times, or his poetry will be ever cold and feeble. The intellect, however, and the imitative art, become choked up, restricted in their length and breadth by such apparent improvement in variety. Certain circumscribed boundaries are necessary to the vigorous and successful development of the peculiar feeling of the art, and of what it ought to effect. Truths, dictated by reason, are universal. Imagination loves to wander in the unknown distance, but reason seeks rather to pierce to the lowest depth, and latent origin of what is near to us and around, and so to reproduce it in painting, that in this new-born and clear representation of the incomprehensible mystery of nature, an impulse from the heart may suddenly break through, uttering as it were unspeakable words; while imitation can find none more lofty or expressive than have been already heard. Springing from what is near and peculiar to us, the character of the art will infallibly be local and national. We may trace the general proportions of a beautiful figure according to a certain type or idealization, but to preserve a distinct individuality of

expression and of countenance is also of the highest importance. As long as the art devoted itself to the service of the church and of religion within the mysterious circle of symbolism, that spiritual beauty and holy signification which is the same in all Christian countries, of course supplied the first and highest distinction to which national characteristics must ever be held subordinate. Still this latter element is not to be blotted out, nor entirely lost; it must rather interweave itself with each higher attribute, and thus give to the arrangement of the whole that sensible grace and living charm which are so peculiarly its own. It has already been remarked, that in the works of the oldest masters of the Italian school the national features and physiognomy are so marked as often to appear harsh and glaring, while in the later period all these characteristics disappear in a general ideality, becoming by degrees completely frivolous and characterless. The reverse appears, generally speaking, to be the case with the Germans. In their earliest pictures, designed after the Greek style, a holy symbolism and severe dignity of devotional expression predominate, while the actual characteristics of the people in features and costume are first remarked in a much later period; then it is true, so glaringly brought forward, as often to appear harsh and almost caricatured. This is especially to be observed in Lucas van Leyden and his contemporaries of the Netherlands. The vivacity and varied expression with which Dürer seized and depicted the German national features, contributed to preserve a less variable character in the upper German schools, which in them ever remained predominant, and in time assumed a heavy, dull breadth of expression. It must not, however, be overlooked, that in the schools of the Netherlands, at their best period, all these elements were most happily blended, as in Van Eyck, and Hemling, who united the deep symbolism of devotion and holy beauty with a German abundance of feeling and expression. Nay, Meister Wilhelm, of Cologne, nearly as he assimilates to the Greek style, still in the calm godliness which forms the general characteristic of his pictures, and of his conceptions of the Madonna in particular, and of other glorified saints, clearly indicates a tendency to the rejoicing life of the German manner at that period. We trace this in the countenances, as well as in the surrounding groups of figures, and a certain fantastic richness and delicacy in the many-coloured robes and costume. The study of these lively characteristics and national peculiarities is of especial importance at the present time, as forming a necessary element of every vivid representation, and one in which modern art is most deficient, being more in danger of losing itself in the abstract generalisation of an ideal, equally feeble and frivolous, than of falling into errors of an opposite tendency. Until the amalgamating confusion of later times, every nation had its own distinct features, in manners, customs, feeling, and physiognomy, and equally national peculiarities in music, painting, and architecture. How, indeed, could it be otherwise? Much has been said concerning the universality of beauty, and the art, as unrestricted by the limits of any locality, yet never has a single spot been discovered in which it can successfully throw off the peculiar characteristics of the sphere in which it exists. Certainly the attempts hitherto made on this principle give us little reason to anticipate much advantage from the promulgation of this new faith. The Greeks and Egyptians, the Italians and Germans, all became great in art while it was confined within severe and well-defined limits, and in all alike we may date their decline from that high eminence at the period when indiscriminate imitations were first practised.

The excellence of painting, in particular, which can present an outline only of material forms, depends greatly on its power of seizing both the purely spiritual and the individual expression of those forms, and it should so employ the magic of colouring, as to embody and retain the exact proportions and appropriate ideality of each object, as existing in different nations and localities. The artist will do well to adopt and act upon the well-grounded principles of Dürer, who, when would-be critics blamed his manner of painting, and strove to turn him from his path, replied, 'I will paint nothing antique.' In him the many magnificent works of art displayed at Venice excited no false attempt to imitate the Italian style, for he held it much better to remain true to his own deeply-studied art. He had no higher ambition than to paint as a German, striving to attain the highest perfection in that style, and fully carrying out the vigorous and energetic principles of the upper German school. He united and blended with them the varied vivacity and rich imaginative faculty of the lower German masters; a manner which harmonises entirely with the inconceivable treasures of his own creative genius, and, indeed, is almost necessary to their full development.

* * *

And now, in conclusion, one question arises, standing in close connexion with the chief object of all our observations and reflections. Is it probable that in this present time we shall see either the rise or the permanent establishment of a grand original school of painting? Outward appearances would lead us to reply in the negative; but can we assert its utter impossibility? It is true, certainly, there are no modern artists capable of competing with the great masters of antiquity, and the points in which our attempts are most deficient appear also tolerably clear: partly, a neglect of technical proprieties in the colouring, and, still more, the absence of deep and genuine feeling. Modern artists even of the most judicious and well-directed talents are often found deficient in productive activity; in that certainty and facility of execution which was so peculiar a feature in the old schools. When we consider the infinite number of great compositions which Raphael produced, although snatched away in the bloom of age and the zenith of his fame, or the iron industry of the genuine Dürer, displayed in his innumerable creations of every kind, executed on the most various materials, although to him also a long term of years was denied, we shrink from comparing our own puny period with the vast proportions of that majestic epoch. Yet this is easily accounted for. The habit of universal painting, and the intellectual vanity which was a prevailing bias in the genius and art of our forefathers, naturally led to the breaking up of its spiritual strength, since these properties were most incompatible with the progressive development and final perfection of any one distinct branch. To this source we may refer the separation now existing, in a greater or less degree, between all the intellectual and imitative productions of our time; but in regard to the art of painting, the following observations deserve to be noted as of primary importance. Deep feeling is the only true source of lofty art, and as in our time everything is opposed to this feeling, struggling, as it were, either to destroy, repress, overwhelm, or lead it astray into the by-paths of error, the first portion of an artist's life is consumed in a preliminary struggle, ere the mind can enfranchise its powers from all the unspeakable difficulties imposed by the spirit of the time; a struggle unavoidably necessary, in order to unseal the spring of correct artistic feeling, and free it from the encumbering rubbish of the destroying outer world around.

A highly intellectual nature, spurning the trammels and conventionalities of the day, and rising in daring opposition to the ruling spirit, must ever concentrate its powers within itself, and can rarely attain great vivacity in the creative faculty of imagination. Thus we may account for the slow appreciation of ancient art in our day; but pressing onward with unshaken ardour in spite of all obstacles, it will at length attain a brighter future, and bloom out with new and glorious life in the realms of beauty and inspiration. There appears to be an unfathomable mystery in the fact that some periods, by their own will alone, and apparently without any outward stimulus, become so rich in art, so happy in their artistic productions, while others seem to expend their energy in vain, meeting with no corresponding nor even adequate success in their intellectual productions. It is impossible fully to unravel the mystery, and we must depend only on facts well known and understood, which will prove amply sufficient to guide us to the source of all lofty works of art, and the proper means and materials to be employed; this will lead to the working out of scientific principles, and the conservation of everything beautiful in Christian art, although without the especial gifts of nature, the summit of artistic excellence will ever remain unapproachable.

The one true fountain of beauty and the art is *feeling*. It is *feeling* which reveals to us true ideas and correct intentions, and gives that indefinable charm, never to be conveyed in words, but which the hand of the painter, guided by the poet's soul alone, can diffuse throughout all his works. From religious feeling, love, and devotion, arose the silent inborn inspiration of the old masters: few, indeed, now seek their hallowed inspiration or tread the paths by which alone they could attain it, or emulate that earnest endeavour to work out the principle of serious and noble philosophy which is discoverable in the works of Dürer and Leonardo. Vain will be every effort to recall the genius of the art, until we summon to our aid, if not religion, at least the idea of it, by means of a system of Christian philosophy founded on religion. Still, if young artists deem this road too distant or too difficult of attainment, let them at least study deeply the principles of poetry, in which the same spirit ever breathes and moves. Not so much the poetry of the Greeks, now familiar only to strangers and the learned, or read through the medium of translations from which every poetical association is banished by the wooden clapper-clang of the dactyls, but rather the romantic genre – Shakspeare, and the best Italian and Spanish dramatists, those also of the old German poems which are most accessible, and next such modern productions as are dictated by the spirit of romance. These should be the constant companions of the youthful artist, and will lead him back to the fairy-land of old romantic days, chasing from his eyes the prosaic mist engendered by imitation of the pagan antique, and the unsound babble of conventional art. Still every effort will be fruitless, unless the painter be endowed with earnest religious feeling, genuine devotion, and immortal faith. Fancy sporting with the symbols of catholicism, uninspired by that love which is stronger than death, will never attain exalted Christian beauty.

In what, then, does this exalted beauty consist? It is of the first importance to analyse the good and evil tendency of all theories of the art. Whoever has not himself discovered the fountain of life can never successfully guide others to the source, or unfold to them the glorious revelations of the painter's art; he will rather wander

perplexed amid the dreamy visions of mere external representations, and the creation of his imagination, being totally void of expression and character, will become in fact a mere nonentity. The true object of the art should be, instead of resting in externals, to lead the mind upwards into a more exalted region and a spiritual world. While false-mannered artists, content with the empty glitter of a pleasing imitation, soar no higher, nor ever seek to reach that lofty sphere, in which genuine beauty is portrayed according to certain defined ideas of natural characteristics. It finds on its path the most vivid development of all sensible forms; the fascination of grace, the highest natural bloom of youthful beauty, yet endowed rather with sensual fascination than the inspired loveliness of the soul. When heathen artists attempt to take a higher range, they wander into exaggerated forms of Titanic strength and severity, or melt into the solemn mournfulness of tragic beauty, and this last is the loftiest point of art that they can ever reach, and in which they do sometimes approach nearly to immortality. Here, however, their lofty flight is terminated: the path of spiritual beauty is barred on the one hand by a Titan-like exaggeration, striving to take heaven and the divinity by violence, yet failing in the power to accomplish its endeavour; on the other by an eternal grief, for ever plunged in mortal agony, in the hopeless bondage of its own unalterable doom. The light of hope dawned not on heathen intelligence; impassioned grief and tragic beauty bounded their purest aspirations. Yet this blessed light of hope, borne on the wings of trusting faith and sinless love, though on earth it breaks forth only in dim anticipations of a glorious hereafter, – this glorious hope, radiant with immortality, invests every picture of the Christian era with a bright harmony of expression, and fixes our attention by its clear comprehension of heavenly things, and an elevated spiritual beauty which we justly term Christian.

Many paths, old as well as new, must be tried and broken up before that certain road is laid open, in which renovated art may securely tread, and attaining the long-sought goal, bloom forth in high religious beauty. Here and there, perhaps, extremes may seem to produce the same effect, and it would not be astonishing if in the present universal tendency to imitation, some genius, conscious of its powers, should break forth into a longing desire for absolute originality. If such a genius were penetrated with a true idea of his art, justly esteeming that symbolic expression and revelation of divine mysteries which is its sole appropriate object, and regarding all besides merely as the means, the working members, or characters which, duly combined, produce a correct expression, his compositions would probably be the foundation of quite a new style: genuine hieroglyphic symbols, the simple offspring of nature and natural feelings, but drawn from individual conceptions, and arbitrarily thrown together rather than in accordance with the ancient methods of an earlier world. Every such picture might well deserve to be called a hieroglyphic, or divine symbol; and the question now to be considered is, whether a painter ought to trust thus implicitly to his own genius for the creation of his allegories, or confine himself to the adoption of those old symbols, which have been handed down to us, hallowed by tradition, and will always, if rightly understood, prove sufficiently expressive and effective. The first method is unquestionably the most dangerous, and its results would appear to be accidental if, of many who tried the same path, a few only reached the same point of excellence. Success would be uncertain, as has so long been the case with the sister art

of Poetry. There seems to be more safety in clinging to the old masters, especially to those of the very earliest date, assiduously emulating their unalterable truth and beauty, till it becomes a second nature to eye and soul. Next to the finest of the old Italians, for example, the style of the German masters well deserves our study, mindful that to that nation we also belong, and that the serious earnestness of its character, we, beyond all others, are bound to preserve. Thus we might hope to see combined the symbolically, spiritually beautiful, with the sure method of producing antique grace, whence, as from the very being of the art, even though all knowledge of it were lost, true poetry and science must proceed. The old German style is not only more accurate, and skilful in mechanism than the Italian in general, but it also adhered longer and more faithfully to that wonderful and profoundly true Catholic-Christian symbolism, whence they drew far more precious treasures than were granted to those who suffered their imagination to wander into the merely Jewish subjects of the old Testament, or digressed still farther into the province of ancient Greek mythology.

The Italian schools, indeed, though far superior to those of Upper Germany, can scarcely, even in ideal grace, claim precedence of those of Lower German art, if we judge of its excellence from the period of its maturity, when Wilhelm of Cologne, John Van Eyck, and Hemling [Memling] flourished, and not from later and more degenerate times. We should remember, especially, that an artist ought not to seek, nor expect to attain, the perfect antique by adopting the Egyptian style in the almost image-like position of the feet, the scanty draperies, and long narrow half-shut eyes, any more than by copying bad designs and actual errors or defects. These, in truth, are but the indications of a *false* taste, and have no more affinity with the real Christian antique than the little esteemed imitative manner of the old Germans. The beauty of early Christian art consists not so much in the external parts as in the tranquil, pious spirit universally pervading; and the cultivation of this spirit will give inspiration to the painter, guiding his steps to the pure neglected source of Christian beauty, till at length a new dawn shall break the darkness of the horizon, and shine forth in the clearest meridian splendour throughout the compositions of reviving art.

8 Friedrich Schelling (1775–1854) from 'Concerning the Relation of the Plastic Arts to Nature'

The philosopher Friedrich Schelling was born in Leonberg, near Stuttgart. From 1790 to 1792 he studied at the Tübingen Stift alongside Hölderlin and Hegel (see VA15). He published his first important work, *Ideas for a Philosophy of Nature*, in 1797. The following year he was elected to a chair in philosophy at the University of Jena, where he soon made contact with Friedrich and August Wilhelm Schlegel (see VIA1, 2, 7 and 9), Novalis (see VIA3) and Ludwig Tieck (see VIB2). He lectured on the philosophy of art at Jena from 1802–3 and again in Würzberg from 1804–5. However, his most accessible work on the subject is contained in the address which he gave to the Munich Academy of Sciences in 1807, 'Concerning the Relation of the Plastic Arts to Nature'. Although he accepts the traditional definition of art as imitation of nature, he contends that the concept of nature has consistently been left ambiguous. Rather than elevating the human mind over an inert

realm of nature, we need to recognize a profound interconnection between the two domains. For Schelling, 'spirit is invisible nature' and 'nature is visible spirit.' Not only does nature first come to consciousness in the human mind, but human mental activity is itself part of an already spiritualized nature. Describing nature as 'the world's holy, eternally creating primal energy, which engulfs and actively brings forth all things out of itself', he contends that the same creative principle which animates nature should animate the work of art, thereby overcoming the division between the two. The address was first published as a separate volume under the title *Über das Verhältnis der bildenden Künste zu der Natur*, Landshut: Philipp Krull, 1807. It was reprinted in Schelling's *Philosophische Schriften*, volume 1, Landshut, 1809. The following excerpts are taken from the translation by Michael Bullock in Herbert Read, *The True Voice of Feeling: Studies in English Romantic Poetry*, London: Faber and Faber, 1953, pp. 323–7, 329–32, 335–8. We have omitted the author's footnotes, which were added in the second edition of 1809. The 'profound philosopher' mentioned in the text is Johann Georg Hamann (see IIIB12).

How much sensibility, thought and judgment has been expended upon art since long ago! How then could this lecture hope to give the subject a new attraction in such an eminent gathering of the most enlightened connoisseurs and the most penetrating critics, if that subject did not disdain alien embellishment and rather enable the lecture to reckon with some part of the universal favour and acclaim enjoyed by itself! For other subjects have to be exalted by eloquence, or, if there is something extravagant about them, rendered credible by exposition. Art, however, has the advantage of being visibly present, so that doubts which may otherwise be voiced as to the validity of the assertion that a perfection exceeding in sublimity the common level has been attained, meet a counter-argument in the fact that, in this domain, what was not apprehended in the idea appears incarnate before the eyes. Of additional assistance to the lecture is the consideration that the many theories formulated about this subject have still made far too little attempt to trace art back to its wellsprings. For most artists, though they are supposed to imitate the whole of nature, seldom achieve a conception of what nature's essence is. But experts and thinkers, on account of nature's greater inaccessibility, generally find it easier to derive their theories from the contemplation of the soul than from a science of nature. Such theories, however, are usually far too superficial; in general, they make a number of statements concerning art which are good and true, but which are ineffectual for the plastic artist and entirely fruitless for his practical work.

For plastic art, according to the most ancient definition, is wordless poetry. Without doubt, the author of this statement meant to imply that, like those spiritual thoughts, it should express ideas whose source is the soul, not, however, by means of speech, but, like silent nature, by configuration, by form, by sensuous works which are independent of it. Plastic art, therefore, manifestly occupies the position of an active link between the soul and nature, and can only be comprehended in the living centre between the two of them. Indeed, since it shares this relation to the soul with every other art, including poetry, that which binds it to nature and constitutes a productive force similar to the latter is the only element which remains its peculiar possession: upon this alone, therefore, can a theory be erected which will satisfy the intelligence and be helpful and profitable to art itself.

For this reason we hope, by looking at plastic art in relation to its true model and fountainhead, nature, to be able to contribute something as yet unknown to its theory, to provide some more precise definitions or elucidations of concepts; but above all, to make the inter-relationship of the whole structure of art manifest in the light of a higher necessity.

But has not science, then, recognized this relation from the beginning? Indeed, has not every recent theory started from the definite principle that art should imitate nature? This was true enough: but of what avail was this broad general principle to the artist, in view of the ambiguity of the concept nature and the fact that there are almost as many notions of it as there are different modes of living? To the one it is no more than the dead sum of an indefinite quantity of objects, or the space into which he thinks of things as placed, as into a receptacle; to the other it is merely the soil from which he extracts his food and his livelihood; only to the inspired investigator is it the world's holy, eternally creating primal energy, which engenders and actively brings forth all things out of itself. The foregoing principle would be of high significance if it admonished art to emulate this creating energy: but there can be little doubt as to the sense in which it was intended, if one knows the general condition of the sciences at the time of its genesis. It would be strange if just those who denied all life to nature had set it up as a pattern for art. The words of that profound thinker could have applied to them: Your lying philosophy has done away with nature, and why do you demand that we should imitate it? So that you may take fresh pleasure in exercising the same deed of violence upon nature's pupils?

To them, nature was not merely a dumb, but an absolutely dead image, to which even inwardly no living word was innate: an empty scaffolding of forms of which an equally empty image was to be transferred to the canvas or hewn in stone. This was the right theory for those ancient, crude peoples who, since they saw nothing divine in nature, brought forth idols out of it; while to the perceptive Hellenes, who everywhere felt traces of a vitally operative essence, true gods emerged from nature.

And is the pupil of nature supposed then to imitate all and everything in it indiscriminately? He is only supposed to reproduce beautiful objects, and of these only the most beautiful and perfect elements. The principle is thus more closely defined, but this very definition is an assertion that in nature the perfect is mingled with the imperfect, the beautiful with the unbeautiful. Now, how is the man whose relation to nature is solely that of servile imitation to distinguish the one from the other? It is in the nature of an imitator that he more readily assimilates the faults of his original than its merits, because the distinguishing features of the former are more easily grasped and manipulated; and so too we see that, by the imitators of nature in this sense, the ugly has been more frequently and even more lovingly imitated than the beautiful. If we do not look at things in terms of their inner essence, but only in terms of their empty, abstracted form, they in their turn say nothing to our inner being; we must set our own minds, our own spirits in operation before they will answer us. But what is each thing's perfection? Nothing else than the creative life within it, its power to exist. That deep process, similar to the chemical, by which the pure gold of beauty and truth emerges as though refined in the fire will never take place for him in whose eyes the whole of nature seems a dead thing.

There was no alteration in the main aspect of this relation when the inadequacy of the principle began to be more generally felt. Even Johann Winkelmann's splendid institution of a new theory and fresh knowledge made no difference to it. It is true that he re-established the whole operative function of the soul in art and raised it from ignoble dependence into the realm of spiritual liberty. Deeply moved by the forms of the plastic arts of antiquity, he taught that the production of an ideal figure, more noble than reality, together with the expression of spiritual ideas, was the highest purpose of art.

If, however, we examine the sense in which this surpassment of nature by art was for the most part understood, we find that even with this theory the view of nature as a mere product, of things as lifelessly existent, persisted and that it in no way served to arouse the notion of nature as living and creating. Thus it remained impossible to animate these ideal forms by any positive knowledge of their essence; and if the forms of reality were dead for the dead observers, those of art were no less so; if the former were incapable of self-active procreation, the latter were so too. The object to be imitated was changed, imitation itself remained. The place of nature was taken by the exalted works of antiquity, whose outward form the pupils were at pains to appropriate, but without the spirit which imbued it. However, these works are just as unapproachable, indeed even more unapproachable than those of nature, they leave you yet colder than the latter if you do not bring to bear upon them the spiritual eye that penetrates their husk and feels the force at work within them.

From the other side, artists since that time have admittedly received a certain ideal impetus and conceptions of a beauty more elevated than the material, but these conceptions were like fine words to which deeds do not conform. If earlier artistic practice produced a body with no soul, this view only taught the secret of the soul, but not that of the body. Theory, as is always the way, rapidly moved over to the opposite side, but it had not yet found the living centre.

* * *

Everywhere nature first confronts us in more or less hard form and closed in. It is like that serious and silent beauty which does not attract attention by clamourous signs, does not catch the common eye. How can we, so to speak, spiritually melt this apparently hard form, so that the unadulterated energy of things fuses with the energy of our spirits, forming a single cast? We must go beyond form, in order to regain it as comprehensible, living and truly felt. If you look at the most beautiful forms, what is there left once you have mentally eliminated the operative principle from them? Nothing but purely inessential qualities, such as extension and spatial relationship. Does the fact that one part of matter is beside and outside the other contribute anything to its inner essentiality, or does it rather contribute nothing whatever? Obviously the latter. It is not coexistence that makes form, but the kind of coexistence: this, however, can only be determined by a positive force, which rather runs counter to the existence of things outside one another and subordinates the manifoldness of the parts to the unity of an idea, from the force operating in a crystal to that which, like a gentle magnetic current, gives to the material parts in human constructions such an attitude and position in relation to one another as enables the idea, the essential unity and beauty, to become visible.

But it is not enough for essence in form to be manifest to us as the active principle in general, as spirit and practical science, for us to lay hold of it alive. All unity must be spiritual in kind and derivation, and what is the aim of all investigation of nature if not to find science itself therein? For that which contained no intelligence could not serve as an object for the intelligence either, what was without knowledge could not itself be known. The science by which nature operates is not, of course, one which, like the human, is linked to itself by reflection; in it the idea does not differ from the deed, nor the design from its execution. Hence raw matter tends, so to speak, blindly toward regular shape, and unwittingly assumes purely stereometric forms, which certainly appertain to the realm of ideas and are something spiritual within the material. The most sublime art of number and mensuration is inherent in the stellar system, which performs it in its movements without any notion of it. More distinctly, although beyond their own apprehension, is living knowledge manifest in animals, which we consequently observe achieving numberless effects that are much more splendid than they themselves: the bird which, intoxicated by music, surpasses itself in soulful notes, the little, artistically gifted creature which, without practice or instruction, accomplishes simple architectural works – all, however, conducted by a super-powerful spirit that gleams in single flashes of knowledge, but nowhere emerges as the full sun, as in man.

This practical science is, in nature and man, the link between idea and form, between body and soul. Every thing is ministered over by an eternal idea, designed in the infinite intelligence; but through what does this idea enter into reality and physical existence? Solely through creative science, which is just as necessarily linked to the infinite intelligence as, in the artist, that part of his being which apprehends the notion of non-sensuous beauty is linked to that which gives it sensuous representation. If that artist is to be called happy and pre-eminently deserving of praise upon whom the gods have bestowed this creative spirit, so will the work of art appear excellent in the degree to which it shows us this unfalsified natural force of creation and effectiveness contained, as it were, within a single outline.

It has long been perceived that not everything in art is the outcome of consciousness, that an unconscious force must be linked with conscious activity and that it is the perfect unanimity and mutual interpenetration of the two which produces the highest art. Works which lack this seal of unconscious science are recognizable by the palpable absence of a life which is autonomous and independent of their creator, while on the contrary, where it is in operation, art simultaneously imparts to its work, with the greatest lucidity of the intelligence, that unfathomable reality by virtue of which it resembles a work of nature.

The dictum that art, to be art, must first withdraw from nature and only return to it in its final consummation, has frequently been offered as an elucidation of the artist's position in relation to nature. It seems to us that the true meaning of this can be no other than the following. In all natural beings the living idea is manifested in blind operation only: if it were the same in the artist he would differ in no way from nature. If, however, he were consciously to subordinate himself entirely to nature and reproduce the existent with servile fidelity he would produce masks, but no works of art. Thus, he must withdraw from the product or creature, but only in order to raise himself to the level of creative energy and apprehend it spiritually. This bears him

aloft into the realm of pure ideas; he loses the creature, to regain it with thousandfold interest, and so return, in this sense at least, to nature. The artist ought indeed to emulate this spirit of nature, which is at work in the core of things and in whose speech form and shape are merely symbols, and only insofar as he has apprehended it in living imitation has he himself created something true. For works arising out of the combination of forms which are already beautiful in themselves would be devoid of all beauty, since that which now actually constitutes the beauty of the work or the whole can no longer be form. It is above form, it is essence, the universal, the vision and expression of the indwelling spirit of nature.

* * *

[...] Just as the whole of creation is a work of the greatest renunciation, so must the artist begin by denying himself and descending into the single-creature, not shunning separateness nor the pain, indeed the torment, of form. From its first works onward nature is entirely characteristic; the energy of fire, the flash of light it imprisons in hard stone and the lovely soul of sound in harsh metal; even at the threshold of life and with organic configuration already planned, it relapses into petrifaction, overcome by the power of form. The life of the plant consists in silent receptiveness; but within what a precise and strict outline is this patient life enclosed. Only with the animal kingdom does the struggle between life and form seem really to commence: its first works it conceals in hard shells, and where these are laid aside the animate world reunites with the realm of crystallization through the art impulse. Finally, it steps forth bolder and freer, and active living characters appear which are the same throughout whole genera. Admittedly, art cannot begin at such a deep level as nature. If beauty is equally distributed everywhere, there are nonetheless various degrees of the manifestation and evolution of the essence and, hence, of beauty: but art demands a certain fullness of beauty, and would like to strike up, not the single sound or note, nor even the separate chord, but the whole choral melody of beauty at once. It therefore prefers to seize directly upon that which is highest and most evolved, the human figure. For since it is not given it to encompass the immeasurable whole, and since there appear in all other creatures only single refulgences, in man alone existence full, entire and bereft of nothing, it is not only permissible but actually incumbent upon it to see the whole of nature in man alone. But just because the latter gathers together everything at one point, it also repeats its whole manifoldness and traverses the same path, along which it has already passed in its broad compass, for the second time in a narrower one. Here then arises the demand upon the artist first to be faithful and truthful in the limited, in order to emerge consummate and beautiful in the whole. Here it is a question of wrestling, not in flaccid and feeble, but in strong and courageous combat, with the creative spirit of nature which, in the human kingdom also, apportions character and stamp in unfathomable manifoldness. Restraining exercise in the recognition of that which renders the singularity of things positive must preserve him from emptiness, flabbiness and inner nothingness, before he dare aim at achieving the extreme of beauty in constructions of the greatest simplicity with infinite content, by means of the ever higher combination and ultimate fusion of manifold forms.

Only by the consummation of form can form be destroyed and this, of course, is the final goal of art in the characteristic. But just as apparent agreement comes more

easily to shallow souls than to others, but is inwardly valueless, so is it in art with swiftly achieved outer harmony devoid of the fullness of content, and if theory and teaching have to counteract the spiritless imitation of beautiful forms, they must also combat, above all, the inclination toward flabby, characterless art, whose bestowal of high-sounding titles upon itself merely serves to conceal its inability to fulfil art's basic conditions.

That sublime beauty in which fullness of form does away with form itself was assumed by the new theory of art after Winkelmann to be not only the highest, but the only standard. Because the deep foundation on which it rests was overlooked, however, a negative conception even came to be formed of the sum total of everything affirmative. Winkelmann likens beauty to water drawn from the depths of the well, which is esteemed the more wholesome the less flavour it has. It is true that the loftiest beauty is without character; but it is without it in the same manner as we say the universe has no definite dimensions, neither length, breadth nor depth, because it contains them all in the same infinitude, or that the art of creative nature is formless, because the latter is not itself subordinated to any form. In this and no other sense can we say that Greek art in its highest manifestation ascends to the level of the characterless. It does not strive after this directly, however. Only from within the bonds of nature did it first aspire to divine beauty. No carelessly scattered grain, but only a deeply embedded kernel could have been the seed of this heroic growth. Only mighty movements of the feelings, only profound convulsions of the imagination by the all-animating, all-governing forces of nature could have imbued art with the indomitable vigour with which, from the rigidly enclosed earnestness of the constructions of early times to the works of overflowing sensuous charm, it remained ever faithful to truth and begot in the spirit the loftiest reality it is granted mortals to look upon. Just as their tragedy begins with the greatest steadfastness in moral conduct, so the starting point of their sculpture was the earnestness of nature and the stern goddess Athene the one and only muse of plastic art. This period is distinguished by the style which Winkelmann portrays as still harsh and severe, from which the ensuing or high style was only able to develop by the intensification of the characteristic to the point of sublimity and simplicity. In depicting the most perfect or divine characters it was not merely necessary for the fullness of forms of which the human character as a whole is capable to be united; this union has also to be of the kind that we can visualize in the universe itself, namely one in which the lower forms, or those related to lesser qualities, were subsumed under higher ones and finally all under one highest form, in which, to be sure, they were all mutually extinguished as particular forms, but endured in their essence and energy. If, therefore, we cannot term this lofty and self-sufficient beauty characteristic, insofar as we understand thereby the restriction or relativity of the phenomenon, nevertheless the characteristic continues to operate indistinguishably, as, in the crystal, although it is transparent, its texture is nonetheless preserved; every characteristic element plays its part, however slight, and contributes to the achievement of the sublime indifference of beauty.

The outward face or basis of all beauty is beauty of form. But since form cannot exist without essence, the presence of character as well can be seen or felt wherever there is form. Hence, characteristic beauty is beauty in its roots, from which alone

beauty as fruit can subsequently come into being; essence certainly outgrows form, but even so the characteristic still remains the ever effective fundament of the beautiful.

* * *

9 August Wilhelm Schlegel (1767–1845) 'The Spirit of True Criticism' from *A Course of Lectures on Dramatic Art and Literature*

August Wilhelm Schlegel, elder brother of Friedrich (see VIA1, 2 and 7), was born in Hannover. From 1786 to 1791 he studied classical philology and theology at Göttingen University. In 1795 he settled in Jena, where he edited the journal *Athenäum* together with his brother (1798–1800). He was appointed Professor of Literature and Fine Art at Jena in 1798, and gave an important series of lectures on German literature in Berlin between 1801 and 1804. He travelled widely in the company of Madame de Staël (see VIB6) before taking up a chair in Oriental Languages at Bonn which he held from 1818 until his death. He was an outstanding linguist. He translated works of Italian, Spanish and Portuguese poetry, while his verse renderings of seventeen plays by Shakespeare remain part of the standard German edition (subsequently completed by Ludwig Tieck). He also made a significant contribution to the study of Oriental cultures, editing the journal *Indische Bibliothek* (1820–30) and publishing critical editions of the *Bhagavad-Gita* (1823) and the *Ramayana* (1829–46). In his *Lectures on Dramatic Art and Literature*, given in Vienna in 1808, he draws on his already extensive knowledge of world literature and, for the first time, seeks to give comprehensive articulation to the principles of Romanticism which he had helped to forge in Jena. The lectures begin with a defence of 'criticism' as the mediating link between history and theory. Whilst acknowledging the importance of the classical revival, Schlegel criticizes the subordination of art to models derived from Antiquity. Genuine criticism requires universality of mind and an ability to transcend local conventions. The distinction between ancient and modern is reconfigured as a distinction between the classical and the Romantic. The relation between the two is complementary rather than oppositional, however, since the heterogeneity of Romanticism allows it to accommodate earlier forms. Schlegel's *Vorlesungen über dramatische Kunst und Literatur* were first published in book form, Heidelberg: Mohr und Zimmer, 1809–11. They were warmly welcomed by English critics. William Hazlitt (VIIB11), for example, claimed that Schlegel's lectures offered 'by far the best account of the plays of Shakespeare that has hitherto appeared'. They were translated into English by John Black in 1815. We have used the revised version of Black's translation, *A Course of Lectures on Dramatic Art and Literature*, London: Henry G. Bohn, 1846. The following excerpt is taken from the start of the first lecture, pp. 17–27.

The object of the present series of Lectures will be to combine the theory of Dramatic Art with its history, and to bring before my auditors at once its principles and its models.

It belongs to the general philosophical theory of poetry, and the other fine arts, to establish the fundamental laws of the beautiful. Every art, on the other hand, has its own special theory, designed to teach the limits, the difficulties, and the means by which it must be regulated in its attempt to realize those laws. For this purpose, certain scientific investigations are indispensable to the artist, although they have but

little attraction for those whose admiration of art is confined to the enjoyment of the actual productions of distinguished minds. The general theory, on the other hand, seeks to analyze that essential faculty of human nature – the sense of the beautiful, which at once calls the fine arts into existence, and accounts for the satisfaction which arises from the contemplation of them; and also points out the relation which subsists between this and all other sentient and cognizant faculties of man. To the man of thought and speculation, therefore, it is of the highest importance, but by itself alone it is quite inadequate to guide and direct the essays and practice of art.

Now, the history of the fine arts informs us what has been, and the theory teaches what ought to be accomplished by them. But without some intermediate and connecting link, both would remain independent and separate from one and other, and each by itself, inadequate and defective. This connecting link is furnished by criticism, which both elucidates the history of the arts, and makes the theory fruitful. The comparing together, and judging of the existing productions of the human mind, necessarily throws light upon the conditions which are indispensable to the creation of original and masterly works of art.

Ordinarily, indeed, men entertain a very erroneous notion of criticism, and understand by it nothing more than a certain shrewdness in detecting and exposing the faults of a work of art. As I have devoted the greater part of my life to this pursuit, I may be excused if, by way of preface, I seek to lay before my auditors my own ideas of the true genius of criticism.

We see numbers of men, and even whole nations, so fettered by the conventions of education and habits of life, that, even in the appreciation of the fine arts, they cannot shake them off. Nothing to them appears natural, appropriate, or beautiful, which is alien to their own language, manners, and social relations. With this exclusive mode of seeing and feeling, it is no doubt possible to attain, by means of cultivation, to great nicety of discrimination within the narrow circle to which it limits and circumscribes them. But no man can be a true critic or connoisseur without universality of mind, without that flexibility which enables him, by renouncing all personal predilections and blind habits, to adapt himself to the peculiarities of other ages and nations – to feel them, as it were, from their proper central point, and, what ennobles human nature, to recognise and duly appreciate whatever is beautiful and grand under the external accessories which were necessary to its embodying, even though occasionally they may seem to disguise and distort it. There is no monopoly of poetry for particular ages and nations; and consequently that despotism in taste, which would seek to invest with universal authority the rules which at first, perhaps, were but arbitrarily advanced, is but a vain and empty pretension. Poetry, taken in its widest acceptation, as the power of creating what is beautiful, and representing it to the eye or the ear, is a universal gift of Heaven, being shared to a certain extent even by those whom we call barbarians and savages. Internal excellence is alone decisive, and where this exists, we must not allow ourselves to be repelled by the external appearance. Everything must be traced up to the root of human nature: if it has sprung from thence, it has an undoubted worth of its own; but if, without possessing a living germ, it is merely externally attached thereto, it will never thrive nor acquire a proper growth. Many productions which appear at first sight dazzling phenomena in the province of the fine arts, and which as a whole have been honoured with the

appellation of works of a golden age, resemble the mimic gardens of children: impatient to witness the work of their hands, they break off here and there branches and flowers, and plant them in the earth; everything at first assumes a noble appearance: the childish gardener struts proudly up and down among his showy beds, till the rootless plants begin to droop, and hang their withered leaves and blossoms, and nothing soon remains but the bare twigs, while the dark forest, on which no art or care was ever bestowed, and which towered up towards heaven long before human remembrance, bears every blast unshaken, and fills the solitary beholder with religious awe.

Let us now apply the idea which we have been developing, of the universality of true criticism, to the history of poetry and the fine arts. This, like the so-called universal history, we generally limit (even though beyond this range there may be much that is both remarkable and worth knowing) to whatever has had a nearer or more remote influence on the present civilisation of Europe: consequently, to the works of the Greeks and Romans, and of those of the modern European nations, who first and chiefly distinguished themselves in art and literature. It is well known that, three centuries and a half ago, the study of ancient literature received a new life, by the diffusion of the Grecian language (for the Latin never became extinct); the classical authors were brought to light, and rendered universally accessible by means of the press; and the monuments of ancient art were diligently disinterred and preserved. All this powerfully excited the human mind, and formed a decided epoch in the history of human civilisation; its manifold effects have extended to our times, and will yet extend to an incalculable series of ages. But the study of the ancients was forthwith most fatally perverted. The learned, who were chiefly in the possession of this knowledge, and who were incapable of distinguishing themselves by works of their own, claimed for the ancients an unlimited authority, and with great appearance of reason, since they are models in their kind. Maintaining that nothing could be hoped for the human mind but from an imitation of antiquity, in the works of the moderns they only valued what resembled, or seemed to bear a resemblance to, those of the ancients. Everything else they rejected as barbarous and unnatural. With the great poets and artists it was quite otherwise. However strong their enthusiasm for the ancients, and however determined their purpose of entering into competition with them, they were compelled by their independence and originality of mind, to strike out a path of their own, and to impress upon their productions the stamp of their own genius. Such was the case with Dante among the Italians, the father of modern poetry; acknowledging Virgil for his master, he has produced a work which, of all others, most differs from the Æneid, and in our opinion far excels its pretended model in power, truth, compass, and profundity. It was the same afterwards with Ariosto, who has most unaccountably been compared to Homer, for nothing can be more unlike. So in art with Michael Angelo and Raphael, who had no doubt deeply studied the antique. When we ground our judgment of modern painters merely on their greater or less resemblance to the ancients, we must necessarily be unjust towards them, as Winkelmann undoubtedly has in the case of Raphael. As the poets for the most part had their share of scholarship, it gave rise to a curious struggle between their natural inclination and their imaginary duty. When they sacrificed to the latter, they were praised by the learned; but by yielding to the

former, they became the favourites of the people. What preserves the heroic poems of a Tasso and a Camoëns to this day alive in the hearts and on the lips of their countrymen, is by no means their imperfect resemblance to Virgil, or even to Homer, but in Tasso the tender feeling of chivalrous love and honour, and in Camoëns the glowing inspiration of heroic patriotism.

Those very ages, nations, and ranks, who felt least the want of a poetry of their own, were the most assiduous in their imitation of the ancients; accordingly, its results are but dull school exercises, which at best excite a frigid admiration. But in the fine arts, mere imitation is always fruitless; even what we borrow from others, to assume a true poetical shape, must, as it were, be born again within us. Of what avail is all foreign imitation? Art cannot exist without nature, and man can give nothing to his fellow-men but himself.

Genuine successors and true rivals of the ancients, who, by virtue of congenial talents and cultivation have walked in their path and worked in their spirit, have ever been as rare as their mechanical spiritless copyists are common. Seduced by the form, the great body of critics have been but too indulgent to these servile imitators. These were held up as correct modern classics, while the great truly living and popular poets, whose reputation was a part of their nations' glory, and to whose sublimity it was impossible to be altogether blind, were at best but tolerated as rude and wild natural geniuses. But the unqualified separation of genius and taste on which such a judgment proceeds, is altogether untenable. Genius is the almost unconscious choice of the highest degree of excellence, and, consequently, it is taste in its highest activity.

In this state, nearly, matters continued till a period not far back, when several inquiring minds, chiefly Germans, endeavoured to clear up the misconception, and to give the ancients their due, without being insensible to the merits of the moderns, although of a totally different kind. The apparent contradiction did not intimidate them. The groundwork of human nature is no doubt everywhere the same; but in all our investigations, we may observe that, throughout the whole range of nature, there is no elementary power so simple, but that it is capable of dividing and diverging into opposite directions. The whole play of vital motion hinges on harmony and contrast. Why, then, should not this phenomenon recur on a grander scale in the history of man? In this idea we have perhaps discovered the true key to the ancient and modern history of poetry and the fine arts. Those who adopted it, gave to the peculiar spirit of *modern* art, as contrasted with the *antique* or *classical*, the name of *romantic*. The term is certainly not inappropriate; the word is derived from *romance* – the name originally given to the languages which were formed from the mixture of the Latin and the old Teutonic dialects, in the same manner as modern civilisation is the fruit of the heterogeneous union of the peculiarities of the northern nations and the fragments of antiquity; whereas the civilisation of the ancients was much more of a piece.

The distinction which we have just stated can hardly fail to appear well founded, if it can be shown, so far as our knowledge of antiquity extends, that the same contrast in the labours of the ancients and moderns runs symmetrically, I might almost say systematically, throughout every branch of art – that it is as evident in music and the plastic arts as in poetry. This is a problem which, in its full extent, still remains to be

demonstrated, though, on particular portions of it, many excellent observations have been advanced already.

Among the foreign authors who wrote before this school can be said to have been formed in Germany, we may mention Rousseau, who acknowledged the contrast in music, and showed that rhythm and melody were the prevailing principles of ancient, as harmony is that of modern music. In his prejudices against harmony, however, we cannot at all concur. On the subject of the arts of design an ingenious observation was made by Hemsterhuys, that the ancient painters were perhaps too much of sculptors, and the modern sculptors too much of painters. This is the exact point of difference; for, as I shall distinctly show in the sequel, the spirit of ancient art and poetry is *plastic*, but that of the moderns *picturesque*.

By an example taken from another art, that of architecture, I shall endeavour to illustrate what I mean by this contrast. Throughout the Middle Ages there prevailed, and in the latter centuries of that æra was carried to perfection, a style of architecture, which has been called Gothic, but ought really to have been termed old German. When, on the general revival of classical antiquity, the imitation of Grecian architecture became prevalent, and but too frequently without a due regard to the difference of climate and manners or to the purpose of the building, the zealots of this new taste, passing a sweeping sentence of condemnation on the Gothic, reprobated it as tasteless, gloomy, and barbarous. This was in some degree pardonable in the Italians, among whom a love for ancient architecture, cherished by hereditary remains of classical edifices, and the similarity of their climate to that of the Greeks and Romans, might, in some sort, be said to be innate. But we Northerns are not so easily to be talked out of the powerful, solemn impressions which seize upon the mind at entering a Gothic cathedral. We feel, on the contrary, a strong desire to investigate and to justify the source of this impression. A very slight attention will convince us, that the Gothic architecture displays not only an extraordinary degree of mechanical skill, but also a marvellous power of invention; and, on a closer examination, we recognize its profound significance, and perceive that as well as the Grecian it constitutes in itself a complete and finished system.

To the application! – The Pantheon is not more different from Westminster Abbey or the church of St. Stephen at Vienna, than the structure of a tragedy of Sophocles from a drama of Shakespeare. The comparison between these wonderful productions of poetry and architecture might be carried still farther. But does our admiration of the one compel us to depreciate the other? May we not admit that each is great and admirable in its kind, although the one is, and is meant to be, different from the other? The experiment is worth attempting. We will quarrel with no man for his predilection either for the Grecian or the Gothic. The world is wide, and affords room for a great diversity of objects. Narrow and blindly adopted prepossessions will never constitute a genuine critic or connoisseur, who ought, on the contrary, to possess the power of dwelling with liberal impartiality on the most discrepant views, renouncing the while all personal inclinations.

For our present object, the justification, namely, of the grand division which we lay down in the history of art, and according to which we conceive ourselves equally warranted in establishing the same division in dramatic literature, it might be sufficient merely to have stated this contrast between the ancient, or classical, and

the romantic. But as there are exclusive admirers of the ancients, who never cease asserting that all deviation from them is merely the whim of a new school of critics, who, expressing themselves in language full of mystery, cautiously avoid conveying their sentiments in a tangible shape, I shall endeavour to explain the origin and spirit of the *romantic*, and then leave the world to judge if the use of the word, and of the idea which it is intended to convey, be thereby justified.

The mental culture of the Greeks was a finished education in the school of Nature. Of a beautiful and noble race, endowed with susceptible senses and a cheerful spirit under a mild sky, they lived and bloomed in the full health of existence; and, favoured by a rare combination of circumstances, accomplished all that the finite nature of man is capable of. The whole of their art and poetry is the expression of a consciousness of this harmony of all their faculties. They invented the poetry of joy.

Their religion was the deification of the powers of nature and of the earthly life: but this worship, which, among other nations, clouded the imagination with hideous shapes, and hardened the heart to cruelty, assumed, among the Greeks, a mild, a grand, and a dignified form. Superstition, too often the tyrant of the human faculties, seemed to have here contributed to their freest development. It cherished the arts by which it was adorned, and its idols became the models of ideal beauty.

But however highly the Greeks may have succeeded in the Beautiful, and even in the Moral, we cannot concede any higher character to their civilisation than that of a refined and ennobled sensuality. Of course this must be understood generally. The conjectures of a few philosophers, and the irradiations of poetical inspiration, constitute an occasional exception. Man can never altogether turn aside his thoughts from infinity, and some obscure recollections will always remind him of the home he has lost; but we are now speaking of the predominant tendency of his endeavours.

Religion is the root of human existence. Were it possible for man to renounce all religion, including that which is unconscious, independent of the will, he would become a mere surface without any internal substance. When this centre is disturbed, the whole system of the mental faculties and feelings takes a new shape.

And this is what has actually taken place in modern Europe through the introduction of Christianity. This sublime and beneficent religion has regenerated the ancient world from its state of exhaustion and debasement; it is the guiding principle in the history of modern nations, and even at this day, when many suppose they have shaken off its authority, they still find themselves much more influenced by it in their views of human affairs than they themselves are aware.

After Christianity, the character of Europe has, since the commencement of the Middle Ages, been chiefly influenced by the Germanic race of northern conquerors, who infused new life and vigour into a degenerated people. The stern nature of the North drives man back within himself; and what is lost in the free sportive development of the senses, must, in noble dispositions, be compensated by earnestness of mind. Hence the honest cordiality with which Christianity was welcomed by all the Teutonic tribes, so that among no other race of men has it penetrated more deeply into the inner man, displayed more powerful effects, or become more interwoven with all human feelings and sensibilities.

The rough, but honest heroism of the northern conquerors, by its admixture with the sentiments of Christianity, gave rise to chivalry, of which the object was, by vows

which should be looked upon as sacred, to guard the practice of arms from every rude and ungenerous abuse of force into which it was so likely to sink.

With the virtues of chivalry was associated a new and purer spirit of love, an inspired homage for genuine female worth, which was now revered as the acmè of human excellence, and, maintained by religion itself under the image of a virgin mother, infused into all hearts a mysterious sense of the purity of love.

As Christianity did not, like the heathen worship, rest satisfied with certain external acts, but claimed an authority over the whole inward man and the most hidden movements of the heart; the feeling of moral independence took refuge in the domain of honour, a worldly morality, as it were, which subsisting alongside of, was often at variance with that of religion, but yet in so far resembling it that it never calculated consequences, but consecrated unconditionally certain principles of action, which like the articles of faith, were elevated far beyond the investigation of a casuistical reasoning.

Chivalry, love, and honour, together with religion itself, are the subjects of that poetry of nature which poured itself out in the Middle Ages with incredible fulness, and preceded the more artistic cultivation of the romantic spirit. This age had also its mythology, consisting of chivalrous tales and legends; but its wonders and its heroism were the very reverse of those of the ancient mythology.

Several inquirers who, in other respects, entertain the same conception of the peculiarities of the moderns, and trace them to the same source that we do, have placed the essence of the northern poetry in melancholy; and to this, when properly understood, we have nothing to object.

Among the Greeks human nature was in itself all-sufficient; it was conscious of no defects, and aspired to no higher perfection than that which it could actually attain by the exercise of its own energies. We, however, are taught by superior wisdom that man, through a grievous transgression, forfeited the place for which he was originally destined; and that the sole destination of his earthly existence is to struggle to regain his lost position, which, if left to his own strength, he can never accomplish. The old religion of the senses sought no higher possession than outward and perishable blessings; and immortality, so far as it was believed, stood shadow-like in the obscure distance, a faint dream of this sunny waking life. The very reverse of all this is the case with the Christian view: every thing finite and mortal is lost in the contemplation of infinity; life has become shadow and darkness, and the first day of our real existence dawns in the world beyond the grave. Such a religion must waken the vague foreboding, which slumbers in every feeling heart, into a distinct consciousness that the happiness after which we are here striving is unattainable; that no external object can ever entirely fill our souls; and that all earthly enjoyment is but a fleeting and momentary illusion. When the soul, resting as it were under the willows of exile, breathes out its longing for its distant home, what else but melancholy can be the keynote of its songs? Hence the poetry of the ancients was the poetry of enjoyment, and ours is that of desire: the former has its foundation in the scene which is present, while the latter hovers betwixt recollection and hope. Let me not be understood as affirming that everything flows in one unvarying strain of wailing and complaint, and that the voice of melancholy is always loudly heard. As the austerity of tragedy was not incompatible with the joyous views of the Greeks, so that romantic poetry whose

origin I have been describing, can assume every tone, even that of the liveliest joy; but still it will always, in some indescribable way, bear traces of the source from which it originated. The feeling of the moderns is, upon the whole, more inward, their fancy more incorporeal, and their thoughts more contemplative. In nature, it is true, the boundaries of objects run more into one another, and things are not so distinctly separated as we must exhibit them in order to convey distinct notions of them.

The Grecian ideal of human nature was perfect unison and proportion between all the powers, – a natural harmony. The moderns, on the contrary, have arrived at the consciousness of an internal discord which renders such an ideal impossible; and hence the endeavour of their poetry is to reconcile these two worlds between which we find ourselves divided, and to blend them indissolubly together. The impressions of the senses are to be hallowed, as it were, by a mysterious connexion with higher feelings; and the soul, on the other hand, embodies its forebodings, or indescribable intuitions of infinity, in types and symbols borrowed from the visible world.

In Grecian art and poetry we find an original and unconscious unity of form and matter; in the modern, so far as it has remained true to its own spirit, we observe a keen struggle to unite the two, as being naturally in opposition to each other. The Grecian executed what it proposed in the utmost perfection; but the modern can only do justice to its endeavours after what is infinite by approximation; and, from a certain appearance of imperfection, is in greater danger of not being duly appreciated.

10 Henry Fuseli (1741–1825) from 'Aphorisms on Art'

Fuseli was born Johann Heinrich Füssli in Zurich. Though he was in London from 1764 to 1770, it was not until 1779, after eight years spent in Rome, that he settled permanently in England and changed the form of his name. Salomon Gessner was his godfather (see VB3, 4), while in his initial training from his artist father he assimilated the neo-classical theories of Winckelmann (see IIIA5 and 8) and Mengs (see IIIB13 and IVA4). His earliest publication, in 1765, was a translation of Winckelmann's *Gedanken über die Nachahmung der griechischen Werke*... which did much to form William Blake's interest in the pictured nude. (Fuseli's title was *Reflections on the Paintings and Sculpture of the Greeks*; see IIIA5 for a later translation.) Lavater was to become a close friend (see VA6 and VB10). Fuseli's strongest early interest, however, was in literature, and particularly in the epic and tragic works of Homer, Virgil, Dante, Shakespeare and Milton. His understanding of art was to be coloured throughout his life by his sense of the power of poetic themes. While he was never to lose his enthusiasm for the classical tradition, he maintained an essentially poetic and romantic understanding of crucial concepts such as drama, inspiration, originality and genius. He was impatient of the association of taste with propriety and was to make his reputation through works with a marked phantasmagorical character. He was a principal contributor to John Boydell's Shakespeare Gallery (opened in 1789) and he painted forty-seven pictures for his own unsuccessful Milton Gallery (opened in 1799). His first success at the Royal Academy came with the exhibition of *The Nightmare* in 1781 (now in the Institute of Arts, Detroit). He was elected an Associate in 1788 and a full Academician two years later. He was made Professor of Painting in 1799 and Keeper in 1804. His series of

Academy lectures commenced in 1801. He began noting his aphorisms in 1788, the year in which he published a translation of Lavater's own *Aphorisms on Man*. The final collection, numbering 229, was first published as *Aphorisms, Chiefly Relative to the Fine Arts*, London, 1818. These were reprinted in J. Knowles, *The Life and Writing of Henry Fuseli, Esq*, 3 volumes, London, 1831, volume III, pp. 64–150. Our selection is made from the latter edition. (See also VIB10.)

4. Art is the attendant of nature, and genius and talent the ministers of art.

5. Genius either discovers new materials of nature, or combines the known with novelty.

6. Talent arranges, cultivates, polishes, the discoveries of genius.

7. Intuition is the attendant of genius; gradual improvement that of talent.

10. Some enter the gates of art with golden keys, and take their seats with dignity among the demi-gods of fame; some burst the doors and leap into a niche with savage power; thousands consume their time in chinking useless keys, and aiming feeble pushes against the inexorable doors.

14. Genius without bias, is a stream without direction: it inundates all, and ends in stagnation.

15. He who pretends to have sacrificed genius to the pursuits of interest or fashion; and he who wants to persuade you he has indisputable titles to a crown, but chooses to waive them for the emoluments of a partnership in trade, deserve equal belief.

16. Taste is the legitimate offspring of nature, educated by propriety: fashion is the bastard of vanity, dressed by art.

17. The immediate operation of taste is to ascertain the kind; the next, to appreciate the degrees of excellence.
Corollary – Taste, founded on sense and elegance of mind, is reared by culture, invigorated by practice and comparison: scantiness stops short of it; fashion adulterates it: it is shackled by pedantry, and overwhelmed by luxuriance.
Taste sheds a ray over the homeliest or the most uncouth subject. Fashion frequently flattens the elegant, the gentle, and the great, into one lumpy mass of disgust.
If 'foul and fair' be all that your gross-spun sense discerns, if you are blind to the intermediate degrees of excellence, you may perhaps be a great man – a senator – a conqueror; but if you respect yourself, never presume to utter a syllable on works of taste.

18. If mind and organs conspire to qualify you for a judge in works of taste, remember that you are to be possessed of three things – the subject of the work which you are to examine; the character of the artist as such; and, before all, of impartiality.

Corollary – All first impressions are involuntary and inevitable; but the knowledge of the subject will guide you to judge first of the whole; not to creep on from part to part, and nibble at execution before you know what it means to convey. The notion of a tree precedes that of counting leaves or disentangling branches.

Every artist has, or ought to have, a character or system of his own; if, instead of referring that to the test of nature, you judge him by your own packed notions, or arraign him at the tribunal of schools which he does not recognize – you degrade the dignity of art, and add another fool to the herd of Dilettanti.

But if, for reasons best known to yourself, you come determined to condemn what yet you have not seen, let me advise you to drop your pursuits of art for one of far greater importance – the inquiry into yourself; nor aim at taste till you are sure of justice.

30. Mediocrity is formed, and talent submits, to receive prescription; that, the liveried attendant, this, the docile client of a patron's views or whims: but genius, free and unbounded as its *origin*, scorns to receive commands, or in submission, neglects those it received.

Corollary – The gentle spirit of Rafaelle embellished the conceits of Bembo and Divizio, to scatter incense round the triple mitre of his prince; and the Vatican became the flattering annals of the court of Julius and Leo: whilst Michael Angelo refused admittance to master and to times, and doomed his purple critic to hell.

36. Imitative art, is either epic or sublime, dramatic or impassioned, historic or circumscribed by truth. The first astonishes, the second moves, the third informs.

42. Beauty alone, fades to insipidity; and like possession cloys.

43. Grace is beauty in motion, or rather grace regulates the air, the attitudes and movements of beauty.

54. The painter, who makes an historical figure address the spectator from the canvass, and the actor who addresses a soliloquy to you from the stage, have equal claims to your contempt or pity.

58. All apparatus destroys terror, as all ornament grandeur: the minute catalogue of the cauldron's ingredients in Macbeth destroys the terror attendant on mysterious darkness; and the seraglio-trappings of Rubens annihilate his heroes.

62. All mediocrity pretends.

63. Invention, strictly speaking, being confined to *one* moment, he invents best who in that moment combines the traces of the past, the energy of the present, and a glimpse of the future.

100. Imitation seems to cease, where the ideal part begins.

101. The imitator rises above the copyist by generalizing the individual to a class; the idealist mounts above the imitator by uniting classes.

105. We are more impressed by Gothic than by Greek mythology, because the bands are not yet rent which tie us to its magic: he has a powerful hold of us, who holds us by our superstition or by a theory of honour.

110. The epoch of rules, of theories, poetics, criticisms in a nation, will add to their stock of authors in the same proportion as it diminishes their stock of genius: their productions will bear the stamp of study, not of nature; they will adopt, not generate; sentiment will supplant images, and narrative invention; words will be no longer the dress but the limbs of composition, and feeble elegance will supply the want of nerves.

125. Love for what is called deception in painting, marks either the infancy or decrepitude of a nation's taste.

133. The fewer the traces that appear of the means by which any work has been produced, the more it resembles the operations of Nature, and the nearer it is to sublimity.

162. He who aims at the sublime, consults the classes assigned to character by physiognomy, not its anatomy of individuals; the oak in its full majesty, and not the thwarted pollard.

163. None ever escaped from himself by crossing seas; none ever peopled a barren fancy and a heart of ice with images or sympathies by excursions into the deserts of mythology or allegory.

165. Pure history rejects allegory.
Corollary – The armed figure of Rome, with Fortune behind her frowning at Coriolanus, surrounded by the Roman matrons in the Volscian camp (by Poussin), is a vision seen by that warrior, and not an allegory; it is a sublime image, which, without diminishing the credibility of the fact, adds to its importance, and raises the hero, by making him submit, not to the impulse of private ties, but to the destiny of his country.

166. All ornament ought to be allegoric.

170. Judge not an artist from the exertions of accidental vigour or some unpremeditated flights of fancy, but from the uniform tenor, the never-varying principle of his works: the line and style of Titian sometimes expand themselves like those of Michael Angelo; the heads and groups of Raphael sometimes glow and palpitate with Titiano's tints; and there are masses of both united in Correggio: but if you aim at character, let Raphael be your guide; if at colour, Tiziano; if harmony allure, Correggio: they indulged in alternate excursions, but never lost sight of their own domain.

Corollary – No one, of whatever period of art, of whatever eminence or school, out-told Rembrandt in telling the story of a subject, in the choice of its real crisis, in simplicity, in perspicuity: still, as the vile crust that involves his ore, his local vulgarity of style, the ludicrous barbarity of his costume, prepossess eyes less penetrating than squeamish against him, it requires some confidence to place him with the classics of invention. Yet with all these defects, with every prejudice or superiority of taste and style against him, what school has produced a work (M. Angelo's Creation of Adam, and the Death of Ananias by Raffaelle excepted,) which looks not pale in the superhuman splendour that irradiates his conception of Christ before Pilate, unless it be the raising of Lazarus by Lievens, a name comparatively obscure, whose awful sublimity reduces the same subject as treated by Rembrandt and Sebastian of Venice, to artificial parade or commonplace?

171. Tone is the moral part of colour.

172. If tone be the legitimate principle of colour, he who has not tone, though he should excel in individual imitation, colours in fragments and produces discord.

176. Colour affects or delights like sound. Scarlet or deep crimson rouses, determines, invigorates the eye, as the war-horn or the trumpet the ear; the flute soothes the ear, as pale celestial blue or rosy red the eye.

201. None but indelible materials can support the epic. Whatever is local, or the volatile creature of the time, beauties of fashion and sentiments of sects, tears shed over roses, epigrammatic sparkling, passions taught to rave, and graces trained to move, the antiquary's mouldering stores, the bubbles of allegorists – are all with equal contempt passed over or crushed by him who claims the lasting empire of the human heart.

225. Such is the fugitive essence, such the intangible texture of female genius, that few combinations of circumstances ever seemed to favour its transmission to posterity.

235. Resemblance, character, costume, are the three requisites of portrait: the first distinguishes, the second classifies, the third assigns place and time to an individual.

11 Samuel Taylor Coleridge (1772–1834), 'On the Principles of Genial Criticism'

In his literary theory Coleridge is best known for the centrality he accorded to the imagination. He regarded it as a faculty capable of mediating between the two sides of human consciousness: non-rational intuition of feelings and emotions, and rational conceptualization of the material world. Coleridge wrote copiously on a wide range of subjects, but little on the visual arts. His most sustained discussion of them occurs in three essays contributed to *Felix Farley's Bristol Journal* in August and September 1814. The occasion was an exhibition in Bristol of work by the American painter Washington Allston (1779–1843, see *Art in Theory 1815–1900*, IA17), whom Coleridge had originally met in Rome in 1805. It appears from letters that Coleridge meant to support the artist, whose career at that point was at a low ebb, through 'a bold avowal of my sentiments on the fine arts' underlined 'by continual reference to Allston's pictures' (quoted in Shawcross, edition, 1907, p. 304). During the process of writing, however, his essays took a more general turn and mutated into a theoretical discussion of beauty. Although he makes much use of eighteenth-century association theory, Coleridge also draws on Kant to arrive at a notion of the aesthetic with a significantly modern inflection. For Coleridge, the contemplation of beauty in visual art is an end in itself, to be distinguished both from the pursuit of the good and from the appreciation of the merely agreeable-by-association. Our extracts are taken from 'On the Principles of Genial Criticism Concerning the Fine Arts, more especially those of Statuary and Painting', in Coleridge's *Biographia Literaria, with his Aesthetical Essays*, edited by J. Shawcross, Oxford: Oxford University Press, 1907. We have used the 1967 reprint, pp. 220–1, 226–7, 231–4, 236–9.

All the fine arts are different species of poetry. The same spirit speaks to the mind through different senses by manifestations of itself, appropriate to each. They admit therefore of a natural division into poetry of language (poetry in the emphatic sense, because less subject to the accidents and limitations of time and space); poetry of the ear, or music; and poetry of the eye, which is again subdivided into plastic poetry, or statuary, and graphic poetry, or painting. The common essence of all consists in the excitement of emotion for the immediate purpose of pleasure through the medium of beauty; herein contra–distinguishing poetry from science, the immediate object and primary purpose of which is truth and possible utility. (The sciences indeed may and will give a high and pure pleasure; and the Fine Arts may lead to important truth, and be in various ways useful in the ordinary meaning of the word; but these are not the direct and characteristic ends, and we define things by their peculiar, not their common properties.) [. . .]

There are few mental exertions more instructive, or which are capable of being rendered more entertaining, than the attempt to establish and exemplify the distinct meaning of terms, often confounded in common use, and considered as mere synonyms. Such are the words, Agreeable, Beautiful, Picturesque, Grand, Sublime: and to attach a distinct and separate sense to each of these, is a previous step of indispensable necessity to a writer, who would reason intelligibly, either to himself or to his readers, concerning the works of poetic genius, and the sources and the nature of the pleasure derived from them. But more especially on the essential difference of

the beautiful and the agreeable, rests fundamentally the whole question, which assuredly must possess no vulgar or feeble interest for all who regard the dignity of their own nature: whether the noblest productions of human genius (such as the Iliad, the works of Shakspeare and Milton, the Pantheon, Raphael's Gallery, and Michael Angelo's Sistine Chapel, the Venus de Medici and the Apollo Belvedere, involving, of course, the human forms that approximate to them in actual life) delight us merely by chance, from accidents of local associations – in short, please us because they please us (in which case it would be impossible either to praise or to condemn any man's taste, however opposite to our own, and we could be no more justified in assigning a corruption or absence of just taste to a man, who should prefer Blackmore to Homer or Milton, or the Castle Spectre to Othello, than to the same man for preferring a black-pudding to a sirloin of beef); or whether there exists in the constitution of the human soul a sense, and a regulative principle, which may indeed be stifled and latent in some, and be perverted and denaturalized in others, yet is nevertheless universal in a given state of intellectual and moral culture; which is independent of local and temporary circumstances, and dependent only on the degree in which the faculties of the mind are developed; and which, consequently, it is our duty to cultivate and improve, as soon as the sense of its actual existence dawns upon us. [. . .]

AGREEABLE. – We use this word in two senses; in the first for whatever agrees with our nature, for that which is congruous with the primary constitution of our senses. Thus green is naturally agreeable to the eye. In this sense the word expresses, at least involves, a pre-established harmony between the organs and their appointed objects. In the second sense, we convey by the word *agreeable*, that the thing has by force of habit (thence called a second nature) been made to agree with us; or that it has become agreeable to us by its recalling to our minds some one or more things that were dear and pleasing to us; or lastly, on account of some after pleasure or advantage, of which it has been the constant cause or occasion. Thus by force of custom men *make* the taste of tobacco, which was at first hateful to the palate, agreeable to them [. . .].

The BEAUTIFUL, contemplated in its essentials, that is, in *kind* and not in *degree*, is that in which the *many*, still seen as many, becomes one. Take a familiar instance, one of a thousand. The frost on a window-pane has by accident crystallized into a striking resemblance of a tree or a seaweed. With what pleasure we trace the parts, and their relations to each other, and to the whole! Here is the stalk or trunk, and here the branches or sprays – sometimes even the buds or flowers. Nor will our pleasure be less, should the caprice of the crystallization represent some object disagreeable to us, provided only we can see or fancy the component parts each in relation to each, and all forming a whole. A lady would see an admirably painted tiger with pleasure, and at once pronounce it beautiful, – nay, an owl, a frog, or a toad, who would have shrieked or shuddered at the sight of the things themselves. So far is the Beautiful from depending wholly on association, that it is frequently produced by the mere removal of associations. Many a sincere convert to the beauty of various insects, as of the dragon-fly, the fangless snake, &c., has Natural History made, by exploding the terror or aversion that had been connected with them.

The most general definition of beauty, therefore, is – that I may fulfil my threat of plaguing my readers with hard words – Multëity in Unity. Now it will be always found, that whatever is the definition of the *kind*, independent of degree, becomes likewise the definition of the highest degree of that kind. An old coach-wheel lies in the coachmaker's yard, disfigured with tar and dirt (I purposely take the most trivial instances) – if I turn away my attention from these, and regard the *figure* abstractly, 'still,' I might say to my companion, 'there is beauty in that wheel, and you yourself would not only admit, but would feel it, had you never seen a wheel before. See how the rays proceed from the centre to the circumferences, and how many different images are distinctly comprehended at one glance, as forming one whole, and each part in some harmonious relation to each and to all.' But imagine the polished golden wheel of the chariot of the Sun, as the poets have described it; then the figure, and the real thing so figured, exactly coincide. There is nothing heterogeneous, nothing to abstract from: by its perfect smoothness and circularity in width, each part is (if I may borrow a metaphor from a sister sense) as perfect a melody, as the whole is a complete harmony. This, we should say, is beautiful throughout. Of all 'the many,' which I actually see, each and all are really reconciled into unity: while the effulgence from the whole coincides with, and seems to represent, the effluence of delight from my own mind in the intuition of it.

It seems evident then, first, that beauty is harmony, and subsists only in composition, and secondly, that the first species of the Agreeable can alone be a component part of the beautiful, that namely which is naturally consonant with our senses by the pre-established harmony between nature and the human mind; and thirdly, that even of this species, those objects only can be admitted (according to rule the first) which belong to the eye and ear, because they alone are susceptible of distinction of parts. [...]

But we are conscious of faculties far superior to the highest impressions of sense; we have life and free-will – What then will be the result, when the Beautiful, arising from regular form, is so modified by the perception of life and spontaneous action, as that the latter only shall be the object of our conscious *perception*, while the former merely acts, and yet does effectively act, on our feelings? With pride and pleasure I reply by referring my reader to the group in Mr. Allston's grand picture of the 'Dead Man reviving from the touch of the bones of the Prophet Elisha,' beginning with the slave at the head of the reviving body, then proceeding to the daughter clasping her swooning mother; to the mother, the wife of the reviving man; then to the soldier behind who supports her; to the two figures eagerly conversing: and lastly, to the exquisitely graceful girl who is bending downward, and whose hand nearly touches the thumb of the slave! You will find, what you had not suspected, that you have here before you a circular group. But by what variety of life, motion, and passion is all the stiffness, that would result from an obvious regular figure, swallowed up, and the figure of the group as much concealed by the action and passion, as the skeleton, which gives the form of the human body, is hidden by the flesh and its endless outlines! [...]

RECAPITULATION. *Principle the First*. – That which has become, or which has been *made* agreeable to us, from causes not contained in its own nature, or in its original conformity to the human organs and faculties; that which is not pleasing for its own

sake, but by connection or association with some other thing, separate or separable from it, is neither beautiful, nor capable of being a component part of Beauty: though it may greatly increase the sum of our pleasure, when it does not interfere with the beauty of the object, nay, even when it detracts from it. A moss-rose, with a sprig of myrtle and jasmine, is not more *beautiful* from having been plucked from the garden, or presented to us by the hand of the woman we love, but is abundantly more delightful. The total pleasure received from one of Mr. Bird's finest pictures may, without any impeachment of our taste, be the greater from his having introduced into it the portrait of one of our friends, or from our pride in him as our townsman, or from our knowledge of his personal qualities; but the amiable artist would rightly consider it a coarse compliment, were it affirmed, that the *beauty* of the piece, or its merit as a work of genius, was the more perfect on this account. [. . .]

Principle the Second. – That which is naturally agreeable and consonant to human nature, so that the exceptions may be attributed to disease or defect; that, the pleasure from which is contained in the immediate impression; cannot, indeed, with strict propriety, be called beautiful, exclusive of its relations, but one among the component parts of beauty, in whatever instance it is susceptible of existing as a part of a whole. This, of course, excludes the mere objects of the taste, smell, and feeling, though the sensation from these, especially from the latter when organized into touch, may secretly, and without our consciousness, enrich and vivify the perceptions and images of the eye and ear; which alone are true organs of sense, their sensations in a healthy or uninjured state being too faint to be noticed by the mind. We may, indeed, in common conversation, call purple a beautiful color, or the tone of a single note on an excellent piano-forte a beautiful tone; but if we were questioned, we should agree that a rich or delightful color; a rich, or sweet, or clear tone; would have been more appropriate – and this with less hesitation in the latter instance than in the former, because the single tone is more manifestly of the nature of a *sensation*, while color is the medium which seems to blend sensation and perception, so as to hide, as it were, the former in the latter; the direct opposite of which takes place in the lower senses of feeling, smell, and taste. (In strictness, there is even in these an ascending scale. The smell is less sensual and more sentient than mere feeling, the taste than the smell, and the eye than the ear; but between the ear and the taste exists the chasm or break, which divides the beautiful and the elements of beauty from the merely agreeable.) When I reflect on the manner in which smoothness, richness of sound, &c., enter into the formation of the beautiful, I am induced to suspect that they act negatively rather than positively. Something there must be to realize the form, something in and by which the *forma informans* reveals itself: and these, less than any that could be substituted, and in the least possible degree, distract the attention, in the least possible degree obscure the idea, of which they (composed into outline and surface) are the symbol. An illustrative hint may be taken from a pure crystal, as compared with an opaque, semi-opaque or clouded mass, on the one hand, and with a perfectly transparent body, such as the air, on the other. The crystal is lost in the light, which yet it contains, embodies, and gives a shape to; but which passes shapeless through the air, and, in the ruder body, is either quenched or dissipated.

Principle the Third. – The safest definition, then, of Beauty, as well as the oldest, is that of Pythagoras: THE REDUCTION OF MANY TO ONE . . . of which the following may be

offered as both paraphrase and corollary. *The sense of beauty subsists in simultaneous intuition of the relation of parts, each to each, and of all to a whole: exciting an immediate and absolute complacency, without intervenence, therefore, of any interest, sensual or intellectual.* The BEAUTIFUL is thus at once distinguished both from the AGREEABLE, which is beneath it, and from the GOOD, which is above it: for both these have an interest necessarily attached to them: both act on the WILL, and excite a desire for the actual existence of the image or idea contemplated: while the sense of beauty rests gratified in the mere contemplation or intuition, regardless whether it be a fictitious Apollo, or a real Antinous.

12 Percy Bysshe Shelley (1792–1822) from *A Philosophical View of Reform*

Shelley's standing as a lyric poet has often obscured his devotion to radical politics. Throughout his life he was committed to the cause of social reform, and gave voice to this commitment not only in poems such as *Ode to Liberty* but also in prose writings. Shelley moved to Italy in 1818 and it was there, in September 1819, that he received news of the Peterloo Massacre in Manchester. What followed has been referred to as 'Shelley's revolutionary year' (Foot, 1990). He rapidly wrote a number of political poems including *The Mask of Anarchy* ('I met murder on the way / He had a mask like Castlereagh'), and *Song to the Men of England* ('Wherefore feed and clothe and save / From the cradle to the grave / Those ungrateful drones who would / Drain your sweat – nay, drink your blood?'). These he intended to include in a volume of *Popular Songs*, along with a 15,000-word essay setting out his political ideas. This essay, *A Philosophical View of Reform*, was written between September 1819 and May 1820. At this point it was abandoned unfinished, Shelley's enquiries about publishing the collection in England having come to nothing. It contains one of the great credos of the radical artist: the claim that poets, and, it has been assumed, artists in general, are 'the unacknowledged legislators of the world'. Our extract is taken from the essay's introductory chapter, as published in *Shelley's Revolutionary Year*, edited with an introduction by Paul Foot, London: Redwords, 1990, pp. 39–40 and 46–7.

The just and successful revolt of America corresponded with a state of public opinion in Europe of which it was the first result. The French Revolution was the second. The oppressors of mankind had enjoyed (O that we could say suffered) a long and undisturbed reign in France, and to the pining famine, the shelterless destitution of the inhabitants of that country had been added and heaped-up insult harder to endure than misery. For the feudal system (the immediate causes and conditions of its institution having become obliterated) had degenerated into an instrument not only of oppression but of contumely, and both were unsparingly inflicted. Blind in the possession of strength, drunken as with the intoxication of ancestral greatness, the rulers perceived not that increase of knowledge in their subjects which made its exercise insecure. They called soldiers to hew down the people when their power was already past. The tyrants were, as usual, the aggressors. Then the oppressed, having being rendered brutal, ignorant, servile, and bloody by long slavery, having had the intellectual thirst excited in them by the progress of civilisation, satiated from

fountains of literature poisoned by the spirit and the form of monarchy, arose and took a dreadful revenge upon their oppressors. Their desire to wreak revenge to this extent, in itself a mistake, a crime, a calamity, arose from the same source as their other miseries and errors and affords an additional proof of the necessity of that long-delayed change which it accompanied and disgraced. If a just and necessary revolution could have been accomplished with as little expense of happiness and order in a country governed by despotic as [in] one governed by free laws, equal liberty and justice would lose their chief recommendations and tyranny be divested of its most revolting attributes. Tyranny entrenches itself within the existing interests of the most refined citizens of a nation and says, 'If you dare trample upon these, be free.' Though this terrible condition shall not be evaded, the world is no longer in a temper to decline the challenge. [. . .]

Meanwhile England . . . has arrived like the nations which surround it at a crisis in its destiny. The literature of England, an energetic development of which has ever followed or preceded a great and free development of the national will, has arisen, as it were, from a new birth. In spite of that low-thoughted envy which would under-value, through a fear of comparison with its own insignificance, the eminence of contemporary merit, it is *felt by the British* [that] ours is in intellectual achievements a memorable age, and we live among such philosophers and poets as surpass beyond comparison any who have appeared in our nation since its last struggle for liberty. For the most unfailing herald, or companion, or follower, of an universal employment of the sentiments of a nation to the production of beneficial change is poetry, meaning by poetry an intense and impassioned power of communicating intense and impassioned impressions respecting man and nature. The persons in whom this power takes its abode may often, as far as regards many portions of their nature, have little tendency [to] the spirit of good of which it is the minister. But although they may deny and abjure, they are yet compelled to serve that which is seated on the throne of own soul. And whatever systems they may [have] professed by support, they actually advance the interests of liberty. It is impossible to read the productions of our most celebrated writers, whatever may be their system relating to thought or expression, without being startled by the electric life which there is in their words. They measure the circumference or sound the depths of human nature with a comprehensive and all-penetrating spirit at which they are themselves perhaps most sincerely astonished, for it [is] less their own spirit than the spirit of their age. They are the priests of an unapprehended inspiration, the mirrors of gigantic shadows which futurity casts upon the present; the words which express what they conceive not; the trumpet which sings to battle and feels not what it inspires; the influence which is moved not, but moves. Poets and philosophers are the unacknowledged legislators of the world.

VIB
Painting and Fiction

1 Wilhelm Wackenroder (1773–1798) from *Confessions from the Heart of an Art-Loving Friar*

The son of a Prussian civil servant who later became a minister of justice, Wackenroder was constrained to pursue a career in law despite evidence of a gift for music and a passionate enthusiasm for art. His death at the age of 25 helped to establish the romantic image of a young man whose passionate and sensitive nature was broken by the rigidity of the demands placed upon him. He was a boyhood friend of Ludwig Tieck (see VIB2). Whilst studying at the University of Erlangen in 1793 the two made a number of trips to explore the art and architecture of the region, including nearby Nuremberg and Bamberg. The first fruit of these journeys was the essay 'A Memorial to our Venerable Ancestor Albrecht Dürer from an Art-Loving Friar' which Wackenroder published in the journal *Deutschland* in 1796. This essay was then included in the small volume of essays entitled *Confessions from the Heart of an Art-Loving Friar* which was published anonymously later in the same year. A second collection of essays, *Phantasien über die Kunst* (Fantasies on Art), was published by Tieck in 1799, a year after Wackenroder's death. Whilst the latter collection contains essays by both writers, the *Confessions* is now thought to be almost entirely Wackenroder's work. The book is written in the authorial guise of a friar who has retired to the 'solitude of monastic life' and who shares his emotional and pious responses to art with his readers. The author contrasts his own highly personal and empathetic approach to the rational and classicist aesthetics of Friedrich Ramdohr (see VB12 and VIB12). The essays were enormously influential and helped to stimulate the interest in the art of the medieval period which was so central to the art of the Nazarenes (see VIIB5–7). It is noteworthy, however, that this influence was conveyed by the spirit of tolerance and pluralism advocated in the work, and by the tone of rapt awe in which it is written, rather than by any detailed study of earlier artists. Wackenroder's own preference is for the art of the sixteenth century and the majority of the essays are devoted to Renaissance artists, including Raphael, Leonardo and Piero di Cosimo. *Herzensergießungen eines kunstliebenden Klosterbruders* was first published in Berlin by Johann Friedrich Unger in 1796. Here we include the address to the reader and the three essays which form the heart of the book (the centre of which is the essay on Dürer). We have used the translation by Mary Hurst Schubert, *Wilhelm Heinrich Wackenroder's Confessions and Fantasies*, University Park and London: Pennsylvania State University Press, 1971, pp. 81–2, 108–20.

To the Reader of these Pages

The following essays have come into existence little by little in the solitude of a monastic life, from which I only occasionally think back dimly to the distant world. In my youth I loved art inordinately and this love, like a faithful friend, has accompanied me up to my present age: without realizing it, but acting out of an inner compulsion, I wrote down my reminiscences, which you, beloved reader, must view with an indulgent eye. They are not composed in the tone of the present-day world because this tone is not within my power and because, if I am to speak entirely honestly, I also am unable to like it.

In my youth I was involved in the world and in many worldly affairs. My strongest inclination was toward art and I wished to dedicate to it my life and all my limited talents. According to the judgment of several friends I was not without skill in sketching and my copies, as well as my own creations, were not totally unpleasing. But I continuously thought about the great, blessed saints of art with quiet, holy awe; it seemed strange, indeed, almost absurd to me that I should be guiding the charcoal or the paintbrush in my hand whenever the name of Raphael or Michelangelo came into my mind. I may, indeed, admit that I occasionally had to weep out of an indescribable melancholy fervor, when I pictured to myself most vividly their products and their lives: I could never manage – indeed, such a thought would have seemed impious to me, – to separate the Good from the so-called Bad in my chosen favorites and, in the end, to place them all in a row in order to observe them with a cold, criticizing eye, as young artists and so-called friends of art tend to do nowadays. Therefore, I am willing to admit openly that I have read only very little in the works of H. von *Ramdohr* with pleasure; and whoever likes these may immediately put out of his hand that which I have written, for it will not please him. I dedicate these pages, which I initially did not intend for the press at all, only to young, beginning artists or to boys who intend to dedicate themselves to art and who still carry in a quiet, uninflated heart holy respect for the time which has passed by. Perhaps they will be even more touched by my otherwise insignificant words, inspired to a still deeper respect; for they read with the same love with which I have written.

Heaven has ordained that I close my life in a monastery: these endeavors are, therefore, all that I am now in a position to do for art. If they are not entirely displeasing, then perhaps a second part will follow, in which I should like to refute the evaluations of several individual works of art, if Heaven grants me health and time to arrange the thoughts which I have jotted down regarding this and bring them into a clear exposition. –

A Few Words concerning Universality, Tolerance and Human Love in Art

The Creator, who made our earth and everything upon it, encompassed the entire globe with His glance and poured out the river of His blessing upon the whole earthly realm. However, from His mysterious workshop He scattered over our globe thousands of infinitely diverse seeds of things which bear infinitely varied fruits and, in

honor of Him, shoot up into the largest, most colorful gardens. In a wondrous way He guides His sun around the earth in precise circles, so that its beams fall upon the earth in thousands of directions and extract and stimulate the essence of the soil for a variety of creations in every region under heaven.

At *one* great moment He gazes with impartial eye upon the work of His hands and receives with satisfaction the offerings of all animate and inanimate Nature. The roaring of the lion is as pleasant to Him as the crying of the reindeer; and the aloe smells just as lovely to Him as rose and hyacinth. Man also emanated from His creating hand in thousandfold forms: – the brothers of *one* house do not know and understand each other; they speak different languages and are amazed at each other; – but He knows them all and takes pleasure in all; with impartial eye He gazes upon the work of His hands and receives the offering of all Nature.

In many a way He hears the voices of human beings speaking in confusion about heavenly things and knows that all, – all, even if it were against their knowledge and intention, – nevertheless mean *Him*, the Ineffable One.

In this manner He also hears the inner feelings of people speak different languages in different zones and in different eras and hears how they argue with each other and do not understand one another: but, for the Eternal Spirit, everything dissolves into harmony; He knows that each individual speaks the language which He has created in him, that each expresses his inner feelings as he can and should; – if in their blindness they argue with each other, then He knows and recognizes that each is, for himself, in the right; He looks with pleasure upon each and all and delights in the variegated mixture.

Art is to be called the flower of human emotion. In continuously changing form amidst the manifold zones of the earth it rises up towards heaven, and only *one* united perfume comes forth from this seed for the Universal Father, who holds in His hand the earth with all that is upon it.

In each work of art in all the zones of the earth, He sees the trace of the heavenly spark which, having emanated from Him, passed over through the breast of the individual into his little creation, from which it then glows back again to the great Creator. The Gothic temple pleases Him as well as the temple of the Greek and the crude war-music of the uncivilized is for Him just as lovely a sound as artistic choirs and hymns.

And when, through the immeasurable spaces of heaven, I now return to earth from Him, the Infinite One, and look around among my fellow-brothers, – alas! then I must utter loud laments that they strive so little to resemble their great eternal model in heaven. They quarrel with each other and do not understand each other and fail to see that they are all hastening toward the same goal, because each remains standing firmly upon his own location and does not know how to lift his eyes over all the world.

Stupid people cannot comprehend that there are antipodes on our globe and that they are themselves antipodes. They always conceive of the place where they are standing as the gravitational center of the universe, – and their minds lack the wings to fly around the entire earth and survey with *one* glance the integrated totality.

And, similarly, they regard their own emotion as the center of everything beautiful in art and they deliver the final judgment concerning everything as if from

the tribunal, without considering that no one has appointed them judges and that those who are condemned by them could just as well set themselves up to the same end.

Why do you not condemn the American Indian, that he speaks Indian and not our language? –

And yet you want to condemn the Middle Ages, that it did not build such temples as did Greece? –

O, at least feel your way into these unknown souls and observe that you have received the gifts of the spirit from *the same* hand as your misunderstood brothers! Comprehend, moreover, that each creature can only be creative from within himself with the capacities which he has received from heaven and that each person's creative works must be in conformity with his talents. And if you are not capable of *feeling* your way into all unfamiliar beings and *experiencing* their works through their mentalities; then try, at least, to reach up to this conviction indirectly through the intellect's chains of reasoning. –

If the disseminating hand of heaven had let the embryo of your soul fall upon the African sand deserts, then you would have preached to all the world the shining blackness of skin, the large, flat face and the short, curly hair as essential components of the highest beauty and would have laughed at or hated the first white man. If your soul had arisen several hundred miles further to the East, on the soil of India, then you would feel the secret spirit which exists, concealed from our senses, in the little, strangely shaped idols with many arms and, if you were to see the statue of the Venus of Medici, you would not know what you should think of it. And had it pleased that One, under whose power you stood and are standing, to cast you into the multitudes of southern island dwellers, then you would find in every wild drum-beat and in the crude, shrill shocks of the melody a deep significance, of which you now comprehend not a syllable. In any one of these cases, however, would you have received the gift of creativity or the gift of appreciation of art from another source than the eternal and universal One, to whom you are now indebted for all of your treasures? –

Amidst all the nations of the earth, the multiplication table of reason follows the same laws and is only applied to an infinitely larger field of objects here, to a very small field there. – In a similar way *artistic feeling* is only one and the same divine ray of light which, however, is refracted into thousands of different colors by the diversely polished glass of sensuality in various regions.

Beauty: a wondrously strange word! First invent new words for each separate artistic feeling, for each individual work of art! A different color plays in each and, for each, separate nerves are provided in the structure of the human being.

But, with talents of the intellect you spin a rigorous *system* from this one word and want to compel all men to feel according to your prescriptions and rules, – yet you yourselves do not feel.

He who *believes a system* has expelled universal love from his heart! Intolerance of emotion is still more endurable than intolerance of the intellect; – *superstition* better than *belief in a system*. –

Can you force one who is melancholy to find playful songs and lively dancing pleasant? Or one who is sanguine to offer his heart joyfully to tragic horrors?

O, rather let every mortal being and every race under the sun keep its belief and its happiness! and rejoice when others are happy, – even if you yourself do not know how to be happy about that which is dearest and most precious to them.

We, sons of this century, have had fall to our lot the advantage that we stand on the peak of a high mountain and that many countries and many ages lie spread out around us and at our feet, open to our eyes. Therefore, let us make use of this good fortune and wander about through all the ages and peoples with clear vision and always strive to discover *the human element* in all their manifold sensations and products of sensation. – –

Every creature strives toward that which is the most beautiful: but it cannot transcend itself and sees what is most beautiful only within itself. Just as a different image of the rainbow enters into every mortal eye, so too does the surrounding world reflect for each individual a different imprint of beauty. However, universal, original beauty, which we can *name* only in moments of ecstatic intuition and are unable to reduce to words, reveals itself unto the One who created the rainbow and the eye that beholds it.

I began my discourse with Him and I return to Him again: – in the same way as the spirit of art, – as all spirit goes forth from Him and, as an offering, penetrates through the atmosphere of the earth up to Him again.

A Memorial to our venerable ancestor Albrecht Dürer
By an art-loving friar

Nuremberg! you formerly world-renowned city! How I liked to wander through your quaint streets; with what childlike love I gazed at your antiquated houses and churches, upon which the permanent trace of our early native art is imprinted! How deeply I love the structures of that age, which have such a robust, powerful and true language. How they transport me back into that venerable century when you, Nuremberg, were the vibrantly teeming school of native art and a truly fruitful, overflowing spirit of art lived and thrived within your walls: – when Master Hans Sachs and Adam Kraft, the sculptor, and, above all, *Albrecht Dürer* with his friend, Wilibaldus Pirkheimer, and so many other highly praised men of honor were still living! How often I have wished that I were back in that age! How often it has appeared before me anew in my thoughts, while I was sitting in a narrow corner in your venerable libraries, Nuremberg, in the twilight of the little, round-paned windows and brooding over the folio volumes of valiant Hans Sachs or over some other old, yellow, worm-eaten paper; – or while I was walking under the bold arches of your dark churches, where, through colorfully painted windows, the sunlight splendidly illuminates all the objects of art and paintings of the past age! – –

You are surprised again and gaze at me, you narrow-minded and faint-hearted ones! O, I know them, indeed, the myrtle-forests of Italy, – I know it, indeed, the divine ardor in the inspired men of the blessed South: – how you call me hence, where my soul's thoughts are dwelling constantly, where is the native land of the most beautiful hours of my life! – You, who see boundaries everywhere where there are none! Are not Rome and Germany situated on *one earth*? Has the heavenly Father

not made *pathways* from North to South as from West to East across the globe? Is a human life too brief? Are the Alps insurmountable? – Then, more than *one* love must also be able to live in the breast of man. – –

But now my grieving spirit is wandering about on the consecrated ground before your walls, Nuremberg; on the cemetery where the bones of Albrecht Dürer are resting, who was formerly the embellishment of Germany, indeed, of Europe. Visited by few, his remains rest amidst innumerable tombstones, each of which is marked with a bronze plaque, as the stamp of the early art. Between the graves tall sunflowers spring up in multitudes, which make the cemetery into a lovely garden. In this setting rest the forgotten bones of our old Albrecht Dürer, on account of whom I am glad that I am a German.

Few must have been given the ability to understand the soul in your pictures as well and to enjoy their unique and particular qualities with such fervor as heaven seems to have granted unto me over many others; for, I look around and find few who lingered before you with such an affectionate love, with such emotion as I.

Is it not as if the figures in your pictures were real people who were talking together? Each is etched so distinctly that one would recognize him in a large crowd; each so true to life that he totally fulfills his purpose. Not one is there with half a soul, as people frequently would like to say regarding very ornamental pictures by more modern masters; each is captured in the fullness of life and set down on the panel in this way. Whoever is supposed to lament, laments; whoever is supposed to be angry, is angry; and whoever is supposed to pray, prays. All of the figures speak; they speak openly and with refinement. No arm moves superfluously or merely to please the eyes and fill up space; all of the limbs, everything speaks to us as if with force, so that we comprehend with genuine firmness the meaning and the soul of the entire picture. We believe everything which the artistic man presents to us; and it is never blotted out of our memory.

Why is it that the contemporary artists of our native land seem to me so different from those praiseworthy men of the past and from you, above all, my beloved Dürer? Why is it that I feel as if you all had handled the art of painting far more seriously, more importantly and more worthily than these ornamental artists of our days? I imagine that I see you, how you stand meditating before the picture you have begun, – how the conception that you want to make visible hovers very animatedly before your soul, – how you prudently consider what expressions and positions might affect the viewer the most powerfully and most surely and stir his soul the most forcefully while he is looking at them, – and you then accurately and painstakingly convey to the panel the beings allied with your lively imagination. – But the more recent artists do not seem to want one to participate seriously in that which they portray for us; they work for aristocratic gentlemen, who do not want to be moved and ennobled by art but dazzled and titillated to the highest degree; they strive to make their paintings specimens of many lovely and deceiving colors; they test their cleverness in the scattering of light and shadow; – however, the human figures frequently seem to be in the picture merely for the sake of the colors and the light, I would indeed like to say, as a necessary evil.

I must cry out woe upon our age, that it practices art merely as a frivolous plaything of the senses, while it is actually something very serious and exalted. Do

people no longer pay heed to the human being, that they neglect him in art and find pretty colors and all sorts of tricks with highlights more worthy of contemplation? –

In the writings of *Martin Luther*, who was very highly esteemed and defended by our Albrecht, in which, as I willingly admit, I have done some reading out of intellectual curiosity and in which much good material may be hidden, I found a remarkable passage concerning the importance of art, which now comes vividly to mind. For this man maintains somewhere very daringly and explicitly that, after theology, music occupies the first place among all the sciences and arts of the human spirit. And I must open-heartedly confess that this bold claim attracted my attention very much to this excellent man. For the soul from which such a claim could come had to feel precisely that deep veneration for art which, from whence I know not, dwells in so few minds and which is, nevertheless, seemingly so very natural and so significant.

Now, if art (I mean its principal and essential part) is really of such importance, then it is very unworthy and foolish to turn away from the expressive and instructive human figures of our old Albrecht Dürer because they are not endowed with the glistening external beauty which the world of today considers to be the sole and highest aspect of art. It does not give evidence of an entirely healthy and untroubled disposition, if someone closes his ears to an intellectual reflection which is, in itself, convincing and penetrating, only because the speaker does not arrange his words in fine order or because he has an incorrect, foreign accent or an unattractive motion of his hands. But do not similar thoughts prevent me from appreciating and admiring for its merits this external and, so to speak, merely physical beauty of art where I come upon it?

This is also charged against you as a crude fault, my beloved Albrecht Dürer, that you merely place your human figures so conveniently next to each other, without intermingling them so that they form a methodical group. I love you in your unaffected simplicity and I spontaneously fix my eye first of all upon the *soul* and deep *significance* of your human beings, without such censoriousness even entering my mind. However, many people seem so disturbed by this, as by an evil, tormenting spirit, that they become aroused to despise and to mock before they are able to observe serenely, – and they are least of all capable of transporting themselves beyond the boundaries of the present into past ages. I am quite willing to admit to you, you eager neophytes, that a young pupil might nowadays speak more cleverly and learnedly about colors, light, and arrangement of figures than old Dürer knew how to; but is it the youth's own intellect which is speaking, or is it not, instead, the artistic wisdom and experience of the past ages? Only individual, chosen mentalities comprehend the actual inner soul of art *suddenly*, even if their handling of the paintbrush may still be very imperfect; all the external aspects of art, on the other hand, are brought to perfection little by little through invention, practice, and reflection. It is, however, a base and deplorable vanity which sets the gain of the *ages* upon its own weak head as a crown and wants to conceal its nothingness under borrowed splendor. Away, you wise youths, from the old artist of Nuremberg! – and may no one venture to judge him with mockery who can still childishly turn up his nose over the fact that he did not have Titian or Correggio as teachers or that, in his day, people wore such odd Old-Franconian clothing.

For, on this account as well, today's teachers do not want to call him, as well as many another good painter of his century, beautiful and noble, because they clothe the history of all peoples and even the sacred stories of our religion in the dress of their own times. But, I consider thereby how *every* artist who lets the spirit of past centuries enter into his heart must enliven this with the spirit and breath of *his own* age; and how it is, indeed, appropriate and natural that the creative power of the human being lovingly attract to itself everything strange and distant, even the heavenly beings as well, and envelop all in the well-known and beloved forms of *its* world and *its* mental horizon.

When Albrecht was wielding the paintbrush, the German was at that time still a unique and an excellent character of firm constancy in the arena of our continent; and this serious, upright and powerful nature of the German is imprinted in *his* pictures accurately and clearly, not only in the facial structure and the whole external appearance but also in the inner spirit. This firmly determined German character and German art as well have disappeared in our times. The young German learns the languages of all the peoples of Europe and, examining and evaluating, is expected to draw sustenance from the spirit of all nations; – and the student of art is taught how he should imitate the expressiveness of Raphael and the colors of the Venetian School and the realism of the Dutch and the enchanting highlights of Correggio, all simultaneously, and should in this way arrive at the perfection which surpasses all. – O, wretched sophistry! O, blind belief of this age that one could combine every type of beauty and every excellence of all the great painters of the earth and, through the scrutinizing of all and the begging of their numerous great gifts, could unite the spirit of all in oneself and transcend them all! – The period of individual vigor is over; people wish to simulate the talent which has faded away by means of impoverished imitation and shrewd compilation, and cold, immaculate, insipid works are the fruit. – German art was a pious youth, raised in simplicity within the walls of a small city amidst intimate friends; – now that it is older, it has become a universal man of the world who, along with his provincial manners, simultaneously wiped away the emotion and the unique character from his soul.

I would not wish for all the world that the enchanting Correggio or the magnificent Paolo Veronese or the mighty Buonarotti had painted in the very same way as *Raphael*. And I also do not agree in the least with the utterances of those who say: 'If Albrecht Dürer had only lived in Rome for a while and learned true beauty and the ideal from Raphael, then he would have become a great painter; one has to pity him and marvel that he, nevertheless, achieved so much in his position.' I find nothing to pity here; rather, I rejoice that in this man Fate has granted to German soil a truly native painter. He would not have remained himself; his blood was not Italian blood. He was not born for the perfection and the lofty grandeur of a Raphael; he took his pleasure *in this*, depicting for us human beings as they actually were in his surroundings, and he succeeded most admirably.

But, nevertheless, when I for the first time saw paintings by Raphael as well as by you, my beloved Dürer, in a magnificent art gallery during my younger years, it occurred to me most amazingly that, of all the other painters whom I knew, these two had a particularly close affinity to my heart. It pleased me very much that they both present to our eyes so clearly and distinctly mankind in the fullness of soul, so simply

and straightforwardly, without the ornamental digressions of other painters. At that time, however, I did not dare to reveal my opinion to anyone, for I believed that everyone would laugh at me and I well knew that the majority perceive nothing other than something very stiff and dull in this early German painter. On the day when I had seen that art gallery I was, however, so filled with this new thought that I fell asleep therewith and, in the night, a delightful vision appeared before me which confirmed me even more firmly in my belief. It seemed to me, namely, that after midnight I had gone with a torch out of the room of the castle in which I was sleeping. Totally alone I walked through the dark halls of the building toward the art gallery. When I arrived at the door, I heard a soft murmuring within; – I opened it, – and suddenly I started back in surprise, for the entire large hall was illuminated by a strange light and in front of numerous pictures were standing their venerable masters in living form and in their old-fashioned dress, just as I had seen them in portraits. One of them, whom I did not know, told me that they descended from heaven on many a night and, in the nocturnal stillness, wandered about in picture galleries here and there on earth and viewed the still beloved works of their hands. I recognized many Italian painters; from the Netherlands I saw very few. Full of reverence I passed between them; – and behold! there, apart from all the others, *Raphael* and *Albrecht Dürer* were standing hand in hand in the flesh before my eyes and were silently gazing in friendly tranquillity at their paintings, hanging side by side. I did not have the courage to address the divine Raphael; a mysterious, reverential fear sealed my lips. However, I was just about to greet my Albrecht and pour out my love to him; – but, at that moment, everything became disarranged before my eyes with a great din and I awoke with a violent start.

This vision had given my heart deep joy and the joy became even more complete when, shortly thereafter, I read in old Vasari how, without knowing each other, these two magnificent artists had also really been friends during their lifetimes through their works and how the sincere and life-like products of the early German had been regarded with satisfaction by Raphael and he had considered them not unworthy of his love.

But, to be sure, I cannot conceal the fact that afterwards I always felt just as in that dream regarding the works of the two painters; in the case of those by Albrecht Dürer, namely, I sometimes attempted to explain their true merit to someone and dared to speak expansively concerning their excellencies; but, with the works of Raphael, I always became so surfeited and afflicted in the presence of this heavenly beauty that I was not able to speak about it nor to analyze clearly for someone the source of the divine essence which shone forth for me everywhere.

However, I do not want to turn my attention from you now, my Albrecht. Comparison is a dangerous enemy of enjoyment; even the highest beauty of art exerts its full force upon us only then, as it should, when our eye is not simultaneously looking aside at other beauty. Heaven has distributed its gifts among the great artists of the earth in such a way that we are absolutely compelled to stop before each one and offer up to each his share of our adoration.

True art sprouts forth not only under Italian sky, under majestic domes and Corinthian columns, – but also under pointed arches, intricately ornamented buildings, and Gothic towers.

Peace be with your remains, my Albrecht Dürer! and may you know how I love you and hear how I am the herald of your name in the world of today, unfamiliar to you. – Blessed be to me your golden age, Nuremberg! the only age when Germany could boast of having its own native art. – But the beautiful eras pass away across the earth and disappear, just as shining clouds drift away across the arch of the sky. They are over and are no longer thought of; only a few, out of deep love, call them back to mind from dust-covered books and enduring works of art.

Concerning Two Wonderful Languages and their mysterious power

The language of words is a great gift of heaven and it was a perpetual blessing of the Creator that He enabled the first human being to speak, so that he could name all the things which the Highest One had placed around him in the world and all the spiritual images which He had implanted in his soul and could exercise his mind in the diverse play with this abundance of names. We rule over the entire globe by means of words; with easy effort we acquire for ourselves through trade all the treasures of the earth by means of words. Only *the invisible force which hovers over us* is not drawn down into our hearts by words.

We have the earthly things in our hand when we speak their names; – but when we hear the infinite goodness of God mentioned, or the virtue of the saints, which are indeed subjects that ought to grip our whole being, then our ears alone become filled with empty sounds and our spirit is not elevated as it should be.

However, I know of *two wonderful languages* through which the Creator has permitted human beings to perceive and to comprehend heavenly things in their full force, as far as this (in order not to speak presumptuously) is possible, namely, for mortal creatures. They enter into our souls through entirely different ways than through the aid of words; they move our entire being *suddenly*, in a wondrous manner, and they press their way into every nerve and every drop of blood which belongs to us. God alone speaks the first of these wonderful languages; the second is spoken only by a few Chosen Ones among men, whom He has anointed as His favorites. I mean: *Nature and Art.* –

Since my early youth, when I first became acquainted with the God of mankind from the ancient holy books of our religion, *Nature* always seemed to me the most fundamental and the clearest book of explanation concerning His being and His attributes. The rustling in the treetops of the forest and the rolling of the thunder told me mysterious things about Him which I cannot set down in words. A beautiful valley surrounded by fantastic cliff formations or a calm river in which leaning trees are reflected or a pleasant green meadow, shone upon by the blue sky, – ah! these things have inspired more marvelous emotions deep within me, have filled my spirit more fervently with the omnipotence and infinite goodness of God, and have purified and elevated my entire soul far more than the language of words was ever capable of doing. It is, in my opinion, an all too earthly and clumsy instrument to handle the spiritual as well as the physical realm with it.

I find here a great inducement to praise the power and goodness of the Creator. Around us human beings He placed an infinite number of things, each of which has a different nature and none of which we can understand and comprehend. We do not

know what a tree is; nor what a meadow nor what a cliff is; we cannot communicate with them in our language; we only understand *each other*. And, nevertheless, the Creator has placed in the human heart such a marvelous sympathy for these things that they bring to it by unknown pathways emotions or sentiments, or whatever one may call them, which we never acquire through the most measured words.

Out of a zeal for the truth which is in itself laudable, the philosophers have gone astray; they have wanted to uncover the mysteries of heaven and place them amidst the things of earth in earthly illumination and have expelled the *dim intuitions* of the same from their breasts with bold advocacy of their right. – Is the weak human being capable of clarifying the mysteries of heaven? Does he rashly think that he can bring to light what God has hidden with His own hand? May he, indeed, arrogantly dismiss the *dim intuitions* which descend to us like veiled angels? – I honor them in deep humility; for it is a great benevolence of God that He send down to us these genuine witnesses of the truth. I fold my hands and worship. –

Art is a language of a totally different type than Nature; but, through similar dark and mysterious ways, it also has a marvelous power over the heart of man. It speaks through pictures of human beings and, therefore, makes use of a hieroglyphic script, whose symbols we know and understand in their external aspect. But it fuses spiritual and supersensual qualities into the visible shapes in such a touching and admirable manner that, in response, our entire being and everything about us is stirred and affected deeply. Many a painting of the Passion of Christ or of our Holy Virgin or from the history of the saints has, I may indeed say it, cleansed my mind more and inspired my inner consciousness with more blessedly virtuous convictions than systems of morality and spiritual meditations. Among others, I still think with fervor about a most magnificently painted picture of our Saint Sebastian, how he stands naked and bound to a tree, how an angel draws the arrow out of his breast and a second angel brings a floral wreath from heaven for his head. I am indebted to this painting for very penetrating and tenacious Christian convictions and I now can scarcely bring the same vividly back to mind without having tears well up in my eyes.

The teachings of the philosophers set only our brains in motion, only the one half of our beings; but the two wonderful languages whose power I am proclaiming here affect our senses as well as our minds; or, rather (I cannot express it differently), they seem thereby to fuse all the parts of our nature (incomprehensible to us) into one single new organ, which perceives and comprehends the heavenly miracles in this twofold way.

One of the languages, which the Highest One Himself continues to speak from eternity to eternity, continuously active, infinite *Nature*, leads us through the vast expanses of the atmosphere directly to the godhead. *Art*, however, which, by means of clever mixtures of colored earth and some moisture, copies the human form in narrow, restricted space, striving for inner perfection (a type of creation as was granted to mortal beings to produce), – it discloses for us the treasures in the human breast, turns our eyes towards our inner selves, and shows us the invisible part, I mean everything that is noble, grand, and divine, in human form. –

Whenever I walk out of the consecrated temple of our monastery into the open air after the contemplation of Christ on the Cross and the sunshine from the blue sky embraces me warmly and vibrantly and the beautiful landscape with mountains,

waters, and trees strikes my eye, then I see a special world of God arise before me and feel great things surge up in my soul in a special way. – And when I go from the open air into the temple again and reflect upon the painting of Christ on the Cross with seriousness and fervor, then I once again see another entirely different world of God before me and feel great things rise up in my soul in another special way.

Art represents for us the highest human perfection. Nature, to the extent that a mortal eye sees it, resembles fragmentary oracular decrees from the mouth of the deity. However, if it is permissible to speak thusly of such things, then one would perhaps like to say that God may, indeed, look upon all of Nature or the entire world in a manner similar to the manner in which we look upon a work of art.

2 Ludwig Tieck (1773–1853) from *Franz Sternbald's Wanderings*

Ludwig Tieck was born and educated in Berlin where he formed a close friendship with Wilhelm Wackenroder (see VIB1). The son of a rope-maker, he revealed an early gift for imaginative writing, publishing a large quantity of fantastical and humorous fiction in journals such as *Die Straußfedern*, edited by Friedrich Nicolai. In 1797 he published three volumes of fairy-tales under the pseudonym Peter Leberecht, including dramatized versions of *Puss in Boots* and *Duke Bluebeard*. His greatest early success was achieved with the novel *Franz Sternbald's Wanderings*, which he published unfinished. The novel tells the story of a pupil of Dürer who journeys from Nuremberg to Holland and then on to Italy. As Tieck himself observed in a postscript to the novel, its structure and composition owe a great deal to conversations with Wackenroder. Indeed, the book is characterized by the same reverent worship of art and delight in nature which is to be found in the *Confessions from the Heart of an Art-Loving Friar*. It exercised a strong influence on Philipp Otto Runge (see VIB5 and VIIA8), who declared 'I have never been so stirred in my innermost soul as I have been by this book.' In the section reproduced here, Sternbald visits an eccentric painter who lives as a hermit high up in the mountains. Sternbald's rapturous responses to the natural world and the high significance he places on art appear to be confirmed by his conversation with the hermit. The recluse's words echo Wackenroder's claim that art and nature represent 'two wondrous languages' through which divine wisdom is revealed. The description of one of his landscape paintings offers a remarkable parallel with the type of subject that was to be painted by Caspar David Friedrich (see VIB13 and *Art in Theory: 1815–1900*, IA8). *Franz Sternbalds Wanderungen* was first published in Berlin by Johann Friedrich Unger in 1798. The following excerpt has been translated for the present volume by Jason Gaiger from the edition edited by Alfred Anger, Stuttgart: Philipp Reclam, 1979, Part II, Book I, chapter 5, pp. 248–57.

The narrow path wound through the rocks, a scrub of fir trees grew up from the barren ground, and after a few hours Franz stood upon the highest point of the mountain.

Once again it was if a curtain had fallen to the ground, the plain opened itself up to his view and the barren rocks beneath him merged delightfully into the jumble of green woods and fields. Hostile nature had disappeared, unified with the charming prospect of the whole; made beautiful, she in turn made everything else more

beautiful. The splendour of the river lay stretched out before him and in this sudden unveiling of infinite, all-encompassing nature he felt as if he would lose himself; it was as if nature spoke to him in a voice which entered into his heart; she stared down at him from the heavens with burning eyes and looked up at him from the shimmering river, gesturing towards him with her giant limbs. Franz reached out his arms as if he wished to press something invisible to his breast, as if he wanted to seize and hold tight that for which he had yearned for so long. The clouds moved across the horizon against the blue sky, and shadows and reflected light stretched over the meadows, changing their colours and sending wondrous tones down the mountainside. Franz felt as if he were rooted to the spot, like someone under a spell who is kept still by a magic power and who, no matter how hard he tries, cannot tear himself free from the invisible circle which surrounds him.

'O powerless art,' he cried out, sinking down upon a green bank of rock, 'how childish and inarticulate are the sounds you make compared to the full, harmonious organ's song which pours forth from the innermost depths of nature, from the mountains, woods, valleys and rivers, in ever fuller and richer chords. I hear, I perceive, how the eternal world spirit with masterly fingers sends forth sounds from its fearsome harp, conjuring forth the most varied images which take wing above the realm of nature. Inspiration impels my small human heart to participate, wrestling with these higher powers until it is exhausted; nature governs gently and will perhaps refuse to acknowledge my striving and my appeals for help with this omnipotent beauty. The immortal melody rejoices and exults and tears away from me; my gaze falls to the ground and my senses are dulled. How ignorant you are, you who believe that all-powerful nature can be made more beautiful by calling upon art and deception to aid you in your powerlessness! What more can you hope for than to give an intimation of nature, if nature herself gives us an intimation of the divine? It is not a presentiment or an intimation which reigns here on the peaks and in the valleys but the power of an originary responsiveness, a religion which receives my prayer with benevolent compassion. The hieroglyph which represents God, the highest, lies there before me, an active power, fulfilling its task of resolution and of bringing itself to speech; I feel the need to resolve the puzzle into concepts – and feel my own humanity. – The highest art can only explain itself, it is a song whose content can only be art itself.'

Reluctantly, Sternbald let go his inspiration and left the place which had so enraptured him. He sorrowed that he could not preserve for ever the freshness and vigour of the words and thoughts which he had spoken and that new impressions and new ideas would erase or cover them over.

At the top, he was met by a thick wood and he often looked behind him, going forwards reluctantly as if he were leaving life behind. The solitary darkness awoke in him a strange feeling towards the open countryside; his breast was oppressed and contracted with anxiety. After half an hour of walking he encountered a small hut which stood open without anyone inside. Exhausted, he threw himself beneath a tree and gazed at the narrow dwelling with its sparse furnishing; he was moved by an old lute lacking one of its strings which hung upon the wall. Palettes and paints were scattered everywhere, together with items of clothing. It was as if Sternbald found himself transported back into the most ancient times, of which we hear tell in stories

with so much pleasure – where there is no lock upon the door and where no miscreant interferes with the belongings of another.

After a while, the old painter returned; he was not at all surprised to encounter a stranger before his door, but instead went into his hut, cleared his things and played upon his zither as if no one were there. Franz watched in astonishment as the old man sat in his house like a child, showing his contentment in his small home, surrounded by the friendly, familiar sounds of his instrument. Once he had finished playing, he unpacked herbs, moss and stones from a bag and carefully laid them out in small boxes, examining each one attentively. Some caused him to smile, whilst others aroused his astonishment, causing him to strike his hands together or gravely to shake his head. Still he did not look at Sternbald, until finally he came into the old man's hut and offered his greetings. The old man gave him his hand and silently gestured him to sit, examining him in wonder as a stranger.

The hut was decorated with a large variety of stones and mussel shells, together with unusual plants and stuffed animals and fish, so that everything took on a fantastical appearance. Silently, the old man reached our friend some fruit which he set before him with a wordless gesture. After Franz had eaten, observing all the while this curious man, he began to speak with the following words, 'For some time now I have taken great pleasure in watching you, and I very much hope that you will show me some of your paintings; this is what I desire most of all, for I too have given myself up to this noble art.'

'Your are a painter?' cried the old man. 'Now, indeed, I am delighted to see you, for it is a long time since I last met one. But you are still very young, and I doubt whether you have yet developed a proper feeling for this great art.'

'I do the best I can,' Franz answered, 'and will always do my best; but I am aware that this is not always sufficient.'

'It is always enough,' cried the old man; 'only the rare few are able to express what is highest and truest; we others can only ever come near, but we will have reached our goal when we are able to recognize and acknowledge that which the Almighty has placed within us. In this world we can only *wish*; we must live with our intentions, for genuine action lies beyond us; it consists no doubt in the most individual and effective thoughts, for in this many-coloured world everything is mixed up with everything else. Thus it is that the omnipotent Creator, in a mysterious way which is proper for us his children, has revealed himself through the realm of nature which belongs to him. He does not speak to us directly, for sometimes we are too weak to understand him. Instead, he gives us signs and in every piece of moss, in every stone, there is hidden a secret number which can never be written out or fully guessed, but which we believe we can always see. The artist works in just the same way: strange, wondrous, unknown rays of light shine forth from him which he reflects towards others through the crystal of art; in this way he does not frighten them, but allows them in their own way to grasp and to understand. Thus the work is completed, a vast land is revealed, a boundless prospect in which all of human life is illuminated by the brilliance of the heavens; flowers grow up mysteriously and even the artist does not know that the finger of God has produced them; we smell their ethereal scent and they silently proclaim the artist a favourite of God. Behold, these are my thoughts about nature and about art.'

Franz was gripped by astonishment, for no one before had ever spoken to him in this way; he shrank back from himself, for he heard his own most personal thoughts spoken in the mouth of someone whom other people called mad; as if under a magic spell, his soul was spirited forth from its distant dwelling-place and he saw his own indeterminate intuitions presented before him in the form of perspicuous images.

'How I welcome this way of speaking,' he cried out, 'I had not gone astray after all when I arrived here in the quiet hope that you might be able to help me and lead me from confusion.'

'We all lose our way,' said the old man, 'it is necessary that we err; but beyond error does not lie truth; these are not opposed to each other – they are only words which man invents in his helplessness in order to describe what he does not mean at all. Do you understand me?'

'Not so well,' answered Sternbald.

The old man continued, 'If I could only paint, or say, or sing what animates my innermost self, then I could aid myself and everyone else; but my soul scorns the words and signs which press in upon it; and since it cannot employ these, it uses them only to play with. This is how art comes into being, this is how true thought is born.'

Franz recalled that Dürer had once expressed this idea in almost exactly the same words. He asked, 'What, then, do you hold to be the highest that man can attain?'

'To be at peace with himself,' cried the old man, 'to be at peace with everything, for then he himself and everything around him vanishes in a heavenly art work, he purifies himself with the fire of the divinity.'

'Is this something we can achieve?' Franz asked.

'We should want to achieve it,' the old man continued, 'and, indeed, this is something everyone does want; it is just that many, indeed the majority, have allowed their minds to become stunted in this strange world we inhabit. For this reason, it is rare for us to become aware of others and even more rare that we become aware of ourselves.'

'I look around for your paintings,' said Sternbald, 'but I cannot see them; after what you have said about art, I anticipate something great.'

'You would be wrong to do so,' answered the old man with some frustration, 'for I was not born to be an artist; I am an unsuccessful painter who has not found his proper vocation. The desire seizes many and makes their life a misery. From my childhood on I sought only to live for art, but, unwilling, she turned away from me and refused to recognize me as her son. Although I continue to work, she has turned her back on me.'

He opened a door and led the painter into a small room full of paintings. The majority were portraits, a few landscapes and yet fewer history paintings. Franz examined them with great attention, whilst the old man silently occupied himself with repairing a broken bird-cage. A severe and earnest character was reflected in each of the paintings; the features were clear, the drawing hard and definite; little attention was paid to ancillary features, but there was something in the faces which both attracted and repelled the gaze; in many of the portraits a happiness was expressed in the eyes which could be termed cruel, whilst others were curiously withdrawn and excited horror through their fearful countenance. Franz felt indescribably lonely, particularly when he looked out of the small window to the

mountain and the woods outside and could not make out a single house or human being in the distant plane.

When Franz had finished looking, the old man said, 'I wonder whether you do not notice something peculiar about my paintings, for I finished them all in a strange state of mind. I do not like to paint unless I see clearly and definitely in front of me what I want to represent. Sometimes when I sit in front of my hut in the evening sun, or in the freshness of the morning as it travels down from the mountain to the meadows below, images of the apostle or of holy martyrs appear in the trees; their faces stare down at me when I pray to them, demanding of me that I draw them. Then I reach for my brush and palette and my agitated soul, filled with ardour for these great men and with love for the ages that are past, seeks to shadow forth their excellency with earthly colours which shine with splendour in my mind and before my eyes.'

'You are happy then,' said Franz, who was astonished at these words.

'As you wish it,' said the old man. 'In my opinion, the artist should not work in any other way. What else is inspiration? For the painter, everything must possess reality, for what else does he wish to represent? His soul must move like a stream, so that his innermost world is shattered to its very ground; then, from the multi-coloured confusion the great forms will emerge which he reveals to his fellow man. Believe me, no artist has ever been inspired in any other way. We speak of inspiration as if it were something natural; but it is wholly incomprehensible – it comes and goes like the first light of Spring which descends unexpectedly from the clouds and then, before you have enjoyed it, disappears.'

Franz was unsure what to answer. He was uncertain whether the artist really had succumbed to madness or whether he simply spoke the language of artists.

'Occasionally,' the old man continued, 'surrounding nature speaks to me and arouses me to practise at my art. But I have never sought to capture nature, only to attune myself to character or physiognomy, inserting a pious thought which transforms the landscape into a beautiful story.'

He then drew the young painter's attention to a landscape which hung somewhat to one side. It was a night scene; a wood, a mountain and a valley lay in unclear masses alongside one another; dark clouds lowered from the sky. A pilgrim wandered through the night, recognizable by his staff and by the mussel shells on his hat. He was surrounded by deepest darkness, illuminated only by the shimmer of a stolen ray of light from the moon. In front of him could be made out a dark path into the woods and high up on the hill a gleaming crucifix separated the clouds. From the moon fell a ray of light which played upon the holy sign.

'Look,' cried the old man, 'here I have sought to paint temporal existence and celestial hope: look at the sign which calls us from the dark valley to the moonlit heights. Are we any further forward than lost and wandering pilgrims? Can anything illuminate our path other than a light from above? It is from the crucifix that light penetrates this world with its gentle force, giving us life and sustaining our strength. Here I have sought to transform nature once again and to say in my own human fashion what nature herself says to us. I have painted a puzzle which not everyone will be able to unlock, but which is easier to solve than the sublime mystery with which nature covers herself.'

'One could,' Franz replied, 'call this painting allegorical.'

'All art is allegorical as you call it,' said the old man. 'Art cannot represent things as isolated objects existing for themselves, eternally separated from the world before us. Nor should art seek to do so: we combine things together and we strive to identify a universal meaning in the particular. This is how allegory comes into being. It means nothing else than true poetry which seeks what is great and noble and which can only be discovered in this way.'

3 Francisco de Goya (1746–1828) on the *Caprichos*

The eighty prints composing Goya's *Caprichos* (Caprices) were published in February 1799. The designs were based on work in two sketchbooks from the years 1796–7. These contained intimate observations made in ink and wash which he made while staying with the Duchess of Alba, together with satirical sketches, anecdotal fragments and caricatures. Underneath one drawing from 1797 he wrote, 'The artist dreaming. His only purpose is to banish harmful, vulgar beliefs, and to perpetuate in this work of caprices the solid testimony of truth.' In the resulting aquatints several of the various vignettes appear with suggestive captions and gnomic comments. The collection as a whole offers vivid and ironic comment both on the patterns of private life and on the Spanish social world of the time, augmented by more enigmatic references to witchcraft and the threat of madness. The final plate of the series was titled *The Sleep of Reason produces Monsters*, to which Goya added the note, 'Imagination, deserted by reason, begets impossible monsters. United with reason, she is the mother of all arts, and the source of their wonders.' Only twenty-seven sets of the *Caprichos* were sold before they were withdrawn from sale, perhaps as a result of protests at their satirical content. They nevertheless played a considerable part in establishing Goya's reputation outside Spain. Though he was denounced to the Inquisition, he was safeguarded by his reputation and by the support of powerful patrons. He presented the plates of the *Caprichos* to the king, who granted a pension to his son in return. The following announcement was published in the paper *Diario de Madrid* for 6 February 1799. Our text is taken from the English version published in José López-Rey, *Goya's Caprichos: Beauty, Reason & Caricature* (1953), Westport, Connecticut: Greenwood Press, 1970, volume I, pp. 78–9. (For a previous text by Goya see IVA14.)

A Collection of Prints of Capricious Subjects, Invented and Etched by Don Francisco Goya. Since the artist is convinced that the censure of human errors and vices (though they may seem to be the province of Eloquence and Poetry) may also be the object of Painting, he has chosen as subjects adequate for his work, from the multitude of follies and blunders common in every civil society, as well as from the vulgar prejudices and lies authorized by custom, ignorance or interest, those that he has thought most suitable matter for ridicule as well as for exercising the artificer's fancy.

Since the majority of the objects represented in this work are ideal, it may not be too daring to expect that their defects will perhaps meet with forgiveness on the part of the connoisseurs as they will realize that the artist has neither followed the examples of others, nor been able to copy from nature. And if imitating Nature is as difficult as it is admirable when one succeeds in doing so, some esteem must be

shown toward him who, holding aloof from her, has had to put before the eyes forms and attitudes that so far have existed only in the human mind, obscured and confused by lack of illustration, or excited by the unruliness of passions.

One would be assuming too much ignorance of the fine arts, if one were to warn the public that in none of the compositions which form this series has the artist had in mind any one individual, in order to ridicule particular defects. For truly, to say so would mean narrowing overmuch the boundaries of talent, and mistaking the methods used by the arts of imitation in producing perfect works.

Painting (like Poetry) chooses from the universal what it considers suitable to its own ends: it reunites in a single fantastic personage circumstances and characteristics that nature has divided among many. From such a combination, ingeniously arranged, results the kind of successful imitation for which a good artificer deserves the title of inventor and not that of servile copyist.

4 Novalis (Friedrich von Hardenberg) (1772–1801) The Blue Flower from *Henry of Ofterdingen*

Towards the end of his short life, Novalis (see VIA3) turned towards the novel, which the early German Romantics conceived as the poetic genre that could encompass all the other genres. He wrote two 'prose romances', *Die Lehrlinge zu Sais* (The Disciples at Sais) and *Heinrich von Ofterdingen*, both of which remained unfinished at his death. Like Ludwig Tieck's *Franz Sternbald's Wanderings* (see VIB2), *Heinrich von Ofterdingen* is the story of an artist, in this case the historical 'minnesinger' or courtly poet who was active in the twelfth or thirteenth century. Novalis imagines the Middle Ages as a period of unity prior to the divisions inaugurated by the 'age of reason'. The story of Heinrich's quest for artistic and personal fulfilment is also an allegory of Novalis' own spiritual life. *Heinrich von Ofterdingen* has been described as the representative novel of early German Romanticism, and in the image of the 'blue flower' it provided this movement with one of its enduring motifs. Heinrich's quest to locate the blue flower which he sees in a dream typifies the Romantic condition of yearning (*Sehnsucht*) for an unobtainable ideal. The idea of a secret symbolism of flowers is also to be found in the work of Philipp Otto Runge (see VIB5). The unfinished novel, which was largely composed in 1799, was first published by Friedrich Schlegel and Ludwig Tieck in the first volume of their edition of Novalis' *Schriften* (Berlin, 1802). The following excerpt, which forms the opening section of the book, is taken from the anonymous translation, *Henry of Ofterdingen: A Romance*, Cambridge: John Owen, 1842, pp. 23–6.

THE parents had already retired to rest; the old clock ticked monotonously from the wall; the windows rattled with the whistling wind, and the chamber was dimly lighted by the flickering glimmer of the moon. The young man lay restless on his bed, thinking of the stranger and his tales. 'It is not the treasures,' said he to himself, 'that have awakened in me such unutterable longings. Far from me is all avarice; but I long to behold the blue flower. It is constantly in my mind, and I can think and compose of nothing else. I have never been in such a mood. It seems as if I had hitherto been dreaming, or slumbering into another world; for in the world, in which hitherto I have lived, who would trouble himself about a flower? I never have heard

of such a strange passion for a flower here. I wonder, too, whence the stranger comes? None of our people have ever seen his like; still I know not why I should be so fascinated by his conversation. Others have listened to it, but none are moved by it as I am. Would that I could explain my feelings in words! I am often full of rapture, and it is only when the blue flower is out of my mind, that this deep, heart-felt longing overwhelms me. But no one can comprehend this but myself. I might think myself mad, were not my perception and reasonings so clear; and this state of mind appears to have brought with it superior knowledge on all subjects. I have heard, that in ancient times beasts, and trees, and rocks conversed with men. As I gaze upon them, they appear every moment about to speak to me; and I can almost tell by their looks what they would say. There must yet be many words unknown to me. If I knew more, I could comprehend better. Formerly I loved to dance, now I think rather to the music.'

The young man gradually lost himself in his sweet fancies, and fell asleep. Then he dreamed of regions far distant, and unknown to him. He crossed the sea with wonderful ease; saw many strange monsters; lived with all sorts of men, now in war, now in wild tumult, and now in peaceful cottages. Then he fell into captivity and degrading want. His feelings had never been so excited. His life was an unending tissue of the brightest colors. Then came death, a return again to life; he loved, loved intensely, and was separated from the object of his passion. At length towards the break of day his soul became calmer, and the images his fancy formed grew clearer, and more lasting. He dreamed that he was walking alone in a dark forest, where the light broke only at intervals through the green net-work of the trees. He soon came to a passage through some rocks, which led to the top of a neighboring hill, and to ascend which he was obliged to scramble over the mossy stones, which some stream in former times had torn down. The higher he climbed, the more was the forest lit up, until at last he came to a small meadow situated on the declivity of the mountain. Behind the meadow rose a lofty cliff, at whose foot an opening was visible, which seemed to be the beginning of a path hewn in the rock. The path guided him gently along, and ended in a wide expanse, from which at a distance a clear light shone towards him. On entering this expanse, he beheld a mighty beam of light, which, like the stream from a fountain, rose to the overhanging clouds, and spread out into innumerable sparks, which gathered themselves below into a great basin. The beam shone like burnished gold; not the least noise was audible; a holy silence reigned around the splendid spectacle. He approached the basin, which trembled and undulated with ever-varying colors. The sides of the cave were coated with the golden liquid, which was cool to the touch, and which cast from the walls a weak, blue light. He dipped his hand in the basin and bedewed his lips. He felt as if a spiritual breath had pierced through him, and he was sensibly strengthened and refreshed. A resistless desire to bathe himself made him undress and step into the basin. Then a cloud tinged with the glow of evening appeared to surround him; feelings as from Heaven flowed into his soul; thoughts innumerable and full of rapture strove to mingle together within him; new imaginings, such as never before had struck his fancy, arose before him, which, flowing into each other, became visible beings about him. Each wave of the lovely element pressed to him like a soft bosom. The flood seemed like a solution of the elements of beauty, which constantly became embodied in the

forms of charming maidens around him. Intoxicated with rapture, yet conscious of every impression, he swam gently down the glittering stream. A sweeter slumber now overcame him. He dreamed of many strange events, and a new vision appeared to him. He dreamed that he was sitting on the soft turf by the margin of a fountain, whose waters flowed into the air, and seemed to vanish in it. Dark blue rocks with various colored veins rose in the distance. The daylight around him was milder and clearer than usual; the sky was of a sombre blue, and free from clouds. But what most attracted his notice, was a tall, light-blue flower, which stood nearest the fountain, and touched it with its broad, glossy leaves. Around it grew numberless flowers of varied hue, filling the air with the richest perfume. But he saw the blue flower alone, and gazed long upon it with inexpressible tenderness. He at length was about to approach it, when it began to move, and change its form. The leaves increased their beauty, adorning the growing stem. The flower bended towards him, and revealed among its leaves a blue, outspread collar, within which hovered a tender face. His delightful astonishment was increasing with this singular change, when suddenly his mother's voice awoke him, and he found himself in his parents' room, already gilded by the morning sun. He was too happy to be angry at the sudden disturbance of his sleep. He bade his mother a kind good morning, and returned her hearty embrace.

5 Philipp Otto Runge (1777–1810) Letters, 1802

Despite his death at the age of 33 and the incomplete state of many of his larger projects, the German painter Philipp Otto Runge made a definitive contribution to Romantic art. He was born in the small harbour town of Wolgast in what was then Swedish Pomerania and was brought up in a strict Protestant household. Runge's artistic theory is closely linked to his religious faith, and biblical references abound in his extensive correspondence, which was largely conducted with members of his own family. From 1799 to 1801 he studied at the art academy in Copenhagen, before moving in 1802 to Dresden, where he met some of the central figures of German Romanticism, including the brothers Schlegel (see VIA1, 2, 7 and 9), Gotthilf Heinrich Schubert (see VIB11), Ludwig Tieck (see VIB2) and Caspar David Friedrich (see VIB13). He also drew upon the nature mysticism of Jakob Böhme (1575–1624) and the ideas of Novalis (see VIA3). The letters in the following selection all date from Runge's Dresden period. The first, written to his father, concerns the annual competition organized by Goethe and Heinrich Meyer in Weimar. The lack of success met by his drawing, *Achilles and Scamander*, leads Runge to reflect on the historical conditions under which art is made. He powerfully rejects the values of Weimar classicism, insisting that art needs a new content and a new form if it is to meet the demands of the modern age. The second letter, to his brother Daniel, has been seen as a form of artist's manifesto, offering a sustained account of Runge's ideas at the time and culminating in a ten-point programme of the creative process. The third and fourth letters, to his brother Daniel and to Ludwig Tieck, elaborate the idea of a symbolic language of flowers which found its fullest expression in the series *Times of Day* (Hamburg, Kunsthalle). Although Runge's own art remained primarily figurative, he envisions a new art of landscape which will transcend the traditional genres of painting and allow truth to nature to be combined with a heightened expression of feeling. The letters of February 1802 to his father, of November 1802 to his brother Daniel and of December 1802 to Tieck have been translated for the present

volume by Nicholas Walker from Philipp Otto Runge, *Die Begier nach der Möglichkeit neuer Bilder: Briefwechsel und Schriften zur bildenden Kunst*, ed. Hannelore Gärtner, Leipzig: Philipp Reclam, 1982, pp. 86–8, 110–11, 118–23. The letter to Daniel of March 1802 is taken from the translation by Michel Sniderman in Joshua C. Taylor, *Nineteenth-Century Theories of Art*, Berkeley and Los Angeles: University of California Press, 1987, pp. 260–9.

Letter to his father, February 1802

The exhibition in Weimar, and the whole approach that is being pursued there, has already begun to take a wholly false path upon which it will be quite impossible to achieve anything valuable. The test subject which they have set, namely 'Achilles on Skyros', is incapable of being fulfilled properly, and while the Roman School has occasionally succeeded in rendering such complicated motifs vividly in a single moment of time, the subject was then never simply given in advance to the artist. Hoffmann's piece is just a swirling turmoil of figures and gets completely lost in subsidiary details, which only serve to confuse the work as a whole even more. Perhaps the gentlemen were mightily impressed by the execution of the thing. Breaking the necklace of pearls like that is not especially characteristic of Achilles and nothing but a curiosity as far as pictorial composition is concerned. – Achilles and the river Scamander, together with all the other things which have still to be properly executed, is, in the last analysis, but a vain and fruitless fantasy; we are no longer Greeks after all, we can no longer respond to the theme as a totality even when we contemplate their perfect works of art, and even less can we actually produce such works ourselves. Why then should we struggle to bring forth something mediocre in comparison? – The new test subject ['Perseus and Andromeda' for 1802] is said to offer an opportunity 'for much feeling and symbolic treatment'; so now we are supposed to go and sit down and feel accordingly, and for us that simply means, to start at entirely the wrong end. The figure of Tiresias represents a 'new discovery in the domain of composition' – and indeed people are all busy hunting down possible subjects, as if art consisted in the latter, or as if they had nothing living to find within themselves. But must something like this really be introduced from the outside? Did not all artists who have ever produced a fine work of art possess some feeling in advance? and did they not always choose a subject appropriate to that feeling?

The art of all times has clearly taught us how humanity has changed, how the same age has never returned again. Whatever has given us the disastrous idea of attempting to revive the art of the past? In Egyptian art we behold the harsh, crude and iron character of the human race. The Greeks deeply felt their religion, which was then sublimated into works of art. Michelangelo marked the highest stage in the development of composition, and historical composition reached its final culmination in his *Last Judgement*. Raphael already painted many works that can no longer be described as purely historical. The *Sistine Madonna* in Dresden is obviously the expression of a certain state of feeling which assumes the form of a familiar figure. And since the time of Raphael there has indeed been no history painting proper. All beautiful compositions now tend towards the subject of landscape, like the *Aurora* of Guido Reni for example. But until the present time no landscape artist has succeeded

in bestowing true significance upon landscape, in endowing the latter with allegorical meaning and beautiful ideas comprehensible to the understanding. But are not all of us capable of perceiving spirits in the clouds at sunset? Does not such an idea suffice to inspire specific thoughts within the soul? Is it not true that the work of art comes into existence only in the moment that we feel ourselves one with the universe? Am I not able to capture the disappearing moon just as I might capture the disappearing figure which has evoked a thought within my mind, and is it not possible for both, moon and human figure alike, to be turned into art? And what artist who had ever really sensed such a thing, who had ever been roused by nature (something which we perceive so clearly only in ourselves, in love, in the sky) could fail to seize upon the appropriate subject for the expression of his feeling? How could such a one possibly lack for a subject? And it is just such a feeling which must precede the choice of subject; how foolish then to rely upon some subject set out in advance! – How can we even think of reviving the art of the ancients? The Greeks carried formal and corporeal beauty to its highest level at the very moment when their gods were dying; the modern artists of Rome brought historical painting to its uttermost point at the very moment when the Catholic faith was dying; and amongst ourselves something is also dying, for we now stand at the brink of all religions which have sprung from the Catholic religion, the abstractions are dying, everything is airier and lighter than it was before, everything is moving ineluctably in the direction of landscape, is seeking something determinate precisely within this indeterminacy, and yet no one really knows how to proceed? Everyone is reaching falsely after historical subjects once again, and getting lost in confusion as a result. But is it not possible to reach a highest point of perfection precisely in this new kind of art – in the art of landscape painting if one wishes to describe it thus – and one which will perhaps prove even more beautiful than what has gone before? I should like to express my life in a series of works; for when the sun is setting and the moon is gilding the clouds I wish to capture the fugitive spirits of this moment. Perhaps indeed we shall not live to experience the blossoming of this art, but we would gladly devote our life to creating such an art in reality and truth; no mean or vulgar thought shall penetrate our souls; those who cherish within themselves the beautiful and the good with fervent love will certainly be able to attain something beautiful in turn. We must become once again as children if we would truly accomplish the highest.

Letter to his brother Daniel, 9 March 1802

It has always rather embarrassed me when Hartmann or someone else assumed about me – or at least said of others: So-and-so actually does not quite know what art is. Because I had to admit to myself that I just could not say what it is either. That weighed on my mind terribly and vexed me. Then I attempted to find some light in such general maxims as, for example, 'a work of art is eternal' or 'a work of art requires the whole being as art requires all mankind' or 'one ought to look upon one's life as a work of art,' and other such things, all of which seemed to raise a point that still had to be probed before I could entirely understand these sayings we hear bandied about. Well, some time ago a kind of light dawned in my soul, and I intend to see if I can communicate my roving perceptions to you briefly and clearly.

Once I thought of a war that could overthrow the entire world, or how such a war would have to arise, and saw simply no means – since war has now become a science throughout the world and thus does not properly exist any longer, and there is no longer any people extant that might massacre all Europe and the entire civilized world as the Germans once did the Romans when the spirit of that people had departed – I saw, as I said, no means other than the Last Judgement, when the earth would open and swallow us all, the entire human race, so that absolutely no trace would remain of all present-day accomplishments.

These thoughts came to me from a few dejected remarks on the spread of civilization that Tieck made when he was ill recently, remarks that also led to the Judgement Day. The question occurred to me: What sort of relation, insofar as our traditions go, does this most advanced civilization – which, it seems, might be brought to consciousness only by such drastic means – bear to humankind as it formerly was constituted? Also, I wondered how the earth itself once looked; how granite and water, raw masses opposing each other, had more and more united. I found both these formations everywhere, in people, in our life, in nature, and in every era of art. I thought of the various religions, how they had originated and gone to ruin, and again an observation by Tieck struck me, that it has always been just after an age has gone down that master-works of art have come into being – for example, Homer, Sophocles, Dante: the great Greek works of art and the more recent Roman ones; also in architecture – and that these works of art have each time borne within them the very loftiest spirit of the uprooted religion. From what has been, it flashed before my eyes that after the zenith in every era of art (for example, after the formation of the Olympian Jupiter and after the creation of the *Last Judgement*), art has declined, disintegrated, and again reached a quite different and almost more beautiful high point. I asked myself, is it not likely that we are again about to carry an age to its grave?

I lost myself in wonderment. I could not think further. I sat before my picture [*Triumph of Love*], and all that I had at first thought about it – how it had originated in me, the feelings that always mount in me upon beholding the moon or the setting of the sun, this foreboding of spirits, the destruction of the world, the distinct awareness of everything that I had ever perceived – passed before my soul. For me this firm awareness became eternity: God you can only sense as being behind these golden mountains, but of your own self you are certain, and what you perceive in your eternal soul, that too is eternal. What you drew from it is everlasting; art must originate there if it is to be eternal. What then happened within me, to what extent I have worked my way out of these confused feelings and sought to regulate them, you will now hear. What transpired subsequently and whatever else requires explanation – I shall tell you later.

When the heavens above me swarm with countless stars, the wind whistles through immense space, the wave breaks roaring in the vast night; when the atmosphere reddens over the forest and the sun lights up the world, the valley steams and I throw myself into the grass amidst sparkling dewdrops; when every leaf and every blade of grass abounds with life, the earth lives and stirs beneath me; when all things resound in a single, harmonious chord – then my soul shouts for joy and flies about in the

immeasurable space around me. There is no more below and above, no time, no beginning and no end; I hear and feel the living breath of God, who contains and carries the world, in whom everything lives and acts. Here is our highest perception – God!

This most profound intimation of our soul, that God is over us; that we see how all has come into existence, has been, and passed away; how everything is coming into existence, being, and passing away around us; and how everything will come into existence, will be, and will again pass away; how there is in us no rest and standing still – this vital soul in us, which issued from Him and will return to Him, which will endure when heaven and earth pass away – this is the most certain, clearest consciousness of ourselves and our own eternity.

We feel that an inexorable severity and appalling everlastingness are opposed to a sweet, eternal, and boundless love in a harsh and violent struggle, like hardness and softness, like rocks and water. We see these opponents everywhere, in the smallest as well as the largest things, in the whole as in the parts. These opponents are the quintessence of the world, are basic in the world, and come from God, and over them is God alone. In violent opposition to each other, they reveal themselves in the origin of every single thing that comes from God, that is basic in man and nature. The more harshly they are opposed to each other, the farther each thing is from its consummation. And the more they come together, the closer each is to its consummation. After the acme of this consummation, the spirit returns to God, whereas the lifeless material elements disintegrate, merge with each other at the innermost core of their existence. Then heaven and earth cease to be, and from its ashes the world develops anew and both forces revive in a pure state, unite, and destroy themselves once more. This unceasing flux we perceive in us, in the entire world, in every lifeless thing, and in art. The human being is born helpless, without consciousness, put into the world so that fate may exercise on him what it can and chooses. Along with what is frightful, that which is most beautiful, maternal love, enters the struggle and unites savage passions with the sweetest love and innocence. At the point of completion, man sees his relationship with the whole world. Earnest desire drives him hence. His soul flies forth without rest through all things and finds no peace, but then love binds him to sweet life and he engages in the circle of life around him. He unifies and completes himself through the opposing forces. Then his spirit returns to God. When our feelings sweep us away so that all our senses tremble through and through, then we search for the firm, meaningful signs outside ourselves that have been found by others, and we unite them with our feelings. In our best moments, we can communicate this to others. If, however, we want to protract these moments, an overstraining occurs, that is, the spirit flees the signs that have been found and we cannot regain the unity in us until we have returned to our original fervor or until we have been transformed to children again. This circle, in which one is invariably rendered dead, everyone experiences; and the more often one experiences it, the deeper and more fervent one's feelings are certain to become. And so art comes into existence and goes to ruin, and nothing remains but lifeless signs when the spirit has returned to God.

This perception of how the entire universe relates to us, this jubilating rapture of the most fervent, most vital spirit of our soul, this harmonious chord which, in

soaring, strikes our every heartstring: the love that holds and carries us through life, this sweet being who is near to us, who lives in us and in whose love our soul glows – it is this urging in our breast that drives us to communicate. We hold fast to the acmes of these perceptions and thus certain ideas arise in us.

We express these ideas in words, tones, or images and thus provoke the same feeling in the bosoms of people near us. The truth of the perception seizes everyone; all feel themselves together in this relationship. All who feel for Him praise the one God, and thus *religion* arises. We unite these words, tones, or images with our most fervent feeling, our intimation of God, and, through perceiving the unity of the whole, with the certainty of our own eternity. That is, we align these feelings with the most significant and vital beings around us, and – in holding fast to characteristic features of these beings, that is, those features that correspond to our feelings – we present the symbols of our thoughts about great forces in the world. These are the images of God or of the gods. The more people keep themselves and their feelings pure and elevated, the more definite do these symbols of God's powers become, the more acutely is the great almighty power perceived. The symbols compress all the infinitely varied natural powers together into one entity; they attempt to concentrate everything simultaneously in one image and thus to present an image of the infinite. (When the human spirit has reached its highest intimation, then an overstraining occurs and, as soon as the spirit has fled, the signs collapse from within and man must begin again from the first childish feeling.)

These symbols we employ when we want to make clearly intelligible to others great events, beautiful thoughts about nature, delightful or terrifying perceptions of our soul, thoughts about occurrences, or the inner unity of our feelings. We search for an occurrence that corresponds in character to the feeling we want to express, and when we have found it, we have selected a *subject* for art.

When we link this subject to our feeling, we juxtapose those symbols of the powers of nature or of the feelings in us so that they express the peculiar characteristics of both the *subject* and *our perception*. This is *composition*. (Here again, as in presenting the single, highest symbol of God, the human being seeks to express an image of God through the loftiest symbolic composition. He unites his loftiest feelings with the world's greatest event and lets all the symbols of his feelings and of nature take effect in that context until he has expressed his thought about the most profound perception of the soul: the omnipotence of God in the world's greatest and last event. In this manner the spirit is again exhausted; the lifeless materials collapse of themselves, and this marks the limit of historical composition.)

Just as we perceive more clearly and coherently the forms of those entities from which we take our symbols, so, too, do we derive more characteristic outlines and representations of them from their basic existence, from our feelings, and from the consistency of the natural subject. We observe the subject in all positions, tendencies, and expressions. We arrange every object within the whole exactly according to nature and in consonance with the composition, the effect, the particular action in its own right, and the action of the entire work. We allow objects to become smaller or larger according to perspective and observe all the subordinate objects that belong to the background, in which everything functions in accordance with nature and the subject. This is *design*.

Just as we behold the colours of the sky and earth, the changes in colour caused in people by affects and feelings, the effect of colours as they occur in grand natural phenomena, and their harmony, to the extent that certain colours have become symbolic, so do we give to every compositional subject and to each symbol and object individually its colour in harmony with our first, deep feeling. And this is the *colour scheme*.

We diminish or augment the purity of these colours according to how near or far each object should appear to be or how great or small the extent of atmosphere between the object and the eye. This is the *ordering of colour*.

We observe the consistency of each object in its local colour as well as the effect of brighter or weaker light on it, just as we examine the shadow and the effect on it of nearby, illuminated objects. This is *colouring*.

We attempt to find gradations among the reflections and effects of one object on another and among their colours. We examine all colours in accord with the effect of the atmosphere and time of day, attempting with utter thoroughness to discern this tone as the last resonance of our feeling. And this is the *tone* – and the end.

Thus art is the most beautiful endeavour when it proceeds from and is one with what belongs to all. I wish, then, to set down once more the requisites of a work of art with regard not only to the order of their significance but to their proper order in the creative process:

1. Our intimation of God,
2. the perception of ourselves in relation to the whole; and out of these two:
3. religion and art, that is, expression of our loftiest feelings through words, tones, or images; and there pictorial art seeks first:
4. the subject, then
5. the composition,
6. the design,
7. the colour scheme,
8. the ordering of colour,
9. the colouring,
10. the tone.

In my opinion, a work of art simply cannot come into being when the artist does not proceed from these primary instances. Moreover, in no other way is a work of art eternal, for the eternality of a work lies really only in its association with the artist's soul, and through this it is an image of the eternal source of his soul. A work of art that originates in these primary impulses and develops only to the stage of composition is worth more than any fancy piece that is begun as mere composition, without the initial stages, even if it is fully executed to the point of tone. Clearly, without that which is primary the remaining parts cannot attain relatedness and purity. Only in this order, then, can art rise again. Here, in the innermost core of the person, it must originate; otherwise it remains mere trifling. Here it arose in the case of Raphael, Michelangelo Buonarroti, Guido, and others. Afterward, it is said, art declined. What does that mean but that the spirit has fled? – Annibale Carracci and the like began

only at the level of composition, and Mengs at design; our people currently making noise are concerned only with tone.

When I look at this progression and apply it to life and see a perfectly stylish gentleman who can do nothing more than *parler* French and yet knows how to keep himself in full swing, then it instinctively occurs to me: he is at the stage of tone. Yes, the entire progression holds true also in human life, and 'blessed are the pure in heart, for they shall see God.'

And what is to come out of all the chitchat in Weimar, where they foolishly want to evoke what has already been, through mere signs? Has such ever been reborn? I hardly believe that so beautiful a thing as the zenith of historical art will occur again until all the corruptible newer works of art have perished. Then it would have to happen in a completely new way, which is already rather evident. Perhaps the time might come when a quite beautiful art could again arise, and it would be landscape painting. Probably we can say that there have actually never been any real artists in this area, only a few now and again, and particularly in more recent times, who have sensed the spirit of art there.

Is it not singular that we become clearly and distinctly aware of the entirety of our life when we see thick, heavy clouds now hastening past the moon, now having their edges gilded by the moon, now altogether swallowing the moon? Existence becomes intelligible to us, as if we could write our whole life history solely in such pictures. And is it not true that there have been no more genuine historical painters since Raphael and Buonarroti? Even Raphael's painting in the gallery here [*Sistine Madonna*] shows a downright tendency toward landscape painting – of course by *landscape* we must here understand something quite apart.

Behold, just as a work of art develops from the first basic feeling, where the two raw forces stand opposed, so, too, has the whole human race developed. Every era of art has shown us how these two forces have increasingly united in the purest beings of the age. In the Egyptians' pictorial art, as in their architecture and in all symbols at that time, there was something far harder and more resistant than in Greek art; so too, the first human beings worshiped every last spring, every tree, rock, fire, and so on. The Christian religion, I mean the Catholic one, still needed four persons in its godhead. Through the Mother of God, there was still the good life in heaven; all the saints went there; and thus historical composition thrived until this religion waned. The Reformation limited itself to three persons in the godhead, which now seems to have collapsed. The spirit of this religion has been more abstract but by no means less fervent; a more abstract art must also arise from it. Now people want to stay with one God. If, however, He is lost to them, then there is probably no other remedy but the coming of the Judgement Day.

Just as a work of art that is not rooted in our own eternal existence will not endure, so too it surely is with the person who is not rooted in God. The blossoms we sprout from a consciousness of this, our primal origin, wherein the sap is drawn from this trunk of the world, will grow into fruit. Every man is a twig on this great tree, and only through the trunk can we obtain the sap for eternal, immortal fruit. He who, within himself, no longer feels union with the trunk has already withered away.

Letter to his brother Daniel, 7 November 1802

I am very pleased that it looks as though some real art will be reaching Hamburg. As far as my own abandonment of the respectable path is concerned, I must indeed confess, to the great discomfort of all respectable folk, that things will have to get a lot worse yet. I now feel quite convinced that the elements of art can only be discovered in the elements themselves, and that it is there they must once again be sought; but the 'elements themselves' are within us, and everything therefore should and must emerge once again from our own innermost being.

In the beginning men embodied the various elements and forces of nature within the human form, it was only ever in man himself that they beheld nature stirring; the authentic historical perspective lay precisely in perceiving these mighty forces moving within history itself: this was history as such; the greatest image that emerged from this perspective was that of the Last Judgement; the very rocks themselves had come to resemble the human figure, and the trees, the flowers and the waters were all confounded with one another.

But now our attention has fallen rather upon the other extreme. And just as the philosophers have come to the conclusion that we actually only imagine everything from within ourselves, so that now we see or at least should perceive in every flower the living spirit which man himself has put there; and that is how landscape first emerges for all the animals and flowers themselves are only half-present until man supplies the better part in his own right; thus it is that man impresses his own feelings upon the objects that surround him, which is precisely how everything acquires significance and language. I shall attempt to explain that these forms and shapes are nothing apart from ourselves: 'And the lord God formed man of the dust of the ground, and breathed into his nostrils the breath of life; and man became a living soul. And the Lord God planted a garden eastward in Eden; and there he put the man whom he had formed.' And furthermore: 'And out of the ground the Lord God formed every beast of the field, and every fowl of the air; and brought them unto Adam to see what he would call them: and whatsoever Adam called every living creature, that was the name thereof.'

The delight we take in flowers is properly something that comes to us from Paradise. Thus it is that we always associate some inner meaning with the flower, that is to say some kind of human shape, and it is only then that we perceive such a thing with delight. When we see how it is only our own life that is thus reflected in the whole of nature, it is clear that it is only in this way that landscape proper can arise, as something quite distinct from the kind of composition that takes human action or historical events as its subject.

Flowers, trees and figures will then emerge as significant in our eyes, and we shall have taken another step closer to meaning of colour! For colour is the ultimate in art, and colour is and must always remain something mystical for us insofar as we can only really comprehend it in a mysteriously intuitive fashion through our perception of flowers. The whole symbolism of the Trinity itself is concealed in flowers: light or whiteness, black or darkness, are not themselves colours; light represents the good, dark the evil (again I am thinking of the Creation narrative); we cannot possibly grasp

light and we ought not to try and grasp darkness. And then when man was granted Revelation, colour first came into the world: blue and red and yellow. Light is the sun at which we are not permitted to gaze directly. But as soon as the sun turns its face towards the earth, and towards man, the sky is turned to red. Blue inspires a certain sense of reverence within us, and represents the Father, while red properly represents the Mediator between earth and heaven. When both disappear, then fiery flames illuminate the night for us, and this yellow represents the Comforter who has been sent down to sustain us; – for the moon too is entirely yellow.

But one might well ask: what then is the point of all this art and foolery? For this is not itself the ultimate reality, it is merely something which the latter has produced within us, and on this path one could very easily end up with a kind of idolatry. – This is true enough, but we can only grasp the primary (and highest) reality by recourse to the secondary one, and if there is anything that can lead us back towards the former, it can only be this latter; for idolatry is nothing but the passion of man himself.

* * *

Letter to Ludwig Tieck, 1 December 1802

My dear T, it really seems to me that I shall soon see my way to becoming a thoroughly respectable person. Everything now suggests that at last I shall be able to find a firmer sense of purpose within me and that I can rely on.

A number of different thoughts have occurred to me which seem to be so well-founded that they cannot be brought to totter, and I almost dare to believe that they are indeed firmly based. I think I am now beginning to understand a little what you actually mean by 'landscape'. In all ancient history – or so it appears to me – artists have always striven to see and to express in terms of man himself the stirrings and motions of the elements and forces of nature. In Homer, and in actual history, people are never treated merely individually but rather in such a way as to present the mighty times that stirred within them; this is also the case with Shakespeare, and pre-eminently in all the pictorial images of the ancients. And this, according to my way of thinking, would also represent the distinguishing mark and essential difference between art on historical subjects and art concerned with 'landscape'; and in the area of the former it is impossible to imagine that anything greater can now be achieved after Michelangelo's *Last Judgement*.

'Landscape' on the other hand would naturally be based upon the opposite premise, namely that people would perceive themselves, along with their various characteristics and passions, in all the flowers and other growing things, indeed in all natural phenomena, that surround us. Especially with regard to all kinds of flowers and trees, it has become ever clearer and more certain in my mind how each one harbours a certain human spirit, idea or feeling, and it is obvious to me that all of this can only hail from Paradise itself. This is precisely the purest thing still left in the world in which we can recognize God or his image – as man was called when God came to create him. It is then further said, of course, that man should make unto himself no image of God, and indeed he is incapable of doing so. It is written in the Bible: 'And out of the ground the Lord God formed every beast of the field, and

every fowl of the air, and brought them unto Adam to see what he would call them: and whatsoever Adam called every living creature, that was the name thereof.' – Now I think that this can be interpreted in the following way: whatsoever spirit man bestows upon them, that will be the spirit thereof. And that would indeed be the first proper flower, for I am also assuming that flowers were then at hand; and now, so it occurred to me, we should have to explore precisely what kind of name was implied in such a spirit.

* * *

It is quite clear that flowers – at least in my eyes – are things that are quite capable of being understood. And I can easily imagine that, in the course of my life, I shall succeed in rendering them quite understandable, if only the right approach is intelligently pursued. I would like to tell you precisely how I intend to present to myself, and to the worthy public – if they care to know about it – a theme which I could treat repeatedly and execute in detail.

You are well aware of my ideas concerning 'The Water Spring'. I have often enough discussed it with you before and the following thoughts have come to me as a result. In this picture I desired to portray all the flowers with which I am myself familiar and which possess a certain significance, as indeed all flowers do if we only take pains to observe them in that light. I would try and express this whole idea through the very composition of the flowers, beginning with the first formation of the latter, the lily standing in the highest light where the red, yellow and blue flowers are clustered, where the oak tree, like some hero, spreads his branches over them all. The flowers will receive their true significance through the joyous sounds of spring which disperse amongst the flowers. The composition of the flowers must be designed in such a way that a sense of gradual transition is achieved. Just as the spirit inhabits the flowers, so too it must inhabit the trees as well. Of course it is essential to find the right spot for the figure in the flower, but I am sure I shall be able to manage that. Everything depends here upon the courage and practice of the artist. A good butcher, after all, is quite capable of bringing down the meat cleaver between his own toes without even hurting himself! Now I believe that if the appropriate and corresponding human feelings were thus invariably painted in every picture of flowers, people would gradually and inevitably become accustomed to the idea of thinking in this way on each particular occasion. Of course, this is certainly not something that could be accomplished overnight, and that is why I shall never in my life attempt a flower picture without the accompaniment of corresponding figures.

I cannot properly say, and much less express in writing, the way in which I actually understand these things. I had originally intended to depict in my paintings how it was that I came to such ideas concerning flowers and nature in general. I did not merely want to show what I believe, what I cannot avoid feeling, what genuine and interconnected ideas are expressed in such pictures, but also how I arrived at this approach, how I continue to see, think and feel, together with the path that I have travelled up to this point. It would be strange indeed if no one else were utterly unable to understand any of this. Now what I originally hoped to do has proved much more difficult and requires an enormous exercise of self-discipline, but there is no other approach which could be of very much use to me. Most days, indeed, it is not possible to pursue this path without exposing oneself to madness. Everything will

turn out well in the end through constant practice. The subject-matter can all the more easily lead us in the direction of arabesques and hieroglyphics. However, 'landscapes' themselves should emerge from the latter, just as the art of historical composition also once emerged from them. The art of landscape can only be properly understood through recourse to the deepest mysticism of religion. For art must originate in and be firmly based upon the latter if it is not eventually to collapse like a house that is built on sand. I am also now almost convinced that everything is ruined once we attempt to discuss such matters with someone incapable of understanding or grasping them. And it would be even worse to try and do so in public. That cannot possibly lead anywhere. Those who do not comprehend and cannot grasp this art – even if I have to say this a thousand times – must be led to understanding in a practical fashion before their very eyes. This is certainly the better way.

6 Madame de Staël (Anne Louise Germaine Necker, Baroness of Staël-Holstein, 1766–1817) from *Corinne*

Madame de Staël was born in Paris, daughter of the financier Jacques Necker, whose dismissal by the French Crown was a contributory cause of the Fall of the Bastille. In the years immediately before and after the Revolution her salon provided a forum for political discussion. In 1792, however, she left France, travelling to England and then to Geneva, where she entertained Rousseau and A. W. Schlegel, among others. After a return to France in 1795 she was exiled by Napoleon and travelled to Weimar, Berlin, Rome, Vienna and Dresden. She had a considerable and varied literary output, including a volume of *Lettres sur les écrits et le caractère de Jean-Jacques Rousseau* (Letters on the Writings and Character of Rousseau), published in 1788, and her major work, *De l'Allemagne* (On Germany), published in Paris in 1810 and in London in 1813, which served to inform French and English readers about the Romantic movement in Germany. European fame came with the publication in 1807 of her romantic novel *Corinne, ou l'Italie*. (A *Portrait of Madame de Staël as Corinne*, painted by Elisabeth Vigée-Lebrun in 1807–8, is now in the Musée des Beaux-Arts, Geneva.) The Corinne of the title is equipped with talent, wealth, beauty and a villa in Tivoli, near Rome. She is also possessed of a gallery of paintings. In Book I, chapter IV of the novel she displays these to the male interest, an English lord called Oswald. Among the recognizable works in her carefully composed collection are David's *Brutus* (see IVB2, 3) and paintings by two of David's pupils, Jean-Germain Drouais' *Marius at Minturnae* (Louvre, Paris) and François Gérard's *Belisarius* (formerly Leuchtenberg Collection, St Petersburg, now lost). She has religious paintings by Francesco Albani (an allegory of the Passion) and by Titian, and four 'poetic' works on themes from Virgil, Tasso, Shakespeare and Racine. Finally there is a group of landscapes. The first of these is an unpopulated scene by Salvator Rosa, while the second and third have Roman and Gothic settings respectively. Madame de Staël uses the imaginary episode to speculate about the means by which pictures communicate their subjects and about the relative expressive powers of paintings and poetry. Our text is taken from the translation published as *Corinne; or, Italy*, Philadelphia: E. L. Carey & A. Hart, ('third American edition') 1836, pp. 152–5.

Her gallery was composed of historical, poetic, religious subjects, and landscapes. None of them contained any great number of figures. Crowded pictures are,

doubtless, arduous tasks; but their beauties are mostly either too confused or too detailed. Unity of interest, that vital principle of art, as of all things, is necessarily frittered away. The first picture represented Brutus, sitting lost in thought, at the foot of the statue of Rome, while slaves bore by the dead bodies of the sons he had condemned; on the other side, their mothers and sisters stood in frantic despair, fortunately excused, by their sex, from that courage which sacrifices the affections. The situation of Brutus, beneath the statue of Rome, tells all. But how, without explanation, can we know that this *is* Brutus or that those are his children, whom he himself has sentenced? and yet the event cannot be better set forth by any painting. Rome fills its back-ground, as yet unornamented as a city, grand only as the country that could inspire such heroism. 'Once hear the name,' said Corinne, 'and doubtless your whole soul is given up to it; otherwise might not uncertainty have converted a pleasure which ought to be so plain and so easy into an abstruse enigma? I chose the subject, as recalling the most terrible deed a patriot ever dared. The next is Marius, taken by one of the Cimbri, who cannot resolve to kill so great a man. Marius, indeed, is an imposing figure; the costume and physiognomy of the Cimbrian leader extremely picturesque: it marks the second era of Rome, when laws were no more, but when genius still exerted a vast control. Next come the days in which glory led but to misfortune and insult. The third picture is Belisarius, bearing his young guide, who had expired while asking alms for him; thus is the blind hero recompensed by his master; and in the world he vanquished hath no better office than that of carrying to the grave the sad remains of yon poor boy, his only faithful friend. Since the old school, I have seen no truer figure than that: the painter, like the poet, has loaded him with all kinds of miseries – too many, it may be, for compassion. But what tells us that it is Belisarius? what fidelity to history is exacted both of artist and spectator! a fidelity, by the way, often ruinous to the beautiful. In Brutus we look on virtues that resemble crime; in Marius, on fame causing but distress; in Belisarius, on services requited by the blackest persecution. Near these I have hung two pictures that console the opposed spirit by reminding it of the piety that can cheer the broken heart, when all around is bondage. The first is Albano's infant Christ asleep on a cross. Does not that stainless, smiling face convince us that heavenly faith hath nought to fear from grief or death? The following one is Titian's Jesus bending under the weight of the cross. His mother on her knees before him: what a proof of reverence for the undeserved oppressions suffered by her Divine Son! What a look of resignation is his! yet what an air of pain, and therefore sympathy, with us! That is the best of all my pictures; to that I turn my eyes with rapture inexhaustible: and now come my dramatic *chefs-d'œuvre* drawn from the works of four great poets. There is the meeting of Dido and Æneas in the Elysian fields: her indignant shades avoid him; rejoicing to be freed from the fond heart which yet would throb at his approach. The vaporous colour of the phantoms, and the pale scenes around them, contrast the air of life in Æneas, and the Sibyl who conducts him; but in these attempts the bard's description must far transcend all that the pencil reaches; in this of the dying Clorinda our tears are claimed by the remembered lines of Tasso, where she pardons the beloved Tancred, who had just dealt her the mortal wound. Painting inevitably sinks beneath poetry, when devoted to themes that great authors have already treated. One glance back at their words effaces all before us. Their favourite situations gain

force from impassioned eloquence; while picturesque effect is most favoured by moments of repose, worthy to be indefinitely prolonged, and too perfect for the eye ever to weary of their grace. Your terrific Shakspeare, my Lord, afforded me the ensuing subject. The invincible Macbeth, about to fight Macduff, learns that the witches have equivocated with him; that Birnam wood is coming to Dunsinnane, and that his adversary was *not* of woman born, but torn from his dying mother. Macbeth is subdued by his fate, not by his foe; his desperate hand still grasps its glaive, certain that he must fall, yet to the last opposing human strength against the might of demons. There is a world of fury and of troubled energy in that countenance: but how many of the poet's beauties do we lose? Can we paint Macbeth hurried into crime by the dreams of ambition, conjured up by the powers of sorcery? How express a terror compatible with intrepidity; how characterise the superstition that oppresses him? the ignoble credulity which, even while he feels such scorn of life, forces on him such horror of death! Doubtless the human face is the greatest of all mysteries; yet fixed on canvass it can hardly tell of more than one sensation; no struggle, no successive contrasts accessible to dramatic art, can painting give, as neither time nor motion exists for her.

'Racine's Phedra forms the fourth picture. Hippolitus, in all the beauty of youth and innocence, repulses the perfidious accusations of his stepmother. The heroic Thesus still protects his guilty wife, whom his conquering arms surround. Phedra's visage is agitated by impulses that we freeze to look on; and her remorseless nurse encourages her in guilt. Hippolitus is here even more lovely than in Racine; more like to Meleager, as no love for Aricia here seems to mingle with his tameless virtue. But could Phedra have supported her falsehood in such a presence? No, she must have fallen at his feet: a vindictive woman may injure him she loves in absence, but, while she looks on him, that love must triumph. The poet never brings them together after she has slandered him. The painter was obliged to oppose them to each other; but is not the distinction between the picturesque and the poetical proved by the fact, that verse copied from paintings are worth all the paintings that have imitated poetry? Fancy must ever precede contemplation, as it does in the growth of the human mind. [...]

'My Lord, there remain but three landscapes for me to show you; two possess some interest. I do not like rural scenes that bear no allusion to fable or history: they are insipid as the idols of our poets. I prefer Salvator Rosa's style here, which gives you rocks, torrents, and trees, with not even the wing of a bird visible to remind you of life! The absence of man, in the midst of nature, excites profound reflections. What is this deserted scene, so vainly beautiful, whose mysterious charms address but the eye of their Creator? Here, on the contrary, history and poesy are happily united in a landscape. This represents the moment when Cincinnatus is invited by the consuls to quit his plough, and take command of the Roman armies. All the luxury of the South is seen, in this picture, – abundant vegetation, burning sky, and an universal air of joy, that pervades even the aspect of the plants. See what a contrast is beside it. The son of Cairbar sleeps upon his father's tomb. Three nights he awaited the bard who comes to honour the dead. His form is beheld afar, he descends the mountain's side. On the clouds floats the shade of the chief....'

7 William Blake (1757–1827) Letters

From the age of 10, Blake was at drawing school, where he copied casts of antique sculpture. Then at 15 he was apprenticed to an engraver, James Basire. After the completion of his apprenticeship in 1779 he briefly entered the Royal Academy, but he found the experience unprofitable. Later he was to be deeply critical of Reynolds (see VIB8). He exhibited with the Academy throughout his career, however, and was supported by many of its members, not least Fuseli and Flaxman. Nonetheless, Blake was guaranteed a distinctive sense of the place of art, both by his London artisanal milieu and by family connections into the radical religious tradition which descended from the English revolution of the seventeenth century (Thompson 1993). The visionary nature of his calling was encouraged at the end of the 1780s by a religious crisis and by the death of his younger brother Robert. A further factor was the impact of the French Revolution. Blake was in a circle including William Godwin and Mary Wollstonecraft, and in 1791 he illustrated the latter's book *Original Stories from Real Life*, on the education of children. (It is worth noting in this connection that in his marginalia to Lavater's *Aphorisms*, Blake pronounces '*Keep him at least three paces distant who hates bread, music and the laugh of a child* ' as 'The best in the book'.) The present letters forcefully demonstrate both Blake's essentially mystical understanding of art, and his unshakeable confidence in his own standing relative to the most exalted practitioners of previous ages. The recipient of the first two letters was Dr John Trusler, author of a study *Hogarth Memorialized* and a neighbour of Blake's friend, the artist George Cumberland. Cumberland had recommended Trusler as a client, but his unsympathetic response to the picture *Malevolence* spurred Blake to articulate his credo that the real business of the artist was to evoke 'a world of imagination and vision' rather than to imitate nature. Our third letter was addressed to Thomas Butts, a minor civil servant and one of Blake's most loyal patrons, for whom he made many drawings and watercolours, mostly on religious subjects. The letter was written from Felpham in Sussex, where Blake lived for three years from September 1800. After moderate success in the 1780s and early 1790s his engraving business had declined and he accepted a post which Flaxman found for him as assistant to the poet William Hayley. Blake suffered deep melancholia during this period, but it was at Felpham that he began to conceive *Jerusalem*, which appeared in 1804. Our final letter was written to Hayley two years after Blake's return to London. It begins as an expression of gratitude for Hayley's support in subscribing to Robert Blair's *The Grave*, which Blake was illustrating (see VIB10). Blake speaks of the spiritual crisis through which he has passed and of his exalted sense of the artistic calling: 'the mocker of art is the mocker of Jesus.' The letters are taken from *William Blake's Writings*, volume II, edited by G. E. Bentley, Oxford: Clarendon Press, 1978, pp. 1524–5, 1525–8, 1559–62, 1629–31. We have retained punctuation added to the letters in this edition.

16 August 1799

To The Revd Dr Trusler

Revd Sir

I find more & more that my Style of Designing is a Species by itself & in this which I send you have been compelld by my Genius or Angel to follow where he led;

if I were to act otherwise it would not fulfill the purpose for which alone I live, which is in conjunction with such men as my friend Cumberland to renew the lost Art of the Greeks.

I attempted every morning for a fortnight together to follow your Dictate, but when I found my attempts were in vain, resolved to shew an independence which I know will please an Author better than slavishly following the track of another however admirable that track may be. At any rate my Excuse must be: I could not do otherwise, it was out of my power!

I know I begged of you to give me your Ideas & promised to build on them; here I counted without my host. I now find my mistake.

The Design I have Sent, Is

A Father taking leave of his Wife & Child, Is watched by Two Fiends incarnate, with intention that when his back is turned they will murder the mother & her infant. If this is not Malevolence with a vengeance I have never seen it on Earth, & If you approve of this I have no doubt of giving you Benevolence with Equal Vigor, as also Pride & Humility, but cannot previously describe in words what I mean to Design for fear I should Evaporate the Spirit of my Invention. But I hope that none of my Designs will be destitute of Infinite Particulars which will present themselves to the Contemplator. And tho I call them Mine I know that they are not Mine being of the same opinion with Milton when he says That the Muse visits his Slumbers & awakes & governs his Song when Morn purples the East, & being also in the predicament of that prophet who says I cannot go beyond the command of the Lord to speak good or bad.

If you approve of my Manner & it is agreeable to you, I would rather Paint Pictures in oil of the same dimensions than make Drawings, & on the same terms. By this means you will have a number of Cabinet pictures, which I flatter myself will not be unworthy of a Scholar of Rembrandt & Teniers, whom I have Studied no less than Rafael & Michael angelo. Please to send me your orders respecting this & In my next Effort I promise more Expedition.

I am Revd Sir
Your very humble Servt
Willm Blake

23 August 1799

To 'Revd Dr Trusler / Englefield Green / Egham / Surrey'

Revd Sir

I really am sorry that you are falln out with the Spiritual World Especially if I should have to answer for it. I feel very sorry that your Ideas & Mine on Moral Painting differ so much as to have made you angry with my method of Study. If I am wrong I am wrong in good company. I had hoped your plan comprehended All Species of this Art & Especially that you would not reject that Species which gives Existence to Every other, namely Visions of Eternity. You say that I want somebody to Elucidate my Ideas, But you ought to know that What is Grand is necessarily obscure to Weak men. That which can be made Explicit to the Idiot is not worth my

care. The wisest of the Ancients considered what is not too Explicit as the fittest for Instruction because it rouzes the faculties to act. I name Moses Solomon Esop Homer Plato.

But as you have favord me with your remarks on my Design permit me in return to defend it against a mistaken one, which is, That I have supposed Malevolence without a Cause. Is not Merit in one a Cause of Envy in another & Serenity & Happiness & Beauty a Cause of Malevolence? But Want of Money & the Distross of A Thief can never be alledged as the Cause of his Thieving, for many honest people endure greater hard ships with Fortitude. We must therefore seek the Cause else where than in want of Money for that is the Misers passion, not the Thiefs.

I have therefore proved your Reasonings Ill proportioned which you can never prove my figures to be; they are those of Michael Angelo, Rafael & the Antique & of the best living Models. I percieve that your Eye is perverted by Caricature Prints, which ought not to abound so much as they do. Fun I love but too much Fun is of all things the most loathsom. Mirth is better than Fun & Happiness is better than Mirth. I feel that a Man may be happy in This World. And I know that This World Is a World of Imagination & Vision. I see Every thing I paint In This World, but Every body does not see alike. To the Eyes of a Miser a Guinea is more beautiful than the Sun & a bag worn with the use of Money has more beautiful proportions than a Vine filled with Grapes. The tree which moves some to tears of joy is in the Eyes of others only a Green thing that stands in the way. Some See Nature all Ridicule & Deformity & by these I shall not regulate my proportions, & Some Scarce see Nature at all. But to the Eyes of the Man of Imagination Nature is Imagination itself. As a man is So he Sees. As the Eye is formed such are its Powers. You certainly Mistake when you say that the Visions of Fancy are not to be found in This World. To Me This World is all One continued Vision of Fancy or Imagination & I feel Flatterd when I am told So. What is it Sets Homer, Virgil & Milton in so high a rank of Art? Why is the Bible more Entertaining & Instructive than any other book? Is it not because they are addressed to the Imagination which is Spiritual Sensation & but mediately to the Understanding or Reason? Such is True Painting and such was alone valued by the Greeks & the best modern Artists. Consider what Lord Bacon says: 'Sense sends over to Imagination before Reason have judged & Reason sends over to Imagination before the Decree can be acted'. See Advancemt of Learning Part 2 P 47 of first Edition.

But I am happy to find a Great Majority of Fellow Mortals who can Elucidate My Visions & Particularly they have been Elucidated by Children who have taken a greater delight in contemplating my Pictures than I even hoped. Neither Youth nor Childhood is Folly or Incapacity. Some Children are Fools & so are Some Old Men. But There is a vast Majority on the Side of Imagination or Spiritual Sensation.

To Engrave after another Painter is infinitely more laborious than to Engrave ones own Inventions. And of the Size you require my price has been Thirty Guineas & I cannot afford to do it for less. I had Twelve for the Head I sent you as a Specimen, but after my own designs I could do at least Six times the quantity of labour in the same time which will account for the difference of price as also that Chalk Engraving is at least Six times as laborious as Aqua tinta. I have no objection to Engraving after another Artist. Engraving is the profession I was apprenticed to, & Should never have attempted to live by any thing else If orders had not come in for my Designs &

Paintings which I have the pleasure to tell you are Increasing Every Day. Thus If I am a Painter it is not to be attributed to Seeking after. But I am contented whether I live by Painting or Engraving.

I am Revd Sir Your very obedient Servant

William Blake

22 November 1802

To 'Mr Butts / Gt Marlborough Street'

Felpham Novr 22: 1802
Dear Sir

My Brother tells me that he fears you are offended with me. I fear so too because there appears some reason why you might be so. But when you have heard me out you will not be so.

I have now given two years to the intense study of those parts of the art which relate to light & shade & colour & am Convinced that either my understanding is incapable of comprehending the beauties of Colouring or the Pictures which I painted for You Are Equal in Every part of the Art & superior in One to anything that has been done since the age of Rafael. – All Sr J Reynolds's discourses to the Royal Academy will shew, that the Venetian finesse in Art can never be united with the Majesty of Colouring necessary to Historical beaut*y*, & in a letter to the Revd Mr Gilpin author of a work on Picturesque Scenery he says Thus: 'It may be worth consideration whether the epithet Picturesque is not applicable to the excellencies of the inferior Schools rather than to the higher. The works of Michael Angelo Rafael &c appears to me to have nothing of it: whereas Rubens & the Venetian Painters may almost be said to have Nothing Else. – Perhaps Picturesque is somewhat synonymous to the word Taste which we should think improperly applied to Homer or Milton but very well to Prior or Pope. I suspect that the application of these words are to Excellencies of an inferior order & which are incompatible with the Grand Style. You are certainly right in saying that variety of Tints & Forms is Picturesque: but it must be rememberd on the other hand that the reverse of this – ('*uniformity of Colour* & a *long continuation of lines*') produces Grandeur.' – S[o] Says Sir Joshua and So say I for I have now proved that the parts of th[e] art which I neglected to display in those little pictures & drawings which I had the pleasure & profit to do for you are incompatible with the designs – There is nothing in the Art which our Painters d*o*, that I can confess myself ignorant of. I also Know & Understand & can assuredly affirm that the works I have done for You are Equal to Carrache or Rafael (and I am now Seven years older than Rafael was when he died) I say they are Equal to Carache or Rafael or Else I am Blind Stupid Ignorant and Incapable in two years Study to understand those things which a Boarding School Miss can comprehend in a fort-night. Be assured My dear Friend that there is not one touch in those Drawings & Pictures but what came from my Head & my Heart in Uniso*n*, That I am Proud of being their Author and Grateful to you my Employe*r*, & that I look upon you as the Chief of my Friends whom I would endeavour to please because you among all men have enabled me to produce these things. I would not send you a Drawing or a

Picture till I had again reconsidered my notions of Art & had put myself back as if I was a learner. I have proved that I am Right & shall now Go on with the Vigor I was in my Childhood famous for.

But I do not pretend to be Perfect, but if my Works have faults Carrache Corregio & Rafaels have faults also. Let me observe that the yellow leather flesh of old men, the ill drawn & ugly young women & above all the dawbed black & yellow shadows that are found in most fine, ay & the finest pictures, I altogether reject as ruinous to Effect tho Connoisseurs may think otherwise.

Let me also notice that Carraches Pictures are not like Correggios nor Correggios like Rafaels & if neither of them was to be encouraged till he did like any of the others he must die without Encouragement. My Pictures are unlike any of these Painters & I would have them to be so. I think the manner I adopt More Perfect than any other; no doubt They thought the same of theirs.

You will be tempted to think that as I improve The Pictures &c that I did for you are not what I would now wish them to be. On this I beg to say That they are what I intended them & that I know I never shall do better for if I was to do them over again they would lose as much as they gained because they were done in the heat of My Spirits.

But You will justly enquire why I have not written all this time to you? I answer I have been very Unhappy & could not think of troubling you about it or any of my real Friends (I have written many letters to you which I burnd & did not send) & why I have not before now finished the Miniature I promised to Mrs Butts? I answer I have not till now in any degree pleased myself & now I must intreat you to Excuse faults for Portrait Painting is the direct contrary to Designing & Historical Painting in every respect – If you have not Nature before you for Every Touch you cannot Paint Portrait, & if you have Nature before you at all you cannot Paint History; it was Michael Angelos opinion & is Mine. Pray Give My Wifes love with mine to Mrs Butts, assure her that it cannot be long before I have the pleasure of Painting from you in Person & then that She may Expect a likeness but now I have done All I could & know she will forgive any failure in consideration of the Endeavour.

And now let me finish with assuring you that Tho I have been very unhappy I am so no longer. I am again Emerged into the light of day. I still & shall to Eternity Embrace Christianity and Adore him who is the Express image of God but I have traveld thro Perils & Darkness not unlike a Champion. I have Conquerd and shall still Go on Conquering. Nothing can withstand the fury of my Course among the Stars of God & in the Abysses of the Accuser. My Enthusiasm is still what it was only Enlarged and confirmd.

I now Send Two Pictures & hope you will approve of them. I have inclosed the Account of Money recievd & work done which I ought long ago to have sent you; pray forgive Errors in [?for and] omissions of this kind. I am incapable of many attentions which it is my Duty to observe towards you thro multitude of employment & thro hope of soon seeing you again. I often omit to Enquire of you But pray let me now hear how you do & of the welfare of your family.

Accept my Sincere love & respect.

I remain Yours Sincerely
Willm Blake

11 December 1805

'To / William Hayley Esqre / Felpham near Chichester / Sussex'

Dear Sir

 I cannot omit to Return you my Sincere & Grateful Acknowledgment*s*, for the kind Reception you have given my New Projected Work. It bids fair to Set me above the difficultie*s*, I have hitherto encounterd. But my Fate has been so uncommon that I expect Nothing – I was alive & in health & with the same Talents I now have all the time of Boydells Macklins Bowyers & other Great Works. I was known by them & was looked upon by them as Incapable of Employment in those Works; it may turn out so again notwithstanding appearances. I am prepared for it, but at the same time Sincerely Grateful to Those whose Kindness & Good opinion has Supported me thro al*l* hitherto. You Dear Sir are one who has my Particular Gratitud*e*, having conducted me thro Three that would have been the Darkest Years that ever Mortal Suffer*d*, which were rendered thro your means a Mild & Pleasant Slumber. I speak of Spiritual Thing*s*, Not of Natural, Of Things known only to Myself & to Spirits Good & Evi*l*, but Not Known to Men on Earth. It is the passage thro these Three Years that has brought me into my Present Stat*e*, & *I know* that if I had not been with You I must have Perish'd. Those Dangers are now Passed & I can see them beneath my feet. It will not be long before I shall be able to present the full history of my Spiritual Sufferings to the Dwellers upon Eart*h*, & of the Spiritual Victories obtaind for me by my Friends – Excuse this Effusion of the Spirit from One who cares little for this World which passes away, whose Happiness is Secure in Jesus our Lor*d*, & who looks for Sufferings till the time of complete deliverance. In the mean Whil*e*, I am kept Happy as I used to b*e*, because I throw Myself & all that I have on our Saviours Divine Providence. O What Wonders are the Children of Men! Would to God that they would Consider it, That they would Consider their Spiritual Life Regardless of that faint Shadow Calld Natural Lif*e*, & that they would Promote Each others Spiritual Labour*s*, Each according to its Rank & that they would Know tha*t* Recieving a Prophet As a Prophet is a Duty which If omitted is more Severely Avenged than Every Sin & Wickedness beside. It is the Greatest of Crimes to Depress True Art & Science. I know that those who are dead from the Earth & who mockd & despised the Meekness of True Art (and such I find have been the situations of our Beautiful Affectionate Ballads), I Know that such Mockers are Most Severely Punished in Eternity. I know it for I see it & dare not help. – The Mocker of Art is the Mocker of Jesus. Let us go on Dear Sir following his Cross; let us take it up daily Persisting in Spiritual Labours & the Use of that Talent which it is Death to Bur*y*, & of that Spirit to Which we are Called [. . .]

 Wishing You & All Friends in Sussex a Merry & a Happy Christmas

<div align="right">

I remain Ever Your
Affectionate
Will. Blake & his Wife Catherine Blake

</div>

8 William Blake (1757–1827) Marginal Notes to Reynolds' *Discourses*

It was Blake's habit to annotate the books he read with extensive marginalia, something he did irrespective of whether he was reading poetry or prose. He maintained this form of running dialogue with several works of the religious mystic Emanuel Swedenborg, with Lavater's *Aphorisms*, with Dante's *Inferno* and with the poems of Wordsworth. Most acerbically, though, he commented on Joshua Reynolds' *Discourses*. Reynolds had been the figurehead of art in England across all its aspects, practice, theory and organization. Yet the first line of Blake's judgement, written on Reynolds' title-page no less, is 'This man was hired to depress art.' What is at stake in Blake's marginalia is not mere opinion, let alone personal pettiness, but a fundamental clash of values as to what the serious practice of art should amount to. Not all of Reynolds' Discourses were subjected to Blake's attentions. He worked from the first volume of the collected *Works*, published by Edmund Malone in 1798, which contained only the first eight Discourses. He seems to have looked at the book first in 1801–2, and then to have returned to it during 1808–9. Blake's comments are extensive and fill fifty pages of his collected *Writings*. We have therefore restricted our selection to those Discourses excerpted earlier in the present anthology, apart from the notes to the introductory matter and to the first Discourse, which we have retained because of the relatively general nature of the commentary. We have followed the convention established by Bentley, who gives the relevant extract from Reynolds' text with its Malone page number in a small typeface, before Blake's marginal comment. The extracts are taken from *William Blake's Writings*, volume II, edited by G. E. Bentley, Oxford: Clarendon Press, 1978, pp. 1450–2, 1460–1, 1469–74, 1487–9.

[*Title-page top*]
 This Man was Hired to Depress Art.
 This is the opinion of Will Blake; my Proofs of this Opinion are given in the following Notes.

[*Title-page bottom*]
 Advice of the Popes who succeeded the Age of Rafael

 Degrade first the Arts if you'd Mankind Degrade.
 Hire Idiots to Paint with cold light & hot shade:
 Give high Price for the worst, leave the best in disgrace,
 And with Labours of Ignorance fill every place.

[*Title-page verso*]
 Having spent the Vigour of my Youth & Genius under the Oppression of Sr Joshua & his Gang of Cunning Hired Knaves Without Employment & as much as could possibly be Without Bread, The Reader must Expect to Read in all my Remarks on these Books Nothing but Indignation & Resentment. While Sr Joshua was rolling in Riches Barry was Poor & Unemployd except by his own Energy, Mortimer was called a Madman & only Portrait Painting applauded & rewarded by the Rich & Great. Reynolds & Gainsborough Blotted & Blurred One against the other & Divided all the English World between them. Fuseli Indignant almost hid himself – I am hid.

[First Contents leaf]

The Arts & Sciences are the Destruction of Tyrannies or Bad Governments. Why should A Good Government Endeavour to Depress what is its Chief & only Support?

The Foundation of Empire is Art & Science. Remove them or Degrade them & the Empire is No More – Empire follows Art & Not Vice Versa as Englishmen suppose.

[Third Contents leaf verso]

Who will Dare to Say that [fine *del*] Polite Art is Encouraged or Either Wished or Tolerated in a Nation where The Society for the Encouragement of Art Suffered Barry to Give them his Labour for Nothing, A Society Composed of the flower of the English Nobility & Gentry – A Society Suffering an Artist to Starve while he Supported Really what They under Pretence of Encouraging were Endeavouring to Depress. – Barry told me that while he Did that Work, he Lived on Bread & Apples.

TO THE KING.

The regular progress of cultivated life is from necessaries to accommodations, from accommodations to ornaments.

The Bible says That Cultivated Life Existed First – Uncultivated Life comes afterwards from Satans Hirelings. Necessaries, Accomodations & Ornaments are the whole of Life. Satan took away Ornament First. Next he took away Accomodations & Then he became Lord & Master of Necessaries.

[Page ii, Dedication continued]

To give advice to those who are contending for royal liberality, has been for some years the duty of my station in the Academy....

Liberality! we want not Liberality. We want a Fair Price & Proportionate Value & a General Demand for Art.

Let not that Nation where Less than Nobility is the Rewar*d* Pretend that Art is Encouraged by that Nation. Art is First in Intellectuals & Ought to be First in Nations.

[Page 2 DISCOURSE I]

I consider Reynolds's Discourses to the Royal Academy as the Simulations of the Hypocrite who Smiles particularly where he means to Betray. His Praise of Rafael is like the Hysteric Smile of Revenge, His Softness & Candour, the hidden trap, & the poisoned feast. He praises Michael Angelo for Qualities which Michael Angelo abhorrd; & He blames Rafael for the only Qualities which Rafael Valued, Whether Reynolds knew what he was doing, is nothing to me; the Mischief is just the Same, Whether a Man does it Ignorantly or Knowingly: I always considered True Art & True Artists to be particularly Insulted & Degraded by the Reputation of these Discourses, As much as they were Degraded by the Reputation of Reynolds's Paintings, & that Such Artists as Reynolds, are at all times Hired by the Satans, for the Depression of Art. A Pretence of Art: To Destroy Art.

[*Page 5*]

Reynolds Opinion was that Genius May be Taught & that all Pretence to Inspiration is a Lie & a Deceit to say the least of it. [If the Inspiration is Great why Call it Madness *del*] For if it is a Deceit the whole Bible is Madness. This Opinion originates in the Greeks' Calling the Muses Daughters of Memory.

The Enquiry in England is not whether a Man has Talents & Genius, But whether he is Passive & Polite & a Virtuous Ass: & obedient to Noblemens Opinions in Art & Science. If he is; he is a Good Man: If Not he must be Starved.

[*Page 50* DISCOURSE III]

The following [Lecture *del*] Discourse is particularly Interesting to Blockheads, as it Endeavours to prove That there is No such thing as Inspiration & that any Man of a plain Understanding may by Thieving from Others, become a Mich Angelo.

[*Page 52*]

The wish of the genuine painter must be more extensive: instead of endeavouring to amuse mankind with the minute neatness of his imitations, he must endeavour to improve them by the grandeur of his ideas

Without Minute Neatness of Execution The Sublime cannot Exist! Grandeur of Ideas is founded on Precision of Ideas.

[*Page 54*]

The Moderns are not less convinced than the Ancients of this superior power existing in the art; nor less sensible of its effects.

I wish that this was True.

[*Page 55*]

Such is the warmth with which both the Ancients and Moderns speak of this divine principle of the art;

And Such is the Coldness with which Reynolds speaks! And such is his Enmity.

but, as I have formerly observed, enthusiastick admiration seldom promotes knowledge.

Enthusiastic Admiration is the first Principle of Knowledge & its last.

Now he begins to Degrade, to Deny & to Mock.

. . . a student by such praise may have his attention roused . . . HE EXAMINES his own mind, and perceives there nothing of that divine inspiration, with which, he is told, so many others have been favoured.

The Man who on Examining his own Mind finds nothing of Inspiration ought not to dare to be an Artist; he is a Fool & a Cunning Knave suited to the Purposes of Evil Demons.

[*Page 56*]

He never travelled to heaven to gather new ideas; and he finds himself possessed of no other qualifications than what mere common observation and a plain understanding can confer.

The Man who never in his Mind & Thoughts traveld to Heaven Is No Artist.

Artists who are above a plain Understanding are Mocked & Destroyed by this President of Fools.

But on this, as upon many other occasions, we ought to distinguish how much is to be given to enthusiasm, and how much to reason...taking care...not to lose in terms of vague admiration, that solidity and truth of principle, upon which alone we can reason, and may be enabled to practise.

It is Evident that Reynolds Wishd none but Fools to be in the Arts & in order to this, he calls all others Vague Enthusiasts or Madmen.

What has Reasoning to do with the Art of Painting?

[*Page 58*]

and the whole beauty and grandeur of the art consists, in my opinion, in being able to get above all singular forms, local customs, particularities, and details of every kind.

A Folly! Singular & Particular Detail is the Foundation of the Sublime.

All the objects which are exhibited to our view by nature, upon close examination will be found to have their blemishes and defects. The most beautiful forms have something about them like weakness, minuteness, or imperfection.

Minuteness is their whole Beauty.

... This long laborious comparison should be the first study of the painter, who aims at the greatest style.he corrects nature by herself.... This idea of the perfect state of nature, which the Artist calls the Ideal Beauty, is the great leading principle by which works of genius are conducted.

Knowledge of Ideal Beauty is Not to be Acquired. It is Born with us. Innate Ideas are in every Man, Born with him; they are truly Himself. The Man who says that we have No Innate Ideas must be a Fool & Knave, Having No Con-Science or Innate Science.

[*Page 60*]

Thus it is from a reiterated experience, and a close comparison of the objects in nature, that an artist becomes possessed of the idea of that central form...from which every deviation is deformity.

One Central Form Composed of all other Forms being Granted, it does not therefore follow that all other Forms are Deformity.

All Forms are Perfect in the Poets Mind, but these are not Abstracted nor Compounded from Nature but are from Imagination.

[*Page 65*]

When the Artist has by diligent attention acquired a clear and distinct idea of beauty and symmetry; when he has reduced the variety of nature to the abstract idea...

What Folly!

[*Page 67*]

... the painter ... must divest himself of all prejudices in favour of his age or country; he must disregard all local and temporary ornaments, and look only on those general habits which are every where and always the same....

Generaliz[ing] in Every th[ing,] the Man w[ould] soon be a Fool bu[t] a Cunning Fool.

[Page 71]
Albert Durer, as Vasari has justly remarked, would, probably, have been one of the first painters of his age . . . had he been initiated into those great principles of the art, which were so well understood and practised by his contemporaries in Italy.

What does this mean, *'Would have been' one of* the *first Painters of his Age'*? Albert Durer *Is!* Not would have been! Besides, let them look at Gothic Figures & Gothic Buildings & not talk of Dark Ages or of any Age: Ages are all Equal. But Genius is Always Above the Age.

[Page 144]
DISCOURSE VI.

When a Man talks of Acquiring Invention & of learning how to produce Original Conception he must expect to be called a Fool by Men of Understanding but such a Hired Knave cares not for the Few. His Eye is on the Many, or rather the Money.

[Page 147]
Those who have undertaken to write on our art, and have represented it as a kind of *inspiration* . . . seem to insure a much more favourable disposition from their readers . . . than he who attempts to examine, coldly, whether there are any means by which this art may be acquired

Bacons Philosop[hy] has Destroyd Art & Science. The Man who says that the Genius is not Born b[ut] Taught – Is a Knav[e.]

[Page 152]
. . . the *degree* of excellence which proclaims *Genius* is different, in different times and different places

Never!

and what shews it to be so is, that mankind have often changed their opinion upon this matter.

Never!

[Page 153]
These excellencies were, heretofore, considered merely as the effects of genius; and justly, if genius is not taken for inspiration, but as the effect of close observation and experience.

Damnd Fool!

[Page 154]
He who first made any of these observations . . . had that merit, but probably no one went very far at once . . . others worked more, and improved further

If Art was Progressive We should have had Mich Angelo's & Rafaels to Succeed & to Improve upon each other But it is not so. Genius dies with its Possessor & comes not again till Another is Born with It.

[Page 155]
. . . even works of Genius, like every other effect, as they must have their cause, must likewise have their rules

Identities or Things are Neither Cause nor Effect. They are Eternal.

[*Page 157*]

... our minds should be habituated to the contemplation of excellence ... we should, to the last moment of our lives, continue a settled intercourse with all the true examples of grandeur. Their inventions are not only the food of our infancy, but the substance which supplies the fullest maturity of our vigour.

Reynolds Thinks that Man Learns all that he Knows. I say on the Contrary That Man Brings All that he has or Can have Into the World with him. Man is Born Like a Garden ready Planted & Sown. This World is too poor to produce one Seed.

The mind is but a barren soil; a soil which is soon exhausted, and will produce no crop

The mind that could have produced this Sentence must have been a Pitiful, a Pitiable Imbecillity. I always thought that the Human Mind was the most Prolific of All Things & Inexhaustible. I certainly do Thank God that I am not like Reynolds.

9 William Blake (1757–1827) from *Descriptive Catalogue*

The years around 1808–9 were not good for Blake. His finances had been strained for some time, and he then faced public attack in a review of *The Grave*, published in *The Examiner* in August 1808, which asserted 'the utter impossibility of representing the *Spirit to the eye*' (cited by Bentley, p. 847). The need both to sell and to publicly defend his ideas led Blake to conceive an exhibition of his work. This duly opened in May 1809, and although it was planned to last only until the end of September, Blake kept the exhibition open until the summer of the next year. For the occasion he produced a 72-page *Descriptive Catalogue* which contained his account of the most important paintings. The exhibition was a failure, and Blake worked in poverty and obscurity for most of the next decade, until 1818 when he was introduced to John Linnell and the circle that included Samuel Palmer. The *Descriptive Catalogue* consists of explanations of sixteen watercolour paintings and drawings. (Blake insisted on calling the paintings 'frescos', to distinguish them from oil paintings, which he disliked.) The works described ranged from pictures of contemporaries such as Nelson and William Pitt, to Chaucer and his Pilgrims en route to Canterbury, and the three surviving Ancient Britons left alive after King Arthur's final defeat by the Romans. In our extracts Blake asserts the importance of a strong linear element derived from Raphael and Michelangelo, deprecating the emphasis on chiaroscuro and 'hellish brownness' which he associates with the Venetian tradition and seventeenth-century Flemish and Dutch art, as well as the contemporary English academic style of 'blotting and blurring'. He is also at pains to defend his view of art as 'visionary conception' against the 'sordid drudgery of facsimile'. The selections are taken from *William Blake's Writings*, volume II, edited by G. E. Bentley, Oxford: Clarendon Press, 1978, pp. 825, 827–8, 828–9, 847–8, 855–8, 860–1.

<div align="center">

A DESCRIPTIVE CATALOGUE

OF

BLAKE's EXHIBITION,

At No. 28, Corner of

BROAD-STREET,

GOLDEN-SQUARE.

</div>

THE grand Style of Art restored; in FRESCO, or Water-colour Painting, and England protected from the too just imputation of being the Seat and Protectress of bad (that is blotting and blurring) Art.

In this Exhibition will be seen real Art, as it was left us by *Raphael* and *Albert Durer, Michael Angelo*, and *Julio Romano*; stripped from the Ignorances of *Rubens* and *Rembrandt, Titian* and *Correggio* [...]

Preface

The eye that can prefer the Colouring of Titian and Rubens to that of Michael Angelo and Rafael, ought to be modest and to doubt its own powers. Connoisseurs talk as if Rafael and Michael Angelo had never seen the Colouring of Titian or Correggio: They ought to know that Correggio was born two years before Michael Angelo, and Titian but four years after. Both Rafael and Michael Angelo knew the Venetian, and contemned and rejected all he did with the utmost disdain, as that which is fabricated for the purpose to destroy art.

Mr. B. appeals to the Public, from the judgment of those narrow blinking eyes, that have too long governed art in a dark corner. The eyes of stupid cunning never will be pleased with the work any more than with the look of self-devoting genius. The quarrel of the Florentine with the Venetian is not because he does not understand Drawing, but because he does not understand Colouring. How should he who does not know how to draw a hand or a foot, know how to colour it?

Colouring does not depend on where the Colours are put, but on where the lights and darks are put, and all depends on Form or Outline, on where that is put; where that is wrong, the Colouring never can be right; and it is always wrong in Titian and Correggio, Rubens and Rembrandt. Till we get rid of Titian and Correggio, Rubens and Rembrandt, we never shall equal Rafael and Albert Durer, Michael Angelo, and Julio Romano.

Number I.

The spiritual form of Nelson guiding Leviathan, in whose wreathings are infolded the Nations of the Earth.

Clearness and precision have been the chief objects in painting these Pictures: Clear colours unmudded by oil, and firm and determinate lineaments unbroken by shadows, which ought to display and not to hide form, as is the practice of the latter Schools of Italy and Flanders.

Number II, Its Companion

The spiritual form of Pitt, guiding Behemoth; he is that Angel who, pleased to perform the Almighty's orders, rides on the whirlwind, directing the storms of war: He is ordering the Reaper to reap the Vine of the Earth, and the Plowman to plow up the Cities and Towers.

This Picture also is a proof of the power of colours unsullied with oil or with any cloggy vehicle. Oil has falsely been supposed to give strength to colours: but a

little consideration must shew the fallacy of this opinion. Oil will not drink or absorb colour enough to stand the test of very little time and of the air. It deadens every colour it is mixed with, at its first mixture, and in a little time becomes a yellow mask over all that it touches. Let the works of modern Artists since Rubens' time witness the villainy of some one at that time, who first brought oil Painting into general opinion and practice: since which we have never had a Picture painted, that could shew itself by the side of an earlier production. Whether Rubens or Vandyke, or both, were guilty of this villainy, is to be enquired in another work on Painting, and who first forged the silly story and known falsehood, about John of Bruges inventing oil colours: in the mean time let it be observed, that before Vandyke's time, and in his time all the genuine Pictures are on Plaster or Whiting grounds and none since.

Number IV.

The Bard, from Gray

Weaving the winding sheet of Edward's race by means of sounds of spiritual music and its accompanying expressions of articulate speech is a bold, and daring, and most masterly conception, that the public have embraced and approved with avidity. Poetry consists in these conceptions; and shall Painting be confined to the sordid drudgery of fac-simile representations of merely mortal and perishing substances, and not be as poetry and music are, elevated into its own proper sphere of invention and visionary conception? No, it shall not be so! Painting, as well as poetry and music, exists and exults in immortal thoughts. If Mr. B.'s Canterbury Pilgrims had been done by any other power than that of the poetic visionary, it would have been as dull as his adversary's.

The Spirits of the murdered bards assist in weaving the deadly woof.

> With me in dreadful harmony they join,
> And weave, with bloody hands, the tissue of thy line.

The connoisseurs and artists who have made objections to Mr. B.'s mode of representing spirits with real bodies, would do well to consider that the Venus, the Minerva, the Jupiter, the Apollo, which they admire in Greek statues, are all of them representations of spiritual existences of gods immortal, to the mortal perishing organ of sight; and yet they are embodied and organized in solid marble. Mr. B. requires the same latitude and all is well. The Prophets describe what they saw in Vision as real and existing men whom they saw with their imaginative and immortal organs; the Apostles the same; the clearer the organ the more distinct the object. A Spirit and a Vision are not, as the modern philosphy supposes, a cloudy vapour or a nothing: they are organized and minutely articulated beyond all that the mortal and perishing nature can produce. He who does not imagine in stronger and better lineaments, and in stronger and better light than his perishing mortal eye can see does not imagine at all. The painter of this work asserts that all his imaginations appear to him infinitely more perfect and more minutely organized than any thing seen by his mortal eye. Spirits are organized men: Moderns wish to draw figures without lines, and with

great and heavy shadows; are not shadows more unmeaning than lines, and more heavy? O who can doubt this?

Number VIII.

The spiritual Preceptor, an experiment Picture.

THIS subject is taken from the visions of Emanuel Swedenborg. Universal Theology, No. 623. The Learned, who strive to ascend into Heaven by means of learning, appear to Children like dead horses, when repelled by the celestial spheres. The works of this visionary are well worthy the attention of Painters and Poets; they are foundations for grand things; the reason they have not been more attended to, is, because corporeal demons have gained a predominance; who the leaders of these are, will be shewn below. Unworthy Men who gain fame among Men, continue to govern mankind after death, and in their spiritual bodies, oppose the spirits of those, who worthily are famous; and as Swedenborg observes, by entering into disease and excrement, drunkenness and concupiscence, they possess themselves of the bodies of mortal men, and shut the doors of mind and of thought, by placing Learning above Inspiration. O Artist! you may disbelieve all this, but it shall be at your own peril.

Number IX.

Satan calling up his Legions, from Milton's Paradise Lost; a composition for a more perfect Picture, afterward executed for a Lady of high rank. An experiment Picture.

This Picture was likewise painted at intervals, for experiment on colours, without any oily vehicle; it may be worthy of attention, not only on account of its composition, but of the great labour which has been bestowed on it, that is, three or four times as much as would have finished a more perfect Picture; the labour has destroyed the lineaments, it was with difficulty brought back again to a certain effect, which it had at first, when all the lineaments were perfect.

These Pictures, among numerous others painted for experiment, were the result of temptations and perturbations, labouring to destroy Imaginative power, by means of that infernal machine, called Chiaro Oscuro, in the hands of Venetian and Flemish Demons; whose enmity to the Painter himself, and to all Artists who study in the Florentine and Roman Schools, may be removed by an exhibition and exposure of their vile tricks. They cause that every thing in art shall become a Machine. They cause that the execution shall be all blocked up with brown shadows. They put the original Artist in fear and doubt of his own original conception. The spirit of Titian was particularly active, in raising doubts concerning the possibility of executing without a model, and when once he had raised the doubt, it became easy for him to snatch away the vision time after time, for when the Artist took his pencil, to execute his ideas, his power of imagination weakened so much, and darkened, that memory of nature and of Pictures of the various Schools possessed his mind, instead of appropriate execution, resulting from the inventions; like walking in another man's style, or speaking or looking in another man's style and manner, unappropriate and

repugnant to your own individual character; tormenting the true Artist, till he leaves the Florentine, and adopts the Venetian practice, or does as Mr. B. has done, has the courage to suffer poverty and disgrace, till he ultimately conquers.

Rubens is a most outrageous demon, and by infusing the remembrances of his Pictures, and style of execution, hinders all power of individual thought: so that the man who is possessed by this demon, loses all admiration of any other Artist, but Rubens, and those who were his imitators and journeymen, he causes to the Florentine and Roman Artist fear to execute; and though the original conception was all fire and animation, he loads it with hellish brownness, and blocks up all its gates of light, except one, and that one he closes with iron bars, till the victim is obliged to give up the Florentine and Roman practice, and adopt the Venetian and Flemish.

Correggio is a soft and effeminate and consequently a most cruel demon, whose whole delight is to cause endless labour to whoever suffers him to enter his mind. The story that is told in all Lives of the Painters about Correggio being poor and but badly paid for his Pictures, is altogether false; he was a petty Prince, in Italy, and employed numerous Journeymen in manufacturing (as Rubens and Titian did) the Pictures that go under his name. The manual labour in these Pictures of Correggio is immense, and was paid for originally at the immense prices that those who keep manufactories of art always charge to their employers, while they themselves pay their journeymen little enough. But though Correggio was not poor, he will make any true artist so, who permits him to enter his mind, and take possession of his affections; he infuses a love of soft and even tints without boundaries, and of endless reflected lights, that confuse one another, and hinder all correct drawing from appearing to be correct; for it one of Rafael or Michael Angelo's figures was to be traced, and Correggio's reflections and refractions to be added to it, there would soon be an end of proportion and strength, and it would be weak, and pappy, and lumbering, and thick headed, like his own works; but then it would have softness and evenness, by a twelvemonth's labour, where a month would with judgment have finished it better and higher; and the poor wretch who executed it, would be the Correggio that the life writers have written of: a drudge and a miserable man, compelled to softness by poverty. I say again, O Artist, you may disbelieve all this, but it shall be at your own peril.

Number XV.

Ruth. – A Drawing.

This Design is taken from that most pathetic passage in the Book of Ruth, where Naomi having taken leave of her daughters in law, with intent to return to her own country; Ruth cannot leave her, but says, 'Whither thou goest I will go; and where thou lodgest I will lodge, thy people shall be my people, and thy God my God: where thou diest I will die, and there will I be buried; God do so to me and more also, if ought but death part thee and me.'

The distinction that is made in modern times between a Painting and a Drawing proceeds from ignorance of art. The merit of a Picture is the same as the merit of a Drawing. The dawber dawbs his Drawings; he who draws his Drawings draws his

Pictures. There is no difference between Rafael's Cartoons and his Frescos, or Pictures, except that the Frescos, or Pictures, are more finished. When Mr. B. formerly painted in oil colours his Pictures were shewn to certain painters and connoisseurs, who said that they were very admirable Drawings on canvass; but not Pictures: but they said the same of Rafael's Pictures.

Mr. B. thought this the greatest of compliments, though it was meant otherwise. If losing and obliterating the outline constitutes a Picture, Mr. B. will never be so foolish as to do one. Such art of losing the outlines is the art of Venice and Flanders; it loses all character, and leaves what some people call, expression: but this is a false notion of expression; expression cannot exist without character as its stamina; and neither character nor expression can exist without firm and determinate outline. Fresco Painting is susceptible of higher finishing than Drawing on Paper, or than any other method of Painting. But he must have a strange organization of sight who does not prefer a Drawing on Paper to a Dawbing in Oil by the same master, supposing both to be done with equal care.

The great and golden rule of art, as well as of life, is this: That the more distinct, sharp, and wirey the bounding line, the more perfect the work of art; and the less keen and sharp, the greater is the evidence of weak imitation, plagiarism, and bungling. Great inventors, in all ages, knew this: Protogenes and Apelles knew each other by this line. Rafael and Michael Angelo, and Albert Durer, are known by this and this alone. The want of this determinate and bounding form evidences the idea of want in the artist's mind, and the pretence of the plagiary in all its branches. How do we distinguish the oak from the beech, the horse from the ox, but by the bounding outline? How do we distinguish one face or countenance from another, but by the bounding line and its infinite inflexions and movements? What is it that builds a house and plants a garden, but the definite and determinate? What is it that distinguishes honesty from knavery, but the hard and wirey line of rectitude and certainty in the actions and intentions? Leave out this line and you leave out life itself; all is chaos again, and the line of the almighty must be drawn out upon it before man or beast can exist. Talk no more then of Correggio, or Rembrandt, or any any other of those plagiaries of Venice or Flanders. They were but the lame imitators of lines drawn by their predecessors, and their works prove themselves contemptible disarranged imitations and blundering misapplied copies.

10 Henry Fuseli (1741–1825) Introduction to *The Grave*

Originally published in 1743, *The Grave* was the work of Robert Blair (1699–1746), a Scottish poet and clergyman. In moralizing upon the subject of death, it followed a precedent set by Edward Young's *Night Thoughts*, the first part of which had appeared the previous year. Like Young's work, it attracted the attention of religious dissenters of a literary inclination. In 1797 Fuseli had contributed an unsigned introduction to a new edition of *Night Thoughts*, illustrated by William Blake. In 1808 Blake provided twelve illustrations to be engraved for a new edition of *The Grave*, and Fuseli again contributed an introduction, this time in his own name. Following the spirit of the enterprise, he sermonized on the bankruptcy of such conventional imagery as had previously served to emphasize the fact

of mortality, praising the combination of unaffectedness with originality that he observed in Blake's figures. In fact the publication was not a success. Criticism in *The Examiner* led Blake to mount a defence of his own work through a public exhibition in 1809–10. It was for this occasion that he compiled *The Descriptive Catalogue* (VIB9). Fuseli's untitled introduction was originally printed in *The Grave, a poem. By Robert Blair. Illustrated by Twelve Etchings executed from original designs*, London: R. H. Cromek, 1808, pp. xiii–xiv. Our complete text is taken from this edition. (See also VIA10.)

The moral series here submitted to the Public, from its object and method of execution, has a double claim on general attention.

In an age of equal refinement and corruption of manners, when systems of education and seduction go hand in hand; when religion itself compounds with fashion; when in the pursuit of present enjoyment, all consideration of futurity vanishes, and the real object of life is lost – in such an age, every exertion confers a benefit on society which tends to impress man with his destiny, to hold the mirror up to life, less indeed to discriminate its characters, than those situations which shew what all are born for, what all ought to act for, and what all must inevitably come to.

The importance of this object has been so well understood at every period of time, from the earliest and most innocent, to the latest and most depraved, that reason and fancy have exhausted their stores of argument and imagery, to impress it on the mind: animate and inanimate nature, the seasons, the forest and the field, the bee and ant, the larva, chrysalis and moth, have lent their real or supposed analogies with the origin, pursuits, and end, of the human race, so often to emblematic purposes, that instruction is become stale, and attention callous. The serpent with its tail in its mouth, from a type of eternity, is become an infant's bauble; even the nobler idea of Hercules pausing between virtue and vice, or the varied imagery of Death leading his patients to the grave, owe their effect upon us more to technic excellence than allegoric utility.

Aware of this, but conscious that affectation of originality and trite repetition would equally impede his success, the author of the moral series before us, has endeavoured to wake sensibility by touching our sympathies with nearer, less ambiguous, and less ludicrous imagery, than what mythology, Gothic superstition, or symbols as far-fetched as inadequate, could supply. His invention has been chiefly employed to spread a familiar and domestic atmosphere round the most important of all subjects, to connect the visible and the invisible world, without provoking probability, and to lead the eye from the milder light of time to the radiations of eternity.

Such is the plan and the moral part of the author's invention; the technic part, and the execution of the artist, though to be examined by other principles, and addressed to a narrower circle, equally claim approbation, sometimes excite our wonder, and not seldom our fears, when we see him play on the very verge of legitimate invention; but wildness so picturesque in itself, so often redeemed by taste, simplicity, and elegance, what child of fancy, what artist would wish to discharge? The groups and single figures on their own basis, abstracted from the general composition, and considered without attention to the plan, frequently exhibit those genuine and unaffected attitudes, those simple graces which nature and the heart alone can dictate, and only an eye inspired by both, discover. Every class of artists, in every

stage of their progress or attainments, from the student to the finished master, and from the contriver of ornament, to the painter of history, will find here materials of art and hints of improvement!

11 Gotthilf Heinrich Schubert (1780–1860) from *Views on the Dark Side of Natural Science*

Gotthilf Heinrich Schubert was born in Hohenstein in Saxony. He initially studied theology in Munich before transferring to Jena to study medicine. There he was strongly influenced by Friedrich Shelling's lectures on the philosophy of nature (see VIA8). From 1805 to 1809 he lived in Dresden, where he was a practising doctor. He formed a friendship with Caspar David Friedrich and in the second volume of his autobiography (*Der Erwerb aus einem Vergangenem und die Erwartung von einem zukünftigen Leben*, Erlangen, 1855) offers valuable reminiscences of Friedrich and of his studio. During his Dresden period Schubert gave a series of lectures on the philosophy of nature. These covered a wide range of topics, including the original relationship of mankind to nature, the laws governing the planetary system, and 'animal magnetism'. The lectures were subsequently published as *Views on the Dark Side of Natural Science* and enjoyed considerable popularity. In the twelfth lecture, Schubert inserted a description of an early version of Friedrich's allegorical cycle, *The Times of Year*, a subject to which the artist frequently returned. Schubert's text offers a sympathetic attempt at interpreting the complex symbolism of the artist's work. The lectures were first published as *Ansichten von der Nachtseite der Naturwissenschaft* by the Arnoldische Buchhandlung in Dresden in 1808. The following excerpt is taken from the translation in William Vaughan, Helmut Börsch-Supan and Hans Joachim Neidhardt (eds), *Caspar David Friedrich, 1774–1840, Romantic Landscape Painting in Dresden*, London: The Tate Gallery, 1972, pp. 105–6. The translator notes that 'the autumn crocus, which blossoms in autumn while its leaves and seed pods do not appear until the following spring, is called in German "Die Zeitlose" (the timeless one).'

Here I could not do better than follow closely the work of my friend, the landscape painter Friedrich, and tell faithfully the story of the development of our own nature as it is depicted by him in the four seasons of the year and the four stages of human life. I shall do so even at the risk that my words may lag far behind his brush.

We do not know what profound charm lies over the beginning of childhood. It may be that it is glorified by an echo of the unknown dream whence we came or by that reflection of the divine which hovers in its purest form above the quiet and the childlike. When we wake from that dream we find ourselves in the morning glow of an everlasting spring day and no trace of a bygone autumn tinges its bright green. We awake among flowers by the clear source of life, where the eternal sky is mirrored in its virgin purity. The wind does not strive yet beyond the brink of the nearby hills. We seek and understand in Nature the flowers only and we still perceive life as an image of playful, innocent lambs. There the first ray of that longing which guides us from the cradle to the grave touches an early unfolding mind and unaware of the endless distance, which separates us from the eternal source of light, the child's arms open wide to grasp what he believes to be within his reach. But his first steps already

are an error and from the lovely hill of childish dreams where we perceived the first rising rays, we hurry downward into the deep bustle of life, where another twilight surrounds us.

The clear source soon swelled into a river, the inner striving, grown stronger and more powerful, carried us out further and further. Indeed, the hours of dawn were soon over; far behind us are left the green hills of childhood with their spring flowers and the dream of playing lambs. Brighter and grander shines the sun rising towards its zenith and the fresh trail is not yet threatened by any obstacles. When in the glittering hours of noon the blossoming world opens itself so freely to the inner eye, when to the keen mind – yet unaware of the limits of its aspirations – the distant high clouds appear like distant mountains, still to be reached easily in the end, then in the sweet time of roses all deep longing seems to have found its fulfilment. There, where the lily weds the rose, where slim trees with dark green branches entwine, youthful love clasps its arm round us. There the blissful heart no longer needs the outside world, we only dream of the still, lonely hut on a green mount, of the pastoral song of the turtle-dove and the lonely valley. For moments all further striving is forgotten and for the first time – maybe also for the last – we rest in perfect, blissful contentment. For look! among the roses and lilies there also stood the tall sunflower which with its faithful head follows the path of the eternal light. A deeper longing in us has as yet not been stilled and reawakens the eternal ideal with a stern voice.

There in the interplay of many aspirations mid-day is reached and passed; past is the time of roses and lilies. Evening reveals the land in its last and strongest aspect, at the time of its maturity. The flowers which before have delighted the heart, are over, only a few have born fruit, more remained barren and upon the autumnal soil there blossoms with the shade of the evening light the late, lonely autumn crocus whose fruit will only ripen in another spring. The dreams of quiet huts on blossom-covered hills, the song of the turtle-doves have been supplanted by the crude noise of the city.[1] But at last, past mid-day it has become clear to the mind what that profound striving, that longing within us, desires. See these immortal heights with their three-peaked summit, lofty above the flying clouds, shrouded by everlasting snow, but still in untroubled serenity, gleaming in the rays of the sun, a high symbol of the eternal light. There the soul strives with its highest powers towards the immortal heights. But the impulse of passions within us has turned into a river carrying ships down its way. In vain we often struggle with its waves in order to reach the other bank and the high mountains; only in the hours of exultation the spirit rises towards the immortal heights like that eagle who has left the clouds and the river far behind. Now that the inner striving has grown weary on the last part of the path which was full of rocks and crags here, on this side of the river a place of rest is found beneath the cross which rises peacefully above the cliffs. At last the mind understands that the abode of that longing which has guided us so far, is not here on earth. Speed on then, river, down your way! Where your waves flow into the infinite sea on a far distant shore we have heard of a last place of rest. There indeed the inner fire shall cool, the deep wound shall heal. Cease blooming then, poor autumn crocus, when winter approaches – you one, late blossom which does not bear fruit. A new, distant spring beyond winter, will ripen your fruit, you wonderful flower.

At last, see, the sun of man's power and glory has sunk. The last part of the way was barren and lonely. All blossoms have gone, so has even the fruit which they had brought us. For fate has taken back its gift which we had thought to be ours for ever. Before our very eyes part of our work which seemed built for eternity has fallen into ruins and is forgotten by the young world. Only the will, the striving within us which has persevered to the very grave, becoming all the while purer and better, has remained ours; and in it we put our inner trust. The quiet coast where the once so powerful stream has become lost in the ocean has been reached and the grey wanderer finds himself lonely among the graves. The deep-rooted longing which has guided us so far, is still not satisfied but, alas, the promise of the summer which should have brought it to fruition, has been a vain hope and the season of snow covers the crop of a future spring. And there the moon shines in full brightness through the ruins of an ancient, noble past. The sky reveals itself above the sea once more in its clear blueness as it did in our early childhood. There in a prophetic glimmer we get the vision of the coast of a far-away land across the sea. We have heard of its everlasting spring and how in it our innermost being, which we bring there as a bud, will ripen. Then take away, time, even the last debris of our life on earth, take away for a while even the memory of the path we have followed and let us, if it be the command of your eternal law, arrive slumbering in the fatherland which we have desired for so long.

So, when we contemplate the formation of the human mind and its development from the cradle to the grave, amidst earthly striving another higher one may be perceived which even seems to contradict the first and which, at least in the bustle of life, can only rarely or never blossom. The lofty world of poetry and the artist's ideals, even more the world of religion, can never fit completely into our life on earth and tends to resist a fusion with its elements.

[1] In childhood we still see by the green bank of the brook nothing but flowering shrubs; in youth, beyond the stream, a few scattered huts, in manhood, beyond the bank of the river, a large city. In old age we see a churchyard.

12 Friedrich Ramdohr (1752–1822) 'Remarks upon a Landscape Painting intended as an Altarpiece by Herr Friedrich in Dresden, and upon Landscape Painting, Allegory and Mysticism in General'

Shortly before Christmas 1808, Caspar David Friedrich exhibited in his studio in Dresden a small landscape painting entitled *The Cross in the Mountains*, which had been commissioned for the private chapel of Count Thun und Hohenstein's castle in Tetschen. The painting, now in the Gemäldegalerie Neue Meister in Dresden, shows a fir-clad mountain before the rays of the setting sun with the silhouette of a cross bearing a figure of Christ at its summit turned so as to face into the depth of the pictorial space. It is set in an ornate frame in the shape of a Gothic arch, with palm leaves and Christian symbols, specially made for Friedrich by the sculptor Gottlob Christian Kühn. The various innovations which the artist brought to bear in this work came under severe criticism from the art critic and theorist, Friedrich Ramdohr (see also VB12). Not least of these was the novelty of making a

landscape painting into an altarpiece, Although the tone of Ramdohr's piece is critical throughout, his commitment to the principles of classicist aesthetics renders him unusually sensitive to what was genuinely new in Friedrich's work. He is also prepared to pay detailed attention to the way in which the image has been constructed and to the possible meanings it was intended to convey. He objects, however, to the artist's neglect of the technique of aerial perspective and of the gradation of colour which enables space and distance to be effectively articulated. He further contends that the abrupt cutting away of the foreground by the picture frame deprives spectators of any indication of their own position in relation to the scene depicted. Most important of all, however, he questions whether a landscape can be used to convey the definite meaning which an altarpiece requires. Although a landscape can be evocative or suggestive of a mood or feeling, he rejects the idea that it can take on an explicit religious content. To compensate for this, he suggests, the artist has had to make recourse to an elaborate frame which imposes a determinate meaning on the painting from without. Ramdohr uses his analysis of Friedrich's painting to mount an attack on Romanticism in general, returning with good measure the criticism he had suffered at the hands of Wackenroder (see VIA1). For Friedrich's response to Ramdohr's criticisms, see VIB13. The article was first published as 'Über ein zum Altarblatte bestimmtes Landschaftsgemälde von Herrn Friedrich in Dresden, und über Landschaftsmalerei, Allegorie und Mystizismus überhaupt' in the *Zeitung für die elegante Welt*, nos 12–15, January 19–21, 1809. This translation has been made for the present volume by Nicholas Walker from Sigrid Hinz ed., *Caspar David Friedrich in Briefen und Bekenntnissen*, Berlin: Henschelverlag, 1968, pp. 112–24, 129–31.

I take no pleasure in coming out publicly in criticism of a work from the hand of a contemporary artist. If the altarpiece which the landscape painter Herr Friedrich has exhibited here in Dresden during the Christmas holidays just past were a work executed in accordance with those principles that long experience has tested and the example of great masters sanctioned – and whether it were excellent or poor – I should gladly remain silent. For a work that is simply ordinary or poor soon brings itself to judgement. It is a sagacious maxim not to disturb the peace in literary and cultural matters unless it is absolutely necessary. But Herr Friedrich's painting is very far from ordinary: it opens up a new and, to me at least, hitherto unrecognized perspective upon landscape painting; it gives evidence of a highly imaginative and extremely sensitive artist; it expresses the attitudes of the public; and it has made a considerable impression upon the general multitude. But when I see that the approach here taken by this talent is detrimental to all good taste, that it robs the essence of painting, and particularly of landscape painting, of its most distinctive and appealing features, that it is related to a broader spirit that is the wretched spawn of the present age and a fearful premonition of a rapidly approaching barbarism, then it would be pusillanimous to remain silent – pusillanimous for anyone who believes that he might be able, through rational argument, to prevent art and science from embarking upon a false course, and particularly pusillanimous for myself who have cast off the fetters which formerly bound me to painting of a purely local significance and have now dedicated the remainder of my days to the propagation of everything that is good and beautiful in all its limitless range.

I repeat, and I say it even more clearly and definitely: my criticisms are not directed simply against Herr Friedrich's picture but against the entire system to

which it gives expression, against a large number of ideas which are beginning to creep into art and science, against certain errors which in part the picture itself does not reveal, although those it does are closely connected with them. The public will forgive me, therefore, if I here present them with such a lengthy disquisition upon a single picture.

The true standpoint of the critic, of the writer on art, is often misunderstood. The critic cannot presume to tell the artist how he should proceed in order to produce a good work of art. No such work has ever been successfully composed or painted by following a theory of art. But the critic can prove useful through his warnings: useful to the creative genius who would break out on new paths, and useful to the age when it is either dulled by a blind faith in the prevailing styles or mesmerized by daring virtuosity or surprise effects. In this respect, men like Mengs, Winckelmann and Reynolds have incontestably performed a great service. They were successful in defeating the ecclesiastical style and the boudoir manner, the whole insipid and deleterious expression of taste which dominated the first half of the eighteenth century.

Of course it is true that they have helped to encourage the repellent tendency to fabricate frigid compositions by anxiously copying and collecting fragments from the life of nature, the works of the great masters and the products of Antiquity, or even to colour marble statues. And they have also encouraged the no less mistaken tendency to attempt the mere effects of great masses disposed in various forms and styles of lighting and offer us brightly illuminated sketches neglecting all true detail in place of finished works of art. But these errors of our time cannot properly be justified by appeal to the express intentions of those worthy writers. But why would any painter attempt to learn from the latter how he should set about his own work? All they can possibly teach him is how he should not set about it. [...]

But to the painting itself! As far as its dimensions are concerned, it is approximately three feet wide and four feet tall. The lower part of the painting is occupied by a craggy mountain peak. The latter is covered in fir trees, and the tops of some of them tower up from behind the peak, while half of one tree rises up in the foreground. For the greater part of the trunk, down to the roots, is cut off by the picture frame. The fir trees rising up at the back are arranged more or less symmetrically on both slopes of the mountain, and thus form no groups of their own. They rise rather in a stepwise fashion towards two unequal rocky boulders disposed in such a way as to suggest a pair of mountain horns, between which there is just enough space for a crucifix in the middle. The Christ figure is bronze, the front of which is turned in three-quarter profile towards the back of the mountain, so that the viewer in the foreground can barely see a quarter of the figure properly. At the foot of the mountain there are a couple of blocks of granite lying on the stony ground, which is covered here and there in moss and from which a couple of young spruce and pine trees struggle laboriously upwards.

The pyramid-shaped earthy mass of the mountain is sharply profiled against the surrounding sky. The sky is a dirty violet towards the top but becomes redder as it descends and ends in a cold yellowish hue. The upper part of the picture swarms with vermilion streaks. But the whole scene is also bisected by rays of light which

indicate how low the sun has already set and illuminate nothing else on the mountain but a few aspects of the Christ figure on the cross, namely the head, the lower part of the body and one knee. Everything else on the mountain, including the cross itself, suggests a kind of twilight caught in such an unequal contest with the night sky that one can hardly distinguish it, especially standing some little distance away, from the darkness itself.

The unprejudiced viewer cannot possibly doubt that an allegorical significance underlies the composition. This is also strongly suggested by the frame which encloses the picture, filled as it with various symbols which I shall discuss further below. The frame must have met the approval of the artist since the picture has been expressly exhibited in this way. And the fact that the painting is intended to function as an altarpiece also suggests as much. The crucifix in the picture, two or three inches high, turned away from the viewer as it is, is itself hardly enough to justify this function. There is no doubt that the natural scene depicted here conceals an allegorical meaning that is designed to evoke in the viewer a pious mood akin to participating of the Lord's Supper.

What then is this allegorical meaning? I shall attempt to unravel it. If I have seen less here than I was meant to see, so much the worse for Herr Friedrich. For why then did he not express himself with greater clarity? Why, in a painting intended to edify so many, did he rely upon the special perspicacity of a select few?

I imagine that Herr Friedrich beheld this natural scene himself and then attempted to express the feelings which it provoked in him. I shall allow him to interpret his own painting in the following way:

'Everything about me was still dark when I came upon the place which supplied me with the material for the picture that is exhibited here. The sky was already brightening behind the mountain that lay before me. Streaming flecks of red across the sky announced the imminent arrival of day, and the reflection of other rays in the skies above already suggested the sunrise which was still concealed by the intervening mountain. The sun was hidden away deep behind the mountain. The various aspects of the earthy mass were more surmised in this ambivalent light than directly perceived, but the outline of the mountain itself stood out sharply against the sky. At the summit there stood a crucifix, its face turned towards the hidden side of the mountain, as I could just make out from the few patches already illuminated by the sun's rays. – What a wealth of meaning lay within this sight! Christ the crucified one standing in such solitary bleakness! At the turning-point between darkness and light! But still enthroned high above the highest in nature itself, visible to all who seek him! But He, He beholds the light face to face, while to us, surrounded by twilight in this vale of tears as we are, whose dull eyes could not yet bear the clear and undiminished light of splendour, he imparts merely its reflected gleam! Thus, as a proclaimer of the salvation that awaits us, he also immediately becomes the mediator between earth and heaven. And we ourselves, we take heart, we rejoice in his tidings and his service, just as we rejoice at the approach of the sun when, after the nocturnal darkness, we first perceive its faint illumination and the effects thereof even before its actual appearance. And here I felt a need to celebrate that commemorative feast which, itself a mystery, becomes the symbol of another: the Incarnation and the Passion of God!'

If I might flatter myself in the hope of having understood Herr Friedrich entirely here, I should cry out: What an abundance of sentiment, of imagination! But when and where? If I had read this description in the confessions of a pious soul, in a novel written in the style of [Chateaubriand's] *Atala*, such would indeed be my response. If the owner of a chapel in the vicinity of this mountain and its crucifix were to have an opening made in the altar, and the gazes of the faithful on approaching the altar were led in accordance with perspective towards this natural scene, the idea would be fanciful enough, but I could easily imagine that, from certain positions at certain hours of the day, the sight could inspire many a pious soul to a solemn mood like that Herr Friedrich himself had experienced.

But here we have a painted picture, a work of art before us, and quite different questions come into consideration as a result.

Can this particular natural scene be painted without sacrificing the most essential and positive features of painting, and particularly of landscape painting? Is it a happy thought to employ a landscape as an allegory of a specific religious idea, or even with the purpose of evoking pious sentiments? And finally, is it compatible with the dignity of art and the truly pious individual to encourage religious worship by such means as Herr Friedrich has employed here?

I intend to examine these questions in turn, but in answering the first I shall also attempt to assess the quality of the execution as well.

My intention here cannot possibly be to present a general theory of landscape, least of all my own. I must nevertheless lay down a few basic principles which must prove convincing to anyone, including laymen, and have a direct bearing on Herr Friedrich's painting. The figure painter who presents me with an individual body, or a number of bodies grouped together, especially if the human figure is at issue, will naturally expect me to direct my attention to the same aspects as I would if I were actually confronted by a body directly before me and a short distance away. In attempting simply to perceive the figure as an independent whole and to distinguish it as a single individual from other bodies, I will naturally interpret it in terms of line and specific form, in terms of a quickly comprehensible division of planes and masses *within the body itself*, in terms of the effortless transition of the eye from one part to another, in terms of the uninterrupted and continuous outline which circumscribes the entire body and differentiates it from the others. With respect to colour I will pay particular attention to the fidelity of the local colour or the colour peculiar to the represented body, to its general coherence and particular variations. With respect to chiaroscuro effects I will inspect the modelling and the authentic disposition of the light through which the principal aspects of form and colour are pre-eminently emphasized. All of this properly belongs to the view, and the appearance of judicious disposition, which figure painting offers us: conspicuously well-proportioned with regard to the mutual differentiation of the parts, the equally conspicuous unification of the parts to form an independent whole through the fluent delineation, I might even say through the casting, of outlines; truth, variety and harmony in the local hues; harmonious modelling in terms of shape and colour, and the favourable arrangement of light and its effects, these are particular advantages that belong to figure painting. Everything it may offer over and beyond this is a valuable addition perhaps, but is not essential to my enjoyment of the work.

Landscape painting, on the other hand, lays down before me a surface upon which a group of objects has been arranged – one should not describe them all as bodily figures in the painter's sense – layer by layer, like stage scenery, one behind the other, and always presented to the eye from some distance away. This ensures that my attention will concentrate itself precisely upon what is to be recognized and evaluated when I adopt *a view upon external nature*. A certain variety is what I look for first, and if I also seek satisfaction in the differentiation and the interconnection of the material, I still prefer this aspect to be implicitly concealed rather than explicitly striking. Thus the various masses will be roughly balanced in relation to one another, the outlines of the individual planes will be modulated, that is, will incline towards and gently succeed one another, rather than all flowing in together at a single stroke. There must be a harmony here, if I might so express myself, but not the melody that is characteristic of figure painting. The definite and graduated differentiations, the undivided confluence of the outlines would merely destroy the character of free inanimate nature. Landscape painting must, therefore, renounce the pleasing forms of organic nature. But free inanimate nature, on the other hand, possesses its own kind of pleasing form which arises from the layered disposition of objects protruding from behind one another at different distances: the pleasing form which is intelligibly presented to us in natural grottoes, in the perspective of the stage, in the excellently composed landscapes of a Nicolas Poussin. As for the latter, just think how delightfully the eye passes on from one plane to the other, how it is challenged by this straight line, drawn along by that turning and winding one, encouraged to leap up by a third combining the features of the other two! And how do these various planes and lines succeed one another? Not in a gradual process of uninterrupted continuation, of undivided interconnection. No! They present themselves rather to the eye as a gentle means of transition from one differently configured aspect of nature to another! This is the pleasing harmony offered by the various depths and hollows suggested by the painted surface, or if one prefers to express it thus, this is itself the pleasing harmony of compositional and linear perspective!

With regard to colour, landscape painting cannot expect to represent local hues as faithfully, that is, expose them to so close an examination, as can figure painting. Between my eye and the objects which the landscape painter represents to me as coloured through the distance, there invariably intervenes so much air as to project a kind of mist or haze which not only modifies the local colour but actually transforms it. The more distant the objects are in relation to me, the more conspicuous such changes become. The brown or green colouring of the mountain becomes violet, blue, and so forth. But between myself and the objects initially presented in the foreground there already prevails this haze which also immediately imparts its own hue to the objects I perceive further back. In spite of this, landscape painting possesses its own truthfulness in the matter of colour, knows how to take advantage for its own particular purposes of the effects of aerial perspective, of the total transformation of local colour produced by distance, of the haze or mist which suffuses all its objects. For in the strongest sense the images of landscape painting are characterized by a certain general tone or feeling, something which is indeed not entirely foreign or unfavourable to figure painting but is certainly not essential to it, and cannot be expressed so strikingly in that context either. Landscape painting

reproduces in its entirety the harmonious effect which a dark mirror or natural reflections in water can produce, the harmonious effect which infuses every local colour with the prevailing hue of the picture surface upon which a number of differently coloured objects are also presented. And how wonderfully the Dutch painters have exploited this particular advantage of painting, even if they sometimes rather misused it as well! And think what immeasurable advantage Lorrain has drawn from this transformation of colours through aerial perspective! Let us then define the peculiar characteristics of colouring in landscape painting in accordance with such aerial perspective.

Finally, landscape painting does not regard light simply as a means of modelling figures, or of setting off pleasing form or the charms of colour. No! It paints light itself, and combines this representation with the most piquant effects. One need only consider a sunrise by Claude Lorrain, a forest suffused by shafts of light as in a work by Ruisdael, or many similar pieces by Cuyp and other Dutch artists, where the rays of the sun appear to gild the objects upon which they fall. No figure painter, not even Correggio, has ever achieved this, and nor should or could he attempt to do so since his purposes are quite different and he cannot fully master the great variety of reflections, the manifold sources of light or the aerial perspective which also claims its rights in landscape painting. I shall now briefly summarize the foregoing considerations and draw certain conclusions from them.

The harmonious form of linear perspective is especially characteristic of landscape; equally characteristic is the charm attaching to the picture's general tone and the aerial perspective in relation to light and colour; only linear perspective is able wholly to command the most piquant effects of light produced in open air.

If we grant the validity of the principle that every art ought properly to pursue the particular advantage it enjoys over others, it follows that a beautiful landscape must present us with several planes in order to exemplify the harmonious effect of linear perspective, and that the representation of no individual object in a landscape, whether it be a tree, a mountain summit, a house or a motionless pool, can take priority over the former. It follows from this that the landscape must not express any detail as if it were being contemplated from close by and without the intervening haze of light. And further that no landscape should present the impression of twilight or darkness which would utterly disturb the effects of aerial perspective and the expression of light. The opposite approach may well produce a great effect in a sepia drawing, at least for lovers of novelty and highly sophisticated technique. But it contradicts the serious intention of a perfectly finished work of art.

Now with his altarpiece Herr Friedrich has directly and quite intentionally violated all these fundamental principles. He has, without any perceptible indication of different levels, filled the lower part of his picture entirely with a single craggy summit resembling a cone in shape. He has banished any trace of aerial perspective and, what is even worse, has covered the earth in darkness and thereby deprived himself of all the favourable effects which the presence of light can afford.

At the beginning of the eighteenth century and in the second half of the seventeenth, several Neapolitan and Venetian masters hit upon the idea of introducing the specific features of landscape painting into the domain of history painting. They arranged their figures exclusively in levels or as in a stage scene, concealed the

balancing of different masses as much as possible, and did their utmost to emphasize instead the general tone, the *sfumato* effect in the colour, and the gleaming effects of light. Such a false expression of taste is now widely proscribed. But has not Herr Friedrich simply fallen into the opposite error? Is he not attempting to treat the landscape as if it were a figure placed directly in front of me, one that I can make out individually in the half-shadow because the surrounding light still at least reveals its harmonious shape, its local colour and its general outline?

Quite apart from any allegorical intent, it is also possible that Herr Friedrich has been seduced by a certain striving for noble simplicity into his false choice of subject. But in art and the moral world alike, there is a kind of presumptuous simplicity which can prove quite wretched. An artist of noble simplicity is one who is no more extravagant in the execution and the work than is required by the true nature of both. Without this the artist will become crude, clumsy and barren. I hope Herr Friedrich will forgive this remark, which is directed not against his talent but his underlying system. His problem is not so much barrenness as a falsely affected economy.

The execution of the picture exhibits all the consequences that follow inevitably from the neglect of the principles I have set out above. The painter has taken up no point of view at all, and nor is there any he could take up in order to express what he wanted to express. In order to perceive the mountain and the sky together in this expanse, Herr Friedrich would have had to stand several thousand paces away, on the same level as the mountain itself, with the line of the horizon in parallel with the latter. From such a distance he would not have been able to perceive any details within the outline of the mountain: no granite boulders, no moss, no trees surrounding the front. All of this would necessarily have vanished, and the entire earthy mass would simply project itself sharply against the sky like a black silhouette. And not merely that! For assuming, what cannot be denied, that the line of the horizon runs parallel with the summit of the mountain, then the illumination of the crucifix completely contradicts the first principles of optics. For if we trace the prismatic reflection of the sun-rays that bisect the sky back to their point of origin, the resulting position is so low that Herr Friedrich, from his position behind the mountain, could not possibly perceive any reflected light shining on the Christ figure, least of all from below. In support of this claim, I would simply refer to the best treatise on perspective, namely the *Traité de perspective* by Valenciennes, chapter 7, §4. [. . .]

What has led Herr Friedrich into this error, which violates all the rules of optics, is either that he cast an artificial light upon a clay or wax model of the mountain or imagined himself standing at the side of the mountain instead of behind it. In the latter case the sunlight would indeed have poured across the mountain, which lies much lower than the sun. But then not merely would the crucifix have been illuminated, though certainly not from below, but equally everything else that lies upon the mountain. Standing behind the mountain, Herr F would have been quite unable to see anything of the sun's rays, just as little as if he had held his hand horizontally in front of his eyes.

Another error in the picture is that the time of day remains uncertain owing to the absence of all illuminated surfaces. The coldness of the air suggests morning, but the lack of mist does not. The silver star on the head of the highest angel in the frame is

presumably intended to make good this absence. But Herr F might just as well have written over it: This is Morning!

The mountain mass has a bluish-brown and entirely monotonous colouring. Entirely deprived of light, it is quite flat and lacks all rounding out. It therefore stands in the most strident contrast to the bright sky around it, without transition or a trace of harmony. This can only make a great effect on those who are prepared to accept such a division into a great light mass and a great dark mass as a kind of chiaroscuro.

* * *

Let us now see how far it is possible to allegorize with landscape. Allegorical paintings are those which present perceptible objects in the picture under such conditions as we are not accustomed to see such objects in everyday life or in the story or fable presented in the picture itself. This strange relationship between perceptible objects and their presentation in the picture under circumstances different from more usual ones is precisely what alerts us to the hidden meaning that is the basis of allegory and the key to its interpretation.

How then is it possible in a landscape to transform the visible and familiar conditions of objects into one so strange that we tell ourselves: this is allegory? One could of course locate the earth at the top and the sky below, one could paint pastry on the trees in place of foliage, etc. But this would simply destroy nature itself. Figure painting can retain its own nature when it allegorizes. It simply extends this nature through the fable it presents. It differs principally from our customary view of things only through the way in which it depicts specific customs and characteristics. Nevertheless, where it cannot lend at least some moral probability to the allegory or offer in addition to the allegorical meaning a purely human or historical one, then it should not dare to attempt allegory at all.

Let us not confuse an expressive landscape with allegory! In the gallery in Dresden we can behold a landscape with a cemetery by Ruisdael [*The Jewish Graveyard*, *c*.1655]. A replica of larger proportions, considered to be an original, is in the possession of M. Tourton in Paris. The work is a masterpiece of expression. It depicts a scene presenting a universal predicament of human life, and awakens not merely a solemn mood in general, but the specifically felt, solemnly religious emotions aroused by reflection upon the nothingness and transitoriness of all that is human. But where is the allegory in this? Nowhere, except in the common prosaic minds of presumptuous declaimers who dare to wax poetical when they are coldly playing with symbols, to awaken emotion when they are merely reasoning about emotion.

It is undeniable: he who would deviate from nature, as we generally see her every day, in the domain of landscape either creates the impression of an erroneous imitation or that of some alien scene in a distant and remote part of the world, and the latter in turn also involves expression. One will therefore never be able to allegorize with any properly composed landscape. It is quite true that the figures in such a landscape could express an allegorical event. But if they are subordinated to the landscape itself, they remain a secondary feature, a symbol or attribute of the latter. If they are the principal subject on the other hand, the landscape merely presents the scene for the event and belongs in the expressive domain of history

painting. The allegorical meaning of a landscape must therefore always be sought outside the painting itself, in the site for which it is destined, or in the frame. And this is precisely what Herr Friedrich has done, and could not indeed help doing, since if it were exhibited in a public gallery without this frame, his landscape would appear as nothing more than a poorly chosen nature scene and the crucifix merely as an accessory figure or fabrication. But he never stopped to consider that he has thereby degraded an independent work of art into a bare symbol which, like the scales which Justice holds in her hands, can only be explained by asking: how have you come to stand in this frame, within this chapel, upon this altar?

'But surely,' so it will be protested, 'if a landscape can supply the expressive scene for a universal and yet specific predicament of human life, why can it not depict the realm where every cultivated mind will gladly abandon itself to reverence? The holy nature made by God is also his fairest temple!'

It is here that the important difference between powerful external [*pathologischer*] and properly aesthetic feeling comes into question.

Go out into nature as she really is! The fresh air you inhale, the authentic splendour of the sun, the mountain heights and the broad expanses that surround you, etc. – immediately they affect every organ, rouse and strengthen through exertion and repose, through piquant influence upon the nerves, those ideas of grandeur, of benevolence and of life in general which move every healthy soul to love, gratitude and admiration for the Creator. It is truly absurd to expect powerful external feelings such as these from a painting that necessarily lacks the appropriate means for it. What a painting offers is an aesthetic sentiment which allows us, constantly aware of the distance from real life, to enjoy the playful way in which art moves our sentiments. If it were possible for art to transport us into truly powerful external sentiments, then the aesthetic sentiment would disappear: the work of art would simply pass over into nature, our experience of the beautiful into that of sympathy. Would that prove an advantage to the work? By no means! Any relic of a widely venerated saint set out upon the altar can rouse our powerful feelings more strongly than the most beautiful work of art, and the coarsest caricature enjoys a less disputed claim to this advantage than the most beautiful of paintings.

If the painting is not to be the real basis of our powerful external feelings, of our true devotion, should this properly be found in the pious acts that we perform before the altar? Should the work of art merely *support* [*unterstützen*] this mood by means of aesthetic sentiment? – but in how much closer relation, then, to such a purpose historical painting stands! – the kind of art which paints devotion itself, which depicts events long since familiar to us, the gentlest intimation of which suffices to inspire a host of touching episodes, of characteristic deeds, of sayings! The kind of painting, finally, which represents the very love-feast which we all wish to share, which invites us to worthy participation in this solemn occasion through its depiction of the figures involved, through the expressive presentation of the Saviour and his faithful companions, just as it can warn us from unworthy participation in this touching feast of commemoration through its expressive presentation of the traitor amongst them.

O you protagonists of the new! You might still recall to us a thousand times those touching words: '*Do this in remembrance of me*', without ever fully exhausting the character, the intrinsic expression revealed by Him who spoke these words, and

ineluctably revealed by those who heard them. Indeed it is a true presumption when landscape painting would slink into the churches and creep onto the altars. But let us leave all this aside and ask after what is ultimately the most important thing of all.

Is it compatible with the dignity of the truly pious man to try and encourage devotion by such means as Herr Friedrich has here employed?

And here I must discuss the frame which surrounds the picture. It stands in an immediate relationship with the picture and constitutes an integral factor of the same, for without the frame the allegory would not be even remotely intelligible and the frame itself effectively forms the upper section of the altar. In addition to this, the carved and silver-coated evening star at the top above the painting obviously alludes to the time of day represented.

When I stepped into the room where the painting was displayed here in Dresden, I found it in its frame standing on a brown table which itself was covered with a black cloth.

Yet the frame lacks any proper relation to the picture. At the bottom there is a large pedestal with steps attached. In the middle of the lower frame one sees an eye in a triangle surrounded by rays of light, and a winding grapevine and ear of wheat on either side. Two variously fluted Gothic columns stand upon the pedestal with palm branches emerging from the capitals to form a kind of arbour at the top. Children's heads with wings peer out from the branches. Above the uppermost child's head there stands a silver-coated star. Everything else is gilded all over.

If one now unites these emblematic forms with the allegory of the painting itself and evaluates the general tendency of the whole, while sacrificing all truth and taste, what results is indeed a worthily revered and consoling, though hardly aesthetic, religious idea: one symbolizing our belief in the mysterious effects of the Lord's Supper. It is surely impossible to mistake the influence which a currently prevailing system of thought has here exercised upon Herr Friedrich's composition: that mysticism which is now creeping into everything and enveloping art as well as science, philosophy as well as religion, with a haze of narcotic intoxication! that mysticism which would treat symbols and fantasies as the equivalent of painterly and poetic images and exchange the works of classical antiquity for Gothic woodwork, hide-bound craftsmanship and ancient legends! that mysticism which plies its verbal games instead of concepts and bases its principles upon the most remote of allegories, which searches on all sides for mere presentiment where we should know and recognize the truth or modestly hold our peace! that mysticism for whose adherents the ignorance of facts and literature is such a shibboleth! that mysticism which exalts the Middle Ages and its precepts far above the age of the Medici, of Ludwig and of Frederick! that mysticism which would gladly conflate the bold and vigorous fervour that properly accompanies the authentic religion of Christ with a languishing and exaggerated devotion to the cross! that mysticism, finally, which makes me tremble for the consequences of the present age and calls to mind all those who with the end of the Roman Empire hastened the decline of taste and all true learning! For then as now, the Neoplatonic sophists, the Gnostic and Orphic shamans, appeared upon the scene, then as now, they played with legends and pronouncements, with amulets and symbols, and then as now, they crippled art with the presumption that they would bring it back to its original simplicity.

Courageous Frederich, and all you men of genius and talent whom current fashion once distracted from the true path, return again to that which experience alone has shown to be the tried and proper one. Such a passing fashion will never spread so readily where history is taught with thoroughness, where classical Antiquity is preached with taste, where ability and knowledge still represent the goal of the artist and the scholar. But in the principal cities, in the vicinity of the courts, anywhere indeed where diversion prevents men from studying thoroughly whatever lies beyond the sphere of commercial life, where art and learning are principally employed for light social entertainment, where the glutted senses seek ever new enticements and heightened pleasures of imagination, there alone, I say, will doctrines which vaunt their images and wordplay, their eccentric half-grasped observations garbed in high-flown phrases, as knowledge and wisdom find a ready welcome, and especially those, as far as art is concerned, who chatter on about divinity and the heart without endeavouring to acquire the first condition of both: namely truth and a skilled hand!

13 Caspar David Friedrich (1774–1840) On *The Cross in the Mountains*, letter to Professor Schulze, 8 February 1809

Friedrich responded to Ramdohr's criticism of his painting, *The Cross in the Mountains*, in a letter to Johann Schulze (1786–1869). Schulze was at this time in Dresden working on the Weimar edition of Winckelmann's writings, which he edited with Heinrich Meyer and Karl Ludwig Fernow (see VIIA6). Through Schulze the letter reached the editor of the *Journal des Luxus und der Modens*, who published a shortened version of Friedrich's account of the painting in April 1809. Clearly stung by Ramdohr's remarks, Friedrich offers a detailed account of the symbolic meaning which the painting was intended to convey. He freely admits that he has broken with long-standing rules of pictorial composition, but insists that he has used different means in pursuit of legitimate goals. The absence of traditional effects of light and aerial perspective, for example, should not be read naturalistically but as a representation of the departure of God as a direct presence in the world. His presence is henceforth known only through the reflected light which reaches us from the figure of the Redeemer on the cross. The letter has been translated complete for this volume by Nicholas Walker from Hermann Uhde-Bernays ed., *Künstlerbriefe über Kunst*, Frankfurt am Main, Zurich, Vienna: Jess Verlag, 1962, pp. 246–52. Friedrich frequently refers to Ramdohr as Herr Kammerherr (chamberlain) von R or simply as K von R. The Herr von Kügelgen mentioned at the end of the letter was a friend of Friedrich's who later published an essay in defence of *The Cross in the Mountains* in the *Zeitung für die Elegante Welt*, no. 49, 1809.

My dear Professor,
In your last letter you asked if I would communicate to you my thoughts concerning my altar painting. At that moment I did not really feel in a position to do so and shared my thoughts about a different picture with you instead. But I have recently been impelled by the appearance of an essay directed expressly against myself by Herr Ramdohr to present my thoughts on the altar painting after all. I have now woven them into a short piece intended as a riposte to the essay in question. I have written the piece even though I have expressed myself in the third person, although I do not

rightly know why I proceeded in this way. Several individuals have advised me to publish the piece and indeed I am not wholly disinclined to do so. I would also be very grateful to learn your own opinion with regard to this possibility. I am assuming that you have already read the essay by Ramdohr; if not, I would ask if you could read it beforehand since otherwise my own piece might very well strike you as rather strange.

If the picture by the said painter Friedrich had indeed observed the rules of art which have been acknowledged and sanctified through the centuries, if, in other words, F had availed himself of the crutches proffered by art instead of presuming to follow his own way, then Herr Kammerherr von R would never have roused himself from slumber. If Herr F had simply followed the already established road where every donkey bears its burden, where cat and dog take care to stay for safety's sake, where after all the celebrated artists of earlier times have been set up along the way as models and examples for all future ages, then K von R would surely have held his peace. But it was not actually these artists who expressly presented themselves as the one and only signpost for us to follow. For these worthy masters were all too aware that the roads that lead to art are in fact infinitely various, that art is properly speaking the focal point of all the world, the focal point of the highest of our spiritual aspirations, and that artists stand together in a circle around this focal point. That is why it so easily transpires that two different artists can actually move towards one another insofar as both are striving to reach a single point. For the variety of possible standpoints here is also the variety of individual hearts and minds, and both artists could achieve the same goal in travelling their opposite roads. It is merely those narrow and heartless art critics, whose writings have often enough chilled or blasted many a fragile soul, that could even entertain the idea that there is only one road to art, namely the one they themselves have proposed. Of course, if the picture of Herr F were wholly without value, then Counsellor R would certainly have extended his hand in friendship instead of mounting the stage as his opponent. The ordinary and the bad in art will surely perish of itself, but the half-way decent must be expressly toppled.

But why on earth did Herr F fail to share his views on landscape painting with Herr von K beforehand? Why did he fail to ask such an outstanding connoisseur of art whether the latter was already acquainted with these views? For that would also have sufficed to answer the question whether or not he lent any credence to the latter. Let F therefore accept Herr von R's sermon of denunciation as a natural consequence of his own stubbornness. For what matter if the picture is pleasing to the multitude, if it is not pleasing to Herr von R!

It must be a painful experience for a man like K von R when he looks around and beholds the horrors of the present age, the omens of advancing barbarism, black as night, pressing on defiantly and contemptuously trampling underfoot all the rules, the chains, the bonds with which the human spirit was once kept in line along the well-established straight and narrow. Is it not obvious that the artistic spirit of our age has put its foolish, pitiable and unlimited faith in a purely imaginary spiritual reality? Has it not clearly abandoned itself with a child-like, indeed childish, enthusiasm to every sacred stirring of the inner life? Is it not ready to revere, with a kind of blind devotion, every pious presentment, as if all this were without question the

purest, most transparent source and origin of art? Without even asking or discovering whether a Claude Lorrain, a Nicolas or Caspar Poussin, a Ruisdael, or what is far more important, a K von R would give his approval first?

The 'effect' [*Effekt*] or rather, to speak in plainer German terms, the way my picture 'works' [*die Wirkung*] upon the beholder is enough to justify its worth as long as it works truthfully, as long as its truth is directed towards what is noble. If a picture works feelingly and spiritually upon the beholder, if it inspires a fairer mood within the heart, then it has already fulfilled the first demand placed upon a work of art, however poor it might otherwise be in respect of draughtsmanship, the use of colour, the painting technique, etc. If a picture leaves the feeling and responsive beholder cold and the heart untouched, however exemplary it might otherwise be in respect of form and colour, then it can lay no claim to the name of an authentic work of art [*eines wahrhaften Kunstwerks*], although it may well deserve the name of a most beautiful piece of artifice [*einer schönen Künstelei*]. But a perfect work of art will combine both of these aspects within itself.

A description of the picture

An upright cross, green ivy clinging around its stem, and surrounded by evergreen fir trees, stands on the summit of a rocky outcrop. With the sinking of the glowing sun the Saviour is gleaming in the reddish-purple of evening.

A description of the frame

The frame, as we know, is not merely fashioned in general agreement with the painter, but entirely in accordance with his express design. If there is anything wrong with the disposition of the frame, this is not to be ascribed to the sculptor Kühn but solely to the painter himself. Along the sides the frame effectively forms a pair of rather Gothic columns. Palm branches spring forth from the columns and arch over the picture. There are five angelic heads set within the palm branches, all looking down in prayer upon the cross below. The evening star, in pure gleaming silver, stands directly above the central angel. At the bottom of the frame, in extended relief, we behold the all-seeing eye of God in a sacred triangle surrounded by rays of light. Sheaves of corn on one side and vine leaves on the other turn inwards towards the all-seeing eye. These are intended to signify the body and blood of Him who is nailed to the cross. There are three donors at the bottom beneath the frame itself.

Secretary R does not properly know how to imitate the tongue of the painter F, and I am convinced that F would certainly never have expressed himself as he is here represented as speaking. It is quite true that the picture possesses an allegorical meaning, even if that meaning is not immediately clear to the Secretary! It is quite deliberate that Jesus Christ, nailed to the rood, is turned away towards the sinking sun, itself an image of the all-seeing and all-life-giving Father. An ancient world came to perish with the teachings of Jesus, a time when God the Father still walked visibly upon the earth, when He spoke unto Cain, saying: Why dost thou wax wrothful, and why dost thou dissemble?, when He delivered amidst thunder and

lightning the tables of the Law, when he spoke unto Abraham, saying: Take off thy shoes for thou standest on holy land! The sun sank down, and the earth could no longer grasp the departing light. The Saviour on the cross shines here, like the purest and noblest of metals, in the reddish-golden glow of evening, and is himself reflected, though with milder light, upon the earth. The cross stands forth, unshakeably firm, upon the rock, like our own faith in Jesus Christ. The fir trees, evergreen through the ages, stand about the cross, like our own hope in Him, the Crucified One. When the Herr Secretary says that F has banished every trace of aerial perspective from his picture he is quite wrong; but if he had said that it was expressed but weakly there, he would have been right. If the secretary finds only darkness where other honest men can still clearly perceive objects, then the fault lies not with the picture, but in the weakness of his own eyes.

The Secretary's unconditional demand that a landscape must always present several different planes is not one that is accepted by Herr F. Nor indeed does Herr F accept that the greatest possible variation of form and colour alone represents the essence of painting, that straight lines must invariably be complemented by curvilinear ones, that while one line encourages a kind of dynamic delight, another meanders slowly and mournfully instead, that while one line gradually disappears into the undergrowth, another is friendly enough to suggest Ramdohr's *Urania*, and a third generously serves up the rules of art. In short F is a disillusioned friend of what is generally described as 'contrast'. He believes that the attempt to express oneself through contradictions (for this is how the coarse and slick interpret contrast) is utterly deluded. On his view of things every truthful work of art must express a specific meaning, must move the soul of the beholder to the experience of joy or grief, of melancholy or happiness, but that does not mean simply throwing every possible feeling together and churning them up indiscriminately. The work of art must simply strive for unity, and a single intention must throughly permeate the whole. Every individual part of the work must be stamped by the sense of the whole rather than resembling a crowd of human beings who hide behind flattering words and evil cunning.

Contrast, so you all say, is the rule of all rules, the fundamental law of art. But only for you who are a contrast with the spirit, you who are nothing but body! This is indeed the right rule for you!

Art can never be at home with those whose hearts and souls are cold. Landscape nature appears inanimate to Herr von R precisely because he has no living feeling for nature.

F forgives Herr von R his coarseness. F forgives the heathen who finds the Christian theme unseemly. First the Secretary complains about the all-pervading darkness, while later on he claims we see too much. The Secretary's malicious lie that the cross is illuminated from below most certainly should merit censure, but only serves clearly to reveals his feral malice. The cross is not illuminated at all, but simply gleams in the reddish glow of evening. The Secretary refers F to the writings of Lairesse, but I would refer him to the first commandment in which it is written: Thou shalt not bear false witness against thy neighbour.

But if one can perceive the air behind the rocks, why should one be unable to perceive the sun's rays too? F concedes that the redness of the air is misleading, and

therefore leaves us doubtful whether it is morning or evening, and that the mountain lacks a rounded profile. But the crudity of K von R's remarks on the subject merits only contempt. He even writes as if he had witnessed F sitting and drawing before a mountain modelled out of wax or clay!

Herr von R claims to have demonstrated that F has failed to provide a good painting. He may be right, for F himself is convinced that there are many faults and defects in his picture, but, unlike the Secretary, he is not convinced of the utter worthlessness of his work. But even more than the faults and defects of his picture, F is rightly convinced of the baseness of Herr von K.

This short essay was not intended for F to defend his picture, but rather as an occasion for informing the lovers of art in brief about his own views concerning art and the sacred in art. But Herr K von R has demeaned himself rather than F, and pilloried himself as a heartless man!

I have chosen to ignore the final page of Herr von R's essay since I am too disgusted to respond to it. It is indeed no small task simply to try and read the essay from beginning to end.

Herr von Kügelgen has arrived here safely, and his wife's condition has improved from the very hour he entered the house. Kügelgen reported on Weimar with much warmth and affection, and spoke a good deal about the welcome reception he received there.

May God preserve you in good health, my dear Schulz, and so write soon to your friend, C. Friedrich.

14 Clemens Brentano (1778–1842) 'Various Emotions before a Seascape by Friedrich'

Clemens Brentano belonged to the Heidelberg school of Romanticism whose members included Ludwig Achim von Arnim and Joseph Görres (see VIA4). He was born in Ehrenbreitstein to a wealthy merchant father. From 1797 he studied in Jena where he came into contact with some of the leading members of early German Romanticism. His most important work is the collection of folk-songs, *Des Knaben Wunderhorn*, which he edited with Arnim between 1805 and 1808. He also wrote numerous novels, fairy-tales and plays. He later converted to Catholicism and in 1818 he withdrew to the monastery of Dümen near Münster, recording the revelations of the visionary nun, Anna Katharina Emmerich (*Das bittere Leiden unsers Herrn Jesu Christi*, 1833). The following text dates from 1810 and was originally intended for publication in Heinrich Kleist's journal, *Berliner Abendblätter*. However, Kleist severely shortened and adapted the piece, later accepting that the published version (see VIB15) represented his own work. Caspar David Friedrich's *The Monk by the Sea* (Berlin, Charlottenburg) was included in the annual exhibition at the Berlin Royal Academy of Art which opened on 23 September 1810. Brentano's inventive and humorous account of the various responses to Friedrich's painting is full of wordplay difficult to render in English. It is likely that Arnim contributed to its composition. He is the 'tall and reserved young man' who appears at the end, and the final description of the painting is thought to have been written by him. The full text was first published in *Iris. Unterhaltungsblatt für Freunde des Schönen und Nützlichen*, no. 20, 28 January 1826. The following translation has been made for the present volume by Jason Gaiger from Clemens

Bretano, *Werke*, ed. Friedhelm Kemp, volume 2, Munich: Carl Hanser Verlag, 1963, pp. 1034–8. Notes have been added.

It is splendid, in infinite loneliness by the shore of the sea under a cheerless sky, to stare at a limitless expanse of water; in part, this is due to the fact that one has gone there, that one must return, that one would like to cross over, that one cannot do so; that everything belonging to life is missing and that one hears one's own voice in the roar of the tide, in the billowing of the wind, in the passing of the clouds and in the lonely cry of the birds; in part it is due to a demand which is made by the heart and by the withdrawal of nature. This is impossible before this painting, however, and that which I should have found in the painting I could find only between myself and the painting, that is to say, a demand which the painting makes on me but which it does not fulfil; and so I became the monk and the painting became the dune, but that upon which I gazed with yearning, the sea, was not there at all. In order to discover this wonderful feeling, I listened to the comments of the various different visitors and considered them as something belonging to the painting; it is a form of decoration before which some sort of action must take place, for it does not allow anyone to rest.

A lady and a gentleman, who is perhaps very clever, came forward; the lady looked in her catalogue and said:
'Number two: Landscape in Oil. Do you like it?'
GENTLEMAN: Infinitely deep and sublime.
LADY: You mean the sea, it must be astonishingly deep, and the monk is also very sublime.
GENTLEMAN: No, Frau Kriegrat, I mean the feeling of Friedrich himself before this picture.
LADY: Is it so old, then, that he has seen it?[1]
GENTLEMAN: Oh, you misunderstand me. I am talking of the painter Friedrich; Ossian plays his harp before this painting.[2] (*Exeunt*)
Two young ladies
FIRST LADY: Did you hear, Louise? That is Ossian.
SECOND LADY: No, you misunderstood him. That is the ocean.
FIRST LADY: But he said that he plucks his harp.
SECOND LADY: I do not see any harp. It is very greyish to look upon. (*Exeunt*)
Two connoisseurs of art
FIRST: Yes, greyish indeed, it is all quite grey; why does he wish to paint such dry things?
SECOND: You should rather ask, why does he wish to paint such wet things so dry?
FIRST: He will have painted it as well as he can. (*Exeunt*)
A governess with two demoiselles
FIRST DEMOISELLE: That is the sea at Rügen.
SECOND DEMOISELLE: Where Kosegarten[3] lives.
FIRST DEMOISELLE: Where colonial goods come from.
GOVERNESS: Why does he paint such a cheerless sky? How nice if he had painted some men fishing for amber in the foreground.

FIRST DEMOISELLE: Oh yes, I too would like one day to fish together a beautiful necklace of amber. (*Exeunt*)

A young lady with two blond children and a pair of gentlemen

GENTLEMAN: Splendid, splendid, this man is the only one who expresses character in his landscapes; there is great individuality in this painting, elevated truth, loneliness, a cheerless, melancholy sky – he knows what he wants to paint.

SECOND GENTLEMAN: And he paints what he knows, he feels it and he thinks it and he paints it.

FIRST CHILD: What is that there?

FIRST GENTLEMAN: That is the sea, my child, and a monk who goes for a walk and is sad that he does not have a well-behaved boy like you.

SECOND CHILD: Why doesn't the monk dance around at the front and why doesn't he shake his head like he does in the shadow play? That would be nicer.

FIRST CHILD: Is it one of those monks who tell the weather such as we have outside our window?

SECOND GENTLEMAN: No, it is not one of those, my child, but he too shows the weather, he is the unity in the totality, the lonely centre of a lonely circle.

FIRST GENTLEMAN: Yes, he is the character, the heart, the reflection of the entire painting in itself and beyond itself.

SECOND GENTLEMAN: How divinely chosen is the staffage: it is not, as with ordinary painters, a mere device for gauging the height of the objects; it is the subject itself, the painting; as in a melancholy mirror, the monk seems to dream his own isolation into this place, and the shipless, all-encompassing sea, which constrains him like his vows, and the desolate sand dune, which is as devoid of joy as his life, push him symbolically onwards like a shore plant which offers its own prophecy.

FIRST GENTLEMAN: Marvellous, you are undoubtedly right; (*to the lady*) but my dearest, you do not say anything.

LADY: Before this painting, it was as if I were at home; it touched me deeply and it is only natural that it would do so; when you spoke it was as incomprehensible to me as when I walk with our philosophical friends along the shore; only I wished that a fresh sea breeze was blowing, driving a sail towards us, and that a ray of sunlight shimmered below and the water murmured; to me it is like a nightmare and yearning in a dream for the fatherland; come, let's go on, it makes me sad. (*Exeunt*)

A lady and a guide

LADY (*stands for a long time without speaking*): Grand, incomprehensibly grand! It is as if the sea had Young's *Night Thoughts*.[4]

GENTLEMAN: You mean, it is as if they had occurred to the monk?

LADY: If only you did not always jest and disturb my state of mind. Secretly you have the same feelings as me, but you prefer to laugh at in others what you revere in yourself. I say, it is as if the sea had Young's *Night Thoughts*.

GENTLEMAN: And I agree, and also the Karlsruhe reprint and the *Bonnet de nuit* by *Mercier*[5] and Schubert's *View of Nature from the Night Side*[6] too.

LADY: I cannot answer you better than with a parallel anecdote. When the immortal Klopstock[7] wrote for the first time in one of his poems, 'The dawn smiles,' Madame Gottsched[8] responded when she read it. 'What sort of mouth does she pull?'

GENTLEMAN: Certainly not a mouth as beautiful as yours when you tell me that.

LADY: And now you are going too far.

GENTLEMAN: And Gottsched gave his wife a kiss for her *bon mot*.

LADY: I would give you a nightcap for yours, if you were not one already.

GENTLEMAN: I would rather have a view of your nature from the night side.

LADY: You misbehave.

GENTLEMAN: If only we stood there together where the monk stands.

LADY: I would leave you and go over to the monk.

GENTLEMAN: And ask him to couple us together.

LADY: No, to throw you in the water.

GENTLEMAN: And then you would remain alone with the father and seduce him and spoil the whole picture with its night thoughts; that is how you women are; in the end you destroy what you feel and out of pure lies you tell the truth. Oh I wish I were the monk, eternally alone, gazing out over the dark, promising sea which lies before him like the apocalypse; I wish I could yearn for all eternity after you, dear Julie, and miss you forever, for this yearning is the only magnificent feeling in love.

LADY: No, no, my dear, in this picture of yours, if you speak in this way, I would leap after you into the water and leave the monk standing on his own. (*Exeunt*)

The whole time, a tall and reserved young man had listened on with some signs of impatience. I stepped lightly on his foot and he answered me as if I had meant to ask him his opinion. 'It is a good thing that paintings cannot hear, otherwise they would long since have veiled themselves over; people treat them with so little respect and they are quite convinced that they have been put in the stocks because of some secret crime which they as spectators must discover.' – 'What, then, is your opinion of this picture?' I asked. – 'I am pleased,' he answered, 'that there is still a landscape painter who pays attention to the wondrous conjunction of the seasons with the sky, which even in the most desolate regions produces the most arresting effects; but I would have preferred it if this artist possessed not only the right feeling but also the appropriate gifts and study to be able to reproduce this in his picture; in this respect, he stands as far behind certain Dutch artists who have painted similar things as he excels them in the state of mind with which he has grasped them; it would not be difficult to list a dozen paintings in which the sea, the shore and a monk are better painted. From a certain distance, the monk looks like a brown mark; if there has to be a monk there, I would rather he was stretched asleep upon the ground, or praying, or cast down and gazing up with humility so as not to spoil the view of the sea which clearly makes a greater effect upon the spectator than the tiny monk. Whoever might afterwards seek to discover the inhabitants of the coast would still find in the monk an opportunity to express what several of the spectators have loudly communicated with expansive familiarity to everyone else.'

This speech pleased me so much that I immediately went home with this man where I still find myself and where I shall be found in the future.

[1] The lady assumes that the reference is to Friedrich II, the Great (1712–86).

2 A reference to the legendary Gaelic bard and warrior whose verse was popularized in the eighteenth century in 'translations' by the Scottish poet, James Macpherson (1736–93). *Finegal* appeared in 1762 and *Temora* in 1763.

3 The German poet, Christian Ludwig Kosegarten (1758–1818), who was an influence upon the young Friedrich.

4 A reference to Edward Young (1683–1765) whose long poem *The Complaints or Night Thoughts on Life, Death and Immortality* (1742–5) which was widely read in Germany.

5 Louis Sébastien Mercier (1740–1815) was a historian and playwright, who, together with Diderot, founded the school of bourgeois drama. His *Mon bonnet de nuit* appeared in 1784.

6 Gotthilf Heinrich Schubert (1780–1860) published his *Ansichten von der Nachtseite der Naturwissenschaft* (Views from the Night Side of Natural Science) in Dresden in 1808. See VIB11.

7 Friedrich Gottlieb Klopstock (1724–1803), author of highly emotional and sentimental religious poetry.

8 Louise Adelgunde Viktorine Gottsched (1713–62), wife and co-worker of Johann Christoph Gottsched (1700–66), who sought to apply the rules of rationalism to literature.

15 Heinrich Kleist (1777–1811) 'Emotions before Friedrich's Seascape'

The German poet and dramatist Heinrich Kleist was born into a military environment in Frankfurt-am-Oder. In 1799 he resigned his commission as an army officer in order to study philosophy and mathematics at his home university. His studies led to disillusionment with science's apparent claims to objectivity and he came to trust instead only inner emotional truth. He has been described as the first great dramatist of the nineteenth century. In the years prior to his early death in 1811 he produced a remarkable series of plays and novellas, including *Der zerbrochene Zug* (1808) and *Michael Kohlhaas* (1810). However, in November 1811 he ended his own life by shooting himself on the shores of the Wannsee, near Potsdam. As editor of the *Berliner Abendblätter* he adapted and rewrote Clemens Brentano's 'Various Emotions Before a Seascape by Friedrich' (see VIB14) in a shortened version which, after the first few lines, constitutes his own work. The playful irony of Brentano's writing is replaced by Kleist's characteristically earnest and painful response to the painting. The references to Young's *Night Thoughts* and to Ossian are explained in the footnotes to Brentano's text. Kleist's version was first published in the *Berliner Abendblätter*, volume 12, part 13, 13 October 1810. It has been translated complete for the present volume by Jason Gaiger from Heinrich von Kleist, *Werke und Briefe*, ed. Siegfried Streller, volume 3, Berlin und Weimar: Aufbau Verlag, 1978, pp. 502–3.

It is splendid, in infinite loneliness by the shore of the sea under a cheerless sky, to stare at a limitless expanse of water; in part, this is due to the fact that one has gone there, that one must return, that one would like to cross over, that one cannot do so; that everything belonging to life is missing and that one hears one's own voice in the roar of the tide, in the billowing of the wind, in the passing of the clouds and in the lonely cry of the birds; in part it is due to a demand which is made by the heart and by the withdrawal of nature, if I may so express it. This is impossible before this painting, however, and what I should have found in the painting I could find only between myself and the painting, that is to say, a demand the painting makes on me but does not fulfil; and so I became the monk and the painting became the dune, but that on which I gazed with yearning, the sea, was not there at all. Nothing can be more melancholy and unpleasant than this position in the world: to be the only spark

of life in the wide realm of death, the lonely centre of a lonely circle. The painting stands there with its two or three mysterious objects like the apocalypse, as if it possessed Young's *Night Thoughts*, and since in its monotony and boundlessness it has nothing but the frame for a foreground, when one looks at it, it is as if one's eyelids had been cut away. Without a doubt, the artist has opened up a completely new path in this field of art; I am convinced that with his spirit this artist could depict a square mile of sand in the Brandenberg Marches, with a crane preening itself on top of a barberry bush, and that this painting would affect us in the same way as Ossian or Kosegarten. If one were to paint this landscape with its own chalk and its own water, one could make the foxes and wolves howl: and this is the greatest praise which can be bestowed on this sort of landscape painting. – But my own emotions before this painting are too confused, and before I venture to express them fully I have decided to let myself be instructed by the comments of those who pass before this painting in pairs from morning to evening.

16 Heinrich Kleist (1777–1811) 'Letter from a Young Poet to a Young Painter'

Heinrich Kleist's short 'Letter from a Young Poet to a Young Painter' appeared in the same journal as his 'Emotions before Friedrich's Seascape', the *Berliner Abendblätter*, of which Kleist himself was the editor. Employing the conceit of a letter from one novice to another, Kleist challenges the dependence of painting upon rules and examples drawn from the work of previous artists. His insistence upon the artist's freedom to pursue his own ideas in an open and exploratory fashion echoes Caspar David Friedrich's comment in his reply to Ramdohr that he had sought to go upon his own two feet rather than use the 'crutches' of past art (see VIB12 and 13). Indeed, it is likely that the debate surrounding Friedrich's *Cross in the Mountains* provided the starting-point for Kleist's reflections. The letter, which ends on a characteristic note of cynicism, was first published as 'Brief eines jungen Dichters an einen jungen Maler', *Berliner Abendblätter*, no. 32, part 6, November 1810. The following translation of the complete text has been made for the present volume by Jason Gaiger from Heinrich von Kleist, *Werke und Briefe*, ed. Siegfried Streller, volume 3, Berlin and Weimar: Aufbau Verlag, 1978, pp. 569–71.

To us poets it is incomprehensible how you painters can resolve to spend years copying the works of your great masters when your art possesses such infinite resources. The teachers under whom you are schooled tell you not to present your own ideas on the canvas until the time is right. Placed in your position, we poets would have exposed ourselves to ceaseless beatings rather than accept this cruel ban. The power of imagination would have stirred indomitably within us; as soon as we knew that we had to paint with the head of the brush rather than with its handle, and in defiance of our inhuman teachers, we would secretly have locked our doors at night in order to try out our capacity for invention, the play of the blessed. Where imagination stirs in your youthful spirit, it is pitilessly and irretrievably destroyed by the copying in museums and galleries to which you are condemned. If a painting touches you, and you wish to make its excellence your own, what more is required

than with piety and love to gaze at the painting for hours, days, weeks, months, for half a year if need be. At the very least, it seems to us, two different uses can be made of a painting. First there is the use you make of it, that is, to copy out its individual features in order to learn its handwriting; another use is to seek from the very outset to invent something new in the same spirit. But even this should be put to one side as soon as possible in favour of pursuing art itself, whose essential character resides in free invention in accordance with one's own laws. For heaven's sake! The real task is not to be someone else but to be oneself, to use lines and colours to make visible one's deepest and truest ideas and feelings. How can you hold yourselves in so little esteem that you are prepared to prevent yourselves from appearing in any form whatsoever? The existence of the great masters whom you so admire should not reduce you to nothing, but should awaken in you the right eagerness and equip you with the strength and serene courage to pursue your own proper path. But you believe that you must first make your way through these masters, through Raphael or Correggio, or whoever it is that you have identified as your model. But why do you not turn around, set your back against him and set off in the diametrically opposite direction in order to find and scale the pinnacle of art you have in mind? – You will look at me and say, 'What else is new that this young man has to tell us?' and you will laugh and shrug your shoulders. Let God decide what happens next! It is 300 years since Copernicus said that the world was round and I do not see what good it can do for me to repeat it here once again. Farewell!

17 E. T. A. Hoffmann (1776–1822) 'Beethoven's Instrumental Music'

Hoffmann was born in Königsberg in Prussia, where he went on to study law at the university. From his early twenties he worked in the Prussian legal and governmental apparatus, while also writing, painting and composing. When the Prussian bureaucracy was dissolved following defeat by Napoleon in 1806, Hoffmann was freed to pursue a career in his first interest, music. He went on to become a leading figure in the German Romantic movement as composer, conductor and theatre director. Towards the end of the French revolutionary wars, he was able to resume his career in the law, combining it from then on with his writing. He remains best known today for his macabre fiction, which employs sinister and uncanny elements to explore themes of madness and conflicts of personal identity, and for Offenbach's later operatic setting of *Tales of Hoffmann*. Hoffmann was also a pioneer of musical criticism, keen to emphasize the specificity of the expressive language of music. In the visual arts, as imitation and narrative were subjected to question by the nineteenth-century avant-garde, modernist critics increasingly looked to music for their models of an independent art. To that extent, Hoffmann's Romantic appreciation of Beethoven's instrumental music prefigures the tenor of much subsequent writing on the visual arts. The essay was first published anonymously in the *Zeitung für die elegante Welt* in Leipzig in December 1813. It was based on an earlier review of Beethoven's Fifth Symphony, also published anonymously in July 1810 in the *Allgemeine musikalische Zeitung* (Leipzig). The opening sections, reprinted here, represent Hoffmann's most enduring contribution to criticism, frequently quoted and republished. Our extract is taken

from the translation in *Source Readings in Music History*, selected and annotated by Oliver Strunk, New York: W. W. Norton, 1950, pp. 775–7.

When we speak of music as an independent art, should we not always restrict our meaning to instrumental music, which, scorning every aid, every admixture of another art (the art of poetry), gives pure expression to music's specific nature, recognizable in this form alone? It is the most romantic of all the arts – one might almost say, the only genuinely romantic one – for its sole subject is the infinite. The lyre of Orpheus opened the portals of Orcus – music discloses to man an unknown realm, a world that has nothing in common with the external sensual world that surrounds him, a world in which he leaves behind him all definite feelings to surrender himself to an inexpressible longing.

Have you even so much as suspected this specific nature, you miserable composers of instrumental music, you who have laboriously strained yourselves to represent definite emotions, even definite events? How can it ever have occurred to you to treat after the fashion of the plastic arts the art diametrically opposed to plastic? Your sunrises, your tempests, your *Batailles des trois Empereurs*,[1] and the rest, these, after all, were surely quite laughable aberrations, and they have been punished as they well deserved by being wholly forgotten.

In song, where poetry, by means of words, suggests definite emotions, the magic power of music acts as does the wondrous elixir of the wise, a few drops of which make any drink more palatable and more lordly. Every passion – love, hatred, anger, despair, and so forth, just as the opera gives them to us – is clothed by music with the purple luster of romanticism, and even what we have undergone in life guides us out of life into the realm of the infinite.

As strong as this is music's magic, and, growing stronger and stronger, it had to break each chain that bound it to another art.

That gifted composers have raised instrumental music to its present high estate is due, we may be sure, less to the more readily handled means of expression (the greater perfection of the instruments, the greater virtuosity of the players) than to the more profound, more intimate recognition of music's specific nature.

Mozart and Haydn, the creators of our present instrumental music, were the first to show us the art in its full glory; the man who then looked on it with all his love and penetrated its innermost being is – Beethoven! The instrumental compositions of these three masters breathe a similar romantic spirit – this is due to their similar intimate understanding of the specific nature of the art; in the character of their compositions there is none the less a marked difference.

In Haydn's writing there prevails the expression of a serene and child-like personality. His symphonies lead us into vast green woodlands, into a merry, gaily colored throng of happy mortals. Youths and maidens float past in a circling dance; laughing children, peering out from behind the trees, from behind the rose bushes, pelt one another playfully with flowers. A life of love, of bliss like that before the Fall, of eternal youth; no sorrow, no suffering, only a sweet melancholy yearning for the beloved object that floats along, far away, in the glow of the sunset and comes no nearer and does not disappear – nor does night fall while it is there, for it is itself the sunset in which hill and valley are aglow.

Mozart leads us into the heart of the spirit realm. Fear takes us in its grasp, but without torturing us, so that it is more an intimation of the infinite. Love and melancholy call to us with lovely spirit voices; night comes on with a bright purple luster, and with inexpressible longing we follow those figures which, waving us familiarly into their train, soar through the clouds in eternal dances of the spheres.

Thus Beethoven's instrumental music opens up to us also the realm of the monstrous and the immeasurable. Burning flashes of light shoot through the deep night of this realm, and we become aware of giant shadows that surge back and forth, driving us into narrower and narrower confines until they destroy *us* – but not the pain of that endless longing in which each joy that has climbed aloft in jubilant song sinks back and is swallowed up, and it is only in this pain, which consumes love, hope, and happiness but does not destroy them, which seeks to burst our breasts with a many-voiced consonance of all the passions, that we live on, enchanted beholders of the supernatural!

Romantic taste is rare, romantic talent still rarer, and this is doubtless why there are so few to strike that lyre whose sound discloses the wondrous realm of the romantic.

Haydn grasps romantically what is human in human life; he is more commensurable, more comprehensible for the majority.

Mozart calls rather for the superhuman, the wondrous element that abides in inner being.

Beethoven's music sets in motion the lever of fear, of awe, of horror, of suffering, and wakens just that infinite longing which is the essence of romanticism.

[1] A reference to *La Grande Bataille d'Austerlitz* (1806), a symphony by Louis Jadin.

18 Caspar David Friedrich (1774–1840) Letter to Arndt, March 1814

Throughout the Wars of Liberation from Napoleonic troops, Friedrich supported the cause of German patriotism. He produced numerous drawings and paintings on patriotic themes, including *The Grave of Arminius* (Kunsthalle, Bremen) and *The Chasseur in the Forest* (Private Collection, Bielefeld). He also contributed works to the exhibition of patriotic art organized in Dresden in 1814 by Fürst Repnin to celebrate the freeing of the city. From the following letter to Ernst Moritz Arndt, a childhood friend from Greifswald, we learn that Friedrich had asked his compatriot to write an inscription for a memorial to the German military commander, Gerhard Johann David Scharnhorst (1755–1813). Friedrich had met Arndt once again when the latter visited Dresden in April 1813 and both were greatly moved by Scharnhorst's death that same year. Arndt had paid to tribute to the soldier in a poem, whilst Friedrich sketched a memorial to him and planned a painting on the same theme. On the back of the letter Arndt had written 'To the calm, pious and bold Scharnhorst, who inspired and prepared the way for German honour and freedom.' It is known that the letter passed through the hands of the censors, for certain passages have been underlined. William Vaughan has suggested that Friedrich's sympathies extended to a form of pan-German patriotism, whose goals included not merely the expulsion of the

French but the creation of a liberal German state (Vaughan, 1980). This claim is supported by Friedrich's insistence that no great patriotic monuments could be erected 'as long as we remain servants of princes (*Fürstenknechte*)'. The letter was first published in Ernst Moritz Arndt's *Notgedrungener Bericht aus seinem Leben*, volume 2, Leipzig, 1847. It has been translated complete for the present volume by Jason Gaiger from Sigrid Hinz (ed.), *Caspar David Friedrich in Briefen und Bekenntnissen*, Berlin: Henschelverlag, 1968, p. 25.

Dresden, 12 March 1814

Highly esteemed compatriot!

I have received your kind letter and the accompanying drawings. I am not at all surprised that no memorials are to be erected, either to the great achievements of the people or to the courageous deeds of specific German individuals.

As long as we remain the servants of princes no such great things will take place. Where the people do not have a voice, they will not be able to recognize and honour themselves.

At the moment I am working on a painting which depicts the market-place of an imaginary town in which a memorial has been erected. I wanted to dedicate this memorial to the noble Scharnhorst and to ask you to compose an inscription for it. The inscription cannot be more than twenty words, however, for I lack space for anything longer. I trust in your kindness to fulfil my request.

Your compatriot Friedrich

Part VII
Observation and Tradition

Part VII
Observation and Tradition

VII
Introduction

At the close of the year 1799 Napoleon Bonaparte was installed as First Consul in France. Over the next few years, political opposition was silenced and censorship reimposed. Political clubs were banned, and old Jacobins and sans-culottes were deported on trumped-up charges. At the time of Napoleon's coup, Paris had seventy newspapers. After a decade or so, four survived, which was just the same number as there had been before 1789. The fear that revolution might spread among the other European countries turned into the very real threat of an organized and expansionist military power. Russia having withdrawn from the alliance against France, Austria was defeated at Marengo and forced to sign the Treaty of Lunéville in 1801. Standing alone in opposition, Britain agreed to an uneasy peace at Amiens the following year, though the prospect of a continental Europe united under French domination was not one that British interests would accept as a status quo. In his turn Napoleon continued with plans for an invasion of England until 1805, when the scheme was finally ruled out by the defeat of his naval forces at the battle of Trafalgar. A year later, however, the French effectively defeated a renewed European alliance involving Britain, Austria, Russia, Sweden, Naples and some of the German states, in the process achieving the final overthrow of the Holy Roman Empire. Napoleon's imperial ambition was confirmed in 1806, when he proclaimed himself Emperor. The ever-loyal Jacques-Louis David recorded the event in a colossal painting, capturing for eternity the moment when Napoleon, who bowed to no one, took the crown from the attendant Pope, and placed it on his own head. Now at its height, the French Empire extended from the Dalmatian coast to the Pyrenees and from the Elbe in the north to the toe of Italy in the south. By 1808 Napoleon's brothers were installed as kings in Westphalia, Holland and Madrid, and his brother-in-law in Naples, while he assumed the crown of Italy himself.

At that point Spanish resistance opened a further front of European opposition, leading to the invasion of British forces in Portugal and the ensuing Peninsular War. While this war was still proceeding, Napoleon moved against Russia and was drawn gradually further into a disastrous invasion. Following the retreat from Moscow in 1812, he was unable fully to recover his forces or his military initiative. Heavy defeats followed against the combined armies of Austria and Prussia on his eastern front and against the British in the Peninsula. Following the surrender of Paris in March 1814,

Napoleon was finally deposed by the French senate, to be replaced by Louis XVIII, the eldest surviving brother of the king the revolutionary regime had sent to the guillotine twenty-two years earlier. France was confined within the limits of its 1792 boundaries, while the former Emperor was exiled to Elba.

However, the great majority of the French population remained hostile both to the restored Bourbon monarchy and to the return of royalist émigrés. (Elisabeth Vigée-Lebrun, originally listed as a proscribed émigré, had been allowed to return earlier, following the success of an artists' petition in 1800.) When Napoleon escaped from exile and landed in the south of France, he was able to attract a considerable army of followers, and in the spring of 1815 he re-entered Paris in triumph. The triumph was short-lived. In June the hastily remobilized allies finally imposed a decisive defeat at the battle of Waterloo. The former Emperor was exiled to the more distant and more secure island of St Helena. France was contained again, this time within her boundaries of 1790, and a second reinstatement of Louis XVIII inititated a short period of 'White Terror'. Within fifteen years, the Bourbons were to be ejected for the last time, but by then Napoleon was dead. His fall had in the end been as absolute as his reign. For all that, no restoration could overturn the changes he left in the administrative structure of France, in the class composition of its population, and in the relationship between the two. His legacy persists in the bureaucratic character of modern Europe.

Napoleon also left a disturbing legacy in the European imagination. In justification of his authority, he had luxuriated in an imagery of republican virtue that the revolutionaries had originally taken from the legacy of ancient Rome. His adopted title of First Consul was a clear reference to that legacy. It is to this basically political tension between republican enthusiasm and nostalgic idealism that we should perhaps look in accounting for the uneasy combination of disciplined vitality with sensuous lassitude that imbues the neo-classical art of the early nineteenth century (see VIIB2, VIIB9). Testament to the fascination Napoleon exerted during his rule survives in the painting of David and of Jean-Dominique Ingres, in the sculpture of Antonio Canova and in the music of Beethoven. In the icons the artists provided for the Emperor, the classical references are certainly carefully established, as they were in much of the rhetoric that accompanied artistic practice at the time (VIIB3). And yet the very depth of its implication in the legacy of revolution and the rise of Napoleon invests early nineteenth-century neo-classicism with a paradoxical and uncomfortable modernity. As one whose power was achieved rather than inherited, the former First Consul had also become the type at once of the modern hero and of the modern despot. Long after his fall, he remained an abiding example to those for whom the meaning of ambition was the pursuit of agency by the individual; the more so, ironically, the more pervasively success for the individual came to be measured in terms of commercial and social self-establishment.

If neo-classicism was implicated in the shifting political values of the period, classical art itself remained a source of abiding interest to European intellectuals, largely irrespective of the course of European wars and revolutions. Increasingly, however, that interest came to be inflected by others, which served to modify the very meaning of the classical. Greek art in particular was re-examined in the light of a growing tendency to naturalism (VIIA), itself fuelled by considerable developments

in scientific knowledge and by the spread of scientific method (VIIA5, 7, 9, 13). In England, one of the most celebrated surviving ensembles of classical sculpture was to become the focus for intense debates about the character of Greek art and its status as example. In 1807, The Earl of Elgin put on display the marble carvings he had appropriated – or saved – from the Parthenon in Athens, with a proposal that they be bought from him by the British Government. In the resulting controversy it was not clear which view offered the better justification for their acquisition: that they represented the supreme realization of that abstract ideal by which all high art should be guided; or that they furnished examples of the most exquisite naturalism, thereby countering the assumption that a tendency to idealization lay at the heart of all true classical art. (See VIIB11 (i–vi).)

It was in the developing genre of landscape painting that the importance of naturalistic observation was most vividly demonstrated. Behind Pierre-Henri de Valenciennes' 'Advice to a Student...' (VIIA3) lay a quantity of small informal sketches, painted at the end of the eighteenth century and devoted to the capture of specific atmospheric effects (see VIIA3). In England, John Constable gave increasing priority to the preservation of detail and character from particular rural motifs (see VIIA4). We do not mean to suggest that these or any other significant artists at the time believed that a satisfactory painting could be made without reference to the example of previous art. (Valenciennes' true ambitions lay in the field of 'historical' rather than naturalistic landscape, while Constable's interest in earlier painters is clearly revealed both in his work and in his correspondence.) Nor had the painters of the eighteenth century generally composed their works without making careful studies from life. What was new in the advanced landscape painting of the early nineteenth century was the idea that the phenomenal experience of the natural world should be taken as a measure, and that it was against this measure that the achieved effects of the painted composition should in the end be judged. At the same time, the study of phenomenal effects through the practice and connoisseurship of landscape painting in watercolours was encouraged, in England particularly, by the possibility of high-quality colour illustration (VIIA11), while interest in the scenic and the topographical was in general fuelled by rapid developments in the technology of reproductive printing (VIIB12).

Two further factors were at work to complicate and to enlarge the understanding of tradition as it bore upon the practice of art in Europe. In Germany, Romantic nationalism had led to celebration of the indigenous art of the Middle Ages, in a tendency exacerbated by the effects of French imperial expansion. In France itself, the Musée des Monuments had grown out of Lenoir's efforts to salvage medieval and other monuments displaced by the Revolution. In the early years of the century, an idealized understanding of the Middle Ages – of the supposed unity of its social orders and of the supposed simplicity and purity of its faith – served as an imaginary counter to the disastrous conflicts and secular loyalties of the present. In the work of the German Nazarenes, reaction against academic classicism issued in the combination of a self-consciously 'medieval' or neo-Renaissance style with an aestheticized Christian iconography (see VIIB5, 6, 7). In the French writings of the royalist Comte de Chateaubriand we find the 'beauties' of Christianity similarly associated with an idealized Middle Ages in reaction against the secular classicism of the revolutionary

period (VIIB4). Despite the appeals to community that we find alike in the programmes of the Nazarenes and in the work of Chateaubriand, implicit in their responses is a rejection of the egalitarian aspects of that nascent socialism which Enlightenment and Revolution had in their different ways encouraged.

The second factor leading to a revised European understanding of artistic traditions was the rapid expansion that took place in the late eighteenth and early nineteenth centuries in the range of artefacts that came up for consideration as artistic. This expansion was primarily geographical, as information spread about increasingly remote civilizations and as the fruits of anthropological study were published in illustrated form. But it was also chronological, as knowledge of pre-classical civilizations was disseminated through archaeological appropriation and publication. Two examples will testify to the processes in question and to their consequences. The first is Benjamin West's 'Discourse to the Students of the Royal Academy', delivered following his election to the Presidency in 1792 (VIIB1). In his better-known Discourses, West's predecessor Sir Joshua Reynolds had had in view a single continuous tradition connecting the academic artist of the recent past and the present back through the Italian Renaissance masters to the painters and sculptors of Greece and Rome. For West, however, the field of possible reference includes material from North and South America, from India and from the Middle East. The second example is the massive 'Description of Egypt', published between 1809 and 1820 by artists and 'savants' who had accompanied Napoleon on his Egyptian campaign of 1798–9 (VIIB8). Acquaintance with the extent and antiquity of Egyptian civilization greatly encouraged a broader understanding of the antecedents of the European tradition, while stimulating further interest in the cultures of the ancient Middle East and of Africa.

Expansion in the range of cultures and artefacts admitted into the history of art led not simply to a revision in the understanding of artistic traditions. It also encouraged changes in the methods by which individual works of art were classified and interpreted. Inquiries of the kind represented by Georg Friedrich Creuzer (VIIB10) and Richard Payne Knight (VIIB13) were driven by an anthropological curiosity concerning the wide range of human artefacts and the common tendencies they might reveal. So long as the interpretation of art was submissive to a fixed canon of values, curiosity of this order was likely to be inhibited, whether the authority in question was vested in religious doctrine or in academic protocol, or in some combination of the two. By the end of our period, however, the factors principally determining both the production and the interpretation of art were such as neither Churches nor Academies could control.

VIIA
Objects of Study

1 Johann Wolfgang Goethe (1749–1832) Introduction to the *Propyläen*

Together with Herder and Schiller (see VA7, 12 and 13), Goethe was one of the leading exponents of the *Sturm und Drang* (Storm and Stress). This was a primarily literary movement which emphasized individual and national genius at the expense of a reliance on tradition. Goethe's writings of the early 1770s (see VA4 and VB7), in particular his novel *The Sufferings of Young Werther*, were later to be taken up by the Romantics as paradigmatic of the new spirit of freedom from conventional modes of expression. However, his appointment to the court of the Duke of Weimar in 1775, and above all, the effect of his journey to Italy between 1786 and 1788, led him to a new appreciation of the classical heritage. In the late 1790s he collaborated with Schiller to produce two short-lived journals dedicated to raising the level of art in Germany and exploring the Greek ideal. The best known of these was the *Propyläen* (1798–1800), which took its title from the name of the gateway to the Acropolis in Athens. It was also at this time that Goethe organized an annual competition under the auspices of the 'Weimar Friends of Art' to encourage painting of a neo-classical style and subject-matter. The competition attracted hostile comment from the younger, Romantic generation (see VIB5) and was conspicuously unsuccessful in fostering a classical revival. In his introduction to the *Propyläen*, Goethe sets out his ideas for the way forward in art, advocating the close observation of nature, informed and guided by an understanding of the classical ideal. Goethe seems to sense the paradox of wanting something 'both natural and beyond nature'. But in his search for classical harmony, he emphasizes a point which, since Lessing (IIIA10), was becoming increasingly significant in the theory of art. The desired overall harmony of form must be rooted in an acknowledgement of the constraints of the particular medium. If two and three dimensions are mixed, 'true art is in decline.' Our extracts are taken from *Goethe on Art*, selected, edited and translated by John Gage, London: Scolar Press, 1980, pp. 3–4, 6–7, 10–11. (For an example of Goethe's later thinking on art, as distilled into his 'Maxims and Reflections', see *Art in Theory 1815–1900*, IA12).

The youth who begins to feel the attraction of nature and art believes that a serious effort alone will enable him to penetrate to their inner sanctuary; but the man discovers that even after lengthy wanderings up and down, he is still in the forecourt.

This is what has given rise to our title; the step, the door, the entrance, the antechamber, the space between the inner and the outer, the sacred and the profane, this is the place we choose as the meeting-ground for exchanges with our friends.

It will not be inappropriate if by this word *Propyläeum* the reader is reminded of that edifice that led to the citadel of Athens and the Temple of Minerva; but let no one suggest that we are presuming to attempt such artifice and splendour here. The name of the place will suggest what might have been done there, and discussions and conversations not unworthy of it will be expected.

Will not thinkers, scholars, artists be drawn to such a place to spend their best hours, and to dwell, at least in imagination, among a people endowed by nature with that perfection we desire but never attain, who achieved the continuous development of a culture that is only piecemeal and fleeting with us?

What modern nation does not owe its artistic culture to the Greeks; and, in some respects, who more so than the Germans?

So much in extenuation of our symbolic title, if that be necessary. Let it remind us that we shall depart as little as possible from Classic ground; let its brevity and its rich significance inform those friends of art whom we hope to interest in this work, that it is to present the observations and reflections on nature and art of a like-minded group of friends.

He whose vocation is to be an artist should pay vital and constant attention to everything around him, observe closely all objects and their parts, and by making practical use of what he has experienced, come to observe ever more sharply, first on his own behalf, but later for such information as he will gladly give to others. To this end we shall relate and present our readers with much that we have noted in various circumstances over the years, which we trust will be both useful and agreeable.

But who will not admit that unprejudiced observations are rarer than is generally believed? We are so ready to interject our own fancies, opinions, judgements into what comes to our notice, that we do not long remain quiet observers, but begin to reflect. [. . .]

The highest demand made on an artist is this: that he be true to nature, that he study her, imitate her, and produce something that resembles her phenomena. How great, how vast this demand is, is not always borne in mind, and even the true artist only learns it by experience in the course of his progressive development. Nature is separated from art by an enormous chasm which genius itself cannot bridge without outside assistance.

All that we see around us is but raw material. If it is rare enough for an artist, through instinct and taste, by practice and experiment, to reach the point of achieving the beautiful exterior of things, selecting the best from the good in front of him and producing at least a pleasing appearance, it is rarer still, especially in modern times, for an artist to penetrate into the depths of things as well as into the depths of his own soul, so as to produce in his works not only something light and superficially effective, but, as the rival of nature, something spiritually organic, and to give it a content and a form by which it appears both natural and beyond nature.

Man is the highest and the proper subject of art; to understand him, to extricate oneself from the labyrinth of his anatomy, a general knowledge of organic nature is imperative. The artist should also familiarize himself with inorganic matter, and with

the general operations of nature, especially where, as in the cases of sound and colour, they are adaptable to the purposes of art. But what a circuitous route he would be obliged to follow, if he were to take the trouble to seek out in the schools of the anatomist, the naturalist, or the professor of science what serves his purposes. It is indeed questionable whether he would find what is necessarily most important to him there. Those gentlemen have to satisfy the quite different needs of their own students, without thinking about the specialized and particular needs of the artist. Hence we propose to take a middle course, and although we do not imagine we can be exhaustive we may nevertheless give a survey of the whole field, and at least introduce the detailed studies.

The human figure cannot be understood merely through the observation of its surface: the interior must be laid bare, the parts must be separated, the connexions perceived, the differences noted, action and reaction observed, the hidden, constant, fundamental elements of the phenomena impressed on the mind, if we really wish to contemplate and imitate what moves in living waves before our eyes as a beautiful, unified whole. [. . .]

For the German artist, and for the modern or northern artist in general, the transition from formlessness to form, and the maintenance of form once attained, is difficult, nay, almost impossible. Let any artist who has spent some time in Italy ask himself whether contact with the best examples of ancient and modern art has not inspired him with the desire to study and imitate the human figure, its proportions, forms and character, and to spare no pains in this pursuit, to come close to the autonomy of those works and to produce something that both satisfies the senses, and, at the same time, lifts the soul into its highest regions. But he must also confess that, after his return, his efforts relaxed little by little, for he found few who saw truly what he represented, but only such as regard a work superficially for its agreeable suggestion, and who feel and enjoy something after their own fashion.

The worst picture can speak to our perception and imagination, for it sets them in motion, makes them free, and leaves them to themselves. The best also speaks to our perceptions, but in a higher language, one, certainly, which has to be understood, but which chains our feelings and our imagination and robs us of our will-power, for we cannot do what we please with the perfect, we are compelled to surrender to it in order to receive ourselves again, raised and ennobled.

That these are no idle dreams we shall endeavour to prove by our treatment of details, and we shall draw particular attention to one contradiction in which the Moderns so often get entangled. They call the Ancients their teachers, they attribute to their works an unapproachable perfection, and yet they distance themselves in theory and practice from the precepts which the Ancients constantly observed.

Leaving this important point, to which we shall often have occasion to return, we find others of which some notice should be taken.

One of the most striking signs of the decay of art is when we see its separate forms jumbled together. The arts themselves, in all their varieties, are closely related to each other, and have a great tendency to unite, and even lose themselves in each other. But herein lies the duty, the merit and the dignity of the artist: that he knows how to separate his own branch from the others, and to isolate it as far as may be.

It has been noticed that all visual art tends towards painting, all poetry towards the drama; and this may in future be the occasion of important observations.

The true, prescriptive artist strives after artistic truth; the lawless artist, following blind instinct, after an appearance of naturalness. The one leads to the highest peak of art, the other to its lowest depths.

This is no less true of the individual arts than of art in general: the sculptor must think and feel differently from the painter, and must set about a work in relief in a different way from the way he would deal with a free-standing statue. When the low relief is raised little by little, and then parts and figures are cut free from the ground and finally buildings and landscapes admitted, producing a work which is half picture, half puppet-show, true art is in decline, and it is to be deplored that excellent artists have taken this course in modern times.

2 Priscilla Wakefield (1751–1832) from *Reflections on the Present Condition of the Female Sex*

Wakefield was a well-to-do Quaker philanthropist. Her main work was in the field of education, and she wrote many essays of moral instruction for parents and their children. The principal purpose of the present text is to discuss ways in which women can become more useful members of society. The passages we have selected concern women of what she calls the 'first and second ranks' of society who, through some kind of misfortune, are in the position of needing to fend for themselves. Faced by the relative triviality of the pursuits with which gentlewomen were associated, Wakefield lays the blame not on innate incapacity but on women's inadequate education and understanding of their own potential. Accordingly she surveys occupations which appear suitable for women of a certain social standing, through the practice of which they might expect to maintain their independence and livelihood. Among these are the arts. Wakefield first discusses the fine arts, from history painting to portraiture, maintaining that women have the capacity to succeed in them. At the same time, she acknowledges the actual social obstacles which stand in the way of women making a career in the arts: that art tends to be treated merely as a form of amusement for fashionable young ladies; that theoretical ('scientific') treatments of the subject tend to be unavailable to women; that they are denied access to an intellectual community in which art is taken seriously; and that they have little opportunity to engage with the fount of artistic achievement, namely 'the precious models of antiquity'. She further acknowledges, beyond enumerating these practical obstacles, that the 'genius' necessary for a successful career in art is likely to be no more evenly distributed among women than it is among men. Accordingly she also considers the possibility of women developing careers in the applied arts and design. She suggests the colouring of prints, designing frontispieces for books, needlework, miniatures, book illustration and engraving. Even sculpture is not precluded, despite its more physical demands. Apart from the obvious question of gender imbalance in eighteenth-century society, and its consequences for the arts as for any other walk of life, the interest of the text for the present anthology lies also as much in what it does not say as in what it does. Wakefield eschews all high-flown estimates of the arts, of their stimulus to spiritual improvement or their civilizing potential. From her point of view, the key issue is that 'the fine arts offer a mode of subsistence' and that, since they require 'the exercise of intellectual rather than bodily powers', they represent an option for women seeking – or needing – economic

independence from men. Our extracts are taken from chapters I and VI of *Reflections on the Present Condition of the Female Sex; with Suggestions for its Improvement,* London: J. Johnson, 1798, pp. 1–3, 6–7, 124–34.

It is asserted by Doctor Adam Smith, that every individual is a burthen upon the society to which he belongs, who does not contribute his share of productive labour for the good of the whole. The Doctor, when he lays down this principle, speaks in general terms of man, as a being capable of forming a social compact for mutual defence, and the advantage of the community at large. He does not absolutely specify, that both sexes, in order to render themselves beneficial members of society, are equally required to comply with these terms; but since the female sex is included in the idea of the species, and as women possess the same qualities as men, though perhaps in a different degree, their sex cannot free them from the claim of the public for their proportion of usefulness. That the major part of the sex, especially of those among the higher orders, neglect to fulfil this important obligation, is a fact that must be admitted, and points out the propriety of an enquiry into the causes of their deficiency.

The indolent indulgence and trifling pursuits in which those who are distinguished by the appellation of gentlewomen, often pass their lives, may be attributed, with greater probability, to a contracted education, custom, false pride, and idolizing adulation, than to any defect in their intellectual capacities. [. . .]

In civilized nations it has ever been the misfortune of the sex to be too highly elevated, or too deeply depressed; now raised above the condition of mortals, upon the score of their personal attractions; and now debased below that of reasonable creatures, with respect to their intellectual endowments. The result of this improper treatment has been a neglect of the mental powers, which women really possess, but know not how to exercise; and they have been contented to barter the dignity of reason, for the imaginary privilege of an empire, of the existence of which they can entertain no reasonable hope beyond the duration of youth and beauty.

Of the few who have raised themselves to pre-eminence by daring to stray beyond the accustomed path, the envy of their own sex, and the jealousy or contempt of the other, have too often been the attendants; a fate which doubtless has deterred others from attempting to follow them, or emulate, even in an inferior degree, the distinction they have attained.

* * *

It is far from my present design, to point out all the various pursuits which may consistently engage the talents, or employ the industry of women, whose refinement of manners unfit them for any occupation of a sordid menial kind; such an undertaking would require an extensive acquaintance with the distinct branches of the fine arts, which adorn, and of the numerous manufactures which enrich, this country. But a few remarks upon the nature of those employments, which are best adapted to the higher classes of the sex, when reduced to necessitous circumstances, may, perhaps, afford useful hints to those, who are languishing under the pressure of misfortune, and induce abler pens to treat a subject hitherto greatly neglected.

Numerous difficulties arise in the choice of occupations for the purpose. They must be such as are neither laborious nor servile, and they must of course be productive, without requiring a capital.

For these reasons, pursuits which require the exercise of intellectual, rather than bodily powers, are generally the most eligible.

Literature affords a respectable and pleasing employment, for those who possess talents, and an adequate degree of mental cultivation. For although the emolument is precarious, and seldom equal to a maintenance, yet if the attempt be tolerably successful, it may yield a comfortable assistance in narrow circumstances, and beguile many hours, which might otherwise be passed in solitude or unavailing regret. The fine arts offer a mode of subsistence, congenial to the delicacy of the most refined minds, and they are peculiarly adapted by their elegance, to the gratification of taste. The perfection of every species of painting is attainable by women, from the representation of historic facts, to the minute execution of the miniature portrait, if they will bestow sufficient time and application for the acquisition of the principles of the art, in the study of those models, which have been the means of transmitting the names and character of so many men, to the admiration of posterity. The successful exercise of this imitative art requires invention, taste and judgment: in the two first, the sex are allowed to excel, and the last may be obtained by a perseverance in examining, comparing, and reflecting upon the works of those masters, who have copied nature in her most graceful forms.

Compared with the numbers of the other sex, it does not appear that many females, either in ancient or modern times, have rendered themselves celebrated in this line of excellence; but the cause of this disproportion may surely, with greater probability, be attributed to its having been attempted by so few women, than to incapacity; among the very small number of female artists, who have practised painting as a profession, there have not been wanting some instances of rare merit. But it is to the genial influence of education only, that society must stand indebted for the frequent recurrence of such examples: rare, indeed, is that genius which overcomes all obstacles; too often do the powers of the mind, like the undiscovered diamond in the mine, lie dormant, if they be not called forth by a propitious combination of circumstances. As it is not customary for girls to study the art of painting, with a view to adopt it as a profession, it is impossible to ascertain the extent of their capacity for the pencil; but certainly there appears no natural deficiency, either mental or corporeal, to prevent them from becoming proficients in that art, were the bent of their education favourable to the attempt. It must be allowed, that within the last twenty years, it has been a general fashion for young ladies to learn to draw, and that it is not unusual to see performances executed in such a manner as to excite a reasonable expectation that their powers, if properly cultivated, would produce testimonials of no inferior ability. But as the view of the generality is only elegant amusement, they do not endeavour to attain any degree of excellence, beyond that of copying prints or drawings; original design is too arduous, and it is conceived that the qualifications it requires, would engross too large a portion of time. They neither read those books which treat of the subject in a scientific manner; they do not associate with those persons, whose conversation is adapted to form their taste, nor have they an opportunity of imbibing the enthusiasm, which is produced by the

contemplation of the precious models of antiquity. No surprise can therefore be excited, that those fruits are not visible, which are the effects of such necessary preparation.

But as neither exalted genius, nor the means of cultivating that portion of it which nature has bestowed, to the utmost extent, are likely to be very generally possessed; it is fortunate for those who are less liberally endowed, that there are many profitable, though inferior branches of design, or of arts connected with it. The drapery and landscape both of portraits and historical pieces, are often entrusted to the pupils of the master, and constitute a branch of the art, for which women might be allowed to be candidates. The elegant as well as the humorous designs which embellish the windows of print-sellers, &c. also sketches for the frontispieces of books, and other ornaments of the same kind, must employ many artists, nor does it appear that any good reason for confining them to one sex has been assigned.

Colouring of prints is a lucrative employment; there was a few years ago in London, a French woman, who had a peculiar method of applying water colours to prints, by which she might have gained a very liberal income, had her industry and morals been equal to her ingenuity. Designs for needle-work, and ornamental works of all kinds, are now mostly performed by men, and those who have a good taste, obtain a great deal of money by them; but surely this employment is one, among many, which has been improperly assumed by the other sex, and should be appropriated to women. The delicate touches of miniature painting, and painting in enamel, with devices for rings and lockets in hair-work, are more characteristic of female talents than of masculine powers. The delineation of animals or plants for books of natural history, and colouring of maps or globes may be followed with some advantage. Patterns for calico-printers and paper-stainers are lower departments of the same art, which might surely be allowed as sources of subsistence to one sex with equal propriety as to the other.

Engraving, though it differ from painting in the execution, may be said to have the same origin, both being regulated by similar principles, as far as relates to design and shadow; therefore, if the faculties of women are capable of directing the pencil, there can be no apprehension that they are not also equal to guide the graver with the same success.

Statuary and modelling are arts with which I am too little acquainted to hazard any opinion concerning, but the productions of the honourable Mrs. Damer, and a few others, authorize an assurance, that women have only to apply their talents to them in order to excel. If the resistance of marble and hard substances be too powerful for them to subdue, wax and the other materials of a softer nature, will easily yield to their impressions. The necessity of vigour and perseverance in cultivating natural talents, is equally great in attaining perfection of any kind.

3 Pierre-Henri de Valenciennes (1750–1819) from 'Advice to a Student on Painting, and particularly on landscape'

Valenciennes was born in Toulouse, and spent his early years combining training in history painting with small-scale studies of the French landscape. He was in Italy in 1769 and for

a longer period between 1777 and 1785. Responding to instruction from Joseph Vernet, in the latter part of this period he made a number of open-air studies in oil on paper, the most remarkable of which show wide and atmospheric skies above low horizons. He was received as an Academician in 1787, and from then until his death regularly submitted large-scale landscapes with idealized classical motifs painted in an attenuated neo-classical style. His more informal and more interesting work was not well known until a large number of his oil sketches were donated to the Louvre in 1930. His importance for subsequent developments thus rests largely on his major theoretical work, *Elémens de perspective pratique, à l'usage des artistes* (Elements of Practical Perspective, for the Use of Artists), to which was appended *Réflexions et Conseils à un élève, sur la peinture, et particulièrement sur le genre du paysage*, Paris: Desenne and Duprat, 1800. This was the first treatise to be written on painting which assumed that landscape painting was a genre deserving of exposition and instruction, that it required appropriate forms of study and practice, and that it was not to be dismissed either as a mere support to history painting or as a refuge for those unable to rise to the challenge of the higher genre. It was to remain a basic resource for French painters for the best part of a hundred years. In 1812 Valenciennes was appointed Professor of Perspective at the Ecole Impériale des Beaux-Arts (the Napoleonic replacement for the Académie Royale). It was a consequence of his efforts to raise the status of the genre that a special Rome Prize in 'historical landscape' was instituted in 1816. The prize came too late, however, to breathe new life into the kind of large-scale classical composition it was designed to stimulate. The positive effects of Valenciennes' teaching were instead to be felt in the longer term in works by Corot and the Impressionists that shared some of the spontaneity and informality of his own sketches – works that he himself would have classed as mere preparatory exercises. Our excerpts are taken from the *Réflexions et Conseils*, in the original 1800 edition of the *Elémens de perspective pratique*, pp. 380–8, 404–9, 417–27, translated for the present volume by Christopher Miller.

There are two ways of envisaging nature; each offers a myriad nuances that form and determine the artist's talent.

The first directs us to see nature just as it is, and to represent it as faithfully as possible. In this manner, objects insufficiently interesting are excluded; those that show some affinity are set side by side, however far apart they were found; harmonies and contrasts are sought; in short, the artist selects a particular view because it seems more agreeable and more picturesque.

The second directs us to see nature as it might be: such as the embellished imagination represents it to the man of genius who has seen much. His choice of what nature offers is the fruit of careful comparison, analysis and reflection. He knows nature's beauties and its defects; when he reads, his imagination takes fire; he identifies with those celebrated poets who have described and hymned the beauty of nature; in a poetical description, he sees the place itself. In the works of Homer, Xenophon, Diodorus [Siculus], Pausanias and Plutarch, he has an eye for both custom and costume. Such a man lives now with Anacreon and Sappho, now with Venus, Cupid and the Graces; now he descends into Tartarus with Virgil, and sees Sisyphus straining at his rock and Ixion turning his wheel; now he wanders over the arid rocks and deserts peopled by the phantoms of Ossian's imagination, or seeks to lose himself in the delicious valleys of Arcadia or Tempe; he makes himself, in short, the companion of men from every country and century by reading and learning their history.

There can be no doubt that this way of seeing and studying nature is far more difficult than the first. One must be born with genius, travel a great deal and reflect on one's travels still more. One must nurture oneself on the ancients and moderns; familiarize oneself with the productions of the great painters; one must, in short, have endowed oneself with creative faculties, if one is to beget masterpieces that command the attention of the philosopher and the man of learning. Only then can one successively produce in one's works all those sensations by which one has been affected oneself, inspiring in the soul of the spectator various emotions – melancholy or fright, calmness or trembling, sadness or rejoicing – but never less than admiration and enthusiasm. When the artist is thus prepared, the nature that he portrays is no cold, inanimate, insignificant entity; he paints it so that it speaks to the soul. In his hands, it has an impact on the feelings; the sentiments it expresses are specific, and easily communicate themselves to the man of sensibility.

How great a difference there is between a painting showing a cow and sheep at pasture, and that of the funeral of Phocion; between a landscape portraying the banks of the Meuse, and one showing the shepherds of Arcady; between rainy weather in Ruysdael and the Flood in Poussin! The former are painted with a feeling for colour, the latter with the colour of feeling.

In that first way of envisaging nature, models are never lacking; whatever the country, there they stand, before one's eyes; and several artists ancient and modern have amply demonstrated that, by choosing the least little object and copying it, even with abject fidelity, one can, with a sense of touch and a feeling for colour, make 'a pretty picture'.

But what models did Poussin copy when he sought to represent the earthly paradise? What models did he study to paint the landscape of his Polyphemus? His sublime genius has shown us by turns Egypt, Greece, Syria, and Chaldaea; the sublime Rome of Coriolanus, and Rome abased beneath the Popes. He has successively interpreted Moses, Joseph[us Flavius], Homer, Plutarch and others, to such perfection that when we see his immortal works we are convinced that he lived with these great men: that he drew their dwellings, copied their costumes, and depicted their domestic scenes just as nature presented them, in order to hand them down to posterity.

* * *

Every artist is convinced that there is in nature an ideal beauty; the Greeks clearly perceived, and contrived to represent it, in the figures of their gods and heroes: the Apollo, the Venus, the head of Medusa, the Olympian Jupiter, and the Farnese Hercules are irrefutable proof of this. The men of genius who, so to speak, created these figures, had exalted their imaginations to such a pitch that they believed themselves to be of the gods' society, and therefore capable of transmitting their portraits to mortals – in whom these figures inspired so profound an effect, that, astonished by this wonder, they at length adored those images of divinity that the perfection of art presented for their homage.

We shall not speak here of ideal beauty in general; Winckelmann and other well-known authors have defined it and analysed its every part; we shall simply attempt to prove that there is also an ideal beauty in historical landscape painting, and that the works of the great masters who perceived this have nothing to fear but the ravages of

time; for as long as they exist, they will be admired by every man of certain taste and sensitivity.

Happy indeed is the artist who, surrendering to the charms of illusion, thinks that he sees nature such as nature should be! His joy is unbounded; he has the satisfaction, he feels the pride and nobility of creating, as it were, a perfection of nature too rare ever to be encountered. Of necessity, what he creates is new, because his imagination, inflamed and nourished by the descriptions of the poets, assumes infinite variety and multiplicity. Having set before us the furious north wind, tumultuously bursting from the deep caverns where Aeolus had imprisoned it, he likes to regain his calm by showing Narcissus at the margin of a fountain, whose calm and limpid waters give back in every detail the visage of this unhappy lover: those languorous, blighted features, which prefigure the relentless fate by which his soul must be laid to rest. He moves from the darkness of Tartarus to the serenity of the Elysian Fields; from the smoking mouth of Etna to the plain of Amphitrite; he brings forth Venus from the breast of the foaming deep, whose silvery waves advance to bestow on the goddess of beauty an amorous caress.

When the man of genius wishes to repose and refresh his imagination, he opens his eyes to nature again. He contemplates and observes it; he seeks all around him the models that may help him paint what his enthusiasm has revealed to him. Alas! He finds little or nothing; he sees nature as it is; he admires but is not satisfied. Rocks seem to him pitiful, the mountains abased, and the precipice without depth. His genius at first contracts, as it is assailed on every side by the myriad details presenting themselves to his eye. But soon, he severs the links by which they are bound; then, freeing himself of the scrupulous verities by which he was enchained, he magnifies the rocks and carries the mountain peaks to the clouds; hurling his imagination into the chasms, he invests them with the depth of the abyss. Now these oaks are vast and majestic; they are the forest of the Druids. The smallest objects acquire nobility and fire; everything takes life beneath his sorcerer's brush. The very reeds that quiver in the wind have ceased to be those simplest productions of marshy soil, and become the unhappy monument of Pan's lover, bathed by the limpid waters of the river Ladon, and already yielding the plaintive harmonies of the flute.

The obstacles in the way of one seeking to make his name in the genre of historical landscape are many, it is true, but they are not insurmountable, as Poussin has shown. Though none has since equalled that great man, one should not believe the task impossible; the torch of genius has not been extinguished. We have great models; with the courage to imitate them, and a noble conviction of our power to succeed, we may come close to their talent. Boldness and tenacity attain the most difficult goals. Virgil first said it: *Labor omnia vincit improbus*. It is in this conviction that we set out to give advice to the young artist, and to show him the route that he must follow, and the studies to which he must devote himself if he is to acquire a talent that may one day make him commendable in the eyes of men of sensitivity and learning. To merit the approval and esteem of such men is eminently pleasing; for it must be admitted that, of all the praise and criticism one receives, either positive or negative, there is little enough by which the artist's vanity should be swayed. True connoisseurs are so rare, compliments so common, and criticism so facile that it is proper to be on one's

guard, and of all that one hears, believe only what bears the hallmark of justice and carries conviction.

We shall attempt to instruct a pupil in whom we suppose a good general aptitude for painting, and an innate sentiment of good taste in this art. We shall outline the knowledge that is prerequisite; we shall direct him in our studio, so that his eye is practised and his hand assured; we shall then take him into the countryside, to study nature; finally, we shall take him travelling in distant countries, in order to break his routine and vary his talent. Hiding nothing of what we know, we shall teach him to learn even what we ourselves do not know. If he is able to make good use of our lessons, which are the fruit of study and experience; if he feels the strength and the compulsion to raise himself above the common herd of painters; if he has the courage to undertake what others do not, he will surely be no ordinary man; he will merit the name of artist, and his productions will speak to the heart and mind alike.

We should not conceal from him the difficulties that he will have to surmount and the disappointments he will have to endure; he must reconcile himself to toil, fatigue and reverses. But when he thinks where his studies will lead: of the talent that he can acquire, of the joy of being considered a great artist, of the hope that his country will one day be proud to count him among the illustrious men that it has produced, his soul will be magnified, and his courage will rise above the obstacles. He will hasten to undertake studies that give constant pleasure, and will seek, by perseverance, to bring forward the hour when he reaps the fruits of his labour.

The counsels that we give are those that we received from our masters, and those that experience has suggested; those that we have followed, and even those that we could not turn to account. We shall add certain observations concerning nature and the places through which we have passed. We shall have attained our goal, and consider ourselves happy indeed, if this modest essay on an art that is our sole delight should prove of service to a single pupil, and help to mould a single artist in the genre of landscape.

* * *

For some months, our pupil has been drawing under our supervision; he has copied several paintings by the greatest masters; but he has not seen nature. He needs to consult it, and in the summer we go together to the countryside. There we communicate our observations on the proper way to make studies that will subsequently be of service in composing paintings. These observations are important for *all* painters, in that most of them, out of negligence, misunderstanding, or lack of thought, commit a grave error; they insist on bringing too high a level of finish to studies that should be nothing more than hasty sketches, intended to catch nature in the act.

A history, portrait, flower or still-life painter copies nature in his studio, where it is constantly illuminated by the same light. Since this light is only secondary, it is more or less even and uniform during the hours when the sun lights the atmosphere; its few variations are all but imperceptible. When the sky is covered with clouds that absolutely interrupt the great original source of light, daylight is more or less the same from morn till night, as it is in the studio; under those circumstances, one has the time carefully to complete and finish all the details of the object one is studying.

But when this object is lit by the sun, and sunlight and shadows are changing continuously because of the movement of the earth, one cannot take one's time copying nature; the chosen light-effect varies so quickly that it is no longer recognizable in the state with which one began. We have already indicated that the effects of nature are almost never the same at the same instant or hour of the day. These variations depend on a host of different circumstances, such as the purity of the light, the quantity of vapour in the atmosphere, the wind, the rain, the elevation of the site, and the different reflections of the clouds, caused by their colour, weight or weightlessness; in short on an infinite number of causes, so many that they cannot all find a place in this very short work. But what we have said must suffice to show that it is absurd for an artist to spend an entire day copying a single view from nature. He can hardly fail to see that in this way he would paint the sky at sunrise, the background a little later, the distance at midday, the middle distance at four in the afternoon, and the foreground in the light of the setting sun. The sky is consequently of a silvery colour, the background misty, the distance is evenly illuminated without any long shadows, the middle distance is touched with gold, and the foreground is lit by the setting sun. The shadows in the background stretch out towards the front of the picture; those of the foreground point inward to the back; those in the distance point one way, and those in the middle distance another. It should not be thought that this criticism is intended as an unwarrantable exaggeration; we have seen a picture by Locatelli charming in both its colours and composition, but which was lit half from one side and half from the other.

We have seen innumerable pictures painted by less famous artists, in which all the mistakes enumerated above are to be found. Those who painted them called them studies from nature, but they were errors, perverse errors, and traduced nature. To seek to bind together all the successive instants of the day and their graduated effects in a single moment is the height of falsity, and clearly demonstrates a complete lack of judgement.

There are others, and they are a majority, who copy nature only during a two-hour interval, and who return the following day at the same time to continue their studies. These are undoubtedly more reasonable than the first, in that their works possess a greater unity of effect. But who can vouchsafe, when they break off their work today, that they will find the same mist, the same tones of light, shadow and reflection, on the morrow? It is an old adage, and a true one, that one day comes after another, and never two alike. So true is it that we have known artists of merit helpless to finish their many half-completed studies because they were unable to find the same effects in nature.

The pupil who wishes to work from nature must therefore take a different way about, or lose his pains. First, one must confine oneself to copying, as best one may, the main tones of nature in the effect one has chosen. Begin your study with the sky, which gives the tone of the background; this, in its turn, gives those of the planes with which it connects. In this way, gradually advance towards the foreground, which consequently is always harmonious with the sky used to create the local tone. Clearly, using this method, nothing can be treated in detail. Indeed, all studies should be made rigorously within the space of two hours at the most; if the effect is that of the rising or the setting sun, no more than an hour should be spent on it.

We know only too well that great abilities and much practice at painting from nature are necessary if one is to make anything worthwhile. But follow these rules, and this indispensable practice will easily be acquired; in short order, you will learn to make an extremely rapid sketch from nature.

It will no doubt be objected, that he who follows this method cannot learn how to finish a painting. There is some truth in this. But one can study the finishing of pictures from nature by copying parts of it when the weather is overcast, and objects are deprived of sunlight throughout the day. Then one seeks to render, as accurately as possible, every detail that one sees; and this form of study is indeed imperative, in that it teaches one to finish a painting and enrich it with absorbing details.

It is certainly much easier to finish the detailed parts of a painting than to capture the overall view, the local tone, and the light of the particular moment of the day that one seeks to paint. If one already has, in a well-executed sketch, the local tone of the effect one wishes to render, one can use it to establish the tone of the effect, and subsequently finish it from particular studies, which then serve only for touch and colour. For the tone in the details must always be at one with the local colour recorded in the sketch, which serves to determine the overall effect and define the unity of tones prevailing at the chosen time of day.

You must also be intimately persuaded that the overall effect of a painting depends on the tone of the sky; if one should fail to render the truth of this tone, the rest will necessarily jar. So if you should not at first succeed with the local colour of the sky, you must start again, whatever pains you have taken. Otherwise you will have a disagreeable experience, that of producing an effect contrary to the one you initially conceived. Rubbing out the sky is a better resource than rubbing out the rest.

It is a good thing to paint the same view at different times of day, in order to observe how light alters forms. So clearly perceptible and so astonishing are these changes that the objects are scarcely recognizable.

After these general principles, we enter upon the question of detail: 'There are objects,' we tell our pupil, 'that you can study separately, because they are fixed, such as monuments, ruins, cottages, trees, boulders, and so on; in short, anything that will maintain its natural state. And this sometimes includes an entire landscape, if the sky remains overcast throughout the day, or the light varies only imperceptibly.'

* * *

One essential thing, on which you must concentrate most particularly, is to acquire the habit of making studies from memory. These should reproduce the studies that you make daily, either by imitating the masters or by copying nature. It is a sure means of training the memory and stocking it with objects of interest; it facilitates genius, and its utility is clearer still when one is travelling. On the road, one is not always master of one's time; one often passes superlative landscapes without being able to stop and sketch them. Sometimes when a storm blows up, it affords extra-ordinary effects, such as striking pockets of moonlight, in short, all of those short-lived phenomena of nature that cannot, for lack of drawing materials, be captured on the instant. Unless one's memory is trained by habitual exercise, these objects quickly fade from it, however strongly it was first struck by them. They are replaced by those that came immediately thereafter, which may have less claim on our attention; whereas, if one is accustomed to working from memory, one can, at the first halt,

make a sketch of objects only fleetingly seen, but whose outline remains fresh. These sketches serve thereafter as a repertoire; what has been set down on paper recalls the parts needed to complete the main body of the places or things that deserve to be represented.

We have known artists of merit who, with great talent for imitating nature, entirely lacked the faculty of recalling scenes that were no longer before their eyes. Accustomed to having a model, they could not execute the least detail without it. It is, no doubt, an excellent thing to use a model; but since it is, in many cases, impossible to procure one, the painter who cannot work from memory is constantly brought up short or reduced to unsatisfactory execution, because he does not have enough recall of things he has seen.

We therefore exhort you: when you have made a study of something, do it again without looking at the model. Then, when you have strained your memory for the least detail and nothing more is forthcoming, you should compare the second study with the first; you will see the things you added and the things you left out. Your first few efforts will no doubt prove embarrassing; but be assured, you will soon accustom yourself to the method, and when you have, in this way, gradually stocked your mind, you will compose your works with much greater facility. [. . .]

In speaking of the ordering and composition of a landscape, we shall perhaps contradict the feelings of certain artists, who believe that, to make a good picture, it is quite sufficient to copy nature as it is. Their opinion would be correct if nature were always and everywhere beautiful, either overall or in detail. But as nature is perfect only in part, it is essential, in the composition of a painting, to select and then combine objects of beauty. Tact and learning are required in making this choice, in order to distinguish the beautiful from the defective and even from the mediocre; for there are objects which seem agreeable to the eye but cannot be accommodated in painting; while others would be perfectly satisfactory on their own, but lose all merit when combined with other masses. This discernment can be acquired only by seeing much, comparing what one has seen, and reflecting both on nature and on what the great masters have made of it. To these carefully worked pictures we owe insights that we should be long in acquiring, if we were obliged to seek them ourselves in consultation with nature. The labours of men of genius abbreviate our own; by making the most of their discoveries, we save precious time, and put ourselves in a position to make new ones.

Knowing beauty – how to find it, and how to capture it where it is found – one is already close to desiring it where it is lacking. To support this statement, here is an example:

Let us imagine ourselves in a beautiful place where variegated nature lays much of its bounty before us. Sitting in the shadow of an oak, we see, some fifty paces off, a fountain built of large stones, whose basin is only slightly raised; some of the spring water brims over and flows babbling down the slope. The sinuous rill bends its course now here, now there, half covered by newly grown grass and wild flowers. In front of the fountain is a great leaning tree, its trunk garlanded with moss, ivy and wild vine. Between the ends of its limbs, here and there, healthy and vigorous branches emerge; their leaves flutter down to earth under the impulse of a light breeze. On the side of the great stones of which the fountain is made, various aquatic

plants are growing. Dark green reeds and lake-tinted brambles partly cover this mass of stones, as do the shrubs that give it shade. A little further on, beside a lane, there is a dense wood that limits the view and concludes this landscape.

We are unsatisfied with this view, which, though picturesque in every detail, offers only one level for our painting. We look to one side and make out the end of the wood, which, extending into the plain, allows us to see, in part, a wide river that winds majestically through meadowland populated with cattle. Beyond this we can see plantations and thickly wooded areas, a village, and some isolated dwellings scattered along the slope of a hill, behind which there gradually rise groups of beautiful mountains that border the horizon. To make a delicious painting from this new viewpoint, all that is lacking is a foreground of the kind we have just described.

The imagination transports this agreeable fountain and its accessories, placing it at the foot of the second view. The artist takes his pencil, draws them, and makes, by this combination of two beautiful objects, a more perfect painting than if he had copied them separately. It remains to animate this landscape and place figures in it to impart a sense of action. One desires such figures ardently; the lane running past the fountain permits us to hope that we have not long to wait. And indeed, here comes a peasant woman in the distance; her red corslet, lit by the sun, will surely catch the light when she passes the fountain. She comes forward, arrives at that point, and one seizes the moment when she passes it to mark the place and thereby ensure the almost complete effect of the painting.

Above that part of the foreground on which the light lies and is caught by the figure, there is a cloud that also catches the light; the contrast of its brightness diminishes that of the peasant woman. We stop work for a moment, and wait for the slowly moving cloud to be carried by the wind into a part of the painting where it reflects no light; there we place it in the drawing, and the effect is the more striking for the contrast it provides.

This example should make clear what is meant by a composition from nature; by this means, and through our indispensable knowledge of architecture and perspective, a little hut set on the summit of a mountain can, at the stroke of a pencil, become an elegant temple; bushes become vigorous trees; a stone becomes a boulder, and a boulder a mountain. But to allow oneself such changes, one must have studied nature a great deal, studying detail above all; otherwise, one is liable to make a great tree no larger than a bush, and an enormous boulder that retains the form and physiognomy of a pebble.

To these preliminary rules we shall add some general observations on sketches and the composition of landscape.

You should take care to avoid a small, scant, dry manner in your composition; we have advised you to study details, but they should not lead you into narrow, mean compositions. Expansive fore- and backgrounds prove one capable of a grand gesture, and this is the mark of an accomplished artist.

Most landscape painters are in the habit of placing a dark mass in the foreground of their paintings, in order to make the background seem more remote; they call it a *repoussoir*. It is a fault to be avoided; you will be astonished to find that, if you place several paintings side by side, all these corners look alike, and the effect is ridiculous.

Never confuse the effects produced by masses with those made by objects that stand out through local colour. Rembrandt produces his effects through *chiaroscuro*, and Titian through local colour. The latter hides his secrets better, and is the more magical for doing so, whereas Rembrandt shows his finesse by the great sacrifices that he makes; not everyone likes this.

In the countryside, examine the movement of the little streams whose winding course beneath the willows is hemmed with reeds. There are marvellous paintings to be chosen in these places, and they are very easy to organize, because the play of the current through the reeds allows you to place the light as you will, since it is always moving hither and thither. Moreover, a great variety of plants and flowers grow by the water or on its banks. The aquatic birds that live by the water or swim on its surface can be made attractive, when they are intelligently used to give life to certain places, and bring echoes of light to them. All these springs, which are at first separate but later join to form a river, produce very pleasant movements and are bound to be effective in the foreground. Only think of those clusters of aquatic plants that intertwine in clumps, whose large colourful leaves float on the surface of the water. It is hardly conceivable that one finds no trace of these in landscape paintings, even in those of the greatest masters. Is this apparent proscription of such delightful objects deliberate and premeditated on their part? Despite our veneration for their sublime talents, we are convinced that there are many things, forgotten or neglected by them, of which much could be made. They did a great deal for the perfection of art; but how much remains to be done! Such discoveries await the men who are bold enough to attempt them! Unfortunately, the artists we see today are all stay-at-homes or timid travellers who dare not leave the high road and venture down unknown paths.

An artist who has consulted and studied nature at length will eventually be able to discern at a glance the objects that deserve to enter a composition. What the vulgar find magnificent in its monotonous regularity, a vast and extensive perspective in which there is no mass upon which the eye may repose, and which offers no contrast in either its depths or its foreground, will be of little interest to him. On the contrary, he is looking for a place that is by turns rugged, harmonious and contrasted; and these are characteristics that he seeks not only in the great masses but in the details. Sometimes the least little pocket of landscape will attract his attention; there he is delighted with an old tree that he wants to paint. It has lost some of its sap, but beside the withered branch it still shows foliage of a manly, vigorous green. The deeply fissured trunk is covered in moss, and ivy surrounds and is supported by it. At its side, a young sucker grows, proudly sporting a stalk whose frail branches display all the fresh brilliance of youth. Here the greensward is studded with undergrowth, there boulders stand out amid a clump of bushes. At the water's edge, the black trunk of a broken-down willow seems barely able to carry the weight of its branches, and forms an image of old age struggling against weakness and incapacity.

Generally speaking, there is never a bad moment to copy and represent nature; it is always beautiful when one knows how to choose it. But certain moments lend themselves more than others to the capture of its more pleasing and brilliant aspects. One should, for example, take care not to paint after a gale has blown, because the dust raised by high winds carries onto the trees and everything else, discolouring and fading them, and giving a false impression of their true shades. Wait till the rain has

washed them and restored their brilliance. Yet you should not paint immediately after the rain: give the earth time to drink in the water lying on its surface, which would otherwise make it too brown. Give the branches and bark of the trees time to dry out, as they are darkened by the moisture. Immediately after the rain, every colour has a blackish tinge. But after an hour, when natural colours return to every object, that is the moment to seize upon. The clouds are broken up and dispersed through the sky; their mass is imposing and variously lit; sunlight pierces them and spreads its dazzling rays of light. The colours of the boulders are vivid; trees and plants take on a new vigour; leaves that hung down, seemingly withered, rise on their stems and clothe themselves in shiny fresh green. The calyx of the flower reopens; the emerald tones of moss and greensward are again apparent. In all nature, whatever lives now seems to have gained new life. The health-giving water penetrates and stimulates the vegetable faculties; the birds who had taken cover or hidden during the storm joyfully reappear and present their soaked feathers to the beneficial rays of the sun, which dries and colours them. It is as if they sought, by their warbling, to thank the Supreme Being and hymn the marvels of nature. What man can resist this sublime spectacle? *A fortiori*, what painter can see it without enthusiasm?

4 John Constable (1776–1837) Letters to Dunthorne, 1799–1814

Constable more than any other English artist is associated with the development of a naturalistic form of landscape painting, and with the elevation of landscape to the status of the highest genres. He was introduced at an early stage in his career to debates on the picturesque, and in 1806 made a seven-week tour of the Lake District, the subject of one of Gilpin's *Observations*, published in 1786 (see VB5). As Constable's early letters make clear, his practice as a painter was informed both by his attachment to specific rural scenery and by his admiration for the work of earlier painters, Gainsborough, Claude Lorrain and Jacob Ruisdael foremost among them. His development of a fluent oil-sketching technique after nature was crucial in enabling him to reconcile these two interests. John Dunthorne was a friend from his youth in East Bergholt, in whose company he had painted before gaining admission to the Royal Academy Schools in 1799. (The 'Johnny' mentioned in the letter of 1814 was Dunthorne's son, whom Constable occasionally employed at that time as an assistant.) In 1802 Constable was offered a post as drawing-master at the Royal Military Academy, through the intercession of Dr John Fisher, then Canon of Windsor. He rejected the post on the advice of Benjamin West, then President of the Academy (see VIIB1), and of the painter Joseph Farington and the painter and collector Sir George Beaumont, the Academicians largely responsible for his instruction. The letter Constable wrote to Dunthorne on 29 May following his rejection of the post is the fullest surviving statement of his early views on his profession. It contains several echoes of Reynolds' Discourses (IVA7, 8), with which the artist was clearly familiar. In the same year he exhibited for the first time at the Academy. Constable's maturity as a painter is marked by a series of highly individual Suffolk landscapes painted in 1814–15. As he recorded particular places and particular moments from the calendar of rural activities, he brought a lucid compositional organization to the results. And a few years later, when he came to work on large set-piece compositions, he was able to bring an animating naturalism to their atmosphere and detail. Our text of the letters is taken from *John Constable's Correspondence II: Early Friends and Maria Bicknell*, ed. R. B. Beckett,

Ipswich: Suffolk Records Society, volume VI, 1964, pp. 22–4, 31–5, and *John Constable's Correspondence: The Family at East Bergholt 1807–1837*, London and Ipswich: HMSO and Suffolk Records Society, volume IV, 1962, p. 101. (For later writings by Constable see *Art in Theory 1815–1900*, IB4, 7 and 8.)

London. February 4th, 1799.

Dear Dunthorne

I am this morning admitted a student at the Royal Academy; the figure which I drew for admittance was the Torso. I am now comfortably settled in Cecil Street, Strand, No. 23. I shall begin painting as soon as I have the loan of a sweet little picture by Jacob Ruysdael to copy. Since I have been in town I have seen some remarkably fine ones by him, indeed I never saw him before; yet don't think, by this, I am out of conceit with my own, of which I have seen a print, 'tis of the same size and reversed.

I shall not have much to show you on my return, as I find my time will be more taken up in *seeing* than in painting. I hope by the time the leaves are on the trees, I shall be better qualified to attack them than I was last summer. All the time that you can conveniently spare from your business may be happily spent in this way, perhaps profitably, at any rate innocently....

Smith's friend Cranch has left off painting, at least for the present. His whole time and thoughts are occupied in exhibiting an old, rusty, fusty head, with a spike in it, which he declares to be the real embalmed head of Oliver Cromwell! Where he got it I know not; 'tis to be seen in Bond Street, at half a crown admittance.

How goes on the lay figure? I hope to see it finished when I return, together with some drawings of your own from nature....

John Constable

[Spring 1800]

Dear Dunthorne

I have copied a small landscape of A. Caracci, and two Wilsons, and have done some little things of my own. I have likewise begun to copy a very fine picture by Ruysdael, which Mr. [Philipp] Reinagle and myself have purchased in partnership for £70....

I hope to see you in the spring, when the cuckoos have picked up all the dirt. Every fine day makes me long for a walk on the commons....

I have finished my copy from Ruysdael, all but the glazing, which cannot be done till the picture is dry. It has been roasting in the sun these two or three days. Tomorrow I hope to go on with my copy from Sir George Beaumont's little Claude. I shall remain in town the chief of this summer. Indeed I find it necessary to fag at copying, some time yet, to acquire execution. The more facility of practice I get, the more pleasure I shall find in my art; without the power of execution I should be continually embarrassed, and it would be a burthen to me.

This fine weather almost makes me melancholy; it recalls so forcibly every scene we have visited and drawn together. I even love every stile and stump, and every lane in the village, so deep rooted are early impressions....

John Constable

London. 29 May 1802.

My dear Dunthorne,

I hope I have done with the business that brought me to Town with Dr. Fisher. It is needless now to detail any particulars as we will make them the subject of some future conversation – but it is sufficient to say that had I accepted the situation offered it would have been a death blow to all my prospects of perfection in the Art I love.

For these few weeks past I believe I have thought more seriously on my profession than at any other time of my life – that is, which is the shurest way to real excellence. And this morning I am the more inclined to mention the subject having just returned from a visit to Sir G. Beaumont's pictures. – I am returned with a deep conviction of the truth of Sir Joshua Reynolds's observation that 'there is no *easy* way of becoming a good painter.' It can only be obtained by long contemplation and incessant labour in the executive part.

And however one's mind may be elevated, and kept up to what is excellent, by the works of the Great Masters – still Nature is the fountain's head, the source from whence all originally must spring – and should an artist continue his practice without refering to nature he must soon form a *manner*, & be reduced to the same deplorable situation as the French painter mentioned by Sir J. Reynolds, who told him that he had long ceased to look at nature for she only put him out.

For these two years past I have been running after pictures and seeking the truth at second hand. I have not endeavoured to represent nature with the same elevation of mind – but have neither endeavoured to make my performances look as if really *executed* by other men.

I am come to a determination to make no idle visits this summer or to give up my time to common place people. I shall shortly return to Bergholt where I shall make some laborious studies from nature – and I shall endeavour to get a pure and unaffected representation of the scenes that may employ me with respect to colour particularly and any thing else – drawing I am pretty well master of.

There is little or nothing in the exhibition worth looking up to – there is room enough for a natural painture. The great vice of the present day is *bravura*, an attempt at something beyond the truth. In endeavouring to do something better than well they do what in reality is good for nothing. *Fashion* always had, & will have its day – but *Truth* (in all things) only will last and can have just claims on posterity.

I have received considerable benefit from exhibiting – it shows me where I am, and in fact tells me what no body else could. There are in the exhibition fine pictures that bring nature to mind – and represent it with that truth that unprejudiced minds require.

These are reflexions that at this time I should have written for my own use – but as I know that I could not write to you on a subject that would be more agreable, I send you them as a letter.

And indeed I have had much ado to keep my mind together enough to write to be understood owing to a reumatick pain in one side of my head, particularly in my teeth and lower jaw, which has caused one cheek to swell very much. I believe I got cold at Windsor as I was there in the late severe weather.

Should you want any thing in the pencil way &c let me know next week for I hope the next to leave London.

Remember me kindly to your wife & beleive me

to be sincerely yours
John Constable

London. May 23rd 1803.

Dear Dunthorne,

I have for some time felt a weight on my mind from having so long neglected writing to you. Indeed there is this strange fatality about me, that I seem to neglect those whose love and friendship I most value. . . .

My voyage I will mention first. I was near a month on board, and was much employed in making drawings of ships in all situations. I saw all sorts of weather. Some the most delightful, and some as melancholy. But such is the enviable state of a painter that he finds delight in every dress nature can possibly assume.

When the ship was at Gravesend, I took a walk on shore to Rochester and Chatham. Their situation is beautiful and romantic, being at the bottom of finely formed and high hills, with the river continually showing its turnings to great advantage. Rochester Castle is one of the most romantic I ever saw. At Chatham I hired a boat to see the men of war, which are there in great numbers. I sketched the 'Victory' in three views. She was the flower of the flock, a three decker of (some say) 112 guns. She looked very beautifull, fresh out of Dock and newly painted. When I saw her they were bending the sails – which circumstance, added to a very fine evening, made a charming effect. On my return to Rochester, I made a drawing of the Cathedral, which is in some parts very picturesque, and is of Saxon Architecture.

I joined the ship again at Gravesend, and we proceeded on our voyage, which was pleasant enough till we got out to sea, when we were joined by three more large ships. We had almost reached the Downs when the weather became stormy, and we all put back under the North Foreland, and lay there three days. Here I saw some very grand effects of stormy clouds. I came on shore at Deal, walked to Dover, and the next day returned to London.

The worst part of the story is that I have lost all my drawings. The ship was such a scene of confusion, when I left her, that although I had done my drawings up very carefully, I left them behind. When I found, on landing, that I had left them, and saw the ship out of reach, I was ready to faint. I hope however I may see them again some time or other. Now I think I must have tired you, and I will change the subject.

The exhibition is a very indifferent one on the whole. In the landscape way most miserable. I saw, as I thought, a great many pictures by Sir F. Bourgeois [Sir Peter Francis Bourgeois, elected R.A. in 1793], but it proved that not half of them belonged to him, but to another painter who had imitated his manner exactly. Sir Francis was the hangman, and was so flattered by these imitations that he has given them as good places as his own. There are, however, some good portraits in the exhibition.

I have seen some fine pictures lately, and have made a few little purchases – twelve prints by Waterloo, and four fine drawings by him, with some other prints. But my

best purchases are two charming little landscapes by Gaspar Poussin, in his best time....

I feel now, more than ever, a decided conviction that I shall some time or other make some good pictures. Pictures that shall be valuable to posterity, if I reap not the benefit of them. This hope, added to the great delight I find in the art, buoys me up, and makes me pursue it with ardour.

Panorama painting seems all the rage. There are four or five now exhibiting, and Mr. Reinagle is coming out with another, a view of Rome, which I have seen. I should think he has taken his view favourably, and it is executed with the greatest care and fidelity. This style of painting suits his ideas of the art itself, and his defects are not so apparent in it – that is, great principles are neither expected nor looked for in this mode of describing nature. He views Nature minutely and *cunningly*, but with no greatness or breadth. The defects of the picture at present are a profusion of high lights, and too great a number of abrupt patches of shadow. But it is not to be considered as a whole....

I shall soon be at home again. The weather is not however very tempting, and while I find so much to interest me, at this busy time of the Arts, in London, I shall stay a week or two longer....

John Constable

Charlotte St., Feby. 22nd, 1814

My dear Dunthorne,

I am rather disappointed in not seeing Johnny here yet, but as the weather is now fine tho' yet cold I wish you would let him come. I am rather desirous of having him now for I think he may be useful to stimulate me to work, by setting my palate &c. &c. – which you know is a great help and keeps one cheerfull. Be so good as to let me know when and where he comes to, and what time I must send to meet him. It is quite convenient for us to have him.

I am anxious about the large picture of Willy Lott's house, which Mr. Nursey says promises uncommonly well in masses &c., and tones – but I am determined to detail but not retail it out. Mr. Nursey is in Town to ship his son John to the East Indies.

I have added some ploughmen to the landscape from the park pales which is a great help, but I must try and warm the picture a little more if I can. But it will be difficult as 'tis now all of a peice – it is bleak and looks as if there would be a shower of sleet, and that you know is too much the case with my things. I dread these fields falling into Coleman's hands as I think he will clear them a good deal and cut the trees – but we cannot help these things.

Tell Abram that Mr. Cox intends having my Windmill engraved and has put it into Mr. Landseer's hands for that purpose, who is a very superior landscape engraver. This I am glad of, for it is a pretty subject – it is one of the Stoke mills I was at with you & Mr. Frost when I did it many years ago.

I have much to say to you about finishing of my studies more in future – but I look to do a great deal better in future. I am determined to finish a small picture on the spot for every one I intend to make in future. But this I have always talked about but

never yet done – I think however my mind is more settled and determined than ever on this point. Hitherto (as Shakespeare says) 'I have been too infirm of purpose.'

I was glad to hear by Abram that you were all well. Remember me kindly to Mrs. Dunthorne, and family, and believe me, my dear fellow, – to be always sincerely yours

John Constable

5 Thomas Wedgwood (1771–1805) and Humphry Davy (1778–1829) 'An Account of a Method of Copying Paintings Upon Glass, and of Making Profiles'

Artists had been making use of the device known as the *camera obscura* since the Renaissance (see IIIA9). Moreover, experiments in the making and fixing of images by the action of light on a sensitive medium had been going on throughout the eighteenth century, and were sufficiently well known to have attracted the attention of imaginative authors (see IIIB11). As early as 1727 Johann Heinrich Schulze had discovered the light-sensitivity of silver salts. Thereafter the work had been carried on by Beccarius, Scheele, Bergmann, Priestley, Senebier and others, with a particular upsurge of activity in the 1770s and 1780s. Bergmann's report of his 1776 experiments was read in 1797 by Tom Wedgwood, younger son of the founder of the pottery, who then began to try and produce pictures by laying objects on paper and leather sensitized with silver nitrate solution. Wedgwood was joined in the photographic experiments by Humphry Davy, later one of the most eminent scientists of his time but then a young chemist working in Bristol. The experiments were successful insofar as images were produced, but no way could be found to fix them. A report titled 'An Account of a Method of Copying Paintings Upon Glass, and of Making Profiles, by the Agency of Light Upon Nitrate of Silver', was published in the *Journal of the Royal Institution of Great Britain* in 1802, pp. 170–4. We have used the text as reprinted in Beaumont Newhall ed., *Photography: Essays and Images*, New York, Museum of Modern Art, 1980/London: Secker and Warburg, 1981, pp. 15–16. We have omitted a technical footnote given by Wedgwood and Davy. (For more texts on the early development of photography and for debates about its status as an art, see *Art in Theory 1815–1900*, IIC6 and 7, and IVC *passim*.)

White paper, or white leather, moistened with solution of nitrate of silver, undergoes no change when kept in a dark place; but, on being exposed to the day light, it speedily changes colour, and, after passing through different shades of grey and brown, becomes at length nearly black.

The alterations of colour take place more speedily in proportion as the light is more intense. In the direct beams of the sun, two or three minutes are sufficient to produce the full effect. In the shade, several hours are required, and light transmitted through different coloured glasses, acts upon it with different degrees of intensity. Thus it is found, that red rays, or the common sunbeams passed through red glass, have very little action upon it: yellow and green are more efficacious; but blue and violet light produce the most decided and powerful effects.

The consideration of these facts enables us readily to understand the method by which the outlines and shades of painting on glass may be copied, or profiles of

figures procured, by the agency of light. When a white surface, covered with solution of nitrate of silver, is placed behind a painting on glass exposed to the solar light; the rays transmitted through the differently painted surfaces produce distinct tints of brown or black, sensibly differing in intensity according to the shades of the picture, and where the light is unaltered, the colour of the nitrate becomes deepest.

When the shadow of any figure is thrown upon the prepared surface, the part concealed by it remains white, and the other parts speedily become dark.

For copying paintings on glass, the solution should be applied on leather; and, in this case, it is more readily acted upon than when paper is used.

After the colour has been once fixed upon the leather or paper, it cannot be removed by the application of water, or water and soap, and it is in a high degree permanent.

The copy of a painting, or the profile, immediately after being taken, must be kept in an obscure place. It may indeed be examined in the shade, but, in this case, the exposure should be only for a few minutes; by the light of candles or lamps, as commonly employed, it is not sensibly affected.

No attempts that have been made to prevent the uncoloured parts of the copy or profile, from being acted upon by light have as yet been successful. They have been covered with a thin coating of fine varnish, but this has not destroyed their suscept-ibility of being coloured; and even after repeated washings, sufficient of the active part of the saline matter will still adhere to the white parts of the leather or paper, to cause them to become dark when exposed to the rays of the sun.

Besides the applications of this method of copying that have been just mentioned, there are many others. And it will be useful for making delineations of all such objects as are possessed of a texture partly opaque and partly transparent. The woody fibres of leaves, and the wings of insects, may be pretty accurately represented by means of it, and in this case, it is only necessary to cause the direct solar light to pass through them, and to receive the shadows upon prepared leather.

When the solar rays are passed through a print and thrown upon prepared paper, the unshaded parts are slowly copied; but the lights transmitted by the shaded parts, are seldom so definite as to form a distinct resemblance of them by producing different intensities of colour.

The images formed by means of a camera obscura, have been found to be too faint to produce, in any moderate time, an effect upon the nitrate of silver. To copy these images, was the first object of Mr. Wedgwood, in his researches on the subject, and for this purpose he first used the nitrate of silver, which was mentioned to him by a friend, as a substance very sensible to the influence of light; but all his numerous experiments as to their primary end proved unsuccessful.

In following these processes, I have found, that the images of small objects, produced by means of the solar microscope, may be copied without difficulty on prepared paper. This will probably be a useful application of the method; that it may be employed successfully however, it is necessary that the paper be placed at but a small distance from the lens.

With regard to the preparation of the solution, I have found the best proportions those of 1 part nitrate to about 10 of water. In this case, the quantity of the salt

applied to the leather or paper, will be sufficient to enable it to become tinged, without affecting its composition, or injuring its texture.

In comparing the effects produced by light upon muriate of silver, with those produced upon the nitrate, it seemed evident, that the muriate was the most susceptible, and both were more readily acted upon when moist than when dry, a fact long ago known. Even in the twilight, the colour of moist muriate of silver spread upon paper, slowly changed from white to faint violet; though under similar circumstances no immediate alteration was produced upon the nitrate.

The nitrate, however, from its solubility in water, possesses an advantage over the muriate: though leather or paper may, without much difficulty, be impregnated with this last substance, either by diffusing it through water, and applying it in this form, or by immersing paper moistened with the solution of the nitrate in very diluted muriatic acid.

To those persons not acquainted with the properties of the salts containing oxide of silver, it may be useful to state, that they produce a stain of some permanence, even when momentarily applied to the skin, and in employing them for moistening paper or leather, it is necessary to use a pencil of hair, or a brush.

From the impossibility of removing by washing, the colouring matter of the salts from the parts of the surface of the copy, which have not been exposed to light; it is probable, that both in the case of the nitrate and muriate of silver, a portion of the metallic oxide abandons its acid, to enter into union with the animal or vegetable substance, so as to form with it an insoluble compound. And, supposing that this happens, it is not improbable, but that substances may be found capable of destroying this compound, either by simple or complicated affinities. Some experiments on this subject have been imagined, and an account of the results of them may possibly appear in a future number of the Journals. Nothing but a method of preventing the unshaded parts of the delineation from being coloured by exposure to the day is wanting, to render the process as useful as it is elegant.

6 Karl Ludwig Fernow (1763–1808) 'On Landscape Painting'

The German artist and writer Karl Ludwig Fernow was born in Blumenhagen in the Uckermark. To escape Prussian military service he fled to Lübeck where he formed a close friendship with Asmus Jacob Carstens (see VA14). After a number of years as an amateur painter and a private tutor in Ratzeburg, Lüneberg and Schwerin, he took up the study of philosophy at the University of Jena. In 1793 he moved to Rome. According to Goethe's friend and artistic adviser, Heinrich Meyer, in the winter of 1795/6 Fernow gave a series of lectures on Kant's *Critique of Judgement* (see VA10) which were well attended and which succeeded in introducing the philosopher's ideas to the large colony of German artists working in the city. From 1795 to 1802 he shared a house with the landscape painter, Johann Christian Reinhart (1761–1847), whose work provided the primary inspiration for many of the ideas articulated in 'On Landscape Painting'. Indeed, when Fernow republished the article in his *Römische Studien* (Zurich, 1808) he dedicated it to the painter, declaring that 'the major portion of the essay is the fruit of the many informative hours which I spent in your studio observing and discussing your sketches, studies and finished works.'

However, the theoretical apparatus which underpins the essay is largely drawn from Kant, above all, from the account of 'aesthetic ideas' given in section 49 of the *Critique of Judgement* (reproduced in VA10 above). What is new is Fernow's attempt to apply Kant's arguments directly to landscape painting. He starts out with a fairly conventional distinction between topographical views and ideal landscape painting. In this latter the artist produces his own composition rather than imitating an actual scene in nature. Fernow goes on to argue that such ideal scenes are particularly well suited to produce the state of mental attunement or harmony identified by Kant as the basis of aesthetic pleasure. Insofar as a landscape painting can move us without presenting any determinate subject or content, he likens it to music. However, he is not fully prepared to accept the devaluation of narrative, suggesting that landscape becomes 'more aesthetically interesting' when peopled with figures. 'Über die Landschaftsmalerei' was first published in two parts in Wieland's *Neuer Teutscher Merkur*, Weimar, November and December 1803. The following excerpt has been translated for the present volume by Jason Gaiger from Part I, pp. 527–30, 533–43.

Painting, whose domain encompasses the entire visible world, has a particular branch dedicated to the representation of *places* or *natural scenes*. Its sites are the *land* and the *sea*, and both are often be found together in the same picture. Insofar as it is principally given over to landscape scenes or to scenes of water, this branch is divided into *landscape painting* and *marine painting*.

The same distinction which is made in respect of the depiction of human beings between the *faithful* imitation of *real* individuals and the *free* representation of *ideal* individuals is also to be found in this branch of the art. A landscape or marine painting is either faithfully *copied* after nature or it is poetically *invented*. In the latter case, the picture is a representation of an *ideal* landscape or seascape; in the former case it is a *prospect* of a place which really exists. Consequently, this art can be divided into the *representation of ideal natural scenes* and *prospect painting*.

There is no ideal of a beautiful place, that is to say, no originary image which corresponds to a determinate concept through which the artist can lift himself above reality in the representation of natural scenes so as to bring forth something more perfect and beautiful. In the same way, there is no ideal of a beautiful tree, of a beautiful rock, or of a mountain, for individual objects of this sort are not bound to any specific genus or type, although each of them has its own distinct character. There are, however, *ideal natural scenes* which the artist invents in accordance with an idea which he holds in his mind and which is capable of infinitely varied modification. Such pictures are not borrowed from reality, but are created in the artist's imagination. In the same way, the artist forms the individual objects he represents, the trees, the rocks, the mountains, the clouds, and so forth, not after real models chosen from nature but from an idea in his mind – and yet each is formed in accordance with its own natural character. In this way, both the individual parts and the whole of his ideal representation remains like nature and true to it, yet without being a copy.

In order to determine the aesthetic status of the different arts we should not consider the nature of the objects they depict nor the greater or lesser difficulty which they require to master, but rather the *greater or lesser capacity for expressing aesthetic ideas* which each art possesses. By aesthetic ideas I mean those representa-

tions of the imagination which are capable of setting into play the sensuous and intellectual forces of the soul and of bringing them into a state of free and harmonious accord.

For this reason, it is not animal painting which should be considered next in status after history painting but landscape painting. For landscape painting is more capable of bringing the mind into an aesthetic state.

* * *

We may concede that animal painting, as the art of depicting living creatures, requires a greater gift of imagination and more knowledge of physiognomy in order to capture the proper character of each type of animal and to articulate with truth and animation the fleeting expression of different movements and feelings. Nonetheless, we must recognize that landscape painting presupposes a higher aesthetic culture in the artist than animal painting. If the artist wishes to bring about in us a state of aesthetic harmony through his work, he must himself have felt the same concord in respect of the idea which informs it. And whoever seeks to lift our souls above reality to the level of ideas must himself have cultivated his imagination in such a way that he is responsive to this domain. The strings which he seeks to sound harmoniously within us must first have sounded harmoniously within him. Such effects, which cannot be demanded from a work of animal painting, are expected from ideal landscapes. This is the principal reason why so few amongst the large number of landscape painters who invent their subject have achieved anything great in the poetic aspect of their art. The majority are satisfied with a pleasing manner, insignificant compositions and empty effects, for they do not have an elevated conception of their art and lack sufficient aesthetic culture to regard nature poetically.

History painting has greater interest for the heart and the mind, and greater beauty than landscape painting. Yet even when the truth of the expression allows us to place ourselves in the situation of the characters who are depicted, we still participate in the action only as *spectators*. By contrast, the grace of a beautiful landscape allows us to roam through its fields, to wander into the delightful distance and to rest in its cool shadows. We are no longer mere spectators, but find ourselves in the natural scene which is represented. That a landscape painting does not have a specific content like a history painting, but merely depicts natural scenes in which the harmonious combination of a plurality of different objects creates a total effect upon our feelings, makes it all the more capable of bringing the soul into a purely aesthetic state. In this it is related to music. The harmony of the colours which are spread across a landscape has a similar effect upon the soul as the melodies and harmonies of music.

As the representation of an action, a situation or an event, involving real or imaginary persons, history painting always has a determinate historical or poetic content. Only once this content is articulated through the appropriate form of expression does it give rise to an aesthetic mood and the spectator can always give clear reasons for his response. By contrast, landscape painting which represents ideal natural scenes has no need for a *determinate* content. It brings together a plurality of things from nature into a whole in accordance with an idea. The total effect is sufficient to bring about a certain mood and this effect is always realized before the mind starts to make clear to itself the content of the landscape.

In a history painting the various individual figures make a claim upon our interest through the action they carry out and the significance which is attached to it. We recognize the necessity of their relation to the whole and judge their aesthetic effectiveness accordingly. They must be exactly as they are, and not otherwise. Nothing here can appear arbitrary or contingent. For the specific content of the representation determines all the different parts which go to make it up. In a landscape, however, every object appears more contingent and arbitrarily chosen. And this is how things should appear, even though here too every part is chosen by the artist so as to contribute to the harmony of the whole. No individual object has its own independent aesthetic meaning or interest. Rather, it gains both through the connection and harmony it enjoys with the other parts; it is this which make the whole into something meaningful and beautiful. This is not so much known as immediately *felt* in the conception of the whole. Even when a landscape is given a particular character and content through specific natural phenomena or some significance in the staffage, this is to be regarded as something accidental. However, it does contribute to the classification of landscape into landscapes of effect, historical landscapes, and so forth, in which a particular interest is bound up with the aesthetic mood. But this mood must always derive primarily and immediately from the landscape itself. It can be supported, modified, and more closely determined by ancillary ideas, but these cannot be its source. Whatever content a landscape may have, if this effect is missing, if it does not make a claim upon our feelings through the impression of the whole in which the keynote is given by the landscape itself, then it lacks what is essential, the poetry of the scene, and it is not the product of a poetically attuned imagination, not a genuine work of art.

The state of aesthetic harmony or concord which nature and art bring about in the mind actually consists in the mind freeing itself of all determinate content whilst yet remaining active. It embraces the entire compass of aesthetic feelings in all their different modifications, from the delightful and the graceful through to the fearful and sublime. However, the object which brings about this state of harmony must itself have an aesthetic character; it must appear in a situation which makes a claim upon the mind. And this is something which the natural landscape possesses, for different places have different aesthetic characters and the landscape appears in a variety of constantly changing guises.

The character of a place or a landscape is contained in what is *enduring* and is principally determined by the forms of each of the individual objects and by the composition of the whole. The source of the individual features and their variations which determine the character of different landscapes is partly to be found in the different shapes which the surface of the Earth takes, but also in differences of climate and in the products of human culture. The first determines the form of inanimate natural objects, the mountains, valleys, fields, shores and so forth. The second determines the different types of vegetation. And both of these together determine the transitory phenomena which nature displays in its different sites. Finally, culture determines the character of the buildings which adorn a place, though this too is influenced by climate.

The mountainous regions of Switzerland have a completely different character from those in Italy. Think of the shape of the mountains, the way in which they are

ranged behind one another in narrow valleys like a stage backdrop, the steep, jagged, snow-covered peaks, the valleys of ice and the glaciers, the green alpine meadows crowned with dark pine forests from which roaring streams plunge downwards, and the pure ethereal atmosphere, which even from a great distance leaves the local colours of objects scarcely modified. In Italy the lines of the mountains are softer and more elongated, the valleys broader and more open, the bare peaks generally without snow and vegetation, the floor of the valleys full of chestnut trees, the air warmer and the distances more hazy. The evergreen oak, the pine, the cypress, the plane tree, the laurel, the olive, the fig, the aloe, the Babylonian willow and the palm tree belong to the South, whereas the darker fir, the German oak, the beech, the lime, the hardy willow and so forth give to the landscapes of the northern countries their own climatic character. The flat landscapes of lower Germany have a different physiognomy from the flat lands of Lombardy. The sky and the sea appear different on the coast of the Mediterranean than on the North Sea coast. The atmosphere, too, is different. In the North it is generally clear, but hard and bright, whereas in the South it is always hazy, warm and harmonious.

These are just a few of the more conspicuous differences in the character of the landscapes proper to different regions. Just as manifold are the different *situations* which are caused by *changes in what is transitory*, such as the time of day and the time of year, the light, the clouds, storms, showers, volcanoes, and other natural phenomena. Each of these has its own individual character. Some are delightful, graceful, cheerful, relaxing or touchingly beautiful. Others are great, splendid, festive or magisterial. Yet others serious, dark, eerie, terrifying, horrible or fearfully sublime. Corresponding to these different characters and situations, the aesthetic mood in which the soul is placed is modified in a variety of different ways.

In these reflections I have sought to investigate the aesthetic properties of the natural landscape independently of all the ancillary effects which are brought about by other objects. We are now in a position to conclude that the essence and proper goal of landscape painting can only be: *to bring about an aesthetic mood or state of harmony through the representation of ideal natural scenes.* To achieve this goal, the natural scene represented must have a specific aesthetic character and must appear in a situation which makes a claim upon the soul.

This definition gives us what is essential to the goal of landscape painting, but it does not express everything which it can achieve nor every purpose it fulfils. It establishes only the necessary condition, without which no good landscape is possible. Whatever significance the other aspects of a landscape may have, and whatever interest they carry with them, the landscape itself should possess a particular character and it should reveal nature in a particular situation. Only in this way can it give rise to an aesthetic mood and be considered interesting and beautiful *as a landscape.*

Although landscape painting, which we look at, speaks to the senses more clearly than music, which merely expresses feelings, the aesthetic effect of both is approximately the same. Both bring about a state of aesthetic responsiveness by harmoniously combining a manifold of different impressions into a total impression. Music does so successively through melody and the harmony of the tones; painting does so simultaneously through a unified and harmonious impression made up of manifold forms

and colours. Music on its own can awaken sentiments and set the mind in a certain mood without expressing any determinate content. However, if music is set to a text or accompanied by actions, it can connect concepts and images to these sentiments and a bring a series of connected ideas to the mere mood. The impression which it makes is then clearer, more interesting, and more satisfying. In the same way, a landscape can be made more significant, its character more determinate, its content richer and more poetic, and the impression it creates clearer and more satisfying. In short, the representation of an ideal natural scene becomes more aesthetically interesting when, like real nature, it appears as the abode of living creatures, that is to say, when it is animated by human beings and animals, cultural artefacts, interesting events, and occurrences. A landscape which shows a delightful but completely unpopulated scene without any trace of human habitation would for that very reason please less and for all its beauty leave us unsatisfied. For the full harmony of the chord to be sounded, a note would still be missing.

7 Charles Bell (1774–1842) from *Essays on the Anatomy of Expression in Painting*

Bell was born in Edinburgh and studied medicine at the university there. In 1804 he moved to London, where he held a variety of surgical and teaching posts. His *New Idea of the Anatomy of the Brain* (1811) was regarded as the 'Magna Carta' of modern neurology. Knighted in 1831, he returned to Scotland where he ended his career as Professor of Surgery at Edinburgh University. His *Essays on the Anatomy of Expression in Painting* offered an unparalleled resource to artists. Its six chapters provided detailed anatomical analyses, including studies 'Of the skull and form of the head' (Essay II), 'Of the muscles of the face in man and animals' (Essay III) and 'Of the expression of passion as illustrated by a comparison of the muscles in man and animals' (Essay IV). The text was supported by detailed engravings of the bones and muscles, as well as by more theatrical sketches of facial expressions. Going beyond the earlier efforts of academicians such as Le Brun (see IB14), Bell sought to ground the representation of expressed emotion in a scientific understanding of how those expressions were physiologically produced. We have made selections from the preface and opening chapter in which Bell argues his case for the importance of a study of anatomy by artists, and – the other side of the same coin – against an over-dependence both on classical models and on academic poses. To speak with benefit of hindsight, however, there was a historical irony attendant upon Bell's project. At a certain moment in the early nineteenth century, experimental science was able to provide artists with the materials for an accurate replication of expressions of emotional states. But this moment preceded by only a few decades the point at which advanced art turned definitively away from mimesis as such. Well before the end of the century, the skills Bell sought to inculcate in artists in order to facilitate their expressive genius had become irredeemably conservative. (For a modernist account of artistic expression which explicitly rejects the aim of reproducing the 'passions glowing in a human face or manifested by violent movement', see *Art in Theory 1900–1990*, IB5.) The extracts from Bell are taken from *Essays on the Anatomy of Expression in Painting*, London: Longman, Hurst, Rees and Orme, 1806, pp. vi–viii, 2–4, 8–12.

By anatomy, considered with a view to the arts of design, I understand not merely the study of the individual and dissected muscles of the face, or body, or limbs; I consider it as including a knowledge of all the peculiarities and characteristic differences which mark and distinguish the countenance, and the general appearance of the body, in situations interesting to the painter or statuary. The characters of infancy, youth, or age; the peculiarities of sickness or of robust health; the contrast of manly and muscular strength, with feminine delicacy; the appearances of diseases, of pain, or of death; the general condition of the body; in short, as marking to the eye of the beholder interesting situations; – all these form as necessary a part of the anatomy of painting as the tracing of the muscles of expression in their unexerted state, and of the changes induced upon them as emotions arise in the mind.

The anatomy of painting, taken according to this comprehensive description, forms not only a science of great interest, but that from which alone the artist can derive the true spirit of observation; learn to distinguish what is essential to just expression; and be enabled to direct his attention to appearances which might otherwise escape his notice, but on which much of the effect and force, and much even of the delicacy of his delineations, will be found to depend.

Among the errors into which a young artist is most likely to be seduced, there are two against which the study of anatomy seems well calculated to guard him. The one of these is, the blind and indiscriminate imitation of the antique; the other, an opinion that in the academy figure he will find a sure guide in delineating the natural and true anatomy of the living body. These are subjects on which it may be excusable to insist somewhat at large.

If, as I fear it too often happens, an artist should make the imitation of the antique the beginning and the end of his studies, instead of adopting it as a corrective of his taste, after having laid a sure ground-work in the study of anatomy and a close observation of nature, and after having attained a correct and powerful execution, he will be apt to degenerate into a tame and lifeless style; he will be in a danger of renouncing, in pursuit of ideal beauty, the truth of expression and of character. – Nay, I cannot help suspecting that many painters have copied after casts of the antique for years, without perfectly understanding what they should imitate, without even perceiving the necessity of previously studying the nature of the subject; entering fully into the idea of the artist; and being aware of the peculiarities of his mode of composition. Into this fault, one who is learned in the science and anatomy of painting can never fall. But he who has not compared the natural with the antique head, or learned the characteristic differences, or studied the principle on which the ancient artists composed, may be betrayed into the grossest misconceptions by too implicitly following their models. In painting a hero, for example, on whom an ancient would have bestowed strong character, with bold anatomy and powerful expression, he may follow the ideal form of a deity, in which the Grecian artist had studiously divested his model of all that could indicate natural character, or might seem to pertain to humanity. The ancient artist, in following the mythology of his country, and the description of her poets, studied to bestow the character of divinity, by giving repose to the limbs without any indication of muscles or veins, and by exhibiting a face full of the mild serenity of a being superior to the passions of mankind, as shadowing out a state of existence in which the will possesses the most

perfect freedom and activity without the exertion of the bodily frame. But those ideal forms are scarcely ever to be transferred to the representation of the human body; and a modern artist who indiscriminately follows such a model, misapplies the noblest lessons of his art. [...]

Perhaps, I may be thought to have sufficiently pointed out how dangerous it is, for one solicitous to excel as a painter, too closely and indiscriminately to imitate the antique, and especially the productions of ancient sculpture. But it is not unnatural for the student to believe that the study of the academy figure may serve as a guard against all such danger; and afford him a sure criterion for judging of the anatomy of his figures.

The study of the academy figure is, undoubtedly, most essential, but unless conducted with some regard to science, it necessarily leads to error.

In the first place, it may be remarked, that the academy figure can give no aid in the study of the countenance. Here the lessons of anatomy, taken along with the descriptions of the great poets, and the study of the works of eminent painters, afford the only resource.

But even for the anatomy of the body and limbs, the academy figure is very far from being an infallible guide. The display of muscular action in the human figure is but momentary, and cannot be retained and fixed for the imitation of the artist. The effect produced upon the surface of the body and limbs by the action of the muscles, the swelling and receding of the fleshy parts, and that drawing of the sinews or tendons, which accompanies exertion, or change of posture, cannot be observed with sufficient accuracy, unless the artist is able to class the muscles engaged in the operation; and unless he have some other guide than the mere surface presents, which may enable him to recollect the varying form.

When the academy figure first strips himself, there is a symmetry and accordance in all the limbs; but when he is screwed up into a posture, there appears a constraint and want of balance. It cannot be supposed, that, when a man has the support of ropes to preserve him in a posture of exertion, the same action of muscles can be displayed as if the limbs were supported by their own energy; and, in all academy drawings, we may perceive something wrong where the ropes are not represented along with the figure. In natural action there always is a consent and symmetry in every part. When a man clenches his fist in passion, the other arm does not lie in elegant relaxation: When the face is stern and vindictive, there is energy in the whole frame: When a man rises from his seat in impassioned gesture, there pervades every limb and feature a certain tension and straining. This universal state of the body it is difficult to excite in those who are accustomed to sit to painters; I see them watch my eye, and where they see me intent, they exert the muscles. The painter, therefore, cannot trust to the man throwing himself into a natural posture; he must direct him, and be himself able to catch, as it were intuitively, what is natural, and reject what is constrained. Besides, those soldiers and mechanics who are employed as academy figures are often stiff and unwieldy; and hard labour has impaired in them the natural and easy motion of the joints.

Until the artist has gained a perfect knowledge of the muscles, and is able to represent them in action without losing the general tone of the figure, he is apt to produce an appearance like spasm or cramp in the limbs from one part being in

action, while the other is loose or relaxed. For it is always to be remembered, that whether the body be alive or dead, whether the limbs be in action or relaxed in sleep, a uniform character must pervade the composition. Whether the gently undulating line of relaxed muscle be the prevailing outline; or the parts be large and strong, and the muscles prominent, bold, and angular; there must be perfect accordance, otherwise there will be no beauty of expression.

I think, that in the sketches, and even in the finished paintings of some artists, I have observed the effect of continuing to draw from the model, or from the naked figure, without due attention to the action of the muscles. I have seen paintings, where the grouping was excellent, and the proportions exact, yet the figures stood in attitudes when they were meant to be in action; they were fixed as statues, and communicated to the spectator no idea of exertion or of motion. This sometimes proceeds, I have no doubt, from a long continued contemplation of the antique, but more frequently from drawing after the still and spiritless academy figure. The knowledge of anatomy is necessary to correct this; but, chiefly, a familiar acquaintance with the classification of the muscles, and the peculiarities and effect of their action.

The true use of the living figure is this; – after the artist has learnt the structure of the bones and the classification of the muscles, he should attentively observe the play of the muscles when thrown into action and attitudes of violent exertion; but, chiefly, he should mark the action of the muscles during the striking out of the limbs. He will soon, in such a course of observation, learn to distinguish between posture and action, and to avoid that tameness which results from neglecting the play of the muscles. And in this view, the painter, after having learnt to draw the figure, as it is usually termed, would do well to make the academy figure go through the exercise of pitching the bar, or throwing or striking. He will then find that it is chiefly in straining and pulling in a fixed posture, that there is an universal tension and equal prominence of the muscles; and that in unrestrained actions only a few muscles rise strongly prominent, and are distinctly characteristic of that action. He will not, perhaps, be able to catch the character of muscular expression, and commit it to paper at once; but with accurate notions of the classification of the muscles, and of the effect of each action in calling into exertion particular sets of them, knowing to what point his observation should be applied, and correcting his preconceived notions by the actual appearance of the limb, each succeeding exhibition of strength will accelerate his progress in the knowledge of anatomical expression, and in correctness of design.

The true corrective for the faults we have pointed out, is to be found in the study of anatomy. It may well be said, that anatomy is the true basis of the arts of design; and it will, infallibly, lead to perfection those who, blessed with true genius, can combine correctness and simplicity with the higher graces and charms of the art. It bestows on the painter a minuteness of observation, which he cannot otherwise attain; and, I am persuaded, that while it will enable him to give vigour to the whole form, it will, also, teach him to represent certain niceties of expression, which, otherwise, are altogether beyond his reach.

8 Philipp Otto Runge (1777–1810) Letter to Goethe, 3 July 1806

The initial inspiration for Runge's study of colour was given by the mystical writings of Jacob Böhme (see VIB5, in particular Runge's letter to his brother of 7 November 1802). From 1804 onwards, however, his enquiries took on a more methodical and 'scientific' character. He was primarily concerned with colour as an observable phenomenon, rather than with its physical basis. His studies were published in the short text, *Farben-Kugel* (Colour Sphere), in Hamburg in 1810. The book was intended to serve as a manual for practising artists, and all reflections on the associational and symbolic character of colours were left to an afterword by the philosopher of nature, Henrik Steffans (1773–1843). In Runge's own artistic practice, however, colour continued to fulfil an important symbolic role. In the painted version of *Morning* (Kunsthalle, Hamburg), for example, the predominance of red is used to signify the dawn of life. In *Farben-Kugel* Runge uses a number of hand-coloured prints to illustrate his theory. The 'colour sphere' itself is a transparent three-dimensional sphere in which twelve individual coloured fields are separated at the two poles by the 'non-colours' of black and white. The model is used to demonstrate the interrelation of colours and the role of light in revealing and dissolving colour. The earliest coherent statement of Runge's theory is contained in the following letter to Goethe of 3 July 1806. We have used it here because it is not dependent upon colour illustrations, as is the book itself. The previous year Runge had sent the poet etchings of his *Times of Day* series, which were warmly received. Goethe offered considerable encouragement to the younger artist and later published the letter in his own *Theory of Colours* (see VIIA9). Runge's ideas were to exercise a powerful influence upon later artists, including Paul Klee, Johannes Itten and members of the *Blaue Reiter*. The letter has been translated complete for the present volume by Nicholas Walker from Philipp Otto Runge, *Die Begier nach der Möglichkeit neuer Bilder: Briefwechsel und Schriften zur bildenden Kunst*, ed. Hannelore Gärtner, Leipzig: Philipp Reclam, 1982, pp. 177–85.

On returning from a brief walking tour through our delightful island of Rügen, where the quiet gravity of the ocean is broken in so many ways by friendly peninsulas and valleys, by hills and rocks, I found, together with the friendly welcome of my family, your esteemed letter. It is a great relief to my mind to find that my sincere wish has been fulfilled, that my work has really found favour in some way. I appreciate very much how you can esteem an approach that does not take the path which you yourself would wish art to pursue; it would be just as foolish for me to impart my reasons for working in this way as it would be to try and persuade you that my way is the right one.

If the skills that are required by painting are associated with such great difficulties for everyone, then this is pre-eminently the case for a person in our time who has begun to practise in quite elementary fields at an age when the intellect has already reached a superior level. It is therefore impossible for such a person, without falling apart, to abandon his individuality and participate in a common effort. One who loses himself in the infinite abundance of the life spread all around him, and is therefore drawn irresistibly to imitate that life, also finds himself seized most powerfully by the total effect in question. He will certainly, in pursuing every characteristic detail, also explore the relationships within nature, the force of great masses. Anyone who, with constant feeling, observes the great masses of all that lives right down to the tiniest

details, and is in turn affected by his observations, cannot imagine how to proceed without a special sense of relationships and connections, cannot even begin to represent his subject without investigating all the basic motifs involved. And in doing so he cannot attain any primary freedom until he has to some extent worked down to the solid foundation.

To make my meaning clearer: I believe that the old German artists, if they had understood the nature of form, would have forfeited precisely that directness and naturalness with which they succeeded in expressing their figures, at least until they could attain a certain level of technical expertise. There have been many people who have been able with a free hand to produce bridges, architectural structures, and truly artistic objects. It may require a long time, but if the artist attains a certain level and suddenly hits upon certain mathematical conclusions for himself, it is quite possible to lose all his talent as a result, unless and until he thoroughly works through the science himself and thereby acquires his freedom once again. For this reason I found it impossible to find respite after I was initially astonished by the special phenomena involved in the combination of colours, until, that is, I was able to develop an image of the entire world of colours, one that would be comprehensive enough to encompass every change and every phenomenon.

On beholding a beautiful landscape, on being touched in some way by an effect of nature, it is most natural for a painter to ask himself with precisely what mixture of substances this effect should be reproduced. This question drove me to investigate the peculiarities of the various colours, to try and penetrate if possible so deeply into their particular qualities that I would clearly understand what these colours can accomplish, what is affected by them, and what in turn affects them.

I hope that you will peruse with generous forbearance this essay which I have written solely with the aim of explaining my views, which I believe must be expressed in their entirety if they are to prove at all useful. However, I do not think that looking at colours in this way is useless for the art of painting, or that the latter can be pursued without it. This opinion will also neither contradict nor render superfluous any optical experiments undertaken in order to acquire more definite knowledge of colours. Since I cannot offer you any incontestable proof based upon exhaustive empirical investigation, I would beg you instead to rely upon your own feeling in interpreting what I meant in saying that the painter need not concern himself with any elements beyond those that are listed here.

1. As is well known, there are really only three colours: yellow, red and blue. If we regard them in all the fullness of their power and represent them to ourselves in a circle, for example, then the three colours give rise rise to three transitional hues: orange, violet and green (I call orange everything that falls between yellow and red or which tends in this direction from the extremes of yellow and red), and these hues, which represent the pure mixtures of colours, are at their brightest in the intermediate position.

2. Trying to imagine a bluish orange, a reddish green or a yellowish violet can only strike us like the idea of a southwesterly north wind. But there is perhaps some substance in what follows that will explain the possibility of a warm violet, and other similar effects of nature.

3. Two pure colours like yellow and red produce a pure mixture: orange. But if we now mix blue with such a hue, it only becomes dirty, and indeed if this is done with equal parts of both the colour is entirely transformed into a dull grey. Two pure colours can be mixed with one another, whereas two intermediate colours simply annul or dirty one another since part of the third colour has also been added. If the three pure colours are transformed to grey, then the three mixtures of orange, violet and green do the same in their intermediate position because the three colours are again all equally strong here. Now since the entire circle only contains the pure transitions of the three colours, which combine with one another only to produce the addition of grey, there is beyond them only black and white to facilitate the multi-plication of further possibilities.

4. All colours are dulled when mixed with white, and even if they become lighter they still lose their clarity and ardour.

5. Black makes all colours dirty, and even if it makes them darker, they too lose their purity and clarity.

6. White and black when mixed together produce grey.

7. One can easily see that this range of three colours, together with white and black, does not exhaust the impressions communicated to us through the eye by the elements of nature. Since white renders colours dull and black makes them dirty, we are therefore tempted to assume a gradation of light and dark. But the following observations will show how far this is really tenable.

8. Apart from this distinction between light and dark in the pure colours, nature also presents us with another striking and important distinction. If we assume, for example, the bright and pure presence of red fabric, paper, satin, taffeta or velvet, of a red sunset or a transparent red glass, there is also the distinction concerning the transparency or opacity of the material in question.

9. If we mix three opaque colours like red, blue and yellow with one another this yields a grey, which can equally be produced by mixing white and black.

10. If therefore we mix the three transparent colours with one another in such a way that no one colour is preponderant, we obtain a dark hue which cannot be produced by either of the other constituent parts.

11. Both white and black alike are opaque or corporeal colours. One should not really object to the expression: a 'white' glass, where it is clear that we mean a clear glass. But one cannot properly imagine water, which is pure, as white, any more than we can imagine the idea of clear milk. If black merely made colours dark, then it could indeed be clear; but since it actually dirties them, it cannot be so described.

12. The opaque colours stand between the colours of white and black, and they can never become as light as white or as dark as black.

13. The transparent colours, whether in brightness or in darkness, are unlimited, just as fire and water can be regarded as marking their height and depth respectively.

14. Grey, the product of the three opaque colours, cannot be rendered pure once again through light, nor through any further mixture of colours. It either fades away into white or darkens into black.

15. Three pieces of glass, each one corresponding to one of the three pure transparent colours, and superimposed upon one another, would produce a dark hue which is deeper than any of the colours taken individually. And precisely in this way: three transparent colours together will yield a dark colourless hue which is deeper than any of the colours themselves. Yellow is, on the one hand, the lightest and brightest of the three colours, and yet, if we mix yellow with a very dark violet until they annul one another, the darkness is strengthened to a very high degree.

16. If we take a dark transparent glass, like a typical optical glass, together with a polished piece of coal of the same thickness, and place both of them upon a white background, then the glass will appear lighter. But if we duplicate both, the piece of coal will appear the same by virtue of its opacity, whereas the glass will darken further in infinite degrees, even though this remains imperceptible to the human eye. This kind of darkness can also be attained by the individual transparent colours, whereas black on the other hand will only appear like a dirty stain.

17. If we attenuate such a transparent product of the three transparent colours in this way and allow the light to shine through, this will also yield a kind of grey, but one very different from the mixture of three opaque colours.

18. The brightness of a clear sky at the rising of the sun, either directly round about the sun itself or in its immediate path, can be so great as to be almost unbearable to us. Now if we wished to infer from this colourless clarity, as the product of the three colours, to the colours themselves, then they would be so bright, would so far transcend our own powers, that they must remain as fundamentally mysterious to us as they are when shrouded in darkness.

19. But now we can also see that brightness and darkness cannot be compared or related to the transparent colours in the same way that black and white can be compared and related to the opaque colours. They represent rather a single quality at one with clarity and colour itself. If one imagines a pure ruby, as thick or thin as one likes, it is always one and the same red, nothing therefore but a transparent red which can become bright or dark depending upon whether it is roused or abandoned by the light. Light naturally also ignites the product of these colours in all its depth and elevates the same to a gleaming clarity which allows every colour to shine

through it. This illumination, of which every colour is capable, insofar as light ignites it to an ever higher intensity of ardour, often wells imperceptibly around us, revealing surrounding objects in a thousand transformations which would never have been conceivable through any simple combination of colours, leaving or even intensifying everything in its own clarity. Thus it is that we can often sense a certain mood diffused over the most indifferent of objects, a mood which more often tends to inhabit the illuminated air that lies between ourselves and the objects than in the actual illumination of the objects themselves.

20. The relationship between light and transparent colour is, if we are prepared to immerse ourselves within it, infinitely appealing. And the sudden intensification of colours, the way in which they merge with one another, along with their reappearance and disappearance, resembles some kind of breathing in the mighty pauses in between one eternity and the next, from the greatest intensity of light right down to the lonely and immortal peace of the deepest tones of all.

22. The opaque colours, on the other hand, resemble flowers which dare not measure themselves against the heavens, and yet participate on the one hand in weakness, that is in white, and on the other in evil, that is in black.

22. But the opaque colours are also precisely capable, when they are combined with neither white nor black but are thinly superimposed upon them, of producing such attractive variations and such natural effects that the practical application of ideas must hold fast precisely to these colours; thus in the final analysis the transparent colours come to play like spirits above the former, serving solely to heighten and intensify their power.

The firm belief in a certain spiritual connection between the various elements can at least offer the painter a comfort and encouragement that he is incapable of discovering in any other way. Even as he loses himself entirely in his work, the cause, means and aims of his art together produce in him, at last, a certain perfection, a perfection that certainly requires the exercise of constant, diligent and faithful effort and cannot therefore fail to exert a beneficent effect upon others.

If I consider the materials with which I work, and maintain the appropriate standard of quality, I certainly know precisely where and how to employ them, since no material that we work with is ever entirely pure. I cannot say much more about the technical aspects here, first because this would prove too lengthy, and secondly because my intention was simply to explain the point of view from which I try and observe colours. I will also readily confess that what I say is still infected with much error. But you will, at the least, be able to acknowledge my efforts here, and further that I will not allow anyone to deter me from the method which, such is my opinion, must be adopted if the stupidities involved in the technical aspects of painting today are to be effectively resisted from within. Nor do I believe that I have followed this path until now without being able to benefit others. But I do lack the requisite chemical and mathematical knowledge to accomplish something more fundamental. I desire with all my heart to find the opportunity of acquiring this knowledge.

If this expression of my views has been successful in clarifying for you certain things in the four engravings [*The Times of Day*], I am sure that I shall be able to

clarify them even more if I might one day send you a sketch in oils. I hope you will also have gathered from my preceding remarks just how little commentary of this sort can succeed in making such things properly intelligible.

For your own information I should say that the sheets in question were not actually engraved by me. 'Morning' and 'Evening' were engraved by Herr Seifer in Dresden, and with regard to the two other pieces, the figures were engraved by Herr Krüger and the ancillary details by Herr Darnstedt, also in Dresden. Since I did my original drawings directly with the pen which they subsequently copied in pencil and imprinted on the plate, it was possible to maintain the design very accurately, although a lot is still lost in the process, as you will see yourself if I may take the opportunity of sending you the original drawings.

As soon as I have time I shall attempt to comply with your further desire to receive some flowers and a silhouette, and it will always prove a pleasure to serve you in any way I can.

I would be most grateful if you would extend my heartfelt greetings to Herr Voigt and his wife, and remain yours in devoted friendship,

Phil. Otto Runge

9 Johann Wolfgang Goethe (1749–1832) from *Theory of Colours*

Like Runge (see VIIA8), Goethe was primarily concerned with colour and light as perceived phenomena and with the accurate description of our actual *experience* of colour. However, his substantial *Theory of Colours*, first published in 1810, formed part of a more ambitious attempt to overcome the divisions attendant upon modern science. He rejects the priority given to mathematics and calculation in the natural sciences, promoting instead a view of science as the discernment of primal phenomena (*Ürphänomena*) and primal polarities (*Ürpolaritäten*). A significant part of the *Theory of Colours* is given up to a sustained, and largely unconvincing, attack on Newton's theory of optics. Nonetheless, Goethe's rehabilitation of subjective experience and his reliance upon the eye as a sufficient tool for the study of colour led to the inclusion of a wealth of observational detail. This made his book a rich source for painters and other interested non-specialists. Whereas Newton maintained that colours were a division of light, Goethe contends that light is homogeneous and that colour arises only when light is disturbed by darkness. There are two primary colours: yellow and blue. The first is positive because of its proximity to light, the second negative because of its proximity to darkness. The two interact through a process of 'augmentation' (*Steigerung*) to produce a third colour, *purpur*, or pure red. Goethe also sought to address the emotive and symbolic qualities of colour and to incorporate these reflections within the framework of scientific enquiry. *Zur Farbenlehre* was first published in Tübingen in 1810. It was translated into English by Charles Eastlake as *Theory of Colours* (London: John Murray) in 1840. Turner read this translation in the 1840s, noting in the margin of his copy the words 'Light and Shade' alongside Goethe's table of polarities given at §696 (see Gage, 1993). One of his own late paintings, on the subject of the 'The Deluge' (Tate Gallery, London) bears the title *Light and Colour: Goethe's Theory*. The following excerpts, from the preface and from parts IV and VI, keep Goethe's original paragraph numbering. We have used the reprint of Eastlake's translation published by MIT Press, Cambridge, Massachusets, 1970, pp. xxxvii–xl, 273–9, 304–18.

It may naturally be asked whether, in proposing to treat of colours, light itself should not first engage our attention: to this we briefly and frankly answer that since so much has already been said on the subject of light, it can hardly be desirable to multiply repetitions by again going over the same ground.

Indeed, strictly speaking, it is useless to attempt to express the nature of a thing abstractedly. Effects we can perceive, and a complete history of those effects would, in fact, sufficiently define the nature of the thing itself. We should try in vain to describe a man's character, but let his acts be collected and an idea of the character will be presented to us.

The colours are acts of light; its active and passive modifications: thus considered we may expect from them some explanation respecting light itself. Colours and light, it is true, stand in the most intimate relation to each other, but we should think of both as belonging to nature as a whole, for it is nature as a whole which manifests itself by their means in an especial manner to the sense of sight.

The completeness of nature displays itself to another sense in a similar way. Let the eye be closed, let the sense of hearing be excited, and from the lightest breath to the wildest din, from the simplest sound to the highest harmony, from the most vehement and impassioned cry to the gentlest word of reason, still it is Nature that speaks and manifests her presence, her power, her pervading life and the vastness of her relations; so that a blind man to whom the infinite visible is denied, can still comprehend an infinite vitality by means of another organ.

And thus as we descend the scale of being, Nature speaks to other senses – to known, misunderstood, and unknown senses: so speaks she with herself and to us in a thousand modes. To the attentive observer she is nowhere dead nor silent; she has even a secret agent in inflexible matter, in a metal, the smallest portions of which tell us what is passing in the entire mass. However manifold, complicated, and unintelligible this language may often seem to us, yet its elements remain ever the same. With light poise and counterpoise, Nature oscillates within her prescribed limits, yet thus arise all the varieties and conditions of the phenomena which are presented to us in space and time.

Infinitely various are the means by which we become acquainted with these general movements and tendencies: now as a simple repulsion and attraction, now as an upsparkling and vanishing light, as undulation in the air, as commotion in matter, as oxydation and deoxydation; but always, uniting or separating, the great purpose is found to be to excite and promote existence in some form or other.

The observers of nature finding, however, that this poise and counterpoise are respectively unequal in effect, have endeavoured to represent such a relation in terms. They have everywhere remarked and spoken of a greater and lesser principle, an action and resistance, a doing and suffering, an advancing and retiring, a violent and moderating power; and thus a symbolical language has arisen, which, from its close analogy, may be employed as equivalent to a direct and appropriate terminology.

To apply these designations, this language of Nature to the subject we have undertaken; to enrich and amplify this language by means of the theory of colours and the variety of their phenomena, and thus facilitate the communication of higher theoretical views, was the principal aim of the present treatise.

* * *

General Characteristics.

688. We have hitherto, in a manner forcibly, kept phenomena asunder, which, partly from their nature, partly in accordance with our mental habits, have, as it were, constantly sought to be reunited. We have exhibited them in three divisions. We have considered colours, first, as transient, the result of an action and re-action in the eye itself; next, as passing effects of colourless, light-transmitting, transparent, or opaque mediums on light; especially on the luminous image; lastly, we arrived at the point where we could securely pronounce them as permanent, and actually inherent in bodies.

689. In following this order we have as far as possible endeavoured to define, to separate, and to class the appearances. But now that we need no longer be apprehensive of mixing or confounding them, we may proceed, first, to state the general nature of these appearances considered abstractedly, as an independent circle of facts, and, in the next place, to show how this particular circle is connected with other classes of analogous phenomena in nature.

The faculty with which colour appears.

690. We have observed that colour under many conditions appears very easily. The susceptibility of the eye with regard to light, the constant re-action of the retina against it, produce instantaneously a slight iridescence. Every subdued light may be considered as coloured, nay, we ought to call any light coloured, inasmuch as it is seen. Colourless light, colourless surfaces, are, in some sort, abstract ideas; in actual experience we can hardly be said to be aware of them.

691. If light impinges on a colourless body, is reflected from it or passes through it, colour immediately appears; but it is necessary here to remember what has been so often urged by us, namely, that the leading conditions of refraction, reflection, &c., are not of themselves sufficient to produce the appearance. Sometimes, it is true, light acts with these merely as light, but oftener as a defined, circumscribed appearance, as a luminous image. The semi-opacity of the medium is often a necessary condition; while half, and double shadows, are required for many coloured appearances. In all cases, however, colour appears instantaneously. We find, again, that by means of pressure, breathing heat, by various kinds of motion and alteration on smooth clean surfaces, as well as on colourless fluids, colour is immediately produced.

692. The slightest change has only to take place in the component parts of bodies, whether by immixture with other particles or other such effects, and colour either makes its appearance or becomes changed.

The force of colour.

693. The physical colours, and especially those of the prism, were formerly called 'colores emphatici,' on account of their extraordinary beauty and force.

Strictly speaking, however, a high degree of effect may be ascribed to all appearances of colour, assuming that they are exhibited under the purest and most perfect conditions.

694. The dark nature of colour, its full rich quality, is what produces the grave, and at the same time fascinating impression we sometimes experience, and as colour is to be considered a condition of light, so it cannot dispense with light as the co-operating cause of its appearance, as its basis or ground; as a power thus displaying and manifesting colour.

The definite nature of colour.

695. The existence and the relatively definite character of colour are one and the same thing. Light displays itself and the face of nature, as it were, with a general indifference, informing us as to surrounding objects perhaps devoid of interest or importance; but colour is at all times specific, characteristic, significant.

696. Considered in a general point of view, colour is determined towards one of two sides. It thus presents a contrast which we call a polarity, and which we may fitly designate by the expressions *plus* and *minus*.

Plus.	Minus.
Yellow.	Blue.
Action.	Negation.
Light.	Shadow.
Brightness.	Darkness.
Force	Weakness.
Warmth.	Coldness.
Proximity.	Distance.
Repulsion	Attraction.
Affinity with acids	Affinity with alkalis.

Combination of the two principles.

697. If these specific, contrasted principles are combined, the respective qualities do not therefore destroy each other: for if in this intermixture the ingredients are so perfectly balanced that neither is to be distinctly recognised, the union again acquires a specific character; it appears as a quality by itself in which we no longer think of combination. Thus union we call green.

698. Thus, if two opposite phenomena springing from the same source do not destroy each other when combined, but in their union present a third appreciable and pleasing appearance, this result at once indicates their harmonious relation. The more perfect result yet remains to be adverted to.

Augmentation to red.

699. Blue and yellow do not admit of increased intensity without presently exhibiting a new appearance in addition to their own. Each colour, in its lightest state, is a dark; if condensed it must become darker, but this effect no sooner takes place than the hue assumes an appearance which we designate by the word reddish.

700. This appearance still increases, so that when the highest degree of intensity is attained it predominates over the original hue. A powerful impression of light leaves the sensation of red on the retina. In the prismatic yellow-red which springs directly from the yellow, we hardly recognise the yellow.

701. This deepening takes place again by means of colourless semi-transparent mediums, and here we see the effect in its utmost purity and extent. Transparent fluids, coloured with any given hues, in a series of glass-vessels, exhibit it very strikingly. The augmentation is unremittingly rapid and constant; it is universal, and obtains in physiological as well as in physical and chemical colours.

Junction of the two augmented extremes.

702. As the extremes of the simple contrast produce a beautiful and agreeable appearance by their union, so the deepened extremes on being united, will present a still more fascinating colour; indeed, it might naturally be expected that we should here find the acme of the whole phenomenon.

703. And such is the fact, for pure red appears; a colour to which, from its excellence, we have appropriated the term 'purpur.'

704. There are various modes in which pure red may appear. By bringing together the violet edge and yellow-red border in prismatic experiments, by continued augmentation in chemical operations, and by the organic contrast in physiological effects.

705. As a pigment it cannot be produced by intermixture or union, but only by arresting the hue in substances chemically acted on, at the high culminating point. Hence the painter is justified in assuming that there are *three* primitive colours from which he combines all the others. The natural philosopher, on the other hand, assumes only *two* elementary colours, from which he, in like manner, develops and combines the rest.

Effect Of Colour With Reference To Moral Associations.

758. Since colour occupies so important a place in the series of elementary phenomena, filling as it does the limited circle assigned to it with fullest variety,

we shall not be surprised to find that its effects are at all times decided and significant, and that they are immediately associated with the emotions of the mind. We shall not be surprised to find that these appearances presented singly, are specific, that in combination they may produce an harmonious, characteristic, often even an inharmonious effect on the eye, by means of which they act on the mind; producing this impression in their most general elementary character, without relation to the nature or form of the object on whose surface they are apparent. Hence, colour considered as an element of art, may be made subservient to the highest æsthetical ends.

759. People experience a great delight in colour, generally. The eye requires it as much as it requires light. We have only to remember the refreshing sensation we experience, if on a cloudy day the sun illumines a single portion of the scene before us and displays its colours. That healing powers were ascribed to coloured gems, may have arisen from the experience of this indefinable pleasure.

760. The colours which we see on objects are not qualities entirely strange to the eye; the organ is not thus merely habituated to the impression; no, it is always predisposed to produce colour of itself, and experiences a sensation of delight if something analogous to its own nature is offered to it from without; if its susceptibility is distinctly determined towards a given state. [. . .]

764. The colours on the *plus* side are yellow, red-yellow (orange), yellow-red (minium, cinnabar). The feelings they excite are quick, lively, aspiring.

Yellow.

765. This is the colour nearest the light. It appears on the slightest mitigation of light, whether by semi-transparent mediums or faint reflection from white surfaces. In prismatic experiments it extends itself alone and widely in the light space, and while the two poles remain separated from each other, before it mixes with blue to produce green it is to be seen in its utmost purity and beauty. [. . .]

766. In its highest purity it always carries with it the nature of brightness, and has a serene, gay, softly exciting character.

767. In this state, applied to dress, hangings, carpeting, &c., it is agreeable. Gold in its perfectly unmixed state, especially when the effect of polish is superadded, gives us a new and high idea of this colour; in like manner, a strong yellow, as it appears on satin, has a magnificent and noble effect.

768. We find from experience, again, that yellow excites a warm and agreeable impression. Hence in painting it belongs to the illumined and emphatic side.

769. This impression of warmth may be experienced in a very lively manner if we look at a landscape through a yellow glass, particularly on a grey winter's day. The

eye is gladdened, the heart expanded and cheered, a glow seems at once to breathe towards us.

770. If, however, this colour in its pure and bright state is agreeable and gladdening, and in its utmost power is serene and noble, it is, on the other hand, extremely liable to contamination, and produces a very disagreeable effect if it is sullied, or in some degree tends to the *minus* side. Thus, the colour of sulphur, which inclines to green, has a something unpleasant in it.

771. When a yellow colour is communicated to dull and coarse surfaces, such as common cloth, felt, or the like, on which it does not appear with full energy, the disagreeable effect alluded to is apparent. By a slight and scarcely perceptible change, the beautiful impression of fire and gold is transformed into one not undeserving the epithet foul; and the colour of honour and joy reversed to that of ignominy and aversion. [...]

Red–Yellow.

772. As no colour can be considered as stationary, so we can very easily augment yellow into reddish by condensing or darkening it. The colour increases in energy, and appears in red-yellow more powerful and splendid.

773. All that we have said of yellow is applicable here in a higher degree. The red–yellow gives an impression of warmth and gladness, since it represents the hue of the intenser glow of fire, and of the milder radiance of the setting sun. Hence it is agreeable around us, and again, as clothing, in greater or less degrees is cheerful and magnificent. [...]

Yellow–Red.

774. As pure yellow passes very easily to red–yellow, so the deepening of this last to yellow–red is not to be arrested. The agreeable, cheerful sensation which red–yellow excites, increases to an intolerably powerful impression in bright yellow–red.

775. The active side is here in its highest energy, and it is not to be wondered at that impetuous, robust, uneducated men, should be especially pleased with this colour. Among savage nations the inclination for it has been universally remarked, and when children, left to themselves, begin to use tints, they never spare vermilion and minium.

776. In looking steadfastly at a perfectly yellow–red surface, the colour seems actually to penetrate the organ. It produces an extreme excitement, and still acts thus when somewhat darkened. A yellow–red cloth disturbs and enrages animals. I have known men of education to whom its effect was intolerable if they chanced to see a person dressed in a scarlet cloak on a grey, cloudy day.

777. The colours on the *minus* side are blue, red–blue, and blue–red. They produce a restless, susceptible, anxious impression.

Blue.

778. As yellow is always accompanied with light, so it may be said that blue still brings a principle of darkness with it.

779. This colour has a peculiar and almost indescribable effect on the eye. As a hue it is powerful, but it is on the negative side, and in its highest purity is, as it were, a stimulating negation. Its appearance, then, is a kind of contradiction between excitement and repose.

780. As the upper sky and distant mountains appear blue, so a blue surface seems to retire from us.

781. But as we readily follow an agreeable object that flies from us, so we love to contemplate blue, not because it advances to us, but because it draws us after it.

782. Blue gives us an impression of cold, and thus, again, reminds us of shade. We have before spoken of its affinity with black. [. . .]

Red–Blue.

786. We found yellow very soon tending to the intense state, and we observe the same progression in blue.

787. Blue deepens very mildly into red, and thus acquires a somewhat active character, although it is on the passive side. Its exciting power is, however, of a very different kind from that of the red–yellow. It may be said to disturb rather than enliven.

788. As augmentation itself is not to be arrested, so we feel an inclination to follow the progress of the colour, not, however, as in the case of the red–yellow, to see it still increase in the active sense, but to find a point to rest in.

789. In a very attenuated state, this colour is known to us under the name of lilac; but even in this degree it has a something lively without gladness.

Blue–Red.

790. This unquiet feeling increases as the hue progresses, and it may be safely assumed, that a carpet of a perfectly pure deep blue–red would be intolerable. On this account, when it is used for dress, ribbons, or other ornaments, it is employed in a very attenuated and light state, and thus displays its character as above defined, in a peculiarly attractive manner.

791. As the higher dignitaries of the church have appropriated this unquiet colour to themselves, we may venture to say that it unceasingly aspires to the cardinal's red through the restless degrees of a still impatient progression.

Red.

792. We are here to forget everything that borders on yellow or blue. We are to imagine an absolutely pure red, like fine carmine suffered to dry on white porcelain. We have called this colour 'purpur' by way of distinction, although we are quite aware that the purple of the ancients inclined more to blue.

793. Whoever is acquainted with the prismatic origin of red, will not think it paradoxical if we assert that this colour partly *actu*, partly *potentiâ*, includes all the other colours.

794. We have remarked a constant progress or augmentation in yellow and blue, and seen what impressions were produced by the various states; hence it may naturally be inferred that now, in the junction of the deepened extremes, a feeling of satisfaction must succeed; and thus, in physical phenomena, this highest of all appearances of colour arises from the junction of two contrasted extremes which have gradually prepared themselves for a union.

795. As a pigment, on the other hand, it presents itself to us already formed, and is most perfect as a hue in cochineal; a substance which, however, by chemical action may be made to tend to the *plus* or the *minus* side, and may be considered to have attained the central point in the best carmine.

796. The effect of this colour is as peculiar as its nature. It conveys an impression of gravity and dignity, and at the same time of grace and attractiveness. The first in its dark deep state, the latter in its light attenuated tint; and thus the dignity of age and the amiableness of youth may adorn itself with degrees of the same hue. [. . .]

Green.

801. If yellow and blue, which we consider as the most fundamental and simple colours, are united as they first appear, in the first state of their action, the colour which we call green is the result.

802. The eye experiences a distinctly grateful impression from this colour. If the two elementary colours are mixed in perfect equality so that neither predominates, the eye and the mind repose on the result of this junction as upon a simple colour. The beholder has neither the wish nor the power to imagine a state beyond it. Hence for rooms to live in constantly, the green colour is most generally selected.

Completeness And Harmony.

803. We have hitherto assumed, for the sake of clearer explanation, that the eye can be compelled to assimilate or identify itself with a single colour; but this can only be possible for an instant.

804. For when we find ourselves surrounded by a given colour which excites its corresponding sensation on the eye, and compels us by its presence to remain in a state identical with it, this state is soon found to be forced, and the organ unwillingly remains in it.

805. When the eye sees a colour it is immediately excited, and it is its nature, spontaneously and of necessity, at once to produce another, which with the original colour comprehends the whole chromatic scale. A single colour excites, by a specific sensation, the tendency to universality.

806. To experience this completeness, to satisfy itself, the eye seeks for a colour-less space next every hue in order to produce the complemental hue upon it.

807. In this resides the fundamental law of all harmony of colours, of which every one may convince himself by making himself accurately acquainted with the experiments which we have described in the chapter on the physiological colours.

808. If, again, the entire scale is presented to the eye externally, the impression is gladdening, since the result of its own operation is presented to it in reality. We turn our attention therefore, in the first place, to this harmonious juxtaposition.

809. As a very simple means of comprehending the principle of this, the reader has only to imagine a moveable diametrical index in the colorific circle. The index, as it revolves round the whole circle, indicates at its two extremes the complemental colours, which, after all, may be reduced to three contrasts.

810. Yellow demands Red–blue,
 Blue demands Red–yellow,
 Red demands Green,
and contrariwise.

10 Joseph Mallord William Turner (1775–1851) 'Backgrounds, Introduction of Architecture and Landscape'

Turner was a successful student at the Royal Academy schools from the age of 14, and first exhibited in their annual exhibitions in 1796. He was elected an associate member in 1799, and then a full member in 1802. He became Professor of Perspective in 1807.

Despite the extent of his reading, and his possession of what Constable called 'a wonderful breadth of mind', Turner's lectures were notoriously difficult to follow. His course usually consisted of six talks, and was given twelve times between 1811 and 1828. Historians have found his notes virtually unintelligible, and have only been able to piece together small parts of them, though John Gage has provided a notable reconstitution of the fifth lecture on colour, from 1818 (see *Art in Theory 1815–1900*, IB2). Apart from that, the only lecture to have been published in full is the present one, which was delivered as the last in Turner's inaugural series on 12 February 1811. In view of the uncommon difficulty of Turner's text, it is useful to consider what his editor has had to say: 'Ostensibly the purpose of this lecture was to explain the role of backgrounds in painting. In fact however, Turner set out to do much more. Even though falteringly, he presents a case for a landscape art capable of stimulating the imagination much as a history painting might' (Ziff, p. 131). For Turner, the most eloquent testimony to the status of landscape art was to be found in the Venetian school, and in particular in the work of Titian. He also esteemed Claude Lorrain and Poussin for their acknowledgement of 'the necessity of rules to produce propriety even in landscape'. By contrast he was critical of the Dutch, with the partial exception of Rembrandt, since they seemed to lack the elevation which Turner believed could set Landscape on a par with History painting. From the British school, Turner singled out for approbation the classical landscapes of Richard Wilson. Our extracts are taken from '"Backgrounds, Introduction of Architecture and Landscape": A Lecture by J. M. W. Turner', edited with an introduction by Jerrold Ziff, *Journal of the Warburg and Courtauld Institutes*, vol. XXVI, London, 1963, pp. 124–47; extracts from pp. 133, 135–6, 137–9, 143, 144–7. We have omitted all but one of Ziff's explanatory footnotes.

To select, combine and concentrate that which is beautiful in nature and admirable in art is as much the business of the landscape painter in his line as in the other departments of art. And from the earliest dawn of colouring, or of combinations from nature, there can be traced, as can be found in the work of Pietro Perugino, the value of attending to a method of introducing objects as auxiliaries by which each master endeavoured to establish for himself a different mode of arrangement by selecting what appeared most desirable in nature and combining it with the highest qualities of the Historic school either as a part of the subject, or even at times allowed [it] to be equal in power to the Historic department. [...]

[T]he highest honour that landscape has as yet, she received from the hands of Titian, which proves how highly he considered its value not only in employing its varieties of contrast, colour and dignity in most of his Historical Pictures; but the triumph even of Landscape may be safely said to exist in his divine picture of St. Peter Martyr. No thought of narrow subservience enters the Idea or appears in the arrangement of that truly great specimen of his powers and of art. The Diana and Acteon is of course from his hand, in the Marquis of Stafford's Collection, in which it [landscape] forms part of a whole with respect to the Subject and general style of the picture, a whole in regard to light and shade, and a whole of everything appropriate. And so connected that [it] becomes one of the main objects of the Picture.

The part, tho' small compared with many of his pictures of landscape, which enters into the composition of that picture he painted of Phillip's Mistress, or known by such name of which formerly grac'd the Orleans collection but now of Earl Fitzwilliam at Richmond, is replete with all his love and true regard for the value

he held of landscape. Brilliant, clear and with deep-toned shadows, it makes up the equilibrium of the whole by contrasting its variety with the pulpy softness of the female figure, glowing with all the charms of colour, bright, gleaming, mellow, full of all the voluptuous luxury of female charms rich and swelling. The sight must return and rest there, altho' the landscape insensibly draws the eye away to contemplate how valuable is its introduction. To keep up that union of interest and support its assistance in attracting the eye from the right hand of the picture can be no small honour.

Here then do I rest my claim that backgrounds, as they are generally call'd, should be divided into such, or those whose merit deserves a better title like the one mention'd before be admitted as part of the picture. For History either disgraces herself by being always in debt to such aids, and degrading those aids with a term applicable to the most useless of the name, or places or considers it so subordinate that its situation might be occupied by any other form equally well. [. . .]

Architectural introductions originated with Paolo Uccello; and Albert Durer continually made use of such arrangements, to the detriment of some of his designs of which his wood plates in the years 1508 to 1515 give ample proof. Yet architecture has been generally admitted as connected with History from its quality as well as the subject of the picture which often requires its introduction. But Paul Veronese has so undoubtedly fixed her powers of combinations for colours, for lights, and for shade as to be of the utmost use, so much so in the picture of the Marriage at Cana as to be inseparable with the design of the whole composition that to take it away a great part of the celebrity of that picture would be taken away with it.

This picture is now at Paris, but it formerly graced the Church of St. George at Venice. The centre is occupied by a sky of pure white and blue; the architecture, light ton'd white marble pavement and the front squares of light colour'd ground without the least indication or intention of shadow across such a space. The figures are wrought to the same high tone as the sky and each figure, single or grouped, relieved from the pure white cloth on the table by the several powers of primitive bright and full toned colours. The only mass of shade exists in the architectural arrangements and the figures under the portico; without the shadow caused by the architecture, no balance or even shade could have been effected so effectively to show his consummate powers of producing so artful an arrangement of light and colour without the appearance of positive shadow or even of it being his intention.

Another specimen which fortunately rests with us is of equal importance to convince everyone of Paolo's powers and of his peculiar choice of architectural Pictures wrought according [to] the words of a great Master upon the same high pitch in the same high key which keynote is likewise blue, but placed on one side of the picture whereas in the former arrangement it holds the centre, forming with the white, the greatest mass of light while the second arrangement is in the Picture of Mercury and Herse in the collection of Earl Fitzwilliam at Richmond. The centre is occupied exclusively by architecture, sculpture and furniture and constitutes the whole mass of shade, particularly a table cover'd with tapestry, making a square form equal to the quarter of the whole. Tho' of different embossed patterns and colours yet it is not allowed to hold the least light. Neither can it be called in shade, possessing a peculiar semi-diaphanous thermae [herm] shadow'd by a rich pink damask curtain

hanging from a composite column on the right behind Mercury, whose entrance interrupted by Aglauros between his feet occupies one side of the picture composed entirely of light colours relieved only by the dark, rich, olive-toned garment thrown behind him. Opposed to this mass of light and colour is the figure of Herse clad in positive blue and white upon a white and dark colour'd pavement. A low-toned sky seen through an architectural arrangement of the composite order behind in shadow makes the remaining part of the picture. Thus the very furniture, the sculpture and architecture, as in the former, *constitute* in a great measure this wonderful production which beyond all doubt weakens Fresnoy's principles of colouring.[1] But each as pictures, these such examples of arrangements cannot or ought not to be considered backgrounds where their parts are keys of tones to the whole picture or at least in the making up of the last picture without which no union of light could have been obtained throughout the whole part but by the bright pavement. And supposing a change, must not the whole be changed? If then by such means as those pointed out such a wonderful production of art has been effected, the joint union of the three departments is established of Landscape, architecture, and sculpture with History. For History suffers only by a union with commonality. Whatever is little, mean and commonplace enters not, or ought not, the landscape of History as an assistant or as a Historical Landscape, or Architecture or Sculpture. Each, tho' separately drawn from the same source, yet should be considered separately for its subject by combining what is truly dignified and majestic and possessing Nature of an elevated quality. This [is the] class of Titian and Giorgione landscapes and Paolo's architecture and other works [which] elucidate the coalition of such powerful auxiliaries that in many instances they not only assert their value but dispute for the palm of celebrity.

Such presumptions must have brought down upon them, and particularly landscape, the dire disgrace she suffers under the hands of Paul Bril and Rottenhammer who, as they saw, painted Nature individually, not collectively, while Bassano's Master [i.e. Titian] has left us the greatest specimen of landscape for grandeur and dignified character, arising from the simplest forms in nature, a few mellow lines, but whose aggregate form seems to have aroused the mind of Titian in the composition of St. Peter Martyr to that point which will be the very standard of his powers and, perhaps, of Landscape. [...]

To Nicolas Poussin let me direct your observation. His love for the antique prompted his exertion and that love for the antique emanates through all his works. It clothes his figures, rears his buildings, disposes of his materials, arranges the whole of his picture and landscape and gives, whether from indifference or strength of his ground, a colour that often removes his works from truth. The Flight of Young Pyrrhus is a tablet of his powers in Landscape composition for grandeur and sublimity by simple forms and lines. The parallel triumphal arch in the right with the foreground trees and the classical introduction of the Ancient Hermes, interrupting the parallel lines, constitute the leading features of the arrangement. The group of frighten'd females, the supplicant with the child, the spearman throwing the dart across the allegorical stream at once show his uncommon abilities in detailing his history and his ruling passion for the antique and allegorical allusion.

The six pictures generally called his landscapes, formerly in the Louvre, are now *dispersed*. One of them, the Roman Youth in the collection of Sir Watkin

Williams-Wynn, The Burial of Phocion in Mr. Hope's and the Street Scene in the late Desenfans' collection, are with us as powerful specimens of his Historic Landscape. A slight view of them is sufficient to demand our admiration and enforce respect for their purity of conception uncharg'd with colour or of strained effects. Buildings [are] classically consider'd and introduc'd with the rules of parallel perspective everywhere regulating and enforcing the wholesome conviction; namely, the necessity of such *rules* to produce propriety even in landscape. [. . .]

Pure as Italian air, calm, beautiful and serene springs forward the works and with them the name of Claude Lorrain. The golden orient or the amber-coloured ether, the midday ethereal vault and fleecy skies, resplendent valleys, campagnas rich with all the cheerful blush of fertilization, trees possessing every hue and tone of summer's evident heat, rich, harmonious, true and clear, replete with all the aerial qualities of distance, aerial lights, aerial colour, where through all these comprehensive qualities and powers can we find a clue towards his mode of practice? As beauty is not beauty until defin'd or science science until reveal'd, we must consider how he could have attained such powers but by continual study of parts of nature. Parts, for, had he not so studied, we should have found him sooner pleased with simple subjects of nature, and [would] not [have], as we now have, pictures made up of bits, but pictures of bits. Thus may be traced his mode of composition, namely, all he could bring in that appear'd beautifully dispos'd to suit either the side scene or the large trees in the centre kind of composition. Thus his buildings, though strictly classical and truly drawn from the Campo Vaccino and Tivoli, are so disposed of as to carry with them the air of composition.

But in no country as in England can the merits of Claude be so justly appreciated, for the choicest of his work are with us, and may they always remain with us in this country. [. . .]

The Flemish school approaches to individual nature, and only two, Rembrandt and Rubens, ever dared to raise her above commonality. Rembrandt depended upon his chiaroscuro, his bursts of light and darkness to be *felt*. He threw a mysterious doubt over the meanest piece of Common; nay more, his forms, if they can be called so, are the most objectionable that could be chosen, namely, the Three Trees and the Mill, but over each he has thrown that veil of matchless colour, that lucid interval of Morning dawn and dewy light on which the Eye dwells so completely enthrall'd, and it seeks not for its liberty, but as it were, thinks it a sacrilege to pierce the mystic shell of colour in search of form.

No painter knew so well the extent of his own powers and his own weakness. Conscious of the power as well as the necessity of shade, he took the utmost boundaries of darkness and allow'd but one-third of light, which light dazzles the eye thrown upon some favourite point, but where his judgment kept pace always with his choice surrounded with impenetrable shade still remains.

Rubens, Master of every power of handicraft and mechanical excellence, from the lily of the field to animated nature, disdained to hide, but threw around his tints like a bunch of flowers. Such is the impression excited in his Fête in the Louvre, wholly without shadow compar'd to Rembrandt's mode, obtaining everything by primitive colour, form and execution, and so abundantly supplied by the versatility of his genius with forms and lines, could not be happy with the bare simplicity of pastoral

scenery or the immutable laws of nature's light and shade, feeling no compunction in making the sun and full moon as in the celebrated picture of the Landscape with the Waggon, or introducing the luminary in the Tournament, while all the figures in the foreground are lighted in different directions. These trifles about light are so perhaps in Historical compositions, but in Landscape they are inadmissible and become absurdities destroying the simplicity, the truth, the beauty of pastoral nature in whose pursuit he always appears lavish of his powers. Full of colour, the rapidity of his pencil bears down all before it in multitudes of forms, not the wild incursions full of Grandeur as Salvator Rosa, but [the] swampy vernality of the Low Countries.

Without affecting to do anything, Teniers has given us that individuality, which the great genius of Rubens in his Flemish Fête and pastorals always seem'd in search of. Artfully arrang'd and exquisitely touched tho' looking careless, bearing a freshness and silvery tone pervading everywhere thro' all the diversity of colours, tho' scatter'd upon the innumerable figures of the Flemish Marriage Feast at Louther Castle, yet all the tones tend by his consummate management, concentrated, to one figure in white and grey which binds the whole together.

Cuyp, Paul Potter and Adrian van der Velde sought for simplicity below commonality which too often regulated their choice and alas their introductions, yet for colour and minuteness of touch of every weed and briar long bore away the palm of labour and execution. But Cuyp to a judgment so truly qualified knew where to blend minutiae in all the golden colour of ambient vapour.

Gainsborough, our countryman, rais'd their beauties by avoiding their defects, the mean vulgarisms of common low life and disgusting incidents of common nature. His first efforts were in imitation of Hobbema, but English nature supplied him with better materials of study. The pure and artless innocence of the Cottage Door now in the possession of Sir John Leicester may be esteemed as possessing this class, as possessing truth of forms arising from his close contact with nature, expression, full-toned depth of colour and a freedom of touch characteristically varied with the peculiarities of the vigorous foliage or of decaying nature.

To this rustic simplicity of nature unadorned contrast the meretricious Zuccarelli with all the gay materials of Watteau without a grain of Watteau's taste. His figures are often beautiful, but in general poor, plac'd always to demand attention as to colour, yet they defrauded the immortal Wilson of his right and snatched the laurel from his aged brow. In vain did his pictures of Niobe in the possession of Sir George Beaumont and the Duke of Gloucester flash conviction of his powers, or Ceyx and Alcyone and Celadon and Amelia display contending elements or the Cicero at his Villa sigh for the hope, the pleasures of peaceful retirement, or the dignified simplicity of thought and grandeur, the more than solemn solitude that told his feelings. In acute anguish he retired, and as he lived he died neglected.

[1] Turner probably had in mind Du Fresnoy's admonition against using the same key or brightness of colouring.

11 David Cox (1783–1859) from *A Treatise on Landscape Painting and Effect in Water Colours*

As a medium for the recording of topography and for capturing atmospheric effects, watercolour received its most extensive exploration in Britain during the later eighteenth century, where it was associated with widespread interest in landscape as a source of the picturesque. Besides the considerable number of professional artists who worked in watercolours, a host of amateurs adopted the medium with varying degrees of success. As a consequence there was a ready market for practical instruction. David Cox was one of a number of artists of his generation who worked primarily in the medium of watercolour, though he also began to paint in oils at a relatively late stage in his life. After a varied early career in Birmingham, in 1804 he moved to London, where he received some instruction from John Varley. He rapidly made a name for himself as a painter in watercolours, specializing in the relatively new genre of rustic scenery – new insofar as its subjects included the 'lowly' and previously unconsidered elements of the countryside: cottages and farms, lanes and rivers, pollarded willows and collapsing fences. He exhibited for the first time with the Royal Academy in 1805 and with the Associated Artists in Water-Colours in 1809. He was made President of the latter the following year, and in 1812 was elected an Associate of the Society of Painters in Water-Colours, founded eight years previously. He began teaching in 1808 and issued three books of instruction between 1813 and 1820. The first of these was *A Treatise on Landscape Painting and Effect in Water Colours, from the first rudiments to the finished picture. With examples in Outline, Effect, and Colouring*, London: S. and J. Fuller, 1813–14. A revised edition was issued in 1840–1. Advances in the technology of reproductive printing in the late eighteenth and early nineteenth centuries did much to enlarge the market both for topographical studies and for books of instruction (see also VIIA12). Cox's volumes were clearly intended to cater to both. They were handsomely illustrated with soft-ground etchings after his own pencil and crayon drawings, and with aquatints after his sepia studies and watercolours, 'so selected, as to display an unusual variety of the most picturesque scenes in England and Wales' (from the advertisement on the cover of the original 1813 edition). Our excerpts from Cox's introduction are taken from the Studio reprint of the 1813 edition, ed. Geoffrey Home, London: The Studio, 1922, pp. 11–15.

General Observations On Landscape Painting.

The principal art of Landscape Painting consists in conveying to the mind the most forcible effect which can be produced from the various classes of scenery; which possesses the power of exciting an interest superior to that resulting from any other effect; and which can only be obtained by a most judicious selection of particular tints, and a skilful arrangement and application of them to differences in time, seasons, and situation. This is the grand principle on which pictorial excellence hinges; as many pleasing objects, the combination of which renders a piece perfect, are frequently passed over by an observer, because the whole of the composition is not under the influence of a suitable effect. Thus, a Cottage or a Village scene requires a soft and simple admixture of tones, calculated to produce pleasure without astonishment; awakening all the delightful sensations of the bosom, without trenching on the nobler provinces of feeling. On the contrary, the structures of greatness

and antiquity should be marked by a character of awful sublimity, suited to the dignity of the subject; indenting on the mind a reverential and permanent impression, and giving, at once, a corresponding and unequivocal grandeur to the picture. In the language of the pencil, as well as of the pen, sublime ideas are expressed by lofty and obscure images; such as in pictures, objects of fine majestic forms, lofty towers, mountains, lakes margined with stately trees, rugged rocks, and clouds rolling their shadowy forms in broad masses over the scene. Much depends upon the classification of the objects, which should wear a magnificent uniformity; and much on the colouring, the tones of which should be deep and impressive.

In the selection of a subject from Nature, the Student should ever keep in view the principal object which induced him to make the sketch: whether it be mountains, castle, groupes of trees, corn-field, river scene, or any other object, the prominence of this leading feature in the piece should be duly supported throughout; the character of the picture should be derived from it; every other subject introduced should be subservient to it; and the attraction of the one, should be the attraction of the whole. The union of too great a variety of parts tends to destroy, or at least to weaken the predominance of that which ought to be the principal in the composition; and which the Student, when he comes to the colouring, should be careful to characterise, by throwing upon it the strongest light. In his attention to this rule, however, the Student must be particular not to fall into the opposite extreme, by suffering the leading object of his composition so fully to engross his attention as to render him neglectful of the inferior parts. Because they are not to be exalted into principals, it does not follow that they are to be degraded into superfluities.

All the lights in a picture should be composed of warm tints, except they fall on a glossy or reflective surface; such as laurel leaves, glazed utensils, etc., which should be cool, and the lights small, to give them a sparkling appearance: but care must be taken not to introduce a cold colour in the principal light, which, as already mentioned, should be thrown upon the leading feature of a picture, as it conduces to destroy the breadth that should be preserved; while on the contrary, the opposition or proximity of a cool to a warm colour assists greatly in giving brilliancy to the lights. If the picture, for instance, should have a cool sky, the landscape ought to be principally composed of warm tints; as contrast of this description tends to the essential improvement of the general effect.

All objects which are not in character with the scene should be most carefully avoided, as the introduction of any unnecessary object is sure to be attended with injurious consequences. This must prove the necessity of becoming thoroughly acquainted with, and obtaining a proper feeling of, the subject. The picture should be complete and perfect in the mind, before it is even traced upon the canvas. Such force and expression should be displayed, as would render the effect, at the first glance, intelligible to the observer. Merely to paint, is not enough; for where no interest is felt, nothing can be more natural than that none should be conveyed.

Finally, it may be observed, that it is only by a due attention to each distinct part, and by a skilful combination of all, that the whole can be effective and delightful.

On Outline.

The young draftsman who is ambitious of future eminence must be close in his attention to those minute points which, skilfully combined, constitute the excellence of the painter. In the outset, it will be necessary for him to be particular in his designation of the Outline, for the perfection of which, he must possess a clear conception of his subject; otherwise, be his genius what it may, he will wander wildly, without either promoting his own satisfaction, or conveying a definite or correct idea to the observer. Too little attention has generally been paid to this point, by Students: they are too apt to appear disconcerted and discouraged, when the task wears a complexion of difficulty.

A clear and decided Outline possesses a manifest superiority over an imperfect or undecided one, inasmuch as it renders unnecessary those continual references to Nature or to copy, which must be had recourse to, where the Outline is defective. He who devotes his time to the completion of a perfect Outline, when he has gained this point, has more than half finished his piece; while the author of a slovenly Outline creates for himself an infinity of trouble, in order to evade additional errors in the colouring of his subjects; and after all his efforts, finds it impossible to produce a picture perfect in any one part. To attain proficiency in the art of pencilling, the Student is recommended to practise Drawing from the casts of the antique, by which study he will acquire a growing facility in the designation of fine forms, as well as a more correct and decided mode of outlining. The Pupil will also find his progress greatly accelerated by the dedication of his leisure moments to copying objects of still life – a practice which will be found replete with advantage, when he studies combinations of subjects for compositions of landscape scenery.

In tracing the distinct objects of a landscape, it is recommended to attend more particularly to the general forms than to detail: for example, in sketching a mountain, it will be sufficient to describe the extreme Outline, without descending to the diversified and numerous ridges which may appear; for although these uneven divisions arrest the attention of the Student, when engaged in tracing the particular form of the eminence, they are lost to the eye which embraces, at one view, the whole of the scene. A greater degree of minuteness, however, ought to be observed in the Outline of the fore-ground of a picture, where the features of the object assume a more specific appearance, shewing decided forms, and obtruding all their diversities of shape upon the view. To obtain excellence in this respect, it will be necessary to make correct drawings from Nature, of weeds, plants, bark of trees, and such objects as usually constitute the foreground of a landscape.

The Student must first commence with perpendicular, horizontal, and diagonal lines, to give the hand that freedom and certainty which are necessary. The Drawing must be strongly marked in the shade and fore-ground of the subject, but more delicately in the lighter parts, and as the distance gradually increases. Due attention to this cannot fail to give the true spirit and perspective. The Plates of this Work should be copied in regular succession, and any bad line that may be made should be entirely expunged; for all effort to rectify, by retouching, will only give the piece

a scratched and indecisive appearance, and consequently will cause confusion and mistakes in the colouring.

Any little failure must not be made the source of discouragement; and in case the Student should not have succeeded altogether so well as could be wished, in the first attempt, he ought by all means to persevere until completely successful; carefully endeavouring, in his renewed efforts, to avoid the same errors. This mode will assuredly be followed with far greater improvement than can possibly attend hasty transitions from one subject to another, without producing perfection in either.

The best and surest method of obtaining instruction from the Works of others is not so much by copying them, as by drawing the same subjects from Nature immediately after a critical examination of them, while they are fresh in the memory. Thus they are seen through the same medium, and imitated upon the same principles, without preventing the introduction of sufficient alterations to give originality of manner, or incurring the risk of being degraded into a mere imitator.

If the mind be fixed and sincere in pursuit of the Art, difficulties will be easily surmountable: they will rather quicken than damp the desire for improvement; for it is only where talent is required that Genius can be active. The accomplishment of one task will only give additional stimulus for the performance of another. Increasing pleasure will naturally flow from progressive improvement. The mind will ever be busily and pleasingly employed; for 'the effect of every object that meets a Painter's eye may give him a lesson.'

12 William Henry Pyne (1769–1843) Preface to *Etchings of Rustic Figures*

Pyne was trained as an artist in London and worked as a draughtsman, illustrator and writer. He first exhibited at the Royal Academy in 1790 and was a founder member of the Society of Painters in Water-Colour in 1804. He is best known for his volumes of picturesque vignettes, printed in etching and aquatint from his own drawings. The first of these was *Microcosm*, issued from 1803 to 1808. *The Costume of Great Britain* appeared in 1808. Pyne contributed the text to the first two volumes of Rudolph Ackermann's *Microcosm of London*, published in the same year, and wrote on a regular basis for Ackermann's monthly magazine *Repository of Arts*, published from 1809 to 1828. *Etchings of Rustic Figures, for the Embellishment of Landscape* was issued in London in 1815 by M. A. Nattali, with a preface written by the artist. The numerous illustrations provided readily transplanted examples of 'staffage' for painted landscape, in some cases with the addition of suggestive backgrounds. Pyne's text provides evidence both of the prevalence of amateur landscape painting in the early nineteenth century, and of Gainsborough's importance in establishing the genre of 'English pastoral'. The other artists referred to were all known at the time for their work on rural subjects. Richard Westall (1765–1836) painted genre subjects in a style elevated to the point of archness (and is more likely to be the subject of Pyne's reference than his artist brother William). Joshua Cristall (1765–1836) worked mainly in watercolour and brought an interest in classical style to carefully observed genre subjects. Thomas Barker (1769–1847) published his *Impressions of Rustic Figures after Nature* in the new technique of lithography in 1813. George Morland (*c.*1763–1804) established a widespread reputation both in England and on the Continent.

A large number of his works on rural themes were engraved between 1780 and 1797. Pyne was to be ruined by his next venture, *The History of the Royal Residences*, with 100 engravings illustrating his own text, published between 1816 and 1819. Our complete text of the Preface to *Etchings of Rustic Figures* is taken from the reissued edition of 1820, pp. 3–8.

In no age and in no country perhaps, have the fine arts met that public patronage which they happily experience in England in the nineteenth century. Every respectable member of the superior classes of society appears emulous to afford his children the advantages of an enlightened education: hence the most distinguished professors in every branch of science have ample employment in communicating their knowledge to the rising generation. The art of painting, among the first in utility, forms a material feature in the plan of education; and the encouragement which its professors have experienced, has called forth their utmost energies in producing works that will facilitate the improvement of their disciples: preceptive books, upon almost every department of the art, have been published. The little work here offered to the public will, it is hoped, contribute something to the general stock of information.

Landscape-painting has long been cultivated with the utmost success by British artists, and works have been produced by them that rival those of the Italian, Flemish, or other distinguished ancient schools.

The rage for making tours, which has so long distinguished the British people, has increased for several years, until it has become the prevailing taste of the higher families to explore the country in search of the picturesque. Numerous portfolios are filled every summer with topographical studies made by amateurs, as well as artists, during these excursions, until those who remain at home can indulge in viewing the romantic and rural scenery of our beautiful island by their fire-side.

The study of appropriate figures for the embellishment of these scenes has not been followed with equal ardour: hence many whose taste is displayed in the representation of landscape, lose their credit by the introduction of groups of figures that are greatly inferior to their well-painted designs. To remedy this defect in some measure, these groups have been formed: their costumes, characters, and general employments have been attended to; which may not alone furnish subjects to compose groups from, but may also lead the student to select figures of a similar class in nature, from which they may make their own original studies.

It has not been the object of the author of this work to represent elegant forms, or to aim at correct drawing; his intention has been, simply to sketch the prominent character and habits of the rustic. Those young students who desire to excel in painting groups of figures in their landscapes with original feeling, may commence by drawing from the etchings here offered, and may derive much improvement by contrasting their dresses by the application of such colours as are usually exhibited in great variety, by persons whose attire is regulated by no rules of taste. Those whose travel will improve their knowledge in these matters, by marking in a common-place book the contrasts which they may find in contemplating the dress of this class of people in the towns and villages where they may chance to stop: this practice will be attended with no trouble. Reference to such memoranda, in the painting-room, readily furnishes the mind with what it otherwise might seek for very long, or

perhaps in vain. In London, or other populous towns, where there is a general uniformity of dress, these necessary observations cannot be made.

It has long been the practice of those who make sketches of views from nature, to leave the embellishments of figures, animals, &c. to a future period, fancying that groups for this purpose can be composed at leisure: this practice is erroneous. It is highly essential to sketch figures, animals, or other objects, to embellish the design, upon the spot: the groups then assume the air of nature; their occupations are mostly accordant to the scene; and they are consequently appropriate in action, character, and every essential that constitutes fitness or propriety.

The eye that is accustomed to look for truth of representation in all the embellishments of a landscape, cannot tolerate what is so commonly met with in pictures of great merit in many other respects; namely, the want of character, not only in figures, but in expletives, that should give value from their form and appropriate uses. A pump or well, a wheel-barrow, a cart, plough, or other object, if not represented with attention to mechanical construction, instead of adding to the interest of the piece, really deteriorates its merit.

The student should make himself acquainted with the true form of these objects, by carefully drawing them in every point of view. This study is amusing as well as useful, great satisfaction resulting from a successful imitation of any object that can be introduced into a picture. Our best painters copied nature in detail, or they could never have produced such identity in every object which they represent. Nothing appears a labour to those who have drawn with accuracy at the commencement of their study. Gainsborough, whose pictures appear to the unskilled in art scarcely intelligible, copied weeds, dock-leaves, and all the minutiæ of fore-grounds with unwearied accuracy: hence a few touches of his magic pencil described the character of such objects.

It would be no less useful to copy groups of animals from the best prints of these subjects, previously to attempting to draw them from nature: for cows, horses, asses, deer, sheep, dogs, and pigs, should be represented with as much truth of character as the human figure; and a landscape, however well painted, wherein these domestic animals appear defective in character, loses half its charm.

Hills's Etchings of Animals drawn from nature form the most celebrated work designed for this purpose, and should be possessed by all who feel desirous of acquiring a just knowledge of their picturesque character. The whole work may be too voluminous for every one to possess; but as separate parts can be had, 'neat cattle, sheep, horses, deer, asses, mules,' &c. it is recommended, that some specimens of them should be procured, as they comprise all that is excellent in the study of domestic animals.

The same mode of acquiring a certain knowledge of colouring animals should be resorted to as described for figures. The student should sketch, however slightly, the masses of black, brown, red, and other colours that variegate the hides of animals; by which means the most beautiful combinations of tints may be procured, and without which practice this necessary art can never be sufficiently understood.

That species of landscape composition which best suits rustic figures of the humble class, similar to those contained in this work, is most generally cultivated by the artists and amateurs of this country; it has been denominated English pastoral.

To explain what is understood by this term, reference may be made to the compositions of Gainsborough, whose landscapes possessed no other characteristics than those which the woods, copses, hamlets, heaths, lanes, and such places, unadorned by art, offered for his imitation. It was in the midst of such scenes in the county of Suffolk that he first studied drawing. His feeling mind led him to select such parts and such objects as nature, or the rudest works of art, combined with nature, afforded in these sequestered spots. The humble inhabitants that peopled these scenes he made the equal objects of his study, and chose from among them such as were most congenial to his poetic fancy: for all that he copied, although it had the appearance of fidelity to its prototype, yet had a certain portion of his original feeling incorporated therein, that accorded with what the poets have termed the pastoral style.

If he sketched a milk-maid, he selected a girl for his model that captivated by her beauty and native sweetness. Cottage children, whom he delighted to paint, were the offspring of health and innocence. His old men were not like those of Ostade, Hemskirk, and other painters of the Dutch and Flemish schools, sordid boors; they were open, artless, grey-headed swains, scarcely bending beneath the burthen of old age.

The groups that are represented in the accompanying plates, are designed to embellish landscapes wherein the figures are secondary objects. Those who desire to study the same class of characters on a larger scale, may select groups or single figures therefrom, and enlarge them by the addition of a little original feeling of their own, which will afford a useful preparatory exercise, fitting them to draw rustic figures from nature.

To improve in such a pursuit, it is recommended to study the works of those artists who have most excelled in forming pictures representing the peasantry of our country. Westall's compositions will afford them the means of acquiring as much elegance of form and tasteful arrangement as such a style can possibly admit of; indeed, some of the pictures of this artist have a superabundance of these qualities, amounting to a fault. But it is the business of him who wishes to improve, to study those works which possess the greatest degree of originality and boldness of design. A great genius will sometimes outstep the boundary of truth; but the energies of such a mind afford examples that genius alone will venture to produce, stimulating the imitator to try his own strength in bold flights of the imagination, which experience will regulate by sober rules.

The works of Cristall in this department will afford the student the means of much improvement; simplicity of character, united with grandeur of style, distinguish his designs. His cottage groups, gleaners, fishermen, and other subjects of the humble class of life, are admirable specimens of the graphic art.

Another eminent artist, Barker, may be instanced, whose works display a great acquaintance with these subjects. Those who admire the compositions of Gainsborough will find much of his taste in the figures and general compositions of this artist. Perhaps among all the living painters, no one has so successfully continued Gainsborough's style of design.

A work of Rustic Figures has lately been published at Bath by this artist; the characters are well drawn, are natural, and engraven in the polyautographic art. They

would afford improvement to those who would copy them with attention, as the style is not difficult, and is replete with freedom of line.

The engraved Rustic Figures in imitation of the original drawings in chalk by the late George Moreland, are also excellent specimens of style; they are executed with the utmost freedom of pencilling, and exhibit a just observation of character. A knowledge of breadth may easily be acquired by imitating these original works.

In drawing figures of this class from nature, it is recommended, to commence by making a faint outline of the general form of the object; when that is effected, the proportions must be studied, which should also be made out by tender lines. The masses of shadow should next be lightly rubbed in with a blunt pencil or chalk; this prepares the sketch for finishing. The lines towards the light should be drawn delicately and with determination of form. The shadows on the light side must be kept in so low a tone as not to interrupt the breadth of effect. The bolder pencilling should be reserved for the last process, and principally confined to certain shadows of the features, the hair, and the drapery on the shadowed side. By a steady adherence to these rules, when drawing from nature, the character of masterly execution may with certainty be attained.

13 Henry Richter (1772–1857) from *Daylight: A recent Discovery in the Art of Painting*

Richter was an English engraver and watercolourist active in the Associated Artists in Water-Colours, who had some success with small-scale genre scenes on paper. His eccentric publication was directed 'to the Governors and Directors of the British Institution for promoting the Fine Arts in the United Kingdom'. It is prefaced by a brief 'Advertisement' in which he disparages 'the present style of Art in Paris' for pursuing an impossible perfection, and for preferring 'the imitation of an imitation to the more active and immediate study of the great original'. In contrast he expresses his hope for a new 'period of intellectual grandeur', informed by the example of Shakespeare's genius, by the achievements of Hogarth and Reynolds, and by the philosophy of Immanuel Kant. The conclusion to his Advertisement is that 'Originality is the Soul of Art'. The text that follows – the *Daylight* of Richter's title – is framed as an imaginary and humorous discussion between the author and a number of Dutch and Flemish painters, Teniers, Cuyp, Rubens, Van Dyck and Rembrandt among them, at the closing of an exhibition of Dutch and Flemish pictures at the Royal Institution (the event that presumably motivated Richter in the first place). The discussion concerns the relative darkness of the paintings on display, and the changes that might be effected by lighting painting as though by daylight with the sun overhead. Richter's apparent purpose is to suggest that differences in style are to be accounted for by differences in the conceptions imposed upon nature. His 'daylight' functions as a kind of metaphor for the 'direct appeal to Nature itself', which he sees as the mark of originality. The imaginary discussion occupies a mere dozen pages, but it is accompanied by a further fifty pages of footnotes. The majority of these are taken up by note 4, which is indexed to a question voiced by Richter concerning 'The diversity of styles, or, as they are termed, the different ways of seeing Nature'. The note expands into a lengthy discourse upon the theory of painting. We include four excerpts. The first offers a critique of David's *Brutus* (Louvre, Paris) as an example of painting regulated by a classical ideal (see IVB2, 3).

The second is concerned with the indispensable role of invention in history painting, and in art in general. The third argues for the status of painting as a form of language. In the fourth Richter argues that the intrinsic poetic function of painting is to be found in its relation to Mind, and that in modern times this function can only be obscured by dependence on irrelevant classical mythology. Our text is taken from the original edition, *Daylight; A recent Discovery in the Art of Painting: with hints on the Philosophy of the Fine Arts, and on that of the Human Mind, as first dissected by Emanuel Kant*, London: R. Ackermann, 1817, pp. 20–3, 33–6, 36–40, 50–4.

How general and simple in its form is the *nose* of the EARLY ANTIQUE bust! – It is made by the means of a few measurements from half a dozen points accurately and judiciously settled in the mind of the sculptor, and then transferred to the marble.

There was never, in fact, *such a nose* on any living face; but it serves admirably well as the *nose of a statue*. The same thing may indeed be said even of the most refined of the antique marbles.

The affectation of this *marble style*, with the addition unfortunately of no small portion of the very matter and substance of the marble itself, forms the basis of the *bel idéal* of the modern French.

It may be said, perhaps, that there is actually buried within each of their marble figures one of their admirable stuffed *Dolls*, and that the surface is only a case of *cement*, cut after the antique fashion; – but, plausible as this may seem, whoever looks upon the BRUTUS of DAVID will see too plainly, that the dolls there exhibited have at least *a heart of stone*.

The following rude outline of the method used in the production of certain works in the *grand style* of Art in Paris, though strongly marked, and describing the mechanical part of the process only, is by no means uncharacteristic.

The artist takes as many *Dolls*, of the size of life, as he means to have figures in his picture, and sets them all up in such attitudes as suit his notions of composition – dresses them in the actual costume required by his subject, according to the best authorities, with helmets, swords, shields, &c. of *papier mâché* painted or gilt: – he then goes off to a distance, and makes a correct drawing of the whole.

Here begins the more difficult part of the work.

He takes his drawing to the Louvre, before the public is admitted, or refers to his own private collection of antique casts, and there he picks out such legs, arms, heads, hands, feet, &c. as come the nearest in attitude to those of his drawing which remain uncovered by drapery.

From these casts he copies the markings of the anatomy with great minuteness, finishing with the finger and toe-nails, and the clotting of the hair after the manner of the stony wigs of the Greeks.

The DESIGN being thus completed, the artist returns to his *atélier*. There stand his Dolls, and his canvas *fair* and *smooth*. He delivers the drawing to his *élève*, to enlarge and transfer to the cloth; and, in the mean time, walks on the Boulevards to receive the salutes and congratulations of his friends.

Again he returns to his patient and indefatigable Dolls. From them he paints his picture. Still *something* is wanting. Even French taste would not be yet content with it.

'Il y manque un peu de nature, d'âme, de sentiment.'

'Eh bien donc, voici ce qu'il fait.'

He hires a *valet de place*, shifts a Doll at a time, and puts him in the room of it; first strips one leg and then another; and *from the very life itself*, by a thin glazing, tinges the naked parts of his figures with the colours of *real skin*.

Nothing is now wanting but the last magical touches, 'pour y donner l'expression.'

Madame, or Mademoiselle, who has already obliged the painter by the display of her *carnations* for the skin of his female figures, and Messieurs, his male friends, are now called upon to perform their last kind and important offices, by sitting for the gloss of the eyes and teeth, as in the intervals of the work they had indeed occasionally done, for the knitting of the brows and the other contortions of the face.

'Et voila tout. Ah, qu'il est naturel et imposant!'

It would be no bad test of pictures to conceive them suddenly endowed with life, and that each figure should express the thought that might fairly be supposed to pass in its mind.

A trial of this sort really took place in the Louvre upon the *Brutus* of Baron David.

The headless trunks of the sons began to move forward. The lictors, one of whom is evidently the same young gentleman that looks on with so much graceful indifference at their execution in M. le Thiere's picture, are bringing the bodies into the very chamber where the wretched mother and sisters have retreated.

'Ah, que le moment est interessant!' said a Frenchman at my back.

'Quel fond d'esprit il faut que M. David âit eu pour choisir une telle position!!!' said I.

'Diable! vraiment il a beaucoup d'invention.'

At this instant we all started to hear the wife of Brutus exclaim, 'Où avez vous laissé leurs têtes? – Pourquoi ne les avez vous pas apportées avec vous? – Allez quelqu'un – les chercher.'

And one of the daughters immediately added, 'Ah, qu'ils sont vilains sans têtes!'

Brutus himself sat quietly in the corner. With one hand he griped hard a roll of parchment, the other inclined gently toward his head. We heard his toe-nails scratch the pavement; but, to our great disappointment, he said nothing.

Some English officers who were present laughed heartily at this little farce, and the Frenchman muttered, 'John Bull!'

So much for the *abuse* of the OLD ANTIQUE, and for the *marble manner* which the French painters have founded upon it. What better use will be made of the NEW antique remains to be seen.

When the marbles of Phidias shall have been more profoundly studied, and after repeated copyings the happy students shall have 'plucked out the heart of their mystery,' I am in hopes that we may be favoured with an *exposé* of the principles upon which *their peculiar excellence* is founded, with some concise and clear directions for the production of works equally *accurate, noble*, and *original*; and to those students I leave for the present the task of comparing them with the other STONES of the ANCIENTS. I shall also be extremely anxious to learn from their successful labours, whether, after the fall of the Apollo, the Torso, the Gladiator, &c. &c. the objects of our hitherto BLIND IDOLATRY, the claim of ABSOLUTE INFALLIBILITY is to be set up *anew* in favour of these NEW DIVINITIES; to the 'uncriticizing' and '*brooding*' admiration of

which, the modern artist, during TWO THIRDS, if not THE WHOLE OF HIS LIFE, is again to be held in a state of 'subjection,' and taught that 'HE MUST STILL BE AFRAID OF TRUSTING HIS OWN JUDGMENT.'

* * *

I conclude it to be the opinion of most people, that, were it possible to arrest the course of events at the precise *moment* when some great action was arrived at its crisis, the faithful representation of *this* would, in all cases, constitute the most perfect picture of the action; but the venerable President of the Academy knew well, when he painted the DEATH OF WOLF, that this was a very great mistake. The business of Nature and of Life is not to construct pictures; and the hero in the midst of his action no more adapts his attitude to the requisites of painting, than his words to the language of poetry.

It is from the *general storehouse* of Nature that the Painter selects the materials for each individual work, surveying at once all that is connected either in fact or by association with the incident he depicts; he adopts all that can convey and impress the sentiment or explain the action, and rejects whatever might distract the judgment or weaken the feeling.

HISTORICAL PAINTING is, in fact, not a representation of a written history, it is not even a strict imitation of an historical event; it is A HISTORY IN ITSELF, told in a peculiar language of its own: and INVENTION, viewed in *this* light, must be admitted to be completely TECHNICAL, requiring a peculiar education and habit of mind in the Painter.

It speaks a language, indeed, highly congenial to our nature, being founded upon that lively *play of the judgment* which we denominate *Fancy*, and which adorns and illustrates its more serious labours.

This faculty, of which our enthusiastic Professor of painting speaks with an ardour that well becomes one so highly endowed with it, he rightly terms a power of 'unpremeditated conception.' It operates according to natural and unerring laws, subject only to the restrictions which the legislation of Reason itself, in the organization of a systematic whole, imposes upon it.

This, in the Fine Arts, is GENIUS – the INVENTIVE FACULTY *itself*. It consists entirely in an exuberant activity of the judgment, which, in seeming sport, darts through the fields of thought, and often lights on regions never before explored, bringing home the treasures of science on the light wings of the wit. [. . .]

When MAN is the object which the Painter aspires to represent, it is beneath HIS intellectual and moral dignity that the human form should be displayed as a mere beauty of Nature, for HIS *chief* excellence does not consist in this. Even corporeal action, however applied, does not sufficiently characterize HIM; it ranks him but as an instrument. It is MAN, the impassioned, the reasoning self-ruling power alone, whose actions are interesting to beings of a similar high character. No act, which does not imply this nature in the agent, or produce a lively consciousness of it in the mind of the spectator, is really *worthy*, or indeed *capable*, of the high interest which this Art, at its summit, is qualified to excite, or of the exertion of those talents and endowments which its votaries are required to possess.

From *this* root alone, all great and permanent interest must spring; and *this*, therefore, is the central point from which all LEGITIMATE INVENTION must radiate.

In glancing the eye through the LOUVRE, with a view to invention merely, how *few* subjects were there, comparatively, that possess either a powerful or a lasting claim to our attention!

Unfortunately, the Art has at all times, in a great measure, been deprived of this its noblest member. Its vital part has been too often inconsiderately torn away, and it is even now made *a question*, whether it ever really possessed A SOUL OF ITS OWN.

It is evident, that in proportion to the comparative value of the various excellencies required to be combined in an Art, should be the honour and encouragement bestowed upon those who successfully cultivate those excellencies.

To require at once a *combination of all*, however desirable, or to exact the meaner and pardon the neglect of the more noble, were to destroy, not to patronise.

This I am aware has long been felt by the higher order of amateurs in this country, and they have given some decided proofs of it: the Exhibition of the Cartoons of RAPHAEL at the BRITISH INSTITUTION, in comparison with so many works highly estimable for the inferior excellencies, was well calculated, as it was no doubt intended, to spread the same conviction in the public mind.

Yet I cannot help thinking, that even those who have reflected upon the *Art as a whole*, and with a view to its general aim and character, have almost uniformly considered INVENTION not as an *essential* and *technical* part of it, but as something extrinsic, and depending merely upon that taste which is the result of 'general education.'

I have endeavoured to shew, that this is really not the ease, and I could wish to impress the idea, that INVENTION, the soul of Art, the heir of Nature, animated by a genuine sentiment of humanity alone, and bearing the stamp and distinguishing characteristic of a natural and fortuitous COMPOSITION, is the quality that should be *first* sought for. CHARACTER to be appropriate must build itself upon *this*, and DESIGN to be just must be founded upon Character. ART, therefore, must spring up entire from LIVING NATURE, and it is in vain to attempt to *steal* it from the triumphal monuments of its departed glory. They stand, indeed, the finger-posts upon the road, but they do not shorten the journey *one single step*. The Genius of Invention of Originality is the only traveller that will ever be seen upon that road.

* * *

...Painting must be considered not as a mere art of mechanical imitation, but as a LANGUAGE – THE LANGUAGE OF VISIBLE IMAGERY. In this light Raphael and Hogarth equally viewed it, and the chief law which governed them in its use was THE LAW OF INTELLIGIBILITY, to which every other 'rule of consistency,' whether it be the *unity* of *time*, of *place*, or even of *chiaroscuro* itself, must be considered subservient. Excellent as these inferior principles undoubtedly are, confined within their proper limits, yet when opposed to the higher, they no longer regulate but destroy.

The WORDS of this Language are Figures, or Images consisting of Form and Colour.

They represent their objects as they have been previously conceived in the mind of the Painter.

FORM is that on which the *meaning* of the Painter's Words chiefly depends.

The variations of Light and Colour are equivalent to the sound and tone of the voice: they may sometimes add emphasis and communicate feeling; but the chief use

of colour, like that of sound, is *distinctness to the sense*. The sensations of sound and colour render words audible and figures visible, without much contributing to their intelligibility, which in Painting may be expressed by mere Lines coloured or cut, as in the Hieroglyphics or Monograms of the ancients.

Colour is then the medium of communication, Form the idea communicated – not form as belonging to any object in itself, but form as the artist, whether ignorantly or intelligently, has conceived it. These WORDS of the Painter cannot be given to him, they must be composed by himself from the great alphabet of Nature, out of which he must create his own vocabulary.

As he performs this task well or ill, and it requires an original if not an inventive act to accomplish even this – as his words approach to the general language, or are restricted to a particular dialect, he will be qualified to speak either to the ignorant or to the enlightened, to the vulgar or to the more elevated and refined.

Suppose him possessed of Words, let us now examine how he is to convert them into speech. What is required to constitute a *sentence*? It must be some relation of the *words* to each other. But how shall the *fixed* Images of Painting be made to *act* upon one another? They cannot really act, nor is the art at all *illusory* in this respect; all its Images are evidently lifeless, they have not an atom of power. Shaftesbury therefore made a fatal mistake in conceiving this ART as 'completely imitative and illusive,' and as 'aspiring in a directer manner towards *deceit* and a command over our very sense,' than all other human fiction, or imitative arts, making 'her chief province *the specious appearance* of the objects she represents.' Who was ever deceived by the Cartoons of Raphael? Who mistakes the figures drawn and framed upon a wall, or the statue fixed upon its pedestal, for beings endowed with life?

The Drama is much more a deceptive Art than Painting. Which of us has not been for a moment at least totally lost and absorbed in the contemplation of a great actor, *scarcely* conscious that we were sitting at a play? Painting can never work so powerfully on the sense; and perhaps this power is *sometimes* abused and carried to an excess too painful even upon the stage itself.

It is an essential characteristic of Painting, that its Images are silent and immoveable: the idea of their speech and motion, and of their action upon each other, must therefore be conveyed by a *substitute* for action and for speech.

The imagination of the spectator must be excited to supply this radical deficiency in the Art. The Painter cannot make his figures 'fight' and 'fall;' yet he must somehow convey this history of successive events, since all action is successive, or he will tell no story at all. The character and attitude of the agent must serve as *the Sign of the Act*, and in the patient we must see *some token of the consequent Effect*.

The understanding will then indeed very readily connect these Signs, and willingly interpret these *lispings* of the Fancy in the language of Art, for the sake of that truth which her infantine expression serves but to render more interesting by the enthusiasm it evinces to contend with the impediments to its utterance. Painting speaks a *dumb* language; and shall she not be allowed to express herself by *signs*? Shall the arm and the finger of her indication be as rigidly bound down to her side, as if she had a tongue to speak with? Must she be dumb to the Eye as well as to the Ear? [...]

That painting, at its commencement, was a species of *written language* is generally agreed. The common 'tool' originally employed in painting and writing is a circumstance of trifling importance; but the common object which these two Arts originally had in view, ought never to be lost sight of, for it will be found, that in all its subsequent application, though superseded in its necessity by literature, Painting has uniformly preserved its original character.

It is, indeed, either a Language, or it is nothing – nothing deserving the attention of an enlightened mind.

That the ancient Artists used it as a Language, and that the world interpreted it as such, and was indeed deeply read in it, the whole mass of the imagery of the heathen mythology is an unanswerable proof.

That this innocent and delightful Art became the tool of idolatry and superstition, will not perhaps, in these enlightened days, be held a sufficient cause for persecuting her, when it is duly considered, on the other hand, how much more inexcusably guilty the *direct written language* of man has been in this respect, and how much the abuse of *speech* itself, the elder offspring of the mind, has contributed to darken and to enslave it.

The Language of Painting, however, has not always been employed in furthering the views of those who either wished, or were compelled, to govern by delusion; in the hand of Genius it has sometimes been a warning to Tyranny itself.

* * *

If it be admitted, that Painting is essentially a Language, whose *Forms* are its Words, speaking through the eye to the mind; the compositions it presents may be justly considered but as another species of poems; and I cannot foresee how it will be possible to refuse them this character.

It will follow also, unless I have been so unfortunate as that the whole view which I have taken of the Art is erroneous, a view which has arisen on no ground systematically assumed, but which has freely sprung up from a reflection ever open to the lessons of experience; – it will follow that the technical principles of the Art of Painting must, like those of every other species of Poetry, be sought in the peculiar circumstances to which it is subjected by the *means* it has recourse to.

It will then be necessary to examine first what Painting is in itself, before we venture upon an elaborate comparison of it with any other Art; at least it will be prudent to do so before we consent, that the laws imposed upon other Arts, whether wisely or not, should transfer their authority to this.

According to the principles, therefore, which have spontaneously formed themselves in my mind, I am compelled to reject the use of the terms *Epic* and *Dramatic* as applicable to Painting, or at all requisite to its illustration; I can see no other possible result from this figurative and indefinite use of them, but to render the theory of that Art confused and unintelligible, which in its own nature might perhaps be found to be extremely simple.

There is indeed one characteristic of Painting which, it might be imagined, would have deterred the most ardent assertor of this analogical theory from proceeding to lay a second stone of his edifice.

There lies between the *pure Poetry* of *Words* and that which has recourse to visible and fixed Images, a gulph never to be passed but by a flight of the poetic mind itself.

We must always remember, that the Conceptions of the Poet are vague and indeterminate, and the Images of the Painter strictly limited and defined: these actually visible and substantial; those in their very nature incapable of being either seen or felt, and in many instances totally inconsistent and beyond the reach of the understanding itself.

It is very easy for the Epic Poet to mount up to the grandeur of *indefinite conceptions*, to mingle with the pure phantoms of an imaginary world, and to give even to nothingness itself, as the phrase is, 'a local habitation and a name.' He has but to say, 'Let there be light, and there is light'; he need but pronounce the words, 'height, depth, the vast, the grand; darkness, light; life, death; the past, the future; man, pity, love, joy, fear, terror, peace, war, religion, government'; heaven, earth, hell; – and all these rise up in their utmost abstraction, or agreeably to the different tastes and habits of thinking of each individual, in the fancy of his hearers. Let but his magic word call up a Venus from the sea, and every man beholds in her the mistress he adores, or rather that phantom of beauty which he has chosen her to designate and to realize to his sense.

The *word Beauty*, whether in the mouth of the Poet or the Actor, is absolutely *perfect*; and were a very angel in human form to descend upon earth, no higher title of admiration could be bestowed upon her: such are the unlimited powers of the Poetic Art. But can the painter of a Venus flatter himself, that he shall ever be able to give universal satisfaction by any *determined* form he may adopt, however admirable it may really be? Ah, no! Has it not even been boldly and very justly asserted, that 'no face of Raphael's is perfectly beautiful.'

Where indeed upon this earth, either in the works of Nature or of Art, is this perfection to be found? The central form, or rather the vague phantom of beauty in most men's minds, the casual result of a limited experience, may indeed be distinctly reflected to their sight, and its character elevated and enlarged in the definite Form presented to them by some great Artist: but it is yet not absolutely perfect; the vague imagination still advances, urged by an immortal impulse, and the pursuit of Genius never comes to an end.

Great as have been the attainments of the Greek Artists, it is an evident absurdity to pretend, that they actually arrived at a point which in the nature of things it is impossible for any human power to reach. The '*superlative*' panegyrics bestowed upon them cannot be said to convey *instruction*, they rather tend to cloud the mind of the student with a superstitious terror, that represses the aspiring flame of genuine devotion.

They disguise from him the true nature of the Art, hold out to him an unattainable perfection as actually existing, and at the same time bid him despair of realizing it.

The absolute perfection of the *ideal*, in which the Poet easily indulges to the utmost excess of riotous extravagance, is totally and for ever excluded from the definite forms of the Painter, which are but steps upon a ladder that ascends to infinity.

Painting, then, differs essentially from every other branch of the Poetic Art; it is not Epic, it is not Dramatic – it has a nature of its own, and a name which sufficiently expresses it.

It is true indeed that these sister Arts embrace, sustain, and mutually adorn each other, and it is highly desirable that their intercourse should be of the most intimate and friendly nature.

May that *unnatural* hand repent its deed which rashly struggled to unlock this fond embrace! May that poetic voice subside into the silence of reflection that has pronounced, though in a whisper, the sentence of its scorn! 'Go,' it exclaimed, 'thou Art of silent mockery, nor aspire beyond the strict limits of imitation; let Painting attempt nothing which she cannot more completely accomplish than any other Art.'

And will Poetry abide the retaliation of such severity? Will she relinquish all attempts where Painting or Music is *her* superior? Will the Epic submit to refund all that may be justly claimed of her by the Dramatic, or which the stage has appropriated to itself by this novel and dangerous right of ejectment and possession, founded upon the presumption of a more complete occupancy? And shall the Drama, because it adds *motion* to the exhibition of its figures, deny to Painting the use of figures and of exhibition altogether?

The diversity of opinion which evidently prevails in whatever relates to this difficult Art, renders it highly desirable that its principles should be thoroughly examined; and there is a more encouraging motive to enter upon such an inquiry at present than at any former time, since a disposition has been strikingly manifested, and a variety of efforts made, for the promotion of the Fine Arts. Whatever may be thought of the success which has hitherto attended those efforts, it must surely be gratifying to all *parties* and *persons* concerned; to reflect, that *some attempt at least has been made*, and that *a public pledge* has been given of that favour and protection, which, as it becomes more experienced and enlightened, cannot but ultimately attain its end.

Hitherto it has been customary to look more to the ancient character and origin of the Arts, than to their intrinsic and essential nature, founded upon the permanent basis of their relation to the Mind.

It ought to be considered, however, that all traditionary systems derived from remote antiquity are involved in great doubt and obscurity, and that the exact progress of Grecian Art is but matter of conjecture. In attempting to imitate that progress, therefore, we must always proceed in doubt. But what is still a more important consideration is this: Ancient Art had for its preceptor and patron the superstitions of ancient Mythology, now sunk for ever. The Gods of Homer have fallen asleep, never to awake again; the Deities of 'Athens and Olympia' have 'migrated' far beyond 'Pella;' Alexander himself has yielded his mock thunder to the Jupiter of the Luxemburg, and he has danced into oblivion over the boards of the Italian opera. It is not, therefore, choice but necessity that drives back modern Art to the simple and pure principles from which Art originally sprang, and which urges it to divest them of that garb in which a perishable mythology once clothed them. That idolatrous, that colossal and monumental style which chilled the blood in the veins at the aspect of a man formed of the rock, who seemed to hide within his breast the dormant powers of Nature; that boasted god-creating style, the admiration and the scourge of ignorance, refined afterwards and at length dissipated by a more humane taste, is now completely wasted away; nor can it ever grow again to the same height by *similar means*. Is it indeed to be wished that it should?

14 Elisabeth Vigée-Lebrun (1755–1842) Advice on the painting of portraits

The daughter of a Parisian portrait painter, Elisabeth Vigée-Lebrun enjoyed early success an an artist, practising professionally from the age of 15. By 21 she was in receipt of her first royal commissions, and over the next decade became closely associated with the court circle of the *ancien régime*. She was a member of the Académie de St Luc from 1774, but was excluded from membership of the Académie Royale (ostensibly on the grounds that her husband was an art dealer) until personal intervention by the royal family ensured her admission on 31 May 1783. (For a review of her first Salon exhibition, see IVB1.) Her success with Marie-Antoinette, who sat for no less than thirty portraits, allowed Vigée-Lebrun to command higher fees than her male contemporaries, history painters included. This close association with the Queen led to her leaving France in October 1789, within three months of the Revolution. Thereafter she pursued her career abroad in court circles in Italy until 1793, then in Vienna, Prague and Berlin, and from 1795 to 1801 in Russia, principally St Petersburg. Vigée-Lebrun's French citizenship was restored in 1800, but at first she was unsettled in Paris, and she lived in London from 1803 to 1805. She finally returned permanently to France in 1805. Throughout this peripatetic period Vigée-Lebrun maintained a career as one of the foremost portrait painters of the day, with a roster of aristocratic and artistic clients throughout Europe, from Catherine II of Russia to Byron. She was far from being merely an ornament of society. She lived an extraordinarily independent life for a woman of any rank at that time, and combined her career with responsibility for the upbringing of her daughter. After her daughter's death in 1819, Vigée-Lebrun developed an affection for her niece. The girl studied painting, and this prompted the artist to compose the present text. In the three volumes of Vigée-Lebrun's *Souvenirs*, this is the only part which bears directly on her painting practice. It is a clear statement of the mixture of precise observation, technical acuity and psychological knowingness at the disposal of the successful eighteenth-century portrait painter. The date of composition is uncertain, but the text was written late in her life, probably between 1820 and 1830. Our version is taken from the unabridged French edition of the *Souvenirs* (Paris: Charpentier et Cie, 1869), in *The Memoirs of Elisabeth Vigée-Lebrun*, translated from the French by Siân Evans, London: Camden Press, 1989, pp. 354–7.

Points That Should Be Observed Before You Begin To Paint

You should always be ready half an hour before the model arrives. This helps to gather your thoughts and is essential for several reasons:

1 You should never keep anyone waiting.
2 The palette must be prepared.
3 People or business should not interfere with your concentration.

An Essential Rule

You must sit your model down, but at a higher level then yourself. Make sure that the women are comfortable, that they have something to lean against, and a stool beneath their feet.

You should be as far away from your model as possible; this is the only way to catch the true proportion of the features and their correct alignment, as well as the sitter's bearing and particular mannerisms which it is essential to note; the same applies when trying to achieve an overall likeness. Do we not recognise people we know from behind, even when we cannot see their face?

When painting a man's portrait, especially that of a young man, he should stand up for a moment before you begin so that you can sketch the general outline of the body. If you were to sketch him sitting down, the body would not appear as elegant and the head would appear too close to the shoulders. This is particularly necessary for men since we are more used to seeing them standing than seated.

Do not paint the head too high on the canvas since it makes the model look too tall, though if you draw the head too low, the model will become too small; when drawing the body, take care to allow more space on the side to which the body is turned.

You should also have a mirror positioned behind you so that you can see both the model and your painting at the same time, and it should be in a place where you can refer to it all the time; it is the best guide and will show up faults clearly.

Before you begin, talk to your model. Try several different poses. Choose not only the most comfortable but also the most fitting for the person's age and character, so that the pose will only add to the likeness. Likewise for the head, which should either be facing forward or at a three-quarter turn; this adds to the resemblance, especially for the public; the mirror might also help you decide upon this point.

You should try and complete the head, or at least the basic stages, in three or four sittings; allow an hour and a half for each sitting, two hours at the most, or the models will grow bored and impatient and their expression will change noticeably, a situation to be avoided at all costs; this is why you should allow models to rest and aim to keep their attention for as long as possible. My experience with women has led me to believe the following: you must flatter them, say they are beautiful, that they have fresh complexions etc. This puts them in a good humour and they will hold their position more willingly. The reverse will result in a visible difference. You must also tell them that they are marvellous at posing; they will then try harder to hold their pose. Tell them not to bring their friends to the sitting, for they all want to give advice and will spoil everything, although you may consult artists and people of taste. Do not be discouraged if some people cannot find any likeness in your portraits; there are a great many people who do not know how to look at a painting.

While you are working on the head of a woman dressed in white, drape her in a neutral-coloured fabric like grey or light green, so that your gaze does not wander from the model's head; if however you wish to paint her in white, keep a little white fabric to drape around the head, for it too should receive some of the reflected light.

The background to the sitter should in general be a subtle and uniform tone, neither too light nor too dark; if the background is sky then the rules are different and you should put something blue behind the head.

Whether you are painting in pastels or oils, you should build up from the darkest colour, then paint the mid-tones and finally the highlights.

Always thicken the highlights and always make them golden. Between the highlights and the mid-tones there is another tone not be overlooked, which has tints of violet, blue and green. Study van Dyck. The mid-tones should be broken up and less

thick than the highlights, and the highlighting on the head should emphasise the bone and muscle, the latter being weaker than the former.

Immediately after the first layer comes the flesh tone, chosen according to the complexion of the sitter; this will eventually blend with the mingling, shifting mid-tones.

Shadow must be strong but transparent at the same time, that is to say not a thick but a ripe tone, accompanied by a strong reddish touch in the cavities, such as the eye socket, the nostrils and the darker, interior parts of the ear etc. The colour of the cheeks, if they are unpowdered, should have a peach tone in the hollows and a golden rose colour on the more fleshy parts, the two colours merging imperceptibly with the highlights to emphasise the facial bones which should be golden. There should always be highlights on the brow bone, the cheek bone near the nose, above the upper lip, in the corner of the lower lip and at the top of the chin and they should always blend in with the surrounding tones. You should take care that the highlights diminish gradually and that the most salient and consequently the brightest part is always the most luminous. On the head, the sparkling lights, both sharp and diffuse, are either in the pupil or in the white of the eye, depending upon the position of the head and the eye; these two highlights often give way to others less golden in the middle of the upper eyelid, in the middle of the lower eyelid, or at least along some part of it, according to the way light falls upon the head, then on the middle of the nose, on the bridge and the lower lip. The sharper the nose, the finer the light should be. Never use a heavy consistency of paint on the pupils: they will look more real if they have a transparent quality. You should paint in as much detail as possible, take care not to give the sitter an ambiguous gaze, and ensure that you make the pupils round. Some people have large pupils and others small, but they are always perfectly round. The upper half of the pupil is always intercepted by the upper eyelid, but if the person is angry you will often see the whole pupil. When the eye smiles, the lower half of the pupil is intercepted and covered by the lower eyelid. The white of the eye in shadow should be a pure and pristine tone, and the mid-tones, although they are not quite the natural colour (this is so with any object you paint), should never look grey or dirty. Sometimes the eye should reflect light from the nose and share some of its shadow. The eyelashes in the shaded part are clear and stand out bright and this is why you should use ultramarine when painting a light part that is in shadow. Observe the eye socket, which should be darker or lighter depending on its shape. It is made up of shadow and highlights, mid-tones and reflections from the nose. The eyebrow should be prepared in warm tones and one should be able to see the flesh beneath the gleam of the hairs which should be light and delicate.

The setting of the eye is always painted in delicate blueish or violet tones, depending upon the whiteness and delicacy of the skin. Take care not to be too heavy with the latter or the eye will look as though it's full of tears. For this reason one should sometimes break into the blue tones with gold, but always cautiously.

Observe the forehead well; it is vital for a true likeness and is a very important key to the personality. When the forehead has a square but prominent bone, such as in the self portraits of Raphael, Rubens or van Dyck, there is a definite concentration of light on these prominent areas. The first is at the top of the forehead, just beneath the hairline. It is then interrupted and reappears near the eyebrow. This in turn gives

way to the colour of the temple where there will often be a blue vein visible, especially if the sitter's skin is very fine. In between these highlights is the natural flesh tone which fades into the centre. The light returns, if more feebly, on the same bone on the other side. This mid-tone mingles softly with all the other mid-tones, eventually becoming the shadow that defines the shape of the brow bone. After this shadow, there is a slightly golden reflection, depending upon the colour of the hair. Above the eyebrow, the tone should become a little warmer: the accumulation of these hairs has the same effect as a mass of curls falling onto a well lit forehead. The shadow is warm. Look at the heads of Greuze and study the way in which your model's hair grows, this will add to the likeness and the painting will be more truthful. You should observe the part where the hair falls next to the skin so that you will be able to render it as realistically as possible; there should never be a hard line between the two; the hair and the skin should mingle slightly, in form and colour; this way the hair will not look like a wig, an inevitable error if one does not follow the method I have just described.

The hair should be drawn in a body and should remain as such for the most part; it is probably better to use a glaze, otherwise the colours may bleed into the shadow and the main flesh tones of the face. The highlights on the hair are only visible on the prominent parts of the head; curls reflect light in the centre and a few stray hairs break the uniformity. The edge of the hair should, like metal, have something of the background colour, for this helps to accentuate the turn of the head.

It is also essential to study the ear and to place it in the correct position, understanding that it is a link between the head and the neck; you should make the shape as beautiful as you can; study the art of antiquity or beautiful examples in nature. For example, you might notice how in general the German, and especially the Austrian race, have ears that are situated a little too high according to perfect proportion. Likewise, the way the neck sits upon the shoulders is different from that of other peoples: it is wide, thick and rises high behind the ear. These people also have very strong temple bones. So if you happen to be painting a German, you should conserve this characteristic trait, along with the prominent forehead and the usually flat, sunken cheeks. As far as possible, try and paint the complete ear and study its cartilage formation well, even if you are going to paint hair over it. The colour that determines its shape should be warm and transparent, apart from the earhole which should always be dark and opaque. Its flesh tones, even when highlighted, should in general be less luminous than the cheek, which is more prominent. The shadow thrown on the neck by the ear is very warm in daylight; the jaw should be drawn in subtle tints with delicate mid-tones in order to obtain the depth between jaw and neck. If the head belongs to a woman, the base of the jaw should have warmer tones than that of a man, whose beard absorbs the naturally warm flesh tones beneath. The shadow on the neck should also be very subtle and less ruddy than the face. It is essential to observe the proportion of the collarbones relative to the position of the head, as well as the way they reflect light; the chest area becomes a little deeper in colour towards the point where the collar bones meet; in general the articulations, such as the elbow, the kneecap, the heel and the knuckles are always darker than the rest of the body.

If you have to paint breasts, put the model in a position where they are well lit; the best conditions for painting breasts occur when the light is direct and the colour should grow gradually stronger towards the nipple; the mid-tones which curve around the breast should be as light and fresh as possible; the shadow between the breasts should be warm and transparent.

There are rules for the gradation of light, such as I have described for the head, for the rest of the body. If the figure is seated, the light focuses strongly upon the thighs and will gradually fade towards the heel.

VIIB
The Continuity of Symbols

1 Benjamin West (1738–1820) 'Discourse to the Students of the Royal Academy'

West had been one of the forty founders of the Royal Academy, and on the death of Joshua Reynolds in 1792 he was elected to its Presidency. For a period during the early 1800s he fell out of royal favour as a consequence of his support for the French Revolution and for Bonaparte, and there was a brief hiatus in his Presidency of the Academy in 1805–6, but his career revived thereafter and he remained a central figure in the development of English and American art for the remainder of his life. His address to the students of the Academy was given on 10 December 1792. It is notable for the evidence it provides of a widening in the canon of art deemed relevant to the aspiring practitioner. Reference to the 'great masters of Spain' is rare before this date, while it would have come as a surprise to West's audience to learn that anything deserving to be considered as art had emerged from the native cultures of South or North America, of India or the Middle East. This liberalization in the understanding of other and earlier cultures was a general consequence of the spread of Englightenment. Where the Christian 'God' might be replaced by the wider notion of a 'Supreme First Principle', a far greater range of cultures could be allowed to have had a 'theology' – and thus to have endowed their artefacts with symbolic meaning. More specifically, West's liberalism may be associated with his personal sympathy for the anti-authoritarian and anticlerical tendencies in French and American thought. His address was published as *A Discourse delivered to the Students of the Royal Academy, on the Distribution of the Prizes by the President*, London: Royal Academy, 1793. Our excerpt is taken from the original pamphlet, pp. 15–23. (See also IVA5, 6.)

A COLLEGE of arts, founded in this part of the world, cannot be expected, like a COLLEGE of literature, to lay before its young members all that may be necessary to complete their depth of knowledge and their taste. What is to be had from books, may be had almost every where. But the books of instruction, by which the artist must be perfected, are those great works which still remain immoveable in that part of the world, where the fine arts were carried to their highest perfection in modern ages; and where they afford a most wonderful field of examples, from the study of which

no feelings of taste can return unripened. This COLLEGE of arts, from its own stores of instruction, can fill the mind with principles, and give all the foundation on which either taste or genius can rise. It can lead that taste and genius to great lengths. But as the discriminations of both are infinite, these discriminations can only be wound up fully to their respective points, by contemplating the infinitely discriminated perfections of those original works which the various schools of Italy in their purest days brought forth, and that which was formed in Flanders under the illustrious RUBENS; with some works of a few great masters in Spain, and others to be met with on the continent of Europe, the authors of which were nevertheless formed in some of the Italian schools. Thus it is that genius and taste will best become finished; and, at least, the fire of either must be caught in those enchanting walks that are beyond the sea. Is there not wisdom then in the provision, which encourages and assists the young artist to travel? I trust a period will come, when this Academy will be able to send him, not from one spot or one seminary to another, but to gather that improvement from every work of art, wherever situated, by which alone he can become a luminary in his profession.

These provisions interwoven in our foundation are the kind means of opening and assisting the first choice of professional art. But the progress and all the future success of the artist must depend upon himself. He engages in one of the most elegant pursuits, to which the human mind can be attached; and it is necessary that all the passions of his mind should go along with him in that engagement. He must be in love with his art, or he will never excel in it. And in order to feel the impressions of that affection, it is necessary that his mind should be possessed with those views of his profession, which may reasonably give it consequence and estimation; and from whence he may reflect with satisfaction, that he stands on a ground extremely flattering to every man that has chosen it for his own. Feeling himself and the art which he has embraced in these views, he will throw into his profession all the ardour which is ever felt by those who are proud of what they cherish, and which should be felt by every mind for that which is of all things most liberal in its nature. On this subject I wish to press some observations on the minds of the young artists, for their encouragement.

That the arts of design were among the first impressions vouchsafed by heaven to mankind, is not a proposition at which any man needs to start, who will look into all the evidences of its truth. That truth is manifested by every little child in the world, whose first essay is to make for itself the resemblance of some object to which it has been accustomed in its nursery.

In those arts of design were conveyed the original means of communicating ideas, which the discoverers of countries shew us to have been seized upon, as it were involuntarily, by all the first stages of society. Although the people were rude in knowledge, in manners, and indeed in every thing; yet they were possessed of the means by which they could draw the figures of things, and they could make those figures speak all their purpose to every other person as well as to themselves. The Mexicans conversing with one another in that way, when CORTES came among them, and the savages of North America still employing the same means of conveying intelligence to others, are among a thousand instances which might be adduced from every rude people upon the earth.

When therefore you have taken up the arts of design as your profession, you have embraced that which has not only been sanctioned by the cultivation of the greatest antiquity, but to which there is no antiquity prior, unless the visible creation.

Religion itself, in the earlier days of the world, would probably have failed in its progress, without the arts of design. That religion was emblematic. The emblematic spirit soon began to seize on the early mind. It was conceived to be more reverential, although it became in the end to be much more dangerous, to worship the SUPREME FIRST PRINCIPLE through the medium of an emblem than in abstract idea. But what could an emblematic theology do without the aid of the fine arts, and especially of sculpture, to give it all its effect, and to spread that effect through the earth? They sprang up therefore together, introduced by the same people, and they went hand in hand devoted to each other's spirit; first through the continent of Asia, then through Egypt, next through Greece and its colonies, and in process of time through every part of Italy, and also through all the north of Europe. How soon that joint career commenced in the world, is not impossible to be told. Many of its early evidences however are still existing. In the pagodas of India, in some caverns of ancient Media, and in various ruins in Persia, whose age and destination have been strangely mistaken, are to be seen those early monuments of emblematic art, stupendous in themselves, and wrought in all the possible difficulties of skill. If we are not pledged to particular systems of chronology for the age of the world, and if we will be decided by proofs drawn from astronomical observations which will bring us to many of those facts themselves, some of them may be demonstrated to have been wrought above three thousand years before the christian æra. Combined with that theology, whose records are still found in the archives of those Asiatic nations, and particularly of India, the spirit and purpose of those monuments is no more difficult to be understood, than their antiquity is to be ascertained. With that clue all that is ænigmatical in the sculptural arts of Egypt will readily be solved: with that clue all the most ancient coins, and medals, and other sculptures of Greece, will soon become plain to our apprehensions: and without it, all is confusion, perplexity, and darkness in the ancient world.

So early then were those arts, which you have taken for your profession, called forth as the records of all that was most valuable to the consideration of the human mind: and so early were the treasures and labours of empires devoted to raise those monuments, which no length of ages might destroy.

When in the space of two thousand years after the erection of some of those monuments, the fine arts came to be established in Greece on a better spirit than the emblematic, on the spirit of nature and truth, for the first essays of which the Greeks were indebted to DÆDALUS one thousand two hundred and sixty years before our æra: when, I say, the true spirit of the arts came to feel its strength in Greece: let the young artist look there for that character of his profession, which should always be present before his eyes. A higher estimation could not be annexed to any circumstance in Society, than was given to those arts by that wise and elegant people. They were looked upon as the public records of the country, as the means of perpetuating all public fame, all private honor, and all valuable instruction. The professors of them were considered as public characters, who watched over the events that were passing, and who had in their hands all those powers so important or pleasing to all.

And is not the case still the same with the artists of every country, how varied soever may be its maxims, or its system of action, from those of Greece? Is he not that character, to whom the country looks for all those powers? Is he not by the energy of his own mind, and by his attachment to his art, that watchman who observes the great incidents of his time, and rescues them from oblivion? Is it not from his hands that every scene, which is interesting to a present age, is most completely carried down to another?

2 Jacques–Louis David (1748–1825) 'The Painting of the Sabines'

During the period of his imprisonment in 1794–5 (see IVB12), David had started work on a large history painting, taking as his subject the intervention of the Sabine women in the battle between Roman and Sabine men – a theme significant of reconciliation. (As he observes in a footnote to the following text, the connected episode of the Rape of the Sabine Women had been treated by Poussin.) In contrast with the 'Roman' vigour and austerity of the *Oath of the Horatii* and the *Brutus* (see IVB1–3), the *Sabines* makes reference to the smoother style then associated with Greek sculpture, while the entire composition is both more complex and more reliant upon sensuous effects than the earlier works. The painting occupied him for four years. In order to recover his costs, and perhaps with the aim of re-establishing his public identity on different terms, David arranged for it to be shown publicly in a separate room in the Louvre, to which – exceptionally – visitors were to be charged entrance. The exhibition was advertised in advance in the press, David assuring his fellow citizens that this was not a 'vile speculation' but an 'honourable initiative on behalf of art and artists', in order that he might receive the recompense of the public for his four years' work. For the entry fee of 1 franc 24 centimes they would also receive a printed booklet, the full text of which is reproduced here. The exhibition opened on 21 December 1799 and remained open during the next five years. The proceeds were sufficient to finance David's acquisition of a property in the country. In his foreword to the booklet the artist defends his method of exhibition, referring to the successful pre-cedents of West's *Death of General Wolfe* (see IVA6) and Copley's *Death of Chatham* (see IVA5), which he mistakenly also attributed to West. In the following section David explains his historical theme and its significance, adding a note in justification of the nudity of his heroes. Our complete text is taken from *Le Tableau des Sabines, exposé publiquement au Palais National des Sciences et des Arts, salle de la ci-devant Académie d'Architecture, par le Citoyen David, membre de l'Institut National*, as reproduced in J.-L. Jules David, *Le Peintre Louis David 1748–1825*, Paris: Victor Havard, 1880, pp. 352–8, translated for this volume by Akane Kawakami.

The Painting of the Sabines exhibited to the public at the National Palace of the Sciences and the Arts

Room of the former Academy of Architecture
by Citizen David, Member of the National Institute

Antiquity has never ceased to be the great school for modern painters, the source of the beauties of their art. We seek to imitate the ancients in the genius of their conceptions, the purity of their drawings, the expression of their faces and the

grace of their forms. Can we not take one step further, and imitate them also in their morals and the institutions established by them in order to bring the arts to a state of perfection?

The painter's practice of exhibiting his works to the eyes of his fellow citizens, in return for individual remunerations, is not a new one. The abbot-scholar Barthélemy, when speaking of the famous Zeuxis in his *Voyage of the young Anacharsis*, does not miss the opportunity to observe that this painter collected such sums from exhibiting his works that he often made presents of his masterpieces to the nation, saying that no individual could afford to pay for them. He cites the witnesses of Aelian and Pausanias on this subject. They prove to us that, with regard to painting, the practice of public exhibitions was accepted by the Greeks; and we can hardly doubt that, in the realm of the arts, we need not fear of losing our way by following in their footsteps.

In our day this practice is observed in England, where it is called *exhibition*. The paintings of the *Death of General Wolf* and of *Lord Chatham*, painted by our contemporary West, earned him immense sums in that country. The exhibition has existed for a long time there, having been introduced to England by Van Dyck in the last century, whose public came in droves to admire his works; by this method he amassed a considerable fortune.

Is it not an idea as just as it is wise; one which procures the arts with the means to exist independently, to maintain themselves through their own resources, and to enjoy the noble independence which so befits genius, without which the flame which gives it life is soon extinguished? On the other hand, what worthier method could there be to take honourable advantage of the fruit of one's labours, than to submit it to the judgement of the public, and to expect no recompense other than what it deigns to give him? If the work is mediocre, the judgement of the public will soon do it justice. The author, receiving neither glory nor indemnity, will learn from harsh experience ways in which to make good his faults, and to capture the attention of his viewers with happier conceptions.

Of all the arts which profess genius, painting is incontestably the one which requires the greatest number of sacrifices. It is quite common to spend up to three or four years to finish a historical painting. I will not enter here into any of the details concerning the preliminary expenses necessary to a painter, but even the cost of costumes and models is considerable. These difficulties, we do not doubt, have repelled many an artist; and it may well be that we have lost many a masterpiece conceived by the genius of several of them, and that their poverty impeded them from executing. Let me go further: how many honest and virtuous painters, who would never have taken up their brushes to paint anything but noble and moral subjects, have been forced to degrade and debase them through sheer need! They have prostituted their works for the money of the Phrynes and the Lais: it is solely their poverty which has made them guilty; and their talent, formed to fortify respect for mores, has contributed to their corruption.

How wonderful it would be, how fortunate I would consider myself, if, by giving one example of a public exhibition, I could bring about the practice of it! if this practice could offer talented artists a means of saving them from poverty, and if, as a consequence of this first advantage, I could contribute to returning the arts to their

true destination, which is to serve morality and elevate the soul, by transmitting the noble emotions which the artists' works remind us of, into the souls of the viewers! The power to move the human heart is a great secret; and this means of doing it can give a great impetus to public energy and national character. Who can deny that, until the present day, the French people have been strangers to the arts, that they have lived in their midst without participating in them? Whenever painting or sculpture produced a rare work, it would immediately turn into the conquest of a rich man who would make off with it, often at some mediocre price, and who, jealous of his exclusive ownership, would suffer only a small number of his friends to see it: the rest of society would be banned from the privilege. At the least, by favouring the system of public exhibitions, the people, for a small contribution, would enter into a share of the riches of genius: they would become enlightened about the arts, to which they are not as indifferent as some people claim; their knowledge would increase, their tastes would become formed; and although they would not be sufficiently experienced to judge of the finer points or difficulties of art, their judgement, being always dictated by nature, and always produced by emotion, will often flatter, and even at times instruct an author who knows how to appreciate it.

What is more, how regrettable and painful it is (for men who are sincerely attached to the arts and to their country) to witness the departure of a considerable number of priceless monuments into foreign nations, monuments of which their own nation, which had produced them, is hardly aware! Public exhibitions tends to keep masterpieces in the happy land where they were born; they are the means by which we must hope to relive the golden age of Greece, where an artist, satisfied by the sums that were procured for him by the remuneration of his fellow citizens, was pleased to make a present to his country of the very masterpieces that she had admired; having honoured her with his talents, he became most worthy of her by his generosity.

No doubt it will be objected that each nation has its practices, and that the practice of public exhibitions of art objects has never entered France. First, I would respond that I make no attempt to explain human contradictions, but I ask you: does not a playwright give his work the greatest possible publicity, and does he not receive a portion of the spectators' money in exchange for the emotions or different pleasures that he has caused them, through his painting of the passions or of ridicule? Is a composer of music, who has given his life and soul to a lyrical poem, ashamed to share with the author of the words the profits of its performance? Can it be that what is honourable for some can be humiliating for others? and if the different arts make up a family, may it not be that all artists regard each other as brothers, and may follow the same rules to attain fame and fortune?

I would also respond that we should hasten to do what has not been done, if some good is to come of the result. What prevents us from introducing into the French Republic something which both the Greeks and the modern nations practise? Our former prejudices are no longer opposed to the exercise of public freedom. The nature and the course of our ideas have changed since the Revolution; and we will not return, I hope, to the false sophistication which repressed genius in France for so long. For my part, I can think of no greater honour than that of being judged by the public. I fear from it neither passion nor partiality: its contributions are voluntary gifts which prove its inclination for the arts; its praises are the free expression of the

pleasure that it feels; and such rewards are, no doubt, worth as much as those of the reign of the academies.

These reflections that I have proposed here, and the system of public exhibitions, of which I will have been the first to give an example, were suggested to me principally by the desire to procure for professional painters a means of being indemnified for their time and expenses, and to secure for them a resource against poverty, which is all too often their sad fate. I have been encouraged and aided in upholding these views by the government, who, in this instance, have given me a great proof of the welcome protection it gives to the arts, furnishing me with a location for my exhibition, and other considerable instances of help: but I will have received the most flattering of recompenses if the public coming to see my painting opens a useful route for artists, which in turn, by firing their enthusiasm, may contribute to the advancement of art, and to the perfecting of morals, which is the goal that we must ceaselessly pursue.

Having declared my true intentions, there is nothing more for me to do here except to give the public an explanatory note of the subject that I offer their eyes.

... *ament meminisse periti* [the experts may wish to bear this in mind]

Exhibition: The Painting of the Sabines

The origin of the Roman Empire is shrouded in darkness. The fact about which historians are the least divided is that after the fall of Troy, a few Trojans who had set sail were thrown by the winds onto the coast of Tuscany, disembarked near the Tiber, and settled at the foot of the Palatine hill.

It is beyond the scope of my subject to enter into details concerning the events preceding the existence of Romulus. I will simply concentrate on explaining the ideas of greatness and of divine extraction that the Roman people were pleased to bestow upon their founder.

That which is but fiction for the historian is an incontestable truth for the painter and the poet: to their eyes, Romulus and Remus, his brother, are the twin children of Mars and Rhea, a priestess consecrated to the cult of Vesta.

Amulius, king of Alba and father of Rhea, considering the maternity of his daughter with opprobrium, resolved to let the children perish by having them exposed, the two of them in the same cradle, on the waters of the Tiber. These offspring of a god were saved by a double miracle. They were thrown onto the riverbank; and a she-wolf, casting aside for them her natural ferocity, took care to suckle them. The shepherd Faustulus, witnessing this prodigious event, was struck with wonder at it; and, touched by the graces of these little children, he took them home, and brought them up as if they were his own.

From their earliest childhood, an air of nobility and greatness which surrounded their whole person, together with their extraordinary height, seemed to presage for them a noble destiny. Romulus, however, was superior to his brother, as much in the strength of his character as in the boldness of his ideas. The children of the neighbouring shepherds, their companions, were not slow to recognize his superiority: so they named him their leader, and made him their captain in all their games.

Romulus loved war. His natural ambition was fortified further by revelations made to him through certain oracles, predicting that one day he would found a city which would reach the zenith of splendour and glory. As soon as he had laid out the foundations of Rome, he spared no pain in order to attract shepherds from neighbouring countries, fugitive slaves, and any strangers ready for grand enterprises. Such were the feeble beginnings of an empire which, in later years, would subjugate the universe. *Genus unde latinum* [Whence the people of Rome].

In these early stages, the Romans had few women. The daughters of the Sabines, a people who lived in the neighbourhood of Rome, about five miles away, had attracted their attention. They were already celebrated for their beauty and their modesty. In order to avail himself of them, Romulus used a method familiar to all warring peoples: violence.

First, he circulated rumours that he had discovered underground the altar of a god called Consus, a divinity greatly venerated by his neighbours, who was believed to be an equestrian Neptune. When this rumour began to be believed, he let it be known everywhere that on a day fixed by him he would make a solemn sacrifice, after which there would be a celebration with a feast and games, to which he invited all kinds of strangers, and in particular the Sabines, whose women he coveted. The strangers flocked to this spectacle from all over. Romulus, decked out in purple, and flanked by the most important Romans, was seated in the most prominent place. He had arranged the following signal: he would stand up, fold over a swathe of his robe, then unfold it, at which point his soldiers would throw themselves on the Sabine daughters, seize them and bear them away, leaving the men to flee freely.

This bold plan was executed, and the young Sabine women, despite their prayers, their despair and their cries, were abducted, and led to Rome, where the Romans married them, and treated them with all due respect.[1]

The punishment was to follow sooner or later. The Sabines, cut to the quick by the outrage done to their daughters, attempted to take revenge on several occasions. Three years later, after the Sabine women had become mothers, Tatius, their king, still outraged by the odious abduction, once again assembled his bravest warriors and fell upon Rome, to exterminate the ravishers. Rome was taken by surprise; already the Sabines were upon the ramparts of the Capitol, of which they had taken possession through the treachery of Tarpeia. When they heard this news, the Romans hastily armed themselves, left their houses, and marched on the enemy. Fighting commenced with both sides attacking, when the two leaders, moved with an equal fury and meeting in the thick of the fight, readied themselves to do single combat, following the practice of that heroic age.

But what can resist the joint effect of conjugal and maternal love? Suddenly the Sabine women who had been abducted by the Romans ran onto the battlefield, their hair flying, carrying their little children naked on their breasts, across the piles of dead bodies and the horses excited by the fighting. They cried out loudly for their fathers, their brothers and their husbands, now addressing the Romans, now the Sabines, calling them by these, the sweetest of names known to men. The soldiers, moved to pity, let them pass; Hersilia, one of the women and wife to Romulus, to whom she had given two children, stood between the two leaders and cried out: 'Sabines, what have you come to do under the walls of Rome? Here are no more

daughters for you to take back to their parents, nor ravishers for you to punish; you would have done better to drag us from their arms when we were still strangers to them: but now that we are linked to them by the most sacred of chains, you have come to take wives away from their husbands, mothers from their children. The help that you wish to give us now is a thousand times more painful than the abandonment in which you left us when we were abducted. If you have come to fight for some cause which is not ours, even then we would have some right to your pity, as it is by us that you have become ancestors, fathers-in-law, brothers-in-law, and allies of the very people you are fighting. But if this war was undertaken for our sake, we beg you to give back to us, from amongst yourselves, our fathers and our brothers, without depriving us, from amongst the Romans, of our husbands and our young children.'[2]

These words spoken by Hersilia, and accompanied by her tears, echoed in all their hearts. Amongst the women who were with her, there were some who put their children at the feet of the soldiers, who let fall their bloody swords from their hands; others lifted up their infants in the air, holding them up like shields against the forest of spears, which were lowered at the sight. Romulus lowered the javelin he was about to throw at Tatius. The general of the cavalry put his sword back into its scabbard. Soldiers lifted their helmets in a sign of peace. The emotions of conjugal, paternal and fraternal love spread from rank to rank in the two armies. Soon the Romans and the Sabines embraced each other, and were as one people.

A note on the nudity of my heroes

A complaint which has already been made to me, and which will no doubt be made again, is the issue of the nudity of my heroes. There are so many examples to be cited in my favour in what remains of the works of the ancients that my sole difficulty is one of choice. Here is my response. It was an accepted practice amongst the painters, sculptors and poets of Antiquity to depict nude the gods, heroes and all kinds of men in general that they wished to paint. If they painted a philosopher, he would be nude, save for a cloak on his shoulders, and the attributes of his character. If they painted a warrior, he would be nude, a helmet on his head, his sword attached to a shoulder-strap, a shield on his arm, and boots on his feet; sometimes they would add a piece of cloth, if they judged that it would enhance the grace of his figure: as with others, such as my Tatius, or better still in the figure of Phocion, newly arrived from Rome, on display for all to see in the Central Museum of Fine Art. Are the two sons of Jupiter not nude, Castor and Pollux, the works of Phidias and Praxiteles, which can be seen in Rome at Monte Cavallo? The Achilles at the Villa Borghese is similarly nude. At Versailles, on the vase called the Medici vase is a bas-relief depicting the sacrifice of Iphigenia: Achilles is nude there too, as are most of the warriors around the vase. Amongst the works of the sculptor Giraud, which can be seen in his museum on the Place Vendôme, is the bas-relief of Perseus and Andromeda. In it the hero is nude, although he has just fought a monster who spits venom. The same thing is to be found in the book of prints of Herculaneum in the Bibliothèque Nationale, the print of Hippolytus departing for the hunt, in the presence of Phaedra; he is nude. And how many other authorities could I not cite? Those which I have just described will no doubt be sufficient for the public not to be surprised that I have attempted to

imitate these great examples in my Romulus, who is himself the son of a god. But here is one I have kept until last, because it complements all the others; it is Romulus himself, who is depicted on a medal, at the moment when, having killed Acron, king of the Caeninenses, he is carrying on his shoulders a trophy made up of his weapons, which he deposits later in the temple of Jupiter Feretrius; these came to be known as the first instance of the spoils of war. Now that I believe I have responded in a satisfactory fashion to the reproach made to me, or which may be made to me in the future, on the subject of the nudity of my heroes, allow me to call my fellow artists to my defence. They know better than anyone how easy it would have been for me to have clothed my figures: let them tell you how clothes and drapes would have furnished me with far easier ways of bringing my figures out in relief from the canvas. I believe, on the contrary, that they will be grateful to me for the difficult task that I imposed on myself, filled with this truth, that he who is capable of the more difficult is capable of the less difficult. In a word, my intention, in creating this painting, was to paint the *mœurs* of Antiquity with such precision that the Greeks and the Romans, upon seeing my work, would not have found me a stranger to their customs.

1 Let us note here, in passing, that the moment of this abduction has already been dealt with by the sensitive and precise paintbrush of Poussin, to whom the modern Romans have conferred the epithet of 'divine'. I have dared to depict the continuation of the same subject, at the moment when the Sabine women come to separate the armies of the Sabines and the Romans.

2 See Plutarch, *Life of Romulus*.

3 Pupils of David: 'Discourse addressed to Vien'

Joseph-Marie Vien (1716–1809) was an influential advocate of the reform of art in France through the revival of an archaeologically correct classicism and through concentration upon drawing and painting from the life. David studied with him as a well-regarded pupil from $c.1765$ until 1771, when their relations were strained by the younger artist's unsponsored and unsuccessful application for the Prix de Rome. In 1775, however, David accompanied his teacher to Rome on the latter's appointment as Director of the French Academy. Vien returned to Paris in 1781 and was appointed Premier Peintre du Roi eight years later. As the last President of the Académie Royale before it was transformed into a state institution, he was responsible for organization of the Salon of 1789, in which David's *Brutus* was shown. Thereafter his relationship with David afforded him a measure of protection, though he was to withdraw from Salon exhibition after 1793. During the revolutionary period, festivals of one kind or another had been much employed as means to celebrate publicly the achievement of liberty and to establish solidarity. In 1799 a succession of artists' banquets was staged to celebrate the success in that year's Salon of Pierre-Narcisse Guérin's neo-classical painting *The Return of Marcus Sextus*. At one of these Vien was fêted as a progenitor by some fifty younger artists. Guérin had been a pupil of Jean-Baptiste Regnault, who had in turn been taught by Vien. Regnault had been David's contemporary at the French Academy in Rome, and when he established his own teaching studio in Paris in the 1780s it was a potential rival to David's. The fête given in Vien's honour in 1800 may be seen as a response to the earlier celebration and as an attempt by

David's pupils to re-establish the 'true' line of succession. It also furnishes evidence of David's position as an object of devotion to a number of loyal though competing younger artists, many of whom had worked on his major paintings and on replicas made from them. The point that the heritage of classical culture was rightfully claimed by the modern guardians of liberty was one regularly made at revolutionary and post-revolutionary festivals. It was also used to justify the large-scale appropriation of classical works from Italy that took place under Napoleon. Vien was ennobled by Napoleon in 1808. The address was originally published in pamphlet form as *Discours adressé au citoyen Vien, membre du Sénat Conservateur, par les Elèves du citoyen David, dans une fête qui lui ont donnée le 9 brumaire an 9*, Paris: De l'imprimerie Giguet et Cie, 1800. Our complete text is taken from the original pamphlet, translated for this volume by Akane Kawakami.

When at the Olympic Games, amidst the applause of a people impassioned by glory, the athletes received their illustrious crowns, the heralds proclaimed, together with the names of the winners, the names of their fathers, of the masters who had instructed them, and of the fortunate cities which had witnessed their birth. Virtuous children, moved to gratitude by the spectacle of public recognition, triumphantly lifted up on their shoulders the father who had brought them up to be courageous and virtuous, saying to the people: it is not us that you must applaud; here is the winner, here he is; we owe our victory to him, and it is for his sake that our victory is so sweet; please accept, father, our most glorious homage; the radiant olive branch should encircle your silver hair.

Such are the emotions that we needed to express to you, courageous founder of the new French School, the glorious author of a long posterity of artists, you who were the guide, the friend, the father of our master, and whom, for this reason, we lovingly nominate our ancestor. When our imaginations transport us to Delphi or Olympia; when we feel as if we have received immortal crowns there, we bring them all here to place on your venerable head, we deposit them on your heart, we lift you up in triumph on our shoulders: we will consecrate these crowns in the temple of Minerva, and our filial hands have written there the following words: Vien was the master of David, David was our master; our glory is David's, and David's is Vien's.

Celebrated old man! how gloriously filled your long career has been! Your latter days are as beauteous as those in which your genius, at its dawn, struggled against tastelessness; as those in which your genius saw tastelessness perish in the flames of its noon.

You have vanquished false masters whose opinions were made even more dangerous by the fact that they believed themselves to be inspired; you overturned systems which were fatal because, by teaching that we should surpass nature, they made us forget it; they honoured the false, the mannered, the gigantic, telling us that these proud follies were the product of what was then known as genius and taste.

Hearing these humiliating adages about art gave you much pain: that the arts were the offspring and slaves of luxury; that they were the frivolous pastimes of lazy minds; that as it is the rich man who pays for them, it is for the rich man to lead them. In contrast, you hear and sustain today these fecund truths: the arts are the children of liberty, and should also be its support; it is to encourage public virtue that

we should demand masterpieces of the artists; who should lead them? public taste; to lead them to perfection, they must be made useful, because it is only then that they will be truly loved, and judged by sentiment alone.

You see in a government which appreciates the arts in this way, a minister, as profound in his opinions as he is wise in his eloquent speeches, a friend of the arts as much from his own inclination as from sagacious policy; giving up, in spite of his wisdom, his ministerial but destructive right to make his own judgements of the works of art; encouraging emulation by competitions, and giving homage, even in matters of taste, to the sovereignty of public opinion.

There are two routes to immortality for an artist; by way of their work and by way of their pupils. You are striding along both. David, your pupil (the Greeks would have called him your son) held up the torch you handed to him with a new energy, spread and distributed a light which grew brighter and brighter. He taught, he produced, and every day his new masterpieces augmented your glory and his own.

Note, if you would, the moment that we have chosen to declare our gratitude to you, and you will see that we are doing nothing but paying a part of the public's debt to you. This is the moment when the masterpieces of ancient sculpture are about to appear in all their glory in front of the eyes of France, who has conquered them; it is the moment when the divine Homer, Plato, the Muses, Apollo himself, who, ever faithful to the free peoples of this world, have chosen to live amongst the French, and are to be adored in their living images. Ah! Who would be able to step into the temple of these divinities without saying to himself: these masterpieces, these gods had ceased to be gods for us; the cult of Antiquity had been forgotten; who would believe it? Cold idols had taken their place; their worshippers had been chased away; it is Vien, it is David, who then made themselves into their apostles and ministers; it is through them that this great revolution, which has at least given us the hope of creating gods ourselves, has taken place in the arts.

Let us tell you again that this is the moment in which three of us have just received crowns in the competition of the public school; the moment in which a Salon is about to close, a Salon in which works by our elder brothers in craft have shown you the vitality of the sap that we have received from you!

Pupils of the illustrious rivals of our master, this feast would not be complete without the expression of our feelings for you! Yes, Vien belongs to us all. His principles germinated in all the schools. Friendship, frank criticism, sincere admiration of true talent, a constant search for perfection; these are the objects of the only rivalry that should exist between us, and the emotions of which we give our solemn assurance. May we surpass you in our art, so that you may surpass us in your turn, and so that, with renewed efforts, we may surpass you once more! Finally, in the same way that an enlightened government has placed the father of our painters amongst the custodians of our laws, raising our art to the highest point of sublimity, let us swear together . . . we swear it here ourselves, that we will never let our works serve anything but the establishment and maintenance of good morals, the propagation of virtue, and the conservation of a wise and generous liberty!

4 François-René, Comte de Chateaubriand (1768–1848) 'Of the Subjects of Pictures' from *The Genius of Christianity*

At the height of the Revolution in 1791, Chateaubriand left France for America, returning a year later to fight as a royalist before escaping to exile in England, where the present work was largely written (see also VB17). He returned to France in 1800 and published a novel *Atala, ou les amours de deux sauvages dans le désert* in Paris in 1801 (the source for Girodet's painting *The Burial of Atala*, exhibited in the Salon of 1808 and now in the Louvre). *Le Génie du christianisme* was well received on its publication in 1802, coming as it did at a time of reconciliation between the French government and the papacy. (The revolutionary régime had decreed an end to Christian worship in 1793.) Opposition to Napoleon was nevertheless to prevent Chateaubriand from pursuing a successful public career until after the Bourbon Restoration. The significance of his book for the study of art lies in its assertion of the *aesthetic* superiority of works of art produced in the name of the Christian religion. It is also significant in the very fact of its appearance at the commencement of the nineteenth century. Published by a sophisticated writer and welcomed by cultured readers, a work celebrating the relative *beauties* of Christian costume and Christian iconography can hardly be seen as testifying to a revival of the religious spirit, albeit this is exactly what Chateaubriand sought to achieve. (He later claimed that his 'Génie' had reopened the doors of the churches after the Revolution.) Rather it furnishes compelling evidence on the one hand for the replacement of religious concepts by aesthetic values, and on the other for an incipient decline in the status of the classical. Chateaubriand's work was originally published as *Le Génie du christianisme, ou beautés de la réligion chrétienne*, Paris, 1802. Our text of Book III, chapter IV, 'Of the Subjects of Pictures', is taken from the translation by Charles I. White, published as *The Genius of Christianity; or the Spirit and Beauty of the Christian Religion*, Baltimore: John Murphy & Co., second revised edition, 1856, pp. 378–80.

Fundamental truths.

Firstly. The subjects of antiquity continue at the disposal of modern painters; thus, in addition to the mythological scenes, they have the subjects which Christianity presents.

Secondly. A circumstance which shows that Christianity has a more powerful influence over genius than fable, is that our great masters, in general, have been more successful in sacred than in profane subjects.

Thirdly. The modern styles of dress are ill adapted to the arts of imitation; but the Catholic worship has furnished painting with costumes as dignified as those of antiquity.

Pausanias, Pliny, and Plutarch, have left us a description of the pictures of the Greek school. Zeuxis took for the subjects of his three principal productions, Penelope, Helen, and Cupid; Polygnotus had depicted, on the walls of the temple of Delphi, the sacking of Troy and the descent of Ulysses into hell; Euphranor painted the twelve gods, Theseus giving laws, and the battles of Cadmea, Leuctra, and Mantinea; Apelles drew Venus Anadyomene with the features of Campaspe; Ætion represented the nuptials of Alexander and Roxana, and Timantes delineated the sacrifice of Iphigenia.

Compare these subjects with the Christian subjects, and you will perceive their inferiority. The sacrifice of Isaac, for example, is in a more simple style than that of Iphigenia, and is equally affecting. Here are no soldiers, no group of people, none of that bustle which serves to draw off the attention from the principal action. Here is the solitary summit of a mountain, a patriarch who numbers a century of years, the knife raised over an only son, and the hand of God arresting the paternal arm. The histories of the Old Testament are full of such pictures; and it is well known how highly favorable to the pencil are the patriarchal manners, the costumes of the East, the largeness of the animals and the vastness of the deserts of Asia.

The New Testament changes the genius of painting. Without taking away any of its sublimity, it imparts to it a higher degree of tenderness. Who has not a hundred times admired the *Nativity*, the *Virgin and Child*, the *Flight in the Desert*, the *Crowning with Thorns*, the *Sacraments*, the *Mission of the Apostles*, the *Taking down from the Cross*, the *Women at the Holy Sepulchre*. Can bacchanals, festivals of Venus, rapes, metamorphoses, affect the heart like the pictures taken from the Scripture? Christianity everywhere holds forth virtue and misfortune to our view, and polytheism is a system of crimes and prosperity. Our religion is our own history; it was for us that so many tragic spectacles were given to the world: we are parties in the scenes which the pencil exhibits to our view. A Greek, most assuredly, felt no kind of interest in the picture of a demi-god who cared not whether he was happy or miserable; but the most moral and the most impressive harmonies pervade the Christian subjects. Be forever glorified, O religion of Jesus Christ, that hast represented in the Louvre the *Crucifixion of the King of Kings*, the *Last Judgment* on the ceiling of our court of justice, a *Resurrection* at the public hospital, and the *Birth of our Saviour* in the habitation of those orphans who are forsaken both by father and mother!

We may repeat here, respecting the subjects of pictures, what we have said elsewhere concerning the subjects of poems. Christianity has created a dramatic department in painting far superior to that of mythology. It is religion also that has given us a Claude Lorrain, as it has furnished us with a Delille and a St. Lambert. But what need is there of so many arguments? Step into the gallery of the Louvre, and then assert, if you can, that the spirit of Christianity is not favorable to the fine arts.

5 Franz Pforr (1788–1812) Letter to Passavant, 6 January 1808

Franz Pforr was one of the founder members of the Lukasbrüder (Brotherhood of Luke). Together with a number of other young artists, including Friedrich Overbeck (see VIIB6), he sought to regenerate German art by reorienting it to earlier schools of painting, above all the art of Dürer. He was born in Frankfurt am Main in 1788 and underwent his earliest training with his father, the painter Johann Georg Pforr (1745–98), and with Johann Tischbein the younger (1742–1808). In 1805 he enrolled at the art academy in Vienna but was out of sympathy with the pervading ethos of neo-classicism. In this letter to Johann David Passavant, a friend from Frankfurt who later wrote a historical study of the Nazarenes, he voices strong criticism of the exclusive focus on classical subjects. Above all, he

criticizes the lack of *feeling* and the absence of truth which the reliance on classical models engenders. In its place he identifies the Middle Ages as a valid source of inspiration and insists that art should fulfil a moral function. The Englishman of whom he speaks is Henry Fuseli (see VIA10), the Swiss-born professor of painting at the London Royal Academy, whose *Lectures on Painting* (1801) appeared in a German translation in 1803. Pforr's early death from tuberculosis prevented him from seeing through his programme for artistic reform, but he did complete a number of major works on medieval themes, such as the *Entry of Rudolf von Habsburg into Basle in 1723* (Städelisches Kunstinstitut, Frankfurt 1808–10). The letter has been translated for the present volume by Nicholas Walker from Fritz Herbert Lehr, *Die Blütezeit romantischer Bildkunst, Franz Pforr, der Meister des Lukasbundes*, Marburg: Verlag des kunstgeschichtlichen Seminars der Universität Marburg, 1924, pp. 268–70.

[. . .] I can hardly say how much I agree with you when you take the artist to be the happiest of men, but with one small qualification, to whit, that he is equally the unhappiest of men. I have not advanced very far in art, and yet the sufferings I have endured for her sake are already great. I do not heed the physical sufferings to which the artist, particularly as a learner, finds himself subjected, for it is still easier to forgo things that would delight a young man of any profession than to endure restless labour without a goal. For the path of the artist is indeed without a goal, he must restlessly push forward without pause; if he stands still, alas, he actually regresses, he sees what lies behind him sink away into the blue haze, and hence perceives no glimmering end to his path. So he rushes onwards until he is overtaken by death. And then when he has graciously departed from the scene, what is his fate? That a few individuals value him and lovingly admire his works, while most will only regret that a man has given himself to art – not as an artist, but because he would have benefited everyone the more if he had chosen a more sensible profession, a benefit well and truly lost since he actually became an artist. I hardly think I am exaggerating in saying this, for there are so many people who simply place the artist on a level with a wandering vagabond! I am far from thinking that a city without artists must be an unhappy one, but I do believe that there are few people who can have such an effect upon morality and virtue as the artist. I also find it quite difficult, therefore, to reject entirely the widely shared and common view that art has suffered a great decline. When one considers the purposes to which art is put today, one cannot but regret that this decline is so widespread. There was a time when the painter's labours were all designed to inspire piety through the presentation of revered subjects, to encourage emulation through the depiction of noble deeds, but now? – A naked Venus with her Adonis, or a bathing Diana, what possible good can come of such conceptions? And why do we try and search out subjects that are so remote that they lose all interest for us, rather than finding those which concern us directly? We find far more material in ancient Jewish history than in any other. Tell me if there is any story which presents such a beautiful picture of valour and intelligence, of moderation and love of justice, of the sacrifice of everything one possesses for the sake of virtue and the common good, than the story of the priest Mattathias and his sons in the books of Maccabeus? Do the Middle Ages not offer us subjects which are worthy of being treated for all time, but who represents them to us now? – Everyone is chasing after an ideal that has been set before us by a few individuals who entertained

a disproportionate regard for the works of Greek and Roman art. What man of feeling can conceal his distaste on reading how a certain Englishman esteems the painting of the ancients, which neither he nor anyone else of our time has ever seen, higher than our cherished Raphael, or claims that the latter might have achieved something had he had better subjects at his disposal, if he had painted a Medea or a raging Ajax instead of the *School of Athens* or the *disputo del sacramento*. Is it not pitiful to see how people can be so deluded? I must confess that even the most beautiful ancient figure has always struck me as little more than an attractively embellished stone where one seeks in vain for that soul or the heart which the artists of the fifteenth and the early sixteenth century knew so perfectly how to express. I am really convinced that I harbour little bias in favour either of the old or the more modern painters, but what I have written to you here I hold to be an incontrovertible truth; just as I also firmly believe that art, from a practical point of view, has indeed fallen very low. The old painters sought to produce works that are good, the modern painters works that appear good. And this is also the reason why a painting by the old artists makes little effect in the first instance but increasingly draws us in the longer we contemplate it, while a modern painting exercises exactly the opposite effect. In the latter case we are surprised and astonished, our attention is entirely drawn to the principal subject, which is fully treated and developed, while the viewer does not notice the rest in the first instance. But now we begin to examine it all in a colder spirit. We are immediately struck by the unnatural fact that it is almost only the principal group or the principal figure that is fully worked out and developed, that is fully treated in terms of light. But if one goes further and seeks for nature and truth, where on earth can they be found in our flying robes, our rippling muscles, our exaggerated postures? And yet one continues to hear praise for the masterly execution, for the boldness and facility with which everything has been painted, so that in the end one hardly sees the object any longer and merely admires the artistry revealed in the bravura of the brushwork! The old artists are often reproached for the harshness and firmness of their contours, but that is a failing I should very much like to possess. Which is easier, to delineate the contour of a figure to the accuracy of a hair's breadth, or one that is two fingers broad and fades away into the background to boot? It would seem to me that the answer is obvious. But our eyes have been spoilt and ruined, so that what we no longer properly perceive we now call harsh and sharp. And I would merely ask you to consider nature. I do not feel that we can so easily transgress the determinate character possessed by nature itself.

6 Friedrich Overbeck (1789–1869) 'The Three Ways of Art'

Born in Lübeck, Overbeck studied from 1806 to 1809 at the Akademie in Vienna, where Franz Pforr was a fellow student, and where the instructors included Eberhard Wächter, a disciple of Asmus Jakob Carstens (see VA14). A growing sense of discomfort with the academic regime was fuelled both by his reading in such writers as Wackenroder and Friedrich Schlegel and by a conviction that the Christian religion was the true source of spiritual value in art. In 1809 he formed the Lukasbrüder (Brotherhood of Luke) with Pforr (see VIIB5) and a group of other like-minded artists. Following the French occupation of

Vienna, the brotherhood moved to Rome, where they occupied an empty monastery, dedicating themselves to the pursuit of an art purged of both classical and modern impieties. In their conviction of the endemic 'beauty' of Christian themes they were on common ground with Chateaubriand (see VIIB4), and they were to be followed in their advocacy of a moral and unclassical art by the English Pre-Raphaelite Brotherhood (see *Art in Theory 1815–1900*, IIIC *passim*). Overbeck's 'Three Ways of Art' borrows from the tradition of religious homilies contrasting the paths of vice and virtue. It was originally addressed to his fellow Nazarenes – as the community came to be called – and was written as part of their programme of study and self-examination. After 1810 new recruits came south to Rome, among them Peter Cornelius (see VIIB7), but the community left the monastery after Pforr's death in 1812, and effectively disbanded. Overbeck remained in Rome, however, and worked with Cornelius on a series of frescos commissioned for the Palazzo Zuccari. His *Triumph of Religion in the Arts* of 1831–40, painted after his return to Germany, was to be the subject of a trenchant critique by Friedrich Theodor Vischer (see *Art in Theory 1815–1900*, IIB5). 'The Three Ways of Art' was written about 1810. Pforr's transcript of the text was published in F. H. Lehr, *Die Blütezeit romantischer Bildkunst: Franz Pforr, der Meister des Lukasbundes*, Marburg: Verlag des kunstgeschichtlichen Seminars der Universität Marburg, 1924, pp. 303ff. Our version is taken from the English translation of this text in Lorenz Eitner ed., *Neoclassicism and Romanticism 1750–1850: Sources and Documents*. Volume II. *Restoration/Twilight of Humanism*, Englewood Cliffs, NJ: Prentice-Hall, 1970, pp. 37–9.

Three roads traverse the Land of Art, and, though they differ from one another, each has its peculiar charm, and all eventually lead the tireless traveller to his destination, the Temple of Immortality. Which of these three a young artist should choose ought therefore to be determined by his personal inclination, guided and fortified by reflection.

The first is the straight and simple Road of Nature and Truth. An uncorrupted human being will find much to please his heart and satisfy his curiosity along this road. It will lead him, for better or for worse, through fair, productive country, with many a beautiful view to delight him, through he may occasionally have to put up with monotonous stretches of wasteland as well. But, above these, the horizon will usually be bright, and the sun of Truth will never set. Of the three roads, this is the most heavily travelled. Many Netherlanders have left their footprints on it, and we may follow the older ones among them with pleasure, observing the steadiness of their direction which proves that these travellers advanced imperturbably on their road: not one of these tracks stops short of the goal. – But the most recent footprints are another matter; most of them run in zig-zags to the right and the left, indicating that those who made them looked this way and that, undecided, wondering whether or not to turn back and take another road. Many of these tracks, in fact, disappear into the surrounding wastes and deserts, into impenetrable country. What the traveller on this road must chiefly guard against are the bogs along one side where he may easily sink into mud over his ears, and the sandy wastes on the other side which may lead him away from the road and from his destination. But if he manages to continue along the straight, marked path, he cannot fail to reach his destination. The level country makes this road agreeable to travel, there are no mountains to climb, and the walking is easy, so long as he does not stray to one side or the other,

into bog or desert. Besides, there is plenty of company to be found on this road, friendly people, representing all nationalities. And the sky above this country is usually serene. The careful observer will find here everything the earth offers, he need never be bored on this road. And yet, I must warn the young artist not to raise his expectation too high, for, frankly, he will see neither more, nor less than what other people also see, every day, in every lane.

The second road is the Road of Fantasy which leads through a country of fable and dream. It is the exact opposite of the first. On it, one cannot walk more than a hundred steps on level ground. It goes up and down, across terrifying cliffs and along steep chasms. The wanderer must often dare to take frightening leaps across the bottomless abyss. If he does not have the nerve for it, he will become dizzy at the first step. Only men of very strong constitution can take this road and follow it to the end. – Strange are its environs, usually steeped in night; only sudden lightning flashes intermittently illuminate the terrible, looming cliffs. The road often leads straight to a rock face and enters into a dark crevice, alive with strange creatures. Suddenly, a ray of light pierces the darkness from afar, the light increases as one follows it through the narrow crevice, until abruptly the rocks recede and the brightness of a thousand suns envelops the traveller. Then he is seized, as if by heavenly powers, he eagerly plunges into the bright sea of joy, drinking its luminous waters with wild desire, then, intoxicated and full of fresh ardor, he tears himself from the depths and soars upward like an eagle, his eyes on the sun, until he vanishes from sight. Thus joy and terror succeed each other in sharpest contrast. Not the faintest glimmer of the light of Truth penetrates into these chasms, insurmountable mountains enclose the land, and only rarely do fleeting shadows or dream visions which can bear the light of Truth venture to drift across the barriers, where they then seem to stride like giants from peak to peak.

Just as this land is the opposite of the land of Nature in every feature, it is its opposite also with respect to population. In the other land, the road is constantly thronged with travellers; here it is usually empty. Few dare to enter this region, and even these few have little in common with one another, they go their separate ways, each sufficient to himself, none paying attention to the others. Michelangelo's luminous trace shines above all in this darkness. What distinguishes this road from the other is the colossal and sublime. Never is anything common or ordinary seen here, everything is rare, new, unique. Never is the wanderer's mind at peace: wild joy and terror, fear and expectation beset him in turn.

Let those who love strong emotion and lawless freedom travel this road, and let them walk boldly, it is sure to take them most directly to their destination. But those who love gentler impressions, who can neither grasp the colossal, nor bear the humdrum, and who like neither the bright midday light of the land of Nature, nor the stormy night of the land of Fantasy, but would prefer to walk in the gentle twilight, my advice to them is to take the third road which lies midways between the other two: the Road of the Ideal or of Beauty. Here he will find a paradise spread before him where the flower-fragrance of spring combines with autumn's fruitfulness. – To his right rise the mountains of Fantasy, to his left the view sweeps across fertile vineyards to the beautiful plain of the Land of Nature. From this side, the setting sun of Truth sheds its light; from the other, the morning light

of Beauty rises from behind the golden mountains of Fantasy and bathes the entire countryside in its rosy haze. Thus sunrise and sunset, Truth and Beauty alternate here, and combine, and from their union rises the Ideal. Here even Fantasy appears in the light of Truth, and naked Truth is clothed in the rose-fragrance of Beauty.

This road, besides, is neither so populous as the first, nor so deserted as the second, and the travellers on it differ from those of the second road by their sociability. One sees them walking in pairs, and friendship and love, their constant companions and guides, strew flowers on their way. Then, too, this road is neither so definitely marked as the first, nor so unkempt as the second. It runs, in beautiful variety of setting, from hill to meadow, from lake shore to orange grove. Every imaginable loveliness contributes to this variety. But in the very charm of this road there lies a danger to the traveller, for it may cause him to forget his destination, and cause him to lose all desire for the Temple of Immortality. Thus it happens that some of the travellers are overtaken by death before they reach the Temple. A loving companion may then carry their body to the Temple's threshold, where it will at once return to life and everlasting youth.

These then, dear brothers in art, are the three roads; choose between them according to your inclination, but test your powers first, by using reason. Whichever road you choose, I should advise you to go forward on it without looking too much to the left or right. [. . .] the proof that each of the three roads leads to the goal is given by three men who went separate ways and whose names are equally respected by posterity: Michelangelo took the road of Fantasy, Raphael the road of Beauty, and Dürer that of Nature, though he not infrequently crossed over into the land of Beauty.

7　Peter Cornelius (1783–1867) Letter to Joseph Görres

Cornelius was born in Düsseldorf, where he remained until 1809, studying at the Akademie and working in the prevailing classical manner. After a move to Frankfurt am Main he modified his graphic style by reference to earlier German work, particularly the prints of Albrecht Dürer, though in common with many artists of his generation who reacted against academic classicism, he regarded Raphael's work as the model for a revived religious art. He travelled to Rome in 1811 and was drawn to the circle of the Nazarenes (VIIB6), who shared his ambition for an art that would be at once religious and specifically German. While in Rome he also became preoccupied with the need – as he saw it – for a revival of the techniques of fresco painting, by which means art could reclaim its position on the walls of churches and other public buildings. These were the views which he expressed to Josef Görres (see VIA4), the nationalistic editor of the *Rheinischer Merkur*, in a letter written in November 1814. The opportunity to put his views into practice came with a commission from the Prussian Consul-General in Rome to decorate a room in the Palazzo Zuccari. This work was undertaken in 1816–17 by Cornelius together with Overbeck and two further members of the Nazarenes (the resulting paintings are now in the Nationalgalerie, Berlin). Cornelius' letter to Görres was published in H. Uhde-Bernays, *Künstlerbriefe über Kunst*, Dresden: Jess Verlag, 1926. Our text is taken from the translation printed in Elizabeth Gilmore Holt ed., *From the Classicists to the Impressionists: Art and Architecture*

in the 19th Century (1966), London and New Haven: Yale University Press, 1986, pp. 97–101.

Rome, November 3, 1814

My friends from Frankfurt notified me that you had been kind enough to try to secure a pension for me at the Prussian court. Please accept my most sincere gratitude not only for the benefits which the success of your kind attempt would have for the practice of my art, but also for the good faith and trust which you have in my minor talents and their application. Therefore, please accept my apologies, if I open my heart to you – stimulated by the same faith – to say a few words to you about a topic which fills it completely; I mean Art, that is the art of our fatherland. Unfortunately one must say that at the present time it has been surpassed by the Italians in true culture, as well as in spirit and life. The least of their heroes who voluntarily joined that veritable crusade carried in his breast a higher poetry – if I may call it that – than the foremost professors of any very wise academy, befogged by the gloom of their negative *eclectic storeroom of antiquated ideas about art*. This, however, seems to me to be the harshest word of judgment on any spiritual endeavor in the world and above all in art, for it should be a part of the salt of the earth. If such salt, however, has become tasteless, it is good for nothing, except to be thrown into the alleys and trodden on by the people. You will undoubtedly consider it to be a most desirable, excellent thing, if art in our fatherland would awaken to its old power, beauty, and simplicity, and would keep in step with the reborn spirit of the nation; if it would follow quietly, clearly, and lovingly its powerful but mysterious longing for higher realms, not breaking any power, but putting it in order, directing it to the highest Being, as is the task of all true education, as true art has done at all times and among all noble ancestors. Our fatherland has reached a point where it should not lack such art; it could be a mighty tool for many excellent things! I do not doubt in the least that such an art can rise again like the Phoenix from its ashes; the seed lies embedded deeply in the German mother earth, and spring is near – this thought first and above everything else! Secondly, I believe that God wants to make use of all the splendid seeds that lie within the German nation, in order to propagate a new life, a new kingdom of his power and glory on the earth. Thirdly, I believe that the nation is free, free by its own power and virtue and through God, who has endowed it with this freedom; the nation knows this power and longs for its original source in everything positive; it does not want to lose this precious, unique possession, and it has a genuine joy in every fruit that comes forth from its womb. Fourthly, a small number of German artists – permeated as if by divine revelation by the true nobility and godliness of their art – have begun to clean the grown-over path to their holy temple, in order to prepare it for him who shall come, in order to rid its interiors of buyers and sellers. This small group waits for a worthy opportunity and burns with the desire to show to the world that art can now enter gloriously into life, as it did before, if it will only stop being a venal servant of presumptuous masters, a shop-keeper and a miserable maid-servant of fashion; if overpowered by a mighty love, it will go about in a vassal's garb, with no other adornment than love, purity, and the power of faith as the true patent of its divine origin.

The factors which terribly hinder the free development of such an art are, in my opinion: first, the total lack of sensibilities of a higher nature among our princes and noblemen. They are truly the camel that is to go through the eye of a needle; their hearts are not where the hearts of the people are; they have drunk too deeply from the cup of the great whore! Secondly, there is the lying spirit of modern art in general, which, with its negative eclecticism, agrees perfectly with the vanity and weakness of our nobles. Especially the deadly art academies and, in our country, their stiff directors, who have as goal only themselves, their machine-like correctness, and nothing else, and know how to direct into their channels everything important that the state wants to do for art, where it just dissolves in foam and smoke. For as long as academies have existed, nothing great has been created, and those things that were created are good only when they distance themselves from their spirit and powerless existence. Yet with all this inner nothingness, this lank academic Philistine armed with all the worthiness of bourgeois life, entrenched behind a thousand bulwarks and breastplates of hundred-year-old authority, seems invincible; he even quotes nature, Raphael, and the ancients continuously and calls to them, as the Pharisees did to Moses and the prophets. However, I am of the firm conviction that sooner or later a small rock will be slung at his forehead.

Finally, I will speak of what according to my innermost conviction is the most powerful – I would like to say – the infallible remedy to give German art the basis for its direction to a new great age, worthy of the spirit of the nation. This is nothing but the reintroduction of fresco painting as it was in Italy during the time of the great Giotto up to the time of the divine Raphael. Since I have seen works of this epoch, have familiarized myself with them, and have compared them with those of our ancestors, I must indeed confess that the latter art has an intention just as high, pure, and true, perhaps even deeper and most certainly more unique. However, with reference to the former, I must agree with those who are of the opinion that it has developed more freely, more perfectly and greater in its nature. Next to the extra-ordinary and true encouragement, which art received through the lively participation of the whole nation, and next to other external causes, I consider the practice of fresco painting as the foremost that caused this. Of course, I presuppose inner causes; because if the spirit of God is not with art, all other means do not help at all, and the greatest efforts and encouragement are nothing but trifles. Presupposing this spirit, fresco painting is well suited to adopt all the elements of art in the freest and greatest manner. Instead of merely wanting to unite incompatible external properties in the manner of empty eclecticism, it centers as in a focal point all the life rays radiating from God in a blazing fire that benevolently lights and warms the world. From a spiritual and a physical viewpoint, these works belong actually to that spot on the earth where they were created; they are in most beautiful unison with God, nature, time, and surrounding life; no educated barbarian will carry them away; they are like a noble, excellent man, whose power and high value of humanity is in general a blessing, a joy. Yet the most beautiful, the most effective part, the most tender relations of his life belong to a small, close circle of selected hearts, who actually possess him. For the furtherance of a good beginning in this matter nothing would be more desirable and more effective than to have well-deserved confidence in someone who has seized the truth in art with a brave heart and has increased and formed its

power in the struggle. Thus united powers should be used – according to their unanimous wish – for a great, dignified, extensive work in a public building in any German city. Public life is poor indeed in all noble ornamentation, and much talent and power is consumed in unsatisfied longing for activity and employment. Of what use is a light burning under a bushel when it should shine before the world? There is, after all, enough darkness in the world. If my suggestion were realized, I believe I could predict that this would give the signal from the mountain tops to a new noble upsurge in art. In a short time, powers would show themselves of which no one had believed our modest people were capable of in this art. Schools would be founded in the old spirit which would pour their truly exalted art with effective power into the heart of the nation, into the full life of man, and would adorn it so that from the walls of high cathedrals, of quiet chapels, and lonely monasteries, of city halls, stores, and halls, old, patriotic, well-known figures in renewed, fresh abundance of life would tell the new generations in sweet color language of that old love, old faith, and in the new generations the old strength of our forefathers would be reborn, and therefore the Lord God would be again reconciled with his people. These, my most worthy man, are the words that shout from a full German heart to you across the Alps into the fatherland. Would to God that the arrow of their truth might pierce your heart in spite of the feeble talent of the speaker, and that you would be the man who could find between us and our people the tie of unity that is lacking in order to apply and further develop, for God's honor and that of our nation, the powers which He and nature have given us!

Finally, I do not beg your forgiveness for my frankness, so you may not believe that I have spoken for myself and for my advantage; rather, I put my hand on my heart, unstained by that fault, with the assurance that I have spoken with the purest, most ardent love (a measure of which you can find only in your own heart) and in the name of many richly talented, noble, and proven people, not in my own; and to you as one of the noblest members of our people. Please accept this as a token of our gratitude, our veneration, and our love. I commend myself especially to your further good will and remembrance.

<div style="text-align:right">

P. CORNELIUS,
German painter, at the Café Greco.

</div>

8 Edmé François Jomard and others (active 1800–10) from *The Description of Egypt*

Parts of ancient Egypt had been explored by European travellers during the sixteenth and seventeenth centuries, and by the mid-eighteenth century Egyptian artefacts and engravings of monuments were circulating among interested amateurs. By this time the Grand Tour was occasionally extended as far as Cairo, though rarely further south. The Comte de Caylus was one of the first writers to identify Egyptian culture as a significant pre-classical phase and to conceive of its products as forms of art (see IIA11). The effects of fascination with the 'Egyptian' style were much in evidence during the later eighteenth century – in the engravings of Giovanni Battista Piranesi, in the architectural designs of Etienne-Louis Boullée and Claude-Nicolas Ledoux, in the pottery of Josiah Wedgwood, and in the design

of fashionable interiors. A major turning-point in knowledge and understanding of Egyptian culture came with Napoleon's Egyptian campaign of 1798–9. Though the military objectives were abandoned at an early stage, the expedition was accompanied by a team of 175 savants, draughtsmen and engineers. An Egyptian Institute was established in Cairo and the majority of the team remained for several years, excavating, describing, measuring and drawing in the Nile Valley from Nubia to the Mediterranean. Their discoveries included the Rosetta Stone, which enabled Jean-François Champollion finally to decipher Egyptian hieroglyphics in the early 1820s. A first report on the expedition's findings was published in 1802 by Vivant Denon, appointed in that year as Director-General of the Imperial Museums. The major project of publication, however, was the massive *Description de l'Egypte, ou receuil des observations et des recherches qui ont été faites en Egypte pendant l'expédition de l'armée français.* This was edited principally by Edmé François Jomard, and was issued in phases between 1809 and 1828, the earliest volumes by the Imprimerie Impériale in Paris and later ones by the Imprimerie Royale. Nine large volumes of text were accompanied by a further volume of *Explication des planches* (Explanation of the Plates), and by the plates themselves, some 900 separate engravings designed to be bound in up to twelve volumes of two different sizes. (Due to the sequential form in which the material was issued, and to the complexity of its overall organization, different bindings of the first edition tend to vary both in the order of individual sections and in the overall tally of volumes.) In 1820, before the first edition was complete, a second was begun by the Parisian bookseller C. L. F. Panckoucke. This comprised twenty-four octavo volumes, with a further twelve volumes of plates. It was completed in 1830. Our first passage is from the *Préface historique* (Historical Preface) by Baron Joseph Fournier. In the first edition this was attached to the *Explication des planches*, published in 1809 and designed to follow the nine main volumes of text. In the second edition, however, the *Historical Preface* appears in volume I. The following excerpt is taken from pp. cxxxii–cxli of the latter edition. The second and third passages are taken from sections II and VII respectively of the 'General Description of Thebes' in the first edition of 1809, where they appear in volume I, chapter IX, pp. 4–6 and 185–7. The authors of the material on Thebes are MM. Jollois and Devilliers, who are described as 'Engineers of Bridges and Highways'. The material has been translated for the present volume by Jason Gaiger.

Historical preface

Prior to the French expedition we had only a defective knowledge of the monuments which immortalized Egypt, or rather, we were completely ignorant of them. The following work will offer a meticulous description of them. The exact geographical position of each monument has been established and is indicated on the maps. Detailed topographical plans have been drawn up which show the relative positions of buildings in the same town, and their position in relation to the Nile or the neighbouring mountains. We have also provided a large number of picturesque views of these magnificent ruins. The artists responsible for this work were too struck by the beauty of the subject and by its peculiar grandeur to import any arbitrary composition. They have devoted themselves to truthful imitation in order faithfully to transmit the impression the spectacle of Egypt made upon them. Never have the works of man offered a more sublime subject to the genius of drawing.

The dimensions of the buildings together with their principal parts and accessories have been measured several times with the greatest care and attention. All these monuments are represented by plans, elevations, views taken from different sides and perspective views. The drawings and the descriptions which give the results of these measurements leave nothing to be desired as regards the study of Egyptian architecture; they can be used to construct buildings which resemble those described in every respect. Let us observe here that this work was not restricted to a few isolated ruins which had escaped the effects of time but included the principal monuments of an enlightened nation [*nation éclairée*] to whom the majority of other nations owe their institutions. Southern Egypt does not suffer from the multiple causes which lead to the continual destruction of buildings in other climates and which often efface them down to the last vestiges. The very size of the monuments also protects them against the efforts of man. For this reason it is possible today to form a picture of the architecture of the Egyptians with the certitude of having included their most beautiful buildings. It is clear that those which still exist at Thebes, at Apollinopolis, at Abydos and at Latopolis are the palaces that were occupied by the kings, or were the most remarkable temples, and that these are the same monuments which were described by Hecataeus, Diodorus and Strabo. Nothing can be of greater importance for the history of the arts than knowledge of these great models which aroused the admiration of the Greeks and helped give rise to their genius.

Great efforts have been made to copy exactly the innumerable sculptures which decorate these edifices. The designs of the bas-reliefs represent the widest variety of objects and throw new light on the science of Antiquity: they relate to the practices of war, religious ceremonies, astronomy, government, public customs, domestic habits, agriculture, navigation and all the civil arts. We have sought to transcribe exactly the hieroglyphic characters on a large number of these designs and to conserve not only the individual forms but also the order and relative disposition of the signs. We have gathered the ancient inscriptions which are of interest to literature and to history. And we have carefully copied the colours which still adorn several monuments and seem to have lost nothing of their original brilliance.

To the topographical plans, picturesque views, architectural plates and drawings of bas-reliefs have been added extended descriptions which draw together all those useful observations which cannot be communicated by means of drawings. These descriptions contain the results of a prolonged examination that involved the co-operation of several witnesses. The goal of these descriptions is to make known the current state of the monuments and the deterioration they have suffered over time, the type of materials used, and several other circumstances worthy of attention. They also contain a variety of observations on the architecture, the method of its construction, the colours, the forms and the use of the objects that are represented, the nature of the soil, the changes which result from the periodic floods, and other questions which are not sufficiently extensive to require treatment in a separate report.

The same care has been employed in describing the magnificent sepulchres of the ancient kings of Thebes, the funeral chambers in which domestic piety led the ancient Egyptians to perpetuate the memory and the mortal remains of their ancestors, and the other underground chambers which seem to have been dedicated to mysterious ceremonies.

The famous pyramids of Memphis are of less interest in relation to the fine arts. But other motives guided our careful research into these vast monuments, which have given rise to so many uncertain observations. We have determined with precision their geographical location, the direction of their sides in respect of the meridian line, the exterior dimensions and the dimensions of all the rooms into which it is possible to enter; finally, we have described all the accessory buildings.

The obelisks, the sphinxes, the colossal statues, the sarcophagi and various other monoliths are reproduced in separate drawings. It would not have been possible to transport these precious ornaments of the buildings and sacred places to Europe without a degree of effort impossible under the circumstances. But there are a large number of other objects of smaller dimensions which have been gathered and preserved by different people and which are now in public museums. We have brought from Egypt engraved stones, complete and truncated statues, bronzes, fragments of enamel and porcelain, stones which have been cut or polished and which bear inscriptions, together with other objects of the arts which relate to the ancient religion, to the sciences and the customs of this country. We have carefully examined a vast quantity of mummified human beings, quadruped animals, reptiles and birds, of which we have preserved several. In the boxes or vases which contained the desiccated bodies we found cloths made of a precious fabric, gold necklaces, amulets, rings and a large number of remarkable fragments. From these boxes we removed several volumes of papyrus covered in hieroglyphic signs or alphabetic characters. These objects were discovered in the middle of the ruins of ancient towns, in numerous excavations, which required the examination of the buildings, in public or royal sepulchres, and even, on occasion, in dwelling-places that are still occupied. They were collected throughout the French expedition and we judged it necessary to insert drawings of them into the general collection.

The plates relating to modern Egypt represent: (1) the mosques, the palaces, the gateways of the towns, the squares, the tribunals, the aqueducts, the sepulchres, the areas and buildings dedicated to commerce, inscriptions and medals; (2) the gardens, the baths, the schools, tools relating to the arts, arms, family tombs, the houses of citizens, buildings intended as workshops, machines, studios, and instruments relating to different professions; (3) annual ceremonies, processions, public gatherings, meetings, domestic celebrations, military exercises, funeral customs, marriages, births, the purchase of slaves and their emancipation; (4) finally, remarkable individuals within the different classes of inhabitants or from foreign races, and the clothes and arms which distinguished them.

* * *

§II General outline of the ancient monuments of Thebes

There is a small number of scattered villages in the middle of a plain once occupied by a vast town. These miserable dwellings contrast in a striking manner with the opulent remains of a superb city.

Towards Libya, Koum el-Ba'yrât, Medynetabou and Qournah still possess the remains of large monuments. Halfway between these last two villages, there is a site

devoid of Arab buildings which all the ancient and modern travellers have designated with the name *Memnonium*, and which is equally full of antique buildings. Towards Arabia, Luxor and the two *Karnaks*, built upon magnificent ruins, are connected by an unbroken series of ancient remains. From some distance to the north there can be seen at Med-a'moud several columns which are still upright and a man-made mound covered in the remains of old buildings.

The remains of the city of Thebes are not to be looked for only in the area which is watered by the Nile. As if the portion of the valley which it occupied was insufficiently vast to contain it, this ancient city extended as far as the mountains. In fact, the part of the Libyan chain next to the monuments which still exist is pierced by an innumerable quantity of underground chambers; several of these may well have served as places of refuge for the first troglodyte inhabitants of Egypt. But all of them must be seen as the last abode of the citizens of this ancient capital.

For the reader to experience all the feelings which are aroused on arriving at a place which awakens so many memories, we would have to be able to describe that state of anxious curiosity in which one's desire is to embrace everything at once. It seems that the senses lag behind, so that one is unable to take in all that is there; the mind is confronted with a million questions it wishes to resolve, a million facts it seeks to confirm at the same time. Where are the hundred gates of which Homer sang, and through which one did the 200 chariots armed for war depart? Surrounded on all sides by magnificent ruins, it is easy to surrender oneself to one's imagination; all the exaggerations of poetry seem to take on reality. Where is the statue of Ozymandias, vaunted by Hecataeus as the most colossal of all those which Egypt once contained? Where was the famous circle of gold one cubit high and 365 cubits in circumference, on which was shown the rising and setting of the stars for every day of the year? Where was the site of that great *Diospolis* whose vastness was celebrated by ancient authors and which contained one of the largest edifices that the Egyptians ever built? Where were the dwelling-places of those kings whose renown was such that their wisdom raised them to the rank of gods, and whose precious and useful institutions still solicit the admiration of all those who come to understand them? Where, finally, is that colossal statue of Memnon whose voice sounding at dawn was heard by so many illustrious people? Did Thebes have a city wall? And do traces of it still remain? All of these questions, and a thousand others, present themselves to the mind of the traveller. They cast him into a singular state of agitation, stimulating a desire for action that cannot be satisfied. Drawn towards a multitude of new objects, and a colossal architecture to which his eye is not accustomed, he examines everything with avid curiosity. The vast quantity of sculptures, which cover the walls of the temples and palaces, awakens his astonishment no less than the grand and beautiful lines of the architecture. When after leaving the monuments he seeks to gather together and take stock of what he has seen, he finds that his memory and powers of reflection furnish only confused ideas and he is forced to recognize the insufficiency of his first encounter.

It is only through frequent visits to the same monuments, and only after having carefully studied their shapes, that the visitor is able to comprehend the gravity which characterizes all the works of Egypt and to understand the

powerfully expressed intention of their founders that they should be made inde-
structible.

It is not only those who have dedicated themselves to the study of the arts whose
feelings are awakened by the view of Thebes. Its magnificent buildings offer beauties
of such high degree that they draw the attention of men whom one would think least
inclined to appreciate them. They are like great accidents of nature or dazzling
phenomena which not only capture the minds of those equipped to examine
them but also produce the most vivid and profound impression upon the mass of
people. The soldiers were at first struck with astonishment at the sight of these
imposing masses, but then set off in search of the smallest of ornaments which
decorate them.

A traveller who arrives close to the monument that he intends to study begins by
forming a general idea of the whole without dwelling on any detail in particular. If
there is one place where the spectator is driven to follow this natural sequence with
particular attention, it is the area over which the remains of Thebes are scattered.
Whatever impression one may have formed of this spectacle through the many tales
which have come down to us over the centuries, it presents so many and such
unexpected sights that even the most avid curiosity must be continuously nourished
and reawakened again.

* * *

§VII Description of the ruins of Luxor

[. . .] If he has been led there by an appreciation for art and antiquities, as soon as a
traveller arrives at Luxor he quickly crosses the area covered in ruins which separates
the river from the monument. He then finds himself transported into the middle of a
forest of columns, some six metres, others ten metres in circumference. To the right
there are numerous vestibules, to the left are the obelisks and the imposing mass of
the gateway: on every side grandeur and magnificence surround him. He traverses
several porticoes and colonnades; he climbs the highest mounds to gain a perspective
upon the entire mass of ruins; he hastens as if the monument were at any moment
about to collapse and disappear for ever. After this poorly executed examination,
which leaves the eye and the mind equally exhausted, he returns to the rowing boat,
more astonished than satisfied. If the threats of the anxious inhabitants or the caprice
of some sheikh forces him to leave the river bank, he will take with him only a
confused idea of the buildings of Luxor. And if he seeks to comprehend what he has
seen, he will have only an uncertain grasp of the massess of the monuments and an
exaggerated picture of the distinctive characteristics of its architecture without being
able to call to mind the beauty of the details, for these depend upon the precision with
which they were executed and cannot be rendered with the same exactness. Every-
thing is unnatural; he takes from it and he brings to it only false ideas. Such errors
merely perpetuate and further reinforce the unfavourable prejudices of the reader,
for whom the monument is nothing but a shapeless mass and proof of the barbarism
and ignorance of those who built it. Such have been for the most part the results of
the encounter which resulted from the majority of journeys to Egypt prior to the
French expedition.

In contrast, someone who is able to recall in perfect security the most striking of the objects he has seen, to reunite them in his thought and to co-ordinate them with one another, is in a position to develop a more methodical plan of examination with which to carry out future searches. This was the favourable situation in which we found ourselves. It was easy for us to see that we had entered the palace from one of its sides somewhere towards the middle and that because of the irregular route we had taken we were unable to gain a correct conception of the buildings as a whole.

We then tried to gain access to the square in front of the first gate from inside the village. It can be reached by two different roads. The first begins at the riverbank from which one normally set out; it leads to the entrance of the palace past ruins which lie close to modern habitations, making a double detour in the opposite direction along narrow lanes. The other road leads from Karnak. It is now the principal road of Luxor and is undoubtedly built upon the remnants of the old road that united the two districts of Thebes situated on the eastern bank of the Nile. The discovery of the remains of sphinxes along the whole extent of this road, reaching all the way to Karnak, led us to assume that it had once been lined with sphinxes. The remains of pedestals alternated with fragments of sphinxes possessing the body of a lion and the head of a woman. The closer we approached Karnak, the more numerous the fragments became and the less they were disfigured; at Karnak itself we discovered complete sphinxes still raised upon their pedestals. When the Nile floods, the waters flow along this road. Should we not believe that they also did so at the time of the splendour of Thebes and that these sphinxes were situated along the banks of a canal that was full of boats during the period of inundation and that afterwards was used as one of the main avenues?

As we arrived in front of the palace of Luxor we were met by an increasing number of monuments of a colossal grandeur which aroused both astonishment and admiration. Above all, we noticed two monolithic obelisks in red granite. The excellent quality of this granite, which can only be found in a single part of Egypt, would have been sufficient reason for us to believe that these obelisks had been taken from the mountains of Syène, if in the quarries close to the town we had not also discovered unequivocal traces that these sorts of monument had been worked upon. The hieroglyphs which decorate the obelisks of Luxor are sculpted with the ultimate precision; the figures of the animals above all combine the beauty and finish of the sculptures with a great purity of design. The hieroglyphs are arranged in three lines or vertical columns. Those in the middle have been brought to a perfect polish and are embedded at a depth of five centimetres; those on the two outer sides have only been carved on the surface, whilst those parts of the sides which have not been sculpted have been dressed with care. This variation in the degree of work, joined with the fact that the depth of the sculptures in the middle is twice that of the others, gives rise to differing tones and reflections. Contrasts are established which render everything clear and distinct so that even the smallest details are easy to see. This was evidently the goal of the Egyptian artists and it is hard to conceive how anyone can have taken for a state of imperfection what is the result of a highly intricate scheme.

9 John Flaxman (1755–1826) 'Style'

Flaxman's father had been a maker of plaster casts, for the Wedgwood pottery among others, and the son showed promise as a sculptor from an early age. However, at the age of 20 he failed to win the Royal Academy gold medal that would have underwritten a trip to Italy. Instead he built up his business in England, mostly in the field of monumental sculpture, while also working for the Wedgwood concern. He eventually undertook the journey to Rome in 1787 with money he had made himself. While there he met Canova and became successful both with sculptures and with engraved illustrations of literary classics such as the *Iliad*, the *Odyssey* and Dante's *Divine Comedy*. These almost exclusively linear works brought him success throughout Europe. He continued to produce monuments, with an increasingly religious inflection, becoming the foremost English sculptor of his time. He was elected Professor of Sculpture at the Royal Academy in 1810, from which time he regularly delivered his series of lectures on the techniques and history of the subject. The final lecture on 'Style' offers a brief overview of art from the Greek classical age, through a decline under Rome to the inception of Christianity, culminating in the rebirth of classical style with the added bonus of Christian content in the Renaissance. Before launching his survey, however, Flaxman provides us with an instance of contemporary thinking on the relation of pre-classical, non-Western visual cultural artefacts to the succeeding Western tradition: a relation he expresses through a metaphorical contrast between the 'earliest dawn' and the 'sunrise of human intelligence'. Our extracts are taken from 'Lecture VII. Style', in Flaxman's *Lectures on Sculpture*, London: John Murray, 1829, pp. 196–202, 211–12.

The introduction to a theory, whether of science or art, practical or abstracted, should contain such a compendious view of the subject, as will connect all the branches or members with the principle on which they depend for their essential quality, and peculiar characteristic distinction; so that our view of the whole should comprehend the parts of which it is composed, and our inquiries concerning the parts should be guided and regulated by that common principle in which they are all united.

This universal and indispensable maxim, applied to a course of Lectures on Sculpture, will naturally lead us to some well-known quality which originates in the birth of the art itself – increases in its growth – strengthens in its vigour – attains the full measure of beauty in the perfection of its parent cause – and, in its decay, withers and expires! – Such a quality will define the stages of its progress, and will mark the degrees of its debasement; – it will point out how, and when, proportions were obtained by measure and calculation – when geometrical figures more simple, or complicated, decided form – how the harmony of lines in composition produce energy by contrast, and sympathy by assimilation. – Such a quality immediately determines to our eyes and understanding, the barbarous attempt of the ignorant savage – the humble labour of the mere workman – the miracle of art conducted by science, ennobled by philosophy, and perfected by the zealous and extensive study of nature.

This distinguishing quality is understood by the term Style, in the arts of design. This term, at first, was applied to poetry, and the style of Homer and Pindar must

have been familiar long before Phidias or Zeuxis were known; but, in process of time, as the poet wrote with his style or pen, and the designer sketched with his style or pencil, the name of the instrument was familiarly used to express the genius and productions of the writer and the artist; and this symbolical mode of speaking has continued from the earliest times through the classical ages, the revival of arts and letters, down to the present moment, equally intelligible, and is now strengthened by the uninterrupted use and authority of ancients and moderns.

And here we may remark, that as by the term style we designate the several stages of progression, improvement, or decline of the art, so by the same term, and at the same time, we more indirectly relate to the progress of the human mind, and states of society; for such as the habits of the mind are, such will be the works, and such objects as the understanding and the affections dwell most upon, will be most readily executed by the hands. Thus the savage depends on clubs, spears and axes for safety and defence against his enemies, and on his oars or paddles for the guidance of his canoe through the waters: these, therefore, engage a suitable portion of his attention, and, with incredible labour, he makes them the most convenient possible for his purpose; and, as a certain consequence, because usefulness is a property of beauty, he frequently produces such an elegance of form, as to astonish the more civilized and cultivated of his species. He will even superadd to the elegance of form an additional decoration in relief on the surface of the instrument, a wave line, a zig-zag, or the tie of a band, imitating such simple objects as his wants and occupations render familiar to his observation – such as the first twilight of science in his mind enables him to comprehend. Thus far his endeavours are crowned with a certain portion of success; but if he extend his attempt to the human form, or the attributes of divinity, his rude conceptions and untaught mind produce only images of lifeless deformity, or of horror and disgust.

When we consider these weak and inefficient attempts for a moment, with what astonishment shall we turn to the almost breathing statue, whose mimic flesh seems yielding to the touch! whose balance alarms with the expectation of movement! whose countenance beams with the sweetest charities of humanity! In these opposite descriptions we contemplate the productions of man just emerging from gross and savage nature, and civilized man, formed to moral habits, intellectual enjoyments, and delighting to trace the Creator in his works. Such is the difference between the beginning and the perfection of art. [. . .]

The characters of style may be properly arranged under two heads, the Natural and the Ideal.

The Natural Style may be defined thus: a representation of the human form, according to the distinctions of sex and age, in action or repose, expressing the affections of the soul.

The same words may be used to define the Ideal Style, but they must be followed by this addition – 'selected from such perfect examples as may excite in our minds a conception of the supernatural.'

By these definitions will be understood, that the natural style is peculiar to humanity, and the ideal to spirituality and divinity.

In our pursuit of this subject we are aware of the propensity to imitation common in all, by which our knowledge of surrounding objects is increased, and our

intellectual faculties are elevated; and we consequently find in most countries attempts to copy the human figure, in early times, equally barbarous, whether they were the production of India, Babylon, Germany, Mexico, or Otaheite. They equally partake in the common deformities of great heads, monstrous faces, diminutive and mis-shapen bodies and limbs. We shall, however, say no more of these abortions, as they really have no nearer connection with style, than the child's first attempts to write the alphabet can claim with the poet's inspiration, or the argument and description of the orator.

We shall now proceed to mark the character, and trace the progress of style, not from the earliest dawn, but rather from the sun-rise of human intelligence, when the imitative faculty is assisted by rule, and corrected by reflection – when the representation partakes, in some degree, of man's dignity in countenance and figure. In this state we find painting and sculpture among the Egyptians, whose application to geometry, and inquiries concerning the animal structure, enabled them to give a general, though imperfect, proportion and outline to their figures, whose forms, however, were more determined by simple geometrical lines, than a scrupulous attention to nature. [. . .]

The Egyptian statuaries were laborious mechanics; their works were lifeless forms, menial vehicles of an idea, or the fixed slaves of uniformity in a temple or a palace.

In Greece, painting and sculpture were liberal arts: they were studied by the noblest and best-educated persons; they were improved by the accumulation of science; they were employed to excite and celebrate virtue and excellence: and, finally, to exalt the mind of the beholder to the contemplation of divine qualities and attributes.

Neither our present limits nor the intention of this Academy, permits us to extend our inquiries beyond a rational theory to regulate the study of design; but strictly within these limits we may observe, that in whatever instances the institutions of Greece cultivated and rendered more powerful the virtuous exertions of mind and body, the arts of design also were animated by their beneficial effects, to a degree which surpassed the other nations of antiquity, and has laid a foundation of principles and practice for all succeeding ages.

10 Georg Friedrich Creuzer (1771–1858) from *Symbolism and Mythology of the Ancient Peoples, particularly the Greeks*

The German philologist and classical scholar Georg Friedrich Creuzer was born in Marburg. He studied theology and philology at his home university and in Jena, and in 1804 he took up a professorship at the University of Heidelberg, where he was broadly sympathetic to the aims and ideas of the Heidelberg Romantics. Aspects of Joseph Görres' lectures on early myth and culture (subsequently published as *Mythengeschichte der asiatischen Welt*, 1810) were assimilated into his major work, *Symbolism and Mythology of the Ancient Peoples*, published in four volumes between 1810 and 1812. (For Görres' earlier *Aphorisms on Art*, see VIA4.) Creuzer challenges the opposition between the classical and the modern which is still present in the work of figures such as Friedrich Schiller (see VA12) and August Wilhelm Schlegel (see VIA9) by identifying an earlier 'symbolic' stage prior to

the harmony or resolution of the classical world. The symbolic is marked by the awareness of an unbridgeable gulf between the finite vehicle of artistic expression and the divine content which this is intended to articulate. Unlike allegory, which merely stands in for or points to something not physically present, the symbolic aims to provide immediate sensuous access to that which is infinite and unconditioned. Creuzer's ideas exercised a decisive influence upon the formation of Hegel's aesthetics, in which the symbolic forms the first of three great historical stages of art (see *Art in Theory 1815–1900*, IA10). Hegel formed a close friendship with Creuzer during his period at Heidelberg and he frequently acknowledged the importance of the latter's work. The following excerpt has been translated for the present volume by Jason Gaiger from *Symbolik und Mythologie der alten Volker, besonders der Griechen*, volume 1, Leipzig and Darmstadt: Karl Wilhelm Leske, 1810, pp. 65–85.

§28 – After these preliminary remarks, let us proceed to discuss expression through images. The characteristics identified by Aristotle through the examples he gives of metaphor (μεταφορα) and simile (εικων) lead us directly to the fundamental concepts of symbolic representation. This critic observed that when the poet says 'Achilles leapt forward like a lion' he presents us with a simile, but when he uses the expression 'the lion leapt forward' in relation to Achilles he presents us with a metaphor.[1] A range of different properties, such as strength, courage, the inspiration of irresistible terror and so on are gathered together in the focal point of a single phrase which expresses Achilles' character at a stroke. This is true of all the various sorts of metaphors which employ tropes, whether they rest upon a perceived similarity (metaphor) or upon an external or internal connection between two things (metonymy and synecdoche). The essential characteristic of this form of representation is that it presents something single and indivisible. The understanding, whose task is to distinguish things and to combine them, brings together the various features of an object in order to form a concept, and, in the same way, separates a succession of things into their component parts. In contrast, the vivid procedure of metaphor offers us everything all at once and in a single moment. A glance suffices to take in the whole. [...]

§29 – But if the soul wishes to achieve something greater, that is, if it wishes to ascend to the realm of ideas, and to make the image into a representation of the infinite, it is confronted by a great and irreducible contradiction. For how can what is limited become, so to speak, the vessel or dwelling-place of what has no limits? How can what is sensuous stand in for what is not accessible to the senses, for what can be known only in pure thought? Trapped in this contradiction and cognizant of it, the soul at first finds itself in a state of longing or yearning. It seeks to grasp the essence completely and without alteration and to give it life; but the essence cannot be constrained within the limits which this form imposes. The desire to give birth to the infinite in the finite is a painful yearning. The mind which is trapped in this nocturnal underworld seeks to raise itself up and to break through to the full clarity of the daylight world. It wants to perceive the sole and invariable truth without veils, as it exists in itself, and to capture its image in the changeable world of shadowy existence.

Thus the soul hovers between the world of ideas and the world of the senses, seeking to bring the two into connection and to discover the infinite in the finite.

How can it be otherwise than that things which are produced out of such a struggle bear the mark of their origin, betraying this double nature in their own essence? And indeed, this double origin is clearly revealed in the essential elements and features of the symbol.

§30 – At first the symbol is characterized by just this state of *suspension*, by a condition of indeterminacy between form and essence. In the symbol there is a universal concept which approaches and withdraws but which eludes our grasp whenever we seek to seize hold of it. Although the concept arises from the world of ideas and – to use a Platonic expression – radiates with the full light of the sun like an astral body, it is obscured by the medium through which it travels and by which it enters the eye. Just as the colours of the rainbow arise from the broken image of the sun against dark clouds, so the symbol breaks up the simple light of the idea into a coloured ray of meaning.

For the symbol first becomes meaningful and stimulating precisely through this incongruity between its essence and its form, through the superabundance of its content in comparison to its mode of expression. A symbol is all the more stimulating the more it incites us to reflection. For this reason, the ancients valued the symbol above all for its capacity to raise people out of the habitual character of their everyday lives and to awaken them to higher endeavours. A critic who thought about the nature of language with unusual acumen has rightly observed that 'What is implied always strikes more terror than that which lies uncovered in front of us. That is why the mysteries are revealed in the form of symbols, as in night and darkness. In fact, the symbolic should be likened to darkness and to night.'[2]

§31 – The ability of symbols to stimulate and to unsettle us is connected with another important property – that of *brevity*. A symbol is like a sudden apparition, a bolt of lightning which momentarily lights up the dark night. It is an instant which makes a claim upon our whole being, a glance into the infinite distance from which our minds return enriched. This momentary quality is highly fertile for the responsive mind. The intellect experiences a lively pleasure in separating and then gradually assimilating into itself the constituent parts of the diversity of things which are locked together in the pregnant moment of the image, and it is satisfied by the fullness of the gain which it gradually begins to oversee. For this reason too, the ancients showed a preference for this form of expression. If at first they were led to it by a fortunate natural impulse, they subsequently took full account of it, likening the symbol to Spartanism in virtue of its fruitful brevity. Here too, Demetrius provides a helpful explanation: 'In all circumstances the Spartans had a natural inclination towards brevity in speech. Brevity, after all, is more forceful and peremptory, while length in speech suits supplications and requests. This is why symbols are so forceful, since they resemble brevity in speech. We are left to infer a great deal from a short statement, as in the case of symbols.'[3]

However, only pregnant brevity is forceful. The capacity to stimulate stands in exact relation to the importance of the content. The person who says something trivial but employs contrived taciturnity in order to suggest that he is saying something important fails to achieve his goal and becomes risible. It is the same with

symbolism. To cover a shallow thought in the cloak of symbolism is like covering one's wretchedness in a sumptuous costume. Whoever was hoping to learn something will inevitably experience disappointment at a false expectation and will take revenge through laughter. Only what is meaningful can become significant and only what is important can take on the dignity of the symbol. That which we intimate or fear, that which makes a claim upon our entire being, recalling the mystery of our existence, animating and giving content to our life, the most precious bonds and connections, unity and separation, love and abandonment, that upon which the happiness of our life as a whole depends – these are the things which require a symbol and with which it seeks to enter into unity. [...]

§32 – This leads us to an increase in the potency of the symbol, or to its higher use. When the creative mind comes into contact with art, when it dares to embody religious intuitions and beliefs in a visual form, it must extend the symbol into the realm of the infinite and limitless. It seeks to raise itself above itself and to find embodiment for the highest and most universal concepts. But how is form to be given to the inexhaustible fullness and unfathomable depths of the essence? This is a task which, properly considered, must annul itself. For how can what is conditioned take the place of the unconditioned, how can what is mortal become the vehicle of what is immortal? Since the symbol is always insufficient for such a task it enters into a dual striving. The first is to follow its natural tendency towards the infinite, and to seek, as its sole task, to satisfy its desire to be significant. In this case, it does not seek merely to express many things – it must express everything. It must measure the immeasurable and compel the divine into the restricted sphere of human forms. Always insufficient, the symbol nevertheless follows the hidden impulsion of unidentified intimations and beliefs. Without respect for any natural laws it transgresses all boundaries, but for just this reason it remains in a state of suspended indeterminacy and becomes enigmatic. The inexpressible prevails, and although the essence seeks expression in terrestrial forms it eventually shatters all such vessels through the infinite power it contains. Thereby clarity of vision is itself destroyed and only speechless wonder remains. Here we have characterized the most extreme case and we may term this form of symbolism *mystical*. Yet as long as the limits upon the symbol are recognized, and it does not strive for the utmost, this way of proceeding can succeed in giving meaningful expression to religious faith.

The other alternative is that the symbolic imposes restrictions on itself, keeping to a delicate middle line between spirit and nature. Through this restraint it achieves what is most difficult of all. It is able, to a certain degree, to render the divine visible. Far from lacking significance, it is charged with meaning through the great content which it expresses. With irresistible force it draws the spectator towards it, seizing hold of our soul with the same necessity as the world spirit itself. From the symbol there streams forth an exuberance of living ideas. What reason in combination with the understanding strives to attain through a series of inferences, the symbol, in union with the senses, attains all at once and at a single stroke.

Here the essence does not overflow beyond every boundary. Instead it obeys nature, adapting itself to nature's forms, penetrating them and giving them life. The conflict between the infinite and the finite is resolved and the infinite, limiting

itself, takes on a human scale. From the purification of the image-realm, on the one hand, and the free renunciation of the boundless on the other, there blossoms forth the most beautiful fruit of all symbolism: the symbol of the god, which wondrously combines beauty of form with the highest plenitude. Since this reaches its perfection in Greek sculpture we may call this the *sculptural* [*plastische*] symbol.

§33 – The highest product of man's creative capacity we term the *symbol* and it is to this narrow sphere of embodied ideas that this term should be restricted in its strict scientific sense. It expresses everything that is proper to this genre, raising it up to the highest level: *immediacy*, *totality*, the obscurity of its origin and *necessity*. This single word serves to designate the appearance of the divine and the transfiguration of the terrestrial image. As we have shown, it is fully in accord with the higher use of language of the ancients, even though they extended the scope of this richly significant word to include other, lesser concepts.

In contrast, the German word for symbol, *Sinnbild*, lacks this higher significance and dignity. For this reason its use should be restricted to the lower spheres of artistic activity and it should not be used to refer to symbolic utterances. It is often employed to characterize those forms of representation which require the use of an accompanying text. The Greeks rarely made use of this sort of support and in high Antiquity they employed it principally for reliefs and upon vases. [. . .]

§34 – This reference to *Sinnbilder* which are accompanied by a text leads us to consideration of certain *demands* which are placed upon the symbol. Here we shall limit ourselves to a discussion of the most important, for the rest will be explained by what follows. First and foremost is the demand for clarity. Yet this demand appears contradictory insofar as it threatens to annul the essential character of the symbol. For as the ancients already recognized, the symbol is by nature dark and obscure. How then can it deny its own nature and become clear? Insofar as the symbol possesses something that no image possesses, or rather, insofar as it strives to represent the highest idea of the divine in the form of an image, it cannot send out the full light of the divine radiance undimmed. It betrays its terrestrial origin through its twilight character and its dark gleam. Although the symbol strives to escape the earth and to reach the very highest, it quickly overreaches itself when it ignores the constraints imposed upon it. The demand for clarity, then, is no more than a reminder of the laws of nature which can never be transgressed without penalty. In other words, the symbol wishes to and should express a great deal; it wishes to and should point us towards the divine. But what it has to say it must say decisively, without distraction or confusion. It should express its meaning simply and clearly.

These demands are particularly necessary in relation to symbolism in art. The Greeks, in their best period, observed them rigorously, renouncing all distracting accessories. Whereas more recent symbolism requires all sorts of support, the Greeks were satisfied with a small number of articulate characteristics. How much they achieved with so little! They remained true to nature and avoided what lacked proportion. Thereby, too, they avoided obscurity. Brevity was their second law; they sought to reach their goal by the shortest possible path. They aimed to achieve expression in a way which is pleasing to the senses. Not to offend the senses was their

first concern, and through rigorous abstinence under fortunate circumstances they achieved *loveliness* and *beauty*. Their art was appropriate to this sense of measure. And yet the Greeks also possessed another form of symbolism. When they sought to express a higher wisdom and to elevate their secret teachings above common beliefs, they made the symbol into the organ of mysterious truths and intimations. In fulfilling this vocation the most important thing was for the symbol to be significant, without concern for what is pleasing or beautiful. The more it fulfilled this holy requirement, the more it tended towards obscurity, until ultimately it became an embodied mystery. This is the origin of a large part of the most ancient Greek and Roman temple symbolism. It is often the case that a highly significant temple image is open to several interpretations. This is even more so in the case of properly mystical symbols. Here we need only read what Clement of Alexandria said about the many interpretations of Orphic thallophory.[4] We are astonished that such a simple custom could possess so many meanings. We have lost the key which was passed on through initiation into the mysteries. The symbolism which was employed in these secret duties presupposed instruction which the novice received from the priests and the exegetes. For the symbolism of the art work to be fully and clearly comprehensible, and for what we term education to have enabled someone to understand it, they must first have been given special instructions which could allow them to break through its hard shell to the meaning which lay hidden underneath.

§35 – We have presented the symbolic as the root of all expression through images and at the same time as its highest articulation or flowering. We must now confirm this by comparing the symbol with the other main forms of iconicism. Let us start with *allegory* which in everyday speech is so often confused with the symbol. The essence of the allegorical image is best explained through contrasting it with a historical image, or, as it is perhaps properly expressed, the curiological. Place someone before a history painting and ask him to explain what he sees. What must he do? He must put into words what he sees, and if painting is mute poetry as the ancients claimed, then it will lend the viewer the words with which to speak. Here the viewer is asked to transpose what is expressed in the image into a different form, but he does not need to transpose his own soul into the image. He reports, he does not interpret. Now place the same person before an allegorical picture. Here too, he reports what he sees. But has he thereby exhausted the meaning of the image? Has he taken from it what it contains? Not at all. A mere report such as this will not satisfy anyone. The viewer needs to add something further, something which reveals the meaning lying below the surface. He must articulate more than simply what he sees. He must interpret the picture. Let the painting represent the metamorphosis of Odysseus' companions. If we look at it as a history painting, we will describe only what we see with our eyes. However, if like Socrates and the other ancients we see in this story – and hence in the painting – a representation of the debasement of man through sensuous desire, then we must begin to interpret it. This is expressed both by the older term for this form of representation, υπονοια, as well as by the more recent term, αλληγορια, for both signify a veiled or hidden meaning, indicating that the picture says or means something else.

We can now clearly identify the difference between symbolic and allegorical representation. Allegory presents a general concept or an idea from which the representation remains distinct. But a symbol is itself the embodied idea made accessible to the senses. Allegory involves a form of substitution: we see an image which then refers us on to a concept which we have to seek out. But a symbol shows us the concept itself descended into the physical world: we see the symbol immediately in the image. Accordingly, the distinction between the two is to be found in the quality of immediacy, which allegory lacks. The symbol presents the idea completely and in a single moment, seizing all our psychic energy. It is a beam of light which enters our eye directly from the dark ground of being and of thought. In contrast, allegory entices us to look up and to follow in our own minds the passage of thought that is hidden in the picture. Whereas the symbol gives us everything in a single moment; allegory gives us a sequence of separate stages. [...] Our soul is seized by the symbol and we are dominated by a sense of nature's necessity. Allegory and symbol are similar insofar as both hide deep and important truths under a dark exterior. However, the symbol is like a half-closed flower-bud which holds what is most beautiful sleeping and undeveloped in its chalice, whereas allegory is like the wide climbing branches of a rich and luxurious plant. The most successful allegories of the ancients provide proof of the close relationship and the differences between these two forms.

1 See Aristotle, *Rhetoric*, 1406b (translator's note).
2 Demetrius, *On Style*, §100 ff.
3 *Ibid.*, §243.
4 The carrying of olive branches by old men in sacred processions (translator's note).

11 The Debate on the Elgin Marbles 1808–1816

The surviving elements of the Parthenon frieze and its related sculptures were stripped from the temple on the Acropolis in Athens between 1801 and 1803 on the orders of Thomas Bruce, Earl of Elgin and British Ambassador to the Ottoman Empire. After several vicissitudes, including shipwreck and the imprisonment of Elgin himself by the French, the marbles were put on display in London in 1807, housed in a temporary enclosure set up in the garden of Elgin's home. They immediately became the object of controversy, not least because of Elgin's intention to sell them to the government. In this he was inspired by a mixture of motives ranging from a personal interest in Antiquity to the desire for profit and a wish to outdo the French, who had recently been sequestrating art treasures from the rest of occupied Europe and installing them in the Louvre. A volatile issue lay concealed behind both the financial aspect and the misgivings voiced, even at that early date, by the Society of Dilettanti: misgivings that the government would be condoning plunder if it purchased the marbles for the nation (albeit others spoke of Elgin saving the marbles from neglect and barbarism). The issue was this: classical Antiquity was the absolute cornerstone of modern Western culture (as has been evident from documents throughout the present anthology). The problem with the Parthenon marbles was that if they were genuine they caused difficulties with received notions of the classical ideal, particularly as that ideal was enshrined in the dominant artistic credo of the period, neo-classicism. Among the key points at issue then are: the merit of the sculptures as art; their potential value to the British

nation; and the value of an abstract ideal for art relative to the pursuit of natural truth. The status of Greece at the head of the Western canon was beyond challenge. Nonetheless, times were manifestly changing. What is in play in many of the accounts is a rereading of the Greek heritage, in terms of a more modern disposition to greater naturalism. Succeeding decades saw this revision of the canon mutate further into a challenge to the canon itself under the growing impact of modernity. (For a selection of texts representative of this shift, see *Art in Theory 1815–1900*, sections I and II *passim*.) We reproduce here a selection of documents from the debate over the provenance and the implications of the Parthenon marbles.

11 (i) George Cumberland (1754–1845) Letter to the *Monthly Magazine*

Cumberland, a friend of William Blake, was an engraver as well as an advocate of the need for a national collection. He was among the first to see the marbles and immediately wrote to the *Monthly Magazine* to publicize them. His letter is mainly descriptive, but it conveys a good sense both of the impact the marbles had on one seeing them for the first time, and of the intertwining of national rivalry with considerations of the public benefit that might accrue from their acquisition. Cumberland's letter was published in the *Monthly Magazine*, London, 1 July 1808, pp. 519–20. We have taken the text from Elizabeth Gilmore Holt (ed.), *The Triumph of Art for the Public*, Princeton, NJ: Princeton University Press, (1979) 1983, pp. 116–20.

Sir,

Ever since the year 1762, when the first volume of *Stuart's Athens* made its appearance, has the public curiosity been raised to the highest pitch, to view even small fragments of the sculpture still abounding in that celebrated city and its vicinity. I well remember the pride with which the architect Reveley [i.e. Revett], who was there with Dr. Richard Worsley, once shewed me a piece of moulding that for many years he had carefully carried about with him, and which was equally remarkable for the delicacy of its finish, and the justness of its proportions. Since that period, another traveller, a Mr. Walker, brought over a few fragments, one of which, a small figure in bas-relief, now in my possession, he had carried on a mule above eight hundred miles. But I know of nothing else of any size, or likely to convey to us an idea of the grandeur of art, at the period of the building of the temple in the *Acropolis*, until Lord Elgin, availing himself of his advantageous situation at Constantinople, found means to acquire that noble collection, now happily deposited near Hyde-Park Corner, in a building erected purposely for their security; and, on Saturdays and Sundays, most liberally opened to the inspection of the public, as such things ought to be, without fee or reward, or even the necessity of previous application.

These now consist first of a considerable part of the frieze that surrounded the porticos under the soffit of Peripterous. They are three feet four inches in height, and were continued all round the outside of the wall of the temple; so that the whole, consisting of a procession, measured above five-hundred feet. This procession was the *Panathenaic*, consisting of horsemen and charioteers, some clothed in

the chlamys and tunic, others in the tunic only, and many, as from the bath, quite naked.

Among those of Lord Elgin's marbles are the three scaphephori, or men carrying trays, the sacrificers of the ox, the noble sitting figures of *Neptune* and *Ceres*, the *Hydriaphorae*, or women carrying pitchers of water, the *Canephorae*, or basket carriers, and others that I cannot now recollect; for, at the first view of such stupendous works of art, the mind is too much elated for the memory to exert its activity with precision. Next we find the greater part of the *Metopes* of the frieze of the south side; many in fine preservation, and nearly statues; for they are in very protuberant alto-relievo, consisting of part of the groupes of figures on the south side also, which were ninety-two in number, each representing a centaur combating one of the *Lapithae*; all infinitely varied, and some not much injured by the hand of time.

Thus we are become possessed of two species of specimens of Greek sculpture in their utmost perfection; but what renders this noble museum complete, is, we find these entire figures from the pediment, and statues of the *Caryatides* from the temple of *Erechtheus*, in the most perfect preservation.

Of the statues from the pediment, that of Theseus reposing on a skin of the feline kind is the first that commands our attention. It was, I apprehend, to the right of the western pediment of the portico, that, in the time of Stuart and Revely [Revett], was a mere fragment of a vast pediment filled with excellent sculpture.

This figure is reposing, nearly naked, with the head, trunk, and limbs, almost entire; every part is simple, composed, and dignified; it is a genuine fine specimen of what the Italians would call the Pastoso, in marble, soft, plump, and fleshy, looking truly like a figure covered with skin; a gentle relaxation pervades the whole recumbent image; while it represents that species of strength, which belongs to blood rather than bone. [...]

There are also, on this magnificent pediment, four or five other statues, particularly two dressed figures sitting, that look as if the sculptor had worked in clay instead of marble, so profound are the folds, and so flowing the lines, of their draperies; – to speak of the beauties of which, as they deserve, would, in this place, take up too much room. We may, however, venture from these to prognosticate, that the art of sculpture will now take good footing in this country; our artists having before them in the British Museum, the high Egyptian antiques, the Greek and Roman specimens selected by the late Mr. Townley; and, not to mention the numerous fine casts we possess, Mr. Knight's inestimable collection of bronzes in Soho-square; Tassie's vast collection of gems; and, lastly, these treasures of Lord Elgin's snatched from the Turks; consequently we may boast, that scarce any helps are wanting towards the revival of the noblest art that the faculties of man have hitherto produced. [...]

Such a treasure as we here have before us, would have gratified the ambition of any of the Roman Emperors; and will at this day excite the envy of every collector in Italy. Even the French, after all their depredations, must at a peace, submit to cross the channel, if they wish to see such specimens of art, as Paris, with all its boasted splendour, cannot exhibit. [...]

I trust that this opportunity of completing our studies, so as to rival our neighbours on the Continent, will not be neglected; and that the parliament of England

will, among other subsidies, consent to subsidize the arts; by purchasing, if possible, this entire collection, and building a well-lighted museum to contain it, so situated that the whole public may benefit by the magnificent exhibition.

Your's, &c.

G. Cumberland

11 (ii) Benjamin West (1738–1820) Letter to the Earl of Elgin

West was an American-born painter who succeeded Joshua Reynolds as President of the Royal Academy. He was best known for history painting, in particular for his representation of *The Death of General Wolfe* (1771, see IVA6). Then aged 70, West evidently made numerous studies from the antique sculptures, which he combined into ambitious compositions of his own. For another vivid account of drawing from the marbles, see Haydon at (iii) below. Like Cumberland, West also stresses both the unrivalled status of the sculptures as works of art and their potential role in raising the level of the national culture. We reprint the text of West's letter of 6 February 1809 included in the pamphlet *Memorandum on the Subject of the Earl of Elgin's Pursuits in Greece*, Edinburgh: Balfour, Kirkwood and Co., 1810, pp. 29–33.

My Lord,

I have to acknowledge the receipt of your Lordship's obliging letter from your residence in Scotland; and have to thank you for the indulgence you afforded me, to study, and draw from, the sculptures by Phidias, in your Lordship's house in Piccadilly.

I have found in this collection of sculpture so much excellence in art, (which is as applicable to painting and architecture,) as well as to sculpture, and a variety so magnificent and boundless, that every branch of science connected with the fine arts, cannot fail to acquire something from this collection. Your Lordship, by bringing these treasures of the first and best age of sculpture and architecture into London, has founded a new Athens for the emulation and example of the British student. Esteeming this collection as I do, my Lord, I flatter myself it will not be unacceptable for your Lordship to know, what are the studies I have made from it.

I must premise to your Lordship, that I considered loose and detached sketches from these reliques, of little use to me, or value to the arts in general. To improve myself, therefore, and to contribute to the improvement of others, I have deemed it more important to select and combine whatever was most excellent from them, into subject and composition.

From the Centaurs in *alto relievo*, I have taken the figures of most distinguished eminence, and formed them into groupes for painting; from which selection, by adding female figures of my own, I have composed the Battle of the Centaurs. I have drawn the figures the size of the originals, on a canvass five feet six inches high, by ten feet long.

From the equestrian figures in *relievo*, I have formed the composition of Theseus and Hercules in triumph over the Amazons, having made their queen Hippolita a prisoner. In continuation, and as a companion to this subject, I have formed a

composition, in which Hercules bestows Hippolita in marriage upon Theseus. Those two are on the same size with the Centaurs.

From the large figure of Theseus, I have drawn a figure of that hero, of the same size with the sculpture. Before him, on the ground, I have laid the dead body of the Minotaur which he slew. As, by this enterprise, he was extricated from the Labyrinth by the aid of Ariadne, I have represented that Princess sitting by his side, gazing on him with affection. In the back ground, are the Athenian youths, whom he delivered from bondage; and near them, the ship 'with black sails,' (in the poetic fancy of Pindar), which brought him to Crete. The size of this canvass is six feet high, by nine feet long. [...]

In order to render the subjects, which I selected with perspicuity, and the effect, which arises from combined parts and the order of arrangements, comprehensive, I have ventured to unite figures of my own invention with those of Phidias [...] In following this system of combination, I had the singular good fortune, by your Lordship's liberality, to select from the first productions of sculpture which ever adorned the world in that department in art; which neither Raphael, nor any of the distinguished masters, had the advantage to see, much less to study, since the revival of art. I may, therefore, declare with truth, my Lord, that I am the first in modern times who have enjoyed the much coveted opportunity, and availed myself of the rare advantage of forming compositions from them, by adapting their excellencies to poetic fictions and historical facts. I sincerely hope that those examples of art, with which your Lordship has enriched your country, and which has made London, if not the first, one of the most desirable points in Europe to study them – will not only afford to the British people, the frequent opportunity of contemplating their excellencies; but will be the means of enlightening the public mind, and correcting the national taste, to a true estimation of what is really valuable and dignified in art. The influence of these works will, I trust, encourage the men of taste and opulence in this country, to bestow a liberal patronage on genius to pursue this dignified style in art, for the honour of genius, themselves, and the country.

11 (iii) Antonio Canova (1757–1822) Letters to Quatremère de Quincy and the Earl of Elgin, 1815

The Italian sculptor, painter, draughtsman and architect Antonio Canova was born in Possagno, near Treviso. He quickly rose to become one of the most celebrated artists in Europe, pursuing a long and highly productive career. After leaving Venice for Rome he developed an innovative neo-classical style. His work was compared by his contemporaries with the best sculptures remaining from Antiquity and many saw him as having succeeded in realizing Winckelmann's ideal of beauty. In 1802 he was appointed by Pius VII as 'Inspector General of Antiquity and Fine Arts' for the Papal States. He took considerable interest in ongoing archaeological excavations and did what he could to prevent the break-up and exportation of the remains that were uncovered. In 1815 he was invited to London to certify the authenticity of the Parthenon marbles which the Earl of Elgin had brought back from Greece. As his letter to Quatremère de Quincy reveals, he was greatly affected by what he saw. In his detailed and careful report he recommended that the marbles should be left unrestored for fear of causing further damage. The letter to Quatremère has been

translated for the present volume by Jason Gaiger from Paola Barrochi, *Testimonianze e polemiche figurative in Italia*: Messina and Florence: Casa Editrice G. D'Anna, 1972, pp. 57–8. The book by Quetremère referred to in the letter is probably his archaeological study, *Le Jupiter Olympien, ou l'art de la sculpture antique, considerée sous un nouveau point de vue* (Paris, 1815), which revealed for the first time the polychromatic character of Greek sculpture. The letter to the Earl of Elgin is taken from *A Letter to the Earl of Elgin and Two Memoirs read to the Royal Institute of France on the Sculptures in the Collection of the Earl of Elgin; by the Chevalier E. Q. Visconti*, London: John Murray, 1816, pp. xxi–xxii.

Letter to Quatremère de Quincy

9 November 1815

Here I am in London, my dear and excellent friend, a remarkable city of beautiful streets, beautiful squares, beautiful bridges and great cleanliness; what surprises me above all is that one sees everywhere the well-being of humanity. But to turn to what concerns us! I have seen the marbles brought from Greece. You and I perhaps already had some idea of the bas-reliefs from copies and from the casts and pieces of marble we had already seen. But of the complete figures, in which the artist was truly able to display his knowledge and ability, we knew nothing.

If it is true that these are the works of Phidias, or if they were created under his direction and merely given the finishing touch by him, they clearly show that the great masters were true imitators of beautiful nature [*la bella natura*].

There is nothing mannered or exaggerated about them; nor is there anything hard or anything that could be described as geometrical or conventional. On this account, I conclude that all of those statues which reveal an excessive dependence on conventions must be copies made by the numerous sculptors who copied beautiful Greek works in order to send them to Rome.

But these works of Phidias are true living bodies [*vera carne*], that is to say, beautiful nature. The Belvedere Mercury without arms is a living body, the Torso is a living body, the fighting Gladiator is a living body, the numerous copies of the Satyr of Praxiteles are living bodies, the Cupid of which so many fragments are found is a living body, the Venus is a living body, and the Venus which belongs to this Royal Museum is a living body, just like the two small Satyrs, etc.

I must confess, my dear friend, that seeing these beautiful things has aroused my own *amour propre*; for I had always felt that the great masters must have worked in this way and in no other. Do not believe that the style of the bas-reliefs from the interior of the temple of Minerva is any different; all have the same fine form and carnal quality, for human beings have always been made of the same supple flesh and not of bronze.

I have spoken to many people about your excellent book, and your treatise is now being printed in English. Continue in that love towards me which you have shown on every previous occasion by speaking frankly and without reservation about every aspect of my work.

Give my regards to the most esteemed Madame Quatremère. With all his heart and soul your friend embraces you.

Canova

Letter to the Earl & Elgin

London, 10th November, 1815.

Allow me, my Lord, to express to you the lively sentiments of pleasure which I feel, from having seen in London the inestimable antique marbles brought by your Lordship from Greece. I can never satisfy myself with viewing them again and again; and although my stay in this great metropolis must of necessity be extremely short, I am still anxious to dedicate every leisure moment to the contemplation of these celebrated relics of ancient art. I admire in them the truth of nature combined with the choice of beautiful forms: every thing about them breathes animation, with a singular truth of expression, and with a degree of skill which is the more exquisite, as it is without the least affectation of the pomp of art, which is concealed with admirable address. The naked figures are real flesh, in its native beauty. I esteem myself happy in having been able to see these masterpieces with my own eyes; and I should be perfectly contented with having come to London on their account alone. I am persuaded therefore that all artists and amateurs must gratefully acknowledge their high obligations to your Lordship, for having brought these memorable and stupendous sculptures into our neighbourhood. For my own part I give you most cordially a thousand thanks; and,

I have the honour to be,
&c. &c. &c.
Canova.

11　(iv) From *Report of the Parliamentary Select Committee on the Earl of Elgin's Collection of Marbles*

In response to Elgin's campaign urging that the government should purchase the Parthenon marbles for the nation, a House of Commons Select Committee was appointed on 15 February 1816 with a brief to take evidence from leading figures in the art world. The hearings began on Thursday 29 February with two days of testimony by the Earl of Elgin. They then continued through the following two weeks, taking evidence from sixteen prominent artists and Members of both Houses of Parliament, and concluding on 18 March with the written testimony of Benjamin West, in his capacity as President of the Royal Academy. We include a passage from the Committee's report, and extracts from the testimonies of Joseph Nollekens (1737–1823), John Flaxman (1755–1826), Richard Westmacott (1775–1856), Thomas Lawrence (1769–1830), Richard Payne Knight (1751–1824) and Benjamin West (1738–1820). Our source is the *Report of the Parliamentary Select Committee on the Earl of Elgin's Collection of Marbles*, London, 1816, pp. 6–7 (from the Report by the Committee's Chairman, Henry Bankes); p. 30 (Nollekens); pp. 31–2 (Flaxman); pp. 34–6 (Westmacott); pp. 37–8 (Lawrence); pp. 39 and 42–3 (Payne Knight); pp. 58–60 (West).

[A]lthough in all matters of Taste there is room for great variety and latitude of opinion, there will be found upon this branch of the subject much more uniformity

and agreement than could have been expected. The testimony of several of the most eminent Artists in this kingdom, who have been examined, rates these Marbles in the very first class of ancient art, some placing them a little above, and others but very little below the Apollo Belvidere, the Laocoon, and the Torso of the Belvidere. They speak of them with admiration and enthusiasm; and notwithstanding the manifold injuries of time and weather, and those mutilations which they have sustained from the fortuitous, or designed injuries of neglect, or mischief, they consider them as among the finest models, and the most exquisite monuments of antiquity. The general current of this portion of the evidence makes no doubt of referring the date of these works to the original building of the Parthenon, and to the designs of Phidias, the dawn of every thing which adorned and ennobled Greece. With this estimation of the excellence of these works it is natural to conclude that they are recommended by the same authorities as highly fit, and admirably adapted to form a school for study, to improve our national taste for the Fine Arts, and to diffuse a more perfect knowledge of them throughout this kingdom. [. . .]

It is surprising to observe in the best of these Marbles in how great a degree the close imitation of Nature is combined with grandeur of Style, while the exact details of the former in no degree detract from the effect and predominance of the latter.

The two finest single figures of this Collection differ materially in this respect from the Apollo Belvidere, which may be selected as the highest and most sublime representation of ideal form, and beauty, which Sculpture has ever embodied, and turned into shape.

Joseph Nollekens, Esquire, R. A. called in, and Examined.

Are you well acquainted with the collection of Marbles brought to England by Lord Elgin? – I am.

What is your opinion of those Marbles, as to the excellency of the work? – They are very fine; the finest things that ever came to this country.

In what class do you place them, as compared with the finest Marbles which you have seen formerly in Italy? – I compare them to the finest of Italy.

Which of those of my Lord Elgin's do you hold in the highest estimation? – I hold the Theseus and the Neptune two of the finest things; finer than any thing in this country.

In what class do you place the bas reliefs? – They are very fine, among the first class of bas relief work.

Do you think that the bas reliefs of the Centaurs are in the first class of art? – I do think so.

Do you think the bas relief of the frieze, representing the Procession, also in the first class of the art? – In the first class of the art. [. . .]

To which of the works you have seen in Italy do you think the Theseus bears the greatest resemblance? – I compare that to the Apollo Belvidere and Laocoon.

Do you think the Theseus of as fine sculpture as the Apollo? – I do.

Do you think it is more or less of ideal beauty than the Apollo? – I cannot say it is more than the Apollo.

Is it as much? – I think it is as much.

Do you think that the Theseus is a closer copy of fine nature than the Apollo? – No; I do not say it is a finer copy of nature than the Apollo.

Is there not a distinction amongst artists, between a close imitation of nature, and ideal beauty? – I look upon them as ideal beauty and closeness of study from nature.

John Flaxman, Esquire, R. A. called in, and Examined.

Are you well acquainted with the Elgin collection of Marbles? – Yes, I have seen them frequently, and I have drawn from them; and I have made such enquiries as I thought necessary concerning them respecting my art.

In what class do you hold them, as compared with the first works of art which you have seen before? – The Elgin Marbles are mostly basso-relievos, and the finest works of art I have seen. Those in the Pope's Museum, and the other galleries of Italy, were the Laocoon, the Apollo Belvidere; and the other most celebrated works of antiquity were groups and statues. These differ in the respect that they are chiefly basso-relievos, and fragments of statuary. With respect to their excellence, they are the most excellent of their kind that I have seen; and I have every reason to believe that they were executed by Phidias, and those employed under him, or the general design of them given by him at the time the Temple was built; as we are informed he was the artist principally employed by Pericles and his principal scholars, mentioned by Pliny, Alcamenes, and about four others immediately under him; to which he adds a catalogue of seven or eight others, who followed in order; and he mentions their succeeding Phidias, in the course of twenty years. I believe they are the works of those artists; and in this respect they are superior almost to any of the works of antiquity, excepting the Laocoon and Toro Farnese; because they are known to have been executed by the artists whose names are recorded by the ancient authors. With respect to the beauty of the basso-relievos, they are as perfect nature as it is possible to put into the compass of the marble in which they are executed, and that of the most elegant kind. There is one statue also which is called a Hercules or Theseus, of the first order of merit. [. . .]

In what estimation do you hold the Theseus, as compared with the Apollo Belvidere and the Laocoon? – If you would permit me to compare it with a fragment I will mention, I should estimate it before the Torso Belvidere. [. . .]

Do you think it of great consequence to the progress of art in Britain, that this Collection should become the property of the Public? – Of the greatest importance, I think; and I always have thought so as an individual.

Richard Westmacott, Esquire, R. A. called in, and Examined.

Are you well acquainted with the Elgin Marbles? – Yes.

In what class of art do you rate them? – I rate them of the first class of art.

Do you speak generally of the principal naked figures, and of the metopes and the frieze? – I speak generally of their being good things, but particularly upon three or four groups; I should say that two are unequalled; that I would oppose them to any

thing we know in art, which is the River God and the Theseus. With respect to the two principal groups of the draped figures, I consider them also of their kind very superior to any thing which we have in this Country in point of execution.

Do you reckon the metopes also in the first class of art? – I should say generally, for style, that I do.

Do you say the same of the frieze? – I think, both for drawing and for execution, that they are equal to any thing of that class of art that I remember. [. . .]

In what rate should you place the Theseus and the River God, as compared with the Apollo Belvidere and the Laocoon? – Infinitely superior to the Apollo Belvidere.

And how as to the Laocoon? – As to the Laocoon it is a very difficult thing for me to answer the question, more particularly applying to execution, because there is not so much surface to the Theseus or Ilissus as there is to the Laocoon; the whole surface to the Laocoon is left, whereas to the other we cannot say there is more than one-third of the surface left.

Which do you prefer; the Theseus, or the River God? – They are both so excellent that I cannot readily determine; I should say the back of the Theseus was the finest thing in the world; and that the anatomical skill displayed in front of the Ilissus, is not surpassed by any work of art. [. . .]

Do you think these Marbles are well calculated for forming a school of artists? – I have no doubt of it.

You state, that you think the Theseus much superior to the Apollo Belvidere; upon what particular view do you form that opinion? – Because I consider that the Theseus has all the essence of style with all the truth of nature; the Apollo is more an ideal figure.

And you think the Theseus of superior value, on that account? – Yes; that which approaches nearest to nature, with grand form, Artists give the preference to.

Sir Thomas Lawrence, Knt. R. A. called in, and Examined.

Are you well acquainted with the Elgin Marbles? – Yes, I am.

In what class of art do you consider them? – In the very highest.

Do you think it of importance that the Public should become possessed of those Marbles, for the purpose of forming a school of art? – I think they will be a very essential benefit to the arts of this Country, and therefore of that importance. [. . .]

Have you had opportunities of viewing the antique sculpture which was formerly in Italy, and recently at Paris? – Very recently at Paris.

Can you form any estimate of the comparative merit of the finest of the Elgin Marbles, as compared with the finest of those works of art? – It is rather difficult; but I think that the Elgin Marbles present examples of a higher style of sculpture than any I have seen.

Do you conceive any of them to be of a higher class than the Apollo Belvidere? – I do; because I consider that there is in them an union of fine composition, and very grand form, with a more true and natural expression of the effect of action upon the human frame, than there is in the Apollo, or in any of the other most celebrated statues.

You have stated, that you thought these Marbles had great truth and imitation of nature; do you consider that that adds to their value? – It considerably adds to it, because I consider them as united with grand form. There is in them that variety that is produced in the human form, by the alternate action and repose of the muscles, that strikes one particularly. I have myself a very good collection of the best casts from the antique statues, and was struck with that difference in them, in returning from the Elgin Marbles to my own house.

What do you think of the Theseus, compared with the Torso Belvidere? – I should say that the Torso is the nearest, in point of excellence, to the Theseus. It would be difficult to decide in favour of the Theseus; but there are parts of the Torso in which the muscles are not true to the action, and they invariably are in what remains of the Theseus.

Richard Payne Knight, Esquire, called in, and Examined.

Are you acquainted with the Elgin Collection? – Yes; I have looked them over, not only formerly, but I have looked them over on this occasion, with reference to their value.

In what class of art do you place the finest works in this Collection? – I think of things extant, I should put them in the second rank – some of them: they are very unequal; the finest I should put in the second rank.

Do you think that none of them rank in the first class of art? – Not with the Laocoon and the Apollo, and these which have been placed in the first class of art; at the same time I must observe, that their state of preservation is such I cannot form a very accurate notion; their surface is gone mostly.

Do you consider them to be of a very high antiquity? – We know from the authority of Plutarch, that those of the Temple of Minerva, which are the principal, were executed by Callicrates and Ictinus, and their assistants and scholars; and I think some were added in the time of Hadrian, from the style of them.

Do you consider what is called the Theseus and the River God, as works of that age? – The River God I should think, certainly – of the Theseus I have doubts whether it was in that age or added by Hadrian; there is very little surface about it therefore I cannot tell: the River God is very fine.

Do you consider the River God as the finest figure in the collection? – Yes, I do.

In what class do you rank the fragments of the draped female figures? – They are so mutilated I can hardly tell, but I should think most of them were added by Hadrian; they are so mutilated I cannot say much about them: they are but of little value except from their local interest, from having been part of the Temple. [...]

Have those statues which have lost the surface, suffered materially as models to artists? – Very greatly, I think.

Have you examined minutely the parts that are most perfect in the River God? – Yes; the under parts.

Do not you think that is as highly finished as any piece of sculpture you know? – It is highly finished, but it is differently finished from the first-rate pieces; there are no traces of the chissel upon it; it is finished by polishing. In the Laocoon and the things

of acknowledged first-rate work, supposed to be originals, the remains of the chissel are always visible. That is my reason for calling these of the second-rate. [. . .]

Do you consider the River God as considerably superior to the Theseus? – Yes, I do.

Then do you consider the Theseus as vastly inferior to the Torso of Belvidere? – I consider it considerably inferior, not vastly inferior; it is difficult to speak to the degrees of things of that kind, especially when the surface is so much corroded. [. . .]

Have you formed any estimate of the value of these Marbles, wholly unconnected with their value as furniture, and merely in the view of forming a national school for art? – The value I have stated, has been entirely upon that consideration of a school of art; they would not sell as furniture; they would produce nothing at all. [. . .]

QUESTIONS sent to the President of the Royal Academy, his Health not permitting him to attend the Committee; with his Answers thereto.

1. Are you well acquainted with the Elgin collection?

2. In what class of Art do you rank the best of these Marbles?

3. Which, among the Marbles; do you consider as the most excellent?

4. In what class do you rank the draped female figures? [. . .]

12. As compared with the Apollo Belvidere, the Torso of the Belvidere, and the Laocoon, how do you estimate the Theseus or Hercules and the River God or Ilissus?

13. Do you consider it of importance to promoting the study and knowledge of the Fine Arts in Great Britain, that this Collection should become public property? [. . .]

17. Does the close imitation of nature (in your opinion) which is observable in the statues of the Theseus, Ilissus, and some of the best Metopes, take from, or add to their excellence? [. . .]

30. Can you compare, in money value, Lord Elgin's Marbles, or any part of them, with the money value of the Phygalian, or the Townley collection?

ANSWERS to the foregoing QUESTIONS. [Benjamin West]

1. – I am – having drawn the most distinguished of them, the size of the original Marbles.

2. – In the first of dignified art, brought out of nature upon unerring truths, and not on mechanical principles, to form systematic characters and systematic art.

3. – The Theseus, the Ilissus, the breast and shoulders of the Neptune, and the horse's head.

4. – In the first class of grandeur. [. . .]

12. – The Apollo of the Belvidere, the Torso, and the Laocoon, are systematic art; the Theseus and the Ilissus stand supreme in Art.

13. – I think them of the highest importance in Art that ever presented itself in this Country, not only for instruction in professional studies, but also to inform the public mind in what is dignified in Art. [. . .]

17. – The close imitation of nature visible in these Figures, adds an excellence to them which words are incapable of describing, but sensibility feels, and adds to their excellence. [. . .]

30. – I judge of the Elgin Marbles, from their purity and pre-eminence in art over all others I have ever seen, and from their truth and intellectual power.

11 (v) Benjamin Robert Haydon (1786–1846) from *The Judgement of Connoisseurs upon Works of Art*

Haydon was a history painter whose career was dogged by controversy. A mixture of unpropitious circumstances in the landscape- and portrait-dominated English art world, exacerbated by his own combative personality, led ultimately to failure and suicide. Nonetheless he was a prominent figure in the early years of the nineteenth century and he played a major role in the campaign concerning the Parthenon marbles. He had been deeply impressed by them since he first saw them in 1808, and in his *Autobiography* he left a vivid account of how he 'drew at the marbles ten, fourteen and fifteen hours at a time; staying often till twelve at night, holding a candle and my board in one hand and drawing with the other'. In 1816, during the deliberations of the Parliamentary Committee, he published a pamphlet extolling the virtues of the carvings, and attacking those connoisseurs such as Richard Payne Knight (see VB14 and VIIB13) who had doubted their authenticity. The influence of the anatomical teachings of Charles Bell (see VIIA7) may be discerned in Haydon's vigorous argument that the Greek artists' point of departure was naturalistic. Likewise there is a clear sense of the imminent overthrow of what he calls 'the old antique', that is to say, of neo-classicism. Our extracts are taken from *The Judgment of Connoisseurs upon Works of Art compared with that of Professional Men; in reference more particularly to the Elgin Marbles*, London: J. Carpenter & Son, 1816, pp. 3–11.

That the Nobility and higher classes of this country have so little dependence on their own judgment in elevated Art, is principally owing to a defect in their education. In neither University is Painting ever remembered: its relations, its high claims, the conviction that taste is necessary to the accomplishment of a refined character, and to complete the glory of a great country, neither the public tutors of the Nobility, nor the private tutors of the Prince, ever feel themselves, or ever impress upon their

pupils. Thus the educated, the wealthy, and the high-born, grow up and issue out to their respective public duties in the world, deficient in a feeling, the cultivation of which has brightened the glory of the greatest men and most accomplished Princes; but, soon aware of their defects, and soon anxious to supply them, they either fly to that species of art which they can comprehend – the mere imitation of the common objects of our commonest perception; or, if they are desirous to encourage the more refined department, being too proud to consult the artist of genius, they resign their judgment to the gentleman of pretension. – He that is learned in antiquity, and versed in its customs, is believed to be equally learned in nature, and sensible to its beauties. To know one master's touch, and another master's peculiarity; to trace the possessors of a picture as we trace the genealogy of a family; to be alive to an error and insensible to a beauty; are the great proofs of a refined taste and a sound judgment, and are sufficient reasons to induce an amiable nobleman, desirous of protecting art, to listen to his advice and to bow to his authority. In no other profession is the opinion of the man who has studied it for his amusement preferred to that of him who has devoted his soul to excel in it. No man will trust his limb to a connoisseur in surgery. No minister would ask a connoisseur in war how a campaign is to be conducted. No nobleman would be satisfied with the opinion of a connoisseur in law on disputed property. And why should a connoisseur of an art, more exclusively than any other without the reach of common acquirement, be preferred to the professional man? What reason can be given why the painter, the sculptor, and the architect, should not be exclusively believed most adequate to decide on what they best understand, as well as the surgeon, the lawyer, and the general?

I have been roused to these reflections, from fearing that the opinion of Mr. Payne Knight, and other connoisseurs, may influence the estimation of the Elgin Marbles. Surely the Committee will never select this gentleman as one to estimate the beauty of these exquisite works of art! Are they aware of the many mortified feelings with which he must contemplate them? Do they know the death-blow his taste and judgment have received, in consequence of their excellence being universally established? Have they been informed that he at first denied their beauty and originality? And are they so little acquainted with human nature, as to expect from any human being an impartial judgment under such circumstances? – Perhaps they never heard that Mr. Payne Knight at first denied their beauty – then said that they were of the time of Adrian! – then, that they were the work of journeymen, not worthy the name of artists! – and now, being driven from all his surmises, by the proper influence of all artists and men of natural taste, at last hints they *may* be original, but are too much broken to be of any value! Far be it from Mr. Knight to know, that in the most broken fragment the same great principle of life can be proved to exist as in the most perfect figure. Is not life as palpable in the last joint of your forefinger, as in the centre of your heart? – Thus, break off a toe from any fragment of the Elgin Marbles, and *there* I will prove the great consequences of vitality, as it acts externally, to exist. The reasons are these:

All objects, animate and inanimate, in nature, but principally men and brute animals, are the instruments of a sculptor and painter, as influenced by intention or passion acting on feature or form, excited by some interesting object or some powerful event. Man being the principal agent, and his features and form being the

principal vehicle of conveying ideas, the first thing to ascertain is, the great characteristic distinction of man in form and feature as a species, and as an intellectual being, distinguished from brute animals: the next thing, the great causes of his motion, as a machine directed by his will: and the last, what of these causes of motion are excited at any particular passion or intention. We know not how an intention acts by the will on the frame, any more than we know what vitality is; – we only know it by its consequences: and the business of the artist is, to represent the consequences of an idea acting on the form and feature, on the parts which it does influence, and on the parts it does not, so truly, as to excite in the mind of the spectator the exact associations of the feelings intended to be conveyed. The bones are the foundation of the form, and the muscles and tendons the means by which a man moves them, as his passions excite him. Each particular intention or passion will excite a certain number of these means to execute its intentions and express its meanings, and none more or less than are requisite: the rest will remain unexcited. The bones (the things moved) and the muscles (the things moving) are all covered by *skin*, and the mechanism of the art is to express the passion or intention and its consequences by the muscles that are, and those which are not influenced, and to exhibit the true effect of *both*, acting *beneath* and showing *above* the skin that covers them. When the mind is thoroughly informed of the means *beneath* the skin, the eye instantly comprehends the *hint above* it; and when any passion or intention is wanted to be expressed, the means and their consequences, if the artist be deeply qualified, will be as complete in form, and as true in effect, as nature; and the idea represented will be doubly effectual by the perfection of the means of representation. If the character be a god, his character, in feature and in form, must be built on these unalterable principles; for how can we represent a god but by elevating our own qualifications?

These are the principles, then, of the great Greek standard of figure: – first, to select what is peculiarly human in form, feature, and proportion; then, to ascertain the great causes of motion; to remember that the opposite contours of a limb can never be the same from inherent formation; nor of a trunk, if the least inclined from the perpendicular; that the form of a part varies with its action or its repose, and that all action is by the predominance of some of the causes of motion over the others; for, if all were equally to act, the body would be stationary. The peculiar characteristics of intellect and causes of motion, and none more or less, being selected, as external shape depends on internal organization acting on external covering, the forms will be essential. This is the standard of man's figure as a species, and *the principle by which to estimate the period of all the works of antiquity*. The various characters of humanity must be left to the artist's own choice and selection; and an ideal form must never be executed without the curb of *perpetual* and *immediate* reference to nature.

It is this union of nature with ideal beauty, the probabilities and accidents of flesh, bone, and tendon, from extension, flexion, compression, gravitation, action, or repose, that rank at once the Elgin Marbles above all other works of art in the world. The finest form that man ever imagined, or God ever created, must have been formed on this eternal principle. The Elgin Marbles will as completely overthrow the old antique, as ever one system of philosophy overthrew another more enlightened: were they lost, there would be as great a gap in the knowledge of art, as there would have been in philosophy, if Newton had never existed. This is truth, and truth

it can be proved; and let him who doubts it, study them, as I have done, for eight years, daily, and he will doubt it no longer.

11 (vi) William Hazlitt (1778–1830) 'The Fine Arts' from Supplement to the *Encyclopaedia Britannica*

Hazlitt had contemplated becoming an artist before turning to a career as a writer. One of the foremost essayists of his time, he wrote over fifty articles and reviews on art. (Two of these can be found in *Art in Theory 1815–1900*, IA9 and IB3.) His antipathy to conceptions of Idealism in art was fuelled alike by his nonconformist education and by his consistent commitment to liberty and to the ideals of the French Revolution. Due to the debate over the Elgin marbles, the issue of the competing claims of Naturalism and the Ideal were very much in the air at the time when Hazlitt composed his essay on 'Fine Art' for the new Supplement to the *Encyclopaedia Britannica* in 1816 (subsequently incorporated into the seventh edition of 1830–42). Hazlitt's article comes down strongly on the side of Naturalism, going so far as to link the vigour of the Greek sculptures to the tradition of the Dutch and Flemish schools and even Hogarth, rather than to neo-classicism. For Hazlitt, the perfection of the Greeks can be attributed to their attention to nature rather than to any supposed turning away from it in favour of an abstract ideal. Our extract is taken from Hazlitt's text as reprinted in *Painting and the Fine Arts: being the articles under those heads contributed to the seventh edition of the Encyclopaedia Britannica*, by B. R. Haydon and William Hazlitt, Edinburgh: Adam and Charles Black, 1838, pp. 8–12.

The term Fine Arts may be viewed as embracing all those arts in which the powers of imitation or invention are exerted, chiefly with a view to the production of pleasure by the immediate impression which they make on the mind. But the phrase has of late, we think, been restricted to a narrower and more technical signification; namely, to painting, sculpture, engraving, and architecture, which appeal to the eye as the medium of pleasure; and, by way of eminence, to the two first of these arts. In the following observations we shall adopt this limited sense of the term; and shall endeavour to develope the principles upon which the great masters have proceeded, and also to inquire, in a more particular manner, into the state and probable advancement of these arts in this country.

The great works of art at present extant, and which may be regarded as models of perfection in their several kinds, are the Greek statues – the pictures of the celebrated Italian masters – those of the Dutch and Flemish schools – to which we may add the comic productions of our own countryman Hogarth. These all stand unrivalled in the history of art; and they owe their pre-eminence and perfection to one and the same principle, – *the immediate imitation of nature*. This principle predominated equally in the classical forms of the antique and in the grotesque figures of Hogarth: the perfection of art in each arose from the truth and identity of the imitation with the reality; the difference was in the subjects – there was none in the mode of imitation. Yet the advocates for the *ideal system of art* would persuade their disciples, that the difference between Hogarth and the antique does not consist in the different forms of nature which they imitated, but in this, that the one is like and the other unlike nature. This is an error the most detrimental perhaps of all others,

both to the theory and practice of art. As, however, the prejudice is very strong and general, and supported by the highest authority, it will be necessary to go somewhat elaborately into the question in order to produce an impression on the other side.

What has given rise to the common notion of the *ideal*, as something quite distinct from *actual* nature, is probably the perfection of the Greek statues. Not seeing among ourselves any thing to correspond in beauty and grandeur, either with the features or form of the limbs in these exquisite remains of antiquity, it was an obvious, but a superficial conclusion, that they must have been created from the idea existing in the artist's mind, and could not have been copied from any thing existing in nature. The contrary, however, is the fact. The general form, both of the face and figure, which we observe in the old statues, is not an ideal abstraction, is not a fanciful invention of the sculptor, but is as completely local and national (though it happens to be more beautiful) as the figures on a Chinese screen, or a copperplate engraving of a negro chieftain in a book of travels. It will not be denied that there is a difference of physiognomy as well as of complexion in different races of men. The Greek form appears to have been naturally beautiful, and they had, besides, every advantage of climate, of dress, of exercise, and modes of life to improve it. The artist had also every facility afforded him in the study and knowledge of the human form; and their religious and public institutions gave him every encouragement in the prosecution of this art. All these causes contributed to the perfection of these noble productions; but we should be inclined principally to attribute the superior symmetry of form common to the Greek statues, in the first place, to the superior symmetry of the models in nature; and in the second, to the more constant opportunities for studying them. If we allow, also, for the superior genius of the people, we shall not be wrong; but this superiority consisted in their peculiar susceptibility to the impressions of what is beautiful and grand in nature. It may be thought an objection to what has just been said, that the antique figures of animals, &c., are as fine, and proceed on the same principles, as their statues of gods or men. But all that follows from this seems to be, that their art had been perfected in the study of the human form, the test and proof of power and skill; and was then transferred easily to the general imitation of all other objects, according to their true characters, proportions, and appearances. As a confirmation of these remarks, the antique portraits of individuals were often superior even to the personifications of their gods. We think that no unprejudiced spectator of real taste can hesitate for a moment in preferring the head of the Antinous, for example, to that of the Apollo. And in general it may be laid down as a rule, that the most perfect of the antiques are the most simple, – those which affect the least action, or violence of passion, – which repose the most on natural beauty of form, and a certain expression of sweetness and dignity, that is, which remain most nearly in that state in which they could be copied from nature without straining the limbs or features of the individual, or racking the invention of the artist. This tendency of Greek art to repose has indeed been reproached with insipidity by those who had not a true feeling of beauty and sentiment. We, however, prefer these models of habitual grace or internal grandeur to the violent distortions of suffering in the Laocoon, or even to the supercilious air of the Apollo. The Niobe, more than any other antique head, combines truth and beauty with deep passion. But here the

passion is fixed, intense, habitual; – it is not a sudden or violent gesticulation, but a settled mould of features; the grief it expresses is such as might almost turn the human countenance itself *into marble!*

In general, then, we would be understood to maintain, that the beauty and grandeur so much admired in the Greek statues were not a voluntary fiction of the brain of the artist, but existed substantially in the forms from which they were copied, and by which the artist was surrounded. A striking authority in support of these observations, which has in some measure been lately discovered, is to be found in the *Elgin marbles*, taken from the Acropolis at Athens, and supposed to be the works of the celebrated Phidias. The process of fastidious refinement and indefinite abstraction is certainly not visible there.

The figures have all the ease, the simplicity, and variety, of individual nature. Even the details of the subordinate parts, the loose hanging folds in the skin, the veins under the belly or on the sides of the horses, more or less swelled, as the animal is more or less in action, are given with scrupulous exactness. This is true nature and true art. In a word, these invaluable remains of antiquity are precisely like casts taken from life. The *ideal* is not the preference of that which exists only in the mind to that which exists in nature; but the preference of that which is fine in nature to that which is less so. There is nothing fine in art but what is taken almost immediately, and as it were, in the mass, from what is finer in nature. Where there have been the finest models in nature, there have been the finest works of art.

12 Jean-Auguste-Dominique Ingres (1780–1867) from Notebooks and Letters

Ingres was born in Montauban and studied in Toulouse before entering David's studio in Paris in 1797. He worked on the older painter's portrait of *Madame Récamier* (Louvre, Paris), though he was not among the more favoured of his acolytes. Among the resources that helped to direct Ingres' deep engagement with the classical were Winckelmann's writings on Greek art (see IIIA5) and Flaxman's illustrations to Homer and Dante, which were widely circulated in engraved form (see VIIB9). He was awarded a Prix de Rome in 1801, but due to the financial problems of the administration was not able to take it up until five years later. In the interim he received a commission for a portrait of Napoleon from the city of Liège. He finally left for Rome in 1806, pursued by adverse criticism of the portraits he had left on exhibition in the Salon, which included the ambitious *Napoleon I on the Imperial Throne* (Musée de l'Armée, Paris). His submissions to the 1808 and 1810 Salons included the *Valpinçon Bather* (Louvre, Paris) and *Jupiter and Thetis* (Musée Granet, Aix-en-Provence) respectively, but these were no better received. Though Ingres was able to support himself through portrait commissions in Italy, the reaction to his work in Paris may account in part for that occasional need for self-reassurance which is revealed in his early writings. A second reason was the high standard he set himself. He idolized Raphael and seems often to have been so painstaking in his pursuit of the ideal that paintings remained unfinished for decades. His reputation as a history painter was established first in Rome following commissions in 1812–13. After 1815, however, the withdrawal of Napoleonic forces obliged him to turn to new means of support, among them the making of portrait drawings for tourists. After an acquisition from the restoration government, he submitted

to the Salon once again in 1819, only to find his *Grande Odalisque* (Louvre) condemned for the apparent arbitrariness of its anatomy. He was to stay in Italy until 1824, moving in 1820 from Rome to Florence. Ingres made few formal statements on his art, but left written observations in notebooks and other manuscripts. After his death these were transcribed by H. Delaborde and were published, together with surviving correspondence and with statements recorded by pupils, in his *Ingres. Sa vie, ses travaux, sa doctrine, d'après notes, manuscript et lettres du maître*, Paris: Henri Plon, 1870. Much of this material is undated and was organized by Delaborde under thematic headings. We have selected items which can be directly attributed to the artist and which can be positively identified with the early stages of his career. Delaborde's organization of the material was largely followed by Walter Pach in his *Ingres*, New York and London: Harper & Bros., 1939. Our translations are taken from this source, pp. 144–7, 197. (For later material by Ingres see *Art in Theory 1815–1900*, IIB1 and IIID1.)

When one knows one's craft well, when one has learned well how to imitate nature, the chief consideration for a good painter is to *think out* the whole of his picture, to have it in his head as a whole, so to speak, so that he may then execute it with warmth and as if the entire thing were done at the same time. Then, I believe, everything seems to be felt together. Therein lies the characteristic quality of the great master, and there is the thing that one must acquire by dint of reflecting day and night on one's art, when once one has reached the point of producing. The enormous number of ancient works produced by a single man proves that there comes a moment when an artist of genius has a feeling as if he were being swept along by his own means, when, every day, he does things which he thought he could not do.

It seems to me that I am that man. I am making advances every day; never was work so easy for me, and yet my pictures are by no means scanted: the exact opposite is the truth. I am finishing more than I used to do, but much more rapidly. My nature is such that it is impossible for me ever to do my work in any other than the most conscientious fashion. To do it quickly in order to earn money, that is *quite impossible for me.* (1813)

I went with Paulin to see the *Stanze*. Never had Raphael seemed so beautiful to me, and, more than ever before, I was conscious of the way that divine man stands out above other men. I am convinced that he worked according to the dictates of his genius and that he carried the whole of nature in his head, or rather in his heart. When a man reaches that point, he is like a second Creator.

The *Disputa* and above all the *Mass of Bolsena* appeared before my eyes as marvelous masterpieces. In the latter work, what portraits! And in the other, what beautiful and noble symmetry! one that he has almost always employed, and that gives to his compositions that air which is so grand, so majestic!

In the *Heliodoros*, he placed, according to custom (and it is a beautiful one), the principal groups at the edges, leaving an empty space in the middle.

The folds look as if they wanted to make place for others, so well do they imitate nature and movement.

I should need a book, volumes, to dwell upon the qualities of Raphael and upon his incomparable inventions: but I will say that the frescoes of the Vatican are, by

themselves, of far more value than all the picture galleries put together. That beautiful museum is so varied, the man who made it touched so well all the strings, so well imitated the suppleness of nature in the very diversity of his effects! And all of that was painted by Raphael from drawings!

And so let us go on, and strive to imitate him, to understand him; I am, myself, in the unhappy position of having to regret, throughout my life, that I was not born in his century. When I think that, three hundred years earlier, I might actually have become his disciple! (1814)

As regards the arts, I am what I have always been. Age and reflection have, I hope, rendered my taste more certain without lessening its warmth. My adorations are still Raphael, his century, the ancients, and above all the divine Greeks; in music, Gluck, Mozart, Haydn. My library is composed of some twenty volumes, immortal master-pieces – you can well guess which ones; and, with those things, life has many charms. (1818)

To brave everything with courage, never to work save with the idea of pleasing first one's conscience, then a small number of other persons: there is the duty of an artist; for art is not merely a profession, it is also an apostleship. All such courageous effort has its recompense, sooner or later. I shall have mine. After so many days of shadow, the light will come. (1820)

To live with moderation, to limit one's desires and think oneself happy is to be so in reality. To be neither rich nor poor is a blessed state. It is the best of conditions in which to live. Luxury corrupts the virtues of the heart, for the unhappy truth is that the more one has the more one wants to have, and the less one thinks to have. Without the stupid dissipations of what is called society, one lives with a small number of friends whom one has gained through inclination and experience; one practices the arts with delight; literature and the study of mankind may occupy you at any hour and render you different from the crowd. The sources of such enjoyment are inexhaustible. Here then, in my opinion, you see the happy man, the true sage, true philosophy. (1821)

Down to the present time (April 20th, 1821), I have produced a good many works at least as good as those of others, and perhaps, indeed, directed toward a better goal: but never has the desire for gain caused me to be hasty in the way I have produced my pictures, which are conceived and executed in a spirit that is foreign to the modern spirit; for after all, in the eyes of my enemies, the greatest defect of my works is that they do not sufficiently resemble their own work. I do not know whether they or I will turn out to be right in the end; the matter is not yet judged: it is necessary to await the slow but equitable decision of posterity. In any case, I am willing to have it known that for a long time my work has recognized no other discipline than that of the ancients, of the great masters of that century of glorious memory when Raphael laid out the eternal and incontestable boundaries of the sublime in art. I think I have proved in my pictures that my sole ambition is to resemble them, and to continue art by taking it up at the point where they left it.

I am therefore a conserver of the good doctrines, and not an innovator. Neither am I, as my detractors claim, a servile imitator of the schools of the fourteenth and fifteenth centuries, though I know how to make use of them with more of results than they can see. Virgil could find pearls in the manure of Ennius. Yes, even should I be accused of fanaticism for Raphael and his century, I shall never have any modesty except as concerns nature and as concerns their masterpieces. (1821)

I count very much on my old age: it will avenge me. (1821)

It must not be thought that the exclusive love which I have for this painter (Raphael) causes me to ape him: that would be a difficult thing, or rather, an impossible thing. I think I shall know how to be original even when imitating. Look: who is there, among the great men, who has not imitated? Nothing is made with nothing, and the way good inventions are made is to familiarize yourself with those of others. The men who cultivate letters and the arts are all sons of Homer. (1821)

If nature has endowed me with any intelligence, my effort is to penetrate more deeply to the truth, through study of every kind; and if I feel that I sometimes make a few steps ahead, it is precisely because I see *that I know nothing*. Yes, since the moment when I first came to feel what grandeur and perfection are, I find myself admitted to an advantage which may well bring one to despair: that of measuring the extent of these qualities. I destroy more than I produce and I am too slow in arriving at a combination of the results of beauty, for I am above all a lover of the true, and see the beautiful only in the true, the quality which has produced the beauty of Homer and of Raphael.

Add to that the ignorance and the stupidity of the public and you see that I have enough occupation to fill up every moment of my time and to give me sleepless nights. In reality, all this trouble and labor resemble the delightful suffering of lovers, or rather the courageous and tender suffering of motherhood. A success, a bit of acclaim, above all a conscience that has been more or less satisfied – and one resumes one's beloved pain. (1821)

13 Richard Payne Knight (1751–1824) from *An Inquiry into the Symbolical Language of Ancient Art and Mythology*

In 1781 Knight was elected to the Society of Dilettanti. In 1786 his *An Account of the Remains of the Worship of Priapus* was published privately by the society, accompanying a letter from Sir William Hamilton asserting that phallic worship survived in Christian cere-monies in Sicily. The *Account* was based in part on a work in French by the Baron d'Hancarville, published the previous year, which attempted a systematic account of the symbolic language of ancient Greek art. Knight's work was widely regarded as obscene and anti-religious. The *Inquiry* was written as a preface to the second of two illustrated volumes of *Specimens of Ancient Sculpture*, on which Knight worked with his friend Charles Townley, a supporter of d'Hancarville's ideas and a major collector of classical sculpture. In the event, though the first volume of the *Specimens* had been published in 1809 (by the Society of Dilettanti), the second was delayed until 1835 through lack of funds, and it was

decided to issue the *Inquiry* separately in advance. Continuing the quasi-anthropological project established by d'Hancarville and by Knight's own *Worship of Priapus*, the *Inquiry* investigates the genetic character of symbols and the patterns of their occurrence in different cultures. Knight drew upon considerable reading, in classical authors, in accounts by travellers, and in previous forms of early anthropology (his copious footnotes and citations have been excluded from our excerpts). He also drew upon his own resources as a collector. On his death he left 5,205 coins, 111 gems, 800 bronzes and a large number of drawings and prints to the British Museum. In the breadth of his curiosity about the myths, practices and artefacts of human cultures, and in his treatment of Christianity as one religion among many, Knight continued the intellectual commitments of the Enlightenment. The *Inquiry* also gathered copious material on human symbolism and mythology which was later to be mined by the anthropologist James Frazer, author of *The Golden Bough* (1890, revised edition 1911–15), and by the psychoanalysts Sigmund Freud and Carl Jung. Our excerpts are taken from the original edition of 1818, published in London by the Society of Dilettanti, pp. 7–8, 12–18, 93–6. The passages in square brackets are transcriptions from Knight's own marginal additions in the copy held in the British Library.

12. The art of conveying ideas to the sight has passed through four different stages in its progress to perfection. In the first, the objects and events meant to be signified, were simply represented: in the second, some particular characteristic quality of the individual was employed to express a general quality or abstract idea; as a horse for swiftness, a dog for vigilance, or a hare for fecundity: in the third, signs of convention were contrived to represent ideas; as is now practised by the Chinese: and, in the fourth, similar signs of convention were adopted to represent the different modifications of tone in the voice; and its various divisions, by articulation, into distinct portions or syllables. This is what we call alphabetic writing; which is much more clear and simple than any other; the modifications of tone by the organs of the mouth, being much less various, and more distinct, than the modifications of ideas by the operations of the mind. The second, however, which, from its use among the Ægyptians, has been denominated the hieroglyphical mode of writing, was every where employed to convey or conceal the dogmas of religion; and we shall find that the same symbols were employed to express the same ideas in almost every country of the northern hemisphere.

13. In examining these symbols in the remains of ancient art, which have escaped the barbarism and bigotry of the middle ages, we may sometimes find it difficult to distinguish between those compositions which are mere efforts of taste and fancy, and those which were emblems of what were thought divine truths; but, nevertheless, this difficulty is not so great, as it, at first view, appears to be: for there is such an obvious analogy and connection between the different emblematical monuments, not only of the same, but of different and remote countries, that, when properly arranged, and brought under one point of view, they, in a great degree, explain themselves by mutually explaining each other. There is one class, too, the most numerous and important of all, which must have been designed and executed under the sanction of public authority; and therefore whatever meaning they contain, must have been the meaning of nations, and not the caprice of individuals.

14. This is the class of coins, the devices upon which were always held so strictly sacred, that the most proud and powerful monarchs never ventured to put their portraits upon them until the practice of deifying sovereigns had enrolled them among the gods.

* * *

17. By opening the tombs, which the ancients held sacred, and exploring the foundations of ruined cities, where money was concealed, modern cabinets have been enriched with more complete serieses of coins than could have been collected in any period of antiquity. We can thus bring under one point of view the whole progress of the art from its infancy to its decline, and compare the various religious symbols which have been employed in ages and countries remote from each other. These symbols have the great advantage over those preserved in other branches of sculpture, that they have never been mutilated or restored; and also that they exhibit two compositions together, one on each side of the coin, which mutually serve to explain each other, and thus enable us to read the symbolical or mystical writing with more certainty than we are enabled to do in any other monuments. It is principally, therefore, under their guidance that we shall endeavour to explore the vast and confused labyrinths of poetical and allegorical fable; and to separate as accurately as we can, the theology from the mythology of the ancients: by which means alone we can obtain a competent knowledge of the mystic, or, as it was otherwise called, the Orphic faith, and explain the general style and language of symbolical art in which it was conveyed.

18. Ceres and Bacchus, called, in Ægypt, Isis and Osiris; and, in Syria, Venus and Adonis, were the deities, in whose names, and under whose protection, persons were most commonly instructed in this faith.

* * *

21. General tradition has attributed the introduction of the mystic religion into Greece, to Orpheus, a Thracian; who, if he ever lived at all, lived probably about the same time with Melampus, or a little earlier. The traditions concerning him are, however, extremely vague and uncertain; and the most learned and sagacious of the Greeks is said to have denied that such a person had ever existed: but, nevertheless, we learn from the very high authority of Strabo that the Greek music was all Thracian or Asiatic; and, from the unquestionable testimony of the Iliad, that the very ancient poet Thamyris was of that country; to which tradition has also attributed the other old sacerdotal bards, Musæus and Eumolpus.

22. As there is no mention, however, of any of the mystic deities; nor of any of the rites with which they were worshipped, in any of the genuine parts either of the Iliad or Odyssey, nor any trace of the symbolical style in any of the works of art described in them; nor of allegory or enigma in the fables, which adorn them; we may fairly presume that both the rites of initiation and the worship of Bacchus, are of a later period, and were not generally known to the Greeks till after the composition of

those poems. The Orphic hymns, too, which appear to have been invocations or litanies used in the mysteries, are proved, both by the language and the matter, to be of a date long subsequent to the Homeric times; there being in all of them abbreviations and modes of speech not then known; and the form of worshipping or glorifying the deity by repeating adulatory titles not being then in use, though afterwards common.

23. In Ægypt, nevertheless, and all over Asia, the mystic and symbolical worship appears to have been of immemorial antiquity. The women of the former country carried images of Osiris, in their sacred processions, with a moveable phallus of disproportionate magnitude, the reason for which Herodotus does not think proper to relate, because it belonged to the mystic religion. Diodorus Siculus, however, who lived in a more communicative age, informs us that it signified the generative attribute, and Plutarch that the Ægyptian statues of Osiris had the phallus to signify his procreative and prolific power; the extension of which through the three elements of air, earth, and water, they expressed by another kind of statue, which was occasionally carried in procession, having a triple symbol of the same attribute. The Greeks usually represented the phallus alone, as a distinct symbol, the meaning of which seems to have been among the last discoveries revealed to the initiated. It was the same, in emblematical writing, as the Orphic epithet ΠΑΓΓΕΝΕΤΩΡ, *universal generator*; in which sense it is still employed by the Hindoos. It has also been observed among the idols of the native Americans, and ancient Scandinavians, nor do we think the conjecture of an ingenious writer improbable, who supposes that the may-pole was a symbol of the same meaning; and the first of May a great phallic festival both among the ancient Britons and Hindoos; it being still celebrated with nearly the same rites in both countries. The Greeks changed, as usual, the personified attribute into a distinct deity called Priapus, whose universality was, however, acknowledged to the latest periods of heathenism.

24. In this universal character, he is celebrated by the Greek poets under the title of Love or Attraction, the first principle of animation; the father of gods and men; and the regulator and disposer of all things. He is said *to pervade the universe with the motion of his wings, bringing pure light: and thence to be called the splendid, the self-illumined, the ruling Priapus*; light being considered, in this primitive philosophy, as the great nutritive principle of all things. Wings are attributed to him as the emblems of spontaneous motion; and he is said to have sprung from the egg of night, because the egg was the ancient symbol of organic matter in its inert state; or, as Plutarch calls it, the material of generation, containing the seeds and germs of life and motion without being actually possessed of either. It was, therefore, carried in procession at the celebration of the mysteries, for which reason, Plutarch, in the passage above cited, declines entering into a more particular disquisition concerning its nature; the Platonic Interlocutor, in the Dialogue, observing, that though *a small question, it comprehended a very great one, concerning the generation of the world itself, known to those who understood the Orphic and sacred language; the egg being consecrated, in the Bacchic mysteries, as the image of that, which generated and contained all things in itself.*

25. As organic substance was represented by the symbol of the egg; so the principle of life, by which it was called into action, was represented by that of the serpent; which having the property of casting its skin, and apparently renewing its youth, was naturally adopted for that purpose. We sometimes find it coiled round the egg, to express the incubation of the vital spirit; and it is not only the constant attendant upon the guardian deities of health, but occasionally employed as an accessary symbol to almost every other god, to signify the general attribute of immortality. For this reason it served as a general sign of consecration; and not only the deified heroes of the Greeks, such as Cecrops and Erichthonius, but the virgin Mother of the Scythians, and the consecrated Founder of the Japanese, were represented terminating in serpents. Both the Scythians and Parthians, too, carried the image of a serpent or dragon, upon the point of a spear, for their military standard; as the Tartar princes of China still continue to do; whence we find this figure perpetually represented on their stuffs and porcelaine, as well as upon those of the Japanese. The inhabitants of Norway and Sweden continued to pay divine honors to serpents down to the sixteenth century; and almost all the Runic inscriptions, found upon tombs, are engraved upon the sculptured forms of them; the emblems of that immortality, to which the deceased were thus consecrated. Macha Alla, the god of life and death among the Tartars, has serpents entwined round his limbs and body to express the first attribute, and human skulls and scalps on his head, and at his girdle, to express the second. The jugglers and divines also, of North America, make themselves girdles and chaplets of serpents, which they have the art to tame and familiarise; and, in the great temple of Mexico, the captives taken in war, and sacrificed to the sun, had each a wooden collar in the shape of a serpent put round his neck while the priest performed the horrid rites. In the kingdom of Juida, about the fourth degree of latitude, on the western coast of Africa, one of these reptiles was lately, and perhaps is still, worshipped as the symbol of the Deity; and when Alexander entered India, Taxilus, a powerful prince of the country, showed him a serpent of enormous size, which he nourished with great care, and revered as the image of the god, whom the Greek writers, from the similitude of his attributes, call Dionysus or Bacchus. The Epidaurians kept one in the same manner to represent Æsculapius; as did likewise the Athenians, in their celebrated temple of Minerva, to signify the guardian or preserving deity of the Acropolis. The Hindoo women still carry the lingam, or consecrated symbol of the generative attribute of the Deity, in solemn procession between two serpents; and, in the sacred casket, which held the egg and phallus in the mystic processions of the Greeks, was also a serpent. Over the porticoes of all the ancient Ægyptian temples, the winged disc of the sun is placed between two hooded snakes, signifying that luminary placed between its two great attributes of motion and life. The same combination of symbols, to express the same attributes, is observable upon the coins of the Phœnicians and Carthaginians; and appears to have been anciently employed by the Druids of Britain and Gaul, as it still is by the idolaters of China. The Scandinavian goddess Isa or Disa was sometimes represented between two serpents; and a similar mode of canonization is employed in the apotheosis of Cleopatra, as expressed on her coins. Water-snakes, too, are held sacred among the inhabitants of the Friendly Islands; and, in the mysteries of Jupiter Sebazius, the initiated were consecrated by having a snake put down their bosoms.

120. The allegorical tales of the loves and misfortunes of Isis and Osiris are an exact counterpart of those of Venus and Adonis; which signify the alternate exertion of the generative and destructive attributes. Adonis or Adonai was an oriental title of the Sun, signifying Lord; and the boar, supposed to have killed him, was the emblem of Winter; during which the productive powers of nature being suspended, Venus was said to lament the loss of Adonis until he was again restored to life: whence both the Syrian and Argive women annually mourned his death, and celebrated his resurrection; and the mysteries of Venus and Adonis at Byblus in Syria were held in similar estimation with those of Ceres and Bacchus at Eleusis, and Isis and Osiris in Ægypt. Adonis was said to pass six months with Proserpine, and six with Venus; whence, some learned persons have conjectured that the allegory was invented near the pole: where the sun disappears during so long a time: but it may signify merely the decrease and increase of the productive powers of nature as the sun retires and advances. The Vistnoo or Jaggernaut of the Hindoos is equally said to lie in a dormant state during the four rainy months of that climate: and the Osiris of the Ægyptians was supposed to be dead or absent forty days in each year, during which the people lamented his loss, as the Syrians did that of Adonis, and the Scandinavians that of Frey; though at Upsal, the great metropolis of their worship, the sun never continues any one day entirely below the horizon. The story of the Phœnix; or, as that fabulous bird was called in the north, of the Fanina, appears to have been an allegory of the same kind, as was also the Phrygian tale concerning Cybelè and Attis; though variously distinguished by the fictions of poets and mythographers.

121. On some of the very ancient Greek coins of Acanthus in Macedonia we find a lion killing a boar; and in other monuments a dead boar appears carried in solemn procession; by both which was probably meant the triumph of Adonis in the destruction of his enemy at the return of spring. A young pig was also the victim offered preparatory to initiation into the Eleusinian mysteries, which seems to have been intended to express a similar compliment to the Sun. The Phrygian Attis, like the Syrian Adonis, was fabled to have been killed by a boar; or, according to another tradition, by Mars in the shape of that animal; and his death and resurrection were annually celebrated in the same manner. The beauty of his person, and the style of his dress, caused his statues to be confounded with those of Paris, who appears also to have been canonised; and it is probable that a symbolical composition representing him in the act of fructifying nature, attended by Power and Wisdom, gave rise to the story of the Trojan prince's adjudging the prize of beauty between the three contending goddesses; a story, which appears to have been wholly unknown to the ancient poets, who have celebrated the events of the war supposed to have arisen from it. The fable of Ganymede, the cup–bearer of Jupiter, seems to have arisen from some symbolical composition of the same kind, at first misunderstood, and after-wards misrepresented in poetical fiction: for the lines in the Iliad alluding to it, are, as before observed, spurious; and according to Pindar, the most orthodox perhaps of all the poets, Ganymede was not the son of [a Trojan King], but a mighty genius or deity who regulated or caused the overflowings of the Nile by the motion of his feet. His being, therefore, the cup–bearer of Jupiter means no more than that

he was the distributor of the waters between heaven and earth, and consequently a distinct personification of that attribute of the supreme God, which is otherwise signified by the epithet Pluvius. Hence he is only another modification of the same personification, as Attis, Adonis, and Bacchus; who are all occasionally represented holding the cup or patera; which is also given, with the cornucopiæ, to their subordinate emanations, the local genii; of which many small figures in brass are extant.

122. In the poetical tales of the ancient Scandinavians, Frey, the deity of the Sun, was fabled to have been killed by a boar; which was therefore annually offered to him at the great feast of Juul, celebrated during the winter solstice? Boars of paste were also served on their tables during that feast; which, being kept till the following spring, were then beaten to pieces and mixed with the seeds to be sown, and with the food of the cattle and hinds employed in tilling the ground. Among the Ægyptians likewise, those who could not afford to sacrifice real pigs, had images of them in paste served up at the feasts of Bacchus or Osiris; which seem, like the feasts of Adonis in Syria, and the Juul in Sweden, to have been expiatory solemnities meant to honor and conciliate the productive power of the Sun by the symbolical destruction of the adverse or inert power. From an ancient fragment preserved by Plutarch, it seems that Mars, considered as the destroyer, was represented by a boar among the Greeks; and on coins we find him wearing the boar's, as Hercules wears the lion's skin; in both of which instances the old animal symbol is humanised, as almost all the animal symbols gradually were by the refinement of Grecian art. [The ceremony of serving up a decorated Boar's Head on Christmas day, not yet quite extinct, is a Relick of the same symbolical superstition.]

* * *

229. This triform division of the personified attributes or modes of action of one first cause, seems to have been the first departure from simple theism, and the foundation of religious mythology in every part of the earth. To trace its origin to patriarchal traditions, or seek for it in the philosophy of any particular people, will only lead to frivolous conjecture, or to fraud and forgery; which have been abundantly employed upon this subject: nor has repeated detection and exposure either damped the ardor or abashed the effrontery of those, who still find them convenient to support their theories and opinions. Its real source is in the human mind itself; whose feeble and inadequate attempts to form an idea of one universal first cause would naturally end in generalising and classing the particular ideas derived from the senses, and thus forming distinct, though indefinite notions of certain attributes or modes of action; of which the generic divisions are universally three; such as goodness, wisdom, and power; creation, preservation, and destruction; potential, instrumental, and efficient, &c. &c. Hence almost every nation of the world, that has deviated from the rude simplicity of primitive Theism, has had its Trinity in Unity; which, when not limited and ascertained by divine revelation, branched out, by the natural subdivision of collective and indefinite ideas, into the endless and intricate personifications of particular subordinate attributes, which have afforded such abundant materials for the elegant fictions both of poetry and art.

230. The similitude of these allegorical and symbolical fictions with each other, in every part of the world, is no proof of their having been derived, any more than the primitive notions which they signify, from any one particular people; for as the organs of sense and the principles of intellect are the same in all mankind, they would all naturally form similar ideas from similar objects; and employ similar signs to express them, so long as natural and not conventional signs were used. Wolves, lions, and panthers, are equally beasts of prey in all countries; and would naturally be employed as symbols of destruction, wherever they were known: nor would the bull and cow be less obvious emblems of creative force and nutrition; when it was found that the one might be employed in tilling the earth, and the other in constantly supplying the most salubrious and nutritious of food. The characteristic qualities of the egg, the serpent, the goat, &c. are no less obvious; and as observation would naturally become more extensive, as intellect became more active, new symbols would everywhere be adopted, and new combinations of them be invented in proportion as they were wanted.

Bibliography

This bibliography combines the following types of reference in one alphabetical listing, with cross-references where appropriate.

1 Sources for all those texts which are printed and excerpted in the anthology, with dates of original publication given in brackets, where these are different. Texts are listed by author. The editorial prefaces to the individual anthologized texts should be consulted for more detailed references to original occasions of publication.

2 Collections of theoretical and critical materials in which these and related texts may be found, by artist/author, or by editor for compilations from more than one artist/author.

3 Sources for relevant authors and texts not themselves included in the anthology, but referred to or quoted within either editorial matter or anthologized texts.

4 Some further sources for material from the period 1648 to 1815 of relevance to concerns addressed in the anthology.

5 Studies of the art, art theory and criticism of the period which the editors have found of particular value in the selection and tracing of texts.

Abrams, M. H., *The Mirror and the Lamp: Romantic Theory and the Critical Tradition*, Oxford, 1953
Académie Royale des Beaux-Arts [Students], 'Vœu des Artistes', Paris, 1789 (IVB4)
Académie Royale de Peinture et de Sculpture. Statuts et Réglements (1648), in L. Vitet, 1861 (IB5)
Addison, J., *The Pleasures of the Imagination* (1712), in J. Addison, 1826 (IIB4)
Addison, J., *The Spectator with a Biographical, Historical and Critical Preface by the Rev. Rob. Lynham, in Six Volumes*, London, 1826
Aglionby, W., *Painting in Three Dialogues, Containing some Choice Observations upon the Art*, London, 1685 (IA5)
Algarotti, F., *An Essay on Painting* (1762), trans. London, 1764 (IIIA9)
Alison, A., *Essays on the Nature and Principles of Taste*, Edinburgh, 1810 (VA11)
Alpers, S., *The Art of Describing*, Chicago, 1983
Alpers, S., *Rembrandt's Enterprise*, Chicago, 1988
Alpers, S., 'Roger de Piles and the History of Art', in P. Ganz, 1991
Andrews, M. (ed.), *The Picturesque: Literary Sources and Documents*, 3 vols, Mountfield, 1994
Angel, P., *Lof der schilder-konst*, Leiden, 1642 (IE4)
Austen, J., *Northanger Abbey* (*c*.1799–1803), London, 1906 (VB19)

Baillet de Saint-Julien, Louis-Guillaume, *Lettre sur la peinture, sculpture et architecture, Avec un Examen des principaux ouvrages exposés au Louvre au mois d'août*, Paris, 1748 (IIIC3)

Barasch, M., *Theories of Art: From Plato to Winckelmann*, New York, 1985

Barasch, M., *Modern Theories of Art, 1; From Winckelmann to Baudelaire*, New York and London, 1990

Barrell, J., *The Dark Side of the Landscape: The Rural Poor in English Painting, 1730–1840*, Cambridge and New York, 1980

Barrell, J., *The Political Theory of Painting from Reynolds to Hazlitt*, New Haven and London, 1986

Barrochi, P., *Testimonianze e polemiche figurative in Italia*, Messina and Florence, 1972

Barry, J., *A Letter to the Dilettanti Society respecting certain Matters essentially necessary for the Improvement of Public Taste*, London, 1798 (IVA6)

Barry, J., *An Inquiry into the Real and Imaginary Obstructions to the Acquisition of the Arts in England*, London, 1775 (IVA10)

Baumgarten, A. G., *Aesthetica* (1750), Hildesheim, 1961 (IIIB2)

Baumgarten, A. G., *Reflections on Poetry* (1735) trans. K. Aschenbrenner and W. B. Holther, Berkeley and Los Angeles, 1954 (IIIB1)

Beardsley, M. C., *Aesthetics from Classical Greece to the Present*, New York, 1966

Becq, A., *Genèse de l'esthétique française moderne, 1680–1814*, Paris, 1994

Behler, H., *German Romantic Art Theory*, Cambridge, 1993

Bell, C., *Essays on the Anatomy of Expression in Painting*, London, 1806 (VIIA7)

Bellicard, J.-C. and Cochin, C. N. fils, *Observations upon the Antiquities of the Town of Herculaneum*, London, 1753 (IIIA4)

Bellori, G. P., 'The Idea of the Painter, Sculptor and Architect, Superior to Nature by Selection from Natural Beauties' (1664), trans. V. A. Velen in E. Panofsky, 1968 (IB8)

Berkeley, G., 'Third Dialogue', in *Alciphron, or the Minute Philosopher* (1732), ed. D. Berman, London and New York, 1993 (IIB8)

Bermingham, A., *Landscape and Ideology: The English Rural Tradition, 1740–1860*, London, 1987

Bisschop, J., Dedication to Constantijn Huygens from *Icones I* (1660), in J. G. van Gelder and I. Jost, *Jan de Bisschop and his Icones and Paradigmata*, ed. K. Andrews, Doornspijk, 1985 (IA4)

Black, J. and Porter, R., *A Dictionary of Eighteenth-Century World History*, Oxford, 1994

Blake, W., Letters to T. Butts, W. Haley and J. Trussler, 1799–1805, in W. Blake, 1978 (VIB7)

Blake, W., *Descriptive Catalogue* (1809), in W. Blake, 1978 (VIB9)

Blake, W., Marginal Notes to Reynolds' *Discourses* (1801–9), in W. Blake, 1978 (VIB8)

Blake, W., *William Blake's Writings*, vol. II, ed. G. E. Bentley, Oxford, 1978

Blanchard, L. G., 'Sur le mérite de la couleur' (1671), in A. Fontaine, 1903 (IC8)

Blunt, A., *Nicolas Poussin*, London, 1967

Boime, A., *Art in an Age of Revolution: 1750–1800*, Chicago and London, 1987

Boschini, M., *Le Ricche Minere della Pittura Veneziana* (1676), ed. A. Pallucchini, Venice and Rome, 1966 (IC6)

Bouhours, D., *The Conversations of Aristo and Eugene* (1671), trans. in S. Elledge and D. Schier, 1970 (ID7)

Bowie, A., *Aesthetics and Subjectivity: from Kant to Nietzsche*, Manchester, 1990

Brentano, C., 'Verschiedene Empfindungen vor einer Seelandschaft von Friedrich' (1810), in Clemens Bretano, *Werke*, ed. F. Kemp, vol. 2, Munich, 1963 (VIB15)

Brewer, J., *The Pleasures of the Imagination: English Culture in the Eighteenth Century*, London, 1997

Burke, E., *A Philosophical Inquiry into the Origin of our Ideas of the Sublime and the Beautiful* (1757), ed. Adam Phillips, Oxford and New York, 1990 (IIIB6)

Canova, A., Letter to Quatremère de Quincy, 1815, in P. Barrochi, 1972 (VIIB11iii)

Canova, A., Letter to the Earl of Elgin, 1815, trans. in E. Q. Visconti, *A Letter to the Earl of Elgin and Two Memoirs read to the Royal Institute of France on the Sculptures in the Collection of the Earl of Elgin*, London, 1816 (VIIB11iii)

Carriera, R., 'A Proposito degli Studi Femminili' (after 1700), in B. Sani, 1985 (IIA3)

Carstens, A. J., Letter to Karl Friedrich von Heinitz, 1796, in C. L. Fernow, 1806 (VA14)

Cassirer, E., *The Philosophy of the Enlightenment* (1932), trans. F. C. A. Koelln and J. P. Pettegrove, Princeton, NJ, 1979

Caylus, Comte de, 'De la composition' (1750), in Comte de Caylus, 1910 (IIIC4)

Caylus, Comte de, 'On Drawings' (1732), trans. E. G. Holt, in E. G. Holt, 1958 (IIA11)

Caylus, Comte de, 'The Life of Antoine Watteau' (1748), trans. R. Ironside in E. and J. de Goncourt, 1948 (IIA12)

Caylus, Comte de, *Vies d'Artistes du XVIIIe siècle, Discours sur la Peinture et la Sculpture, Salons de 1751 et de 1753 – Lettre à Lagrenée*, ed. A. Fontaine, Paris, 1910

Chambers, E., *Cyclopaedia: or an Universal Dictionary of Arts and Sciences*, 2 vols, London, 1728

Chamberlain, T. J., *Eighteenth Century German Criticism*, New York, 1992

Chambray *see* Fréart de Chambray

Champaigne, P. de, 'Second Conference' (1667), anonymous trans., in A. Félibien, 1740 (IB12)

Champaigne, P. de, 'Sur *La Vierge à l'Enfant avec saint Jean* de Titien' (1671) in A. Fontaine, 1903 (IC7)

Chantelou, P., *Diary of the Cavaliere Bernini's Visit to France* (1665), trans. M. Corbett, Princeton, 1985 (IC3)

Charlesworth, M. (ed.), *The English Garden: Literary Sources and Documents*, 3 vols, Mountfield, 1993

Charmois, M., 'Requête au Roy et a nosseigneurs de son conseil' (1648), in Vitet, 1861 (IB4)

Chateaubriand, F. R., 'Of the Subjects of Pictures' from *The Genius of Christianity* (1802), trans. C. I. White, Baltimore, MD, 1856 (VIIB4)

Chateaubriand, F. R., 'Lettre sur le paysage' (1795), in *Correspondance générale, I, 1789–1807*, ed. B. d'Andlau, P. Christophorov and P. Riberette, Paris, 1977 (VB17)

Chudleigh, M., 'To the Reader' in *Essays upon Several Subjects in Prose and Verse*, London, 1710 (IIB4)

Clark, T. J., 'Painting in the Year II', in *Farewell to an Idea*, New Haven and London, 1999

Colbert, J.-B., Letter to Poussin (*c*.1665), in C. Perrault, 1909 (IB7)

Coleridge, S. T., 'On the Principles of Genial Criticism' (1814), in S. T. Coleridge, 1967 (VIA11)

Coleridge, S. T., *Biographia Literaria, with his Aesthetical Essays* (1907), ed. J. Shawcross, Oxford, 1967

Constable, J., *John Constable's Correspondence II: Early Friends and Maria Bicknell*, ed. R. B. Beckett, Ipswich: Suffolk Records Society, vol. VI, 1964

Constable, J., *John Constable's Correspondence: The Family at East Bergholt 1807–1837*, ed. R. B. Beckett, London and Ipswich: HMSO and Suffolk Records Society, vol. IV, 1962

Constable, J., Letters to Dunthorne, 1799–1814, ed. R. B. Beckett, 1962 and 1964 (VIIA4)

Cooper, A. A. (third Earl of Shaftesbury), 'A Notion of the Historical Draught of the Tablature of the Judgement of Hercules' (1712), in A. A. Cooper, 1969 (IIB3)

Cooper, A. A. (third Earl of Shaftesbury), 'The Moralists, a Philosophical Rhapsody', in A. A. Cooper, 1964 (IIB2)

Cooper, A. A. (third Earl of Shaftesbury), *Characteristics of Men, Manners, Opinions and Times* (1711), ed. J. M. Robertson, Bloomington, IN, 1964

Cooper, A. A. (third Earl of Shaftesbury), *Second Characters, or the Language of Forms*, ed. B. Rand (1914), New York, 1969

Cornelius, P., Letter to Joseph Görres, 1814, trans. in E. G. Holt, 1986 (VIIB7)

Costa, Felix da, *Antiquity of the Art of Painting (c.*1690), trans. G. Kubler, G. L. Hersey, R. F. Thompson, N. G. Thompson and C. Wilkinson, New Haven and London, 1967 (IC11)

Cox, D., *A Treatise on Landscape Painting and Effect in Water Colours*, London, 1813–14 (VIIA11)

Coypel, A., 'L'Excellence de la peinture' (1721), in H. Jouin, 1883 (IIA9)

Coypel, A., 'Sur l'esthétique du peintre' (1721), in H. Jouin, 1883 (IIA8)

Cozens, A., 'A New Method of Assisting the Invention in Drawing Original Compositions of Landscape' (1785), in A. P. Oppé, 1952 (VB9)

Craske, M., *Art in Europe 1700–1830*, Oxford, 1997

Creuzer, G. F., *Symbolik und Mythologie der alten Volker, besonders der Griechen*, vol. 1, Leipzig and Darmstadt, 1810 (VIIB10)

Crousaz, J.-P., *Traité du Beau* (1714), Amsterdam, 1715 (IIB5)

Crow, T., *Emulation: Making Artists for Revolutionary France*, New Haven and London, 1995

Crow, T., *Painters and Public Life in Eighteenth-Century Paris*, New Haven and London, 1985

Cumberland, C., Letter to the *Monthly Magazine*, 1 July 1808, in E. G. Holt, 1983 (VIIB1 1(i))

Cuvillier, C.-E.-G., Letter to Joseph-Marie Vien, 1789, trans. R. L. Herbert, in R. L. Herbert, 1972 (IVB2)

David, J.-L, 'Discours prononcé à la Convention Nationale le 29 mars 1793' (1793), in J.-L. J. David, 1880 (IVB10)

David, J.-L., *Le Tableau des Sabines, exposé publiquement au Palais National des Sciences et des Arts*, in J.-L. J. David, 1880 (VIIB2)

David, J.-L., 'Plan de la Fête qui aura lieu le 10 Thermidor pour décerner les honneurs du Panthéon à Barra et à Viala', in J.-L. J. David, 1880 (IVB11)

David, J.-L., 'Project pour l'érection d'un monument consacré à la gloire du Peuple Française', in J.-L. J. David, 1880 (IVB11)

David, J.-L., 'Rapport fait au nom du Comité d'instruction publique' (1793), in J.-L. J. David, 1880 (IVB10)

David, J.-L., Pupils of, *Discours Adressé au citoyen Vien*, Paris, 1800 (VIIB3)

David, J.-L. J., *Le Peintre Louis David 1748–1825*, Paris, 1880

Davies, M., *Turner as Professor: The Artist and Linear Perspective*, London, 1992

Delaborde. H., *Ingres: Sa vie, ses travaux, sa doctrine, d'après les notes manuscrites et les lettres du maître*, Paris, 1870

Deloynes, Collection, *Collection des piéces sur les beaux-arts imprimées et manuscrites recueilies par Pierre-Jan Mariette, Charles-Nicholas Cochin et M. Deloynes, auditeur des comtes*, microfilm, Paris (Bibliothèque Nationale)

Denvir, B. (ed.), *The Eighteenth Century: Art, Design and Society, 1689–1789*, New York, 1983

Diderot, D., *Oeuvres de Denis Diderot publiées sur les manuscrits de l'auteur par Jacques-André Naigeon*, 15 vols, Paris, 1799

Diderot, D., *Oeuvres*, ed. L. Versini, 5 vols, Paris, 1966

Diderot, D., *Oeuvres esthétiques*, ed. P. Vernière, Paris, 1967

Diderot, D., *Denis Diderot's The Encyclopedia*, ed. and trans. S. J. Gendzier, New York, Evanston, IL, and London, 1967

Diderot, D., *Oeuvres complètes*, ed. H. Dieckmann, J. Fabre, J. Proust, J. Varloot *et al.*, Paris, 1975–

Diderot, D., 'Art' (1751), trans. N. S. Hoyt and T. Cassirer, in S. Eliot and B. Stern, 1979 (IIIC7)

Diderot, D., *Diderot on Art – I: The Salon of 1765 and Notes on Painting*, trans. and ed. J. Goodman, New Haven and London, 1995 A

Diderot, D., *Diderot on Art – II: The Salon of 1767*, trans. and ed. J. Goodman, New Haven and London, 1995 B

Diderot, D., 'Notes on Painting' (1765), trans. J. Goodman, in Diderot, 1995 A (IIIC13)

Diderot, D., 'Pensées détachées sur la Peinture, la Sculpture et la Poésie pour servir de suite aux Salons' (1781), in Diderot, 1996 (IVA11)

Diderot, D., 'Salon de 1763' (1763), in Diderot, 1996 (IIIC12)

Diderot, D., 'Salon of 1765' (1765), trans. J. Goodman, in Diderot, 1995 A (IIIC13)

Diderot, D., 'Salon of 1767' (1768), trans. J. Goodman, in Diderot, 1995 B (IIIC14)

Dresdner, A., *Die Entstehung der Kunst-Kritik*, Munich, 1915

Dryden, John, *The Works of John Dryden*, ed. A. E. W. Maurer and G. R. Guffrey, vol. 20, Berkeley, Los Angeles and London, 1989

Du Bos, Jean-Baptiste, Abbé, *Critical Reflections on Poetry, Painting and Music* (1719), trans. T. Nugent, London, 1748 (IIB6)

Du Fresnoy, C.-A., *De Arte Graphica* (1667), trans. J. Dryden, in A. E. W. Maurer and G. R. Guffrey, 1989 (IC4)

Dubreuil, J., Preface to *Perspective Practical* (1651), trans. R. Pricke, London, 1672 (IE6)

Duff, W., *Critical Observations on the Writings of the Most Celebrated Original Geniuses in Poetry*, London, 1770 (VA3)

Eagleton, T., *The Ideology of the Aesthetic*, Oxford, 1990

Edwards, J., *Images or Shadows of Divine Things*, ed. P. Miller, New Haven, 1948

Edwards, J., *The Beauty of the World* (c.1750), in J. Edwards, 1948 (IIB12)

Eitner, L., *Neoclassicism and Romanticism 1750–1850*, 2 vols, Englewood Cliffs, NJ, 1970

Eliot, S. and Stern, B. (eds.), *The Age of Enlightenment*, London, 1979

Elledge, S. and Schier, D. (eds), *The Continental Model: Selected French Critical Essays of the Seventeenth Century, in English Translation* (1960), rev. edn, Ithaca, NY, 1970

Falconet, E., 'Reflexions on Sculpture' (1761), trans. W. Tooke, in W. Tooke, 1777 (IIIC11)

Farington, J., *The Farington Diary*, ed. J. Grieg, 8 vols, London, 1920

Félibien, A., 'Preface', *Seven Conferences held in the King of France's Cabinet of Paintings* (1667), anonymous trans., London, 1740 (IB10)

Félibien, A., *Entretiens sur les vies et les ouvrages des plus excellents peintres anciens et modernes* (1666–88), Farnborough, 1967 (IB9; ID6)

Fernow, K. L., *Leben des Künstlers Asmus Jakob Carstens. Ein Beitrag zur Kunstgeschichte des 18. Jahrhunderts*, Leipzig, 1806

Fernow, K. L., 'Über die Landschaftsmalerei', *Neuer Teutscher Merkur*, Nov. and Dec. 1803 (VIIA6)

Flaxman, J., *Lectures on Sculpture*, London, 1829 (VIIB9)

Fontaine, A., *Conférences inédites de l'Académie royale de Peinture et de Sculpture*, Paris, 1903

Fontaine, A., *Les Doctrines d'art en France. Peintres, Amateurs, Critiques, de Poussin à Diderot* (1909), Geneva, 1970

Fontenelle, B., 'A Digression on the Ancients and Moderns' (1688), trans. in S. Elledge, 1970 (IA6)

Foot, P. (ed.), *Shelley's Revolutionary Year*, London, 1990

Fort, B. (ed.), *Les Salons des 'Mémoires Secrets'*, Paris, 1999 (IIIC9)

Fréart, Roland, Sieur de Chambray, *An Idea of the Perfection of Painting* (1662), trans. J. Evelyn, London, 1668 (IB6)

Fried, M., *Absorption and Theatricality: Painting and Beholder in the Age of Diderot*, Berkeley, Los Angeles and London, 1980

Friedrich, C. D., Letter to Arndt, 1814, in S. Hinz, 1968 (VIB19)

Friedrich, C. D., Letter to Schulz, 1809, in H. Uhde-Bernays, 1962 (VIB13)

Fuller, J. C., *The Decisive Battles of the Western World*, London, 1970

Funt, D., *Diderot and the Esthetics of the Enlightenment* (Diderot Studies, XI), Geneva, 1968

Fuseli, H., 'Introduction' to *The Grave, a poem. By Robert Blair. Illustrated by Twelve Etchings executed from original designs*, London, 1808 (VIB11)

Fuseli, H., *Aphorisms, Chiefly Relative to the Fine Arts* (1818), in J. Knowles, 1831 (VIA10)

Gadamer, H.-G., *Truth and Method* (1960), trans. Garrett Barden and John Cumming, New York, 1975

Gage, C, *Colour and Culture: Practice and Meaning from Antiquity to Abstraction*, London and New York, 1993

Gage, J., *Colour in Turner*, London, 1969

Gage, J. (ed. and trans), *Goethe on Art*, London, 1980

Gainsborough, T., *The Letters of Thomas Gainsborough*, ed. M. Woodall, Birmingham, 1961–3 (VA1)

Galt, J., *The Life and Works of Benjamin West Esq.*, London and Edinburgh, 1820

Ganz, P. *et al.* (eds), *Kunst and Kunsttheorie, 1400–1900*, Wiesbaden, 1991

Gazat (Minister of the Interior), preliminary statement to the Official Catalogue of the Salon of 1793 (1793), trans. E. G. Holt, in E. G. Holt, 1983 (IVB9)

Gerard, A., *An Essay on Taste* (1759), Edinburgh and London, 1764

Gessner, S. and Gessner, K., *The Letters of Gessner and his Family* (1801), anonymous trans., London, 1804

Gessner, S., 'Letter on Landscape Painting', trans. M. J. Hope, in S. Gessner, 1797 (VB3)

Gessner, S., *The Death of Abel in Five Books* (1758), trans. M. J. Hope, London, 1797

Gilpin, W., 'The Principles of Painting considered, so far as they relate to prints', in *Essay upon Prints*, London, 1768 (VB2)

Gilpin, W., *Observations on the River Wye*, London, 1782 (VB5)

Gilpin, W., *Three Essays: on Picturesque Beauty; on Picturesque Travel; and on Sketching Landscape: to which is added a poem on Landscape Painting*, London, 1792 (VB11)

Goethe, J. W., 'On German Architecture' (1772), trans. J. Gage, in J. Gage, 1980 (VA4)

Goethe, J. W., Introduction to the *Propyläen* (1798), trans. J. Gage, in J. Gage, 1980 (VIIA1)

Goethe, J. W., *Italian Journey* (1816–17/1829), trans. R. R. Heitner, Princeton, NJ, 1994

Goethe, J. W., *Naturwissenschaftliche Schriften*, Hamburger Goethe-Ausgabe, vol. XIII, Hamburg, 1955

Goethe, J. W., *Theory of Colours* (1810), trans. C. Eastlake, Cambridge, MA, 1970 (VIIA9)

Goethe, J. W., Review of *The Fine Arts in their Origin, their True Nature and Best Application*, by J. G. Sulzer (1772), trans. T. J. Chamberlain, in T. J. Chamberlain, 1992 (VB7)

Goncourt, E. and Goncourt, J., *French XVIII Century Painters* (1860), trans. R. Ironside, London, 1948

Görres, J., *Aphorismen über die Kunst. Als Einleitung zu Aphorismen über Organonomie, Physik, Psychologie und Anthropologie*, Koblenz, 1802 (VIA4)

Goya, F, 'Address to the Royal Academy of San Fernando regarding the method of teaching the visual arts' (1792), trans. J. A. Tomlinson, in J. A. Tomlinson, 1992 (IVA14)

Goya, F., on the *Caprichos* (1799), trans. in J. López-Rey, 1970 (VIB3)

Gracián, B., *The Art of Worldly Wisdom* (1647), trans. J. Jacobs, London and New York, 1892 (ID2)

Gracián, B., *The Hero* (1647), anonymous trans. London, 1726 (ID1)

Great Britain. *Parliamentary Select Committee, Report on the Earl of Elgin's Collection of Marbles*, London, 1816 (VIIB11iv)

Green, V., *A Review of the Polite Arts in France at the Time of their Establishment under Louis XIV compared with their Present State in England*, London, 1782 (IVA13)

Grimm, F. M., *Correspondence littéraire*, 15 December 1756, trans. M. Fried, in M. Fried, 1980 (IIIC10)

Grimm, F. M., *Correspondence littéraire, philosophique, et critique par Grimm, Diderot, Raynal etc.*, ed. Maurice Tourneux, 16 vols, Paris 1877–82

Habermas, J., *Structural Transformations in the Public Sphere* (1962), trans. T. Burger and F. Lawrence, Oxford, 1989

Hagedorn, C., *Betrachtungen über die Mahlerey*, Leipzig, 1762

Hamann, J. G., 'Aesthetica in nuce' (1762), trans. J. P. Crick, in H. B. Nisbet, 1985 (IIIB12)

Harris, H. S., *Hegel's Development: Towards the Sunlight, 1770–1801*, Oxford, 1972

Haskell, F., *Patrons and Painters: Art and Society in Baroque Italy*, New Haven and London, 1980

Hauser, A., *The Social History of Art*, vol. 3: *Rococo, Classicism and Romanticism*, trans. S. Goodman, London and Henley, 1962

Haydon, B. R. and Hazlitt, W., *Painting and the Fine Arts: being the articles under those heads contributed to the seventh edition of the Encyclopaedia Britannica*, Edinburgh, 1838

Haydon, B. R., *The Judgement of Connoisseurs upon Works of Art compared with that of Professional Men; in reference more particularly to the Elgin Marbles*, London, 1816 (VIIB11v)

Hazlitt, W., 'The Fine Arts' (1816), in B. R. Haydon and W. Hazlitt, 1838 (VIIB11vi)

Hegel, G. W. F., 'Earliest System-Programme of German Idealism' (*c*.1796), trans. H. S. Harris, in H. S. Harris, 1972 (VA15)

Hemsterhuis, F., *Lettre sur la Sculpture* (1765), Amsterdam, 1769 (IVA3)

Herbert, R. L., *David: Brutus*, London, 1972

Herder, J. G., *Herders Sämtliche Werke*, vol. 8, ed. Bernard Suphan, Berlin, 1892

Herder, J. G., *Plastik: Einige Warhnehmungen über Form und Gestalt aus Pygmalions bildendem Träume* (1778), in J. G. Herder, 1892 (VA7)

Hidalgo, J. G., *Principles for studying the sovereign and most noble Art of Painting* (1693), trans. Z. Veliz, in Z. Veliz, 1986 (IE9)

Hinz, S. (ed.), *Caspar David Friedrich in Briefen und Bekenntnissen*, Berlin, 1968

Hobbes, T. 'Answer to Davenant's Preface to *Gondibert*' (1650), in *The English Works of Thomas Hobbes*, vol. IV, ed. W. Molesworth, London, 1840 (ID3)

Hoffmann, E. T. A., 'Beethoven's Instrumental Music' (1813), trans. in O. Strunk, 1950 (VIB17)

Hogarth, W., 'Of Academies' (*c*.1760–1), in W. Hogarth, 1833 (IVA2)

Hogarth, W., *Anecdotes of William Hogarth, written by himself*, ed. J., Ireland, London, 1833

Hogarth, W., *The Analysis of Beauty* (1753), New Haven and London, 1997 (IIIB3)

Holt, E. G., *A Documentary History of Art*, Princeton, 1958

Holt, E. G., *From the Classicists to the Impressionists: Art and Architecture in the 19th Century* (1966), London and New Haven, 1986

Holt, E. G., *The Triumph of Art for the Public 1785–1848*, Princeton, NJ (1979), 1983

Honour, H, *Neo-classicism*, Harmondsworth, 1968

Honour, H., *Romanticism*, New York, 1979

Hoogstraten, S., *Inleyding tot de hooge schoole der schilderkonst, anders de zichtbaere werelt*, Rotterdam, 1678 (IE7)

Hume, D., 'Of the Standard of Taste' (1757), in D. Hume, 1758 (IIIB5)

Hume, D., *Essays, Moral, Political, and Literary* (1758), ed. E. F. Miller, Indianapolis, 1985

Hutcheson, F., 'Preface' in *An Inquiry into the Original of our Ideas of Beauty and Virtue* (1725), London, 1738 (IIB7)

Ingres, J. A. D., Notebooks, *c*.1812–21, trans. W. Pach, in W. Pach, 1939 (VIIB12)

Jomard, E. F. *et al.*, *Description de l'Egypte, ou receuil des observations et des recherches qui ont été faites en Egypte pendant l'expédition de l'armée français*, Paris, 1809–28, and 1820–30 (VIIB8)

Jones, V. (ed), *Women in the Eighteenth Century*, London, 1990

Jouin, H. (ed), *Conférences de l'Académie Royale de peinture et de sculpture*, Paris, 1883

Junius, F., *The Painting of the Ancients* (1637), ed. K. Aldrich, P. Fehl and R. Fehl, Berkeley, CA, and Oxford, 1991 (IA1)

Kant, I., *Critique of Judgement* (1790), trans. H. Bernard, London, 1914 (VA10)

Kant, I., 'What is Enlightenment?' (1784), trans. H. B. Nisbet, in I. Kant, 1970 (VA8)

Kant, I., *Kant's Political Writings*, ed. Hans Reiss, Cambridge, 1970

Kitson, M., 'Hogarth's "Apology for Painters"', in *The Forty-First Volume of the Walpole Society 1966–1968*, Glasgow, 1968

Kleist, H., 'Brief eines jungen Dichters an einen jungen Maler' (1810), in H. Kleist, 1978 (VIB17)

Kleist, H., 'Empfindungen vor Friedrichs Seelandschaft' (1810), in H. Kleist, 1978 (VIB16)

Kleist, H., *Werke und Briefe*, vol. 3, ed. S. Streller, Berlin and Weimar, 1978

Klingender, F., *Art and the Industrial Revolution*, rev. edn, St Albans, 1975

Knight, R. P, *The Landscape: a Didactic Poem. Addressed to Uvedale Price Esq., The Second Edition*, London, 1795

Knight, R. P., *An Analytical Inquiry into the Principles of Taste*, London, 1805

Knight, R. P., *An Inquiry into the Symbolical Language of Ancient Art and Mythology*, London, 1818 (VIIB13)

Knowles, J., *The Life and Writing of Henry Fuseli, Esq*, 3 vols, London, 1831

Kramnick, I. (ed.), *The Portable Enlightenment Reader*, New York, 1995

Kristeller, P. O., 'The Modern System of the Arts', in Kristeller, 1965

Kristeller, P. O., *Renaissance Thought II: Papers on Humanism and the Arts*, New York, 1965

Kulturmann, U., *Geschichte der Kunstgeschichte*, Frankfurt am Main, Berlin, Vienna, 1981

La Curne de Sainte-Palaye, Jean-Baptiste de, *Lettre De M. de S. P. à M. de B. sur le bon goût dans les Arts & dans les Lettres* (1751), Geneva, 1972 (IIIC6)

La Font de Saint-Yenne, Etienne, *Réflexions sur quelques causes de l'état présent de la peinture en France*, The Hague, 1747 (IIIC1)

Lairesse, G. de, *The Great Book on Painting* (1707), trans. J. F. Fritsch as *The Art of Painting in All its Branches*, London, 1738 (IIA1)

Lamy, R. P. B., 'The Excellency of Painting' from *A Treatise of Perspective* (1684), trans. A. Forbes, London, 1702 (IE8)

Laugier, M.-A., *Essay on Architecture* (1753), trans. London, 1755 (IIIC5)

Lavater, J. K., 'Ueber das Landschaftsmalen. An Herrn Steiner in Winterthur', in *Antworten auf wichtige und würdige Briefe weiser und guter Menschen*, Zürich, 1790 (VB10)

Lavater, J. K., *Essays on Physiognomy for the Promotion of the Knowledge and the Love of Mankind*, trans. T. Holcroft, London, 1789 (VA6)

Le Blanc, Jean-Bernard, Abbé, *Lettre sur l'exposition des ouvrages de peinture, sculpture, etc., de l'Année 1747*, Paris, 1747 (IIIC2)

Le Brun, C., 'Conference on Expression' (1668), trans. J. Smith, *The Conference of Monsieur LeBrun . . . upon Expression, General and Particular*, London, 1701 (IB14)

Le Brun, C., 'First Conference' (1667), anonymous trans., in A. Félibien, 1740 (IB11)

Le Brun, C., 'Sentiments sur le discours du mérite de la couleur par M. Blanchard' (1672), in Fontaine, 1903 (IC9)

Le Brun, C., 'Sixth Conference' (1667), anonymous trans., in A. Félibien, 1740 (IB13)

Lee, R. W., *Ut Pictura Poesis: The Humanist Theory of Painting* (1940), New York, 1967

Lehr, F. H., *Die Blütezeit romantischer Bildkunst, Franz Pforr, der Meister des Lukasbundes*, Marburg, 1924

Lenoir, A., *Description historique et chronologique des Monumens de Sculpture, réunis au musée des Monumens Français*, vol. 1, Paris, 1795 (IVB13)

Leslie, C. R., *Memoirs of the Life of John Constable* (1843), ed. J. Mayne, London, 1951

Lessing, G. E., *Laocoön: An Essay on the Limits of Painting and Poetry* (1766), trans. E. A. McCormick, Baltimore and London, 1984 (IIIA10)

Lichtenberg, G. C., *Letters from England* (1776–8), trans. M. L. Mare and W. H. Quarrell, in M. L. Mare and W. H. Quarrell, 1938 (VA5)

Lichtenstein, J, Groulier, J.-F., Laneyrie-Dagen, N. and Riout, D. (eds), *Textes Essentiels: La Peinture*, Paris, 1995

Lichtenstein, J., *La couleur éloquente*, Paris, 1989

Liotard, J.-E., *Traité des principes et des règles de la peinture* (1781), ed. Pierre Cailler, Geneva, 1945 (IVA12)

Lipking, L., *The Ordering of the Arts in Eighteenth-Century England*, Princeton, NJ, 1970

Locke, J., 'Of the Association of Ideas' in *An Essay Concerning Human Understanding* (1700), ed. P. H. Nidditch, Oxford, 1975 (IIB1)

López-Rey, J., *Goya's Caprichos: Beauty, Reason & Caricature* (1953), Westport, CN, 1970

Mahon, D, *Studies in Seicento Art and Theory*, London, 1947

Mare, M. L. and Quarrell, W. H. (eds. and trans.), *Lichtenberg's Visits to England*, Oxford, 1938

Marin, L., *To Destroy Painting* (1977), Chicago, 1995

Marivaux, P., *Le Cabinet du philosophe* (1734), Geneva, 1970 (IB11)

Martinez, J., *Discursos practicables del nobilisimo arte de la pintura* (c.1675), ed. J. Gallego, Barcelona, 1950 (IC11)

McCoubrey, J., *American Art 1700–1960*, Englewood Cliffs, NJ, 1972

McGarr, Paul, 'The Great French Revolution', *International Socialism*, no. 43, June 1989.

McWilliam, N., Schuster, V. and Wrigley R. (eds), *A Bibliography of Salon Criticism from the Ancien Régime to the Restoration 1699–1827*, Cambridge, 1991

Mende Maupas, Comte de, Review of the Salon of 1789, trans. R. L. Herbert, in R. L. Herbert, 1972 (IVB3)

Mengs, A. R., 'A Discourse upon the Academy of Fine Art at Madrid' (1792), trans. J. N. D. Azara in A. R. Mengs, 1796 (IVA4)

Mengs, A. R., *Reflections upon Beauty and Taste in Painting* (1762), trans. J. N. D'Azara, in A. R. Mengs, 1796 (IIIB13)

Mengs, A. R., *The Works of Anthony Raphael Mengs*, trans. J. N. D'Azara, London, 1796

Mérot, A., *Nicolas Poussin*, London, 1990

Meulen, M. van der, *Rubens Copies After the Antique*, vol.1: Text, London, 1994

Montague, J., *The Expression of the Passions: The Origin and Influence of Charles Le Brun's 'Conference sur l'Expression Generale et Particuliere'*, New Haven and London, 1994

Montesquieu, Charles-Louis de Secondat, Baron de, 'An Essay on Taste' (1757), trans. in A. Gerard, 1764 (IIIB7)

Moritz, K. P., 'On the Creative Imitation of Beauty' (1788), trans. R. R. Heitner, in J. W. Goethe, 1994 (VA9)

Nahm, M. C., *Readings in Philosophy of Art and Aesthetics*, Englewood Cliffs, NJ, 1975

Newhall, B. (ed.), *Photography: Essays and Images*, New York, 1980/London, 1981

Nisbet, H. B. (ed.), *German Aesthetic and Literary Criticism: Winckelmann, Lessing, Hamann, Herder, Schiller, Goethe*, Cambridge and London, 1985

Norgate, E., *Miniatura or the Art of Limning* (1628/48), ed. J. M. Muller and J. Murrell, New Haven and London, 1997 (IE1)

Novalis (Hardenberg, F.), The Blue Flower, from *Henry of Ofterdingen: A Romance* (1799–1801), anonymous trans., Cambridge, 1842 (VIB4)

Novalis (Hardenberg, F.), 'Fugitive Thoughts' (1798–1801), trans. M. J. Hope, in *Novalis (Friedrich von Hardenberg). His Life, Thoughts and Work*, London, 1891 (VIA3)

Oppé, A. P., *Alexander and John Robert Cozens*, London, 1952

Overbeck, F., 'The Three Ways of Art' (1810), trans. in L. Eitner, 1970 (VIIB6)

Pach, W., *Ingres*, New York and London, 1939

Pacheco, F., *Arte de la Pintura* (1649), ed. F. J. Sanchéz Canton, Madrid, 1956 (IA3; IE5)

Palomino y Velasco, A., *El Museo Pictórico, y escala óptica*, Madrid, 1715 (IIA5)

Panofsky, E., *Idea: a Concept in Art Theory* (1924), trans. J. J. S. Peake, Columbia, 1968

Parliamentary Report see Great Britain.

Pascal, B., *Penseés* (*c*.1654–1662), trans. A. J. Krailsheimer, Harmondsworth, 1966 (ID5)

Paulin, T., *The Day-Star of Liberty: William Hazlitt's Radical Style*, London, 1998

Pears, I., *The Discovery of Painting: The Growth of Interest in the Arts in England 1680–1768*, New Haven and London, 1988

Perrault, C., *Mémoires de ma vie*, ed. P. Bonnefon (1909), Paris, 1993

Perrault, C., *Parallèle des anciens et des modernes*, Paris, 1688 (IA7)

Perry, G. and Rossington, M. (eds), *Femininity and Masculinity in 18th century Art and Culture*, Manchester, 1994

Pforr, F., Letter to Passavant, 6 January 1808, in F. H. Lehr, 1924 (VIIB5)

Piles, R. de, 'Remarks on *De Arte Graphica*' (1668), trans. J. Dryden, in A. E. W. Maurer and G. R. Guffrey, 1989 (IC5)

Piles, R. de, *Dialogue upon Colouring* (1673), trans. J. Ozell, London, 1711 (IC10)

Piles, R. de, *The Principles of Painting* (1708), anonymous trans., London, 1743 (IIA2)

Plymley, K., Notebook and diary entries, *c*.1790–7, unpublished notebooks and diaries, Shropshire Research and Records Office (VB16)

Potts, A., 'Political Attitudes and the Rise of Historicism in Art Theory', *Art History*, vol. 1, no. 2, June 1978

Potts, A., 'Winckelmann's Construction of History', *Art History*, vol. 5, no. 4, December 1982

Potts, A., *Flesh and the Ideal: Winckelmann and the Origins of Art History*, New Haven and London, 1994

Poussin, N. 'Observations on Painting' (*c*.1660–5), trans. A. Blunt, in A. Blunt, 1967 (IB2)

Poussin, N., Letters to Chantelou and to Chambray (1647/65), trans. A. Blunt, in A. Blunt 1967 (IB1)

Poussin, N., Recollections of Poussin (1662–85), trans. F. Claris and B. Maison, in A. Mérot, 1990 (IB3)

Praz, N., *On Neoclassicism* (1940), trans. A. Davidson, London, 1969

Price, U., *A Dialogue on the Distinct Characters of The Picturesque and the Beautiful in answer to the Objections of Mr. Knight*, London, 1801 (VB15)

Price, U., *An Essay on the Picturesque, as Compared with the Sublime and the Beautiful*, London, 1794 (VB13)

Puttfarken, T., *Roger de Piles' Theory of Art*, New Haven and London, 1985

Pyne, W. H., *Etchings of Rustic Figures, for the embellishment of Landscape*, London, 1815 (VIIA12)

Quatremère de Quincy, A. C., *Considérations sur les Arts du Dessin en France*, Paris, 1791 (IVB7)

Ramdohr, F., 'Über ein zum Altarblatte bestimmtes Landschaftsgemälde von Herrn Friedrich in Dresden, und über Landschaftsmalerei, Allegorie und Mystizismus überhaupt' (1809), in S. Hinz, 1968 (VIB13)

Ramdohr, F., *Charis, oder ueber das Schöne und die Schönheit in den nachbildenden Künsten*, Leipzig, 1793 (VB12)

Ramsay, A., 'Dialogue on Taste' in *The Investigator*, no. CCCXXII, London, 1755 (IIIB4)

Read, H., *The True Voice of Feeling: Studies in English Romantic Poetry*, London, 1953

Reid, T., *Essays on the Intellectual Powers of Man* (1785) in T. Reid, 1803 (IIIB15)

Reid, T., *Essays on the Powers of the Human Mind*, 3 vols, Edinburgh, 1803

Rembrandt van Rijn, Letters to Constantijn Huygens 1636–9, in W. L. Strauss and M. van der Meulen, 1979 (IE3)

Repton, H., *Letter to Mr Price*, London, 1794.

Repton, H., *Sketches and Hints on Landscape Gardening*, London, 1795

Reynolds, J., *Discourses* (1769–1790), ed. P. Rogers, Harmondsworth, 1992 (IVA7, 8; VA2)

Reynolds, J., Letters to the *Idler* (1759), in J. Reynolds, 1992 (IIIB9)

Richardson, J., *A Discourse on the Dignity, Certainty, Pleasure and Advantage of the Science of a Connoisseur*, London, 1719 (IIA7)

Richardson, J., *Essay on the Theory of Painting* (1715), London, 1725 (IIA6)

Richardson, J., *Works*, London 1773

Richter, H., *Daylight; a recent discovery in the Art of Painting*, London, 1817 (VIIA13)

Rosenblum, R., *Transformations in Late Eighteenth-Century Art*, Princeton, NJ, 1967

Rousseau, J.-J., 'Discourse on the Arts and Sciences' (1750), trans. G. D. H. Cole. in J.-J. Rousseau, 1913 (IIIA2)

Rousseau, J.-J., 'Discourse on the Origins of Inequality' (1755), trans. G. D. H. Cole. in J.-J. Rousseau, 1913 (IIIA3)

Rousseau, J.-J., *The Social Contract and the Discourses*, trans. G. D. H. Cole, London, 1913

Roworth, W. W. (ed.), *Angelica Kauffmann: A Continental Artist in Georgian England*, London, 1992

Roworth, W. W., 'Kauffmann and the Art of Painting in England', in *Angelica Kauffman. A Continental Artist in Georgian England*, London, 1992

Rubens, P. P., 'De Imitatione Statuorum' (*c.* 1608–10), anonymous trans. in R. de, Piles, 1743 (IC1)

Rubens, P. P., Letter to Franciscus Junius, 1637, trans. in F. Junius, 1991 (IA2)

Runge, P. O., *Die Begier nach der Möglichkeit neuer Bilder: Briefwechsel und Schriften zur bildenden Kunst*, ed. H. Gärtner, Leipzig, 1982

Runge, P. O., Letter to Goethe, 3 July 1806, in P. O. Runge, 1982 (VIIA8)

Runge, P. O., Letter to his brother Daniel, 9 March 1802, trans. M. Sniderman, in J. C. Taylor, 1987 (VIB5)

Runge, P. O., Letters to his father, his brother Daniel and Ludwig Tieck, 1802, in P. O. Runge, 1982 (VIB5)

Saint–Lambert, J.-F., 'Genius' (1757), trans. S. J. Gendzier, in S. J. Gendzier, 1967 (IIIC8)

Salon reviews from *Mémoires secrets* (1783–5), in B. Fort, 1999 (IVB1)

Sani, B. (ed.), *Rosalba Carriera: Lettere, Diari, Frammenti*, Florence, 1985

Scannelli, F., *Il microcosmo della pittura* (1657), ed. G. Giubbini, Milan, 1966 (IC2)

Schama, S. *Rembrandt's Eyes*, London, 1999

Schama, S., *The Embarrassment of Riches: an Interpretation of Dutch Culture in the Golden Age*, London, 1987

Schelling, F., 'Concerning the Relation of the Plastic Arts to Nature' (1807), trans. M. Bullock, in H. Read, 1953 (VIA8)

Schiller, F., *On the Aesthetic Education of Man in a Series of Letters* (1795–6), trans. and ed. E. M. Wilkinson and L. A. Willoughby, Oxford, 1967 (VA12)

Schiller, F, *On the Naive and Sentimental in Literature* (1795–6), trans. H. W. O'Kelly, Manchester, 1981 (VA13)

Schlegel, A. W., *A Course of Lectures on Dramatic Art and Literature* (1808), trans. John Black, London, 1846 (VIA9)

Schlegel, F., 'Athenaeum Fragments' (1798), trans. P. Firchow, in F. Schlegel, 1991 (VIA2)

Schlegel, F., 'Critical Fragments' (1797), trans. P. Firchow, in F. Schlegel, 1991 (VIA1)

Schlegel, F., *Description of Paintings in Paris and the Netherlands in the Years 1802–04* (1805), in F. Schlegel, 1848 (VIA7)

Schlegel, F., *Philosophical Fragments*, trans. P. Firchow, Minneapolis and Oxford, 1991

Schlegel, F., *The Aesthetic and Miscellaneous Works of Friedrich von Schlegel*, trans. E. J. Millington, London, 1849

Schubert, G. H., *Views on the Dark Side of Natural Science* (1808), trans. in W. Vaughan, H. Börsch-Supan and H. J. Neidhardt, 1972 (VIB12)

Shaftesbury, Third Earl of, see Cooper, A. A.

Sharpe, L, *Friedrich Schiller: Drama, Thought and Politics*, Cambridge, 1991

Shelley, P. B., *A Philosophical View of Reform* (1819–20), in P. Foot, 1990 (VIA12)

Shenstone, W., Letter to Richard Graves, 8 January 1760, in W. Shenstone, 1777 (IVA1)

Shenstone, W., 'Unconnected Thoughts on Gardening' (1764), in *The Works in Verse and Prose of William Shenstone*, London 1764 (VB1)

Shenstone, W., *Works* (1769), ed. R. Dodsley, London 1777

Sheriff, M. D., *The Exceptional Woman: Elisabeth Vigée-Lebrun and the Cultural Politics of Art*, Chicago, 1996

Smith, J. T., *Remarks on Rural Scenery*, London, 1797

Staël, Madame de (A. L. G. Necker, Baroness of Staël-Holstein), *Corinne; or, Italy* (1807), trans. Philadelphia, 1836 (VIB6)

Strauss, W. L. and van der Meulen, M., *The Rembrandt Documents*, New York, 1979

Strunk, O., *Source Readings in Music History*, New York, 1950

Stuart, J. and Revett, N., *The Antiquities of Athens*, London 1762 (IIIA7)

Sulzer, J. G., *Allgemeine Theorie der schönen Künste*, Leipzig, 1774 (VB6)

Taylor, B., *Art for the Nation*, Manchester, 1999

Taylor, J. C., *Nineteenth-Century Theories of Art*, Berkeley and Los Angeles, 1987

Ten Kate, L. H., *The Beau Ideal* (1728), trans. J. C. Le Blon, London, 1732 (IIB10)

Testelin, H., *The Sentiments of the most Excellent Painters Concerning the Practice of Painting; Collected and Composed in Tables of Precepts* (1680), anonymous trans., London, 1688 (IB15)

Teyssèdre, B., *Roger de Piles et les débats sur le coloris au siècle de Louis XIV*, Paris, 1964

Thompson, E. P., *Witness Against the Beast: William Blake and the Moral Law*, Cambridge, 1993

Tieck, L., *Franz Sternbalds Wanderungen* (1798), ed. Alfred Anger, Stuttgart, 1979 (VIB2)

Tiphaigne de la Roche, C. F., *Giphantia* (1760), trans. London, 1761 (IIIB11)

Tobler, G. C., 'Die Natur' (1782–3), in J. W. Goethe, 1955 (VB8)

Tomlinson, J. A., *Goya in the Twilight of the Enlightenment*, New Haven and London, 1992

Tooke, W., *Pieces written by Mons. Falconet and Mons. Diderot on Sculpture in General*, London, 1777.

Trumbull, J., Letter to Thomas Jefferson, 1795, in J. W. McCoubrey, 1965 (IVB5)

Turnbull, G., *A Treatise on Ancient Painting*, London, 1740 (IIIA1)

Turner, J. M. W., 'Backgrounds, Introduction of Architecture and Landscape' (1811), ed. J. Ziff, *Journal of the Warburg and Courtauld Institutes*, vol. XXVI, London, 1963 (VIIA10)

Uhde-Bernays, H. (ed.), *Künstlerbriefe über Kunst*, Frankfurt am Main, Zurich, Vienna, 1962

Valenciennes, P.-H., *Elémens de perspective pratique, à l'usage des artistes, suivis de Réflexions et Conseils à un Elève, sur la Peinture, et particulièrement sur le genre du Paysage*, Paris, 1800 (VIIA3)

Vaughan, W., Börsch-Supan, H. and Neidhardt, H. J., *Caspar David Friedrich, 1774–1840, Romantic Landscape Painting in Dresden*, London, 1972

Vaughan, W., *German Romantic Painting*, 2nd edn, New Haven and London, 1994

Veliz, Z. (trans. and ed.), *Artists' Techniques in Golden Age Spain. Six Treatises in Translation*, Cambridge and London, 1986

Venning, B., 'Turner's Annotated Books: Opie's *Lectures on Painting* and Shee's *Elements of Art*', Parts I, II, and III, in *Turner Studies*, London, vol. 2, no. 1, Summer 1982; vol. 2, no. 2, Winter 1983; vol. 3, no. 1, Summer 1983

Vigée-Lebrun, E., *The Memoirs of Elisabeth Vigée-Lebrun*, trans. Siân Evans, London, 1989 (VIIA14)

Vitet, L., *L'Académie royale de peinture et de sculpture, Étude historique*, Paris, 1861

Voltaire (Arouet, F.-M.), 'Essay on Taste' (1757), trans. in A. Gerard, 1764 (IIIB8)

Voltaire (Arouet, F.-M.), 'Beautiful, Beauty' from *Dictionnaire Philosophique* (1764), in *Les Oeuvres complètes de Voltaire*, vol. 35, Oxford, 1994 (IIIB14)

Vries, L. de, *Gerard de Lairesse*, Amsterdam, 1998

Wackenroder, W., *Confessions from the Heart of an Art-Loving Friar* (1796), trans. M. H. Schubert, in *Wilhelm Heinrich Wackenroder's Confessions and Fantasies*, University Park and London, 1971 (VIB1)

Wakefield, P., *Reflections on the Present Condition of the Female Sex*, London, 1798 (VIIA2)

Watelet, C.-E. and Lévesque, P.-E., *Dictionnaire des arts de peinture, sculpture et gravure* (1792), Geneva, 1972 (IVA15)

Webb, D., *An Inquiry into the Beauties of Painting*, London, 1760 (IIIA6)

Wedgwood, T. and Davy, H., 'An Account of a Method of Copying Paintings Upon Glass, and of Making Profiles', *Journal of the Royal Institution of Great Britain*, 1802 (VIIA5)

West, B., *A Discourse delivered to the Students of the Royal Academy*, London, 1793 (VIIB1)

West, B. and Copley, J. S., Correspondence 1766–7, in *Letters and Papers of John Singleton Copley and Henry Pelham, 1739–1776*, Boston: Massachusetts Historical Society, no. 71, 1914 (IVA5)

West, B., Letter to the Earl of Elgin, 6 February 1809, in *Memorandum on the Subject of the Earl of Elgin's Pursuits in Greece*, Edinburgh, 1810 (VIIB11ii)

West, B., *The Death of General Wolfe* (*c.*1771), in J. Galt, 1820 (IVA6)

Whately, T., *Observations on Modern Gardening*, London, 1770

Willard, S., Sermon LI (1701), in Willard, 1726 (ID8)

Willard, S., Sermon XVII (1689), in Willard 1726 (ID8)

Willard, S., *A Compleat Body of Divinity in Two Hundred and Fifty Expository Lectures on the Assembly's Shorter Catechism*, Boston, 1726

Winckelmann, J. J., *A History of Ancient Art* (1764), trans. G. H. Lodge, New York, 1968 (IIIA8)

Winckelmann, J. J., *Reflections on the Imitation of Greek Works in Painting and Sculpture* (1755), trans. E. Heyer and R. C. Norton, La Salle, IL, 1987 (IIIA5)

Winstanley, G., *The Law of Freedom and other Writings*, ed. C. Hill, Harmondsworth, 1973 (ID4)

Wollstonecraft, M., 'On Poetry and our Relish for the Beauties of Nature', *Monthly Magazine*, April 1797 (VB18)

Wollstonecraft, M., *A Vindication of the Rights of Men in a Letter to the Right Honourable Edmund Burke* (1790), in M. Wollstonecraft, 1989 (IVB6)

Wollstonecraft, M., *The Works of Mary Wollstonecraft*, ed. J. Todd and M. Butler, London, 1989

Wordsworth, W., 'Advertisement' to *Lyrical Ballads* (1798), in W. Wordsworth, 1974 (VIA5)

Wordsworth, W., 'Preface' to *Lyrical Ballads* (1800), in W. Wordsworth, 1974 (VIA6)

Wordsworth, W., *The Prose Works of William Wordsworth*, vol. 1, ed. W. J. B. Owen and J. W. Smyser, Oxford, 1974

Wotton, W., *Reflections upon Ancient and Modern Learning*, London, 1694 (IA8)

Wrigley, R., *The Origins of French Art Criticism*, Oxford, 1993

Young, E., *Conjectures on Original Composition* (1759), Leeds, 1966 (IIIB10)

Ziff, J., 'J. M. W. Turner on Poetry and Painting', in *Studies in Romanticism*, vol. III, no. 4, London, Summer 1964

Copyright Acknowledgements

Index